The Bauhaus

Weimar Dessau Berlin Chicago

Hans M. Wingler

1919–1925	Bauhaus Weimar
1925–1932	Bauhaus Dessau
1932–1933	Bauhaus Berlin
1937–1938	The New Bauhaus Chicago
1939–1944	School of Design Chicago
1944–	Institute of Design

The MIT Press Cambridge, Massachusetts
and London, England

Translated by Wolfgang Jabs
and Basil Gilbert.
Edited by Joseph Stein.

Originally published in German in 1962
under the name "Das Bauhaus" by Verlag
Gebr. Rasch & Co., Bramsche and M Du-
Mont Schauberg, Cologne, Germany. Sec-
ond, revised edition published in 1968.

This English-language edition was adapted
from the German text and includes exten-
sive supplementary material.

English adaptation
Copyright © 1969 by
The Massachusetts Institute of Technology

Most of the illustrations were reproduced
from material supplied to the publisher by
Hans M. Wingler. Those no longer available
were reproduced from the German edition.

Design by Muriel Cooper
Set in Linofilm Helvetica by Book Graphics,
Inc.
Printed on Mohawk Superfine
by Halliday Lithograph Corporation
Bound by Russell-Rutter Company

Color plates 1–8 and 17–24 printed by Dr.
Cantzsche Druckerei, Stuttgart–Bad Can-
statt, and color plates 9–16 printed by Gebr.
Rasch & Co., Bramsche, Germany.

SBN 262 23033 X

Library of Congress catalog card number:
68–20052

In Memory of my Parents Hans Wingler 1890–1965 and Gertrud Wingler née Lange 1899–1968

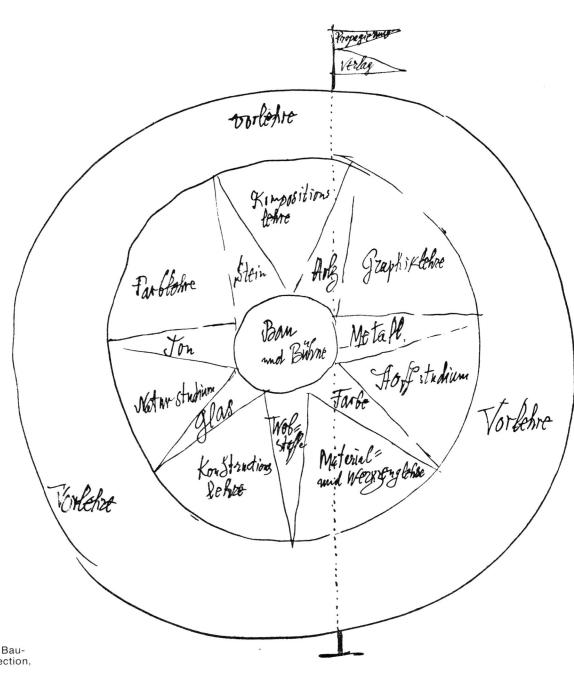

1
Paul Klee: Idea and structure of the Staatliche Bauhaus. Pen-and-ink drawing. 1922. Private collection, Darmstadt.

Ludwig Mies van der Rohe
The Bauhaus was an Idea. . . .
(Quoted from Siegfried Giedion, ''Walter Gropius,'' Reinhold Publishing Corp., New York, 1954)

''The Bauhaus was not an institution with a clear program—it was an idea, and Gropius formulated this idea with great precision. . . . The fact that it was an idea, I think, is the cause of this enormous influence the Bauhaus had on every progressive school around the globe. You cannot do that with organization, you cannot do that with propaganda. Only an idea spreads so far. . . .''

Foreword

The primary purpose of this publication is documentation. It is intended to acquaint the reader with the significant milestones in Bauhaus history—significant in the immediate as well as in the secondary sense—and as a detailed commentary to the documented facts. It was not our aim to establish a theory. Final judgment about the accomplishment of the Bauhaus will undergo many changes for a long time to come; this is a sure sign of its vitality. This presentation serves exclusively to supply source material. It would be most welcome if the material here presented would contribute to further intellectual studies.

The impetus for the investigation of the history of the Bauhaus was supplied by Dr. Emil Rasch of Osnabrück. It was to a large extent his generous support that made the completion of this book possible. The realization of our intention to bring as broad a basis as possible to this undertaking was largely due to the efforts of Professor Walter Gropius of South Lincoln, Massachusetts. Thanks to his confidence and his positive attitude it was possible to tap sources that otherwise would have remained closed. In addition, this work was supported by Professor Ludwig Mies van der Rohe of Chicago and many other former Masters and students of the Bauhaus and their families. The friendly help supplied by various institutions, particularly the Busch-Reisinger Museum of Germanic Culture in Cambridge, Massachusetts, and the Museum and Landeshaupt-archiv in Weimar was invaluable.

Financial support for the years of study and extended travel was supplied primarily by the Rockefeller Foundation of New York and by Theodor Heuss, who was then President of the Federal Republic of Germany, the Industry Form Association of Essen, and the wallpaper manufacturers Rasch Brothers & Co. in Bramsche.

A wealth of pictorial material which became available since the publication of the first German edition of this book in 1962 made it possible to undertake a whole series of changes and supplements in this edition. The bibliography and the roster of former students could also be extended. An additional trip to the United States became necessary. It was generously supported by the Graham Foundation of Chicago. Its Director, John D. Entenza, suggested extending the investigation so as to include the successor institutions originally founded by Moholy-Nagy in Chicago in 1937. These included the New Bauhaus, which after a dramatic inception and a troubled career continued its existence as the "School of Design," later renamed "Institute of Design." A number of selected documents attempt to bring to life both the external and internal development of the Institute during its most important stages. In this research the following were particularly helpful: Professor Sibyl Moholy-Nagy of New York, Professor Serge Chermayeff of New Haven, Professor Jay Doblin of Chicago, Mrs. Marli Ehrman of Oak Park, Illinois, and Professors Richard Koppe, Elmer Ray Pearson, and John Walley, all of Chicago. In addition to the abundance of material which these people put at our disposal, valuable information and suggestion were supplied by a number of other former Bauhaus Masters and students.

All those who have been named, and many who have not, deserve sincere thanks. This appreciation is also expressed in the name of the Bauhaus-Archiv in Darmstadt, which was founded in connection with the preparative work for this book in 1960, largely due to the support which Professor Gropius extended to this project. The work done has been of invaluable help to the Bauhaus-Archiv, particularly during the first years of its existence. At the same time it became a fundamental prerequisite for its systematic continuation.

Hans Maria Wingler

Contents

xv

From Paul Klee's course: manuscript page by
Klee with notes concerning the problem of
"arrangement," "reversals," and "mirroring" of
the colors. Original in the Paul Klee Foundation
at the Bern Art Museum.
One of the numerous class notes for the compulsory
second-semester course. Klee, always concerned with
methodical improvement and development, taught
this course at the Bauhaus from 1920 until his de-
parture in 1931.

2
From Ludwig Hirschfeld-Mack's workshop:
combinations of black, white, and red; arrange-
ments of the three colors according to the prin-
ciples of division into three (left column), arith-
metic progression (second column), geometric
progression (third column), and the golden
section (right column). Tempera. Reconstructed
in 1967 after Hirschfeld's original. Property of
the Bauhaus-Archiv, Darmstadt.
Hirschfeld-Mack complemented Johannes Itten's pre-
liminary course with his workshop, which concerned
itself with questions of color theory and composition.
3
From Wassily Kandinsky's color seminar: stu-
dent projects from the 1929-1930 classes. Upper
group: studies concerning the affinity between
color and line; left, study by Eugen Batz; right,
study by Hans Thiemann. Lower group: studies
concerning the affinity between color and form,
executed by Eugen Batz. Tempera on press-
board. Property of the Bauhaus-Archiv,
Darmstadt.
Kandinsky's color seminar was an integral part of the
preliminary course and was compulsory for the first
semester. Kandinsky contributed to the elementary
courses from 1922 until 1933 by conducting his semi-
nars, which included that of "analytical drawing."

Products of the Workshops

4

Typographical work by Moholy-Nagy, Bayer, and J. Schmidt. 1923-1929. Upper left: Joost Schmidt, brochure for an office-supply house in Weimar, 1924. Upper center: Herbert Bayer, brochure (front and back) for a product of the Fagus works, 1923. Upper right: Bayer, poster for the Kandinsky exhibition at the Anhalt Art Association in Dessau, 1926. Center left and lower left: Laszlo Moholy-Nagy, prospectus (front and back) for the Bauhaus-Verlag and for the Bauhaus books originally planned for publication there, 1924. Center right: Bayer, invitation to the building-completion festival in Dessau, 1926. Lower right: Moholy-Nagy, "14 Bauhaus books," cover for an eight-page prospectus of the Albert Langen Verlag in Munich, 1929.

Specimens of these prints are in the possession of the Bauhaus-Archiv, Darmstadt.

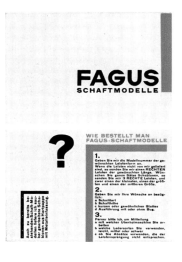

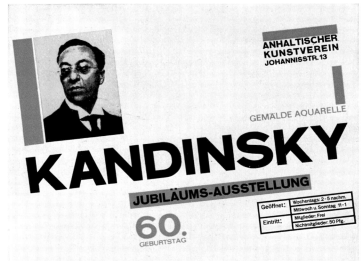

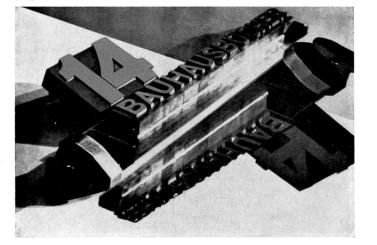

Typographical work by Bayer and J. Schmidt. 1923-1926. Upper left: Herbert Bayer, cover for a book edited at the Bauhaus in Weimar concerning the work done during 1919-1923 at the Institute, 1923. Upper right: Bayer, invitation to the ''White Festival'' of the Bauhaus in Dessau, 1926. Lower left, Joost Schmidt, front cover of the special edition of the journal ''Offset, Buch und Werbekunst'' dedicated to the Bauhaus, 1926. Lower right: Bayer, poster for the exhibition ''European Arts and Crafts 1927'' at the Grassi Museum in Leipzig; designed in 1926. Specimens of these prints are in the possession of the Bauhaus-Archiv, Darmstadt.

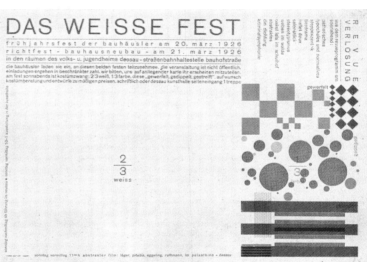

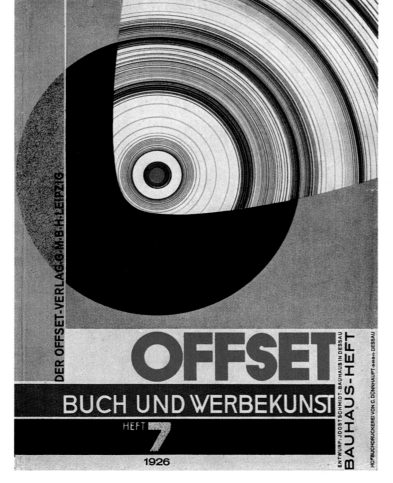

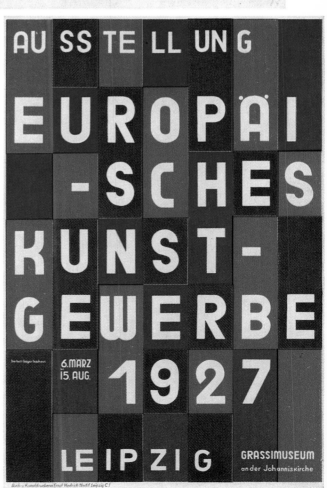

6
Advertising and exhibition designs by Herbert
Bayer. Upper left: kiosk for newspaper and
cigarette sales, tempera, 1924. Upper right:
open waiting room for a streetcar stop, com-
bined with a newsstand, tempera, 1924. Lower
left: exhibition pavilion, assembled from pre-
fabricated wall components, for showing agri-
cultural machinery, tempera, 1928. Lower left:
exhibition stand with equipment for sales pro-
motion by means of moving pictures, public-
address systems, luminescent signs, and letters
formed by smoke emission, tempera, 1924.
Original designs in private collection, Aspen, Colorado.

7
Stage designs by students at the Bauhaus. Top:
Kurt Schmidt, design for the ''Mechanical
Ballet'' of the Bauhaus stage, tempera, 1923;
private collection, Stuttgart. Center: Xanti
Schawinsky, design for the sketch ''Olga-Olga''
of the Bauhaus stage, tempera, 1927; private
collection, New York. Bottom: design for the
hotel scene (act IV) of ''USA with Music'' of the
Friedrich Theater in Dessau, tempera with spray
technique, 1930.
Private collection, Zurich.

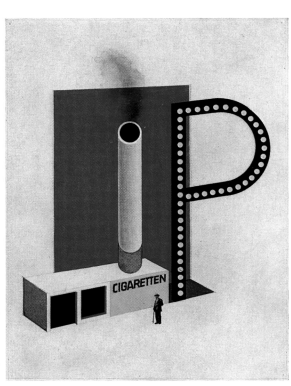

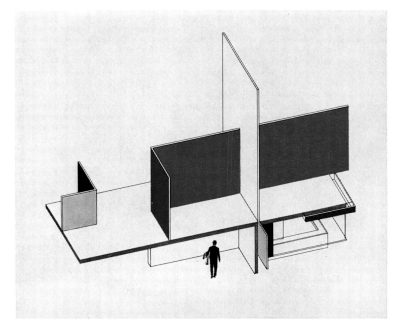

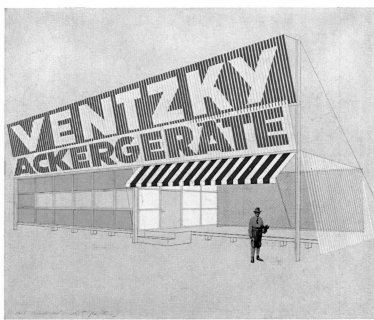

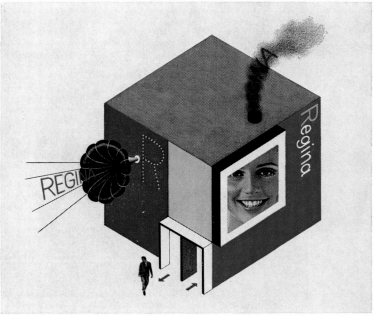

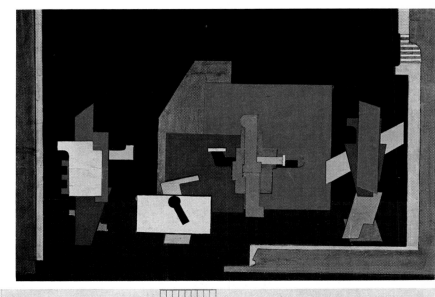

8
Anni Albers: wall hanging, double weave of silk, 222 x 122 cm, produced in the weaving workshop of the Bauhaus in Dessau, about 1927-1928. Bauhaus-Archiv, Darmstadt.
This work is characterized by formal strength and in this respect determined the later development of the Bauhaus weaving program.

9
Gunta Stölzl: wall hanging (slit gobelin) of linen (warp) and cotton (woof), 142 x 110 cm, produced in the Bauhaus weaving workshop in Dessau. 1927-1928. Bauhaus-Archiv, Darmstadt (on permanent loan from the Carpet Association in Wuppertal).
One of the significant artistic achievements of the Bauhaus weaving workshop, created during a period in which its primary efforts were directed toward industrial series productions.

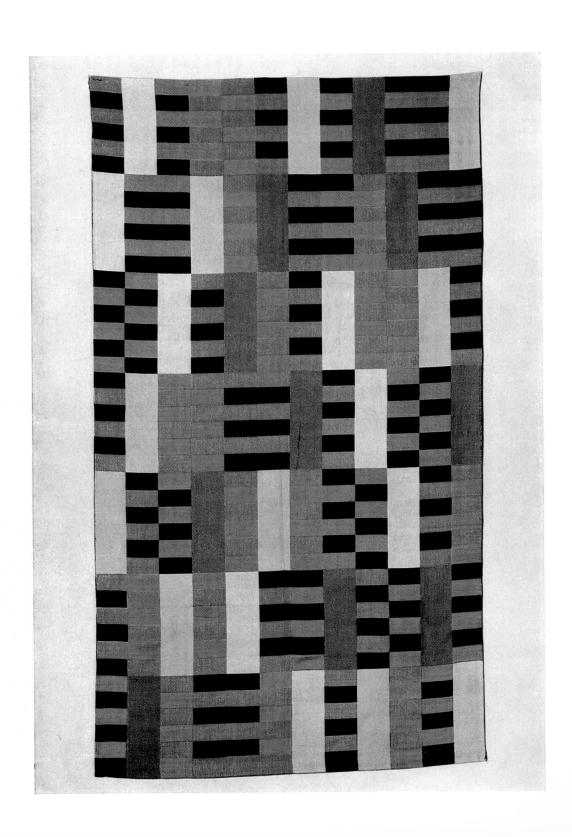

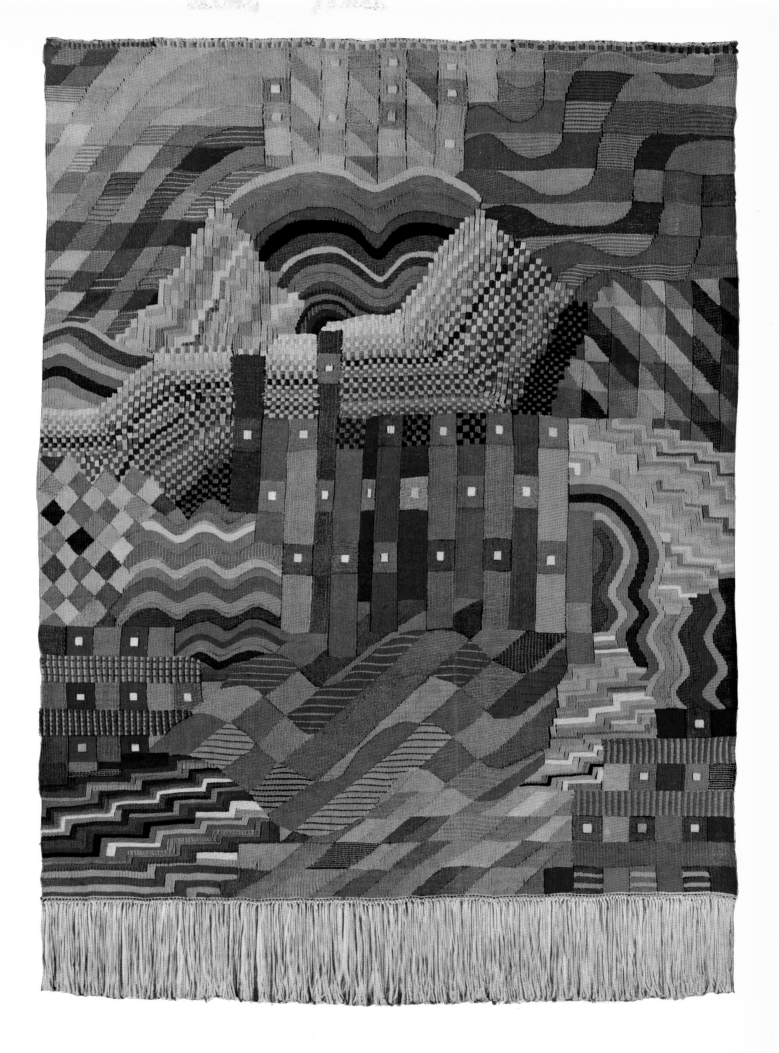

10

Utility textiles produced by the weaving work-
shop of the Bauhaus in Dessau. Original sizes
of swatches. Left, couch cover, upholstery and
drapery material, produced from designs of
Gunta Stölzl. 1925-1928. Right, upholstery
materials and (second from bottom) drapery
material using viscose fibers, produced from
designs by Otti Berger. 1928-1932. Bauhaus-
Archiv, Darmstadt.
These swatches are very characteristic for the weaving
done at the Bauhaus, especially with respect to struc-
ture and coloration. Industry increasingly drew sub-
stance from this impetus.

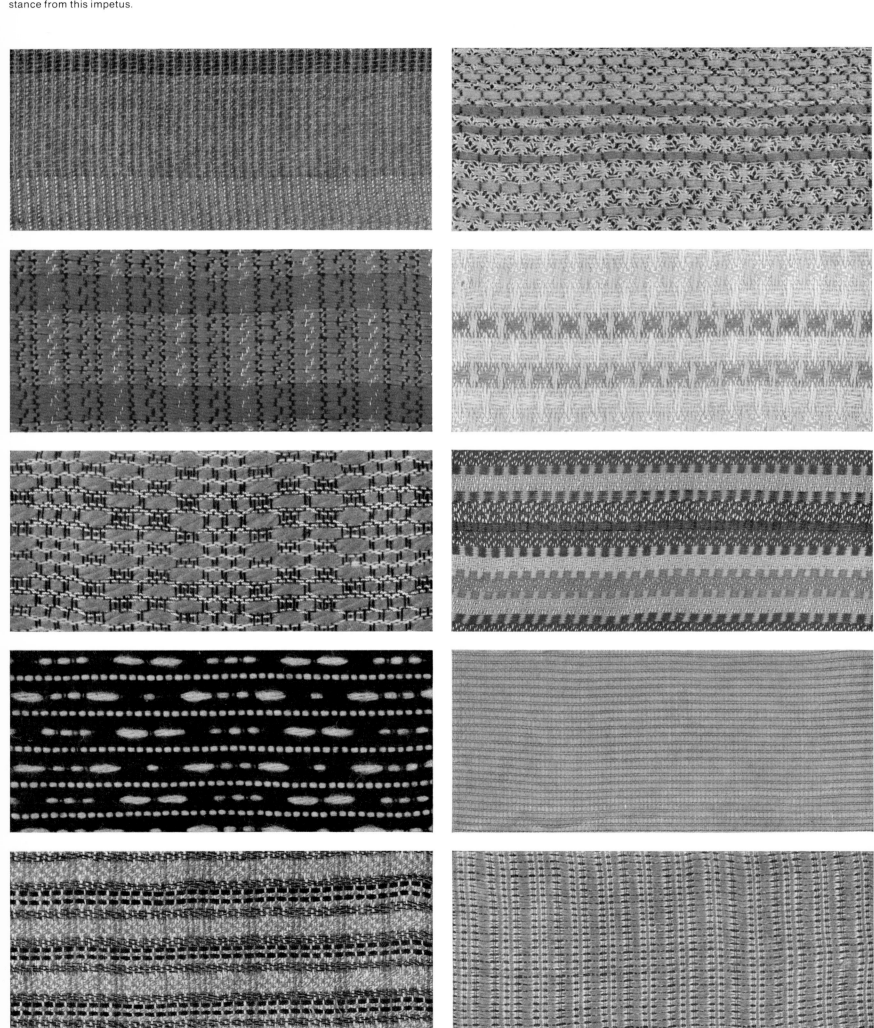

Bauhaus wallpapers. From the 1930 collection.
Original sizes of swatches. Industrially produced
and sold by the wallpaper concern Rasch
Brothers & Co., of Bramsche, after designs of
the workshop for wall painting at the Bauhaus
in Dessau. Bauhaus-Archiv, Darmstadt.
The first Bauhaus wallpaper collection to be marketed
was developed in 1929. The 1930 collection embraced
more than one hundred varieties of patterns and color-
ation. The Bauhaus wallpapers were distinguished by
their fundamental avoidance of representational
ornamentation and by their clear structure, which
along with the coloration was the determining factor
for their effect.

Artistic Work—Masters and Students

12
Johannes Itten; color sphere in seven color-ations and twelve gradations of color. Basic study for the theory of colors. Published in the periodical "Utopia—Dokumente der Wirklich-keit" (Utopia, Documents of Reality), Weimar, 1921. (Scale 2:3.)

13
Lyonel Feininger: "Upper Weimar." Oil on canvas, 80 x 100 cm, 1921. Boymans—van Beuningen Museum, Rotterdam.
Feininger paraphrased Thuringian architectural motives in countless paintings and graphic works. The rural suburb of Upper Weimar was a favorite gathering place for the teachers and students of the Bauhaus.

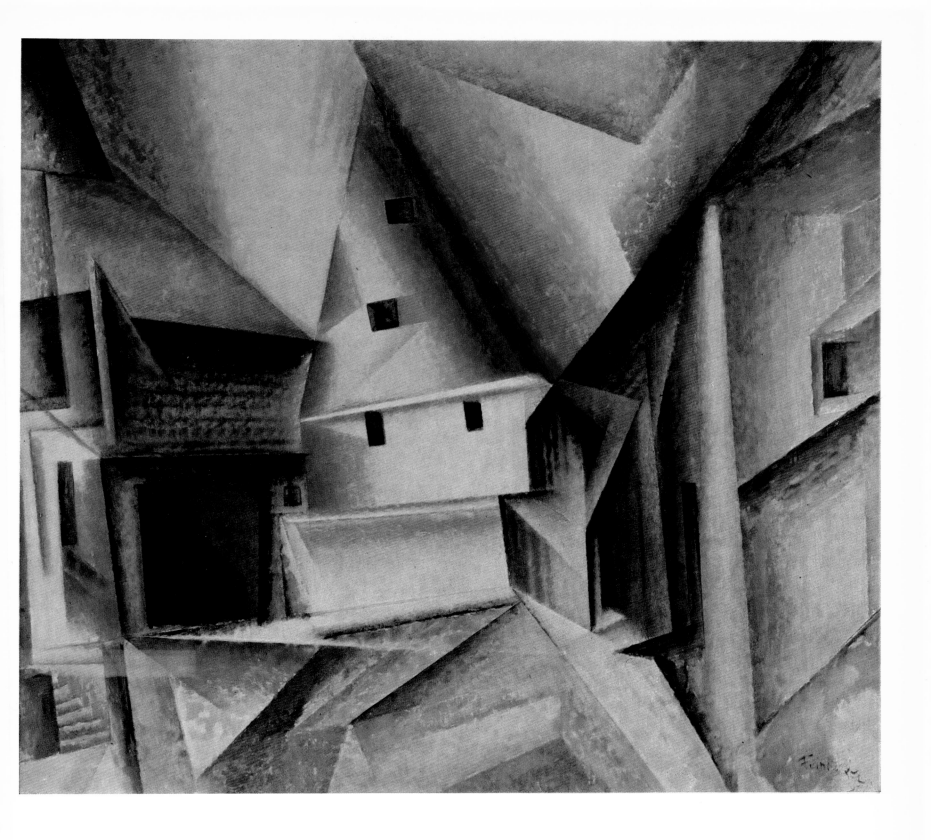

14
Paul Klee: "Senecio." Oil on canvas, 41 x 38 cm, 1922. Art Museum, Basel.
The Weimar Bauhaus period represented a time of highest productivity for Klee, during which he produced a remarkable number of his principal works.
15
Wassily Kandinsky: "Red in the Net." Oil on cardboard, 62 x 49 cm, 1927. Formerly in Leonard Hutton Galleries, New York.
In Dessau, where in their "Master houses" they lived and worked "wall to wall," a remarkably fruitful intellectual exchange took place between Kandinsky and Klee, which manifested itself in many of their works. Paintings such as the one here reproduced bear witness to this creative communication.

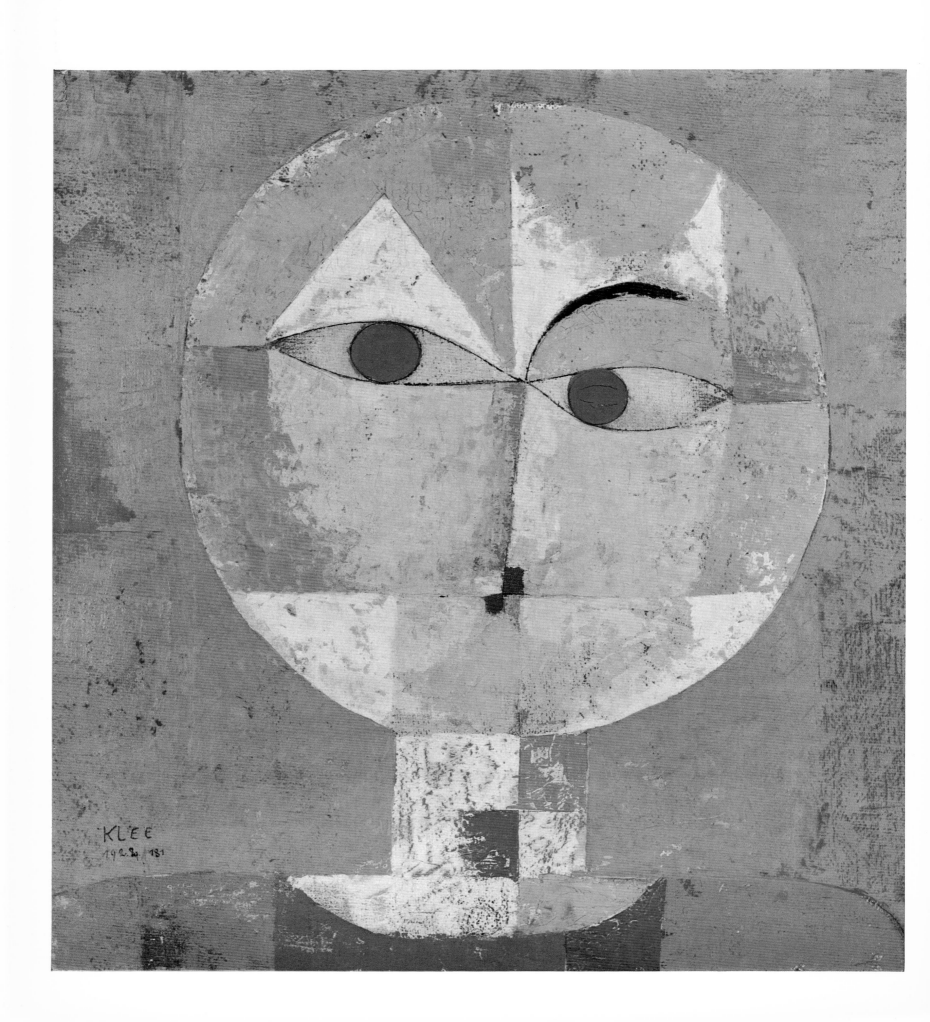

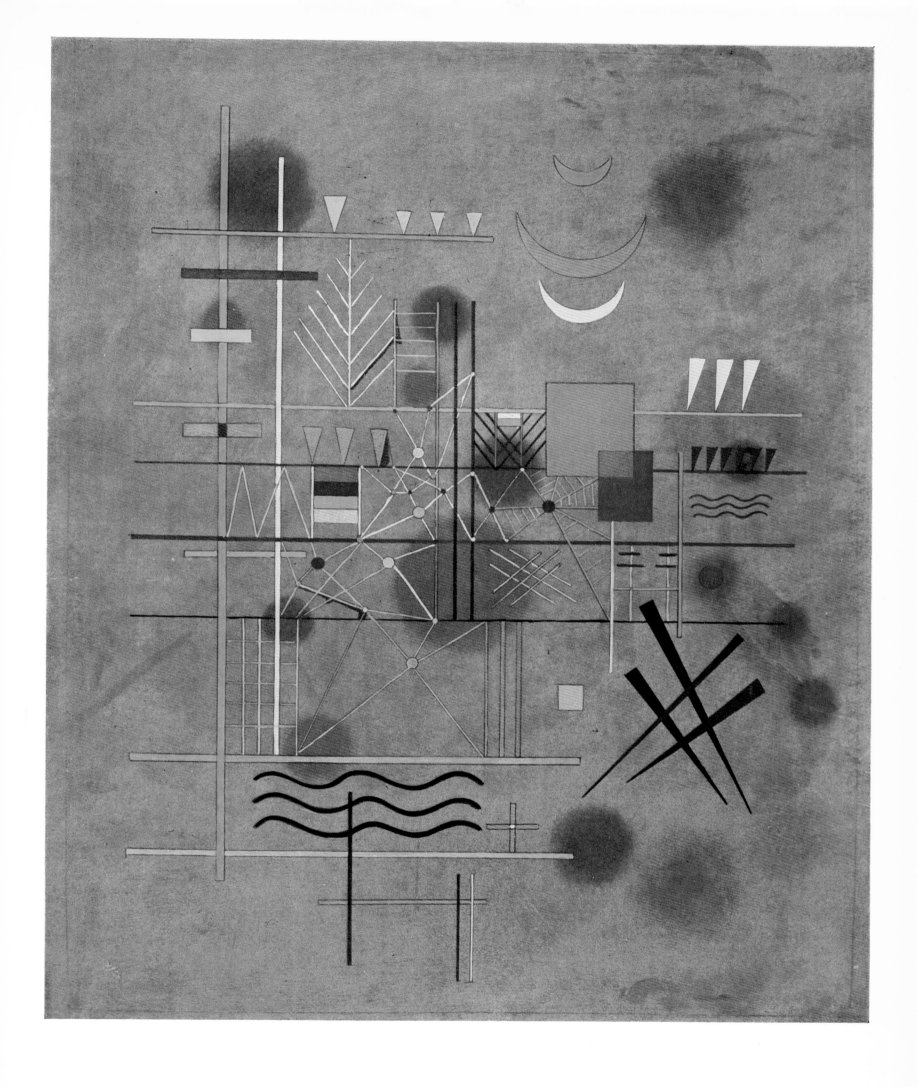

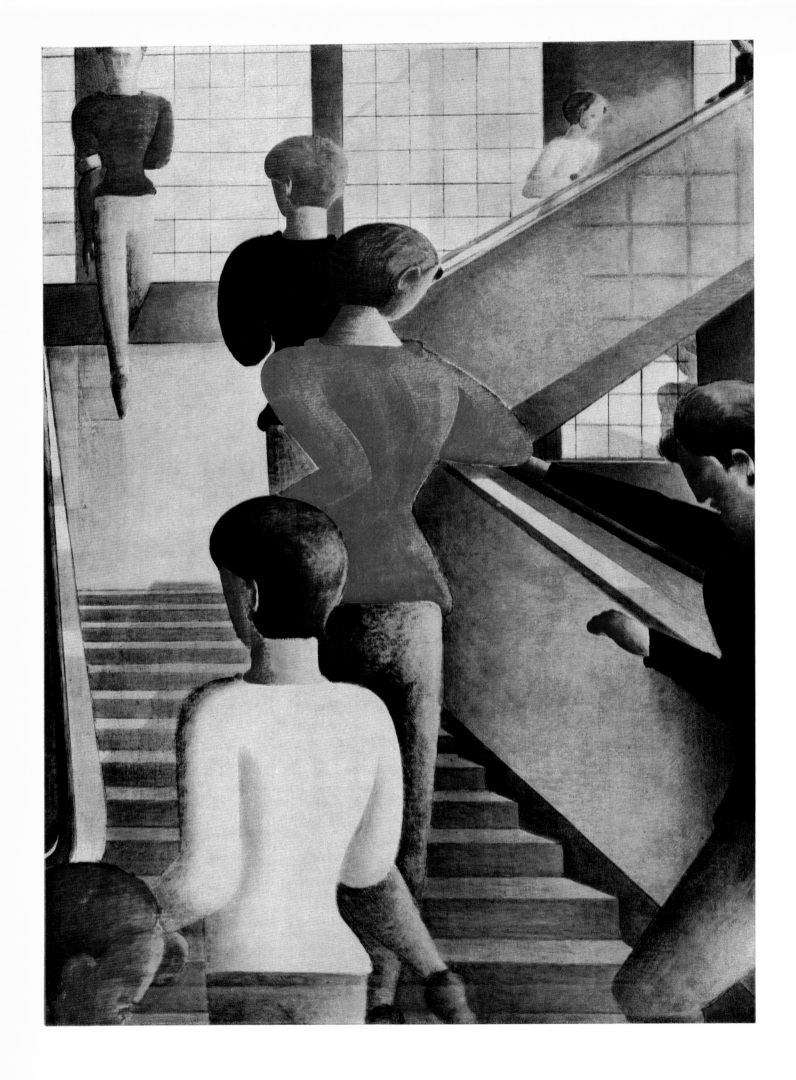

16
Oskar Schlemmer: "Bauhaus Staircase." Oil
on canvas, 162 x 103 cm, 1932. Museum of
Modern Art, New York (gift of Philip C. Johnson).
Schlemmer has produced this painting, which can be
considered not alone one of his own principal works
but one of those of the entire Bauhaus school, at the
time of his professorship at the Breslau Academy, in
memory of the staircase of the Dessau Bauhaus
building.
17
Oskar Schlemmer: Sketch for the wall designs
in the staircase of the workshop building at the
Weimar Bauhaus. Water color and pencil,
41 x 53 cm, 1923. Bauhaus-Archiv, Darmstadt,
on loan from Mrs. Tut Schlemmer, Stuttgart.
This is the over-all sketch used for the execution of
the wall designs; cf. the reproductions of the rooms
and (reconstructed) models in the picture section of
this volume devoted to the Bauhaus exhibition of the
summer of 1923. In addition to this sketch there also
exist several studies for individual figures, resp.
figure groups.

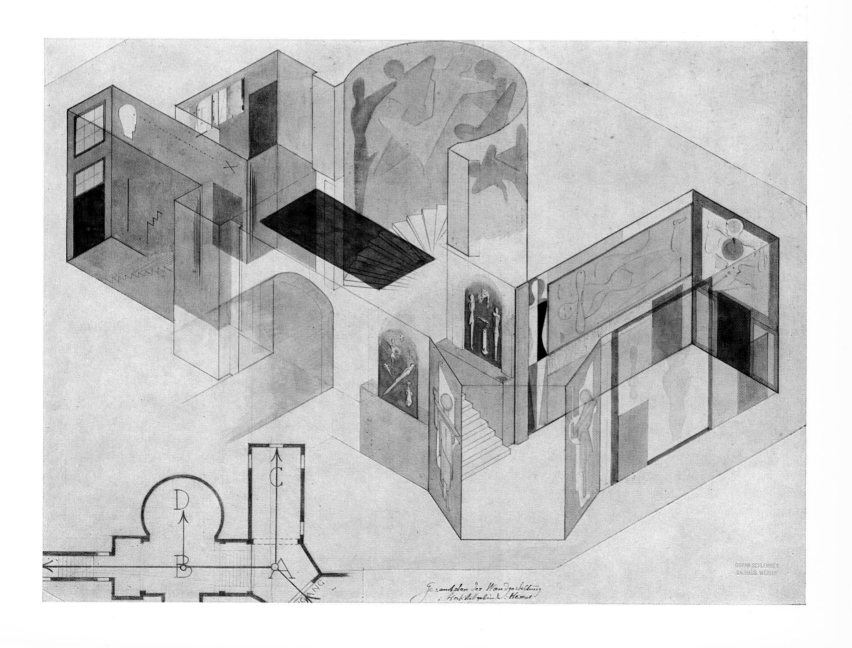

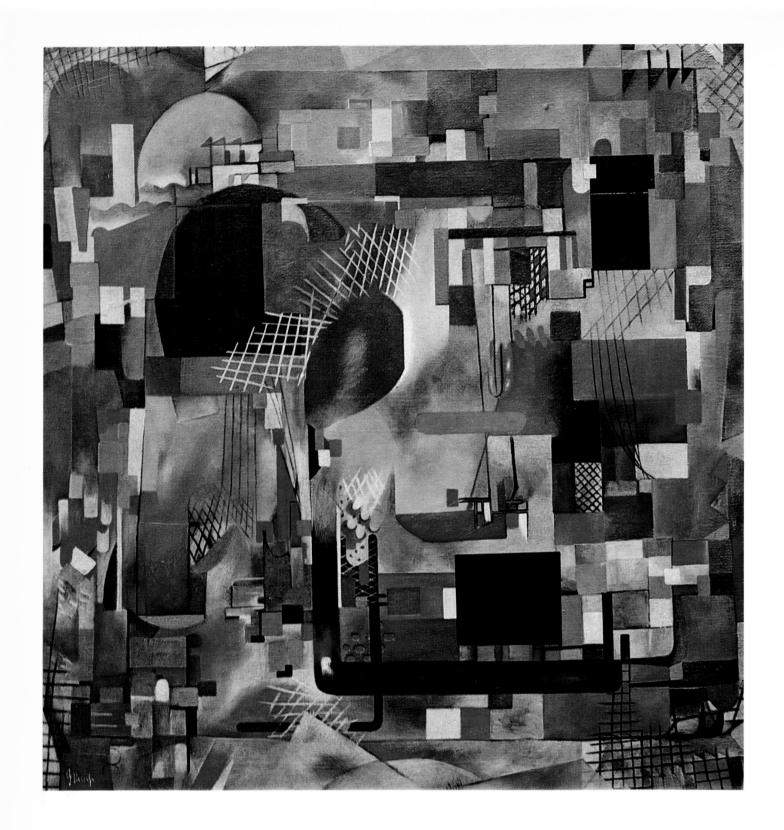

18

Georg Muche: "Picture with lattice motif I."
Oil on canvas, 151 x 136 cm, 1916. Private col-
lection, Schlüchtern (Hessen).
A remarkably early abstraction by Muche, created at
the time of his first one-man show at Herwarth
Walden's "Sturm" gallery in Berlin.

19

Laszlo Moholy-Nagy: "A m 7." Oil on canvas,
76 x 95 cm, 1926. Private collection, Munich.
"The fact that Moholy-Nagy turned to a rhythmically
extremely delicate and richly moving form design and
a brilliant gamut of colors, with the determination
characteristic of him, is probably due to his essentially
Hungarian heritage. The lightly mobile, sensually
joyous elements of this consciousness recoil from ex-
cessively abrupt and final ties. Consequently, the easel
painting by no means signified to Moholy-Nagy a stale,
rudimentary throwback to old times, as it may appear
in the eyes of other constructivists. In any event, the
architectonic unity toward which constructivism
strives cannot be achieved solely through a wall paint-
ing or a relief. . . . [The easel painting] may well be
conceived as a draft for wall painting, this as a pre-
liminary stage for the perfectly stable incorporation
of the free wall-space formation into architectural
space. It can be understood as a jump-off place toward
the cinematographic construction picture. On the
other hand, the easel painting can also be considered
as a faint image of a set of colored light bundles, de-
void of all architectonic connections or even ap-
proaches, which radiate out into wide space. Moholy-
Nagy concerned himself in great detail with this
thought, both theoretically and practically. A long
series of constructions with transparent forms super-
imposed on one another aims toward the solution of
the problem of the reflectory play of light in free
space." (Quoted from Ernst Kállai, "Neue Malerei in
Ungarn" (Modern painting in Hungary), Leipzig, 1925,
pp. 112f.)

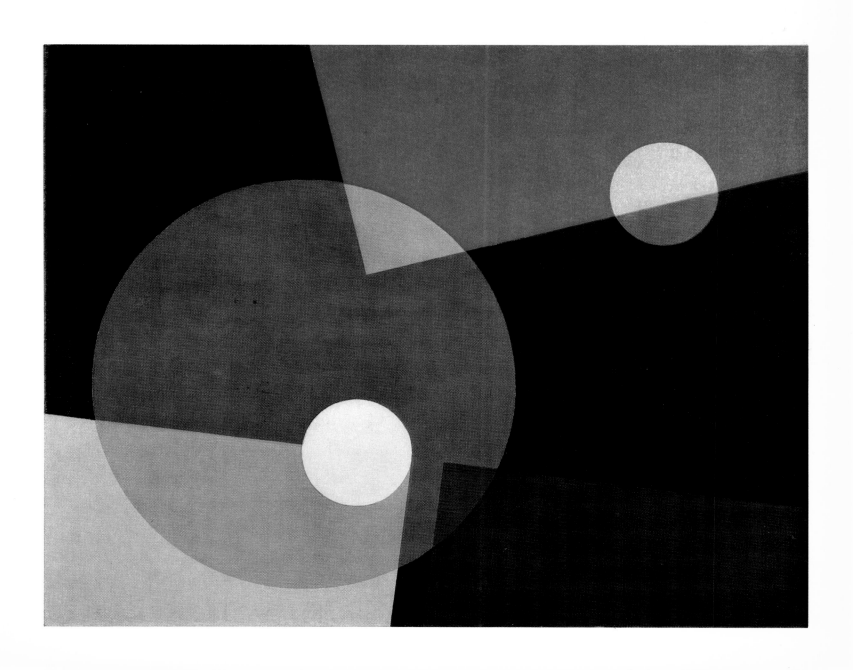

20

Xanti Schawinsky: "Explosion." Oil and tempera on canvas, 61 x 43 cm, 1926-1927. Private collection, New York.

During his period as Bauhaus student, from 1924 to 1926, Schawinsky was in particularly close contact with Oskar Schlemmer. His achievements, especially in the design of exhibits during these and later years, were excellent. After his Bauhaus period he worked as illustrator for the city administration of Magdeburg and also in Berlin. In Italy, where he moved in 1933, he attracted attention because of his highly effective advertising material for Olivetti. Since 1936 he lives in the United States, where he began as a faculty member at Black Mountain College, N.C., along with Josef Albers. He settled in New York in 1936, where he is active as a free-lance artist. The paintings of his Bauhaus period, such as the one reproduced here, were created outside the regular classroom work, as independent, entirely personal manifestations. The surrealistic tendencies that characterize Schawinsky's early work, which may have disclosed the style of the "Neue Sachlichkeit" (New Objectivity), at the time in the foreground of Germany's artistic trends, were similarly present in the works of other young Bauhaus painters. There is a sense of compilation of various elements into a single image which seems to cry out for practical applications, for concrete problems, such as those offered by advertising art, by exhibit design, and by stage structure.

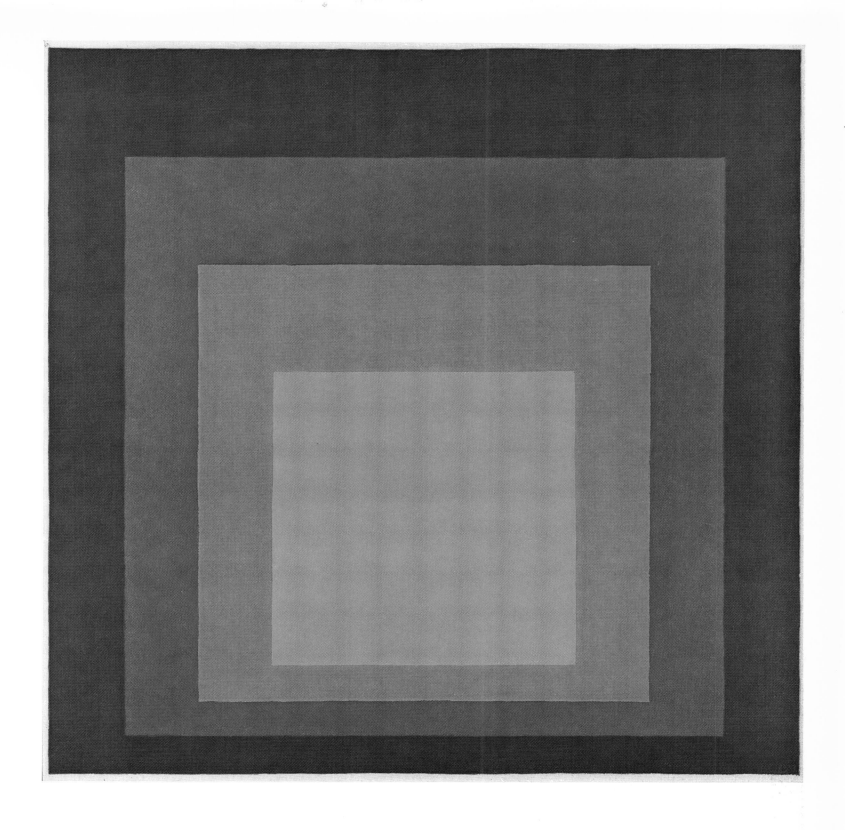

**Further Development: Later Paintings
21**
Josef Albers: "Homage to the Square — Fall
Finals." Oil on fiberboard, 76 x 76 cm, 1963.
Galerie Müller, Stuttgart.
As a creative artist as well as a theoretician, Albers
became one of the most significant, in fact pioneering,
colorists during his decades of work in the United
States; one facet of his genius that had not manifested
itself prior to 1933 now came into full bloom. In his
extensive series "Homage to the Square" a recurring
composition of interlocked squares becomes the
conveyor of colored fields of seemingly unending
variety. "Seeing several of these paintings next to
each other makes it obvious that each painting is an
instrumentation in its own. This means that they are
all of different palettes, and, therefore, so to speak, of
different climates. Choice of colors used, as well as
their order, is aimed at interaction — influencing and
changing each other forth and back. Thus, character
and feeling alters from painting to painting without
any additional 'hand writing' or, so called, texture.
Though the underlying symmetrical and quasi-con-
centric order of squares remains the same in all paint-
ings — in proportion and placement — these same
squares group or single themselves, connect and
separate in many different ways. In consequence, they
move forth and back, in and out, and grow up and
down and far and near, as well as, enlarged and di-
minished. All this, to proclaim color autonomy as a
means of plastic organisation." (Quoted from Josef
Albers, "On my 'Homage to the Square,'" in the
catalog of the Albers exhibit at the Gallery Gimpel
Fils, London, July 1961.)

22

Johannes Itten: "Spirals." Oil on canvas, 50 x 50 cm, 1967. Private Collection, Zurich.
Itten completed this painting in March of 1967, shortly before his death. It may well be considered one of those works in which his creative strength and above all his striving for color have reached a climax. Ever since his early years of study he has constantly pursued coloristic problems, such as, for example, simultaneous contrasts; yet during the middle period of his creativity the artistic realizations have to take second place to his accomplishments as an educator, a theoretician, and an institute administrator. His autonomous artistic work outshines his earlier as well as his later period. Erwin Gradmann, in the catalog for the Itten Memorial Exhibit in Darmstadt, 1967, writes: "This is a work that arose in quiet seclusion, without striving for publicity, and that today, as we review it, surprises us by its vitality and the mastery of its manifold expression. . . . Itten's last works thus have metaphysical character—the shadows of fading life. In whatever Itten has created it is the spirit of search that speaks, a truly artistic force and a harmony with nature and humanity."

Herbert Bayer: "Chromatic into Two Centers."
Oil on canvas, 127 x 127 cm, (measured diag-
onally), 1967 (No. 44). Private collection, Aspen,
Colorado.
In the monograph edited by himself in 1967, he con-
fesses: "I consider myself to be primarily a painter,
and painting is the continuous link connecting the
various facets of my work. . . . Abstract art, to which
I became exposed at the Bauhaus, introduced me to
the phenomena of pure and elemental form and color.
But being of an impressionable nature with an active
imagination, I see the rich diversity of life with its un-
bounded possibilities for the artist. . . . Although con-
cern with subject matter at various periods over-
shadowed my interest in pure elements and in the
structural in painting, it sustains all of my imagery
and became more pronounced since 1954. . . . The
latest works explore concrete elements of unblem-
ished purity such as the abstract line and the properties
of monochrome coloring. Occupation with such ele-
ments stems from the desire to reduce the image to a
minimum . . . to free it of complexities and implica-
tions." (Quoted from "herbert bayer — painter, de-
signer, architect," Reinhold Publishing Corp., New
York, 1967.)

Fritz Winter: "Before Blue." Oil on canvas,
135 x 97 cm, 1967. Private collection, Nürnberg.
Fritz Winter, born 1905 in Altenbögge (Westphalia),
a student at the Bauhaus from 1927 until 1930, is one
of the most prominent exponents of abstract painting
in the West German Federal Republic. He lives in
Diessen/Ammersee (Upper Bavaria) and since 1955
holds a chair at the Academy of Fine Arts in Kassel.
"Fritz Winter most clearly belongs to that fine con-
tinuity of German romantic thought that the Blaue
Reiter introduced into modern sensibility and that
was further developed by Klee's work. . . . Winter
started from that point. . . . There was in addition his
own personal experience. In his youth Winter had
worked as a miner and there, in the gray glimmer of
the rocks, had seen and lived with sunken primeval
forms, the imprints of an earlier world. The processes
of becoming and passing away here came to life for
him in a secret stratum. . . . Winter sought a form at
the level of the pictorial that could convey this poetic
experience. . . ." (Quoted from an article by Werner
Haftmann in the catalog of the exhibition "German
Art of the Twentieth Century," Museum of Modern
Art, New York, 1957.)

The Bauhaus

Weimar Dessau
Berlin Chicago

The Bauhaus

Weimar Dessau
Berlin Chicago

Origin and History of the Bauhaus

The Bauhaus is, from the standpoint of cultural history, no isolated phenomenon. It was the climax and focus of a very complex and multifaceted development which reaches back to the romantic period, continues at the present, and is unlikely to terminate in the near future. Today the Bauhaus can be seen from a historical-critical point of view, and thus has already become an appropriate subject for research. Yet the wealth of ideas intimately embodied in the Bauhaus, which were exemplary both in their conception and in their transformation into reality, are continually being questioned as to their validity in the present-day world. Indeed, it is in this sense of their topicality, whether it be a question of their attack or defense, that the continuing strength of the Bauhaus heritage is to be found.

Institutionally the Bauhaus was an institute for art, which emerged as the successor to an academy and a school of arts and crafts through their mutual "integration." However, it must be borne in mind that the arts and crafts school in reality no longer existed, and the Bauhaus was marked by an antiacademic attitude from its very beginnings. It was a practical educational establishment with all the usual theoretical trappings and with a strong tendency toward practical and manual training. This practical tendency was so dominant that theoretical ideas were a little suspect, despite the fact that theory actually prevailed in the early days. However, within a few years of its inception, the educational ideals of craftsmanship were already giving way to thoughts of educating designers capable of designing products for mass production. It even became one of the goals of the Bauhaus to undertake product development in its own workshops and thus provide a broader economic basis which in turn could prove profitable for the institution. The very complexity of the intellectual problems and of the technical problems of administration—both in their conception and in their solution—was the expression of a living reality, and it is in this sense that the phenomenon demands to be viewed as a totality, not through mere intellectual understanding, but through the powers of sympathetic awareness. In fact, one is obliged to keep in mind that it is only through such intuition that the Bauhaus in its deepest and final significance can be fully and completely understood.

How and where is the achievement of the Bauhaus to be concretely grasped? What, in short, is that achievement? Does it lie, first and foremost, in the powerful impulse given to the "New Architecture" by the Bauhaus architects—especially Walter Gropius and Ludwig Mies van der Rohe? Is it in the contribution the Bauhaus made to the revolutions in the fields of home environment and industrial design? Or should it be seen primarily in the creative contributions of Bauhaus painters to the history of art, in that they, perhaps more than others, influenced the development of modern art during this century? The fundamental teaching methods of the Bauhaus have transformed art-teaching methods throughout the world. Is it in this revolutionary method that the essential achievement is to be found?

What gave the Bauhaus its singular position and extraordinary influence was more than the sum total of the achievements of its Masters; for the Bauhaus incorporated something intangible—a fundamental human quality—which encompassed the whole community, teachers and students alike. In no way were the students mere learners and thus passive receptacles of knowledge: giving and receiving were thoroughly interchangeable. However, the community found its greatest expression in the consciousness of a common social responsibility—in that social ethic to which Gropius had irrevocably bound the Bauhaus and those striving to achieve its ideals in his Manifesto of April 1919.

This Manifesto of 1919 emphasized two ideas: It called for the unity of all the creative arts under the primacy of architecture and for a reconsideration of the crafts by the artist. The thesis "Art and Technology—A New Unity" was added in 1923 as a third programmatic goal, extending and partially revising the requirement regarding the reacquisition of handicraft fundamentals. Such reflections had moved progressive thinkers and designers ever since the middle of the 19th century, and the history of their reflections and polemical arguments is an essential part of the history of ideas leading to the Bauhaus.

Triggered by 19th-century technological-industrial development, a seemingly unbridgeable gap had opened between artistic conception and realization, between the "spiritual" on one hand and the "materialistic" on the other. With the closing of the late baroque period, architecture and the art of building cities, the highest form of the architectonic, had lost their capability of binding the other creative arts together and uniting them into an all-inclusive "total work of art" (Gesamtkunstwerk). As isolation and lack of unity between the arts increased, the status of the crafts dropped. Emphasis shifted unfavorably from the finished work to the concept itself, toward the sketch, toward the "touch of genius." In the fields of sculpture and painting this led to that phenomenon which was later disparagingly called "salon art." For architecture and the applied arts the consequences were even more serious, since progressive mechanization and the consequent possibility of producing cheap, yet deceptively real, substitutes for handmade work brought the value of craftsmanship into question. Once the creative designer had thought up and put his ideas on paper, it seemed irrelevant whether these ideas were realized by hand or machine. By the first decades of the 19th century the role of the craftsman had dropped to that of manual assistant. With the intention of raising the standards of hand work, Schinkel had already undertaken the publication of "pattern sheets" to serve as design models, making it possible for the least imaginative craftsman to put well-shaped goods on the market. However, such tutelage really only doctored the symptoms and actually led to a further debilitation of the already ailing crafts.

Around the middle of the century, Gottfried Semper stood nearly alone with his critical insight that a new and fruitful solution to the problem would emerge only when the machine had thoroughly destroyed traditional craft fundamentals. An approach to

the solution had already been made by Sir Henry Cole in England with the founding of the "Art Manufacturers" in 1847. Cole was not content merely to come to terms with the machine, but sought to use it constructively in the arts and crafts. But the realization of his aim—the elevation of public taste by the esthetic and qualitative improvement of machine products—certainly required more accurate knowledge of the specific potentialities of machine production than was available at that time. The most outspoken pioneers of the movement for a regeneration of the handicrafts (the writer John Ruskin and the talented and versatile designer William Morris) both passionately rejected the machine and claimed that only through creative handicraft could an increase in human happiness be achieved. What made Morris one of the foremost reformers, apart from the high quality of his own contributions to the arts and crafts, was his bold attempt to break the chains of historic style imitation. Style imitation had become such a passion during the nineteenth century that it seemed doubtful whether anything independent— in the sense of a "style"—would ever be forthcoming again. The trauma of the impotence of art relative to its powerful and extremely rich history was to continue much longer. As late as the beginning of the nineteen twenties the great historian Ernst Troeltsch, in his book "Der Historismus und seine Probleme" (Problems of Historicism), had postulated that the backward orientation of culture could be overcome only by the authoritative power and qualities of a widely influential work of art, such as the "Divine Comedy" had represented in another era. By the time Troeltsch made this demand—then one of common concern—the most important works of the Cubists and the "Blaue Reiter" had long been finished, buildings such as the "Faguswerk" in Alfeld had been completed, and a community had formed at the Weimar Bauhaus which, perhaps more than any other, contributed to the establishment of new cultural values.

The intense longing for the comprehensive Gesamtkunstwerk came to life again only shortly after it had been relegated to the historical past and was no longer unquestioningly regarded as the highest fulfillment of the great, collectively-supported processes of artistic evolution. It was not only Richard Wagner who had it in mind to create such a work in the realm of the theatre; the concept was present in the thought of all important creative personalities around 1850, and it acquired something of a mystical dimension, with a promise of artistic rebirth. Above all, this ardent desire for the Gesamtkunstwerk referred repeatedly to historical precedents. Fighting to the last, Gottfried Semper desperately evoked the past in his own architectural works, and yet he was the very architect who had so sensibly evaluated the beginnings of mass production in the home-building industry which he had observed in England and who, as few others had done, grasped the significance of honesty of material and genuineness of workmanship, and enunciated principles whose validity stands undiminished even when applied to modern industrial design. Here the discrepancy persisting in 19th-century thought between the ambitious concept of "grand art" and the domain of the utilitarian, of practical objects designed for use, becomes strikingly evident, and can most clearly be seen in the field of engineering structures—built with a grandiose élan but with little serious consideration for artistic principles. But a universal mind such as that of Gottfried Semper was able to realize itself most fruitfully when dealing with problems of education or when grappling with the concept of "totality" or "completeness," where human qualities are emphasized above artistic ones. It seems that some of Semper's most important suggestions were followed in the establishment of the South Kensington School in London, the most distinguished school of arts and crafts in the second half of the century.

Some of the German schools of arts and crafts of this period, which in some respects ranked high above the international average, also attempted to attune theory and practice to each other in a remarkably impartial manner, and to regard craft training not as a secondary but as a quite fundamental factor in education. The two most progressive among the schools of arts and crafts after 1900 were certainly that led by Henry van de Velde in Weimar and, even more important for historical development, that in Vienna, where Franz Cižek developed new principles of fundamental education. The tendency of the academies and the schools of arts and crafts to draw mutually closer to each other, which had produced good results, was strengthened most of all through the programmatic demands of Wilhelm von Bode, the influential Director of the Berlin Museum.

It was England, with its tendencies toward the practical, which was most susceptible to the movement to reform the handicrafts. In the arts and crafts movement arose an immensely influential—and hence propagandistically important—group, which was dedicated to the idea of achieving high quality in hand-produced goods. Again, very beneficial to the tendency toward a "total" design of the living environment was the fact that the traditional type of English countryhouse lent itself in a meaningful and efficacious way to reinterpretation according to modern needs. Thanks to such architects as Richard Norman Shaw, not only had English home building profited from this but also, since the end of the century, home building in Central Europe, to which Shaw had given a substantial stimulus. The development that took place in the United States, especially between 1870 and 1895 was similar in some respects.

Free from esthetic prejudices, American industry produced useful appliances that were not meant to "represent" anything but simply to serve their designated purpose, and thus many of these anticipated the functional forms which designers in Europe began seeking only shortly before the First World War. The achievements of engineers in the field of technical, utilitarian architecture—for instance in the building of bridges, silos, and warehouses—showed the way. The frank approach to technology swept away differences between "merely utilitarian" and "grand" architecture. The great architects who assembled after the Chicago fire of 1871 to effect the rebuilding of the city—including such brilliantly gifted men as Henry Hobson Richardson and Louis Sullivan—were able to turn the achievements of the engineers to their own constructive use. By altering the

1

structural body of the building, they gave rise to the steel-skeleton-supported office building, presenting it in accordance with Sullivan's dictum that "form follows function." It was in this presentation that functional architectural thought, to a certain extent still in the act of being born, found its first consummate expression.

Frank Lloyd Wright, Sullivan's pupil, extracted from the elements of the traditional American farm house possibilities and principles of design for contemporary and comfortable residential country architecture. But the dawn of a new architecture and a new industrial design was largely doomed to stagnation when European historicism invaded America around the middle of the 1890's. The next decisive steps were taken once again in the Old World, but they were not uninfluenced by those early American achievements, which had become known through publications. Adolf Loos told of what he had seen while working in Chicago, and expressed it in his buildings and writings, in which he proclaimed the esthetic charm of the ornament-free, of beauty which could be achieved through proportion and by allowing materials to reveal their true nature.

The architecture of *Art Nouveau* however, as represented by the buildings of Victor Horta for example, was still overgrown with decoration. But in its flowing spaciousness, thanks to the artistic discovery of iron and glass and a new sense of space, the intimate union of engineering and architecture now became an event of utmost significance in the center of Europe. The Scotsman Charles Rennie Mackintosh and the artists of the Wiener Werkstätte, who had been stimulated by his work, celebrated the angular beauty of geometry—the square—in their architecture and handicrafts, and, as pioneers, contributed significantly to the comprehension of the specifically technical form. The first to tackle this problem consciously and systematically was the architect Peter Behrens, who, from 1907 onward, was design consultant to the Allgemeine Elektrizitäts-Gesellschaft (AEG) in Berlin, in particular with respect to the production of their appliances.

Behrens's architectural office was also of pivotal importance in the history of architectural development in that it employed assistants who, each in his own manner, were to become the leading creators of the "New Architecture"—Gropius, Mies van der Rohe, and Le Corbusier. Before he moved to Berlin, Behrens had collaborated with the Viennese architect Josef Maria Olbricht and with others in the artists' colony at Darmstadt, which had been founded shortly before the turn of the century by the Grand Duke of Hesse, Ernst Ludwig. On the Mathildenhöhe, a hill on the outskirts of the city, the princely patron had given the artists the opportunity to realize their ideals in the building of houses and studios down to the last artistic detail. Whatever had been finished by 1901 was truly a triumph for the city, an architectural conception enveloping and binding the different creative arts to one another. All told, the development at Darmstadt had relatively little influence later, since the *Art Nouveau* pathos peculiar to the Mathildenhöhe became suspect during the following years. Only the predominantly Utopian architectural projects of the late Expressionist period were born again from similar emotional suppositions and similar exuberance. But, although a romantic current continued to exert itself in discussions of cultural topics or on the nature of art, interest in practice turned to more sober things, to the more immediate problems of form and design in everyday life.

All those who were by now striving to achieve the common goal of broadly based reform of environmental design—especially through the productive work of craftsmen, industrialists, and architects—joined together in the "Deutsche Werkbund," founded in Munich in 1907. Speaking of the Werkbund, Richard Riemerschmid declared that it endeavored "to spread the realization among the German people that it is not only improper but outright stupid to execute work with one's hands only for the sake of appearance and without love." In essence, this idea recognized the same ethical principles which, to an even larger degree, shaped the first Bauhaus Manifesto. During discussions at the annual conference in 1914, the inquiry narrowed down to the antithesis "standardization" (as applied to industrial production) versus "individuality" (as the characteristic of craft products). The reservations brought forth against standardization, and thus against mechanization (the speaker upholding this opinion being van de Velde), sprang mainly from doubts that top quality could be maintained with such methods.

One of the younger and most active members of the Werkbund was Walter Gropius. He was well enough esteemed to be asked to contribute an office building and a machine hall to the 1914 programmatical exhibition of the Werkbund in Cologne. With the building of the Faguswerk, Gropius had already, in the words of Gideon, formulated "a new architectural language," in that he had relieved the exterior walls of the building from the task of bearing and support, designing them as light, transparent shields against the weather. In the accuracy, elegance, and transparency of this building was embodied an esthetic idea that had been made possible only by modern technology and its materials. The same awareness of the necessity for transforming technical means into artistic ones and for using them creatively was voiced in the home-building program Gropius had drafted in 1910, which demanded the adoption of standardization and norms, but for the realization of which the time was certainly not yet ripe.

The birth of the new cultural conception was imminent everywhere. Its picture was substantially complete when World War I began. The Expressionists and the Fauves had painted their visions—the one rising to heights of ecstasy, the other plumbing spiritual and psychological depths. The Futurists had transposed action and action sequences—kinetic phenomena—into pictorial composition. Kandinsky and Marc, members of the Blaue Reiter, spoke of the great spiritual awakening that was to come, and they expressed in symbols and abstraction emotional qualities that previously had not been so directly represented in painting. Delaunay and Hölzel probed into the esoteric world of color and examined the laws of pictorial composition based on coloration. The Cubists had abrogated the classical laws of composition, perspective, and organic structure and estab-

lished rules that allowed a painting to be understood and constructed as an autonomous unity. Most avant-garde painters knew each other by name and had seen each other's works; they exhibited together, or at least at the same time in the same place.

They met in Paris and in Munich, and—especially important as a link between them—in Herwarth Walden's "Sturm" Gallery in Berlin, which was a stronghold of all the later Bauhaus painters. During the war the Dadaists were bold enough to grant chance, actual or directed, a major role in the process of artistic creation, and Cižek in Vienna built his basic art instruction upon similar fundamental principles, in that he was able to bring to light the individual potential of each student through the playful and creative use of different materials.

All the determining factors of the Bauhaus had been, so it seems, already present for some time before its formation. The situation around 1910, with its rational tendencies and speculation on standardization, mechanization, and corresponding methods of production, appears extraordinarily akin to that at the beginning of the Dessau period. The similarities are such that one could assume these two stages of development to be directly linked to each other. Seen in this light, the first Weimar years appear like an Expressionist interlude. And yet, despite all the apparent, forward-looking "modernity" of the prewar situation, a long road remained to be traveled to reach the reality of the Bauhaus. The synthesis of ideas achieved by the Bauhaus was more than a simple bringing together; it was a sovereign creative act.

The general intellectual atmosphere of 1919 was totally changed relative to that of the prewar years. The war had plunged its survivors into material poverty and had left the people with a badly shaken currency, with privation, hunger, and unemployment.

The years of misguided patriotism bore fruits of political extremism and bloody disturbances, but also sobriety and a Candide-like confidence in the evolution of a better, more understanding world. Schismatic prophets roamed about and had many followers, including many of those who had returned from the war with hardly more than bitter experience and stripped-down uniforms in their possession. Thus, in the technical universities where the discharged soldiers gathered to study, an air of excitement was particularly dominant. It was a colorful picture.

The peculiar unison of the moods of despair and of hope were captured in literature and in the visual arts in such works as the absurdities of the Dadaists and in an explosive Expressionism. The latter had in part already begun to slip into being trivial and had come in danger of being dubbed the style of "yesterday." The boldest of the architects—with what could they have actually built monuments in these times of need?—conjured up the vision of future architecture, more human and social than that of the past. Ahead of everyone else, Gropius and Bruno Taut, leading members of the revolutionary "Working Council for Art" (Arbeitsrat für Kunst) in Berlin, drew up a highly important fundamental program. In its basic tenets this program of work coincided with that of the Weimar Bauhaus, which Gropius formulated during those very same months.

Thus a large and significant part of the preparatory work for the Bauhaus was accomplished in the turbulent capital city of Berlin. For Gropius and his circle the city of Weimar, dreamily reminiscent of the times of Goethe, signified a work refuge in a confined provincial town, even though Weimar in 1919 had become a center of daily interest, being the seat of the Republican National Constitutional Assembly.

Gropius had come into contact with Weimar in 1915 through van de Velde, who had proposed him as his successor at the School of Arts and Crafts. It had already become apparent during the negotiations that took place the following year that Gropius would not simply continue what van de Velde had begun, but would modify it significantly in accordance with those considerations which he had first hinted at in his memorandum on the industrialization of the home-building industry of 1910. Pointing in the same direction was the intention expressed in Weimar of establishing a counseling service for the crafts and industry. These plans, however, were dropped when the Arts and Crafts School building was converted into a reserve military hospital, and when the decision about the future of the school was postponed until after the war. When in fact Gropius did receive the appointment to Weimar at the end of the war, the call came from the Art Academy. The faculty of the academy had in the meantime become more involved with Bode's reform plans, which incorporated the idea of a closer relationship between the arts and architecture. In this situation the professors recalled the enterprising architect who had presented similar ideas to the Grand Duke in 1916. The program Gropius put into effect turned out to be, in spite of programmatical analogies, something entirely different from that which the basically very conservative college professors had envisioned when they appointed him. The fact that Gropius had to carry over the old professors into his institute—at least those who had not yet withdrawn at the time of his taking office—was cause for repeated difficulties. These difficulties stemmed from differences not only in artistic but also in political convictions. All in all, such frictions turned into a dramatic manifestation of the generation gap.

Even after the secession of the old professors and the founding of their own art academy (1921), which reaffirmed the academic tradition, these problems did not come to an end. The Bauhaus was now faced with the vital problem of which of the two rival institutions would become the legal successor to the former Grand-Ducal school, with all the rights deriving from such succession. Though the decision on that problem favored the Bauhaus, the existence of an "old-style" academy with its intrigues spelled acute danger —especially when rightist radicals came to power in the government of Thuringia in the spring of 1924.

What made the Bauhaus suspect in the eyes of the residents of Weimar was not only the novelty of its artistic conceptions, but most of all its social tendencies, which were labeled anarchistic. This prejudice was reinforced by the Bohemian conduct that char-

3

acterized many of the students during the early Bauhaus years. What the Bauhaus produced turned out to be something quite different from the kind of achievement in craftsmanship the public had come to expect from the postulates of the program. The suspicion deepened further when, in the beginning, practically nothing was produced. First the educational and technical prerequisites had to be provided—a fact the public did not want to appreciate. Yet, even without these difficulties, the Bauhaus would not have been able to start production work, for, except in the weaving and bookbinding workshops, the most essential tools were missing until 1921–22. The functioning of the institute depended (how should it have been otherwise?) on its material situation, which was, as can be imagined, quite bad during the postwar and inflationary period.

The basic components of the Weimar Bauhaus were established by Gropius's program of April 1919 and by the concept of fundamental education which had been built on the knowledge of Hölzel and Cižek and which was introduced by Itten, who had been appointed with Feininger and Marcks at the beginning of the first term, but who took office a few months later. At first the emphasis was on the requirement of a synthesis of the crafts and art. To give meaningful expression to the ideal, and no less to the practical, union with the crafts, Gropius dispensed with the academic title of professor. Instead he introduced for the teaching staff the use of the craftsman's title "Master," which was also to be conferred upon the students at the conclusion of their course of studies. After completing an obligatory basic course, students joined the Bauhaus workshop of their choice and worked there, like craftsmen in the making, as "apprentices" and later as "journeymen." The students were required to take the journeyman's examination and the master craftsman's examination before the Apprenticeship Board. For education in subjects outside the competency of the Board—the stage workshop for example—the principle of "free analogy" was applied.

Since the artists teaching at the Bauhaus could not be expected to have had any experience as practicing craftsmen, they, as "masters of form" were associated in leading the workshops with regular "masters of craft." Hence the workshops were always headed by two masters, the form masters often changing their department. Even before the workshops had begun to operate smoothly, the basic course, under Itten's direction, had already taken shape. The nucleus of this basic course, inspired by Cižek, consisted of studies on materials (play with various materials, from paper, plaster of Paris, and wood, to glass, cane, and even briquettes) to develop a feeling for and an understanding of their specific qualities. The solution of any given problem, compiling materials and using them in three-dimensional composition studies, was restricted only by the individual's imagination. It was an educational process designed to bring to life the student's hidden creative abilities. This procedure was basically very similar to the projective tests later developed in psychology. Accurate studies of nature, stressing the reproduction of surface texture, and compositional and structural analyses of the paintings of the old masters were a rational supplement to Itten's teaching. Itten also strove for fundamental knowledge in his color theory, which was mainly derived from that of his teacher Hölzel and which incorporated all the advances gained since the romantic era—particularly the teachings of Goethe. Itten deserves credit for having employed his extraordinary teaching ability and his capacity for empathy to foster and help unfold the young personalities entrusted to him. His classes and his whole environment were permeated by his philosophical views—oriented toward the Far East—and this sometimes made him appear like a magician and put him in the position of being the most influential and persuasive personality on the staff during the early years of the Bauhaus.

Itten was assisted by Gertrud Grunow, whose teaching was based solely upon intuition; in it she attempted to supplement the synesthetic thinking of the romanticists with modern psychological knowledge; as a teaching method it was, in fact, more like a psychological counseling service for the students. To supplement the preliminary course, drawing from life was taught under rotating teachers, not the least of whom was Paul Klee. On the whole, Itten's tendencies were not without danger, due to the temptation of "talking a design problem to pieces" and of depreciating the principle of execution that Gropius had outlined. This created tensions between the two exponents of the Bauhaus, which, after heightening dramatically in 1921, came to an end only with Itten's strongly emotional resignation in the spring of 1923. His departure was a great loss, but nevertheless was a necessity for the maintenance of stability in the Bauhaus. It was characteristic of the mood and atmosphere of this first phase of the development of the Bauhaus that Itten—the esoteric in contrast to the practical man—had been able for some time to attract the larger number of teachers to his side, and that the pendulum seemed to swing in his favor. At that time there existed something like a solidarity of painters: Itten, Muche, Klee, Schlemmer, Schreyer, and Kandinsky—their affiliation with Sturm, for some only a passing one, provided a community of interest. They were at home in the same world of ideas and used the same studio vocabulary. Feininger and Marcks stood closer to Gropius.

Itten's successor, Moholy-Nagy, stressed problems of balance in his preliminary course in order to promote a sense of space and of the weight displacement of three-dimensional elements. The favored materials were wire, sheet metal, paper, and wood. Josef Albers, who was the first member of the student body to earn the Master title, systematized in his workshop teaching—on which the preliminary course was more and more concentrated—what Itten had begun. Here paper was the principal material. Folding and shaping put unexpected strength into it; these experiments demonstrated to the students the extraordinary significance of the correlation of form and material. It further taught to what extent changes in form can influence the behavior of material. The phenomenon of optical illusion was also examined. Albers's course, perhaps even more

than Itten's, has exerted a marked influence throughout the world.

Eminently important to all preliminary courses were the required lectures by Klee and Kandinsky, which dealt with fundamental problems of linear and color composition. Klee's "Educational Sketchbook" and Kandinsky's "Point and Line to Plane" are products of the work done in these lectures. The two masters were, in their teaching, intellectually very much akin. In fact, a reading of their lecture notes makes it seem at times as though the two had interchanged parts. The wealth of ideas emanating from these lectures was irreplaceable; Klee's and Kandinsky's practical accomplishments in the workshop were secondary by comparison. The personal aura of the Bauhaus masters contributed much to the credit of the Institute; these imponderable and irrational factors cannot be rated highly enough in an assessment of the history of the Bauhaus. A case in point is the position of Feininger, who, through his teaching or as form master in the printing workshop, achieved little prominence and who ceased teaching altogether after 1924, yet whose mere presence was nevertheless crucial for the Bauhaus.

Despite all these conflicting currents at the Bauhaus, Gropius was able to carry his point at decisive moments, and this was indeed decisive for the development of the institute. His unobtrusive authority asserted itself particularly in the "Council of Masters" (Meisterrat)—the committee of form masters, which was renamed "Bauhaus Council" after the addition of the master craftsmen and senior journeymen. The council was ruled democratically, and it was Gropius's persuasive reasoning that finally turned the scales in most cases. In Laszlo Moholy-Nagy, who was appointed in 1923, Gropius found a loyal supporter. But during the dispute between Gropius and Itten in the preceding years, another propagator of constructivism who resembled Moholy-Nagy in his intellectual elasticity stirred the smoldering crisis that pervaded the Bauhaus. This was Theo van Doesburg, editor of the magazine "de Stijl" and head of a group of artists carrying the same name. He resided at that time in the immediate neighborhood of the Bauhaus in Weimar and assembled many of the young people around him, to whom the prevailing intellectual direction—from Sturm Expressionism to the teachings of the Blaue Reiter— spelled disorder, doctrine, and staleness. Being the architect of Sommerfeld House, Gropius himself had paid tribute to Expressionism. In this situation the dangerous counter-trend of van Doesburg's followers acted upon the Bauhaus like a catalyst. With the exception of Rietveld's constructivist chairs, which were later the stimulus for Breuer's first furniture designs, the Stijl influence contributed nothing essentially new to the Bauhaus. But it helped to bring about the final breakthrough of partly concealed and repressed ideas such as those that Gropius had already embodied in the Faguswerk, and effectively led the Bauhaus community to find itself. The new goal was "Art and Technology—A New Unity," the theme of Gropius's lecture on the occasion of the Bauhaus Week in the summer of 1923. It was Moholy-Nagy, with his enthusiasm, his experiments, and his numerous publications who had the major share in the realization of this goal.

Workshop production was in full swing by 1922. Of course, the success of that production depended not only on the abilities of the personalities entrusted with the management of the workshops and their co-workers but also on the market situation, the possibility of improving existing production through product-development work, and the demand by the public for goods. Whoever could offer a product satisfying a general need was in the most advantageous starting position. The workshops that were in that position and profited were the cabinetmaking workshop led by Gropius; the metal workshop excellently led by master craftsman Christian Dell (particularly after Moholy-Nagy had accepted the task of form master); the weaving workshop led by Muche and Helene Börner; and the ceramic workshop. In the ceramic workshop—an outpost, so to speak, at Dornburg on the Saale—form master Gerhard Marcks was assisted by master craftsman Max Krehan, an experienced specialist. It was this workshop, with the two journeymen Otto Lindig and Theodor Bogler setting the tone, that demonstrated to what extent the students' imagination, achievement, and design sensitivity carried co-responsibility for the accomplishments of the Bauhaus. The printing workshop, led by Feininger in association with master craftsman Zaubitzer, gained similar cooperation from Ludwig Hirschfeld, a journeyman constantly searching for novel ideas (he privately worked out a new theory of color and became one of the initiators of reflected light compositions). Marcel Breuer and Gunta Stölzl, in the cabinetmaking and weaving workshops, respectively, emerged as strong-willed and promising young personalities. Independent creative thought appeared everywhere, and in some students, notably Bayer, Joost Schmidt, and Arndt, it was already remarkably mature. Occasionally there was too much sky-storming originality to profit the material production, which could not be based on beautiful and novel ideas alone but required simple mechanical work entailing endlessly repetitive operations. The almost notorious dislike of mechanical routine at times hampered the running of the departments considerably, especially in the printing and weaving workshops. In spite of the students' pursuit of originality, the workshop products exhibited consistency; all of them showed something characteristically "Bauhaus." Aside from the formal ideas of the masters, folklore exerted a strong influence on the products of the ceramic and weaving workshops. Strict stereometry and emphasis on structure and function characterized the work of the cabinetmaking and metal workshops. Some of these products reminded one, perhaps not without cause, of the "square" style originated by the Wiener Werkstätte before the war. At first, manual production methods promoted a craft-oriented formalism that was overcome only toward the end of the Weimar period, after the connection with industry had been accomplished and the principles of mass production began to be studied. After that came an exceedingly effective stage of development which led to industrial production of economical yet solid and formally respectable furnishings and commodities.

Gropius strove for financial independence of the Bauhaus; with the proceeds from the sale of products which the workshops were to manufacture, he wanted to free it from the limitations of a much-too-tight budget. While the teaching in the basic course and the workshops was to be financed by the state, income from private commissions or from the results of practical research undertaken at the Bauhaus's own risk was to pay for further experimentation. The first warnings about the basic difficulties of combining a subsidized educational establishment with a profit-seeking commercial enterprise were given by the Bauhaus manager, the architect Emil Lange, who had been appointed head of the planned, but never instituted, building research section. Gropius had underestimated the problems of a clear rendering of accounts, which turned out to be almost impossible to cope with. From the beginning, the state administration had been skeptical of this financial venture, although it was by and large still favorably disposed toward the Bauhaus. After the political upheaval early in 1924, the plan of a combined educational and commercial enterprise served, among other pretenses, the rightist radicals, the "Völkischen," as a welcome opportunity for withdrawing the basis of existence from the Bauhaus. In any event, to stress the economic aspects was risky. This also became apparent in the internal relationships, since the less lucrative workshops—the stained-glass workshop led by Klee and Albers, the wall-painting workshop led by Kandinsky, the sculpture workshop led by Schlemmer and Hartwig, and the Bauhaus theater, to which Schlemmer had given new meaning and significance after the resignation of Schreyer, could not fail to fall behind the "earning" workshops. The value of autonomous art came into question. Schlemmer and Kandinsky spoke vehemently against the pragmatism of the "practical men." To what extent music had a legitimate place at the Bauhaus, and whether it was educationally necessary, remained the neuralgic problem during the continually resumed discussions of fundamental principles until the final dissolution of the Bauhaus in 1933.

The big, central event of the Weimar Bauhaus was the 1923 Exhibition, coupled with a Bauhaus Week, which the Council of Masters decided to hold in spite of some reservations. In the opinion of many it was held too early. In giving an account of the work done, the event represented the end of the "Expressionist" period of the Bauhaus, and at the same time marked a decisive turning point with respect to its program and stylistic history. Students and teachers exhibited their individual work; the entire training program, from the preliminary course up to the products of the workshops, was explained and the resulting work shown; stage presentations and lectures put forth a comprehensive picture of all the intellectual endeavors. The fact that the Deutsche Werkbund met at Weimar at the same time guaranteed for the exhibition a resonance reaching far and wide. The most significant artistic contribution was Schlemmer's design of the vestibule and staircase in the building housing the workshops, for which he employed both painting and sculpture. This work amounted to a broad and well-considered attempt to achieve a synthesis of the arts within architecture. Still more fascinating was the Utopia of the Bauhaus housing settlement, a cooperative enterprise to be built in the near future, which had already been started with the display of a model house especially designed for the exhibit by Muche and furnished by the workshops. The Bauhaus had also established its own publishing venture to provide for the dissemination of its ideals, and an organization for the sale of workshop products (in the form of a corporation) had been formed to obtain financial security as well as wider distribution of Bauhaus products. An unfortunate entanglement of external and internal factors—political intrigue, inflation and the subsequent shortage of money, the organizational weaknesses of the Bauhaus—stifled the optimistic enterprises. They became a reality for the first time at Dessau, after having been modified and better adapted to the circumstances. The sale of products, at the Leipzig Fair for instance, or of models for industrial mass production, was a success in that it gained the Bauhaus recognition, but it did not bolster the bank account nor justify the investment. During the Weimar years, industry was a long way from recognizing the full extent of the possibilities opened by the product-development work carried out at the Bauhaus. Even the programmatical and art publications were selling badly. Of the magnificent portfolios of graphic work which the Bauhaus had published, in part under its own direction and in part in conjunction with private publishers, large numbers of copies were left unsold at the time of the move to Dessau. Those that remained had to be disposed of below cost.

The Bauhaus at Weimar did not have a department of architecture. Some lectures were held—for example in statics—and Gropius's private office kept contact with the Bauhaus and enlisted the workshops to cooperate on problems of interior design. Gropius was of the opinion that the time for the establishment of a regular department of architecture, which was to be, so to speak, the consummation of the work of the Bauhaus, had not yet arrived. But in the meantime the students pressed increasingly for the fulfillment of the program. In the spring of 1924 the students formed an architecture seminar to explore potential possibilities. Some of its members were masters and some were journeymen, among them Muche and Breuer. It is open to conjecture what might have developed from these initial steps if the Institute had been able to grow without interruption, for the particular strength of the Weimar Bauhaus was its ability to improvise and to make use of what was at hand. The hostile measures taken by the Völkisch (rightist) government and the increasingly vituperative press campaign of the right-wing extremists, combined with the apprehensions of those sympathetic craftsmen who felt their existence threatened by the industrial forms and technology propagated by the Bauhaus, blocked further development of the Institute in Weimar. Even the law yielded to political forces; Gropius and the educational authorities brought a lawsuit against a slanderous and inflammatory booklet, the "Gelbe Broschüre" (Yellow Pamphlet), which had been circulated since May 1924 by disloyal Bauhaus employees who had been discharged and who were joined

6

by a master craftsman. This action was continued by the court until it fell under the statute of limitations. Years later, in an entirely different context, the matter was finally settled. In September of 1924, the government gave notice to the Bauhaus masters that, for reasons of economy, it would no longer be able to support them. At the budget negotiations in the fall, when Gropius was able to announce pledges from industry for substantial financial participation in the manufacture of products, it became altogether evident that the limitations imposed upon the Bauhaus by the state government were much less guided by material than by politico-philosophical motives. The financial means were cut below the barely acceptable minimum. When it was unquestionably established that the government negotiators were merely trying to wear down the resistance of its opposition and that in fact there were no reasonable hopes for a settlement, the masters declared the Staatliche Bauhaus to be dissolved, effective March 31, 1925. Actually the declaration of dissolution was illegal, since the Bauhaus was, after all, a state institution; however, it was accepted. The closing of the Weimar Bauhaus was commented upon and regretted in the international press. Already its unique quality was recognized in many places in Europe and America.

It was a fortunate turn of events for the Bauhaus masters that they were given a new home and an opportunity to continue their work in the city of Dessau. The Frankfurt Art School had shown interest in taking over the teaching staff—meaning the painters without their director—but it would undoubtedly have dominated the Bauhaus faction or what would have been left of it. Like Weimar, Dessau was a city rich in tradition, which had reached its cultural climax during the time of Goethe. However, Dessau had not closed its gates to modern industry. The existence of the Junkers aircraft works added something of the progressive spirit of technical civilization to the aura of the city. The Elbe, dominating the plains, flowed powerfully by. The lively metropolis of Berlin was only two train hours away.

It was the art historian Ludwig Grote who recommended that the city fathers of Dessau invite the Bauhaus. Mayor Fritz Hesse, a community politician of great ability, acted immediately. His flexibility and conviction enabled him, the representative of a relatively small liberal party, to govern with the votes of the majority party—the Social-Democratic Party—and he managed to gain popularity for decisions reached with their aid. Such ability was an important asset, especially in this case, since the financing of the Bauhaus added a heavy weight to the city budget, and opposition against the adoption of the Institute was systematically stirred up by middle-class circles, especially craft groups, in Weimar. But mayor Hesse even managed to win appropriations for a new building and for seven "master" houses for the Bauhaus. Thus Gropius was able to establish a nearly ideal working and living environment for himself and his supporters. Until the National Socialists seized power, Fritz Hesse sheltered the Bauhaus against all attacks from the outside, and there were many of them right from the start. Notwithstanding the constantly widening circle of friends and patrons, and despite impressive material success, one could not expect much enthusiasm among the general public for such cultural avant-gardism, the significance of which they were unable to grasp. Much less was sympathy to be expected from the taxpayers for an apparently costly institute which had been allowed to build extravagantly while pennies had to be counted in other areas. In view of the general poverty, the buildings of the Bauhaus, the educational and living quarters, were indeed taken as provocation; the Bauhaus therefore always remained a problem at the center of community politics and election campaigns. That the budget in reality was in no way too large, was not discerned by the outsider. It took considerable effort before a budget covering all needs was granted. The financing of the stage workshop, among others, was uncertain at the beginning of the Dessau period. It was not until the end of 1925 and the beginning of 1926 that the continuation of the courses was finally assured to the full extent desired by Gropius. Hence, some teachers who were able to make a living in Weimar, or who had had offers elsewhere, had hesitated to follow the Bauhaus to Dessau. Schlemmer, for one, was undecided, since Gropius was unable to make him a firm offer. Marcks followed a call to the school of art at Giebichenstein, and the Dessau Bauhaus did not set up a ceramic workshop. Feininger followed his friends to Dessau but did not accept teaching responsibilities because he had always disliked active teaching. Some of the former Weimar Bauhaus students and assistants, such as Hirschfeld, accepted teaching positions at the successor institute in Weimar, where Otto Bartning had become director. This school followed the Bauhaus program closely, and, during the first months of its existence, even adopted its name.

The Dessau Bauhaus was supported by the city. This made it a communal institution, which meant that it worked at the same level as the city's own School of Arts and Crafts. While waiting for the completion of its own buildings, the Bauhaus was provisionally housed together with this school. The originally intended fusion of the two and the admission of the School of Arts and Crafts into one wing of the new Bauhaus buildings were dropped because the bad experience with the rival institute in Weimar threatened to repeat itself. To differentiate clearly between the two institutes, formal recognition of the Bauhaus as an "Institute of Design" was granted by the State government of Anhalt in October 1926.

Until its dissolution in 1932, the Dessau Bauhaus maintained its academic standing. From 1926 on, a certain academic tendency was generally evident. A symptom of that trend was the official conferment of the title of professor to those teachers who had been masters of form at Weimar. Master craftsmen did not teach at the Dessau Bauhaus. It had now become possible to dispense with the dual appointments to the workshops, artist and craftsman side by side, since younger Bauhaus-trained people were available to complement the teaching staff. These young teachers had been educated in the spirit of the new program and combined design capability with manual skill. The designation

"junior master" (Jungmeister) was retained for Bauhaus use only, to differentiate them from the "old" masters. The gradation apprentice—journeyman—master, which had been characteristic of the training at Weimar, as well as the obligation to pass the examinations of the Apprenticeship Board, was abandoned. From 1928 on, students finished their courses of studies with a Bauhaus diploma.

The change in the inner structure of the Bauhaus manifested itself most clearly in the division of departments. The administrative tasks, the demands of public relations and of intensive advertising for the Institute and his large architectural commissions—which directly or indirectly benefited the Bauhaus—kept Gropius so busy that he was no longer able to take charge of a workshop. Kandinsky and Klee continued with their compulsory courses in basic instruction, the former accentuating analytical aspects and the latter investigating mainly geometric, constructive problems. Schlemmer, as before, led the Bauhaus theatre; Moholy-Nagy had the exceedingly important metal workshop under him, and Muche was responsible for the weaving workshop, where he was assisted by his former student Gunta Stölzl, who in the meantime had received her "master" title. All the other workshops were also led by former Bauhaus students: Herbert Bayer took typography and advertising art; Marcel Breuer headed the furniture (cabinetmaking) workshop; Hinnerk Scheper, an excellent practical artist himself, led the wall-painting workshop, and Joost Schmidt pursued fundamental studies in plastic form in the sculpture (plastic) workshop and conducted a basic course in lettering. Josef Albers, who experimented more systematically than ever, held a key position as head of the preliminary course. Albers's experimentation was based on the recognition of the specific qualities of materials, such as strength, nature, and texture, and of the modification produced on them by changes in form. His work was supplemented by the courses of Moholy-Nagy which dealt with the development of an awareness of plastic-spatial relationships.

The teaching program of the Gropius era was eventually rounded off and brought to completion in 1927 with the establishment of a department of architecture. To lead this department the Basel architect Hannes Meyer was appointed. He brought along with him the talented Hans Wittwer, with whom he had previously worked on some noteworthy architectural designs. The most prominent project on which Meyer and Wittwer were working at the time was the design for the League of Nations Building in Geneva. Their entry for this international competition was awarded a third prize. The first concrete task offered the department of architecture was collaboration in the commissions Gropius had received, the main project being development work for the experimental housing project at Dessau-Törten, for which the problems of standardization and the testing of industrial production methods had to be solved.

It soon became clear that in Hannes Meyer and Moholy-Nagy the Bauhaus was harboring exponents of two opposite points of view. What Moholy-Nagy demanded and depicted in his numerous publications was the esthetic experience, the vision of a new unity of art and technology, and the way to the realization of an optical culture, born from a specific visual awareness. For Moholy-Nagy as an artist, questions of form were primary. He enthusiastically studied dynamic and kinetic phenomena, such as are inherent in film and in the fluctuating spaces of glass architecture, in which transparent walls are simultaneously able to divide and unite separate compartments into one flowing space. He celebrated the sleek beauty found in mechanically mass-produced technical products. This esthetic concept was also revealed in Moholy-Nagy's typography, which was then modified by Herbert Bayer into an essentially different, lighter, and more flexible form. In fact, Moholy's concept was the one that manifested itself in all the products of the Dessau Bauhaus, from the lamps of Marianne Brandt and the tubular steel furniture designed—privately—by Marcel Breuer, to the textiles of Gunta Stölzl, Anni Albers, and Otti Berger. They designed textiles to be manufactured with a mixture of synthetic fibers, producing new effects in material, which had not been achieved in mechanical weaving before. The workshops were active and gave a good account of themselves. In organizational matters the Bauhaus had learned since Weimar. It had at its disposal a partially functioning corporation and sold progressively more and more licenses for the industrial mass production of its prototypes, which, to use a popular phrase of those days, had been developed in the "research laboratories." Slowly, practical affairs became a matter of routine for the Bauhaus.

The intellectual position was now being defined in the Bauhaus Journal, founded by Gropius and Moholy-Nagy, and on a broader artistic and scholarly basis in a series of Bauhaus Books published by the Albert Langen Press. The series of more than fifty books by well-known authors was planned to include all fields of intellectual endeavor. The necessity of limiting this number—only fourteen appeared—constituted a regrettable loss of scope, but on the other hand led to the crystallization of those aspects which were most typical of the Bauhaus. These aspects were, understandably, most emphatically accentuated in the five numbers of the Journal that appeared during the years between 1926 and the end of the Gropius era; later (until 1931) ten more issues were to follow. Opposite the formal-artistic approach to design, to which Moholy-Nagy subscribed, stood Hannes Meyer, expounding a decidedly socialistic philosophy, which, as the expression of humanitarian ideals, was in no way foreign to Gropius and his circle. But in Meyer these ideals were blended with political ideas and—perhaps because political tendencies had until then been rejected by the Bauhaus, and were thought to be dangerous—with an aggressiveness in ridiculing design "formalism"; this led to new tensions. The homogeneity of the spiritual climate had been disturbed, and drastic changes were required in order to master the problems. The changes of personnel that took place simultaneously with and after the resignation of Gropius triggered a chain reaction that drove the Bauhaus to the edge of self-inflicted ruin during the subsequent

years. One of the earliest alarming signs of an inner crisis (already discernible at the beginning of the Dessau period) was the diminishing solidarity displayed by Kandinsky and Klee when they refused to join in a fund-raising drive for the benefit of the community. Both were painters and wanted to be nothing but painters. Consequently they appeared to feel increasingly out of place in an institute that expected the individual to join the common cause. Muche was not at home in the weaving workshop, for he desired to paint and, above all, to build. His resignation in 1927 was the result of this difficulty. Gropius exhausted his energies in publicity work for the Bauhaus and in defending it against never-ending assaults. A particular menace was the perfidious skill of some hostile professionals in the field (like the engineer Nonn), who were capable of building up the most monstrous polemic from any essentially justified, and therefore unrepudiated, criticism. What the Bauhaus really needed was peace in order to unfold its potential. Since Gropius was the focus of all attacks, and his adversaries sought to hurt the Bauhaus through him, he decided to withdraw. He resigned as Director on March 31, 1928. His resignation immediately made everyone realize just how much the Bauhaus was associated with his person and how towering his position had been. Marcel Breuer (who had already intended to become independent), Moholy-Nagy, and Bayer left at the same time. In accordance with the program of the Bauhaus and upon Gropius's own recommendation, the head of the department of architecture, Hannes Meyer, was appointed as his successor.

Hannes Meyer was director for a little more than two years, from spring 1928 until summer 1930. It was certainly not easy for him to fill the place of the man who had been the founder of the Bauhaus and who had led and shaped it for nine years. It was difficult to live up to the requirements of that office. The commanding dignity with which Gropius had directed the Bauhaus put the obligation upon Meyer to stand his own ground. For a man of an entirely different temperament it was a continual strain to be measured against such a predecessor, and Meyer had to fight against these difficulties. It was his fate, at the age of thirty-nine, boyishly enthusiastic himself and able to inspire others as well, to confuse fanciful ideology with knowledge and a programmatic objective. Meyer's strict rejection of the "formalism" of Gropius and Moholy-Nagy must have been, in the main, the protest of a man coming from a lower middle-class background against the new cosmopolitan environment.

Opposite the demand for the best attainable quality, Meyer set his own socialist ideal of practical work in the service of everyone in the community. To define Meyer's dialectic thesis is difficult, since it was never clearly formulated. He did not, of course, relinquish the demand for quality in design, but simply assigned a different place to it in his hierarchy of values. This spirit of questioning existing values restored, for a time, some of the sweeping élan of the first Weimar period to Meyer's Bauhaus. However, this vivacity did not bring about either a clarification or a new synthesis, but instead led to increasing anarchistic tendencies and eventually fostered a process of progressive disintegration. This process was to be halted only by a change of administration. This was finally accomplished—primarily because of Kandinsky's urging but also because of political pressure—when Hesse dismissed Meyer.

Meyer's tangible and indisputable achievement lay in the fact that he stepped up the productive capacity of the workshops and freed them from speculative and playful tendencies of which the Weimar master craftsmen had often complained. The new attitude meant an emphasis on production, which was only realizable because it was possible to draw and build on the wealth of experience available from the previous nine years. The dawn of financial success, at last, also owed much to the preparatory work of many years, both in the realm of art and in the field of publicity. The style of the industrial exhibitions, to which Joost Schmidt in particular gave his personal stamp, was another popular result and helped win popularity for the Bauhaus of Meyer. A further source of publicity was the Dessau building itself, with which Gropius attracted the attention of international architectural, and other professional, circles. According to the journal of the Bauhaus secretariat, the institute had from 100 to 250 visitors a week in 1928 coming from all over the world, and including many East and West European as well as American architects. Meyer used this asset skilfully. Furthermore, the Bauhaus Journal gained a new edge under the editorial direction of the Hungarian writer Kállai. Schlemmer's Bauhaus theater had now, just before its final dissolution, gained maximum exposure and influence, resulting from a tour of Central Europe. Well-designed exhibits of Bauhaus products afforded people in German and Swiss cities an opportunity to become acquainted with the usefulness of these products which carried a certain revolutionary aura about them. Even firms that had nothing at all in common with the aims of the Bauhaus but were impressed by the enticing force of its name began offering their fashionable articles under the catch phrase "Bauhaus Style."

The genuine, essential, and original attainments of the Meyer era were based on collective work. Thus the trade-union school in Bernau, near Berlin, was built in cooperation with the department of architecture and the workshops. "People's furniture" was introduced, which was both reasonable in price and practical, and Bauhaus wallpapers were developed in the department for wall painting (especially under Arndt). The derivatives of these wallpapers are still being produced by the original manufacturer, more than thirty years later. With a group of "balcony" housing units at the edge of the Dessau-Törten settlement, Hannes Meyer and his assistants in the architecture class put into practice a technically and functionally convincing solution for economical mass housing. Whatever was planned and executed in the field of building and furnishing conformed indeed to the idea of a program for Everyman.

Meyer strove to organize the curriculum so as to impart to the students a life-related general education, and he also applied stricter methods in specialized training. Most

important of all, he put system into architectural education. Thorough studies of environmental relationships, planning and preliminary design for estimated space needs, and possible local disturbing factors, laid the foundations for, and supplemented, the actual creative process. The appointment of the architect Ludwig Hilberseimer, already well known in architectural circles through his penetrating publication on the theme "The City," was extraordinarily important for the Bauhaus. Hilberseimer taught mainly on the subject of mass housing and commented on problems of city planning. Finally, photography was awarded an official place in the curriculum, after almost having become a teaching subject through the private work—although related to the teaching—of Moholy-Nagy and his wife Lucia. Walter Peterhans led this department. The secondary subjects were built up according to Meyer's pragmatic tendencies. Noteworthy among these were the study of industrial organization and—based on Wundt and Krueger, the representatives of the Leipzig school—of Gestalt psychology. In order to satisfy the demand for teachers in the secondary subjects and in the now focal department of architecture, Meyer invited many guest lecturers. From the circle of former students, Alfred Arndt, an experienced practical man, joined the teaching staff. The task of contributing special courses to Albers's basic course had to a large degree been assigned to the artists. Hence, next to Kandinsky, Klee, and Joost Schmidt, Schlemmer now taught within the framework of the preliminary course, expounding on the theme "Man." Because of the new appointments and the program revisions, a complete rearrangement of personnel for the classes and the workshops became necessary. Work areas and spheres of competency were pulled together, while others were split. Such reorganization initiated a development that was to be continued by Meyer's successor. The reform attempts went to the roots of the institution, to the inner structure of the Bauhaus. But its Director lacked the coordinating skills necessary to realize them. Many promises were not kept, and so especially the most able and artistically distinguished personalities, those who had carried the Bauhaus jointly with Gropius, became discontented. Classes in free painting were promised to the leading artists Klee and Kandinsky. Yet, in the reality of the Bauhaus, art was repudiated, and even the significance of the preliminary course was disputed. Albers, Kandinsky, Klee, and Schlemmer, who most markedly embodied the Bauhaus tradition, felt more and more isolated. In 1929 Schlemmer made the logical move and accepted an appointment to the Breslau academy. The new group that had gathered around the Director lacked the homogeneity necessary to sustain the Bauhaus. The fact that the Director forfeited his authority brought the danger of stagnation to the cooperative effort and of chaotic dissolution of the entire institute. Hesse recognized the signals of catastrophe and took the only step possible at this time that could remove the danger.

In the summer of 1930, Hesse, following Gropius's recommendation, put the direction of the Bauhaus into the hands of Ludwig Mies van der Rohe. The new Director had been known not so much for the range but rather for the epochal significance of the buildings he had designed. Some of these projects remained on the drawing board, as for example the glass-enclosed office building of 1921. When the Werkbund entrusted him in 1927 with the over-all supervision of the building of the Stuttgart "Weissenhof-Siedlung," his position among the architectural elite was acknowledged. With the German pavilion at the World's Fair at Barcelona in 1929, Mies van der Rohe had presented a brilliant example of his concept of space—a composition of interlaced and interrelated spaces—and of his unusually sensitive knowledge of materials. House Tugendhat in Brünn, also one of his most distinctive works, followed in 1930. For the latter, as well as for the pavilion at Barcelona, Mies van der Rohe provided specially designed chairs made of ribbon-steel springs and upholstered with leather cushions, which have become classics of modern furniture design. At the time of his Bauhaus appointment he lived in Berlin. He continued to keep his office there, and thus had to commute often between Berlin and Dessau. Mies van der Rohe's first act was to take stringent steps to restore order, which the political activities and lack of discipline of part of the student body at the Bauhaus had disturbed. Due to the limitless freedom of the recent years, it was difficult for the students to understand the attitude of academic aloofness which characterized the new Director. But, above all, it took more mature insight to be able to recognize that Mies van der Rohe's absolute insistence on the highest quality, with which he opposed Meyer's demand for practical and useful results to be achieved as quickly as possible, did not signify an estrangement with reality nor a lack of social responsibility. At first many students and teachers interpreted his pursuit of formal perfection and his love of valuable and lasting materials as a propensity for art for art's sake. But he was held in even higher esteem after people began to understand his intentions.

Under Mies van der Rohe's leadership, the Bauhaus developed along the lines of an academy of architecture. The organizational differences relative to the Meyer Bauhaus were less conspicuous than those between the latter and that of the Gropius era. Mies van der Rohe halted the manufacture of goods almost entirely, in order to be able to concentrate the saved investment and manpower on teaching. The first and most important tasks were the rationalization and consolidation of the existing means and methods. The workshops were re-formed in the direction of "interior decoration," being linked to all aspects of architecture. Some of the lecturers who had come to the Bauhaus since 1928 as guests or had been permanently employed were asked to leave. With the exception of Lilly Reich, replacing Gunta Stölzl (who left in 1931) in the weaving workshop, no new appointments were made until the end of the Dessau Bauhaus. It was only natural that teachers like Peterhans and qualified specialists like Engemann and Rudelt, the statics expert, were kept on. Hilberseimer came into the foreground. Next to Mies van der Rohe, whose fascinating formal-esthetic achievement was an admired example, Hilberseimer, with his didactic capability and his realistic approach to the problems of mass housing, made a most important contribution to the architectural training program. The classes of

these two architects supplemented each other in a manner little short of ideal. The artists, on the other hand, did not receive the recognition from the new administration that they had long desired. Thus Paul Klee chose to accept a professorship at the Düsseldorf academy, rather than remain at the Bauhaus. A controversy between Kandinsky and Mies van der Rohe on the function of art in fundamental education illustrated clearly to what extent the development and specialization in the direction of an academy of architecture had progressed by 1932. Had it not been for Kandinsky's protests, even the art classes would probably have disappeared from the curriculum by the time the Bauhaus moved to Berlin. For autonomous artistic work the scope had been considerably constricted, to say the least.

In 1931 the National Socialists stepped up their campaign of harassment against the Bauhaus. Assured of a majority in the Dessau city parliament and backed up by the expert opinion of the nationalist architect and art-historian Schultze-Naumburg, they moved in the summer of 1932 to close the Bauhaus, effective from September 30 of the same year. Based on one of the "emergency decrees" with which the weakened Reich government laboriously struggled to shore up its authority, the dissolution of the Institute at the end of the year could have been easily arranged. But the Nazi delegates were not patient enough to wait out the remaining few months of the year, showing how deeply their hatred ran against the Bauhaus. During negotiations concerning the fulfillment of the employment contracts, which was a prerequisite for the continuation of the Bauhaus as a private institution, two factors strengthened Mies van der Rohe's position: the impatience of his adversaries, and the fact that the legality of the parliamentary decision was highly questionable. Hesse, the faithful friend of the Bauhaus, was his energetic support during this struggle. The city of Dessau was forced to continue the payment of salaries in accordance with its contractual obligations and to provide, in limited quantities, tools and means of instruction. With this financial backing, Mies van der Rohe was enabled to take over the Bauhaus as his own personal responsibility. He moved it to Berlin, where Albers, Engemann, Hilberseimer, Kandinsky, Peterhans, Lilly Reich, Rudelt, and Scheper joined him.

The Berlin Bauhaus began operations in October 1932 in an abandoned telephone factory building that Mies van der Rohe had rented, located between Steglitz and Lankwitz at the southern edge of the city. Regular classes could be started during the winter semester. The programmatical basis was Mies van der Rohe's modified version of the Dessau Bauhaus concept. After a period of comparative calm, alarming disturbances appeared once again, introduced into the Bauhaus by rightist extremists. Hilberseimer, Kandinsky, Mies van der Rohe, and Albers were violently and recklessly attacked. The Nazi press denounced the Bauhaus, as they had already done in Dessau, as a "breeding ground of Bolshevism." When Hitler's seizure of power and his despotic legislation had rendered all legality questionable, and the law in part was suspended altogether, Dessau abruptly stopped all salary payments, so that from now on the Bauhaus had to be financed solely by the royalties from the licenses it had sold to the manufacturer of the Bauhaus wallpaper. Under the pretext that the Bauhaus had printed and distributed Communist pamphlets, police and storm troopers seized and searched the telephone factory building on April 11th, 1933. The doors were sealed. There was no possibility of continuing classes. In negotiations with Rosenberg and other representatives of the new power during the following days and weeks, Mies van der Rohe tried to procure conditions that would enable the Institute to continue an intellectual and—very modest—material existence. In view of the apparently hopeless situation, the faculty decided to dissolve the Bauhaus for good, two days before the Gestapo offered the prospect of a resumption of classes. This decision was made on July 19th, 1933; in order to avoid reprisals, it was explained on economic grounds. It was, at this time, quite clear that even if the Bauhaus had ample funds at its disposal, it would not have been able to maintain itself, progressive and true to its principles as it had remained to the last hour.

Then, the emigration began, both inside and outside Germany. For a number of leading "Bauhäuslers," the United States became the destination. Bauhaus ideas were carried to all parts of the world. Gropius most profitably introduced Bauhaus methods at Harvard in 1937, where Breuer also taught for a while. Albers developed the preliminary course further at Black Mountain College, North Carolina, and later at Yale. The Chicago "New Bauhaus" of the pugnacious Laszlo Moholy-Nagy revived, for a short time, more than just the name of the old institute. When, due to financial difficulties, the New Bauhaus had to be closed, Moholy-Nagy originated a worthy successor in his "School of Design." In the department of architecture at the Illinois Institute of Technology, also in Chicago, Mies van der Rohe assembled Bauhaus teachers like Hilberseimer and Peterhans and former Bauhaus students. On all continents the former comrades-in-arms of the Bauhaus now found important posts in art schools or as practicing architects or designers. In Germany, after the Second World War, the Ulm Institute of Design derived its orientation from the Bauhaus. In endeavoring to bring system and science into the classroom, this institute's curriculum underwent transformations similar to those of the Dessau Bauhaus. In general, one of the broadest and most lasting influences emanating from the Bauhaus was its system of basic education, which is practiced today in nearly every modern art school and academy in a modified, more modern form. Another stems from the idea of— as Walter Gropius said upon the occasion of the opening of the Bauhaus-Archiv in Darmstadt—"a diversity of individuals who are willing to cooperate without relinquishing their identity."

The Documents of the Bauhaus

The number of documents concerning the history of the Bauhaus is large. The most important ones are to be found in Germany, the United States, and Switzerland. If the printed contemporary accounts, controversies, and reviews were to be added to the number of documents as such—the records, files, letters, and other handwritten notes—the resulting number of pages would amount to between sixty and eighty thousand.

The documentary collection of the Bauhaus-Archiv which was founded in 1960 in Darmstadt offers the best survey of the entire Bauhaus development. The basis of the collection is formed by Walter Gropius's systematically built collection, started in 1919. It consists mainly of the correspondence Gropius maintained with artists and the authorities, of law-suit records—interesting since they reveal the contemporary reaction to the Bauhaus—programmatical notes, printed material, and newspaper clippings. Documents and other material from the possession of former Bauhaus Masters—Ludwig Mies van der Rohe, Josef Albers, Ludwig Hilberseimer—and other Bauhaus members complete this collection. The Bauhaus-Archiv also includes a collection of copies of original documents that are kept elsewhere, a specialist library, and a museumlike section displaying Bauhaus products. The Bauhaus-Archiv endeavors to clarify the role of the Bauhaus in the history of ideas.

Similar intentions are pursued by the Harvard-affiliated Busch-Reisinger Museum of Germanic Culture in Cambridge, Massachusetts, which has concerned itself with the Bauhaus ever since the 1930's. The museum owns paintings, graphics, and products of the Bauhaus, but mainly documentary material, including rewritten lecture notes, obtained from the circle of Bauhaus members who had emigrated to America.

The Bauhaus is also excellently represented in the art collections and libraries of the Museum of Modern Art in New York and in the Stedelijk Museum in Amsterdam. But in these collections the documentary aspects are secondary.

Of extraordinary importance is the material in Weimar. The art collection in the Schlossmuseum contains an outstanding selection, in regard to quantity as well as quality, of the workshop products of the Weimar Bauhaus. The document collection in the Thuringian Landeshauptarchiv is the most complete concerning the Weimar period of the Bauhaus. It consists of papers, very informative about the beginnings of the Bauhaus, belonging to the former Hofmarschallamt, which retained co-responsibility for the administration of art schools for some time after the 1918 Revolution. Moreover, these files are largely composed of the files of the directorate of the Weimar Bauhaus. Most significant among these are the correspondence with the authorities, the ministerial instructions, the minutes of the Council of Masters, and workshop reports. The documents concerning the controversy with the authorities are all the more valuable, for the files of the Bauhaus opponents—in this case the authorities themselves—have been largely destroyed. While the documents of the Hofmarschallamt had been bound and numbered, those of the Bauhaus were at the time this publication was prepared essentially in the same condition as they had been before the Landeshauptarchiv took possession of them, only a small number having been numerically registered on slips of paper. The large number of documents is supplemented by printed minutes of the Landtag, newspapers, address books, and other publications, interesting for their local historical value.

The Dessau Stadtarchiv possesses a nearly complete file of newspapers covering the period between 1925 and 1932. Of interest here in Dessau, as in Weimar, is all the printed material that concerns the local history, especially the city budgets. Despite the heavy diminution of the collection, it is nevertheless indispensable for a study of the Dessau period of the Bauhaus. The documents which the investigating committee set up in 1939 by the National Socialists selected as "incriminatory evidence" against the liberal Mayor Hesse, and the propaganda pamphlets of the notorious adversaries of the Bauhaus are for the most part intact.

The documents of the Berlin Bauhaus, so far as they still exist, are in the private possession of Ludwig Mies van der Rohe. At the time of the dissolution of the Dessau Bauhaus, he had also received some earlier documents (primarily personal records), important in regard to the continuation of the institute. This material, which is to be added to the Darmstadt Bauhaus-Archiv in the form of a donation by Mies van der Rohe has been sequestered in East Germany.

Correspondence and other personal documents relating to the history of the Bauhaus and its internal relations are to be found (other than in the Bauhaus-Archiv) in the private collections of former Bauhaus masters, principally Johannes Itten, Josef Albers, Herbert Bayer, and Lothar Schreyer, or of their heirs and relatives. Of these, Mrs. Léna Meyer-Bergner in Basel, Mrs. Nina Kandinsky in Neuilly, Mrs. Tut Schlemmer in Stuttgart, Mrs. Helene Schmidt-Nonne in Darmstadt, Mrs. Julia Feininger and Mrs. Sibyl Moholy-Nagy in New York possess substantial material in the estates of their husbands. The estate of Paul Klee is administered by Felix Klee and the Klee Foundation in Berne. A valuable private Bauhaus collection has been brought together by Ludwig Grote, the general director of the Germanisches Nationalmuseum in Nuremberg, who, as conservator of Anhalt, was one of the initiators of the Dessau Bauhaus. The Bauhaus is also very well represented in a number of private collections in America, both with documentary material and even more with examples of its art. The editor is grateful to the former members of the Bauhaus, their families, the collectors, and institutes for their generous help that made possible the study of the documents and the preparation of this edition.

1 The Prehistory of the Bauhaus

Gottfried Semper
Science, Industry, and Art
(Wissenschaft, Industrie und Kunst)
Published by Friedrich Vieweg and Son,
Braunschweig 1852 (Excerpt)
The impressions of the Great Exhibition in
London induced Semper to write this article in
1851. He was probably the first to see clearly the
significance of industrialization for the arts. As
a result he concluded that a disintegration of the
craft traditions would have to be completed
before one could hope for a new and substantial
attitude toward art. With his demand for honesty
of material and genuineness of workmanship
and for the reunification of the arts in building,
Semper formulated thoughts that were to deter-
mine the road and the development leading to
the Bauhaus. The reorganization within art
schools which he demanded was, as far as was
possible at that time, aspired to by the South
Kensington School in London, probably owing
to his suggestions. Semper's theoretical
dissertations were hardly known to the re-
formers of the 20th century, including Gropius.
These ideas now lay in the atmosphere, so to
speak; they were conceived anew and revised.
Here one notices the curious phenomenon that
the concepts of the 20th century had been
anticipated by the 19th century in their most
audacious flights of thought—but, after all, it
was the 20th century that found the courage to
put them into practice.

Unremittingly, science enriches itself and life with newly discovered useful materials and
natural powers that work miracles, with new methods and techniques, with new tools
and machines. It is already evident that inventions no longer are, as they had been in
earlier times, means for warding off want and for helping consumption; instead, want
and consumption are means to market the inventions. The order of things has been
reversed.

What are the necessary consequences? The modern age finds no time to adjust to the
benefits that were half forced upon it and to become their master. It is like a Chinaman
who is obliged to eat with knife and fork. For speculation combines with means and
presents us with palatable benefits; where there are none, speculation creates a thousand
useful things, large and small; when it can no longer invent something new, long-
forgotten comforts are revived. Borrowing its tools from science, it masters the most
difficult and troublesome tasks—the hardest porphyry and granite are cut like chalk and
polished like wax, ivory is softened and pressed into shapes, caoutchouc and gutta-
percha are vulcanized and used to produce deceptive imitations of carvings in wood,
metal, or stone, whereby the natural aspects of the simulated materials are greatly
surpassed. Metal is no longer cast or embossed, but is electrolytically deposited with
hitherto unknown natural powers . . . The machine sews, knits, embroiders, carves, paints,
invades far into the domain of human art, and puts every human skill to shame. . . .

The abundance of means is the first serious danger with which art has to struggle. This
term is in fact paradox (there is no abundance of means, but rather a lack of ability to
master them), yet it is justified insofar as it correctly describes the absurdities of our
situation. In practice we labor in vain to master the body of material, particularly in terms
of its spiritual aspects. Science provides the tools for any further utilization in practice,
but no style has developed during the many hundreds of years of common use . . . What a
marvelous invention is the gas lamp! How it enriches (apart from the unlimited importance
to the necessities of life) our festivities! Nevertheless, in the salons one seeks to hide the
gas jets so that they appear like candles or oil lamps. . . .

Style is the elevation to artistic significance of the content of the basic idea and all the
external and internal coefficients, which by their incorporation into a work of art are able
to modify it actively. Lack of style is, by this definition, the term for what is lacking in a
work, which accrues from a disregard for the basic idea and from clumsiness in the
esthetic utilization of the available means for its accomplishment. The basic form, as the
simplest expression of the idea, is modified particularly by the materials that are used for
the improvement of the form, as well as by the instruments employed. Finally, there exist
many influences outside the work itself which are important factors contributing to its
design,—for example, location, climate, time, custom, particular characteristics, rank,
the position of the person for whom the work is intended, and so on. . . .

Where will the depreciation of material that results from its treatment by machines, from
the substitutes for it, and from so many new inventions, lead? And where the depreciation
of labor, of paintings, of fine art, and furnishings, which originates from the same causes?
Of course, I am not speaking of depreciation in price but rather of depreciation in signifi-
cance, in the idea. . . . How will time or science bring law and order into this until now
thoroughly confused state of affairs? How will it prevent the general devaluation from
expanding into the area of work which is executed by hand in the true old fashion, so that
one may find more in it than affectation, antiquarianism, superficial appearance, and
obstinacy? . . . But while our art industry will muddle on without direction, it will un-
wittingly perform a noble deed by slowly destroying traditional prototypes with ornamental
treatment. . . .

Industry, speculation, and applied science must first complete this process of disintegra-
tion of the existing prototypes of art before something new and wholesome can follow. . . .
We have artists, but no actual art. The academies established by the government train
artists for the "high style," and, apart from the masses of the mediocre, the number of
highly capable talents is by far larger than the demand for them. Very few find their
aspiring, youthful dreams fulfilled. But when they do, the dreams are achieved only at the
expense of reality, by negating the present and fantasmagorically evoking the past. The
others find themselves thrown on the market and seek accommodation wherever they are
able to find it. Here again emerges one of the many contradictions of our time. How shall
I explain the contradiction in a few words? It will not be clear if I say that art applies itself
to craft as the crafts earlier applied themselves to art, for I do not intend to imply that a
commercial, nonartistic attitude has begun to predominate. This statement can only be
justified insofar as the impulse to refine form no longer starts from the bottom up, but is
passed from the top down. But even this interpretation does not satisfy, for the very same
thing occurred in the days of Phidias and Raphael, occurred even more consistently with
the Old Egyptians and has always occurred whenever architecture reigned hierarchically
over the other arts. The anomaly consists essentially of the fact that this influence from
above occurs in an age that no longer recognizes the dominance of architecture. . . . In
this respect everyone goes his own way, and it becomes obvious that no firm attitude can
be maintained under such circumstances and conditions. . . .

Basically, these great academies of art are little more than institutions for the sustenance
of professors, whose clique is a long way from recognizing its isolation from society.
People will suspect and censure my utterances; however, this is now my honest convic-
tion. The future will settle all this. The real force, defying all difficulties and following its
own instinct, will more accurately find the best fulcrum on the lever on which it must work,
to become acknowledged. A brotherly relationship between the master and his journey-
men and apprentices will signal the end of the academies and industrial schools, at least
as we know them today. . . .

William Morris
Arts and Crafts Circular Letter
Published by Longmans & Co., London.
1898 (Excerpt)
This circular letter presents the text of a lecture which Morris, the initiator and pioneer of the Arts and Crafts Movement in England, delivered on the 27th of February 1894 before the members of the municipal Arts and Crafts School in Birmingham. This lecture was influential not only in England but also in Germany, where it was distributed in form of a booklet published by A. Seemann in Leipzig in 1901. With penetrating vision Morris showed that whatever has become part of the past—the historical—is not reproducible and that the public has a right to an esthetically pure environment. The warning against the cultivation of an art proletariat could be ignored no longer after Morris. The concept of the artist in an industrial age as primarily a decorator is clear evidence of the distance still remaining to the Bauhaus, and of the progress this signifies relative to the thinking of the late 19th century.

. . . All nations of us must go through the mill in which the commercial period is grinding us; and England has at least this advantage: that she was thrown into the hopper first, and as a consequence is showing signs of consciousness that there is a future for Art. In short, we are willing to rebel against the tyranny compounded of utilitarianism and dilettantism, which for the greater part of this century has forbidden all life in Art. Only as yet we do not quite know what form our rebellion is to take; nor do I feel that in this business I can do more than generalize; for, in fact, if we already knew in detail what to do toward the furtherance of Art, that would mean that we were practising Art, & should not want to talk about it: people do not talk about matters that are going smoothly.
As to my generalizations, I can only say, first, that, in order to have a living school of Art, the public in general must be interested in Art; it must be a part of their lives; something which they can no more do without than water or lighting. We must not be able to plead poverty or necessity, as we do now, as an excuse for ugliness or dirt. If we raise a building, whether it be palace, factory, or cottage, it must be a thing well understood that it must be sightly: if a railway has to be run from one place to another, it must be taken for granted that the minimum of destruction of natural beauty must be incurred, even if that should increase the expense of the line largely; disfiguring waste of coal-pits or manufactories must be got rid of, whatever the cost may be; and so on. . . .
. . . About the beginning of this century, a few people began to open their eyes to Mediaeval Art. . . . Again came a period which learned so much more about the Gothic style, as it was once called, that great and successful architects practised in it, producing buildings which did no great harm, when they did not take the place of old buildings. But in another direction this new knowledge had very bad consequences. By this time our ancient buildings, having been both neglected and ill-treated by many generations, needed serious repair in many cases. The distinguished architects abovesaid undertook these repairs, and, as repairs, often did them very well. But they also undertook to re-do literally those parts which the neglect and stupidity aforesaid had injured or even obliterated, and seemed to have no doubt that they could do so. And they knew so much about the old buildings and the ways of their builders, that I cannot much wonder at their temerity. But what I do rather wonder at is, that they did not see, when they had thus 'restored' old work, that it did not look right; that, though their mouldings were identical of section with those of the 13th century, and though their carved foliage and figures were 'accurately' (Heaven help us!) copied from casts of that period, they did not look in the least like 13th century work; nay, that they could not build a plain wall at all like 13th century masons. I say that, if they had had the due use of their eyes, they would have seen this at once, and then fallen to reason as to why it was so; in which case, they would surely soon have found out that there were abundant reasons against the possibility of imitating the ancient work: the principal one being that since that time the whole structure of society has altered, and the position of the workman changed; that the long chain of tradition which was unbroken till the end of the middle ages has been snapped. . . .
. . . I always have warned, and always shall warn, when I have the opportunity, young people against looking on the practice of the arts as a mere profession, a career to be chosen for the earning of livelihood. I am often consulted on this point, and my answer is always the same: 'If you are quite sure that you have got in you the irrepressible desire, you need no test of capacity to begin with; you will yourself know that you have in you some power of creation; in that case do not hesitate, but throw yourself into it for better or worse, and take what will come. But if you do not feel that you have the capacity or desire, then, by all means, if you can, study Art as a recreation or a piece of education, but do not pledge yourself to live by it; for, if you do, you will be a burden to Art, and . . . feel yourself to be in a false and ignominious position. . . . So, I say, make yourself sure that you have in you the essentials of an artist before you study Art as a handicraft by which to earn your bread. . . . You must be absolutely faithful to your Art. . . . Your position as modern artists makes this all the more imperative on you. To the mediaeval craftsman generally, ornament was only incidental. If his ornament was not good (which by the way it almost always was), at least he was making a shoe, or a knife, or a cup, or what not, as well as ornament. But you who make nothing but ornament, please to remember that a piece of white paper, or an oak panel, is a pretty thing, and, don't spoil it. Well, that is all the sermonizing. . . .

Deutscher Werkbund
Program (1910)
Under the leadership of architects (such as Hermann Muthesius and Theodor Fischer), industrialists, and writers the Deutsche Werkbund, founded in 1907, attempted to put into practice the reform ideas that had matured primarily in the English arts and crafts movement. But the antithesis, ''Crafts'' versus ''Industry,'' crystallized sharply even during the first years. While Henry van de Velde, at the Annual Conference of 1914, insisted that the crafts, now as ever, were the great creative reservoir, Muthesius claimed that ''architecture and the entire sphere of activity of the Werkbund'' presses ''for standardization'' and can ''only recover through it that universal significance which it possessed in ages of harmonious culture.''

The association wants to select the best representatives of art, industry, the crafts, and the trades. It wants to bring together all available forces striving for the achievement of quality in production work. It will form the rallying-point for all those willing and able to work for high quality and all those who regard production work as one part—and not the smallest—of general cultural tasks. It exists for all those who want to establish a center for themselves and for others that will represent their interests by following the precept of quality exclusively. Therefore, the aim of the association is ''the refinement of production work in a united effort of art, industry, and the crafts through education, publicity, and concerted action in regard to all pertinent questions'' (bylaw 2). In this manner the association, as the representative of professionals, works for a cultural goal far beyond immediate specialized interests, with production work itself the main beneficiary.
The association seeks its collaborators first of all in that area where production work proves accessible to refinement through artistic ideas. In pursuit of these efforts, it focuses its attention on the entire field of industry producing finished goods, particularly on the so-called arts and crafts.

Walter Gropius
Program for the Founding of a General Housing-Construction Company Following Artistically Uniform Principles, 1910
BD, Gropius Collection (First publication, in excerpt)

Gropius presented this memorandum (totaling 28 typewritten pages) to the Berlin industrialist Emil Rathenau in April 1910. In it, his ideas on a ''larger box of 'building blocks,' '' and some fundamental concepts, especially of the Dessau Bauhaus, are outlined.

The company to be established sees as its aim the industrialization of the building of houses, in order to provide the indisputable benefits of industrial production methods, best materials and workmanship, and low cost.

Abuses in the Building Industry of Today

Due to extensive building speculation and poor management throughout the past decades, the state of building has deteriorated, both in taste and in durability, to such an extent that the public, consciously or unconsciously, suffers under these conditions. Anyone who has preserved his sensitivity for thoroughness must find unbearable the ostentatious, purely superficial appearance of comfort, which building contractors want in their buildings for the sake of publicity, but at the expense of good material, solid workmanship, distinction, and simplicity. Instead of good proportions and practical simplicity, pomposity and a false romanticism have become the trend of our time.

The reason for this malaise is the fact that the public is always at a disadvantage, whether it builds with a building contractor or an architect. The contractor is understandably avoided, because he unscrupulously hurries projects through in order to save costs, but at the expense of quality. The architect, on the other hand, who only draws up the plans, is interested in increasing the building expenses, for his fee is determined by the total costs. In both cases it is the client who suffers. For him the ideal is the artist who sacrifices everything to his artistic aspirations and in the process suffers a financial loss.

The Remedies

These points clearly evidence the unhealthy state of today's building industry. Enterprises whose production is based on craftsmanship (to a certain extent still including the building trade) can no longer bear the competition of industry. For, in the case of quantity production, the expenses for inventing and developing ideal prototypes are negligible in proportion to turnover, whereas in the production of single units they are prohibitive.

The fundamental principle of all industry is the division of labor. The inventor concentrates all his mental energies on the viability of the idea, the invention; the manufacturer on cheap and durable production; and the merchant on organized marketing of the finished product. It is only with the aid of such specialists that it becomes possible to make the essential, i.e., the spiritual creation, economically feasible and at the same time provide the public with products of esthetically and technically good quality.

The very same conclusions may be drawn for the building of houses. To some extent, industrial production methods have already been introduced, but the prototypes built by the contractors in accord solely with economic considerations are immature and technically as well as esthetically bad and therefore inferior in quality to houses whose components are still produced by hand. However, the craftsman's work has proved to be too expensive and thus from the start has been eliminated wherever possible by those building contractors who seek lower production costs. Our organization now wants to draw the consequences from this situation and through the concept of industrialization unite the creative work of the architect with the economic talent of the contractor. This would improve on present conditions and produce striking advantages, particularly with respect to the quality of design. For whereas up to now the busy architect has had to rely more or less on trained assistants and was not able to attend personally to all the details of his designs, the projects of this company and the designs for their individual components can be painstakingly and thoroughly prepared down to the minutest detail by responsible designers before they are ready to be executed, for the expenses for this work would now be bearable. Thus, art and technology would be happily united and the public at large would be able to acquire truly mature, good art and solid, genuine goods.

Artistic Uniformity—A prerequisite of "Style"

Whereas the thorough development of all details benefits the individual residence, there is a deeper cultural implication underlying this principle. It is the concept of a ''Zeitstil''

A convention, in the best sense of the word, cannot be hoped for by emphasizing individuality. It results, rather, from the achievement of an integration that will develop from the rhythm of repetition and from the uniformity of proven and recurring forms. Our age, after a sad interregnum, is once again approaching a Zeitstil which honors tradition but fights false romanticism. Functionalism and solidity are once more gaining ground.

The necessity for a convention can also be demonstrated on practical grounds. An individual floor plan forfeits quality when it [deviates] from acknowledged [norms, which have resulted from the practical experience of countless predecessors]. But what applies to the floor plan applies to the entire house. Former cultural periods respected tradition. Even the Dutch brick house, the French block of flats of the 18th century, and the Biedermeier town house of about 1800 were repeated in series using the same forms. In England, this desire for conventional conformity, based on an urge to organize, led to the development of terrace housing, with each house looking exactly like the next and spreading in unbroken rows through whole districts. The result offered great economy and, even if unintentionally, produced artistic unity.

However this company not only intends to supply its customers with low-cost, well-built, and practical houses in good taste, but it will also endeavor to comply with requests for individual variations, provided they do not intrude on the principle of uniformity based on industrial production.

The Practical Realization of the Idea

I. *Use of the same building components and materials for all houses.* To implement the concept of the industrialization of house construction, the company will repeat individual components in all of its designs and hence facilitate mass production, promising low costs and easy rentability. Only through mass production can really good products be provided. . . . Industrial production methods can be applied to nearly all parts of a house. . . . The trend of our age to eliminate the craftsman promises far greater industrial

rationalization, which for the time being still appears Utopian in our country. In America, Edison has already had entire houses including walls, ceilings, stairs, plumbing, etc., poured in concrete, using variable iron forms, and was even able to dispense with the bricklayer and the carpenter.

Standard Sizes

For all essential building components the most advantageous dimensions were sought first of all, and these standard sizes form the actual basis for such designs and are to be retained in the new designs. Only with these methods can large-scale sales be guaranteed and special manufacturing in cases of additions and repairs be avoided.

Accommodation to Individual Needs

Each house maintains an individual personality through variations in form, material, and color. . . .

II. *Multiple Use of Completed Plans.* Out of the rich experience of many years and the study of traditional building methods of all civilized countries of the world, the best and most stimulating information was gathered and examined for its suitability to our time and our climatic conditions. Following this study of the proven traditions, old and living, there began an intensive task of planning, the result of which, after many experiments, was a series of designs for dwellings of various categories. These encompass the sum total of all practical, technical, and artistic experience and appear suitable for an exemplary standard on which multiple execution can be based, of course employing variable forms . . . The governing principle of the enterprise will be to make these houses comfortable, not in terms of overdone gilded pomp but rather in clear and open spatial arrangements and in the selection and application of proven materials and reliable techniques. What is to be offered here is excellence, to be guaranteed for many years. . . .

Henry van de Velde
Letter of April 11, 1915 to Walter Gropius
BD, Gropius Collection (First publication)
Since van de Velde, being a foreigner, was increasingly persecuted during the war, he decided to leave Germany. His recommendation to appoint Gropius as his successor at the Weimar School of Arts and Crafts started a long series of negotiations, which eventually resulted in the establishment of the Bauhaus.

Weimar, April 11, 1915
. . . Would you be inclined to accept the post of director of the School of Arts and Crafts in Weimar? I had submitted my resignation for the first of April; now I have been asked to remain until the first of October 1915.
Where and in what periodicals can I find publications of your works?
As my successor, I have recommended to the Ministry, *you,* Obrist, and Endell.
You are, dear Herr Gropius, among those people whom I have always wished well and hoped the world would remember. . . .

Henry van de Velde
Letter of July 8, 1915 to Walter Gropius
BD, Gropius Collection (First publication, abridged)
Henry van de Velde left Weimar shortly afterwards. The building of his School of Arts and Crafts was used as a reserve military hospital. Only two workshops were continued privately. In 1919 they became affiliated with the Bauhaus.

Weimar, July 8, 1915
. . . It is only since a few days ago that I have been fully informed about the negotiations of the various ministries on the future of my creation, the School of Arts and Crafts. Everything is so pitiful and sad that one could weep.
The Grand Duke has decreed that the Grand-Ducal School of Arts and Crafts cease to exist as of October 1; furthermore, he opposes attempts to make the school a state institution or anything along the lines of keeping the school intact.
Consequently, the ministerial department of the House of the Grand Duke, which was responsible for the school, has handed the matter to the office of the Ministry of the Interior, with instructions to find a solution or to establish a new institution that would benefit the industry and craftsmen of the Grand Duchy.
The Ministry of the Interior has so far not found anything better and has the intention of reviving an old institution, to which industrialists and craftsmen may turn for advice, etc. A similar organization existed in Saxe-Weimar twenty years ago but proved to be a sinecure. I tried to instill new life into such an institution, in that I attempted to help industry and the craftsmen with advice and assistance free of charge, that is, with drawings and models, and I established the Craft Seminar in Weimar.
The Craft Seminar, with its aid and advice, was so infrequently consulted that a few years later I founded the School of Arts and Crafts, in order to prepare and develop the younger generation of Saxe-Weimar in all areas of the crafts.
As long as things are going well for the industrialist or the craftsman, that is, as long as he finds a market for his goods, no matter what sort or quality they may be, he will not consult the artist. But when he does, when things are going badly for him, he seeks him as he would seek the devil to sell his soul, determined to do anything to fill his threatened purse. And if the artist fails to help the manufacturer sell a hundred dozen of each of the new models at the next Leipzig Fair, then the time is up, for the devil or the artist!
Now the Ministry of the Interior is engaged in negotiations with Endell about such a post. I wish him everything that may help him materially and that may satisfy him. When I visited him in Berlin a few days ago I knew nothing of that which I am confiding to you, nor did Endell tell me anything of these negotiations with the Ministry of the Interior.
I regret his lack of confidence in me, since I did not deserve his distrust. I assure you that I have spoken up equally for the three of you—you, Endell, and Obrist—and I have always insisted that the three of you are equally close to me.
Whatever else may develop in this matter, dear Herr Gropius, should be of no concern to us, except that you might still be able to help Endell. This is no longer a position suitable for you, and other challenges await the fulfillment of your talent, your art, and your determination to seize upon such important tasks. . . .
If I were not intensively occupied with my new book on my new Theory of the Line and my dynamographic ornament, my situation would be desperate. . . .

Fritz Mackensen and Walter Gropius
Correspondence of October 1915
BD, Gropius Collection (First publication, in excerpt)
After the dissolution of the Weimar School of Arts and Crafts, Mackensen proposed to incorporate an architecture class into the art academy which he directed, to be entrusted to Gropius. This correspondence discloses the extent to which the concept of an integration of the arts was alien to the "academism" embodied in Mackensen.

DIREKTION DER
GROSZH. SÄCHS.
KUNSTGEWERBE
2 SCHULE, WEIMAR

3

4

5

[Fritz Mackensen to Walter Gropius]
Weimar, October 2, 1915
. . . I am not shedding a single tear [for van de Velde's School of Arts and Crafts], for such schools are, in my opinion, very seldom institutes that really advance the applied arts, and least of all, architecture. In time it turned out that architecture, the important element, was neglected, and what remained received a somewhat feminine character. The workshops were supposed to support themselves eventually, but of course that was not to be expected. The Masters accomplished beautiful work but the apprentices lacked the strict discipline without which the trades and also the crafts cannot manage. I would like to hear from you now whether you regret the abolition of the workshops.
In the place of the School of Arts and Crafts, a professorship of architecture should be established at our Art Academy, to bear the name "Department of Architecture and Applied Art." Such was *my* intention!
The professor of this department should lecture on the essential nature of architecture, etc., using illustrations of the most significant works of the past. Moreover, he should advise our students when they have to execute paintings and sculpture for an architectural setting. . . . However, in my opinion it would be necessary to institute a small school of architecture and applied art to which students could be specifically admitted, being independent of the head of the department of architecture in question, as is done in the department of sculpture under Engelmann. In this department, architecture and applied art must be designed to stimulate all German art and the craft interests of the grand duchy realistically. . . .
[Fritz Mackensen to Walter Gropius]
Worpswede, October 14, 1915.
. . . Since only loyal conviction can benefit art, I valued van de Velde's endeavors very highly. . . . The school was dissolved against my wishes. I will now save what there is to save and have succeeded for the time being in retaining all that is installed, until some specialist, that is, van de Velde's successor, can make further decisions.
As I gather from your letter, you have an incorrect impression of the school itself. Only trivial things were made in the workshops: batik, bookbinding, pottery, etc.; almost nothing that fits into the framework of architecture. The students were, for the most part, ladies. But nowhere in Germany has a better relationship with the crafts been established than in Weimar. They were promoted not so much by the student workshops as by business transactions. . . . Van de Velde's influence on these enterprises was extraordinarily beneficial; in conjunction with them, he solved many an artistic problem. This active cooperation with the handicraftsmen must be retained by all means and expanded on a large scale wherever possible. In this respect, van de Velde's successor will find the way excellently prepared. The school, which in my opinion will have to develop step by step, must under all circumstances be relieved of the trivia and be evolved with a more generous, artistic, and architectural approach.
To me, the setting of an art academy appears in general to be better than that of a school of arts and crafts. Architecture, after all, develops from the study of nature, as do all arts that contribute to it. Therefore, the spirit that lives in a real academy of art, devoted entirely to the study of the visible wonders of nature, is a source of perpetual renewal for an architecture department. And yet, work with students of the painting and sculpture classes should be entirely secondary to the head of the architecture school; he has to build independently and consequently have his own technically trained students. Such an architecture class can best be developed under the auspices of the academy. The class must be newly created, for nothing of this kind existed in Velde's school. It can develop gradually and organically in association with the art academy, according to the wishes of the master.
[Walter Gropius to Fritz Mackensen]
In the Field, October 19, 1915.
. . . I was happy to note that you concur with my views on the Weimar architecture school, and I am beginning to think now that something gratifying could develop out of it after all. But what I think is still missing is a positive suggestion as to the kind of affiliation with the academy of art and as to the *independence* of the architecture school. . . . In your last letter you spoke of a small, independent architecture school. . . . I am not able to conceive my position as holding the lecturer's chair of an architecture class, and could never view the teaching of architecture as a subdivision, since it is all-encompassing. What I envision is an autonomous teaching organism, which of course has to develop from a modest base but which is artistically *independent* and which perhaps (at first) is administratively *coordinated* with the existing academy. . . . On all essential matters I would be able to work well only according to my *own* ideas. . . . The *absence of restrictions* must be an explicit condition. . . .

2
Signet of the Grand-Ducal Saxon School of Arts and Crafts in Weimar during van de Velde's tenure.
3
Colophon for August Endell's "On Beauty," 1896.
4
Signet of the Grand-Ducal Academy of Art in Weimar during Mackenson's tenure.
5
Folder for the documents concerning the history of the origins of the Bauhaus, in the Grand-Ducal Hofmarschallamt (Thuringian State Archive, Weimar).

Walter Gropius
Recommendations for the Founding of an Educational Institution as an Artistic Counseling Service for Industry, the Trades, and the Crafts

BD, Gropius Collection (First publication, in excerpt)

Gropius sent this manuscript, consisting of eight typewritten pages, to the Grand-Ducal Saxon State Ministry in Weimar on January 25, 1916. Shortly before, the Ministry had asked him to orally "supplement his statement concerning architectural education in the art academy by an explanation of the kind of influence the crafts would receive from the artistic side and from the giving of instruction in handicrafts to masters, journeymen, and apprentices."

Whereas in the old days the entire body of man's products was manufactured exclusively by hand, today only a rapidly disappearing small portion of the world's goods is produced without the aid of machines. The natural desire to increase the efficiency of labor by introducing mechanical devices is growing continuously. The threatening danger of superficiality, which is growing as a consequence of this, can be opposed by the artist, who holds the responsibility for the formation and further development of form in the world, only by sensibly coming to terms with the most powerful means of modern formal design, the machine of all types, from the simplest to the most complicated, and by pressing it into his service, instead of avoiding it as a result of his failure to recognize the natural course of events. This realization will, of necessity, lead to a close partnership between the businessman and the technician on the one hand, and the artist on the other.

In the entire field of trade and industry there has arisen a demand for beauty of external form as well as for technical and economic perfection. Apparently, material improvement of products does not by itself suffice to achieve victories in international competitions. A thing that is technically excellent in all respects must be impregnated with an intellectual idea—with form—in order to secure preference among the large quantity of products of the same kind. Firms employing manual workers and small traders have, because of their very nature, never lost touch with art entirely; to influence them artistically no longer satisfies modern demands. Today, the entire industry is also confronted with the challenge of applying its mind seriously to artistic problems. The manufacturer must see to it that he adds the noble qualities of handmade products the advantages of mechanical production . . . Only then will the original idea of industry—a substitute for handwork by mechanical means—find its complete realization.

As long as the collaboration of the artist was held to be superfluous [by industry], machine products were bound to remain inferior substitutes for handmade goods. But gradually, business circles are beginning to recognize the new benefits to industry that are derived from the creative work of the artist. As a result of greater knowledge one now attempts to guarantee the artistic quality of machine products from the outset and to seek the advice of the artist at the moment the form which is to be mass-produced is invented. Thus a working community is formed between the artist, the businessman, and the technician, which, organized according to the spirit of the age, may in the long run be capable of compensating for all the elements of the earlier individual work. . . . For the artist possesses the ability to breathe soul into the lifeless product of the machine, and his creative powers continue to live within it as a living ferment. His collaboration is not a luxury, not a pleasing adjunct; it must become an indispensable component in the total output of modern industry. One easily tends to underestimate the value of artistic strength which at first does not manifest itself in a material sense to most manufacturers inexperienced in esthetic problems. It does not suffice to hire pattern draftsmen who are supposed to turn out "art" seven to eight hours daily in return for a small salary, working independently and mostly without adequate schooling, and to spread their more or less insipid designs in thousands of copies all over the world. . . . It is not that easy to acquire artistically mature designs. Just as technological invention and business management require independent minds, the invention of beautiful and expressive forms demands artistic potency, artistic personality. . . .

It cannot be denied that a gap exists in the communication between these two groups of vocations—the technological and the artistic—which must be bridged from both sides with a reasonable approach and much good will. The businessman or the technician accuses the artist of lack of practical discipline, while the latter accuses the businessman of lack of taste. Both may have accumulated ample reasons for their judgment. But, where the clear foresight of some individuals has nevertheless led to partnership, unmistakable attainments prove that this approach promises a fortunate solution. . . . The moment the artist appreciates the important experience of the businessman and the technician and values their expert advice without pretentiousness, but also knows that his own work . . . will be acknowledged, the first bridge of mutual understanding is built. A clear division of responsibilities, conferring upon each the decisive word in his limited field of work, will inevitably lead to the success of the products of their joint efforts.

As long as this recognition remains isolated, the majority of manufacturers will unfortunately still confront free-lance artists with hesitation and rejection. An educational institution, established by the state as an artistic counseling service, directed by a renowned and technically experienced artist, should be more likely to win the confidence of the manufacturer. . . . The approval of the tradesmen and industrialists, primarily their willingness to send students, is a necessary prerequisite for the founding of the projected school. Its institutional structure is thought of as follows:

The careful selection of the students according to their previous training and their natural capabilities deserves the utmost attention of the masters and manufacturers who send them. . . . The participating student has to prove that he has learned a craft or that he has worked for a certain period of time as a craftsman for a firm engaged in production. From the workshop he brings along the material for his work in the school. This will be in the form of certain commissions from his master that are of immediate importance for the firm concerned. These may be design commissions for new products or merely for products needing improvement. Under the guidance of the teachers in the institution's design studio, the student develops the form in detail on paper and returns to his master's workshop for the execution. . . . The teachers of the school also personally visit the workshops and the factories to follow carefully the carrying out of the designs and frequently to inform themselves about the special characteristics and the developmental possibilities of the respective drawing offices, their auxiliary machines and tools, and the materials to be used; they instigate new technical experiments and keep in close contact with the

directors of the firms.

For students possessing the technical qualifications but lacking adequate training in draftsmanship, a special drawing class should be set up. There, thorough training in free-hand and technical drawing will be offered and the fundamental principles of artistic design will be explained before the students are admitted to the working design studio. The director of the school decides upon the suitability of the student for admission. During the practical instruction in the studio, the teacher will frequently find a chance to interject remarks of a theoretical nature; but special courses on system and development history using examples from the past will be of real benefit only to the student who is already advanced in his practical training. Only practical experience will steer the student clear of the danger of understanding theory merely as pure art history or as a pattern book for imitations, and instead help him to convert this theory profitably into his own designs. From time to time the more mature students should hear self-contained theoretical lectures by the director of the institute or by specially invited outside authorities. The need for instructional aids will be limited to a continually supplemented collection of materials (samples of wood, metals, fabrics, leather, colors, etc.), and a good library. The school's dependence on existing practical firms saves the costly maintenance of its own experimental workshops and simultaneously eliminates any fears of competition on the part of manufacturers, since it has no intention of entering the market. The costs to the manufacturer are confined to the small fee for the instruction of the student whom he sends to receive an education. In return, he comes into exclusive possession of high-quality designs according to the actual needs of his workshops.

Ambiguities of a technical, commercial, or artistic nature are resolved in close cooperation between the designers and the manufacturers throughout the development of the design and prior to its execution. . . . The teaching of *organic design* takes the place of the old, discredited method, which was to stick unrelated frills on the existing forms of trade and industrial products. . . . Accurately cast form, bare of ornamentation, having clear contrasts and consistency of form and color become commensurate with the energy and economy of modern life—the esthetic equipment of the modern applied artist.

It has to be the unceasing aspiration of the leading teacher, from the start, to implant a clear artistic credo into the students as the most important endowment which should ripen within them like leaven, so to speak. He has to impress upon them the conviction that only the capacity to revalue and to form anew the changed or entirely new condition of life in our age, determines the achievement of an artist. False historical nostalgia can only blur modern artistic creation and impede artistic originality. He has to direct the students to look ahead and strengthen their confidence in their own nature and in the power of time, but without neglecting the legacy of the art of past ages with false pretentiousness.

A school led in the above way could bring real support to the trades and industry and would be able . . . to stimulate the industrial arts in their entire scope, more so than their own production of exemplary pieces would. Among its participants a similarly happy partnership might re-emerge as that practiced in the medieval "lodges," where numerous related artist-craftsmen—architects, sculptors, and craftsmen of all grades—came together in a homogeneous spirit and humbly contributed their independent work to the common tasks resting upon them. This was done out of respect for the unity of a mutual idea which inspired them and the meaning of which they understood. With the revival of such proven working methods, to be adopted according to the ways of the contemporary world, the expressive image of our modern manifestation of life must gain uniformity in order once again to merge into a "new style" during the days ahead.

Wilhelm von Bode
The Tasks of Art Education after the War
From the journal "Die Woche" (Berlin), Vol. 18, No. 14, pp. 469 ff., April 1, 1916 (Excerpt)

Wilhelm von Bode, Director General of the Berlin museums and one of the most influential German art specialists of his time, proceeded in his reform recommendations primarily from practical and economic considerations. With von Bode's ideas, the debate on the necessity and the direction of a general reform of the art schools received a lasting stimulus.

. . . Art education must have its foundations in life and must be adapted to the requirements of life. Public instruction in art in the broadest sense is as necessary as any other instruction, but just as general education is based on and developed from the elementary school, so art instruction should be based on drawing and modeling, which is something anyone can learn as well as he can learn to read and write, even if not as art. It is upon this base that instruction in all art and craft subjects has to be built; only those students of the general preparatory school who demonstrate extraordinary talent for the fine arts should receive their training in one of the preferably small number of artists' and masters' studios. Thus art academies, schools of arts and crafts and art schools can be merged into a single institution in which the major objective should be training for one of the many vocations in the field of the arts and crafts and which should be in close contact with the technical schools. But only a truly chosen few should find the transition to independent art. How beneficial such a separation of fundamental instruction from specialized instruction can be has been demonstrated by several schools of arts and crafts (such as those in Breslau and Berlin). Then the young students of this new art institute will be no more affected with a one-sided, false aspiration toward the higher arts, than for instance, the student in the "Gymnasium" is affected by the desire to strive only for an academic teaching career. Such reform, providing mutual preparatory training for the artist and the handicraftsman, comes at a most opportune moment, when we have the present distress and isolation of the fine arts on the one hand and a growing esteem for the handicrafts and their versatile and profitable application in modern life on the other. Also, the reform of the entire curriculum, which is now generally demanded, makes the inclusion of art instruction appear perfectly natural. . . . In hardly any other area does the reform appear . . . a more urgent duty than in art education, since it . . . not only causes the state . . . unnecessary expenses and produces insufficient achievements, but above all withdraws thousands of competent hands from useful employment. . . .

. . . Just as Greek will hopefully be maintained in the secondary schools, at least in the classic Gymnasium, so the preparatory training for the artist will have to remain as

thorough as possible. But by referring the larger part of the young people to the arts and crafts, by restricting the instruction to the upper level and by rigorous selection, there would not be ten thousand "painters" and "sculptors" populating the German cities in the future. At best, there would be one tenth or one twentieth of that number, who, moreover, being enlisted as teachers for preparatory instruction, would have a more promising future than at present.

Such a reform of our art-educational system would correspond quite well with the good old Prussian traditions. The guidelines here described had already been explicitly emphasized as leading principles in the reform, or more accurately, in the reorganization of the Berlin Academy, which Frederick the Great had chartered in February 1786, and which his most excellent Minister of State von Heinitz, of whom Freiherr von Stein proudly professed to be a student, later implemented. Heinitz, who since that time was curator of the Academy, expressed this most clearly almost ten years later in a review on his activity as curator. "He endeavored," he reported to King Frederick Wilhelm II, "not so much to attract many actual artists (such as painters, etc.) to the academy, (since in large numbers they are basically more damaging than they are useful to the state, which cannot employ and sustain them all), but principally to make the academy a foster mother and a patroness of good taste in all branches of the national industry, whose manufacture was in need of embellishment and improvement through the use of regular drawings. Thus the national industry was to be given new momentum in order that its products and tasteful articles of all kinds would no longer be inferior to foreign ones, and thereby the interests of art would be linked with the immensely more important interests of the state."

These principles, from which the 19th century increasingly departed to the detriment of art, can and should once again form the precepts for the future.

Grand-Ducal Saxon Academy of Art
Petition to the Ministry of State Regarding Reform Recommendations from the Faculty.
Minutes of the Proceedings of October 3, 1917
LW, unregistered files: teaching schedules, curricula, and circulars,
March 1907—June 1921, I (First publication)

In addition to Mackensen—the Director of the Academy—the professors Engelmann, Klemm, and Hagen were the main participants in the drafting of the petition. The enclosures attached to the document asked for the appointment of technicians for the departments of Klemm (graphics) and Engelmann (sculpture), who were to impart manual skills and assist in the execution of commissioned work.

An impassioned polemic started about the value of academies in Germany, the expression of which culminated in an insurmountable disagreement between his Excellency Wilhelm von Bode, Director General of the Royal Prussian Museums, and Professor Arthur Kampf, Director of the Berlin Academy of Art.

The faculty now stands on Bode's side. It is of the opinion that the academies of art in Germany no longer reflect the spirit of the time. The academies should no longer serve merely the so-called fine arts but should also offer the applied arts a basis for existence which the schools of arts and crafts cannot provide satisfactorily, since they look at art from much too low a level, namely that of generalization. Furthermore, the old academies commit the grave error of not making sufficient use of the wealth of individual personalities on their faculties but force students into the hands of any master available. For that reason, they do not fulfill the foremost duty of an art academy, which is to educate the student according to his individual nature. From the first, they classify, in the sense that they induce the young student to specialize immediately; they press him into a field—portrait painting, still-life, interior, landscape, sculpture, or graphics—instead of letting him first do art without prior reflection. Such institutes steer young people in one direction much too early, and then they can only free themselves with great difficulty, if at all. Right from its beginnings, the Weimar Academy has stood in sharp contrast to these obsolete academies and has, over the years, increasingly developed in this direction, the last time being in 1910, when the nature classes were merged with the painting classes in order to afford the students the possibility, while still in the drawing class, of choosing a teacher from the faculty. In close connection with this arrangement and with the affiliation of the sculpture department stands the fact that the operating costs of the Weimar Academy are astonishingly low, in contrast with all other academies.

It remains to be considered whether an entirely different form of administering art instruction could not be instituted in the place of the academies by appointing, for example, artists who would be provided with studios and who, instead of receiving salaries, would be guaranteed a certain income from the acquisition of their works for the collections. This arrangement must be rejected completely, even more so than the obsolete academies. It might be able to exist beside an academy, but never by itself. The costs are no lower either. . . . But the greatest disadvantage would be that young people would not be offered an opportunity to be trained, as at an academy. . . . A transformation of the academy in this sense would equal its demolition rather than its strengthening.

More than any other town in Germany after the war, Weimar will be called upon to re-establish Germany's intellectual communication with other countries of the world, and therefore is urged to do everything that could be of benefit in this regard. Its own well-understood interests would be promoted at the same time. Weimar must not forget to use this never-returning opportunity to foster its economic interests, which are closely connected with art, during the reconstruction of Europe. Further promotion of the fine arts would be a primary part of this. The following are to be [sought]:

1. To expand the academy to the extent that a department of architecture and arts and crafts would be affiliated with it, and to appoint, in addition to an architect, several other personalities.

2. To appoint a competent director for the museums, who would, above all, have the task of developing Weimar into one of the first markets for good German art in Central Germany, of advancing the idea of the broad-based museum with all possible means, and of working in close cooperation with the academy of art.

At the time of the investiture of His Royal Highness the Grand Duke, the idea of a unified art academy corresponding to today's concept, had already come to life—both the Arts and Crafts School and the School of Sculpture had been founded. But a productive unity did not come about. As a result, the individual sections worked exclusively for their own interests, without consideration of common objectives. Now the moment for integration

has come and should not be passed over. No other academy in Germany has a structure that lends itself to integration as this one does. A department of architecture and arts and crafts could be affiliated just as easily as the School of Sculpture was.

The faculty will be able to take a positive stand on establishing a specific plan for this department only after a director for it has been named. But the faculty holds it to be absolutely necessary to declare now that the school of nature study of the academy must be the foundation for all departments.

Furthermore, a common studio for stone preparation, etc., should be set up for the arts and crafts and the sculpture departments, and, as a part of the whole, a studio for the drawing of plants. The teacher of the latter could, at the same time, take on the teaching functions which the drawing school has carried out up to now. In addition to their duties as teachers in the Nature Study School, the professors to be appointed to the vacant positions could at the same time be specialists in the following areas:
1. the theatrical arts, 2. glass painting.

An academy such as the faculty envisions it and as has been described above in its basic outline, would also be of the greatest advantage for extremely gifted young people, in that it would afford them an opportunity to exercise their talents—which are not to be underestimated—in the arts and crafts.

Hagen, Klemm, Engelmann, Mackensen.

Walter Gropius
Letter of January 31, 1919 to Oberhof-marschall Baron von Fritsch
LW, Hofmarschallamt files 3707, Title LVIII No. 1, 1917–1919, pp. 125f. (First publication)
Gropius's request refers to his appointment to the former Grand-Ducal Academy of Art. At the time of the inquiry, Gropius still worked as a practicing architect in Berlin. He became very active in the "Working Council for Art" which had been founded after the revolution and was working—as was Bruno Taut—for those reform ideas which he later put into practice in the Bauhaus.

[Berlin,] January 31, 1919
Your Excellency,
Some years ago, the ministry in Weimar, still under the old government, entered into negotiations with me concerning my possible transfer to Weimar as the successor of Professor van de Velde. Following an audience with the Grand Duke and conferences in the ministry, several letters encouraged me to assume that the proper authorities would be sympathetically inclined toward a selection favoring me. Recently, Dr. Köhler has similarly spoken up on my behalf. But I have not been able to ascertain which persons are responsible for the decision in this matter since the Revolution [of 1918]. Mr. Ernst Hardt has now written me a letter in which he advises me to address myself to Your Excellency, as the administrator of all the art institutes in Weimar. May I therefore today respectfully ask whether the appointment to the director's position will be forthcoming within a forseeable time?

Since the beginning of the war I have served at the front and am now about to start building my life anew. I am facing the question of whether I should commit myself to another offer, which is, of course, much less attractive to me. For a long time I have been preoccupied with the idea of a reorganization of artistic life in Weimar and have developed definite plans for this, part of which I submitted to the ministry in the form of a brochure some time ago. At present I am engaged here in Berlin speaking and writing on the proposition that the separate "arts" must be freed from their isolation and must be brought back into intimate contact, under the wings of a great architecture. But I am fully aware of the fact that such ideas are hardly able to flourish in a large city, but rather in a small circle of intimate artists in a small town, particularly where there are the remains of an old tradition to help. In any event I am determined, be it where it may, to dedicate my entire life work to the realization of this concept.

I would be grateful to Your Excellency, if you could inform me about the matter in question.
Yours very faithfully, Walter Gropius

Walter Gropius
Proposed Budget for the Art Academy and the School of Arts and Crafts in Weimar 1919/20
LW, unregistered documents, budget estimates October 1913—May 1922 (copy) (First publication)
As shown by the budget estimate for 1919/20, the Bauhaus concept was to be realized only gradually. In essence, the figures of the budget still reflect the academic curriculum, which was the point of departure for the Bauhaus. The extremely limited financial means prevented free and generous planning.

After a series of negotiations, the governing authorities in Weimar have offered me the directorship of the erstwhile Grand-Ducal Academy of Art, including the former School of Arts and Crafts. Before I accept this honorable appointment, it will be necessary to call to the attention of the proper authorities that the momentary financial situation does not promise favorable working conditions. In the following, I am presenting a closely calculated account of the necessary expenditures. It must thereby be borne in mind:

1. that the value of money today amounts to only about 1/3 to 1/4 of that in peace time,
2. that the budget, as drawn up here, is calculated to include both institutes (including the school of arts and crafts),
3. that the productive workshops of the School of Arts and Crafts, which had existed during peace time, have been dissolved, and the school has no chance to gain an income at this time.

I also point to the importance of a proliferation of the crafts and industry in the state of Weimar as a result of the remolding of the schools in accordance with a craft-oriented, practical approach. With the workshops that are to be newly established working in close cooperation with the master studios which are at hand, it should be possible to build a working community of the collective artistic disciplines, which, out of its own resources and working in closest contact with the existing crafts and industries of the state, should eventually be capable of producing everything related to *building:* architecture, sculpture, painting, furnishings, and handicrafts.

I request help to the extent that the present government put the school into a viable condition by supporting my financial application and including the estimated sum in the state budget.

Weimar, February 28, 1919
Gropius

Proposed Budget for 1919/1920

Expenses:

Director	M	10.000.00
2 Masters already present (Thedy, Klemm)		10.000.00
4 Masters (Decorative Painting, Glass Painting, Landscape, Life Painting)		20.000.00
2 Masters (Sculpture) 1 already present		12.000.00
1 Drafting instructor for apprentices in the lower school		4.000.00
1 Substitute teacher for the sculpture class (Plaster casting, Marble cutting, Woodworking)		3.000.00
1 Substitute teacher for the architecture class		3.000.00
1 Art printer and assistant for the lithographic department		4.500.00
Lectures: Perspective, Anatomy, Anatomic Draftsmanship, History of Art, Architecture, Arts and Crafts		4.800.00
For guest lecturers		4.000.00
Administration (secretary and typist)		7.500.00
Building custodian, assistant, furnace man		6.000.00
Cashier		500.00
Model fees		10.000.00
Interior maintenance of three buildings		2.000.00
Library and instruction aids		4.000.00
Maintenance and acquisition of inventory		2.000.00
Heating and lighting three buildings		15.000.00
Water and utilities for three buildings		2.400.00
Materials for the lithographic and sculpture departments		2.400.00
Office expenses (advertising, printed matter, postage)		4.500.00
Additional expenses (travel expenses, etc.)		3.000.00
Contribution toward cantine and students' medical insurance		2.500.00
Materials for architectural models		2.000.00
Maintenance of an erection site for large-scale models for architecture, sculpture, and painting combined		6.000.00
Contracts with outside workshops for practical training of apprentices		5.000.00
Establishment of a studio for glass painting (initial costs of tools plus material for one year)		5.000.00
Establishment of a metalworking forge (initial costs of tools plus material for one year)		5.000.00
Workshop for stucco work		
Workshop for structural ceramics		
Workshop for locksmith work (not included in budget because of lack of material)		
Contingencies		2.300.00
Total expenses	M	163.000.00

Receipts:

Tuition			
(100 men @ M 150)	15.000.00		
(50 women @ M 180)	9.000.00	M	24.000.00
Auditors			1.000.00
Registration fees			500.00
Earnings of the lithographic department			1.500.00
Interest and dividends (Weimarfarbe)			1.000.00
Interest on college fund (approximate)			10.000.00
Interest on arts-and-crafts school fund (appr.)			1.600.00
Total receipts		M	39.600.00

Summary:

Expenses	M	163.000.00
Receipts	M	39.600.00
Support required	M	123.400.00

Voranschlag für 1919/20.

Ausgaben: Leiter ... M 10 000,-
2 Meister, vorhanden (Thedy, Klemm) ... " 10 000,-
4 Meister, (Dekorationsmalerei, Glasmalerei, Landschaft, Akt) ... " 20 000,-
2 Meister, (Bildhauer) 1 vorhanden ... " 12 000,-
1 Zeichenlehrer für die Vorschule für Lehrlinge ... " 4 000,-
1 Hilfslehrer für die Bildhauerklasse (Gipsgießen, Steinmetzarbeiten und Holzbildhauerei) ... " 3 000,-
1 Hilfslehrer für die Architekturklasse ... " 3 000,-
1 Kunstdrucker und 1 Hilfsarbeiter für die lithographische Abteilung ... " 4 500,-
Vorträge: Perspektive, Anatomie, Anatomisches Zeichnen, Kunstgeschichte, Architektur, Kunstgewerbe ... " 4 800,-
für Einzelvorträge Auswärtiger ... " 4 000,-
Verwaltung (Sekretär und Schreibhilfen) ... " 7 500,-
Kastellan, Hilfskastellan, Heizer ... " 6 000,-
Kassierer ... " 500,-
Modellgelder ... " 10 000,-
Unterhaltung des Innern der 3 Gebäude ... " 2 000,-
Bibliothek und Lehrmittel ... " 4 000,-
Unterhaltung und Anschaffung des Inventars ... " 2 000,-
Heizung und Beleuchtung des 3 Gebäude ... " 15 000,-
Wasser und Hausaufwand der 3 Gebäude ... " 3 000,-
Material für die lithogr. Abteilung und für die Bildhauerabteilung ... " 2 400,-
Büroaufwand (Anzeigen, Drucksachen, Porti) ... " 4 500,-
Sonstige Ausgaben (Reisekosten usw.) ... " 3 000,-
Zuschuß für Kantine und Krankenversicherung der Studierenden ... " 2 500,-
Material für architektonische Modelle ... " 2 000,-
Unterhaltung eines Probierplatzes zum Aufbau von großen Modellen für Architektur, Plastik, Malerei in ihrer Verbindung ... " 6 000,-
Uebertrag Mark 145 700,-

Uebertrag Mark: 145 700,-

noch Ausgabe: Lehrverträge mit fremden Werkstätten zur praktischen Vorbildung von Lehrlingen ... " 5 000,-
Einrichtung einer Werkstätte für Glasmalerei (Grundanschaffungskosten von Werkzeug und Material für das erste Jahr) ... " 5 000,-
Einrichtung einer Metallschmiede und Gießerei (Grundanschaffungskosten von Werkzeug und Material für das erste Jahr) ... " 5 000,-
Werkstätte für Stuckateure
" Baukeramik
" Schlosserei
aus Mangel an Mitteln noch nicht im Etat aufgenommen
Unvorhergesehenes ... " 2 300,-
Ausgabe Mark: 163 000,-

Einnahme: Schulgelder (100 Herren à 150 M 15000,-
50 Damen à 180 M) 9000,- Mark: 24 000,-
Hospitanten ... " 1 000,-
Aufnahmegebühren ... " 500,-
Ertrag der lithogr. Abteilung ... " 1 500,-
Bankzinsen und Zinsen Weimarfarbe ... " 1 000,-
Zinsen des Hochschulfonds zirka " 10 000,-
Zinsen des Kunstgewerbeschulfonds " 1 600,-
Einnahme Mark: 39 600,-

Vergleichung: Ausgabe Mark: 163 000,-
Einnahme Mark: 39 600,-
demnach erforderliche Zuschüsse Mark: 123 400,-

2 Bauhaus Weimar
From its Founding to the 1923 Exhibition

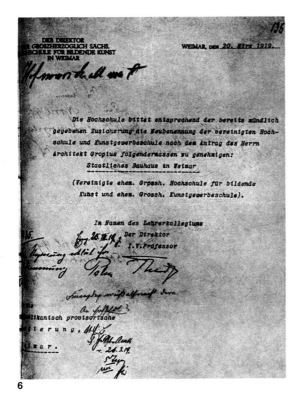

6

Grand-Ducal Saxon Academy of Art
**Request to Change the Name to
"Staatliches Bauhaus"**
LW, Hofmarschallamt files 3707, Tit. LVIII
No. 1, 1917—1919, p. 135 (First publication)
The government approved the change of name
at the end of March 1919. The revival of the
name of the school of arts and crafts—which
had been closed in 1915—in the subtitle of the
Bauhaus corresponded to Gropius's reform
ideas.

Hofmarschallamt in Weimar
**Ratification of the Renaming of the Art
Schools into "Staatliches Bauhaus"**
LW, unregistered files: state, court, and
city authorities 1917—September 30, 1919
(First publication)
The Hofmarschallamt, which still had formal
control of the art schools, was little inclined
to acquiesce to the renaming. However, it was
unable to withhold approval, since the request
had already been granted by the republican
government.

Weimar, March 20, 1919
In accordance with the assurance already given verbally, the academy requests approval
for the renaming of the combined Academy and the School of Arts and Crafts, in agree-
ment with Herr architect Gropius's application, into the following:
Staatliches Bauhaus in Weimar
(Combined former Grand-Ducal Academy of Art and former Grand-Ducal School of Arts
and Crafts).
In the name of the faculty, the director, per professor . . .
Endorsement: The government declares its approval.

Weimar, April 11, 1919
We respectfully inform the director's office of the Academy of Art that the provisional
republican government has approved the request to grant the renaming of the combined
Academy of Art and the School of Arts and Crafts as follows:
Staatliches Bauhaus in Weimar
(Combined former Grand-Ducal Academy of Art and Grand-Ducal School of Arts and
Crafts)

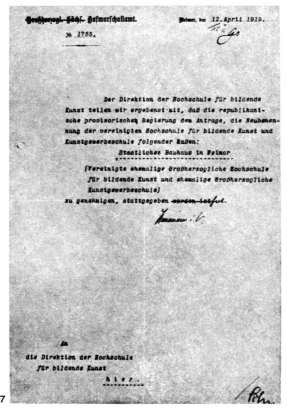

7

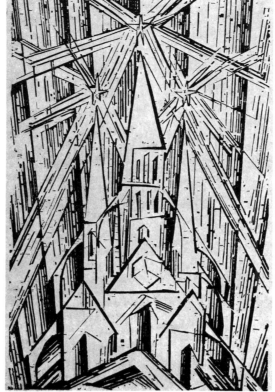
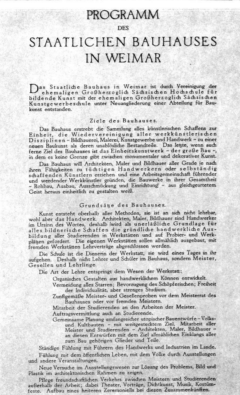

8

Walter Gropius
Program of the Staatliche Bauhaus in Weimar
Published by the Staatliche Bauhaus, Weimar, April 1919
Four-page leaflet with a title-page woodcut ("Cathedral") by Lyonel Feininger and Gropius's Manifesto and Program. The preliminary course, which later became the cornerstone of the teaching method, is not mentioned in this first official publication of the Bauhaus.

The ultimate aim of all visual arts is the complete building! To embellish buildings was once the noblest function of the fine arts; they were the indispensable components of great architecture. Today the arts exist in isolation, from which they can be rescued only through the conscious, cooperative effort of all craftsmen. Architects, painters, and sculptors must recognize anew and learn to grasp the composite character of a building both as an entity and in its separate parts. Only then will their work be imbued with the architectonic spirit which it has lost as "salon art."

The old schools of art were unable to produce this unity; how could they, since art cannot be taught. They must be merged once more with the workshop. The mere drawing and painting world of the pattern designer and the applied artist must become a world that builds again. When young people who take a joy in artistic creation once more begin their life's work by learning a trade, then the unproductive "artist" will no longer be condemned to deficient artistry, for their skill will now be preserved for the crafts, in which they will be able to achieve excellence.

Architects, sculptors, painters, we all must return to the crafts! For art is not a "profession." There is no essential difference between the artist and the craftsman. The artist is an exalted craftsman. In rare moments of inspiration, transcending the consciousness of his will, the grace of heaven may cause his work to blossom into art. But proficiency in a craft is essential to every artist. Therein lies the prime source of creative imagination. Let us then create a new guild of craftsmen without the class distinctions that raise an arrogant barrier between craftsman and artist! Together let us desire, conceive, and create the new structure of the future, which will embrace architecture and sculpture and painting in one unity and which will one day rise toward heaven from the hands of a million workers like the crystal symbol of a new faith.
Walter Gropius

31

Program of the Staatliche Bauhaus in Weimar

The Staatliche Bauhaus resulted from the merger of the former Grand-Ducal Saxon Academy of Art with the former Grand-Ducal Saxon School of Arts and Crafts in conjunction with a newly affiliated department of architecture.

Aims of the Bauhaus

The Bauhaus strives to bring together all creative effort into one whole, to reunify all the disciplines of practical art—sculpture, painting, handicrafts, and the crafts—as inseparable components of a new architecture. The ultimate, if distant, aim of the Bauhaus is the unified work of art—the great structure—in which there is no distinction between monumental and decorative art.

The Bauhaus wants to educate architects, painters, and sculptors of all levels, according to their capabilities, to become competent craftsmen or independent creative artists and to form a working community of leading and future artist-craftsmen. These men, of kindred spirit, will know how to design buildings harmoniously in their entirety—structure, finishing, ornamentation, and furnishing.

Principles of the Bauhaus

Art rises above all methods; in itself it cannot be taught, but the crafts certainly can be. Architects, painters, and sculptors are craftsmen in the true sense of the word; hence, a thorough training in the crafts, acquired in workshops and in experimental and practical sites, is required of all students as the indispensable basis for all artistic production. Our own workshops are to be gradually built up, and apprenticeship agreements with outside workshops will be concluded.

The school is the servant of the workshop, and will one day be absorbed in it. Therefore there will be no teachers or pupils in the Bauhaus but masters, journeymen, and apprentices.

The manner of teaching arises from the character of the workshop:

Organic forms developed from manual skills.

Avoidance of all rigidity; priority of creativity; freedom of individuality, but strict study discipline.

Master and journeyman examinations, according to the Guild Statutes, held before the Council of Masters of the Bauhaus or before outside masters.

Collaboration by the students in the work of the masters.

Securing of commissions, also for students.

Mutual planning of extensive, Utopian structural designs—public buildings and buildings for worship—aimed at the future. Collaboration of all masters and students—architects, painters, sculptors—on these designs with the object of gradually achieving a harmony of all the component elements and parts that make up architecture.

Constant contact with the leaders of the crafts and industries of the country. Contact with public life, with the people, through exhibitions and other activities.

New research into the nature of the exhibitions, to solve the problem of displaying visual work and sculpture within the framework of architecture.

Encouragement of friendly relations between masters and students outside of work; therefore plays, lectures, poetry, music, costume parties. Establishment of a cheerful ceremonial at these gatherings.

Range of Instruction

Instruction at the Bauhaus includes all practical and scientific areas of creative work.

A. Architecture,

B. Painting,

C. Sculpture

including all branches of the crafts.

Students are trained in a craft (1) as well as in drawing and painting (2) and science and theory (3).

1. Craft training—either in our own, gradually enlarging workshops or in outside workshops to which the student is bound by apprenticeship agreement—includes:
 a) sculptors, stonemasons, stucco workers, woodcarvers, ceramic workers, plaster casters,
 b) blacksmiths, locksmiths, founders, metal turners,
 c) cabinetmakers,
 d) painter-and-decorators, glass painters, mosaic workers, enamelers,
 e) etchers, wood engravers, lithographers, art printers, enchasers,
 f) weavers.

Craft training forms the basis of all teaching at the Bauhaus. Every student must learn a craft.

2. Training in drawing and painting includes:
 a) free-hand sketching from memory and imagination,
 b) drawing and painting of heads, live models, and animals,
 c) drawing and painting of landscapes, figures, plants, and still lives,
 d) composition,
 e) execution of murals, panel pictures, and religious shrines,
 f) design of ornaments,
 g) lettering,
 h) construction and projection drawing,
 i) design of exteriors, gardens, and interiors,
 j) design of furniture and practical articles.

3. Training in science and theory includes:
 a) art history—not presented in the sense of a history of styles, but rather to further active understanding of historical working methods and techniques,

b) science of materials,
c) anatomy—from the living model,
d) physical and chemical theory of color,
e) rational painting methods,
f) basic concepts of bookkeeping, contract negotiations, personnel,
g) individual lectures on subjects of general interest in all areas of art and science.

Divisions of Instruction

The training is divided into three courses of instruction:
 I. course for apprentices,
 II. course for journeymen,
III. course for junior masters.

The instruction of the individual is left to the discretion of each master within the framework of the general program and the work schedule, which is revised every semester.
In order to give the students as versatile and comprehensive a technical and artistic training as possible, the work schedule will be so arranged that every architect, painter, and sculptor-to-be is able to participate in part of the other courses.

Admission

Any person of good repute, without regard to age or sex, whose previous education is deemed adequate by the Council of Masters, will be admitted, as far as space permits. The tuition fee is 180 marks per year (It will gradually disappear entirely with increasing earnings of the Bauhaus). A nonrecurring admission fee of 20 marks is also to be paid. Foreign students pay double fees. Address inquiries to the Secretariat of the Staatliche Bauhaus in Weimar.
April 1919.
The administration of the
Staatliche Bauhaus in Weimar:
Walter Gropius.

Oberhofmarschall (retired) Baron
von Fritsch
Letter of April 20, 1920 to the Hofmarschallamt in Weimar
Explanation of the appointment of Walter Gropius to the former Grand-Ducal Academy of Art.
LW, Hofmarschallamt files 3708, Title LVIII No. 1, 1919—1922, pp. 12 ff.
The cause for this explanation was a slander campaign launched by nationalist circles and friends of the old academy professors against Gropius, which attempted to cast doubts on the legality of his appointment to Weimar and the founding of the Bauhaus. Gropius himself commented several times on this matter in the newspaper "Deutschland," which then published Fritsch's explanation.

At the beginning of the year 1919 Professor Thedy, who at that time was deputy Director of the Academy of Art, came to see me and submitted the request that architect Gropius be appointed Director of the academy. This request represented a unanimous decision of the entire faculty of the academy. A few days later, Professors Engelmann and Klemm appeared at the Hofmarschallamt to confirm that it was the unanimous wish of the faculty of the academy to have Gropius appointed as Director. I turned, in writing, to his Excellency von Bode in Berlin and asked him whether in his opinion it would be advisable to appoint an architect as head of the academy and whether Gropius would be qualified for the position. Excellency von Bode replied that it was quite admissible to appoint an architect as Director of the Academy of Art; that lately the idea of putting a nonpainter at the head of an academy for painting had been variously considered and held desirable, and that he, Excellency von Bode, after having spoken to Herr Gropius about this matter and having seen his works, could recommend him as qualified for the position.
But in a letter of January 13, 1920, Excellency von Bode expressed his opinion as follows:
"After what I have read in the newspapers about the goings-on at the Bauhaus, your Excellency must have received quite a strange idea about my own conception of art and about my conscientiousness in giving information. I am absolutely appalled, and at the time of the first appointment by Gropius—of the cubist Feininger—I expressed my astonishment to him. Gropius had presented me with a program that to me appeared a little radical but was quite acceptable in its essential points. He elucidated it verbally, to the effect that he was primarily concerned, as I am, with the reestablishment of the crafts; that he intended first to enlist only competent craftsmen and to train young people thoroughly in the crafts for some years—fine art would have to come later! And then he started right off with the appointment of Feininger!"
The appointment of Herr Gropius was then concluded by the Hofmarschallamt, after I had obtained the approval of the chairman of the then provisional government, Herr Baudert. His Royal Highness, the Grand Duke, had not been given notice of the intended appointment of Herr Gropius. The negotiations with Herr Gropius were carried on verbally in Weimar. He was often in Weimar personally and also conferred directly with Herr Baudert. Herr Gropius was appointed Director of the Academy of Art. The fact that the contract of employment also mentions his appointment as Director of the former Grand-Ducal School of Arts and Crafts is wrong in that this institution no longer existed at that time. In § 5 of the employment contract it is explicitly stated that Gropius submit to the existing statutes and regulations of the Academy of Art and to those perhaps yet to be issued with his cooperation. As long as I directed the business of the Hofmarschallamt, there were no changes made in the statutes.
Approval for the change of name of the academy to Staatliche Bauhaus was granted by the government without consulting the opinion of the Hofmarschallamt. I mentioned to Herr Gropius that I considered the term Staatliche Bauhaus unsuitable.
Because of the employment of Herr Gropius as Director of the Academy of Art. it was naturally impossible, and not desirable, to change the legal relationships that existed between the House of the Grand Duke and the institute, especially those with respect to funds available for purposes of the institute: the academy fund (apparently also called disposition fund); the art expansion fund; and the fund established at the time of the dissolution of the School of Arts and Crafts. But the establishment of new stipulations on this matter must be reserved for the negotiations whose subject is the dispute between the Grand-Ducal House and the State, as has already been explicitly provided for in the declaration of June 26, 1919 on the compensation conditions.
Neubabelsberg, April 20, 1920
Baron von Fritsch

33

Lyonel Feininger
From Letters to Julia Feininger (1919)
BR, gift of Julia Feininger (First publication)
Feininger had met Gropius shortly before the
war in the Working Council for Art in Berlin.
Following his appointment, he arrived on May
18, 1919 in Weimar, where he already felt at
home because of the time he had spent there
prior to the war. His family remained in Berlin-
Zehlendorf until the summer of 1919, since
there was no housing immediately available.

Friday morning, May 30, 1919
. . . Yesterday I couldn't get around to writing, perhaps because I had not heard anything
definite on the housing problem and did not want to discourage you, for I didn't see
clearly myself. . . . It is said that the National Assembly won't be returning here! That
would be a blessing for all, and conditions would change in no time. The villages, already
crammed full by the military who confiscate and eat up everything, will then finally be
relieved too. So, sit still until I wire you, today or tomorrow. . . . Yesterday, we had tea
at Klemm's. There were fifteen or more people there, all of them Weimar intellectuals.
Reitz, whom I like very much and who conducts the opera, and his young wife, very
pleasant. And various actresses and singers, writers, and so forth. And then! Our Herr
Director and his wife. Well, I don't want to write about that now, but I have been thinking
a lot on the theme "Gropius." In him and in her we are facing two completely free, sincere,
exceptionally broad-minded human beings, who don't admit of evasion, characteristics
of great rarity in this country. Naturally people react against them and they are looked
upon as alien and disturbing elements. I can only say that to this day they have com-
pletely respected me and, from the very first, granted me the right to make fully inde-
pendent decisions. I don't think I could get along with them otherwise—you know that
I am also a fanatic. Gropius sees in art the craft—I the spirit. But he will never demand
that I change my art, and I want to help him and give him all the backing in my power,
since he is a man so loyal and candid, and so full of idealism, without any selfishness.
Be he creative or not, he is a personality—second to none here, and "she" also has a
distinction all of her own! . . .
Saturday, June 14, 1919
. . . A westerly storm is blowing, with gray skies and heavy driving clouds. It rained solidly
during the morning, and the weekly market was completely soaked and looked quite
bleak. . . . I am expecting a young man in half an hour who wants to become my student,
the same fellow of whom I wrote yesterday. He looked at me as if all salvation were to
come from me. But what more can the best of art teachers impart than guidance.
Strengthening and development of inherent faculties,—one can but rarely speak of a
God-given gift—everything else is the struggle of years, of decades if a new artist and
not just an artisan is to emerge. I should like best of all to have a hard-headed student
who has the power within himself just to be himself. If he is worth his salt he will learn
to obey necessity more than me—I don't want to train any tame followers! . . .
Weimar, Staatl. Bauhaus, June 17, 1919
. . . I have just received your letter of Sunday . . . and I have the following answer: We are
going to move now, and the furniture will just have to be stored here until we can move
in, into our little house. This may be soon, but it also might, and probably will, be only
at the beginning of October. So, away from Zehlendorf . . . I am so well rested that I feel
very happy. These last few days I have gone outdoors in the mornings and afternoons
for 4 to 5 hours of sketching, and I am regaining my old discipline, from nature. Thus
I now know much better how to deal with my students . . . I feel I am really becoming
some sort of psychiatrist, my influence at the outset being more of a psychological kind. . . .
Weimar, Staatl. Bauhaus, June 22, 1919
[During the afternoon and evening the masters had surveyed the first exhibition of work
by students of the Bauhaus and had deliberated on the granting of scholarships.]
. . . I saw the works of the students for the first time exhibited together. In the beginning
I had great difficulty in adjusting to them. Some of them simply dumbfounded me and
made me ashamed of my own inadequacy—in the course of time and with the worries of
work I really have become a remote sort of animal—but on the other hand there was a
confused mass of industrious studies without any signs of talent; maybe these represent
an even higher accomplishment in terms of work? But after a while the over-all picture
became a little clearer. Gropius had already told me privately that he intended to deal
harshly with and go against certain elements uncompromisingly—and so he did. I have
to admit that he was perfectly right. He has precise judgment, and what a man like myself
might have cherished out of tradition, he is apt to overthrow. This seems hard, but it is
stimulating. . . . In my opinion, there is some quite significant talent at the school, even
when measured against the yardstick of so-called mature art. Thedy's group got the worst
of it, being represented entirely and without exception by good and dry academic work.
A student in such a class could never in all his life free himself, unless he were given
his walking papers by Thedy himself—a step which this good-hearted, gentle Philis-
tine could never take . . . He was beside himself about the vote, completely dismayed.
In the end it was pathetic when he got up at the meeting and declared it "unjust" to
simply pass over this or that student. Shaking his head, he declared "good" works
of students of other groups to be "hideous," he could not understand it, etc. . . . I had
to struggle with myself to deny him my vote too—but that is just what I am here for: to
fight against sterility in art. But may God prevent a similar thing from happening to me
some day, as happened to Thedy. . . .
Staatl. Bauhaus, 8 a.m., June 27, 1919
. . . But now the graphics exhibition is up, since yesterday afternoon, and it has turned
out to be really presentable. Three days, from eight in the morning until nine in the
evening, I stood and took engravings and photographs of famous old masters out of the
big frames that normally adorn the halls of the Bauhaus, cut sheets of paper to size as
backdrops, glued them together and fitted them into the frames and then sorted and
fastened a few hundred sketches, drawings, water colors, and small woodcuts, and at
the end, without a helping hand, put the things back into the frames and nailed them
shut . . . To select just the good ones from several thousand sketches, and among them
to make the right choice and find the correct combination for each frame! . . . From this,
students can see what it took to come this far, and how one can study even without

drawing in class . . . I put up the whole show in the large skylighted studio, here on my floor—almost next door—with the help of three students, two of whom have already signed up as my pupils for fall—such helpfulness. . . .

The national assembly has now run off in all directions—Scheidemann nearly had to flee, because soldiers were out to get him and "hang" him for his signing of the peace treaty—he got away by car to Ossmanstedt. . . . It has been mad during the last few days here at the Bauhaus—there is blazing or brooding rebellion all around; reason: the prize-awarding. There are many indignant withdrawals and a very dark camarilla that wants to petition the Minister with a demand for nothing less than the immediate dismissal of Gropius from the director's position! Last night a big discussion between Gropius and the rebels took place. He appeared at a meeting and listened to everyone who had anything on his or her mind. That eased the tension and helped clear the air. These little people are a miniature Germany at large—they are immediately up through the roof, beside themselves with indignation, uncertain about what was said or meant, they simply lose their heads and are inclined to lend credibility to every horror story. What the students blame Gropius for most, and not entirely without justification, is that he said he would at all times stand up for the "most extreme art," art which is a sign of the times. But how can one expect a school of 150 young people to practice "extreme art"! That simply means practically to force them into imitating some idol, transcending any development that surely would take decades. I am going to mention this today to Gropius. Yes, these days are full of events, internal and external world history. . . .

Wednesday, July 9, 1919

. . . We have the little house! It has been firmly promised me in a personal interview with the city building inspector at his office and papers have already been passed. . . . It is like a dream that we are getting this house . . . Now I am so happy! Because of the uncertainty of these past few days I have been simply miserable, just as you have. And you cannot imagine how people here fight for every home. There is great misery; I had to wait behind 20 people at the building office before it was my turn—and none of them received a positive answer. We received the house only because we are eight (with Mamma, whom I firmly included in the account)—actually there should be nine or ten, but the inspector promised that we will not be bothered. There is room really for ten people! . . .

Johannes Itten and Lyonel Feininger
On the Problem of State Care for Intellectuals in the Professions
LW, unregistered files: Ministry of Culture, October 1, 1919—August 1, 1922 (First publication)
The Ministry of Culture had asked the masters for their opinion on a petition from the East Thuringian Art Union which had applied for state care for intellectuals in the profession. The answers were probably written in December 1919.

9

The state / an organization for the preservation and regulation of the economic problems of a community / nation / or its representation / the government / is only interested in its own interests. If the mind / here art / serves the state / it will be supported / if the mind does not serve it / it will be suppressed. Since every true art acts supranationally / cosmo-politically / intellectually / it will always be suppressed. Only parasites of art have become parasites of the state.
The mind stands outside any organization. Where it has nevertheless been organized (religion, church), it has become estranged from its innate nature.
Whoever is not willing to sacrifice his body for the sake of the mind / is no spiritual man; for the sake of art—no artist.
The state should take care that none of its citizens starves / but it should not support art.
In short: Leave the cultivation of art to those who are called upon to do that by the power of their spirit and not to those who are called upon to do that by the power of the state.
Johannes Itten

There is hardly an infallible solution to the problem of the care of indigent intellectual workers; but it is certain that they have a valid claim to protection by the state!
The suggestions made here appear to me to be practicable; the plight is such that it would well be right to try to do something. Here, ways have been shown; suggestions alone are not enough!
Lyonel Feininger

10

Walter Gropius
Address to the Students of the Staatliche Bauhaus, Held on the Occasion of the Yearly Exhibition of Student Work in July 1919
LW, individual file No. 149: Student exhibitions 1916—1919 (First publication, excerpts)

In his opening remarks, Gropius declared that the exhibition revealed both "talent and disruption." One noticed that the convulsions caused by the war had not yet been mentally overcome. He had especially asked the students for design and idea sketches, but what had been submitted kept close to academic conventions. No one had "brought forward a compositional idea."

I suggest that, for the time being, we refrain from public exhibitions and work from a new point of departure, so that, in these turbulent times, we can collect our thoughts anew and become first of all self-sufficient, and that will hopefully be a great deal. . . . The main thing for all of us is undoubtedly experience, and what we as individuals make out of it. We find ourselves in a colossal catastrophe of world history, in a transformation of the whole of life and the whole of inner man. This is perhaps fortunate for the artistic man, provided he is strong enough to bear the consequences, for what we need is the courage to accept inner experience, then suddenly a new path will open for the artist. . . . Indifference, dozing, and indolence are the worst enemies of art. . . .

Some day you will break free of your own limitations and will know where you have to go. We will encounter surprises, some will make decisions to start anew, even if they have already gained some renown. Since I feel all this so distinctly, I, for my part, do not want to do anything by force. It will all come from yourselves. . . .

[During the period before the war] we designed artistic ashtrays and beermugs, and in that way hoped to work up to the great building. All that by smooth organization. That was an incredible presumption on which we were shipwrecked, and now things will be reversed. No large spiritual organizations, but small, secret, self-contained societies, lodges. Conspiracies will form which will want to watch over and artistically shape a secret, a nucleus of belief, until from the individual groups a universally great, enduring, spiritual-religious idea will rise again, which finally must find its crystalline expression in a great Gesamtkunstwerk. And this great total work of art, this cathedral of the future, will then shine with its abundance of light into the smallest objects of everyday life. . . . We will not live to see the day, but we are, and this I firmly believe, the precursors and first instruments of such a new, universal idea. Up to now, the artist has stood by himself, for in these chaotic times there is no rallying idea discernible which would spiritually and materially reverse the order of things. On the strength of his visual gifts, the artist reads the spiritual parallels of his time and represents them in pure form. When such spiritual common property is lacking, there is nothing left for him but to build up his metaphysical element from his own inner resources. He stands aloof, and at best a few friends understand him, but not the general public. We artists therefore need the community of spirit of the entire people as much as we need bread. If the signs are correct, then the first indications of a new unity which will follow the chaos are already to be seen. I am dreaming now of the attempt to gather a small community from the scattered isolation of the individual; if this succeeds, we will have achieved a great deal. . . .

The coming years will show that for us artists the crafts will be our salvation. We will no longer stand by the side of the crafts but be a part of them, since we have to earn money. For great art, this is a historically inevitable process, a necessity. All great works of art in past ages sprang from absolute mastery of the crafts. You will ask what my intentions are for the crafts so that an exodus from our midst by those unable to support themselves with free-lance art may be prevented. I work ceaselessly on the realization of my plans. To begin with, a practical workshop outfitted for sculptors will be ready in the fall, and for painters, hopefully an apprentice course with a painter and decorator. Then it will also gradually become clear who will want to stay with us and who will rightfully be an apprentice, journeyman, or junior master, for at this moment these terms are just a game, since they still lack meaning in regard to the crafts. Much now depends on my being able to get our budget passed, despite the gloomy economic prospects. If successful, I will throw myself this fall into the task of reorganizing the Bauhaus, and I hope to create a basic plan for you, with which you will be quite content.

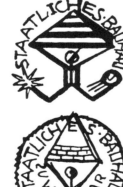

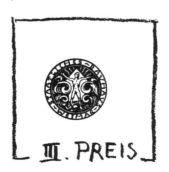
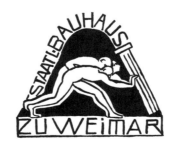

11
Designs for a signet for the Staatliche Bauhaus—entries for a contest held in 1919. Left: "Little star man," by J. Auerbach and Blüthner (?); center: sketch by M. Marchand; right: sketch by G. Fischer. Student work.

12
Signet of the Staatliche Bauhaus from 1919 until 1921.

Dr. Emil Herfurth
Weimar and the Staatliche Bauhaus
Pamphlet, job printed by Hermann Böhlaus'
Successors, Weimar, February 1920 (excerpt)
The "Citizens' Committee," built up primarily
from the camp of the National People's Party,
which was opposed to the Bauhaus, became a
malicious weapon in the hands of the clever
dialectician, Dr. Herfurth, and was a constant
threat to the institute. Compare the rebuttals
of the Bauhaus and the Ministry of Culture to
Herfurth's cunning mixture of actual and
fictitious assertions.

First demand: We demand that the independence and the further organic development of the hitherto existing "Academy of Art" be secured by the government and the legislative bodies.
Justification: The hitherto existing "Academy of Art," founded as an art school in 1860 by Carl Alexander, expanded by the addition of a school for sculpture in 1905 and raised to the rank of an academy at its fiftieth anniversary, enjoyed a distinguished reputation throughout Germany and even beyond and, until the very last, produced acknowledged works, especially in the field of landscape painting. . . . Free from the coercion of any stereotype, this institution was one of the "liveliest academies" in Germany. . . . The art that blossomed there was healthy from within, was attached to the soil, national, and humble, was German in the best sense, that is, full of vigor and honesty, full of enjoyment in observation and creative interpretation. Close ties of cordial sympathy and mutual understanding united artists and art lovers, and the gay celebrations of the artists were climaxes in the otherwise very quiet life of the city of Goethe. . . .
We demand that it be reinstated with its natural characteristics, that it freely unfold again in its respectable home, as master not maid, and that its director think of himself as its first servant and carefully tend to the institute which has been entrusted to him. . . .
Second demand: We demand that the proper authorities, respecting the will of the citizens, carefully consider whether Weimar of all cities, with its tradition and with its present financial possibilities, is at all suitable for the implementation of the Bauhaus idea in its hitherto pursued form.
[Justification:] As far . . . as the Bauhaus plan itself is concerned, the contention that we are hostile toward it on principle, is an unfounded and irresponsible suspicion. We are well acquainted with the history of the demand for craft-oriented unified instruction and welcome, in most of the ideas of Richard Riemerschmid and Bruno Paul as well as of the Werkbund, desirable and promising progress. Particularly in Weimar, even before Gropius, the necessity of thorough artistic and craft training of painters, according to the example of the old Master Schools, has been repeatedly stressed, and long before the War Henry van de Velde successfully cultivated the closest bonds between art and the crafts and industry at the School of Arts and Crafts. We also willingly and respectfully recognize the "purposeful cohesion and organic attraction" of the "Program of the Staatliche Bauhaus" published in April 1919 by Walter Gropius—for whose idealism we feel full sympathy. But for the time being, the Bauhaus idea still remains a theory, whose promise, as is evidenced by the beginnings of its implementation in Weimar, remains far from guaranteeing its fulfillment. The dithyrambic ending of the inspiring call for new action, which precedes the program, still reminds one, in thought and tone, of "Meister Heinrichs Wunderglockenspiel" in Gerhart Hauptmann's "Sunken Bell." The slogan of the "new Gothic," with which one seeks to stun opponents and win supporters in Weimar, if used too often, rouses the suspicions not only of the expert of art history. Parallels to past ages, much as they flatter the ear, always bear many a concealed flaw. . . .
Third demand: We demand that in the state institutions for the fine arts in Weimar freedom of artistic creation be guaranteed and the intolerable predominance of a one-sided direction in art be avoided.
The endeavor for a closely knit community, which is so representative of the Bauhaus plan, can, if exaggerated, lead to an impeding uniformity and one-sidedness. From the very beginning the leadership of the Bauhaus has failed to avoid this danger of an artistic dictatorship, which has found special support in the strength of will and purpose of the personality of its leader. It has declared a single direction in art, that of Expressionism in its strictest form, to be sole master and judge. Such one-sidedness is a sin against the spirit of art. . . . In a state institution for the fine arts complete freedom for artistic work must be guaranteed, else talent will be banished and mediocrity bred. . . . We particularly stress the observation that the "Open Declaration of the Artists of Weimar," which among other things is directed against "the one-sided and intolerant reign of the most extreme Expressionism at the Bauhaus," bears on the top line the names of Max Thedy and Otto Frühlich, who formed their judgment from personal experience as teachers at the Staatliche Bauhaus. . . . At Weimar, Expressionism in its most extreme form is the apparently solid but single brace which holds the new "building" together. Should it sever, the whole will collapse . . .
Fourth demand: We demand that the personal conduct of the members of the art institute conform to the spirit of our great tradition and the way of life of Weimar.
. . . The city has also been most indulgent to the large crowd of new artists, especially when one considers the great difficulties created in housing the greatly increased number of students at this time. The guests show little gratitude. They consciously act as foreigners, deliberately display their contempt of the old Weimar, and by their conspicuous conduct provoke the opposition of the most patient citizen. We are not so unworldly and pedantic to attempt to force the hotter temper of the artist into narrow social channels, and we know that young intellectuals have always been quite a bother to the grouchy citizens of all university towns, . . . finally, we are aware that it would be unjust to generalize individual incidents thoughtlessly, as town gossip does. But there are too many individual cases and some simply call for generalized conclusions. . . .
. . . We were happy when a fresher breeze and a brighter voice entered our tranquility, with the students at the former academy. But the "cheerful ceremonial" which according to the program of the Bauhaus determines the conduct of its students, has nothing in common with youthful freshness and healthy vigor . . .

The Staatliche Bauhaus in Weimar
The Dispute over the Staatliche Bauhaus
(Der Streit um das Staatliche Bauhaus)
Hectographed brochure, Weimar 1920
The impetus for this publication was the general
attack leveled against the Bauhaus in December
by circles of the "National Peoples Party." The
charges culminated in the article by Dr. Herfurth
and in the affair concerning a Bauhaus student
named Gross. This affair sparked the secession
of the old academy professors whom the
Bauhaus had taken over, and led to the founding
of a rival art academy, which was accommo-
dated in the same building. This fact resulted
in uninterrupted friction until 1925.

13
The signatures of Gropius, Engelmann, Klemm,
Feininger, Marcks, Itten, and Thedy on a declaration
of the Council of Masters, May 22, 1920. LW Kultus-
ministerium.

. . . The transformation of the Weimar art schools had hardly been tackled before an
increasing number of groups began to recognize that the new school was standing on
shaky ground and was clearly bearing the traces of experimentation. . . . It was further
alleged that the Staatliche Bauhaus had emphasized its aims too obtrusively by an
exhibition of works of the most extreme Expressionism—although the Staatliche Bauhaus
never authorized this or any other public exhibition. But the opponents found their most
popular material for agitation in the shocking news "that the Director of the Bauhaus
had demanded of the municipal authorities that Bauhaus students be permitted to paint
the city hall." In this form, the account was a distortion of the facts . . . Essentially, the
question was that the city art commission, instead of selecting a few of the already
finished paintings of local students, as was usually done, decided to announce a design
competition for the painting of a public hall. From the results of the competition, the
commission would then make a selection according to its own judgment. The work was
planned to be executed by collaboration between masters and students, and the purpose
of this suggestion, which caused such bewilderment, discord, and indignation, was
merely to bring the school into contact with the city, and the work of the Bauhaus into
contact with the public of Weimar, and to make possible a collaboration that would suit
both sides.
This point was also a topic of discussion at a citizens' meeting called by the Free Asso-
ciation for Civic Interests, which was an immediate occasion for a public airing of the
Bauhaus dispute. During the meeting, on the occasion of by-elections for the municipal
council, both the Bauhaus and modern art became subjects of a spirited discussion,
being examined according to local-political, natural-scientific, and ethnological points
of view. The controversy was now carried over into the daily newspapers and immediately
entered into its decisive stage. With the Weimar state newspaper "Deutschland" and its
columnists Leonhard Schrickel and Fräulein Mathilde von Freytag-Loringhoven taking
a verbal lead, the dispute was quickly politically interpreted and exploited. Whoever
traces the controversy back to the beginning of its public exposure will realize that there
never was any material point of departure to it and that the opposition only much later
brought less irrelevant topics into the center of the conflict. However, this was done
long after people throughout the nation had energetically rejected the campaign against
the Bauhaus, begun by the above-mentioned pair, as nationalistic and anti-Semitic
slander. . . .
A petition, dated December 19, 1919, was addressed to the State Ministry by a large
number of Weimar artists and dilettantes. The already settled allegations of political
tendencies within the Staatliche Bauhaus were rehashed and a few special cases were
cited, intended to support this contention—and they were consequently used in the
out-of-town press in an embellished manner to stir up opposition. So, for instance,
pamphlets with strong "spartacist" tendencies were alleged to have been distributed
officially to each and every student, and the leader of the spartacists, Sachs, was sup-
posed to "have repeatedly been visiting the school". . . .
A different, objective point, on the other hand, deserves all the more consideration.
The signers of the petition . . . repeated the rumored allegation "that the management
purposefully works to divest the Bauhaus more and more of its character as an art in-
stitute." Nothing but a very subjective concept of the essence of an art institute under-
lies this rumor, since at the Bauhaus painting and drawing, modeling, graphics, etc.,
are as intensively practiced as the material circumstances (space, heating, etc.,) permit.
Since the Bauhaus has no other aim than to strengthen and purify common artistic pro-
ductions from within, . . . it would certainly work against its central aim if it were to
abandon the character of an art institute or to impair it. On the contrary, the Bauhaus
wishes to be an exemplary art institute without "throwing the whole tradition overboard"
and without closing its mind to the vital necessities of our time. . . .
. . . On January 22, at a meeting called by various citizens' committees, a resolution was
passed whose central theme,—recently published in form of a brochure—is supposed
to represent the "opinion and will of almost all the inhabitants of Weimar" and "all
political factions." Herein lies an inaccuracy, since at the close of that meeting, as well
as afterward, the representatives of the Socialist parties emphatically refused to join the
art-political maneuvers of the local citizens. But since the followers of the Socialist
parties, according to the composition of the parliamentary bodies, represent a sizeable
part of the population, every such allegation which the opponents of the Bauhaus like
to bring forward to support their cause is not just an exaggeration but a conspicuous
falsehood. Furthermore, it must be added that a large number of personalities, residents
of Weimar who belong to various political persuasions, do not count themselves among
the followers of the "citizens' committees". . . .
This observation is made merely for reasons of objectivity, for in no case, including that
when the opinion and the wishes of a majority of the inhabitants run in favor of the
Bauhaus, can the right to decide cultural problems be conceded to a numerical ma-
jority. . . .
At the meeting in the "Armbrustsaal" a resolution was passed whose principal points
are repeated in the brochure "Weimar and the Staatliche Bauhaus." . . . As usual, the
signers do not fail to cite the names of great artists of past periods who have worked in
Weimar, although they must know that those who in fact truly form a part of the history
of art and not just of local history have never been in tune with, but rather always in
opposition to, the often conjured artistic spirit of the city. Weimar's art history is a
chronicle of this misunderstanding between artist and public. Such friction is by no
means a local phenomenon, and there is no difference in this respect between Weimar
and other art cities. The causes are much deeper . . . that great art personalities must,
of inner necessity, remain misunderstood by their contemporaries, and that public

acclaim generally does not attest to the value of the artist. And the fact that the signers also refer to Henry van de Velde proves just how little even those whom one would expect to be acquainted with the cause they oppose are conversant with the program of the Staatliche Bauhaus. . . .

. . . From the citizen's right to practice self-determination in political matters another claim is derived, namely, to pass judgment on matters that stand outside and beyond political affairs. Politico-cultural theory makes it quite clear that such thinking over-strains the term "democracy" when democracy is thereby carried into areas assigned to a different category of terms; and that such a false application of the principle of self-determination easily appears where democratic tendencies are still young and are seeking to spread wherever possible, without consideration of the limitations inherent in every political principle. When a citizen who is new to democracy does not yet understand how to use his majority rights, such a transfer of claims into certain cases where the claim can have no validity—especially in the practice of public concern for the arts—causes this contradiction, the solution of which is increasingly felt to be an urgent necessity. . . .

. . . Were one to examine the excursions of the opposition into Expressionism, which they "are far from dismissing as a fashionable disease," but which they are not so far from dismissing as a mental disease, then it would be necessary to enter into a dissertation on art. But since the opinions expressed display, word by word, such an elementary lack of knowledge of art, we refer them to any one of the numerous informative works on this subject. However, one can hardly expect those possessed of a mental attitude that "remains suspicious and uncommitted" about new ideas—although they are, on the other hand, aware of the fact that a standstill always means regression—and who remain waiting to be convinced of the value of these new ideas—although this conviction can only be achieved by passionate devotion—that people of such an attitude, which indeed deserves to be called a transgression against all intellect, will one of these days "be wholeheartedly committed to bring sacrifices for new ideas."

The wish to have the newly appointed masters of the Staatliche Bauhaus reveal their intentions and abilities in an exhibition of their works must go unfulfilled for the time being . . . The exhibition would hardly serve the purpose of instruction, assuming that such instruction were even desired; for the indispensable prerequisites are still lacking, without which new phenomena—not even miracles—have ever been understood or even appreciated by the masses. The individual finds his way to these more easily. He also finds his way into the Staatliche Bauhaus, and enlightenment, and such good will as he himself brings along. . . .

Ministry of Culture in Weimar
Results of the Investigation Concerning the Staatliche Bauhaus in Weimar
Supplement to "The Dispute over the Staatliche Bauhaus," hectographed, Weimar, 1920
This remarkably objective reply to the accusations of the Nationalists sketches also an iridescent picture of the manners and morals of general politics and the special conditions at the Bauhaus. Here, various tendencies interpenetrated, and, typically for the early postwar period, a scurrilous sectarianism with a soul-hunting claim to the Absolute appeared and set sentiments aflame.

Under date of December 30, 1919, a number of citizens, including particularly members of the artistic professions, addressed a petition concerning the Staatliche Bauhaus in Weimar to the State Ministry. In it, serious accusations were leveled against the management and the student body of the Institute. The former was alleged to be working toward divesting the Bauhaus of its character as an art institute and increasingly molding it into an institution that would end up by serving only for the training of advanced craftsmen. The whole tradition of the Academy of Art was being thrown overboard and everything that once made Weimar proud was being treated with deliberate contempt. It was further alleged that the Director handles the management in a manner incompatible with the principles of objectivity and justice. He unilaterally favors elements alien to the race at the expense of German nationals and deprives master students of their studios in order to offer them as homes to alien elements taking account of the prevalent housing shortage. These elements of alien lineage behave themselves in the most improper manner at the Bauhaus and seek to dominate it with their ideas. It was also claimed that with respect to politics there prevails a tendency that cannot be tolerated. A large number of representatives of Communist-spartacist persuasion were said to exist and to disseminate their ideas. A pamphlet with spartacist tendencies was stated to have been officially distributed to each and every student, and the spartacist leader, Sachs, was said to have repeatedly visited the Bauhaus. Such conditions, it was said, should not be tolerated at an academy if its standing is not to be endangered.

Finally, a special case was pointed out in the petition, in which a master student, Hans Gross, was said to have been rudely insulted by the students for his manly stand during a meeting and for his plea that the Bauhaus idea be based on *German* foundations, and to have been disciplined by the directors of the Bauhaus by the withdrawal of his scholarship. . . .

The accusations concerning the manner in which the Bauhaus is directed, the conditions within the student body, as well as those concerning the Gross case, have been the subject of an investigation that produced the following results:

On December 12, 1919, a meeting called by the "Free Association for Civic Interests" was held at the "Erholung." The first point on the agenda was "The New Art in Weimar. Speaker, Building Inspector Ehrhardt." Since the speaker was unable to attend the meeting, Dr. Kreubel spoke in his place and directed the most vehement accusations against the Staatliche Bauhaus in Weimar.

Among those who spoke during the course of the debate was the painter Hans Gross, master student at the Staatliche Bauhaus. His remarks were variously interpreted. Some were of the opinion that they had been directed against the Bauhaus and its Director. Others thought this opinion unfounded. But a number of the latter also considered the speech inopportune and unfortunate. Gross himself insisted that he did not intend to say anything against the Bauhaus and its Director. The wording of the speech is not established with absolute certainty. According to newspaper reports, it went as follows:

"I should like to reject strongly the remark of Dr. Kreubel that 'The Bauhaus is spartacistic and bolshevistic.'

"On the whole, it is not a very thankful task to speak on art, particularly on the so-called 'new art.' For me these terms do not exist. True art remains art; it is not bound to any particular time or any particular direction. All formal creations of an artist are nothing but the expression of a mysterious primitive form from within the artist himself. The more purely and powerfully this form expresses itself in his works, the more mature and greater is the artist who created it. And it makes no difference by what name art is called, whether it is Futurism, Cubism, Expressionism, or heaven knows what else; the 'isms' can go on forever. But only when the artist is a real man, a fellow of steel and iron, will he come up to expectations. It is he who is called upon to lead. But our age—the so-called 'age of freedom and salvation'—can it teach us anything? This age boasts its personalities, but all these are nothing but names turned into personalities, empty letters which fall out of the air on to the people and dazzle them. The intellectuals herald the salvation of the world, the new culture, but they do not know that this culture 'had its origin in farming, and is not meant for him who cunningly rummages around your shack with all the rubbish.'

"Only that personality is missing which, through its energy and will, can convince and carry everyone along with it; the power of leadership, which carries in itself true German nature and German characteristics. For our age no longer knows any Germans, and much less an art which is German. We have, after all, denounced ourselves. We never want to be what we are—Germans! Ever since the Gothic era, we have degenerated. We have always ignored the warnings of our greatest men. Where is a better place for international humbug than here in Germany; German spirit, German feelings, everything is thrown on the dungheap, infected with decomposing bacteria—is trodden on, avoided like a stinking carcass. Is it such an inferior product in comparison with everything else? You blind people, you have lost the recognition of your native soul completely—the words 'German character' have become distasteful to you. You have many people who are supposed to be German, but who do not feel German—you have a few who are German, but you despise them. . . . You wander along in stupor and indifference, not feeling the thorn that pierces you. The grip of death is not far from you—but you wake only when the knife is held to your throat. The wolves thirst for your blood: just one step more and you will plunge into doom, into the stinking, suffocating mire, never to get up again. The revenge is cruel for a people that renounces itself. Bear in mind that you are Germans! Think and act!''

Gross contends that his speech was worded exactly as the newspaper reprinted it. Other persons claim, however, that parts of the speech had been different. They say this was already the case with respect to the first sentence, for Dr. Kreubel had accused the Bauhaus, among other things, of having spartacist and bolshevist elements, while Gross had repudiated this and emphasized that there were not just spartacist and bolshevist elements there. They note that perhaps Gross had meant to contend with this statement that there were none there at all; it had sounded, however, as though such elements were there, but not only such. . . .

These statements gain in probability when one considers that the day after the meeting, Director Gropius and one of the student representatives had examined the manuscript and had noticed modifications of the original text in it, which Gross had probably inserted at the meeting, while only the original wording had come to be published in the newspaper. . . . Whoever reads the text that the newspaper published will find a multitude of clichés, but not really anything overtly and clearly directed against the Bauhaus, even if the sentences on the qualifications for leadership in art and on the lack of qualified leaders sound insidious. But it has to be considered that, as far as the first point on the agenda is concerned, the meeting had surely been called to air feelings against the Bauhaus and that therefore everything that was said on this point must be assumed to have been related to the Bauhaus. Gross's words then, also have to be taken as having applied to the agenda. Gross was aware of this. . . . He had . . . read his speech to a friend on the same day, remarking that he wanted to deliver it that evening, and his friend had most emphatically advised him against it, referring to the dangers of being misunderstood. . . . Immediately after the meeting he was reproached by some students at the "Kaiser Café" for having spoken out against the Bauhaus. He denied it. When the students attempted to prove their point by quoting from his manuscript, he stubbornly denied owning one at all. The student Gilles declared that if he did not have the courage to show his manuscript and to stand up for it, he was a scoundrel. The students suspected that Gross would change the text afterwards. Finally, shortly before his departure, Gross confessed to having worked out his speech in advance . . .

Some of the students were angry enough about Gross's behavior to press for a clarification of the matter and called a student meeting for that purpose. It was resented that Gross had in fact appeared without giving prior notice of his intentions to the student representatives, for there existed an agreement . . . that such an independent appearance of a student was to be announced to the representatives beforehand. One wanted to prevent a *faux pas*. . . .

The course of the student meeting was as follows: At first, the student Gilles led the meeting. But since Gilles appeared as the plaintiff, the second chairman, Winkelmayer, with the approval of those present, took over the meeting in the place of the first chairman, Determann, who was ill. Although he attempted to calm the students, tempers ran high. The accusations against Gross were vehemently repeated. Gross himself was shamefaced and defenseless and made a pitiable impression, very much in contrast to his appearance at the "Erholung." Though called upon to do so, he did not attempt to justify himself. He merely stated that he had just been with the Director, had spoken to him for a long time, and that everything was in order. This statement and the fact that some foreigners . . . interceded for Gross induced the students to adjourn the meeting without passing a formal resolution, for they wanted to avoid taking a stand in possible opposition to the Director. But one student offered the opinion that Gross, having come to know the mood of the

students, might resign of his own accord.

Gross had indeed been with the Director prior to the student meeting, the latter having summoned him to reproach him for his conduct at the "Erholung." The Director also had the impression that Gross by his speech had deliberately placed himself in opposition to the Bauhaus and its Director and furthermore had seriously endangered the Bauhaus idea by mixing politics and art. The Director was all the more painfully affected by these events, since he had actively supported Gross on every occasion, had tried to assist him in every way, and had quietly aided him financially to relieve him in his hard-pressed situation. The very morning before the meeting . . . he had been assured by Gross that he fully approved of the objectives of the Bauhaus and was prepared to stick with the Director come what may. . . .

Gross's account of the events at this conference with the Director differs from that of the Director in one essential point. Gross says that the Director, deeply moved, had reproached him for his appearance at the "Erholung," declared that he would lose his scholarship because of that, and added that the students would decide upon any further steps to be taken. On the other hand, Director Gropius, who had written down the text of the conversation immediately following the talk . . . declared that the contention that he had withdrawn Gross's scholarship and had mentioned that the students would decide upon any further steps was completely incorrect. It was not within his jurisdiction to withdraw scholarships, as this could only be done by the Council of Masters. He had reproached Gross for having, contrary to his assurances of the same day . . . knifed the Bauhaus in the back with his speech, and added that he would now withdraw his support from him. . . .

Gross's account is in contradiction to the fact that, according to the statutes, the Director is indeed not in a position to withdraw a scholarship. This is solely within the jurisdiction of the Council of Masters. In addition, Gross's own subsequent conduct stands in contradiction to his statements. At the meeting of the students he declared that he had talked to the Director and that all was well. These words would have been incomprehensible had Gross just received the crushing announcement of the withdrawal of his scholarship. . . .

. . . In a letter to the Council of Masters dated December 17, Gross tendered his resignation from the Bauhaus. He declined, in writing, the invitation to come for a consultation . . .

The wording of this letter and the fact that Gross let four days pass before he drew the consequences from the alleged reprimand and left leads to the conclusion that he had in the meantime been incited by some group to leave the Bauhaus, and in general to take his later stand against it . . .

During the days of December 16 and 17, thirteen more students left the Bauhaus. One of them later re-enrolled. The question of the motives for their departure has been variously answered. The reasons given were partly the Bauhaus program, partly the composition of the student body, partly the international or antinational sentiments and actions of some of the students. All those who left mentioned the Gross case as having been the final impetus for their decision.

The following remarks concern the further content of the petition mentioned at the outset.

The allegation that students alien to the race were favored over Germans and at their expense, be it through free meals or through scholarships, is unfounded. Up to now . . . every needy student who applied for it, or whose need had otherwise become known, was given a free meal, with one single exception, where it was not merited . . . Only three of the students from areas outside the Reich hold scholarships . . . However these three had already been at the academy before the Bauhaus. . . .

It is also not true that the administration of the Bauhaus has allegedly taken away studios from former master students or intends to do so in order, for instance, to give them to nonresident foreign elements. It is correct that in the fall of 1919 a movement opposed to studios for master students had emerged among the new students. But when it was pointed out to these students that one could not very well take away studios from returned veterans who depended on them financially, the matter was soon dropped. Indeed, not a single master student lost his studio, despite the shortage of rooms . . . But the older students who had already been at the academy for 12 to 15 years were given notice to begin looking for their own rooms, in order to make room for the younger students . . . Of the total number of 23 student studios with 24 studio occupants, only one room is occupied by 2 German-Austrians (war veterans), all the other studio occupants being Reich Germans. Furthermore, no scholarship has been withdrawn from any of the former master students.

Because of the great housing shortage and poverty in the middle of October 1919, revocable permission was given to live and sleep in the student studios. For this purpose, house rules were drawn up which emphasized that if any illicit conduct should occur the permission would be withdrawn for all. There are only gas lamps in the student studios. Since the gas supply during the winter months was very limited, low gas consumption resulted of itself. Cooking and laundering are strictly forbidden in these rooms. . . .

. . . Concerning the allegation that elements alien to the race, specifically Jews, were unduly pushing themselves into the foreground and were seeking to lead and dominate the Bauhaus with their ideas, it is quite remarkable that two older master students, Linzen and Schrammen, emphatically declare that they have never seen such behavior . . . And it would also be strange if 17 Jews—all the others are of Aryan origin—were able to dominate 200 other students. The Itten students are said to have repeatedly attempted to enforce their opinion on the arrangement of the evening life-classes, so that some confusion resulted from the to-and-fro and the pro-and-con, which made orderly work impossible. But such tendencies had their origin in different conceptions of educational requirements. Annoyances threatening to result from that situation have been removed by a regulation

devised by the Council of Masters. Moreover, the fact that the procurement of appropriate life models met with great difficulties because of costs as well as inadequate heating, is here mentioned only incidentally.

Among those students who are alleged to be pushing themselves into the foreground, the same names are always mentioned. Investigation has shown that the students concerned are those who are particularly talented and mentally alert, who take a great interest in art, science, and literature, and especially philosophy. One girl among this group of students is an especially mature and serious-minded personality, whose helpful and always unselfish nature is recognized without reservation. . . . The administration has at all times strictly prohibited any political activity among the students, and it has repeatedly and emphatically restated this prohibition. That a small number of the students have radical political tendencies and are inclined to demonstrate these occasionally in public cannot be denied. The administration forcefully opposes these tendencies and does not fail to warn the students. That young people of this age should take an interest in politics and in forming political beliefs is, however, readily understandable . . . Difficulties are occasionally unavoidable in these times of excitement and with the temper of youth. . . .

Nothing is known about the alleged distribution of the "Red Flag" at the Bauhaus.

The Munich socialist, Sachs, has been at the Bauhaus only once, not as a politician but rather in the capacity of a painter and as author of two extensive works on the technique of mural and panel painting, as well as on the technique of the batik process. He presented these works to the director and to the other masters, with the request for an opinion. After that, he left. Any kind of political activity by Sachs during his very short stay at the Bauhaus has not been confirmed in fact . . . The "document with spartacist tendencies," which is said to have been "officially" distributed among the students, is presumably the pamphlet "To All Artists." According to investigations by the Director's office, this document was sent in the spring of 1919 free of charge to all artists and institutes (including moreover the local State Ministry) by the Publicity Office of the German Republic in Berlin. It was not officially distributed; whoever wanted to have it—his attention having been aroused by the flashy title page—could take one. There was no reason for the Bauhaus administration to prevent this, since the content of the pamphlet was regarded as being nonpartisan and at most as being art-political.

. . . It cannot be denied that some students, both men and women, leave something to be desired in their conduct and dress. The main reason for this is the prevailing poverty. Most of the time, the most proficient and talented students are also the poorest. People who have to live on thirty or forty marks a month are certainly not in a position, under prevailing conditions, to dress as would be desirable. But the Director's office adamantly combats any intentional relaxation of behavior that transgresses the limits of the permissible, particularly when it is coupled with intentional disrespect of the opinions of the citizens. However, the fact that the language and conduct of the students has often given cause for censure surely has to be attributed to a considerable degree to the war and to the changed conditions produced by it and the revolution. After all, similar signs are to be seen elsewhere. Moreover, a complaint has been made that the neighborhood of the Bauhaus—especially since the canteen has been established—is often disturbed by noise during the night hours. Even granted that the disturbances in that area are all, without question, due to Bauhaus students, the fact that things at times do get a little noisy should be attributed to the liveliness and cheerfulness of youth. The canteen, whose establishment has become a blessing to many students, constitutes the only place to sit for numerous poor students. Everyone likes to use the canteen, even though, with the exception of noontime, it is not heated. Off and on, lectures are given there in the evenings. The Director himself has often seen the goings-on in the canteen and never found cause to criticize or to intervene. The morale of these young people, as can be confirmed in various quarters, is generally excellent. The students respect one another, have developed a good community spirit, and are helpful and devoted. Excesses of behavior, especially between the sexes, have not become known. The Director's office would not tolerate any such excesses should they come to its attention. . . .

. . . One of the Bauhaus neighbors has observed that since the end of January this year there has been a noticeable change for the better in the conduct of the students. One can hope that in time the relations between the citizens of Weimar and the members of the Bauhaus will become friendlier. To achieve these better relations, good will and tolerance are requisite on both sides; but also that people will not lend their ears quite so willingly to the malicious disseminations about the Bauhaus and the ill gossip of irresponsible persons, as has so far been the case.

Walter Gropius
Speech before the Thuringian Landtag in Weimar on July 9, 1920.
From minutes of the 83rd session of the Thuringian Landtag of July 9, 1920.
Point 1: First reading of the budget of the Staatliche Bauhaus in Weimar
Gropius attended the Landtag session on the budget as a government-delegated specialist. In a detailed speech, he entered into an explanation of the historical development of ideas relating to art schools (up to the ideas of the Bauhaus). He saw himself forced to reject political charges and to fight for a budget that was completely inadequate in this situation.

[No "experiment"—reform ideas, typical of the time]
. . . It is now my task to demonstrate that this is not an experiment, nor, as has been further claimed, an "original idea" emanating from a single individual. Based on indisputable facts, I am now going to show convincingly that what the Bauhaus has accomplished is an uninterrupted and logical development that must take place, and already is taking place everywhere in the country; and I am also going to prove that the Bauhaus is a further development of, and not a break with, tradition. In order to make myself understood, I first have to go a little deeper into the subject. Because today, adaptation to the completely changed times demands great flexibility from the community, because old-time circumstances . . . simply no longer hold, because people, largely through the war, have become changed, so that today reconstruction everywhere means experiment in the usual sense of the word. You can certainly see this development in politics; it is exactly the same. So many pillars of the material and spiritual world have crumbled that anyone who governs, no matter of which party he may be a member, must today always look upon his government as an experiment. There is practically nothing left that still stands so secure that we

can definitely count on it. Particularly the spiritual things no longer allow themselves to be viewed from comfortable partial aspects, as was formerly the case when we were living under clear and secure conditions. Today we have to take up the challenge of the totality of life . . . the new "Weltanschauung" is today still shaky ground for everyone, and no one is able to say with certainty what will develop out of it, since we are standing between two eras. . . .

I am now relying on the following important facts: can anyone doubt that the Bauhaus is not just an "original idea," but is rather something that has become indispensable and that has serious and solid foundations, when . . . 22 directors of the most important art institutes in Germany and Austria, among them the best-known names in the field of art education . . . have come out in support of the Bauhaus? . . . But there are innumerable further statements supporting the Bauhaus. . . . The tremendous sympathy for the Bauhaus cause shown by the press last winter manifests the general interest that the Staatliche Bauhaus, its ideas, and its work have aroused. I have approximately two hundred articles from newspapers all over Germany as well as from foreign countries, which were written about the Bauhaus . . . Furthermore, many specialists in the field, from other cities, have visited me, so that at times I have hardly been able to escape from such visits. . . .

Three weeks ago Prussia sent a Privy Councilor of the Ministry to the Bauhaus . . . to inform himself about organizational matters, since Prussia intends to institute a basic reform of its academies after the pattern of Weimar, to the extent of combining them with schools of arts and crafts, as has been done here. . . .

Now to further evidence that the Bauhaus idea stands in close connection with the attitudes of competent men in this field . . . : The well-known architect Theodor Fischer, who has designed the University at Jena, in his . . . article on "For German Architecture" expresses the very same requirements on which the Bauhaus is based, namely that art schools combining an academy and a school of arts and crafts be established, in which architects, sculptors, and painters will be trained at the same time, on a basis of craft fundamentals. The same demands are also made by the German Committee for Technical Education in the document "The common education of architects, structural engineers, sculptors, painters, handicraftsmen, etc." The problem has been tackled in a practical manner by the painter Wilhelm von Debschitz in his master-training workshops in Hannover, which have been established along the same lines. Otto Bartning in Berlin (a member of the executive committee of the German Werkbund), also expresses the same guiding principles. He has compiled detailed material on these salient questions for the German Werkbund. For the German Committee on "Education and Training," Senior Building Director Prof. Schuhmacher of Hamburg has outlined a basic approach yielding the same results. His book is called: "The Reform of Art-Technical Education." He calls for the establishment of "Institutes of Design" to unite structural engineers, architects, handicraftsmen, and free artists. The same requirement is stressed by Professor Bosselt, director of the school of arts and crafts at Magdeburg. He calls for "unification of the education for architects, painters, and sculptors, based on craftsmanship." . . . Professor Bruno Paul, director of the great school of arts and crafts in Berlin, advisor to the Prussian government before the war . . . has now worked out a report for the state on these questions. The essential demands, which he puts forth in his article on "The Education of the Artist in State Schools," are: "I. Training of the artist based on craftsmanship. II. Unification of the artistic training of architects, sculptors, and painters of all specialties in common educational institutions." . . . Professor Richard Riemerschmid in Munich, long-time director of the school of arts and crafts there . . . is today engaged in negotiations with the state about the reform of his school. His plan has already been accepted by the Bavarian government. He wants to found a "State School for the Fine Arts," whose program is extraordinarily similar to that of the Bauhaus . . . Finally, a federal association of the students of all German art schools has been organized in order to establish very sensible guidelines that the young people themselves think desirable. They call for "concentration of all craft schools, arts and crafts schools, academies, and architecture schools into uniform 'Art Workshops'." Here all handicrafts are to be combined into one establishment, organized as a workshop. This will bring about the master, journeyman, and apprentice relationship.

And finally, there is an interesting document from the first conference of the German art academies at Dresden of July 24 and 25 [1919]. The newly constituted art institutes stayed away from this conference, however, leaving virtually only the reactionary institutions to meet. Nevertheless, in their concluding resolution we find the following statement: "The idea of a common preparatory training for architects, sculptors, and painters in the free and the applied pursuits must be declared to be fruitful."

[On the budget of the Bauhaus]

. . . The present figures before the Landtag were, with the exception of the increase due to higher costs, as drawn up a year ago. We have had to wait a year, and we have had no money to furnish the workshops or to acquire material and equipment. But today, with the same money, as you well know yourselves, we are able to obtain only one quarter to one fifth, at most, of what might have been possible a year ago. . . . I would just like to quote, as an example, how the costs for a simple machine stand today. We wanted to buy a second copper-plate press which used to cost about 400 marks before the war. That press has now been offered to us for 34,000 to 38,000 marks. You can see the tremendous difficulties in furnishing workshops today. I must now also turn to the false reports that a certain newspaper is currently issuing about fully equipped workshops I am supposed to have taken over. I do not claim as my own work anything that is not in fact mine. With the exception of the book bindery, the private concern of Herr Dorfner, which has essentially remained the same as before, the workshops have been rebuilt under my direction. The textile department has been changed completely; it is also not privately owned, except for a few looms, but has been taken over by the Bauhaus and been reorganized . . . The metal

43

workshop did not exist at all when I arrived. All of van de Velde's workshops were broken up, everything had been sold, and I was confronted with completely empty rooms. And these empty rooms had to be refurnished from scratch. Every piece of equipment in this metal workshop which you have seen has been newly acquired; in part only very recently, as we received our first funds only eight weeks ago. . . .

I would now like to present the figures of the budget in a comparative analysis. The state subsidy requested by the Bauhaus, not counting the increase due to higher costs and after deduction of income, amounts to 164,000 marks. I now give you budgets of other art institutions in Germany, calculated on the same basis, that is, not counting the increase due to higher costs and after deduction of income . . . : Breslau M 160,000, Düsseldorf M 207,000, Leipzig M 105,000, Munich M 168,000, Dresden M 400,000, Elberfeld M 145,000, Stuttgart M 175,000, Hannover M 303,000, Karlsruhe M 150,000, Hamburg M 500,000, Berlin M 395,-000. You can see that the financial help requested is by no means too high, especially when you consider that the institutes I have mentioned are either academies or else schools of arts and crafts, whereas I have taken over two institutes here and have combined them into one. . . .

The Statutes of the Staatliche Bauhaus in Weimar

Pamphlet, published in January 1921
The plan of instruction published here in slightly condensed form is the first one officially authorized for the Bauhaus. With the exception of minor modifications (1922 edition), this plan remained in force until 1925. In practice there emerged an important correction in the inner structure, in that the Council of Masters was enlarged into the Bauhaus Council. (This meant that the master craftsmen and some journeymen were represented in an advisory capacity.) The statutes of 1921 emphasize the lodge-like character, which lent the Bauhaus its peculiar aura during the early years.

14
Signet of the Staatliche Bauhaus, after a design by Oskar Schlemmer, in use since 1922.

With the approval of the regional government, Department of Culture, the following Statutes of the Staatliche Bauhaus are hereby proclaimed.
The Staatliche Bauhaus
(Former Grand-Ducal Saxon Academy of Art and former Grand-Ducal Saxon School of Arts and Crafts, combined.)
Weimar, January 1921
The Administration
Walter Gropius

I. Teaching Regulations

§ 1 Scope:
The Bauhaus endeavors to educate artistically gifted men and women to become creatively designing craftsmen, sculptors, painters, or architects. Thorough training of all students in the crafts provides the unifying foundation.

§ 2 Members:
Members of the Bauhaus are masters, junior masters, journeymen, and apprentices. Apprentices who pass the journeyman's examination become journeymen; journeymen who pass the master's examination become junior masters. Masters are appointed.

§ 3 Admission:
Admission to the Staatliche Bauhaus takes place only at the beginning of the semester. Applications arriving after March 1 or September 1 will be considered only for the semester following. Admittance as apprentice will be granted to any person regardless of age or sex, whose talent and previous education are deemed sufficient by the Council of Masters, and as far as space permits. Admittance as journeyman or junior master will be granted only to those who have had thorough previous training in the crafts and have passed their journeyman's or master's examination before the Council of Masters of the Staatliche Bauhaus or before outside masters.
The length of the individual courses of instruction for apprentices or journeymen is determined by statutory regulation (cf. § 6). Applications must be made in writing. The following must be furnished as a basis for admission:
1. Original work (drawings, paintings, sculpture, craft work, designs, photography, etc.);
2. Curriculum vitae, including a statement of previous education, personal situation, and means of support (in the case of minors this information to be furnished by parents or guardian);
3. Police certificate of good conduct;
4. Doctor's certificate of health;
5. Where applicable, certificates of previously completed training in the crafts (e.g., journeyman's certificate).
Every applicant will at first be admitted only for a trial period of six months. This probationary period can be suspended only in exceptional cases of special talent, artistic maturity, and personal knowledge. During this period the preliminary course is obligatory. This course consists of elementary instruction in form, in conjunction with studies of materials (in the experimental craft workshop).
Final admission is dependent on the applicant's completion of the above classes and on the quality of his independent work finished during this six-month trial period. Only after being finally approved by the Council of Masters may the newly accepted student join the workshop of his choice and freely select his artistic master from among the membership of the Council of Masters.

§ 4 Curriculum:
The instruction at the Bauhaus covers all practical and scientific areas of creative activity
a) architecture
b) sculpture
c) painting
including related branches of the crafts. Instruction is divided into
1. Instruction in the crafts for:
 a) stonemasons, stucco-workers, woodcarvers, ceramic workers;
 b) blacksmiths, locksmiths, founders, metal-turners, enchasers, enamelers;
 c) cabinetmakers, wood turners
 d) muralists, panel painters, glass painters, mosaic workers;
 e) art printers (etchers, wood engravers, lithographers):
 f) bookbinders;
 g) weavers, embroiderers, fabric printers.

2. Form instruction:

 a) study of elementary materials;

 b) nature study;

 c) instruction in design (drawing, painting, modeling, building), study of elementary forms, design of surface, body, and space, instruction in composition;

 d) technical drawing (instruction in projection and construction drawing) and building of models of all three-dimensional structures (objects of daily use, furniture, rooms, buildings).

3. Supplementary subjects of instruction:

 a) study of materials and tools;

 b) physical and chemical theory of color (in connection with rationalized methods of painting);

 c) basic elements of bookkeeping, contract making, price calculating;

 d) lectures in all areas of art and science of the past and present.

Principles of teaching: every apprentice and journeyman studies with two masters at one and the same time: one master craftsman and one master of form. Both masters work in close collaboration with each other (cf. § 3, last sentence).

§ 5 Masters:

Masters are appointed and direct the individual instruction of the apprentices and journeymen according to their own judgment, within the framework of the general plan of instruction and of the work schedule, which is to be revised every semester.

Independent masters, architects, sculptors, and painters are appointed to conduct the course in form instruction.

Master draftsmen are appointed to provide instruction in the crafts and to lead the individual workshops.

When necessary, assistant masters will be employed for courses in form instruction, and assistant craftsmen for instruction in the crafts. Talks and lectures will in part be given by outside teachers.

§ 6 Examinations:

Apprentices who have joined a workshop after their successful completion of the six-month probationary period, conclude an apprenticeship agreement with the Apprenticeship Board. At the end of the legally set duration of the apprenticeship and after fulfillment of the legal requirements, apprentices may enroll for their journeyman's and journeymen for their master's examination. The examinations are taken before the Apprenticeship Board, respectively the Council of Masters.

Repeated failure in the examinations will result in suspension from the Bauhaus.

§ 7 Rights and responsibilities of the students:

Respectable, comradely behavior, diligence, and compliance with the instructions of the Director, the masters, and the administration, as well as observance of the statutes and the rules of the house are taken for granted.

Craft instruction and form instruction are compulsory. No apprentice or journeyman can be excused from attending either of these. Every student, after successful completion of the six-month probationary period, is free to choose a master and a workshop, but this is dependent on the available space and the approval of the respective master. The student is allowed to change his form master only after consultation with his present and newly selected master and after notifying the director's office of the Bauhaus in writing. This can be done only at the end of a semester.

Every student may, with prior permission of his master, also seek technical or artistic advice from other masters.

Change of workshops and the corresponding change of apprenticeship agreement can only be approved by the Council of Masters under special circumstances and must be applied for in writing. Students may publicly exhibit their work only with the consent of the Council of Masters.

Every student is required to attend the Bauhaus regularly, especially the compulsory classes in form instruction, and he must also observe the work schedules of his workshop. Should absence be unavoidable, then both masters are to be notified in writing. Absence for a period of more than three days has to be reported in writing also to the secretariat. Address and name of landlord, as well as changes of address, are to be given forthwith to the house warden. All workrooms left to one or more students are to be regarded as classrooms.

Furnishings, machines, and equipment in the workshops must be treated with utmost care. The individual is liable for any damage he causes; if the responsibility cannot be ascertained, all students of the respective class are held equally liable. The apprentices themselves have to tidy up the workshops and clean the machines and tools.

Students must under all circumstances obey the instructions given by the head of the workshop or his deputy; serious offenses against workshop rules will result in suspension from the workshop or the Bauhaus.

The Bauhaus provides every apprentice and journeyman with the materials necessary for his craft work. Students must give the head of the workshops a receipt for all materials taken out.

Everyone is held liable for the materials entrusted to him. Continued waste of material will result in suspension from the workshops.

In general, a card for the material and a work sheet must be completed for all work undertaken. These must be signed by the head of the workshop or his deputy.

All work produced with Bauhaus materials remains the property of the Bauhaus. Exceptions will only be made in special cases. All finished work is to be handed in to the workshop authorities together with the work sheet. The workshop authorities collect these and pass them on to the secretariat.

The originator of works kept permanently by the Bauhaus will receive payment. The Director of the Bauhaus together with the two masters of the originator will decide whether the object is to be kept by the Bauhaus and with what sum the originator shall be reimbursed for his work.

Those works not kept by the Bauhaus may be sold by the originator on the free market or given away after paying the costs of materials and general expenses.

Before accepting commissions, students must consult their two masters and formally direct the commissions through the secretariat. The Bauhaus is artistically and financially responsible to the client.

Every student is entitled to submit proposals; these must be handed in to the Director's office in writing.

The students elect from among themselves one or two persons to represent them; these, as well as the statutes of any student organizations, have to be approved by the Director of the Bauhaus.

Student representatives are entitled to submit proposals on all important matters to the administration: for example, new appointments of masters, final acceptance of apprentices, etc. Decisions rest with the Council of Masters.

§ 8 Withdrawal from the Bauhaus:

Students may withdraw from the Bauhaus at any time, provided they have fulfilled their obligations to it.

If the withdrawal is intended for the following teaching year, notice of departure must be given in writing to the director's office no later than April 1. Reasons for withdrawal must be presented in writing to the Director's office and the Council of Masters.

Premature departure from the Bauhaus does not relieve the person from the further payment of tuition fees (see § 14).

§ 9 Suspension:

Continued lack of interest and of diligence as well as gross violation of the statutes will result in suspension.

§ 10 Guest auditors:

Guest auditors can only be accepted for the evening life classes and the special lectures mentioned under § 4, Section 3d. They are entitled to withdraw on thirty days' notice but otherwise are subject to the statutes of the Institute. Acceptance, according to the space available, is granted by the Director and one master.

§ 11 Leasing of working space:

The Council of Masters has been authorized by the Ministry of Culture to lease working space for a limited period of time to independent reputable masters not employed by the Bauhaus. The rooms may be leased with or without charge, provided they are not needed for teaching purposes.

§ 12 Teaching aids:

All members of the Bauhaus have access to the library and to the collections of the institute. The life models from which the students work under the direction of the masters are provided free of charge for apprentices and journeymen. They will be provided for junior-masters as far as the means are available. The use of the collections of the Weimar museums and library, is also encouraged whenever possible.

§ 13 Period of instruction:

The teaching year runs from April to April. The workshops are open all year round without interruption. Short vacations at Christmas and Easter will be announced at the time.

Leave of absence will be granted only in urgent cases and for specific purposes of study. Applications for leave of absence must be submitted at the secretariat in writing, 8 days in advance, and the written answer from the administration must be received before leaving.

The classes in form instruction are suspended during the summer (July, August, September). The administration will announce the beginning and the end of these classes at the time. If requested, the Director may permit students to continue working in the studios during the summer recess and to provide life models at their own expense.

. . . During the time classes are held, work will take place daily, with the exception of Sundays and holidays. The arrangement of working hours is subject to the regulations of the Council of Masters.

The talks and lectures (§ 4, section 3d) will take place at times to be arranged by the administration, preferably during the winter semester. The general plan of instruction for each semester is being drawn up by the administration in consultation with the Council of Masters.

§ 14 Tuition fees:

The tuition fee for one year is 180 marks, without exception . . . registration fee of 20 marks also has to be paid . . .

Leaving or dismissal before the end of the year does not release the student from the obligation of paying tuition for the remaining part of the year. However, payment may be suspended if the student gives the secretariat immediate notice of intention to leave and if an urgent reason for the departure is produced.

Guest auditors must pay in advance, 10 marks for every month during which they participate in the evening life classes. For participation in a series of lectures, 10 marks for each half year must be paid in advance.

Foreign students pay twice the amount in all cases.

The Council of Masters may release needy students and guest auditors from all or part of the tuition payment.

The number of scholarship students may however not exceed 12.

Weimar is the jurisdictional location for all claims against the Bauhaus.

II. Administrative regulations

§ 15 Relationship to the State Government:

The administration of the Bauhaus is under the authority of the Ministry of Culture.

The director of the Bauhaus offers proposals for the appointment of free masters. The Council of Masters votes on these proposals. In case of a tie, the Director carries the decisive vote.

In cases of important decisions and new appointments, votes of absentee masters must be secured in writing.

The appointment and the dismissal of the Director are determined by the Ministry of Culture, upon recommendation of the Council of Masters.

The appointment and dismissal of the business administrator and masters of the Bauhaus are determined by the Director, in accordance with the budget, with consent of the Ministry of Culture and after consultation with the Council of Masters in closed-door session.

The free masters elected by the Council of Masters are, when newly appointed, at first employed for a period of three years. The renewal of contracts, extended for a longer period of time when appropriate, is made upon recommendation by the Director in consultation with the Ministry of Culture.

The appointment of master craftsmen (leaders of the workshops), assistant teachers, and assistants is made by the Director with the approval of the Ministry of Culture.

The drafting of the yearly budget for the Bauhaus is the responsibility of the Director in consultation with the Ministry of Culture.

Expenses that become necessary but were not included in the budget have to be approved by the Ministry of Culture.

The annual balance sheet of the Bauhaus is audited by the Ministry of Culture.

§ 16 Branches of the administration:

The branches of the administration are:

a) the Director;

b) the business administrator;

c) the Council of Masters.

§ 17 The Director:

The Director carries all artistic and administrative responsibilities of the Bauhaus (see §§ 15 and 23).

He represents the institute in all except legal matters, for which the representation is delegated by law to the Ministry of Culture. The Director also deals with discipline at the Bauhaus and has warden's powers. Alterations within the budget, with the exception of the contractually guaranteed salaries, are left to his discretion.

§ 18 Business reports:

The Director is required to file a business report with the Ministry of Culture at the end of each year of instruction.

§ 19 Buildings:

The Director has immediate supervision over the buildings of the Bauhaus, which are otherwise subject to the administration of the Ministry of Culture. . . .

§ 20 Inventory:

Two lists have to be maintained for the building inventory, and the furniture and equipment. These lists have to be kept in order and up to date by the business administrator. . . .

§ 21 Vacation and replacement:

The Director is authorized to grant vacations of up to 5 days to masters, office workers, and employees; requests for longer vacations have to be . . . submitted to the Ministry of Culture.

The Masters of form instruction shall, however, be given the opportunity to devote a considerable period of their time completely to their own artistic work, both in Weimar and outside. Toward this end they may, with permission of the Director, substitute for each other. However, the classes in form instruction may not be reduced through this arrangement.

§ 22 The business administrator

The business administrator is responsible for aiding the Director in the administration of the Bauhaus and for attending to business matters.

He substitutes for the Director in his absence and when the director is prevented from carrying out his duties with respect to all current business matters; however decisions on fundamental matters are the province for the Director. The administrator writes the drafts of the required reports on Bauhaus activities . . .

§ 23 The Council of Masters:

The Council of Masters consists of the Director and the "Masters with seat and vote," who are elected by the Council of Masters. The Council of Masters decides:

1. on proposed changes in the statutes,

2. on the general plan of work,

3. on tentative and final acceptance, as well as dismissal, of students,

4. whether students have successfully passed the journeyman or master examinations,

5. on the distribution of working space to students,

6. on collective exhibitions,

7. on the partial and total exemption from tuition fees,

8. on the granting of scholarships,

9. on general competitions for prizes,

10. on proposals from students.

Teachers who are not members of the Council of Masters, and the student representatives, can be called for consultation in all cases (see I, § 7).

§ 24 Regulations for the meetings of the Council of Masters:

The Council of Masters is called into session by the Director of the Bauhaus, or, in his absence, by the business administrator. The summons to the meeting is considered given when the business administrator has arranged for the letter of invitation, together with the

agenda, to be handed to each of the "Masters with seat and vote."

The Director opens, chairs, and closes the meeting; in his absence he appoints a deputy. The business administrator keeps the minutes of the meeting; in his absence the Council of Masters elects a deputy for him. All points on the agenda have to come up for discussion during the meeting, if time is available. If there is a quorum and none of the members raises any objections, the Council of Masters may pass resolutions on subjects that have not been previously placed on the agenda. Every member is entitled to make motions. Proposals to change the statutes have to be submitted in writing and have to be discussed in two readings, one week apart. As an exception, the second reading may, if unanimously decided, be held shortly after or during the same meeting.

All motions are carried by a simple majority. The Director's vote is the deciding one in cases of a tie. In his absence, the vote of the chairman of the meeting is decisive, but important decisions may not be made in the absence of the Director.

The minutes of the meeting are read by the recording secretary at the conclusion of each meeting. After any necessary corrections are made, the minutes are closed and signed by the members of the Council of Masters who are present at the meeting; or after having been written up from the notes of the recording secretary after the meeting, are submitted for approval and signature to these members of the Council.

§ 25 Voting by circular:

In matters needing no special consultation, the Council of Masters may reach decisions by way of a circular letter. In such cases the vote of the Director is decisive in the case of a tie; in the absence of the Director, it is the vote of the senior member of the Council that decides. Decisions reached by way of a circular have to be made known at the next meeting of the Council of Masters.

[§ 26 Trusteeship
§ 27 The officials
§ 28 Keeping of accounts
§ 29 Rendering of accounts
§ 30 The office employees
§ 31 The wardens]

III. Regulations for scholarships

The Council of Masters may grant 12 scholarships; i.e., it may grant exemptions from tuition payment totaling up to 2160 marks.

The award of these free places takes place every six months upon decision of the Council of Masters . . . The Council has to examine the applications, wherein solely need, in addition to diligence and talent, but never the length of holding the privilege, is decisive.

IV. Regulations for financial endowments

. . . Out of endowments, money is given in the form of scholarships for exceptional achievements or lent to students of the Staatliche Bauhaus as prizes in competitions. . . . The decisions on . . . such applications are made by the Council of Masters.

V. Lending regulations

Original works of art may only be used within the confines of the Bauhaus. Books, unless they are very valuable or rare books, may be taken out of the Bauhaus.

Books and other objects may be lent to scholars and artists who are not members of the Bauhaus (but only in exceptional cases and with the special permission of the Director). . . . Books and objects that have not been returned by the end of the specified loan period are collected by messenger and a messenger fee of 50 pfg. is charged.

VI. Honorary masters and honorary members of the Bauhaus

The Council of Masters may propose the appointment of prominent artists as honorary masters and of personalities who have rendered meritorious service to the Bauhaus as honorary members of the Institute.

The Masters of the Staatliche Bauhaus in Weimar

Bauhaus Prints—New European Graphics, (Bauhausdrucke—Neue europäische Graphik)

Published and Produced by the Staatliche Bauhaus in Weimar

Müller & Co. Publishers, Potsdam

From the prospectus in which, in 1921, the Bauhaus announced the presentation of 5 portfolios of works

The portfolios were produced in the printing workshop of the Bauhaus. Delays occurred during publication, due to perennial financial difficulties, and the last portfolio was not finished until 1924. The publication of a collection of French graphics, originally planned as the second of the series, had to be omitted altogether. The financial success which the Bauhaus had hoped for was completely unrealized. A considerable amount of the edition was still unsold at the time of the dissolution of the Weimar Bauhaus. Eventually, these portfolios had to be sold below cost.

For the first time, we offer the collector the chance to purchase an international collection of graphic works, which, in the current economic situation, is otherwise impossible to obtain. The collection is of fundamental importance as a representation of the most significant artists of Germany, France, Holland, Italy, and Russia. The success of this venture must be attributed to the devoted collaboration of artists of all countries and the help of widows of deceased artists. The arrangement of the portfolios will meet with the approval of all those who recognize some kind of leadership in the names of the following, and who wish to serve that leadership:

Archipenko | Bauer | Baumeister | Beckmann | Benes | Boccioni (posthumous) | Braque | Burchartz | Campendonk | Carra | Chagall | Chirico | Coubine | Delaunay | Derain | Dexel | Max Ernst | Le Fauconnier | Feininger | Filla | Fiori | Oskar Fischer | De la Fresnaye | Gleizes | Gontscharova | Gris | George Grosz | van Heemskerck | Heckel | Hoetger | Itten | Jawlensky | Jeanneret | Kandinsky | Kirchner | Klee | Kokoschka | Kubin | Larionow | Laurencin | Lehmbruck (posthumous) | Léger | Lhote | Lipschitz | Macke (posthumous) | Marc (posthumous) | Marcks | Marcoussis | Matisse | Meidner | Mense | Metzinger | Molzahn | Morgner (posthumous) | Muche | Otto Mueller | Munch | Ozenfant | Pechstein | Picabia | Picasso | Prampolini | Rohlfs | Scharff | Schlemmer | Schmidt-Rottluff | Schreyer | Schwitters | Severini | Soffici | Survage | Stuckenberg | Topp | Tour-Donas | Wauer.

Almost all artists, among them some of the most renowned names, have already affirmed their support and some have even sent their contributed works for printing. Among them, the last unpublished original woodcut from the estate of Franz Marc deserves special mention.

During the first two years of the Bauhaus we have laid the foundation which we felt was the correct one. In order to do this with due concentration, we secluded ourselves from the public, as far as was possible, even incurring the danger of having the significance

of our endeavors go unrecognized for the sake of peace for our work. All those who are of our heart and mind know that we had to proceed this way.

But now we turn to the public with a document which will demonstrate how the artistic generation of our times shares the ideas of the Bauhaus and is willing to make sacrifices by donating some of their works to us.

We decided to publish the portfolio collection in order to secure greater financial support for our endeavors than the state of Thuringia is able to provide. We have to gain this support, since the significance of the Bauhaus reaches far beyond the limits of the usual state institute. We are able to issue this portfolio because we were assured of the recognition and the devoted cooperation of an entire generation of German and non-German artists. Hence, this unique portfolio collection has been realized without regard to personal doubts or individual directions, as a manifestation of support for the idea of the Bauhaus by the artists of our time.

Through this work the attention of all those who do not yet know of the work of the Bauhaus shall be drawn to us. We believe that the number of those who are with us in spirit is not small. We are counting on their help.

The Masters of the Staatliche Bauhaus in Weimar

Lyonel Feininger|Walter Gropius|Johannes Itten|Paul Klee|Gerhard Marcks|Georg Muche|Oskar Schlemmer|Lothar Schreyer

Bruno Adler
Fine Art in Weimar

From the newspaper "Das Volk," Weimar, April 22, 1921

Among Weimar intellectuals, the writer Bruno Adler was one of the very few who approached the Bauhaus with open-mindedness and willingness to communicate. His observations reveal the roots of the animosity with which the non-political, "educated" groups persecuted the Bauhaus.

It is well known that Weimar is a city of art. It is justly proud of that distinction, not to speak of the glory of its classic past, for the activity of artists residing there has for decades been the center of the social and intellectual life of the city, which has always remained aloof from such less idyllic phenomena as, for instance, those created by the transforming forces of the social movement. Art cities usually have a certain sleepiness, or one can say dreaminess, about them; an atmosphere of good middle-class leisure. Solid average achievement thrives in this atmosphere; this is where the middle class feels at home. This art easily captures the interest of the fellow citizen, because it translates his "Sunday feelings" into a spirited language which he understands, and slowly gains a significance in public life which it does not on any account deserve. It is high time for those devoted to the intellect and to art to speak out openly against the overestimation of these semivalues, which works against the development of a true culture. The most pedantic little problems of the so-called "art life" are made into daily worries by the newspapers and the public of the art city, and are treated with an importance that would, for example, never be devoted to the problem of infant mortality. And no one shall call the immortal names of Athens and Florence to witness! For disregarding the fact that every age creates its very own, different, and cogent expression for the meaning of history, it is indeed true today that the really significant creative artists flee the art city unless they choose to live in constant battle with it. Hence the art city excludes itself, without realizing and believing it, from the course of development, and the art lover some day happily discovers in the unassuming neighboring towns—like Jena or Erfurt—all that he had been missing at home in the art city; a vigorous if moderate artistic life, full of love for creation; searchers going forward; unsophisticated people for whom art is not material for education or daily conversation, but experience and fulfillment. . . .

Johannes Itten
Analyses of Old Masters

From the almanac "Utopia. Documents of Reality," published by Bruno Adler, Utopia Press, Weimar 1921
(Excerpt)

Itten's lasting contribution was that he introduced the obligatory preliminary course to the Bauhaus and established its basic precepts. In a rather playful manner, the students were to develop their tactile and visual capabilities and to learn to apply them in an artistically meaningful way. Analyses of the paintings of Old Masters served to strengthen recognition of the precepts of art and to develop formal consciousness. To Itten, art was primarily a pyschic means of expression, of high ethical and educational value. Itten did not follow Gropius's pragmatic tendencies in his philosophically determined teaching, a fact which, especially during 1921–1922, caused very tense relations within the Bauhaus.

. . . To experience a work of art means to re-experience it; means to awaken the essential in it, to bring the living quality which is inherent in its form to independent life. The work of art is reborn within me.

We say: to experience a work of art is to re-create it. Because, intellectually speaking, there is no great difference between a person who experiences a work of art and a person who outwardly represents an experienced form in a work. Every human being can be taught to draw a circle, but not every human being has within him the power to experience a circle. I am able to set free this power within him, but am not able to give it to him. Since experiencing is dependent on forces of the mind and soul and since we will never comprehend what these really are, we shall say it is a gift of God that is inborn in His image, through which path He breathes His spirit into man's soul.

A living representation is always something experienced, and something experienced is always represented with life. Nothing dead will ever come to life, and nothing living will ever die.

The ability for outward representation is dependent on the substance, and the physical constitution of a human body, the fingers, the hands, the arms, the feet, the legs, the trunk; on internal organs like the heart, the lungs, the stomach, on sensory organs and the brain. In short, such ability is dependent on the constitution of all physical substances and organs.

Experiencing is a faculty of the mind and spirit. If it concerns phenomena of a coarse material kind, then it is the physical faculties which produce the experience; on the other hand, if it relates to sensitive spiritual phenomena, then it is the spiritual faculties that produce the experience.

To perceive means to be moved, and to be moved means to form. Even the slightest sensation is a form that radiates movement. Everything that is alive reveals itself to man by means of movement. Everything moves and nothing is dead, for otherwise it would not exist.

Everything that exists is differentiated according to quantity and quality of movement, is differentiated according to time and space. All forms are differentiated, just as movements are differentiated. . . .

Without movement—no perception, without perception—no form, without form—no substance. Substance—form. Form = movement in time and space; thus, substance = movement in time and space.

Above, we have contended that all substances are means of representation. But now, all substances are forms. Thus, form is a means of representation. If this is so, and if the essence of form is based on its spiritual and mental origin, which can never be grasped, then the conclusion results quite easily:

The means of representation are as little teachable as form itself. To teach and to learn means to have comprehended and to comprehend. The claim that form can be taught can therefore only seem true to a person of little understanding.

Question: Are teaching and comprehending possible at all? We shall never get to the bottom of a thing. Neither substance nor form nor movement can be taught, can be comprehended. Perception alone is perceivable.

Modesty and great humility before Him, the Incomprehensible, help us bear the gravity of this insight.

I am able to perceive the perception. I am able to perceive the consciousness of being moved, not movement itself, but being moved. So, all teaching or learning is perception of how the person who is teaching or the person who is learning is being moved. Being moved begets being moved. . . .

Movement gives birth to form, form gives birth to movement. Every point, every line, plane, every body, every shadow, every light, every color, are forms born of movement, which again give birth to movement. Sadness and happiness, hate and love, antipathy and sympathy, are forms of the psyche, caused by movement.

If I want to experience a line, I must either move my hand in accordance with the line or I must follow the line with my senses; hence, I have to be psychically moved. Finally, if I am able to visualize a line, then I am mentally moved.

These now are the three differentiated degrees of the act of being moved: If I draw the line with my hand, then I am physically moved; this is the first, the physical degree of "being moved." If I move my senses along a line, then I am in the second, the psychic degree of "being moved." If I mentally visualize a line, then I am in the third, the mental degree of "being moved." The physical degree is an act of being moved outwardly; the mental degree is an act of being moved internally; the psychic degree is a combined act of being moved, internally and outwardly. Seen from above, lightness and clarity correspond to the internal, the mental act of being moved; and darkness and gloom to the external, the physical act of being moved. Just as the sun illuminates the moon, so the third degree illuminates the first and rescues it from the darkness. . . .

Paul Klee
The Play of Forces in the Bauhaus
BD, Collection Gropius
This is presumably a statement in answer to an inquiry Gropius had addressed to the masters.

I welcome the fact that forces so differently oriented are working together in our Bauhaus. I also approve the conflict between these forces if its effect is evidenced in the final accomplishment. To meet an obstacle is a good test of strength for every force,—provided it is an obstacle of an objective nature.

Value judgments are always subjectively limited, and thus a negative judgment on someone else's work can have no significance for the work as a whole.

In general, there is no right or wrong; rather, our work lives and develops through the interplay of opposing forces, just as in nature the good and the bad work together productively in the long run.

Klee
Dec. 21.

16

50

Walter Gropius
The Necessity of Commissioned Work for the Bauhaus
Notes, dated December 9, 1921, for discussion in the Council of Masters
BD, Collection Gropius (First publication, in excerpts)
At the preceding meeting of the Council of Masters, Itten basically rejected the Bauhaus Program of 1919, particularly the requirement calling for training in practical tasks, and declared himself in favor of free artistic manifestation as a pedagogic principle.

... Now, as before, I stand for the basic ideas of the program and the statutes of the Staatliche Bauhaus, whose main tenets are quite clear. The most important ideas are expressed in the following: "The old schools of art were unable to produce this unity; and how could they, since art cannot be taught? They must be merged once more with the workshop."—"The origin of art transcends all methods; in itself it cannot be taught, but the crafts certainly can be."—"The school is the servant of the workshop; it will one day be merged with it. Therefore there will be no teachers and pupils in the Bauhaus but masters, journeymen, and apprentices." In these lines my basic philosophy is clearly expressed: We are not in a position to awaken creative powers and to develop the innermost thoughts and feelings of young people through educational means. This can only be done through what we call personality. Only matters of knowledge and skill, theory, and practice, can be taught. Hence the conflict with the Academy, which is of a fundamentally different opinion and has ranked the snobbishness of the schoolman above the practical worker.

According to my ideas, the Bauhaus should again unite creative work into a totality, in the sense that together with a theoretical teaching of form all real things should be taken equally into account. The work is not an end in itself; [the philosophical conception] gives it direction and cohesion. ... This determines the outer limits of the collaborative work at the Bauhaus.

In my program I have dealt quite clearly with the question of commissioned work. In its present form, the Bauhaus stands or falls with the recognition of the necessity to accept commissions. I would consider it a mistake if the Bauhaus were not to face the realities of the world and were to look upon itself as an isolated institution. This is the basic mistake of the present "art schools," which train drones for society. The fact that up to now the commissions have created problems is not due to any weaknesses in the idea itself but rather to economic and personal difficulties, which must gradually be overcome. ...

Born of the knowledge that the hitherto usual methods of designing buildings have been wrong in the broadest sense of the word, and that productive work ... has been placed in the hands of "pencil strategists," the demand was raised to provide every creatively working person with fundamental training in the crafts. This means, then, that the manner of working together shall not be conceived as it was by the previous generation (van de Velde, Peter Behrens, Bruno Paul). [Rather, it is important] to clear the way for the creative energies of the individual and to establish an objective foundation upon which individuals will be able to collaborate. ...

Consequently, this unity cannot be represented by one person but only by the concerted efforts of a number of people in harmony with each other.

Walter Gropius
The Viability of the Bauhaus Idea
Notes of February 3, 1922, in a circular to the Bauhaus Masters
BD, Collection Gropius (First publication, in excerpts)
The conflict with Itten, which went to the very heart of the existence of the Bauhaus, moved Gropius to render to himself and to the masters an account of the viability of his conception. The draft for this circular covers eight pages. The emphasis on the importance of industrial production (versus handwork) is symptomatic of the first major internal transformation of the Bauhaus.

The differences of opinion on crucial problems in the Bauhaus, which have lately concerned the masters, have persuaded me, as founder of the Bauhaus, to review, primarily for myself, the theoretical and practical principles on which it is based.

All of us are fully aware that the old attitude of *l'art pour l'art* is obsolete and that things that concern us today cannot exist in isolation, but [must] be rooted in our developing attitudes. Thus the basis upon which our work is built cannot be broad enough. Today this basis is too small rather than too large. This is made clear by reports of Russian experiments, similar to ours, which have incorporated music, literature, and science as coming from *one* source. ...

Recently, Master Itten demanded from us a decision either to produce individual pieces of work in complete contrast to the economically oriented outside world or to seek contact with industry. It is here, in this method of formulating the question I believe, that the big unknown that needs to be solved is hidden. Let me at once clarify this: I seek unity in the *fusion,* not in the separation of these ways of life. Why is it that we can appreciate equally well the form of a well-built automobile, an airplane, and a modern machine as individual works of art beautifully formed by creative hands? It is by no means our nature to reject one or the other; instead, it clearly concerns two entirely separate processes of design that exist side by side, of which the one is by no means outmoded while the other is modern. ... For some time, industry has been trying to attract creative men ... to develop the forms of their products (Deutscher Werkbund). On the other hand, young artists are beginning to face up to the phenomena of industry and the machine. They try to design what I would call the "useless" machine (works of Picasso, Braque, Ozenfant, Jeanneret, the new Russian and Hungarian schools, Schlemmer, Muche, Klee, etc.); thus a bringing together of the two processes of design!

... This facing up to reality does by no means have to result in compromise. What remains decisive is whether the objective remains clear and is lucidly advocated. ... The Bauhaus has made a start in breaking with the usual academic training of artists to be "little Raphaels" and pattern designers, and has sought to bring back to the people those creative talents who have fled the artistic working life, to their own and the people's detriment. It consciously strove to replace the principle of division of labor with that of unified collective work, which conceives the creative process of design as an indivisible whole. To do this, it was necessary to rebuild from the very roots in order to have a chance to be able to give back to the present generation the correct feeling for the interrelation of practical work and problems of form. Genuine crafts also have had to be reborn in order to make intelligible to our youth, through handwork, the nature of creative work. But this by no means implies a rejection of the machine or industry. The only basic contrast lies in the division of labor on the one hand and the unity of labor on the other. ...

If a creatively talented person had a factory at his disposal with all its machinery, he would be able to create new forms that would differ from those produced by hand crafts. ...

The Bauhaus could become a haven for eccentrics if it were to lose contact with the work and working methods of the outside world. Its responsibility consists in educating people to recognize the basic nature of the world *in which they live,* and in combining their

knowledge with their imagination so to be able to create typical forms that symbolize that world. What is important then, is to combine the creative activity of the individual with the broad practical work of the world! If we were to reject the world around us completely, the only remaining way out would be the "romantic island." I see a danger to our youth in the indications of a wild romanticism that derives from an understandable reaction against the predominating state of mind—numbers and force—and from the breakdown of countries. Some of our Bauhaus members subscribe to a kind of misunderstood "return to nature" doctrine of Rousseau's. It would be consistent if a person who disavowed this whole world were to retreat to an island. But if he remains in this world, the forms of his work will show its rhythms all the more as he strives to understand its challenges. . . .

The entire "architecture" and the "arts and crafts" of the last generation . . . is, with very few exceptions, a lie. In all of these products one recognizes the false and spastic effort "to make Art." They actually stand in the way of the development of pure joy in the art of "building." Today's architect has forfeited his right to exist. . . . The engineer, on the other hand, unhampered by esthetics and historical inhibitions, has arrived at clear and organic forms. He seems to be slowly taking over the heritage of the architect, who evolved from the crafts.

How the broad gulf between the activity we practice in our workshops and the present level of the crafts and industry outside will some day be closed, that is the unknown quantity. . . . Contact with industry and with the practical work of the world can only be established gradually. It is possible that the work in the Bauhaus workshops will lead more and more to the production of single prototypes [which will serve as guides to the craftsman and industry]. Students who have gone through the Bauhaus will be in a position, with the knowledge they have acquired there, to exert a decisive influence on existing craft [enterprises] and industrial works, if they will just decide to join these and exert their influence from within. The big transformation from analytic to synthetic work is proceeding in all areas, and industry will follow suit. It will seek people with the kind of thorough training which we in the Bauhaus try to give, and these people will free the machine from its [lack of creative spirit]! The independent artist, groping his way toward the "useless" machine, is already orienting himself with this compass of the future. He is no opponent of the machine—he wants to overcome its demon. . . .

This is also the focus for the terms "sacred" and "profane" which are so frequently confused in today's chaos of confused feelings. The dying religions conjured up the desecration of the sacred just as much as they have precipitated a real cult of the profane. There is one remedy for this mania: if the words "art" and "religion" were answered with silence [then they might regain substance].

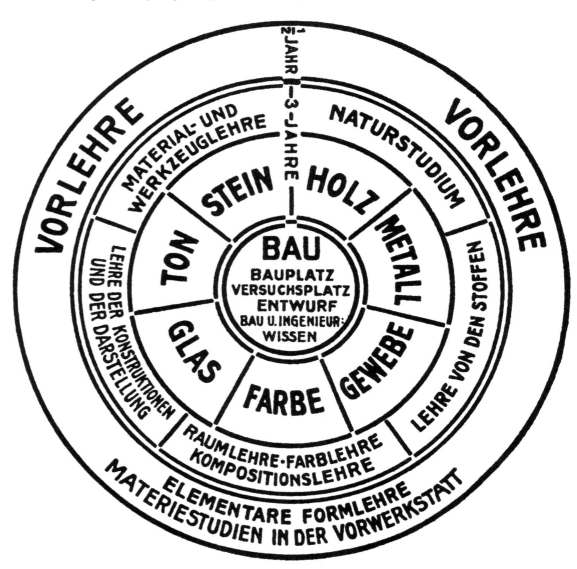

17
Schematic representation of the study courses at the Bauhaus. From: Gropius, "Idea and Structure of the Staatliche Bauhaus Weimar."

Schedule—Winter Semester 1921–1922

	Monday	Tuesday	Wednesday	Thursday	Friday	Saturday
8 AM–2 PM	Workshop	Workshop	Workshop	Workshop	Workshop	Workshop and preparative training
2 PM–5 PM	Klee	Group I: Schreyer	Group II: Mechanical drawing			Form instruction
5 PM–7 PM		Group II: Schreyer	Group I: Mechanical drawing	Life models	Life models	Itten Analysis
7:30 PM–9 PM	Lectures	Life models	Life models			

18

18
Weekly work schedule—winter 1921–1922.
LW, Innere Verwaltung
19
Floorplan of the preliminary-course workrooms.
LW, Innere Verwaltung.
20
Journeyman's certificate for a Bauhaus student.
21
Student identification card.

19

20

21

Staatliches Bauhaus in Weimar
Exhibition of the Work of Journeymen and Apprentices in the Staatliche Bauhaus Weimar, April—May 1922
Pamphlet, published for the first public exhibition of student work of the Bauhaus. The text describes the preliminary course as taught by Itten (that is, up to the spring of 1923).

Our Bauhaus exhibition will strike many passing visitors as strange, for it offers an introduction to a course of instruction which is both new and unusual. Therefore, a short reference to the methods practiced in this course may be permitted in order to provide the opportunity for everyone to get an idea of the development of the work of the apprentices and journeymen.

Every student is at first admitted for a six-month trial period. During this probationary period he participates solely in the preliminary course of instruction. This instruction is intended to liberate the student's creative power, to give him an understanding of nature's materials, and to acquaint him with the basic principles that underlie all creative activity in the visual arts. Every student arrives encumbered with a mass of accumulated information which he must discard before he can achieve a perception and knowledge that are really his own. For instance, the student who wants to work with wood or stone has to experience the material, or better, the matter he intends to employ, with all his faculties. More precisely, he who works with wood must have a "feeling" for wood. To understand its basic nature exactly, he must also understand its relationship to other materials, such as stone, glass, and wool. Whoever wants to specialize in wood later on, must work also with the other materials during the preliminary course. He must combine and compose these various materials in close contact in order to make their relationship fully apparent. Such peculiar experiments often puzzle the outside visitor. Since he is not acquainted with our training program, he does not know what to make of these compilations of wood, glass, wire, wool, and other materials. He takes them to be something playful or even for finished work, whereas they are preparatory work from within the course.

Such preparatory work also includes exact representation and drawing of different materials. If, for example, a student makes a drawing of a piece of wood, true to nature in every grain, it serves both his appreciation of the nature of the material and its representation in a different medium. The representation of materials in other media is a basic prerequisite for the visual arts. Consequently, the analysis of Old Masters, in whose works the different materials are so expertly represented, occupies an important place in the preliminary course. The works of such masters as Bosch, Meister Franke, or Grünewald, also provide the basic knowledge for the study of form, which is also an essential part of the preliminary course. This form instruction is intended to enable the student to perceive the harmonious relationship of different rhythms and to express such harmony through the use of one or more materials. The first attempts to make this balance of forces visible are already part of the study of materials.

Thus the preliminary course concerns the student's whole personality, since it seeks to liberate him, to make him stand on his own feet, and it makes it possible for him to gain knowledge of both material and form through direct experience.

A student is tentatively admitted into a workshop after the six-month trial period if he has mastered form and materials sufficiently to specialize in one material only. If he has a talent for wood, he goes into the carpentry shop; if his preference is for woven materials, he goes into the weaving workshop. When the student has successfully completed this six-month trial period, he is definitely admitted to the workshop and becomes an apprentice. After three years as an apprentice he is eligible for the examinations that qualify him to become a journeyman.

The exhibition has on display apprentice work from the weaving, pottery, metal, and cabinetmaker's workshops. It is a general principle that students in the workshops do not work from outside designs, nor from designs supplied by Bauhaus masters. Instead, every apprentice must design and execute his own work. Only when form and material are brought into intimate fusion through an independent mind can creative work be achieved. Only in this way is it possible to come nearer to the objective that craft is not only a prerequisite for a work of art but that in a work of art spiritual work and manual work form a single entity.

The juxtaposition in our exhibition of work from the preliminary course with work from the workshops is intended to show the path we are following. The personality of each student is allowed to develop freely in his work in order to enable him to contribute to the practical realization of the common idea.

Members of the Council of Masters of the Weimar Bauhaus
"Master" or "Professor," Opinions on the Title Question
LW, unregistered file: memoranda to the form masters 1919—4/1/1925 (First publication)
After the secession of the old academy professors, the question whether the Bauhaus Masters were able to claim the title of professor which Gropius renounced in 1919, became more and more a matter of prestige. In April 1922 the Council of Masters addressed themselves to this problem. The Masters wrote down their opinions on the circular.

Weimar, April 21, 1922
Enclosed: Circular to the form masters, regarding professor title.
Gropius

Master Feininger: Absent

Master Itten: Same opinion as Herr Klee.
JI

Master Klee: I suffer more acutely under the half-measure of daily being addressed with a title without always being able to, nor wanting to, prevent this with explanations. I suffer from this more than I thought likely at first, and more than the formality of granting the title can seem harmful to me. This has nothing to do with the Bauhaus program. The petition, however, can be submitted by those Masters who have spoken out in favor of it.
Klee

Master Muche: Am after much experience *for* the title of professor, but on the other hand I am *not* for elevating the designation of master to the rank of a title. This would be taking a title much too seriously. "Master" as a title seems to me to be presumptuous; professor seems to be an advantageous convention which one prudently thinks little of, but goes along with.
G. Muche

Master Schlemmer: If we do without, then I am for a large-scale international propaganda

campaign to abolish all titles (including the title of "Master"). In doing that, the Bhs has a chance to gain world fame. This is the only way we can avoid becoming martyrs to a cause which sooner or later will become obsolete by abolition of titles altogether.
Sch.

Master Schreyer: I enclose my opinion and request it be made known to the Council of Masters.

Master Marcks: I confess to being guilty of having used the title of professor in order to obtain a maid for my wife. But this time the devil did not take the bait, and having said *pater peccavi* I will, from now on, continue to disclaim the once rejected title of professor. Besides, I feel just as stupid as a professor as I do as a master.
Marcks.

Weimar, April 25, 1922
Enclosed for your information are the *answers* of the masters to the circular regarding title of professor:
Gropius

Master Feininger: Am personally, as a painter, completely opposed to any professor title. This is the reason why I call myself neither "master" nor "professor." But for reasons of the B'haus program I think "master" appropriate for *internal* communication.

Master Itten: Either we reject all titles (apprentice, journeyman, junior-master, Master, Director, administrator, etc.), and start the international "anti-title-war" which Schlemmer proposed, or I am of the opinion that Prof. sounds less pretentious than Master. And am *for* the Prof.
Itten

Master Klee: Remain in favor: Master Schreyer overestimates the significance.
K

Master Muche: I regret that this simple matter has developed into such a major affair and remain of the same opinion as before—consequently *for.*
G. Muche

Master Schlemmer: In public, everyday life, there is no such thing as an "apprentice" Smith or a "director" Gropius. The designation "master craftsman" or better still "form master" means something entirely different there than it does to us here in the Bauhaus. But this is what we would have to call ourselves in contrast to the master craftsmen. But since we are citizens in addition to being Bhs members, and as citizens recognize the constitution, a constitution that has not abolished titles but on the contrary has created new ones, we must therefore accept the edicts of the government. After all, we are actually doing this, except for this one point in which we want to oppose ourselves against the government. Are we allowed to do that as *"Staatl."* Bauhaus? Maybe we will soon have a government that will abolish all titles. Then we are well off and so are all others. My opinion on this matter has always been to obtain a statement from the government authorizing us to use the designation provided for us by the state budget in our dealings with public offices and in everyday life.
Schlemmer

Master Schreyer: Am convinced that we are making a mistake. But I tend to participate in the errors of my friends when I am unable to persuade them otherwise. I regret that I cannot avert the error. Consequently, I will participate in the petition in order to avoid causing a major affair. For whatever we do in the name of the Bauhaus is only sensible if we do it together.
Schreyer

22 23

Wassily Kandinsky
The Value of the Title of Professor
LW, unregistered file: memoranda to the form masters 1919—4/1/1925 (First publication)
In April 1922, at the time when the Council of Masters debated the question of whether to petition the Ministry for approval to carry the title of professor, Kandinsky was not yet in Weimar. He handed in his statement the following September.

The question that has been raised reminds me of the story of the art schools in Russia. There too, the teachers at first were very eager to get the title of master, and were happy not to be called professors, for they wanted to have nothing in common with the outmoded academies. During the subsequent reform they again accepted the title of professor.

As far as I am concerned, I would like to see every chance used to demonstrate that the title problem is a completely useless problem. This was my reason for insisting in Russia on naming an institute for the science of art the '*Academy* of the Science of Art.' With that name I wanted to show that that which is important is the inner characteristic of the nut, not the naming of the shell. It is not mainly titles that have to be fought for, but respect for them. The right content establishes the right form itself.

If the masters who, as is generally known, rejected the title of professor as I did, will now seek the title once more, then in the eyes of the students the exterior value of the title will be emphasized and increased. And this I think would be detrimental.

A statement by the government to the effect that the master title is equivalent to the title of professor would, I think, also be an external solution to the problem.
Kandinsky
September 1922

Lyonel Feininger
From a Letter to Julia Feininger
Dated September 7, 1922
BR, gift of Julia Feininger (First publication)
The rival efforts of Theo van Doesburg, the spokesman of the ''Stijl'' group, exercised a strong influence on many of the young Bauhaus students.

9/7/22 between 2.30 a.m. and 4 o'clock, when all are sleeping, after supper!
. . . Kandinsky says that Doesburg is leaving soon, in fall, to go to Berlin, Weimar being too restrictive for his activities. Tell me, honestly, how many are there in the Bauhaus who really know what they want to achieve, or who are strong enough to make something of themselves through painstaking work? For most of them the unsentimental—if also completely uninspired—Doesburg is something of a pillar among all the heated and conflicting points of view, something definite and clear, which they can hold on to. . . . Why, how is it that there are so many voluntary submissions to the tyranny of van Doesburg and this mulish noncompliance against all requests or even suggestions put forth by the Bauhaus? I don't believe one can do much about it. Either the ideology of the Bauhaus is strong enough to overcome opposition from within and without or it will break down, because there are so few nowadays who unequivocally and with conscious judgment are willing to adhere to the cause. We proceed from suspicion to suspicion, from danger to danger. . . . We are obliged to do that, for the Bauhaus places one under an obligation, whilst van Doesburgism implies nothing of the sort; one can come and go, it is a completely voluntary submission, from which one, as everyone has learned, can soon be made free again. Of course, it is crass sabotage against everything the Bauhaus stands for. But one must always go through something like this before a balance is found. If Doesburg were a master at the Bauhaus, it would not harm the work in general, it could even be useful, for he would be a counterattraction to that rampant romanticism that is haunting us. Only I don't suppose he would be capable of keeping within his own bounds but would, like Itten, soon want to assume command over the whole works. . . .

Lyonel Feininger
From a Letter to Julia Feininger
Dated October 5, 1922
BR, gift of Julia Feininger (First publication)
Feininger believed, as did most of the other members of the Bauhaus, that the great Bauhaus exhibition planned for 1923 was premature. He observed with fine perception—perhaps as the first—the central change in Gropius's attitude toward craft work and design for industry.

Thursday, October 5, 1922
. . . We are making a great and weighty concession in the Bauhaus by going ahead now with the planned exhibition. We are all reluctant inside to abide by such ''art politics.'' I can't write about it yet—tonight there is a big discussion with the students, and much demands on that as to how things stand. But this much is sure—if we cannot show ''results'' to the outside world and win the ''industrialists'' to our side, then the prospects for the future existence of the Bauhaus are very dim indeed. We have to steer toward profitable undertakings, toward mass production! That goes decidedly against our grain and is a forestalling of the process of evolution. If we are successful in clarifying this and in averting a great plunge into ruin, then the sacrifice will not be in vain. Today the cry is ''Light the fires!'' And the time to prepare for this exhibition is so short—from now on the workshops will remain open also in the afternoons. You can imagine how the atmosphere is charged. *I see a new Gropi*—but, thank God, Kandinsky, Itten, and Muche preserve the pedagogic balance very well. And I, as a nonpedagogue, will get by in my printing shop. On Wednesday, Marcks was with me. We left the session together, and then prepared supper as best we could, using the egg-slicer (which Marcks looked upon as a mouse trap). Kandinsky and I are as comradely as ever, Saturday I shall be with Klee; they are all such wonderful fellows, Muche, Schlemmer, and the other colleagues. I recognize an accumulation of power emerging from this group, devolving from the intensity of their human qualities. . . . Gropi can be difficult at times, only immediately to repent it and become unsure; but it is only a flicker and nothing permanent. He wants the best, from the point of view of good craftsmanship, but in practice must compromise, and his conception is less essential. ''Whoever cannot now show what he is worth, can go to the Devil with his art,'' he said, during the session; so I, as a young chap, would have been sent to the Devil long ago. But Gropi has a clear grasp of realities, and that is something we others haven't. Or perhaps, by realities we understand something deeper, something which takes time to grow. . . .

Gerhard Marcks
On the Planned Bauhaus Week. Letter Addressed September 22, 1922 to the Council of Masters
LW, unregistered file: Exhibition 1923 I
(First publication)
During the time of its preparation, the ''Bauhaus Week'' (exhibition in summer 1923) had to take a great deal of ridicule. Teachers and students were aware of the fact that the Bauhaus idea was still at the very beginnings of its realization.

Marie-Luise von Banceis
Bauhaus Kite Festival in Weimar
From the newspaper ''Berliner Tageblatt,''
October 28, 1922
The midsummer lantern party and the kite festival in the fall always offered the Weimar Bauhaus staff and students a welcome opportunity for playful realization of their creative imagination.

The Bauhaus Week has begun! Posters in all the transcontinental trains! The President is coming to the opening. The hotels are overcrowded with foreign visitors. One thousand homes had to be evacuated for the art critics. The Bauhaus Internationale is being played in every square. Everyone smokes Bauhaus brand. Big speculations are shaking the Stock Exchange.
And the reason for all this? In the museum there are a few cabinets full of little pots and little woven things. This is what Europe is all excited about. Poor Europe!
That, for what it is worth, is my opinion of the Bauhaus Week 1923.
Faithfully,
G. Marcks
9/22/22

. . . The sun risked a scant glimpse. And there they all are, up in the sky, bathed in their own glamor; those kites that seemed so big down here on earth, up there appear like little dots, some hardly visible to the eye. Very beautiful ones boast their splendor: polygonal monsters playing in a thousand colors, fish with long glittering tails, swaying and fluttering; strange, cubistic fantasies, crystals, snakes, balloons, suns, stars, blimps, shells, lamps; small, tiny ones, and giants; kites of the most fanciful forms; marvelous magic birds out of artistic fairy-tale dreams; the Griffin bird, the poet's winged horse, the enchanted flying coat. And, something rarely seen: cheerful, whimsical little kite men with hair of gold foil, plump body with nose and ears, arms and legs made of paper snips . . .
A peculiar crew, these so-called Bauhäusler of the Weimar school. Well enough known to the residents that nobody turns to stare any more at these strange apprentices. But they still arouse the curiosity of strangers, and would cause people to gather if a troop of them were to roam the busy streets of a large city. In bright skirts colored like a goldfinch, the boys with flying hair the girls with short haircuts, wearing fanciful, loosely flowing dresses, stylized, timeless; capriciously bizarre, more or less well chosen, invented, composed. Clasps in their hair, ribbons, bare feet, sandals, low-necked, short-sleeved, bare-headed. Through the thin cloth suits of many a young art student peeks something like bashful poverty. . . .

25

25
Lyonel Feininger: Postal card for the Bauhaus lantern festival of June 21, 1922.

Walter Gropius
The Work of the Bauhaus Stage
Draft for a contribution to the information
leaflet of the Bauhaus stage, dated October
20, 1922
LW, unregistered file: Stage XI, 1919—
4/1/1925 (First publication)
An altered version of this essay was published
in "Die Bauhausbühne"—director: Lothar
Schreyer—first communication, December
1922.

The collective work of the Bauhaus derives from the effort, within the limits of space and its design, to participate actively in the building of a new concept of the world, the outlines of which are beginning to appear. We wish to instill a new spirit of building into all creative work and to help focus the work of each individual on this aim. Our field of endeavor embraces the whole range of the visual arts under the guidance of architecture.

We are also working on the development of the stage. To purify and renew today's stage, which, it seems, has lost its intimate ties to the world of human feelings, is a task for those who, starting from a common point, are devotedly working to accomplish a fundamental clarification of the all-embracing problem of the stage, both in theory and in practice, unaffected by personal considerations and free of the limitations of the commercial theater. In its origin the stage derives from an ardent religious desire of the human soul (theater = show for the gods). It serves, then, to manifest a transcendental idea. The power of its effect on the soul of the spectator and auditor is therefore dependent on the success of the transformation of the idea into (visually and acoustically) perceivable space.

The phenomenon of space is conditioned by finite limitation within infinite free space, by the movement of mechanical and organic bodies within this limited space, and by the oscillations of light and sounds within it. To be capable of creating moving, living, artistic space requires a person whose knowledge and abilities respond to all the natural laws of statics, mechanics, optics, and acoustics and who, in having command of all these fields of knowledge, finds sovereign means of giving body and life to the idea which he bears within himself.

This realization determines the work of the Bauhaus stage: the clear definition of the complicated total problems of the stage and its derivation from the origin of its evolution, form the point of departure for our stage work. We are investigating the problems of space, body, movement, form, light, color, and sound. We shape the movement of the organic and the mechanical body, the sounds of voice, music, and noise, and we are building stage space and stage figures. The conscious application of the laws of mechanics and acoustics are decisive for our stage design.

The architectonic problem of stage space has particular significance for our work. Today's deep stage, which lets the spectator look at the other world of the stage as through a window, or which separates [itself from him] by a curtain, has almost entirely pushed aside the central arena of the past, which forms an indivisible spatial unity with the spectator, drawing him, as it were, into the action of the play instead of separating him from it. The spatial problem of the picture-frame deep stage is a two-dimensional one. The visual field, which is limited by the stage frame, constitutes an optical plane comparable to the field of projection in the cinema or to a framed painting. The problem of the central arena stage, on the other hand, is a three-dimensional one; instead of a changing action plane there is an action space, in which sculptural bodies are moving.

Both stage forms have their artistic justification, but the spiritual prerequisites and the laws of its structure are of a fundamentally different kind—somewhat like the differences between a painting and a sculpture. We intend to include in our work this important, but today so neglected, problem of the central arena stage and to investigate it in practice.

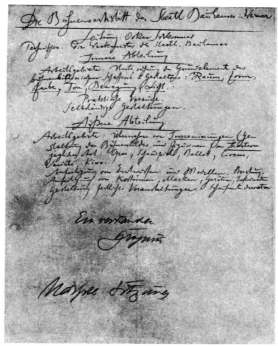

26

Oskar Schlemmer
The Stage Workshop of the Bauhaus in Weimar
LW, unregistered file: Stage XI, 1919—
4/1/1925 (First publication)
Schlemmer drafted this program for the work of the Bauhaus stage probably in 1923—when he took over the direction of the stage workshop —and submitted it for approval to the Council of Masters.

The stage workshop of the Bauhaus in Weimar
Direction: Oskar Schlemmer
Technical direction: The master craftsmen of the Staatl. Bauhaus
Internal department
Field of activity: investigation of the basic elements of stage production and design:
space, form, color, sound, movement, light.
Practical experiments.
Independent designs.
External department
Field of activity: taking charge of *productions* (design of stage sets and figures) in *theaters* of every kind: opera, play, ballet, circus, variety theater, cinema.
Preparation of designs and models. Consultation.
Production of costumes, masks, apparatus, instruments.
Design for festivities. Decoration of shop windows.
Approved.
Gropius

Oskar Schlemmer
The Figural Cabinet
LW, unregistered file: Bauhaus Week 1923 (First publication)
"The Figural Cabinet" was performed on August 17, 1923, in the Jena Municipal Theater as part of the festival program (Bauhaus Week) of the first major exhibition of the Bauhaus.

The figural cabinet (4th day of the Bauhaus Week, mechanical cabaret: Municipal Theater at Jena)
The figural cabinet, part shooting gallery, part "metaphysicum abstractum," is a section of the stage, arranged with full, half, and quarter figures in relief, in multi, plain, or metallic colors. The figures are set in motion by invisible hands, and—with or without sound— walk, stand, float, slide, roll, or rollick for a quarter of an hour. Babylonian confusion, full of method, a potpourri for the eye, in form, style, and color.
Direction: Caligari—America and Oskar Schlemmer—Weimar.

27

Oskar Schlemmer
**On the Situation of the Workshops for
Wood and Stone Sculpture**
Letter dated November 22, 1922 to the
Council of Masters
LW, unregistered file: Memoranda to the
Form masters 1919—4/1/1925 (First publication)

The question of the function of the independent arts within the Bauhaus program led to an impassioned debate among the masters. And since the opinions on it were divided, it raised serious problems for the painters as well as for the institution itself, which were never fully solved.

In regard to the letter from Master Hartwig, I would like to say this:
It concerns the central problem of the sculpture workshops: the stone and wood workshops. Originally the Bauhaus was founded with visions of erecting the cathedral or the church of socialism, and the workshops were established in the manner of the cathedral building lodges ("Dombauhütten"). The idea of the cathedral has for the time being receded into the background and with it certain definite ideas of an artistic nature. Today we must think at best in terms of a house, perhaps even only *think* so, but in any case in terms of a house of the *simplest* kind. Perhaps, in face of the economic plight, it is our task to become pioneers of simplicity, that is, to find a simple form for all of life's necessities which at the same time is respectable and genuine.
The question is whether our work shall be determined by considerations of such a social and ethical nature or by the fact of the existence of workshops which, simply because they are there, have to function. In addition, there are the requirements of the Apprenticeship Board and its rules for the examination of journeymen and apprentices which are binding for the workshop leaders.
We avoid carving in wood at the Bauhaus, not, as Master Hartwig suggests, because it did not occur to us, but because our conscience forbids us to do that. The woodturner's shop and not the woodcarving workshop would be today's corresponding shop to be affiliated with the cabinetmaking workshop. A piece of furniture today should be a work of art in its entire structure and not a skeleton to which a little art has been added. But it is quite different to regard the woodcarving workshop as a place for independent art exercises, a position to which the stone-cutting workshop has been forced through lack of assignments. But this approach places the sculptural workshops outside the other Bauhaus workshops and it would be a similar state of affairs if the wall painters were painting murals.
The trouble is that big commissions are lacking. Perhaps the exhibition will offer them—but only perhaps!
Oskar Schlemmer
Nov. 22, '22
In addition to Master Hartwig's letter and my own reaction thereto, I would like to offer the following:
My financial plight and the resulting impossibility of realizing specific projects—and thus the opportunity in the workshop for work, stimulation, and interest—the observation that such work would be sought and welcomed by the workshop, and in addition, the fact that I recognize this to be the only way to influence the workshop, have lead me to suggest the following arrangement to the Bauhaus:
The workshops (first of all those under my command: wood and stone sculpture and metal workshops) to work according to my instructions and under constant supervision (providing the current work of the workshops permits this). Those (masters, journeymen, and apprentices) hereby employed (voluntarily!) will be paid according to agreement by the Bauhaus. This pay and the materials used will be recorded.
In the case of works sold (if necessary, auctioned), the expenses accrued to the Bauhaus will be deducted from the proceeds first, thereafter one share of the profits, to be determined, goes to the Bauhaus and the originator of the work. Up to the time of the sale, which is subject to my permission, the work remains the property of the Bauhaus, but I will have first option on the purchase.
Oskar Schlemmer

State Minister Max Greil
Answer to a Question to the Minister by the Völkische Party, Given in the Thuringian Landtag on March 16, 1923
From minutes of the 156th session of the Thuringian Landtag on March 16, 1923

The question to the Minister, which had been posed by one of the most fanatical opponents of the Bauhaus, Dr. Emil Herfurth, was primarily based on information supplied by the dismissed accountant Beyer—whose allegations had already been refuted by the government. Herfurth questioned the usefulness of the organization of the Bauhaus, accused it of lack of frugality and, with these arguments, rejected a credit request for the 1923 exhibition. Minister Greil stood up for the Institute in the most loyal manner, as always.

It must be pointed out for the record that a number of artistic personalities are serving the Bauhaus, and that the world envies us for them, and for having artists of world-wide renown united in the Bauhaus, for there are few places in the world where so many artists are assembled in such a small space as in the Bauhaus. Thuringia and Weimar should be particularly proud of this fact and should avoid bringing discredit to the institution.

For the time being, the Bauhaus remains an experiment. No one of us can guarantee that this experiment will succeed. But whoever wants progress has to have the courage to experiment. Every new idea must somewhere and at some time be put into practice for the first time. Every new idea must be given time to develop. But, one must not consistently place obstacles in the way of this development, as in fact is being done with this question and with the whole procedure of the delegate, Dr. Herfurth. One may respond differently to the ideas of the Bauhaus. One's opinion may be completely positive or completely negative and one can also adopt a doubting or a wait-and-see attitude. But I would like to tell even those ladies and gentlemen who have adopted a wait-and-see attitude that one must nevertheless provide the Bauhaus with the means for its continuation. Considering that the experiment has been under way for three years, it would be the greatest folly to break up its development and to abandon the incomplete experiment at a moment when the Bauhaus is able to demonstrate what it is capable of achieving. One first has to give the Bauhaus an opportunity, through an exhibition to present a complete picture of what it is able to do. . . .

The attack which today—even though in disguised form—is being carried out against the Bauhaus is not the first one; the first one was started in the Weimar Landtag, initiated by the same group. Just as the attack was repelled then, so it will always be repelled, as it will this time. I think Dr. Herfurth will evoke the opposite effect with his constant attacks on the Bauhaus. For all the people will tell themselves that the cause against which representative Herfurth is fighting must, in the final analysis, be quite good.

3 Bauhaus Weimar
From the 1923 Exhibition
to the Declaration of Dissolution

IDEE UND AUFBAU
DES STAATLICHEN BAUHAUSES
WEIMAR
VON WALTER GROPIUS

BAUHAUSVERLAG G.M.B.H. MÜNCHEN

Walter Gropius
On the Proposed Remodeling of the Vestibule of the Weimar Art School, for the Bauhaus Exhibition Summer 1923
From a letter of January 29, 1923 to the
Weimar Academy of Art,
LW, unregistered file: Authorities, May 1,
1922—October 1, 1925 (First publication)
With the design for the remodeling of the vestibule for the Art School, Gropius encountered strong resistance from the administration of the neighboring Academy and from the government agencies in charge. The plans were modified. In their final execution, the educational intentions were not realized as effectively as they are here represented.

Oskar Schlemmer
Design Principles for the Painting and Sculpture Decoration of the Workshop Building of the Staatliche Bauhaus
From the magazine "Das Kunstblatt"
(Potsdam), Vol. VII, 1923, pp. 340 ff.
With his decoration for the staircase wall in the workshop building, Schlemmer produced a most remarkable example of the complete unity of the arts in architecture—a fact of which even many Bauhaus members were not totally aware. The murals and reliefs were ordered destroyed in 1930 by Schultze-Naumburg, who had been appointed head of the Art School by the Thuringian National Socialist regime. On this topic, see Schlemmer's "Briefe und Tagebücher," Munich, 1958, pp. 274 ff.

One of the various projects for the first major exhibition of the Staatliche Bauhaus in the summer of 1923 is that for remodeling the vestibule of the Art School building. Here, for want of bigger tasks, painting and sculpture have an opportunity to display themselves and to work in collaboration with each other.
By means of a simple design in color and plastic forms, it is planned to remove from this room the present atmosphere of emptiness. Since this room is a public passageway, we intend to provide a visual demonstration of general elementary laws and art forms. These include the prime colors which are given in the color circle (Runge, Ostwald), the primary forms in one-, two-, and three-dimensional representation (cube, pyramid, sphere, cylinder, point, line, circle, square, rectangle, ellipse) and the interpenetration of these forms. A rotatable color wheel will be installed to illustrate the mixing of colors by superimposition; a prism will demonstrate refraction and the colors of the spectrum, etc. Moreover, we are thinking of putting up representations of the human figure, done in a simple linear manner from which dimensions and proportions can be derived (according to Dürer's charts), and also anatomical representations.
We intend to replace the existing, primitive lighting with a new lighting fixture made of mirror-glass, frosted and milky glass and opalescent glass, composed of simple forms: spheres, cubes, planes, and illuminated by colored lights.
With this educationally visual design, the Bauhaus hopes to make the vestibule a center of attraction for the students and the citizens and to bridge the differences between Academy and Bauhaus by the interests we share. And last but not least, we hope to demonstrate Goethe's ideas on the correlation of art and science. . . .
The work will be carried out by students of the Bauhaus, under the direction of Master Oskar Schlemmer. . . .

Given was the interior decoration of van de Velde, whose once soberly whitewashed walls were, after all, walls that had for some time been fervently eyed by a generation of young artists hoping to free themselves from unproductive picture painting.
The self-imposed task of redecorating these rooms with paintings and sculpture originated in the desire to demonstrate at long last some cherished ideas and intentions.
Happy to have an opportunity at all, I accepted with clear conscience the odium of compromise which might lie in the fact that I had not built the rooms myself. I admit, too, that I was in a hurry; it was the closing of the door, not just on an era which may prohibit such work for a long time to come, but also of a mental attitude which will make a clear and radical sweep of everything that is called art, metaphysics, and faith. Some day, when the doors will open again, the controversy over the worth or uselessness of these things will be decided.
What remains to be said is that in the irreligious world of today, the arts concerned with great themes—as monumental painting and sculpture are—stand particularly forsaken. The foundations which once supported those arts—national conscience, ethics, religion —have been shaken or have crumbled. The new ideas are in the throes of birth—disputed, unrecognized. Nevertheless, there is one great theme remaining which is ancient and yet eternally new, a subject for artists of all times—Man, the human figure. It has been said of Man that he is the measure of all things. Well, then! Architecture is the noblest art of measuring: Let us unite.
I ought to mention that the measure which we carry within ourselves is, when it comes to be expressed creatively, always capable of being different and of creating something new. Certainly, geometry, the golden section, the theory of proportions, all these are dead and unproductive if they are not experienced, felt, sensed. We must allow ourselves to be taken by surprise by the miracle of proportion and by the magnificence of numerical relationships and harmonies and from the result of this we must form principles. The counterpoint of painting will never be found, or else it will, compared with that of music, be a barren scheme. The result: The creative processes of these two art forms are quite different. Unintentionally, in such a secret way, it came about that in the work in the workshop building the numbers 3,5,7 predominated in varying forms and relationships. The instinct composed, the intellect established. As it was with form, so it was with color. The triad of the primary colors red-blue-yellow, their supplementation by the noncolors black and white to 5, and the numerical progression resulting from mixing them, all these numbers have their counterpart in the primary forms of plane and sculpture but are always no more than

the basic structure of unaccountable vibrations.

The elemental aspect of the figure is the type. Its creation is the ultimate and highest task and it is perhaps presumptuous to touch on that subject when the fate of the prerequisites for its fulfillment hang in the balance. Variations on the figurative theme are carried out in sculpture (in relief) in color and in line. The figures as abstraction are proportionally exaggerated in scale, very much larger or very much smaller than living man, who should remain the measure and the mean. (Among colors, green has this role, being the predominant exterior color, which is avoided in interior space.)

The technically required use of (nonchemical) earth colors which can be glazed, provides a color scale that carries its own natural harmony. They are the principal colors: English red, ultramarine, ochre (white as base and black) and the secondary colors: caput mortuum, burnt umber, indigo. Also the metallic colors: gold, silver, copper; blue-silver, violet-silver.

Tour: Entrance to *A*. Pentagonal hallway, divided by the axes *B* and *C*. Multiple field of vision. The room stabilized with soothing blue. Two relief groups of large forms in a yellow mortar mix on the two walls. Male and female principle. "Tempelhüter" (temple guard). Three interlocked semifigures, relating to the directional axes, on the ceiling.

The two wall reliefs are supplemented in room *C* by the elongated black-and-white figure, in that the figure forms a neutral, so to speak, temporary transition across the undulated, reclining female figure to the principal figure on the front wall. The most important pictorial representation is on this surface as it is closest to being a pure wall: male heroic linear figure. Wide caput mortuum—borders and white surface. Soft black rising and falling contour. The head disk silver, the breast disk gold, leg band copper. On the adjoining long wall is one large and one small pale gray figure silhouette.

Main axis *B*. The small stairs; niches on both sides with five small, different relief figures in each. Movement, produced by form and metallic lustre, corresponding to the dynamics of the stairs. Themes of movement: standing (front view, side view), inclining, plunging, falling, also floating, flying. Color: base, dark English red; figures, gold, silver, copper, blue-silver, violet-silver. Center *B,* white walls, hairline contour figure. Dark blue ceiling. The adjoining exit: light English red. White figures on the ceiling, outlined in black. On the walls, one head with forward and one with backward directed view. Blue frosted windows. Black-blue doors.

From the middle of *B* to the large staircase. Large, pale-colored torso figures ascending. Wall, light violet. Figures: caput mortuum, light English red, light ultramarine, umber, violet, English red, ultramarine. Ceiling, black window frame. Ribbons: gray, light yellow, white, key form.

Two linear figures on a light violet base opposite the upper end of the stairs. In the niche: frieze with five heads. Dark gray—English red.

Oskar Schlemmer

The Staatliche Bauhaus in Weimar

Manifesto from the publicity pamphlet "The First Bauhaus Exhibition in Weimar, July to September 1923."

The manifesto was printed in agreement with the Council of Masters as part of a four-page publicity pamphlet in color but without having been submitted to the Council before its completion. The words "cathedral of socialism" made it necessary—because of the dangers of political misinterpretation—to destroy the part of the pamphlet containing the manifesto. Despite all precautions, a few complete copies reached the public and evoked vehement attacks against the allegedly political inclinations of the Bauhaus.

The Staatliche Bauhaus in Weimar

is the first and so far the only government school in the Reich—if not in the world—which calls upon the creative forces of the fine arts to become influential while they are vital. At the same time it endeavors, through the establishment of workshops founded upon the crafts, to unite and productively stimulate the arts with the aim of combining them in architecture. The concept of building will restore the unity that perished in debased academicism and in finicky handicraft. It shall reinstate the broad relationship with the 'whole' and, in the deepest sense, make possible the total work of art. The ideal is old, but its rendering always new: the fulfillment is the style, and never was the "will-to-style" more powerful than today. But confusion about concepts and attitudes caused the conflict and dispute over the nature of this style which will emerge as the "new beauty" from the clash of ideas. Such a school, animating and animated itself, unintentionally becomes the gauge for the convulsions of the political and intellectual life of the time, and the history of the Bauhaus becomes the history of contemporary art.

The Staatliche Bauhaus, founded after the catastrophe of the war, in the chaos of the revolution and in the era of the flowering of an emotion-laden, explosive art, becomes the rallying-point of all those who, with belief in the future and with sky-storming enthusiasm, wish to build the "cathedral of socialism." The triumphs of industry and technology before the war and the orgies in the name of destruction during it, called to life that impassioned romanticism that was a flaming protest against materialism and the mechanization of art and life. The misery of the time was also a spiritual anguish. A cult of the unconscious and of the unexplainable, a propensity for mysticism and sectarianism originated in the quest for those highest things which are in danger of being deprived of their meaning in a world full of doubt and disruption. Breaking the limitations of classical esthetics reinforced boundlessness of feeling, which found nourishment and verification in the discovery of the East and the art of the Negro, farmers, children, and the insane. The origin of artistic creation was as much sought as its limits were courageously extended. Passionate use of the means of expression developed in altar paintings. But it is in pictures, and always in pictures, where the decisive values take refuge. As the highest achievement of individual exaggeration, free from bonds and unredeemed, they must all, apart from the unity of the picture itself, remain in debt to the proclaimed synthesis. The honest crafts wallowed in the exotic joy of materials, and architecture piled Utopian schemes on paper.

Reversal of values, changes in point of view, name, and concept result in the other view, the next faith. Dada, court jester in this kingdom, plays ball with paradoxes and makes the atmosphere free and easy. Americanisms transferred to Europe, the new wedged into the old world, death to the past, to moonlight, and to the soul, thus the present time strides along with the gestures of a conqueror. Reason and science, "man's greatest powers," are the regents, and the engineer is the sedate executor of unlimited possibilities. Mathematics, structure, and mechanization are the elements, and power and money are the dic-

tators of these modern phenomena of steel, concrete, glass, and electricity. Velocity of rigid matter, dematerialization of matter, organization of inorganic matter, all these produce the miracle of abstraction. Based on the laws of nature, these are the achievements of mind in the conquest of nature, based on the power of capital, the work of man against man. The speed and supertension of commercialism make expediency and utility the measure of all effectiveness, and calculation seizes the transcendent world: art becomes a logarithm. It, long bereft of its name, lives a life after death, in the monument of the cube and in the colored square. Religion is the precise process of thinking, and God is dead. Man, self-conscious and perfect being, surpassed in accuracy by every puppet, awaits results from the chemist's retort until the formula for "spirit" is found as well. . . .

Goethe: "If the hopes materialize that men, with all their strength, with heart and mind, with understanding and love will join together and become conscious of each other, then what no man can yet imagine will occur—Allah will no longer need to create, we will create his world." This is the synthesis, the concentration, intensification, and compression of all that is positive to form the powerful mean. The idea of the mean, far from mediocrity and weakness, taken as scale and balance, becomes the idea of German art. Germany, country of the middle, and Weimar, the heart of it, is not for the first time the adopted place of intellectual decision. What matters is the recognition of what is pertinent to us, so that we will not aimlessly wander astray. In balancing the polar contrasts; loving the remotest past as well as the remotest future; averting reaction as much as anarchism; advancing from the end-in-itself and from self-directedness to the typical, from the problematical to the valid and secure—thus we become the bearers of responsibility and the conscience of the world. An idealism of activity that embraces, penetrates and unites art, science, and technology and that influences research, study, and work, will construct the "art-edifice" of Man, which is but an allegory of the cosmic system. Today we can do no more than to ponder the total plan, lay the foundations, and prepare the building stones.

But

We exist! We have the will! We are producing!

Adolf Meyer
The Construction of the Experimental House
From "An Experimental House of the Bauhaus in Weimar," Bauhaus Books, volume 3; compiled by Adolf Meyer. Albert Langen, Publishers, Munich, undated.

The experimental house was built for the exhibition of 1923 on a plot called "Am Horn," which the Bauhaus had acquired, after a design by Georg Muche. It was executed by the architecture studio in conjunction with private firms under the direction of Adolf Meyer, and furnished by the Bauhaus workshops. The house was intended to be a model of a modern dwelling. It was sold to an interested party soon after the exhibition. Later, some changes were made by outsiders, with the result that it can no longer be taken as representative of the Bauhaus.

Georg Muche
The Single-Family Dwelling of the Staatliche Bauhaus
From the magazine "Velhagen & Klasings Monatshefte," Berlin—Bielefeld—Leipzig—Vienna, Vol. 38, No. 9 (May 1924), pp. 331 ff.

The experimental house of the Bauhaus—cf. Meyer, "The Construction of the Experimental House"—was intended to be the start of a Bauhaus housing development which, however, never proceeded beyond organizational preparations (founding of a housing development corporation) and over-all planning. At that time, Muche was preoccupied with various architectural projects. Later, in Dessau, he designed a metal house, which was also built.

The single-family dwelling of the Staatliche Bauhaus was built in 1923 as the first unit of a planned housing settlement.

It took four months to complete the building. The cornerstone was laid on April 11 and the house was finished on August 15, 1923.

The construction period coincided with the time of the inflation. Consequently, the choice of building materials and construction methods was restricted. The fact that in spite of these handicaps it was possible to erect a building according to the standards of modern building techniques is essentially due to the sympathetic cooperation of the participating industries.

In selecting building materials and construction techniques preference was given to those that responded to the new ideas of architectural synthesis.

Substitutional building methods were eliminated intentionally. Instead, great emphasis was placed on the harmony of materials and construction in order to point out a possible direction for the future, transcending the present economic restrictions. . . .

. . . For this first house we intentionally chose the simplest and most clearly defined floor-plan arrangement (high-ceilinged, large, central living room surrounded by low-ceilinged, smaller auxiliary rooms). This arrangement proves to be the most practical and natural, since it keeps the house small in size and, thereby, simultaneously achieves economy in both construction and household management. . . . Within an area of 12.70 by 12.70 meters, the layout was so divided as to produce the most useful relationship between the individual rooms. Therefore, connecting passages, entrance halls, and stairs were kept to a minimum or avoided altogether. Each room was furnished entirely according to its purpose. Thus, the kitchen is a kitchen only and not at the same time a meeting place for the family (not a family room). It is as practical as possible and moreover has been equipped with appliances to facilitate work: water heater, sink, special laundry sink, telephone with house extensions, outlet for gas and electric stove, pantry, and broom closet. The table stands in front of the window and forms, together with the stove, the tops of the low kitchen cabinets, and the sink, a wide and continuous working counter of uniform height, so that the usable area of this small kitchen is equal to that of a conventional kitchen two to three times its size. Analagously, the dining room is only a place for dining and not a working or living room at the same time. It is designed for relatively short occupation and, therefore, needs to be no larger or smaller than is required for the comfortable seating of four to six people at the table. A china cabinet has been built in, so that this room with its colored, patterned floor, colored walls and a high, wide window contains only the furniture that is absolutely necessary for a dining room. It is outfitted with neither carpets nor the customary sideboard. The dining room is so placed that it also protects the rest of the house from kitchen odors. The kitchen is isolated from the entrance hall by an air-trap. The centrally located living room, the main room for the family, is intended to be quite large in contrast with the other rooms, which were designed for occupation by one person only. The surrounding rooms protect the large central room (6 meters square) from cooling by the outside temperature, and since the ceiling and the exterior walls in the upper part of the room were both isolated with "Torfoleum" tiles, this part of the house can also be easily heated and, during the

summer, is well insulated against solar heat. Light for this interior room is provided by clerestory windows (double windows with frosted glass on the inside) and by a wide window in the niche containing the writing table. The master bedroom, amply furnished with built-in wardrobes, is designed as a double room with bath and washroom adjoining. The bathroom walls are lined with white alabaster glass for practical and esthetic reasons. Rubber tile was used as floor covering. The children's room has immediate access to the dressing room of the lady of the house and a door to the terrace outside. This room has been designed to offer a good healthy environment for the child. A wainscot of blue, yellow, and red chalk-board to write on covers all of the walls of the playroom. The toy cupboard is in part made of lightweight, movable, pale-colored boxes that also serve as children's chairs and tables and can be used as building blocks and for general playing. The other part of the room is the actual bedroom, with a chest of drawers, bed, and wash basin (with running water). Storage and utility rooms and laundry (with electric washer and dryer) and the boiler for the central heating are located in the light basement area. Of the new materials, colored and transparent plate glass especially were used in various ways. This plate glass is particularly beautiful, and because of its smooth surface can be cleaned easily and therefore lends itself well to practical use. The single-pane pivotal windows were also fitted with plate glass. The use of recessed lamps for lighting the room is a new experiment. The formal design of the enclosures and the partial use of opaque and mirrored tubes makes the use of special lighting fixtures unnecessary. A good combination of a number of lighting tubes has a beautifying effect on the whole lighting system.

All of the equipment for the rooms, furniture, carpets, and lighting fixtures, etc., were produced in the workshops of the Bauhaus. . . .

Walter Passarge
The Bauhaus Exhibition in Weimar
From the magazine "Das Kunstblatt," Potsdam, Vol. VII, 1923, pp. 309 ff.
Work from the preliminary course and the workshops was exhibited in the two school buildings. In the main building an international architectural exhibition was also arranged. The Landesmuseum provided rooms for works of painting and sculpture. The "model house" ("Am Horn") which was especially constructed for the exhibition, demonstrated the Bauhaus program in so far as it concerned residential architecture and its furnishings. At the beginning of the exhibition, a "Bauhaus Week" was held with lectures, musical and theatrical events, and a conference of the German Werkbund was convened. Weimar seemed to be the private domain of the Bauhaus and its many prominent guests.

Having kept silent for a long time, the Bauhaus, which was developed under the direction of Walter Gropius with the collaboration of teachers like Feininger, Klee, Kandinsky, Schlemmer, Muche, and others, presents itself to the public. It is only natural that after four years of work no one can expect to see even the beginnings of approaching fulfillment. In his opening address, Gropius himself pointed out that no more than beginnings would be shown here. This is far less due to the many internal and external difficulties with which the school has had to struggle from the very outset than to the fact that for the first time a completely new approach representing a radical break with the past is being practiced. Whoever expects to find something that is finished and complete will be thoroughly disappointed. Perhaps more restraint should have been practiced in the programmatical announcements on this point, for these were in part really misleading. On the other hand, no one will be able to avoid seeing with what earnestness and determination the basic problem of the integration of craft, art, and technology has been tackled. To be sure, side by side with excellent work there is always much that is unresolved, and a stricter selection of material would certainly have been of advantage. But this does not alter the fact that an energetic attempt is being made here to reorganize our future cultural life.

The spirit of architecture hovers over the exhibition. The actual heart is the international architecture exhibition, while the show of free art in the Landesmuseum is only marginal. One common characteristic unites the architecture of the young Germans, Dutch, Czechs, Danes, Russians, and French: the tendency to achieve the highest form of homogeneity, relevance, and clarity, a tendency much closer to the spirit of our age than all "Utopian" and "Expressionistic" architecture. Especially worth mentioning are the structures of the Dutch architects (Oud, van Loghem, Dudok, among others) and the design for a metropolis by Le Corbusier. Among the German work, the factory and country-house buildings which Gropius designed with Adolf Meyer are naturally the most interesting. . . .

Special emphasis is given to the design of space. The most significant achievement in this area is by Oskar Schlemmer in the decoration of the vestibule and staircase in the workshop building. His work is most convincing in his paintings: giant figures of marionette-like ornamentality, their sensitive contours placed against a light-colored background, enlivening and intensifying the form of each corresponding wall surface to perfection. In addition, the delicately balanced color: light blue, brown-violet, pink, lilac, pale gold. Schlemmer has a pronounced talent for the monumental which is also to be seen in his sculptures; these in part are still very experimental. The abstract architectural sculpture in the vestibule by Joost Schmidt is an attempt to derive sculptural effects from complex stereometric forms. Finally, the beautiful but unfortunately uncompleted workroom by W. Gropius deserves to be mentioned. Remarkable are the experiments to arrive at a new form of lighting.

Among the products of the workshops there are very beautiful textiles, ceramics, and metal work. The carpets and tapestries exult in the joy of pure color and pure form and in the composition of different materials. In all these works, one perceives the thorough training in craftsmanship. The effort that went into the making of these things alone deserves recognition. Good work is also presented by the cabinetmaking shop. In the area of glass painting, only small, brightly colored pieces are displayed; some large windows already decorate two houses designed by Gropius, in suburbs of Berlin. The workshop for wall painting displays interesting experiments with new techniques. A large selection of theoretical workshop projects gives evidence of the almost scientific seriousmindedness of the educational plan.

The single-family house "Am Horn" seeks to demonstrate collaboration in building design. It is thought of as a prototype for a housing settlement. The rooms are arranged around a central, high-ceiling room with clerestory windows. The exterior design is based on the effects of the simplest cubic planes, consisting of a flat roof, smooth walls, doors and windows cut flush into the walls, large plate-glass windowpanes. The interior is in

harmony: plain doors and wardrobes, cubic furniture, light, cool colors. There are still some problems in the details. On the whole, the building does not yet represent a final solution, and as an experimental house using some quite expensive materials, it is not a model for a simple settlement house. The restraint in the use of color is a necessary and welcome reaction to certain excesses of colored architecture.

In the exhibition of free art it is Feininger who leaves the strongest impression. His "Church" (Gelmeroda), glistening in blue and silver, belongs, with respect to the use of color, to the most magnificent achievements of contemporary German painting. Klee displays beautiful works but does not offer anything essentially new. Kandinsky approaches constructivism in his later works. Schlemmer is captivating in his posing of problems; Muche clearly points the way from strong-colored abstraction to distinctively objective representation. Sculpture is mainly represented by Marcks. Among the students, Johannes Driesch's strong talent must be mentioned.

In retrospect, it must be emphasized again that the exhibition offers a picture not of a mature school but of one that is in the process of maturing. It is, in regard to the representational arts, one-sided to the point of exaggeration; architectonic forms dominate even the works of the free arts, and the drawing of the architectural workshops, next to the technical drawing, provides a strong lead. Further development will—and must!—lead again to greater external independence of the arts, without thereby having to lose the inner unity which is in the process of developing. The idea of unity is still often taken too literally and superficially. This is the necessary consequence of the traditional disruption of the arts. Yet a reversal is impossible without this one-sidedness. But it must be overcome if the dangers of academic rigidity are to be avoided for any length of time.

The turning, especially among the younger spirits at the Bauhaus, toward a more intensive occupation with objectivity is not an accident. This direction is in tune with tendencies which are becoming visible all over Europe. Some have called it a "new naturalism." This is only conditionally correct. This movement has nothing to do with the naturalism of the 19th century, which was primarily preoccupied with the picturesque. In the metallic harshness of form, in the precision of contour, and in the new feeling for material and plasticity there lives an uncompromising down-to-earth spirit and an affirmation of reality, which comes out much more strongly than in any abstract organization or ornamental use of technical forms—which the engineer in particular rejects as being essentially romantic. It is a spirit that has already found expression convincingly in the best buildings of today's architecture.

29
Program for the "Triadic Ballet" performance during the Bauhaus week.
30
Gerhard Marcks: Postal card for the Bauhaus exhibition 1923.

Paul Westheim
Comments on the "Squaring" of the Bauhaus
From the magazine "Das Kunstblatt,"
Potsdam, Vol. VII, 1923, p. 319
Westheim, friend and biographer of expressionist painters (such as Kokoschka) and publisher of the consistently nondoctrinaire and individualistic "Kunstblatt," found the stylistic direction of the Bauhaus quite unintelligible. The "square style" of the Wiener Werkstätte two decades before, had already once before inspired sarcastic comments. In this geometric rigidity Westheim perceived, not entirely without reason, the danger of passing over the problem of design with a schematic and ultimately noncommittal, formal apparatus.

Lyonel Feininger
From a Letter to Julia Feininger Dated August 1st, 1923
BR, gift of Julia Feininger (First publication)
This letter reflects the skepticism shared by the painters in the Bauhaus over the slogan, "Art and Technology—A new Unity," which had been formulated by Gropius and programmatically presented in a lecture delivered on the occasion of the exhibition in the summer of 1923.

Gertrud Grunow
The Creation of Living Form through Color, Form, and Sound
From "Staatliches Bauhaus 1919—1923,"
Bauhaus Press, Weimar—Munich (1923),
pp. 20–23
An extraordinary ability to empathize enabled Gertrud Grunow to recognize specific talents. Her ideas and theories on synesthetic relationships placed her in closest intellectual kinship with Itten, who had recommended her appointment to the Bauhaus. Despite her reserve, the strength of her personality exerted a very essential influence on the Weimar Bauhaus and its masters.

At the Bauhaus there are a few masters who are also masters even without the Bauhaus; the others are just Bauhaus masters.

Bauhaus is a more concise name for a school of arts and crafts. The Bauhaus is a school of arts and crafts, not because it has workshops, but in spite of them.

Wherein does the Bauhaus differ from other schools of arts and crafts? In the schools of arts and crafts there is talk of the "art in the crafts," and in the Bauhaus one uses a few more words, namely, the "unity of art and craft."

The progress is: In the schools of arts and crafts students are plagued with stylizing cabbage leaves from nature, and at the Bauhaus people plague themselves with stylizing squares from ideas.

Three days in Weimar and one can never look at a square again for the rest of one's life. Malewitsch invented the square way back in 1913. How lucky he didn't have his invention patented.

The ultimate of Bauhaus ideals: the individual square.

Talent is a square, genius an absolute square.

The "Stijl" people have put on a protest exhibition in Jena—they claim to possess the only true squares.

Wednesday, August 1st, 1923 seven-thirty in the morning.

. . . Yesterday I ran into Gropius—he approached me affectionately, took me by the arm and wanted to say a few things to me—so I went with him to the Bauhaus. He never complains, never seems exhausted or embittered. He works until 3 in the morning, hardly sleeps at all, and when he looks at you his eyes shine more than anyone else's! And he doesn't know, moreover, what he should do to make it all a success . . . One can feel sorry for anyone who cannot, somehow or other, take heart from this man. Often enough I have quite positive criticisms to make against the whole project, I am often deeply unhappy about the way things are going; but there is certainly a power at work here, which is the only one that could make things work. If much of it is simply in vain and will be frustrated, this cannot be blamed on Gropi—it is part of the time and the people. With absolute conviction I reject the slogan "Art and Technology—A new Unity"—this misinterpretation of art is, however, a symptom of our times. And the demand for linking it with technology is absurd from every point of view. A genuine technologist will quite correctly refuse to enter into artistic questions; and on the other hand, the greatest technical perfection can never replace the divine spark of art. But the aimlessness of the typical art school, etc., is, I think, clearly evident, as is the lack of prospects for most young art students ever to be able to make a living without a profession on the side. . . .

The great significance that sound and color have for man has long been envisaged. But so far it has been impossible to arrive at general, fundamental laws. The physicists did not succeed through the measurement of wavelengths, nor did the psychologists with the science of dual sensation (synopsy). Appearances were judged and measured against each other; but appearance is a sensation. If, instead of attempting to explain the appearance objectively by hypothesis, one went back to the sensations of the appearances, namely to their nature and origin, which, after all, constitute the substance of the appearances, then relationships can be discovered and an order appears that reveals far more than had been sought and expected up to now. And that is the structure of the entire real world, as it develops biologically-historically from the human organism and the human spirit. There is not space enough here to explain the extent and range of light and color energies in conjunction with the order given by the world of sounds, nor to explain how all this interacts in a living manner. Moreover, there is no opportunity to give an insight into cultures, races, nationalities; into the aspects of the nature of manual tools, so far little or not at all pursued; into fashion, which in certain periods developed according to definite rules; into architecture, painting, and the other arts, and also into problems of health.

Light, colors, are not only to be taken as blue, red, etc., specific to the eye, but primarily as a living force. Every organic being accommodates itself to light and enters into a form, according to time-space and space-time. Everything happens in a lawful order, externally (with respect to form) and internally (materially, in states of aggregation). Every with, by, above, below, behind interrelation in the living interchange of forces is based on a special, lawful inner order and evokes a particular sensation and an external appearance.

The supreme law, according to which all order is structured, is called equilibrium. Nature, having placed the organ of equilibrium in the ear, has given man a guardian and protector of order, the ear thus being designated to be the immediate and highest judge of order within the human organism. The strong effects that sounds have on man can be attributed to equilibrium. The ear, during strain on the organism, senses the living order of that organism in its own specific, highest form of sensation, namely as a sound (of any kind, even noise). Every living force, and thus every color, corresponds to a lawful order, to a sound. The relationships are close or distant. A form of life emerges from the unity of sound and color, that is, a sensation as well as a concrete, comprehensible, and palpable phenomenon which most easily and powerfully manifests itself in the upright human figure and its spiritual and psychic expression. The more complicated the life formed, the richer and more refined becomes the world of forms and the material configuration.

The building of living form can only proceed from the greatest simplicity, the simplest order, and must not serve specific purposes—to the eye or ear—too early, if it is to have universal validity and be fundamental; from this, as the universal synthetic base, values of general reality are developed and built. Any particular force and any form of life can only be successful for any period of time if all other forces are pure and are flowing freely

to the fullest extent. They are the content of the specific in its very individual way; the specific rests on the whole.

Something that is upright is something that is static and spatial, something solid, a weight that straightens and lifts itself. Since light is the foundation of color, anything static and spatial must correspond to color and must be in a state of ultimate equilibrium, in ultimate harmony, when its appearance emerges from the unity of color and sound. Static configurations bear a characteristic mark, just as light shines and becomes effective in colors. These configurations rest upon specific centers of gravity at particular points in the human body and rise from these in a specific manner. An ordering of static configurations will depend on the level of strain and expansion and will be identical with an arrangement of light and colors. This ordering of colors is equal to the chromatic structure of the tones from c to b. But the order of colors does not result from the intellectual calculation that the tone scale from c to b is based on progressive tension; instead, it is found subconsciously and spontaneously by anyone because of the gravitations within the living and active body. This order occurs as a circular one and constitutes an outward oriented tension of forces, of a length and a direction which correspond to the forces (colors) and which result from the structure and the composition of the human form. The interrelationships of colors and sounds, as well as the just mentioned circular order are the same for all human beings. The circle, a circle of gravity and equilibrium, the deepest, simplest color-harmony is, therefore, of universal significance. The circle is a fundamental phenomenon and is of the same importance to statics as the golden section had been for measurements. Since gravity, and not number, is the primary element, the order of colors ranks above the golden section as the determining criterion. In the living organism the forces join in particular measures and interrelate in definite degrees; from a center outward, outside with reference to a center. The act of weighing derives from the mind "judiciously," progressing materially from the heaviest, structurally firmest to the lightest, most ephemeral, most flexible. The scales and degrees increase and once more require a special order of colors (forces). This is a firm order, a unit of measure for all colors; it is based on the construction of the human figure, its frame, the spinal column, vertically in height and depth, and in expansion, horizontal, active, movable on the diaphragm. This order of colors, too, is subconsciously independent; it stands in particularly close connection with the lamellar nature of the muscular system. The dynamics are numerical and are identical with the order of octaves; downward and upward from the center and, furthermore, from low to high and from high to low. Compared with the first circle, as the circle of equilibrium, the second circle is the circle of dynamics, mechanics, matter, the intellect, the construction. The first circle already bears the second one within it; the second rests on the first, is only capable of deriving from it in the form of quantities from qualities. A dynamic element is equal to a specific element, deduced from the synthetic, the totality, which is of a lower or higher degree, a certain color, and is a form, size, material on the one hand, and a quality, scale, and weight on the other. The kinetic form of such a balanced force represents an angle, a right, acute, or obtuse, of a curvilinear type, and, as an entity completed on all sides, yields geometric shapes. They are physical forms of life that enter the consciousness and that in the living being spiritually form themselves into phantasies (beings and objects) according to their emphasis on form or material. And they are also actively felt in that they lead man to actions, creation, and production. Matter is sensed as entity, as force and energy, and further, as a condition. Materials such as stone, wood, etc., vegetable, animal and human forms and shapes, solidity, compactness, including the liquid condition and the atmospheric state, also psyche, are all forces and forms of life that are closely connected with light, with color. The material of which the human being is created, in all of its various kinds, intuitively enters the consciousness as imagination and as idea. Man behaves according to his intuition; with his awareness of the "I" and self-consciousness he expresses his will and governs himself as well as other things.

All living things and all beings outside of man are complementary to him; on the other hand, man transfers his perceptions and experiences into his environment and thus sees and forms the world. Those aspects complementary to man have been cultivated in much too small a range, and all that has been discovered, made, and thought has been taught from without with too much emphasis on civilizing points of view. And qualities were presupposed that are not living, deeply rooted, and available, since the second category, that of independent perceptions and experiences which are born in the unconscious, has not, or only insufficiently, been cultivated. So far, universal fundamental laws have been lacking. One should not be surprised that brilliant work and the highly creative and imaginative attitude have disappeared, that a much too perfunctory understanding prevails of things, people, and the world; and one often asks: "What does this mean?", "How is that done?" In a place where all endeavors are directed toward reconstruction and companionship in liveliest reciprocation with the world, as in the Bauhaus, the cultivation of independence, born in the subconscious, will, as beginning and constant aid, not be dispensable. For, only from such independence can a renewal, an intensification, and a strengthening of sensitivity and receptivity originate in the purest and most thorough way, can expressiveness develop which is living, pure, thorough, and rich. Both are prerequisites for a successful companionship of man and the world. Every age has its forms of life; they are expressive of the age and are ahead of the everyday world. Today's forms of expression represent the emergence of natural forces, which seem to be requisite for the blossoming of a great, universal art. The assumption that with the building of living form through color, form, and sound, a theory is in the foreground is contrary to the fact that works born of genius, independence, and the subconscious can never originate and develop theoretically. Moreover, if the metaphysical, the abstract is genuine, great, powerful, and pure, it then stands on a firm base; the metaphysical is

then the most sensitive spiritual perception of the physical, the abstract is the concrete within physical, chemical form, and emotion becomes reason. The artist creates subconsciously, and he must go beyond the conscious in order to act subconsciously.

Comments on the illustrations:
1. With the drawing of a vest (textile form), a sample of material and the instructions for its making, as well as with the three sketches of the texture, a woman student from the weaving workshop offers a first example of a lively imagination born of necessity. The drawing represents a form, directly acknowledging movement, and it does this on account of experiencing a color in regard to the second circle, dynamically balanced in scale and degree. The movement would have developed naturally into the forms of knitting or weaving, as the case may be, but in the drawing has been interrupted and modified for the sketching hand. The student's designation of "weaving color" refers to the color (force) on which the act of weaving is based.
2. "Second circle," cross next to connecting lines; and further,
3. Angular forms have been drawn up by two students who, by themselves, have found symbols for primary connections of forces and basic diagrams for exercises. Contrary to the first circle (equilibrium, static-dynamic) these diagrams have dynamic-static importance. The results of these exercises are the same with all people, individually modified and shaded.

31
1. Evolved from material out of the result of the first grade and second measure (individually Agnes Roghé). Green and unbleached color. Vest knitted to the right. Zephir wool.
2. Evolved from the loom (machinery) out of the result of the first grade and first measure. Blue on unbleached. Undulating form of strong material. Rayon.
3. Result of the first grade and third measure. Undulating form in very perfect technique. Close mesh. Fine silk.
4. Result of the second grade and first measure. White on unbleached. Linen binding. Linen weave in a single piece of goods, ratio 2:3 or as pattern form.

32 33
Schema. Fundamental for the construction. Evolved from the circular order of the next illustration.

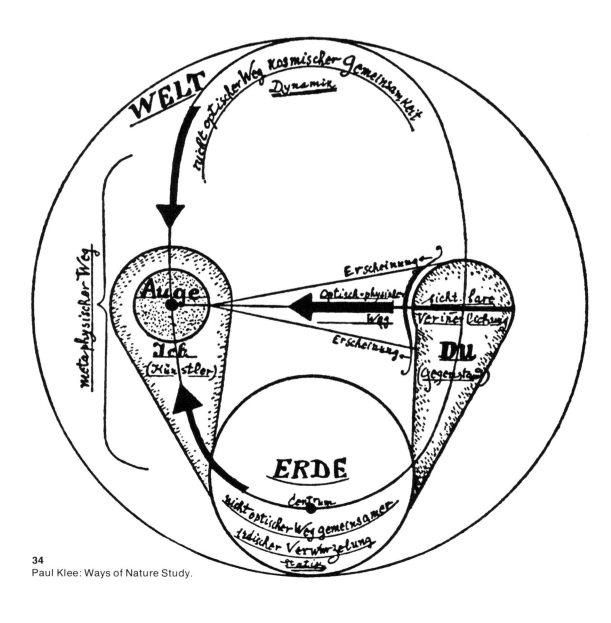

34
Paul Klee: Ways of Nature Study.

Paul Klee
Ways of Nature Study
From ''Staatliches Bauhaus Weimar 1919—
1923,'' Bauhaus Press, Weimar—Munich
(1923), pp. 24f.
This essay was one of the programmatical
contributions to the book which was published
on the occasion of the Bauhaus exhibition of
1923.

For the artist, dialogue with nature remain a *sine qua non*. The artist is a man, himself nature, and a part of nature within natural space.

Depending upon the attitude of the individual with reference to his sphere of influence, it is a matter of the number and the kind of paths he may pursue, both in his productivity and in the related nature studies.

Often these paths appear to be quite new without perhaps basically being so. Only their combination is new, or else they are really new in comparison with the variety and kind of ways of yesterday. But to be original as compared with yesterday is after all a mark of revolutionary zeal, even if it is not an event that shakes the foundation of the old, established world. This does not mean that the joy of novelty has to be disparaged, but that a wider historical view should guard us from desperately seeking novelty at the expense of naturalness. The artistic attitudes of yesterday, along with the corresponding ways of nature study, consisted, one could say, of a meticulously detailed investigation into the appearance of things. The ''I'' and the ''you,'' the artist and his object, sought to establish optical-physical relationships, through the layer of air between the ''I'' and ''you.'' In this way, excellent pictures of the surface of the object, filtered by the intervening air, were obtained and the art of viewing optically was improved, while the art of contemplating and envisaging nonoptical impressions and conceptions was neglected. Yet the achievements in exploring the appearance of nature should not be underestimated; they should be extended. Today, this one way of studying nature no longer meets all of our needs any more than it did the day before yesterday. The artist of today is more than an improved camera, he is more complex, richer, and wider. He is a creature on the earth and a creature within the whole, that is, a creature on a star among stars.

This is being increasingly expressed in the fact that a sense of the total nature of things is entering the conception of the natural object, be this object plant, animal, or human being. It is happening whether it rests in the space of a house, of a landscape, or in the space of the universe, and in such a manner that a much more spatial concept of the object is being born.

The object grows beyond its appearance through our knowledge of its inner nature. It grows by the knowledge that a thing is more than its outward appearance suggests. Man dissects the thing and with plane sections demonstrates the inner structure of it, whereby the character of the object is built up by the number and kind of the required sections. This is visual penetration, partly by means of the simple, sharp knife, partly with the help of more delicate instruments that can reveal the material structure or the material function to us.

The sum of such experiences enables the ''I'' to draw conclusions about the inner nature of the object from the appearance of its exterior. And this is done intuitively, in that the optical-physical appearance stimulates the ''I'' to produce feelings which, more or less elaborately according to their direction, can transform outward impression into functional penetration. What was anatomical becomes now more physiological.

Beyond these ways of looking into the object there are further paths leading to the ''humanization'' of the object, in which the ''I'' is brought into resonance with the object, transcending the optical fundamentals. First, there is the nonoptical way of a common, deeply rooted earthbound connection which rises from below into the eye of the ''I,'' and second, there is the nonoptical way of a cosmic bond which descends from above. These in their unification are the metaphysical ways.

It must be emphasized that intensive study leads to experience through which the processes mentioned are consolidated and simplified. But perhaps it should be explained here, that the lower way leads through the realm of the static and produces static forms, whereas the upper way leads through the realm of the dynamic. The problems of static equilibrium, which are characterized by the phrase, ''To stand despite all possibilities of falling'' are to be found on the lower way that gravitates toward the center of the earth. The yearning for freedom from earthly bonds leads to the higher ways, through swimming and flying to free movement and free flight.

Here, in the eye, all these ways come together and, being transposed into form, lead to a synthesis of ''outward sight'' and ''inner vision.'' At this point constructions are formed which deviate totally from the optical image of the objects and yet, from an over-all point of view, do not contradict it.

Through the experience he has gained in these various ways and which he has turned into visible accomplishment, the student manifests the degree to which he has achieved a dialogue with the natural object. The growing maturity in his attitude toward, and observation of, nature, enables him, as he arrives at forming his own philosophical outlook on the world, to achieve a completely free representation of abstract shapes, which beyond the consciously schematic approach reaches a new naturalness, the naturalness of the work. He then creates a work or participates in the creation of works that are the image of God's work.

Wassily Kandinsky
The Fundamental Elements of Form
From "Staatliches Bauhaus Weimar 1919—1923," Bauhaus Press, Weimar—Munich (1923), p. 26
In this contribution to the first large collection of documents published by the Bauhaus for the 1923 exhibition, Kandinsky builds up on his earlier theoretical work, particularly "On the Spiritual in Art." With his courses on form and color he made important contributions—as did Paul Klee—to the basic instruction in the preliminary course of the Bauhaus.

The work of the Bauhaus is devoted in general to the emerging unity of various areas that until recently were still considered strictly separate from each other.
These newly converging areas are: art in general, primarily so-called "fine art" (architecture, painting, sculpture); science (mathematics, physics, chemistry, physiology, etc.); and industry, in the form of technical possibilities and economic factors.
The work in the Bauhaus is synthesis.
The synthetic method naturally embraces the analytical one. The interrelation of these two methods is inevitable.
The instruction in the fundamental elements of form must also be built on this basis.
The general problem of form must be divided into two parts:
1. Form in its narrower sense—plane and space.
2. Form in its broader sense—color and the relation to form in its narrower sense.
In both cases the work has to begin with the simplest shapes and systematically progress to more complicated ones. Hence, in the first part of the investigation of form the plane is reduced to three fundamental elements—triangle, square, and circle—and space is reduced to the resulting fundamental space elements—pyramid, cube, and sphere.
Since no plane and no space can exist without color, that is, since form in the narrower sense must, in reality, immediately be investigated as form in the broader sense, the division of the problem of form into two parts can be made schematically. On the other hand, the organic relationship between the two parts must be recognized from the outset—the relationship of form to color and vice versa.
The science of art, which is still in the process of developing, can give practically no explanations of this problem from art-historical point of view, and thus, for the time being, the way indicated will have to be paved first.
Hence, every single investigation is confronted by two equally important tasks:
1. The analysis of the given phenomenon, which must be observed in isolation from the other phenomena as far as possible.
2. The interrelation between the phenomena that were first studied in isolation from each other—synthetic method.
The first, narrow and limited as much as possible; the second, broad and unlimited as much as possible.

35
Wassily Kandinsky: Questionnaire to determine the synesthetic relations between color and form. 1923. This questionnaire was sent by the wall-painting workshop to all members of the Bauhaus. In their replies, the statistical majority chose yellow for the triangle, red for the square, and blue for the circle. This confirmed Kandinsky's thesis.
Text:
Profession
Sex
Nationality
For purposes of investigations, the wall-painting workshop requests solutions to the following problems:
1. Fill these three forms with the colors yellow, red, and blue. The coloring is to fill the form entirely in each case.
2. If possible, provide an explanation for your choice of color.
Explanation:

Fachgebiet (Beruf):
Geschlecht:
Staatsangehörigkeit:

Zu Untersuchungszwecken bittet die Werkstatt für Wandmalerei des Bauhauses Weimar, folgende Aufgaben zu lösen:
1. Füllen Sie diese drei Formen mit den drei Farben Gelb, Rot und Blau aus. Die Farbe sollte die jeweilige Form ganz ausfüllen.
2. Geben Sie, wenn möglich, eine Erklärung für Ihre Farbverteilung.
Erklärung:

Wassily Kandinsky
Color Course and Seminar
From "Staatliches Bauhaus Weimar 1919—
1923," Bauhaus Press, Weimar—Munich
(1923), pp. 27ff.
Kandinsky's insights into the nature of color
were put to practical use mainly in the workshop
for wall-painting which he headed. In this con-
text see "The Work in the Wall-Painting Work-
shop" and his essay of the Dessau period,
particularly "The Value of Theoretical Instruc-
tion in Painting."

Color, just as any other phenomenon, must be investigated from various points of view,
in various directions, and with appropriate methods. From a purely scientific point of
view these directions are divided into three areas: that of physics and chemistry, that of
physiology, and that of psychology. (A special problem of particular importance is posed
by sociological interrelationships, but these are beyond the scope of the color problem
as such and therefore require a separate study.) When these areas are applied to human
beings in particular, then the first area deals with the nature of color, the second with
means of external perception, and the third with the results of the internal effect.
So, it is clear that these three areas are equally important and inescapable for the artist.
He must proceed synthetically and employ the given methods in accordance with his
objectives.
Furthermore, the artist can theoretically investigate color in two directions, whereby his
point of view and his personal characteristics must complement and enrich the three
areas mentioned. These two directions are:
1. The examination of color—the nature of color, its characteristics, forces, and effects—
without regard to practical application; in other words, "useless" science.
2. The examination of color along the lines dictated by practical necessity—strict pur-
pose—and the systematic study of color, which, however, poses difficult problems of
its own.
For the artist these two directions are bound together, and the second is unthinkable
without the first. The method of these investigations must be analytical and synthetic.
These methods answer to three major headings which again are organically linked with
three additional major questions. Together, these embrace all individual questions of the
two directions:
1. The investigation of color as such—its nature and its characteristics:
a) isolated color $\left.\right\}$ absolute and relative value
b) juxtaposed color
Here one starts with color as abstract as possible (imagined color) and changes over to
the colors existing in nature—beginning with the colors of the spectrum—and continues
to color in the form of pigments.
2. The proper alignment of color within a homogeneous structure—construction of color.
3. The subordination of color—as an individual element—and of the suitable alignment
thereof—as construction—to the artistic content of the work—composition of color.
These three questions correspond therefore to three questions which result from the
problem of form in its narrow sense—in reality, color cannot exist without form:
1. Organic alignment of the isolated color with the corresponding primary form—ele-
ments of painting,
2. Appropriate building up of color and form—construction of the full form, and
3. Subordinate juxtaposition of the two elements in relation to the composition of the
work.
Since in the Bauhaus color is related to the aims of the various workshops, the solutions
to particular individual problems must be derived from the solution of major problems.
In so doing, the following conditions have to be observed:
1. The requirements of plane and spatial forms.
2. Characteristics of the given material.
3. Practical requirements of the given object and the concrete task. Orderly relationships
must be found.
The individual uses of color demand special study: the organic consistency of the color,
its vitality and fastness, the possibilities of adhesion by binding agents—corresponding
to a concrete example—along with naturally related techniques, the manner in which
the color is applied—corresponding to the given purpose and the material—and of the
combination of the color pigments with other colored materials, such as stucco, wood,
glass, metal, etc.
This kind of work, especially the measurements, must be executed with the most accurate
tools. They are tied in with exact experiments—experimental procedure—which start
with the simplest forms and systematically continue to more and more complicated ones.
In these experiments too, both the analytical and the synthetic method have to be used:
appropriate dissection of the given form and systematic and appropriate rebuilding.
This scientific art work takes place through:
1. The guiding lectures of the masters.
2. The talks by students, resulting from their independent investigations of a particular
problem.
3. The collaborative work of the masters and the students on systematically submitted
material—collaborative observations, conclusions, setting up of particular problems,
checking the solutions, and development of further steps to be taken in the seminar.
Particular emphasis is placed on architectural demands: the interior and the exterior
architecture, which form the basis of the synthesis.

Walter Gropius
Letter of Complaint Dated November 24, 1923 to Lieutenant-General Hasse, Military Commandant in Thuringia
BD, Gropius collection (copy) (First publication, in exerpts)
Because of political unrest, Thuringia was occupied by the Reichswehr (German Army) and placed under martial law during the latter part of 1923. Opponents of the Bauhaus took advantage of this situation by accusing Gropius and his friends of subversive activities. The military commandant answered Gropius's letter of complaint with the threat of legal prosecution because of "affront to the Reichswehr and insulting me personally."

Walter Gropius
Breviary for Bauhaus Members (Draft)
BD, Gropius Collection (First publication, in excerpts)
This four-page manuscript was probably written in the spring of 1924.

K. N. [K. Nonn]
The State Garbage Supplies. The Staatliche Bauhaus in Weimar
From the newspaper "Deutsche Zeitung," Berlin, No. 178, April 24, 1924
Nonn's unscrupulous hostility toward Gropius and the Bauhaus derived primarily from his different politico-philosophical attitude. It constituted a serious danger, because he benefited from his authority as a State-employed expert. Exaggerating negligible mistakes, he tried to destroy the entire Bauhaus concept with a polemic that lasted for many years (cf. the statement by the architectural association "Der Ring," 1927).

Weimar, November 24, 1923
. . . Yesterday at 10.30 a.m. I was summoned from my office to my home by a Reichswehr soldier, for a warrant to search the house had been issued there. The search was conducted in a dramatic manner by a deputy officer and six men. This warrant could only have been issued following a malicious and irresponsible denunciation that had not been checked. . . .
In public, before the Thuringian Landtag, I have strongly rejected all attempts of political parties to use my institute for party-political purposes, pro or con, on a parliamentary level. . . . I . . . now have to endure having the public point its fingers at me and having the students who were entrusted to me become insecure; all this thanks to the unscrupulous manner in which the search was conducted, as if its object were a public enemy. . . .
Since I have at no time given the slightest cause for such measures, I am ashamed of my country, your Excellency, that despite the accomplishments I can claim I am apparently without protection in my own country, and only because today irresponsible elements are beginning to exploit our Army for catchpole services . . . I demand an immediate inquiry into this action . . . I reserve the right to report this incident to the Minister of Defense and to the Reichstag . . .

Art and technology, a new unity! Technology does not need art, but art very much needs technology—example: architecture! They differ in nature; therefore their addition is not possible, but their common creative source must be explored and rediscovered by those who are endeavoring to establish the new "idea of building." The means: thorough preparatory training for these people in the crafts and technology. The crafts are thus merely an indispensable means to an end. Specialization only *after* completion of preliminary training.
In order to design a thing so that it will function correctly, we [first] have to investigate its nature. The elements aiding the study of the nature of a thing are not only the laws of mechanics, statics, optics, and acoustics, but also the laws of proportion. These are a matter of the world of the intellect. In order to achieve precision here, we must consciously seek to make the personal factor more objective, but every work of art carries the signature of its creator. From the multiplicity of equally economical solutions—for there is not just one in each case—the creative individual selects the one that suits his personal feelings and taste. . . .

. . . Gropius, (with his program), is not new; he is not even relevant today. New is merely his crass negation of all . . . principles with regard to his own and his students' work—in spite of the [published] program—for in their performance the Bauhaus people grossly rebuff all precepts of reason. This is the fault of the totally misdirected permeation of concrete reality with an abstract, almost mystical conception of art, which does not deserve the name "philosophy" claimed for it. Whoever ventures to follow the reasoning set down in writing in the publications of the Staatliche Bauhaus will put down the book— if he has sufficient self-control to read through the entire book—with a feeling of shame that such illogical presentations are being offered to the world, with the sanction of the state, to make a laughing stock of all that is German.
The material results of these "abstract" art practices—as they are actually being called— are lamentable. Instead of an art with spiritual content, which honors craftsmanship and genuineness of material and which answers to actual needs, we are faced by the results of puttering around with all kinds of "materials," like briquettes, garters, old chair seats, and tin cans, which are labeled compositions and studies. We are offered scribbles lacking content, such as have been laughed at for the past ten to twelve years in futuristic, etc., exhibitions. And comparable to this are the technical-architectural pseudo-philosophical phrases of the "instruction" on the "creation of living form through color, form, and sound." The Bauhaus people have established an "abstract stage synthesis," and they have "created" a "new typography" by having a Japanese write German letters from the top down, instead of from left to right. They have composed a new ballet and for that purpose founded a Bauhaus stage; the Bauhaus kitchen and the Bauhaus housing settlement were the last requisites remaining for the completion of the communal type of living based on a cosmic point of view.
And finally, they organized an international Bauhaus exhibition during the fall of 1923, corresponding to the mixed make-up of Bauhaus followers, and published the already mentioned Bauhaus book with a program and the results of their work, in three languages. The scandal was even international. In Germany, the reaction, after a speechless silence of shocked astonishment, was a cry of anger from the specialists at this outrageous extravagance in employing state funds for such oddities. Some former friends hastily tried to disassociate themselves with discomfited stammerings, for what the Bauhaus offered in these first public displays stands so far beyond the pale of any kind of art that it can only be evaled pathologically, even if one is willing to take it for outrageous personal publicity. The clearly recognizable philosophical attitude, which is entirely devoted to negating everything that exists, causes the Bauhaus people to lose all social connection, in the widest sense, with the rest of the world. They are extravagant in their aspirations, and are sterile like all "artists." The work of the Bauhaus carries signs of the deepest spiritual isolation and disintegration. The public therefore rightfully objects to the notion that in this manner young artists and craftsmen in Thuringia who still have sober and honest aspirations are simply going to be barred from a thorough education if the Staatliche Bauhaus continues to exist in its present form. A small band of interested persons, who for the most part are foreigners, should not be allowed to suffocate the healthy mass of youthful German art students like a layer of oil on clear water. Moreover, this undertaking was only ostensibly based on artistic endeavors. It was, in reality,

intended to be politically partisan from the beginning, for it proclaimed itself the rallying point for the sky-storming socialists who believed in the future and who wanted to build a cathedral of socialism. Well, the reality around us shows what this cathedral looks like. The Bauhaus in Weimar, too, contributes a fitting artistic note with its "works of art" that are put together from the ingredients of a junk pile. The blossoms of this direction of art have been amply sufficient to prove the futility of the Mephistophelian spirit of negation, which has been its distinguishing mark since 1919. It was left to Gropius himself to disgrace his art in the manner described. But instead of Faust, why shouldn't his evil ghost have haunted Weimar for a change? The Landtag will exorcise the ghosts of the Blocksberg. Life arises only from the will to positive action and not from negation on principle.

Walter Gropius
The Intellectual Basis of the Staatliche Bauhaus in Weimar
BD, Gropius collection (First publication, in excerpts)
Draft of a statement in answer to charges accusing the Bauhaus of indecision in an article entitled "Architectural Development" by the art critic Paul Westheim (in the magazine "Glocke," No. 6). Probably written in April 1924.

The charge of a shift of emphasis from craftsmanship to constructivism is false. In the Bauhaus, craft work was never conceived as a kind of eccentricity, but rather as a means to an end. It is only natural that such an experimental institute is especially sensitive to fluctuations in the developments of the times, and that the immature and only partly trained students who are searching in all directions, since all academic barriers have been removed here, should particularly reflect these pulsations. But the value of the Bauhaus lies directly in the fact that the masters teaching here are consciously fighting superficial acceptance of "isms" and dogmas. . . . Instead, they are progressing systematically along the long and difficult path of acquainting the individual with the objective bedrock foundations of creativity; this, therefore, implies that an attitude is fostered which is directed against academic or arts-and-crafts principles. Criticism is more severe at the Bauhaus than anywhere else. It is obvious that all the weaknesses of a period—constructivism, machine romanticism, square stylization—will show up clearly in an institute which is the focus of experimental and pioneering work; but the direction in which our work is aiming is the decisive factor, and so far we have steered clear of the cliffs of German dogmatism and have remained true to these aims despite constant and active changes. . . .

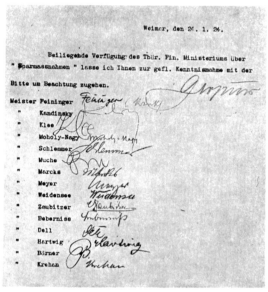

36
Signatures of the form and craft masters under a circular dated January 24, 1924. LW, "Circulars."

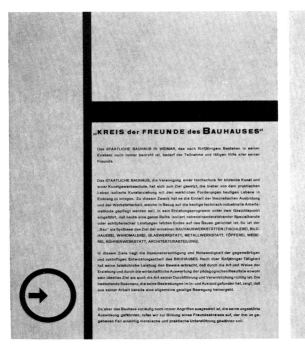

Governing Board of the "Circle of Friends of the Bauhaus"
An Invitation to Join the "Circle of Friends"
Information leaflet, typographical design by Moholy-Nagy (1924)

Above all, the "Circle of Friends" gave the Bauhaus intellectual support. It contributed significantly to the improvement of the Institute's reputation in scholastic circles. During the Dessau period, it arranged lectures and musical evenings in order to establish contact with citizens interested in art.

"Circle of Friends of the Bauhaus"
The Staatliche Bauhaus in Weimar, whose existence is still threatened after five years, is in need of participation and active help from all of its friends.

The Staatliche Bauhaus, originating from the union of an Academy of Art and a School of Arts and Crafts, has set itself the task of bringing art education—formerly isolated from the mainstream of everyday life—into close harmony with the practical demands of today. For that purpose, it has merged in its educational program theoretical instruction with workshop training, which will be cultivated in light of today's technological and industrial methods of production. This was done with the thought in mind that today a whole series of isolated yet coexisting specialized occupations and creative endeavors are, in the final analysis, closely concerned with building. Hence, "building" as a synthesis is the aim of the individual Bauhaus Workshops (Cabinetmaking, Sculpture, Wall-Painting, Glass, Metal, Ceramics, Weaving Workshops, and Architecture Department).

This goal represents the justification for the existence, and the necessity for the present and future development, of the Bauhaus. After more than five years of activity, its actual accomplishments have proved that by the educational method and by the economical utilization of the pedagogic results the theoretical aim as well as its practical realization in the Bauhaus is correct. The significant response which its endeavors have found both inside and outside Germany demonstrates that a general intellectual movement is already emerging as a result of the Bauhaus experiments.

But since, for the time being, the Bauhaus still serves as a target for attacks that are jeopardizing its peaceful work, we are calling for the formation of a circle of friends which will lend its unanimous moral and material support whenever the need for it arises. We therefore urge you and all those who are of the same heart and mind as we are to join the "Circle of Friends of the Bauhaus" and to support its endeavors.

Anyone paying the minimum annual dues of 20 marks can become a member of the "Circle of Friends of the Bauhaus." For life membership a nonrecurring minimum amount of 100 marks is payable. Donations in excess of the minimum dues are rewarded with one original graphic print each, done by one of the Bauhaus masters: Feininger, Kandinsky, Klee, Marcks, Moholy-Nagy, Muche, Schlemmer. The selection is open to the donor. These graphics are especially made for this purpose by the Bauhaus and are not commercially available.

Dues and donations will be used for the furthering of Bauhaus production and for the extension of the Bauhaus movement. The administration of the funds is in the hands of Walter Gropius, the Director of the Staatliche Bauhaus, and two treasurers approved by the board (Bruno Wollbrück, book dealer in Weimar, and Countess Daisy zu Dohna, Weimar).

We are convinced that the Bauhaus will be better enabled to withstand the continually repeated attacks and complete without hindrance the work it has so promisingly started, the more firmly and unequivocally it unites its group of friends.

We would be grateful if you would advocate our cause among your acquaintances and if you would win further friends for it. For this purpose you will find a form for names attached which we ask you to return, after completion, to the STAATLICHE BAUHAUS, WEIMAR. Please send your contribution to the "BANK OF THURINGIA," Weimar, Hummelstrasse, for the account of the "CIRCLE OF FRIENDS OF THE BAUHAUS."

The Governing Board:

Prof. Peter Behrens, Berlin	Dr. h. c. Gerhart Hauptmann, Agnetendorf
Dr. H. P. Berlage, The Hague (Holland)	Prof. Josef Hoffmann, Vienna
Prof. Adolf Busch, Berlin	Prof. Oskar Kokoschka, Vienna
Marc Chagall, Paris	Prof. Hans Poelzig, Potsdam
Prof. Dr. Hans Driesch, Leipzig	Arnold Schönberg, Vienna
Prof. Dr. Albert Einstein, Berlin	Adolf Sommerfeld, Berlin
Herbert Eulenberg, Kaiserswerth	Prof. Dr. Strzygowski, Vienna
Prof. Edwin Fischer, Berlin	Franz Werfel, Vienna

38

Paul Klee: From the "Pedagogic Sketch Book."
The first of the volumes published in the series
"Bauhaus Books" after resettlement in Dessau, it
resulted from Klee's instruction at the Weimar
Bauhaus prior to the summer of 1924.
Text:
Exercises (based upon the triple structure):
first organ active (brain)
second organ medial (muscles)
third organ passive (bones)
(a) Water wheel and hammer (Fig. 25):

I Water drop (active) II Machinery (medial) III Hammer (passive)

Water buckets of the large wheel Spokes of the small wheel

Drive belt

(b) The water-driven mill (Fig. 26):
 I The two forces: (a) gravity, (b) the interfering
 mountain (active)
 II The diagonal to the forces Ia and Ib: the water
 drop (medial)
III The turning wheel (passive)

79

Wassily Kandinsky
The Work of the Wall-Painting Workshop of the Staatliche Bauhaus
LW, single file No. 126; minutes of meetings of the Council of Masters and the Bauhaus Council, 1920–1924. Attached to the minutes of April 4, 1924 (First publication)
As form master of the workshop for wall-painting, Kandinsky concerned himself primarily with the design of large areas of color and their incorporation into architecture. The fact that this consisted less of the painting of actual murals and more of simply coloring walls, was a shortcoming at that period. The intended plan of having the workshops become self-supporting with regular production would have—as was the case in the sculpture workshop—further increased these problems. At Dessau, this situation finally changed fundamentally under Hinnerk Scheper, at which time the Bauhaus received a permanent commission to design wallpaper.

Laszlo Moholy-Nagy
Modern Typography. Aims, Practice, Criticism
From the Periodical "Offset, Buch und Werbekunst" (Offset, Book, and Commercial Art), Leipzig, 1926, No. 7 (Bauhaus number)
This essay was written in 1924. With his own typographical experiments Moholy-Nagy made an important contribution to the efforts for a reform of lettering and printing styles. This reform was carried on and broadened by Bayer at the Dessau Bauhaus.

The workshop for wall-painting differs from all the other workshops of the Bauhaus in that one cannot produce any articles with color alone.
Of the various forces that are inherent in color, the Bauhaus is primarily concerned with that force by which color is able to change a given form so that a new one evolves from the given form. In principle there are two possibilities for this:
1. The concurrence of color with the given form, whereby the effects of the form are increased and a new form is created.
2. The divergence of color, whereby the given form is transformed. One of these two forces must be employed whenever color is added to form.
The resulting ability of color to mold a given space in this or some other manner is one of the primary concerns of all Bauhaus work.
This especially complicated and difficult task can really only begin to be solved after a systematic program has been introduced into the workshop for wall-painting. Two separate investigations belong here, which embrace the nature of color in the sense which is most essential for the workshop:
1. The chemical-physical characteristics of color—its material substance.
2. The psychological characteristics of color—its creative forces.
Associated with these two problems there are two methods of working:
1. Technical work—the utilization of various characteristics, various pigments and binding-agents, application of the color.
2. Speculative experiments—analytical and compositional experiments—designs and decoration of surfaces and the treatment of space.
Color offers a large number of possibilities for the treatment of space, or for the design of space with color, which necessitates preliminary experience with surfaces. One must first get to know color under simple conditions; thus the treatment of surfaces is a necessary stage.
As far as practical work in the workshops is concerned, this briefly mentioned program should be made obligatory, with all the resulting consequences.
Even the practical outside commissions of the Bauhaus will have to be subordinate to this program, since all attempts to give them equal treatment have failed. Thus, the production work of the workshops should take second place.
Besides the wall-painting workshop, this problem also concerns the sculpture, glass-painting, and stage workshops, and in part also the printing workshop. The adaption of the workshops to production alone would force the above-mentioned workshops to close, and this would prove disastrous to the ultimate aim of the Bauhaus—the development of the idea of a synthesis in art. Apart from the fact that the Bauhaus is a school that cannot be adapted to production exclusively, the Bauhaus should constitute a community which, next to the current work for immediate, direct application, sets as its highest aim the cultivation of the idea of synthesis and the preparation of students to accept this idea.
Kandinsky

Typography is modern in concept if it derives its design from its own laws. . . . The utilization of the possibilities offered by the machine is characteristic and, for the purposes of historical development, essential to the techniques of today's productions. Thus, our modern printing products will, to a large extent, be commensurate with the latest machines; that is, they will have to be based on clarity, conciseness, and precision.
The development of printing methods from setting the type by hand to setting it by machine was long and complicated; and the final and unequivocal adjustment to machine-set type will yet lead to greater tensions. The future form of typographical communication will be to a large extent dependent on the development of machine methods; on the other hand, the development of typographical machines will, in some respect, be determined by a reorientation of typography, which today is still largely influenced by handsetting.
The typographical process is based on the effectiveness of visual relationships. Every age possesses its own visual forms and its own corresponding typography. A visual experience that allows itself to be articulated depends on light and dark contrasts or color contrasts. . . . The old incunabula, and also even the first typographical works, made ample use of the contrasting effects of color and form (initials, multicolored lettering, colored illustrations). The widespread application of the printing process, the great demand for printed works, along with the economical and money-oriented utilization of paper, of the small format, of cast letters, of the single-color print, etc., have changed the vital, contrast-rich layouts of the old printed works into the generally quite monotonous gray of later books.
This monotone of our books has resulted in disadvantages: first, a visually clear articulation of the text has become more difficult to achieve, despite the significant possibilities for articulation offered by the paragraph indent; second, the reader tires much more easily than he would by looking at a layout built on contrasts of light and dark or contrast of color. Thus, the majority of our books today have come no further in their typographical, visual, synoptical form than the Gutenberg production, despite the technological transformation in their manufacture. . . . The situation is much more favorable with newspapers, posters, and job printing, since typographical progress has been almost entirely devoted to this area.
All of today's known attempts at typographical reform consciously or unconsciously start with these facts. The monotony and the lack of contrast in modern books were . . . grasped intuitively, but the reaction to this was nothing but a retrospective demonstration. [These typographers] by the use of hand-set type . . . have produced curious effects, and have called attention to hitherto unknown charms of typographical material—such as lines, rules, circles, squares, crosses, etc. With these structures they "stuccoed"—with a purely craftlike mentality—illustrations, objects, figures, all very interesting because of

their uniqueness. But on the whole they were far from influencing significantly any possible future development of typography. This will be left to those typographers who can not only grasp the developmental possibilities and the flexibility of typographical machines and materials, but who can also understand the larger horizon of today's visual experiences. Innovations (such as the wider distribution of photography, of film, and of photoengraving and electroplating techniques) have yielded a new, constantly developing creative basis also for typography. The invention of photogravure, its further development, the photographic typesetting machine, the use of advertising with light, the experience of the visual continuity of the cinema, the simultaneous effects of perceptual events (the city), all these make possible and call for an entirely new level in the field of the visual-typographical. The gray text will change into a colored picture book and will be understood as a continuous visual design (a coherent sequence of many individual pages). With the expansion of the reproduction technique . . . all, possibly even philosophical works, will be printed using the same means for illustrations . . .

Whereas typography, from Gutenberg up to the first posters, was merely a (necessary) intermediary link between the content of a message and the recipient, a new stage of development began with the first posters. . . . One began to count on the fact that form, size, color, and arrangement of the typographical material (letters and signs) contain a strong visual impact. The organization of these possible visual effects gives a visual validity to the content of the message as well; this means that by means of printing the content is also being defined pictorially. . . . This . . . is the essential task of visual-typographical design.

What is necessary, for example, is a unitary type of lettering, without small and capital letters; letters unified not only in size but also in form. . . . Of course here one could also put up ideal demands which would go far beyond a modernization of our present-day type forms. Our lettering, aside from the very few phonetically derived symbols, is based on a time-honored convention. The origin of these signs is hard to ascertain today. They are very often no more than formal stylistic (or practical) modifications of traditional forms which are no longer recognizable. So, one will be able to speak of an actual reorganization of (printed) lettering only when this reorganization has been carried out in an objective, scientific manner. Perhaps on the basis of opto-phonetical experiments. . . . The adoption of basic forms—such as the circle, square, and triangle—in the reform of lettering admittedly leads today to interesting formal, and even essential practical results. [Seen] from what is today still a Utopian point of view, they are, however, not to be taken as the correct understanding of the problem . . . [It] is very likely that this kind of investigation will [lead] at first to the construction of automatic typewriters and typesetting machines working from dictation. But for the time being we do not even have a practical type face of the right size that is clearly legible, has no individual peculiarities, is based on a functional, visual form, and has neither distortions nor curlicues. We have, on the other hand, good fonts of type that are sometimes suitable for labels and title pages . . . but when used in larger quantities they begin to "swim." The tensions that stem from contrasting visual effects are most thoroughly created by opposites: empty—full, light—dark, polychrome—monochrome, vertical—horizontal, upright—oblique, etc. These contrasts are primarily produced by means of the type (letters). Today, we seek to create the "style" for our works—not from borrowed requisites but out of this . . . typographical material. There are [but] a few well-suited forms, [however] there are many ways of using them, a fact which contributes to the precision [and] clarity . . . of the visual image. The whole field of the photoengraving techniques also belongs in this area. In order to bring typographical design into conformity with the purposes of typography, it might possibly be well even to use various line directions and the like (thus not just horizontal arrangements). The nature and the purpose of the communication (leaflet or poster) determine the manner and the use of the typographical material. Typographical signs (like points, lines, and other geometrical forms) can also be used to advantage. . . .

An essential component of typographical order is the harmonious arrangement of the surface spaces, the invisible and yet clearly perceivable tension-laden linear relationships that permit various possibilities of balance apart from symmetrical equilibrium. In contrast to the centuries-old static-concentric equilibrium, one seeks today to produce a dynamic-eccentric equilibrium. In the first case the typographical object is captured at a glance, with all the centrally focused elements—including the peripheral ones; in the second case, the eye is lead step by step from point to point, whereby [the awareness of] the mutual relationships of the individual elements must not suffer (posters, job printing, titles of books, etc.) . . .

One could point out many more possibilities for achieving new effects that lie in the same direction as the essential typographical development mentioned here. . . .

Ludwig Hirschfeld-Mack: Page from the score of a reflected-light composition.

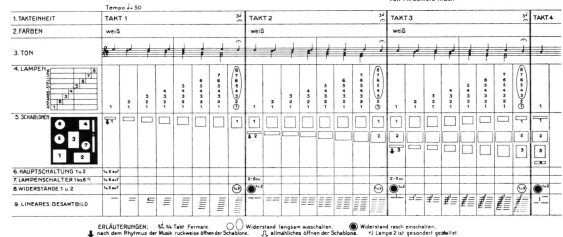

Ludwig Hirschfeld-Mack
Reflected-Light Compositions
From "Reflected-Light Compositions. (Reflektorische Farbenlichtspiele) Nature—Aims—Criticism," privately printed, Weimar (1925)

The "Reflected-Light Compositions" by Hirschfeld-Mack were an experiment very characteristic for the phase of development between 1922 and 1925. They were shown in Weimar, Berlin, Vienna, Leipzig, Greiz, Halle, and Celle. Another experimental group was directed by Kurt Schwerdtfeger.

I. Reflected-light compositions:
A composition of yellow, red, green, and blue areas of light in motion, developed in organically conditioned gradations from darkness to highest luminescence.
Setting:
A transparent screen.
Means for the design:
Colors, shapes, music:
In angular, sharp, pointed shapes; in triangles, squares, polygons, or in circles, curves, and wave shapes. Carried through all possible gradations of rhythmically controlled motion—upward, downward, and sideways—the elements of this composition with color and light are brought together to form an artistically planned, orchestral representation.
The composing, mixing, and overlapping of the colors and shapes are combined with musical elements which are developed and interwoven with these colors and shapes.
Development:
The reflected-light compositions evolved directly from inner necessity. Indirectly, they followed the desire to excite the colored shapes, which in a painting simulate movement and tension illusionistically by their proportions and relations to each other, to *actual motion.*
A survey of modern art shows how its development has departed more and more from being an expression of human community, an expression based on natural law and rooted in humanity itself, grown in the experience of the people and in turn refreshing its own soil. This division dates back to Rembrandt, with his use of light as a self-sufficient function, independent of his objective representations. He intellectually as well as materially left the grounds of ecclesiastical painting in order to create his own personal artistic expression. Today, this separation has become so large that the works of important painters are appreciated merely by an infinitesimal group of people—the practicing painters, the experts, and the connoisseurs who, above all, take an active interest in modern painting because of their knowledge of form and esthetics.

The painter of today, unlike the painter of the Gothic period, stands with his work in almost complete isolation from his fellow man. He is no longer inspired by his community, as was the case during the Gothic period, and he is no longer supported by a "belief in Christ, common to all." He can no longer create out of intuitive necessity for a like-minded community, drawing from common experience. He stands isolated from the people; uprooted from his people, he searches for a people. Seriousness and fervor in their creative work and their search are no less important to the painters of our day than to those in the past, and their creative work, as fulfillment of a personal calling, is a necessity. But the question is raised whether painting as a whole is still necessary as an essential factor of expression for all people? Is painting still the strong means of cohesion and expression which it used to be for all people, *or has it been replaced by a new means of expression for pictorial representation—by reflected-light compositions?*
Experiments:
The first experiments and results came about in the summer of 1922 at Weimar (with Joseph Hartwig and Kurt Schwerdtfeger). They originated in the workshops of the Staatliche Bauhaus at Weimar by a remarkable coincidence of struggle and chance, whose basis lies in the above-mentioned problems in the work of the painter. One particular coincidence acted as the decisive stimulus: at a simple shadow show that had been planned for a "lantern party," an acetylene lamp had to be replaced. In the process, shadows appeared double on the translucent paper screen and because of the many differently colored acetylene lamps a "cold" and a "warm" shadow became visible. Immediately, the thought came to mind to double the sources of light, or even to increase them sixfold and to put colored glass in front of them.
Thus the foundation for a new mode of expression was established: Mobility of colored light sources and movement of mechanical templates.
After many experiments it became possible to control the fortuitousness and to arrange the artistic and technical tools in such a way that it became feasible to present the public with the first performances in May 1924 (a film matinee at the "Volksbühne Berlin") and in September 1924 ("Festival of Music and Theater" in Vienna, under the auspices of the municipality of Vienna).

II. Musical Elements:

Even before working out the reflected light compositions, I was engaged in studying the representational means of the cinema. I received the impetus from the overwhelming impression the first motion picture I saw in Munich in 1912 made on me. The plot of the movie was insipid and left me indifferent. But the power of the abrupt changes from sudden to slow movements, of a multitude of light in a darkened room, the transformation of the light from the brightest white to the darkest black—a wealth of new possibilities of expression!—these had a decisive influence on me. Of course, these primary means of expression of the motion pictures—*light in motion, arranged in a rhythm based on time sequences*—had by no means been exploited in this film, same as they are usually neglected in most modern films.

Of equal significance to me was the experience of the music accompanying the film. Despite the fact that as usual the music being played was something quite independent of the film presentation, I became aware that the unreeling film lacked an essential element when the music paused. This was also noticeable in the audience by a growing restlessness, while my own uneasiness finally developed into an intolerable depression which gave way only after the music was reintroduced.

I explain this observation in the following way: *the time sequence of a movement can be understood more easily and accurately by an acoustic than by a visual arrangement. But when the representation of a spatial situation is organized, according to time, into an "actual" motion, then the understanding for the temporally rhythmic sequence is enhanced by acoustic devices.* The regular tick-tock of a clock produces a more direct and more accurate sense of time than the visual appearance of a small, regularly turning hand of a clock isolated from sound. This observation and others of a similar kind, such as the association of the monotonous ringing of bells with the element of time, suggest the validity of the above statement.

In any case, in recognition of this necessity, we specified for some of the moving-light compositions some interwoven music in simple rhythms. Lamps and templates and other aids were introduced according to the motion of the music, so that the time sequence becomes clearly defined by the acoustical rhythm, and the visual movements, developments, contractions, intersections, gradations, climaxes, and fadings, are emphasized and augmented.

Score:

In this manner a kind of orchestra develops in which every participant, following our instructions that are written down like a sheet of music, does whatever is required of him at any particular moment and at any particular place during the course of the performance.

III. Form elements:

The formal means of representation are the following: the colored point in motion, the line, and the plane. Each one of these elements can be set in motion at any desired velocity and in any direction, can be enlarged or reduced, can be made brighter or darker, can be projected with sharp or blurred edges, can change color, can be interfused with differently colored shapes so that visual mixtures develop at the points of overlap (e.g., red and blue become violet). One element can be evolved from another, the point into a linear and then into a planar motion so that the plane form can take on any appearance desired. By using a mechanism for dimming the lights and by switching resistors into the circuit, it is possible to increase the intensity of individual and larger areas of colored shapes gradually from a dark background to extreme brightness and colorful luminescence, while at the same time other areas disappear slowly and eventually dissolve into the black background. Sudden appearance and disappearance of parts of the composition are achieved by the use of switches. By exact knowledge of these basic means, which make possible an infinite number of variations, *we endeavor to create a fugue-like color composition that is strictly organized and each time derived from some particular theme of color and form.*

Possibilities and objectives:

With the reflected-light compositions we believe we have come closer to a new "genre" of art which, with its powerful physical and psychological effects, is capable of evoking pure and profound tensions from the experience of color and music. Since the reflected-light compositions touch on the substratum of feeling and on the instincts of color and form in a similar manner, we have faith in its role as a bridge of communication for the many who stand perplexed before abstract paintings and new tendencies in all the other areas, including the new creative attitude from which these were born. Beyond that, we see possibilities of a fruitful influence on the motion picture in its present form. For the stage, the reflected-light compositions—introduced as elements of the action and the production and carefully coordinated with them—could produce a powerful, original effect, which would make possible a greatly simplified but yet in essence richly differentiated, presentation of stage productions.

Kole Kokk
The Bauhaus Dances...
From the newspaper "8 Uhr Abendblatt,"
Berlin, February 18, 1924
The special charm of the numerous Bauhaus parties in Weimar lay in the naïve freshness with which they were improvised. These parties were talked about and proved to be an attraction, due to a large extent to the success of the student jazz band. From time to time even the Berlin newspapers enjoyed reporting about them.

... The Ilm Chalet is located way out in Upper Weimar. Through the dusk one gropes along the deserted and snowed-in Belvedere Allee sensing somehow the presence of Goethe's summer house nearby on the left somewhere. One asks a couple of times, loses the way and asks again, only to find out that one has been right in front of that unassuming little house before, which now turns out to be the Ilm Chalet. What an imaginative and dainty name and what a shack that adorns itself with it! Through a narrow corridor you reach a ballroom of medium size and extravagant ugliness. The decorative paintings of the walls must surely be left over from the eighteen eighties—depicted there are young maidens on a plush, Arcadian meadow playing the harp. Do the disciples of Kandinsky, Lyonel Feininger, Paul Klee really want to dance there? Is a constructivist permitted to enter this room without immediately marching on these female harpists of the 'eighties with the fanaticism of the iconoclast?

Silly reservations; they are all gone after half an hour of eager participation. There is more artistic and youthful energy in this royal chamber of Victoriana than in the stylishly decorated ballrooms of the Zoo, the Reimann, the Secessionist and the State Art Society annual dances all put together. Everything is primitive, there is not the slightest bit of refinement. But there is also not that blasé manner which greets you with an audible yawn at every one of our masked balls, and neither is there that overcharged atmosphere which necessitates a policeman in front of every dark corner.

Everything is done by the Bauhaus people themselves. First, there is the band. I am not worried about those five young fellows who constitute the ensemble. Whenever painting no longer satisfies, they can start on a concert tour immediately. It is the best jazz band I have ever heard roaring away at it, musical to their very finger tips. Never has the "Banana Shimmy" been played better; nowhere do the "Java Girls" come off more saucily ... One dance follows another, almost without interruption. But when they do take a break, there is an attractive girl who lets her bare legs dangle from the stage and who handles the squeeze box with captivating virtuosity. But the bare legs should not induce anyone to gather that the good, middle-class Berlin ballroom slogan: "little to show and nothing at all to back it up" has been reinterpreted with artistic freedom by the Bauhäusler. On the contrary: to a Berlin eye the whole affair seems surprisingly dignified. My talent for statistics helped me to register a total of two undraped female shoulders. But maybe this should rather be put down to artistic conviction, although here, as everywhere, the women are the ones who consider attractiveness as the main thing and couldn't care less about Bauhaus theories when it is time to bring out their own lovely personalities.

With the men the case is different. Their strength of character has always been firmer. They pledge their honor to prove that constructivism can be put into practice. You have to grant that their costumes are far more imaginative and colorful than anything we are used to seeing. These are by no means "Vogue" patterns, and you may agree or disagree with this direction in art, but one thing is certain: It is excellently suited as a stimulus for the imagination in creating costumes. ...

The Bauhaus community—masters, journeymen, and apprentices—form a small secluded island in the ocean of the Weimar Philistines. Four years of serious work have not succeeded in getting the Bauhaus people used to Weimar, nor the people of Weimar used to the Bauhaus. Men like Gropius and Kandinsky who, no matter whether or not you agree with them and their art, should be valued for their intellectual capacity and who should be a credit to any society. They are in fact, living a lonely life, relying entirely on the circle of those who have been attracted to the Bauhaus by the power of the personalities of these men. In his quiet and yet humorous way Kandinsky reports of the attempts of a magnanimous lady of long and noble descent to establish contact between the educated young people of Weimar and the students of the Bauhaus. This story amuses and ashames at the same time. The lady invited both groups to her house, but the educated young people carefully avoided any sort of contact with the Bauhaus people and the latter, in the face of such rejection, were much too proud not to become even more buttoned up.

Walter Gropius
The Staatliche Bauhaus and the Thuringian Landtag
From the newspaper "Deutschland,"
Weimar, No. 114, April 24, 1924
After the Landtag elections of 1924, which had given a majority to the rightist parties, the attacks against the Bauhaus in the Thuringian parliament became more severe. Since the Ministry of Culture did not in fact protect him, Gropius saw himself forced to take his case directly to the public.

Weimar, April 23, 1924
On April 12, the faction of the German Völkische [later known as Nazi] group in the Thuringian Landtag put the following "Small Question" to the state government:
"According to § 1 of the Bauhaus statutes the training of the Bauhaus students provides for the completion of their apprenticeship with an examination for a journeyman's certificate to be taken before the Handwerkskammer (Apprenticeship Board).
According to our information the teaching staff of the Staatliche Bauhaus consists of 19 Masters under whose direction approximately 15 students have completed the Bauhaus training in the period of four and a half years of the existence of the Bauhaus. These students passed their journeyman's examination before the Handwerkskammer, but only five of them are said to be still active in the Bauhaus.

Our questions are:
1. Is it true that this glaring disproportion between teaching staff and the number of trained journeymen exists at the Bauhaus, and does the government think the big expenditure required by the Bauhaus budget is justified by the ridiculous number of Bauhaus journeymen?
2. Is it true that the government has not taken any steps so far to phase out such an unprofitable institution as the Bauhaus, despite pleas from various sides demanding such action and despite the fact that before April 1 of this year there would have been an opportunity to start such action by terminating the contracts of a number of Bauhaus Masters?
3. Is it true that doubts have been raised about the moral qualities of the Director of the Bauhaus, Gropius, and does the government have any evidence to justify such accusations?"

In reply to this "Small Question," the Director of the Staatliche Bauhaus, Walter Gropius, issues the following statement:

"The question put to the state government on April 12, by the faction of the Völkische parties in the Thuringian Landtag and directed against the Staatliche Bauhaus and against me as its Director evidences a deplorable lack of information and understanding of the acknowledged cultural work of this Institute and its leading personalities. The incomprehensible looseness in regard to the information gathered for the question and the superficial view of the work of the Bauhaus which it expresses makes it incumbent upon the Bauhaus to furnish a strong reply.

To Point 1:

The Bauhaus is not a trade school. The crafts are a means of training students within the comprehensive artistic and professional education which the Bauhaus offers. Therefore the mere number of journeyman's certificates issued is not the determining factor by which to judge the institution, but rather that accomplishment of the Bauhaus which has been acknowledged by a wide section of the public and by numerous experts in the field. Yet, in spite of the fact that because of the reconstruction of the workshops regular training of apprentices started essentially only as late as 1921—hence just three years ago—the numerical results, contrary to the assertion of the inquiry, are as follows:

a) 23 (not 15) apprentices at the Bauhaus received their public journeyman's certificates from the Handwerkskammer. (Of that number 12—not 5—journeymen are still at the Bauhaus.) Furthermore, an additional 6 apprentices of the Bauhaus are presently taking their journeyman's examination before the Handwerkskammer. 11 students who joined the Bauhaus as journeymen (six of them as heads of workshops) have earned their Master's certificates from the Handwerkskammer.

b) 28 apprentices, aside from those counted under "a," have reached journeyman's status in those workshops for which the Handwerkskammer does not issue public certificates (the weaving workshop, the glass-painting workshop, and the stage workshop). (12 of these are still at the Bauhaus.)

c) 19 students, in addition to those mentioned under "a" and "b," joined the Bauhaus as trained journeymen for further studies. (Of that number 9 are still at the Bauhaus.)

d) According to § 7 of the statutes, last section, 10 students were accorded "special standing," which released them from workshop training.

e) At this moment there are 129 students at the Bauhaus. 25 apprenticeship agreements are currently registered with the Handwerkskammer. 13 apprentices are at present taking courses without articles of apprenticeship for reasons stated under "c"—"e." ("Special standing," weaving workshop, printing workshop, and stage workshop.) (On considerations of general principles the printing workshop no longer issues articles of apprenticeship.) 24 apprentices are presently serving their probationary period, the success of which determines the presentation of their articles of apprenticeship to the Handwerkskammer. 27 apprentices are at the moment beginning the preliminary course.

f) A total of 526 students have been enrolled at the Bauhaus since October 1919. A larger number of them completed the preliminary course only. Numerous apprentices had to discontinue their training in the middle of their course of studies at the Bauhaus and often even shortly before their journeyman's examination because of their financial plight during the time of inflation. But the majority of these students found employment on the open market because of the valuable knowledge they had acquired at the Bauhaus; they passed their journeyman's examinations elsewhere. Since the beginning of 1923, 47 students have been struck from the lists, or their applications have been rejected because of the acute shortage of space for work areas; also, the principle of maintaining a high level of competence necessitated a strict selection.

The budget allowances for this dual institute (formerly the Grand-Ducal Saxon Academy of Arts and the Grand-Ducal Saxon School of Arts and Crafts) have been demonstrably lower than those of most of the corresponding single institutes in the country. Side by side with the school activity, the production activity, which was established by the state, has even yielded a surplus of 30,292 gold marks in capital goods and cash, based on a conservative estimate and after deduction of all state allowances and loans.

This was possible despite exceptional local and general obstacles which were overcome only by the most resolute devotion on the part of the Bauhaus members. Since the success of this year's Leipzig Spring Fair (contracts amounting to approximately 12,900 gold marks) the possibility of economic self-sufficiency has greatly increased.

The actual results of the Bauhaus—the first successful attempt of a basic training for journeymen, the exhibition of 1923, and the artistic, economic, and educational achievements —represent a unique cultural accomplishment unprecedented in Germany, particularly since the entire institute had to be rebuilt during a time of general decline. We look back upon this accomplishment with pride.

To Point 2:

According to the resolution of the Thuringian State Ministry of July 1923, the contracts of the Masters at the Staatliche Bauhaus were extended until March 31, 1925. Therefore, there could not have been a termination of contracts on April 1 of this year.

To Point 3:

Of the teaching staff at the Bauhaus, which at the moment consists of 16 permanent Masters, including the Director and the business manager, and 2 part-time teachers, two Masters are foreigners: the world-renowned Russian painter Kandinsky, who has spent most of his life in Germany and has written his books in German, and the distinguished Hungarian painter Moholy-Nagy. The painter Feininger, who is equally well known all over the world, was born in America but is of German descent and since the war has been without a nationality. The German students in the Bauhaus consider it an honor to profit

from the encouragement of these artists who are renowned in the entire cultural world. The fact that these irreplaceable men are being attacked on account of their non-German origin is a disgrace for our German culture, which is greatly enriched by contact with them. The German Bauhaus is proud of them.

To Point 4:

Since no objective points of attack could be found, the inquiry falls back on the method of publicly casting suspicion upon my person. Cause for this question to the government was the disgraceful slander that was brought forth against myself and the Bauhaus more than a year ago by a number of former employees who had been dismissed without notice. These libelous statements, having been carried to the state government and other public offices, have been officially investigated upon my request and been rejected as "unfounded," "irresponsible," and "dishonorable" by the Ministry of Education. Retribution for these insults through public legal action is about to be concluded. Stemming from the same sources was the public attack in the Landtag in 1923 against me and the Bauhaus, which was subsequently dismissed by the Landtag.

In view of the facts here stated, the entire question posed to the government on April 12 collapses. For the past four and a half years the Staatliche Bauhaus has been hampered in its important work by ignorance and malicious slander of the most humiliating kind. When now even public representatives are beginning to believe these false machinations, then the Bauhaus has to protest very strongly against such derogation, particularly at a moment when distinguished experts all over the country in important publications of all persuasions welcome the constructive work of the Bauhaus as an essential cultural factor in the development of an "intellectual Germany," and when, based on the achievements that have become known up to now, these men urgently demand its patronage by the state. Gropius, Director of the Staatliche Bauhaus.

40
"Josef Hartwig's Chess Set." Advertising leaflet, 1924.

DAS SCHACHSPIEL VON JOSEF HARTWIG

GES. GESCHUTZT

NEUE BAUHAUS-SCHACHSPIELE
40

Thuringian State Treasury
Report on the Audit of the Bookkeeping at the Staatliche Bauhaus in Weimar
Booklet, published by the Thuringian State Treasury at Weimar, September 1924 (Excerpt)

The meticulous exactitude of the Thuringian State Treasury was almost proverbial. This report shows how impossible it is to do justice to the problems of the Bauhaus with the kind of thinking and the accounting methods practiced by this office. But it also proved that part of the problem was inherent in the organization and administration of the Bauhaus itself. In 1923, the then Bauhaus business manager, Emil Lange, had already warned of the difficulties in combining production-oriented experimentation based on free enterprise with state-subsidized teaching activity. A great deal of the misunderstanding and criticism of the Bauhaus resulted from the fears of smaller firms that public financial aid was being used improperly to promote the already much stronger competitors in industry. The fact that time and again Gropius tried emphatically to raise the hopes for the future possibility of Bauhaus production for profit was both psychologically and objectively risky. As Emil Lange stated in a 1923 memorandum to the Director's office, it was questionable in the first place to assume that the producing workshops of the Bauhaus, uncompromising in their designs, would be able to support themselves financially at a time when neither industry nor the public were ready and willing to accept the new technological forms. In fact, up until the end of the nineteen twenties the expenditure for the production and the returns were always out of balance. Furthermore, the pressing problems—in Weimar—were aggravated by the fact that the office personnel were unable to keep up with the multitude of problems. Inflation depreciated the budget before it could be used, and at times it was impossible to keep orderly accounts. The Bauhaus had five different business managers during the six years of the Weimar period.

Weimar, September 9, 1924
Thuringian State Treasury
We have audited the accounts of the Staatliche Bauhaus in Weimar from July 18 to 21 and from July 31 to August 8 of this year. The report is as follows:

1. Cash accounts
The computation of the cash balance on July 18 showed an amount of 150.10 gold marks. The calculation of the assets produced some difficulties at first, since the books had not been kept up to date. The cash journal, which had been added up in pencil, established a balance of 342.30 gold marks. A record was shown, noting advance payments totaling 194.00 gold marks, which had been paid to Bauhaus members (in most cases to students in due payment of wages, etc.) and had not yet been posted. That leaves 148.30 gold marks.
The 1.80 gold marks, which according to this account are additional, were marked by the cashier as proceeds from the sales of Bauhaus spinning-tops and booked as receipts, so that the account is balanced.
There are no individual receipts for the advance payments, and they were partly paid out upon the cashier's own decision. Was the cashier authorized by the Director's office to decide when to make advance payments?
All entries in the cash journal were transferred into the ledger. The entries were made up to the end of June 1924, but during the last months were not added up at all and before that only in pencil. . . .

2. Bookkeeping in general
One has to distinguish between the teaching activity (the school itself) and the production activity.
The teaching activity is under the jurisdiction of the revenue office of Thuringia. This office pays salaries and reimbursements and expenses for material, the latter upon instruction by the Bauhaus, within the limits of the special budget for the Bauhaus. . . .
For the production activity of the Bauhaus separate cash accounts and bookkeeping have been maintained at the Bauhaus since July 1, 1922. Up to that time the receipts and expenses of the production activity were dealt with in the Bauhaus accounts of the revenue office, while the Bauhaus also kept accounts of its business dealings with clients and customers. Beginning July 1, 1922, the Bauhaus was required to render accounts of its production activity. These were due first for the period of July 1, 1922 to March 31, 1923 and thereafter for each budget year. But up to now neither the accounts for the period of July 1, 1922 to March 31, 1923 nor those for the year 1923 have been submitted.
The commercial system of bookkeeping is used for the production activity. Therefore, according to the provisions of the budget regulations of the state of Thuringia . . . and the law governing the Thuringian State Treasury . . . a complete account, a detailed inventory and balance, a detailed profit-and-loss statement as well as an annual report have to be filed with the State Treasury. [Up to now] the production activity has submitted . . . merely an opening balance sheet in gold marks for January 15, 1924, a trial balance for April 1, 1924, and a profit-and-loss statement for January 15 to April 1, 1924. . . . This fact makes it necessary to ask when the missing accounts on the production activity will be ready for submission? Until now, no one seems to have been concerned about rendering accounts in compliance with the existing regulations. As will become clear in our further explanations, the subsequent rendering of accounts will be extraordinarily difficult, if possible at all.
The cashier's office of the Bauhaus sometimes takes in money that belongs to the accounts for the teaching activity (revenue office), such as tuition payments, and uses these funds for other expenses for which the revenue office is supposed to pay. Such receipts and expenses are kept in a special account, the budget account, which is then cleared with the revenue office. . . . To this day there has never been any such refund given during the entire time since separate cash accounts and separate bookkeeping have been maintained for the production activity. . . .

3. The bookkeeping for the production activity
The bookkeeping for the production activity had at first been set up as German single-entry bookkeeping and consisted of: a) the cash journal, b) the current accounts ledger. The first available cash journal starts with July 1, 1922 and lists a carry-over of receipts amounting to M 2,852, the origin of which can no longer be determined . . . The current accounts ledger consists of two volumes, one each for accounts receivable and accounts payable. . . . As early as September 1922 the current accounts ledger was completely lacking in accuracy and order. Invoices were not debited, and incoming payments were not credited to their accounts. It seems not to have been considered necessary to close the accounts in this book any more than to check them for accuracy or to keep them up to date. Almost 100 accounts are today still unbalanced. . . .
From the beginning of July 1923 on, the accounting consists merely of loose sheets that have not always been added up and which for a number of days are missing altogether. During this time when no accounts were kept, the daily receipts were, according to the former business manager, Mr. Lange, used on the same day to cover expenses without being posted as receipts and expenses. These days fell into the period of the Bauhaus exhibition. Mr. Lange explains the fact that these entries are missing by the great shortage of time which really made it impossible to enter these amounts into the books. It needs no special mention that the persons responsible for the accounts are guilty of a gross violation of their duties. The lack of entries, especially during the time of the exhibition, is all the more regrettable since it renders the settling of accounts for the expenditures of the exhibition impossible. The accounts for the exhibition were of special importance because of the possibility of the granting of a retroactive subsidy for the costs of the exhibition by

the federal government, which is still the subject of negotiations.... Beginning with the employment of the qualified accountant Beiersdorfer on September 1, 1923 the bookkeeping returns to normal. But he disregarded everything that took place before and, most important of all, he left the current accounts book uncompleted without carrying over the balances of the individual accounts ... The bookkeeping has been set up adequately. If it is kept accurate and up to date, it offers a good check at the end of each month on the profitability of the individual workshops, on the state of affairs of the entire enterprise and makes it possible ... to render an accurate and commercially correct balancing without particular difficulties.

[4. Tuition fees]

5. The workshops

There are seven of them: the cabinetmaking workshop, the metal workshop, the weaving workshop, the workshop for wall-painting, the printing workshop, the sculpture workshop and the ceramics workshop in Dornburg. Each workshop is supervised by a form master (theory) and a master craftsman (practical work). Those working in the workshop are: 1. so-called "budget" journeymen, 2. journeymen, 3. apprentices, 4. workers....

The following workshops have been inspected: weaving, cabinetmaking, metal, printing, and the workshop for wall-painting. The results were favorable.... The workshops were in good order, machines and tools had been very well cared for, and the materials supply efficiently kept....

[6. The opening balance sheet of January 15, 1924]

[7. The balance sheet of April 1, 1924]

[8. The profit-and-loss statement for the period of January 15 to March 31, 1924]

9. The present state of affairs

The whole undertaking is presently, without question, unprofitable. It is at this time not only unable to refund the revenue office for its share of the expenditure for employees, as required by the provisions of the proposed state budget for the years 1923 and 1924, but is also incapable of covering its own expenses. The total operating expenses, including the amount of the cost for employees which is due to the revenue office, for the time between January 1, 1924 until July 18, 1924, are higher than the value of all the products accounted for during that same period. No money would remain for the payment of wages in the workshops or for raw materials.

The cause for this discrepancy lies in the fact that the administrative overhead stands in no healthy relation to the value of the goods produced and that the production operations cannot work at full capacity today. In order to increase production, a larger market would have to be created....

The debt which the production activity has incurred [46,966 gold marks] ... amounts to several times the total accounts receivable. This puts the production activity of the Bauhaus into a difficult situation. The expensive bank debt, the high amount still owed for bills, the bank drafts due at the beginning of October, which has been accepted by the Bauhaus, all these bring close the danger of a suspension of payments for the production activity of the Bauhaus that ought to be averted in time ...

[10. The currency account]

[11. Payments to office employees]

12. The house "am Horn"

A large part of the energies of the Bauhaus in 1923 were put into the construction of the model house "am Horn." The bookkeeping does not provide sufficient information about the financial results of this enterprise. Although there exists an account for the house, it was not possible to determine from it what the experimental house had cost the Bauhaus, since this account was at the same time a personal account for Mr. A. Sommerfeld of Berlin, the buyer of the house, who has further business connections with the Bauhaus....

13. The Bauhaus housing settlement

The "Bauhaussiedlung" was founded as a corporation on April 13, 1922 and was registered on May 3, 1922 in the register of cooperative enterprises at the district court at Weimar. The object of this enterprise is the construction of houses for rent or sale to the members of the cooperative and the use of a special lot of land for a Bauhaus kitchen.

The state of Thuringia sold an area of land of 3,778 square meters to the Bauhaus on which the experimental house, the so-called "am Horn", was built. Both the land and the house have in the meantime passed into possession by the firm of A. Sommerfeld in Berlin, which has already sold it to a third party.

The Bauhaussiedlung has leased a second area of public land in Oberweimar, on which it has started a gardening enterprise. This enterprise delivers its produce almost exclusively to the Bauhaus kitchen, against payment. From the proceeds the gardener is paid, seed is purchased, etc.

Payments were made by the members of the cooperative between April 22 and October 31, 1922 amounting to M 500 per share (44 shares were sold to 20 cooperative members; the state owns no shares).

The Bauhaus Masters made a loan available to the Bauhaussiedlung in the form of paintings which for the most part were sold for the benefit of the settlement.

The account of the Bauhaussiedlung was, as the Bauhaus itself stated in a letter to the revenue office in Weimar, somewhat badly arranged by the member of the Board of Directors who was then in charge of keeping the books, and today it is impossible to audit this account....

... The relatively favorable financial situation of the Bauhaus housing settlement is based in part on the fact that it received 1000 gold marks out of the proceeds of the house "am Horn," in consideration of the plot which had formerly been its property. The price which

the Bauhaus housing settlement at that time had to pay was fixed by the district government of Weimar on May 7, 1923, at M 517,750. This sum was not paid to the fiscal office of the state of Thuringia until August 8, 1923, when its value had declined to about one half of one gold mark . . .

14. The Bauhaus kitchen

The Bauhaus kitchen is managed by a commission of five students of the Bauhaus. The chairman of this commission is the student Hoffmann. The kitchen offers the Bauhaus pupils a simple dinner for 0.30 gold marks and a supper for 0.20 gold marks. Since meals were generously served, the prices paid for them is totally inadequate. Due particularly to the efforts of the women students at the Bauhaus, larger amounts of money have been donated by parents or friends, and food has also been contributed. Moreover, the Bauhaus kitchen received 60 gold marks from the federal subsidy for students, and 400 gold marks plus £ 30 from the European Aid for Students. The latter have been distributed in the form of tickets for free meals for 1120 dinners and 1120 suppers to needy Bauhaus students. . . .

15. Number of teachers and students

There are [at the end of July 1924]:

16 teachers (form masters, assistant masters and master craftsmen). The draft for the state budget provides for 20 teachers

7 "budget" journeymen—as provided for by the budget.

23

The number of students amounts to:

16 journeymen

43 apprentices

23 new students, summer 1924

82

In the printing workshop there are next to

1 form master

1 mastercraftsman

1 "budget" journeyman

a total of only three apprentices.

Of the total of 82 students only 7 are from Thuringia.

Weimar, September 9, 1924
Thuringian State Treasury
(sig.) König

Staatliches Bauhaus (W. Gropius and Dr. Necker)

Report on the Economic Outlook of the Bauhaus

(Bericht über die wirtschaftlichen Aussichten des Bauhauses)

Supplement to the booklet published by the Thuringian State Treasury in September 1924 "Report on the audit of the bookkeeping at the Staatliche Bauhaus in Weimar," dated September 1924

The government of Thuringia had, "as a precaution," given notice to the masters of the termination of their employment in September 1924. The fate of the Institute had in fact already been decided at the time Gropius and Dr. Necker (the last accountant of the Weimar Bauhaus) prepared this answer to the report of the State Treasury. The continuation of the negotiations about the budget and the future status of the Bauhaus were merely a tactical maneuver on the part of the government.

Until recently the Staatliche Bauhaus has been working essentially on experiments and on the production of prototypes. Every enterprise aiming at the manufacture of a new product must allocate a certain amount of time to its development. Most companies and workshops are merely concerned with the manufacture of some article or other which, after the completion of a series of experiments can be economically marketed provided the necessary funds are available. Of course modifications and improvements will still be made after that, but production continues without interruption.

The situation is different in an enterprise which is endeavoring to work out a new direction and new attitudes in a wide cultural area and which strives to apply them in practice. The concern is not with a single or even a number of articles, but rather the aim is to change the aspects of whole areas of production. It is obvious that this requires a longer period of experimentation and a greater amount of work. In . . . the case of the Staatliche Bauhaus there is an additional difficulty. Unlike industry, it did not have the supply of capital necessary to do the work required of it. Instead, the Bauhaus had to produce, so to speak, everything from nothing. The costs for the experimental work were increased by the manufacture of many individual parts outside the Bauhaus, due to the fact that essential machines and tools, which are more vital in an experimental workshop than in any other workshop, were lacking. Furthermore, the Bauhaus had to buy its raw materials in small, uneconomical quantities. The larger part of the first earnings had to be spent on acquisitions in order to build up the proper machinery for production and thus was lost as working capital.

Under such conditions the profits of the Bauhaus workshops, if one were to hope for such at all during the period of experimental work, had to be low. The selling prices of the goods had to be greatly increased because of the poorly equipped workshops and the wasteful manner of purchasing in small quantities without any opportunity of taking advantage of favorable market conditions. The high prices made themselves felt in the decreasing number of sales.

In addition to these difficulties there was the complete dependence on the inflexible budget. Thus it was impossible to obtain new working capital in the form of loans at the time when it was needed most urgently. Due to the requests for new allocations or the arrangements for credits, much time was lost and good opportunities were missed. Moreover, the open hostility against the Bauhaus for political reasons, because of artistic intolerance or because of lack of understanding, naturally also contributed a great deal to the weakening of the manufacturing set-up. No solid business enterprise can establish long-range ties with an undertaking whose existence is insecure.

In spite of all these problems, the Bauhaus has, for quite some time now, been on the road to economic recovery. The first prerequisite for this recovery was that a market be found for the products manufactured. The last industrial fairs were evidence of the increasing demand for Bauhaus products. Especially at the fall fair in Leipzig . . . a wide range of prototypes were bought which have already been reordered (a total of about 100 orders).

One series of Bauhaus goods has now been completed to the point where they represent final prototypes for which the experimental work is finished and industrial production can start. . . .

. . . Active sales are now hampered only by the lack of proper organization of the production plant according to private-enterprise methods, lack of availability of adequate working capital, and the existence of an expensive loan. The sales machinery exists; that is, there are a number of salesmen already at hand as well as established connections to industry and retailers which guarantee secure and permanent sales and do not leave the Bauhaus dependent on occasional sales.

Weimar, October 19, 1924

Gropius, Dr. Necker

The Budget Committee for the Thuringian budget of 1923 and 1924

Report No. 80, Dated December 9, 1924, Chapter VII: Ministry of Education, Section 23: Art Institutes, a1: Staatliches Bauhaus in Weimar

From Committee Report of the Thuringian Landtag, 1924, pp. 175 ff.

The termination of the contracts of the Bauhaus masters revealed the actual intentions of the rightist Thuringian government. The partial conversion of the Bauhaus into a private enterprise was suggested in order to insure its continued existence. The government dragged out the negotiations, and when it finally decided to reduce the budget for the teaching activities of the Bauhaus to what amounted to a totally inadequate sum, the fate of the Weimar Bauhaus was sealed in spite of promises of aid from industry.

Negotiations were carried on in the presence of government officials between November 7 and 9 [1924]. Before entering into the general discussion the chairman read a petition submitted on November 6, 1924, by a number of industrialists from Erfurt. It was decided to multigraph the petition and to invite the undersigned and Director Gropius to a special meeting which took place on the morning of November 11. On November 7 the petitions and letters which the budget committee had received were read and reported on.

From Weimar came a petition for the continuation of the Staatliche Bauhaus. It had 612 signatures of people from all walks of life, headed by Johannes Schlaf and Sigrid von Klösterlein. The petition emphasizes that "the Bauhaus would not think of eliminating the crafts and the master craftsmen" and that it is thanks to the Bauhaus that "today a fresh, joyous, and active artistic life is pulsating from Weimar throughout Thuringia and Germany. To deprive the young people of such an encouraging and productive impulse would be utterly irresponsible."

Then follow 57 communications from the Association of German Art Critics and from the Association for the Protection of German Writers; they also emphasize that the Bauhaus "has successfully carried out the attempts to provide art education with the necessary fundamental training in the crafts and has already had some artistic and economic successes. Despite differences of opinion on matters of art, experts in Germany are unanimous in their acknowledgment of the serious intentions and the valuable innovative ideas of the artistic and cultural endeavors of the Bauhaus, which are of great significance for a regeneration both of the spirit and of the crafts. Consequently, the undersigned feel it their duty to express to the Thuringian Landtag their firm conviction that the forcible dissolution represents a gross injustice toward the teachers and students and inflicts great damage to the important cause of art education." Joining in this opinion are: the German Federation of Builders, the Federal German Federation of Trade Unions, the General Free Association of Employees, Professor Peter Behrens [and among many others, Ludwig Fulda, Martin Wagner, Christian Rohlfs, Richard Hamann, Professor Georg Kerschensteiner, Professor Hölzel, Dr. Georg Swarzenski, Dr. Kaesbach, Lovis Corinth, Fritz Schumacher, Dr. G. F. Hartlaub, Hans Poelzig, Professor Max Dessoir, Leopold Jessner, Ludwig Justi, Heinrich Tessenow, Dr. Ernst Gosebruch, August Endell, Bernhard Pankok, Richard Riemerschmid, Hans Thoma, Hermann Sudermann, Max Osborn]. Moreover, there were 30 telegrams, letters, and expert opinions, among them those from the architectural association "Architectura et Amicitia" of Amsterdam, . . . from 38 architects, artists, and scholars in Erfurt, . . . from the Deutscher Werkbund (Berlin), the Federation of German Trade School Teachers (Kiel), Overseas Publishing Co. (Hamburg—Berlin—Munich), municipal architect J. J. P. Oud (Rotterdam), Professor Regener and Professor Hildebrandt (Stuttgart), . . . Museum Director Dr. Walter Riezler (Stettin), the Administrator of Federal Art Institutions Dr. Redslob, Gerhart Hauptmann, Henry van de Velde (the Hague). In addition, the committee received . . . one letter from the Federation of German Architects, a petition from the Austrian Werkbund, one from the Staatliche Art Theater of Riga, from Dr. Oskar Schürer (Prague), from the Director of the Dresden Municipal Collection, Professor P. Schmidt, and from many others. Every one of these petitions urgently advised against interfering with the development of the Staatliche Bauhaus; indeed, they most emphatically supported the call for its continuation and further development.

On the morning of November 11, in the presence of Director Gropius, two gentlemen from Erfurt, Dr. v. Löbbecke and Alfred Hess, were consulted about their recommendation of November 6, 1924, which proposes "to enable the continuation and the extension of the production activity of the Bauhaus with private finances" and "also wishes to interest the Federal Association of German Industry and the associated organizations in the problem." These businessmen plan to "establish a company with corporate status" with an initial capital of M 100,000 to M 150,000. "The Landtag should decide soon whether the state is interested in participating directly in the enterprise through the provision of buildings and machines." The continuation of the teaching activity is expected to be guaranteed by an annual state subsidy, an application for a federal subsidy, and the contractual transfer to the Bauhaus of the facilities and inventory which it has used up to now. The state would be able to represent its interests on the Board of Directors, and by acquiring shares of the initial capital issue at the time the company is formed.

The businessmen from Erfurt stressed the fact that their interest was purely economical and cultural in nature and not political. The Bauhaus with its teaching facilities would serve at the same time as a workshop for the development of prototypes and as a sort of laboratory for industry and the handicrafts, to be supported by a mixed or privately controlled productive pilot plant set up by the above company. The draft for a contract agreement which provides for complete separation of the production plant from the teaching activity, was read and discussed. The state is to be entitled to one quarter of the shares (in return for providing the machinery) and to furnish 2 of the 7 members on the Board of

Directors. The government declared its willingness to negotiate but said it was unable to express definite views on the matter so long as no precise plans were submitted. It would be very hard to provide more space for the proposed production operations, and new (financial) burdens for the state would not be feasible. Various representatives expressed reservations, especially about the complete separation of teaching and production and about the insufficiency of the proposed financing. Some of them demanded assurances concerning fixed state aid, without which one would hardly reach any agreement during the negotiations. On the following day, a representative of the government explained in detail the reasons for the present reservations on matters concerning the Bauhaus. The government had not failed in its duty by terminating the employment contracts and was free of any political influences. The plan to expand the production plant, which was already on the desk when the government entered office, had been unworkable and much too risky for the state. Artistically the Bauhaus was dominated by a tendency toward extreme Expressionism, whereas it should follow a neutral educational direction. The crafts in Thuringia were unalterably opposed to the Bauhaus; this fact had been decisive for the government. It was intended to continue the Bauhaus in a respectable form as an arts and crafts institute with practical teaching activity but not as an academy of art. This function should be served by the present State Academy of Art which had been physically hampered by the expansion of the Bauhaus. The government intends to establish connections between the two institutes and also to provide a common artistic educational base, because this would help young artists to become acquainted with practical work at an early time and to be able to make a living more easily later on. The recommendations of the Erfurt businessmen will be investigated and the Landtag shall then make a decision.

A representative of the Social Democratic Party pointed to the severe criticism which was also being leveled at the deficient administration of the [rival] Art School by members of the right-wing parties, and demanded that the government and the State Treasury take equal measures with all higher institutes. The representative of the D.N.P. [the German National People's Party] stood for the merging of the two institutes and particularly for a common foundation in the crafts which the Federal Association of German Art Academy Students was also demanding. With respect to the corporation that was to be formed he was not hopeful of success, since Mr. Gropius was to be its business manager and he was not qualified for that position. The experiences with the experimental house "am Horn" had not been favorable; and he would like to know what price the Bauhaus had received for the land which it had sold together with the house. A representative of the Country Party also objected to this sale. The representative of the D.P. [Democratic Party] criticized the premature termination of the contracts and expressed the desire that Gropius be kept on as Director of the Bauhaus, which artistically stood or fell with him. To this, the government replied that it had terminated the contracts only as a precaution until the Landtag reached a decision and, moreover, that the Bauhaus would not be endangered by the departure of Gropius. A certain reduction of the teaching activity was intended but certainly not the dissolution of the Bauhaus, which in any event is already precluded by the contractual agreement. The representative of the D.P. suggested that the production operations be handed over entirely to the new company and a fixed, continuous state subsidy of at least 75,000 gold marks be granted for teaching activities. A representative of the D.V.P. [German People's Party] insisted on the removal of Gropius, since he had not been a stimulating influence on the Bauhaus, but had rather given it a one-sided Communist-Expressionist direction. A second representative of the same party joined in the call for a change in directorship and criticized Gropius's excessive publicity, which he was probably forced to undertake because his work did not speak well enough for itself. A representative of the K.P. [Communist Party] gave assurance that the Bauhaus had nothing at all to do with Communism; it was a bourgeois institution, certainly not a trade school; it was seeking new standards for industry, so naturally this would be more interesting for industry than for the crafts. The fight against Gropius, he felt, was politically motivated. A woman representative of the D.P. declared that her Party could only consider objective and artistic motives and moved to summon Director Gropius to appear as an expert witness in these matters. This motion was defeated by the votes of the right-wing parties and the National Socialists against those of the parties of the Left and the Democrats.

After that, the debate moved to individual questions of the special [budget] estimates. . . . [The essential parts of the estimated expenditures were approved by the Democrats and to a large degree also by the parties of the Left. The parties of the Right were aiming at more or less stringent reductions, while the National Socialists voted to strike out all provisions.] The votes were divided along the same lines in the final tally on the entire amount of the expenditure of 101,750 gold marks, which was favored only by the Left and the Democrats. The three parties of the Right explained their abstentions with their mistrust of the present business management.

[The Democrats and the parties of the Left, in general, went along with the government during the debate concerning the income, while the parties of the Right adopted a much less friendly attitude toward the Bauhaus and repeated their reservations against the Director and against any possible economic experiments. After a heated debate the right-wing parties prevailed against the votes of the Democrats and the left-wing parties—despite the declaration by the government that Gropius considered a subsidy of 100,000 marks essential and that any reduction would entail the closing of workshops—in passing the following motion of the German National People's Party:]

1. In future the Staatliche Bauhaus will receive a fixed state subsidy of 50,000 marks, including any possible federal subsidy.

2. The government will be authorized to carry on the negotiations initiated by private interests about the establishment of a company for the maintenance and enlargement of the productive operations of the Bauhaus, on condition that the teaching activity of the Bauhaus will not be infringed upon and that any danger of the state incurring a loss or of the Thuringian crafts and trade sustaining damages are excluded.

3. The government is directed to take all steps necessary to guarantee an orderly management of the business of the Bauhaus and to initiate a closer and more organic relationship between the Bauhaus and the Academy of Art, with the aim of fusing the two institutes in the near future under a common artistic and business leadership.

. . . In answer to a question the government declared that following this decision to grant a subsidy of only 50,000 gold marks it would consult with the Director of the Bauhaus about the future size of the latter, but it would not suggest that Gropius resign.

Walter Gropius
Circular Letter Dated December 23, 1924
LW, unregistered documents: memoranda to the master craftsmen 1919—April 1, 1925 (First publication)

One waited hour after hour for members of the government on whose verdict the continuation of the Weimar Bauhaus depended.

12/23
Circular
I have just heard that the meeting of the State Ministry is still going on, and I therefore ask you to have patience. The Ministry will notify me in due course as to the arrival of the Ministers, and I shall inform you immediately.
Gropius

41

The Director and Masters of the Staatliche
Bauhaus, Weimar
Declaration of Dissolution of the Institute.
Open Letter
The declaration of dissolution was published
(with minor alterations of the text) in numerous
daily newspapers. The present text was taken
from the newspaper "Deutschland" (Weimar)
of December 29, 1924.

Weimar, December 26, 1924
The Director and the Masters of the Staatliche Bauhaus in Weimar make known to the
public their decision to dissolve the Bauhaus, which they had built out of their initiative
and conviction, effective as of the date of the expiration of their contracts on April 1, 1925.
We deplore the fact that interference in the objective and always nonpolitical cultural
work of the Bauhaus by party-political intrigues has been tolerated and supported, par-
ticularly at a moment when the foundations necessary for the establishment of a Bauhaus
Corporation, which was to relieve the State of the main portion of the financial burden,
had been laid by private industry (121,000 marks in shares and loans have already been
subscribed).
On the basis of the articles of incorporation the Budget Committee of the Thuringian
Landtag on November 16, 1924, authorized the government to "carry on the negotiations
initiated concerning the establishment of a company for the maintenance and enlarge-
ment of the production operations of the Bauhaus." Nevertheless, the management of
the Bauhaus was put off time and again with new demands for guarantees for the com-
pany without receiving any indications that, as a basic prerequisite for further negotia-
tions, the termination of the teaching contracts would be withdrawn.
The decision to terminate the contracts was conveyed to the Director and the Masters at
the end of September as a specifically precautionary measure pending a final decision by
the representatives in the Landtag, which was reached on November 16, 1924.
On December 13 of this year the Board of Directors of the Central German Association of
Industry—after an inspection of the Bauhaus—sent three of the members of its presidium,
who, in the name of the Association, spoke emphatically for the continuation of the
Bauhaus and requested an immediate withdrawal of the notices of dismissal. The Minister
demanded a written statement of these proposals, which, however, because of protests
by some members of the Association, was not made available in time.
On December 23, in connection with the meeting of the State Ministry, the entire Ministry
went on a tour of the Bauhaus.
The day before this visit, the Director of the Bauhaus demanded, in a letter written in the
name of all the Masters, a final decision on the fate of the Institute and on the contracts of
the Masters. When he repeated this demand at the conclusion of the visit, he received the
answer that the Ministry would, in the most favorable case, renew the contracts with *at
most a six-month period during which notice could be given.*
Since, in view of such a short contract period, the planned Bauhaus company becomes
illusory for the people responsible for it, we are breaking off the discussion of the Bauhaus
matters by means of this public statement.
At this time it cannot be foreseen whether the Bauhaus will continue its work in a different
location.
Walter Gropius. Lyonel Feininger. Wassily Kandinsky. Paul Klee. Gerhard Marcks. Adolf
Meyer. Ladislaus Moholy-Nagy. Georg Muche. Oskar Schlemmer.

The Members of the Staatliche Bauhaus
in Weimar
Letter of Protest Dated January 13, 1925,
Addressed to the Government of Thuringia
BD, Gropius Collection (copy)
In the end, some of the Bauhaus members could
not make up their minds to leave Weimar, the
place they had come to love. The successor
institute of the Bauhaus, under the direction of
Otto Bartning, profited from these—in part,
highly important—supporters.

Weimar, January 13, 1925
To the government of Thuringia, Weimar
We hereby inform the government that we, the members of the Staatliche Bauhaus, are
leaving the Bauhaus at the same time as the leading men, who are being forced to depart.
We will promote the ideas of the Bauhaus by active participation in other locations. The
last chance of carrying on "our Bauhaus" in Weimar will finally be gone with our de-
parture—because the important Bauhaus work in the workshops has been performed by
those people who voluntarily joined efforts here. Since we have ascertained from recent
incidents that the government is neither informed about the value of the Bauhaus nor
about its inner structure, we are forced to clarify our position within the Bauhaus. This
collaborating group at the Bauhaus, which has publicly been called students, pupils,
journeymen, and apprentices, consists in large part of independent men and women who
have come together here in Weimar from all social strata of German-speaking areas,
following Gropius's call, in order to participate with positive action in the general build-
ing-up effort.
Indeed, during five years of labor it has been possible for us to reach a clear agreement in
the Bauhaus on the most important problems of design, a fact which finds its expression
in our common work. This work has received the liveliest intellectual and, in the last half
year, economic interest reaching far beyond the borders of Germany.—It was Weimar
alone which was incapable of acknowledging the inevitably new achievements of the
present generation. The very opposite: just here in Weimar we have been fought in the
most malicious manner, in the newspapers, in pamphlets, and in protest meetings.
We state categorically that the government has impaired our work and has failed to
protect us against slander.
The Bauhäuslers
signed L. Hirschfeld

4 The Transfer from Weimar to Dessau

Lyonel Feininger
From Letters to Julia Feininger, February and March 1925
BR, gift of Julia Feininger (First publication)
The Mayor of Dessau, Dr. Fritz Hesse, was made aware of the significance of the Bauhaus by Dr. Ludwig Grote, the then museum curator for the state of Anhalt. At the beginning of 1925 the members of the Council of Masters were hoping to move to Frankfurt on Main which was one of the focal points of the new architecture and the home of one of the liveliest art schools. The Bauhaus was to be incorporated in that school. The Director of the Frankfurt art school, Dr. Fritz Wichert, insisted on the condition that Gropius resign the directorship in his favor. Gropius agreed, but it became clear during the negotiations that Wichert was much more interested in absorbing the Bauhaus entirely into his art school than in continuing it. Forced into a minor role, the Bauhaus would practically have ceased to exist. The offer from Dessau represented unexpected help. Feininger was by no means the only one who hesitated to join those moving to Dessau. He had already retired from active teaching in 1924. The fact that he was offered one of the "Master houses" in Dessau without any obligations on his part demonstrates how important he was to the Bauhaus.

Wednesday, February 11, 1925
. . . the Kandinskys are now not leaving for Dresden before Friday morning, because many things have turned up from Dessau which absolutely require Kandinsky to meet with the gentlemen from there, the curator of the museum and the mayor, on Thursday, for very important discussions. It seems to be such a serious offer, and it applies immediately, on April 1. . . . And good old Gropi far away and nowhere to be reached! This we really couldn't foresee when he left on his four-week vacation with the blessing of us all . . . And the craft masters have already almost accepted the offer of the local government to stay. Things will go so far that Weimar will have to fight for "its" Bauhaus and to defend itself against Dessau with Gropius and our Bauhaus. Instead of being dead, the Bauhaus has all of a sudden doubled, it has calved. . . . And now the question is whether all of us can stick together. Klee unfortunately has committed himself to Wichert [Frankfurt am Main] and feels that he cannot withdraw—even though Wichert told Muche the other day, "If you receive an offer from someone else, take it"—and that went for Klee too. But that is entirely Klee's business and no one else's; I am just afraid that he will feel disappointed if Frankfurt should "work out." . . . Except for us [the Feiningers] everyone agrees that they should leave here "en bloc"—I am for it, conditionally. With us, the situation with our boys makes things difficult . . . If I can work with complete freedom, I would hardly have anything against trying it. It would be dreary and solitary, if the others went away, to stay here in Weimar all by ourselves . . .
Thursday, February 12, 1925
. . . at five o'clock I went down and met the men from Dessau in person. In Klee's studio this morning at 11, we Masters had already talked over and noted down all the points we thought worth negotiating—even my stipulation of not being obliged to teach, which was granted by the Dessau gentlemen that afternoon without a hitch. . . . Kandinsky and Muche will go there on Thursday the 19th in order to get an idea of the situation there and then. . . . We might have to count on this thing seriously—and, moreover, if we do not scatter,

we will represent, as a community, a power both in this country and abroad....
Friday, February 13, 1925
...As to Dessau—and a second phase of the struggle for the Bauhaus in general—I feel quite certain that none of us would start all over again light-heartedly—in the end it is only need that forces us to make sacrifices; everyone dreams of independent work! Dear old Klee, he was quite upset yesterday, and said, "Yes, now I am beginning to understand you!" He would like to take "a good long pause." But remaining in a body together is for all of us the most important consideration and a great comfort....
Friday, February 20, 1925
...Today at noon, a meeting of all the Masters, a report by Kandinsky and Muche on Dessau. The visit of the gentlemen there, with their wives, went splendidly, giving the greatest satisfaction all around. In Dessau, Mrs. Kandinsky and Mrs. Muche were delegated to look around the town—the initial impression was quite poor—but then, beyond the workers' quarters, it improved to the point of utter enthusiasm. Better than the other way round. For the Masters they are going to put up special buildings according to our own wishes and plans, in the wonderful park, homes to be finished by October! With studios right on top of the house! Water everywhere: the Mulde meets the Elbe, watersports, sailing—fishing—motor boating. Sent a telegram to Dessau today saying we agree in principle, "letter following." The Masters' wives are now going to get together in order to consult on their own; only my "Meisterin" is missing!... Met Professor Fleischer (the "more-light-man"), today on the Bauhaus stairs, exchanged pleasantries—in the company of a man of noble birth—ah—introduced—hope expressed that I would not turn my back on Weimar—they would have to have me there (here)! "A sensitive artist like you certainly belongs among us" ("or words to that effect," as Kipling puts it). It's all over with Weimar, my dear gentlemen, we are on our way to Dessau now! Too bad, just when it's beginning to get nice!... Marcks is going to Halle; Klee is waiting to see what Wichert is going to do (does nothing! Comment by the editor); Schlemmer has almost decided; the others are all certain and in favor of Dessau. Are we going to take Gropi along? (Question by the editor)—Suddenly I lost my connection here. I would be happy if you could come for two or three days....

Monday, March 9, 1925
...Gropi is a little reserved about Dessau—the atmosphere is favorable and the prospects are for very good development later—but, for the time being things are not quite as rosy as we had first envisioned.... And also the housing problem is not yet clear. Only one third of the million is available for our buildings—and even that third is not being given willingly by the city representatives to us outsiders when they are not allowed to build for themselves. Gropi went there today to deliver a lecture (probably "Art and Technology, the New Unity") and to have a look around for himself. And in order to discuss everything
...Well, there is nothing more to say on this subject—but during the last, good weeks of work here and without Gropi and the Bauhaus trivialities, everything went so wonderfully well with me that I have some faint misgivings about how things are going to be again, in new surroundings. The trend of the Bauhaus is stated more precisely... in an essay in the catalogue of the L.I.A., written by Moholy... This essay makes me cringe! Nothing but optics, mechanics, taking the "old" static painting out of service, which one has to "look into" first—time and again, he talks of movies, optics, mechanics, projections, and movement, and even of mechanically produced "optical slides," multicolored, in beautiful colors of the spectrum, which one can keep the way one keeps records and which can be put before a projector "as required," in order to project the images on a wall. We can say to ourselves that this is terrifying and the end of all art—but actually it is a question of mass production, technically very interesting—but why attach the name of art to this mechanization of all visual things, why call it the only art of our age and, moreover, of the future? Is this the atmosphere in which painters like Klee and others among us can develop further? Klee was very uneasy yesterday when he spoke of Moholy.... Template intellectuality....

March 12, 1925
...Today there will probably be a meeting of the Masters, at which Gropius, who returned from Dessau last night, will give a report. Actually, it is correct form that I do not participate in it—and I have not been asked. Consequently, I find myself the odd man out with regard to the Bauhaus.... Engelmann has repeatedly indicated that they want me here, without obligation on my part and with a salary... but of course this has now been thrust into the background, somewhat owing to the fact that my moving to Dessau seems to be generally accepted as fact. I place a lot of emphasis on personal relationships with the people around me, since I am the chief sufferer from unresolved or even unfriendly relationships.... And then the question of Moholy and his influential opinions; these would never bother me were they not considered by Gropi to be the most important at the Bauhaus. And for him and for a technical institute, which we tend more and more to become, Moholy is the only person of practical importance. The fact that we unite all the aspects of today in the persons of the various Masters, could even become a blessing for our community. Andreas told me that at least 20 students had asked him if I were coming along to Dessau. Yes—that should somehow be important enough for Gropi—but if he is only afraid of hurting my feelings when he does not ask me to come along, then that puts me in a false position.... I will now let this question mature with the others. I will calmly wait for a discussion. Even Kandinsky has repeatedly said, "We are going to miss Weimar there," and they feel this very strongly. In the early days we used to love Weimar above all other cities of Germany, and only the Bauhaus plunged us into the tumult of passions and party controversies and turned Weimar into an aerie of vultures who constantly strike at us.... Meanwhile I only think with regret of the fact that our friends might be separated from us and that there would be great lonesomeness all around us here...

Inventory of Work and Ownership Rights of the Workshops of the Staatliche Bauhaus in Weimar

LW, single document number 117: agreement negotiations between the Bauhaus Corporation/Bauhaus Dessau and Weimar, 1925 (First publication)

The list includes work that had been completed prior to April 1, 1925 and was still at the Bauhaus. The reaction of the public to the declaration of dissolution by the Council of Masters aroused renewed interest among government circles in the program and the products of the Bauhaus; it was believed in Weimar that with a new teaching staff (under the direction of Otto Bartning) the Bauhaus could be continued, hence legal claims were raised accordingly. Thus, having moved to Dessau, the Bauhaus was faced with a competitor in its successor institute at Weimar, which carried the same name and pursued the same ideas. In order to clarify the legal situation, Gropius, on December 3, 1925, negotiated with Dr. Herfurth and with Bartning at the Ministry of Education in Weimar. In these negotiations he succeeded in getting the Weimarers to forego the rights for the Bauhaus products—except for those belonging to Lindig—and even, as of April 1, 1926, the right to use the name "Bauhaus."

Property rights of the metal workshop

No.	Item	Owner
MT 2a	large floor lamp	Julius Pap
MT 2	candelabrum with seven arms	Julius Pap
MT 7	Mocha coffee machine	W. Wagenfeld
MT 8	table lamp	W. Wagenfeld
MT 15	gravy dish (fat/lean)	W. Wagenfeld
MT 26–32	jugs	W. Wagenfeld
MT 40–43, 45	coffee service and teapot	W. Wagenfeld
MT 50	gravy dish (fat/lean)	W. Wagenfeld
MT 38–39	tea caddies	W. Wagenfeld
MT 59	small drip tray for a tea-infusion egg	W. Wagenfeld
MT 56	lighting fixtures for dining-room	A. Meyer
MT 11	tea infuser (spherical)	W. Tümpel
MT 20–23	holder for tea infuser	W. Tümpel/ O. Rittweger
MT 35	ashtray with movable tray	M. Brandt
MT 36	ashtray with lid	M. Brandt
MT 49	small jug for condiments	M. Brandt
MT 50–55/55a	service, with water jug and kettle	M. Brandt
MT 57	brass tray	M. Brandt
MT 58	holder for a tea-glass	M. Krajewski
MT 59	tea cosy	Gropius
MT 33	liqueur jug	F. Marby
MT 1	samovar	K. J. Jucker
MT 5	electric samovar	K. J. Jucker
MT 6	piano lamp	K. J. Jucker
MT 9	table lamp made of glass	K. J. Jucker

Property rights of the weaving workshop

No.	Item	Owner
No. 1	curtain	G. Stölzl
No. 52	carpet-runner	G. Stölzl
No. 61	cloth	G. Stölzl
No. 104	sample material	G. Stölzl
No. 135	cloth, pale green	G. Stölzl
No. 284	striped cloth	G. Stölzl
No. 296	cushion	G. Stölzl
No. 145	cover for grand piano	G. Stölzl
No. 159	cloth, white	G. Stölzl
No. 3/31	wall hanging, black and white	G. Stölzl
No. 3/32	wall hanging, colored	G. Stölzl
No. 10	tapestry	B. Otte
No. 18	material, red-black-brown	B. Otte
No. 45	curtain	B. Otte
No. 56	rug	B. Otte
No. 58	cushion, swastika	B. Otte
No. 94	foot cushion	B. Otte
No. 338	cushion	B. Otte
No. 339	cushion	B. Otte
No. 340	wall hanging	B. Otte
No. 20	material	R. Valentin
No. 55	carpet-runner	R. Valentin
No. 185	cloth	R. Valentin
No. 249	child's dress	R. Valentin
No. 250	child's dress	R. Valentin
No. 297	child's dress	R. Valentin
No. 31	sample material (strips)	A. Fleischmann
No. 32	sample material (strips)	A. Fleischmann
No. 33	sample material (strips)	A. Fleischmann
No. 57	cloth	A. Fleischmann
No. 67/68	cloth (inserted forms)	A. Fleischmann
No. 230	cloth	A. Fleischmann
No. 233	scarf	A. Fleischmann
No. 239	cushion	A. Fleischmann
No. 281	cloth	A. Fleischmann
No. 282	scarf	A. Fleischmann
No. 283	scarf	A. Fleischmann
No. 333	wall hanging	A. Fleischmann
No. 82	material, Persian	A. Fleischmann
No. 12	sample material	Düllberg/Slutzki
No. 42	cloth, black-gray	Düllberg/Slutzki
No. 66	cover for grand piano, gray yellow	Düllberg/Slutzki
No. 70	carpet-runner	Düllberg/Slutzki
No. 162	cushion	M. Heimann
No. 179	cushion	M. Heimann
No. 175	cushion	M. Heimann
No. 176	cushion	M. Heimann
No. 177	cushion	M. Heimann
No. 208	scarf	M. Heimann
No. 232	cloth, pearl-yarn	M. Heimann
No. 242	cloth, gray-blue-white	M. Heimann
No. 262	material	M. Heimann
No. 264	material	M. Heimann
No. 286	tapestry, blue-white	M. Heimann
No. 289	tapestry, blue-white	M. Heimann
No. 290	cloth, gray-yellow-green	M. Heimann
No. 316	cushion	M. Heimann
No. 317	cushion	M. Heimann
No. 318	cushion	M. Heimann
No. 323	cushion	M. Heimann
No. 324	cushion	M. Heimann
No. 329	cushion	M. Heimann
No. 336	tapestry	M. Heimann
No. 2	cushion, red	Willers
No. 9	cushion, black-white	Willers
No. 22	strips	Willers
No. 43	bonnet	Willers
No. 77	dress	Roghé
No. 78	dress	Roghé
No. 109	material	Roghé
No. 237	cushion, gray	Ackermann
No. 272	cushion, gray	Ackermann
No. 273	cushion, gray	Ackermann
No. 291	scarf	Ackermann
No. 337	wall hanging, black-yellow	Ackermann
No. 199	wall hanging	R. Hollos
No. 773	children's bedspread	R. Hollos
No. 810	silk scarf	R. Hollos
No. 813	material	R. Hollos
No. 835	cushion	R. Hollos
No. 842	cushion	R. Hollos
No. 846	cushion	R. Hollos
No. 015	tablecloth	R. Hollos
No. 052	cloth, blue	R. Hollos
No. 11	dress material	Wulff
No. 41	scarf	Wulff
No. 46	wall hanging	Wulff
No. 50	cover for a grand piano	Wulff
No. 23	belt	E. Niemeyer
No. 52	curtain	E. Niemeyer
No. 63	tapestry	E. Niemeyer
No. 86	semi-Gobelin	E. Niemeyer
No. 91	material	E. Niemeyer
No. 6	child's bedspread	H. Jungnik
No. 54	wall hanging	H. Jungnik
No. 93	curtain	H. Jungnik
No. 99	cloth	H. Jungnik
No. 7	curtain	Brensing
No. 74	sample material	I. Kerkovius
No. 73	sample material	I. Kerkovius

No. 72	sample material	I. Kerkovius	No. 365	material	Hirschfeld
No. 9	tapestry	D. Helm	No. 387	material	G. Hantschk
No. 60	bedspread	D. Helm	No. 550	cushion	G. Hantschk
No. 10	tapestry	M. Köhler	No. 026	carpet	G. Hantschk
No. 62	wall hanging	M. Köhler	No. 065	wall hanging	G. Hantschk
No. 20	blouse material	L. Deinhardt	No. 064	cushion	G. Hantschk
No. 44	material	L. Deinhardt	No. 063	cushion	G. Hantschk
No. 48	wall hanging	L. Deinhardt	No. 388	wall hanging	Lederer
No. 92	scarf	L. Deinhardt	No. 389	striped material	Lederer
No. 24	wall hanging	M. Erps	No. 449	scarf	Lederer
No. 110	material	M. Erps	No. 576	cushion	Lederer
No. 217	cloth	M. Erps	No. 768	material	L. Beyer
No. 55	petit point	M. Peiffer-Watenphul	No. 769	material	L. Beyer
No. 29	material	Muth	No. 517	cushion	Lion
No. 30	material	Muth	No. 655	cloth	Jäger
No. 49	cloth	Muth	No. 656	cloth	Jäger
No. 78	material	Muth	No. 658	dress material	Jäger
No. 94	petit point	Muth	No. 880	child's dress	Jäger
No. 73	sample material	G. Muche	No. 881	child's dress	Jäger
No. 84	petit point	Schlevoigt	No. 649	wall hanging	Gugg
No. 98	material	Schlevoigt	No. 701	wall hanging	Krause
No. 201	ribbon	Bogler	No. 729	cushion	Krause
No. 235	scarf	Bogler	No. 848	experiment	Krause
No. 236	material	Bogler	No. 878	cloth	Krause
No. 292	material	Bogler	No. 888	cushion	Krause
No. 291	material	Bogler	No. 889	scarf	Krause
No. 297	material	Bogler	No. 012	cloth	Krause
No. 300	cushion	Bogler	No. 071	cushion	Krause
No. 410	material	Bogler	No. 072	cushion	Krause
No. 203	cushion	L. Leudesdorff	No. 073	cushion	Krause
No. 335	window drapes	L. Leudesdorff	No. 084	wall hanging	Krause
No. 257	material	Heye	No. 745	sample material	Fleck
No. 258	material	Heye	No. 852	tablecloth	Fleck
No. 279	cloth	Neustadt	No. 853	cloth	Fleck
No. 280	cushion	Neustadt	No. 011	cushion	Fleck
No. 281	curtain	Neustadt	No. 069	cloth	Fleck
No. 283	sample material	Neustadt	No. 787	experiment	Braun
No. 338	cloth	Hirschfeld	No. 807	material	Braun
No. 341	material (striped)	Hirschfeld	No. 808	material	Braun
No. 347	material (striped)	Hirschfeld	No. 849	experiment	H. Nonne
			No. 895	sample material	H. Nonne
			No. 094	petit point	Sell

**Produced in the cabinetmaking workshop
1921–1925**

by: Marcel Breuer
Photo No.

II/1	armchair (with petit point seat and back by Stolzl)	II/46	child's chair (colored lacquer, variations I–III with adjustable seating height of 29, 35, 42 mm)
II/4	table (square, teak, for the hall of Sommerfeld House)	II/41	child's table (round, colored lacquer)
II/5	lounge chair (teak, red and black Morocco leather)		child's table (rectangular, colored lacquer, variations I–II with table top 50/50 cm and 100/50 cm)
II/7	chair (black, belt-webbing by Stolzl)		
II/8	tea table (black, round)	II/41	child's chair (beech, fabric seat, and back)
II/10	living-room chair (fabric seat, back made of webbing)	II/43	bookcase (glass partitions, sliding glass doors, maple, paduc)
II/12	cabinet (maple, gray and black)	XII/6	living-room table (square; paduc, maple; frame and legs with square cross section)
II/17	writing desk (with visible drawer; tracks of red stained cherry and maple)		living-room table (square, oak or cherry, frame and legs with square cross section)
II/22	living-room cabinet (paduc, maple, ash, glass)		
II/23	dresser for a lady (lemon, walnut, nickel, glass)	XII/6	living-room couch (cherry, removable upholstery)
II/24	bed for a lady (lemon, walnut; foot of bed curved)	XII/19	swivel chair (lemon, walnut, back upholstered or made of fabric)
II/25	armchair (horsehair upholstery, oak)	XII/20	built-in wardrobes (bedrooms in the house "am Horn"; lemon, maple, polished black)
	kitchen (colored lacquer):		
II/29	cabinet		
II/28	table		*by: Erich Dieckmann*
II/27	bench	II/13	table (oak, paduc)
II/27	chair	II/16	bed for a man (oak and paduc, or painted in color)
II/37, 38	writing desk, combined with book shelf (8-mm plywood, lacquered, linoleum base)		

	bedroom set (elm and walnut)		**by: Rudolf Hartogh**
II/26	three-piece cabinet with mirror		tea table (with compartments for
II/45	bed		cups; glass; colored lacquer)
	bedside-table		lounge chair
	dresser with mirror		
	chair		**by: Andreas Feininger**
II/39, 40	writing desk (blond and dark oak, alpaca)		kitchen furniture (colored lacquer)
			cabinet with linoleum top
II/44	three-piece wardrobe (walnut with mirror)		table with maple top
			chair with maple seat
XII/13	built-in wardrobe (man's bedroom in the house "am Horn," oak and paduc)		bench with maple seat
			bench with maple seat
			footstool with linoleum
	furniture for the bachelor room (colored lacquer)		**by: Hans Fricke**
	clothes cupboard with book shelf		tea table (walnut, natural cherry)
	table		**by: Josef Albers**
	stool	II/47	wall chair (with folding seat, belt; oak)
	dresser		
	armchair	II/51	conference table (blond and dark oak)
	bookcase (three-part, with sliding glass doors and glass shelves; walnut, maple)		
		II/18	showcase (blond and dark oak, frosted glass, glass, nickel)
	cabinet for drawings (walnut, maple)		newspaper and music shelves (blond and dark oak)
	drafting table (maple, polished and natural)		bookcase (colored lacquer, pine, sliding glass doors)
	tea table (walnut, maple, polished; glass)		**by: Peter Keler**
	stool (upholstered, maple, polished)	II/14	cradle (colored lacquer, woven cordage)
	small upholstered bench (maple)		

	by: Erich Brendel
II/3	conference table (oak, round, six legs)
II/6	armchair (seat and back upholstered, oak)
II/19	tea table (round, with six legs, black lacquer)
	writing desk for a lady (colored lacquer, legs of linoleum)
	by: Alma Buscher
	furniture for a children's room (colored lacquer)
II/30	wardrobe
II/31, 32	chest of drawers (with baby table and linen cabinet
II/33, 34	cabinet for toys with toy blocks and chest (with linoleum)
II/35	bed (with wicker-work)
II/36	stroller (with linoleum)
	by: Erich Consemüller
II/49	desk (oak, open sliding partitions)
	by: Hans Ulrich Fuchs
II/49	desk with book shelf (pine, stained)
	by: Ernst Gebhardt and Benita Otte
XII/28	kitchen furniture (in the house "am Horn," white lacquer) with built-in table, cupboards, and stools
	by: Ernst Gebhardt
II/42	couch for children (beech, covered with fabric)
	by: Heinrich Nösselt
II/52	chess table (with compartments for chessmen, tea, and ashtrays; light and dark beech, glass)

Ceramic department:
prototypes that have become patterns
A: cast from a plaster model.
B: produced by hand-turning.

	1. *Otto Lindig*		2. *Theo Bogler*

1. *Otto Lindig*
A:

L 10	coffee pot (porcelain)
L 11	milk jug (for mocha as well)
L 12	cup and saucer and plate = coffee service, with sugar bowl L 45
L 15	pot for hot chocolate or coffee (porcelain)
L 16	pot for hot chocolate (as L 15, but with attached spout)
L 46	milk jug or small mocha pot (shape same as L 16, but smaller)
L 45	sugar bowl = hot chocolate or tea-set, with cup L 12
L 19	teapot (porcelain)
L 21	wide, flat pot for hot chocolate
L 22	same as L 21, without spout and handle, made as a jar
L 25	pot (same as L 21, but tall)
L 52	same as L 25, without spout, made as a jar
L 44	cup for hot chocolate, with base
L 58	same as L 44, without handle, made as a beaker
L 51	same as L 15/16, without spout, handle, and lid, made as a vase
L 59	same as L 46, without spout, handle, and lid, made as a vase
L 65	same as L 11, without spout and handle, made as a small vase with lid = tea set with either of the teapots L1 or 6, 7, 24
L 66	small cooky jar
L 49	tall vase with lid

B:

L 30	mocha pot with sieve
L 31	milk jug
L 32	sugar bowl
L 33	cup and saucer
L 34	ashtray = mocha-set
L 36	big, black jar
L 39	teacup
L 63	writing-utensil tray with plate

2. *Theo Bogler*
A:

L 1	four teapots, made by combining individually molded parts in various ways
L 6	
L 7	
L 24	
L 2	small jug for extracts
L 3	sugar bowl
L 4	cup and saucer and plate
L 5	ashtray = tea set with either of the teapots L 1 or 6, 7, 24
L 23	cooky jar
L 28	jar for spices
L 29	jar for spices
L 50	storage cask
L 60	beaker
	mocha-maker, done in porcelain

B:
pot for hot chocolate

3. *Werner Burri*
B:

L 40	small beaker, colored
L 41	tall beaker with base
L 67	small jar

4. *Eva Overdieck*
B:

L 61	jar with base
L 68	bowl with base
	milk jug
	bowls

Master Carpenter Wagner
An Inspection Tour of the Weimar Bauhaus (1925)
From the newspaper "Anhalter Anzeiger" (Dessau), No. 65 of March 18, 1925 (from the article series "For and against the Bauhaus")
As chairman of the guild committee of Dessau, Wagner was a member of the subcommittee which, on March 7, 1925, inspected the Weimar Bauhaus with a view to its being moved to Dessau. The curious mixture of economic self-interest and pseudocultural tendencies is characteristic of the lack of intelligent judgment on the part of small-town craftsmen whose support was of essential importance for the further existence of the Bauhaus, since it was an institute that relied on public finance for its work.

After a brief lecture by Professor Gropius, the Director of the Institute, we were shown some textiles in one of the rooms at the Bauhaus. These were strange. . . . I turned my attention to the other products. I was unable to spot much art or any new ideas among the ceramics. . . . There was a table with chairs for the children's room, or, as the Director of the institute pointed out correctly, for furnishing a kindergarten. The method of construction differed from the conventional one. But, with this kind of production the life expectancy of the chairs would be very limited when such a chair is knocked over, as would happen quite often in children's rooms. It was possible to find the desks that were there acceptable. In contrast to the items from the ceramic workshop, the desk-chair combinations and the armchairs at least offered some new ideas in the way they were made, though not exactly likely to exert an enticing charm on the buying public. Desk lamps were produced in other rooms. It appears as if the manufacture of lamps, next to the cabinetmaking workshops, is especially designed to yield a profit. But one can find such lamps, and of much more beautiful design, in any store that sells electric lighting fixtures. There was a lathe in one of the side rooms. The only demonstration was that a young man was turning a wooden cylinder, as if for a rolling pin. He had neither a drawing nor a model, nor anything else to work from. . . . I shall pass over the adjacent rooms with their lithograph, copperplate, and wood engravings, since time was much too short to examine all the things that were presented there. Moreover, it was not possible to determine which of these designs had been carried out in the Bauhaus and which had been left there by outside artists for copying. . . . In one part of the Institute the weaving workshop is active; this seems to be the workshop that has been set up best of all. The things produced and shown there deserve recognition, which is something I cannot say for the cabinetmaking workshop. . . . The kitchen furniture made there was similar in external appearance to planed and painted boxes. A comparable method of creating a style was shown at the Brussels World Fair in 1910, except for the fact that the furniture produced in Weimar belongs in the kitchens of Lilliputians and will hardly find buyers. When looking at this furniture one had doubts as to whether it was supposed to represent a table or a cabinet or something else. In order to give some relief to the plane surfaces, some of the doors and other parts were painted in various colors.

At the conclusion of the tour we heard a lecture and saw slides about the nature of modern building. I do not want to judge the practicality of this method of building nor the life expectancy of such houses but rather leave that to the gentlemen of the building trade who participated in the inspection tour. But I cannot get rid of the impression that if such buildings were put up along a whole street or even just along a part of a street, its appearance would not be improved, since most of these houses in their exterior appearance do not look like apartment houses to me but rather as if they were intended to be stables. This slide lecture, as well as the introductory lecture by Professor Gropius, repeatedly mentioned the association between the crafts and the Bauhaus and the benefit which the crafts would derive from it. The benefit would be the fact that the Bauhaus would develop prototypes and place them at the disposal of the crafts and industry, or rather sell such prototypes to them. But the goods produced there that were shown to us are not suitable as prototypes for the crafts. The crafts can only maintain their place if they move in the direction of furnishing high-quality work instead of being enticed to produce work from such prototypes, that is, factory-made goods, such as were common during the eighteen eighties, when a headpiece in the shape of a sea shell, which was produced by the hundreds, was put as crowning decoration on each and every piece of furniture. And if in the old days sculptors and woodturners, and also the glass industry, were still able to participate in and supply work for production, the prototypes developed by the Bauhaus would make this completely impossible. These craftsmen will then again be unemployed and will be in distress, as they were after the Brussels World Fair. The decorative trades breathed easier when this period was over and have no desire for another one. This method of production could not contribute to an elevation of the crafts.

Also, the apprentices employed in the cabinetmaking workshop and the other kinds of workshops in the Bauhaus would not find it easy to hold their own in another workshop after leaving this institute. . . . On the other hand, the crafts are also entitled to be educated in the ways of the arts, in as far as they are concerned with the real art of craftsmanship. And this should be the proper function of such an institute. Unfortunately I was unable to find indications of such art and especially not in regard to my own profession. In order to make sure that I was not being too pessimistic and that I did not go wrong in my judgment, I went to . . . the Handwerkskammer in Weimar. There my opinion was confirmed in every way. . . . The crafts in Weimar in their entirety declare that they have no interest in the Bauhaus in its present form, since it does not benefit the crafts at all. . . .

School Inspector Prof. Blum
The Bauhaus—An Educational Achievement
From the newspaper "Anhalter Anzeiger" (Dessau), No. 65 of March 18, 1925 (from the article series "For and against the Bauhaus")
School Inspector Blum was one of the first to recognize that the Bauhaus was a necessary and significant manifestation of a general historical development. By stating his opinion in the discussion, he tried to dispel the reservations, in March 1925 especially by craftsmen, against the re-establishment of the Bauhaus in Dessau.

The question of the Dessau Bauhaus has entered its decisive stage. . . . Concerning the matter itself, we must recognize that in this case we are dealing with new ideas which must of course struggle against all the difficulties that are encountered when one introduces something new and particularly something of fundamental importance. We need to ask whether these new ideas are the arbitrary inventions of an individual or a group, are the whim of a more or less ingenious man, or whether, as is usual with new, epoch-making works of art, they manifest the creative consciousness of the common needs of the time. Now, people have said that Gropius's aspirations are actually nothing very new. His work is said to represent merely the continuation of the ideas of the Werkbund. If this were correct—and it surely is correct in part—then the argument would not speak against but rather for Gropius, because it would mean that he does not expound an idea that is the wilful whim of an artist, but rather attempts to consciously guide a general movement. But I believe there are significant differences between the ideas of the Werkbund and those of the Bauhaus. In any case, it seems to me that the essence of the work of the

Bauhaus is the pedagogical interpretation of new ethical problems and *educational achievement.*

Also, the logical founding and pervasion of the new ideas in the handicrafts and in architecture and their educational interpretation are certainly original. . . . For Gropius and his group it is characteristic that they . . . do not give way to their feelings but instead try to discover the principles of a new style, so to speak scientifically, based on historical and psychological analysis. Except for the obvious difference in temperament, Gropius's attitude to the facts of modern culture may be compared with those of Rousseau. Rousseau recognized the unnatural and degenerate aspects of the playful culture of his environment. In rejecting this culture entirely, he sought for a completely new point of departure for the shaping of life's forms. Hence his call, "Back to nature!" Gropius is searching for a new point of departure for the original elements of form, from which an artistic and practical form will result . . . Thus he finds the basic elements for his applied design ("Werkgestaltung"). These forms themselves result from the economic and technological situation of the present day, which presses for standardization, mechanization, and mass production. This is the reason for his attempt to relate education directly to the crafts and to industry.

Gropius pursues his basic idea with the utmost resolution and almost ascetic rigor. But in this fact lies, in my estimation, the educational significance of his endeavors. He requires absolutely objective work and complete understanding on the part of the craftsmen for the special tasks, and thereby he demands a strong-willed, characteristic way of thinking in respect to the work. His Bauhaus is a laboratory. Hence the concentration on the production of single articles . . . One does not find in the Bauhaus a great quantity of produced goods but what one does find is totally and systematically thought out. The forms which have been found as a result of the present design concept at the Bauhaus are not of essential importance. Some people will not be happy with the plainness and the highly stressed simplicity of the products. . . . The Bauhaus reform finds itself . . . in its developmental phase, at its rationalistic stage. This development will later have its romantic and its classical periods. . . .

Resolution to Take Over the Bauhaus
Report of the meeting of the Dessau City Council on March 24, 1925
From the newspaper "Anhalter Anzeiger" (Dessau), No. 71 of March 25, 1925
In order to win approval for reinstating the Bauhaus at Dessau at all, Mayor Hesse had to assign to the Institute a very modest sphere of operation at first. The Bauhaus was to be incorporated in the municipal School of Arts and Crafts. Hesse's intention to get the Bauhaus its own quarters received indirect support later on because of the fears of middle-class circles for the independence of the School of Arts and Crafts. However, the opposition gained ammunition from unavoidable expenses in the budget estimate.

The only point on the agenda of today's meeting of the City Council was the incorporation of the Weimar Bauhaus into the city's Arts and Crafts and Trade School.

Mayor Hesse, in an extensive statement at the beginning of the meeting, commented on the entire matter once again. First, he discussed the preliminary negotiations and the reservations that have been raised about this project. Next, he explained the statutes and the curriculum of the Bauhaus . . . The objections concerning the subject matter have been overruled, the mayor claimed, by the manifestations of support received by the City Council. . . . He continued by stating that reservations had also been raised about the possibility of infringing upon the School of Arts and Crafts and that in a letter addressed to him he had been urged not to make any significant changes in the present organization of the school, nor in the curriculum and the teaching staff. In response to the letter, the speaker stated that there were no intentions of instituting any basic changes. . . . Certain organizational alterations would be required, he added, but this would be done only with the closest consultation with the interested groups, namely industry and the crafts. . . . With these assurances, the mayor felt, the reservations on the part of industry and the crafts had been dispelled . . . The teaching staff of the Bauhaus would be committed for five years only; consequently the city could not incur any financial losses. *The subsidy would not exceed* M 100,000 *per year.* . . . The fact that a new building is required is not due to the Bauhaus but rather to the already inadequate facilities of the existing school. The conditions there have become so intolerable that sooner or later new buildings will have to be erected. The required expenditure is not such that it exceeds the capacity of the city. . . . The mayor concluded by reminding that it was in the interest of all of Germany to provide the Weimar Bauhaus with a place to work and a chance to develop . . .

[After a discussion in which especially the parties of the Right had once again summed up their arguments, Hesse introduced the following motion:]

"The City Council agrees to the incorporation of the Weimar Bauhaus into the city's School of Arts and Crafts, and the Trade School under the following conditions:

1. All valuable assets of the School of Arts and Crafts and the Trade School, particularly the departments of mechanical engineering, the building trades, and the courses for craftsmen must be maintained.

2. The direction of both schools, the School of Arts and Crafts and the Trade School, and the Bauhaus, will be transferred to Professor Gropius, on condition that a contract of no more than five years will be made with him, in order to safeguard the rights of the city. The number of teachers to be appointed to the Bauhaus shall be limited to a total no larger than can be provided for by the M 100,000 which have been requisitioned from the Council. The contracts shall be made for as short a period of time as is convenient.

3. In view of the necessity of putting up a new building for the vocational school, the question shall be investigated whether and to what extent the space occupied by the School of Arts and Crafts and the Trade School can be made available to the vocational school. In return, the Bauhaus and the departments of the School of Arts and Crafts and Trade would be given a new building.

4. The decisions on the above questions shall be made by the finance committee . . ."

The motion was carried by the votes of the Municipal Council, the Social Democrats, and the Democrats against those of the two other parties, by a vote of 26 to 15.

5 Bauhaus Dessau
The Gropius Era

DAS BAUHAUS IN DESSAU.

leitung: walter gropius.

zweck: ausbildung bildnerisch begabter menschen zu schöpferischer gestaltung im berufsgebiet des handwerks, der industrie und des baufachs.

I. gestaltungslehre:
grundlehre
handwerkslehre (ziel: gesellenbrief)
baulehre.

II. versuchsarbeit für die praxis:
herstellung von modellen für handwerk und industrie, hausbau und -einrichtung.

werkstätten: tischlerei, wandmalerei, metallwerkstatt, weberei, buchdruckerei (typographie, reklame, kunstdruck).

beginn des wintersemesters: 14. oktober 1925.
aufnahme in die grundlehre (für jeden obligatorisch) vom 17. lebensjahr ab. — auch ausgebildete handwerker, techniker, mechaniker, architekten werden aufgenommen. — anmeldung sofort.

grundlehre (1 jahr) pro semester: 30 Mk. aufnahmegebühr: 10 Mk. werklehre: frei.

unter gleicher direktion:
kunstgewerbe- und handwerkerschule dessau.

I. baugewerkschule: preußische lehrpläne.
im winter: hochbauklasse V und III.

II. maschinenbauschule: vier aufsteigende halbjahresklassen; gutes reifezeugnis berechtigt zum eintritt in das letzte semester der ingenieurschule zwickau.
(herbstaufnahme für klasse III und I)
(osteraufnahme für IV und II).

III. handwerkerschule: lehrwerkstätten für handwerkliche berufe. abendkurse: zeichnen, mathematik usw. fabrikwerkmeistervorbereitungskurse m. abschlußprüfung.
gewerbliche tagesklasse (jahreskursus, beginn april).

beginn des wintersemesters: 14. oktober 1925.
anmeldung u. schulgeldzahlung: 21.—30. Sept. 1925, bei späterer anmeldung 10 % zuschlag.

42

The Bauhaus in Dessau
Direction: Walter Gropius
Advertisement published in Dessau newspapers, 1925

The Bauhaus in Dessau
direction: walter gropius

purpose:
the training of artistically talented people to become creative designers in the fields of the crafts, industry, and architecture.
I. design instruction:
basic instruction
craft instruction (goal: journeyman's certificate)
architectural instruction.
II. practical research:
production of prototypes for the crafts and industry,
building and furnishings.
workshops:
cabinetmaking, wall-painting, metal, weaving, printing (typography, commercial art, and art prints).
start of the winter semester: october 14, 1925. admission to the basic course (compulsory for everyone) from age 17 onward—experienced craftsmen, technicians, mechanics, and architects will also be admitted—apply now.
basic instruction (1 year) per semester: 30 marks; admission fee: 10 marks. workshop training: free of charge.

under the same direction:
school of arts and crafts and trade school, dessau.
I. school for the building trades: prussian curriculum.
in the winter: architecture classes V and III.
II. school for mechanical engineering: four progressive half-year classes; good grades confer the right of admission to the last semester at the engineering school in zwickau.
(fall admission for classes III and I)
(easter admission for classes IV and II)
III. trade school: teaching workshops for those employed in the trades.
evening classes: drafting, mathematics, etc., preparatory courses for factory foremen, with final examination.
day classes for the trades (yearly courses, beginning in april).
beginning of the winter semester: october 14, 1925 enrollment and payment of tuition: september 21 to 30, 1925
late enrollment, 10% penalty

Bauhaus Dessau
The City of Dessau
From "Bauhaus Dessau," booklet of the Dessau Bauhaus [1927]
At this time Dessau had 70,000 inhabitants—about one fifth of the entire population of the state of Anhalt. The tremendous growth of industry had changed its residential character, making Dessau appear a modern and cosmopolitan city by comparison with Weimar, and this despite its significant and quite noticeable tradition.

Dessau lies between the Elbe and the Mulde rivers in a large area of parks, the most important of which is the Wörlitzer Park. Duke Friedrich Franz, called "Papa Franz" by his people, who created the Wörlitzer Park, was the founder of the cultural tradition in his Duchy of Anhalt, just as Karl August had been for Weimar. His friend and adviser Erdmannsdorff had influence as an outstanding master-builder. Among those who once lived here were Johann Lavater, Friedrich von Matthisson, a friend of Schiller's (Beethoven set his "Adelaide" into music), von Knobelsdorf (architect of Sans Souci), who directed the alterations of the castle, and the philanthropists Basedow, Campe, and Salzmann, who made Dessau the point of departure for educational endeavors during the Age of Enlightenment. At that time, the Chalcographic Society was founded, important art collections were started, Johann Friedrich August Tischbein was court painter. Goethe reports at length about repeated visits to Dessau where, together with Karl August, he received important inspirations for the Weimar Park.
Under the successors of "Papa Franz," Dessau acquired a good reputation as a center for the performing arts which it has kept to the present day. The significant names in this area are Rust, Friedrich Schneider, and Wilhelm Müller.
The preceding generation provided Dessau with large industrial companies. The Berlin-Anhalt Engineering company built several large plants. Dessau became known through the German Continental Gas company, the Askania Works, the Polysius Machine Factory, the Dessau Sugar Refinery, the various Junkers works, especially the internationally known Junkers aircraft factory, a railroad-car factory and a number of medium- and small-sized industries. The other important industries in the vicinity of Dessau, Agfa works at Wolfen, the nitrogen-fixation plant at Piesteritz, metallurgical works at Rodleben, the Riedel company at Rosslau, the power plant at Golpa-Zschornewitz, offer a chance to get acquainted with the different branches of industry by inspection visits at their plants. Dessau is two hours by train from Berlin. Almost equidistant are the cities of Halle, Magdeburg, and Leipzig. The Harz mountains can be reached in three or four hours. The site at the rivers Elbe and Mulde, between vast areas of green, promotes outdoor sports.
[Original without capital letters]

The Bauhaus in Dessau
Curriculum (1925)
Broadside, published in November 1925
In addition to the general curriculum and the program of the principles of Bauhaus production, the Dessau Bauhaus—during the last months of 1925 and the beginning of 1926—issued separate plans for the work of the workshops. The typographical design was done by Herbert Bayer, who also did the other Bauhaus printing during that period.

Curriculum
Purpose:
1. a thorough craft, technical, and formal training for artistically talented individuals with the aim of collaboration in building.
2. practical research into problems of house construction and furnishing. Development of standard prototypes for industry and the crafts.
Areas of instruction:
1. Practical instruction, in
a. wood (cabinetmaking workshop)
b. metal (silver and copper work)
c. color (wall-painting workshop)
d. fabrics (weaving and dyeing workshop)
e. printing—books and art prints
Supplementary areas of instruction:
study of materials and tools
rudiments of bookkeeping, cost estimating, and contract law
2. Form instruction (practical and theoretical)
a. perception
science of materials
study of nature
b. representation
study of geometric projection
study of construction
technical draftsmanship and building of

44
The "Junior Masters," former students of the Weimar Bauhaus who were appointed to teaching positions in Dessau:
Joseph Albers Marcel Breuer Joost Schmidt
Herbert Bayer Hinnerk Scheper Gunta Sharon-Stölzl

models for all three-dimensional structures
designing
c. design
study of space
study of color
Supplementary areas of instruction:
lectures in the areas of art and science
Sequence of instruction:
1. Preliminary course
duration: 2 semesters. Elementary form instruction in connection with practical exercises in the special workshop for basic instruction. During the second semester trial admission into one of the teaching workshops.
Result: final admission
2. General course:
workshop training in one of the workshops under a legal apprenticeship agreement. Supplementary form instruction (including preparatory instruction in architecture; see areas of instruction, 2.b.). Duration: generally 6 semesters (official regulations). Result: journeyman's certificate of the Handwerkskammer. Qualification for admission to courses in building. Where applicable, certificate of studies at the Bauhaus and qualification for transfer into the practical research departments, if transfer into private practice is not chosen.
3. Architectural training:
preparation for the practice of architecture for those who show talent. Training in the architectural design office, in conjunction with actual building projects as far as possible. Building construction (steel, concrete), architectural statics, building of models, and supplementary technical subjects.
Duration: 3 semesters, with interruptions where necessary.
Result: certificate of competence from the Bauhaus.
Practical Research Departments:
for economical, utilitarian prototypes, and work for industry and the crafts, particularly for home building and furnishing. After a minimum of one year of successful work in the research department, the Bauhaus awards a certificate.
Teaching Staff:

W. Gropius	W. Kandinsky	P. Klee	L. Moholy-Nagy	G. Muche
O. Schlemmer	J. Albers	H. Bayer	M. Breuer	H. Scheper
J. Schmidt				

Admission:
The basic course is the indispensable prerequisite for the further work of the Bauhaus and is therefore obligatory for every newly admitted person. Admission to the basic course (in April and October) will be granted everyone whose talent and previous education is deemed sufficient and who is 17 years of age or older.
Talented architects who have successfully completed the basic course and who have attended other technical schools (building and engineering schools) and have completed a course of instruction in a craft or have spent a minimum of 2 years of practical work in building construction will also be admitted to the architectural instruction. Talented engineers, architects, mechanics, technicians, and craftsmen who have successfully completed the basic course and who possess a journeyman's certificate or have spent several years practicing in their field and have received their certificate of study from the Bauhaus will also be admitted to the research departments.
Application for admission to the basic course must be submitted in writing and must include the following:
1. original drawings or craft work
2. curriculum vitae (previous education, nationality, personal circumstances, and means of support—in the case of minors, this information to be given by parents or guardian)
3. police certificate of good conduct
4. health certificate
5. photograph
6. if applicable, certificates about previous craft or theoretical training (journeyman's certificate, school certificate)
Every applicant will first be admitted to the basic course for a period of six months. The trial admission into a teaching workshop depends on the personal qualifications of the applicant and of the work he produced during the trial period.
Tuition fees:
admission fee: 10 marks
preliminary instruction: 30 marks per semester
general instruction: free of charge, possibility of earning money for work utilized
architectural instruction: 50 marks per semester
research departments: possibility of income from the utilization of prototypes and other work
The administration of the Bauhaus in Dessau Walter Gropius
For information write to the business office of the Bauhaus: Dessau, Mauerstr.36
Under the same management:
a) vocational school
b) building school (following Prussian teaching regulations.)
c) school for mechanical engineering
with a separate curriculum and special conditions for admission. Information is available from the business office at Dessau, Mauerstr. 36

Bauhaus Dessau
Work Plan for the Preliminary Course
Printed sheet, no date (1925–1926)
This program for the basic course was binding
during the first years at Dessau. Later it was
modified in some of its points.

Purpose
Introduction into the theory and the work of the Bauhaus through knowledge of the principles of form, material, and production. Guidance in its practical utilization.

Curriculum
Division same as in the general course: practical instruction and form instruction.

I Basic practical instruction:
practical exercises
draftsmanship and projection drawing

II Basic form instruction:
study of nature
study of the elements of form
design

III Scientific subjects:
mathematics, mechanics, physics, chemistry.

Sequence of instruction
Theory and actual work are closely interrelated.

I Basic practical instruction:
Becoming acquainted with various types of materials and tools; devising and building of useful objects in the special workshop for the basic course.
Working out original designs and justifying them with respect to the choice of material, economy, and technique.
Independent execution of designs.
Mutual criticism of the finished product with respect to its function and expressiveness and the possibilities for improvements, with respect to form (scale, material, color), material (quantity, value), economy (expenditure, return) and techniques (construction, production).
Collecting and systematically tabulating samples of materials.
Guided tours through workshops and plants.
Projection and draftsmanship constitute an introduction to the specialized graphic art of the general course.

II Basic form instruction:
Theory and practical exercises:
Analysis of the elements of form (orientation, designation, and terminology).
Organic and functional relationships (principles, construction, structure).
Introduction to the principles of abstraction (appearance, nature, scheme).
Primary and secondary, elementary and mixed application of the means of design.
Design exercises: Drawing, painting, building.

III Scientific subjects:
Basic laws of mathematics, physics, mechanics, and chemistry with respect to their practical application and to the logical understanding of the significance of numbers and measurements, substances and form, force and motion, proportion and rhythm for the processes of design.
The basic course is the indispensable prerequisite for all further work of the Bauhaus and is therefore compulsory for every newly admitted student.

Duration
The basic form course two semesters, the basic practical instruction one semester. Thereafter, the student may be admitted to one of the teaching workshops.

Result
Selection of special field according to personal inclination and talent, through increased understanding of personal relationship to the various materials and fields of work.
In case of satisfactory achievement, final admission and transfer to the general course of instruction.
The administration of the Bauhaus
[Original without capital letters]

Walter Gropius
Bauhaus Dessau—Principles of Bauhaus Production
Printed sheet, published by the Bauhaus
Dessau, March 1926
A different version of this paper appeared in
Volume 7 of the Bauhaus Books under the title
"New Products of the Bauhaus workshops."
The emphasis placed on the laboratory character of the workshops is the result of the revision
in the concepts of "design" and "production,"
which had come about during the last years at
Weimar.

The Bauhaus wants to serve in the development of present-day housing, from the simplest household appliances to the finished dwelling.
In the conviction that household appliances and furnishings must be rationally related to each other, the Bauhaus is seeking—by systematic practical and theoretical research into formal, technical, and economic fields—to derive the design of an object from its natural functions and relationships.
Modern man, who no longer dresses in historical garments but wears modern clothes, also needs a modern home appropriate to him and his time, equipped with all the modern devices of daily use.
An object is defined by its nature. In order, then, to design it to function correctly—a container, a chair, or a house—one must first of all study its nature; for it must serve its purpose perfectly, that is, it must fulfill its function usefully, be durable, economical, and "beautiful." This research into the nature of objects leads to the conclusion that by resolute consideration of modern production methods, constructions, and materials, forms will evolve that are often unusual and surprising, since they deviate from the conventional (consider, for example, the changes in the design of heating and lighting fixtures.)
It is only through constant contact with newly evolving techniques, with the discovery of new materials, and with new ways of putting things together, that the creative individual can learn to bring the design of objects into a living relationship with tradition and from that point to develop a new attitude toward design, which is:

A resolute affirmation of the living environment of machines and vehicles
The organic design of things based on their own present-day laws, without romantic gloss and wasteful frivolity
The limitation to characteristic, primary forms and colors, readily accessible to everyone
Simplicity in multiplicity, economical utilization of space, material, time, and money.
The creation of standard types for all practical commodities of everyday use is a social necessity.
On the whole, the necessities of life are the same for the majority of people. The home and its furnishings are mass consumer goods, and their design is more a matter of reason than a matter of passion. The machine—capable of producing standardized products—is an effective device, which, by means of mechanical aids—steam and electricity—can free the individual from working manually for the satisfaction of his daily needs and can provide him with mass-produced products that are cheaper and better than those manufactured by hand. There is no danger that standardization will force a choice upon the individual, since due to natural competition the number of available types of each object will always be ample to provide the individual with a choice of design that suits him best.
The Bauhaus workshops are essentially laboratories in which prototypes of products suitable for mass production and typical of our time are carefully developed and constantly improved.
In these laboratories the Bauhaus wants to train a new kind of collaborator for industry and the crafts, who has an equal command of both technology and form.
To reach the objective of creating a set of standard prototypes which meet all the demands of economy, technology, and form, requires the selection of the best, most versatile, and most thoroughly educated men who are well grounded in workshop experience and who are imbued with an exact knowledge of the design elements of form and mechanics and their underlying laws.
The Bauhaus represents the opinion that the contrast between industry and the crafts is much less marked by the difference in the tools they use than by the division of labor in industry and the unity of the work in the crafts. But the two are constantly getting closer to each other. The crafts of the past have changed, and future crafts will be merged in a new productive unity in which they will carry out the experimental work for industrial production. Speculative experiments in laboratory workshops will yield models and prototypes for productive implementation in factories.
The prototypes that have been completed in the Bauhaus workshops are being reproduced by outside firms with whom the workshops are closely related.
The production of the Bauhaus thus does not represent any kind of competition for either industry or crafts but rather provides them with impetus for their development. The Bauhaus does this by bringing creatively talented people with ample practical experience into the actual course of production, to take over the preparatory work for production, from industry and the crafts.
The products reproduced from prototypes that have been developed by the Bauhaus can be offered at a reasonable price only by utilization of all the modern, economical methods of standardization (mass production by industry) and by large-scale sales. The dangers of a decline in the quality of the product by comparison to the prototype, in regard to quality of material and workmanship, as a result of mechanical reproduction will be countered by all available means. The Bauhaus fights against the cheap substitute, inferior workmanship, and the dilettantism of the handicrafts, for a new standard of quality work.

The Bauhaus in Dessau
Work Plan of the Metal Workshop
Printed sheet, not dated (1925–1926)
The work plans of the various workshops were essentially the same. This plan, for instance, contains the guide lines that remained effective until the end of the Gropius era.

Metal workshop.
Director: Professor L. Moholy-Nagy
a. Teaching workshop:
The metal workshop of the Bauhaus trains creatively talented people. They are admitted on a trial basis to the teaching workshop after they have successfully completed the six-month course of basic instruction at the Bauhaus, which is compulsory for all students entering the Bauhaus. The trial period in the workshop lasts six months. After final admission has been granted, the student is registered as an apprentice with the Handwerkskammer and commits himself to completing his apprenticeship in the Bauhaus as a copper or silver smith, taking the journeyman's examination before the Handwerkskammer.
In the teaching workshop the students become acquainted with the various metals and their applications, while working on their own projects under the supervision of an experienced master craftsman. The instruction is conducted with the numerous special industrial applications of metal in mind.
The further artistic development of the students is fostered by
1. the leader of the workshop who distributes the assignments and discusses them with each individual student, keeping in mind the demands of time and the stage of development of the student;
2. the classes in the Bauhaus. All members of the teaching workshop are required to attend the general, compulsory classes (draftsmanship, mechanics, etc.).
Following the successful completion of the journeyman's examination, the student may be admitted to the experimental and model workshop or to instruction in architecture.
b. Experimental and model workshop:
The formal and technical instruction is carried on in a broader manner by the workshop leader and the workshop master and by means of special courses.
The members of the experimental and model workshop are better equipped to implement their creative and experimental ideas because of their previously acquired skills in the craft. They prepare models of prototypes for use in craft or industrial production. They also participate in the practical jobs of the workshop. All students are required to attend the general, compulsory courses of the Bauhaus.

Metalworkers who have completed their apprenticeship outside the Bauhaus can be admitted directly into the experimental and model workshop, provided they have successfully completed the basic course of instruction.

After a minimum of one year of satisfactory work in the experimental and model workshop, the members of the workshop receive an official certificate from the Bauhaus as proof that they are capable of assuming leadership in the metal industry and in the copper- and silversmith trades which will do justice to technical and artistic requirements.

From this time on the student may either continue working in the experimental and model workshop, or, if he is talented and so inclined, he may be admitted to the instruction in architecture, on condition that he has already regularly attended the necessary preparatory classes during his apprenticeship (technical drawing, statics, construction, etc.). (See the work plan for the instruction in architecture.)

The Bauhaus retains ownership of all articles produced in the workshop, while the originator of such products, under certain conditions, keeps the rights to the design.

After final admission into the teaching workshop, the student will be reimbursed for those products that can be utilized.

Furthermore, a single-payment compensation or royalties will be paid to the designer for models or prototypes used in series production.

The Director of the Bauhaus

The City of Dessau
Budget Estimate for the Bauhaus 1926/27 (Special Account)
AD, inventory No. 1170 (First publication)
The Bauhaus building complex erected in 1925/26 also housed a municipal vocational school for apprentices; hence, the budget always distinguished between a "common" and the "separate" account, which latter concerned the Bauhaus specifically. The modest budget funds forced—at first—rigorous frugality upon the institute. But thanks to the skill of the Mayor, the Bauhaus budgets were progressively increased each year up to the end of the nineteen twenties, despite the difficult financial situation of the city of Dessau.

Budget estimate, Bauhaus 1926/27

Expenditures of the Bauhaus, special account			Expenditure for part-time		
Gropius		RM 11,000	teaching staff	RM	5,000
Kandinsky			Expenditure for administration		9,000
Muche			Teaching materials and finan-		
Moholy	each	7,000	cial assistance		5,000
Schlemmer			Other expenses		1,000
Feininger	each	2,500	Total expenditure	RM	118,000
Albers					
Bayer			Income of the Bauhaus		
Breuer			Tuition fees, etc.	RM	3,000
Scheper			Net profit of the workshops		15,000
Schmidt	together	24,000	City subsidy		100,000
3 master craftsmen	together	14,000	Total income	RM	118,000
Business manager		10,000			
Office employees		6,000			
total		RM 98,000			

The Bauhaus in Dessau
The Marketing Organization ("The Position of the Bauhaus in Today's Economy")
From the journal "Vivos voco" (Leipzig), Vol. V, No. 8/9, August–September 1926
Attempts to build an organization to market Bauhaus products started back in the Weimar period, but only at Dessau did they yield significant results. An important factor in helping this marketing organization was the public-relations work done by reviewers and industrial consultants (among them Heinrich König).

In order to help establish contact between industry and the Bauhaus, a business organization of the Bauhaus has been founded. Its function is to take care of the sale of prototypes to those branches of industry which can mass-produce from completed prototypes and market the product. The resulting royalties benefit both the Bauhaus, by helping it to enlarge its workshops, and the students working in them. In this way valuable talent is supported by the community which would otherwise be lost to other enterprises, since such students would have to leave in order to earn money before being able to complete their Bauhaus training. And this is exactly what is essential to the Bauhaus: concerted effort, the radiation of energy, the interplay of forces extending from one generation to the next. The financial basis for the survival of the Bauhaus as an educational institution is guaranteed by the aid granted by the city of Dessau. Industry is beginning to acknowledge the importance of the experimental work of the Bauhaus and its development of prototypes and is beginning to participate in supporting this work by cooperating in the technical manufacture of new prototypes and in the carrying out of new experiments. It is further planned to conclude contracts for options between the individual workshops and corresponding branches of industry. The workshop commits itself to offer the prototype of each newly developed product first to the firm holding the options, in return for which that company pays a certain annual option fee. In case the company does not wish to purchase the offered prototype, then the workshop is free to dispose of it elsewhere. . . .

Since an officially subsidized laboratory must appear to be unsuited to be a business partner with private industry, the Bauhaus management has instigated the establishment of a Bauhaus Corporation, with home offices in Dessau-Anhalt. This company has assumed the task of marketing the finished prototypes of the Bauhaus that are to be utilized in actual production, for purposes of reproduction by private industry and craft groups.

District Court of Anhalt
Bauhaus Corporation
From "Anhalt Gazette" (Official Record for Anhalt), published by the State Ministry of Anhalt, Dessau, 162nd year, No. 91, November 13, 1925
The implementation of the plan for the Bauhaus Corporation ran into considerable difficulties resulting from the organizational peculiarity of this enterprise. To find a capable business manager for this company was not easy in view of the limited scope of the operation.

Under No. 200, Section B of the Register of Corporations the following entry has been made: The Bauhaus Corporation at Dessau. The purpose of this company is the marketing, as sole agent, of all the prototypes and products developed by the Bauhaus in Dessau—a city institution. The original capital of the company amounts to 20,000 Reichsmarks. The business manager is Dr. Walter Haas of Dessau. The company is incorporated with limited liability. The contract for the founding of the company was concluded on October 7, 1925. The company is authorized to appoint more than one manager. This may be done in such a way that each manager is entitled to represent the company individually. If several managers are appointed, the company may be represented by one manager and one signing clerk or by two signing clerks.
Dessau, November 4, 1925
District Court of Anhalt

45

46

Wassily Kandinsky
The Value of the Teaching of Theory in Painting
From the journal "bauhaus" (Dessau), Vol. 1, No. 1, 1926
Compare also Kandinsky's "Point and Line versus Plane" (Bauhaus Books, volume 9), and his essays on "Art Education" and "Analytical Drawing" Bauhaus journal, 1928.

45
Wassily Kandinsky: "The thin lines prevail against the heavy dot." From: "Point and Line versus Plane."
46
Wassily Kandinsky: "Colored Vibration Achieved in the Schematic through a Minimum of Color (Black)." From: "Point and Line versus Plane."

Various methods can be used for instruction in painting; nevertheless, these methods remain divided into no more than two main groups:
1. Painting is dealt with as an end in itself, that is, the student is trained to become a painter; the student acquires the necessary knowledge of painting at a school—as far as this is possible by instruction—and does not necessarily have to go beyond the limits of painting.
2. Painting is regarded as a force participating in the process of synthesizing, that is, the student is guided, beyond the limits of painting but by way of its own principles, to the work of synthesis.

This second point of view is the basis for the instruction in painting at the Bauhaus. Of course, different methods may be used here too. Concerning my own guidelines specifically, my opinion is that the following aspects must direct these guidelines as their main purpose and eventually as their final purpose:
1. Analysis of the elements of painting as to their intrinsic and extrinsic values
2. Relationships of these elements to those of the other arts and to nature

3. Composition of these elements of painting in thematic form (solutions to systematic thematical problems) and in relation to painting itself

4. Relationship of this composition to the other arts and to Nature

5. Recognition of laws and purpose

At this point I must be content with a general outline . . . but even this brief, schematic explanation indicates what I have in mind. Up until now, there has in fact not been any systematic analytical thinking in problems of art, and to be able to think analytically means to be able to think logically. . . .

The young and particularly the beginning artist must from the outset become accustomed to objective, that is, scientific, thinking. He should learn to avoid the "isms" that generally do not lead to the point, but rather misconstrue transient details as being fundamental problems. The capability of being objective toward the work of others does not exclude subjectivity in one's own work, which is only natural and completely healthy: the artist is allowed to (or rather "must") be single-minded in his own work. . . .

By studying the elements of painting thoroughly to see which are the building blocks of art, the student develops—aside from a capability of thinking logically—the necessary "feel" for the artistic means. This simple statement should not be underestimated: the means are determined by the end—hence, the end is understood by way of the means. The inner, deeply involved understanding of the means and the simultaneously conscious and unconscious activity with these means discards all those purposes alien to art which, thus, appear unnatural and repulsive. In this case the means, in fact, serve the end.

The feeling of kinship with the elements of one field of art increases . . . with the study of the relationship of these elements to those of the other fields of art. . . . The relationships of the elements of art as such to those of nature put this whole problem on a much broader philosophical base. . . . Thus the search for synthesis in art becomes the search for synthesis in general. . . .

In practice, extreme specialization represents a heavy wall that separates us from the efforts to achieve a synthesis. I hope I need not prove a number of facts generally known today: for example, the recognition of laws in the composition of paintings. Yet, for the student to acknowledge this basic fact is not in itself sufficient—it must be implanted inside the student and it must be done with such thoroughness that the knowledge of this fact enters into his fingertips all by itself. The most moderate or the most powerful "dream" of the artist has actually little or no value as long as his fingertips are incapable of following the "dictates" of this dream with the utmost precision. In order to develop this capacity, the teaching of theory must be combined with practical (thematic) exercises. . . . The laws of nature are alive, since they embrace everything that is static and dynamic; in that sense they are equivalent to the laws of art. . . . [Thus] an understanding of the laws of nature is absolutely necessary for the artist. But this simple fact is still entirely unknown to the art academies.

[Schematic outline: means and purpose of teaching]

Means

1. Analysis of the elements of painting

2. Relationship to the other arts and to nature

3. Composition of the elements of painting in the form of themes and in painting itself

4. Relationship to the other arts and to nature

5. Recognition of laws and purpose

Purpose

Analytical (universal logical) thinking.

Thinking in terms of synthesis. Ability to unite separate parts. Theoretical and actual lawfulness and their relative value in practice.

Synthetic creativity and work, understanding of the creative principles in nature, and Nature's intrinsic kinship to art.

Training of fingertip sensitivity and education of the individual.

It is obvious that the other arts can serve this educational goal just as well as painting does. But it is equally obvious that painting is especially well suited for this educational role at the Bauhaus:

1. Color and its application have a place in all the workshops, where, therefore, the method described can serve purely practical purposes as well.

2. Painting has been the art form which for decades led every one of the movements in art and has provided stimulus for all the other arts—especially architecture.

Dessau, March 20, 1926

[Original without capital letters]

Georg Muche
Fine Art and Industrial Form
From the journal "bauhaus" (Dessau),
Vol. 1, No. 1, 1926

The tendency of taking art as a kind of auxiliary science for industrial design, which predominated at the Bauhaus until 1923, was overcome by the understanding of the fact that industrial design is esthetically independent of art and must be approached according to its own principles. Independent artistic work never again acquired the significance it had held during the first years of the Bauhaus; art was relegated more and more into a peripheral role in the work of the Bauhaus.

After an extraordinarily significant period of creative interchange between two fields that are intellectually at opposite poles, it appears that the close contact between modern art—especially painting—and the technological development of the twentieth century must lead inevitably and with surprising consequence to mutual rejection. The illusion that fine art must be absorbed in the creative types of industrial design is destroyed as soon as it comes face to face with concrete reality. Abstract painting, which has been led with convincingly unambiguous intentions from its artistic Utopia into the promising field of industrial design, seems quite suddenly to lose its predicted significance as a form-determining element, since the formal design of industrial products that are manufactured by mechanical means follows laws that cannot be derived from the fine arts. It becomes evident that technological and industrial development is of a completely characteristic nature, even in regard to design.

The attempt to penetrate industrial production with the laws of design in accordance with the findings of abstract art has led to the creation of a new style that rejects ornamenta-

tion as an old-fashioned mode of expression of past craft cultures, but that nevertheless remains decorative. But it was considered possible to avoid this merely decorative style, just because the characteristic way in which the fundamental laws of form had been creatively investigated by means of abstract painting appeared to have uncovered that these laws do not pertain just to the fine arts but are particularly significant in their general validity.

The enthusiasm for technology took on such proportions that the artist, with his epistemological arguments—often all too logical ones—disproved his own existence. The square became the ultimate picture element for the superfluous—for the dying—field of painting. It became an ingenious and effective document of faith in functional form in the sense of purely constructive design. It became the evil eye against the ghosts of the past, who had enjoyed art for art's sake. The renunciation of art seemed to be the only way to protect oneself from the fate of being an artist in an age that needed nothing but engineers.

This led to a new esthetic from which, in the ecstasy of enthusiasm for modern design, a broad theory was developed which is extraordinarily intolerant toward art. This intolerance resulted from the need for the theory to set a concrete aim evoking the semblance of practical usefulness. But it seems that art, even after it has been broken down into its actually quite art-free elements, cannot evolve where it is considered irresponsibly wasteful to violate the laws of utility by such an abundance of riches as art provides. Such is the case in industry and technology. As long as the engineer was bogged down in the style of past craft cultures, the industrial product remained of inferior quality with respect to its design. The ornamental trimming by the handicrafts did nothing to improve this shortcoming. But also design in accordance with constructivist principles that were derived from abstract painting in such an extraordinarily imaginative and consistent manner, can rarely be justified except in cases where the process of production has not, or not completely, been modernized: in architecture and a few other peripheral areas.

Hence an architecture came about which used forms that looked surprisingly modern—despite the fact that its technology must remain old-fashioned as long as the engineer does not accept the entire problem of constructing dwellings as his own. This architecture, which appears to be more than applied art, is actually nothing more than the expression of a new will-to-style in the traditional sense of the fine arts. Modern architecture is not yet part of the creativity of modern production which, already in its design theme, reflects the methods of industrialized production. The straight line became the formal idiom of the modern architect—especially the straight line in its horizontal-vertical relationship and in its versatility for static-dynamic applications in designs for spaces. This highly intense contrast appeared to be at the same time both the expression of the new attitude toward style and the appropriate basic form for the mechanical process of production. This was an error!

The forms of industrial products, in contrast to the forms of art, are super-individual in that they come about as a result of an objective investigation into a problem. Functional considerations and those of technological, economic, and organizational feasibility, become the factors determining the forms of a concept of beauty that in this manner is unprecedented. Inventive genius and the spirit of commercial competition become factors of creativity. An age—the "age of the machine"—wants to emerge.

The preceding interpenetration of art and technology represented a moment of great significance. That moment freed technology from its last ties to an esthetic that had become old-fashioned and in which art was taken to absurd lengths, and now it was able to go beyond this stage to find itself anew in the limitless sphere of its own reality. Art cannot be tied to a purpose. Art and technology are not a new unity; their creative values are different by nature. The limits of technology are determined by reality, but art can only attain heights if it sets its aims in the realm of the ideal. In that realm opposites coincide. Art has no ties to technology; it comes about in the Utopia of its own reality.

The artistic element of form is a foreign body in an industrial product. The restrictions of technology make art into a useless something—art, which alone can transcend the limits of thought and give an idea of the immensity of creative freedom.

[Original without capital letters]

Laszlo Moholy-Nagy
bauhaus and typography
From the magazine "Anhaltische Rundschau" (Dessau), September 14, 1925
The citizens of Dessau took the zealous enthusiasm with which the Bauhaus went about writing everything in lower-case letters as a provocation. They reacted with indignation and irony. The reasons for the exclusive use of small letters were, without doubt, esthetic. The practical arguments—savings in material and time, and better legibility—were in fact open to criticism, considering the progressively increasing perfection of technology and the demands for a clear arrangement of the complicated image of German type faces.

. . . the utilization of machines is characteristic of the technology of today's production and it is significant in its historical development. as in other areas of production, we must unequivocally design our machines for clarity, conciseness, and precision. today everybody's time is valuable, just as valuable as materials and labor. among the many problems with which today's typographical artist is concerned . . . the problem of uniform lettering is one of the most important. this type of lettering can be traced as far back as jakob grimm, who wrote all nouns with small initials . . . the well known architect loos in his collected essays writes: "for the german there is a wide gap between the written and the spoken word. one cannot speak a capital letter. everyone speaks without thinking of capital letters. but when a german takes a pen to write something, he no longer is able to write as he thinks or speaks."

the poet stefan george and his group have also chosen uniform lettering as a basis for their publications. if anyone objects to this, saying that it was poetic license, then it must be pointed out that it was the level-headed "association of german engineers" ("verein deutscher ingenieure") who in 1920 . . . came out in favor of uniform lettering in a book, "speech and lettering" written by dr. porstmann, with the reasoning that our lettering would lose nothing if written with lower-case initials, but on the other hand would become easily legible, more easily learnable, and would become significantly more economical. they added that it should be unnecessary . . . to double the number of signs for a sound when half are sufficient.

this simplification has consequences in the construction of typewriters and typesetting

114

machines, it saves type and shift keys . . . the bauhaus has investigated at great length all problems concerning typography and has found the reasons given in favor of uniform lettering to be convincing. . . .

Laszlo Moholy-Nagy
"Isms" or Art?
From the journal "Vivos voco" (Leipzig), Vol. V, No. 8/9, August–September 1926
Moholy-Nagy made a clear distinction between autonomous design, which he thought was the task of painting, and illustrative representation, which he attributed to photography. His thesis that the potential of photography exceeds pure reproduction was the stimulus for the Dessau Bauhaus to enter into intensive studies of photography. However, a photography class was formed only after Moholy had left the Bauhaus.

Representative—nonrepresentative
During recent years these two modes of expression, the "representative" and the "non-representative" modes, have been fervently played against each other—particularly in the field of visual design. To this day one has had to decide for one or the other, otherwise one was considered inconsistent.
In reality—according to the present knowledge of design—these two modes of expression have so very little to do with each other that they cannot but be taken to be mutually exclusive. This had become unclear only because of impure intermingling of these modes of expression, which we can analyze from the history of their development, and because of the interchanging and mixing of their means, which resulted from necessity. . . .

The "isms" [in painting]
"Isms" play a most important role in today's terminology. But in reality there are no isms. There are only the individual works of individual artists who derive their work from general premises that are predicated on their time. The final result of their work, despite all formal differences, is an attempt at one and the same clarification of visual design principles.
The "isms" are efforts at overcoming the traditional form of picture painting. They are preparing the way for purely functional design in which the fundamental means of expression . . . correspond to the latent tension relationships within ourselves. But before it became possible to arrive at a pure design, many digressions had to be made. . . .
The common denominator of all the "isms," from naturalism to constructivism . . . is the continuous, unconscious struggle to conquer the pure, primary, and autonomous means of expression and design.
All painters, at all times, tried to apply . . . the fundamental means of expression of the visual arts. All the known compositional rules used by the old masters—the golden section and other artistic canons—have their origin in the perfectly natural human desire to maintain fundamental order and to express themselves in a fundamental way. All the "isms"—impressionism, neo-impressionism, pointilism, futurism, expressionism, cubism, suprematism, constructivism—are also nothing but the intensified individual interpretation of this immanent "will-to-form" ("Gestaltungswillen") which is part of the time. All the deformation, dismemberment, and disintegration of the object, the disfiguration of its naturalistic image, came about from the unconscious desire to elevate the forms and colors that are burdened as carriers of naturalism to sovereign, completely visual means of expression. . . . The possibility of mechanical illustration given in photography has, however, greatly infringed upon the monopoly of representation by means of the manual picture; the desire for autonomous visual representation, free of the constrictions of objective portrayal, became increasingly stronger. The painter wanted to work with color and surface according to their relationships and tensions. Each one in the series of successive "isms" has attempted to carry out such intentions in its different way. . . . But none knew that that which was important was not the manner of destroying, but rather the struggle to find ways and means for autonomous formal possibilities. None had faith in the individual forms [and] methods of the others, for no one discovered their orientation. Hence, at first the painter overlooked all the still indistinct results, and time and again the newcomer has started the struggle against the constraints of nature all over again.
There was the taboo of the old picture: "painting" always had to "represent" something; its point of departure could not be anything but the object in nature, although photography had come a long way in the meantime and the problem of representation had thus been solved by a mechanical process. . . . Consequently, the painter could have devoted himself easily to working on the expression of color with fundamental means . . .
The visual artist works with visual means of expression . . . The clearly recognizable goal enables one to distinguish between concern for fundamental visual relationships and concern for representation.

The representation (photography, film)
Theoretically it is irrelevant whether an artist employs three-dimensional, linear, pictorial, black-and-white, colored, photographic, or other means to represent something. But today it has become almost natural to favor a representation done by mechanical means, with all its consequences, over a painstaking, manually executed visual representation. Hence, the position of photography (film) is clearly outlined. The way in which things in nature, or things in the realm of fantasy and Utopia, or the dreamlike and the supernatural can be represented has been so well defined by this mechanical process and has been developed to such a point, that similar experiments using manual means of representation are hardly ever likely to produce similarly convincing effects. And this is true even with respect to the effects achieved by chance. In this competition the photographic process will win out, because of the immense possibilities for representation. Only a kind of fetishism for "handwork" can be the reason for opposition against this contention. Whoever is capable of abstracting the surface projection of a "holy" hand and of a "soulless" apparatus and is able to discern the creative powers of the artist which went into this effort finds it impossible to be for the brush and against the device. The fact that photography yields such extraordinarily rich results—for those who can see—and that these results have far advanced the new vision of clarity, precision, chiaroscuro, and the immaterial and nevertheless real aspects of representation, compels us to say that the representational artist would do well to concentrate his talent on this most capable of being developed, most versatile, and most magnificent of all methods of representation.

It is certainly true that with the advancement of the photographic-representational process the formal qualities of the new representation will be totally different from those of the hand-produced picture we have known so far. It is obvious that a new technique must create a new and adequate form. It is only natural that technical and mechanical means must be applied to nonobjective visual art as well. The very next step in this inevitable development is the use of reflectors, projectors, and spray-guns, of exact, highly polished surfaces, enamel, artificial horn, "Trolit" and other synthetic plastic materials, which, with their homogeneity of surface-texture, make possible a progressively pigment-free, nonsubstantial luminous effect. . . .

But despite all this sincere enthusiasm for photography, the questionable aspects should not go unmentioned. The very next period of photographic and film practice will attempt to clarify—for better or for worse—the principles of representation through a large number of reports and commentaries on the social and political events of today. Some of these may, of course, destroy many of the more subtle aspects of our fundamental knowledge of design and organic principles . . . by employing a kind of romantic, sentimental monumentality, brutal emotionality and cheap (secondary and tertiary) effects. But this is not because the finer aspects would be worthless or less valuable for the "masses," it is rather that the masses are, for the time being, unable to assimilate them relative to the easy comprehension of exciting events. That is, for the time being and supposedly so. Consequently, at this moment it is particularly important to formulate, in popular terms but nevertheless accurately, the aims of the modern designer and how his achievement can be used to build an organized social order, or even better, to promote the development of a more human human being. It would be disastrous if the next generation would also have to use up its best forces in the external struggle in order to achieve . . . material equality without being able to do anything for its mental and physical harmony. One cannot work hard enough to try to lead people to an understanding of their organic, basic functional structure. This functional structure is the basis and in its . . . effects the essential substance of every creative achievement and of every healthy way of life.

Gunta Stölzl
Weaving at the Bauhaus
From the journal "Offset, Buch- und Werbekunst" ("Offset, Printing, and Commercial Art"), Leipzig, 1926, No. 7 (Bauhaus issue)
While Muche (who at the time of this publication led the weaving workshop) emphasized a coming to grips with the problems of mechanization, Gunta Stölzl and other weavers put more stress on craftsmanship and *intuitive* aspects.

. . . Woven fabric constitutes an esthetic entity, a composition of form, color and material as a whole.

Today in all fields of design there is a quest for law and order. Thus, we in the weaving workshop have also set ourselves the task of investigating the basic elements of our particular field. For example, while at the beginning of our Bauhaus work we started with image precepts—a fabric was, so to speak, a picture made of wool—today we know that a fabric is always an object of use and is predicated equally upon its end use and its origin. The factors affecting the production are:

The loosely knit structure, which can only be made into a definite surface by the arrangement to which it is subjected

A multiplicity of interlocking threads, which produce a "sculptured" surface

The color, which is intensified or toned down by being glossy or dull

The material, whose characteristics limit us in its use

The fabric has to meet further requirements: It has to be a surface and always has to have the effect of a surface. This does not imply that elements of a static, dynamic, sculptural, functional, constructional, and spatial nature are excluded from consideration. These elements count, in as far as they are means of designing the surface and are subject to the laws of plane geometry. . . .

Since today mechanical weaving has not yet been developed to the point of incorporating all the possibilities of hand weaving, and since the developing creative person needs to know all these possibilities, we concern ourselves primarily with hand-loom weaving.

Only work at the hand loom allows the kind of latitude for an idea to be developed from experiment to experiment until it is defined and clarified to the point that sample products can be handed to industry for mechanical reproduction.

Since the applications of fabrics, and hence the problems involved, are so varied, only a few are selected here:

A cloth or a curtain—these are easily movable and easily adaptable objects to suit individual tastes and requirements for color and form.

A carpet can be designed as an integral part of the room and as such can have a space-determining function; but it can just as well be thought of as an independent "thing in itself," whose colors and formal language can express any surface theme.

Upholstery fabric—being fixed in space and being confined to a specific purpose, should have an attractive textural surface quality.

Petit point and tapestry are not "commodities." Other standards apply to these; they belong in the area of free artistic expression but are influenced by the process of weaving.

Weaving is primarily a woman's field of work. . . .

Helene Nonné-Schmidt
Woman's Place at the Bauhaus
From the journal "Vivos voco" (Leipzig), Vol. V, No. 8/9, August–September 1926
The author, wife of Bauhaus Master Joost Schmidt, studied under Klee and worked in the weaving workshop.

. . . The artistically active woman applies herself most often and most successfully to work in a two-dimensional plane. This observation can be explained by her lack of the spatial imagination characteristic of men. Of course there are individual differences and differences of degree here, just as the nature of the sexes seldom is either purely masculine or feminine. In addition, the way the woman sees is, so to speak, childlike, because like a child she sees the details instead of the over-all picture. The woman's way of seeing things is not to be taken as a deficiency; rather it is simply the way she is constituted, and it enables her to pick up the richness of nuances which are lost to the more comprehensive view. But let us not deceive ourselves into thinking that this aspect of her nature will change, despite all the accomplishments of the Women's Movement and despite all the investigations and experiments. There are even indications that woman is counting on her limitations, considering them a great advantage. . . .

Within the Bauhaus and its workshops the woman is primarily interested in the work of the weaving workshop and there finds the widest range of opportunities. Weaving represents the fusion of an infinite multiplicity to unity, the interlocking of many threads to make up a fabric. It is quite evident to what extent this field of work is appropriate to a woman and her talents.

The Bauhaus is attacking the problems of designing housing and its furniture. How does weaving fit into this?

Synthetic materials are being increasingly preferred over natural materials for the construction of buildings, partly for technical and economic reasons and partly for reasons of hygiene. Why are we still weaving fabrics, why are we not searching for entirely new materials that correspond to woven fabrics—being capable of being dyed and produced in any size, being elastic and easily divisible, being soft and, most of all, being economically advantageous, without having to be subjected to that troublesome and—despite the utmost of technological sophistication—restrictive process of weaving? Mechanical knitting, which seems to be slowly replacing the loom, is also not the answer, for it has not come a single step closer to producing a material that cannot be easily torn or damaged.

Today we have the airplane and radio and we understand television—all this has been developed in a relatively short period of time. Hence, some day there will also surely exist such new synthetic material. But this is a job for the chemical industry and for university laboratories. As soon as this material has been invented and can be manufactured economically, weaving will be obsolete.

But this day has not yet come; and as long as there are needs—as is still the case today—there are jobs to be done. The tasks of the Bauhaus weaving workshop (which is said to be a laboratory) lie within the area of interior decoration. These tasks are quite varied, even when they are dictated by functional requirements, except in the case of tapestries. A tapestry or petit point has a place in the modern, ornament-free room, because, as an object freed from the necessity of serving practical ends, it offers itself as a purely visual experience. And man's desire for that will never diminish. The advantage of woven pictures over framed pictures is that they can be easily removed and folded into a very small space. Their special distinction, as against painting, is the wealth of possibilities they offer for varying surface effects by using different materials, such as wool, cotton, linen, silk, rayon, metal, and glass, to obtain smooth, rough, glossy, matt, flat, coarse, fine, soft, hard, thick, and thin effects. There are also rich opportunities for varying the textural structure.

These same characteristics can also be considered for other woven fabrics but are subordinated to the requirements of their use. With respect to such fabrics it is our special task to satisfy practical and esthetic needs at the same time.

The ability of woman to become absorbed in detail and her interest in experimental "play" with surfaces suit her for this work. In addition, her feeling for colors finds free reign for expression in the multitude of possible nuances.

The fact that in the weaving workshop we are developing *standard types* for certain purposes, with regard to material, texture, and color, by no means represents a lack of imagination. Rather, it is the result of the work which the Bauhaus as a whole attempts to accomplish. For to exercise voluntary restraint in using the means of expression requires discipline.

Oskar Schlemmer
The Stage and the Bauhaus
From the journal ''Offset, Buch- und Werbe-kunst'' (''Offset, Printing and Commercial art'') Leipzig, 1926, No. 7 (Bauhaus issue)
In this article Schlemmer outlines the development of the Bauhaus stage up to the beginning of the Dessau period.

The endeavors of the Bauhaus to integrate art and artistic ideals with craftsmanship and technology by way of investigating the elements of design, and the attempts to direct all activities together toward architecture, naturally exert an influence on the work of the stage. For the stage is after all architectonic: it is ordered and planned, and it provides a setting for form and color in their liveliest and most versatile form.

The stage was there on the very day the Bauhaus opened, because enjoyment in designing was there on that first day. This enjoyment was first expressed in the celebrations (the lantern party and the kite-flying party), in the invention of masks, the making of costumes and the decoration of rooms. And it was expressed in *dancing, dancing, dancing!* The music evolved from the Bauhaus dance, which developed from the clown dance into the ''Step''; from the concertina to the jazz band. From this ''dance for everyone'' evolved the ''dance for the individual'' and its reflected form on the stage: the chromatic-normal, the mechanized *ballet*. From inspiration, whim, and a mind to do something primitive, evolved *parodies* on existing theater, opera, drama, circus, and variety shows. Such travesty has positive results: the understanding of the origin of the theatrical play, its conditions and laws. We are breaking conventions where they seem to be already shaky, and we are experimenting with creating new forms.

Where can we create such new forms?

In our particular field, with our particular means, by providing the eyes with what is due them: everything in the realm of the visual, the *show*. The elements of that realm are form, color, light, space, and movement.

The inherent laws of these elements, both the mathematically precise as well as the intangibly metaphysical, will aid our understanding of related and complementary elements, such as language, word, tone, and sound.

Our work is to serve research experiments, for which there is neither time nor inclination in the bustle of today's business scene. For the time being we intend to protect this work from the curiosity and the activity of the public. Whatever achievement, in our opinion, will have acquired significant value and will have taken definite shape, shall then no longer be kept from public view.

Oskar Schlemmer
The Mathematics of the Dance
From the journal "Vivos voco" (Leipzig),
Vol. V, No. 8/9, August–September 1926
In this article Schlemmer outlines his basic
ideas on the ballet—and consequently also the
aims of the Dessau Bauhaus stage, of which he
was the Director.

Let's not complain about mechanization, but rather let us delight in mathematics! But not in the kind which one has to sweat out in school but rather in the kind of artistic, metaphysical mathematics that suggests itself by necessity, as in art, where everything begins with a feeling that slowly becomes form and where the unconscious and the subconscious enter the clarity of consciousness. "Mathematics is religion" (Novalis) because it is the ultimate, the most refined, and the most delicate. It is only where mathematics deadens the feelings and nips the unconscious in the bud that there are dangers. Mathematics, then, is not school-masterly snobbery but artistic wisdom. When the artists of today appreciate the machine, technology, and organization, when they want precision instead of vagueness, then this is nothing but an escape from chaos and a longing for form. And when they turn to the old in art rather than to recent manifestations, then they do this only because they honor convention and law. When Stravinsky reaches back to Bach and Pergolesi, or when Busoni turned to Mozart, or when painting returns on a large scale to representation, then this is nothing but a nod to the basis that is most safe: tradition. If "excess leads to the palace of wisdom," then this is also true of the frequently audacious excursions of the innovators which carry them to the frontiers of art and beyond, from a state of suspension between heaven and earth, back to the facts. Flake's definition of the state of modern art, according to which we are now dealing with the "constraints of the metaphysical," hits the nail on the head. But such constraints are called form, "Gestalt," law, and mathematics. The same is happening in the field of the dance. With traditional ballet, a bit of classical—that is form-determined—art is certainly becoming extinct. The precise training, the choreography that has been developed for centuries, the "freedom within law," all these in their finest achievements are still able to fascinate. The happiest union was still that between the full-blooded dancing genius of the Russians and the French tradition, a union that lead to ultimate victories. After that came chaos: high-school teacher methodology next to expressionistic ecstasy, the saccharine, merely flirtatious, next to heroic rubbish. But this is not to scoff at things of value. And valuable is that which originated with Dalcroze, was arranged by Laban, and intensified by Mary Wigman. But does that imply that the Negro jazz man, the perfect step dancer, or the phenomenon of bodily artistry at the circus and the variety show are therefore of no value? Ethics or esthetics? What standards shall be applied amid this spectacle of a reassessment of values? Who is going to be the determining factor, the minority of intellectuals or the masses that have already made up their mind to seek entertainment wherever they can find it?

... As for myself, I am for the body-mechanical dance, the mathematical dance. And further, I am for beginning with the "one, two, three" and the ABC, because I hold simplicity to be a great force in which every significant innovation is rooted. Simplicity, taken to mean the fundamental and typical which develops organically into multiplicity and the particular; simplicity, taken to mean a field cleared of all eclectic accessories of all styles and all ages, should promise us a path which is called the future. Simplicity does promise this path, if he who subscribes to the idea of dancing is a person of temperament, a human being.

Man is an organism of flesh and blood as well as a mechanism of dimension and proportion. Man is a creature of emotion and reason and many more dichotomies. He carries these within himself and is much better able to reconcile himself continuously to the fact of this duality within himself, than in abstract structures of art outside himself.

I am referring to the creations in ballet that arise from space, from the sensation of space. Space, like architecture, being primarily a thing of dimensions and proportion, is an abstraction in the sense of a contradiction of nature, if not a protest against it. Space, when taken as determining the laws for everything that happens within its limits, also determines the gestures of the dancer within that space. Out of plane geometry, out of the pursuit of the straight line, the diagonal, the circle, and the curve, a stereometry of space evolves, almost of itself, by the moving vertical line of the dancing figure. If one were to imagine a space filled with a soft, pliable substance in which the figures of the sequences of the dancer's movements were to harden as a negative form, then this would demonstrate the direct relationship of the geometry of the plane to the stereometry of space. The body itself can demonstrate its mathematics by setting free its bodily mechanics, which then point in the direction of the areas of gymnastics and acrobatics. Aids such as poles (the horizontal balancing-pole) or stilts (vertical elements) are, as "extension poles of the tools of movement" capable of vivifying space in framelike, linear fashion. Spheres, cones, and cylinders can do the same thing with respect to sculpture. This is the approach to the three-dimensional "costume" which in this form, freed from all reminiscence of styles, should be called "Sachlichkeit" or "Gestaltung" or "style" in the new, absolute sense.

If we think of the possibilities that have been opened up by today's extraordinary technological progress, represented by precision instruments, scientific appliances of glass and metal, artificial limbs of surgery, fanciful diver's suits and military uniforms, and if we imagine these products, serving the rational functions of such a fantastic, materialistic age, applied and transfered into the useless field of art; then things of fancy would be created next to which those conceived by the visionary E. T. A. Hoffmann, or those of the Middle Ages would look like child's play. In our days, which are so very sober and practical, there either is no time left for playing, or else the inclination for it has disappeared. The residual need for it is satisfied with increasingly superficial and vapid pleasure. In this age of deteriorating religions and deteriorating national unity, in this age which destroys sublimity, which rejoices in play only in its drastically erotic or in its artistically exaggerated form, any of the more earnest tendencies in art incur the odium of being schismatic and esoteric. Thus it is sensible and necessary for the art of a new age to make use

of technology and of the newly invented materials of a new age in order to make art serviceable as form and as a vehicle for a substance which is spiritual, abstract, metaphysical, and ultimately religious in nature.

As a start and pointing in such a direction, the ''Triadic Ballet'' was developed . . . , ''triadic'' (from triad—three) because of the three dancers and the three parts of its symphonic, architectonic composition and the fusion of the dance, the costumes, and the music. The special characteristics of the ballet are the costumes which are of a colored, three-dimensional design, the human figure which is in an environment of basic mathematical shapes, and the corresponding movements of that figure in space. The Triadic Ballet, which avoids being actually mechanical or actually grotesque and which avoids actual pathos and heroism by keeping to a certain harmonious mean, is part of a larger entity—a ''metaphysical revue''—to which the theoretical investigations and the actual work of the Bauhaus stage at Dessau are also related. This is a unity for which our immediate desire and intention is to create a comical and grotesque ballet.

47

47
Oskar Schlemmer: ''Man and Artistic Figure'': from Die Bühne im Bauhaus,'' (The Stage in the Bauhaus), volume 4 of the Bauhaus books.

48
''For the mutation of the human body in the sense of this stage costume, the following can be fundamentally decisive: The law of the surrounding cubistic forms; here the cubic forms are transferred to the human body forms: head, torso, arms, legs are changed into spatial-cubistic entities.
Result: *Living architecture.''*

49
The functional laws of the human body in relation to space; these typify the body forms: the oval head, the base form of the torso, the club forms of the arms and legs, the spherical form of the joints.
Result: *The jointed manikin.*

50
The laws of motion of the human body in space; here they are the forms of rotation, direction, section of space: cone, helix, spiral, disk.
Result: *A technical organism.*

51
The metaphysical forms of expression symbolizing the members of the human body: the star form of the spread hand, the ∞ of the crossed arms, the cruciform of the spine and shoulder; also double head, multiple limbs, division and neutralization of forms.
Result: *Dematerialization.*

All drawings from ''Man and Artistic Figure.''

48

49

50

51

Lyonel Feininger
From a Letter Dated August 2, 1926, to Julia Feininger
BR, gift of Julia Feininger (First publication)

Feininger did not teach at the Dessau Bauhaus. In order to keep up the artistic as well as the human contact with him just the same, the Bauhaus put one of the "Master houses," designed by Gropius, in Burgkühnauer Avenue at his disposal. Feininger moved into his house the end of July 1926. In one single-family house and three duplexes on the same street lived Gropius, Moholy-Nagy and Feininger, Muche and Schlemmer, Kandinsky and Klee. The last two houses in the row of duplexes survived the second world war with little damage; the first duplex was heavily damaged and the single-family house was completely destroyed.

Paul Klee and Walter Gropius
Correspondence of September–October 1926 on the Question of a Salary Cut
BD, Gropius collection (First publication)

In order not to overstrain the concessions made by the city of Dessau, which itself was in a difficult financial situation, Gropius suggested that the full-time teachers agree to give up, temporarily, ten per cent of their salary to relieve the burden on the Bauhaus budget. While their colleagues reconciled themselves to the inevitability of having to make a personal sacrifice, Klee and Kandinsky opposed this measure.

Dessau, August 2, 1926
. . . At last I unearthed a pen! I am sitting out on our terrace which is simply delightful. The overhang and the short south wall, about which we were so unhappy in the blueprints of the house, are just the things that make for that comfortable light—without these projections everything would be bathed in the sun and the mid-day heat. The same goes for all of the rooms—they are much more pleasant and almost invariably larger than we had imagined from the plans and without the furniture. . . . On Saturday I put our many boxes into the basement; all the moving-stuff is stowed away. Outside there are many gardeners and people digging, clearing away the rubble. They've put in paths, and the area is being leveled and packed. The many trees are a blessing, for even in the most glaring sun one is not blinded when looking out into the green, and the tree tops are so beautifully silhouetted against the sky. Here is some real *space,* and it feels like being in the open. I never thought I would get over the loss of our balcony in Weimar that easily—on the contrary, it is a thousand times more beautiful here. And airy, a lovely breeze, but broken by the pine forest, so that you can always find shelter somewhere. Our dining room is not at all too narrow, and Andreas's furniture adds so much color and warmth that, even without any pictures, it is already nice and comfortable. The large living room will be nice too—all the books are temporarily tucked away—to put them into order will be mom's job? And the music is splendidly housed in the long, black, re-done bookshelf, so that the miserable drawer business has been done away with. . . . That wretched graphics cabinet of course looks quite atrocious in it, but Gropi told me the other day that "it would have to be taken apart," and as soon as there is time I'll remind him of it. Just now he is very pressed, for the Schlemmers are moving in tomorrow . . . therefore, I will grant Gropi a few days of rest; he has complied with all of the wishes I had expressed, immediately and sympathetically. Yesterday (Sunday) we had afternoon tea at 4:30 at Gropi's and all the Masters were there, as were a number of Dessau society people. The house is fabulously furnished and of course has been designed to be incomparably more spacious and much more for representational purposes. I can't give you a detailed account of all the time-saving appliances now—you will see them and be enchanted. Altogether one can honestly speak of a creation, of a new achievement in building. . . . Huge Junkers airplanes are flying overhead, across our little forest—they are magnificent to see. I am very happy about the staircase, it is so bright and gay, with its red stripes against the flat cobalt blue of the bannister. We must have our wicker furniture painted, or I'll gladly do it myself with enamel paints. What do you think about light red? I think it would look very nice. The local inhabitants are just too curious; it is really amazing how naively they behave; of course, Gropi's house has aroused their interest the most. . . . He has now had to destroy the "façade effect" after all, by having a concrete wall 2-1/2 meters high built around the two sides facing the street, including a garage, for Gropi is now going to acquire a car. . . . He is doing much building, including sixty homes for a housing settlement. . . .

Bern, September 1, 1926
Dear Herr Gropius,
The impression gained at the last meeting remains extremely disgruntling, despite the vacation spirit, sunny days, etc. It seems not to be given us to breathe nonpolitical air, and time and again we are being forced (unfortunately) into politics. This time into city politics.
The fact that the Mayor declares himself powerless in regard to the additional financing necessary for our Bauhaus, and the fact that everyone of us is supposed to bleed for it, must be taken into consideration. But as far as I am concerned, I have to reject any attempt to push part of the moral responsibility for this onto me. It is the other way around: the city is beginning to cease justifying all the confidence we have put in it. This is particularly distressing—disappointing to me, having been urged emphatically to go along to Dessau.
I have avoided influencing any of my colleagues, but I cannot imagine how the reduction of the salaries, now being discussed, would be carried out. By no means by way of a vote, because in that case only unanimity can lead to a conclusion; unanimity which does *not* exist since I as well as Kandinsky, who before he departed for Müritz explicitly informed me and authorized me to that effect, would vote against it.
Thus, I look gloomily ahead to further negotiations and am afraid of something that was avoided even during the worst phase at Weimar: an *inner* disruption.
I am traveling south with the burden of such thoughts. . . .
With best wishes . . .
yours, Klee

Dessau, October 13, 1926
Dear Herr Klee,
I did not want to answer your letter of the beginning of September until the situation here had cleared up a little more. In the meantime this has happened.
Your letter disturbed me, and I am unable to understand even today your refusal in a situation, difficult for all of us, which according to the actual events you are not judging correctly. You cannot blame individuals if things have not gone as well as we thought they would a year and a half ago. Rather, the situation is to blame: the unforeseeable economic decline and the lack of understanding on the part of the public for our artistic conception, in particular as has been repeated time and again, for the representatives of modern painting. These two things make us unpopular. The Mayor, on the other hand, is the backbone of our existence. Unceasingly and intelligently he is striving to improve our state of affairs; I cannot admire him enough for the sense of responsibility with which he

goes about these things. We would do him a gross injustice if we did not gratefully acknowledge this fact. From what you wrote, I recognized how little you still remember about these events and [that] unfortunately, [you] underestimate his and my work—to protect you unremittingly so that you may be able to work in peace and quiet. Every visitor who comes to Dessau is astonished about the fact that the city has done so much for us, and notes that this would hardly have been possible, even in larger cities, under present conditions.

I am unable to understand why, considering all aspects of our situation, the money problem which has developed should in particular be supposed to cause an "inner disruption," as long as we are deeply engaged in our common task. If we no longer had that interest, then the inner impulse to continuously sacrifice myself for our cause would cease to exist for me too. In that case, the Bauhaus would then simply fall apart. Where subjective differences cause an inner crisis we must naturally resolve it together, and especially now I have well-founded confidence in our vigor to regenerate the structure of our Institute where weaknesses have appeared.

I personally find it just as difficult as the Mayor does to have to ask for personal sacrifices, but up to now no one has offered an alternative that might resolve our problems. In our latest calculations which are based on the upper limit that is still bearable for the budget, we have planned on a 10% reduction of the salary of each of the full-time teachers. This would have to remain in effect until further financial support, which will have to be brought in from other sources, will obviate the need for these reductions in our income.

I simply cannot believe that you, dear Herr Klee, will desert me in this matter, and I cordially request you to support me. I am showing this letter to Kandinsky simultaneously and am making the same request of [him]. After you return, we will have to talk about this face to face; I have asked the Mayor not to rush into anything and to let this matter mature quietly.

I thank you and Mrs. Klee for the greetings from Elba. . . . I am going off for a few days myself, to Paris and Bordeaux, finally to get acquainted with Le Corbusier's works. I hope to see you again very soon. With best wishes . . .

yours, Gropius

Notification by the Dessau Magistracy
The Bauhaus—Recognized as School of Higher Learning
From the newspaper "Anhalter Anzeiger" (Dessau), No. 256, October 31, 1926
When, in October 1926, the Bauhaus attained recognition as a "Hochschule," its educational policies became subject to supervision by the state of Anhalt, although the city of Dessau remained responsible for its financing. The teachers, who at Weimar had held the rank of "Masters," were now granted the title of "Professor." The awarding of university status was both educationally and psychologically of significance to the Bauhaus.

. . . According to the statute approved by the Anhalt State Ministry and the government, the Bauhaus will henceforth carry in its subtitle the designation "Institute of Design." . . . The *administration* of the institute will be carried out by the Director, and he will be aided by the Staff Council, the members of which, in addition to the Director, will be the Professors and the full-time teachers. There will also exist a *Board of Trustees* which will be constituted of the following: the Mayor, the Director, a representative of the government of the state of Anhalt, department of education, an elected representative of the Staff Council, a leading representative of the field of architecture in Germany, and five representatives to be elected by the City Council. It is the task of the Board of Trustees to promote the further development of the Bauhaus. The Board deliberates on the budget and is to be kept up to date about all matters of importance at the Bauhaus. The Board also has to be consulted about appointments of Professors and full-time teachers. . . .

semesterplan

52
Curriculum, by semesters, of the Bauhaus Dessau, about 1928. From a prospectus.

Bauhaus Dessau
Statute
From *"bauhaus dessau, satzung—
lehrordnung"* ("bauhaus dessau, statutes
—teaching regulations") published in
1927
These statutes were adopted in October 1926—
after the Bauhaus had been granted the rank of
an "Institute of Design"—and remained in effect
until October 1930. A revised version which was
in force during the last years of the Dessau
Bauhaus granted the Director broad, authori-
tarian powers, necessary for the maintenance
of discipline, which deteriorated steadily from
1928 on.

1. Responsibility for the institute
The Bauhaus is an institution of the city of Dessau and is under the supervision of the
government of the state of Anhalt, department of education.

2. Purpose of the Bauhaus
The purpose of the Bauhaus is
1. to thoroughly train creatively talented people in the intellectual disciplines, the crafts,
and technology in order to prepare them for creative design work, particularly for archi-
tecture, and
2. to carry out practical experiments, particularly on problems of housing construction
and furnishing, and to develop prototypes for industry and the crafts.

3. Areas of instruction and work of the Bauhaus
The training at the Bauhaus covers the following areas of instruction:
1. form instruction
2. workshop instruction
3. architectural instruction
Practical experimentation is carried out (§ 2, No. 2) in special departments whose purpose
it is to produce economically usable samples and prototypes for industry and the crafts,
particularly for housing construction and furnishings.

4. Sequence of instruction
The regular course of instruction at the Bauhaus begins with a preliminary course which
normally takes two semesters.
Following the basic course is the principal course of instruction which is subdivided into
workshop instruction and form instruction. This part generally takes six semesters.
The successful completion of the principal course of instruction entitles the student to
transfer to the architectural course or to the practical research department. The indiv-
idual details of the sequence of instruction will be determined by a special set of teaching
regulations which are published with the consent of the magistracy and are approved by
the government of the state of Anhalt, department of education.

5. Requirements for admission
The basic course of instruction is the indispensable prerequisite for all further work at
the Bauhaus and is therefore compulsory for every newly admitted student. Any person
whose talent and previous education is deemed to be sufficient and who is 17 years of
age or older may be admitted to the basic course of instruction.
Admission to the principal course of instruction, which includes final admission into the
Bauhaus, will be granted those students who have successfully completed the basic
course of instruction.
Admission to the architectural course will be granted those students who have regularly
attended and successfully completed the principal course of instruction and have
acquired a journeyman's certificate from the Handwerkskammer. Talented architects
who have successfully completed the course of basic instruction and who have attended
other technical schools (building and engineering schools) and have completed an
apprenticeship in a craft or have spent a minimum of 2 years in practical construction
work may also be admitted to the architectural course.
Admission to the practical research department may be granted to those persons, who,
a) after successful completion of the principal course of instruction, have acquired a
journeyman's certificate from the Handwerkskammer and a certificate of study from the
Bauhaus
b) not having attended the principal course of instruction but having completed the basic
course, have either successfully completed their apprenticeship and acquired a journey-
man's certificate outside the Bauhaus, or who are talented architects, mechanics, or
technicians who have obtained a journeyman's certificate or have spent several years on
practical work in their field.

6. Enrollment
Applications for admission to the preliminary course of instruction must be submitted in
writing. The following must be included in the application:
1. original drawings or practical work
2. curriculum vitae (previous education, nationality, personal circumstances and means
of support—in the case of minors this information to be given by parents or guardian)
3. police certificate of good conduct
4. health certificate
5. photograph
6. possible certificates about previous or theoretical training (journeyman's certificate,
school certificates).
Every applicant will first be admitted to the basic course of instruction for six months
only.

7. Cancellation and suspension
Students may cancel their enrollment in the Bauhaus any time after completion of their
apprenticeship, provided they have fulfilled all obligations. The intention to cancel must
be presented in writing to the Director's office before the due date.
Students whose accomplishments in form instruction or technical aspects are contin-
ually unsatisfactory, may, upon decision by the Staff Council, be asked to resign.
Gross violations of the rules will result in suspension.

8. Fees

The following fees will be charged:

1. an admission fee to be paid by all newly enrolling students

2. six-month tuition fees to be paid by all participants in the basic course of instruction and the architectural course. Participation in the principal course of instruction and the practical research departments is free of charge. The fees to be charged are determined by the magistracy with the approval of the Board of Trustees.

9. The teaching staff

The teaching staff consists of (1) the Director, (2) the Professors, (3) the full-time teachers, (4) the master craftsmen, and (5) the part-time teachers. The Staff Council is composed of the Director, the Professors, and the full-time teachers.

The Director is appointed by the magistracy upon recommendation of the Staff Council, after a hearing of the Board of Trustees, and his appointment has to be ratified by the government. The Professors and the full-time teachers are appointed by the magistracy upon recommendation of the Director, after a hearing of the Board of Trustees, and their appointments have to be confirmed by the government.

The master craftsmen and the part-time teachers are employed by the Director with the approval of the magistracy.

10. The Director

The Director represents the Institute in those aspects that are not within the domain of the magistracy. He is in charge of all artistic and administrative matters of the Bauhaus.

11. The Staff Council

The Staff Council (9) has to advise the Director in all important matters. It decides on all disciplinary cases concerning students. Before making important decisions affecting the Institute or the students, the Staff Council shall hear the representatives of the students.

12. The Board of Trustees

The Board of Trustees consists of the following:

1. the Mayor of the city of Dessau,

2. the Director,

3. a representative of the government of the state of Anhalt, department of education,

4. an elected representative of the Staff Council,

5. five representatives elected by the City Council and

6. a leading representative in the field of architecture in Germany, who is to be appointed by the magistracy upon suggestion of the Staff Council.

Those members of the Board listed under headings 4, 5, and 6 are elected or appointed for a period of six years. As far as City Councilors are concerned, their membership on the Board terminates at the end of their terms as Councilors. It is the task of the Board of Trustees to promote the further development of the Bauhaus. The Board advises on the budget and is kept up to date about all matters of importance at the Bauhaus.

The chairman of the Board is the Mayor; in case of inability the Director takes over.

13. This statute becomes effective on the day of publication.

Dessau, October 1926

[Original without capital letters]

53
A Weimar couple bringing their Goethe to the Bauhaus in Dessau. Newspaper caricature, late 1926 or 1927.

Max Osborn
The New "Bauhaus" (Bauhaus Building and Master Houses)
From the newspaper "Vossische Zeitung" (Berlin), December 4, 1926
Max Osborn, art critic of the well-known (liberal) "Vossische Zeitung"—for which Lessing had already written—was one of the most emphatic and, thanks to his circumspection, one of the most convincing proponents of the Bauhaus. This article appeared on the opening day of the Dessau Bauhaus buildings.

Not only from Germany but from all over the world, people interested in art will from now on pilgrimage to this pleasant city of Dessau, to see the imposing document of contemporary artistic concepts which has been presented in the complex of new buildings of the Bauhaus.

What has been achieved here is also a remarkable monument to the exemplary energy with which a single man, imbued with and carried by the knowledge of the soundness of his artistic convictions, has fought the opposition that had mounted to fantastic size against him. . . . Without fanfare, tremendous amounts of work have been accomplished. Excavation started the end of September 1925. In March of this year the framework was completed. Beginning in September, the rooms were gradually occupied. . . .

The impression one receives from the broad layout is magnificent and convincing. The main group of buildings rises in the western part of the city, in a continually expanding section where lush woods, with which the beautiful landscape around Dessau abounds, close in upon the city. The buildings are divided into three wings: the "technical school building," serving the functions of the vocational trade school which the Bauhaus has taken over; the actual classrooms of the Bauhaus, or "laboratory workshops;" and the "studio building," including apartments and workrooms for a number of students. These three wings are distinct entities, which, however, Gropius has integrated into a coherent whole. The connecting stretches, one of which bridges a future street and thereby constitutes a particularly fascinating device, are actually passageways. The whole plan has been designed in a free rhythm that avoids applying the conventional parallel symmetry, but on the other hand keeps its inner balance.

In this setting, without other buildings in the immediate neighborhood which might have required special consideration, the new architecture was able to develop its language without inhibitions. Never before has an example so emphatically proven the principles of the clear, cubic arrangement, the system of an unblurred play of the contrasting effects of horizontal and vertical lines. The rectangle governs, and it forces together the multiple viewpoints into an objective, coherent whole. . . .

The ideas were supported by the new materials. Reinforced concrete demands an engineer-like clarity of construction. Everything grows naturally. Esthetic values spring from the natural expression of what the building wishes to be and of what it contains. The workshop building is designed to provide rooms with the greatest possible amount of light. So Gropius equips it with colossal glass walls. Really huge planes of plate glass, divided into rectangular lights and held in place by small steel mullions, make up the façade, which rises from a broad band of stuccoed concrete, projecting a little beyond a base that houses the ground floor, and terminates at the narrow cornice band of the roof line. The glass walls are suspended from cantilevers which project from piers. This is a fascinating picture. The glass which separates, and then half cancels this separation, envelops the giant cube of the building with a transparent skin through which one can see the pulsating activity on the inside of its organism. This is twice as fascinating at night when the cube is lit up and the surroundings are bathed in the blinding light from its interior.

A different effect draws one to the technical school building. Broad bands of windows, taken together, staggered rhythmically on different floors, cut into the light stucco façades as dark planes. The studio building, on the other hand, is intended to proclaim the fact that it contains about 30 single apartments. Hence, every one of them receives a small, iron-railed balcony, the whole lot of which line up cheerfully like a colorful bundle of ornaments, up and down and sideways. The interior furnishings particularly prove how far the work of the Bauhaus has developed. Everything is of the greatest technical simplicity in its design, of the greatest precision in its workmanship and has been thought out extraordinarily well in regard to its practicality. The temporary quality and the experimental aspect which was still present in Weimar have been replaced by solid and final shapes and arrangements.

Nowhere is this change more clearly evident than in the "Bauhaus-Master housing settlement," where Gropius has built homes for himself and for the sextet of his long-time colleagues, Moholy-Nagy and Feininger, Muche and Schlemmer, and Kandinsky and Klee. This settlement is off to one side from the workshop wing, embedded in a knoll of old pines rising from a green lawn. I still remember the experimental house of the Weimar exhibition of 1923 which looked very uncomfortable, puritanically orthodox, and empty and cold. Now the houses have acquired comfort, are liveable and pleasant, both in their interior design and in their furnishings. With careful consideration, every detail has been designed for practical use. The individual inhabitant is not forced into anything. Even though the halves of each of the twin houses for the six Masters mentioned are almost identical, they all look different. Everyone puts his own personality into them. Kandinsky has even added some very fine pieces of antique Russian furniture which he has long possessed, and they fit in excellently.

All interior spaces received a special accent by the bold and extremely effective application of color. Often the walls of the same room have been painted in different and rhythmically changing tones of color. Gold- and silver-painted walls are also not lacking in these homes, producing a most intriguing effect. And there are black walls as well, and one can really say that black, having been tested in paintings by Kandinsky and Moholy, has been discovered by the Bauhaus as a color for the home and been given all the honors. But all this does not stand still at the level of originality, but rather integrates into a light-colored, unsentimental, clean, and exceedingly wholesome setting for human existence and creative activity. . . .

Walter Gropius
Address at the Formal Opening of the Bauhaus Building
From the newspaper "Volksblatt für Anhalt" (Dessau), No. 285, December 6, 1926 ("Formal Opening of the Bauhaus")
More than one thousand guests attended the formal opening on December 4, 1926, among them prominent political figures, German and foreign architects, artists, and scholars. After the formal part of the festivities, the guests were shown around the new building and the exhibition that had been set up for the occasion. Later the partly finished housing settlement at Törten was open for inspection. The Bauhaus stage presented a show in the evening. The festivities continued well into the next day, especially the guided tours and several showings of a film about the Bauhaus.

Walter Gropius
Request for Contributions to the Bauhaus
Printed sheet, undated (1927)
As the estimate for the budget of 1926/27 clearly demonstrates, the provisions were inadequate for the financing of experiments.

When, seven and a half years ago, the Bauhaus was christened at Weimar, the intellectual atmosphere in Germany was considerably loosened, owing to the disruption that had shaken the country. New ideas cropped up in all areas; but these, of course, had to prove their value first. The Bauhaus, which was founded at that time, set itself the task of investigating the entire field of spatial design, its means and possibilities. In that endeavor the Bauhaus followed the principle of collaboration, establishing a common level from which to work, and beginning a search for exact, that is, objective, fundamentals of creativity, the validity of which can be acknowledged by a large number of individuals. Numerous misunderstandings concerning the Bauhaus resulted from this basic preliminary work, which was difficult to comprehend for the layman but which was nevertheless absolutely necessary. But despite these misunderstandings, the Bauhaus has consistently pursued its chosen path, due to the unwavering determination of both Masters and students. Today one can observe with satisfaction that the ideas that were either gathered by or born in the Bauhaus have started an active movement which has become recognized beyond the borders of this country, a movement which bears the structure of our modern life. These results cannot be achieved by an individual—they evolved from the purity of an idea and from the strength of the common achievement of our Masters and students, and I would like to take this opportunity to thank them publicly and with all my heart. The more we succeed in working together in ever closer cooperation, the more we shall succeed, starting from this common spiritual center, in establishing ties between industry, the crafts, the sciences, and the creative design forces of our time. Only when this is accomplished may we speak of the fulfillment of a task. . . . First and foremost, this building has been created for our young people, for the creatively talented young people who some day will mold the face of our new world. . . .

institute of design
bauhaus dessau
date of post mark
dear sirs,
the bauhaus in dessau, institute of design, has developed more and more into a center for the gathering of all ideas concerning the contemporary intellectual and theoretical foundations of building. its founder and director is a member of the committee on housing types which was formed by the reichsrat and is working in the section on modern building construction and building materials.
the integration of practical work and instruction at the institute conveys to the coming architectural generation exactly that which has been missing up to now: an accurate knowledge of new technological inventions, constructions, and materials.
since the provisions of the budget are insufficient, the institute must rely on the thoughtful help of professional organizations and industries. in view of this i would like to solicit your support for our cause by sending us, free of charge, folders, drawings, and especially materials, construction samples, and models. this way we shall best be able to promote your cause by using these for class demonstrations with our students.
yours faithfully, the director

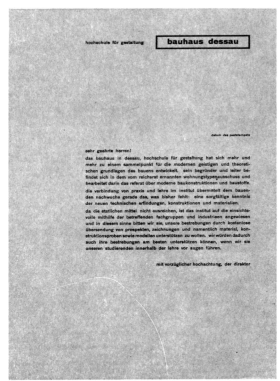

54

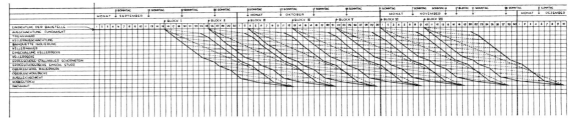

55

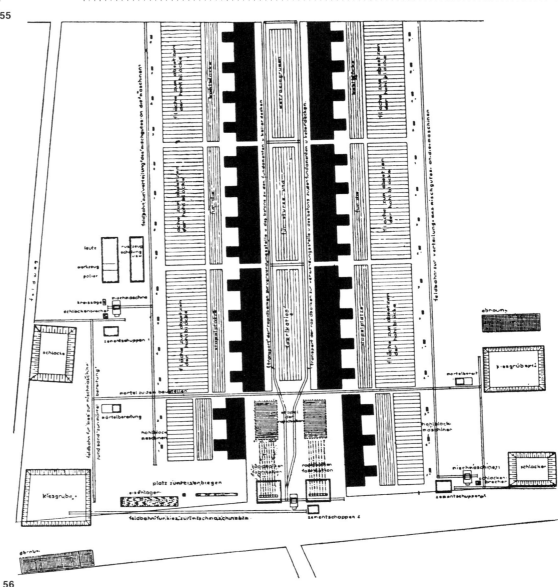

56

55
Timetable for the construction of the Dessau-Törten Housing Settlement 1926. "The sequence of the individual work cycles can be easily read off in the coordinate system. A clear visual survey and control of work phases at all times. Elimination of work stoppages."

56
Plan for a rational layout of the building site. Housing Settlement Dessau-Törten, Construction year 1926.

Walter Gropius
Systematic Preparation for Rationalized Housing Construction
From the journal "bauhaus" (Dessau), Vol. 1, Nr. 2, 1927
The experiment with the housing settlement at Dessau-Törten, which was financed with aid from the Reich, offered Gropius an opportunity to put his ideas on the rationalization of building—which had evolved from the program he had written in 1910—into practice. The most notable aspect of this phase of Gropius's thinking is emphasis on technical planning and on industrial organization. His hopes of establishing a "building research section," which the Bauhaus had attempted to set up in Weimar without success, were only partially fulfilled.

The entire building industry is in a state of transition. Important forces in all parts of the country are beginning to get ready to come to grips with the housing shortage in which we are presently caught. The complexity and size of the building industry have so far prevented a systematic and disciplined organization of it, which would permit an integrated approach to the problem, based on scientific research in the interest of the whole economy. Generally applicable solutions to the building of dwellings that are really in accordance with modern standards have not yet had a chance to be developed, because the problem of housing construction has not yet been studied coherently in its entire sociological, economical, technological, and formal structure. Hence, the problem has never been systematically solved in its entirety. . . . The time of the manifestoes on the new architecture, which helped to clarify the theoretical foundations, has passed. It is high time for us to progress to the stage of sober calculation and accurate analysis. . . . The dwelling is an industrial-technical organism whose unity is composed organically of numerous individual functions. While the engineer has for a long time been working to find optimal solutions for factories and for the products produced by them—making use of the minimum possible expenditure of mechanical and human energy and the least amount of time, material, and money to gain the maximum result—the construction industry has only recently begun to adopt the same goals in the building of houses.
To build means to find forms for the activities of life. For the majority of individuals the necessities of life are the same. It is therefore logical and consistent with an economic approach to satisfy these homogeneous needs uniformly and consistently. Hence it is not justifiable for each house to have a different floor plan, a different shape, different building materials, and a different "style." To do this is to practice waste and to put a false emphasis on individuality. . . . Each individual has the freedom of choice to select from types that are developed side by side. . . . The ultimate objective of this trend will be accomplished only when all the reasonable wishes of the individual for his home can be fulfilled without sacrificing the economic advantages of mass production. The houses and their furnishings will differ in their general appearance to suit the number and kind of their inhabitants. On the other hand, the components from which these buildings are made will be identical. The "type" itself is no obstacle to cultural development; on the contrary, it is almost one of its prerequisites. . . . The danger of a dispersion of effort and

of an irrational and wasteful approach in theoretical and scientific research will remain acute until the Reich and the state governments finally establish public institutions which are commissioned to work on these fundamental problems in close cooperation with specialists in the field and with private enterprise. An objective basis cannot be obtained in any other way, for private enterprise alone must give priority to its special interests in every single case in order to survive in its struggle for existence. . . . Beginnings of an objective study of these sweeping economical problems are to be found in the German Board for Economic Measures ("Reichskuratorium für Wirtschaftlichkeit") and in the German Committee for Housing Types ("Reichs-Wohnungstypen-Ausschuss"). But the essential thing is still missing: permanent places for experimentation, which are best established in conjunction with housing-development projects. . . . The extensive work program for these urgently needed centers of research—theoretical and practical—for the rationalization of the building industry is approximately as follows:

1. The setting up of a generous long-range master plan for the entire Reich to enable the economy to plan projects for years in advance
2. The setting up of a national housing finance plan . . .
3. A legal framework for the master plans of cities and rural areas on a long-range basis (city-planning statute)
4. Planned regulation of the organization of transportation facilities and of the building of road networks for the entire country, taking into account the future development of modern transportation. . . . Determination of the minimum requirements for economically favorable local thoroughfares
5. Long-range planning . . . for economical central facilities for the supply of electricity, water, and heating, in order to lower operating costs
6. Determination from the social as well as economical point of view, of the best types of dwelling (apartment house, multifamily house, duplex, single-family row house, individual residence)
7. Determination of the best—socially as well as economically useful—gardens. Kitchen gardens or decorative gardens and estate landscaping . . .
8. Determination of the optimal standard types for dwellings, socially as well as economically (floor plans and elevations), to constitute genuine products of the specific functions of the living unit
9. Determination of the working method for the individual types of housing developments, the required investment capital, the equipment, the operating process, the operating expenses, and results
10. Revision of building ordinances taking into account technological innovations, for the purpose of lowering production costs
11. A study of new space- and material-saving techniques, and investigation of new materials. Conventional brick building techniques and their simplification by the application of economies, cinder-block processes, [etc.], building techniques using prefabricated units . . . , techniques using steel or concrete frames and fill-in modules . . . , methods using steel . . .
12. A study of methods for the industrial production and storage of housing units in order to change seasonal building activity into a year-round enterprise. Production of parts, including ceilings, roofs, and walls, for later assembly
13. Official standardization of building components based on the highest quality obtainable
14. General standardization of housing-installation components and movable household appliances
15. Establishment of guidelines for the organization of plans and cost-estimate blanks for dwellings . . .
16. Establishment of suitable building methods that eliminate chance and the elements of surprise that used to be part of the old methods. . . . Attempts to become independent of seasonal and weather limitations. Elimination of dampness in buildings, proper fitting of prefabricated units, a more stable price and short, predetermined periods of time for building, under guarantee
17. Determination of the most economical small as well as large construction machinery for use at the site
18. Determination of the expenditure of time and energy for each individual part of the production process during manufacture and assembly of the buildings. . . . Preparation of flow charts of work on the site, according to scientific business principles. Setting up of schedules for the rational organization of the building site and of timetables for the control of the length of the individual work phases
19. Determination of the best arrangement of work shifts for maximum utilization of daylight
20. Determination of the most favorable transport methods to the site and within the site
21. Drawing up of accurate tables of price calculations in order to attain reliable figures for comparing building costs.
[Original without capital letters]

Architects' Association "The Ring"
Statement in Connection with the Controversy Dr. Nonn—Bauhaus
From the newspaper "Dessauer Zeitung,"
No. 87, April 13, 1927
Dr. Nonn, a Berlin architect, in a series of articles motivated by resentment against the Bauhaus, larded these most cunningly with what amounted to irrelevant criticism of details (as for instance the technical outcome of experiments). This kind of inflammatory article represented a serious danger to the Bauhaus, since their author enjoyed the prestige of being an expert in the civil service, who published in such professional journals as the "Zentralblatt der Bauverwaltung." Hence, the declaration of support which the Bauhaus received from a top professional association such as "The Ring" was extremely valuable.

. . . Dr. Nonn is fighting vehemently against the Bauhaus. He is one . . . of those experts who feel their expertise doubted and assailed by the Bauhaus. Such experts are not able to see anything but aberrations in the work of the Bauhaus. The indignation at having the pride in their expertise wounded has now once again resulted in a frontal assault by the "Zentralblatt der Bauverwaltung." While the motives for this tirade are quite understandable, its bias is absolutely deplorable. Here is but one example of the superficial way of looking at things that is employed by this criticism: the chair with the three wooden legs and the fourth made of iron is a figment of Dr. Nonn's. Dr. Nonn, despite his critical inspection, did not observe accurately. In reality, the chair belonging to Gropius has the usual four wooden legs. His attack on the other so-called "aberrations" are based on the same superficial kind of observation. But what is dubious about his essay is that it makes it appear as though the endeavors for which the federal government is said to be extending credit had actually not been initiated by Gropius but rather by his opponents, as though Gropius were just now trying to push himself into these endeavors. Has Dr. Nonn forgotten the fact that these efforts (we note incidentally with satisfaction that he considers them important today) are tied to the name of Gropius? Has he forgotten, or does he just want to make us forget, that it was Gropius in particular, and only a very few others with him, who raised and promulgated the demand for standardization and rationalization in the building of dwellings already before the war and even more energetically after the war? Has he also forgotten that Gropius himself has done the work which should have been done by those state and municipal bodies who are responsible for the financing and promotion of housing, and that he has carried this work as far as one man possibly can, with woefully inadequate means? We hold the kind of expertise which is overly cautious and pedantic responsible for the fact that the proper authorities have so long neglected these tasks. But now that the groups of experts are no longer able to evade the problems of building, is it really Gropius of all people who is supposed to threaten them? For the projected experiments nothing could be worse than to end up in the workshops of the biased technical "experts."
We who are friends of the Bauhaus are well aware of the fact that one may argue about the technical problems and attitudes on education which the Bauhaus expounds. But we know also that these technical and educational, let us say, "aberrations," could be corrected without harming the concept of the Bauhaus in any way. For this concept transcends personalities. It is part of the spiritual substance of our time. Hence, it is little affected by particular and temporary deficiencies in the experiments which are concerned with practical implementation, just as it is little affected by the present opposition of those who are still fighting it for lack of sufficient understanding of it. We believe in this idea. We believe that the new content of our age has posed new problems of design, and we cannot imagine a finer sense of duty to one's profession than is demonstrated by daring to cope with these problems. Gropius has started out on this venture and has pursued his idea in the face of failures and of ill will coming particularly from professional circles. With his Bauhaus he has established a forum in which the new problems of architecture are systematically studied and pursued for their own sakes, for no other purpose than clarification, research, and the attainment of knowledge. We are convinced that, in the interest of the profession, such a research institute, such a laboratory for building, should exist, and we believe that the investments employed are well spent. It is only natural for such research to run into some failures, exaggerations, and even aberrations. They are unavoidable. Nevertheless, it is true that in times which demand such a coming to grips with contemporary problems, "the uncertainty about the absolute is still infinitely more meaningful than any material completeness," as Karl Scheffler wrote in 1910 on a similar occasion, when van de Velde experienced what Gropius is going through now. We are of the opinion that the profession will have good cause to thank Gropius for the unselfish pioneering work which he and his co-workers in the Bauhaus have been doing for years now. For this achievement affects the future and prepares the ground for the fruits it will harvest. We welcome any constructive criticism of this achievement, because it will advance the cause. But we reject the attacks of those wardens of expertise who in their sectarian narrow-mindedness scoff at the technical deficiency of solutions without knowing the problems for which they are devised and who, moreover, do not even stop at casting suspicions on the attitude manifested in this pioneering work. . . .
Architects' Association "The Ring"
The secretary, signed Hugo Häring

The District Court in Dessau
Verdict in the Case Against Georg Büchlein, Merchant, July 29, 1927
AD, files of the attorney general in the county court of Dessau, concerning Georg Büchlein, merchant, defendant. . . .
Büchlein was leader of the "Citizens' Club" which was founded expressly to unite the opposition against the Bauhaus. The legal papers document how unscrupulous the conservative circles were in their attempts to undermine the position of the Bauhaus. The defamations which Büchlein spread about the Bauhaus had been disseminated years before by a disciple of a Communist itinerant preacher (Häusser) and by former employees of the Bauhaus who had been summarily dismissed. The verdict against Büchlein did not become effective until April 1928 (after the appeal had been withdrawn), a time when Gropius had already left Dessau.

In the name of the people!
Proceedings against the merchant Georg Büchlein in Dessau, born on September 27, 1858, in Leipzig-Schönefeld. Action brought for libel.
District Court, Dessau
At the session of June 29, 1927, at which were present Justice Dr. Meyer, chairman, Associate Justice Gehre, second judge, the two jurors, store clerk Friedrich Schröder of Görzig and laboratory technician Bernhard Samland of Dessau, prosecutor's counsel Silex representing the district attorney's office, and the clerk of the court, junior barrister Miehe, has returned the verdict:
The defendant is guilty of public libel according to § 185 of the penal code and therefore is fined 500 (five hundred) Reichsmarks. In case of nonpayment, the defendant will serve one day in prison for every 10 Reichsmarks. The defendant is acquitted of the other charges. The plaintiff is entitled to have the verdict published once in each of the following newspapers within fourteen days from the day on which the verdict becomes effective: "Anhalter Anzeiger," "Volksblatt für Anhalt," "Anhaltische Rundschau," and the "Dessauer Zeitung." The publication costs are to be paid by the defendant. The court costs are to be paid by the defendant if judgment is pronounced against him, otherwise the state bears these expenses.
In the name of justice!

Reasons:

Based on today's proceedings the Court deems the following facts proven:

On Wednesday, November 3, 1926, a meeting of the Citizens' Club was held here at the meeting hall of the "Schwarze Adler," which was presided over by its chairman, the defendant, Büchlein. In the introductory speech, the defendant spoke of the so-called "Yellow Brochure," which had been written in April 1924. Quoting pages 10 to 12 of this pamphlet, the defendant read most of a letter written by a former Bauhaus student and follower of Häusser and addressed to the Council of Masters of the then Staatliche Bauhaus in Weimar, attention of Director Gropius. The fact has been ascertained that the defendant brought at least the first two paragraphs of the letter to the attention of the meeting. The defendant avoided giving more detailed information about the author and in particular did not mention his Häusser affiliation. After having read these extracts of the letter, the defendant pointed out that no legal action had been brought by the deeply insulted Professor Gropius against the author of the letter, according to a letter written to him by the author, Arno Müller of Weimar. The defendant also read this letter. It was not established during the proceedings whether at this meeting the defendant had also accused City Councilman Theiss of having received commissions from the Magistrate of the city of Dessau designed especially for the purpose of inducing him not to oppose the Bauhaus. For this reason, the defendant was acquitted of the indictment for libel against the Magistrate of this city and against City Councilman Theiss, which the defendant had incurred because of his charges of active or passive bribery.

The defendant challenges moreover the contention of having affronted the co-plaintiff Professor Gropius. He claims to have merely read aloud two letters in order to call their content to the attention of the citizens' meeting. One of the letters, he admitted, did contain strong charges against the person and honor of Professor Gropius. But the second only stated that the co-plaintiff had not initiated legal action in Weimar regarding the first letter. A hearing of the witnesses has established that at least the first two paragraphs of the letter out of the Yellow Brochure had been read aloud. This is based particularly on the veracity of statements by witnesses Dr. Zoder, Fräulein Sommer, and Fräulein Fieger. Also a consultation of the files No. 3a D 42/24 of the district court in Weimar showed that Professor Gropius had filed a law suit on May 7, 1924. This suit initiated proceedings against the author of the letter, which to this day have not been concluded. The whole letter, in particular the first two paragraphs, is crammed full of serious insults. To demonstrate this, the first two sentences of the second paragraph shall be quoted here. These read, "If you, Herr Gropius, as the chief leader of this flock, were not so dishonorable, so thick-skinned, so cowardly, and so dishonest with yourself, you would have taken the consequences of the complete failure of your artistic abilities long ago. The thief, the intriguer, the coward lurks in every wrinkle of your sly, furtive face." The defendant read these and other sentences before an audience of about one thousand people. He tries to defend himself by referring to the fact that he had wanted to show only the contempt another person held for Professor Gropius, as demonstrated in this letter. The court was however, unable to accept this explanation. On the contrary, the court is of the opinion that the defendant clearly demonstrated his own contempt as well. This fact is borne out in general by the defendant's whole attitude toward Professor Gropius as Director of the Bauhaus, and in particular by his behavior at the meeting in question. At that meeting, the defendant brought to the attention of the audience the gravest assault imaginable against the person of Professor Gropius, which had been raised against the Bauhaus by another person, and this was not done with the intention of merely pointing out the existence of such assaults. For if this were the case, he would not have kept secret the person of the author, as he did. If he had intended to afford his audience a strictly objective appraisal of this case, he should not have neglected to state that the writer of the letter was a follower of Häusser, which most likely would have given the whole matter a different aspect. But instead, the defendant has implied that these charges were justifiably made, since the gravely insulted Professor Gropius did not defend himself against them. The Court is not interested in examining whether the defendant knew about the pending proceedings in Weimar; the fact of the defendant's special reference to Professor Gropius's silence shows his willingness to accept these charges as justified. Moreover, the defendant used the charges in the letter—which must be taken as evident—in order to prejudice those present at the meeting against the person of the Director of the Bauhaus. In fact, this was the only reason for reading the letter from the Yellow Brochure. The defendant is fighting the Bauhaus by fighting its Director; by belittling the Director he hoped to hurt the Institute itself. At a meeting that is devoted exclusively to the above-mentioned purpose of figthing, the reading of a letter containing an accumulation of abuses directed against its Director inevitably must be taken by the audience as the expression of the reader's own contempt for him, unless he clearly states that he does not accept the charges he reads as his own. But quite to the contrary, the defendant used this letter in a manner which made witnesses present at the meeting . . . wonder how the defendant could do that. . . .

Hence it is sufficiently evident that the defendant has publicly demonstrated his own contempt for Professor Gropius. Moreover, he has not acted in observance of legitimate interests in accordance with § 193 of the penal code. . . . The defendant is not entitled to claim such interests, not even as a representative of the Citizens' Club. . . .

In determining the sentence, the court has taken a lenient view of the fact that it cannot be denied that the defendant acted out of an undeniably decent attitude even if his choice of means was not in tune with that attitude. Moreover, he is a respectable citizen and has not previously been convicted. On the other hand, the seriousness of the insults dealt Professor Gropius and the consequences resulting from them both to him and to the Bauhaus cannot be overlooked. . . .

signed, Dr. Meyer; signed, Gehre

Prospectus "8 Bauhaus Books" by the Albert Langen Press, Munich (1927)

The publication of the first "Bauhaus Books" was originally planned for 1924. Gropius and Moholy-Nagy, who were the co-editors, had envisaged a comprehensive series, covering all aspects of intellectual life, of no less than 50 titles. Up until 1931, 14 volumes had been put on the market, some of them in several editions. During the depression it was impossible to continue publishing. This advertisement, announcing the first eight books, came out in 1927 and was—just as were most of the books—typographically designed by Moholy-Nagy.

The Albert Langen Press, Munich, publishes the Bauhaus Books

Editors: Walter Gropius and L. Moholy-Nagy

The publication of the Bauhaus Books is motivated by the recognition that all areas of design are interrelated. These books deal with problems of art, science, and technology, and for the specialist of today they attempt to furnish information about the complex problems, working methods, and research results in various areas of design, thereby providing the individual with a criterion for his own studies and with progress made in other areas. In order to be able to tackle a task of this magnitude the editors have enlisted the cooperation of the most knowledgeable experts from various countries who are trying to integrate their specialized work with the totality of phenomena of the modern world.

Just appeared:
8 Bauhaus Books

		Illustrations	PRICE hard cover Marks	cloth bound Marks
1	Walter Gropius, **International Architecture.** A selection of the finest works of contemporary architecture.	101	5	7
2	Paul Klee, **Pedagogical Sketchbook.** From his lectures at the Bauhaus with his own text illustrations.	87	6	8
3	**An Experimental House by the Bauhaus.** Modern living. New techniques in building construction.	61	5	7
4	**The Stage of the Bauhaus.** Theory and practical work from a modern theater workshop.	42 3 color prints	5	7
5	Piet Mondrian, **New Design.** Demands of the "new design" concerning all areas of artistic work.		3	5
6	Theo van Doesburg, **Principles of the New Art.** Attempt at a new theory of esthetics.	32	5	7
7	**New Work of the Bauhaus Workshops.** Practical examples of contemporary home furnishing.	107 4 color prints	6	8
8	L. Moholy-Nagy, **Painting, Photography, and Film.** A defense of photography and a basic judgment of abstract and representational painting.	102	7	9

The series will be continued in rapid succession.

In preparation:
Bauhaus Books

W. Kandinsky: Point, Line, Plane
Violet (stage play)

Kurt Schwitters: Merz book

Heinrich Jacoby: Creative music education

J. J. P. Oud (Holland): Dutch architecture

George Antheil (U.S.A.): Musico-mechanico

Albert Gleizes (France): Cubism

F. T. Marinetti and Prampolini (Italy): Futurism

Fritz Wichert: Expressionism

Tristan Tzara: Dadaism

L. Kassák and E. Kállai (Hungary): The MA-group

T. v. Doesburg (Holland): The de Stijl group

Carel Teige (Prague): Czechoslovakian art

Louis Lozowick (U.S.A.): American architecture

Walter Gropius: Modern architectural representation—The flat roof—Prefabricated
houses—The new buildings of the Bauhaus in Dessau

Mies van der Rohe: On Architecture

Le Corbusier-Saugnier (France): On architecture

Knud Lönberg-Holm (Denmark): On architecture

Friedrich Kiesler (Austria): New Forms for demonstrations—The space city

Jane Heap (U.S.A.): The new world

G. Muche and R. Paulick: The standardized metal house

Mart Stam: The "ABC" of building

Adolf Behne: Art, craft, and industry

Max Burchartz: Sculpture of design

Martin Schäfer: Constructive biology

Commercial art and typography of the Bauhaus

L. Moholy-Nagy: Structure of design

Paul Klee: Visual mechanics

Oskar Schlemmer: Elements of the theater

Jost Schmidt: Contemporary picture magazine I

The new synthetic materials

Bauhaus Books may be purchased individually or as a series from any bookseller, or
directly from the ALBERT LANGEN PRESS, MUNICH, Hubertus Street 27
An order form is enclosed with this folder.

Laszlo Moholy-Nagy
The Coming Theater—the Total Theater
From the essay "Theater, Circus, Variety,"
chapter 3, published in "The Stage of the
Bauhaus," volume 4 of the "Bauhaus
Books," Albert Langen Press, Munich,
no date.

Especially in his essays on the theater and the
film, Moholy-Nagy proves to be the exponent
of a generation that felt dynamic-kinetic design
to be the purest expression of their techno-
logically dominated sense of living, and of their
pluralistic way of thinking and imagining.

Each and every form starts out from specific premises which, next to general premises, determine the application of its inherent means. Thus, the forms of the theater can be clarified by an examination of the character of their much-debated means, human language and human actions, and at the same time of the capabilities of their creator: man himself.

The origin of *music* as a conscious form can be derived from the melodic recitals of the heroic legends. When these came to be cast into a system that allowed only the use of "*tones*" that fall into definite intervals, and eliminated the so-called "*sounds,*" only poetry was left to explore particular sound effects. This was the fundamental idea on which the Expressionist, Futurist, and Dadaist poets and playwrights based their "sound poems." But today this sensuous and mechanical effect of sound relationships is no longer exclusive to poetry, since music is now embracing sounds of all types. These sound relationships—like tones—are part of the domain of music, just as it is the task of painting, as the domain of the creation of form with color, to arrange clearly the primary (per-ceptional) effects of color. Thus the fallacy of the Futurists, Expressionists, and Dadaists comes to light, and with it the error in all conclusions based on their findings (for example, *exclusively* mechanized eccentricity).

It must be admitted, however, that such ideas, contrary to the attitude of the literary-illustrative theater, have advanced the creative work of the theater. In the process, the dominance of purely logical-intellectual considerations has been broken. But once an end has been put to this domination, man's associations and his language—and hence man himself in his totality as a means of artistic expression of the stage—can no longer be ruled out. However, he is no longer to be used as the focus—as in the traditional theater—but *as an equivalent next to the other means of design.*

The human being, as the most active phenomenon of life, incontrovertibly is one of the most effective elements of a dynamic (stage) design. Therefore his use on stage, in the totality of his acting, speaking, and thinking, is justified functionally. With his powers of reasoning and mental mobility, his sense of accommodation to every situation by control over his physical and mental capabilities, he is—if concentrated primarily on action—predestined to shape these forces.

Were it not for the stage to provide the free range of possibilities for development of these creative forces, one would have to invent a new branch of art in which they could unfold.

But this use of the human being must be clearly distinguished from his performance in the traditional theater up to now. Whereas there the human being was just the interpreter of a fictional individual or character, in the new *theater of totality* he shall utilize the mental and physical means that are at his disposal independently and *productively,* and shall *provide the initiative* in the process of formal creation.

While in the middle ages (and even in the present) the emphasis in theater productions was placed on the representations of the various characters (hero, harlequin, peasant, etc.), the task of the *future actor* will be to express those aspects which are *common* to all mankind.

In the scheme of such a theater the traditionally rational and causal ties can *no longer* play the lead. In considering stage design as a work of art, one has to learn from the way an artist perceives.

Just as it is impossible to ask what a human being (as an organism) means or represents, so it is inadmissable to ask a similar question of a contemporary nonrepresentational painting, since it is a formal "creation" and thus also a complete organism.

Contemporary painting represents diverse relationships of colors and planes which are artistic "creation" by virtue of their attempt at solving a problem logically and consciously on the one hand, and on the other hand, in their (nonanalyzable) intangible elements, conceivable only by the intuition of its creator.

In the same way the "theater of totality" must be an artistic "creation," must be an organism, with all its diverse areas of relationships of light, space, plane, movement, sound, and human being, and with all the possibilities of variation and combination of these elements.

Thus the integration of the human being into stage formation should not be burdened with moralizing tendencies or with economic or *individual problems.* The human being should participate only as a vehicle of the functional elements of his organic constitution.

It is obvious that all other components of stage design must obtain equal status with the human being which, as a living, psycho-physical organism, as creator of incomparable climaxes and innumerable variations, requires a high level of quality from the contributing factors.

58

Piet Mondrian
Must Painting be Considered Inferior to Architecture?
From Mondrian, "Neue Gestaltung"
("New Design"), volume 5 of the
"Bauhaus Books," Albert Langen Press,
Munich, no date
The relationship between the Bauhaus and the de Stijl group was one of friendly rivalry. Hence it went without saying that the Dutch artists should contribute to the Bauhaus Books series. In addition to Mondrian, van Doesburg and Oud had also been asked to participate. The significance of Mondrian's esthetic principle of rigid rectangular order—which above all applied to architecture—was well known to the Bauhaus.
58
Title page for Piet Mondrian, "New Design," volume 5 of the "Bauhaus Books."

Today, where everything is beginning to be concentrated on the practical aspects of daily life, we notice that as a result many people look upon painting as a "game" or as "fantasy." As opposed to architecture, which is looked upon as being "practical" and "social," painting is seen as being merely the "making-more-comfortable of life." This attitude is quite widespread. The Dictionnaire Larousse, says under "agrément" (making more comfortable): "The arts of *agrément:* music, painting, dancing, horsemanship, and fencing." This overlooks the creative and the formal aspects of art, the logical consequence of which is a disguising of the aspect of pure design. It is, thus, a reaction to the abuse of art.—

The confusion of pure design with forms of capricious rhythms turns art into a game. The "lyrical" (descriptive in word or song) beauty that has resulted from that confusion is playful. Lyrics are a remnant of the childhood of mankind and originated at a time when the lyre was well known but electricity was not. If one wants to adhere to lyricism in painting, it will remain nothing more than a nice game. This will be the case both for those who demand or have to demand that art be "practical," and for those who ask it to be "pure design." The first "desire" fantasy and "playfulness" next to dry practicality. The second are not moved by capricious playfulness in art. But has not the time arrived for those who seek playfulness and fantasy in art to go and find them in the cinema and the like, if they cannot see and gain these things in their everyday life? And that art shall become pure "art"?

Even if architecture may not be looked upon as being "playful," it is in other respects still a purely "making-more-comfortable" of life. At present, architecture often proves to be the practical, and painting the ideal expression of subjective human, rather than of creative, feeling for design. Today this feeling for design is secondary, same as it has been in all previous periods of art. For all sculptural forms relegate pure design to the background.

Pure design is not a reproduction of life. It is the very opposite. It is the equivalent representation of things that are permanent and those that are transitory. It is design with straight lines. As a result of the "new esthetics," painting and architecture are consistently executing compositions of counterbalancing and contrasting straight lines, thus changing the duality of the unchangeable right angle into multiplicity.

As preparation for a universal realization of beauty, a new art and a new esthetic are needed.

Architecture was refined in practical building projects through changed requirements, new techniques, and new materials. Necessity has already led to a pure design of balance, hence to a refined, chaste beauty. But without this new knowledge of esthetics such beauty remains uncertain and accidental. Or, this beauty is once again lost because of unclear concepts and because of concentration on irrelevancies.

The new esthetics of architecture is the same as that of painting. And building, which is in the process of clarifying itself, is already putting into effect the same findings that painting realized in the "new design" after a process of purification heralded by Futurism and Cubism. Because of the unity of the "new esthetics," building and painting can constitute *one* art and mutually absorb each other.
(Paris, 1923)

abcdefghijkl
mnpqrstuvw
xyzag dd

abcdefghi
jklmnopqr
stuvwxyz
a d d

Wilhelm Lotz
On the Design Work of the Metal Workshop of the Dessau Bauhaus
(A contribution to the discussion: ''On the question, Bauhaus Dessau and the precious-metals industry—On the question of the trade school'') From the newspaper ''Deutsche Goldschmiede-Zeitung'' (Leipzig), January 14, 1928
In a letter to the editor, Moholy-Nagy had called for closer cooperation between industry and the workshops of the schools. This letter started a hot debate, in the course of which the serious misunderstanding between the trade circles and the Bauhaus proved to be based on a lack of communication about the nature and role of the ''industrial designer'' (and consequently of the aims of the Bauhaus).

Herbert Bayer
Typography and Commercial Art Forms
From the journal ''bauhaus'' (Dessau), Vol. 2, No. 1, 1928
As a typographer and advertising specialist, Bayer made one important correction to Moholy's concept, which was primarily influenced by esthetic principles: He emphasized the significance of psychological factors in typography and advertising. His own design and his teaching were set up accordingly. Shortly after this review of his work had been published, Bayer resigned from the Bauhaus.
59
Herbert Bayer: Design for the ''Universal'' type face. Narrow version (above) and regular version (below). In the last line of each, specimens of boldface, semibold, and regular are given for comparison. The construction scheme (in the right margin) shows the basic elements of the type, which is constructed of a few curves, three angles, and vertical and horizontal lines. Original concept 1925; revised 1928. PA, H. Bayer, Aspen, Colorado.

... I think that Moholy-Nagy has an entirely different idea of the definition of ''craftsman,'' not the craftsman who produces with his hands, but the person who oversees and directs the process of production in the crafts as well as in industry and by means of this supervision and direction is in a position to influence the design of the product. It makes no difference whether the prototype model, which is to be reproduced by industry, happens to be made by hand or whether a machine can be employed. In either case his design is logically and rationally developed in accordance with the methods of machine production. He is actually the designer in industry. One can say he is more engineer than craftsman. He is fundamentally different from a factory worker. The term ''craftsman,'' then, is a professional qualification for someone who has command of the entire process of production, like the medieval craftsman.... This conception of the craftsman is a consequential enlargement on ideas attuned to industrial production, which have brought about the reorganization of our arts and crafts schools. Arts and crafts schools banished the design draftsman and replaced him with the creative artist-craftsman who is supposed to create his new forms based on the materials and techniques of the workshop. It would have perhaps been better to find a new name for this new craftsman whom the Bauhaus wants to create. That this has not been done may be due to the fact that the Bauhaus group, as has been frequently mentioned, considered the crafts to be a quickly disappearing part in the manufacture of goods. Moreover, they thought that the crafts would be completely replaced by industry, with the possible exception of the trades concerned with repair and installation.... This up to now somewhat one-sided attitude of the Bauhaus, which does not quite coincide with reality, can be well understood, for every innovator who is consistent commits himself wholeheartedly to that field which seems to be on the side of progress. In the process he neglects the remaining areas. The Bauhaus is only interested in influencing industry. Its entire work is based on the nature of industry.... The metal workshop of the Bauhaus, as far as precious metals are concerned at all, works only with silver and prepares prototype models for serial reproduction of consumer articles. It is not in the interest of the Bauhaus idea to produce jewelry or trophies for specific purposes ...

The endeavors of the Bauhaus [to integrate the areas of functional design, after their elements have been studied, into ''architecture''] apply to the area of advertising (publicity) as well. In this area the same economic, social, and ethical considerations and the same questions of form are pertinent. As a consequence of competition, advertising has become a necessity today. But it is also an expression of our culture and a factor in our economy, and hence it is a characteristic feature of our age.
The art-printing workshop in the Weimar Bauhaus served to reproduce free graphics by means of copper-plate printing, lithography, and woodcut techniques. When the workshops in the new building of the Bauhaus in Dessau were equipped, nothing but a more mechanized, technical printing workshop could be considered. Hence, a small book printshop was set up as a student workshop. While filling orders for printing jobs, the students practiced handsetting, printing, and design. Their work was not the fashionable and ''estheticising'' kind in the sense of ''commercial graphics,'' but rather the kind based on the understanding of the purpose and a better utilization of typographical materials, which up to date had been enslaved in the traditions of antiquarian styles.
The system of elemental typography which was first developed by the constructivists doubtlessly pointed out basically new ways of thinking in typographical work. Most of all, it led to a typography built on the inherent qualities of the material, from which a typesetting technique could be developed. The call for clarity, precision, explicitness, and abstract form (in the layout as well) was well received, especially in Germany. The reason for that was probably that the application of visually simple forms and primary colors is related to the general notion that publicity is somewhat primitive. Explicitness is an important requirement, but it is only one of many requirements. Superficial imitation, however, misunderstands or overlooks the actual meaning, namely functional application of the elements. A quick adoption of nothing but external appearance was the result. An example of the proliferation of the ''Bauhaus style'' is seen in the order book of a Frankfurt printer; nearly half of all printing orders received in one year called for work to be done in the ''Bauhaus style.'' What remained were merely heavy dots and bold lines or even ornaments and imitations of nature carried out with typographical material. This meant being right back at the point of departure. Nevertheless, the experiences gained from this development were valuable. A look at what happens in advertising where there is less design consciousness (for example, the U.S.A.) evokes the thought that neither the decorative-speculative, nor the elemental typographical approach to advertising is the right one.... To ''design advertising'' implies not only designing in good taste; ... a truly ''objective'' approach is only one that can prove the outward appearance to have deeper causes, that is to say, that the essential aspects of the problem are understood before and during the design process.
... Functional advertising design should be based primarily on the laws of psychology and physiology. Advertising design today is almost exclusively dealt with on the basis of intuition. Consequently it is still impossible to estimate its success reliably or to aim accurately ... Such thoughts gave rise to instruction in commercial art built on a broad base. Typography should be looked upon as one integral part of that ...
[Original without capital letters]

Walter Gropius
Submission of Resignation to the Magistracy of the City of Dessau
BD, Gropius collection (copy)
Gropius's resignation was submitted to the magistrate by Mayor Hesse on February 4, 1928. His contract was terminated, in compliance with his request, on April 1 of the same year.

Ise Gropius
Gropius Proclaims his Intention to Resign to the Students
Notes of February 4, 1928 from the diary 1924–1928
BD, Gropius collection (First publication)
The painter Fritz Kuhr was one of the student representatives at that time.

A student of the Bauhaus Dessau
Notes on the Announcement of Gropius's Intention to Resign
From the bequest of Otti Berger
BD, Gropius collection (First publication, in excerpts)
Compare Schlemmer's very lively description of the events, which he put down in a letter to his wife on February 5, 1928, published in "Briefe und Tagebücher" ("Letters and Diaries") (Langen-Müller) pp. 288 ff.

Anonymous critic
On the Resignation of Professor Gropius
From the newspaper "Anhalter Anzeiger" (Dessau), No. 32, February 7, 1928
This anonymous contemporary critic, used sovereign judgment in recognizing the achievement, the uniqueness, but also the weakness— the deficiencies in methodology—of the Gropius era. The deeper insight that the lack of system was a manifestation of the exuberant vitality of the early Bauhaus and that it was indissolubly bound with its vitality, was probably impossible to gain from a contemporary point of view.

Walter Dexel
Why is Gropius Leaving? (On the Bauhaus Situation)
From the newspaper "Frankfurter Zeitung," Frankfurt on Main, No. 209, March 17, 1928

Dessau, February 4, 1928
Dear Sir,
After careful consideration I have decided to leave the sphere of activity here, and request an opportunity to discuss with the magistracy an early termination of my contract. I would like from now on to be able to work and develop free from the restrictions of official duties and responsibilities, especially as my public commitments outside Dessau are steadily increasing. I am convinced that the Bauhaus today is strengthened, both inside and out, to the point where I can leave the future leadership of it, without detriment, to my co-workers who have been very close to me both personally and professionally. I intend, in close cooperation with the institute, and with the agreement of any former colleagues, to carry the ideas which have been developed in the Bauhaus into broader applications and to build foundations for them in outside practice.
As my successor I propose Mr. Hannes Meyer, the leader of our department of architecture, whom I deem capable, in his professional and personal qualifications, of leading the Institute to further successful development.
Yours respectfully, Gropius

Dessau, February 4, 1928
. . . Since the news was published in a special newspaper edition that very same evening, Gropius had to announce [immediately] to the students, who had arranged an evening dance, his intentions of resigning. The mood was so downcast that only after long pleading was Gropius able to get the students to continue their dance. But the situation gradually became so explosive that Kuhr stood up and delivered a long speech protesting against Gropius's resignation. He did this in such a moving and convincing way that he was immediately supported by all the Bauhaus members, and it proved to be a very difficult situation for Gropius. In the excitement, Kuhr went so far as to declare Meyer's succession to be a catastrophe; this brought the general mood to such a low point that finally Moholy brought himself to speak up for Meyer in order to prevent a general revolt. In the course of his address, his wonderful unselfishness and his ardent concern for the Bauhaus came out clearly and made a strong impression on everyone. Unfortunately, the students had gained the idea that Meyer had [little by little] pushed Gropius out. It was impossible to find a way of explaining to them that . . . Gropius had hired Meyer to be his likely successor and that this was the very reason for selecting him. Because some of Meyer's actions were not quite loyal toward Gropius and Moholy, he lost sympathies widely, and this was now resulting in immense difficulties. It was interesting to note how the students now appreciated one of Gropius's most important characteristics—his adaptability and his flexibility—which in the early days they had taken for weakness and indecisiveness. They now understand that it was only through this skillful and undogmatic leadership that the Bauhaus has come to mean what it means today. Only in this atmosphere were many people, often opposite in nature, able to develop, and that fact prevented the Bauhaus from becoming a one-sided, stereotyped school.

Kuhr: "There are several things I must say about Gropius's resignation. For you to have given up the whole affair in order better to be able to work was a grave mistake. Even though we haven't always agreed with you, and though you have often led us around by our noses, so to speak—we were fully aware of that—you are still our guarantee that the Bauhaus will not become a school. For the sake of an idea we have starved here in Dessau. You cannot leave now. If you do, the way will be opened for the reactionaries. Hannes Meyer may be quite a fine fellow; I don't want to say anything against him. But Hannes Meyer as the Director of the Bauhaus is a catastrophe."
Gropius: "I subscribe to everything that Kuhr has said about the Bauhaus. But on many other points he is becoming hotheaded. When I leave here now, I am not giving up the whole affair, and [it will] not harm the Institute, because my successor will not be hampered by all the personal difficulties that have been put in my way for the past nine years. And leaving will be better for my own development. [Until] now ninety percent of my efforts were expended defensively. Today the Bauhaus is one of the leading members of the "modern movement," and I can serve the cause far better if I continue working for it in another part of the movement. *Your* job now is to work constructively and positively. Everything has been set up so that the Institute will be able to take a change of personalities without disruption."

. . . He has created a framework that will be filled out by coming generations . . . Gropius has built up the Bauhaus, but he was not able to organize it internally in such a way as to be beyond criticism. . . .
From this point of view the entire Bauhaus activity from 1919 on is a splendid game by a group of artists who with rare naiveté, zest, and devotion believed that, being on the threshold of a new age, they could achieve miracles. They didn't see how much bitterness and distress in the way of abstract-mathematical concentration lies behind an industrial product, for example, of whose design one was somewhat envious. Just as one lets children play and does not want to disturb the naiveté of their creativity, one has observed the wonderful play of forms created by these people, who, precursors of a new age, walk among us disgruntled, stubborn, and cold people. . . .

Gropius is leaving—and there is talk about a crisis in the Dessau Bauhaus. That is both correct and false. It is false, because a crisis is something of a temporary and pressing nature and is based on specific events. But this is not the case here. If a Bauhaus crisis exists at all, then it is in a permanent one—it has been struggling ever since it came into being.
It is one of the most hated institutions of the "new Germany." It has become a first-class

The relatively modest income which the Bauhaus received from the development of prototypes for industrially manufactured articles in no way justified the expenditures they had required. But it was also out of all proportion with the unremunerated inspirations from which industry profited. Occupying a position of neutrality, Walter Dexel was better able than Gropius to speak of such facts publicly. But just like the Bauhaus manager at Weimar, Emil Lange, before him, he also correctly judged the difficulties as being to a large extent the result of the administrative peculiarities of the Bauhaus.

target in election campaigns. Newspaper clippings pro and con have piled up to veritable mountains in its archives. And the end is still not in sight.

What actually is the Bauhaus? . . . In a constant struggle Gropius succeeded in creating a productive, economically and scientifically exploitable institute in place of a purely "teaching" institution such as the academies and vocational schools still are. Experience has changed the original program. Today the Bauhaus is, or pretends to be . . . a laboratory for the development and testing of useful prototypes that can be mass-produced by industry at a considerably lower price. This means the Bauhaus is not producing directly but rather indirectly, after the manner of research institutes and experimental laboratories at universities and large industrial enterprises. It cannot support itself with its own production, as was once envisioned in Weimar. The manufacture of costly individual items lies outside its scope of its interest, while the mass production of goods is neither within its means, nor is it its job. Therefore, the Bauhaus costs money and requires a considerable budget in order to be able to work.

If our large industries were nationalized, things would be much simpler. In that case, the government would be able to appropriate larger sums for a great number of such laboratories or Bauhauses from whose work it would benefit directly. Instead, things are such that the real beneficiary of the Bauhaus work *could* well be industry which, however, makes only limited use of the research results of this institute. But for the time being it also is not at all inclined to contribute any significant financial help. Even so, the number of license agreements has risen sharply during the past year (more than 40 prototypes of the metal workshop are being industrially mass-produced, and to an even greater extent tubular and other furniture, and products of the weaving workshop), but there is still no chance of receiving regular support for new, large-scale experiments. Such experiments can never be conducted without actual commissions—on a very modest level, of course. The finances are not even sufficient for models or finished work to be seen in adequate numbers in the Bauhaus.

There have been rumors of large subsidies. There is talk of 350,000 marks which the National Research Society ("Reichsforschungsgesellschaft") is supposed to have given the magistracy of the city of Dessau, and such sums are mentioned (mostly with howls of protest) in connection with the Bauhaus. But the Bauhaus receives no part of that. The money is appropriated for the construction of dwellings, in the course of which Gropius directs systematic experiments, testing new building materials and construction methods. These dwellings as well as the new buildings for the Department of Labor of the City of Dessau will continue to be constructed by Gropius even after his resignation. The Bauhaus students will have an opportunity to learn, they will have some chance to work on these projects, but their budget is not strengthened by that.

To enable full utilization of the theoretical possibilities which have been worked out so far by this culturally most significant institute will require that industry and the circle of friends of the Bauhaus find ways and means for providing it with larger financial contributions for experimental work.

The city of Dessau is not to be blamed. It has done everything possible. Rightist political intrigues . . . cause never-ending annoyances but no significant damage, at least as long as the present parliamentary structure remains.

The Bauhaus was Gropius's idea and he put it into practice. Today it is strong. It has reached its possible capacity of 160 students, it is successful, and it has attained world renown. It functions as far as its finances permit, but it does not work fully in accordance with the letter of its program and only implements a part of what its Director up to now had intended it to accomplish. Gropius, the grand organizer, has become tired. He prefers to concentrate his energies on his own work, instead of dissipating them by constant bickering against hostile forces and currently, futile attempts to find a stronger and more lasting financial basis for the institute. This is his reason for leaving.

The resignations of the other Masters Moholy-Nagy, the head of the metal workshop, and Marcel Breuer, the head of the cabinetmaking workshop are not due to Gropius's departure but have similar reasons. For Breuer's work to get ahead, he must be able to experiment on a large scale. He hopes to find a better chance for close connections with industry when he is working as a freelancer. Moholy-Nagy's resignation, too, has personal as well as professional reasons. Together with Gropius he will continue editing the Bauhaus Books which are published by the Albert Langen Press, and he will stay in close contact with the Bauhaus, as will the other departing Masters.

Now, the question arises, will the "new man" succeed in intensifying the work of the Bauhaus in some way with the presently available means? He is . . . Hannes Meyer, a Swiss architect who has worked at the Bauhaus for about a year now. He did not issue a program. Up to now he has built up the architecture department of the Bauhaus, which was not active as such prior to his arrival. It seems that he will be teaching more than Gropius did, or than was possible for Gropius to do. His first achievement has been to have the city agree . . . to let the architecture department of the Bauhaus erect [a number] of experimental houses. One usually thinks that there have been many opportunities for such experimentation so far. But the truth is that this represents the first opportunity for the architecture department of the Bauhaus to experiment on a larger scale since the Weimar experimental house "am Horn". . . .

The new Director will . . . have to search out new ways and means to modify the program, despite the existing difficulties, without significantly altering it. It will have to be modified in such a way that these difficulties can no longer exert their influence as they do now. This is surely no easy task. But he certainly lacks neither the practical capabilities nor the ideas required for it. His designs for new schools are as well known among professionals for their straightforwardness as is his prize-winning design for the League of Nations Building in Geneva among nonprofessionals.

137

6 Bauhaus Dessau
The Hannes Meyer Era

60
Signatures of Hannes Meyer and the faculty and
lecturers appointed by him:
Hannes Meyer
Hans Wittwer
Alfred Arndt
Edward Heiberg
Ludwig Hilberseimer
Walter Peterhans
Johannes Riedel
Alcar Rudelt
Mart Stam
Friedrich Engemann
Anton Brenner

Hannes Meyer
Address to the Student Representatives on the Occasion of his Appointment as Director
Notes from the bequest of Otti Berger
BD, Gropius collection (First publication)
Shortly after Gropius's resignation—sometime in February 1928—Hannes Meyer, the incoming Director of the Institute, addressed the student representatives, outlining his educational program. The address had a strong leaning toward a politico-philosophical and collectivist point of view which marked the direction in which the Bauhaus was going to develop during the coming years; it initiated a new era.

... You speak of chaos and I admit that this term is not entirely false. But chaos is not only to be found here in the Bauhaus; the whole world is full of unresolved problems. I am convinced that we, as human beings, are living for no other reason than to solve the problems posed by life. There is absolutely no reason, then, for us to hang our heads low. Concerning internal affairs, I concede that it was a mistake to present you with a *fait accompli* with respect to the change of Directors. But this was only a mistake in theory. Please try to imagine the practical consequences, particularly in respect to external policy, which would have resulted from prior discussions of such a proposition. Nothing would have changed in fact, but the matter would have been exploited to the utmost by the opposition press. Before the decision could be published, a successor had to be chosen. The Bauhaus stood or fell on this point.

The organization of the Bauhaus, if it is to be viable, must be guided by the given facts. It is not possible to reorganize the Bauhaus completely, neither today nor later, nor is this intended. First of all, the organization is going to be geared to the budget. It is impossible to convert the Bauhaus into a scientific school for the simple reason that the small budget does not provide any means for appointing the needed scientifically trained faculty. Moreover, it is not up to the Director of an institute to give it his personal stamp. He is merely the man who is supposed to coordinate all the paths that converge in him and form one constructive entity.

Let us compare the Bauhaus with a factory. The Director is merely an employee, and a change of employees does not disturb the entire set-up. What is the Bauhaus supposed to be and what has it been up to now? It is supposed to be a combination of workshop activity, independent art, and science. The workshop does not merely provide practical training but is meant to develop design ability. Independent art is self-explanatory, and as far as science is concerned, I think that it too is a purely mental activity having nothing to do with dull school methods and red tape.

Why are there conflicts within the Bauhaus about matters of theory and practice? These conflicts are actually identical with those we have with people outside, and they are rooted in a lack of mutual understanding, in the absence of personal communication between human beings. We must approach everything with a little better grasp of psychology. Psychology is everything. But the primary factor we have to deal with is the activity of the mind. I intend to establish a close personal relationship with the students. I admit that this has not been the case so far. I am also sorry to have to confess that I know some of the workshops by their names only. From now on all this is going to change. But this mutual getting to know each other should not just be something for me to work on; it is of vital necessity for all Bauhäusler, Masters as well as students. If you should get into a situation that leads to misunderstandings, I ask you to approach the matter from a psychologic point of view, and then the situation will clear itself.

I have various reasons for wanting to make a few more remarks on the years in Weimar. It was the postwar period, the period of revolution and romanticism. All those who participated, feeling like the "children of their time" were right to do so. It would not have been merely unnatural but indeed wrong not to have been moved in such stirring times. But now the conflict for these people [which makes it difficult for them] in finding their way to us is [this]: They have not been aware that a new age has begun. They should, for once, open their eyes and look around in their environment; then they would notice that conditions have changed radically. Today, as yesterday, the only correct thing is to be "children of [one's own] time". . . .

Our work at the Bauhaus is also linked to this problem. Is our labor going to be determined by internal or by external factors? Do we want to be guided by the requirements of the world around us, do we want to help in the shaping of new forms of life, or do we want to be an island which [promotes the development of the individual] but whose positive productivity, [on the other hand] is questionable? I think that much of the discontent in the Bauhaus can be traced to such difficulties. At least in my architecture department I have observed that work there is suffering somewhat, that people do not know what they are working for because their work is not yet in as close a relationship with the outside world as would be desirable. These people were [almost] in a state of neurosis. . . . Long before the negotiations on the budget began and long before there was any mention of a change in Directors I have revised the curriculum thoroughly.

The draft which you see here is the work of the summer, not that of the conferences of the Masters. I ask you to take this whole thing as nothing more than a draft that will require many changes and improvements. Only a few sections—such as the special section on the architecture department—have been more thoroughly worked out. Hence, I would like to ask you to check these sections particularly carefully and to tell me if they are acceptable. The other sections, above all the departments of painting, are virtually not worked out at all. There I lacked the cooperation of the . . . professors. I would now like to ask [particularly] the students of these departments to give me . . . practical suggestions.

Lyonel Feininger
Extract of a Letter Dated June 29, 1928 to Julia Feininger
BR, gift of Julia Feininger (First publication)
Moholy and Muche were neighbors of the Feiningers on the Burgkühnauer Allee. Muche had left Dessau by July 1927. Moholy was determined to leave once Gropius had resigned, and Breuer and Bayer also left to work elsewhere. Albers and Scheper moved into the homes of Moholy and Muche, and Hannes Meyer moved into Gropius's house.

Deep, June 29, 1928
. . . Now the Moholys are leaving too! Well, now there will really be a gap that cannot be filled. The Muches and the Moholys! All the many people who were welcomed next door at number 2 with loud cheers! Moholy's friendly and strong voice which could be heard in the studio during his conferences! He provided for the exchange and circulation of Bauhaus ideas and was the most amiable and helpful, most vital person. . . .

Josef Albers
Creative Education

From "VI. Internationaler Kongress für Zeichnen, Kunstunterricht und Angewandte Kunst in Prag, 1928" ("Sixth International Congress for Drawing, Art Education, and Applied Art in Prague, 1928"), published in Prague 1931

In this lecture, delivered in Prague in 1928, Albers explains the methods and aims of the workshop training as practiced in the Bauhaus preliminary course. Another version of this lecture was published under the title "Werklicher Formunterricht" ("Practical form instruction") in the journal "bauhaus" (Dessau), Vol. 2, No. 2/3, 1928.

. . . The best education is one's own experience. Experimenting surpasses studying. To start out by "playing" develops courage, leads in a natural manner to an inventive way of building and furthers the pedagogically equally important facility of discovery. . . . Inventiveness is the objective. Invention, and re-invention too, is the essence of all creative work (proficiency is a tool and hence is secondary). Instruction in professional techniques hampers inventiveness . . . Pioneers have often started out as nonprofessionals . . .

Thus, first we seek contact with the material, the more general, broader field. For that, we have the term "feeling for materials." . . . Thus, we give [the students] material to handle. So that they may "handle" it thoroughly, we take all tools away [from them] if possible. We have a good variety of tools and also small machines in our elementary workshop, but they are kept away from the students at first, especially at the beginning of a new chapter in the work with materials. This forces us to begin thinking and doing on our own without introductory instruction, without method, and without tools. And this occurs extremely easily with unlimited competition.

The restriction imposed on the use of tools soon leads to a limitation in the applicability of materials, so far as these are known. Because something that is known can no longer be invented. An example: "outside," that is in industry and the crafts, paper is usually used as a flat sheet and is glued. In that process, one side of the paper often loses its expressiveness. The edge is hardly ever used.

This induces us to utilize both sides of the paper, in an upright, folded, or sculptural manner, with emphasis on the edges.

Instead of pasting it, we will put paper together by sewing, buttoning, riveting, typing, and pinning it; in other words, we fasten it in a multitude of ways. We will test the possibilities of its tensile and compression-resistant strength.

In doing this, we do not always create "works of art," but rather experiments; it is not our ambition to fill museums: we are gathering "experience." Our treatment of materials, then, is intentionally different from that on the "outside." But not on principle. Not in order to do things differently (that would mean paying attention to form); rather we do not want to do things the way others do them (this means emphasizing the method). That is to say: we do not want to imitate, we want instead to search on our own, and to learn to find out things on our own—we want to learn to think constructively.

Later we also glue paper together, but only after we have tried other methods and have found them to be inadequate.

In order to be even surer of avoiding the use of materials in their known application, we prefer to work with such materials or constructive elements as have not yet found a usage or application, or whose treatment is not yet known. For example, we construct with straw, corrugated cardboard, wire mesh, cellophane, stick-on labels, newspapers, wallpaper, rubber, match-boxes, confetti, phonograph needles, and razor blades.

While experimenting, the students often recognize that presumed innovations are already in existence. But there is no harm in that, because the end effect is the experience which the student has gained for himself and hence is a possession, for he has learned and not merely been taught. . . .

We know that this learning process through experimentation takes more time, entails detours and wrong directions. But at the beginning things do not always go right. Walking begins with crawling, and speaking with baby talk. And mistakes that are recognized promote progress. Consciously roundabout ways and controlled mistakes sharpen criticism, teach by experience, and promote the desire to do things better and more accurately. The experience gained in dabbling with materials is often communicated more easily from student to student than by the older, further removed teacher. This is the reason for discussing the work almost daily with the students and having them justify what they have done.

We require a thorough justification for the selection of the material to be used, the manner of working with it, and the forms which are to be employed. The projects are evaluated according to the proportion of "effort" to "effect."

Adding two elements must result in more than just the sum of those elements. The result must also yield at least one relationship. The more these elements strengthen each other, the more valuable the result, the more effective the project.

Thus, an important aspect of the teaching—economy—is stressed. Economy is understood in the sense of thrift in labor and materials and in the best possible use of these to achieve the desired effect.

Practical thrift is [realized] by planning [which] is required prior to every construction. . . . New materials will only be approved when their intended application has been justified. Preliminary tests must be made with the smallest samples, and when dealing with costly materials they must be carried out with less expensive ones where possible. All materials should be used with as little waste as possible.

Thrift makes for an emphasis on weightlessness. Volume can be overcome more effectively by the plane. Graphic constructions are of even greater interest. Greatest interest is evoked by emphasis on the point or the relationship of points.

Interest is further strengthened when mathematical elements [appear] as "negative" elements, that is to say, as voids or as relationships of scale. This creates much stronger effects and greater coherence.

Perhaps the only entirely new and probably the most important aspect of today's language of forms is the fact that "negative" elements (the remainder, intermediate, and subtractive quantities) are made active. . . .

Discussions of the terms positive and active, negative and passive, provides an opportunity to explain the sociological origins of our form language.

Placing the same value on "positive" and "negative" elements makes it impossible for something to remain "left over" . . . We no longer differentiate essentially between those

elements which are "carrying" and those which are "carried," between those "serving" and those "served." Every element or component must be one that is "aiding" and "aided" at the same time, it must be both supporting and supported. Thus the frame and the base, which must "raise" an object, become superfluous. We will get rid of the "monument" which, on a big supporting base, carries but a small supported object.

If in a form there is something that is not utilized, then the calculation has been wrong, for coincidence then plays a part and that is unjustified and unjustifiable. Moreover, it is senseless because it usually results from habit.

Thrift . . . is sought by testing the maximum strength of the material (maximum height and width of the construction and highest stress), the maximum resistance to tensile and bending stresses, the closest connections, the smallest and weakest base . . . Increasing the stress to the point of failure of the material shows where the stress limit is and leads us to use related or else opposite materials. Thus arises . . . the wish to combine and mix various materials in order to enhance their properties . . .

Learning in this way, with emphasis on technical and economical rather than esthetic considerations, results in static and dynamic attitudes; it demonstrates the links between organic and technical properties, while negating their opposition. Apart from leading to thinking in terms of building and construction, it trains the rarer quality of spatial imagination. It provides for the friendly and collective interchange of experiences and [produces] agreement on general and contemporary principles of form—it counteracts the exaggeration of individualism without hampering real individuality.

Individualism is not primarily a school concern, for individualism stresses particularity and separateness. It is the task of the school to integrate the individual into the society and the economy and to have him partake in the activities of his time. The cultivation of individuality is the individual's task and not that of collective enterprise as represented by the school. The school should cultivate individuals passively—by not interfering with personal development. . . . Sociological economy has to reject the personality cult of the current educational system. Productive individuality asserts itself without and despite school education.

We come now to a different, more formal and freer area of experimentation, to the so-called exercises with "matter." These alternate repeatedly during the semester with the material exercises. The exercises with matter are not concerned with the inner qualities of the material but rather with its external appearance. The relationships of the epidermis, the skin, of the material are explored—according to relatedness or contrast. "Like attracts like" and "opposites attract one another." Just as one color influences another by timbre, interval, tone, and tension, so surface qualities, visual or tactilely experienced (with the fingertips), can be related. Just as green and red are complementary to each other, hence are both contrast and balance, so bricks and burlap, glass and wax, aluminum foil and wool, cotton and thumbtacks relate to each other.

We classify the kinds of surfaces according to their structure, facture, and texture. They are used by being painted rather than in material constructions, so that spatial qualities, intersections, mixing, and interpenetration occur by illusion.

[The special interest in the exploration of "matter" appeared during the epochs which were particularly oriented toward structure; it has] been almost completely lost since the Gothic era. At that time one still knew how to combine wood with iron and color, [or] stone and glass and color, until the Renaissance began to build facades entirely of one material, and garments continued entirely in one type of fabric.

[Furthermore] we are translating and producing factures and structures. The group discussions of the results of the exercises induce accurate observation and a new way of "seeing." These discussions show which formal qualities predominate today—harmony or balance, rhythm or scale, geometric or arithmetic proportion, symmetry or asymmetry, rosette or row—and in conjunction with that, what holds more interest—complicated or elementary form, multiplicity or simplicity, composition or construction, mysticism or hygiene, volume or line, beauty or prudence, ancestral portraits or toilets.

The . . . inductive method of instruction attempts to develop responsibility and self-discipline—toward ourselves, the material, and the work. By letting the student work with different materials and tools and by having him visit different industries, this teaching method helps him find the areas of work and the kind of materials that suit him best, and eventually determines his selection of a vocation . . . It attempts to be a training in flexibility providing the broadest possible [nontechnical] basis in order not to let later specialization be isolated. It wants to lead to economical form.

This method stands in contrast to that of vocational school training which "inculcates" manual skills. . . . If one does "a bit of" cabinetmaker's work, "a bit of" tailoring, and "a bit of" bookbinding, one arrives at dilletantism in the bad sense of the word . . . "Also" sawing, "also" planing (the most difficult work in the cabinetmaker's shop), and "also" cutting cardboard and gluing remain unproductive, because these activities do nothing but keep one occupied. They do not satisfy the creative urge.

Thus: no "fiddling around" but building. . . .

The Bauhaus in Dessau
The Compulsory Basic Design Courses of Albers, Kandinsky, Klee, Schlemmer, and Schmidt (1928)
From catalog for the International Congress of Art Teachers, Prague 1928
This excerpt, from the catalog issued on the occasion of the exhibition held in connection with the Congress of Art Teachers in Prague, 1928, presents the program for the basic art education at the Bauhaus, which was compulsory in the early days of the Hannes Meyer era.

Albers's course: learning-by-doing (1st semester)
Subject:
The fundamentals of workshop experimentation.
Use of material with respect to
a) dimension (volume, space, plane, line, point)
b) movement (statics—dynamics)
c) mass (proportion—rhythm, addition—subtraction)
d) energy (positive—active, negative—passive)
e) expression (color, light—dark, matter)
in projects which either are chosen or given.
Collecting and systematically tabulating materials. Visits to workshops and factories.
Area:
Exercises with matter and with materials (repeatedly interchanging).
1. Matter: the relationship of the external appearance of the materials.
Turning to account of structure, facture, and texture of materials.
2. Material: construction for the testing of performance and utilization.
Objective:
To discover and invent independently, the emphasis being placed on economy and responsibility,
Self-discipline and critical ability,
Accuracy and clarity.
For the choice of a vocation: recognition of the area of work and the kind of materials that suit the individual.

Kandinsky's course (1st semester)
I. Abstract form elements
a) Introduction:
analysis in the 19th century, remaining elements of synthesis, beginning—end, new basis for synthesis.
b) Color theory:
isolated color, system of colors, interrelationships, tensions, effects, fitness.
c) Form theory:
isolated form, system of forms, interrelationships, tensions, effects, fitness.
d) Color and form theory:
relationships of colors and forms, arrangement of the same with respect to tensions and effects.
e) Base: tensions.
Method of instruction:
Lectures, exercises by students on subjects that are either chosen or assigned, group discussions of projects, and exercises in accurate analysis.

II. Analytical draftsmanship
a) Elementary:
accurate drawing or still lives arranged by the students themselves,
limited plane, large-scale form, simple relationships.
b) Development of the structural network:
Primary problem: accurate relationships between the individual groups of forms and of individual forms to large-scale forms.
c) Translation
of the object into structural tensions, emphasis of the supporting elements, dynamics, focus.
d) Utilization
of color in order to systematically reinforce the results of the projects of (c).

Klee's course: elementary design theory of the plane (2nd semester)
 I. General
1. Explanation of design theory
2. General orders
3. Specific orders
4. Composition

 II. Planimetric design
 A. Rule
5. Approaches to form, occurrence of tensions, schemes
6. Elementary form
7. Form in respect to shape and size
8. Intermediate format
9. Form configurations
10. Composite form
 B. Deviations from the rule
11. Exception according to the normal scheme
12. Irregular position, irregular form
13. Irregular form configurations
14. Decentralization
15. Free irregularity
16. Irregularity of curves
17. Outward drift of centers
18. Progressions.

Schlemmer's course: life drawing
Compulsory in the 3rd semester. Optional for all students. Two hours per week.
Subject: free-hand sketching of the life model, done from short poses of 5 minutes or
long poses of 1—2 hours, in repose or in quick sequences of movement, using black or
colored pencil.
Method: the students themselves will pose as models; this offers a great variety of body
shapes for drawing.
The life classes are held on the stage or in the auditorium. This, by contrast to the empty
classroom with its monotonous lighting, affords the possibility for a changing setting
(by use of scenery, all kinds of apparatus, spotlighting, and phonograph music).
The teacher analyzes each one of the poses of the model on a blackboard by pointing out
the important aspects, principal axes and lines of movement, proportion, skeletal struc-
ture and musculature, light and shadow.

Joost Schmidt's course: lettering (1st and 2nd semester)
Material
A. Lettering
a) Structure of letter forms:
made up of the circle and straight line, produced with compass and straight edge;
basic scheme—the square and the forms developed from it
capital letters, small letters.
b) Alteration of the scheme of the square into the rectangle for lettering that has to fit
into a narrow space.
c) Lettering of various sizes.
d) Lettering of various weights.
e) Simple lettering problems in application.
f) Experiments with a type of lettering that is structured according to phonetic principles.
B. Lettering, area, color
(preliminary step for the commercial-art department)
a) Color—color system according to Ostwald; color studies.
b) Elementary planar compositions.
Objective:
Mastery of letter forms and simple color—areas—designs
(preparation for instruction in the commercial-art department).
[Original without capital letters]

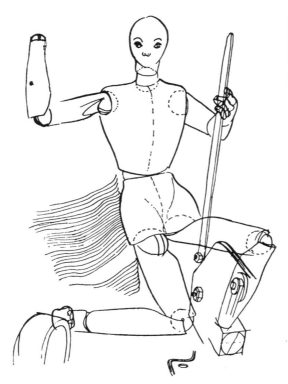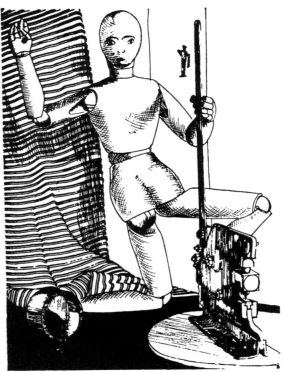

61
From Joost Schmidt's course: Studies by Kurt Kranz;
about 1930.

62
Inception: Organization of individual equivalent objects in large outline. Above: abbreviated form of construction. (Drawing by R, L. Kukowka)
Second stage: Objects recognizable, principal tensions through color; significant emphases designated by bold lines; point of departure of the constructive lattice. Above: abbreviated scheme. (Drawing by Erich Fritzsche)
Third stage: Objects completely translated into energy tensions; complicated constructions with displacements in individual components; over-all scheme made visible by dashed lines. Below: scheme. (Drawing by Fritz Fiszmer)

63
Four drawings from Kandinsky's course: analytical drawing (first semester). Top: Main Theme. Below: four variations of construction, achieved by eliminating individual construction components. Variations to illustrate four totally different tension varieties of the main theme.

62

The Bauhaus in Dessau
Free Painting Course (Kandinsky), Stage Workshop (Schlemmer) and Sculpture (Schmidt)
From catalog for the International Congress of Art Teachers, Prague 1928
This is the program of specialized training in the free artistic disciplines at the beginning of the era of Hannes Meyer. Paul Klee's class in painting is not included here.

63

Kandinsky's course (4th and later semesters)
Free Painting
Method (painting on the plane):
Structural and technical exercises on subjects chosen by the students, or assigned by the teacher, group analysis of free work, mutual criticism, discussion of the basic laws, structure, and purpose.
Experiments with form and color.
Schlemmer's course: Stage (2nd and later semesters)
Workshop for full-time students: 3 times per week (7–12 A.M., 3–5 P.M.)
Specialized drawing for the stage: 2 hours.—Stage theory: 2 hours.
Area of studies: study of the means at the disposal of the stage, their origin and simplicity, as a way toward a new kind of design. Primarily form as line, plane, and volume; color and light; space; the human being as spectator and actor, as technician and participant in action; movement, dance, and pantomime; mask, costume, and properties.
Method: not "design of stage sets" but rather practical work in the workshop (construction of masks, costumes, and machinery) and on the stage (composition and acting).
Technical drawing; diagrams and choreography.
Shows on the stage of the Bauhaus and elsewhere.

Joost Schmidt's course: sculpture (2nd and later semesters)
Material:
A. Elementary three-dimensional configurations and their interrelations.
B. Three-dimensional configurations as sculptural elements.
C. Plastic art and matter:
a) the visual aspects of matter
b) the tactile aspects of matter
D. Sculpture and color:
a) colored areas,
b) dull colors,
c) nonchromatic colors.
E. Sculpture and light.
F. Compositional studies:
a) stabile sculpture
b) mechanical sculpture.
G. Relationship of the human being to three-dimensional objects:
a) the three-dimensional senses,
b) the three-dimensional sensations, perceptions, and conceptions,
c) the attitude toward three-dimensional objects,
d) the implementation of the three-dimensional concept.
Objective:
Development and intensification of the three-dimensional imagination.
[Original without capital letters]

Wassily Kandinsky
Art Education
From the journal "bauhaus" (Dessau),
Vol. 2, No. 2/3, 1928
It is this essay in particular which Kandinsky
wrote to underline the importance of the rational
elements in art and art education, that shows
the rift separating him (as well as Klee) from the
rationalism of the group around Hannes Meyer,
which was governed by ideas of political mate-
rialism. Compare the essay on "Wert des theo-
retischen Unterrichts in der Malerei" ("The
value of theory in painting"), bauhaus journal,
1926.

Not long ago, "art instruction" was generally looked upon as a special area—and this is
still largely true today—which had little in common with the problems of "general"
education. On the other hand, the term "general" education is a thoroughly confused
one. One is justified in maintaining that there is in our time no general education without
a "...". But there is an infinite variety of "specialized" kinds of training which have no
links to general education nor to any of the other specialized areas. Today's art educa-
tion, too, aims at being a specialized training confined to its own field—just like the
specialized training of a doctor, lawyer, engineer, mathematician, and so on. Opposed
to this general situation are those who believed that there can be no such thing as "art
instruction," for it is impossible for art to be either taught or learned. They contend that
art is a matter of pure intuition which, by its very nature, cannot be produced by force
or by way of instruction.
The influential heritage of the 19th century—the extreme specialization and consequent
disintegration—has placed a heavy burden on all aspects of today's life, and forces the
problems of art education, too, further and further into a dead end. It is astonishing to
note how few are the lessons that have been learned from the events of the last ten years
and how seldom one can observe an understanding for the inner meaning of the great
"shift." This inner meaning, or the inner tension of the further "development" should
be made the basis of all instruction; the process of disintegration is gradually being re-
placed by a process of *integration*. The "either—or" concept has to make way for the
"and."
Specialized training without basic knowledge of general humanistic concepts should no
longer be possible. What is missing in today's education—almost without exception—is
an inner view of life or of the "philosophical" foundation of the meaning of human activ-
ity . . . Education usually consists of a process of more or less forced accumulation of
individual facts which students are supposed to learn and for which they have no use
outside their particular "field." Of course, with this kind of learning the capacity for
"integrating," or in other words, the capacity for observing and thinking in terms of a
synthesis, is disregarded to such a degree that, to a great extent, it becomes atrophied.
The primary purpose of any education should be to develop the capacity to think in two
. . . ways:
1. the analytical and
2. the synthetic.
We should therefore further exploit the heritage of the last century (analysis = disinte-
gration) and at the same time supplement and reinforce it with a synthetic point of view.
This should be done in such a way as to develop the young people's capacity to sense a
living, organic link between fields that seem to be widely separated, and to be able to
establish that link (synthesis = integration). In this manner the young people would leave
this inflexible atmosphere of the concept of "either—or" and would enter the flexible and
vital atmosphere of the concept "and"—analysis being the means to arrive at synthesis.
From that one can easily draw the conclusion that
1. the principal foundation of all types of education or all kinds of instruction remains
the same always
2. thus, art instruction is not a field distinct from other kinds of instruction, and
3. what is primarily important, is not *what* is being taught, but rather *how* it is being
taught.
The 3rd point is not meant to be a paradox.
The false belief which evolved during the period of disintegration and which states that
there are different kinds of thinking and hence different kinds of creative work, definitely
has to be rejected from the point of view of the "and" concept. The mode of thinking
and the process of creative work do not differ in the slightest in the various areas of
human activity—be it art, science, technology, and the like. What is important here is
whether one is going to be content with the kind of instruction that provides specialized
education by merely accumulating pertinent facts or whether one is first of all going to
try to develop and cultivate the capacity for thinking analytically-synthetically.
It is more productive for an artist to acquire specialized knowledge in a field foreign to his
own, if he is to develop the above-mentioned capacity to think, than to be thoroughly
"trained" in his own field but to be as incapable of that way of thinking as before.
No further proof is needed that the ideal instruction in every "field" should consist of two
parts, which must be linked inseparably. These are:
1. the development of the capacity to observe, think, and act simultaneously analytically
and synthetically, and
2. the systematic communication and acquisition of corresponding specialized areas of
knowledge.
This of course also applies to art instruction. Art can indeed not be learned—just as
creative work and imagination in the sciences or technology can be neither taught nor
learned. The great art periods in history have always had their "doctrine" or "theory," the
necessity for which was, and continues to be, as understandable as in the case of science.
Such "doctrines" were never able to replace intuition, because knowledge *per se* is un-
productive. It must be content to provide the material and the method. What is productive
is intuition which requires this material and this method as a means to achieve an end.
But this end cannot be achieved without means and in this sense intuition alone would
be just as unproductive. There is no "either—or," but rather an "and."
The artist, like every other human being, produces work on the basis of his knowledge,
and with the aid of his capacity to think, and his intuition. In this respect, too, the artist
cannot be differentiated from any other creatively working person. His work is determined
by rules and by function.
[Original without capital letters]
147

Paul Klee
Exact Experiments in the Realm of Art
From the journal "bauhaus" (Dessau),
Vol. 2, No. 2/3, 1928
In this essay Paul Klee explains the nature and
the objectives of his teaching. At this time, Klee
was primarily investigating problems of geomet-
rical constructions.

We construct and keep on constructing, yet intuition is still a good thing. Without it one can do a lot, but not everything. One may work for a long time, do different things, many things, important things, but not everything.

Where intuition is joined to exact research, it speeds the progress of exact research. Accuracy, inspired by intuition, is at times superior. But exact research being exact research, it can get along, if tempo is disregarded, without intuition. It can remain logical, it can construct itself. It can boldly bridge the distance from one thing to another. It can preserve order amid chaos.

Art, too, possesses sufficient room for exact investigation, and the gates leading to it have been open for some time. What had already been done for music by the end of the 18th century remains at least in its infancy in the pictorial field. Mathematics and physics pro- vide a lever in the form of rules to be followed or broken. They compel us—a salutary effect—to be concerned first of all with function and to disregard finished form. Problems in algebra, geometry, and mechanics are educational steps directed toward the essential and the functional, in contrast to the impressional. One learns to look behind the façade, to grasp the roots of things. One learns to recognize the hidden currents, the prehistory of the visible. One learns to dig below the surface, to uncover, to find causes, to analyze. One learns to look down on formalism and to avoid adopting things that are completed. One learns the special kind of progress that leads to a critical penetration into the past, in the direction of that which has existed before, on which future things will grow. One learns to get up early to familiarize oneself with the course of history. One learns about the things that form a connection along the way between cause and reality. Learns to digest . . . Learns to organize movement through logical relations. Learns logic. Learns organism.

The consequence is a slackening of the tension between us and the result. Nothing exag- gerated, tension within, behind, below. Passion only deep inside. Inwardness.

All this is fine, yet it leaves a void: intuition, after all, cannot be entirely replaced. One proves, explains, justifies, one constructs, one organizes: these are good things, but one does not arrive at "totalization."

One was diligent. But genius is not diligence, as a very fallacious slogan claims. Genius consists not even in part of diligence, even though some men of genius may also have worked hard. Genius is genius, is grace, without beginning and without end. It is pro- creation.

Genius is not teachable, because it is not a norm but an exception. One can hardly count on the unexpected. And yet as a leader it is always far ahead. It dashes ahead in the same direction or in another direction. Perhaps today it is already in a place one hardly thinks of. For, with respect to dogma, genius is often a heretic. It knows no principle except itself.

The school should keep quiet about the term "genius," it should close its eyes inten- tionally, with tactful respect. It should cherish the term as a secret, behind locked doors. It should guard a secret which, were it to come out of its latency, might deceive as being illogical and absurd.

That would result in revolution. Bewilderment out of surprise. Indignation and banish- ment. Out with the total synthesist! Out with the "totalizer"! We are against it! And then the shower of insults: Romanticism! Cosmicism! Mysticism!

In the end one would have to even call in a philosopher, a magician! Or the great dead (who are dead?). One would have to hold classes on holidays, outside the school. Outside, under the trees, with the animals, by streams. Or on mountains in the sea.

There would be assignments to give, such as: the construction of the secret. Sancta ratio chaotica! Scholastic, and ridiculous! And yet, this would be the assignment, if "construc- tive" stood for "total."

But let us calm down, "constructive" does not stand for "total." The *virtue* is, that by cultivating the exact we have laid the foundations for a specific science of art. Including the unknown quantity "x." Making a virtue of necessity.

The school lives. Long live the school!

[Original without capital letters]

64
Paul Klee's course: Demonstration drawings and
exercises for a better understanding of optical and
constructive rules. Variations on a theme given by
Klee. Drawings by Léna Meyer-Bergner. About 1928.
PA, Meyer-Bergner, Basel.

Fannina W. Halle
Dessau, Burgkühnauer Allee 6–7
From the journal "Das Kunstblatt" (Potsdam), Vol. 7, July 1929, pp. 203ff.

The physical closeness of the "Masters' houses" of the Bauhaus extended to a closeness of attitude as well. This was particularly true of Kandinsky and Klee. How close the two men were at that time is demonstrated especially by their teaching courses in which their ideas united into one organic entity. The closeness in their way of thinking was also reflected in the paintings of that period.

At the street crossing in front of the old park of the "Georgium" with its "seven columns" (in reality there are eight), as one comes from the Bauhaus—now the intellectual landmark of the city of Dessau—one has to turn slightly to the left and there, straight ahead, is the Burgkühnauer Allee with Gropius's artists colony.

On the exterior the four Masters' houses—three of them duplexes—look so much alike that one can only tell them apart by their number plates. Everywhere the same functional horizontal composition, the same flat roofs and the same sharp lines of the unframed door and window openings, invariably surpassed anew by the glass wall of a studio. This is a "machine-for-living" straightforwardness which, in its cold, uniform existence, incorporates, however as an artistic component, the moving play of light and shadow of the surrounding wholesome clusters of trees which have not yet been chopped down. But one look inside any one of these houses makes us immediately aware of the great differences between the worlds that are hidden behind all the white-in-white concrete walls. The differences are nowhere so clearly to be seen as in the duplex house, number 6–7, where two such strong artistic personalities as Kandinsky and Klee live under one roof, both form masters at the Bauhaus. Wassily Kandinsky: the left entrance. On the way up to the studio one passes a cool, restrained room done in a pale rose color in which one partition is painted gold, while another is done in pure black. But this room is brightened, as if by two suns, by a colorful, resplendent painting and a large, white table top, shining and round. Then one starts up the small staircase. The very sight of the staircase shows the visitor, merely on his way into the studio of the artist, that the latter loves pure, cold colors and that every form and every color in this house has a meaning of its own and meaning as an integral part of the whole.

A door opens, and immediately we are in the middle of a kingdom detached from the world, whose master, tirelessly creative, forever young and outstanding as a human being, heralded the beginning of a new era, a new "spirituality" as long ago as 1912—before the war, the revolution, and the various alternating "isms." This he did in almost prophetic rebellion.

Now they pour upon us out of every corner, these magic worlds, large and small, that have been lovingly conjured in oil and tempera, in water-color and gouache. These are the ripe fruits of the last years, done with the utmost refinement of ability, eye, and taste. These magic worlds are forever changing. . . .

The possibilities for variation and expression with this art—which in Kandinsky's opinion attains its full strength "when it, completely freed from nature, places a new, independent world next to nature"—are inexhaustible. Each painting—having a destiny of its own—is imbued with a multitude of different tones and reverberations, with a restrained fire, with pulse and with movement whose waves reach into the furthest corners. . . . Thus, by representing experiences solely from the realm of the mind, without regard for the objective world, a new sense of the dynamics of our time is manifested; an atmosphere which, free from all material pressures and reaching beyond the limits of perception, hints at what a future, perhaps not too remote, may contain. This is an atmosphere heralding the coming of the "Epoch of the Great Spirituality."

A thin partition separates Kandinsky's studio from that of his colleague, Paul Klee. Yet one gets the impression that the two live a long way apart; the very air that welcomes the visitor at the front door seems so different, so much more intimate, closer to earth, not to say sultry—and the language spoken within is so dissimilar—quiet yet forceful.

A short listing alone of the titles of the intimate, small paintings and the even smaller, very delicate pen-and-ink drawings which have to be read, too, in order to become more closely acquainted with this art, introduces us to the secrets of their characteristics: "Countercurrent at full noon," "Message of the sylph," "Lowering of the higher region," "There was a child who was never wanted," "Possessed powers," "Before and behind the bridge," "Thought of an animal," etc. What lies hidden behind these titles, which in their own way are just as characteristic as those of Kandinsky's paintings, is also a world removed from reality. But at the same time this world does not lack a base in reality, in that the pictures, dreamed up and envisioned in fairy-tale lands, in the imagination, and in day dreams are integrated with nature, are directly confronted with it. With a delicate hand, Klee creates grotesques, hybrid beings, and phantasmagorias which, as he himself admits, are hardly comprehensible in this earthly world. He says that he lives as much with those who are dead as with those who are not yet born: "A little closer than customary to the core of creation and yet not nearly close enough." It is an enchanted world, lost in thought and transcendental, in which every flower, bridge, and piece of coral has a face and a soul, brought to light from the origin of things with the aid of a childlike, primitive, and thus masterful technique, especially devised for that purpose. A "technique of the dream," using a few delicate strokes, thin spider-threads, ruffled arabesques, or a few colors mixed like light passing at an angle through colored glass and producing daring forms never before envisioned. The colors are magically phosphorescent, emerald green, vermilion, and chrome yellow. A new surrealism, a realm of shadows, inhabited by substanceless beings, beings between reality and imagination, is revealed as in a half-dream. A sixth sense appears—all the visible and the invisible worlds intermix. "Art does not reproduce that which is visible but rather makes visible," says the painter-magician Klee. Like Kandinsky, he too works with symbols in a new way. Thus the pictorial design, the composition of his "visionary miniatures"—changing often, according to the subject—sometimes even approaches the abstractions of Kandinsky with whom he has been friends for many years.

However, Kandinsky's form images are always eccentric and their actual center is invisible, "obscured," sometimes hidden between one or more centers. The focal point is never emphasized, a certain limit never exceeded. Everything is always just hinted at, in order to overcome the "tangible material" and arrive at the tension, the "inner material,"

150

the actual form of the nature of things and the design that is concerned with life (whereby he differs from the constructivists). Klee's forms, in the other hand, are concentric, always proceeding from one focus, one "Leitmotiv," and always playfully returning to themselves. . . .

Kandinsky and Klee: Lately the two artists . . . have increasingly been mentioned together . . . Is it merely a coincidence that in the quiet and remote city of Dessau—the latest intellectual germ cell of Germany and a center of aviation, the technological liberation from the bonds of earth—there are two creative men, also freed from the gravitational pull of the earth—linking east and west—living under one roof ? Or is it a waking call, a symbol of things to come?

The Bauhaus in Dessau
The Course of Training in the Architecture Department
From "bauhaus—junge menschen kommt ans bauhaus" ("bauhaus—young people, come to the bauhaus!"), advertising pamphlet, published by the Bauhaus in Dessau (1929)

The architecture department was at this time led by Hannes Meyer, who also gave theoretical lectures on architecture. Ludwig Hilberseimer directed the instruction in architecture and the classes in construction design. Head of the building studio was Anton Brenner. Other teachers on the staff were: Alcar Rudelt (structural engineering), Wilhelm Müller (instruction in building materials), Mart Stam (guest lecturer in city planning and principles of architecture), and others.

Duration of studies in the architecture department = nine semesters
1st semester: preliminary course.
No kind of previous education whatsoever may excuse a student from attending the preliminary course. The purpose of this course is the development of analytical thinking, familiarization with materials, the greatest possible detachment of the student from conventions, and the awakening of the individual's own energies. These are the foundations of work at the Bauhaus.
2nd semester, 3rd semester: architectural workshop.
Experimentation in the metal workshop, the cabinetmaking workshop or the workshop for wall-painting, in order to promote the development of craftsmanship and design facility.—Free choice of workshop.—Participation in theoretical, art, and science courses.
4th semester, 5th semester, 6th semester: instruction in architecture.
This course imparts to the trained journeymen a more thorough understanding of what is known about the driving forces of all design. It is not the exclusive purpose of this course to train architects; it also offers the journeyman a broadening of his knowledge in his specialty, by the study of the nature of "design for living." Moreover, it shows him the judicious incorporation of his work into the context of today's society. Those who pursue architecture will learn in this course a scientific way of architectural thinking according to the principle: Building signifies "the design of all the activities of life."
7th semester, 8th semester, 9th semester: architecture studio.
Participation in the architecture studio is normally restricted to future architects. All of the work required of a regular architect according to the "Regulations for the fees of architects of July 1926" is practiced in this studio. It is to provide the best possible introduction into the practice of building by "the study of the production process."
Completion of studies as an architect = Bauhaus diploma.
[Original without capital letters]

Alcar Rudelt's Teaching Program in Structural Engineering

From "bauhaus—junge menschen kommt ans bauhaus" ("bauhaus—young people, come to the Bauhaus!"), advertising pamphlet, published by the Bauhaus in Dessau (1929)

The systematization of the architectural instruction which Hannes Meyer tried to initiate benefited primarily the purely instructional and scientific courses. By attempting to impart positive knowledge to the students, the Bauhaus entered into competition with the technical universities, so that in spite of the strong inner tensions of this time, the Bauhaus took on a more and more academic character. Rudelt built his classes primarily around practical examples. He was a member of the Bauhaus from October 1928 until its closing in the summer of 1933.

A. Statics
1. Forces in a plane and determination of the resultant force.
2. Definition of the moment.
3. Determination of the load resistance of simple beams.
4. Determination of the moments for a simple beam.
5. Cremona plans.
6. Water pressure, wind pressure, earth pressure.
7. Definition of form change.
8. Computation of the twisting moment at the points of resistance.
9. Clapeyron equation for the continuous beam.
10. Graphic solution for the continuous beam.
11. Computation of the deflection for a beam.
12. Frames.

B. Strength of Materials
1. Compression.
2. Tension.
3. Shear.
4. Bending and moment of inertia for principal axis and any other axes.
5. Bending and compression, resp. tension.
6. Eccentric load.
7. Buckling.
8. Theory of elasticity, change of form.

C. Mathematics
1. Review of arithmetic.
2. Linear equations.
3. Radical equations.
4. Linear equations with more than one unknown.
5. Quadratic equations.
6. Definition of the trigonometric functions.
7. Sine theorem.
8. Cosine theorem.
9. Equations as curves.
10. Definition of the differential quotient.
11. Fluctuation of the point of inflection of curves.
12. Differentiation of functions.
13. Maxima and minima.
14. Definition of the integral value.
15. Integration of planes and moments of inertia.

D. Reinforced concrete
1. Definition of terms.
2. Gravel, fine-grain aggregate, cement, and steel.
3. Ratio of mix.
4. Advantages and disadvantages.
5. Forms and struts (shoring).
6. Organization on the site and in the office.
7. Theory and its application.
8. Computation of a ceiling with a live load of 1000 kg/m^2.
9. Computation of a reinforced concrete skeleton.

E. Steel
1. Riveting.
2. Simple and continuous supports.
3. Trussed beams and full-flange beams.
4. Computations of purlins and headers and execution of construction drawings.
5. Computation of the structure for a factory.
6. Computation of a steel skeleton.

F. Cost estimates
1. Computation of quantities.
2. Contract regulations.
3. Costs: a) wages, b) materials.
4. Overhead.
5. Selling price.
6. Practical applications.

G. Building construction
1. Foundation: a) normal, b) in places of high water-table, c) with piles, d) with plates.
2. Basement floors.
3. Ceilings of all types.
4. Roofs of all types.
5. Basement walls.
6. Rising bearing-walls.
7. Partitions.
8. Wood skeleton structure.
9. Reinforced concrete skeleton structure.
10. Steel skeleton structure.
11. Stairs
[Original without capital letters.]

Hannes Meyer
Bauen
Aus: »bauhaus«. Zeitschrift für Gestaltung
(Dessau), 2. Jhg., Nr. 4, 1928

Die skurrile Überspitzung, in der Meyer seine
Thesen vorträgt, verdeutlicht mit seinen be-
sonderen Qualitäten zugleich das Schwäche, die
in der Leugnung des Ästhetischen (also doch
auch eines psychischen Werts) und in der Re-
duktion auf das Praktisch-Funktionelle lag.

bauen

alle dinge dieser welt sind ein produkt der formel: (funktion mal ökonomie)

alle diese dinge sind daher keine kunstwerke:
alle kunst ist komposition und mithin zweckwidrig.
alles leben ist funktion und daher unkünstlerisch.
die idee der „komposition eines seehafens" scheint zwerchfellerschütternd!
jedoch wie ersteht der entwurf eines stadtplanes? oder eines wohnplanes? komposition oder funktion?
kunst oder leben?????
bauen ist ein biologischer vorgang. bauen ist kein aesthetischer prozeß. elementar gestaltet wird das neue wohn-
haus nicht nur eine wohnmaschinerie, sondern ein biologischer apparat für seelische und körperliche
bedürfnisse. — die neue zeit stellt dem neuen hausbau ihre neuen baustoffe zur verfügung:

stahlbeton drahtglas aluminium si-stahl ripolin asbest
kunstgummi preßkork euböolith kaltleim viscose azelon
kunstleder kunstharz sperrholz gasbeton eternit casein
zell-beton kunsthorn kautschuk roliglas goudron trolit
woodmetall kunstholz torfoleum xelotekt kanevas tombak

diese bauelemente organisieren wir nach ökonomischen grundsätzen zu einer konstruktiven einheit. so
erstehen selbsttätig und vom leben bedingt die einzelform, der gebäudekörper, die materialfarbe und die
oberflächenstruktur. (gemütlichkeit und repräsentation sind keine leitmotive des wohnungsbaues.)
(die erste hängt am menschenherzen und nicht an der zimmerwand. . . .)
(die zweite prägt die haltung des gastgebers und nicht sein perserteppich!)

architektur als „affektleistung des künstlers" ist ohne daseinsberechtigung.
architektur als „fortführung der bautradition" ist baugeschichtlich treiben.

diese funktionell-biologische auffassung des bauens als einer gestaltung des lebensprozesses führt mit
folgerichtigkeit zur reinen konstruktion: diese konstruktive formenwelt kennt kein vaterland. sie ist der
ausdruck internationaler baugesinnung. internationalität ist ein vorzug der epoche. die reine konstruktion
ist grundlage und kennzeichen der neuen formenwelt.

1. geschlechtsleben 4. gartenkultur 7. wohnhygiene 10. erwärmung
2. schlafgewohnheit 5. körperpflege 8. autowartung 11. besonnung
3. kleintierhaltung 6. wetterschutz 9. kochbetrieb 12. bedienung

solche forderungen sind die ausschließlichen motive des wohnungsbaues. wir untersuchen den ablauf des
tageslebens jedes hausbewohners, und dieses ergibt das funktionsdiagramm für vater, mutter, kind,
kleinkind und mitmenschen. wir erforschen die beziehungen des hauses und seiner insassen zum fremden:
postbote, passant, besucher, nachbar, einbrecher, kaminfeger, wäscherin, polizist, arzt, aufwartefrau, spiel-
kamerad, gaseinzüger, handwerker, krankenpfleger, bote. wir erforschen die menschlichen und die
tierischen beziehungen zum garten, und die wechselwirkungen zwischen menschen, haustieren und haus-
insekten. wir ermitteln die jahresschwankungen der bodentemperatur, und wir berechnen danach den
wärmeverlust der fußböden und die tiefe der fundamentsohlen. — der geologische befund des haus-

64

gartenuntergrundes bestimmt die kapillarfähigkeit und entscheidet, ob untergrundberieselung oder
schwemmkanalisation. wir errechnen die sonneneinfallswinkel im jahreslauf und bezogen auf den
breitengrad des baugeländes, und wir konstruieren danach den schattenfächer des hauses im garten
und den sonnenlichtfächer des fensters im schlafzimmer. wir errechnen die tagesbeleuchtung der arbeits-
fläche im innenraum, und wir vergleichen die wärmeleitfähigkeit der außenwände mit dem feuchtigkeits-
gehalt der außenluft. die luftbewegung im erwärmten raum ist uns nicht mehr fremd. die optischen
und die akustischen beziehungen zum nachbarhaus werden sorgfältigst gestaltet. wir kennen die atavisti-
schen neigungen der künftigen bewohner zu unsern bauhölzern und wählen je nachdem als innenverklei-
dung des genormten montagehauses die flammige kiefer, die straffe pappel, das fremde okumé oder
den seidigen ahorn. — die farbe ist uns nur mittel der bewußten seelischen einwirkung oder ein orien-
tierungsmittel. die farbe ist niemals mimikri für allerlei baustoffe. buntheit ist uns ein greuel. anstrich
ist uns ein schutzmittel. wo uns farbe psychisch unentbehrlich erscheint, mitberechnen wir deren licht-
reflexionswert. wir vermeiden reinweißen hausanstrich: der hauskörper ist bei uns ein akkumulator der
sonnenwärme. . . .

das neue haus ist als trockenmontagebau ein industrieprodukt, und als solches ist es ein werk der
spezialisten: volkswirte, statistiker, hygieniker, klimatologen, betriebswissenschafter, normengelehrte,
wärmetechniker. . . . der architekt? . . . war künstler und wird ein spezialist der organisation!
das neue haus ist ein soziales werk. es erlöst das baugewerbe von der partiellen arbeitslosigkeit eines
saisonberufes, und es bewahrt vor dem odium der notstandsarbeit. durch eine rationelle hauswirtschaft
schützt es die hausfrau vor versklavung im haushalt, und durch eine rationelle gartenwirtschaft schützt
es den siedler vor dem dilettantismus des kleingärtners. es ist vornehmlich ein soziales werk, weil es
(wie jede DIN norm) das industrie-normen-produkt einer ungenannten erfindergemeinschaft ist.
die neue siedlung vollends ist als ein endziel der volkswohlfahrt ein bewußt organisiertes gemeinkräftiges
werk, in welchem auf einer integral-genossenschaftlichen grundlage die kooperativkräfte und individual-
kräfte zum gemeinkräftigen ausgleich kommen. die modernität dieser siedlung besteht nicht aus flach-
dach und vertikal-horizontaler fassadenaufteilung, — sondern in ihrer direkten beziehung zum mensch-
lichen dasein. in ihr sind die spannungen des individuums, der geschlechter, der nachbarschaft und der
gemeinschaft und die geopsychischen beziehungen überlegen gestaltet.

bauen heißt die überlegte organisation von lebensvorgängen.
bauen als technischer vorgang ist daher nur ein teilprozeß. das funktionelle diagramm und das ökono-
 mische programm sind die ausschlaggebenden richtlinien des bauvorhabens.
bauen ist keine einzelaufgabe des architekten-ehrgeizes mehr.
bauen ist gemeinschaftsarbeit von werktätigen mit erfindern. wer als meister in der arbeitsgemein-
 schaft anderer den lebensprozeß selbst meistert, . . . ist baumeister.
bauen wird so aus einer einzelangelegenheit von einzelnen (gefördert durch arbeitslosigkeit und woh-
 nungsnot), zu einer kollektiven angelegenheit der volksgenossen.
bauen ist nur organisation:
soziale, technische, ökonomische, psychische organisation.

hannes meyer

Hannes Meyer
Building
From the journal "bauhaus" (Dessau),
Vol. 2, no. 4, 1928
In the scurrilous overstatement of his theses,
Meyer demonstrates his special qualities and
also his weakness, which lay in his disavowal
of esthetic aspects (hence, also a psychic value)
and in his reduction of all problems to practical,
functional formulas.

building
all things in this world are a product of the formula: (function times economy)
all these things are, therefore, not works of art:
all art is composition and, hence, is unsuited to achieve goals.
all life is function and is therefore unartistic.
the idea of the "composition of a harbor" is hilarious!
but how is a town plan designed? or a plan of a dwelling? composition or function? art
or life?????
building is a biological process. building is not an esthetic process. in its design the new
dwelling becomes not only a "machine for living," but also a biological apparatus serving
the needs of body and mind. the new age provides new building materials for the new
way of building houses:

reinforced concrete	synthetic horn	cold glue	canvas
synthetic rubber	synthetic wood	cellular concrete	asbestos
synthetic leather	aluminum	rolled glass	acetone
porous concrete	euböolith	xelotect	casein
woodmetal	plywood	ripolin	trolite
wire-mesh glass	hard rubber	viscose	tombac
pressed cork	torfoleum	asbestos concrete	
synthetic resin	silicon steel	bitumen	

we organize these building materials into a constructive whole based on economic prin-
ciples. thus the individual shape, the body of the structure, the color of the material and
the surface texture evolve by themselves and are determined by life. (snugness and
prestige are not leitmotifs for dwelling construction.) (the first depends on the human
heart and not on the walls of a room. . . .) (the second manifests itself in the manner of
the host and not by his persian carpet!)
architecture as "an emotional act of the artist" has no justification. architecture as "a
continuation of the traditions of building" means being carried along by the history of
architecture. this functional, biological interpretation of architecture as giving shape to
the functions of life, logically leads to pure construction: this world of constructive forms
knows no native country. it is the expression of an international attitude in architecture.
internationality is a privilege of the period. pure construction is the basis and the char-
acteristic of the new world of forms.

1. sex life	4. gardening	7. hygiene in the home	10. heating
2. sleeping habits	5. personal hygiene	8. car maintenance	11. exposure to the sun
3. pets	6. weather protection	9. cooking	12. service

these are the only motives when building a house. we examine the daily routine of every-
one who lives in the house and this gives us the function-diagram for the father, the
mother, the child, the baby, and the other occupants. we explore the relationships of the
house and its occupants to the world outside: postman, passer-by, visitor, neighbor,
burglar, chimney-sweep, washerwoman, policeman, doctor, charwoman, playmate, gas

inspector, tradesman, nurse, and messenger boy. we explore the relationships of human beings and animals to the garden, and the interrelationships between human beings, pets, and domestic insects. we determine the annual fluctuations in the temperature of the ground and from that calculate the heat loss of the floor and the resulting depth required for the foundation blocks. the geological nature of the soil informs us about its capillary capability and determines whether water will naturally drain away or whether drains are required. we calculate the angle of the sun's incidence during the course of the year according to the latitude of the site. with that information we determine the size of the shadow cast by the house on the garden and the amount of sun admitted by the window into the bedroom. we estimate the amount of daylight available for interior working areas. we compare the heat conductivity of the outside walls with the humidity of the air outside the house. we already know about the circulation of air in a heated room. the visual and acoustical relationship to neighboring dwellings are most carefully considered. knowing the atavistic inclinations of the future inhabitants with respect to the kind of wood finish we can offer, we select the interior finish for the standardized, prefabricated dwelling accordingly: marble-grained pine, austere poplar, exotic okumé, or silky maple. color to us is merely a means for intentional psychological influence or a means of orientation. color is never a false copy of various kinds of material. we loathe variegated color. we consider paint to be a protective coating. where we think color to be psychically indispensable, we include in our calculation the amount of light reflection it offers. we avoid using a purely white finish on the house. we consider the body of the house to be an accumulator of the sun's warmth. . . .

the new house is a prefabricated building for site assembly; as such it is an industrial product and the work of a variety of specialists: economists, statisticians, hygienists, climatologists, industrial engineers, standardization experts, heating engineers . . . and the architect? . . . he was an artist and now becomes a specialist in organization!

the new house is a social enterprise. it frees the building industry from partial seasonal unemployment and from the odium of unemployment relief work. by rationalized housekeeping methods it saves the housewife from household slavery, and by rationalized gardening methods it protects the householder from the dilettantism of the small gardener. it is primarily a social enterprise because it is—like every government standard—the standardized, industrial product of a nameless community of inventors.

the new housing project as a whole is to be the ultimate aim of public welfare and as such is an intentionally organized, public-spirited project in which collective and individual energies are merged in a public-spiritedness based on an integral, cooperative foundation. the modernness of such an estate does not consist of a flat roof and a horizontal-vertical arrangement of the façade, but rather of its direct relationship to human existence. in it we have given thoughtful consideration to the tensions of the individual, the sexes, the neighborhood, and the community, as well as to geophysical relationships.

building is the deliberate organization of the processes of life.

building as a technical process and therefore only one part of the whole process. the functional diagram and the economic program are the determining principles of the building project.

building is no longer an individual task for the realization of architectural ambitions.

building is the communal effort of craftsmen and inventors. only he who, as a master in the working community of others, masters life itself . . . is a master builder.

building then, grows from being an individual affair of individuals (promoted by unemployment and the housing shortage) into a collective affair of the whole nation.

building is nothing but organization:

social, technical, economical, psychological organization.

hannes meyer

Wassily Kandinsky
The Bare Wall . . .
From the journal "Der Kunstnarr" (Dessau), No. 1, April, 1929
Ernst Kállai, the publisher of the bauhaus journal, produced the "Kunstnarr" (the "art fool") under his own editorship. With this journal (which ceased publication after the first issue) Kállai intended to draw attention forcefully to the appreciation of art. This was, at the Dessau Bauhaus, always "officially" dealt with as an accessory. Even the institution of free painting classes was not able to change a great deal in this attitude.

The bare wall! . . .

The ideal wall, against which nothing stands, against which nothing leans, on which no picture hangs, on which *nothing* is to be seen.

The egocentric wall, the wall–in–itself, that asserts itself, the chaste wall. The romantic wall.

I, too, love the bare wall; the opponents of romanticism are today very good friends of art and especially of painting.

And quite especially painting, because of all the arts they are only fighting against painting. Anyone able to *experience* the bare wall is best prepared to experience a painting:

The two-dimensional, immaculately smooth, vertical, proportioned, "silent," noble, self-asserting, inwardly directed, externally limited, and outwardly radiating wall is an almost primary "element."

And the primary element is the "A" of the understanding of art, after which the "B" must inevitably follow: it must, because it can.

A brass band is loud and thunderous, just like an average middle-class home. People today are deafened—they are able to hear nothing but clamorous noises. As long as they are not taken by the scruff of their necks and shaken really well, they are not moved at all. But noise is only *one* part of the whole—who knows whether quiet (and silence) may be an even more important part of the whole?

We painters owe our "enemies" gratitude, because they are our friends.

According to his "direction" and attitude, various things are required of today's painter. Particularly of the "abstract" painter.

Some people require of us to paint nothing but walls.

And only inside.

Some people want us to paint the houses on the outside.

And only on the outside.

Some people require that we serve industry by providing it with patterns for textiles, ties, socks, dishes, parasols, ashtrays, and carpet runners.

Only handicrafts.

It is only painting pictures that we are to shun, for all time.

Some people are more benign and allow us to paint pictures directly on walls, provided we forego painting at the easel.

According to his "direction" and attitude, today's painter is forbidden:

to paint at his easel,

to paint on the wall,

to design patterns for textiles and all other objects,

to paint an exterior wall,

to paint an interior wall,

to paint at all.

There are people today who love painting. They sometimes feel that there is no longer any "real" painting being done. In the opinion of these art lovers the fact that painters are leaving the safe grounds of tradition means their punishment will be sterility.

How often do people mourn, both verbally and in writing: There are no "talented young artists emerging," they say, and "always the same, slowly aging painters—and where are the young painters who should and could carry on the 'sacred banner' of art"?

"Painting is deteriorating and is going to pieces."

Some people mourn, others are delighted.

Some people mourn, others are delighted that there are people in the Bauhaus who paint, that these are not just the "Masters" but also the young people, that for nearly two years there have been regular classes—next to the practical "workshop for wallpainting," painting is now also being cultivated in the impractical "free painting classes."

But in the same Bauhaus one encounters students who are neither in the practical departments nor in the impractical painting classes but who nevertheless are practicing "free painting": for instance, cabinetmakers, metal workers, weavers, and even architects are painting.

Even architects.

Is it any wonder that all of these young people love the bare wall, even though they often do not know how romantic that wall is?

They are painting out of an inner need and they have no doubts about the future of painting. Whenever they theorize, they also theorize in the style of the painter, that is to say, artistically.

The dead word "art" has been resurrected at the Bauhaus, of all places. And deeds are going hand in hand with words.

Fortunately and finally, thanks to our friends (of the bare wall), miscarriages of painting are disappearing from the walls.

And not only we, the patiently holding out, if "slowly aging, Masters," but also the maturing young people are making sure that the bare wall remains bare where necessary, and that the other walls will not again be crowded with miscarriages, but instead, "according to plan and purpose" and with silent joy, will receive those "painted worlds" again.

Whoever finds reason to mourn because of this, should go right on mourning.

We are delighted.

Dessau, January 1929.

Hubert Hoffmann
Apartment House or Individual Residence?
From the journal "bauhaus" (Dessau), Vol. 3, No. 4, October–December 1929
In this essay the author recapitulates some thoughts that Ludwig Hilberseimer presented in his classes. In 1929 Hilberseimer took over the leadership of the instruction in architecture and was particularly interested in problems of city planning and housing developments.

The type of home to be built in the future will be determined by considerations of efficiency. This does not mean that economy, in the sense of a speculative use of land, will be decisive—but rather economy of the kind that takes into account all factors: the needs, requirements, and the ability to pay, of the future occupant.

Thus, one should not ask questions like: "apartment house or individual residence?" One should rather assume that both are justified. The difference is only that the apartment house and the individual residence have been designed for entirely different types of people. . . . Hence, the question should be posed like this: "For what types of person does the individual residence offer the most efficient type of housing and for what type does the apartment house do the same?

For instance, if we observe the life of a child in an apartment house we are bound to conclude that the apartment house is a very ill-suited home for a child. The needs of the child, and thereby those of the family with children, are much better met in an individual residence. Children want to play, chase each other, make a lot of noise, build sand castles, dig, plant, keep pets, and do a lot of other things . . . which are very difficult to do in a block of flats . . . The family feels unhappy and constantly under observation—mainly because the living habits and requirements of the child are not adequately respected.

The single-family residence, then, is undoubtedly the type of housing unit that is most efficient for the family with children. . . . The children can plant and look after the garden. A bachelor would not dream of tending a garden. For him, even a piece of lawn would hardly be worth while, since the larger part of his spare time is spent away from home. Unlike the family, the bachelor wants to be freer, more independent and more flexible. . . . For this kind of mobile person a multistory house with communal facilities would be the requisite living environment. This unit would have to be designed very differently from the old tenements, somewhat similar to the English boarding house or apartment house. The "studio building" of the Bauhaus is already one solution of this genre.

Such considerations make it advisable to use both types of housing units, the apartment house and the individual residence, in housing developments. These should be used in a mixed pattern. Such a combination has the advantage that the high-rise buildings benefit from the speciousness of the gardens around the individual units, which in turn are in a position to share the comforts of the communal facilities of the apartment houses. Also,

Interviews of the journal "bauhaus" with Students of the Bauhaus—Answers by Max Bill and Fritz Kuhr
From the journal "bauhaus" (Dessau), Vol. 2, No. 2/3, 1928
The editors asked the students of the Bauhaus to answer several questions on a questionnaire: Why had they enrolled at the Bauhaus, what had been their first impressions, what did they later think was the significance of the Institute, and what were they planning to do in the future. Twenty answers were published.

the costs for putting in roads for the entire housing development are kept much lower. Particularly in areas near the heart of the city, the mixed pattern would be a more favorable form for designing a development than the use of either one or the other type of units. [Original without capital letters]

Max Bill:

Before I joined the Bauhaus I worked at the School of Arts and Crafts in Zürich but was dissatisfied. At the Bauhaus I first intended to study architecture, for Corbusier had turned my head. My first impression of the Bauhaus was not what I had expected it to be. I was a bit disappointed, but by and by I did find what had actually attracted me: clarity.

I did not receive a new outlook on life; rather, I found my old views confirmed to a constantly growing extent: All creatures of the earth and sky are made up of far-sighted egoism. Man's highest demand with respect to his social life is based on this insight: personal freedom (Gesell: physiocracy through free land and free money). This is the reason why technology is so important. Technology should have freed man, but owing to the capitalist system it has enslaved him even more.

Perhaps, once personal freedom has been achieved, everyone will be his own artist. Some will be better, some worse (same as today). There will be those who merely produce art and those who experience art within themselves.

To leave the Bauhaus is pointless as long as things outside the Bauhaus look as they do today. I take the Bauhaus to be larger than it is in reality: Picasso, Jacobi, Chaplin, Eiffel, Freud, Stravinsky, and Edison, and others, are actually also part of the Bauhaus.

The Bauhaus is an intellectual and progressive direction, a mental attitude, which one might call religion.

Fritz Kuhr:

The circumstances that made me become a student at the Bauhaus are, one might say, coincidences. At the Folkwang Museum in Essen I saw paintings by Feininger and Kandinsky, among others, and I stood in front of them like an ox in front of a red-painted church door. A friend who had confused the Bauhaus with an art academy (he wanted to learn to be a painter), informed me that Kandinsky, Moholy, Klee, and Feininger were teachers at the Bauhaus; he invited me to join it too. I was dying to find out from Kandinsky what his paintings were actually supposed to mean. Well, I arrived in Weimar where I was received by Herr Kandinsky in a very obliging way. He told me something about abstract painting, which seemed to me to be rather implausible, lent me his book "Über das Geistige in der Kunst" (On the Spiritual in Art) and dismissed me. I strolled over to Moholy whom, in the heat of discussion, I reproached, asserting that a picture I saw hanging on his studio wall appeared to me to be nonsense and pure trash (a picture of Moholy's, but I did not know that it was his). Moholy thereupon proved to me with the utmost of precision (in his reasoning he often used the words "tensions" and "inhibition") that I was not entitled to take something to be nonsense and rubbish which I did not understand. That made sense to me. I still didn't know what was happening, but in any case, what impressed me was the conviction with which Moholy defended abstract painting. Due to his initiative I enrolled in the preliminary course.

The preliminary course consisted of three parts: theory, elementary design, and workshop activity. Theory was taught by Kandinsky and Klee, elementary design by Moholy. The workshop activity was supervised and influenced by Albers. Herr Albers took the trouble to examine and pick apart my painstakingly constructed "useful articles" for their practical value. And spoke of unthought-of possibilities (only I didn't happen to notice them). Then, together with a girl-student, I constructed, on paper, an umbrella made of aluminum (all metal). We wanted to prevent the annoying deterioration of the silk. We chose aluminum because of its weight. We decided against implementing the project, because the preliminary course workshop was not equipped for things of that kind. We might have left the project to industry, if it had not occurred to us that industry has no interest in solidly built and lasting umbrellas.

In the elementary design class things didn't go too well. We built three-dimensional compositions in wood, we neatly cut, sanded, and put together small wooden sticks, held pieces of glass or metal against them; but always with the awareness that all of this was a senseless game, nonsense. "I can't figure out what they're after here, it's best that I disappear again quietly." Such was my conviction.

But then came the major and important experience. I had combined a "balancing exercise" with my second wood-sculpture, but had put the main emphasis on the esthetic appeal. During my third sculptural composition I became conscious of the gravitational pull of the earth. That is to say, I had already known about gravity, but only now did I experience, you see, with my heart, with my mind, with every nerve did I experience the gravity of the earth. You know how it is when all at once one grasps something which one sensed before, not "just like that," but quite consistently in every step, only with incredible speed and urgency as if with the entire self. Thus, I built my fourth sculptural composition with wood, iron, sheet metal, copper, glass, and paper, but: The senseless game with materials was not senseless any more.

I toiled, compared, weighed, filed, drilled, daubed, touched up, and drew on my sculpture with a seriousness and eagerness which only a child can still put into his work. I was so free, so relaxed, so "happily exploded" as never before in my life. I felt like another being. There was no form to the sculpture. Anyway, I think it looked somewhat insignificant. I gave it the pompous name "Attempt at a Four-Dimensional Sculpture." But now I was certain that for the time being I would continue to study at the Bauhaus. I understood the essence of the Bauhaus. The fact that I am still a student at the Bauhaus should be taken as proof that for me

The world has meaning only when it is a "Bauhaus." "The whole world one Bauhaus!" [Original without capital letters]

Anonymous newspaper report
"Something Metallic"—Bauhaus Celebration (1929)

From the newspaper "Anhalter Anzeiger" (Dessau), February 12, 1929
The carnival festivities at the Dessau Bauhaus each year were the big social event in the city. One of the most brilliant of these was the "Metallic Festival" (February 9, 1929) for which the Bauhaus buildings were transformed into a fairy-tale vision at a time when nature lay locked in the relentless winter night. While the charm of the earlier parties stemmed primarily from improvisation, the atmosphere was now dominated by the careful arrangement and the great variety of entertainment.

Matinée of the Bauhaus Stage Company in Basel (1929)

From the newspaper "National-Zeitung" (Basel), No. 196, April 30, 1929
With this program, which the Bauhaus stage company presented on its tour in 1929, the group gave a summary of its endeavors. Previous stops on the tour had been Berlin, Breslau, Frankfurt on Main, and Stuttgart. The appearance of the company in the Basel City Theater was doubtlessly aided by the fact that the audience was able to see a display of the visual art of the Bauhaus in the Kunsthalle and the workshop products in the Gewerbemuseum at the same time.

With an elegant metal-colored card, printed with the usual lower-case Bauhaus type, the Dessau Bauhaus and the circle of its friends issued invitations to a "Metallic Festival." Metal is hard. But it is also sparkling and shiny. The festival last Saturday night proved to possess the latter qualities of metal . . . The party sparkled and shone, and yet was of such friendly gaiety and merriment, without ever getting out of hand in any way, that all participants enjoyed it thoroughly. The entrance to the gaily decorated rooms was really ingenious. One entered the party via a chute that was built down from the connecting hallway between the two Bauhaus buildings. Here, even the most dignified personalities could be observed gliding down into the festive rooms, welcomed by the tinkling of bells and a big flourish played by a live four-piece village band which meant well but sounded terrible. . . . And then there was music in the air everywhere, and everything was aglitter wherever one turned. The rooms and studios of two floors, which normally are used for serious work, had been decorated with the greatest variety of forms placed together all over the walls, shinily metallic and fairy-like, the ceilings hung with bizarre paper configurations. . . . In addition music, bells, tinkling cymbals everywhere, in every room, in the stairways, wherever one went. . . .

The government of Anhalt was represented by Prime Minister Deist and State Minister Dr. Weber, and the city of Dessau by Mayor Hesse . . . But the visitors did not come from Dessau alone. Many had come from Berlin, Leipzig, Halle, and other places. Most of them in metallic costumes. Rarely has Dessau seen such a great number of really original and magnificent costumes . . . And wherever an evening suit did appear, it had at least some kind of metal decoration pinned on the lapels.

Thus the brilliance of sparkling lights and the music of happy dance tunes created a gay and colorful image: the chute, loved by young and old, the shooting gallery where the little man and his lady could test their marksmanship, the amusing laughing gallery, the champagne corners, and particularly the different rooms where the guests danced to the tune of some excellent bands—the Bauhaus's own band walking off with the prize. The performances in the lecture hall . . . found an enthusiastic audience. A gay farrago of film pictures alternated with various stage presentations . . . An entertainer told amusing stories . . . So everyone had great fun and enjoyed the party, and it was late when the first guests began to think about facing the piercing cold, which made the way home particularly unpleasant that night. . . .

The curtain rises. Black backdrop and black stage floor. Deep down stage a cave lights up, not much larger than a door. The cave is made of highly reflecting, corrugated tinplate set on edge. A female figure steps out from inside. She is wearing white tights. Head and hands are enclosed by shiny, silvery spheres. Metallically crisp, smooth, and shining music sets the figure to performing crisp movements . . . This whole thing is very brief, fading away like an apparition. The program says "Dance in Metal" . . .

"Dance in Space": a white square, filling the whole stage, has been outlined on the black stage floor, in which a circle and diagonals have been inserted. A fellow in yellow tights comes tripping on stage and traverses it, hopping hurriedly along the white lines. His head is inserted into a globular mask made of colored sheet metal. A second fellow in red tights, also masked, steps on the white lines and paces along them with generous steps. Finally, a third one, in blue tights, calmly strides across the lines. The individual movements of the three encounter each other, interpenetrate, and dissolve in the most diverse figures. Three gaits of the human body—three characteristics of color—three characteristics of form, all of them inextricably linked: yellow, pointed hopping—red, full paces—blue, calm strides . . .

"Dance of Forms": The same three fellows, reinforced with "forms": with a large, white, light ball, with a small, silver, and heavy sphere, with a long, slender, and light baton, with a short, thin, and heavy bar and with something between the two, a club. With gliding, swinging, and angular movements the dancers join these forms into a figure, remain in that pose for a moment, dissolve it and then put together a new, surprising combination. An imaginative game with simple, elementary forms. The human bodies which are participating in this dance are "working" with accuracy, but without showing the kind of drill that is unnatural to the body and without being imitative of puppets. Their bodies are casually tense just as they would be if performing natural movements for some kind of work.

Number four: "Dance of the Stage Wings." A number of partitions are placed one behind the other. Hands, heads, feet, bodies, and—words! appear in a short broken rhythm in the spaces between the partitions. Dismembered, crazy, meaningless, foolish, banal, and mysterious. This is extremely silly and extremely frightening. It reveals the entire meaning and the entire stupidity of the phenomenon "stage wings." And one senses that things like that are not contrived by the intellect, they originate in other regions . . .

Number six: "Dance of Gestures." Once again the three fellows in color. The yellow one jumps on stage with joy and sits down on a chair after making a series of extremely complicated gesticulations. The red one enters with dignity and sits down on a stool in an even more complicated manner than the first. The blue one crawls on stage on his belly and lazily stretches out on a bench. And now the three are performing everything there is in the way of human gestures: Pointed sneezing, broad laughing, and soft listening. But they never slip into a performance of an illustrative anecdote. The imitation, the pantomime is never an end in itself. It is always used as a means, as isolated and abstract form with which man plays his game. And what a witty and amusing game!

Number seven: "Dance of Slats." A female figure dressed in black tights with long white slats fastened to all her limbs. The natural movements of lifting and bending the limbs and the body are seen only in the movement of the slender slats which lead a strange and natural life of their own. This figure looks like a chimerical spider.

Number eight: "Game with building blocks." On stage there is a wall made of building blocks, the size of an ashlar. The three fellows crawl out from behind it. They take down the wall, piece by piece, place one piece at one point in space and carry another somewhere else. They throw the blocks at each other, just as bricklayers throw bricks. Finally, they build a tower and dance around it triumphantly. All this is done with the deadly and solemn earnestness of their masks. Yet, all their doings are so idiotically senseless! No one is able to resist the humor of this grotesque contradiction!

Number nine: "Dance of Hoops." The girl in the black tights is playing with a white hoop. She whirls it around herself, tosses it up, high, low, makes it vibrate—does everything possible with it. Suddenly a whole net of hoops descends from above, and a second one and a third one and then hoop figures, larger than life and looking like the Michelin tire man. The girl takes a tapering bundle of hoops and forms one figure after another with them. But suddenly the human being is tired of being a tool of material things and of twisting into all kinds of poses: it lets go of the hoops and they bounce in every direction. The human being stands there alone and free! It was man who had thought of the whole thing, had kept the hoops together and had formed the figures! When he has had enough of it all, he lets go of everything, and the material things, into whose service she had submitted herself, are powerless, are dead! This reminds one of the critics who accuse the Bauhaus stage of mechanizing and degrading man! Exactly the opposite is the case, the Bauhaus stage demonstrates the sovereignty of man, who is able to play with material things.

Number ten: "Three Baroque Ladies." They might have come straight from a mardi gras in Basel! Sumptuous dresses made of light-colored curtain material with large flower patterns. Broad-brimmed, flapping hats. The three of them bow to each other, spy on each other, and gossip about each other. Then they fix their hair in front of a mirror and pose for an imaginary photographer for sentimental group pictures.

Last number: "Chorus of Masks." Light blue horizon. In the darkened center of the stage stands a long, empty table with chairs and glasses. A large shadow, probably three times life-size, appears on the horizon and shrinks to normal human scale. A grotesque, masked being enters and sits down at the table. This continues until a weird round table of twelve masked characters has assembled. Three characters descend from above, out of nowhere: an "infinitely long one," a "fantastically short one" and a "nobly dressed one." And now a gruesomely solemn drinking ceremony is celebrated. After that the drinking party gets up and comes to the very front of the stage, frighteningly close. Forming complicated figures the party disperses quietly. Nightmarish as only a dream can be. The audience is now really enthusiastic!

People who are trying to discover "something" behind all this—will not find anything, because there is nothing to discover *behind* this. Everything is there, right in what one perceives! There are no feelings which are "expressed," rather, feelings are evoked . . . The whole thing is a "game." It is a freed and freeing "game" . . . Pure absolute form. Just as the music is. . . .

Benno Reifenberg
The Performance of the "Bauhaus Stage Dessau" at the Frankfurt Schauspielhaus on April 20, 1929
From the newspaper "Frankfurter Zeitung" (Frankfurt on Main), No. 296, April 22, 1929
The theaters in Frankfurt were at that time strongholds for Expressionistic stage experiments. Hence, the reservations which qualified critics (like Reifenberg) had about the Bauhaus stage are particularly suited for demonstrating that it was simply impossible to explore the main feature of Schlemmer's preoccupation—the clarification of the relationship between man and space—in a literary and theatrical form.

Soft whistling of a popular tune from the gallery. A voice from the orchestra seats: "Why do you have to disturb the people who have come here with pure hearts to enjoy themselves!"

On the stage there is a breath of the blackness of night; some corrugated sheet metal plates flash from out of the darkness. Between them stands a human figure vehemently moving, like a fencer, dressed in silvery spheres and silhouetted by light bulbs.

Or: a red, a blue, and a yellow, cylinder-like figure stride along with measured pace, then trip along. To the sound of gongs, with heads in diving-helmets.

Or: a woman is strapped in glass spheres, a skirt of glass rods and a glass globe over her blonde head! She is swinging glass to and fro—a little uneasily the way one used to wave a censer. Glissando on a piano.

Or: Fellows dressed in black, with white gloves behind colored partitions. They run past them, between them, through them and alongside them.

Or: a woman dressed in black tights with white slats sewn to them.

Or: wooden hoops swirled around in front of curtains made of more hoops; or stairs, or building blocks, leather balls, clubs, battens, etc., etc.

But what about man? What has happened to God's image? This is what the audience uneasily asks after it has been tortured by this specter as if thumb screws had been applied. The Bauhaus stage, under the direction and production of Professor Oskar Schlemmer, answers these questions as follows: We are basing our work on space, form, color, material; the laws of these elements have a determining effect on psycho-physical behavior. We are interested in exploring "strict regularity"; we are striving to achieve the highest form of art, we are striving to achieve intensity. This is the only way we can regenerate the art of acting. The Herr Professor is a zealot. Schlemmer is an ascetic—he is a reformer. He hopes by abstraction to clear the way to find law, so that later, in a realm of order, he can rediscover renewed man.

One is reminded that the great movement of Expressionism in art began with similar ideas; what one called nonrepresentational art was to be understood only as an attempt at reform and those people who all too pitilessly . . . laughed at Professor Schlemmer should remember that it is hard to interpret Picasso in any other way. . . . There was a similar problem when people were attempting to gain an understanding of Negro sculpture and when they sought to find laws in those strange cubes. This followed a train of thought that had originated a long time ago with Dürer and his "proportion figures," and which was taken up again in those early years of the latest art movement and with which one sought, with a kind of courageous asceticism, to fight through the thicket of an age deprived of religion.

But in summing up one sees that this was leading along the wrong track; those following it were the poor cubists, Mary Wigman with her followers, and Oskar Schlemmer. It led in the end to a bare room. Over the entrance is written in sans-serif type: *arts and crafts.* We are of the opinion that this way of being radical, which hopes to get at "the laws" in such an open and direct manner, must be termed a poor way of being radical. For these laws—of space for instance, or of surface composition or of color as such—are unreal to us, if in order to recognize them, we must first juggle away the human being. Why should we be concerned with ornaments if there is nothing to be decorated; why should we be concerned with a space in which, instead of human bodies, there are cubes sprawled all over? To be honest: you can keep that space.

We are not so insensitive as to be unable to attach our imagination even to objects which are dead. We too, with our gift for fantasy, are able to breathe a kind of half-life into those circles and slats. But we refuse to do that, we are weary of such an effort. We are sick and tired of having people clarify for us the "ABC of walking, striding, and running" since it has long been clear how well we would all walk and run together if we only knew where we were going and why we were running. The true radical, it seems to us, never forgets the dialectic of law and man. The only road is the one through the human heart. Whatever is not on that road remains for all eternity nothing but empty formalism.

Nothing illustrates the incredible "arty-crafty" spirit that rampages on the Bauhaus stage better than the statement in the program saying that the stage hopes, by going the Bauhaus road, to arrive at a style similar to that of the Japanese or the Chinese theater. Yet, and I am ready to bet my last penny, these Oriental conventions are derived from mythology, and that there "style" has been derived as an expression of content that is not subject to doubt.

But what is the content of the Bauhaus stage? The stupid, senseless action of the last sketch manifests with terrible clarity how thin, how unimaginative, and how bricked-in the world looks to these men. For this reason we refuse to take the "Chorus of Masks," which offers superior pranks, to be more than arts and crafts. It would be wrong to deny the fact that this thing cut us to the quick, when this company of old hags, Mars-heads, and pale caricatures, all dressed in black robes, clinked their silvery-sounding glasses. But *we,* the audience, were the ones who had to employ our imagination in order to go along with this. Genuine masks on the other hand—one is reminded of Ensor—pull us down right away into that suspicious world. There is something hidden behind the real mask. But behind the grimaced Bauhaus masks there is absolutely nothing. Consequently they remain what they are: papier-mâché.

Professor Schlemmer will claim that what he is presenting are, so to speak, finger exercises for future generations of stage directors and set designers. Our opinion is that one does not generally go to the concert hall to hear finger exercises. To this, Professor Schlemmer might answer that the music for which he has devised the finger exercises has yet to be written. So much the worse for these exercises, Herr Professor.

Howard Dearstyne
Notes on the Psychology Lectures of
Dr. Karlfried Count von Dürckheim (1930–
1931)
BR, gift of Howard Dearstyne (First publication)

Psychology lectures were introduced at the Bauhaus under Hannes Meyer. They were typical of the tendency that dominated the Bauhaus from 1928 on, to introduce system and scientific method into the curriculum. Count Dürckheim was called in from Leipzig as guest lecturer. He based his own teaching on that of the Gestalt psychologists Wundt and Krueger. But he was also well acquainted with Freud and Adler, and he made a point of emphasizing the importance of broadening the approach of individual psychology into aspects of social psychology. The fact that the theories of Kandinsky and Klee found their scientific affirmation in these psychology classes accounted in great part for their importance to the Bauhaus.

[Dürckheim's mentor], Felix Krueger, builds on the teachings of Wilhelm Wundt—Leipzig (around 1875): Gestalt psychology. Standing out (of the Gestalt) from the background, coherence, arrangement, qualities of wholeness.

Physiologically equal parts change when the environment and the arrangement change. The parts change when the Gestalt changes.

The changing of one part changes the whole [example: A changed attitude of the mouth changes the whole expression of the face]. The magnitude of the change afflicting the whole through the change of one part depends on the importance of that part to the whole. Phenomenon of assimilation and of contrast (colors!).

What is a Gestalt?

1. Definition in space—figure and background.

2. Arrangement.

3. Coherence.

Feelings are qualities of the totality of consciousness.

Proportions make sense only when there is a whole [example: a vase]. The less coherent the parts, the looser the arrangement of the whole.

Dynamics. Importance: that element which determines the character of the whole is of the greatest importance (a church steeple in a village!)

Contrasts.

Optical illusions.

Golden sections.

Greatest sensitivity during circular movement, lowest sensitivity during movement along a straight line. The straight line is not the shortest distance, in the psychological sense. Compare Karl Schneider, "Neue psych. Studien" ("New Psychological Studies"), volume 4; Felix Krueger, "Neue psych. Studien" ("New Psychological Studies") particularly volume 1, no. 4: Psychic Totality. Moreover, in volumes 1 and 4 the contributions by Sander, Gunta Ibsen, Lippart, Karl Schneider. Wertheimer (Berlin): "Drei Abhandlungen zur Gestaltpsychologie" ("Three Essays on Gestalt Psychology").

Man's creative urge forces him to try to give form to shapeless matter.

A point lying outside a circle appears to be moving toward the circle in an attempt to close the same.

One is better able to recognize the major characteristics of the whole with one quick glance than by studying the details; details preclude a clear understanding of the whole. Dynamics of Gestalts:

\int upwards $\qquad\qquad$ \int fast } spirited—hampered—tense.
slow

[The drawings were made on the blackboard by students]
All forms remind us of something. We are unable to eliminate physiognomic aspects. Forms arouse associations [example: various geometrical drawings].
The dynamic impetus is partially diminished, if one sees the figure as a contour of a thing. Static = unequivocal, dynamic = equivocal?
On the psychology of the child:
The way the child sees objects and the way it represents them. [Following are detailed descriptions and examples for the way different age groups experience things. Significance for the child of tactile things, lines, colors, and naive actions. Kinds of object-characterization, mastering of various tasks of representation. The child's development of speech.]
Summer Semester 1931: "The personality in its world."
Total psychology.
The child has its own world. Character, life, social situation, and age make for different worlds. Totality of man and his world. The physical world is not related to man and consequently cannot be experienced.
Space: the determination of position lends it its character. Each space is something special to us as a space of a particular kind of life. Each space imparts a certain attitude to us (church, school, etc.!). The boundaries between consciousness and unconsciousness are fluid.
Lived-in world and lived-in space.
Space as being (physiognomical space). Experience of space.
Functional space (space with a purpose: space as "space for living" in general); space is something special when it is used as space for personal activities.
Personal space (as experience) and objective space. Space as personal property (the fact that a stranger enters it may be insulting).
Intellectual directedness [Klages, "Der Geist als Widersacher der Seele" (The intellect as antagonist of the soul)]. The spiritual world is a complete entity depending solely on itself. Cognition is an intellectual matter. What is cognition? The child does not [yet] ask this question. . . .
There are two basic diametrically opposed . . . approaches to the environment. Objectivity (= distance), the new basic situation, sets in at about the age of 13. At this time begins a new relationship to one's work which does not satisfy the individual until it is finished, as something completed within itself. Intellect is to be found where there is interest in objectivity. Whenever we produce something we link ourselves to the object. An act of free will—as distinguished from drives.
Love; good and bad conscience.
All basic directedness of man is bound to a "feeling of obligation." This feeling of obligation does not exist with respect to the ego . . . How far are obligations absolute values?
The ego stands in opposition to the social commitment. The ego: compare Alfred Adler's "Individual Psychology," which is remarkably one-sided. Emphasizes the struggle of the "I" against the demands of life.
Feeling for the individual—feeling for the community.
Feeling for the community as expression of biological forces.
Even things that seem to have no sense of direction, like lapses of memory, have a definite goal: attempt at rationalization, in order to avoid an unpleasant situation.
Object of the basic directedness of all of life is aspiration for the divine. . . .
Ethical perception has its origin in the helplessness of childhood. Playing gives the child the feeling of "being on top of things." Everyone desires to be "on top" (with respect to his social situation) and wants to secure this position. This desire, too, has its origin in childhood. Our ambition to become godlike will not endure humiliation. Hence, our escape into illness when we fear compromising ourselves: in a state of illness we do not feel responsible. Adler deals with one part of the human personality in an exemplary way, but he does not present the complete picture. Man as a psychic reality is more than a delimited individual.
Intellectual powers are a prerequisite for the experience of values. I experience something as a value, if there is no doubt in my mind as to its claim for existence. The basis for experiencing values is the personality as a whole. The consciousness of that whole is the personal consciousness, or in other words the conscience (responsibility). The structure of the whole becomes evident in the experiences of the conscience. This structure finds its total expression in the experiences of obligation. . . . The true experience of obligation is the abstract correlate of an actually experienced value. Differentiate between abstract experiences of values (beauty, truth, etc.) and the experience of concrete values. In the realm of the social directedness of man one has to differentiate between the drive for individual improvement and the drive to conform with the community. Every community is the expression of a value content. The actual existence of values becomes clear when that entity is endangered from the outside.
The individual is able to recognize his pecularities and to control them. . . .
Phenomenon eroticism—love: it is more than momentary satisfaction. Freud did not fully recognize this higher aim of Eros. Freud was too much a rationalist; but in his later years he changed, wanting not only to free people from complexes but to mold them.

65

Joost Schmidt: Construction design, letter a (about 1930) PA, Nonne-Schmidt, Darmstadt.

Joost Schmidt
On Lettering
PA, Helene Nonne-Schmidt, Darmstadt
(First publication)
From preparatory notes for his course during the period between 1930 and 1932. Next to the classes in lettering, Joost Schmidt also taught commercial art, life-drawing, and sculptural composition. "Schmidtchen," in his great versatility, his never-ceasing interest in experimentation, and his companionship and sociability was the Bauhäusler par excellence. With great personal modesty he contributed a host of ideas to the people around him. His work on typography and his investigations of color belong to the most important of their kind and time.

Ernst Kállai
Ten Years of Bauhaus
From the journal "Die Weltbühne," Berlin, No. 21, January 1930
Kállai's ideas about the role of the Bauhaus were largely determined by the teachings of materialism. In this respect his ideas were similar to those of Hannes Meyer. In his comments, which are full of irony, one detects his disappointment that these demands were only insufficiently put into practice. What is characteristic for this way of thinking is the ignoring of the possibility of striving for a synthesis of art and technology. Kállai's arguments do not take into account the fact that the "Zeiss" lamp, for instance, which he played off against the first "Bauhaus lamp" as being a more thoroughly developed product, also had its origins in Bauhaus experiments made to develop just such products.

Contributing Factors: cultural factors

The form of the lettering
1. language influence
Necessity of visual fixation of the language. Sound—phonetic symbol—character—spelling (orthography).

2. expressive, psychological influence organic aspects
Writing as expression of personality (individual = one person; social = many people). Information about the mentality of the individual or the group; expression of various aspects, like the straightforward, sober, playful, neutral, decorative, functional, organic, inorganic, strong-willed, lyrical, heroic, and dramatic aspects.

3. optical, psychological influences
Legibility, ease of teaching, and ease of learning (possibility for re-producing and remembering). Characterization of the acoustic image = type symbols. Differentiation of the characters (harmony, disharmony). Unifying, separating, and distinguishing elements. Distance, form, and stroke.

4. technical influences factors of civilization mechanical aspects
Typographic technology (cone system, sentence element, suitability for assembling, type system). Technical elements, elements of drawing and of form (circle, straight line, ellipse). \perp — /, easily produced writing—stroke of writing, flow.

5. economic influences
Competition with other kinds of script. Frequency of use of a type of script (reason: fashion, etc.). Costs, profit, and risk when introducing a new kind of script. Production, consumption (life expectancy of the type setting material).
Writing as a medium of communication between individual groups, social function. Writing, if left to the individual (because writing is also a means for the unconscious fixation of expression) develops into individual form (individual, graphological form, strengthening of personal aspects and form of expression, possibility even of development of asocial aspects). Writing, if left to society develops into a collective form due to necessary agreement (danger of misunderstanding individual form) and to the observance of all the above mentioned factors (socio-graphological form of expression).

It was ten years ago that Walter Gropius reorganized the Weimar School of Arts and Crafts and named the new school "Bauhaus." The success of his creation is well known. What, during the early years at Weimar, used to be the vehemently disputed activity of a few outsiders has now become a big business boom. Houses and even whole housing settlements are being built everywhere; all with smooth white walls, horizontal rows of windows, spacious terraces, and flat roofs. The public accepts them, if not always with great enthusiasm, at least without opposition, as the products of an already familiar "Bauhaus style." But in reality the initiative for this kind of architecture originated by no means at the Bauhaus alone. The Bauhaus is just one part of an international movement that developed quite a while ago, particularly in Holland. But the Bauhaus became the first school of this movement. It has been highly effective in disseminating its ideas and has been extraordinarily successful as a place for experimentation. The reputation of the institute has quickly spread and reached even the remotest corners of the country. Today everybody knows about it. Houses with lots of glass and shining metal: Bauhaus style. The same is true of home hygiene without home atmosphere: Bauhaus style. Tubular steel armchair frames: Bauhaus style. Lamp with nickel-coated body and a disk of opaque glass as lamp shade: Bauhaus style. Wallpaper patterned in cubes: Bauhaus style. No painting on the wall: Bauhaus style. Incomprehensible painting on the wall: Bauhaus style. Printing with sans-serif letters and bold rules: Bauhaus style. everything written in small letters: bauhaus style.
EVERYTHING EXPRESSED IN BIG CAPITALS: BAUHAUS STYLE.
Bauhaus style: one word for everything. Wertheim sets up a new department for modern-style furniture and appliances, an arts-and-crafts salon with functionally trimmed high-

fashion trash. The special attraction is the name "Bauhaus." A fashion magazine in Vienna recommends that ladies' underwear no longer be decorated with little flowers, but with more contemporary Bauhaus-style geometrical designs. Such embarrassing and amusing misuses in the fashion hustle of our wonderful modern age cannot be prevented. His Majesty the snob would like something new. Very well. There are enough architects making the Bauhaus style into a new decorative attraction. The exhibition of cold splendor is back again. It has just been rejuvenated, has exchanged the historical robe for a sort of pseudo-technological raciness. But it is just as bad as before . . . The new Berlin despises the swollen marble and stucco showiness of the "Wilhelmian" public buildings and churches, but it revels in the hokus-pokus of megalomaniac motion-picture palaces, department stores, automobile "salons" and gourmets' paradises with their shrieking advertisements. This new architecture, the slender nakedness of its structure shining far and wide and bathed in an orgy of lights at night, is by no means, so we are told, ostentatious; it is rather "constructive and functional." Hence, once more: Bauhaus style. But let us take heart. For small home owners, workers, civil servants, and employees the Bauhaus style also has its social application. They are serially packaged into minimum standard housing. Everything is very functional and economical. Furniture and household articles are within reach and, according to Westheim: the suicidal gas main is in their mouth. . . .

Let us keep the slogan "Bauhaus style," since it has already become a household word, even where it is no more than a cover for a corruption of originally more sincere intentions. With all due respect to the difference between these intentions and the commercialization of the Berlin Broadway. It cannot be denied, however, that the work of the Bauhaus itself is in no way free of esthetic overcultivation and of dangerous formalism. It is true that discarding all ornamentation and banning each and every curved plane and line in the design of houses, furniture, and appliances has led to the creation of very interesting, new, and simple forms. But whatever was obvious about these new functional forms has by no means always made as much sense. Rather, the products which were to be expedient and functional, technical and constructive, and economically necessary were for the most part conceived out of a taste-oriented arbitrariness decked out in new clothes, and out of a *bel-esprit* propensity for elementary geometric configurations and for the formal characteristics of technical contrivances. Art and technology, the new unity—this is what it was theoretically called and accordingly practiced—interested in technology, but art-directed. This is a critical "but." Priority was given to the art-directedness. There was the new formalistic wilfulness, the desire to create a style at all costs, and technology had to yield to this conviction. This is the way those Bauhaus products originated: houses, furniture, and lamps which wrested attention primarily by their obtrusively impressive form and which, as a logical result of this characteristic, were accepted or rejected by the public and the press as being the products of a new style, namely the Bauhaus style. But they were not accepted or rejected for being the products of a new technical development in the building or furniture industries. Of course the Bauhaus, in numerous programmatical and propagandistic publications, affirmed time and time again that the formal characteristics of its products were no more than the inevitable results of a "strictly relevant" fulfillment of function, rather than an intention to create a style. Yet, a few years of practice were already enough even for the eyes of the younger Bauhaus generation to recognize that these products were outdated handicraft. This may be less florid than customary handicraft. But it is instead inhibited, prejudiced by a doctrinaire mock asceticism, stiff, without charm, and yet pretentious to the point of arrogance. Fellow-travelers who are smarter businessmen and are more unscrupulous have not hesitated to make frankly shoddy handicraft out of this somewhat clumsy trouble-child of the new functional design. Where is the dividing line between genuine and false Bauhaus style? The Bauhaus started things rolling with its esthetic ambition; it must now accept the fact that others are going to add all the rest right up to the bitter end. Why is it that a similar fate does not threaten a swivel chair or the "Zeiss" lamp? The reason is that these products are not born of the unity of art and technology but are genuine constructions evolved from industrial technology: they are creations of engineering. It would be revealing to ask one of the "Zeiss" engineers for his opinion on the technical and illumination properties of the Bauhaus lamps.

Gropius established, among others, the following guide lines for the Bauhaus program: "The Bauhaus wants to assist in the development of present-day housing, from the simplest household appliances to the finished dwelling. . . . The Bauhaus workshops are essentially laboratories in which prototypes of products suitable for mass production and typical of our time are carefully developed and constantly improved . . . The prototypes that have been completed in the Bauhaus workshops are reproduced by outside firms with whom the workshops are closely related. . . . The Bauhaus brings creatively talented people with ample practical experience into the actual course of production, people who have mastered both technical and formal problems, and who are to take over the preparation of models for production in industry and the crafts . . .

Particularly with respect to building: the mass prefabrication of houses should be attempted and units should be kept in stock which would be manufactured not on the site but in permanent workshops, to be easily assembled later. These would include ceilings, roofs, and walls. Thus it would be like a children's box of blocks on a larger scale and on the basis of standardization and production of types."

This program is extraordinarily up to date and very "social." Modern industry and business have attracted a tremendous number of people to their places of production and distribution. This has caused a social need in the area of housing which can only be overcome by mass production. The industrialization of the building and the home-appliance industry is an urgent socio-economic and socio-political requirement. Industrial production

methods, by way of a process of mechanical elimination, inexorably cast off any discrepancies with respect to form which might interfere with the impersonal neutrality and complete fulfillment of the function of the articles. To put Bauhaus production into the service of such standardizing elimination and to train, at the Bauhaus, the leaders of a modern construction and home-building industry is admittedly a highly important and productive idea. But this idea must be followed in reality and not, as has many times been the case in practice at the Bauhaus, deviate into formalism.

It is not enough to force industrial mass production and in so doing, in the design of these products, to allow artistry—despite schematic simplification it is still esthetically willful—to triumph over the engineer. Architecture must strive resolutely to accomplish "social, technological, economic, and psychological organization" (Hannes Meyer). Otherwise architecture will remain—Bauhaus style, a hybrid solution, indecisive about form, neither emotional and free like art, nor straightforward, accurate, and necessary like technology. The result of this ambiguity of the Bauhaus style is the strange and inhibited situation of free art at the Bauhaus, especially that of painting. This inhibition stems from the secret or open hostility between most of the architectural and workshop members. These semi-artists and semitechnicians find arguments to present themselves as superior to the painters with respect to their usefulness and their powers of reasoning. No engineer would ever dare take such a position. It is clear that this hostility is no more than their way of protecting themselves against their own artistic drives which have been repressed by the fact of their association with technology. Bad conscience with respect to the demands of form is thus anesthetized.

Yet, painting is avidly carried on at the Bauhaus, right next door to the imposing reinforced concrete structures and the huge glass planes, in the shadow of these strutting, rationally cold, expedient, and industrially esthetic three-dimensional structures, so to speak. Whoever was to find a chance to peek into the rooms and studios of the Bauhaus people at night would be surprised to see how many painters are standing in front of their easels, painting away at their canvases—some of them secretly, like high-school students who furtively write poems, with a bad conscience perhaps, because instead of sweating over functional modern buildings or folding tables or lamps, they remember just that part of the famous Gropius phrase about "art and technology, a new unity" that deals with art, leaving technology to the technologists. These painters are transcending all rationalized expediency and the principle of esthetic usefulness the Bauhaus preaches, with an indifference as if they were living on some fantastic planet of art where everything is in a state of surrealism. The more the efforts of the Bauhaus workshops and the practice of the building industry focus on the achievement of the kind of straightforwardness that is functionally and structurally directed and mass production and standardization oriented, the more the Bauhaus painting falls into the other extreme. Either it revels in dreams, visions, and blunt confessions of the soul or in paradoxical juggler's tricks between tangible reality and its conversion into metaphysics. It is interesting and curious to note that such art, concerned with psychic introspection and with the skeptical and playful enjoyment of contradictions, was able to develop, particularly in such close contact with the modern, daily practice of the purpose-minded Bauhaus. This development is curious and yet characteristic, for it is to be interpreted as a natural relaxation and compensation. The overemphasis on industrial technology and rational organization, on the other hand, is bound to activate all the powers of the spirit. In this respect the Bauhaus can well be considered a proving ground in the sense of intellectual, cultural activities. The discrepancies between the soul and technology which today exist at the centers of the Euro-American civilization are put to their toughest test at the Bauhaus, where close human contact and close associations in practical work have developed under one roof. Daring balance, cerebral and soul equilibristics: Bauhaus style.

Or is it simply a case of the left hand not knowing, or not wanting to know, what the right hand is doing, and vice versa? Is it a case of not knowing that architecture and art are going separate ways, as husband and wife do in a modern companionate marriage? Antiseptically clean separations are basically very well liked at the Bauhaus. One separates painting from representation. The painting has to be abstract. In Kandinsky's paintings a tree or a face may not even accidentally sneak in. They are immediately contorted past recognition or are expunged altogether and assigned to photography. Everything representational belongs to the realm of photography. Violators of this principle are making punishable reversions into an epoch of art that has been discredited. Still, there are painters at the Bauhaus who dare look at nature. Feininger, Klee, and a good number of younger painters. But they don their visionary protective goggles in order not to shield their spiritual eyes from the crude materialism of reality.

Hence once more: clean separation. Just as between soul and belly. "Eros" has very little influence at the Bauhaus. People are either reserved, straightforward, and cerebral, or they are simply sexual in an unsublimated way. People either pray according to German industrial standards or listen to phonograph records of American jazz hits twanging about sentimental voluptuousness. People are balancing out antitheses: Bauhaus style. There is little human fulfillment, little that is vigorous, genuine, and whole. There is far too much theory, over-exaggeration, and abstraction. What is urgently needed is reform. . . .

Hannes Meyer
**My Expulsion from the Bauhaus
An Open Letter to Lord Mayor Hesse of Dessau**
From the magazine "Das Tagebuch" (Berlin), Vol. 11, No. 33, August 16, 1930, pp. 1307ff.

Herr Oberbürgermeister!

. . . Please allow me a moment to introduce the Bauhaus and myself to the readers of "Das Tagebuch." I am Swiss, 40 years old, married, living separated from my family; 5 ft. 9 in. tall, hair flecked with gray, blue-gray eyes; nose, mouth, and forehead, according to my Swiss passport, are "medium," and my special characteristics: externally none. And now, the Institute itself: as the "Bauhaus Dessau" it is an institution of the city of Dessau, receiving a yearly subsidy of RM 133,000; as an "Institute of Design" it is under the

This open letter was published by Hannes Meyer (and is reproduced here in abbreviated form) in answer to the mayor's notice of termination of his contract on August 1, 1930. The letter makes evident the irrefutable credit Meyer deserves for his work, but at the same time it lays bare the hopelessness of his attempts to merge his own concept of the work of the Bauhaus, centering primarily on social and quantitative achievement, with the legacy of the Gropius era.

jurisdiction of the government of Anhalt. The annual budget amounts to RM 167,000. There are 171 students, among them 40 foreigners. There are 13 full-time and 4 part-time teachers, including Paul Klee, L. Feininger, and V. Kandinsky who are artists of world-wide reputation.

What did I find on the occasion of my appointment? A Bauhaus, whose potential exceeded its reputation by orders of magnitude, and which had been receiving an unprecedented amount of publicity. An "Institute of Design" in which every tea glass became a problem in pseudo-constructional form. A "Cathedral of Socialism" in which a medieval cult was being followed by the revolutionaries of prewar art with the assistance of a younger generation which cast sly glances at the Left yet simultaneously hoped some day to be canonized in that very same temple.

Inbred theories closed every approach to a form for right living; the cube was king, and its sides were yellow, red, blue, white, gray, black. One gave this Bauhaus cube to children to play with and to the Bauhaus snob for idle sport. The square was red. The circle was blue. The triangle was yellow. One sat and slept on the colored geometry which was the furniture. One lived in the colored plastic forms which were the houses. On their floors lay, like carpets, the psychological complexes of young girls. Art stifled life everywhere. Thus my tragicomic situation arose: As Director of the Bauhaus I fought against the Bauhaus style. I fought constructively through my teaching: Let all life be a striving for oxygen + carbon + sugar + starch + protein. All design therefore should be firmly anchored in the world of reality. Building should be a biological process and not an esthetical process. Building ought not to be the effective accomplishment of one person but a collective action. It should be the social, psychic, technical, and economic organization of the life processes. Building should be an epistemological demonstration, and strong convictions should be inseparable from concrete realizations of work. I taught the students the link between building and society, the path from formal intuition to research in the science of building, and the requirement: Needs of the people rather than the requirements of luxury. I taught them to scorn the many faces of idealistic reality and I strove with them toward a single, controlled reality of the measurable, visible, and ponderable.

It became my aim to place design on a scientific basis and the educational structure of the Institute underwent important changes: The industrial consultant joined the structural engineer. The new appointments of Bauhaus Masters indicated the course that had been set: the Scoialist architect L. Hilberseimer, Berlin, the mathematician and photographer W. Peterhans, Berlin, the Norwegian philosophical critic and architect E. Heiberg. I tried to counteract the dangers of pseudo-scientific activity by strengthening the guest lecture series and with the ridiculously low annual salary of RM 5,000 I engaged for the Bauhaus the services of personalities like O. Neurath, Vienna, K. von Meyenburg, Basel, Dr. Dunker, Berlin, Dr. H. Riedel, Dresden, Dr. R. Carnap, Freiburg, Dr. W. Dubislav, Berlin, Dr. E. Feigl, Vienna, Dr. L. Schmincke, Neukölln, Count Dürckheim, Leipzig, Karel Teige, Prague, Dr. H. Prinzhorn, Frankfurt, etc., and in addition as "light relief" Hermann Finsterlin, Hans Richter, Ernst Toller, Dsiga Werthoff and Piet Zwaart. I countered the proverbial collective neuroses of the Bauhaus, fruits of a one-sided mental preoccupation, by introducing physical training; a "university without physical exercises" seemed to me to be an absurdity. The weekly schedule took into account the students' periodically changing receptivity to learning, and the main stress fell on three eight-hour workshop days scheduled in the middle of the week. For the winter 1930/31 an elementary course in Gestalt psychology was decided upon, in conjunction with Professor Felix Krueger, Leipzig, and his circle. A course in sociology was in preparation and I had plans for one in social economics which was still lacking. All of which shows how unsuitable I was to be a subordinate business manager of the "era gropii." I had views of my own and I expressed them as clearly as possible.

The material success of these two years of work at the Bauhaus is well known to you, Herr Oberbürgermeister. The annual production, amounting to about RM 128,000 in 1928, has nearly doubled. The number of students enrolled has increased from 160 to 197, and only by limiting admissions were we able to slow down the influx. The membership of the international "Circle of Friends of the Bauhaus" has risen from 318 to more than 500. During the last year of activity RM 32,000 were paid out in wages to students; thus even members of the working class were able to come to the Bauhaus. A traveling Bauhaus exhibit publicized our ideas in Basel, Breslau, Dessau, Essen, Mannheim, and Zurich. As Director of the Bauhaus I preached materialistic design in my lectures in Vienna, Breslau, Basel, Prague, Dessau, Nuremberg, Mannheim, Essen, Brno, etc. Industry became greatly interested, engaged trained Bauhaus students and concluded license agreements for the manufacture of Bauhaus textiles, lamps, standard furniture, and wallpaper. The aircraft, chocolate, and canned goods industries provided us with important commissions to design exhibition displays for them. Within one year, 4000 homes had been lined with Bauhaus wallpaper. Thus our budget had prospects of improving in the only really sound way, namely through self-help. My private commission for the construction of the Union School of the General Federation of German Trade Unions in Bernau near Berlin indirectly involved Bauhaus students and sometimes the Bauhaus itself. One student group worked on the masterplan for Dessau, one on four experimental houses, while another erected 90 workers' flats. Two groups began providing new furniture suitable for the environment of the child and for persons living alone. People seemed to have broken into our elegant glass house. Production to fill popular demand became the dominant theme, and the last of the art students went to mix paints for wallpapers.

Herr Oberbürgermeister! Throughout the period when we worked together, our concern at the threatening increase of political activity within the Bauhaus united us. In your opinion, it appeared to be coming from within the Bauhaus itself, while to me the threat came from the outside. . . . Since I am opposed to the Institute becoming involved in

politics, I acted in my capacity as Director and dissolved the Communist cell of the Bauhaus students in March 1930. You informed the government of Anhalt of this step. Thus, when in mid-July 1930, in connection with a voluntary collection of some individual Bauhaus students for the relief work of the "International Worker's Relief," the local Dessau press came out with the false report alleging the continued existence of a "Local Chapter Bauhaus Dessau" of the German Communist Party, the government of Anhalt demanded—and rightly so—to investigate this contradiction. You were unable to grant this request, since the "secret tribunal" of the cultural reactionaries had long prepared for the kill to take place during the Bauhaus vacation.

Herr Oberbürgermeister! On my return from the opening of the Zurich Bauhaus exhibition which was on tour there, I came to see you on July 29, 1930. There was great excitement in Dessau. The 90 workers' flats of the city housing estate at Dessau-Törten, the first collectively designed commission our architecture department had received, were ready for occupation. Thousands of people visited them. There was unreserved approval in the entire press. A two-and-one-half room flat with kitchen, bathroom, and utilities for RM 37.50 rent a month! At last an achievement in keeping with the role of the new Bauhaus. Although the work was under my guidance, it was independently implemented by a group of young students. I entered your office with a feeling of relief. With a brief reference to the investigation of conditions at the Bauhaus which the government of Anhalt, due to the false report mentioned before, had required of the magistracy, you demanded my immediate resignation. Reason: my alleged introduction of politics into the Institute. A Marxist (you said) could never be Director of the Bauhaus. Cause: my voluntary and private contribution to the relief work of the "International Workers' Relief" to aid the distressed families of striking miners in the Mansfeld area. My repeated assurances that I had never been a member of any political party remained futile. Also futile was my explanation that a "Local Chapter Bauhaus Dessau" of the Communist Party was an absurdity from the party-organization point of view, and again futile my assurances that my activities had always been concerned with cultural policies and never with party politics. You cut me short and interpreted my nervous smile as approval.

Thus I was stabbed in the back. Just when the Bauhaus was closed for the vacation and all my Bauhaus intimates were far away. The Bauhaus camarilla rejoiced. The local Dessau press fell into a moral delirium. The Bauhaus vulture Gropius swooped down from the Eiffel Tower and pecked at my directorial corpse, while, at the Adriatic, V. Kandinsky stretched out on the sand with relief: it was all over.

Herr Oberbürgermeister! Zoological gardens, museums, and race courses are expressions of the municipal urge to assert itself. Next to the "Wörlitz" and "Junkers" plants Dessau has acquired a "Bauhaus." Instead of keeping exotic animals, the city keeps those odd people which the world has come to revere as great artists. It is my deepest conviction that art cannot be taught. The clover-field of young Bauhaus artists, cultivated by the most extraordinary painter individualist, will lie fallow in our period of greatest social transformation and collective need. Moreover, it is a crime to offer young people, who have to be designers in the society of tomorrow, the stale feed of yesterday's art theories as provisions on their way. This is the heart of the matter. You flirt with your "culturally bolshevistic" Institute, yet simultaneously you forbid its members to be Marxists. For the camarilla hidden behind you, the Bauhaus is an object of political megalomania and professorial vanity and an esthetic amusement park. For us in the Bauhaus it is a place for creating new forms of life. Local politics require of you to present great Bauhaus achievements, a radiant Bauhaus façade, and a presentable Bauhaus Director. We in the Bauhaus increasingly contend ourselves with the anonymity of our collective work. The advancing proletarianization of the Institute seemed to us to be in accordance with our times, and the Director was a comrade among comrades. Your Bauhaus was outwardly radiant, ours was shining inside. . . .

Herr Oberbürgermeister! You are now attempting to rid the Bauhaus, so heavily infected by me, of the spirit of Marxism. Morality, propriety, manners, and order are now to return once more hand in hand with the Muses. As my successor you have had Mies van der Rohe prescribed for you by Gropius and not—according to the statutes—on the advice of the Masters. My colleague, poor fellow, is no doubt expected to take his pickax and demolish my work in blissful commemoration of the Moholyan past of the Bauhaus. It looks as if this atrocious materialism is to be fought with the sharpest weapons and hence the very life to be beaten out of the innocently white Bauhaus box. . . .

. . . I see through it all. I understand nothing.

Court proceedings in the controversy Hannes Meyer versus City Council of the City of Dessau

Recommended Settlement of November 5, 1930

From a newsletter of the "Circle of Friends of the Bauhaus," Dessau, November 6, 1930

The members of the arbitration committee, which had been established in the controversy over the dismissal of Hannes Meyer for purposes of working out a settlement between him and the City Council of Dessau, were the art commissioner for Germany, Edwin Redslob (Berlin), the architect Hugo Häring (Berlin), and the school superintendent Johannes (Dessau). The recommended compromise settlement was accepted by both parties.

The City of Dessau has stated that the termination of the contract between the City of Dessau and Hannes Meyer, to take place prior to the expiration of the official period within which notice must be given, has been decided on by the city administration because of its concern for a situation brought on by the abuse of the intellectually political aims of Mr. Meyer for party-political agitation, which would have endangered the continued existence of the Bauhaus.

The arbitration committee recognizes that the City of Dessau with this move has acted in the interest of retaining the Bauhaus, the transfer and continuation of which has to be appreciated as an act of politico-cultural importance. On the other hand, the arbitration committee equally acknowledges the significance of the intellectually political objectives and particularly the architectural theory of Hannes Meyer. It also commends his initiative in submitting his resignation in the interest of the Bauhaus, in order thereby to enable the immediate appointment of a successor and thus serve the continuation of the Bauhaus. In view of this position, which has been accepted by both parties, the arbitration committee deems it suitable to settle the controversy by a compromise which will adjust the economic matters while waiving the right to take the controversy to court.

7 Bauhaus Dessau
Mies van der Rohe Era

66
Signatures of Mies van der Rohe and faculty members
appointed by him.
Ludwig Mies van der Rohe
Lilly Reich
Ernst Walther

City Council of the City of Dessau—Mies van der Rohe

Employment Contract of Mies van der Rohe—August 5, 1930

PA, Mies van der Rohe (First publication)

The City Council appointed Mies van der Rohe to the directorship of the Bauhaus upon recommendation by Gropius. With his model of a glass skyscraper (1920/21), the Weissenhof Housing development in Stuttgart (1927), which was built under his over-all direction, and the construction of the German pavilion at the World's Fair in Barcelona (1929), he had already demonstrated outstanding architectural achievement. In the contract Mies van der Rohe inserted the condition that all rights accruing from the name "Bauhaus" would, in the case of a dissolution of the Institute, pass on to the last Director, a condition which Gropius had already stipulated himself. The promise of participation in appropriate architectural projects for the city remained unfulfilled in practice.

The following contract has been concluded between Herr Mies van der Rohe and the city of Dessau:

§ 1

Effective August 5, 1930, Herr Mies van der Rohe takes over the independent artistic and administrative Directorship of the Bauhaus. He is entitled to maintain a private architectural practice.

§ 2

This contract expires on March 31, 1935. Within this period, Herr Mies van der Rohe is entitled to terminate this contract, giving six months notice in advance. Apart from its authority to terminate contracts according to paragraph 626 of the German Civil Code, the city has the right to terminate this contract only in the case of the dissolution of the Bauhaus.

The Bauhaus can be dissolved only when there are urgent reasons for doing so; for example, when the number of enrolled students sinks below 75, or when the Directorate of the Bauhaus in agreement with the staff decides that the cultural mission of the Institute has been fulfilled or deems it possible to fulfill this mission only at another location. Such a dissolution, in case of disagreement with the city administration, is to be decided by an impartial arbitration committee which shall be constituted by a representative of the city, a representative of the Bauhaus Dessau, and the art commissioner for the German Reich as impartial chairman.

The contractual relationship is automatically extended after March 31, 1935, unless the city explicitly opposes an extension. Mr. Mies van der Rohe has to be notified of such opposition on or before October 1, 1934. In case the contract continues beyond March 31, 1935, either party is entitled to terminate it with six months' notice.

Insofar as either Mr. Mies van der Rohe or the city has the right to terminate the contract in accordance with sections 1 and 3, this right can be exercised only on April 1 or October 1 aside from the provisions of paragraph 626 of the German Civil Code.

§ 3

In the case of a dissolution of the Bauhaus, the rights for the use of the name "Bauhaus" are vested in the last Director.

§4

Mr. Mies van der Rohe will receive a yearly salary of RM 11,200. In addition he will receive an extra lodging allowance according to tariff class 2, and, as far as applicable, a family allowance according to the regulations of the "Act concerning salaries in the state of Anhalt" of December 23, 1927. Payments will be made in advance in monthly instalments. No claim for pension payments exists.

Any general changes in salary payments to city civil servants occurring after the conclusion of this contract will automatically result in respective changes in the above-mentioned payments. In addition, Herr Mies van der Rohe will receive a studio at the Bauhaus, free of charge.

§ 5

In his position as Director of the architecture department, it is Mr. Mies van der Rohe's duty to supervise the administration of the buildings of the Institute and the Masters' houses which are in the care of that department. This supervision is to be carried out with due attention to the city's building code.

In order to afford the Institute a chance to do independent architectural work, the city commits itself to enlist Mr. Mies van der Rohe's participation in solving appropriate architectural problems—particularly wherever possible in the coherent planning of thoroughfares or housing developments. . . .

§ 6

The city is committed to provide Herr Mies van der Rohe with an adequate home. Substantiated moving expenses will be refunded by the city up to the amount for which civil servants are reimbursed.

§ 7

Herr Mies van der Rohe agrees to comply with the existing statutes and regulations of the Institute, or those to be newly issued with his cooperation.

Dessau, August 5, 1930

The City Council

Hesse

Mies van der Rohe

Ludwig Mies van der Rohe
The New Age
From the Journal "Die Form," 5th year,
No. 15, August 1, 1930 p. 406
Concluding remarks of an address to the conference of the German Werkbund in Vienna in 1930

The new age is a fact; it exists entirely independently of whether we say "yes" or "no" to it.
But it is neither better nor worse than any other age. It is purely an established fact and intrinsically indifferent to values. For this reason I will not spend much time attempting to articulate this new age, to show its relationships and to uncover its principal structure. Moreover, let us not overestimate the problems of mechanization, standardization, and normalization.
Let us accept as a fact the changed economic and social conditions.
All these things take their preordained and value-blind course.
What will be decisive is how we are going to retain our values with these given facts.
This is where the problems that challenge our minds begin.
What matters is not "what" is being done, but simply and solely "how." The fact that we are producing goods with these particular tools says nothing about our spiritual endeavors.
Whether we build tall buildings or low ones, whether we construct with steel or glass, says nothing about the merit of the building.
Whether centralization or decentralization is desirable in city planning is a practical question and not a question of values.
But what is decisive is just this question of values.
We have to set new values and to point to the highest intentions in order to obtain standards for judgment.
Purport and justification of any age, hence also of the new age, lie simply and solely in that it offers the spirit the prerequisites, the means for existence.

Anonymous
Herr Kandinsky, is it true . . . ?
From: "bauhaus," voice of the [Communist] students, no. 3 (1930)
The hectographed journal "bauhaus," an illegal and inflammatory news-sheet of a group of leftist radical students, assumed the role of Hannes Meyer's protector and tried to denigrate by slander those members of the Bauhaus who were not in accord with his political tendencies. In its propaganda practices the paper used all means at its disposal.

bauhaus 3
voice of the students
herr kandinsky, is it true
that you or your wife nina spread the news about hannes meyer's contribution to the "red relief" to the proper quarters, so that it could appear in the newspapers?
herr kandinsky, is it further true that you already knew about the things that were going to happen here before you left for your summer vacation? had you, before leaving, already determined with lord mayor hesse who was going to be the successor, or how is it that hesse in his telegram to the masters refers to you of all people?
herr gropius, is it true
that immediately after the dismissal of hannes meyer you suggested to lord mayor hesse to close the canteen completely (except for meals) and the student dormitories? (an attempt was made to close the canteen).
herr gropius, is it further true that after the association of the "circle of architects" had protested against the action of the municipal board you objected to it five minutes later?

67

Anonymous
The new Director!
The new Course?
Polemic against the programmatical statements by Mies van der Rohe delivered at the Vienna conference of the Werkbund. From: "bauhaus," voice of the [Communist] students, no. 3 (1930)

The principles of quality work which were upheld by the Bauhaus were attacked by a fanatical leftist radical minority among the students with a militant Communist demand for complete political penetration of all aspects of life. In this connection, the conservative opponents of the Bauhaus could easily have assured themselves how irrelevant their suspicions of "culturally bolshevistic" tendencies among the teaching staff actually were.

"The new age is a fact; it exists entirely independently of whether we say 'yes' or 'no' to it. But it is neither better nor worse than any other age."

Only a self-centered person who has lost all contact with the rest of the world would be able to view the world in this way. But what right does Mies van der Rohe have to use the word "we"? With this "we" does he mean the alienated artists? In that case he is correct: The new age does exist independently of whether they say "yes" or "no" to it. But things are different when *we* look at the new age not from the metaphysical point of view. There, the age exists too; however, it is no longer independent but directly dependent on whether the "we" represents capitalism or the proletariat. And that again will determine whether the age will be better or worse.

To dwell on such elementary problems would be a useless waste of time. Every Bauhaus student knows enough not to believe in such metaphysical nonsense any longer. This statement would not be worth mentioning if it were not that the *Director of the Bauhaus* made it. But this fact makes it particularly interesting to us. The statement becomes a program and we have to take a stand on it. . . .

[Original without capital letters]

City of Dessau
Budget Estimates for the Bauhaus Dessau 1931 and 1932
AD, inventory nos. 1175 and 1176 (First publication)

A comparison of the expenditures of the "special administration" of the Bauhaus during the years from 1929 to 1932 with those listed in the budget estimate of 1926/27 is very revealing. Up to 1929 the annual expenditures had risen by approximately 50 per cent. The depression imposed rigorous economy measures on the budget. That Mies van der Rohe was able to reduce the expenditures to little more than half the amount of the previous budgets—even less than was appropriated in 1926—was due to the most stringent frugality and concentration of means and to the shift of emphasis from production to teaching.

[inventory no. 1175]
Budget of the city of Dessau for the fiscal year 1931 (4/1/31—3/31/32)

Bauhaus

		Computation				
Receipts:		1931		1930		1929
I. Joint administration						
1. Rent, heating for official apartment		RM 805		RM 806		RM 804
2. Other receipts		RM 700		RM 700		RM —
	Total, title I	RM 1505		RM 1506		RM 804
II. Special administration Bauhaus						
1. Tuition fees		RM 14000		RM 14000		RM 12121
2. Net proceeds from workshops		RM 8000		RM 10000		RM 12000
3. Miscellaneous		RM 100		RM 1500		RM 3104
	Total, title II	RM 22100		RM 25500		RM 27225
Expenditures:						
I. Joint administration						
[11 items, among others for building maintenance, amounting to RM 15,000, and cleaning amounting to RM 5000.]						
	Total, title I	RM 78200		RM 78200		RM 75432
II. Special administration Bauhaus						
1. Personnel expenditure		RM 103200		RM 121526		RM 115164
2. Other personnel expenditure for part-time teaching		RM 22000		RM 16500		RM 18238
3. Premium for social security		RM —		RM —		RM 5122
4. Administrative expenditures		RM 6900		RM 9400		RM 16155
5. Teaching material, model building, students' financial aid		RM 9900		RM 11000		RM 7809
6. Miscellaneous		RM 100		RM 74		RM 15
	Total, title II	RM 142100		RM 158500		RM 162503

(compare enclosure)

Enclosure to the budget of 1931, concerning expenditures of the special administration Bauhaus:

Title II 1 Full-time teaching staff:

	1931 requested	1930
Mies van der Rohe	RM 12662	RM 13120
Kandinsky	RM 7892	RM 8314
Klee	RM —	RM 8554
Albers	RM 7892	RM 8314
Hilberseimer	RM 7892	RM 5574
Scheper (for 9 months)	RM 5700	RM 5973
Schmidt	RM 7046	RM 7414
Peterhans	RM 6519	RM 4950
Rudelt	RM 6344	RM 5574
Sharon (until 9/30/31)	RM 2970	RM 5980
Arndt	RM 5869	RM 1393
Grosch (now title II 2)	RM —	RM 2283

Administration:
[In the administration were employed:
a business manager, an accountant, a
cashier, a budget controller, 1 Director's
secretary, a secretary, 2 typists, 1 helper
for the secretariat, 1 messenger]

Total RM 21300 RM 25235

Master craftsmen:
For the cabinetmaking workshop, metal
workshop, wall-painting workshop,
weaving workshop

Total RM 7000 RM 17563
 (including wages for journeymen)

Title II 2
Lectures, guest classes, chemistry,
mathematics, statics, etc.

Total RM 22000 RM 16500

[inventory no. 1176]
Budget of the city of Dessau for the fiscal year 1932 (4/1/32—3/31/33)

Bauhaus

Receipts:		Computation					
I. Joint administration		1932		1931		1930	
1. Rent and heating, official apartment		RM	800	RM	805	RM	733
2. Other receipts		RM	—	RM	700	RM	854
Total, title I		RM	800	RM	1505	RM	1587
II. Special administration Bauhaus							
1. Tuition fees		RM	12000	RM	14000	RM	14297
2. Miscellaneous		RM	—	RM	8100	RM	2149
Total, title II		RM	12000	RM	22100	RM	16446

Expenses:
I. Joint administration
[11 items, including for personnel
amounting to RM 5000, building main-
tenance, RM 11,000, cleaning RM 4000]

		1932		1931		1930	
Total, title I		RM	59600	RM	78200	RM	89974
II. Special administration Bauhaus							
1. Personnel expenditure		RM	85100	RM	103200	RM	125642
2. Other personnel expenditure for part-time teaching		RM	600	RM	22000	RM	15727
3. Administrative expenditures		RM	3100	RM	6900	RM	7464
4. Teaching material, model building, financial aid, school inventory		RM	3100	RM	9900	RM	10430
5. Others		RM	100	RM	100	RM	318
Total, title II		RM	92000	RM	142100	RM	159581

[Note written in different handwriting] The Bauhaus was dissolved on Oct. 1, 1932.

Leftist radical students
Demand for the Abolition of the Preliminary Course

From: "Vorkurs" (Preliminary course), hectographed proclamation (two pages), published by Communist students at the Bauhaus (July 1930)

The Communists dismissed the elementary artistic instruction as "formalism" since they were unable to interpret it within the context of materialism. For this reason, Kandinsky and Albers in particular were attacked during the last years at Dessau.

Ludwig Hilberseimer
The Minimum Home in a Stairless House

From the journal "bauhaus" (Dessau), January 1931

The point of departure for Hilberseimer's investigations into the problems of housing and housing developments were the given sociological facts, and his aim was to gain fundamental insights into possible optimum solutions. With respect to architectural and esthetic matters he kept an open mind. The problems he gave his students at the Bauhaus were tied to these ideas.

With its practical instruction in form problems and with its experiments with materials, the preliminary course [allegedly] serves to develop a knowledge of these materials and an understanding of their uses. . . . We question the contention that this can be achieved by abstract, hence nonfunctional, use of corrugated cardboard, chicken wire, etc. Contrasting different kinds of material by no means demonstrates their practical value, but is instead a formal "thing in itself." . . .

In the Bauhaus prospectus one can read: By way of analytical drawing the preliminary instruction develops knowledge and mastery of the abstract elements of form in creative work. In "Kandinsky's course" we are instructed in a historical review of art according to the point of view of an abstract artist. It should have been the foremost task of the preliminary course, being the actual elementary course of the Bauhaus, to introduce the students to the historical theory of the development of the social and material foundations and the intellectual consistency resulting from them, and upon this basis to develop the future tasks of the Bauhaus.

What is the content and purpose of analytical drawing? Still life, concise scheme, tensions, structural net, and as the ultimate objective—"free composition of three-dimensional, formal energy tensions." This kind of instruction is bound to lead to individual, abstract, creative work, as is borne out by the various distinctly individual renderings of one and the same still life. This kind of drawing is entirely unsuited for the work in the workshops, since it does not allow for an objective approach.

Why does the preliminary course teach exactly the opposite of what the rest of the Bauhaus has set itself as its goal?

[Demands:]

1. The preliminary course as such is to be abolished; it will be changed into a first-semester workshop.
2. The courses of Albers and Kandinsky are to be optional.
3. Establishment of a course in the theory of history developed on a social and materialistic basis.
4. Immediate admission of trained students into semesters corresponding to their level of knowledge.

Again, we call on all Bauhaus members to give us their support.

One sector of the preliminary-course students.

[Original without capital letters]

One of the most controversial problems in housing is the question of whether high-rise structures or single-story buildings provide the better kind of home. It is wrong to pose this question as an either-or proposition. Rather, the objective should be to offer everyone the free choice, if possible, of the kind of home he prefers.

Despite the promulgation of the residential house, a poll taken some time ago on the question of high-rise or residential building yielded the surprising result that only about one third of those asked decided in favor of the individual home, while approximately two thirds preferred a well-equipped apartment. This rejection of the residential home is primarily due to its poor formal arrangement today, since its rooms are distributed among three or four stories in order to save street frontage. These drawbacks of the individual house can be eliminated by dividing the rooms between only two stories, or even better, by arranging them all on one level. The latter solution naturally requires greater frontage. But the quality of the floor plan can be improved by increasing the amount of frontage without enlarging the volume. . . . The larger the street frontage, the narrower the depth of the building and the more favorable the possibilities for arranging the rooms. While two-story buildings are more expensive because of their larger street frontage, single-story houses can balance the higher costs due to greater frontage by savings in simplified construction and by abolishing the staircase. When all rooms are on one level, as is the case in a stairless house, then the organization of the functions can be greatly simplified and improved, so that keeping a house will not require any more time and effort than an apartment.

The home in a stairless house, which today is becoming once more popular, is a form of dwelling which has been present in all ages. Due to simplified construction, it can now be built at a price that permits the rent to be adjusted to the income of the large majority of those seeking a place to live. Moreover, in it the social and sanitary requirements can be met very simply, as for example the correct position of the rooms relative to one another and to the sun. Three forms of architectural arrangement for the house without stairs are to be differentiated: the row house, the L-shaped house and the free-standing house.

The row house has the simplest and most economical form. But, as in all row houses, the inhabitants are relatively little isolated from their neighbors, although this shortcoming could also be corrected by some special arrangement of the rooms. In addition, normally only the east and west sun can be utilized for the row house, in which case the bedrooms face east and the living room west. The L-shaped house, which is also a row house, combines the advantages of the row house with certain advantages of the free-standing house. It provides, for instance, more exterior walls for possible windows than the ordinary row house without increasing the length of the street frontage significantly. Hence it offers greater freedom in the arrangement of the rooms and opens them more to the sun. . . . Using the L-shaped arrangement as a floor plan solves one of the particularly difficult problems of the small residential development: to be relatively isolated from one's neighbor by the garden immediately connected to the home despite the close proximity of the other houses.

But the best kind of home is naturally the separate house. It does incur considerably higher costs for street access and utilities, but on the other hand, it offers complete freedom in the floor-plan arrangement and . . . maximum sun plus absolute isolation. Yet it is

conceivable that this increase in costs for streets and utilities could be offset by applying industrial production methods in the construction of such a free-standing type of house, since it is this type, not dependent on other houses when being assembled, which is especially suited for comprehensive industrialization.

... There is no basic difference between the arrangement and the kind of street systems and housing blocks used in high-rise and those used in single-story housing developments. In both cases the arrangement is determined by the position in relation to the sun and the traffic situation. Also, in respect to the amount of site area used up and the population density, there is theoretically no difference between high-rise and single-story housing developments; in this connection however, the prerequisite is that the distance between the buildings is always controlled by the angle of the sun. . . .

Contrary to the customary way of constructing housing developments with one type of building, an arrangement of a mixture of types of buildings is always preferable. For instance, single-story houses alternated with four-to-five story apartments. In such a development with mixed types of housing the inhabitant is provided with all the big-city conveniences which the normal residential housing development lacks. Moreover, it respects the different kinds of housing needs and wishes, and gives those who do not desire—or are not able—to have a small separate house, a chance to live in a garden environment. By avoiding enclosed yards and by mixing single-story and high-rise buildings, a development not only becomes freer but also achieves a spatial arrangement which results directly from the requirements and which at the same time does not have to rely on decorative trimmings for its urban design.

[Original without capital letters]

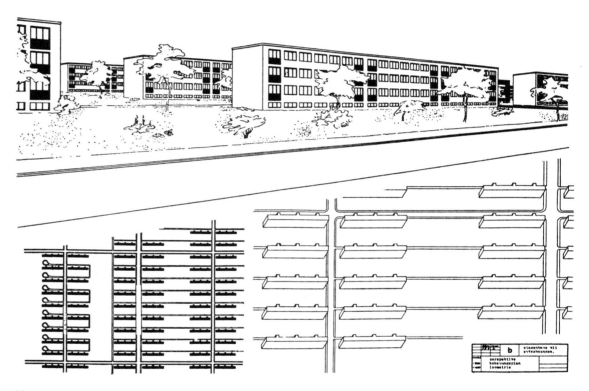

68
Ludwig Hilberseimer: Draft for a (multistory) housing settlement. About 1930.

Gunta Stölzl-Sharon
Utility Textiles of the Bauhaus Weaving Workshop

From the journal "bauhaus" (Dessau),
July 1931
Taken from a review of "The Development of the Bauhaus Weaving Workshop" which was published on the occasion of Gunta Stölzl's departure from the Bauhaus. As successor to Muche, the authoress of this review faced, during the late nineteen twenties, the problems of developing prototype textiles for industrial manufacture.

. . . The transfer to Dessau brought the weaving workshop, as well as all the other workshops and departments, new and healthier conditions. We were able to acquire the most varied loom systems (Kontermarsch, shaft machine, Jacquard loom, carpet-knotting frame), and in addition . . . our own dyeing facilities. The aim of the general education was to loosen up the student and to provide him the broadest possible base and with a direction for a systematic approach to his work.

From now on, there begins a clear and final cleavage between two areas of education that initially were fused with each other:

The *development of textiles* for use in interiors (prototypes for industry) and speculative *experimentation* with materials, form, and color in petitpoint and rugs.

Textiles for everyday use are necessarily subject to accurate technical, and limited, but nevertheless variable, design requirements. The technical specifications: resistance to wear and tear, flexibility, elasticity, permeability or impermeability to light, fastness to color and light, etc., were dealt with systematically according to the end use of the material. The esthetic qualifications, the demand for beauty, the effect of woven fabrics in a room and the feel of it, are much more difficult to define objectively. Whether lustrous or flat, whether soft or severe, whether strong or subdued in texture, whether colored brightly or softly, all this depends on the kind of room, its functions, and not least of all on individual needs.

The tools of the weaver—the material, color, and the bond (structure of the intertwining of the colors)—are subject to constant technical improvement. Wool, silk, cotton, the synthetic fibers (rayon) are continuously being improved by better breeding and cultivating methods, mechanical treatment (process of spinning, refinement), new scientific inventions, and by new dyeing methods. The vitality of the material forces people working with textiles to try out new things daily, to readjust time and again, to live with their subject, to intensify it, to climb from experience to experience in order to do justice to the needs of our time. . . . Experience shows that we are advancing along useful paths: The cultural influence of our work on the textile industry and on other workshops is clearly in evidence today; those who have been trained by us are now occupying top positions in mechanical weaving mills and workshops and also in schools. Only active participation in solving the changing problems of life and home makes it possible to keep the educational and cultural work of the Bauhaus weaving workshop vital and progressive. Woven fabrics in a room are equally important in the larger entity of architecture as the color of the walls, the furniture, and household equipment. They have to serve their "purposes," have to be integrated, and have to fulfill with ultimate precision the requirements we place on color, material, and texture. The possibilities are unlimited. Understanding of and feeling for the artistic problems of architecture will show us the right way.
[Original without capital letters]

Christof Hertel
The Genesis of Forms—on Klee's Theory of Forms

From the journal "bauhaus,"
(Dessau), December 1931
This attempt at explaining the nature of the course given by Paul Klee at the Bauhaus was written and published on the occasion of his appointment to the academy at Düsseldorf.

Paul Klee's educational work at the Bauhaus was divided into the *demonstration of his form theory* (in the second and third semesters) and the *analysis of paintings* (in the painting class).

Klee's form theory, still in the process of continuing development and influencing his creative work more and more, is as multifarous and unending as life itself. It is the accumulated result of a rich and creative life. Like a magician, so to speak, with glance, work, and gesture—making all three possibilities of expression effective with equal intensity—he turned the unreal into reality for us and the irrational into the rational. Things that existed only emotionally . . . became graphically definable. We learned to see that the primary creative consideration of the plane (with means existing only in idea) is not a matter for the very simplest deliberation but rather one of deepest experience. We witnessed the genesis of forms, which were simultaneously real and fantastic to an unprecedented degree. We learned to draw functional diagrams of a creative concept.

The method Klee used was an exact scientific one. But it was very much like Klee, being at one and the same time "closest" and "furthest away" in that it included . . . digressions, when he thought it necessary, and side roads—in the beginning they seemed to us detours —in order to demonstrate to us the multiplicity of the life of forms.

Actually, Klee's teaching was never instruction of the simplest kind, one where the "teacher" lectures and the "student" learns. The whole depth of this sphere of ideas and experiences was opened only to those who felt and experienced with him, a sphere which is a systematized reproduction of life in its fullest significance.

In the beginning it was not always easy to follow with complete understanding. But slowly we began to comprehend that someone—Klee—was telling us about life. We were able to experience, together with him, the development of human existence in its entire imaginative range. Together with him, we sped through thousands of years. Klee made us perceptive again to those original experiences that until then had only touched us mechanically. Was this a "celebration in anticipation of creation" (as an enchanting drawing of Klee's, done in 1914, is entitled) which he prepared for us? There was nothing he wouldn't mention!

Klee taught us to see the composition and structure of vegetable and animal life. Not only did he teach us to perceive it visually, but in his theory of forms he gave us all the principles of creativity. He showed us the all-encompassing synthesis which embraces all organic and inorganic life. The very phenomena we were used to seeing in biology and sociology, suddenly became relevant once more in formal design. Everything: zoology, biology, chemistry, physics, astronomy, literature, and typography helped to make us understand (literally) how we, with every bit of our existence and all of our activities, are part of humanity and the cosmic rhythm and how we are engrained in it.

Klee taught us the important laws of harmony. Once he said, "the very last remains a secret, the great silence." Klee spoke while pacing back and forth, or he drew his

figures on the blackboard. Then, off and on, he was silent, leaving us time to take everything in.

Klee always emphasized the importance of visual control over mathematics. He caused blurred notions in our minds to become clear concepts. . . . For a long time we dealt with the embryology of forms, that is to say, with the clarification of the processes that are behind the finished form, even those behind the elementary form. One does not need to be a mystic, a vague "metaphysician," even though vague "physicists" sometimes maintain this, to recognize that there is always still something more than meets the eye. . . .

Klee told us about expression, told us that things must have form and meaning, that it is the function of artistic activities to express something. We recognize that the question of harmony in a creative work could hardly be solved analytically. Once Klee said: "As a cosmic and as an inspired human being one has to step up to the dynamic configuration." By way of the rational and abstract, the skeletonlike, the nervelike, and the nonsensuous we arrived at sensuousness.

In secondary design Klee told us that the free-lance artist likes to work "sine ratio." But examples in class have to be rationally comprehensible.

In his approach to the painting class Klee also has his method but was never bound to it. Usually he started out by discussing the question of format. Then he advanced to the actual place of action and on to the action itself. Up to this point, everything was dealt with in purely formal terms. After that, the expressiveness of these forms was investigated. How Klee was able to teach the painters to really perceive their own paintings is nearly incomprehensible and can only be explained by intuition. Klee looked at the paintings for a short time, then he began speaking, taking small pauses—creative pauses—from time to time, like a seer. And he saw everything. And told us everything. Did we understand everything?

Like all new things that open new horizons, these formal, genetic investigations originate in intuitive fantasy. They are, as every science is in its beginnings, at first purely speculative. After all, chemistry once was alchemy. The consequences of this work and the possibilities for the development of the exact sciences cannot yet be envisaged. . . .

These formal, visual investigations open up vast new areas to our awareness. Things of whose existence we were not even aware, enter our consciousness and act upon it. Archetypal experiences which had been forgotten due to habit formed over thousands of years . . . are once more becoming new and powerful experiences, penetrating to the bottom of our consciousness and moving us. Empty words and dulled terms are becoming experienced and lively images again. Areas of knowledge, which until now were exclusively the province of the mind, are becoming experience by way of the senses. Thus Klee showed us ways leading into the future (but not "illusionary goals" to which there is no path); thus he did pioneer work. He broadened and deepened the sphere of awareness and experience. . . . He made clear the things that are elementary in order to arrive at conscious creative work which is in tune with life. . . .

[Original without capital letters]

M.

A Swiss Architecture Student Writes to a Swiss Architect about the Bauhaus Dessau

From the journal "Information" (Zurich), No. 3, August—September 1932
The letter was addressed to a Mr. H. . . . and the date is June 26, 1932. Its author, a young Swiss with extreme leftist political orientation, had been admitted to the preliminary course of the Bauhaus two months previously.

. . . A few days after we arrived, new student representatives were to be elected. It was then that we noticed that there are two factions at the Bauhaus that are fighting each other like cat and dog. The Communists and leftists on the one side and the rightists representing all shades, beginning with those of the "youth movement" and right up to the Nazis, on the other. . . . Later when we were all assembled at the canteen (one group seated on the right, the other on the left with three empty tables between them and we, the preliminary-course students sitting in one corner) the old student representatives [who had been suspended by the Director a few days earlier] appeared at the election meeting and attempted to defend themselves before all the students. Thereupon the Director banned them from the premises and they had to leave the canteen. At the beginning, we proposed to elect an intelligent fellow who did not belong to any party but who sympathized with the Communists. As a result, the "rightists" declared us already infected by Communism and left the room, shouting wildly. After the third meeting and several hours of mutual shouting, we finally agreed on one representative of the Left and one of the Right. . . .

Today the Bauhaus is a school in which cliques prevail as hardly anywhere. Absolutely nothing is left of a "free" working community of active people. We enter the building at 8 A.M., and at 5 P.M., after finishing with the day's courses, we go back home again. Of course one can learn a great deal in the individual courses, and some things are excellent. Many say that since the Bauhaus has become more like a technical school it has become much better than before. Mies is a wonderful architect, but as a man, and particularly as the Director, he is very reactionary. We, the preliminary course, have been here for three months now and have yet to see him, quite aside from the fact that he has never spoken one word to us. The fifth and sixth semester work with him exclusively. As newcomers we had to "put on" a party. Mies donated twenty marks but he never showed up. We danced and boozed, that was all. There simply is no life left in the whole shebang.

Obviously, it is a wretched feeling never to know when the place is going to be closed. The budget used to be 150,000 marks (city subsidy), and today it is 80,000 marks. Votes in the city legislature concerning the existence or nonexistence of the Institute are always decided with a margin of one or two votes. . . .

There are still some marvelous masters at the Bauhaus: Joost Schmidt, Scheper, and Arndt. Schmidt is a great commercial artist, and Scheper is a genius when it comes to colors. . . . Arndt teaches descriptive geometry and perspective. All of them are former Bauhaus students and are suffering under today's rigid school methods and classroom instruction. One can learn a lot from Arndt, but most students horse around a lot during his classes because, unlike the other Masters, he does not maintain discipline.

In fact, the work in our semester is a story in itself. We are 23 people, eleven from Dessau, the others from Institutes and only a few come from workshops or factories. They outdo each other pushing and slaving and one works more mechanically than the next. The semester ends on July 1 and is followed by the exhibition in which everyone has to participate and on the basis of which one either advances or does not. This exhibition is what everybody is now grinding for like mad. . . . Nevertheless, I am extremely glad I have come to Germany. I see and experience a great many things every day. It often seems to me as if I had slept until now. It is impossible to conceive what this unemployment is like and how grave the poverty when one just hears about it. I have taken a long look around in the eastern section of Berlin, at the unemployment office. Doing this, one often risks being thrown out or getting kicked in the pants, but one gets an idea of today's kind of government and of the social system. There is also much I can see and learn from the family in Dessau where I rent my room. One must have great respect for a woman who is able to feed a family of three on ten or twelve marks a week, even if these people have old-fashioned attitudes on many things and are patiently bearing their poverty. I am paying 18 marks for my room with a sunny balcony in the housing project outside of town, including breakfast. . . . I need 40 marks a month for living expenses. Of course, the old man sends me more than that. The rest I need for colleagues who are in bad shape and for material for my photography. . . .

Rightist radical parties in the City legislature, Dessau

Motion to Dissolve the Bauhaus (1932)

AD, no. 1284: Minutes of the meetings of the City Council, Dessau 1929–1933

The Dessau City legislature was constituted in 1932 of 4 members of the City Council (Lord Mayor, Mayor, and two city aldermen) and 36 city representatives (15 National Socialists, 5 other members of rightist-radical parties, 12 Social Democrats, 4 Communists). Representative Hofmann, whose motion to dissolve the Bauhaus was successful, represented the NSDAP [National Socialist German Workers' (Nazi) Party].

Third open session of the City legislature, January 21, 1932

Motions by City Council representatives

Representative Hofmann and associates:

"The city legislature should resolve:

that all funds authorized for any purposes of the Bauhaus, hence, including the salaries for teachers and employees, are to be canceled as of April 1, 1932.

The demolition of the Bauhaus is to be prepared, for which the building and the finance committees are to decide the necessary steps immediately.

The students are to be informed today of the closing of the Bauhaus as of April 1, 1932. Teachers of foreign nationality are to be given notice effective from the same date. As far as valuable German personalities are concerned, provisions are to be made to maintain their services in other teaching institutions of the city. The trade school is to be placed in other city school buildings. The site becoming available is to be used for new building purposes.

Of the funds becoming available for fiscal 1932, RM 50,000 are to be allocated for recipients of social welfare, among them primarily families with many children, and RM 170,000 for the creation of jobs."

Contingency motion of Representative Jericke and associates:

"The city legislature should resolve:

that the city council be directed to serve notice on all civil servants, employees, and workers at the Bauhaus at the next legally permissible date and to allocate the funds becoming available from salaries and wages to the welfare department for the assistance of the unemployed."

Following a suggestion by its chairman, the municipal legislature agreed after a general debate to vote first on Section 2 of the motion of Representative Hofmann and associates (demolition of the Bauhaus), then on the rest of the motion of representative Hofmann and associates and on the contingency motion of Representative Jericke and associates.

After Representative Hofmann had explained his motion, the motion concerning the demolition of the Bauhaus was rejected by a vote of 25 to 15. Following this vote, a motion introduced by Representative Kmiec was carried by 20 votes to 19, stating that the vote on the rest of the motion of Representative Hofmann and associates and the contingency motion of Representative Jericke and associates was to be adjourned and that there would be no further discussion on that point.

Seventh open session of the city legislature, August 22, 1932

Motions by City Council representatives

The National Socialist faction introduced the following motions:

1. Teaching activity at the Bauhaus (Institute of Design) is to be terminated effective October 1 of this year.

2. In so far as workers and employees (except teachers) are to be dismissed because of the termination of teaching activity at the Bauhaus, their employment is not to be terminated. These workers and employees (except for the teachers) are to be given work in some other city departments. All teachers of the Bauhaus are to be discharged.

These motions were carried by a vote of 20 to 5, the Social Democrat faction abstaining.

Chairman of the City Council representatives Hofmann (NSDAP—National Socialist German Workers' Party)

What Will Become of the Bauhaus?

From the newspaper "Anhalter Tageszeitung" (Dessau), July 10, 1932

After this inspection tour of the Bauhaus on July 8, 1932 by National Socialist representatives, the fate of the Institute was actually already sealed. The nationalist art critic Schultze-Naumburg, who had been consulted as an expert on these matters, supported the politicians in their fanatical hatred and their intransigence.

On Friday afternoon the Dessau Bauhaus was visited by Minister President Freyberg, chairman of the City Council, Representative Hofmann, and City Council Representative Sommer. They were shown around by Lord Mayor Hesse and the Director of the Bauhaus, Herr Mies van der Rohe. The representatives of the National Socialist Party had asked Professor Schultze-Naumburg to participate in this inspection tour, which he did. With his extensive experience in the field of art he was of great help to the representatives of the NSDAP. Preceding the tour, the Lord Mayor and the Director of the institute welcomed the visitors and explained the development and the educational responsibilities of the Bauhaus.

It was the purpose of this inspection tour through the Bauhaus to inform the National Socialist representatives of the state and of the city of Dessau first hand about the work being done there. The Bauhaus question will be most important during the coming budget discussions, since the National Socialist faction of the city council will under no circumstances approve these sections of the budget and hence will reject the entire budget. How Lord Mayor Hesse will find a majority under such conditions is open to question. The approval of the budget by the government is then likely to be tied to the condition that the expenditures for the Bauhaus be first of all stricken from the budget request, since the inspection of the Institute has considerably strengthened the belief of the National Socialists that it represents a very costly experiment. In view of this, it looks as if the fate of the Bauhaus were sealed. Since the National Socialists will probably not be able to get a majority for the proposed demolition of the institute buildings, efforts will have to be made, for the time being, to use the building for other purposes. This is likely to be very difficult, since this glass and steel skeleton structure can be used neither for educational nor for health facilities, nor for administrative or industrial purposes. Maintenance . . . will put such a heavy financial strain on any new owner that only a nabob would be able to afford such luxury. Whether one likes it or not, then, some day the building will have to be taken down, despite the fact that middle-class representatives view this as a waste of money.

The disappearance of this so-called "Institute of Design" will mean the disappearance from German soil of one of the most prominent places of Jewish-Marxist "art" manifestation. May the total demolition follow soon and may on the same spot where today stands the somber glass palace of oriental taste, the "aquarium" as it has been popularly dubbed in Dessau, soon rise homesteads and parks that will provide German people with homes and places for relaxation. "The robe has fallen, the Duke must follow."

Students of the Bauhaus in Dessau

Petition to the Reich President (July 1932)

AD, collection of newspaper publications: newspaper cutting of unknown origin dated August 2, 1932

This petition was drafted by a nationally oriented group of students at the end of July 1932 and, accompanied by a list of signatures, was sent to the Reich President. Particularly active in this drive were the students Helmut Heide and Carl Bauer. The hopeless attempt to appeal to the basic sense of law was repeated by Heide and his fellow students when they sent a petition to Goebbels after the Bauhaus had been closed in Berlin.

His Excellency
Reich President v. Hindenburg
Berlin

The students of the Bauhaus in Dessau are confidently turning to Your Excellency as the only place in the Reich which is able to judge our distress from a truly superpartisan point of view. According to the expressed will of the present majority in the Dessau City Council, the Bauhaus, the Institute of Design, is to be closed as of October 1, 1932.

The Bauhaus has at present 171 students who have come here with faith in the statutes laid down by the city of Dessau and the state of Anhalt, in order to prepare themselves for their careers. They were promised a qualification in the form of a Bauhaus diploma after six semesters of study.

The students elected to attend the Bauhaus rather than other schools, because here they saw a way out of the hodgepodge of past styles, leading to free creative work which can only evolve out of the meaning of the period itself. In Germany and in the world there is no educational institute to equal the Bauhaus. Particularly during the past two years the relationship between teacher and student has developed here in Dessau into such close collaboration as can be achieved in no other German school. The success of this collaboration is known the world over and is incontrovertible, no matter what position one assumes in artistic endeavors.

By having the Bauhaus transferred to Dessau and by supporting and continuing its efforts, the city of Dessau and the state of Anhalt have accepted responsibilities toward the students, the least of which is the guarantee of completing studies for a degree. If the Bauhaus is going to be closed, then at least this one guarantee must be fulfilled and consideration must be given to the young men and women who are in the middle of their training, giving them a chance to complete their studies under the same auspices under which they began them. Since the Bauhaus is unique among German schools of higher learning, it appears it could be closed to new enrollments; but its final closing and the demolition of the buildings cannot occur before the students now studying there have completed their training.

We students are in no way oriented toward any partisan political activity and hence demand that our claim for the completion of our course of studies not be set aside for any one-sided partisan political considerations. Despite the fact that we, as students, are the ones hardest hit by the proposed closing of our school, we have been silent until now believing in a reasonable settlement of this problem, honoring the student's right to complete his training as a matter of course. But since the development of the last few days has clearly shown that our hopes are in vain and are apparently inopportune, we are now adopting the only way left open to us, in that we are turning to our highly revered Reich President, firmly believing that he will be able to prevent the Bauhaus in Dessau from closing its doors. The general sympathy of the entire German press for the problems of the Bauhaus is proof of the necessity of our action.

The authorities concerned have been informed of the action we have taken.

With sincerest devotion and respect,

The students of the Bauhaus in Dessau.

Eugen Ohm
The End of the Bauhaus
From the newspaper "Frankfurter Zeitung,"
No. 565–566, July 31, 1932
The news of the impending or actual closing of
the Bauhaus produced relatively little reverber-
ation in the German press. The precipitating
political and economic events—turbulent elec-
tion campaigns, changes of government, and
the catastrophic unemployment—monopolized
the attention.

Lord Mayor Fritz Hesse
**The Fate of the Bauhaus—a Final Hour
Account**
From the newspaper "Volksblatt für
Anhalt" (Dessau), August 20, 1932
On August 19, 1932, Hesse made one last
attempt to prevail on the National Socialist
City Council representatives not to continue
insisting on their demand for the closing of the
Bauhaus. He invited them (as well as represen-
tatives of other parties and members of the
Press) to inspect the Institute, where an exhibi-
tion then in progress gave a comprehensive
summary of the teaching methods and the
achievements. On this occasion Hesse gave the
following address.

. . . Now that the principles of the new architecture have been implemented on a wide
scope, what is needed is not so much impassioned propaganda but continued spiritual
and esthetic refinement of the newly won forms. After a period of dangerous division of
energies, the Bauhaus more and more began to look back on its basic educational task.
Under the leadership of the architect Mies van der Rohe, whose calm and thoughtful
manner is a reliable guarantee for thriving development, it has during the past years been
built up into an institute for the practical teaching of architectural design. The artistic
training is completed after six semesters, entitling the student to a diploma. The produc-
tion workshops have been discontinued altogether, and their place has been taken by
workshops for purposes of instruction and for developing prototypes, which are confined
to the manufacture of models for industry. If, in spite of this, the closing of the Institute is
still insisted upon, then it does not necessarily have to mean the end of the Bauhaus. Its
fortune is not tied to Dessau, and it is not hard to imagine that it could be continued else-
where and in an arrangement insuring much greater independence from the chance hap-
penings of the political world. The spirit of modern architecture has its roots in this world
of thinking and feeling, whose creative powers can be temporarily suppressed by the forces
of reaction but cannot be suffocated or stifled. . . . If the National Socialist Party would out-
grow the stage of pure propaganda activities and reach the point of practical constructive
work, it too would have no choice but to begin its artistic education at the very point at
which the Bauhaus is now forced to come to an end.

The Bauhaus, which found a home in Dessau more than seven years ago, renders once
more, in this exhibition, an account of the work it has done, encompassing all subjects
taught here. It demonstrates the responsibility and seriousness with which it works and is
certain with this work to pass any objective examination. It is only natural that any institute
representing a new kind of school and workshop has to go through its years of growth.
The new style would have come even without the Bauhaus. It is necessitated by fate and
does not depend on the approval or disapproval of individuals. The new style has already
reached into all areas, it exists in every lamp, in materials for clothing or curtains, and in
every advertising poster. The new forms are in themselves politically neutral. They are
used by Fascist architects in Italy and by Communist architects in Russia. The new forms
are also supranational, as all styles of past periods have been. Everything depends on the
architect. If he is German in his entire character, his work will be of a German nature.
Consequently, the new forms can no longer be a point of debate. What is important now
is to express something in the realm of the spirit and the soul, using the new textiles and
the new materials. Now the Bauhaus has passed its "Sturm und Drang" period, it is facing
this new and biggest task and in Mies van der Rohe has found a Director from among the
younger generation of architects who has the artistic maturity to master this task. Architec-
ture is not merely function to him, it is not just structure as is an engineering project,
architecture to him is primarily high art. Straightforwardness, then, is no longer an aim
but a natural prerequisite. . . .
The basic difference between the Bauhaus and vocational schools, technical colleges,
and building trades schools is that it takes all fields of knowledge to be a unity. In par-
ticular, all disciplines participating in building are not isolated but rather constitute a
single organism. At the Bauhaus, students are systematically acquainted with working in
wood, in treating walls, in the techniques of lighting, and in the problems of interior
design. Perhaps one can say in short that the Bauhaus is one big architectural office. A
glance into the notebooks and at the materials used for study proves that the course of
studies is planned with strict thoroughness. The students are responsibly trained in
theoretical and scientific subjects as well as in practical and craft work. The individual
subjects can certainly pass the critical examination of any expert. Thorough examinations
ensure that a check is kept of the students' progress.
For a long time past the Bauhaus has no longer had its own workshop production. It is
confining itself to manufacturing prototypes and models which are then given to the
trades and industry for reproduction. Even individual commissions are no longer exe-
cuted at the school but instead are passed on to craftsmen. The well-known lamp man-
ufacturer Körting & Mathiesen, Inc., Leipzig, has entered into a contract with the Bauhaus,
commissioning the metal workshop of the Institute to prepare and test its entire produc-
tion of lighting fixtures. These products are known on the market under the trade name of
"Kandem." The wallpaper company Rasch Brothers & Co. of Hannover, in Bramsche near
Osnabrück, already has come out with three volumes of samples of Bauhaus wallpaper
which has been well received everywhere and has sold no less than three million rolls up
to this point. Finally, the firm of M. van Delden & Co., Gronau in Westphalia, has recently
signed a contract with the Bauhaus concerning the manufacture of printed curtain tex-
tiles. . . . The delivery of a selection of woven curtain textiles is in preparation. . . . Con-
sidering the low prices, particularly of the wallpaper and the printed curtain textiles, it
becomes evident that the success of the Bauhaus work is benefiting all the people.
The regular income in the form of royalties, resulting from the contracts with industry, is
presently about 30,000 marks a year. You will not find a school anywhere in Germany
that can boast of a similar income as the result of its work. Due to this income and simulta-
neous economy measures, it had been possible to cut the city's subsidy for the special
administration of the Bauhaus from 133,000 marks in 1930 to 80,000 marks at present.
Since the income from royalties has a tendency to increase, a further reduction of the
subsidy will most likely be possible. When compared to the disadvantages accruing to the
city and its economic life by a closing of the Bauhaus, which will mean departure of
the students and teachers, and by the lessening of its attractiveness to foreigners, which
the local travel agency according to exact estimates expects to be considerable, then it
will have to be recognized that the subsidy for the Bauhaus in the present amount . . . is

really a productive investment and can be justified even in a time of distress such as the present one.

The number of students is at present 168, including 17 auditors and 9 guests. Of these (including 17 Germans with residence in another country) 135 are Germans and 33 are foreigners. Among the foreigners there are 8 American, 4 British, and 6 Swiss students, . . . History will pass its judgment on the Bauhaus and the work it did. In view of the fact that not only the dean of German architects, Theodor Fischer, but also architects like Peter Behrens, Hermann Riemerschmid, Professor Paul Bonatz, Senior Building Director Fritz Schumacher, and Professor Wilhelm Kreis are guaranteeing the work of the Institute and its present Director, and that numerous other leading personalities of German cultural life . . . are standing up for the endangered Bauhaus, then there is no reason for us and for all friends of German educational and cultural work to be afraid of this judgment.

Fritz Hesse
69

City Council of the City of Dessau—Mies van der Rohe

Contract of October 5, 1932 Concerning the Termination of Employment

PA Mies van der Rohe (First publication)

Under an emergency decree issued by the Reich President, the City of Dessau would have been able to terminate the contracts of employment of the Bauhaus masters before their term had expired at the end of the year [1932]. Terminating them on October 1, though, as the fanatical efforts of the NSDAP faction succeeded in doing, was clearly illegal. This situation offered Mies van der Rohe and the other Bauhaus Masters an advantage, in that it entitled them to claim compensation. Of great importance also was that the city relinquished its claims to the royalties for Bauhaus wallpaper in favor of the Institute. With such financial support as a start, the Institute was able to carry on under its own initiative. This brought about the transfer of the Bauhaus to Berlin.

On August 22, 1932, the city legislature decided to discontinue the classes at the Bauhaus, effective October 1, 1932, and to discharge the entire teaching staff of the Bauhaus. Based on this decision, the City Council notified the teachers of the Bauhaus of the termination of their contracts on October 1, 1932. The teachers thus discharged lodged a protest against this decision and demanded fulfillment of their contracts.

In order to settle this dispute concerning the legality of the contract termination and to clarify the legal situation resulting from the dissolution of the Bauhaus, the following contract is concluded between the former Director of the Bauhaus, Professor Mies van der Rohe, and the City of Dessau:

I. Personal

§ 1

The parties to this contract are agreed that the contract of employment, which has been in effect until now, will expire on September 30, 1932. But Herr Mies van der Rohe will receive the full amount of his salary, which would be due him were he further employed as Director, until March 31, 1933, and half the amount for the period of April 1, 1933 until March 31, 1935.

Should he receive income from other employment which, together with the payments by the City, exceed the amount of his former salary, then the excess amount will be deducted from the payments by the City.

The payments in accordance with section 1 will be made each month after receipt of a statement declaring whether income according to section 2 is being received.

§ 2

The lease for the Master's house No. 1, expires on September 30, 1932.

II. Nonpersonal

§ 3

Since Herr Mies van der Rohe will continue this Institute in Berlin under the name "Bauhaus," the city of Dessau yields the trade-mark "Bauhaus Dessau" and agrees to have this trade-mark withdrawn.

§ 4

The registered rights which the Bauhaus formerly held (patents and registered designs), will be transferred to Herr Mies van der Rohe with all rights and responsibilities, effective October 1, 1932.

Likewise, all rights and responsibilities accruing from existing license contracts with industrial firms will be transferred to Herr Mies van der Rohe.

The payments which are due from the wallpaper manufacturer Rasch Brothers and Co. of Hannover for the period from July 1, 1932 to September 30, 1932, are to be made to Herr Mies van der Rohe in order to pay with these funds those employees—while releasing the city from any such obligations—who so far have been paid from the royalties, and to do so also for the period after October 1, 1932.

§ 5

The records of the students continuing their studies at the Bauhaus and of the teachers and employees taken over will be turned over to Herr Mies van der Rohe. He is committed however, to hand these documents to the city upon demand, or to have copies made.

§ 6

Special arrangements will be made concerning the transfer of inventory items needed for the continuation of the Institute.

§ 7

Herr Mies van der Rohe takes the place of the City of Dessau in the contract of indenture of the weaving workshop which is still in effect and remains party to it until its normal expiration.

§ 8

Herr Mies van der Rohe relinquishes all other claims possibly ensuing against the City, regardless of whether or not they result from the contract of employment.

§ 9

The cost for this contract will be paid for in equal parts by both parties.

Dessau, October 5, 1932

The City Council

(signed) Hesse

Dessau, October 5, 1932

(signed) Mies van der Rohe

8 Bauhaus Berlin
The Private Institute
Suppression and Dissolution

This is what the Future Berlin Bauhaus is Going to be Like . . .
From the newspaper "Volksblatt für Anhalt" (Dessau), October 15, 1932
In an amazingly short time Mies van der Rohe was able to establish the Bauhaus, now a private institution, in the Steglitz district of Berlin. The Berlin Bauhaus was in a relatively good starting position, due to the regular income from royalties and the salary payments which the city of Dessau was forced to continue because of the early termination of the contracts of employment. Dessau even felt compelled to release part of the inventory.

Bauhaus Berlin
Syllabus and Curriculum
Broadside, published in October 1932
The beginnings of the Bauhaus in Berlin looked very encouraging. The teaching staff, with the exception of Arndt and Schmidt, remained the same. Many students had followed their teachers to Berlin and, in addition, the secretariat listed 31 new enrollments. Particularly in this period of political confusion, institutional independence seemed to be the best prerequisite for the regeneration of and the required stability for the development of the Bauhaus. From the very first, Mies attempted to counter any possible disturbances arising from within by giving the new regulations a decidedly authoritarian tone.

The Bauhaus has been set up in Berlin right on time. The Director, Mies van der Rohe, actually intends to have winter semester classes at the Bauhaus in Berlin-Steglitz opened on October 18 [1932].
Of course, a taking over of the Institute by the state of Prussia under Papen and Bracht is out of the question; and the city of Berlin does not have the financial means to rebuild the Bauhaus. In such a situation the strength of the creative idea proves successful: the Bauhaus is going to support itself. The 80,000-mark subsidy from the city of Dessau has ceased, but it will be compensated for by the prospects of getting new commissions and finding new opportunities in the much larger city of Berlin. A helping factor under these circumstances are the royalties the Bauhaus has acquired and the contracts of employment of the teachers, a number of whom will continue for several years to receive their salaries from Dessau because of the City's contractual obligations, meaning that they can teach in Berlin without pay. The most difficult problem, that of finding a place for the school, is already solved: the buildings of the former Berlin Telephone Company in the district of Steglitz have been leased. They do not replace the buildings of the Institute in Dessau but they do yield twelve studios when subdivided by partitions, etc. For the beginning, these are enough.
The National Socialists have caused Dessau a lot of troubles: it has lost the cultural and the economic advantages of the Bauhaus. On the other hand, Berlin, and particularly Steglitz, is gaining an invaluable source of energy in the teaching and practice of the Bauhaus.

bauhaus berlin
the bauhaus, founded in weimar as a state school of higher learning and continued at dessau as a school of design, is an independent teaching and research institute. direction: ludwig mies van der rohe.
the curriculum
of the bauhaus is divided into three stages of instruction and covers 7 semesters.
in the
first stage
students who differ with respect to previous education and talent are brought to a common standard
at the time of acceptance into the
second stage
the students decide upon their specialized area of study:
1. architecture and interior design
2. commercial art
3. photography
4. weaving
5. fine art.
in this stage students are given a practical, technical, and scientific background for their work in the various special fields. theoretical instruction is supplemented by practical experimental work in order to develop a sense for design and quality in manual and technical work.
based on technical knowledge and professional capabilities, in the
third stage
begins independent design work.
in addition to the specialized education, lectures and guest courses are designed to confront the student in depth with the problems of our time.
the teaching staff

l. mies van der rohe	j. albers	f. engemann
l. hilberseimer	w. kandinsky	w. peterhans
lilly reich	a. rudelt	h. scheper

requirements for admission
enrollments take place in april and october.
any student whose talent and previous education are deemed sufficient, and who is more than 18 years of age can be admitted to the bauhaus as a full-time student. no particular kind of previous education (matriculation or similar) is required. if possible, the students should have had previous practical experience. in cases where a student has had greater previous professional training, he may, as an exception, be admitted into one of the advanced semesters, providing he makes up indispensable courses in lower semesters. the director's office decides upon the applications of admission. admission is complete when the student has received written confirmation of the decision and when he has paid all fees required.
students who do not enroll for the prescribed course of studies may be admitted as auditors, space permitting.
enrollment
application for admission should be made on the application form which is provided.
the following is to be included in the application:
1. curriculum vitae (previous education, nationality, personal situation)
2. means of support
3. police certificate of good conduct
4. health certificate
5. photograph
6. certificates about previous manual or theoretical training
7. original drawings or projects requiring craftsmanship.
foreigners are to hand in german translations, certified by their consulates, of these documents.

expenses

the following fees will be charged:
for germans, germans residing outside of germany and german-austrians
1. a nonrecurring admission fee of rm. 20.
2. tuition fees:
a. for full-time students
summer semester rm. 100, winter semester rm. 200.
b. auditors
10. rm. for each hour per week per semester.
3. premium for accident insurance, rm. 5 per semester.
foreigners pay twice the admission and tuition fees.
the fees due per semester are to be paid to the secretariat at the beginning of each
semester. student identification cards are handed out only after the fees have been paid,
and only then is the student entitled to take classes.
semester fees are not refundable.
talented students having no financial support can be exempt from paying tuition fees in
part or altogether only within the limits of the available means.

studies

semesters begin and finish punctually.
the summer semester runs from april to july, the winter semester from october to april.
summer vacations are, if possible, to be spent getting practical experience (working on
actual construction, etc.). summer courses will be held during vacations as required.
daily hours: 9:00 a.m. to 1:00 p.m., 2:00 p.m. to 5:00 p.m., saturday—independent work.
classes are compulsory. students are required to attend classes regularly.
enrollment in a chosen course makes regular attendence mandatory for the duration of
the course. exemption from certain classes or admission to other courses is possible only
with written permission of the director. exemptions can be granted only where there is
proof of adequate proficiency with the material of the course.
leave of absence has to be applied for in writing, giving reasons.
work is judged at the end of each semester; the result of this determines the continuation
of studies and admission to the next higher semester.
upon leaving, every student can apply for a certificate stating the duration and nature of
his work at the bauhaus.
the bauhaus diploma can be earned only after completing the required course of studies
and is dependent upon satisfactory completion of an independently carried-out project
for the diploma.
certificates, diplomas, etc. are only given out when all obligations to the bauhaus have
been fulfilled.
the director's office of the bauhaus has to be informed in writing when a student intends
to leave before completion of his course of studies. the director reserves the right to
suspend students from the bauhaus. students who, because of their behavior disturb the
work will be expelled.
the student is to leave his home address at the secretariat. changes of address are to be
reported immediately.
each student is held liable for any damage caused as a result of negligent or wilful action.
the bauhaus is entitled to the copyright on all work carried out in the bauhaus. when such
is economically exploited by the institute, special financial arrangements can be made.
moreover, the bauhaus reserves the right to keep student work at its disposal for a period
of up to one year after the student has completed his studies. consequently, the publica-
tion, exhibition, and sale of such work is only possible with the permission of the director.
publications which, by addition of the names "bauhaus" or "bauhaus berlin" to the name
of the author or which, by the way they are worded, create the impression of being state-
ments by the institute, require the approval of the director.
the use of the name "bauhaus" or "bauhaus berlin" by students on their projects, on
private or business letters is not permitted.
the curriculum is subject to change.
the work of the institute is covered by house rules.

accident insurance

all students are insured against accidents within the house and on the way to and from
the institute.
for further information apply to the secretariat of the bauhaus.
berlin-steglitz, october 1932

1st stage = 1st semester
practical instruction—for the purpose of
developing a sense for materials and space
mathematics (geometry and algebra)
descriptive geometry
representational drawing
lettering
science of materials
color theory
workshop practice
special field
theoretical subjects are supplemented
by experimental work

2nd stage = 2nd and 3rd semester
architecture and interior design
structural and finish work in connection
with
structural design
strength of materials
static, steel, and reinforced-concrete
structures,
heating and ventilation, installation,
lighting,
cost estimating
construction of furniture
perspective
color theory

2nd stage (continued)
commercial art
practical experimentation: typography, printing, and reproduction processes, cost estimation of printed matter
life-drawing and drawing of figures
instruction in photographic techniques
photography
practical and theoretical fundamentals of photography. experimentation and discussion based on actual tests with copy techniques, reproduction of gray values and colors, lighting and reproduction of material
weaving
study of materials, binding techniques, introduction to the different techniques of weaving
exercises in combinations of material and color
fine art
seminar-type practical and theoretical exercises. independent work. group discussions of the independent work
general instruction
color theory—descriptive geometry—representational drawing—lettering—life-drawing and drawing of figures—practical experimentation

3rd stage = 4th—7th semester
architecture and city planning
interior design
small residential buildings and housing projects
dwelling and office building construction, hotels, schools, etc.
strength of materials
steel-skeleton structures and structures for auditoriums, gymnasiums, hangers, etc.
interior design
furnishing of apartments, individual homes, hotels, etc.
single furniture pieces
combination of materials
commercial art
instruction in the theory of advertising
independent and experimental work in the field of advertising
printed advertising matter
exhibition stands, etc.
statistical and diagrammatic presentation
photography
transition from purely technical experimentation into independent work with reference to the requirements of advertising and reporting
weaving
continuation of the practical exercises at the looms
manufacture of textiles after independent designs or after given projects, using different materials and techniques and with respect to the requirements of contemporary interior design

Wassily Kandinsky
On the Problem of Art Education at the Bauhaus
From a letter to Ludwig Mies van der Rohe, Dresden, dated September 29, 1932
PA Mies van der Rohe (First publication)
According to a letter of September 26, 1932 to Kandinsky, Mies van der Rohe intended to curtail or eliminate the art classes at the Berlin Bauhaus. Kandinsky saw these plans as a danger to the basic Bauhaus idea of an all-embracing education.

I was always proud of the fact that the Bauhaus strives to establish a synthesis in education, that the young men and women who intend to become architects get some idea of the general and contemporary state of painting. Experience has proved that the interest of students in these questions was really very wide. I have always tried not to speak of painting alone or of art alone, but rather to explain, to make evident, the deeply rooted ties with nature, with science and, of course, with other areas of art. Contemporary art, particularly painting, loses more and more the outer connection with "nature," the outer dependence on it, in order to re-establish the "inner" links with *nature,* which have been lost for centuries. This is what I call in my classes "not the shell but the nut." I emphasize the efforts of getting at the roots from which both spiritual *and* material things grow according to one and the same law. All of these are matters of which our new students generally have no idea. But some of them in fact gained no small understanding of them.

Secretariat of the Bauhaus Berlin
Journal Entries 1933
PA Mies van der Rohe (First publication)
The journal which had been begun in 1926, was kept by the secretariat of the Bauhaus during the months of the dramatic events of 1933 right up to the very day when the police and the SA (Nazi storm-troopers) seized the building. The entries of those last months show the everyday life at the Bauhaus. The problems were to get established, to find the most suitable "legal set-up" for the institute, to create sources of income or secure those already existing, and to win new friends. The problem of selling licenses for Bauhaus products became very vital now. However, the wave of nationalism swept away with it most of those who had been interested up until that time. Eventually, royalties for the Bauhaus wallpaper were the only ones they were able to count on.

1/3/33
Beginning of classes. Advisory council (present: Mies, Hilberseimer, Reich, Eichholtz) 1/4/33
Conference: Mies, Albers, Hilberseimer, Kandinsky, Peterhans, Rudelt, Reich, Scheper, Eichholtz, Engemann ill.
The Ullstein Company, due to mediation by Herr Albers, provides material for setting up the printing workshop.
1/6/33
Conference: see minutes. Herr Hoyer starts with a course in lettering for commercial art.
1/7/33
For the remaining part of the semester Kandinsky is to give a course on principles of artistic design for the first semester, each Saturday from 11:00 A.M. to 1:00 P.M.
1/10/33
Meeting with tax consultant Schütz.
1/11/33
Advisory council: see minutes. Bauhaus party meeting. Meeting between Mies and Dr. Baum of the Wood Industry Association.

1/13/33
Discussion concerning festival. Visit of Dr. Porstmann, discussion with Mies about possible lecture. Visit of Dr. Paulsen ("Bauwelt"—architectural magazine).
1/16/33
Repair of the heating system, classes have to be suspended for the most part.
1/17/33
Meeting with student representatives.
1/18/33
Advisory council. Meeting concerning festival.
1/18/33
Meeting concerning festival. Meeting of the Masters concerning the legal set-up.
1/20/33
Meeting about the festival. Invitation.
1/21/33
House burglarized during the night of January 22nd by . . . [?]
1/23/33
Fräulein Aberle visits the Bauhaus in order to publish an article in "Strutture." Meeting with student representatives about the festival. Meeting of the Masters concerning the legal set-up.

1/24/33
Meeting concerning festival. Meeting of the Masters concerning the legal set-up.
1/25/33
Meeting concerning festival and (with Herr Foerster present) meeting concerning the legal set-up. Advisory council.
1/27/33
1937 invitations for the festival sent out.
1/31/33
Advisory council. Meeting concerning festival.
2/1/33
Meeting concerning tablecloths. Preparation for festival.
2/7/33
Advisory council
2/8/33
End of classes.
from
2/9/33
Preparations for festival.
2/18/33
First Bauhaus festival, in all rooms, approximately 700 participants.
2/20/33
Preparation for post-festival party.
2/25/33
Repeat of the Bauhaus festival, approximately 400 participants.
2/23/33
Meeting with Herr Schick concerning legal problems.
2/22/33
Meeting with Herr van Delden and Dr. Emil Rasch.
2/28/33
Conference of the Masters.
3/1/33
Signing of new contracts with the Masters.
3/2/33
Reconstruction of the house after the festival.
3/6/33
Resumption of classes.
3/7/33
Advisory council.
3/8/33
National holiday on the occasion of the election returns of March 5.
3/9/33
Meeting of the Masters concerning the question of whether to display the flag.
3/10/33
Meeting of the Masters concerning the question of whether to display the flag. Departure Frau Sachsenberg.
3/14/33
Advisory council. Meeting about tablecloths.
3/15/33
Meeting of Mies with the county board of teachers. Mayor Lührs resigns his position as chairman of the "Circle of Friends of the Bauhaus."
3/16/33
Receipt of donations from patrons of the house.
3/15/33
Exhibition stand for van Delden at the Leipzig Fair.
3/16/33
Meeting of Mies with Herr Schönkerl [?], on behalf of Herr Schleber, concerning the tiger competition.
3/17/33
Preliminary meeting on wallpaper.

3/20/33
Meeting of advisory council.
3/22/33
Conference and consultation with Herr Schütz. Meeting with student representatives concerning exhibition, scholarships, etc.
3/24/33
Meeting concerning wallpaper. End of classes.
3/27–28/33
Preparation of the exhibition.
3/29/33
Conference on examinations . . .
Meeting concerning the petition of the students Heide and Bauer. Mies is going to talk to the students personally.
3/30/33
Meeting of the Masters concerning change of curriculum and schedule. Beginning of vacations.
4/3–4/33
Meeting concerning curriculum and schedule. Conference and Advisory Council. Beginning of classes. Fourteen new students have so far enrolled. For the time being the schedule of the winter semester will be kept.
4/6/33
Meeting with the commercial art [department]: Mies and Peterhans. Meeting concerning the new selection of textiles with "Politex," between Frau Reich, Herr Tüchel, and Herr Jänsch.
The new schedule is announced and goes into effect Monday, April 10, 1933. Classes daily from 8:00 A.M. to 5:00 P.M., one hour for lunch. No classes on Saturdays.
4/10/33
Beginning of the new schedule.
4/11/33
[At this point the diary leaves off]

Annemarie Wilke
**Carnival Party at the Bauhaus Berlin
Letter of February 21, 1933 to Julia
Feininger**
BD, collection H. M. Wingler (First publication)

The public carnival parties of the Berlin Bauhaus in February 1933 were meant, above all, to be a source of income. Many of the most prominent German artists donated their own work as prizes for the lottery. At these magnificent parties the sense of solidarity, optimism, and imagination triumphed once more over the many difficulties, only a few weeks before the dissolution of the Institute.

Berlin, February 21, 1933
. . . To start out with the most important thing: Our party was wonderful and a great success, as confirmed by all the visitors, and apparently it was something special even for Berlin. . . . About seven hundred guests were present; the rooms appeared very crowded and yet they could have held almost a thousand people, judging by this occasion . . . Our rooms on the ground floor made an unbelievably elegant impression, as though made up for a big social affair. One is not used to this from other Berlin parties. The Academy and the "Bunte Laterne" for example, were very superficially . . . decorated. The relatively valuable material and the care which we had put into decorating our rooms were [noticed] first. Upstairs, things were already a little different. The only one coming close to the style of the Mies room was the Peterhans room which I thought was actually the loveliest one of all, [particularly] if one considers with how little expense . . . this beautiful effect was achieved. But the rooms of Albers and Engemann on the other hand have to be called "popular." Juppi's [Albers] "arena for the people" was really filled to the last seat, like a packed amusement park. Engemann's beer bar looked like one of those tents at the Munich "Oktoberfest" with stylized cactus pots and such on the window sills. But here, too, it was always crowded. When spirits run high, people no longer feel the sense for the esthetic, and the harmonious cheap decorations ("Kitsch") enveloping one in that room matched what was going on in it. The funniest thing . . . with the disposition of the rooms, happened . . . to Kandinsky. Asked about his preferences, he had suggested that the painting class furnish a room with a comfortable seating arrangement along the walls so that the older guests would be able to find a quiet retreat for a moment from the colorful activity of the dancers when it was a little too much for them. It was also designed as a place for quiet conversation. That was what he had in mind. But those who retreated there were not the older guests: on the contrary, these made a [wide] detour around it, and that was [indeed fortunate], for otherwise they would surely have been shocked . . . At 5:00 P.M. the first band, the "White Crows," left; incidentally they were not very good. They had been playing downstairs in the Mies room. The bands upstairs were better, but the bands I have heard in Berlin now are nothing compared with our Bauhaus band that was . . . The lottery was something very important. We had paid for four hundred chances, each one costing three marks. Of course the Bauhaus girls had to do the selling. . . . I had to devote almost the entire evening to it. Six others besides myself helped to sell the tickets. . . . I was busy with this task from ten-thirty until 3 o'clock, without dancing once in all that time. There was no choice. I soon noticed that the others were having little success, as the price of the tickets scared most of the buyers away, and since no one came on his own to buy, one had to use all one's powers of persuasion and charm, etc., because we had hoped to gain our largest profit through the lottery. As a reward, I was chosen to do the drawing of the winners. It was a ceremonial act during which scores of eyes squinted at me either hopefully, disappointedly, hostilely, or beamingly. The wonderful head by Sintenis was won by one of our Bauhaus students . . . who has been with us since fall. He was beside himself, which still is no description of his outburst of enthusiasm. He shouted all the time "at last I have a woman!" The Kolbe sculpture went to an old schoolteacher from Stettin who is certainly not going to value it enough: the Mataré was won by Anni Albers's brother. Mies himself won the Baumeister, which, by the way, is very beautiful. Also, a ticket which he gave away won the Klee. We don't know yet who won some of the things, such as for instance your painting. I was glad about that, because I am sure I would have torn the lucky one to pieces if I had had to watch him walk off with it. I didn't have a ticket myself, I couldn't buy one and I consoled myself with the fact that I am never lucky in these things anyhow. Most of the members of the Bauhaus had none, but Mies spent a lot of money; he bought four tickets from me alone . . . By the way the room in which the things were exhibited looked marvelous; above all, it emphasized the elegant impression which our celebration conveyed. No one romped about in it as we were afraid they would. This was Mies's special room. The large unbleached-silk curtain from Dessau was hung by the windows, the walls and ceiling were neatly draped with cotton cloth, the sculptures stood on the table and the paintings hung on the walls. . . . I thought it was very nice and well arranged by Mies not to have one table for prominent guests but rather for him to be constantly on the move and in all the rooms.
On Saturday we are going to have the second public Bauhaus party. We have no classes this week; Mies himself wanted it that way. We are going [to look at] Taut's new bread bakery and maybe [go on] a joint excursion to Charlottenhof. Tomorrow we intend to give a small intermediate party for Bauhaus members and their friends only, to be held in the Mies room. . . . After that comes the dismantling, when there will hopefully be as many helping hands as there were for putting everything up. This is going to take at least until Wednesday evening of next week. . . .

186

Ludwig Mies van der Rohe
Minutes of a Conference, Recorded from Memory, of April 12, 1933, with Alfred Rosenberg Concerning the Closing of the Bauhaus Berlin, April 13, 1933
PA Mies van der Rohe (First publication, in excerpt)

After the National Socialist regime had decreed the closing of the Bauhaus, Mies had hoped to get support from Rosenberg, the well-known Nazi functionary and author. Rosenberg countered, stating that the Bauhaus was a symbol of those powers "who were putting up the hardest fight against National Socialism." Mies outlined the program of the Bauhaus and emphasized the major concern to be the mastering by the mind of the problems brought on through technological progress.

Lyonel Feininger
Extract of a Letter of May 18, 1933 to Julia Feininger
BR, gift of Julia Feininger (First publication)

Feininger did not follow the Bauhaus to Berlin. Vacationing in the holiday resort of Deep, he remembered, on Walter Gropius's birthday, the continuing effectiveness of the achievements that had accrued as a result of the conception of the Bauhaus. At the same time, Mies van der Rohe did his utmost to negotiate a continuation of the Institute.

City Building Department Dessau and building superintendent Fehn
Testimony Concerning Damage to the Bauhaus Building
AD, reports of the committee investigating Fritz Hesse (1933), file "Damage to the roofing of the Bauhaus." (First publication)

After the "seizure of power" in the Reich, a merciless witch hunt was started against Fritz Hesse. He was arrested and an "investigating committee" was set up in order to establish that he was guilty of irregularities in office. The actual result of the investigation was kept secret and was in flagrant contrast to the findings revealed to the public. Insignificant details for which Hesse could not even be held responsible were exaggerated out of all proportion. He was primarily assailed for having given a home to the "culturally bolshevistic" Bauhaus in Dessau. This was the guiding point of view for the committee's selection of documents from the Bauhaus files, which were then interpreted with unscrupulous arbitrariness. Thus, it was due to initiative from Dessau that the Berlin Bauhaus was searched and closed by force in April 1933. Particularly welcome to the National Socialist propagandists were, of course, facts like the defects in the roofing of the Dessau Bauhaus building. The roof really leaked—in 1926 Gropius had experimented with untested roofing material which manufacturers had just put on the market. It was impossible to count on understanding from the political opponents, that any—and particularly a far-reaching—experiment would always entail risks. For that reason, the roof had always been quietly and privately repaired, when possible. In 1933 this easily reparable technical defect was turned into a prime argument for an indictment against modern architecture.

I put the question to Rosenberg: "Where do you, as the cultural leader of the new Germany, stand on the esthetic problems which have emerged as result of the technical and industrial development? Do you consider it important, culturally, to work on these problems?"
Rosenberg: "Why do you ask?"
Mies: "Because work on such problems is the major concern of the Bauhaus, and I would like to know whether there is any sense in our continuing these efforts."
Rosenberg: "Are these problems not dealt with at the Institutes of Technology?"
Mies: "No. At the Institutes of Technology these fields are split into too many special disciplines and one should take just exactly the opposite course. These problems of esthetics can only be dealt with when taken all together. Moreover, they must really be worked on, which is something impossible to do at institutes where one single teacher has up to one hundred and fifty students. I have, in three different semesters, a total of about thirty young students, so that I am truly able to work with each one of them."
Rosenberg: "Why do you want the backing of political power? We are not thinking of stifling private initiative. If you are so sure of what you are doing, your ideas will succeed anyway."
Mies: "For any cultural effort one needs peace, and I would like to know whether we will have that peace."
Rosenberg: "Are you hampered in your work?"
Mies: "Hampered is not the correct term. Our house has been sealed, and I would be grateful to you if you could look into this matter."
This Rosenberg promised to do. . . .

Deep, May 18, 1933
. . . Yesterday I wrote a letter to Gropi. I was strongly possessed by the thought of how he had been absolutely the first to take up the struggle for the integration of all the intellectual and constructive forces for defeated Germany and had carried it on imperturbably and steadily, only to fall under suspicion and be kicked around by everyone now. In that group *he* was the man who would not tolerate any party biases, any political views. He solicited and fought for the ideal of pure form alone and *he* built the Bauhaus. . . .

[City Building Department to the investigating committee, June 2, 1933]
The question whether the expenses [amounting to RM 3,902.30 from 1928 to 1930] stem from the defective construction of the roof, has to be answered in the negative. The solid concrete slab on which the roofing material was applied expands and contracts constantly due to the changes in temperature to which it is exposed. This circumstance had to cause damage to the supporting walls. But the roofing material had to be flexible enough to take the expansions and contractions without breaking. In addition, it had to withstand the strong heat of the sun without becoming defective. If the roofing material did not meet these requirements, it was not well suited and was not a roofing material that could have been guaranteed.
[Superintendent Fehn before the investigating committee, June 4, 1933]
. . . I would work about one to two weeks, three to four hours daily, then it was a little better again. Some weeks later we had the same thing all over again! . . . If it rained, I put buckets in those places where the rain came through. In the morning they were full. . .

187

The City Council of the City of Dessau
Letter of June 15, 1933 to Josef Albers
PA, Josef Albers, New Haven (First publication)

The premature termination of the contracts with the Dessau Bauhaus Masters was responsible for the fact that they were entitled to a continuation of salary payments. In 1933 Dessau discontinued the payments, basing its decision on a National Socialist law. The letter is characteristic of the manipulations of the law with which the Bauhaus was harassed to the end. Letters of the same tenor were received also by the other Bauhaus Masters who had been dismissed in Dessau in violation of their contracts.

The City Council Dessau, June 15, 1933
Teacher Josef Albers
Berlin-Charlottenburg 9
Sensburger Allee 29
Since you were a teacher at the Bauhaus in Dessau, you have to be regarded as an outspoken exponent of the Bauhaus approach. Your espousing of the causes and your active support of the Bauhaus, which was a germ-cell of bolshevism, has been defined as "political activity" according to § 4 of the law concerning the reorganization of the civil service of April 7, 1933, even though you were not involved in partisan political activity. Cultural disintegration is the particular political objective of bolshevism and is its most dangerous task. Consequently, as a former teacher of the Bauhaus you did not and do not now offer any guarantees that you will at all times and without reserve stand up for the National State.
Based on §§ 4, 15 of the law concerning the reorganization of the civil service of April 7, 1933 (Reich law publication p. 175) in connection with §§ 5, articles 3 and 7, 4 and 3 of the second regulation for the implementation of the law concerning reorganization of the civil service of May, 1933 (Reich law publication p. 233), payment of compensation will be suspended, effectively May 1, 1933.
The salary payments due, according to §§ 4 and 3 of the second implementation regulation, for a period of 3 months beginning at the end of the month during which the private contract of employment concluded between the City and you was dissolved, are regarded as having been made by the payments of salary for the period October 1, 1932 to March 31, 1933 and the payment of half the amount of the salary for the month of April 1933, especially since recoverable salary payments with consideration of the fact that the private contract of employment was concluded according to § 1, chapter I, section 4 of the economy regulations of Anhalt of September 24, 1931 (statute book of Anhalt p. 63, of September 30, 1932) had been dissolved and that after the dissolution obligation for further payment of salaries no longer existed.
The City Council Attested:
(signed) Sander Irmscher
 "Oberstadtinspektor"

Bauhaus Berlin
Minutes of the Meeting of the Faculty of July 20, 1933 (Decision to Dissolve)
BR (duplicate) (First publication)

The forced closing of the Bauhaus in April 1933 compelled Mies van der Rohe to ask the owners of the building to end the lease before the expiration of the lease period. The rights for the wallpaper designs had been transferred to the manufacturer (Rasch Brothers) for a lump sum compensation, since it was impossible to continue regular contractual design work.

Minutes of the conference of July 20, 1933
Present: Albers, Hilberseimer, Kandinsky, Mies van der Rohe, Peterhans, Reich, and Walther.
Mies van der Rohe reports on the last visit with the county board of teachers and on the accounts which the investigating committee in Dessau published in Dessau newspapers. In addition, Herr Mies van der Rohe informed the meeting that it was possible to terminate the lease effective July 1, 1933, but that despite this the economic situation of the Institute, because it had to be shut down, was in such poor condition that it was impossible to think of rebuilding the Bauhaus.
For this reason, Mies van der Rohe moved to dissolve the Bauhaus. This motion was carried by a unanimous vote.
Following the review of the financial situation, Mies van der Rohe announced the agreement which had to be made on April 27, 1933 with the firm of Rasch Brothers. Herr Mies van der Rohe intends, however, to negotiate further with Mr. Rasch, in order to see if he can get another payment to help settle the debts.
If at a later date the financial situation should improve because of the royalties from the curtain materials, for example, Mies van der Rohe will try to pay the members of the faculty their salaries for the months of April, May, and June 1933.
(signed) Mies van der Rohe
[Original without capital letters]

Ludwig Mies van der Rohe
Notification to the Gestapo of the Dissolution of the Bauhaus Berlin, July 20, 1933
PA Mies van der Rohe (duplicate) (First publication)

Other notifications of the same content were sent to the proper administrative and supervisory authorities.

Office of the State Secret Police
for the attention of Ministerialrat Diels
Berlin, Prinz-Albrecht-Strasse
July 20, 1933
Dear Sir,
I beg to inform you that the faculty of the Bauhaus at a meeting yesterday saw itself compelled, in view of the economic difficulties which have arisen from the shutdown of the Institute, to dissolve the Bauhaus Berlin.
Your obedient servant,
Mies van der Rohe

Office of the State Secret Police, Berlin
Letter of July 21, 1933 to Mies van der Rohe
BR (copy) (First publication)
The conditions under which the Gestapo allowed the Bauhaus to continue its work were far too rigorous for the members of the faculty to be induced to withdraw their statement of dissolution; the fact that they would have been accepted had not the dissolution been already decided on, was later claimed solely for reasons of security.

Strictly confidential
State Secret Police
Berlin S. W. 11, July 21, 1933
Prinz-Albrecht-Strasse 8
Professor Mies van der Rohe
Berlin, Am Karlsbad 24
Regarding: Bauhaus Berlin-Steglitz
In agreement with the Prussian Minister for Science, Art, and Education, the reopening of the Bauhaus Berlin-Steglitz is made dependent upon the removal of some objections.
1) Ludwig Hilberseimer and Vassily Kandinsky are no longer permitted to teach. Their places have to be taken by individuals who guarantee to support the principles of the National Socialist ideology.
2) The curriculum which has been in force up to now is not sufficient to satisfy the demands of the new State for the purposes of building its inner structure. Therefore, a curriculum accordingly modified is to be submitted to the Prussian Minister of Culture.
3) The members of the faculty have to complete and submit a questionnaire, satisfying the requirements of the civil service law.
The decision on the continuing existence and the reopening of the Bauhaus will be made dependent on the immediate removal of the objections and the fulfillment of the stated conditions.
By order: (signed) Dr. Peche
Attested: [illegible]
Chancery staff

Ludwig Mies van der Rohe
Announcement to the Students of the Dissolution of the Bauhaus
This information leaflet was the last statement of the Bauhaus.

To the students of the Bauhaus. August 10, 1933
At its last meeting, the faculty resolved to dissolve the Bauhaus. The reason for this decision was the difficult economic situation of the institute.
The Office of the State Secret Police, the Prussian Ministry for Science, Art, and Education, and the school administration have been informed of this decision.
This announcement has crossed with a notification by the Office of the State Secret Police in which we are told that "in agreement with the Prussian Minister for Science, Art, and Education, the reopening of the Bauhaus is made dependent upon the removal of some objections."
We would have agreed to these conditions, but the economic situation does not allow for a continuation of the Institute.
The members of the faculty are of course available to the students for advice at any time. Grade records for all students will be issued by the secretariat.
From now on please address all letters to Professor Mies van der Rohe, Berlin W 35, Am Karlsbad 24.
(signed) Mies van der Rohe.

70

10. 8. 33

An die Studierenden des Bauhauses.

Das Lehrerkollegium hat in seiner letzten Sitzung den Beschluß gefaßt, das Bauhaus aufzulösen. Für diesen Beschluß war die schwierige wirtschaftliche Situation des Hauses maßgebend.

Dem Geheimen Staatspolizeiamt, dem Preußischen Ministerium für Wissenschaft, Kunst und Volksbildung und der Schulbehörde wurde dieser Beschluß zur Kenntnis gebracht.

Diese Mitteilung kreuzte sich mit einem Schreiben des Geheimen Staatspolizeiamtes, worin uns mitgeteilt wurde, daß „die Wiedereröffnung des Bauhauses im Einvernehmen mit dem Herrn Preußischen Minister für Wissenschaft, Kunst und Volksbildung von der Behebung einiger Anstände abhängig gemacht würde".

Mit diesen Bedingungen wären wir einverstanden gewesen. Die wirtschaftliche Lage läßt es aber nicht zu, das Haus weiterzuführen.

Selbstverständlich steht das Lehrerkollegium den Studierenden jederzeit mit seinem Rat zur Verfügung.

Die Zeugnisse für alle Studierenden werden durch das Sekretariat ausgestellt.

Alle Anschriften bitten wir von jetzt an Professor Mies van der Rohe, Berlin W 35, am Karlsbad 24 zu richten.

gez. Mies van der Rohe.

9 The New Bauhaus
The New Bauhaus 1937–1938
School of Design in Chicago 1939–1944
Institute of Design since 1944

71
Signet "the new bauhaus chicago." 1937
Reproduced from the prospectus "the new bauhaus,"
Chicago. Designed with reference to the old Bauhaus
signet, which was originally drafted by Oskar Schlem-
mer and used since 1922. For the later successor in-
stitutions the signet was changed.

The selection of the following texts was made with the object of preserving some of the most significant moments in the intellectual and institutional development of the school that pioneered in carrying on the tradition of the Bauhaus and that may therefore be considered its true successor. "The New Bauhaus," continued after a brief period under the title "School of Design in Chicago" and then renamed the "Institute of Design," has enabled the intellectual legacy of the Bauhaus to be revived in America and has brought it to fruition during three decades of devoted work, in spite of many setbacks and in spite of changes in structure and personnel. The basic ideas of the Bauhaus were constructively developed and adjusted to the new environment.

The documentary material for the history of the New Bauhaus and its successor institutions is deposited for the most part in the archives of the University of Illinois and of the Institute of Design. An additional collection is being accumulated in the Bauhaus-Archiv at Darmstadt. Some significant documents were bequeathed by Laszlo Moholy-Nagy and Walter P. Paepcke. The most important private collections are located in Chicago, Aspen, Colo., and New York.

The only comprehensive publication to date is the biography "Moholy-Nagy—Experiment in Totality," brought out in New York in 1950 and reprinted in Cambridge, Mass., in 1969. In it, Sybil Moholy-Nagy describes with admirable thoroughness the history of the school up to 1946, using remarkable restraint and objectivity in the face of her passionate involvement. Laszlo Moholy-Nagy himself recorded the pedagogical conceptions he practiced in the New Bauhaus in his posthumously published book, "Vision in Motion." In it he provides an authentic interpretation of the projects undertaken, primarily as part of the Preliminary Course. For the subsequent history nothing comparable has been provided, aside from brief statements in catalogues and circulars.

Walter Gropius
Letter to Norma K. Stahle, Executive Director of the Association of Arts and Industries in Chicago
BD, collection of New Bauhaus documents, gift of Sibyl Moholy-Nagy

Soon after the breaking up of the Bauhaus, its educational principles found fertile soil in the United States. Albers joined the faculty of Black Mountain College in North Carolina in 1933, and Gropius accepted a call to Harvard University in 1937. Numerous former members of the Bauhaus emigrated to the United States and there gave full scope to their artistic ideas. The privilege of bringing a legitimate successor institution to life, however, was reserved for Chicago. Decades earlier, the philosopher John Dewey (who later became active at Columbia University in New York) had lived there for some time and had formulated his conviction that creative forces can be awakened in every human being. His theories pointed in the same direction as those of the Bauhaus—the latter with specifically artistic overtones.

During the 1930's the artistic development of Chicago, which had been the scene of significant architectural events during the final decades of the 19th century thanks to such men as Jenney, Burnham, Root, Adler, Sullivan, and Wright, had long bogged down and stagnated. In order to revive the creative impact, an Association of Arts and Industries was formed in 1922. In 1937 this organization, under the extraordinarily energetic leadership of its executive director, Norma K. Stahle, conceived the plan of founding a School of Design, and with this in mind approached Gropius.

Cambridge, Massachusetts
May 18, 1937
Dear Miss Stahle:

Thank you very much for your letter of May 14th telling me about the new School of Industrial Design to be put up in Chicago. I think it is a splendid idea, and there is a real need for this sort of school in every country. I shall watch your endeavourings with greatest interest, but I am afraid I shall not be able to take part in them personally as I have accepted an appointment for an indefinite period at the Harvard Graduate School of Design. However, as you are looking for a head of this school, I should like to suggest Professor Moholy-Nagy. He was my nearest collaborator in the Bauhaus, built up the preliminary courses and was head of some of the workshops. He is the best man you can get, has had very wide experiences and is endowed with that rare creative power which stimulates the students. He is not only a painter of international fame, his recent exhibitions at London and Bâle were very successful, but he has worked for years with industrial firms—in glass, metal, textiles, and wood and is equally skilled in photography, films, typography and commercial advertising. In all these branches he did pioneer work in Germany, and recently in England. This versatility, combined with a delightful and most energetic character, qualifies him very highly as a teacher and organizer. He is about forty-five years old, Hungarian by birth, and speaks English. At present he lives in London, Golders Green, 7 Farm Walk. He might be willing to accept an appointment in the States. If you should succeed in getting him over, I am certain he would develop a most remarkable institution. May I refer to his book "The New Vision," published in the States, which gives an impression of his thoroughly creative mind. Finally, may I draw your attention to my article "Education Towards Creative Design," published in the last issue of the "American Architect," which may interest you.
Sincerely yours,
Walter Gropius

Norma K. Stahle
The New School
From "The Chicago Daily News," August 23, 1937
At the instigation of Gropius, Norma K. Stahle made contact with Moholy-Nagy. The latter arrived in Chicago from England in July 1937 in order to carry on negotiations (cf. the correspondence published in the Moholy-Nagy biography by Sibyl Moholy-Nagy). It was agreed that the new school was to open its doors in October. The former home of the prominent merchant Marshall Field, a mansion built around 1880 and located on the erstwhile elegant Prairie Avenue, was prepared to house the new institution.

Laszlo Moholy-Nagy
Outlines of an Educational Program
Excerpts from a lecture given at the Knickerbocker Hotel in Chicago, September 23, 1937. From Sybil Moholy-Nagy, "Moholy-Nagy—Experiment in Totality," Harper & Brothers, New York, 1950
For the projected institute Moholy-Nagy drafted a program that leaned heavily on the Dessau Bauhaus but which involved the natural sciences even more emphatically; Moholy-Nagy aspired to provide his students with an education based on universal principles. Soon after presentation of the lecture here reproduced in extract form, the school was opened as a non-profit institution, supported by the Association of Arts and Industries. In accordance with a suggestion made by Moholy-Nagy, who was installed as its Director, and with the consent of Gropius, who acted as advisor, the new institute was named "The New Bauhaus," with the subtitle "American School of Design." Thirty-six students enrolled at the beginning of the first semester.

The new school realizes the hopes of many years of work by the Association of Arts and Industries. It is our aim to establish a school of design that will meet the needs of industry and reintegrate the artist into the life of the nation. It has grown out of a great demand on the part of both students and manufacturers.
We expect the new school to attract students from all over the world. It is especially fitting that the central west should be the locale of this great school of design, destined to fulfill a long-felt demand in this country, and no more suitable place could be imagined than Chicago, the industrial metropolis of the world.

Well educated today means accumulate useful experience among historical and present ones. So far all right, but why, I ask you, has the specialist always to think down his channel?
Age of conveyor belt, of disintegrated part, of screw driven into machine of which purpose and function he doesn't know.
Books we should be friends one should get to, to find a rounded-up existence, not only as an excellent basis for specialized education . . .
You speak: words, sounds, in joy, in horror. Are you a speaker? Oh no, you're just a human being. One day you notice that sound is not only loud, it's beautiful. You try again and it makes you feel happy. Your ability to make sound beautiful liberates you . . . You organize your ability to make sound, refine it, find pattern, watch effect. And you're a speaker, a writer, an actor . . . My little daughter wouldn't walk. Why should she? We carry her anyhow. But then she discovers red. Across a lawn are red toys she wants, and she walks because red forces her to take action. Now you who can already walk, you find that color means a life beyond food, drink, sleep. Pleasant, I know, I love to eat. But there's more. Everyone can buy it, without money, with openness of eyes, openness of feeling, readiness to learn. You understand? Everybody is talented . . .
We don't want to add to the art-proletariat that already exists. We don't teach what is called "pure art," but we train what you might call the art engineer. It is a remodeling of art-meaning we are undertaking. If our students become artists—this is their own job. We know that after they have learned to use materials, to understand space, to see color, they'll be better artists no matter how far removed they think they are from practical life. But to you—the industrialists—we offer our services for research. We shall work on your problems. In our workshops we shall provide research possibilities for synthetic fibers, fashion, dying, printing on textiles, wallpaper design, mural painting, the use of varnishes, lacquers, sprays, and color combinations in decorating; we shall explore for microphotography, motion pictures in color and black-and-white, commercial art in posters and packages. We shall design stage display, window and shop display, exposition architecture, and all other architectural structures from a prefabricated bungalow to a factory; and we shall work with stone, glass, metal, wood, clay, and all plastics in the product design and the sculpture classes . . .

72
Signatures of the Directors of the Institutes:
Laszlo Moholy-Nagy (1937–1946)
Serge Chermayeff (1946–1951)
Jay Doblin (since 1951)

The New Bauhaus
Educational Program and Faculty

Reproduced from the prospectus "the new bauhaus," Chicago, 1937–1938

The program of the New Bauhaus was projected in a masterful fashion and served as a significant goal, but it was too ambitious and too detailed for immediate realization. Many of its aims had to remain illusory for the time being. Of the artists listed as faculty members, Bayer, Hélion, and Schawinsky did not in fact participate.

For the preliminary course, which embraced two semesters, Moholy-Nagy was concerned with providing practical experience in materials, in surface effects, in three-dimensional space, and in the phenomenon of volume. To provide courses in the minor subjects of the natural sciences, members of the faculty of the University of Chicago who were interested in the totality of education placed themselves at his disposal. Six workshops were to provide training for the students in their various specialties after completion of the preliminary course. The students were to be given free choice in deciding for one or another of these workshops. The subsequent courses, leading to a degree in architecture in the fifth and sixth year, were contemplated as the final crowning of the education. This teaching program, while reflecting in principle that of the original Bauhaus around 1926, further refined and broadened it.

Circular diagram labels: BASIC DESIGN WORKSHOP · ANALYTICAL and CONSTRUCTIVE DRAWING · TRAINING IN MATERIALS AND TOOLS · NATURE STUDY · WOOD METAL · TEXTILE WEAVING FASHION · TRAINING IN CONSTRUCTION and REPRESENTATION · COMPARATIVE HISTORY OF ART · COLOR PAINTING DECORATING · ARCHITECTURE BUILDING ENGINEERING · DISPLAY EXHIBITION STAGE · TOWN PLANNING SOCIAL SERVICES · GLASS STONE CLAY PLASTICS · SPATIAL TRAINING COLOR TRAINING COMPOSITION · LIGHT PHOTOGRAPHY FILM PUBLICITY · SCIENCE · PRELIMINARY SCIENTIFIC SUBJECTS (etc.) COURSES · 1 YEAR · 5 YEARS · 2 YEARS

73
74

EDUCATIONAL PROGRAM

AIMS The New Bauhaus requires first of all students of talent: the training is for creative designers for hand and machine made products; also for exposition, stage, display, commercial arts, typography and photography; for sculptors, painters, and architects.

ORGANIZATION The education of the student is carried on in theoretical and practical courses and in the workshops of the school. The school year is divided into two semesters, the first extending from the end of September to the middle of February and the second from the middle of February until the end of June. Each student must spend two semesters (a school year) in the preliminary courses and at least six semesters (three school years) in a special workshop. After the successful completion of this training he will obtain his Bauhaus diploma and he may, by continuing four semesters (two years) in the architectural department receive the architect's degree.

PRELIMINARY COURSE The preliminary curriculum offers a test of the student's abilities. It helps shorten the road to self-experience. It embodies briefly the essential components of the training given in the specialized workshops of the new bauhaus. It gives him ample opportunity to make a careful choice of his own field of specialization later.

The preliminary curriculum is divided into three parts:

(A) The basic design shopwork (tools, machines, building musical instruments).

(B) Analytical and constructive drawing, modeling, photography.

(C) Scientific subjects.

THE OBLIGATORY PRELIMINARY COURSE

(A) Basic Design Shopwork

In the basic workshop the student learns the constructive handling of materials: wood, plywood, paper, plastics, rubber, cork, leather, textile, metal, glass, clay, plasticine, plaster, and stone.

(a) their textile values.
(b) structure.
(c) texture.
(d) surface effect and the use of their values
(e) in plane.
(f) in volume.
(g) and in space. Henceforth the student becomes (1) volume (2) space and (3) kinetic conscious.

(h) In order to develop his auditory sense, he experiments with sound and builds musical instruments.
(i) He learns the subjective and objective qualities, the scientific testing of materials.
(j) existence of the fourth dimension (time).
(k) As he experiments he builds, with small nature or other devices, toys, moving sculptures, spatial constructions, etc.

(l) and develops his sense for proportion, and penetrates this work with the different

(B) Drawing, Modeling, Photography
page 5

(m) visual representation. He sketches by hand and with photo apparatus as well in black and white and in color and he works in clay. Standard nature forms will be analyzed and the analytical method made the student to the

(n) elementary being, later to the construction of these forms in relationship to each other
(o) with the aim of free composition.

(C) Scientific Subjects

The following scientific courses complement shopwork and drawing:
1. Geometry
2. Physics — Physical Sciences
3. Chemistry
4. Mathematics
5. Biology
6. Physiology — Life Sciences
7. Anatomy
8. Intellectual Integration

In addition to these, the curriculum includes **Supplementary** broad surveys of

(a) Biotechnique—the system of conscious inventions (e.g. Edison)
(b) Psychotechnique (ability testing)
(c) Music
(d) Guest lectures on other subjects;
(e) Lettering, writing (construction of letters, and printing types);
(f) Light (as an instrument of visual notes, using light as a new medium of expression); photography, film.
(g) Visits to factories, newly constructed buildings, museums, exhibitions, theatres, etc.
(h) Exhibitions (some assembled by the students, some by the faculty or others).

SECOND THIRD and FOURTH YEARS After passing the examination in the preliminary courses the student enters one of the specialized workshops:

(1) Wood, metal.
(2) Textile (weaving, dyeing, and fashion).
(3) Color (murals, decorating, wallpaper).
(4) Light (photography, film, typography, commercial arts).
(5) Glass, clay, stone, plastics (modeling).
(6) Display (theatre, exposition architecture, window display).

FIFTH and SIXTH YEARS (7) Architecture.

EXAMINATION

THE FIRST YEAR After the first half year of the preliminary course the first examination will be held in the form of a students' trial exhibition.
After the second half year a similar exhibition will be held as the final examination in the preliminary course.

THE SECOND THIRD and FOURTH YEARS Workshop, tools and machines, bookkeeping and estimating, drawing, scientific subjects (constructions, and statics) with final examination for a diploma.

THE FIFTH and SIXTH YEARS Architecture, landscape architecture, town planning and scientific subjects. Educational problems: kindergarten, grade, high schools and colleges. Social services: hospitals, recreation, leisure and hobby organization with additional thesis for the bauhaus degree in architecture.

the new bauhaus reserves the right to make necessary alterations to this program.

page 6

INFORMATION

page 8

School doors open at 8:30 A.M.

In case of illness or absence for any other cause notice should be given to the secretary of the school.

Any change of address of the student after registration should be promptly reported to the secretary of the school.

Smoking in the school is prohibited except in the students' lunchrooms.

The students are responsible for cleaning of the workshops and of the machines and tools. In the case of damage to tools or equipment, the individual causing same will be held responsible for costs; if individual not known the class will be held responsible.

All work executed by the students in the school is the property of the school. If the school has no interest in retaining it the student can buy it for the material and additional general cost.

Appointments may be made through the Secretary for consultation periods with the Director. No visitors are admitted to the school classes and workshops without permission.

For the time being the new bauhaus has no dormitories. Consequently the school cannot supervise the life of the students outside of the school. It is hoped that only students sufficiently matured to be responsible for themselves will enroll. An accredited list of rooms and boarding houses will be available at the office of the Secretary.

THE FACULTY

The realization of such a large scale program as the new bauhaus wishes to fulfill depends entirely upon the selection of the right teachers. Thus we choose to admit to our faculty only the best available teachers, not only on the ground of their specialized knowledge, but also because of their human qualities and their artistic ability—particularly in respect to their internationally valued creative contribution to our time. Our faculty is organized on the basis of a common comprehension of our immediate and most urgent problems. The teachers are able to give the students a clear and unmistakable world picture, not through a fictitious or forced agreement, but through the common conception of their life work. This helps us to maintain a high standard in all our teaching and avoids misunderstandings among the pupils who are easily disturbed if confronted with diverging opinions of their teachers.

Alexander Archipenko
Modeling Workshop

Herbert Bayer
Light Workshop

Hin Bredendieck
Basic Design and Wood and Metal Workshop

David Dushkin
Music and Building Musical Instruments

Jean Hélion
Color Workshop

G. F. Keck
Architecture and Engineering

George Kepes
Drawing and Photography

L. Moholy-Nagy
Material, Volume, Space

Xanti Schawinsky
Display Workshop

Andi Schiltz
Technician Basic Design Workshop

Henry Holmes Smith
Technician Photography Studio

Guest Lecturers:

Carl Eckart
Associate Professor of Physics, University of Chicago
Physical Sciences

Ralph W. Gerard
Associate Professor of Physiology, University of Chicago
Life Sciences

Charles W. Morris
Associate Professor of Philosophy, University of Chicago
Intellectual Integration

Director
L. Moholy-Nagy

Assistant Director:
Norma K. Stahle

Advisor:
Dr. Walter Gropius

The names of the Scientists in Sociology and Technology, and the names of the Technicians in the different workshops will be announced later.

Charles W. Morris
**The Contribution of Science to the
Designer's Task**
From the prospectus "the new bauhaus,"
Chicago, 1937–1938

Morris, a devoted disciple of the Unity of Science movement, was associate professor at the University of Chicago. He proved to be one of the most faithful supporters of Moholy-Nagy and the Bauhaus idea; during periods of financial difficulties he lectured at the School of Design, the successor to the New Bauhaus, without honorarium. It was of the greatest significance that scientists, such as Morris, became united with Moholy-Nagy in their optimistic faith in progress and that they enriched the totality of artistic education with their insight and knowledge. In addition to Morris, Professors Carl Eckart and Ralph W. Gerard, both from the University of Chicago and both imbued with great enthusiasm, were guest lecturers and in later years they were joined by others.

The intent of the New Bauhaus to bring its students into direct and constant contact with current scientific thought is of great educational significance. For if the artist is really to function in the modern world, he must feel himself a part of it, and to have this sense of social integration he must command the instruments and materials of that world. It is true that such integration cannot be achieved solely by intellectual understanding, but it certainly cannot be achieved without such understanding. Man is a thinking being whatever else he may be, and no integration is humanly complete which does not include his mind. And so the New Bauhaus shows deep wisdom in using contemporary science and philosophy in its educational task of reintegrating the artist into the common life. In this atmosphere the artificial separation of artist and scientist cannot thrive, nor the false fear that the development of one activity thwarts and endangers the development of the other. It is the same man who seeks knowledge and a significant life, and it is the same world that is known and found significant. Art as the presentation of the significant and science as the quest for reliable knowledge are mutually supporting. Each supplies material for the other and each humanly enriches the other. Students trained in this atmosphere, while yet retaining the orientation of the artist and artisan, should incorporate into themselves something of the mentality of the scientist, and the familiarity of the technician with the resources which that mentality has helped to make available for the service of life
. . . We need desperately a simplified and purified language in which to talk about art (and indeed about all values) in the same simple and direct way in which we talk about the world in scientific terms. For the purpose of intellectual understanding art must be talked about in the language of scientific philosophy and not in the language of art. The program of the New Bauhaus, with its stress upon the esthetical and intellectual elements, should lead to a clearer understanding of the nature of art and its relation to other human activities.
But science has a second contribution to make: it can give new resources for the fulfillment of the artist-designer's task. Only in the most fragmentary way has the fruitful tapping of these resources by the arts begun. It is difficult to envisage the full possibilities of the systematic collaboration of artist and scientist to which the new program points.
Moholy-Nagy knew of the interest of Rudolf Carnap and myself in the unity of science movement. He once remarked to us that his interest went a stage farther: his concern was with the unity of life. It was his belief that all cultural phalanxes at any time moved abreast, though often ignorant of their common cultural front. Certain it is that the integration and interpenetration of the characteristic human activities of the artist, scientist, and technologist is a crying need of our time. The problem is a general problem of all education which aims to be of vital contemporary significance. But it is also a problem of art education, and we can only be grateful that the New Bauhaus has set about to blaze the trail.

195

Laszlo Moholy-Nagy
New Approach to Fundamentals of Design

From the periodical "More Business,"
Vol. 3, No. 11, Chicago, November 1938

The periodical "More Business" devoted an entire issue to the New Bauhaus. The basic papers of Moholy-Nagy and Kepes were illustrated with numerous pictures of the work of faculty and students at the Institute; the whole had the character of a manifesto. However, by the time it appeared in print the New Bauhaus had already closed its doors, and its successor, the School of Design, was not yet on the horizon.

Here Moholy-Nagy wholeheartedly endorsed Dewey's thesis that every human being possesses creative talent. Based on this idea, which coincides perfectly with Moholy-Nagy's own philosophy, a working team of scholars and students developed which was less presumptuous and more naive but hardly less compelling than that of the old Bauhaus. John Dewey himself graciously supported Moholy-Nagy's endeavors during the following years by acting as a member of the Sponsors' Committee of the School of Design, which also included Gropius, Joseph Hudnut, Alfred Barr, W. W. Norton, and William Bachrach.

The idea of the Bauhaus education was born out of the conviction that designs for mass production and modern architecture, with extensive use of steel, concrete, glass, plastics, etc., need new men with new mentality to handle them. Exact knowledge of material and machine are equally necessary to give the product organic function. Thus in the New Bauhaus, men and women are trained practically and theoretically as designers for handmade and machine-made products in wood, metal, glass, textiles, for stage, display, exposition-architecture, typography, photography, modeling and painting.

Based upon the conviction that contemporary education easily leads into isolated specialization, the Bauhaus education gives first the fundamentals of design, a comprehensive knowledge of all fields connected with the future tasks of a designer. Independent workers with new ideas can only grow in an atmosphere of intellectual and artistic freedom. That is why the Bauhaus disregards preconceived traditions which might hamper the student's activity. By integrating sensorial and intellectual experiences, a balanced development of all natural gifts is sought. To reach this objective one of the problems of the Bauhaus education is to retain in the adult the child's sincerity of emotion, his truth of observation, his fantasy and creativeness.

The Course

The basic workshop allows experiments with tools, machines and different materials, wood, metal, rubber, textiles, papers, plastics, etc. No copying of any kind is employed nor is the student asked to deliver premature practical results. By working with materials, he gets a thorough knowledge of their appearance, structure, texture and surface treatment. Step by step he discovers their possibilities which enable him to get more governed results. He becomes volume-and-space-conscious.

In addition to the basic workshop, analytical drawing, geometrical drawing, lettering, modeling and photography provide other media of expression. A class for sound experiments and the building of musical instruments stimulates the auditory sense and furnishes the most direct experience of the organic connections of handicraft and art. The student receives a well-rounded scientific education, too, in physics, chemistry, biology, physiology, and mathematics, taught with a conscious approach to coordination. Guest lectures on the history of art, sciences, philosophy, psychology, etc., widen the knowledge of contemporary movements and inform the student what the world around him may expect from his approach to creative activities.

The basic idea of this education is that everybody is talented—that once the elementary course has brought all his powers into activity, every student will be able to do creative work. This does not mean that the Bauhaus aims at educating "geniuses" or even "free" artists in the old sense. But the knowledge of material, tools and function guarantees for each design, so high a quality that an objective standard, not an accidental individual result, will be obtained. Art is valued by the Bauhaus educators as the highest aim in life and as the expression of the highest level of a cultural epoch; but they do not dare to say that they educate *free* artists. There are too many such in the world, among them, minor talents with minor problems of expression and without the possibility of making a living. The Bauhaus does not want to add to their number. However, by taking in all the practical and spiritual material offered to them during their training, some of the Bauhaus students may develop into free artists. But this will be their own personal achievement. As members of human society, they must first learn to think in terms of materials and tools and functions. They must learn to see themselves as designers and craftsmen who will make a living by furnishing the community with new and useful ideas. This is the realistic basis of the workshop training which follows the basic courses.

Six Workshops

1. Wood, metal (object design)
2. Textile (weaving, dyeing, fashion)
3. Color (murals, decorating, wallpaper)
4. Light (photography, typography, motion picture, light advertising, commercial arts)
5. Glass, clay, stone, plastics (modeling)
6. Display (stage exposition—architecture)

These workshops and studios help to secure an immediate practical realization of all types of design.

The wood and metal workshop develops by experiment and by an unbroken contact with the main purpose: the living space, gadgets and furniture—from better door-handles to complete house equipment. As the student knows about biological needs, he develops goods which ease daily life instead of burdening it. Glass, plastics and metal are so new as materials (apart from traditional uses) they offer a thousand new possibilities.

Among other discoveries steel tubular furniture came out of the old Bauhaus workshops, and plywood furniture has been influenced by the Bauhaus, proving the method is sound and valuable results can be expected.

In the color workshop the student learns of the various color systems from Newton's to Munsell's. He will understand why the artists of each period painted in a special way and what contemporary science has added to the color problem. This theoretical knowledge includes study of techniques—mural painting, decorating, wallpaper design; and it overlaps color photography.

Photography as the most accurate form of mechanical representation offers a very rich field in Bauhaus education. The use of the camera must run parallel to the use of the pencil. The illiterate of the future will be the man who does not know how to handle a camera. Photography will be a measure for the accuracy of drawing.

Prints, enlargements, photomontages, photograms will give the student an exact knowledge of light and shadow, composition and chemistry. The uses of artificial light sources—neon and other gases—also film (motion picture) are on a close relationship to this work and add time, movement and space knowledge to the photographic and kinetic

work. In the light workshop in which all these activities will be summed up, a new era is hoped for in original perception and communication.

The glass, clay and stone (modeling) workshop collaborates closely with the metal workshop (object design) especially for lighting and household devices. The other work is devoted to modeling in which plastics will play a great role. If only physical conditions and quality are properly understood, an unforeseen richness of new forms will develop. The textile workshop has its main task in creating useful patterns and materials for the weaving industry. Exact knowledge of modern painting as well as the chemistry of dyes will add valuable stimulation to the work. This may influence the appearance not only of women's dress but of interior decoration as well.

The stage workshop tries to develop a new technique for display purposes with emphasis on exposition-architecture and on resale business. Window-display as an organic outcome of exact knowledge of material as well as of psychological motifs are taught, integrated with the most useful display art, the stage.

All these topics are grouped around the main purpose—new architecture. Instruction includes planning of single houses, town planning, landscape architecture and social services, such as hospitals, schools, kindergartens, recreation centers, etc. The Bauhaus-trained architect will know that only closest collaboration in every aspect guarantees a unified building, co-ordinating appliances, furniture, color scheme and design, a finished product that guarantees welfare and satisfaction to its inhabitants.

Gyorgy Kepes
Education of the Eye
From the periodical "More Business,"
Vol. 3, No. 11, Chicago, November 1938
Moholy-Nagy had already previously collaborated with his Hungarian compatriot Kepes in England. Kepes was a member of the New Bauhaus and subsequently of its successor institutions until 1946. Among his former students several outstanding talents, such as the photographer and product designer Nathan Lerner, achieved prominence. The artistic and pedagogic work performed by Kepes during this period culminated in his "Language of Vision," a book published in 1944 and later followed by numerous other publications. After Moholy-Nagy's death, Kepes accepted a call to the Massachusetts Institute of Technology.
At the outset Kepes supervised the teaching of drawing and photography, and in the early years of the School of Design that of commercial art as well. The renaming of his department to "Light Workshop," around 1940, reflects the inner development of the school, which led to general, fundamental truths and recognized the experience of visual phenomena and their organization as its ultimate goal. Based on these experience values, each individual could continue along his way with greater security.

As the eye is the agent in conveying impressions to the mind, the achieving of visual communication requires a fundamental knowledge of the means of visual expression. Development of this knowledge will generate a genuine "language of the eye" whose "sentences" are the created images and whose elements are the basic plastic signs, line, plane, halftone gradation, color, etc. Visual observation enables assembly of these signs. One learns to exchange the terms of subject matter, collected through past experiences, vision, touch, locomotion, for the terms of the plane surface. The best way to achieve this is by observing objects not yet stamped in everyone's memory in worn-out visual formulae of the past. Instead of a face, tree or human figure, which are always connected with the old masters, unusual objects and records such as signatures, fingerprints, woodgrain, etc., are substituted for observation and representation. These exercises aid in building the individual's own system of observation, as well as forming aptitude in line qualities. The observation enables the following of the track of working tools—pencil, pen, brush—the meaning of the different thicknesses, flexibility, economy of the line, etc. The study of halftone gradation reveals new components of the created image. The representation of convex, concave, height, depth, transparency of overlapping shapes tests the ability to generate space.

The growing experiences of basic plane elements compel clarification of their interrelationships and the investigation of balance, tension, proportion, symmetry, rhythm, position. They teach a simple grammar of visual means. To complete the knowledge of creating an image, the properties of colors and their relations, within the range of common experiences, also are investigated. A short survey of different color systems defines a rational nomenclature of color relationships. The establishment of charts of color mixtures, different gradations of black and white, the mixture of two, three or more colors produces a full range of obtainable combinations. The color of an object depends to a great extent upon the color of the light in which it is seen. The representation of simple color arrangements, as if filtered through different color lights—and the same color arrangement in actual pigment mixtures—demonstrates the difference of the additive and subtractive admixture of colors. The inherent potentialities of color as structural units of the plane surface are experienced in simple compositions. To learn the color qualities of different materials, as many materials as possible of the same color are assembled in a compositional unit. All these experiences unfold a healthy visual imagination.

Gyorgy Kepes
The Task of the Educator
From "The Educator in Industrial Society,"
reprinted in the prospectus "School of
Design in Chicago," 1939–1940
See the preliminary remarks to the preceding article.

The sensory experiences offer the thousand-fold bridges toward nature. Man needs the greatest radius of registering natural energies and only the full exploitation of his natural tools, his sense organs, enables him to attain a certain horizon of nature. He must be able to see, to hear, to touch, and by the reading of warning or approval signals of nature, he conquers the actual reality. The aim is a capacity to encompass the greatest possible radius of natural forces and to focus it in ourselves as a balance.

The educator is not only one who is handing over knowledge which the previous generation collected, but much more, one who encompasses in one living form man's inherent qualities and the actual terms of his environment. Only this establishment of a vital link between recognized necessities and the potentialities of satisfaction, make the role of the educator a nodal point of progress.

George Fred Keck
The Problem of Architecture
From the periodical "Shelter," March 1938,
reprinted in the prospectus "School of
Design in Chicago," 1939–1940
Keck taught the architecture class at Moholy-
Nagy's school from the very beginning of the
New Bauhaus. During the war he gave up his
teaching activities in order to devote himself
once more to his work in the field of construc-
tion. As an architect he figured as one of the
outstanding representatives of the "Interna-
tional Style," even as early as the mid 1930's.
An apartment house erected by him in Chicago
in 1937 has recently been designated an "Archi-
tectural Landmark."
In Moholy-Nagy's group he proved to be a con-
vinced and trustworthy comrade-at-arms, ready
to work without compensation whenever the
school was in financial straits. In the classroom
he remained objective and strove to attain cri-
teria that were independent of his own artistic
interpretations. In this respect he resembled
Gropius, as distinguished from Wright. Con-
sciously starting out along primitive lines, his
questioning stimulated thinking about the fun-
damental tasks of architecture and led to better
creative communication and further thought
development.

**Declaration of Loyalty of the Members of
the New Bauhaus for Laszlo Moholy-
Nagy, 1938**
Quotation from Sibyl Moholy-Nagy,
"Moholy-Nagy—Experiment in Totality,"
Harper & Brothers, New York, 1950
The development of the school seemed most
promising to Moholy-Nagy. Its pedagogic results
were excellent and, according to Sibyl Moholy-
Nagy, by the beginning of the second semester
an additional 25 students had enrolled, while 20
had signed up for evening courses. Moholy-
Nagy contemplated adding an Institute of De-
sign Research, and hoped to secure Siegfried
Giedion as its head. It was all the more of a
shock to him when, in August 1938, he received
word from the president of the Association of
Arts and Industries to the effect that the school
was not to be reopened after the summer
recess. The New Bauhaus was dissolved.
There had been misunderstandings between
the administration and Moholy-Nagy from the
very beginning. As early as the fall of 1937 the
executive committee had tried to interfere with
educational and curricular affairs; above all it
had overestimated the possibilities for raising
funds for financing the Institute. When the fiscal
crisis came to a head in 1938, Moholy-Nagy
himself visited a series of prominent firms in
the Middle West and the Eastern United States
in order to secure their financial backing. The
practical result, however, was not commen-
surate with the moral support he received. Still,
to him the decision of the Board was incompre-
hensible. The Board, in its thinking along eco-
nomic lines, had failed to realize that an
experimental venture like the New Bauhaus
requires a costly and extended starting-up
period and that material success is no criterion
of its accomplishments. The venture had been
launched without sufficient backing.
The faculty members who held contracts re-
ceived trivial settlements, mostly in the form of
equipment and furniture. For the majority of
those affected, the situation was catastrophic.

School of Design
Faculty, 1939–1940
Toward the end of January 1939 Moholy-Nagy
decided to reopen the Institute on his own,
without depending on outside financing, under
the name "School of Design." His power of
conviction inspired his co-workers from the
New Bauhaus to join him. For the sake of the
cause they declared themselves ready to teach
without compensation until the financial situa-
tion of the school had improved. Their means
of existence was gained by private consulting

This new school does not begin with the weight of tradition behind it. It is free to move
and explore untrod paths in its effort to find creatively new solutions to the pressing prob-
lems of design and architecture. Its instructors have a wealth of experience in these new
fields.
One of the outstanding characteristics of the average American is his faculty for invention
and utter scorn for tradition in the development of new mechanical devices of all kinds.
To mention only a few, we need think of the airplane, battleship, multi-storied building,
grain elevators, automobiles, electricity, bridges, barns, radios, factories—and now he
must think of shelter for himself and his family in the same terms. His house has been
mechanized from the inside out, by the installation of electricity, plumbing, and heating.
Except in an experimental way the shell of the building has not been touched by mechani-
zation. For some inexplicable reason he has hesitated to change this shell and frame-
work. Here very definitely lies the next forward step in the new housing.

We whose privilege it was to teach in The New Bauhaus during the first year of its exis-
tence wish to express our sense of the loss which education and the Chicago cultural
community has sustained in the failure of The New Bauhaus to reopen this fall. The first
year has convincingly shown the promise of the school under the leadership of L. Moholy-
Nagy and we felt that the future development of the school was secure. It came as a great
surprise to hear late in summer that there was even a question as to whether the school
was to reopen.
The very lateness of the decision worked great hardships upon students, upon the existing
faculty, and upon those who had given up positions to become new members of the faculty.
Whatever the circumstances, the fact remains that the Association of Arts and Industries
has failed in its side of the venture, whether the failure lay in starting the school at all
upon an inadequate financial and organizational basis or in being unable to continue the
school at the moment when a promising future seemed assured.
In its failure the Association of Arts and Industries has placed difficulties in the way of
realizing a significant educational venture whose program is congenial to the best educa-
tional leadership and the deepest educational needs of this country. It is to be hoped that
this administrative failure will not be interpreted as a failure of The New Bauhaus itself,
and that L. Moholy-Nagy and the Bauhaus idea, fitted as this idea is to play an important
part in the liberation of American creativity in the arts, will receive from some other
quarters the support necessary to insure its success.
Signed:
Alexander Archipenko
Hin Bredendieck
David Dushkin
Carl Eckart
Ralph Gerard
George Kepes
Charles W. Morris
Andi Schiltz
H. H. Smith

In the School of Design the teachers are not only chosen for what they know, but for what
they are doing. They are creative personalities, engaged in projects of their own as well
as in teaching. The inventive student will discover that these instructors sympathize with
his problems because of their own experiences, and will guide him skillfully into correct
methods of study and into the fruitful attitude of experimentation.
Besides the science guest lecturers from the University of Chicago, Professors Eckart,
Gerard, Krueger, Morris, and Wirth, the school appointed Dr. A. A. Sayvetz for the math-
ematics, physics, and chemistry courses. George Fred Keck heads the department of
Architecture with the assistance of Jan J. Reiner and Robert Bruce Tague. Robert Jay
Wolff heads the Painting and Sculpture Workshops assisted by Daniel Massen and L.
Terebesy. George Kepes is head of the Light Workshop assisted by James H. Brown,

work. Moholy-Nagy himself contributed the entire gross income derived from his activity as artistic consultant for a Chicago firm. After some search he and his friends found inexpensive and roughly suitable quarters on the second floor of a dilapidated building on East Ontario Street. Furnishings and tools were brought in by the staff members themselves; the most valuable contribution was Moholy-Nagy's own photographic equipment. In response to a circular letter sent out by Moholy-Nagy, 62 applicants turned up, and within one week of the opening of the School of Design, in February 1939, 18 full-time and 28 evening students had enrolled.

The curriculum of the workshops continued along the principles laid down by Moholy-Nagy for the New Bauhaus. However, the preliminary course was modified in view of the realization of the need for guidance toward the essential pictorial phenomena (see the preliminary remarks to Kepes's article "Education of the Eye"). Moholy-Nagy collaborated particularly closely with Kepes, who pursued phenomena of light, and with Robert Jay Wolff, who was entrusted with the problem of "volume in all forms," to quote Sibyl Moholy-Nagy. The School of Design would not have been viable without the readiness of Sibyl Moholy-Nagy to sacrifice all familial amenities and without her energetic work in the Institute.

School of Design in Chicago
Evening Classes 1942–1943
From the prospectus "School of Design in Chicago," 1942–1943
Evening classes were not only important as a pecuniary help to the Institute; they were a requirement necessary for the pedagogic-ethical goal of providing an opportunity for unfolding latent creative forces in as many human beings as possible. The program was remarkably varied and detailed, and was attuned to practical ends to a far greater extent than that of the regular curriculum. Practical applicability was especially emphasized after America's entry into the war.

In addition to the evening classes there were also children's classes, under the direction of Gordon Webber. Moholy-Nagy himself often took part in this teaching program. The children recreated visual experiences they had witnessed —perhaps during a visit to the zoo or to a fruit stand.

During the summers of 1939, 1941, 1942, and 1943, vacation courses were arranged in a country house at Somonauk, Ill., which had been placed at the school's disposal by Walter and Elizabeth Paepcke and was about two hours' drive from Chicago. Here work proceeded preferentially in the open air, in close communion with nature. During the summer of 1940 the faculty served as guest lecturers at Mills College in Oakland, Calif. The entire specific summer work constituted a valuable experience.

N. B. Lerner and Frank R. Levstik, Jr., Mrs. Marli Ehrman, formerly of the Bauhaus, heads the Weaving Workshop and Hubert Leckie, the lettering courses. The Basic and Product Design Workshop and two seminars on contemporary art and design problems are under the direction of L. Moholy-Nagy assisted by Eugene Bielawski, James Prestini and Charles W. Niedringhaus. Gordon Webber heads the Children's Class with the assistance of Mrs. Juliet Kepes. Language seminars will be held by Mrs. Ester Perez de King and Mrs. Sibyl Moholy-Nagy. Music appreciation will be given by David Dushkin with the assistance of Miss Patricia Berkson.

1. Dress Design
includes training in Dress Design and Cutting along with basic work in Color, Weaving and Fashion Illustration. Conducted by Marli Ehrman, Sydney Green, Robert Thompson.
2. Model Airplane Building
prepares students in the Principles of Aeronautics, including experiments in plane design. Conducted by Carl Goldberg.
3. Soldering, Brazing and Welding
Preparatory work for War Industries and Industrial Design. Conducted by Eugene Bielawski.
4. The Principles of Camouflage
Research in natural camouflage; surface covering; mimicry; visual illusions; basic photography; investigation of camouflage techniques. Conducted by George Kepes.
5. Design in Plastics
Research into potentialities and use of thermo-setting and thermo-plastics. Conducted by Otis Reinicke.
6. Mechanical and Architectural Drawing
Training for the War Industries, offering opportunities especially for women. Conducted by Robert B. Tague.
7. Graphic Techniques
Silk Screen; Lithography; Typography, including Printing with Wood Blocks and Linoleum. Conducted by Myron Kozman.
8. Airbrush Technique
for beginning and advanced students. Conducted by J. Zellers Allen.
9. Mathematics and Physics
for beginning and advanced students. Conducted by A. Sayvetz.
10. Visual Fundamentals and Advertising Arts
for beginning and advanced students. Conducted by George Kepes.
11. Basic and Product Design
Conducted by L. Moholy-Nagy, assisted by Charles Niedringhaus and James Prestini.
12. Weaving
Textile design and execution. Conducted by Marli Ehrman.
13. Architectural and Interior Design
for beginning and advanced students. Conducted by George Fred Keck assisted by Robert B. Tague.
14. Photography
for beginning and advanced students. Conducted by James Brown, N. B. Lerner and Frank Levstik.
Through the generous grant of the Rockefeller Foundation the School is able to announce also a
15. Motion Picture Class
offering fundamental training and opportunities for research. This grant helps the School to continue the avant-garde work which has been so essential in making the film a prominent part in our search for contemporary expression. Conducted by L. Moholy-Nagy with the assistance of Robert Lewis and Edward Rinker.
These classes, together with some Day classes allow
Combination Schedules
whereby evening students will be allowed to attend Day Classes and day students to attend Evening Classes.

Laszlo Moholy-Nagy
Commencement Address at the End of the Spring Semester 1942
Quotation from Sibyl Moholy-Nagy, "Moholy-Nagy—Experiment in Totality," Harper & Brothers, New York, 1950, The M.I.T. Press, Cambridge, Mass., 1969.
The occasion for this address was the graduation of the first seven students of the School of Design in the spring of 1942. In spite of financial difficulties, and even though many students and faculty members had joined the armed forces since the fall of 1941, the development of the school continued along optimistic lines. The spirit of cooperation and the human climate were excellent. The success of the experimental endeavors was reflected not only in pedagogical areas but also in many ideas and inventions that proved useful for practical applications. During the course of two years, students at the School of Design applied for no less than 17 patents covering essential improvements of consumer articles (cf. Sibyl Moholy-Nagy, p. 175). The school was awarded prizes at competitions involving textiles, posters, and exhibit displays. However, its most important contribution lay without doubt in its ability to bind all those who were involved into one living consciousness of co-responsibility.

... The past four years have proved the workability of the Bauhaus Idea in American vocational training. It was the spirit of collaboration between students and teachers that made us. Everyone working here, from the office force to the visiting professors of the University of Illinois, realized the adversities, but they also realized that at all times our goal was greater than our obstacles.

Since the outbreak of the war, students and faculty have been confronted with queries as to whether our work is not a luxury in times of strife. We have been urged to "teach something real" instead of insisting on experimental work with pencil, brush, camera, tool, and loom. It is in answer to this question that I want to define our moral obligations toward society.

It is a great privilege to be allowed the exercise of one's skill and ambition in times of war when millions die and additional millions barely survive. But it is a privilege granted to you by society, an investment made for the future benefit of man. You are the men and women on whose sincerity and effort depends the future progress of education. It doesn't matter whether you make wood-springs or chairs, design a house or a poster, work with veterans or children. It is all education, adding to the crude struggle for physical survival, the qualities that distinguish man from beast.

Democracy is based upon an exchange of equivalents. It is the obligation of those who were permitted to develop their finest capabilities to exchange one day their creative skill for the productive and harmonious existence of a new generation.

Laszlo Moholy-Nagy
Better than Before
From the periodical "The Technology Review," Vol. XLVI, No. 1, Massachusetts Institute of Technology, Cambridge, Mass., November 1943.
Following the Japanese attack on Pearl Harbor in December 1941, the school program had to be increasingly adjusted to the needs of the war economy. Materials, especially metals, were in short supply, and the significance of formal product development had to defer to other tasks of more immediate import. In order to make the school more useful during those times and at the same time assure its continuity, Moholy-Nagy developed an inspired idea. He established three work programs that conformed in their very essence to the specific educational methods of the School of Design: (1) Many useful contributions to the problem of camouflage—the visual protection of small and large objects against detection, especially from aircraft—could be made by means of an analysis of visual elements and of the psychology of color perception; Moholy-Nagy himself, on official orders, worked out a camouflage scheme for the city of Chicago. (2) Industrially practicable proposals concerning the question of substitution of metals by wood were submitted by the School of Design, thanks to its carefully prepared materials studies. For example, students developed mattress springs made of wooden parts that were so ingeniously interconnected and glued that they attained considerable elasticity. A Chicago manufacturer undertook the production of these wooden inner springs. (3) The methods of the preliminary course and the workshops, which were attuned to independent creative experience, could be readily adapted to serve as occupational therapy for victims not only of the war but, as was repeatedly emphasized by Moholy-Nagy, of industrial accidents as well. The development of the faculties of the senses appeared to Moholy-Nagy as an essential and promising prerequisite for the reconstitution of self-confidence—in other words, of the rehabilitation—of the handicapped. Moholy-Nagy's reflections on the subject of rehabilitation were fundamental.

Rehabilitation is a rather new term. Its content is not yet clear and even its definition needs crystallization. Generally, when we speak about rehabilitation we have five groups in mind: 1) the disabled or handicapped members of the armed forces of the present and the past World War; 2) servicemen discharged from Army camps because of breakdowns during training; 3) Army and Navy aviators withdrawn from the combat zone because of operational stresses; 4) psychopathic cases cared for in state and private hospitals; and last, but not least, 5) injured industrial workers.

But rehabilitation in the future should be understood on a larger scale than just the restoration or reconditioning of disabled persons in these groups. It must reckon also with those persons who now are considered normal but who in reality live on the border line of psychological and physical deficiencies. Of rejected selective service candidates, for instance, 23 per cent are turned back for neuropsychiatric reasons. The statistics in the Cook County jail in Chicago show that 50 per cent of the inmates are repeaters year after year. A constructive and all-inclusive rehabilitation certainly could cut down this figure....

Rehabilitation has many different facets, but its main direction is to restore the patient to the level of his normal status. At present, the task is chiefly in the hands of occupational therapists ... Social rehabilitation, however, is still burdened with the old sentimentality toward the "crippled." Moves in the direction of more constructive solutions are gaining ground rather slowly. The cultural lag between traditional thinking and the requirements of the industrial age often prevents the experts from envisioning for their patients proper forms of adaptation in the normal routine of contemporary life....

The handicapped should be understood as having the same potential source of creative energies as is inherent in every human being. His best qualities must be considered and brought into the open in order that he may not only try to restore the standard of his previous state but attempt to rise beyond it to a higher efficiency and a higher productive level....

Such a person must be trained in the use of all his faculties. In order for his buried energies to be released for contemporary orientation, he has to overcome his old habits, ideas, and judgments not any longer applicable to our age. Creative work and conscious personality development can overcome maladjustments or feelings of inferiority in the competitive and heterosexual relationships, and may open the way for free, efficient, and satisfactory activities.

A second requirement for the successful execution of this plan is to give the patient the conviction that it will be worth while to make strong efforts to overcome his shortcomings. There will be no discrimination or stigma against his physical or mental recovery process. The new aim is the highest possible grade of practical rehabilitation, even if this means only a partial efficiency of the handicapped in the production process. This aim must be made known to the public so that the employment of handicapped people, even if only on a part-time basis, will become a general practice after the war....

The new type of rehabilitation centers would require a layout where flexibility would be the main requirement, so that up-to-date research results could be introduced without delay. As a large-scale unit, such a center would resemble a university campus more than a hospital....

The goal can be achieved, of course, only if enough personnel are available to execute the program. Therapists, psychologists, and physicians have to be willing to revise their traditional attitude and collaborate intensively with each other, considering patients in the totality of their abilities.

... Therefore it is suggested that a laboratory school and research department for problems of rehabilitation be established, designed to place especial emphasis on occupational therapy and psychotherapy.

200

The task of such a school would be to try out a new educational technique. This technique should be the integration of arts, science, and technology, with emphasis on creativeness. Occupational, social, recreational, and educational therapists do not have to be artists to vitalize their patients for creative tasks, but if they are to be good therapists they must have had creative experience. The word "creative" is not used here in relationship to the arts only. "Creativeness" can be applied to all types of work in the artistic, scientific, and technological sphere. It means inventiveness, resourcefulness, the ability to establish new relationships between given elements. Such creative experiences should be the daily routine in every occupational therapy school. . . .

For the training of new personnel in rehabilitation, I believe that the educational technique of the School of Design in Chicago might well be employed. This technique, which could be called "conditioning to creativeness," can be used for the future occupational therapists who will become "teachers," as well for the handicapped patients who will become their "students." In this way the indivisible nature of creative education is emphasized. The difference will be only the application of the same subject matter for general and individual purposes. The occupational therapist will gain self-confidence and security in his profession, acquiring skill to produce and teach. The student, with the help of his newly educated teacher, will go through a gradual process of being conditioned to creative achievements, beginning with his basic capacities. After this development, he will be able to focus his interest more and more on specific vocational tasks in the professional departments of the rehabilitation centers or in other vocational agencies. . . .

The first exercises are built upon sensory experiences through the medium of various materials, and are combined with theoretical studies. The exercises start with the skill of the fingers, the hands, the eye, and the ear, and their co-ordination. This is accomplished through so-called tactile charts composed of textures, the purpose of which is to permit emotional experience to be gained from their organized relationships; through hand sculptures carved out of wood, to be held in the hands and manipulated; through machine woodcuts, which make lumber as elastic as rubber; through paper cuts which, if skillfully handled, lead to the understanding of basic structures—folding, cutting, rolling, scoring, and weaving. In addition, there are metalwork; plastics; weaving; drawing and color; mechanical drafting; photography; motion pictures; group poetry, plays, music, and dance; plane, volume, and space division and their further articulation. Thus a full co-ordination of potentialities can be accomplished.

These basic subjects are organized at the first part of the training in a curriculum in which integration is achieved through a method of simultaneous handling of the same problem in various workshops and classrooms. For example, when a sculpture is made in the modeling workshop, the same sculpture serves as a study for light and form in the photo studio. Again the same sculpture is utilized as a departure for volume and space analysis in the class in mechanical drafting and as a theme in drawing and color exercises. The same object will be analyzed also in scientific and technological classes. Since many different angles are considered in such an approach, the student gains a comprehensive understanding of the same object. . . .

At the School of Design in Chicago we have had tactile charts tested by blind people. These and other tests have shown that such types of exercises could have positive influence on the re-education of the blind, thereby opening up fields and occupations in which special refinement of touch, hearing, or taste is required. In addition, individual and group exercises, such as structural paper cuts and modeling, can be introduced, as can plays, psychodrama, chorals, and group poetry. All these can lead to psychological adjustment, to a certain self-sufficiency, as the most positive departure toward a social integration. The next step would be adjustment through practical work, such as blind typing and stenotypy; then might come basic mechanical assemblage problems; and, finally, studies of law, sociology, and writing. . . .

Because of the dynamic nature of the approach, a number of new tests will be developed as the research progresses. As a result, we may arrive at a new form of psychological research out of which the expression of each individual will appear in an unadulterated purity. Though this may be the way to important psychological findings concerning the handicapped, it is also beyond the scope of immediate urgency. Analyzing the sources and forms of these expressions, we may come to the roots of inventiveness, fantasy, and creative impetus. This knowledge could be applied to handicapped and nonhandicapped people in a new form of vocational guidance. . . .

Institute of Design
Official Directory, 1946
From the prospectus "Institute of Design,"
1946
In the spring of 1944 a group of Chicago businessmen, under the leadership of Walter Paepcke, proposed the formation of a Board of Directors in order to relieve Moholy-Nagy of his concern with financial questions and with administration. To bring its equivalence with a college into focus, the school was renamed "Institute of Design." As it turned out, this did not relieve Moholy-Nagy from his worries about the very survival of the school. The demands of the war reduced the number of students excessively, and those who were still able to study were in general preoccupied with earning a living as soon as possible; the Institute of Design was not especially suited for this purpose. In view of these difficulties, the Board was ready to capitulate in 1945. Moholy-Nagy, however, declared that he would continue the Institute, if necessary without the Board. At this point the number of students suddenly and unexpectedly jumped from 92 to 366; the Board remained. By the fall of 1945 about 800 enrolled as participants in the regular and evening-study programs. Thanks to the G.I. bill of rights, which provided scholarships for returning veterans, this large demand continued for several years. It was not without its pedagogical problems, but it provided a solid basis for the school's continued existence. Because the building on East Ontario Street had to be vacated, having changed hands in the summer of 1945, the Institute was faced with the necessity of finding new quarters. But the new rooms upstairs in a building at the corner of Rush and North State Streets again had to be given up within less than a year. Adequate space was finally acquired, with the help of the Board, in a building formerly occupied by the Historical Society, on North Dearborn Street. It served as home for the Institute for more than nine years, starting in August 1946.
The composition of the faculty was subjected to frequent changes during the last war years and the years immediately following. During 1946 Archipenko, who had already been active in the New Bauhaus, returned to teach, as did Lerner and Siegel, both of whom had been trained under Moholy-Nagy. A new member was Crombie Taylor, who was to take a leading part in later years, after he had been made acting Director in 1951. Except for Moholy-Nagy himself, Marli Ehrman was the only faculty member in 1946 who had been part of the original Bauhaus group.

Board of Directors
Walter P. Paepcke, Chairman
President, Container Corporation of America
Maurice H. Needham, Vice Chairman
President, Needham, Louis and Brorby, Inc.
Guy E. Reed, Vice Chairman
Vice President, Harris Trust & Savings Bank
E. P. Brooks
Vice President, Sears Roebuck & Company
Bertram J. Cahn
President, B. Kuppenheimer & Company, Inc.
Leverett S. Lyon
Chief Executive Officer, Chicago Association of Commerce
L. Moholy-Nagy
President, Institute of Design
William A. Patterson
President, United Airlines
J. V. Spachner
Vice President, Container Corporation of America

Officers
L. Moholy-Nagy, Director
Crombie Taylor, Secretary-Treasurer
Mollie Thwaites, Registrar

Faculty of the Institute of Design
Calvin Albert
Alexander Archipenko
George Barford
Robert Edmonds
Marli Ehrman
Robert Erikson
Joe Feher
Eugene Idaka
Myron Kozman
S. J. Taylor-Leavitt
Nathan Lerner
Frank Levstik
Robert Longini
L. Moholy-Nagy
Sibyl Moholy-Nagy
James Prestini
Ralph Rapson
Else Regensteiner
Nolan Rhodes
Edgar Richard
Arthur S. Siegel
Frank Sokolik
Robert Bruce Tague
Crombie Taylor
Hugo Weber
Ralph Weir
Marianne Willisch
Emerson Woelffer

Laszlo Moholy-Nagy
Design—the Attitude of the Planner
From the minutes of the "Conference on Industrial Design as a New Profession," organized by the Department of Industrial Design, Edgar Kaufmann, Jr., of the Museum of Modern Art in New York, Chairman. Mimeographed, New York, 1947.
Moholy-Nagy delivered this address only a few weeks before his death in November 1946. His proposition that above all the social, artistic-ethical obligations be fulfilled can well be considered his legacy. He himself accomplished, especially during his last years, design work of a pioneering nature. In 1943 he designed a passenger car (never built) for the Baltimore & Ohio Railroad Company, which was intended to be exemplary for the postwar period; as consultant for the Parker Pen Company he was influential in all their design problems, from ink-bottle labels to factory buildings. His esthetically most mature accomplishment here was the design of the "Parker 51" pen, which is still being produced today, unchanged.

. . . Design is not a profession; it is an attitude—the attitude of the planner. Every high school in this country has better equipment than we have or Harvard has. It is simply prodigious. And what do they do with it? Nothing. It is the spirit that determines the whole thing. We have to develop, step by step, an educational procedure in which the creative abilities and capacities of young people are used. That would mean general education. When any human being works with his hands, whatever he does will be translated into the brain as knowledge. This knowledge, in turn, will react on his emotional self. That is how a higher level of personality is achieved.

Laszlo Moholy-Nagy
The Artist in Society
From Laszlo Moholy-Nagy, "Vision in Motion," Paul Theobald & Co., Chicago, 1947
In his posthumously published book, "Vision in Motion," Moholy-Nagy unfolded the synthesis of his artistic insights. It was here that he provided the authentic interpretation of his educational philosophy—citing many examples from the classroom—which he had conceived in the Bauhaus and developed further in the New Bauhaus and its successor institutions. More than ever before, he emphasized the totality of experience, and forcefully assigned an essential, actually a decisive, role in the creative process to the emotional moment—which had long been neglected. "Vision in Motion" is Moholy-Nagy's artistic and educational legacy. It became, especially in the United States, a standard work in the literature of art.

Walter Gropius
An Obituary Note
From "Laszlo Moholy-Nagy, The New Vision and Abstract of an Artist," Wittenborn, Schultz, Inc., fourth revised edition, New York, 1947
On November 24, 1946 Moholy-Nagy, only 51 years old, died of leukemia. His legacy was a lifetime of creative work, whose artistic significance was recognized only gradually; it influenced new artistic directions decisively, especially in the late 1950's. As initiator and Director of the Institute of Design he was indispensable. In the years to come it became clear that scarcely another could fill his place. Gropius, who lost in him his most sensitive artistic associate, remained loyal to the Institute, continuing in his capacity of advisor.

Selected List of Visitors 1937–1948
From the Prospectus "The Institute of design," 1948
In order to widen the horizons of its students, the original Bauhaus had invited prominent representatives of the most varied intellectual disciplines to be its guest speakers. Moholy-Nagy and his successors continued this policy in Chicago. In so doing they were not concerned with having their own point of view confirmed. Diversity of opinion and aspects enriched the possibilities for orientation. These lectures were by no means made easy for the audience. Léger, for example, spoke in French, because he had not mastered English sufficiently; but to be able to offer his students the opportunity of getting to know a personality of the stature of Léger seemed to Moholy-Nagy sufficient justification for inviting him.

One of the functions of the artist in society is to put layer upon layer, stone upon stone, in the organization of emotions; to record feelings with his particular means, to give structure and refinement as well as direction to the inner life of his contemporaries. It is the artist's duty today to penetrate yet-unseen ranges of the biological functions, to search the new dimensions of the industrial society and to translate the new findings into emotional orientation. The artist unconsciously disentangles the most essential strands of existence from the contorted and chaotic complexities of actuality, and weaves them into an emotional fabric of compelling validity, characteristic of himself as well as of his epoch. This ability of selection is an outstanding gift based upon intuitive power and insight, upon judgment and knowledge, and upon inner responsibility to fundamental biological and social laws which provoke a reinterpretation in every civilization. This intuitive power is present in other creative workers, too, in philosophers, poets, scientists, technologists. They pursue the same hopes, seek the same meanings, and—although the content of their work appears to be different—the trends of their approach and the background of their activity are identical. They all must draw from the same source, which is life in a certain society, in a certain civilization. This basic identity is the common denominator, the desire today to find and investigate the fundamentals in every field so that they can become constructive parts of a new civilization.
The problem of our generation is to bring the intellectual and emotional, the social and technological components into balanced play; to learn to see and feel them in relationship. Without this interrelatedness there remains only the disjunctive technical skill of handling human affairs, a rigidity stifling biological and social pulses; a memorized, not a lived life.

With Moholy-Nagy's untimely death a life of tremendous vitality, will power and love has been cut short at its zenith. . . . Moholy-Nagy has bequeathed to us a wealth of art works and writings, which embrace the whole range of the visual arts. We might call the scope of his contribution "Leonardian," so versatile and colorful has it been. He was successful at once as a thinker and as an inventor, as a writer and as a teacher. This would seem to be almost too vast a field for one man to till, but abundant versatility was uniquely his. With his power of imagination he kept this tremendous variety of interests in balance. His vision took brilliant shortcuts, synchronizing his observations into a consistent whole, for he felt today's danger of over-specialization which leads to fallacies.
Constantly developing new ideas, he managed to keep himself in a state of unbiased curiosity, from which a fresh point of view could originate. With a shrewd sense of observation he investigated everything that came his way, taking nothing for granted, but using his acute sense for the organic.
I remember his peculiar freshness when he was facing a new problem in his art. With the attitude of an unprejudiced, happy child at play, he surprised one by the directness of his intuitive approach. Here was the source of his priceless quality as an educator: his neverceasing power to stimulate and to carry away the other person with his own enthusiasm. Can true education achieve more than setting the student's mind in motion by that contagious magic?

Alvar Aalto
Berenice Abbott
Erwin Blumenfeld
Rudolph Carnap
Horace Cayton
J. G. Crowther
Alexander Dorner
R. Buckminster Fuller
Siegfried Giedion
D. W. Gotshalk
Walter Gropius
S. I. Hayakawa
H. R. Hitchcock
Katherine Kuh
Fernand Léger
Richard Neutra
Beaumont Newhall
Man Ray
Herbert Read
Daniel C. Rich
Frank Scherschel
Paul Strand
Roy E. Stryker
James J. Sweeney
José Luis Sert
Szymon Syrkus
Louis Wirth
W. W. Wurster

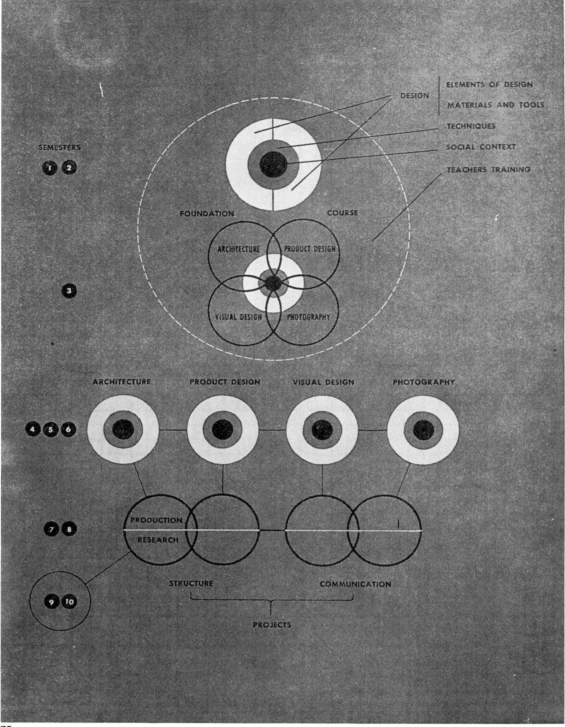

75
Institute of Design—The Course of Instruction, 1948
From the prospectus "the institute of design," Chicago, 1948

Walter P. Paepcke
A Statement
From the prospectus "the institute of design," 1948
Paepcke, who was Chairman of the Board of the Container Corporation of America and since 1944 Chairman of the Board of Directors of the Institute of Design, combined within himself intellectual curiosity, uncommon acumen, and a sense for practical considerations. Moholy-Nagy erected a monument to his friendship with Paepcke and his wife Elizabeth by dedicating his "Vision in Motion" to them. Acting on the advice of Gropius, Paepcke in his capacity as Chairman of the Board invited the architect Serge Chermayeff to take over the directorship after Moholy-Nagy's death. Chermayeff, born in southern Russia in 1900, had spent his younger years collaborating with Erich Mendelsohn in England; he now contributed his experience as an educator, gained from his activity at Brooklyn College, where he had worked as chairman of the Department of Design. However, it was not long before Paepcke and the other Board members were confronted with renewed difficulties, partly due to personal conflicts within the Institute and partly because the number of students diminished rapidly with the curtailment of the veterans' program.

. . . In this postwar era when practically every product is being redesigned, it seems particularly necessary to provide a complete education which encompasses artistry, technology and science. The well coordinated synthesis of these three educational fields is what the Institute of Design offers.
Industry is deriving three benefits from the work of the Institute of Design: (1) the availability of well rounded and well educated young designers; (2) the opportunity to send some of its presently employed designers and artists to the Institute for the stimulus of new and progressive ideas which can be obtained in its night courses, and (3) the submission to the Institute of special problems and projects involving any of the various elements of design.
. . . Industry is gradually beginning to recognize that the Institute of Design can be of real, practical help to industrial companies. Many large and small firms, my own included, are now using these services, and it is my prediction that many, many more will want to benefit by them in the future.

Serge Chermayeff
Remarks at the Opening of the Twenty-First Annual Exhibition of Design in Chicago Printing, 1948
From "Comments by Chermayeff after Judging 735 Entries to the Annual Exhibition of Design in Chicago Printing," The Society of Typographic Arts, Chicago, 1948.
Chermayeff, the President and Director of the Institute of Design since January 1947, distinguished himself not only as an outstanding architect but also as a painter and textile designer. He achieved his authoritative position to a large extent by his astute criticism, in which he postulated the genuine and knew how to justify this criterion, rejecting whatever was half-conceived or imitative. His utterances, such as this one made at the opening of an exhibit sponsored by the Society of Typographical Arts for which, along with two others, he had served as a member of the jury that had rejected 586 out of 735 entries, reflect the principles that guided his conception of the Institute of Design. The ultimate purpose of all design work is to serve the social totality in a constructive manner; functional integrity is its first prerequisite.

Institute of Design
Architecture, Product Design, Visual Design, Photography, and Film (1948)
From the prospectus "the institute of design," 1948
During Chermayeff's tenure the preliminary course was broadened along the lines prescribed by Moholy-Nagy and extended to three semesters. While during Moholy-Nagy's time there existed six workshops (Wood and Metal, Textile, Color, Light, Modeling, and Display) plus an additional required course in architecture, there now remained only five workshops, including the training in architecture: Studio (Sculpture, Painting, and Drawing), Product Design, Visual Design, Photography (including moving pictures), and Architecture. During the years following, the concept "Visual Design" was at times replaced by "Visual Communication." This term, which emphasizes the social function of the visual, was adopted by the Hochschule für Gestaltung in Ulm, Germany, where it remains in use to this day. "Architecture" was defined by the Institute for Design, within Moholy-Nagy's meaning, as housing for people, as shelter, ranging from a dwelling to a communal structure, but by no means as "representational architecture," for which there was no room in the conception of the Institute of Design. Moholy-Nagy obligated, although not in the sense of the joy of experimentation, which had given the Institute its character and which did not recoil from taking risks. The problem, in a nutshell, can be called "consolidation without stagnation."

... We saw a parade of technical tricks employing design idiom and elements, whether photographic, typographic, color, shape or texture, borrowed wholesale from previous work without the essential preliminary study of the purpose the design had to serve and without understanding or feeling for the design elements, production techniques and media.
The experiments of outstanding contemporary designers, which have value and meaning as experiments within particular conditions and context or which had integral individual characteristics and quality, were taken over and made into hideous parodies of the originals. This endless parade of parodies has become a procession of clichés in the hands of the illiterate.
Invention which springs from intelligent grasp of visual problems and first-hand experience with tools and media of production becomes a series of thin tricks devoid of meaning and quality.
Such work speaks eloquently for the motive behind it: the production of something which will strike the advertising agent or his client as novel and up-to-date instead of being either a purposeful and controlled act or a spontaneous expression of the artist.
All this suggests that the majority of practitioners have lost that essential first-hand contact with both the problem itself and the means of its solution.
Photomontage, a magnificently rich medium in the hands of a man who has worked with the photographic process, degenerates into something sterile as a result of acquaintance made through the scissors and the paste pot.
The typographic quality exploited by someone who has actually set type and run a press shows a sensitivity to the right type on the right paper. This turns into dry pedantry or confusion in a world apparently dominated by "slick" paper and mass production.
It is as if our commercial artists are in a vacuum of illiteracy, with no knowledge of or concern for the well established vocabulary of classic typography and printing of the past and having no foothold, however tentative, in the contemporary world of visual expression through new media and techniques. Much old virtue has been lost; little which is genuinely creative or inventive has replaced it.
The immensely expanded technical resources have all too often been misunderstood or misused. Far too many effects are produced by the maximum use of these technical resources. The more commendable process of producing maximum effect with minimum means is disappearing. Complexity or extravagence are substitutes for simplicity and economy.
We saw too much work which displayed an astounding amount of technical proficiency but which was utterly lacking in purpose.
An effort such as the Society of Typographic Arts is making to raise the general standards of performance in this field is of the utmost importance if we are to avoid a point, dangerously near, when most printing design, being illegible, meaningless and dead, will become one of the major instruments for the vulgarization and degeneration of our society.

Architecture
Architectural design is concerned with the provision of a controlled physical environment for living, working, recreation and related activities of social service and transportation of a contemporary society.
Plan, structure and form express social purpose, technical means and pleasure content. These are the bases of any design whether of a house, a piece of equipment or a city plan. In contemporary industrial society, the components are of great complexity: the product of the combined work of many specialists. The architect's part in this collaborative task is that of a correlator integrating functional factors into an expressive and coherent form. The architect can play his part only if he accepts the responsibility of social service as a professional and develops a scientific objectivity as a technician to give strength and meaning to his work as a creative artist.
Architectural students, after the basic preparation in the Foundation course, begin with analysis of man's reaction to his physical and social environment and the purposes architecture may serve to meet man's needs. This analysis becomes the basis of all subsequent design.
Design begins with the simplest dwelling and progressively moves on to the design of essential elements within the framework of a contemporary community.
In the process, students become familiar with the social as well as technical and esthetic factors underlying all design problems.
In the seventh and eighth semesters, architecture students work in collaboration with product designers on research in industrially produced building elements.
The degree of Bachelor of Arts in Architecture is granted upon satisfactory completion of the four-year course in this department. Students who wish to practice professionally will be granted the degree of Bachelor of Architecture upon completion of the fifth year.
Product Design
The experience acquired in the first year of the foundation course is applied in the third semester to actual problems in applied design, beginning with systematic analysis as the preliminary to experiment and execution.
In the fourth through sixth semesters, various objects are designed and constructed in different materials such as wood, metal and plastics. Typical fabricating processes such as casting, spinning, bending and pressure molding are employed.
As the student advances, he becomes acquainted with mass production techniques, product illustration, industrial drafting, estimating, business practice, etc. Field trips are made to industrial plants.
In the seventh and eighth semesters, product design and research is undertaken in coop-

eration with industry.

The aim is to acquaint the student with methods of fabrication and enable him to design for machine production. The potentials of machine production are unlimited and many of its inherent qualities have not yet been exploited.

Throughout, emphasis is placed upon the working out of new methods and devices in product design which will tend to create a demand for superior products and optimum use of our resources.

The degree of Bachelor of Arts in Product Design is granted upon satisfactory completion of the four-year course in this department.

Visual Design
Advertising, Printing, Display

Visual design is directed toward the development of implements for all aspects of visual communication through two and three dimensional means with special emphasis on printed matter generally, advertising and display.

The visual vocabulary of point, line, texture, value, color, intensity, transparency, plane, volume, direction, rhythm and tension acquired in the first year's work are applied purposefully as tools of communication.

In the fourth through sixth semester, the work, although closely integrated throughout, falls under two heads: Creative work with emphasis on originality and expressiveness and experiment in various media, on the one hand; and technical work with emphasis on knowledge of process in lettering, layout, typography and basic printing techniques, skill in control of media and mastery of presentation methods, on the other.

Experiment, using the actual tools of the compositor and printer, extend the previously acquired experience in drawing, painting, montage, collage and photography. A thorough knowledge of lettering form and structure from the hand-drawn alphabet to mechanically produced type is developed.

In the seventh and eighth semesters, projects are carried out employing professional production methods from design, layout, and make-up to actual printing. Projects include advertising posters, booklets, book jackets, covers, illustrations, as well as research into special problems of design and technology such as type-face design, printed textiles and wallpaper.

In addition to two dimensional work, students in master workshops collaborate with other departments on three dimensional projects, such as packaging, display and exhibitions.

The degree of Bachelor of Arts in Visual Design is granted upon satisfactory completion of the four-year course in this department.

Photography and Film

Light is employed as a medium in itself, revealing new means of expression through its particular qualities and characteristics. The use of photography runs parallel to the use of graphic media

The work in film is designed to emphasize the unique characteristics and range of this medium which may combine both visual and sound elements to produce a single expressive form.

Parallel with work in black and white are experiments with color photography to reveal the characteristics of the process: new tone, shadow and color combinations unobtainable by manual means.

Experiment is accompanied by work in established fields of application and technology. Throughout, the creative use of the medium and the student's own direction and expression are stressed and developed.

In the seventh and eighth semesters, work of the photographic department is integrated more directly with that of other departments. Individual and group projects provide photographic material for exhibitions, publications, etc.

The degree of Bachelor of Arts in Photography is granted upon satisfactory completion of the four-year course in Photography.

Institute of Design
Officers and Faculty (1948)
From the prospectus "the institute of design," 1948

Chermayeff retained some outstanding teaching talent on the staff of the Institute of Design, drawn for the most part from Moholy-Nagy's own circle. From the old group of the Bauhaus, Bredendieck (who had been head of Basic Design, the wood and metalworking shops at the New Bauhaus) rejoined the faculty. In addition to Lerner and Siegel, several other graduates of the Chicago institutes, including Koppe and Walley, distinguished themselves as superior instructors. As had been the policy in the Dessau Bauhaus, the faculty was recruited wherever possible from the ranks of those who themselves had gone through the authentic studies of the institutes. This helped to stabilize the instruction, although it is true that at the same time certain academic tendencies were perpetuated. Significantly, the desire to grant academic degrees at the conclusion of the study course became stronger. The decisive step which made this possible was undertaken in December 1949, through incorporation into the Illinois Institute of Technology. This form of

Officers
Director and President, Serge Chermayeff
Secretary-Treasurer, Crombie Taylor
Registrar, Mollie Thwaites
Business Manager, Ruth Soderholm

Faculty
Foundation Course
Richard Filipowski
Richard Koppe
Myron Kozman
Davis Pratt
John Walley
Hugo Weber
Emerson Woelffer

Product Design
Hin Bredendieck
Herman Garfield
Nathan Lerner
Elic Nekimken

Architecture
Serge Chermayeff

institutionalization was, however, also requisite for reasons of financial security, for with the reduction of the student body the income had decreased threateningly. The school continued in its own quarters on North Dearborn Street and retained its curricular independence. Except in the Department of Architecture, to which the former Poelzig student Konrad Wachsmann was called, the era of fearless experimentation, which had been predicated on Moholy-Nagy's vitality, had largely come to a close. Wachsmann sought, as head of the "Advanced Building Research" division, for possibilities to create optimal, and whenever feasible maximal, large spaces that permitted subdivision according to the requirements of the moment. In 1951 he developed, with his students, a sensational aircraft hanger for the United States Air Force. The work of the Institute of Design architects assumed an increasingly characteristic new accent. Chermayeff remained as Director until the end of 1951, at which time he accepted an invitation to teach at the Massachusetts Institute of Technology and shortly thereafter assumed a chair at Harvard University.

Institute of Design
Faculty (1952)
From "Institute of Design Bulletin," 1952–53 and 1953–54.
After Chermayeff's departure in 1951, Crombie Taylor assumed the leadership as Acting Director. Already a member of the Institute under Moholy-Nagy, he had taught architecture and, in close cooperation with the Director, had filled the post of Secretary-Treasurer. Taylor faced the difficult problems of an Acting Director with circumspection and understanding. Even though rival factions, which had to make decisions concerning the future of the Institute and which could not come to an agreement about the appointment of a regular Director until 1955, severely handicapped the smooth functioning of the organization, extraordinary progress was achieved under Taylor (cf. Chancellor's article, "Institute of Design . . . The Rocky Road from the Bauhaus"). He later accepted an appointment at the University of California in Los Angeles, where he also invited Konrad Wachsmann, whom he had learned to value while at the Institute of Design to become chairman of the Department of Architecture. For the Institute, Wachsmann's "Building Research" had represented the most significant contribution since Moholy-Nagy's death. The accomplishments of the Department of Architecture reached their pinnacle. All the tools of technology, of communication theory, and of sociology were exploited; the latest construction methods were investigated, and new, original ones were developed. Wachsmann's structures were to a large extent utilized throughout the world, and "Building Research" became an established concept. From an over-all point of view, the curriculum of the Taylor era closely adhered to that of the Chermayeff era. Within the faculty, Moholy-Nagy's vital spirit persisted; practically all faculty members had still had personal contact with him and continued to work according to his principles.

Robert Tague
Crombie Taylor
John Van der Meulen

Photography
Ferenc Berko
Harry Callahan
Frank Levstik
Hillar Maskar
Arthur Siegel

Visual Design
Eugene Dana
Maurice Friedlander
Michael Higgins
Elsa Kula
George LeBrun
Harold Walter
Laura Zirner

Sciences
S. J. Frankel
Howard Hardy
Britton Harris
Robert Janes
Robert Lewis
Edgar Richard
Robert Rose

Cultural Studies
Hugh D. Duncan
Martin Metal
Margit Varro
Abba Lerner

Acting Director
Crombie Taylor
Professor
Konrad Wachsmann
Associate Professors
Crombie Taylor
Hugo Weber
Assistant Professors
Harry Callahan
Eugene Dana
Charles Forberg
Misch Kohn
Richard Koppe
Jesse Reichek
Peter Selz
Ilmari Tapiovarro
Instructors
Frank Barr
Robert Nickle
Raymond Pearson
Aaron Siskind
Albert Szabo
Part-time Instructors
Vera Berdich
Elsa Kula
Robert Lundberg
Herbert Pinzke
Edgar Richard
Thalia Selz
Thomas Schorer
Arthur Sinsabaugh
Margit Varro
Marianne Willisch
Zeke Zinner

Anonymous Art Critic
Open House: Institute of Design in 1952
From the periodical "arts & architecture,"
Los Angeles, July 1952

Despite the uncertain prospects for the future, despite the disagreements concerning the appointment of a new Director seething below the surface, the Institute of Design experienced a significant period of growth under Taylor; it was by no means a passing phase. The curriculum, developed by Moholy-Nagy, tightened by Chermayeff, and supplemented in a direction pointing toward architecture, provided a solid foundation. Taylor continued to bring about the consolidation of the program and in 1952 introduced Art Education as a special course. His enthusiasm infected the entire community and bound it together. The public was able to gain some insight on the occasions of the "Open House" gatherings, which had a constructive significance for both faculty members and students, similar to that of the Bauhaus festivals held during the 1920's.

Each spring, the Institute of Design of the Illinois Institute of Technology prepares an exhibition and holds open house. The total activities of the school are on display, and the event has become much marked by the public. It draws professional people in many fields, who find insights into new concepts both in design itself and in design education—an educational concept appears in action. At this spring's open house, several thousand visitors were received. . . . To the ID student, open house is of unique value. All students participate, and in doing so are placed in collaboration with all fellow students and with the whole faculty—the one complete collaboration of the year. A comprehensive design problem develops in the planning and execution of open house and leads to an integration throughout all levels: student, class, department. Here the student now sees his individual efforts and his solutions to class problems become part of a total design pattern. Open house at the Institute of Design is a complete experience for the student. He cleans and paints the school. He plans spaces, traffic-flow, structure. He selects, organizes, then presents materials demonstrating his design education. And he carries on all forms of public relations: contacting press and radio; designing, producing and distributing posters, announcements and invitations; conducting tours and demonstrations. . . . The Institute of Design trains its students to take their place in society—modern society with its increasing need for order: design. It recognizes the challenge of the time, the social responsibility of the designer. The school operates on the principle that "everyone is creative" and that his emotional and intellectual endowments can be channelled into creative activity by the educational process. . . . Every entering student is enrolled in the foundation course where emphasis is placed upon developing unrealized capacities through a series of creative exercises. . . . At the end of three semesters, after introductory work in the various departments, he is allowed to concentrate in one of the four sections of the school: visual communication, photography, product design, shelter design and building research. If he enrolls in visual communication he will find himself confronted at once with the broad aspect of his problem: the artistic, social and economic implications of communication through vision. The student sets about solutions by developing his ideas in terms of specific techniques in typography, graphic reproduction, life drawing, film, package design, advertising, display, etc. If he goes into the photography section, the student will begin by exploring the action of light on photo-sensitive materials without the camera (the photogram). He progresses from this to translating the action of light on objects with the camera, working largely with abstract photography in the beginning to teach himself the basic principles of form in the medium. . . . A major in product design starts his work by studying and designing typical equipment for living. He is constantly encouraged to cultivate his own inventiveness for the development of objects best suited to the needs of the individual and the community. He makes working drawings and models, studies techniques of mass production, experiments with a large variety of materials and processes. He seeks solutions for the practical problems of human needs from eating utensils to furniture to sanitation systems. Scientific, technological, economic and human requirements are all related to the planning and creation of useful products. The planned relationships of products within a developing utility pattern is constantly stressed. Social need within the industrialized economy is also a prime emphasis in the shelter design and building research section. This demands understanding and constructive collaboration between the designer, scientist, engineer and planner. The student's program is directed toward the development of materials, methods and concepts based on industrialized building construction. He studies construction; goes on to investigate environment and illumination control, acoustics, hygiene for physical and mental well-being. Beginning with the simplest means and requirements, he progresses to the design of elements and components in a contemporary structure based on the most advanced industrial potential. When the student graduates from the school he is prepared to work as an independent creative designer. He has learned to penetrate basic needs rather than to imitate or blindly extend accepted patterns. He thinks in terms of the total complex and its relationships. He is intimate with the industrial potential or the range of process of his design area. He is a designer potentially able to assist in the endless evolution of improved environment processes. . . .

In this atmosphere the school has grown into a mid-western meeting-place for designers, artists and creative people of all kinds and from all countries. It is often the first stop for any traveler who is concerned or curious about the present and future of modern art, design and technology. The Institute of Design is peculiarly distinguished by its diverse student body, which has come from a wide variety of national, social and educational backgrounds. The faculty is composed of men and women who are outstanding figures in many fields—in architecture, painting, printmaking, typography, product design, photography, art history, etc. Most of them have discovered not only the commonplace that their own accomplishments have aided them in teaching, but conversely that association with the school and its vital educational issues has tended strongly to develop their talents and increase their professional productivity. Principles and ideas developed in sponsored research projects of the Institute of Design assist industry in the solution of many perplexing design problems. Graduate research has ranged from packaging developments to building construction systems. Leading government agencies concerned with building have recognized the advanced building research section of the school as a valuable instrument for the development of new structures. Here new industrialized building principles are formulated to keep in step with the changing technological pattern. A new graduate program in art education has been developed with the purpose of disseminating the school's educational viewpoints. It is based on the recognition that creativity on a sensory level is a universal endowment and a biological need. . . .

The beliefs and results evolved at the Institute of Design for the last fifteen years and introduced into society against, at times, vigorous resistance, have now been largely

accepted into the existing design and educational patterns. Unfortunately, by misunderstanding many of these principles, commercial designers have given birth to monstrosities of pseudo-modern objects, and art schools have copied "hand sculpture" and "mobile" without comprehending the process of evolvement. The object of the school is to develop a designer able to produce implements which will reward society with an ever-increasing quality of performance and constantly decreasing effort of production. This means a task of constant critical evaluation of each design effort.

Peter Selz and Richard Koppe
The Education of the Art Teacher
From the periodical "School Arts," April 1955
The successes of the Institute of Design resulted in a number of superficial imitations of its formal precepts; contrary to its intentions there developed some sort of an "I.D." style comparable to the so-called Bauhaus style of the 1920's —a complete perversion of everything for which the Institute of Design stood. The misinterpretations of the Institute's principles had their origin in part in the schematic application, directed toward external effects, practiced by other schools. For this reason it became imperative to acquaint young art instructors with the fundamental ideas and methods of the Institute of Design. Training art instructors seemed to be the most effective way of disseminating the basic, authentic ideas of the Institute and of countering the insidious dilletantism. Peter Selz, himself author of a standard work on German Expressionism and other books about contemporary art, was a member of the Institute of Design until 1955; later he became active at the Museum of Modern Art in New York and ultimately accepted a call to the University of California in Berkeley. The painter Richard Koppe had been connected with the Institute ever since its founding. He had received his training at the New Bauhaus and at the School of Design, and he had taught at the Institute of Design since 1946. In 1963 he assumed a professorship in the Art Department of the University of Illinois.

Chicago's Institute of Design, now a department of Illinois Institute of Technology, was destined from the first to have an impact on art education in this country. When Moholy-Nagy founded the New Bauhaus in Chicago in 1937, he based its curriculum on a conviction of man's need to express his creative nature and to accent his social responsibility. Although Moholy's approaches to art and design education were new and revolutionary, John Dewey had already established similar educational experiments in Chicago at the turn of the century with the prediction that "schools will become workshops humming with work."

While education at the Institute of Design has led its graduates into many design areas, large numbers of them have naturally turned to teaching. Although this spread of the school's philosophy and methods modernized design education all over the country, at the same time a new academism began to crop up wherever teachers adopted ID products without understanding the philosophy underlying this production, and taught their students to turn out hand or wire sculpture, mobiles and stabiles by the gross, as a few years earlier they had trained these students' older brothers and sisters to follow patterns and execute border designs. From a growth toward inventive expression through experimentation with tools and materials, the aim of the pupil was perverted to the manufacture of "modernistic" products.

In order to avoid this cookbook philosophy, as well as to disseminate further the basic educational philosophy of the Institute of Design, a graduate program in art education was established in 1952. This program does not train specialists to do whatever is fashionable—be this leatherwork, pottery or enameling. While we realize that such specialization is important, we believe that education toward creative thinking can be applied to whatever process may arise. At the same time an individual who has experienced the creative process makes a more understanding teacher. The person who already has specialized skill, however, will often find that it acts as a catalyst to accelerate the impact of the more generalized training at the school.

Of what does art education at the Institute of Design consist? First of all, it is an interrelated program in which the individual problem, even the single course, is less important than the total experience. The student explores a specific problem, such as the meaning of a line, for example, within a given space, in drawing, sculpture, photography, and again in the analytical seminars. The early phase of the work emphasizes the pure act of doing. Almost like the dance, the approach is both physical and emotional. Free arm and finger movements, squeezing of clay, experimenting with wire, liberate the student from preconceived esthetic notions and help him rely on his own ingenuity. The natural arrangement of elements on the paper or in three dimensions is the outgrowth of this free exercise.

At first the student forms directly with his hand and he extends this forming process to the use of a simple hand tool, like a pen or hammer. Simultaneously, he experiments with light and its effect on light-sensitive material in his photography class. When he makes photograms he is forced to rely on his own invention as light, acquiring new properties, begins to add to the total range of his perception and conceptual thinking. The student who may have difficulty in other media is provided with a new outlet of expression.

In the workshop he may attempt to find new structural relationship between ordinary found objects. Washers and sticks, razor blades and strips of glass are explored as to their potentialities of joining, and structures are formed. This is related in principle to prefabricated units in industry. This experimentation with the found object is then carried over into the two-dimensional area where almost any object may become a tool for the opening up of new avenues of expression: pine cones applied to paper, a brayer rolled over a mesh, or a ring pressed into clay in the sculpture workshop. At this point the potentialities are infinite, limited only by the student's imaginative power.

At first also, working with paper, he may merely have crumpled it, thereby creating an uncontrolled surface. Afterwards the surface is controlled; the idea is projected, and paper is re-evaluated as a structural sheet material. It is scored and folded and repeatable surfaces are created while extensions of the hand such as cutters, rulers, and squares are brought into use, which in turn will have a decisive influence on the resulting study. Here the student, beginning with something akin to random action has reached a stage where he constructs a new object.

The student applies the same essential approach to the machine as the use of hand and hand tool. He can employ the same inventive manner in moving a piece of wood through a jig saw. Again he is unconcerned with a prior idea and may violate the usually accepted limitations of materials to find his own answers. A circular saw blade, for example, may be both shaping tool and cutting edge, so that the wood assumes entirely new forms and characteristics. It must be pointed out, however, that while the student working with a machine tool is still exploring, he now must in addition make conceptual decisions since he is engaged in a more intricate forming process with a modern complex machine. Another machine the student uses at this time is the camera. Having already become sensitive to a great range of tonal values, he uses the camera to open a new area of vision. No longer creating the objects, he relies on his heightened visual awareness to halp him discover and select objects in his environment and relate the picture to his feeling for esthetic form.

Subsequent to the process of pure exploration, various esthetic considerations enter the student's growth. After the early and necessary freeing process the student works with ideational concepts. His purpose now is organization and structure. As he was previously engaged in the exploration of tools and materials, he is now drawn to the more formal development of structural elements like line, plane, color, value, shape, volume, space, as well as to tactile experiences. He begins to combine them into organized units. He will work with the two-dimensional plane as a specific shape. In sculpture he may deal with volume and plane in plaster on an armature, which itself was made as an inventive structure, or he may create volume and space through the transparency of a plane of wire and string. Beyond this, an exercise done in the basic workshop, like a structure made of swab sticks, is now photographed resulting in a picture which modulates light and space. The act of doing and the purely inventive exploration of materials are finally brought together with the more formal creative exercises and related in a new context, as in the collage. When drawing natural objects, the awareness, as well as the freedom of conception, enables the ID student to cope with the visual environment in an original way. Again he starts in a completely free and unselfconscious manner while confronted with an object to express a single object or multiples, first, still, then in motion. After his innate ability to draw has thus reasserted itself, he is taught freehand perspective, he observes exact proportions, and learns to draw by construction. Finally, being familiar with the object, he now has a measure and can turn toward an expressive and interpretive treatment of the object world. The process also occurs in reverse: he may discover a human figure, animal, or boat in a completely nonfigurative picture which he had made. Finally the explorative attitude, the conceptual understanding of form, and the new awareness of objects are combined toward a symbolic whole which may communicate a fairly complex message. The result can be a simple painting, sculpture, photograph, or a union of many different media in the form of a montage.

To give greater scope to the student's practical training, graduate seminars have been developed. As most teachers increasingly realize, art education is not an isolated phenomenon but must be regarded in its relation to the total cultural context in which it operates. The student, therefore, investigates the dynamic tradition and contemporary trends in art and art education. As in the workshops, utmost emphasis is laid on individual student participation in these seminars. After his new inventive and creative experiences, he will be able to grasp traditions with greater sensitivity. He carefully analyzes and relates past methods and contemporary approaches to art education. The student discusses methodology of teaching on various age levels and for differing individual needs with the purpose of evolving his own philosophy of art education . . .

The art education program at the Institute of Design is truly an integrated program. Not only its own faculty, but also professors from other disciplines have developed it towards this end. A member of the Illinois Institute of Technology's Department of Language, Literature and Philosophy has devised a course in Visual and Verbal Communication which relates art to literature; a psychologist has developed courses in child psychology and the psychology of perception which are more relevant to the graduate program in art education; while a sociologist has proceeded similarly with a course in the urban environment in which we operate. The graduate student, in addition to taking courses is also encouraged to experiment with the new approaches in a direct teaching situation and to do spade work in the problems of adolescent art training in the newly instituted Junior Workshop, an experimental Saturday class for high school students. Finally, the graduate undertakes an independent project or thesis in art education, which is meant to contribute to his stature as an art teacher in the contemporary social framework. These master's projects reach out in all directions—from designing exhibitions to the making of educational films, to devising pilot curricula and doing historical research; they have included research on psycho-social problems as well as explorations of new processes and techniques in sculpture, printmaking, etc.

The teacher's training program is probably most active during the summer when the whole Institute of Design is turned over to art education . . . Since it began operating in the summer of 1952, some eighty students have entered the graduate program. At the present time forty-four graduate students are enrolled on a part-time and full-time basis. In order to stimulate art teachers and other individuals from the whole community, the art education program has organized a series of exhibitions and public lectures by outstanding speakers in various fields of art and design, art education, psychology and sociology. Perhaps outstanding among them was a lecture by Sir Herbert Read in the spring of 1954. Read, himself an advocate of the Bauhaus philosophy, summarized the point of view of art education at the Institute of Design when he expressed his belief that we must educate man's innate symbolic sensual perceptiveness by means of art so as to develop more communicative as well as emotionally adjusted total personalities.

John Chancellor
Institute of Design . . . The Rocky Road from the Bauhaus
From the periodical "Chicago," July 1955
This article, here reproduced in greatly abridged form, emphasizes the dramatic struggles that had raged around the Institute ever since its founding in 1937. The immediate impetus for this paper was the appointment of Jay Doblin to the directorship of the Institute, and the fear of the Moholy-Nagy circle that now the Institute of Design would degenerate into a mere vocational school for designers and would forfeit its spiri-

The revolution in art education and design, realized in the ID, makes it great. The crisis: will ID forget its role and become a vocational school?

Like an artist in a garret the Institute of Design has had to spend constant effort on the essentials of survival and at the same time, incredibly, has spent even more energy on its creative life.

The ID has dodged thru Chicago for 18 years, from shelter to temporary shelter, living always in the shadow of financial terrors and poor enrolments. Now it is poised to move again, from the old gray Chicago Historical Society building at Dearborn and Ontario streets to a new custom-built home on the international-style campus of the Illinois Institute of Technology.

When the semester ended last month, the ID still had all its glory about it: wherever those graduates go with their diplomas, the world of art and design will regard them as edu-

tual horizons. The disagreements, carried on for years and open to common knowledge, had damaged confidence in the Institute, and of necessity reduced the number of students. During the summer of 1955 the crisis came to a head. In spite of the opposition of the faculty members, who considered Moholy-Nagy's legacy imperiled, the Illinois Institute of Technology, in its capacity as legal supervisor of the Institute of Design, insisted upon Doblin's appointment. He assumed his post in the fall of 1955.

This article was written under the impact of recent developments, and was addressed to a wide circle of readers—evidence of the extraordinarily live interest that prevailed, not only in professional circles but also among the public at large, in the fate of the Institute of Design. The author did not attempt to pay tribute to the accomplishments made after Moholy-Nagy's death—many of which were due to Chermayeff himself.

cated by *the* institute of design. Their regimen of study has been unique and thoro, and the faculty that gave the final exams in June was studded with respectable names.

But in the fall, things will be different—exactly how different is the question that has boiled the friends and foes of the ID to crisis pitch.

The ID, again like the artist in the garret, has never been very well understood—has been perhaps so embroiled in its own world of developing theories that it has failed to make much effort to be understood.

For example, it is possible to arouse hostility on the part of intense ID personnel (they are all intense) by calling the place an art school. It is *not* an art school; it is a school of design. Before the Bauhaus, there were no schools of design; and the ID is the lineal heir of the great German Bauhaus of the 1920s, the organization that broke the visual barrier to make way for the design of all things we call modern.

These days, it's called the Institute of Design of the Illinois Institute of Technology, but that is its married name. In its vagabond youth, it was known as the School of Design, the New Bauhaus or just the Bauhaus. In 36 years of gypsy life, thru a succession of harrowing crises, it has made its influence felt in most schools of architecture in the world, in many millions of products, in the advertising aeries of Madison and Michigan avenues, in print shops and furniture showrooms, and in all things touched by mid-twentieth century design.

It has turned out some 1500 teachers, designers and architects, as well as a relatively good percentage of first class artists . . .

While Moholy lived, the school had been his personal domain and responsibility. Now it shifted to other hands. Serge Chermayeff . . . came to direct the school.

It was at this point that the school, in an effort to settle the financial security question once and for all, merged with the Illinois Institute of Technology, becoming a degree-granting department in the engineering division. Chermayeff left soon after for Harvard. Crombie Taylor, who became acting director, said, "We are afraid of the student depression that would come when the government stopped paying for veterans, and altho we had a $100,000 bank account, we wanted the chance to be part of a larger organization. But there were two things wrong with the move: one, the entrance requirements of IIT included more math than our students need, and more stringent qualifications generally. Two, the Institute of Design was losing its identity as a separate school, and became just another department of IIT." Grades and tests were brought in, and thus was the free-form curriculum of Moholy altered.

The IIT created a screening committee of ID professors, to consider candidates for ID directorship. In three years, 25 candidates were interviewed. It was a difficult post to fill. Moholy had left a job with impossibly high standards, and no one man *could* replace him.

Crombie Taylor suggested to IIT that a dean be appointed over IIT's architecture and urban planning departments and the Institute of Design. But Taylor wanted a shift in the balance: he wanted three schools, divided into architecture, product design and visual communication.

The IIT retained the old balance, and commissioned van der Rohe to draw plans for a single building housing all three departments. The structure, on the site of the old Mecca building, is under construction and scheduled for occupancy this fall.

Several men had been proposed for the directorship but, for one reason or another, none was acceptable to both ID and IIT. Finally IIT, insisting that a budget must be drawn, announced an appointment.

The man was Jay Doblin, 35, a designer who has worked for Raymond Loewy for eleven years. Doblin, a graduate of Pratt Institute, for three years headed that school's evening classes in industrial design . . .

Doblin has made two visits to Chicago to meet the ID faculty and on both occasions was met by a group with high, arched brows. . . . In April, the faculty unanimously signed an open letter to President J. T. Rettaliata of IIT. The letter restated "certain fundamental tenets of our approach to the education of the designer, which we feel have been brought into serious jeopardy. . . . The designer must be more than a stylist or decorator who caters to fashionable or opportunistic needs. The designer must be an ethically responsible professional with a developed creative ability based on the most penetrating scientific and artistic insights of our time. A true, growing and expanding economy demands a growing and expanding culture. . . . The present tendency is to consume the 'yield' of the past two decades. A school that does not fertilize the ground for future growth is not only failing to contribute to the development of its culture, but is actually a parasite on that culture."

It has been reported that several faculty members at the ID have been fired, within the context of the Doblin issue. IIT says this isn't so. Some contracts weren't renewed, they say, because enrolment is down: in 1950 the ID had 328 full-time students, and at the start of the last spring term, only 95 were registered.

Doblin, still at work in the Loewy office in New York, says he is coming here in September. He adds, "I'm amazed at this whole thing. I want these men to teach what they want to teach, in their own way. If we have any teaching disagreements, there won't be any resignations, because I'll make adjustments in the balance thru my own additional appointments to the faculty. I've had petitions from the students, and a couple of rough interviews with the faculty, but I'm coming out anyway. We need more students and a realistic approach to the teaching of designers. When we turn out a graduate, I want him to be a skilled designer, with a good cultural background and a clear view of the realities outside the classroom. There are a lot of design jobs in Chicago: the town can absorb 25 new designers a year. This year, I think, the ID is graduating four, and two of them aren't going into practical design work. I want to fix that, and I want to do some missionary work with industry."

Members of the Institute of Design/Illinois Institute of Technology
Manifesto, 1955
From an undated pamphlet
The manifesto was drafted in the summer of 1955 by the faculty members named in its first paragraph, because of their fear that the Institute of Design was about to be led down the wrong path. It points up the high ethical standards that motivated them and can be considered as an exemplary statement by those faculty members who continued to work in the spirit of Moholy-Nagy—quite aside from the question whether their fears were really justified. Several members resigned from the Institute of Design during the course of the quarrels that arose out of the crisis surrounding the appointment of a new director: Konrad Wachsmann (Building Research), Charles Forberg (Architecture), Hugo Weber (Preliminary Course), Harold Cohen (Product Design), Peter Selz (Art History), and, last but not least, Crombie Taylor, who had headed the Institute as Acting Director since 1951. Their departure greatly weakened the Moholy faction on the staff.

These are some basic convictions. The Institute of Design was founded on them. The Institute of Design must continue to be worthy of them. Members of the Illinois Institute of Technology faculty, Harold Cohen, Charles Forberg, Nathan Lerner, Elic Nekimkin, Robert Nickle, Raymond Pearson (Institute of Design product section) feel they are as timely now as they were when they first appeared in L. Moholy-Nagy's *Vision in Motion*. We quote:

"The speedy dispensation of education for immediate use neglected biological orientation without which the urge for creative activity was lost and with it the most important aid to maturity and judgment. It provided the masses with a quick training but threw overboard its purpose, namely, that 'not knowledge but the power to acquire knowledge is the goal of education.'"

Admittedly this complex world cannot exist without the arduous detail work of the specialist. But the education of the specialist should not start with the training of a single ability before a harmoniously related, all-round education has been completed. This specifically must be the difference between the new and the old specialist. Otherwise flexibility and adaptability will be thwarted. The new specialist will have to integrate his special subject with the social whole. This integration must be based upon a carefully fostered intuitive and reasoning power, the result of emotional and intellectual development in balance. Theoretically, man is the sum total of his psycho-physical, intellectual, and emotional potentialities. His reasoning power parallels the emotional forces. What he knows, he could also feel if he would train himself in both spheres. In fact, this is his historic struggle, to arrive at an integrated life in which he would function to the fullest of his capacities through a synthesis of the intellectual and the emotional, through the coordination of penetrative thinking and profound feeling. To reach this goal—to feel what we know and know what we feel—is one of the tasks of our generation.

Irresponsibility prevails everywhere. An advertising artist, for instance, makes a layout for the sale of a product. He is responsible for nothing but his own art; that is, his professional standard. The merchant sells the product which is advertised. But he is not responsible for its possibly inferior contents, as it is already packed before it reaches him. The manufacturer is not responsible either because he only finances the production; the formula comes from the hired staff of a research laboratory trained to produce results which will compete with products on the market. Altogether, responsibility has been subdivided to the evasiveness of the microscopic.

Competition on the world market will sooner or later require a revision of the American idea of forced obsolescence, i.e., the frequent replacement of merchandise by a new "design" before the previous one becomes technically obsolete. What kind of cultural, social and economic changes such a revision will cause, is as yet difficult to forecast. However, one comment can be made: the theory and practice of artificial obsolescence leads—in the long run—to cultural and moral disintegration because it destroys the feeling for quality and security of judgment. Continuity of culture results from a primary concern for quality rather than for novelty. Instead of striving for "standards" leading to an organic civilization which should be the aim, the responsibility and the duty of the designer, the quick succession of "novelties"—the paradise of the salesman and advertising agencies—forces the designer to satisfy only the desire for the sensationally new in the exterior. Thus "design" today is generally a bid for quick sale, usually nothing but an exterior cloak around a product. Its main characteristic is to be "different" although the function remains the same. The industrial designer is called in to "style" or "fashion" a product already engineered, and the more often he changes a "design," the more he is supposed to have contributed to the salesman's success.

It is a generally accepted premise that capitalism with its industrial technology has to serve in the most economical way for the realization of profit. However the "economical" should be subordinated to human requirements to make technology a benefit instead of a curse. We must control the application of material, technique, science, and art not only economically but also biologically and socially. To meet the manifold requirements of this age with a definite program of human values, there must come a new mentality and a new type of personality. The common denominator is the fundamental acknowledgment of human needs; the task is to recognize the moral obligation in satisfying these needs, and the aim is to produce for human needs, not for profit.

76
Institute of Design—The Courses of Instruction, 1957

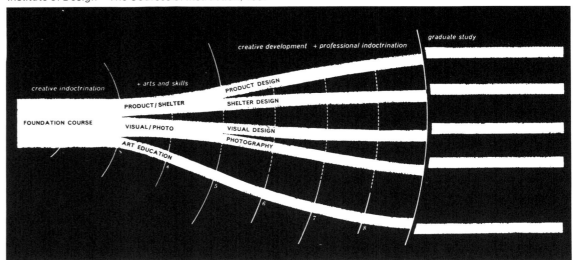

Illinois Institute of Technology
Symbol of Progress
From "S. R. Crown Hall—Dedication Ceremonies." Illinois Institute of Technology, Chicago, April 30, 1956
On April 30, 1956 the "Crown Hall" of the Illinois Institute of Technology, designed by Ludwig Mies van der Rohe, was officially dedicated. It assembled under one roof, distributed between ground floor and basement, three departments which in essence derived their ideas and their personnel from the Bauhaus and which together now constituted a "Division of Design": the Department of Architecture, the Department of City and Regional Planning, and the Institute of Design. The emphasis was unmistakably placed on the Department of Architecture headed by Mies van der Rohe, who had come to Chicago in 1937 to work at the Armour Institute, one of the precursors of the Illinois Institute of Technology. At his side there were Walter Peterhans, who had developed an independent "Visual Training Course" for architecture students, and Ludwig Hilberseimer, who was also Director of the Department of City and Regional Planning.
The ensuing decade saw a distinct decline of the Bauhaus element that was so strongly represented when Crown Hall was first opened. Mies van der Rohe retired in 1959, and his place was taken by one of his former students, George E. Danforth, who proved to be a determined Director, Peterhans died in 1960, and Hilberseimer in 1967. After the latter's death, Howard Dearstyne was the only remaining member who could trace his origin to the original German Bauhaus where he had been a student.

Illinois Institute of Technology
Undergraduate Catalog: Institute of Design (1957–1959)
From "Bulletin of Illinois Institute of Technology," Undergraduate Catalog, Chicago, March 1957
The Institute of Design group that had received its training under Moholy-Nagy kept shrinking more and more. In the early 1960's Eugene Dana, Richard Koppe, and Herbert Pinzke resigned. A drastic reduction of the original program entailed the inevitable renunciation, on the part of the Institute of Design after it had moved into Crown Hall, of its own course in architecture. The Shelter Design course, which was still listed in the 1957 undergraduate catalog, tapered off and was soon completely abandoned. It became evident that the Institute's activities had to restrict themselves to Product Design, Visual Design, and Art Education; this development inexorably took place as an inevitable process, regardless of the Director's personality. In spite of all the differences of temperament and work method, Jay Doblin also embraced Moholy-Nagy's principle of a broadly based education and his socio-ethical conviction.

Dedication of S. R. Crown Hall as the new home of the Institute of Design, and the Departments of Architecture and City and Regional Planning at Illinois Institute of Technology is an event rich in promise of progress the building will stimulate in the continuous advancement of the arts to which it is dedicated.
It will provide the physical means for coordinating the services of the three departments it houses, and enable them individually to gain greater stature through inter-use of their facilities and talents.
The new building permitted relocation of the Institute of Design on the campus, where it will be ideally situated to continue to pioneer in the integration of the world of art with the world of science and technology as its students gain a fuller understanding and appreciation of engineering concepts.
The Department of Architecture, which, like the Institute of Design, commands worldwide respect, for the first time has adequate and appropriate space to encourage the expansion through which it can further advance the leadership of the famed "Chicago School" of architecture.
In the increasingly important work of city and regional planning, an area in which Illinois Tech already offers one of the most complete curriculums available, the added facilities will equip the institute to provide an even better educational program in this field. . . .

Professor
Doblin
Associate Professors
Callahan, Kohn, and Koppe
Assistant Professors
Baringer, Dana, Siskind, and Waddell
Instructors
Campoli, Fink, Martin, Myers, Pearson, and Pinzke
Lecturer
Sherman
The Institute of Design offers four-year curricula in product design, visual design, shelter design, photography, and art education. Upon completion of the work in any of these areas, the student will receive the degree of Bachelor of Science in the appropriate section. The four years of undergraduate study may be followed by graduate studies in these same areas. Master's degrees also are available in these subjects to graduates of other accredited institutions under a special program. . . .

Guiding Principles
All men are biologically equipped to experience space, as well as color, and can acquire experience which will tend to develop this capacity. Through the experimental approach toward handling tools and materials, we are able to increase and refine our native ability to react to, and to control the physical environment in which we live. Science, modern technology and production are the instruments and companions of the artist and designer. The effective control of physical environment, which is the designer's task, depends upon his understanding of contemporary man's needs and his ability to use to their fullest the means at his disposal to achieve greater health and happiness for mankind.

The Educational Principle
Understanding of the fundamental principles of design cannot be achieved by narrow vocational training. Education for a designer must provide a foundation which will enable him to think comprehensively and to act effectively in the complex, industrial world. The new designer is able to face all kinds of problems, not because he is a prodigy, but because he has built up for himself a correct approach.
The student does not study the master, but the principles and facts which the master himself had to study. He must learn for himself. The Institute of Design stimulates the intellectual and emotional powers of the student so that he will be able to do creative work.

Illinois Institute of Technology—Institute of Design

List of Graduate Theses Completed 1957–1966

From a typewritten list.

The graduate program at the Institute of Design culminated in the granting of a Master of Science degree in Product Design, Visual Design, Photography, and Art Education. A listing of the theses completed during one decade indicates how strongly the work had become oriented toward concrete reality under Doblin. For example, the problem of short-haul transportation systems was investigated from a number of viewpoints. In the area of intellectual abstraction some papers by art educators did attain a remarkably high level. Thoroughness was the common characteristic of all theses accepted by the Institute of Design.

		
1957, Jan.	Personal Transportation for the City Dweller	A. J. Ingola
1957, June	Origin, Development, and Design of Minor Resistance Heated Appliances	F. J. Greb
1957, June	Laboratory Work Center with Four Optional Working Arrangements	B. E. Voight
1958, June	Vacuum Form Food Packages for Supermarkets	R. Meyer
1958, June	Basic Unit of Plastic Dinnerware for Industrial Use	M. Yoshioka
1959, Jan.	The Development of a Disposable Food Container-Cooker	R. C. Bettinger
1959, June	The Design of Creative Play Spaces	W. H. Noble
1960, Jan.	The Eating Tool, its Development and Suitability to American Dining	R. C. Allinder
1960, Jan.	Children's Furniture	R. H. Sweet
1960, Jan.	One-Man Transportation Vehicle	L. R. Richards
1961, Jan.	Food Preparation 1970	R. J. Debrey
1961, Jan.	Minimum Transportation: A Power Chair	W. D. Stout
1961, Jan.	The Passenger Seat in Long Distance Transportation	R. P. Straub
1961, June	A Rapid Transportation System	G. Luedeke, Jr.
1962, Jan.	Electric Urban Utility Vehicle	M. C. Averitt
1963, Jan.	Parallels between Audio and Visual Design	K. R. Vreeland
1964, June	The Evaluation of the Effectiveness of Urban Traffic Information	R. W. Guttenberg
1964, June	Communication: A Notation for Planning Product and Design	G. Schluter
1964, June	Development of a Multi-Use Vehicle	E. H. Yonkers
1964, June	The Communication of Time	A. Van Hoboken
1965, Jan.	The Application of Programmed Learning Techniques to the Development of Creativity	C. M. Dole, Jr.
1965, Jan.	The Modulization of Mechanical Systems in the Manufactured Home	C. L. Owen
1965, Jan.	Analysis and Synthesis of Architecture and Industrial Design Education and Practice	C. Testa
1966, Jan.	Basic Visual Testing and the Designer	W. J. Frcka
1966, June	The Design of Disposable Products	L. Singer

77
Circle of the Visual Arts
From a prospectus, "Institute of Design of Illinois
Institute of Technology." After 1960.

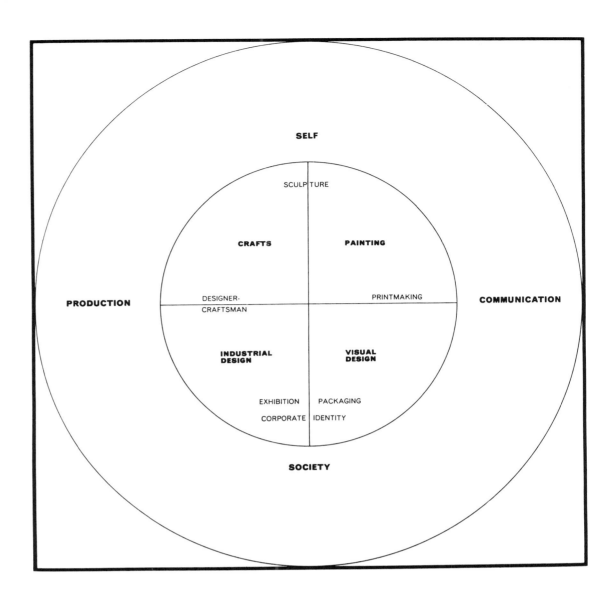

Illinois Institute of Technology
Institute of Design (1966–1967)
From "I.I.T. Bulletin 1966/67." Illinois Institute of Technology, Chicago, 1966
The minutely wrought curriculum of the Institute of Design hardly admits any possibility of change. The founding of the New Bauhaus had taken place thirty years previously. Based on long years of experience, an optimum was attained within the comparatively strict, narrow limits of the curriculum. The purpose of training was now soberly considered; a goodly portion of the soaring, courageous imagination of yesteryear was traded for greater solidity and durability. Of benefit to classroom instruction was the circumstance that for marginal subjects, such as Business and Economics, Political and Social Science, specialized institutions within I.I.T. were available. The faculty, in conformity with the new educational plans and goals, was "rejuvenated": Of Doblin's sixteen co-workers at the Institute of Design in 1967 only three—Campoli, Pearson, and Siskind—had taught longer than he. After an interval of about two decades Siegel, who had collaborated with Moholy-Nagy, at last returned to the Institute.

Faculty
Professors
Doblin (Director), Kohn
Associate Professors
Campoli, Emerson, Martin, Pearson, Siskind
Assistant Professors
Jachna, Kind, Krampen, Montague, [Chad] Taylor
Instructors
Fahnstrom, Karlmark, Marten, Owen, Sharp, Siegel
Undergraduate Catalog
Design is that professional branch of art which combines the esthetic sensitivity and free creativity of the artist with the scientific knowledge and intellectual discipline of the technician, for a socially useful purpose. All the design professions for which the Institute of Design prepares its students are concerned in some way with the effective control of our complex modern environment.
Product Design (Industrial Design) is concerned primarily with the planning, development and production of well-designed objects for human use, usually for mass production. This includes furniture, the endless variety of appliances for home and industry, tools and implements, automobiles and transportation in general, street furniture and aspects of exterior and interior design.
Visual Design is concerned with any of the thousands of items which are produced for purposes of visual communication. For example: advertisements of all kinds, magazine and book illustrations, packages, displays and exhibitions, corporate identity programs, and complete advertising campaigns.
Photography, as a profession, is a medium of unique expressive potentialities for documentation, reportage, portraiture, journalism, and private expression.
Art Education prepares artists and designers to teach their subjects. It makes visual creativity available to young people so that they can, by means of the creative process, increase their understanding of themselves. The designer who is also trained educator forms a vital link between the arts and society of the future.
The undergraduate programs lead to the degree of Bachelor of Science in one of four fields: Visual Design, Product Design, Photography and Art Education. Students in Art Education fulfill the requirements for legal certification as teachers . . .
All entering undergraduate students are required to take the Foundation Year. This work includes the exploration of the basic means, methods and techniques for visual invention. In the Sophomore Year the student begins a specialized study of theory and practice in either Product Design, or in the Visual Design—Photography—Art Education group. The Junior and Senior Years are devoted to increasingly challenging problems in the specific professions for which the school prepares. The liberal education sequence in the humanities and the sciences provides a cultural frame of reference for the designer and designer/educator. . . .

The Curriculum

Abbreviations:

BE	Business and Economics
MAE	Mechanical and Aerospace Engineering
PE	Physical Education
PS	Political and Social Science
ST	Speech and Theatre

Foundation Year Curriculum

First Semester

Engl	Read., Writ., & Think. I	3	0	3
ID	Visual Fundamentals	2	6	4
ID	Basic Workshop	2	6	4
ID	Sculpture	1	3	2
ID	Basic Photography	1	3	1
Math	Elem. Analysis	3	0	3
PE	Physical Education	2	0	0
	Totals	14	18	17

Second Semester

Engl	Read., Writ., & Think. II	3	0	3
ID	Visual Fundamentals	2	6	4
ID	Basic Workshop	2	6	4
ID	Sculpture	1	3	2
ID	Mech. Drawing	0	3	1
ID	Basic Photography	1	3	1
Math	Elem. Analysis	3	0	3
PE	Physical Education	2	0	0
	Totals	14	21	18

Visual Design Curriculum

Third Semester

ID	History of Art	3	0	3
ID	Basic Visual Design	2	9	5
ID	Methods of Photography	2	9	5
Phys	Physics	3	0	3
Psy	Introductory Psych.	3	0	3
	Totals	13	18	19

Fourth Semester

ID	History of Art	3	0	3
ID	Basic Visual Design	3	9	6
ID	Methods of Photography	3	9	6
Humanities Elective		3	0	3
	Totals	12	18	18

Fifth Semester

BE	Principles of Economics I	3	0	3
ID	Drawing & Color	1	6	3
ID	Visual Design	3	18	9
ID	Music Appreciation	1	0	1
ST	Public Speaking	2	0	1
	Totals	10	24	17

Sixth Semester

BE	Principles of Economics II	3	0	3
ID	Visual Design	3	18	9
ID	Music Appreciation	1	0	1
PS	American Const'l System	3	0	3
	Totals	10	18	16

Seventh Semester

ID	Visual Design	4	15	9
ID	Visual Workshop	1	9	4
Humanities Elective		3	0	3
	Totals	8	24	16

Eighth Semester

ID	Visual Design	4	15	9
ID	Visual Workshop	1	9	4
Liberal Arts Elective		3	0	3
	Totals	8	24	16

Total Credit Hours: 137

Product Design Curriculum

Third Semester

ID	History of Art	3	0	3
ID	Basic Product Design	2	6	4
ID	Basic Planning	2	6	4
Math	Elementary Calculus	3	0	3
Phys	Physics	3	0	3
	Totals	13	12	17

Fourth Semester

ID	History of Art	3	0	3
ID	Basic Product Design	2	6	4
ID	Basic Planning	2	6	4
Mech	Mechanics	3	0	3
Phys	Physics	3	0	3
	Totals	13	12	17

Fifth Semester

BE	Principles of Economics I	3	0	3
ID	Product Design	2	15	7
ID	Music Appreciation	1	0	1
MAE	Production Methods	2	3	3
Mech	Mechanics	3	0	3
	Totals	11	18	17

Sixth Semester

BE	Principles of Economics II	3	0	3
ID	Product Design	3	15	8
ID	Music Appreciation	1	0	1
PS	American Const'l System	3	0	3
ST	Public Speaking	2	0	1
	Totals	12	15	16

Seventh Semester

ID	Product Design	4	15	9
ID	Product Workshop	1	9	4
Humanities Elective		3	0	3
	Totals	8	24	16

Eighth Semester

ID	Product Design	4	15	9
ID	Product Workshop	1	9	4
Liberal Arts Elective		3	0	3
	Totals	8	24	16

Total Credit Hours: 134

Photography Curriculum

(For 3rd and 4th semesters,
see curriculum synopsis for Visual Design)

Fifth Semester

BE	Principles of Economics	3	0	3
ID	Drawing & Color	1	6	3
ID	Photography	3	18	9
ID	Music Appreciation	1	0	1
ST	Public Speaking	2	0	1
	Totals	10	24	17

Sixth Semester

BE	Principles of Economics	3	0	3
ID	Photography	3	18	9
ID	Music Appreciation	1	0	1
PS	American Const'l System	3	0	3
	Totals	10	18	16

Seventh Semester

ID	Photography	4	15	9
ID	Photography Workshop	1	9	4
	Humanities Elective	3	0	3
	Totals	8	24	16

Eighth Semester

ID	Photography	4	15	9
ID	Photography Workshop	1	9	4
	Liberal Arts Elective	3	0	3
	Totals	8	24	16

Total Credit Hours: 137

Art Education Curriculum

Third Semester

ID	History of Art	3	0	3
ID	Basic Visual Design	2	9	5
ID	Methods of Photography	2	9	5
Phys	Physics	3	0	3
Psy	Introductory Psychology	3	0	3
	Totals	13	18	19

Fourth Semester

Educ	Educational Psychology	3	0	3
ID	History of Art	3	0	3
Educ	Instructional Materials	2	0	2
ID	Basic Visual Design	3	9	6
	Humanities Elective	3	0	3
	Totals	14	9	17

Fifth Semester

BE	Principles of Economics I	3	0	3
Educ	Meth. of Teaching Reading	2	0	2
ID	Drawing & Color	1	6	3
ID	Visual Design	2	15	7
ID	Music Appreciation	1	0	1
ST	Public Speaking	2	0	1
	Totals	11	21	17

Sixth Semester

BE	Principles of Economics II	3	0	3
ID	Visual Design	2	15	7
ID	Experimental Projects	1	3	2
ID	Music Appreciation	1	0	1
PS	American Const'l System	3	0	3
	Totals	10	18	16

Seventh Semester

Educ	History & Philosophy of Education	3	0	3
Educ	Guidance in Secondary Ed.	3	0	3
ID	Experimental Projects	1	3	2
ID	Visual Design	4	15	9
	Totals	11	18	17

Eighth Semester

Educ	Methods & Techniques of Teaching	2	0	2
Educ	Student Teaching	1	15	5
ID	Art Education Seminar	1	0	1
ID	Visual Design	3	12	7
	Totals	7	27	15

Total Credit Hours: 136

Graduate Study

The Institute of Design offers graduate instruction leading to the degrees of Master of Science in Product Design, Master of Science in Visual Design, Master of Science in Photography, and Master of Science in Art Education. . . .

Master of Science Degrees in Product Design / Visual Design / Photography:
The graduate programs in these areas offer qualified students opportunities for establishing higher standards of professional performance, for conducting study and research in new and creative discoveries in their special field of concentration, and for the investigation of significant directions for the future . . .

Master of Science in Art Education:
The graduate program in Art Education offers designer-educators opportunities to expand and to deepen their personal contacts with design materials, design concepts, and design theory; to experience at first hand the school's unique approaches to design content and teaching methodology; and to increase their professional competence in design and in teaching. . . .

The Institute of Design enjoys an international reputation as a major center of creative thought in its field. The institute traces its ancestry back to the "Bauhaus," founded in Germany between the two World Wars. The Bauhaus was one of the most significant forces in the creation of what we now generally call "modern design". . . .

Illustrations

Prehistory

Architecture

The collaboration of the visual arts in all creative tasks, under the aegis of architecture as advocated at the Bauhaus, was no longer to be taken for granted by the time Gropius published his first Bauhaus Manifesto. Not since the period of around 1800 had architecture been capable of keeping alive the bonds that had once united it with painting and sculpture, forming the larger context of the "total work of art" (Gesamtkunstwerk). The attempts during the nineteenth century to achieve a synthesis, previously arrived at by the arts in the medieval cathedral, for example, were governed by the rules of historicism. The architects' retrospective frame of mind—particularly of those who felt themselves to be "artists" and strove for some ultimate attainment—blocked the development of a new architectural form. Independent accomplishments originated in the fringe areas of the "art" of building: in functional construction and above all in engineering architecture. But their esthetic qualities were not taken seriously at that time. The forms conceived by the Utopian abstractions of French revolutionary architecture at the beginning of this period were discovered by modern architects to contain exciting inspirations for contemporary thinking. The regeneration that came about in the area of residence design was aided a great deal by the rediscovery of the functional attributes and the beauty of the indigenous farm house—especially in England and America. The elements of that farm house lent themselves as a base for a new conception. The arts and crafts movement with its call for quality craftsmanship also originated in England. The first indications of the new synthesis were evident at the time of the Art Nouveau. Gropius's early buildings, around 1910, manifested an architectural attitude which determined the development from then on.

a
Sir Joseph Paxton: design for the Crystal Palace in London. Built in 1850–1851.
This cast-iron and glass structure, the first pavilion for a Worlds Fair, was important not only as an achievement of engineering; it demonstrated a new understanding of space and a changed sense of form, despite the fact that the basic shape was faintly suggestive of the ancient Christian basilica. In the finished building, Paxton paid tribute to the desire of his time for historical and retrospective ornament by adding decorative trimmings.

a

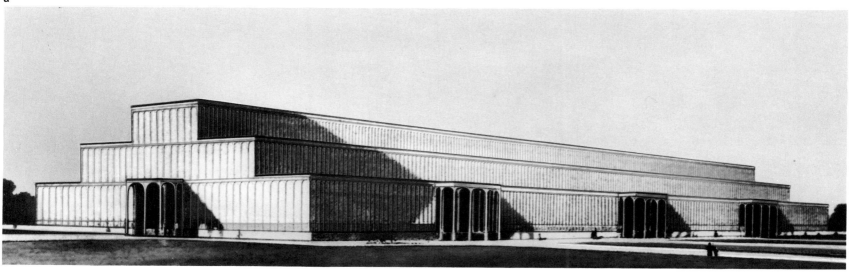

a
Etienne-Louis Boullée: design for a cenotaph for Newton. 1784.
Utopian architecture of the period of the French revolution: the units of which the building is composed have been reduced to basic stereometric elements. The architectonic quality, in the sense of a space-enveloping, abstract sculpture, attains near autonomy. The imagination of the revolutionary architects had, for the time being, hardly any influence on the technology of building.

b
Friedrich Schinkel: the Academy of Architecture in Berlin. Built in 1832–1835.
This represents a significant approach to functional architecture free of all esthetic ties to historical models.

c
Gottfried Semper: Federal Institute of Technology in Zurich. Built in 1860–1864.
Both the possibilities and the limitations of his period are more evident in Semper's work than in almost any one else's. A deep cleavage exists between his critical, even prophetic perceptions and his practice as an architect, in which he remains committed to the attitudes of historicism.

d
Hermann Eggert: middle section of the central railroad station in Frankfurt on Main. Opened for traffic in 1888.
Next to the *Galerie des Machines,* erected for the Paris World's Fair of 1889, this is probably the boldest of the large hall structures of the second half of the nineteenth century. It is engineering architecture, purely functional and developed from the requirements of a technical problem, incorporating a new esthetic impulse.

e
Louis Sullivan: Carson, Pirie, Scott department store, Chicago. Built in three stages: 1899, 1903–1904, and 1906.
This department store is the principal work of the Chicago School which since the eighteen seventies had set the standards for modern high-rise buildings. A new structural principle was developed from the skeleton construction, which was evident in both the three-dimensional organization and the design of the building façade.

f
Victor Horta: lobby in the *Ancien Hôtel Van Eetvelde,* Brussels. 1897–1899.
Art Nouveau architecture: the rampant floral ornaments and cast-iron and glass structure are characteristic for the merging of the decorative handicrafts with architectural conceptions, based on the accomplishments of engineering architecture.

g
Frank Lloyd Wright: Emma Martin House, Oak Park, Illinois. Built in 1901.
Wright emphasizes the "organic" element; he developed a country residential style which employed the vital elements of the American farm house, whereby accommodation to the climate and integration into the landscape were the primary considerations shaping his concept.

h
Charles Rennie Mackintosh: Windyhill House, Kilmacolm, Scotland. Erected in 1899–1901.
In England and Scotland at the end of the nineteenth century a growing awareness of the fundamentals of indigenous traditions led to the regeneration of country residential building. From the British Isles this movement spread to the Continent, above all to Central Europe.

a

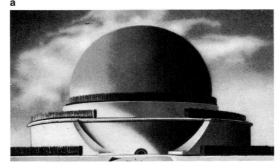

b

c

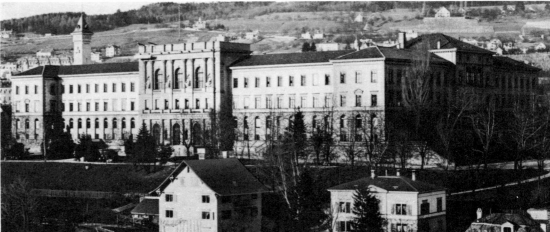

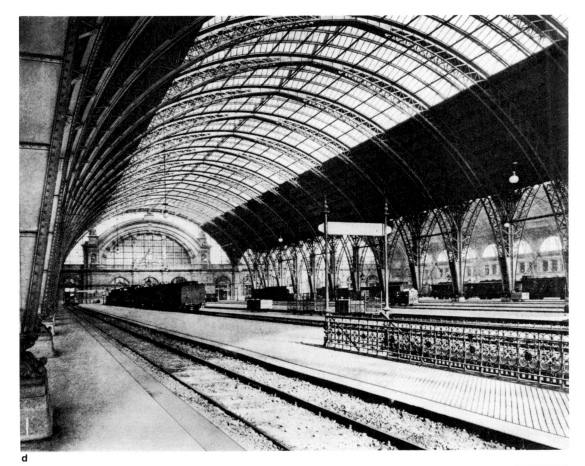

d

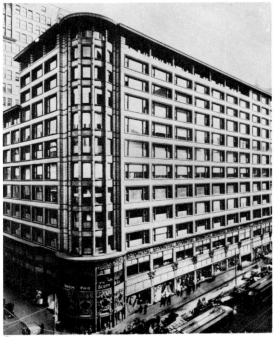

e

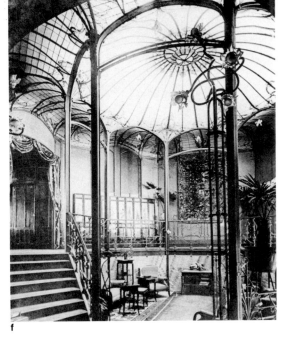

f

g

h

a

At the turn of the twentieth century Peter
Behrens (born in Hamburg in 1868, died in
Berlin in 1940) held a key position as architect
and designer of mass-produced industrial items.
He was working as a painter and book designer
in Munich before he was called to the Artists'
Colony in Darmstadt in 1899. Here he had the
opportunity to work in architecture and interior
design. From 1903 to 1907 he was Director of
the Arts and Crafts School in Düsseldorf. In
1907 he became artistic consultant to the A.E.G.
(General Electric Company, "Allgemeine Elek-
trizitätsgesellschaft") in Berlin. The functional
form of the home appliances designed by him
or under his supervision set the trend for such
appliances. His architectural designs, particu-
larly those for industrial buildings, distin-
guished themselves by the same consistency
of approach. Behrens helped greatly in re-
moving the prejudices against the "purely func-
tional" and in bringing about recognition of the
artistic possibilities which had first been opened
up by engineers. Gropius assisted him in his
architectural office in Berlin; Mies van der Rohe
and Le Corbusier also worked there. In 1922
Behrens took over the graduate school of archi-
tecture at the Academy in Vienna, and during
the last years of his life (from 1936 on) he headed
a master studio at the Prussian Academy of Arts
in Berlin.

a
Peter Behrens: turbine hall of the A.E.G. in Berlin.
1909.

b
Peter Behrens: assembly hall of the A.E.G. in Berlin.
1911–1912. Purely functional and yet deliberately
designed architecture with attention to esthetic con-
siderations.

c
The Artists' Colony on the Mathildenhöhe in Darm-
stadt. Begun in 1900. The center of this colony is
formed by the exhibition building, with the "wedding
tower" designed by Josef Maria Olbrich in 1907.
This colony represents a sweeping attempt at creating
a focal point for the city, uniting all the visual arts. The
work, which had been finished by 1901, was publicized
in an exhibition that had great significance for that
period. Originally the "Ernst-Ludwig House" was to be
the crowning final work of the project which Olbrich in
1900 outlined in these words: "On top of the brow of
the hill shall rise the 'House of Labor'; there, as in a
temple, labor is intended to be a divine service . . . On
the sloping terrain: the residences of the artists, a
peaceful place to which one descends from the Tem-
ple of Diligence after a day's busy work, in order to ex-
change the artist for the man"

d
Bruno Taut: "The great church." Drawing from "The
Dissolution of Cities," a programmatical pamphlet
published by the Folkwang Press of Hagen in 1920.
Utopia of an existence hallowed by labor and the high-
est of ethical standards, finding sacred expression in
the total work of art.

e
Bruno Taut: "Glass House" at the exhibition of the
German Werkbund in Cologne. 1914.
Taut strives for an absolute form. The use of glass is
symbolic—dematerialized matter—standing for the
concept of purity and perfection.

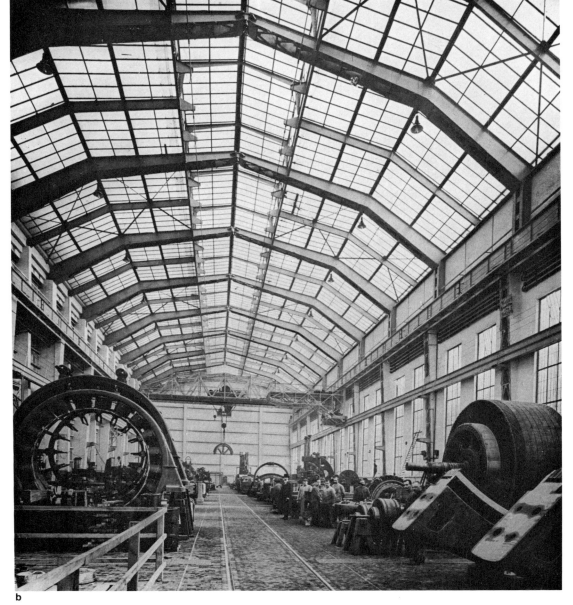

b

226

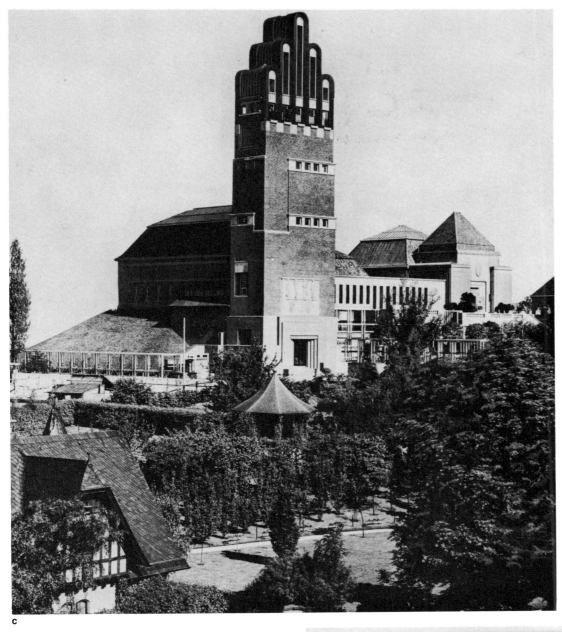

c

Die grosse KIRCHE
 mit exzentrischem Turm.
Gebet u. wachsendes Empfangen

Dank der Gemeinschaften
 im Auftürmen von Hallen
 zu einer grossen vielgliedrigen
 von Generation
 zu Generation

d

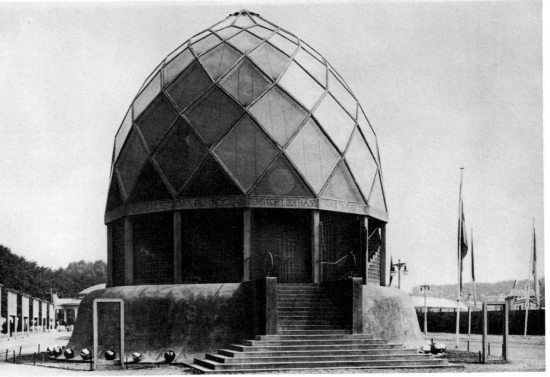

e

a

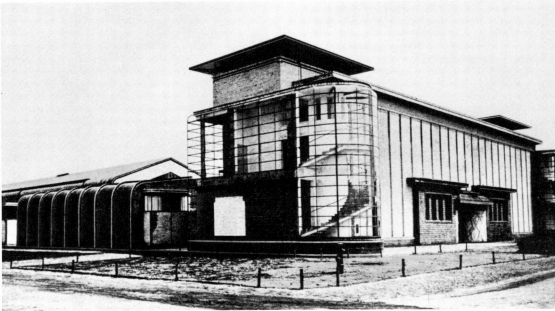

b

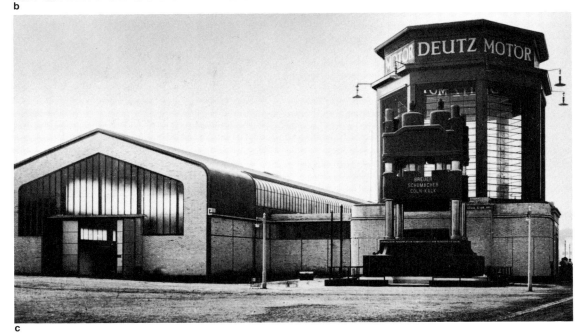

c

Part of the reason for the attention of those interested in cultural activities around 1910 being focused on Walter Gropius—at the time when, after several years of work with Behrens, he had opened his own architectural studio in Berlin—was his active participation in the German Werkbund. In this organization debates centering on matters of principles concerning the problems of quality craftsmanship and industrial mass production (which most of its members took to be antithetical), Gropius emphasized that the possible solution lay in creative synthesis. The fact that esthetic creativity and industrial production methods were by no means mutually exclusive had at that time also been elucidated by him in a memorandum. This same mental attitude, confirming technology and its media, is demonstrated in his buildings. The walls of the Alfeld Faguswerk and the stairwell of the "Office Building" at the Cologne Werkbund Exhibition are largely transparent, making the three-dimensional compartments, usually only separated by glass—interior and exterior space—in effect unite with each other and, from changing points of view, join with each other in new spatial units. These buildings received wide attention even at the time of their construction. Less than about four decades after its erection, the Faguswerk was designated for landmark preservation in recognition of its significance in architectural history.

a
Walter Gropius (with Adolf Meyer): Faguswerk in Alfeld-on-the-Leine. 1911.
Factory for the production of shoe lasts; main wing with workrooms. Cantilevered skeleton structure.
b
Walter Gropius (with Adolf Meyer): "Office Building" at the exhibition of the German Werkbund in Cologne. 1914.
c
Walter Gropius (with Adolf Meyer): "Machine Hall" at the exhibition of the German Werkbund in Cologne. 1914.
These two buildings at Cologne were examples especially erected for the exhibition; they were torn down afterwards.

Staatliches Bauhaus Weimar 1919–1925

Weimar, as a center of intellectual and cultural
activities, bore the stamp of the Reformation, of
Goethe, Liszt, and Nietzsche; until 1918 it was
the capital of the Grand Duchy of Saxony-Wei-
mar-Eisenach, in 1919 the seat of the German
National Assembly, and from 1920 on it was the
capital of the state of Thuringia. The cultural life
of the town was characterized by a kind of retro-
spective tranquility. At the time it housed the
Bauhaus, Weimar had about 30,000 inhabitants.
a
Weimar, map of the city at the beginning of the nine-
teen twenties.
The numbers written into the plan signify the follow-
ing:
 1 Bauhaus, main building (formerly seat of the
 Grand-Ducal Academy of Art)
 2 Bauhaus, workshop building (former Arts and
 Crafts school)
 3 "Tempelherrenhaus" (Itten's residence)
 4 "Reithaus" (Albers' workshop instruction)
 5 Goethe's summer house
 6 "Am Horn" (Bauhaus experimental house)
 7 Upper Weimar
 8 Belvedere Castle
 9 Goethe House at the "Frauenplan"
 10 Market square
 11 "Neues Schloss"
 12 Museum square and Landesmuseum
 13 Main railroad station
b
The Neues Schloss (new castle), built in the seven-
teenth century, was altered after a fire in 1774 and en-
larged in 1803 under the supervision of Goethe. In the
foreground are remnants of the Renaissance building
dating from the middle of the sixteenth century. The
museum (which is quite significant) in the castle has
added a collection of Bauhaus products.
c
The market square, center of communal life, including
the house in which Lucas Cranach lived from 1552 to
1553.
d
Museum square and Landesmuseum. Here, in connec-
tion with the big Bauhaus exhibition in the summer of
1923, were shown the works of art by the Masters and
students.
e
The Belvedere castle near Weimar, built between 1724
and 1732, was a favorite site for Bauhaus student ex-
cursions.

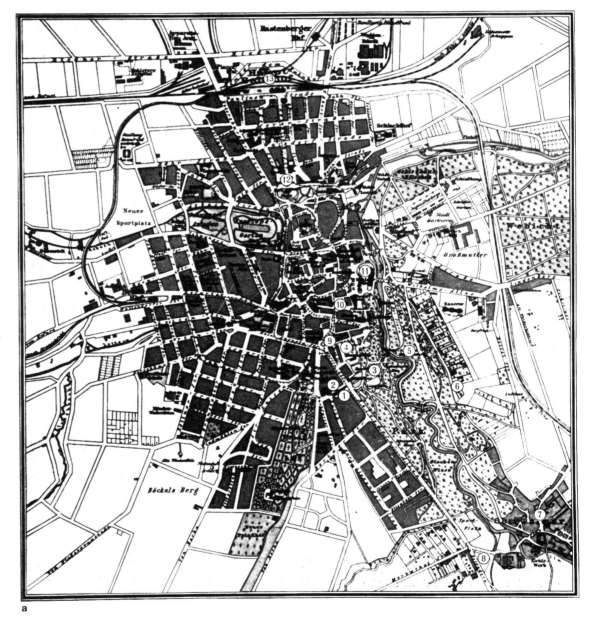
a

c

d

e

b

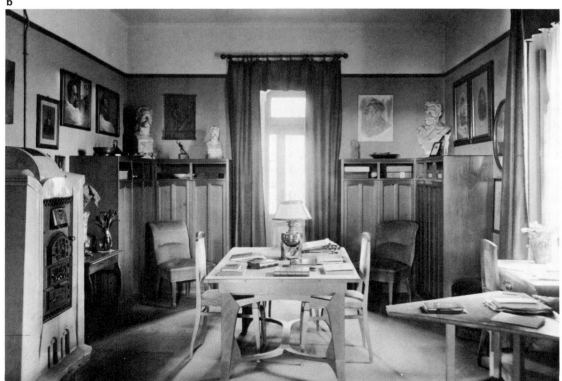

a
Goethe's summer house stands on the edge of the
Weimar park, close to where the small river Ilm winds
through the park. Not far from this site, in a street
called "am Horn," the Bauhaus constructed its first
experimental house. The way from the Bauhaus to
Paul Klee's home also led past Goethe's summer house.
b
Nietzsche Archive, with furniture designed by Henry
van de Velde. Friedrich Nietzsche spent his last years
in Weimar. The archive, under the direction of his sis-
ter Elisabeth Foerster-Nietzsche, hardly functioned in
the sense of his philosophic concepts, however.
c
The Tempelherrenhaus situated in the upper part of
the park near the river Ilm, was an architectural curi-
osity which reflected the sentimental historicism of the
Goethe period. It was only a few minutes' walk from
the Bauhaus. This Tempelherrenhaus was Itten's
house and was the meeting place for his preliminary
course. The level roof was often used by members of
the Bauhaus for sun-bathing, to the dismay of the
Weimar citizenry.
d
Henry van de Velde (born in Antwerp in 1863, died in
Zurich in 1957) was one of the strongest exponents of
Art Nouveau as architect, designer, and writer on mat-
ters concerning art. In 1901 he was called to Weimar
as art consultant to the Grand Duke. He founded the
Grand-Ducal School of Arts and Crafts in 1906.
In this school he tried to implement new educational
principles, an attempt for which he was vehemently
attacked by the inhabitants of Weimar. He left Weimar
in 1915, for after the beginning of the war his position
in Germany—van de Velde being Belgian—was in
jeopardy.
e
The Bauhaus had its administrative offices, class-
rooms, and studios in the building of the former
Grand-Ducal Saxon Academy of Art. The former Acad-
emy professors who had seceded from the Bauhaus
after Gropius had taken them over from the old school
into the Institute in 1919, established a new "Academy
of Art" in the right wing of the building; they rivaled
the Bauhaus on the question of legal succession. The
two antagonistic schools worked in the same building,
in adjacent rooms, until 1925.
f
The building of the former Grand-Ducal School of
Arts and Crafts, like that of the Academy of Art, was
designed by Henry van de Velde in 1904. It was situ-
ated on a quiet street across from the Academy. It was
here that the Bauhaus workshops were set up. The
staircase was decorated with murals and reliefs by
Schlemmer in 1923; these the National Socialists de-
molished as early as 1930.

e

f

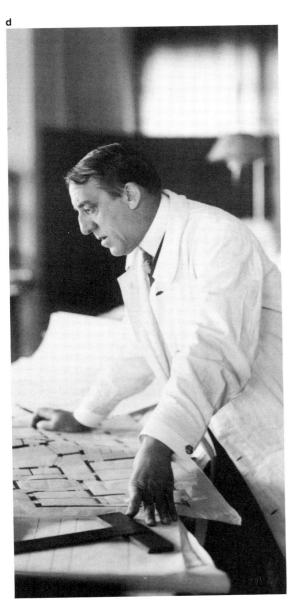

d

Professors of the Weimar Art Academy

a
Walther Klemm (born in Karlsbad in 1883, died in Weimar in 1957) was appointed to the Grand-Ducal Saxon Academy of Art in 1913 as head of the graphics department after he had completed his studies at the Vienna Arts and Crafts School and had worked in the artists' colony at Dachau for some years. He played a considerable part in the reform plans of 1918. At the Staatliche Bauhaus, the academy's successor institution, he was a Master from 1919 until the re-establishment of that academy (in 1921). He was one of the last of the old academy professors to secede from the Bauhaus, and he continued to keep in friendly contact with some of the masters—especially with Feininger.

b
Professors of the Academy of Art, founded in 1921 and competing with the Bauhaus: (left to right) Walther Klemm, Richard Engelmann, Martin Krause, Alexander Olbricht, and Hugo Gugg.

c
Richard Engelmann (born in Bayreuth in 1868, died in 1966 in Kirchzarten in the Breisgau) studied in Munich, Florence, and Paris and did free-lance work in Berlin. In 1913 he was appointed professor of sculpture at the Grand-Ducal Saxon Academy of Art. He was one of the initiators of the reform plans which eventually lead to Gropius's appointment. Like Klemm, he joined the secession of the old professors from the Bauhaus, at which he had been a Master, only after long hesitation. Until 1930 he taught at the academy which was established in 1921 in competition to the Bauhaus.

d
Walther Klemm: "Wieland Square in Weimar." Woodcut. Klemm was a brilliant illustrator. Wieland Square, situated between the academy building and the center of town, was part of the scenery Bauhaus members saw every day.

e
Richard Engelmann: Wildenbruch monument in Weimar. Bronze, 1913.

b

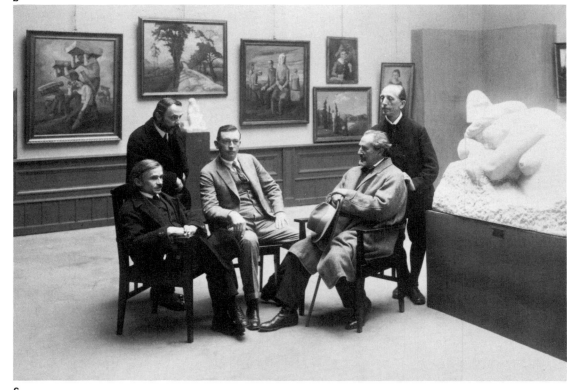

a

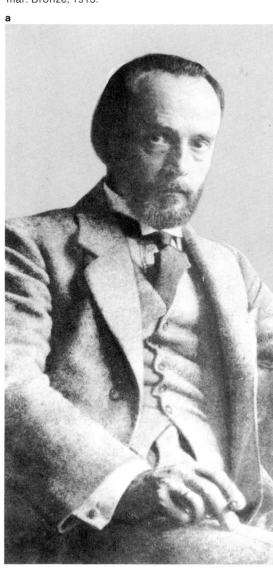

c

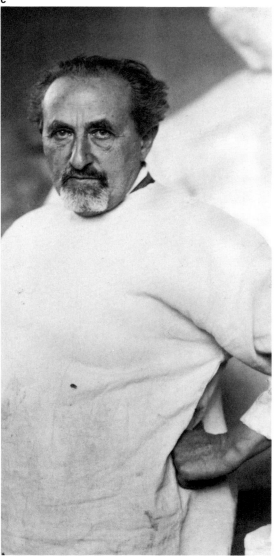

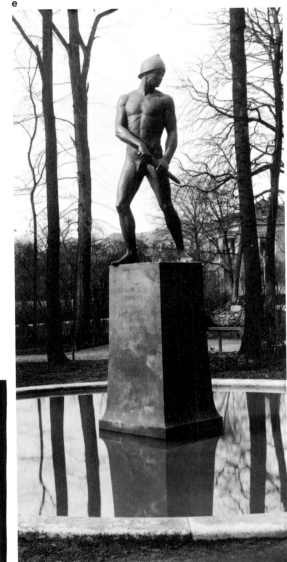

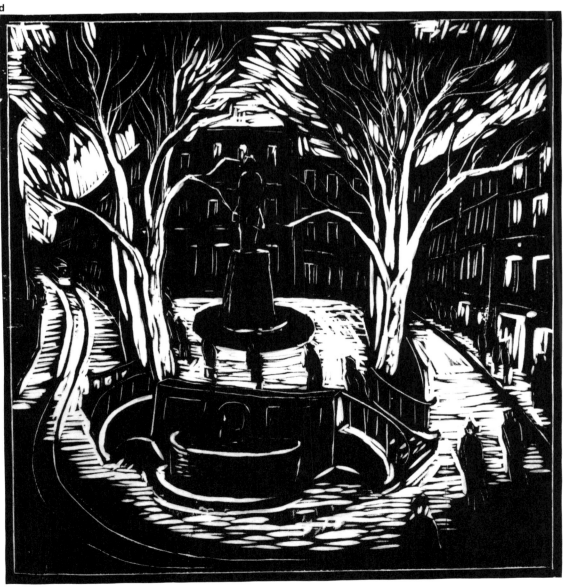

235

a

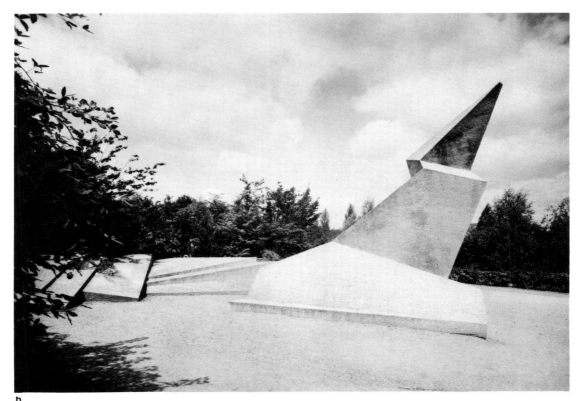

b

Walter Gropius

Biographical notes: born in Berlin on May 18,
1883. Studied architecture at the Institutes of
Technology in Berlin-Charlottenburg and Mu-
nich from 1903 to 1907. During the years follow-
ing he was an assistant in the office of Peter
Behrens in Berlin. In 1910 he opened his own
architectural studio in that city and constructed
his first major buildings (among them the Fagus-
werk). Called to Weimar in 1919 and founded
the Bauhaus. In 1925 the Bauhaus was moved to
Dessau; in 1928 Gropius resigned his director-
ship and returned to Berlin to practice architec-
ture. First trip to the United States. In 1929 the
Institute of Technology in Hannover conferred
on him an honorary doctor's degree in engineer-
ing. In 1934 emigration and work in London until
1937 (in partnership with Maxwell Fry). Ap-
pointed to the Graduate School of Design, Har-
vard University, Cambridge, Massachusetts.
From 1938 until 1952 chairman of the Architec-
ture Department at Harvard. Now living in South
Lincoln, Massachusetts. At first, Gropius con-
ducted his private architectural office in the
United States with Marcel Breuer. In 1946 he
founded the "The Architects' Collaborative," a
team of architects with whom he has executed a
number of gigantic design commissions since
the late nineteen fifties—the over-all concept for
the University of Baghdad, the American Em-
bassy in Athens, "Grand Central City" in New
York. Gropius has received highest honors and
awards all over the world.

a
Walter Gropius in Weimar, 1920
b
Walter Gropius: monument for the "March Heroes" in
Weimar. Concrete. 1921. (Memorial to the casualties of
the revolution of March 1848.)
The only sculpture designed by Gropius. It was torn
down during the Hitler period and reconstructed after
1945.

a

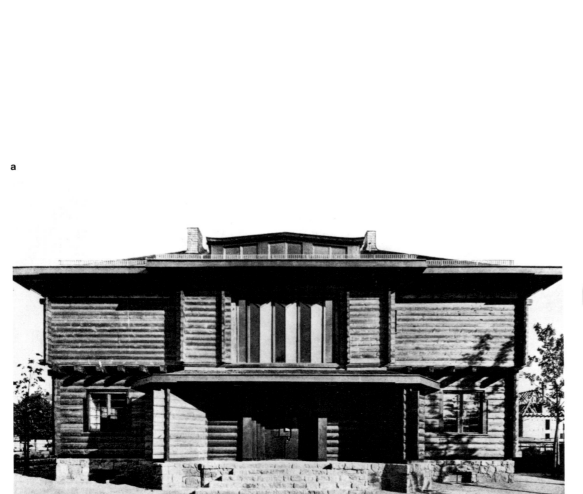

c

b

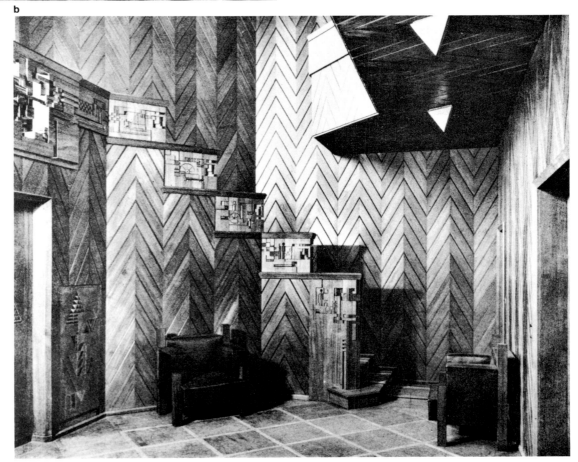

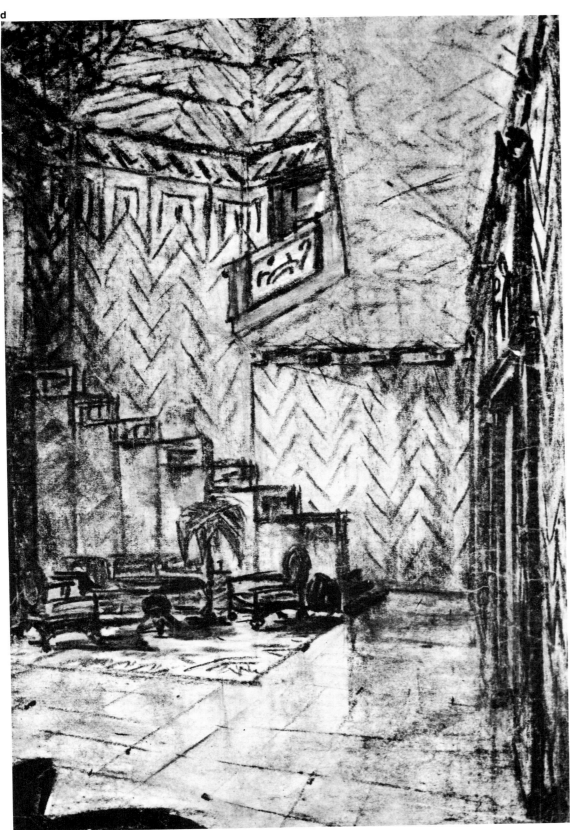

d

W. Gropius and A. Meyer

a
Gropius and Meyer: Sommerfeld House in Berlin-Dahlem. 1921.
Front view. The client, a friend of Gropius', deserves high credit as patron of the Bauhaus.

b
Gropius, Meyer, and the Bauhaus workshops: vestibule and staircase in Sommerfeld House, Berlin-Dahlem. 1921.
The fact that an ample supply of teak—a stroke of good luck in those days—was available for the interior design of the house provided the sculpture workshop of the Bauhaus with a chance to contribute carvings. The sculptural work was primarily carried out by Joost Schmidt.

c
Adolf Meyer (born in Mechernich/Eifel on June 17, 1881, drowned near the island of Baltrum on July 24, 1929) was Gropius's closest collaborator until 1925; between 1911 and 1914 and from the fall of 1919 until the dissolution of the Weimar Bauhaus, the two architects worked as a team. Following his studies at the Düsseldorf Arts and Crafts School, Meyer was employed in the office of Peter Behrens (1907–1908) and that of Bruno Paul (1919–1910) in Berlin. From 1925 on, when he separated from Gropius, until his death, he directed the consulting office for city planning in Frankfurt on Main and the architecture class at the art school there. At Weimar he gave some lectures at the Bauhaus, where he was a part-time teacher; as a practical man his comments on architectural problems were always valued.

d
Gropius and Meyer together with Carl Fieger: design for the vestibule and staircase of Sommerfeld House, Berlin-Dahlem. 1921.
The design was drawn in Gropius's private architectural studio by the architect Carl Fieger according to directions given by Gropius and Meyer: an example of productive collaboration guided by the idea of a working community in which each participant shares in the common task by contributing according to his individual talents. In his own studio Gropius always practiced this principle of collaboration, which was very important to the Bauhaus.

Walter Gropius: office of the Director in the Weimar Bauhaus. 1923.
The furniture in this office was designed by Gropius and built by the cabinetmaking workshop of the Bauhaus. The Constructivist lamp was also designed by him, and used standard available fluorescent tubes. Both the tapestry and the rug were made in the Bauhaus weaving workshop.

b

Walter Gropius: table; its meandering form allows magazines to be placed on many levels. Cherry with plate-glass top.
Built in the Bauhaus cabinetmaking workshop. 1923. Bauhaus-Archiv, Darmstadt.
What little furniture Gropius designed dates mainly from the Weimar period. For the magazine table Gropius hit upon a form of classical simplicity.

c

Gropius and Meyer: municipal theater in Jena. Main entrance. Alteration of an existing building. 1923.
In view of the financial difficulties which handicapped some important building projects during the period of inflation, every project that offered a chance to demonstrate the attitude of the new architecture became significant. In this case, the clarity of the design with planes, the spatial concept, and the precise arrangement of cubes were the chief concern.

d

Gropius and Meyer: Auerbach House in Jena. 1924.
Determinant factors were living requirements (desire for adequate light and a clear spatial arrangement) and economic considerations.

e

Gropius (with Meyer): "Baukasten im Grossen" (large version of children's building blocks). Models for prefabricated houses. 1923.
The concept of the "children's building blocks" illustrates ideas which Gropius had already dealt with in his manifesto on standardization and the application of industrial methods to housing construction in 1910. Gropius comments: "Variability of the same basic type by alternating addition and removal of repeating room units. Basic idea: uniting greatest possible degree of standardization with greatest possible amount of variation." The aim is to attain considerable savings in construction costs and at the same time to preserve the opportunity for producing individual designs.

b

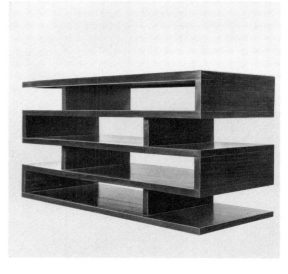

a

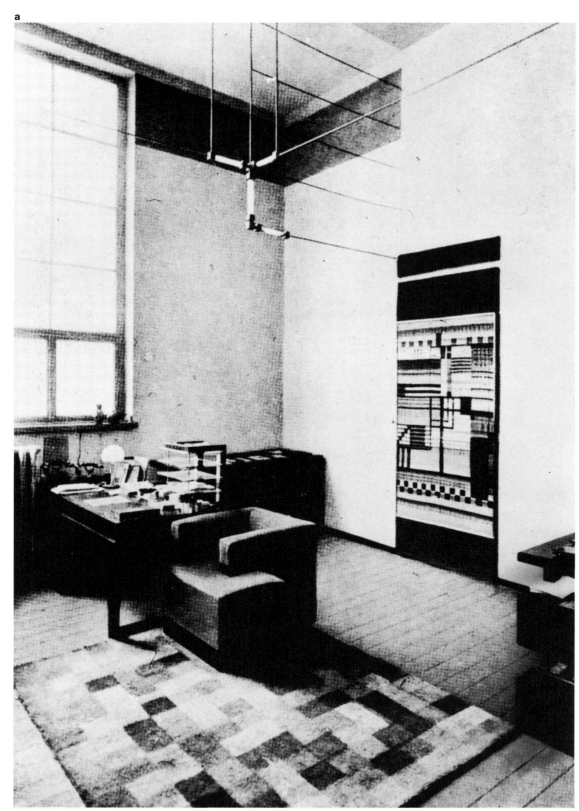

c

d

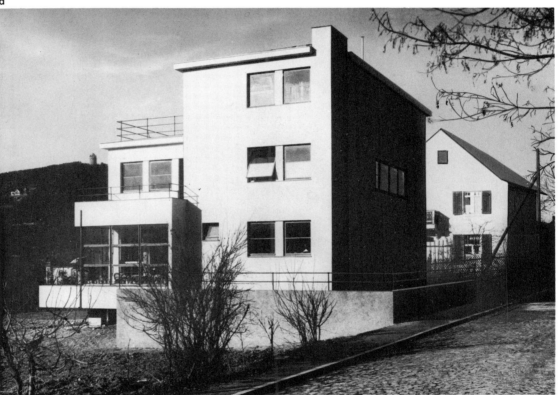

e

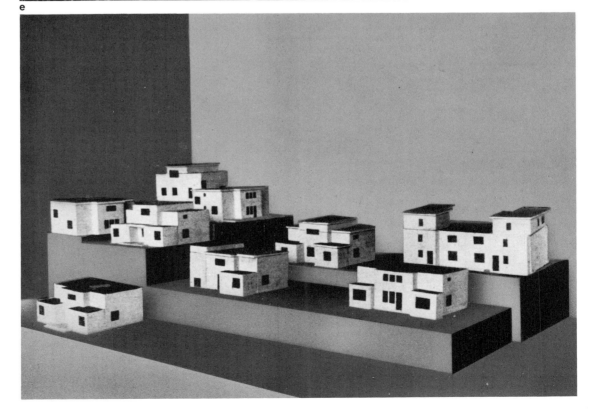

a

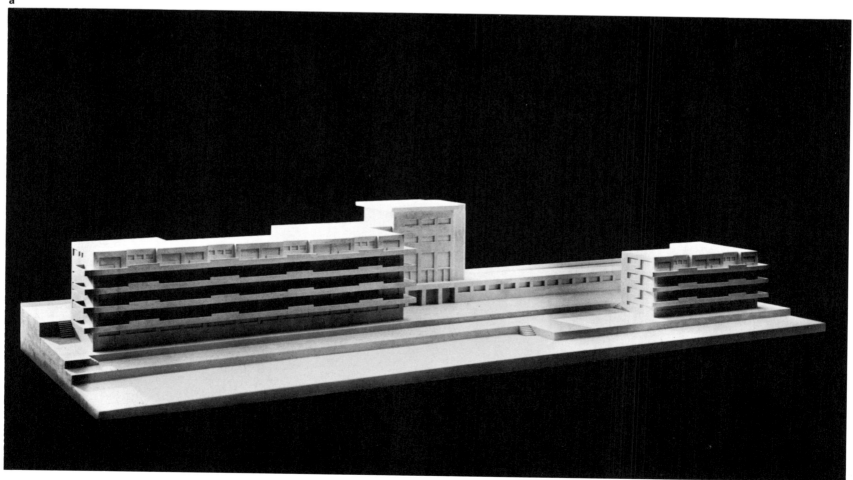

242

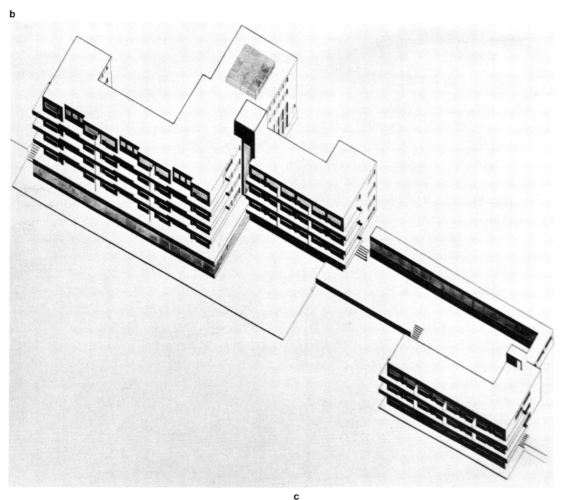

b

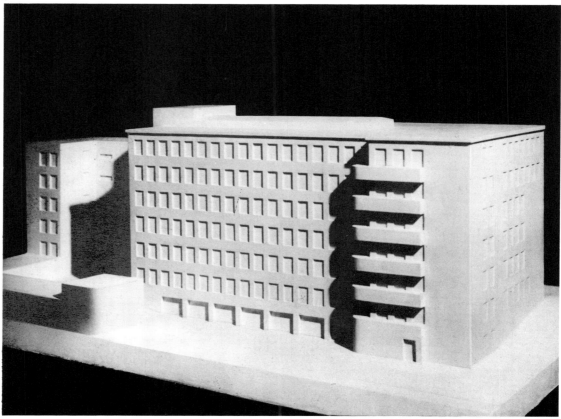

c

243

a

Lyonel Feininger

Biographical notes: born in New York City on
July 17, 1871, died there on January 13, 1956.
Like his parents, who were German immigrants,
Lyonel Feininger had considerable musical
talent, and he went to Germany in 1887 to study
music. But he decided to study painting instead.
He received his training at the Hamburg Arts
and Crafts School, at the Berlin Academy, and
at a private school in Paris. From the eighteen
nineties on he worked as a cartoonist in Berlin
and occasionally in Paris. In 1913 he was asked
by the "Blaue Reiter" to join them in the "First
German Autumn Salon" which was arranged by
Herwarth Walden in Berlin. Gropius appointed
him to the Bauhaus immediately following the
founding of the Institute in Weimar. One of his
special duties was to head the printing work-
shop. Feininger, the man and the artist, was
one of the great individuals at the Bauhaus. He
joined his friends in Dessau but did not teach
there. During those years he did a series of
magnificent paintings of architectural subjects
in Halle on the Saale. After he had been forced
to leave his "Master house" in Dessau in 1933,
he stayed in Germany for a while longer. In
1936 he traveled to the United States and re-
turned there for good in 1937.

a
Lyonel Feininger during the Bauhaus years.
b
Lyonel Feininger: "Markwippach II." Pen-and-ink
drawing; dated Thursday, March 23, 1919.

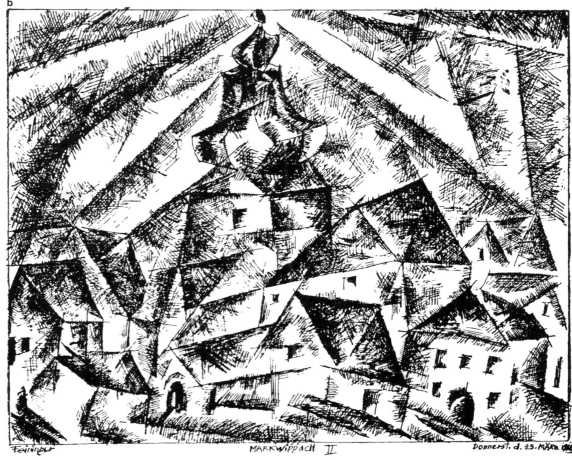

245

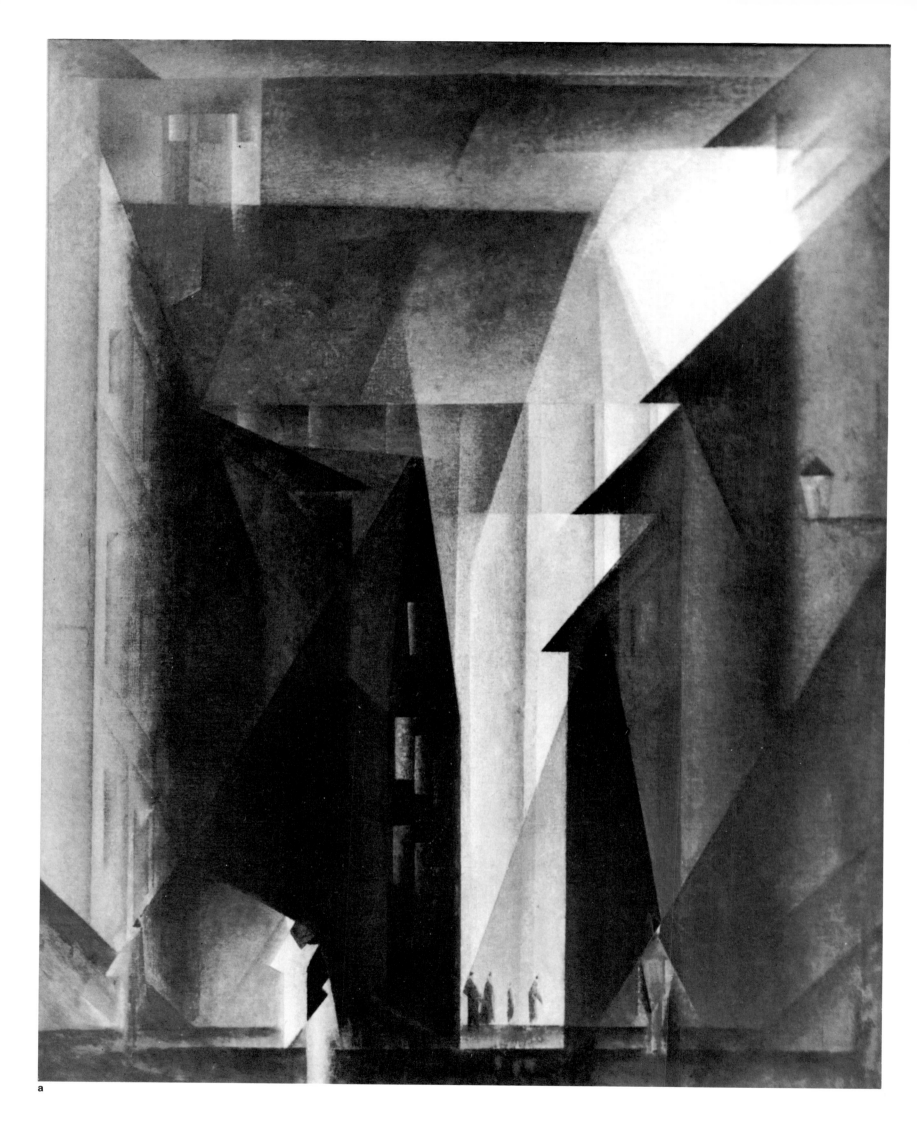

a

a
Lyonel Feininger: "Barfüsserkirche I." Oil on canvas.
1924.
Collection of Dr. Ferdinand Ziersch, Wuppertal.
This is one of the magnificent paintings of architec-
tural subjects that were inspired by Feininger's visits
to the medieval towns in Thuringia. The subject of
this painting is the Gothic "Barfüsserkirche" in Erfurt.
b
Lyonel Feininger: toy train and Thuringian village,
carved in wood. About 1920–1925. On loan in the
Bauhaus-Archiv, Darmstadt. In both Weimar and
Dessau, Feininger often carved toys for his own chil-
dren and for those of his friends. In this rendering of
the old interlocking half-timber houses he made vari-
ations by three-dimensional means of the same sub-
jects that inspired him in numerous drawings and
paintings. The unusual shapes of the train are appar-
ently based on impressions during his own childhood
in America.

b

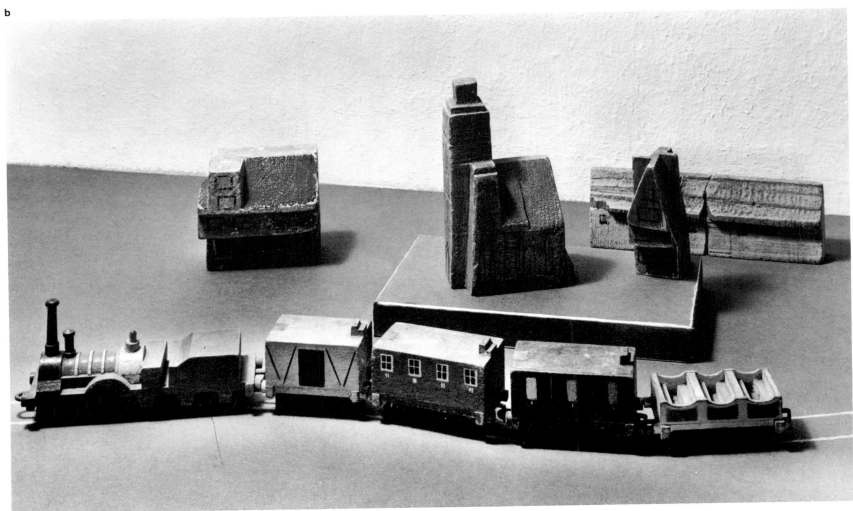

a

b

Gerhard Marcks

Biographical notes: born in Berlin on February
18, 1889, now living in Cologne. Marcks studied
under the sculptors Gaul, Kolbe, and Scheibe.
He was in contact with Gropius prior to World
War I; together with Scheibe he contributed
some terracotta reliefs to the "Diele" (vestibule)
at the Cologne Werkbund Exhibition of 1914,
which Gropius had decorated. With Feininger
and Itten he was among the first Masters ap-
pointed by Gropius to the Bauhaus in 1919. He
was given responsibility for the artistic leader-
ship of the pottery workshop which was located
in Dornburg on the Saale, a small town rich in
traditions, approximately 20 miles from Weimar.
In much of his work he was influenced by the old
art of pottery and by folklore in general. As a
sculptor he searched for a contemporary equiv-
alent to the austere composition of forms of the
archaic period. Marcks did not follow the Bau-
haus to Dessau. In 1925 he was called to teach
at the Art School in Halle-Giebichenstein of
which he was made Director in 1928. In 1933
he was dismissed and retreated to the town
of Ahrenshoop on the Baltic. Denounced as a
"degenerate" artist, he was barred from public
activity and, after 1937, from exhibiting in Ger-
many. From 1946 to 1950 he was professor at
the State Art School in Hamburg. He moved to
Cologne in 1950. Marcks has traveled exten-
sively and has distinguished himself in large,
international competitions, particularly during
his later years.

a
Gerhard Marcks during the Bauhaus years.
b
Gerhard Marcks: "Thuringian Mother." Relief sculp-
ture, Maple. 1921. Griesbach Collection, Zurich. This
figure is characteristic for the Dornburg period of
Marcks's work which reflected an intensive struggle
with tradition.

a

b

a
Gerhard Marcks: portrait of Johannes Driesch on a vase made by Theodor Bogler. Painted on fired clay. Dated 1922.
b
Portrait of Otto Lindig on the same vase (pendant). Bauhaus-Archiv, Darmstadt. Driesch, Lindig, and Bogler were journeymen in the Bauhaus pottery workshop. Marcks seldom formed pots and other ceramic articles for everyday use himself; he preferred adding decorations to the pottery work done by the master craftsman Krehan and the Bauhaus journeymen, which at times were very amusing and always imaginative.
c
Gerhard Marcks: "Lovers." Glazed ceramic. About 1923. Busch-Reisinger Museum of Germanic Culture, Cambridge, Massachusetts. Marcks occasionally used the pottery materials and the tools of the pottery workshop of the Bauhaus for his sculptures.
d
Gerhard Marcks: "Cat and Horse." Woodcut, printed in the printing shop of the Bauhaus. 1921.
e
Gerhard Marcks: "Nidudr's sons." This is number seven of a portfolio on the "Wielandslied" comprising ten woodcuts. It was printed and bound in the workshops of the Bauhaus and was published by the Bauhaus Press in 1923. Bauhaus-Archiv, Darmstadt. Marcks found that woodcuts were also a suitable medium for the expression of his ideas. Graphic art was among his foremost achievements, especially during his Bauhaus years.

c

e

d

b

Johannes Itten

Biographical notes: born in Südern-Linden in the Bernese Oberland on November 11, 1888, died March 25, 1967, in Zurich. Itten was at first a primary-school teacher. He studied for one semester at the *Ecole des Beaux Arts* in Geneva. After completing university studies in mathematics and science, he decided to take up painting in 1912. He had seen works of the Blaue Reiter in Munich and of the Cubists in Paris. The development of his extraordinary pedagogical capabilities in the field of art was fostered, above all, by Adolf Hölzel in Stuttgart, and by Ida Kerkovius, who introduced him to Hölzel's teaching. This was in the years between 1913 and 1916. Here, he met Schlemmer and Baumeister. In 1915 he did his first nonrepresentational paintings, and in 1916 he exhibited in the Berlin art gallery "Sturm." He spent the years from 1916 to 1919 in Vienna where he opened his own private school, the "Itten School." While teaching, he discovered "the significance of automatism in the artistic process." His elementary instruction included studies of form and color contrasts and compositions with textures. His acquaintance with Gropius was established through Alma Mahler (who at the time was married to Gropius). In 1919 he was appointed to the Bauhaus where he introduced his educational principles. It was primarily due to Itten's initiative that Muche, Schlemmer, Klee, and Kandinsky were called to the Bauhaus. From 1923 to 1926 he was in Zurich and from 1926 to 1931 he directed his own art school in Berlin. From 1932 to 1938 he was at the technical school for textiles in Krefeld. After doing some work in Amsterdam, he moved to Zurich. There Itten directed the Arts and Crafts School and the Museum for Arts and Crafts until 1953; also, from 1943 until his retirement, he headed the technical school for textiles and the Rietbergmuseum. Since 1953 until his death he was primarily concerned with painting and theoretical problems.

a
Johannes Itten in the Bauhaus costume he designed. 1921.
b
Johannes Itten: "Saint." Water color. 1917.

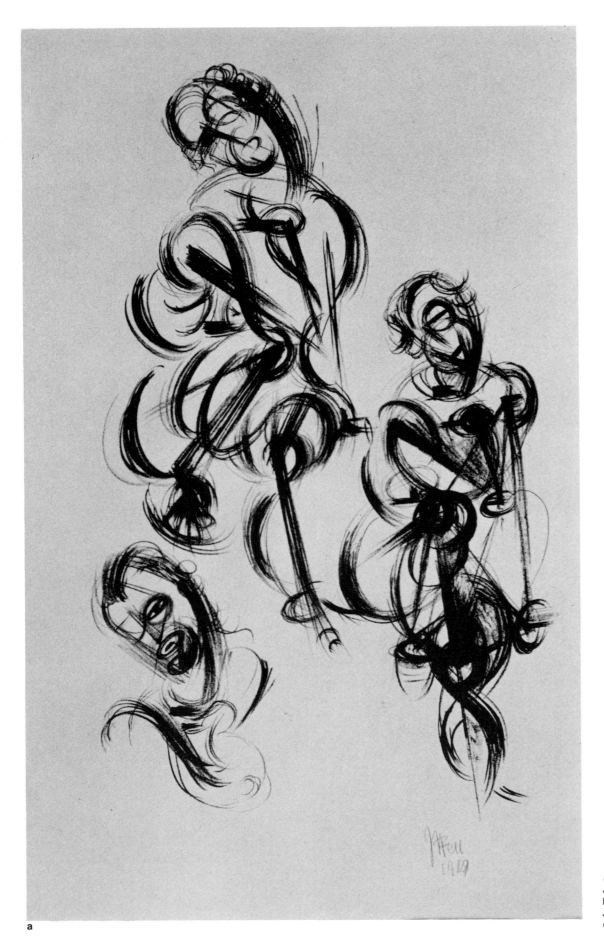

a

a
Johannes Itten: Lithograph with a figural theme. 1919.
b
Johannes Itten: ''Tower of Fire.'' Model, wood and colored glass. Height 142''. 1922. Destroyed.

b

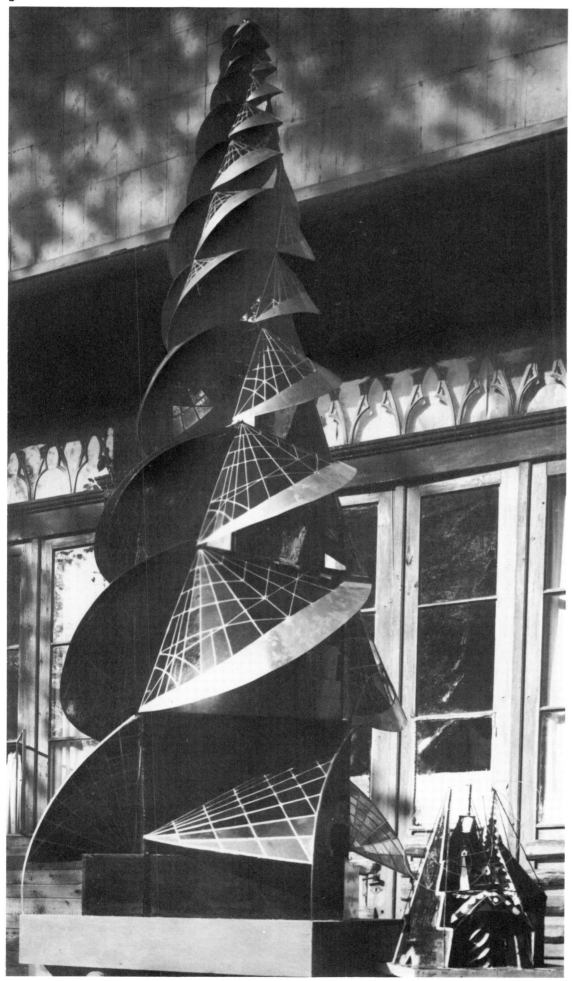

a

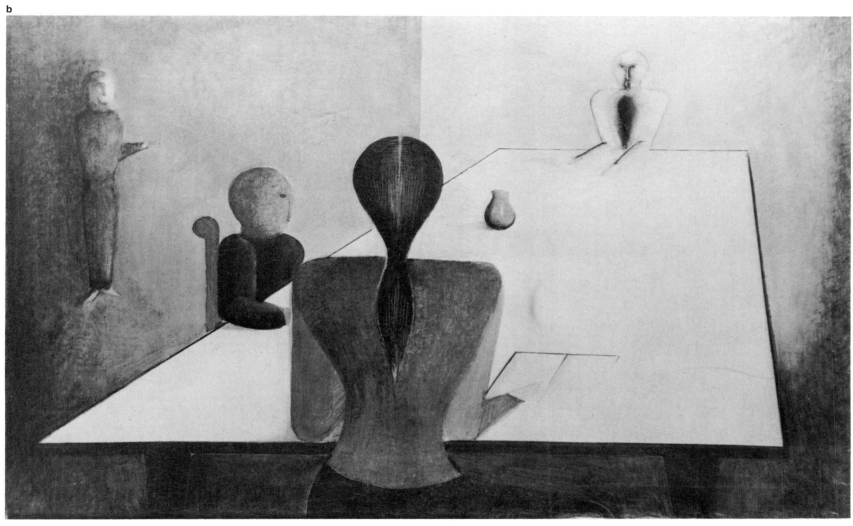

Oskar Schlemmer

Biographical notes: born in Stuttgart on September 4, 1888, died in Baden-Baden on April 13, 1943. During his studies at the Stuttgart Academy, Schlemmer received his decisive inspirations from Adolf Hölzel. In 1914 he volunteered for military service. From 1920 to 1929 he taught at the Bauhaus. During the Weimar period he led the sculpture workshop as form master and from 1923 on also the Bauhaus stage, which he continued to direct at Dessau. He accepted an appointment to the Breslau Academy in 1929 and between 1932 and 1933 taught at the combined state schools in Berlin-Charlottenburg. Following his dismissal from the teaching profession, which had been decreed by the National Socialists, he was forced to take odd jobs in order to manage; he spent the greater part of these years in his native region of southern Germany (Eichberg in the Black Forest, Stuttgart, and Sehringen in Baden) as well as in Wuppertal-Elberfeld. There the lacquer manufacturer Dr. Herberts offered him refuge and work in his firm—just as he had done for Muche and Baumeister. Toward the end of his life Schlemmer was very ill.

a
Oskar Schlemmer during his Bauhaus years.
b
Oskar Schlemmer: ''Company for Dinner.'' Oil on canvas. 1923.
Ströher Collection, Darmstadt.
The definition of the relationship between the human figure and space was Schlemmer's chief artistic problem. The resulting esthetic questions were not resolved in his paintings alone but were also the subject of his occasional experiments with sculpture and, most of all, of his choreography. Schlemmer was an outstanding dancer: he himself performed in his dance compositions, for which the ''Triadic Ballet,'' developed before he joined the Bauhaus, was the basis.

a
Oskar Schlemmer: "Dancer." Oil and tempera on
canvas. 1922–1923.
Collection Mrs. Tut Schlemmer, Stuttgart.
b
Oskar Schlemmer: "Abstract Figure" ("Free-standing
sculpture G"). Plaster. 1921.
Collection Mrs. Tut Schlemmer, Stuttgart.
Front view.
c
Side view.
d
Back view.

a

b

c

d

a

Georg Muche

Biographical notes: born in Querfurt on May 8, 1895, and now living in Lindau-Bad Schachen on Lake Constance. He grew up in the region of the Rhön. From 1913 to 1915 Muche studied painting in Munich and Berlin, where he established contact with Herwarth Walden. He exhibited in the art gallery "Sturm" beginning in 1916, alone or together with other artists (Max Ernst, Paul Klee, Archipenko); from 1917 up to the time of his appointment to the Bauhaus in 1920, he taught at the "Sturm" art school. At the Bauhaus he led the weaving workshop as form master. In 1924 he traveled to America for educational purposes. He went to Berlin in 1927, accepting an appointment to Itten's private art school. The Breslau Academy appointed him professor in 1931. After 1933, when he was dismissed from his teaching post, he spent the larger part of his time studying fresco techniques in Berlin. In 1942 he worked at Dr. Herberts' "Institute for the Study of Painting Materials" in Wuppertal-Elberfeld, together with Schlemmer and Baumeister. Before that time, in 1939, he had been appointed head of the master class for textile art at the Textile Engineering School in Krefeld. He held that position until his retirement in 1959. Muche also distinguished himself as an architect (experimental house in Weimar and the steel house in Dessau-Törten) and, especially during the later years, wrote on theoretical art subjects.

a
Georg Muche in Weimar. About 1921.
b
Georg Muche: "Picture with hovering red." Oil on canvas. 1920.
Collection Hans Jammers, Krefeld.

b

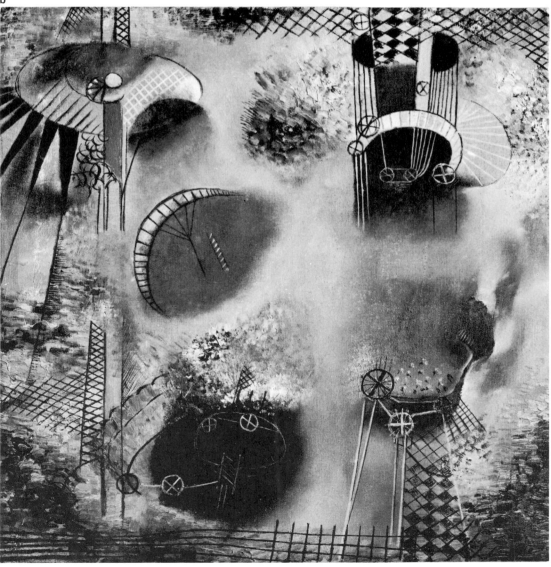

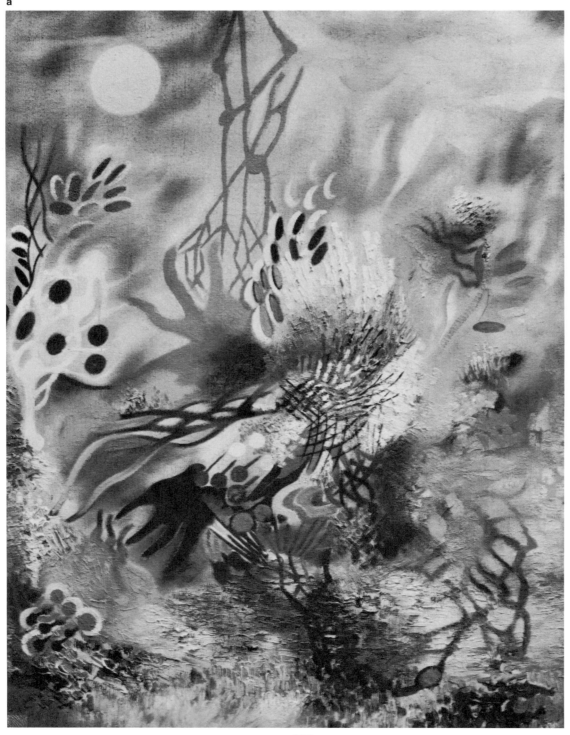

Georg Muche: ''Plants in a thunderstorm.'' Oil on canvas. 1922.
Whereabouts unknown.
b
Georg Muche: ''Still life.'' Oil on canvas. 1924.
Collection Ludwig Steinfeld, Schlüchtern (Hesse).

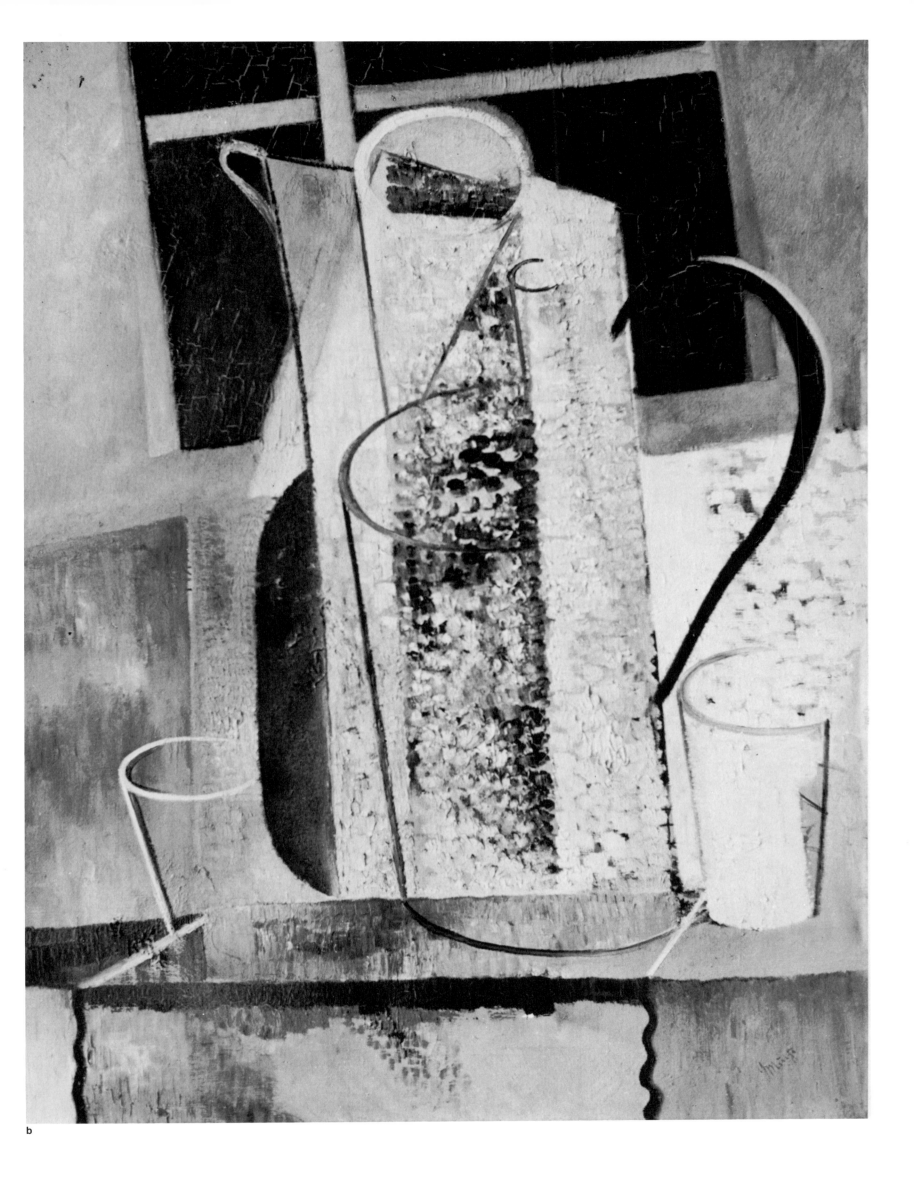

b

a

Paul Klee

Biographical notes: born in Münchenbuchsee near Bern on December 18, 1879, died in Muralto-Locarno on June 29, 1940. Klee began studying in Munich in 1898 with Knirr and later with Stuck. In 1901 he went on a trip to Italy and four years later, in 1905, to Paris. During those years he did minute anatomical studies and his first etchings. He settled in Munich in 1906 and in 1912 came into contact with the "Blaue Reiter." A significant event was his meeting with Delaunay in Paris in 1912. Together with Macke he traveled to Kairouan in 1914. Served in the armed forces from 1916 to 1918. Then he participated in Walden's "Sturm" gallery. From 1920 until 1931 he was Master at the Bauhaus; in Weimar he was responsible as form master for the stained-glass workshop. What was more important, however, was his influence on the weaving workshop and above all his general educational activities which he carried out in conjunction with the preliminary courses. His lectures and classes, which resulted in his "Pedagogical Sketch Book," were fundamental contributions to those elementary courses. From 1924 on he exhibited with Feininger, Jawlensky, and Kandinsky under the *nom de guerre* "Die Blauen Vier." In 1931 Klee took over a painting class at the Düsseldorf Academy. As political developments prevented him from practicing as a teacher, he returned to his native Bern in 1933. There he painted, suffering deeply in his final illness. An important ingredient of his work is his musicality.

a
Paul Klee, about 1920.
Picture postcard with his portrait, published by the "Sturm." Press, Berlin.
b
Paul Klee: "Waking woman." Water color, 1920.
Privately owned, U.S.A.

b

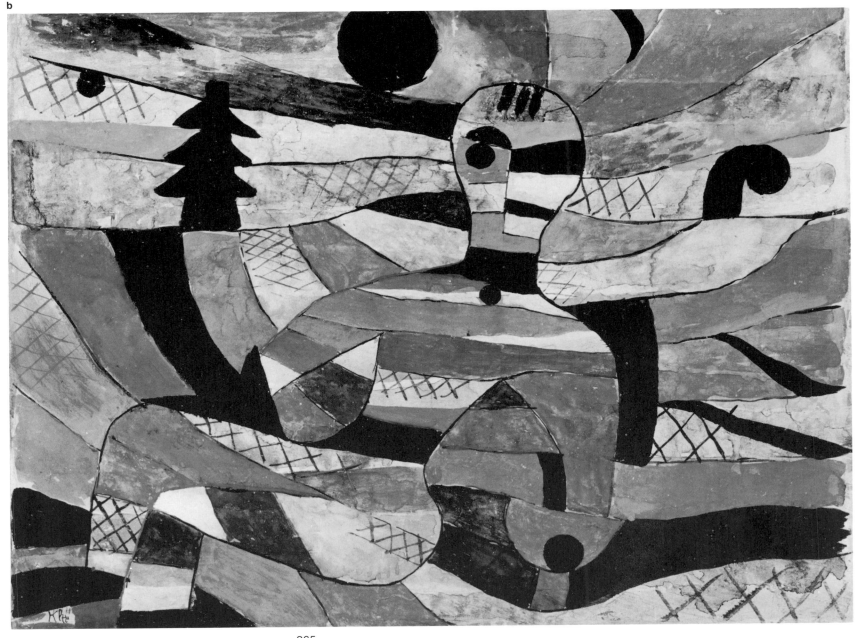

265

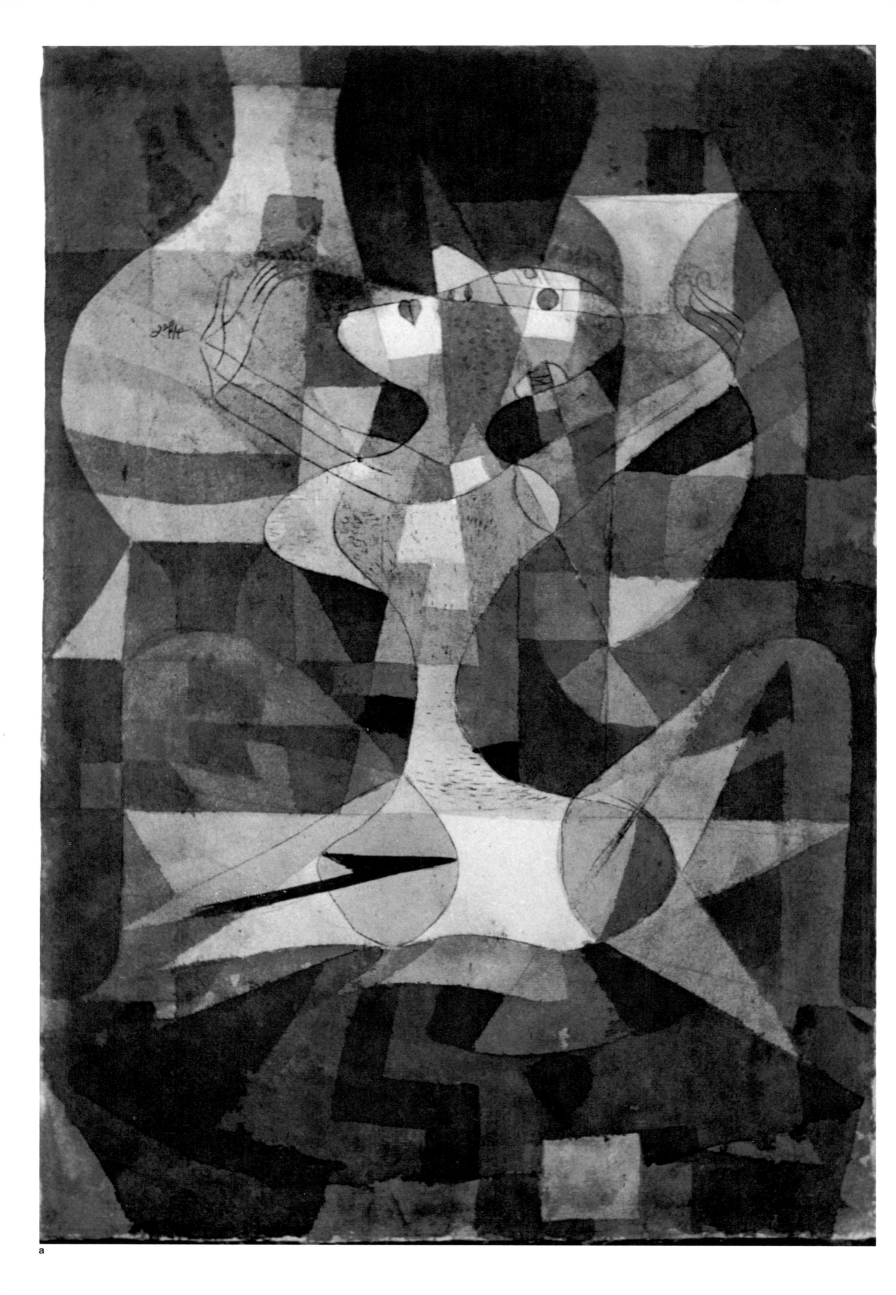

a

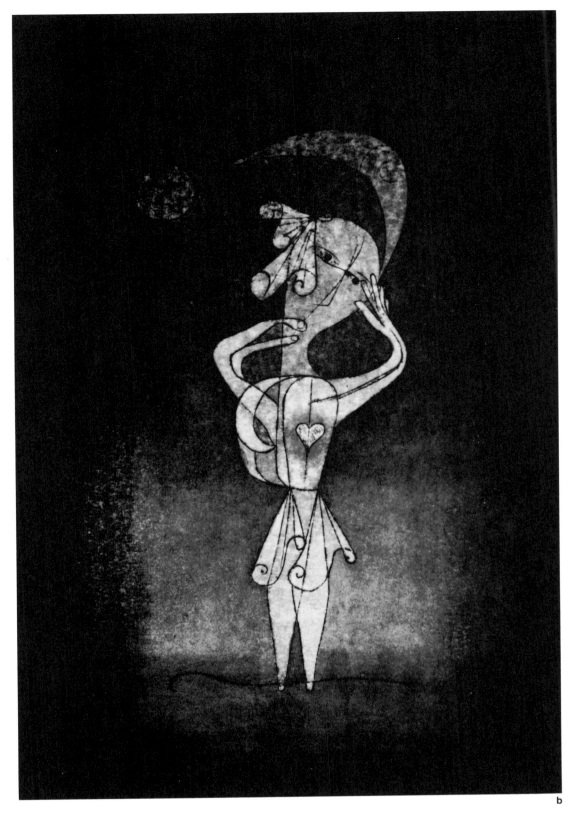

b

a
Paul Klee: "Ceramic-Erotic-Religious (The Vessels of Aphrodite)." Water color. 1921.
Klee Foundation, Bern.
b
Paul Klee: "The woman artist." Water color and ink. 1924.
Privately owned, Stuttgart.

a
Paul Klee: "Bazaar still life." Pen-and-ink drawing.
1924.
Galerie Berggruen, Paris.

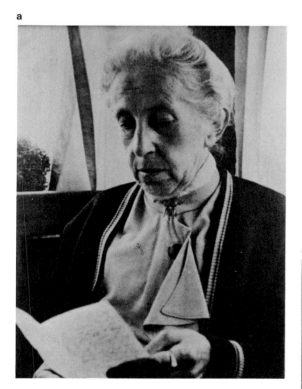

Gertrud Grunow—Lothar Schreyer

Gertrud Grunow (born in Berlin on July 8, 1870) was appointed to the Staatliche Bauhaus upon Itten's suggestion. She was a part-time teacher there. Practical wisdom, psychological experience, and an intuitively sure hand in dealing with young people put her—a middle-aged woman—in an exceptional position. Gertrud Grunow's teaching consisted primarily of a sort of psychological consultation in which she helped the students recognize their specific talents, their wishes and aims. The synesthetic relationship was of foremost importance in her thinking; according to these ideas, one and the same basic entity, the same original phenomenon, is perceivable in sound, color, and form. She did not join the faculty in Dessau. She lived for her studies and taught in a small group. Gertrud Grunow died on June 11, 1944, in Leverkusen.

Lothar Schreyer (born in Blasewitz near Dresden on August 19, 1886, died June 18, 1966, in Hamburg) devoted himself to dramaturgy and painting, after he had received a degree in law. He exhibited his abstractions in Walden's "Sturm" gallery in Berlin and from 1918 to 1921 directed the stage of the "Sturm." In 1921 he was appointed to the faculty of the Bauhaus as an arts and crafts teacher, but his actual work consisted of supervising the stage workshop. His expressionistic interpretation of the problems of the theater did not follow the inner development which the Bauhaus had taken, and for this reason Schreyer left in 1923. From 1924 to 1927 he taught at the "Wegschule" in Berlin and Dresden. In 1927 he moved to Hamburg. He wrote for the stage and published numerous essays on subjects of art history and problems of modern art.

a
Gertrud Grunow. After 1923.
b
Lothar Schreyer: "Death picture of the man for the man's morgue." Wood, painted. 1923.
c
Lothar Schreyer in Weimar. About 1922.

Wassily Kandinsky

Biographical notes: born in Moscow December 5, 1866, died in Neuilly-sur-Seine on December 13, 1944. At the age of thirty Kandinsky broke off a career in the sciences in order to devote himself to painting. He studied with Azbe in Munich between 1897 and 1899 and an additional year with Stuck. His early works bear the influence of impressions he received from Russian folk art and from Art Nouveau in Munich. He was a member of the Berlin Secession, the German Art Association (Deutscher Künstlerbund) and other progressive groups. In 1903 and during the following years he traveled to Tunisia, Italy, and France. He maintained permanent residences in Munich and Murnau until the beginning of the war. Together with Jawlensky he founded the "Neue Künstlervereinigung" in Munich in 1909 which was the first step on the way to establishing the "Blaue Reiter" with Franz Marc, in 1911. During this period Kandinsky painted his first abstractions and edited such trend-setting publications as the almanac "Der Blaue Reiter" together with Marc, and "On the Spiritual in Art." He had contact with Klee, Kubin, and Delaunay; in 1913 he exhibited in Walden's "Autumn Salon" together with his friends from the "Blaue Reiter." During World War I he returned to Moscow. There in 1919 he was made Director of the new State Museum for Painting and in 1920 professor for the science of art.

Disillusioned, he returned to Germany and settled in Berlin in late 1921. In 1922 he was called to teach at the Bauhaus of which he remained a member until its final dissolution in 1933. During the Weimar period he led the wall-painting workshop. Of outstanding importance were his investigations into visual problems (the Bauhaus book "Punkt und Linie zu Fläche") and his courses in analytical drawing. In 1933 he emigrated to France. He spent the last decade of his life working privately near Paris.

a
Wassily Kandinsky during the later Bauhaus years.
b
Wassily Kandinsky: "Blue Circle." Oil on canvas. 1922
Solomon Guggenheim Museum, New York.

b

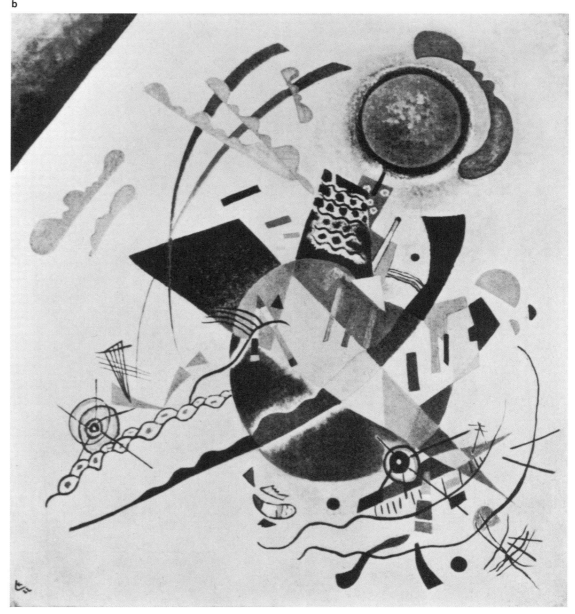

271

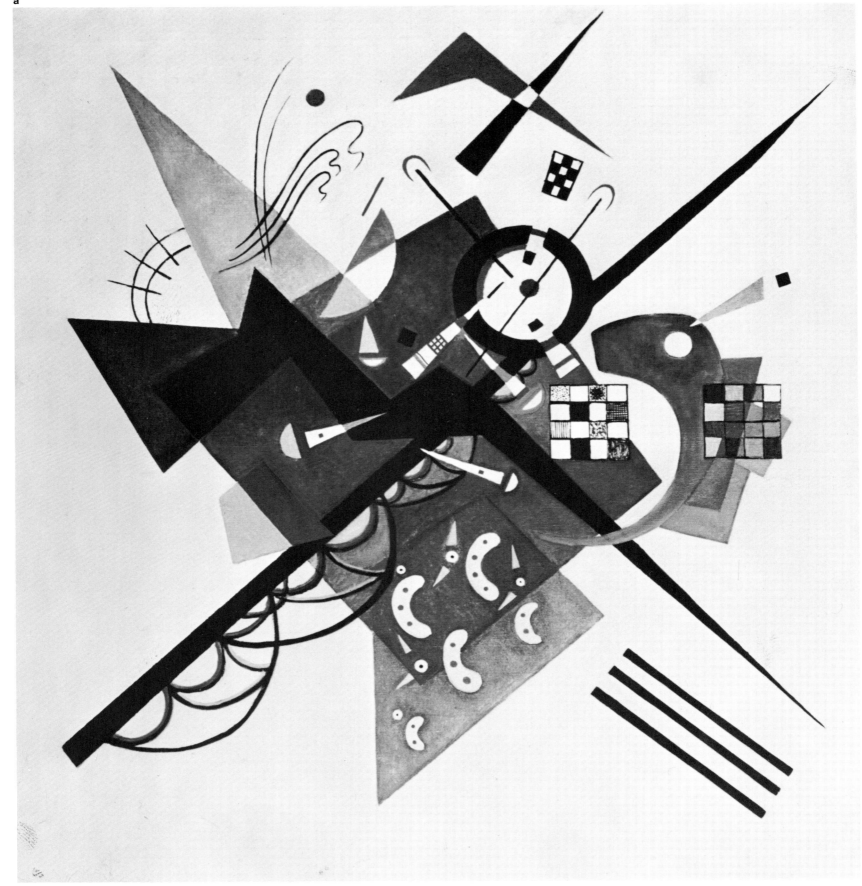

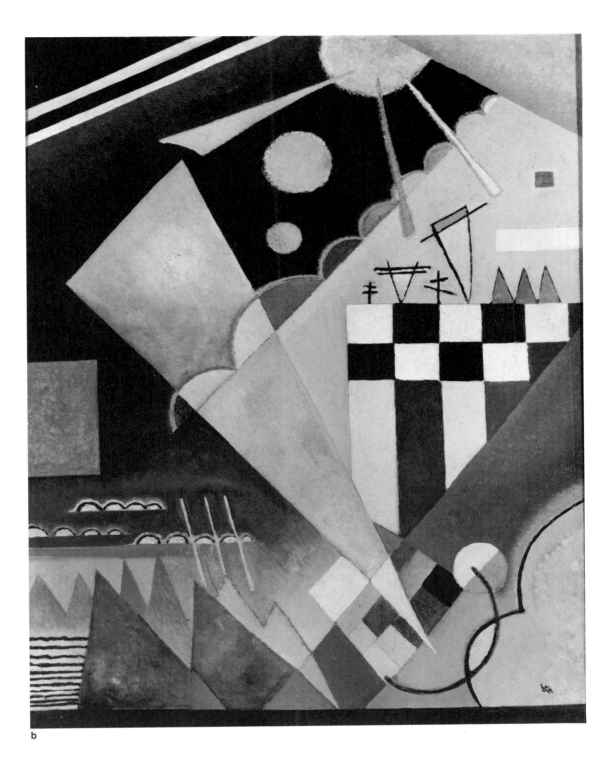

b

a
Wassily Kandinsky: "On White." Oil on canvas. 1923.
Collection Nina Kandinsky, Neuilly-sur-Seine.
b
Wassily Kandinsky: "The sharp-calm pink." Oil on
canvas. 1924.
Wallraf-Richartz Museum, Cologne.

a

b

Laszlo Moholy-Nagy

Biographical notes: born in Bàcsborsod (Hungary) on July 20, 1895, died in Chicago on November 24, 1946. The First World War interrupted Moholy-Nagy's law studies. He began painting while convalescing from serious wounds he had received in combat. He was impressed by the German Expressionists and the Russian avant-garde. Together with four friends he founded the group "Ma" ("Today") and beginning in 1919 he published their programmatical journal. He spent the years 1919 and 1920 in Vienna; in 1921 he met Lissitzky in Düsseldorf and lived from 1921 to 1923 in Berlin. There he established contact with Walden and exhibited in his "Sturm" gallery. In 1923 he was appointed to the Bauhaus as head of the metal workshop and made important contributions to the courses in preliminary instruction. He was co-editor of the Bauhaus Books and wrote two volumes for that series himself. In 1928 he moved to Berlin and experimented with film and stage designs (for Piscator and for the State Opera). He traveled to France, Scandinavia, Italy, and Greece. He was in Amsterdam in 1934. During the next two years in London he was primarily occupied with work on animated and documentary films. In 1937 he took over the direction of the "New Bauhaus" which had been founded by the Association of Arts and Industries in Chicago, but it had to be closed again because of financial difficulties. He therefore opened his own school in Chicago in 1938, the "Institute of Design," which he directed until his death in 1946.

a
Laszlo Moholy-Nagy during the Mid-twenties.
b
Laszlo Moholy-Nagy: "A m 3." Oil on canvas. 1923.
Private collection, Munich.

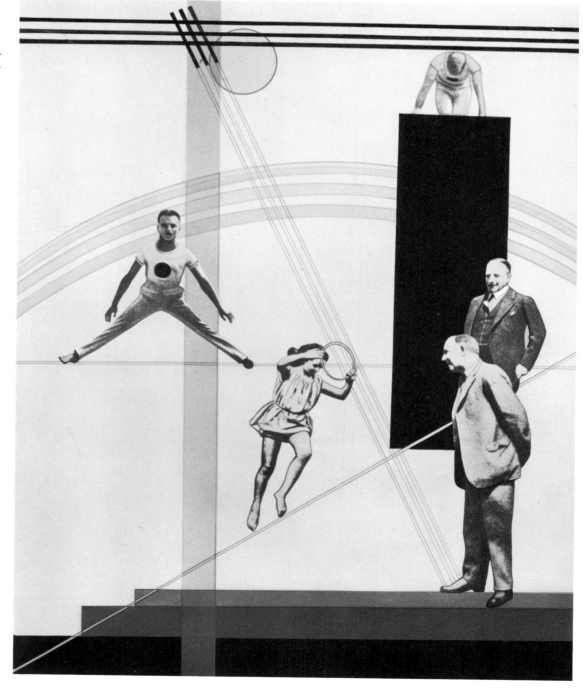

a

Moholy-Nagy was one of the initiators of photography without a camera ("photogram"); he was also one of the first to become aware of the artistic and psychological advertising possibilities of a composition combining veristic, photographic, and abstract graphic elements ("photoplastic"). Ever since his years at the Weimar Bauhaus, Moholy-Nagy concerned himself with experiments in photography and cinema. These led uninterruptedly to the experiments which he and his former wife Lucia Moholy conducted, particularly at Dessau, and from which developed the technique of visual and photographic representation which was later called "subjective photography."

Due probably to the influence of Pevsner and Gabo, Moholy-Nagy and Kemeny published in 1922 a proclamation in the journal "Der Sturm," bearing the strange name of "Dynamic-constructive system of forces," which pointed the way to kinetic sculpture. The esthetic problems resulting from the mobile, three-dimensional work of art, its play of light, and its diverse spatial interrelations, continued to occupy his mind from here on. Particularly during the last years of his life Moholy-Nagy placed great emphasis on these problems.

a
Laszlo Moholy-Nagy: "Circus and the Variety Show poster."
Photoplastic. Middle of the nineteen twenties.
Published in the Bauhaus Book "Malerei, Fotographie, Film" ("Painting, Photography, Film").
b
Laszlo Moholy-Nagy: "Advertising poster." Photoplastic.
Middle of the nineteen twenties.
Published in the Bauhaus book "Malerei, Fotografie, Film" ("Painting, Photography, Film").
c
Laszlo Moholy-Nagy: "Light-space modulator." Mobile metal construction. 1922–1930.
Busch-Reisinger Museum of Germanic Culture, Cambridge, Massachusetts.

d
The same kinetic sculpture in a different phase of motion.

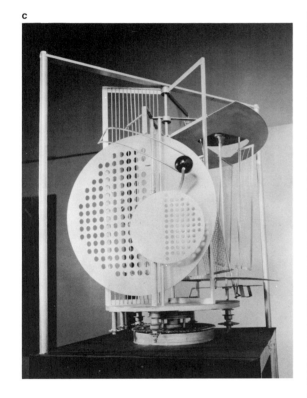

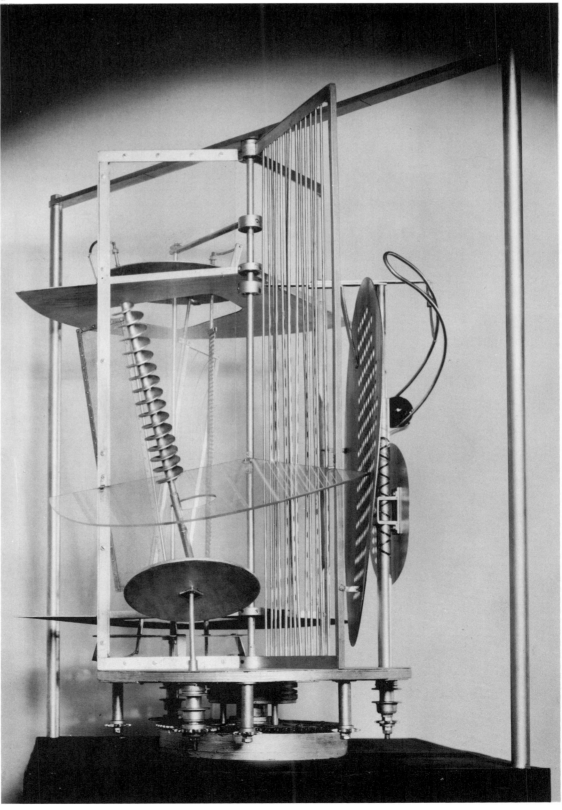

Bauhaus Business Manager
and Master Craftsmen

a

Emil Lange was appointed to the Bauhaus in 1922 as
supervisor of the building-research section, which,
owing to financial difficulties, never materialized. His
appointment had been recommended by Poelzig. He
accepted the post of business manager, even though
he had been trained as an architect, during a period
which was precarious for the Bauhaus (devaluation of
money, the "Yellow Brochure" affair) and stood up to
the adversaries of the Bauhaus with courage and dig-
nity. His resignation from the Bauhaus in 1924 was pri-
marily based on his conviction that the combination of
teaching and the production of marketable goods, in
the way the Bauhaus attempted it, would not be com-
patible. Lange was born in Glogau (Lower Silesia) on
February 4, 1884. He studied at the trade school for
building and at the Art Academy in Breslau. From 1912
on he was an associate of Max Berg's; from 1920 to
1922 he headed the "Bauhütte Breslau." Following his
years at the Bauhaus, he addressed himself to prob-
lems of standardization and economy in the construc-
tion industry, working partly in a leading position as an
employee of a construction firm and partly as an in-
dependently practicing architect. After the Second
World War he settled in Hildesheim and until 1951
worked on architectural planning. In the early nineteen
sixties he retired to Presseck, a rural village in Fran-
conia.

b

Josef Hartwig was a master craftsman in the sculpture
workshop at the Bauhaus from 1921 to 1925. He em-
bodied the good spirit of the crafts par excellence.
Born in Munich on March 13, 1880, he was a stone-
mason and was one of the men who worked on the
Art Nouveau façade of the "Elvira" House in Munich.
He served in the Army and then completed his educa-
tion at the Munich Academy from 1904 to 1908. From
1910 to 1921 he was a (stonemason) foreman in Ber-
lin. He moved to Frankfurt on Main in 1925, where he
died on November 13, 1955. In Frankfurt he was a
teacher at the art school and did restorations for the
municipal art gallery.

c

Christian Dell supervised the work of the metal work-
shop of the Bauhaus from early 1922 until 1925 in the
capacity of master craftsman. The shape of the modern
(office) table lamp was largely developed by him; the
Dell lamps of the nineteen twenties were still being
produced some three decades later. Moreover, he
proved competent as a designer of other mass-pro-
duced articles and as a goldsmith. He was born in
Offenbach on February 24, 1893 and studied at the
Hanau Academy of craftsmanship. Shortly before the
outbreak of the War he worked with van de Velde. The
Frankfurt Art School appointed him to its staff in 1926;
from there he was dismissed in 1933. Since then, he
has lived in Upper Bavaria, in the Harz mountains, and
in Wiesbaden.

d

Max Krehan comes from a family of potters in the state
of Thuringia. He supervised the pottery workshop of
the Bauhaus in Dornburg (Saale) from 1920 to 1925 in
the position of master craftsman. Krehan died in Oc-
tober 1925.

a

b

c

d

Preliminary Course (Itten)

The structural analysis of paintings was an essential component of Itten's elementary instruction. The works of old masters—Meister Francke, Fra Angelico, El Greco, and Rembrandt—were especially preferred as examples from which to study analytically the laws of painting composition. This study was concerned with the recognition and rendering of linear composition, three-dimensional sculptural relationships, and chiaroscuro values (the proportion of light and dark areas in a painting). In addition to pointing out general principles, this series of analytical studies made evident the individual and historical conditions of "seeing" and of creative visual work.

The study of nature was not neglected in Itten's teaching. Its function was as an exercise in observation and in the graphic rendering of material things. Hence, there is by no means a contradiction between the verism of this study and the constructive tendency characteristic of the compositional studies. In addition to these two possibilities, which are complementary to each other, there was a third one: the "capturing" by drawing of the free rhythms of movement.

a

a
Johannes Itten: analytical sketch of the "Adoration" by Meister Francke, which is in the possession of the Hamburg Kunsthalle. Published in "Utopia—Dokumente der Wirklichkeit" ("Utopia—Documents of Reality"), Weimar 1921.

b
Max Peiffer-Watenphul: analytical sketch of a painting by Fra Angelico. From Itten's course. About 1920. Bauhaus-Archiv, Darmstadt.

c
Itten student: study after Grünewald's "Visitation of St. Anthony and St. Paul" from the Isenheim Altar. Presentation of the distribution of lights and shadows. About 1921. Bauhaus-Archiv, Darmstadt.

d
Joost Schmidt: "Thistles." Study from nature—original student work, stimulated by the nature studies carried on under Itten's leadership. Special attention is here given to the effects of light and shadow. Charcoal drawing. About 1920. Private collection, Darmstadt.

e
Erich Dieckmann: study from nature—rendering of a seated old man and various objects. Charcoal drawing. About 1921.

b

c

d

e

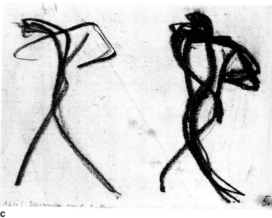

b

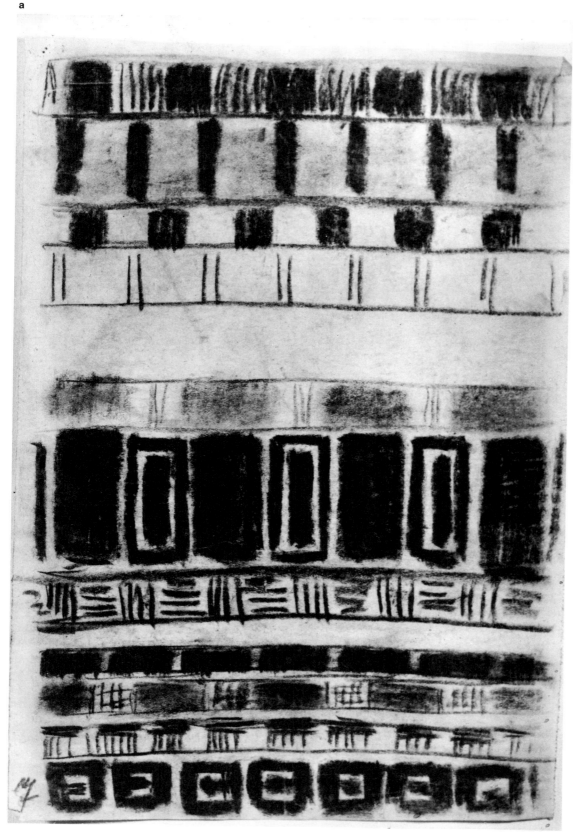

a

c

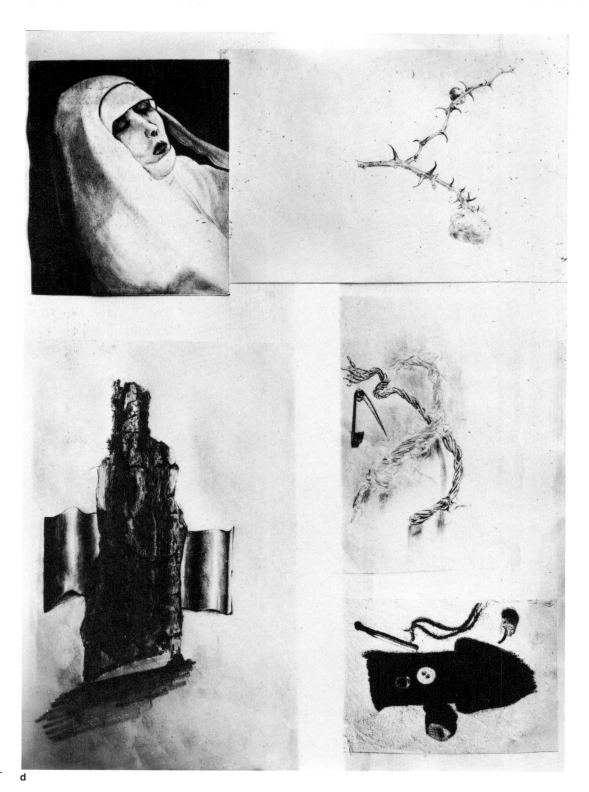

a
Max Peiffer-Watenphul: ornamental abstraction. Charcoal drawing. About 1920.
Bauhaus-Archiv, Darmstadt.
b
Alfred Arndt: expression-form—abstract rendering of flickering fire. Charcoal drawing. 1921.
Bauhaus-Archiv, Darmstadt.
c
Max Peiffer-Watenphul: "Nudes (movements to rhythm)." Charcoal drawing. About 1920.
Bauhaus-Archiv, Darmstadt.
d
Students' work from Itten's preliminary course: exercise in rendering the characteristic qualities of various materials. Above left, a copy after Grünewald. Charcoal drawing. Early nineteen-twenties. Whereabouts unknown.

The naturalistic texture studies and the studies concerning the composition of planes provided inspirations which were particularly productive for the weaving workshop. The ornamental abstraction quite naturally pointed in this direction. One part of the nature studies was instruction in life-drawing which was given alternately by the painters among the Masters during the early years of the Weimar Bauhaus. These studies were not meant merely to further the knowledge of anatomy but also to capture movement—Itten attached great importance to this aspect. The rendering of free rhythms of movement was essentially spontaneous; they were put down on paper automatically, so to speak, but in large part they also drew on the experience gained from life-drawing.

The study of materials served intuitive perception as well as conscious experience of the specific qualities of materials and the exploration of their visual applicability—in both their positive and negative effects. Such experiments were important for the student because they set no conditions and appealed directly to his visual talents. In order to cope with the problem of creating something from discarded pieces of rubbish, the student had to forget all he had learned conventionally. At that moment, the world of academic notions on art became irrelevant. Hence, the elementary task of creating guided him toward his very own potentiality, toward himself.

a
Werner Graeff: rhythmic study, from Itten's preliminary course: "Form of diagonals and acute angles with accentuated points" (Itten). Graphite drawing. 1920. Bauhaus-Archiv, Darmstadt.

b
Werner Graeff: rhythmic study, from Itten's preliminary course. Tempera on paper. 1920. Bauhaus-Archiv, Darmstadt.

c
From Itten's preliminary course: study of materials and composition. Collage of various materials, limited to a surface and supplemented by graphic means to achieve a pictorial effect. About 1920. Whereabouts unknown.

d
From Itten's preliminary course: three-dimensional study of materials. Compilation of various materials to achieve a comparatively representational sculptural effect. Early nineteen twenties.

e
Margit Téry-Adler: three-dimensional study of materials from the preliminary course. Feathers, wood, glass, and other materials, supplemented with paint and composed to yield a representational effect. Early nineteen twenties. Whereabouts unknown.

a

b

c

d

e

285

a
From Itten's preliminary course: three-dimensional study of materials. Plaster or clay, wood, wire, insulators, and other materials. Composed to achieve the effect of a framed relief. Emphasis is placed on the composition. About 1920.
Whereabouts unknown.

b
Mordekai Bronstein: material study from Itten's preliminary course. Composition of various materials, such as wood, woven cane, and string. Rhythmical form. In this exercise the complementary effect of the various materials were to be especially taken into account.
Early nineteen twenties. Whereabouts unknown.

c
Karl Auböck: three-dimensional material study from Itten's preliminary course. Exercise with the object of coordinating several materials to produce a representational effect. Wood, thread, and other materials.
Early nineteen twenties. Whereabouts unknown.

d
From the preliminary course of Itten: three-dimensional material study. Composition of wire, cut sheet metal, etc. Exercise in the observation and perception of tension relationships.
Early nineteen twenties. Whereabouts unknown.

b

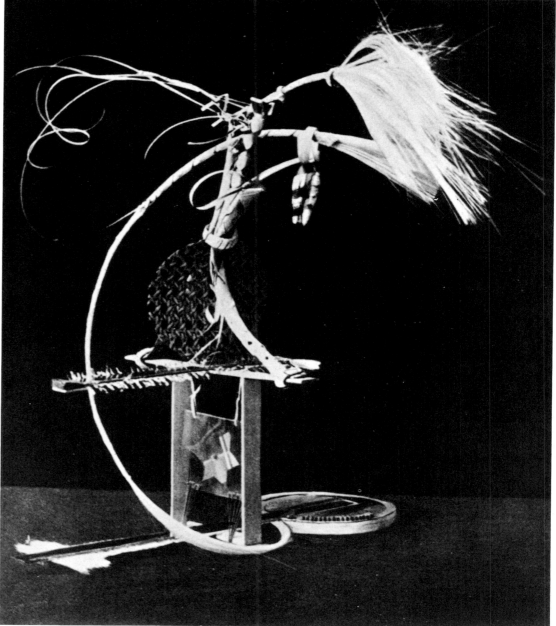

c

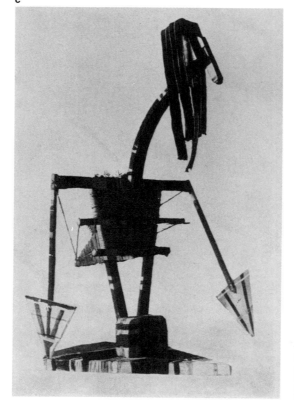

d

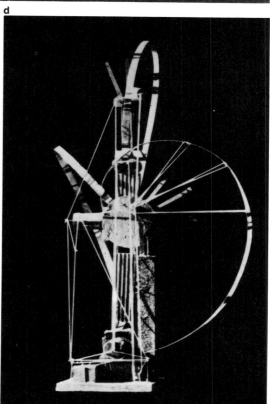

a

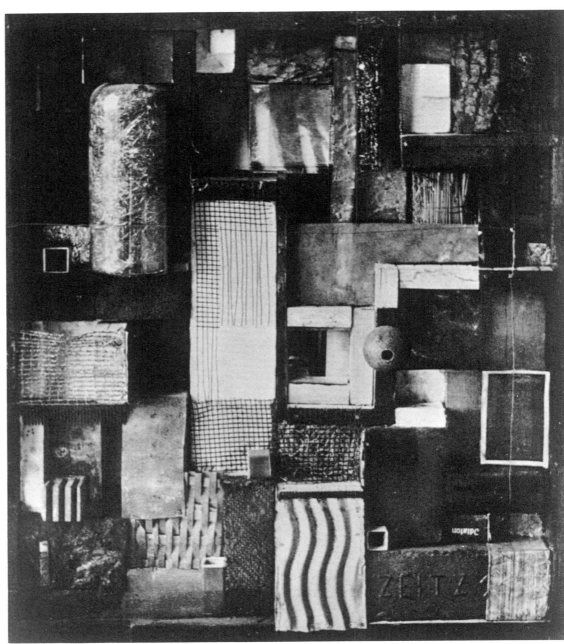

b

a
M. Mirkin: material study from Itten's preliminary
course. Combined contrast effect. Contrast of the
material (glass, wood, iron) and contrast of the form of
expression (serrated, smooth); rhythmic contrast. Ex-
ercise for the observation of "similarity of expression
with simultaneous means of presentation" (quotation
from the "Staatliche Bauhaus in Weimar 1919–1923").
About 1920.

b
Willi Dieckmann: material study from Itten's prelim-
inary course. Combination of the simplest materials
(wooden sticks, straw, wire, briquets, etc.) Exercise
for the development of the tactile sense and for the
realization of a subjective feeling for materials. About
1921.

c
Else Mögelin: three-dimensional representation—
composition of cubes. From Itten's preliminary course.
Exercise for the observation of static-dynamic rela-
tionships.
Early nineteen twenties.

c

a

b

290

Preliminary Course
(Moholy-Nagy and Albers)

After Itten had left the Bauhaus in the spring of 1923, Laszlo Moholy-Nagy accepted the responsibility for heading the preliminary course, having been appointed to take over this vacant position. The problems assigned by Moholy-Nagy served primarily to develop visual perception and thinking regarding construction, static and dynamic factors, balance and space. As for materials, wood, sheet metal, glass, wire, and string were used for the most part. In his classes, Moholy-Nagy had his students design more or less complicated configurations which were to demonstrate, for example, suspended equilibrium, the possibility of balancing something that rests on only one point, and similar phenomena. Other tasks were, for instance, to have the student divide with three-dimensional elements—opaque and translucent ones—the volume over a given base plane, and to make it visually palpable. Such exercises carried fundamental significance for later practice in all fields of design, in free art work, and in architecture.

The workshop instruction by Josef Albers, which was given in the "Reithaus" on the banks of the river Ilm beginning in 1923, was an independent component of the preliminary course. The cornerstone of that workshop course was the study of materials. Albers had developed his methods of instruction during his own studies at the Bauhaus and had already practiced them shortly before Moholy-Nagy joined the staff. Because of the lack of a vacancy on the faculty, he taught unofficially until the end of the Weimar period of the Bauhaus; as head of the department Moholy-Nagy was responsible for the entire preliminary course.

a
Ulrich Klawun: study with different types of wood. From Moholy-Nagy's preliminary course, first semester 1924. "Here the three concepts structure, texture, and facture fuse into one" (quotation from Moholy-Nagy, "From Material to Architecture").

b
Brauneck: facture study. Toy set with preformed pieces of wood. From Moholy-Nagy's preliminary course, first semester 1924.

c
Suse Becken: Sketch for a three-dimensional study. Equilibrium study from Moholy-Nagy's preliminary course, first semester of 1924. The materials projected for this study were glass, metal, and wood.

c

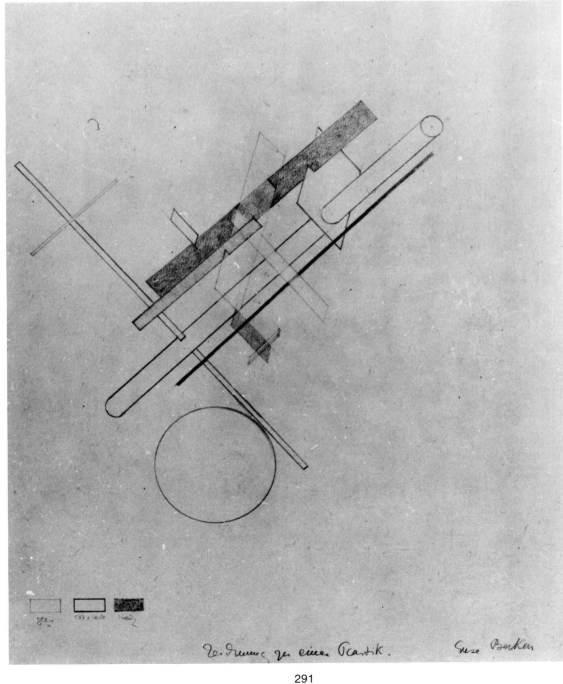

a

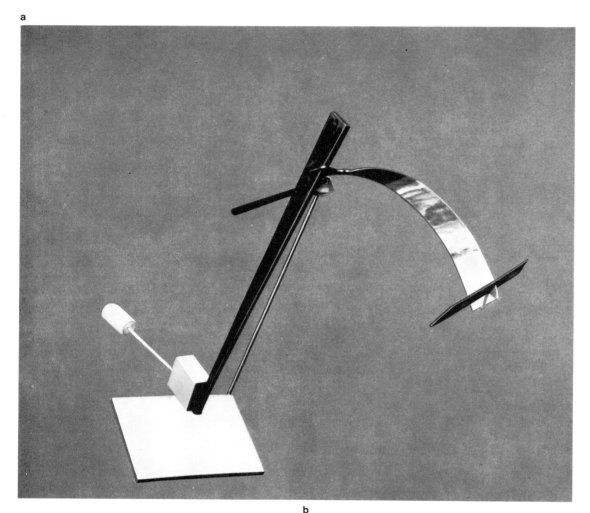

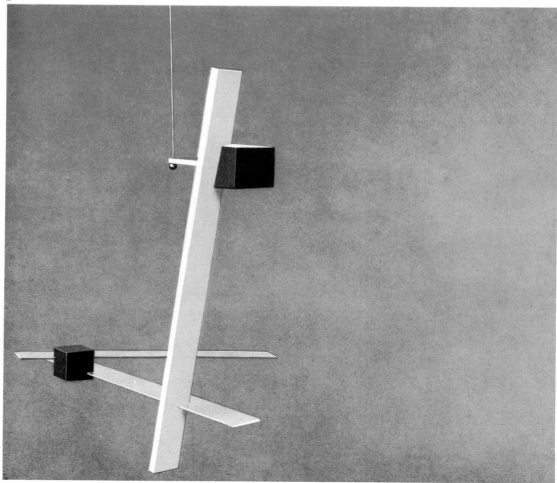

b

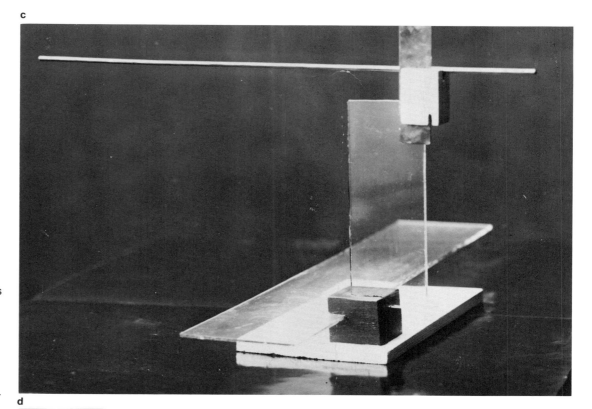

While Moholy-Nagy's classes were concerned with the elementary visual education of the students, the studies Albers conducted, his experiments with materials and his workshop instruction were meant "to prepare the students of the first semester for the subsequent manual work in the various Bauhaus workshops. The students were introduced to a simple, elementary, but appropriate use of the most important craft materials, such as wood, metal, glass, stone, textiles, and paint, and to an understanding of their relationships as well as of the differences between them. In this way we tried, without anticipating later workshop practice, and without workshop equipment, to develop an understanding of the fundamental properties of materials and of the principles of construction. To this end"—as Albers reports (in "Bauhaus 1919–1928," edited by Herbert Bayer, Walter and Ise Gropius)—"we analyzed typical treatments and combinations of materials, and worked them out with our hands. For instance, we visited the workshops of box, chair, and basket makers, of carpenters and cabinetmakers, of coopers and cartwrights, in order to learn the different possibilities of using, treating, and joining wood. Then, we tried to apply our knowledge to the making of useful objects: simple implements, containers, toys, and even toy furniture, first from one material alone, later from several materials combined. . . . Soon, however, we expanded our practical work to allow more inventiveness and imagination, as a fundamental training for later specialized design."

The photographic material taken over from the Bauhaus is not adequate for definite identification of student works from the first years of Albers's course. His preliminary course primarily developed its own specific characteristics, from the assignment of exercises to the final results, during the Dessau period.

a
Marianne Brandt: Equilibrium study, using wood, sheet metal, and wire. From Moholy-Nagy's preliminary course. 1923.

b
Irmgard Sörensen: Suspended three-dimensional study of wood, glass, and string. From Moholy-Nagy's preliminary course, first semester of 1924. In his "From Material to Architecture," Moholy-Nagy makes the following remarks concerning this study: "The material attributes, ductility, expansion limit, elasticity, and so forth, are taken into account in this type of work. For example, the lower glass plate bears a maximum load."

c
Student of the preliminary course of Moholy-Nagy: equilibrium and construction study of wood, glass, and wire. Transparency of the material, perception of space. About 1923.

d
Charlotte Victoria: volume and space study, of glass and calico. From Moholy-Nagy's preliminary course, first semester of 1923.

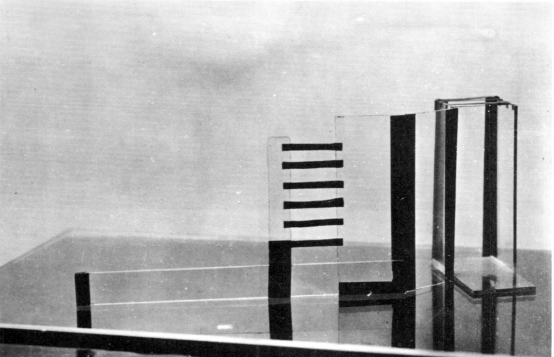

Free Student Work

The students were of course not lacking the urge for artistic communication. This urge found expression in works that were done mostly without special guidance but probably partly after consultation with one of the Masters. The trends in the art of that time are reflected in these graphics, collages, and paintings, spanning the gamut from an academic Expressionism to the paintings of the Bauhaus masters, to Dadaism and the New Objectivity. The "free" work was particularly important as an outlet to students of an institute that emphatically stressed practical aspects.

a
"Der Austausch" ("The Exchange"), May 1919. Title page of a leaflet published by the students, showing a woodcut by Eberhard Schrammen. Bauhaus-Archiv, Darmstadt.
The student journal "Der Austausch" came out in May (leaflet and first issue), June, and July 1919. It contained contributions by the students, programmatical and critical essays, and poetry. In the May edition comments on the Bauhaus manifesto and on Gropius's inaugural address were published, among other things. The issues were illustrated with woodcuts and printed on green, brown, and gray paper.

b
Reinh. Hilker: woodcut or linoleum cut. 1920. Bauhaus-Archiv, Darmstadt.

c
Johannes Driesch: etching. 1923. Bauhaus-Archiv, Darmstadt.

d
Rudolf Baschant: "Bellicose Island." Etching. About 1923.
Private collection, Linz, Austria.

a

Erstes Flugblatt.

Der Austausch

MAI / Veröffentlichungen der Studierenden am Staatlichen Bauhaus zu Weimar / 1919

b

c

d

a
Theodor Bogler: woodcut on yellow paper. 1920.
Bauhaus-Archiv, Darmstadt.
The Bauhaus printing workshop was technically set
up to print the graphic work of the students. At times
these facilities were eagerly used. The number of
copies made was generally small.
b
Paul Citroen: ''City.'' Collage (photomontage). About
1922.
This theme was varied repeatedly. The collage con-
vincingly expresses the chaotic, disorderly, and hectic
characteristics of a big city. The Dadaist technique is
used for expressive, illustrative purposes. Considering
the ample use of photographic cutouts, the time at
which this montage was done is remarkably early.

b

a
Friedl Dicker: water color. About 1923.
This is characteristic for many of the student works
which were visibly inspired by Klee's drawings and
paintings. Elements of the naive painting of the child
have been used here with well-considered intention.
Of course, many of the students' experiments show
that they were carried out in the shadow of the tower-
ing individuals from among the group of the Masters.
b
Herbert Bayer: abstraction. Color lithograph. 1923.
Original (contact print) in "Staatliches Bauhaus in
Weimar 1919–1923," Weimar—Munich (1923).
Cubist, Constructivist tendencies also directed
Breuer's visual experiments. He—like Bayer—made
his creative contribution to the development of the
Bauhaus later, as a junior master.

a
Ludwig Hirschfeld-Mack: "Composition." Tempera.
About 1923.
b
Walter Menzel: "Still life." Oil painting. About 1923.
c
Josef Albers: "Houses." Black and white drawing.
1923 at the latest.

c

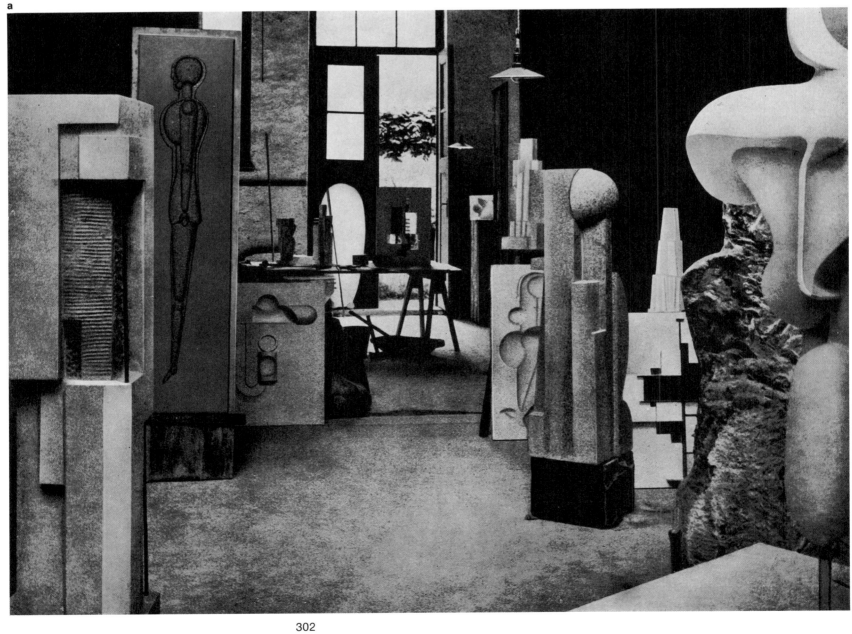

Workshop for Stone Sculpture

In the early days the workshop for stone sculpture was under the artistic direction of Johannes Itten; in 1922 Oskar Schlemmer was appointed to that position. His creative energy influenced a large part of the student work. The technical supervision of the workshop was in the hands of Josef Hartwig from 1921 to 1925. As in all the workshops of the Weimar Bauhaus, this one too was at first hampered in its development by the difficulties of obtaining a qualified craftsman. Masters like Hartwig, or (in the metal workshop) Dell, contributed significantly to stabilizing the situation and developing the potential. Nevertheless, the stone sculpture workshop did not get along well financially; architectural sculpture, which should logically have been the apex of its work, was little in demand and, moreover, it was generally not appropriate for the new architecture. The most important achievements in this area of architectural sculpture at the Bauhaus were the remodeling of the wall in the workshop building by Schlemmer and the reliefs in the vestibule of the building of the art school by Joost Schmidt, which were completed for the exhibition in 1923.

a
The stone-sculpture workshop in the Bauhaus in Weimar. 1923.
In the foreground on the right is a sculpture by Oskar Schlemmer. A free-standing architectural sculpture by O. Werner (journeyman work) stands to the right of center. Between this piece and the Schlemmer sculpture there is an abstract relief and a partially incomplete stone torso by Kurt Schwerdtfeger. In the background on the left are works by Joost Schmidt.

b
Josef Hartwig: "Owl." Veronese marble, polished. About 1923. Private collection, Munich.

c
Kurt Schwerdtfeger: "Architectural sculpture." Sandstone. 1923.
Journeyman work.
Destroyed.

b

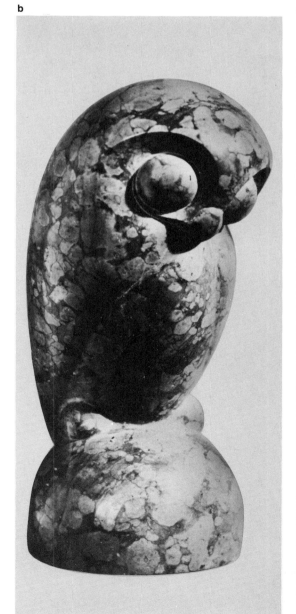

c

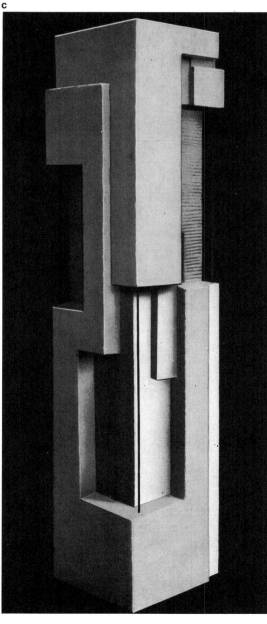

b

Workshop for Woodcarving

Having solved some problems of personnel, the woodcarving workshop, like the stone-sculpture workshop, was placed into the hands of Oskar Schlemmer (master of form) and Josef Hartwig (master craftsman). Before Schlemmer took charge, Georg Muche had worked here as form master for a short time. The division of the sculpture workshop into two entities according to the materials used, stone and wood, followed tradition. Both developed along parallel lines. The most important commission executed by the workshop for wood carving was the decorative woodwork for Sommerfeld House in Berlin. In its use of forms no other workshop was so tied to its time and, when the approach to form changed, so constricted as the wood-carving workshop. Its best period was before 1923, the years when Expressionism was still alive and the examining of folkloristic influences was still a legitimate approach.

a
The woodcarving workshop in the Bauhaus in Weimar. 1923.
The carved chest on the right-hand side in the foreground was an apprentice project designed and executed by Lili Gräf.
b
Heinrich Busse: study. First exercise with woodcarving knives; attempt at testing and representing various carved textures in wood.
c
Joost Schmidt: carved door in Sommerfeld House, Berlin-Dahlem. Teak. 1921–1922.
Apprentice work. Destroyed.
d
Joost Schmidt: carving on the banister in Sommerfeld House, Berlin-Dahlem. Teak. 1921–1922.
Apprentice work. Destroyed.

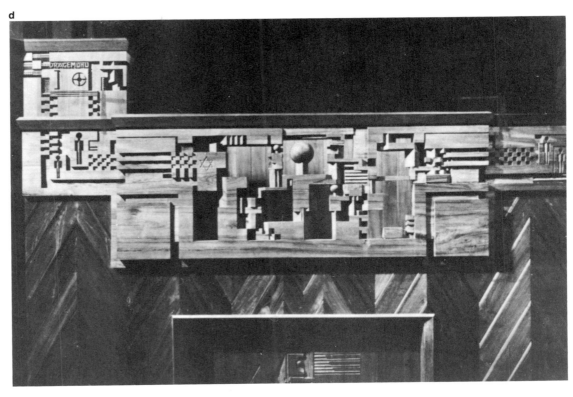

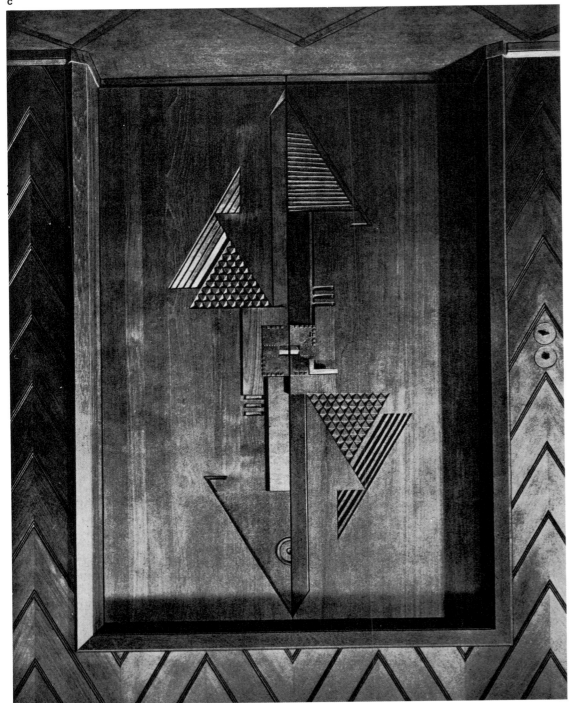

305

a

b

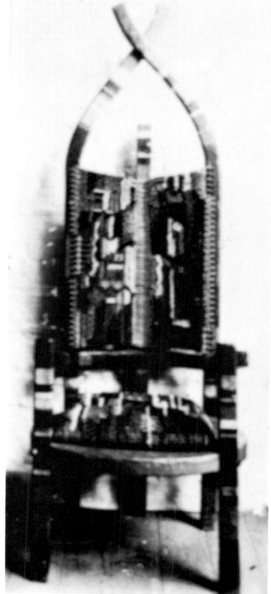

306

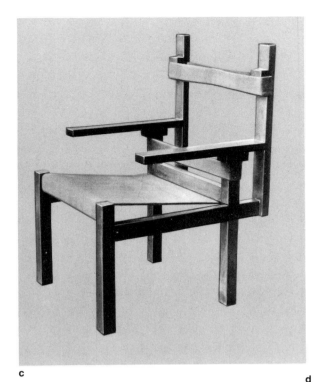

c

Cabinetmaking Workshop

The cabinetmaking workshop of the Weimar Bauhaus was under the artistic leadership of Walter Gropius, except for a short period around 1921 when Itten assisted. From 1921 to 1922 Josef Zachmann was responsible as master craftsman and—after his dismissal—Reinhold Weidensee took over until 1925. In practice the cabinetmaking workshop was the most successful unit after the metal workshop. It executed sizable commissions, such as the furniture for the Bauhaus experimental house and for a children's home in Bad Liebenstein. The skills of cabinetmaking were of course also of importance in the workshop class of the preliminary course, which from 1923 on was headed by Josef Albers. Because of the constant contact between Albers and the cabinetmaking workshop, it gained greater importance within the framework of the general education than the other workshops. Distinguished among the journeymen in the workshop for their independent achievements were, next to Marcel Breuer, Erich Dieckmann and Erich Brendel. The furniture for children designed by Alma Buscher is also among the best the cabinetmaking workshop produced. The sense of form in the workshop developed from the style represented by the Wiener Werkstätte, for instance, and from the constructivist formalism of "de Stijl" to a simple, functional approach. Tubular steel furniture, the decisive step in the further development, was first built by Breuer during the Dessau period.

a
The cabinetmaking workshop of the Weimar Bauhaus. About 1923.

b
Marcel Breuer: "African Chair." Throne-like armchair, made by hand; covered with woven fabric, also made in the Bauhaus (motifs from Hungarian folk art). 1921. An attempt at a radically new orientation, guided by primitive art, characteristic for the early phase.

c
Marcel Breuer: armchair. Wooden construction; backrest, shoulder-rest, and sloped seat made of fabric. Apprentice work. 1922.
In his first designs of strictly functional chairs, Breuer was influenced by Rietveld. But around 1922 he freed himself from the "de Stijl" ideal of the "machine for sitting," which was actually nothing but a rationalization for the esthetic intentions of Constructivism.

d
Marcel Breuer: table with square top. Stained cherry. 1924.
Erich Dieckmann: chairs with seats of woven cane. After 1925.
Bauhaus-Archiv, Darmstadt.
In his attempts at finding new forms, Breuer set the board-like legs of the table parallel to the four edges of the table. The form of the chairs by Dieckmann was derived from models by Breuer. But the chairs were designed after the Bauhaus period; Dieckmann was then working at the successor institution to the Weimar Bauhaus (under Bartning).

e
Marcel Breuer: children's furniture. Round table and armchair (backrests and seats of fabric). About 1922.

d

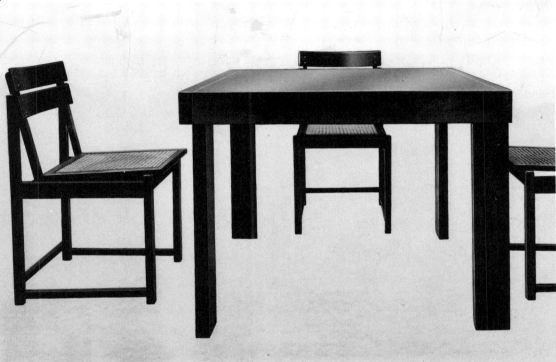

e

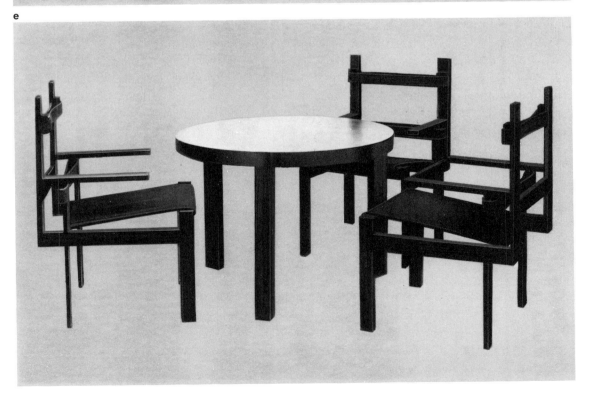

307

a
Josef Albers: church seats. 1923.
During the Weimar period, Josef Albers' contributions, next to those of Marcel Breuer, were among the most decisive in changing the form and improving the construction of chairs. His church seats were shown in an anteroom of the Bauhaus exhibition in 1923.

b
Johannes Itten: crib. Painted wood. About 1923.
Itten designed and painted the bed in imitation of folkloristic motifs. The carpentry was done by apprentices of the cabinetmaking workshop. This is a characteristic example from the first phase of the Bauhaus.

c
Alma Buscher: crib: lacquered wood; sides resilient. About 1924.
The children's furniture designed by Alma Buscher was thought out equally well with respect to practicality, economy, and form; it was among the first of the Bauhaus products to be well received by the public.

d
Marcel Breuer: easy chair. Cherry, leather upholstery. About 1923.
An effort at modernizing the conventional "easy chair." It was esthetically inspired by Constructivism.

e
Walter Gropius: desk (cherry) with glass shelf and upholstered armchair. Made by students. 1923.
A practical attempt at improving the traditional shape of the desk. The formal design emphasizes architectonic quality.

f
Walter Gropius: upholstered armchair. Cherry, lemon-yellow upholstery. Made by students. 1923.
The design of this chair followed architectural considerations primarily; functionally different parts were clearly articulated.

g
Erich Brendel: desk chair. Dark stained oak, leather upholstery. About 1924.
The attempt to break with the predominating form concept in the design of an upholstered armchair met with repeated difficulties during the Weimar period.

a

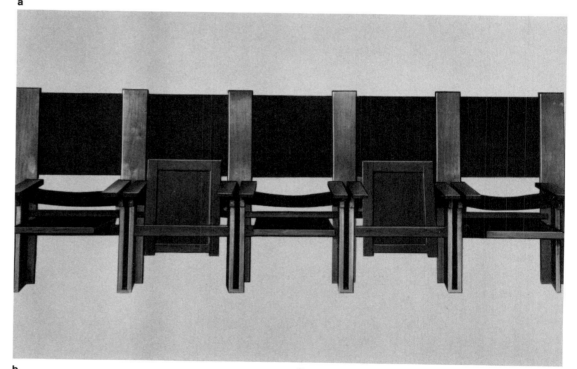

b

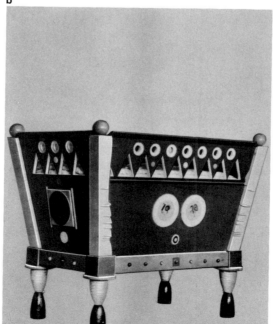

c

d

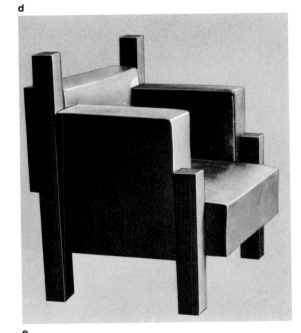

f

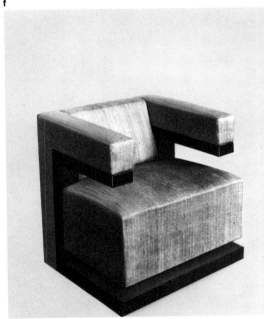

g

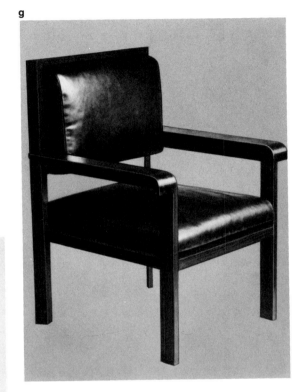

e

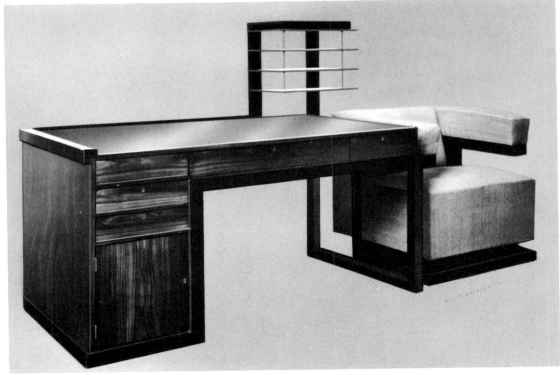

a

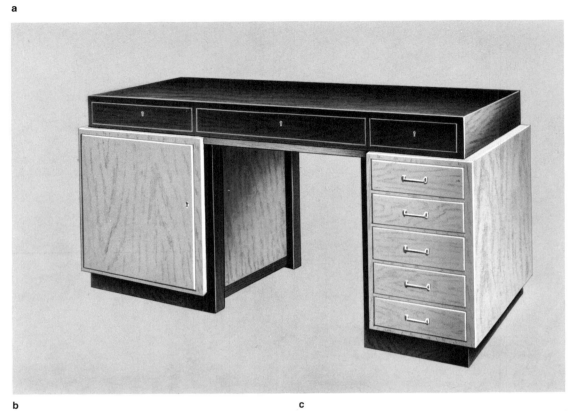

b

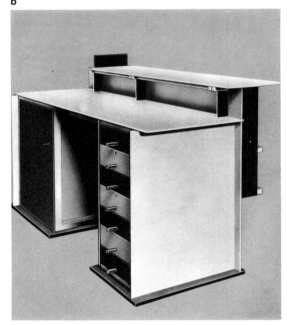

c

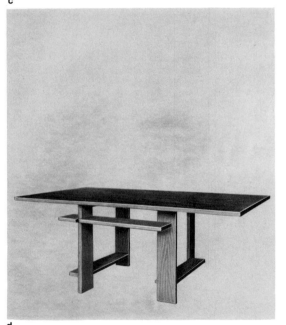

d

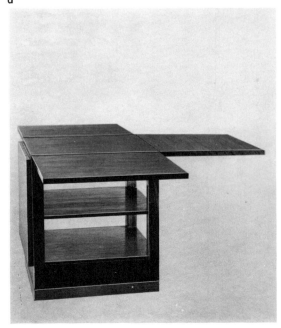

e

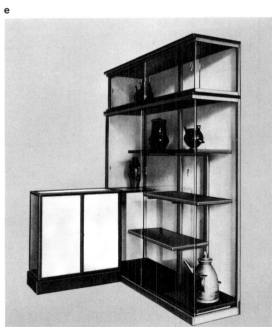

f

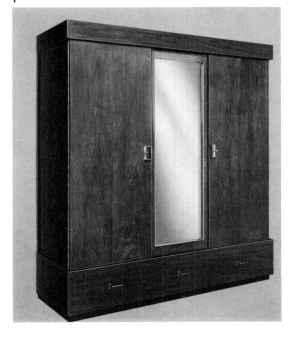

a
Erich Dieckmann: desk. Oak (partially stained dark). 1924.

b
Marcel Breuer: desk combined with a bookshelf at the back. Plywood lacquered in color. 1924.
Breuer's playful joy in experimenting produced not only some of the most interesting furniture models but, above all, pieces most suited for further development.

c
Josef Albers: conference table made of light and dark oak. 1923.
In his early furniture designs Albers accentuated in a very characteristic way the manner in which the cabinetmaker coordinates the various components of a piece of furniture.

d
Erich Brendel: tea table with leaves that can be folded down. Maple, base covered with linoleum. About 1923. Bauhaus-Archiv, Darmstadt.

e
Josef Albers: showcase cabinet. Wood and glass. 1923.
The cabinet was put up in an anteroom at the Bauhaus exhibition in 1923.

f
Erich Dieckmann: wardrobe (walnut and maple?) with mirror. About 1924.
Greatest possible simplicity within the framework of traditional forms.

g
Marcel Breuer: dressing table with movable mirrors and, over the cosmetics box at left, a movable top. Walnut and lemon. 1923.
Designed and made for the "lady's dressing room" in the experimental house of the Bauhaus (exhibition 1923).

h
Alma Buscher: nursery dresser with small table (base for a child's wash basin). Wood lacquered in color. 1924.

i
Alma Buscher: toy cabinet. Wood lacquered in color. 1924.
In designing furniture for children Alma Buscher always considered the latest psychological and pedagogical findings. The toy cabinet was made for the children to play and "build" with; most of it was arranged to be taken apart. The box units (in front) could be used as tables and chairs. Wheels were fixed to one of the boxes so that it could be used as a cart. The cutout in the upper part of the door on the right section of the cabinet was designed to serve as a stage for a Punch and Judy show. The (impractical) shelves in the left section were meant for toys.

j
Marcel Breuer: livingroom cabinet with corner as a glass showcase. Maple (gray), paduc (red), Hungarian ash, and pear. (Black, polished). 1923.
This cabinet was put up in the "living room" of the experimental house (exhibition 1923).

g
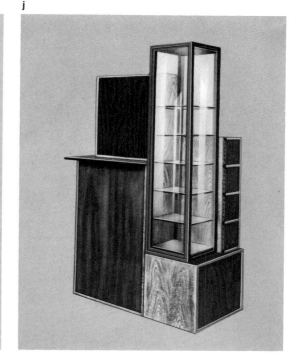

j
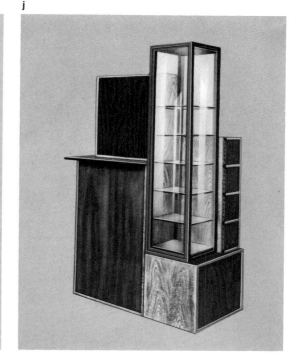

h
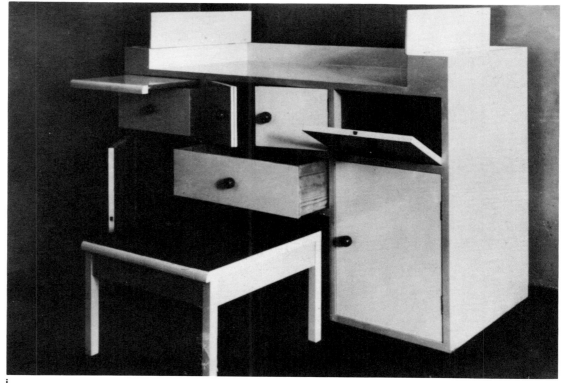

i
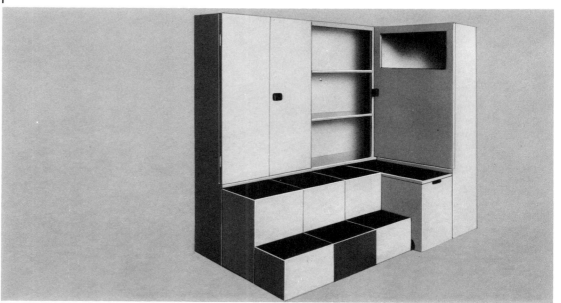

The toys developed in the Bauhaus were designed to stimulate the imagination of the child by giving him things that offered a variety of possibilities for arranging and for freely reproducing familiar objects instead of offering perfect imitations of things from the world of the grownups. With his colored peg top Hirschfeld-Mack emphasized the didactic element in children's toys. Cardboard disks, on which variously colored segments or eccentrically located color-circles were printed, could be thrown around the peg of the spinning top.

The spinning movement mixed the colors optically. Thus, the color theories of Goethe, Schopenhauer, Bezold, and others, were demonstrated.

a
Alma Buscher: doll for throwing ("Wurfpuppe"). Braided bast, wooden darning egg, and wooden beads. About 1924.
On loan to the Bauhaus-Archiv, Darmstadt.
This completely flexible doll, on being dropped or thrown, always takes on a graceful or grotesquely funny attitude.

b
Alma Buscher: game with spheres) Wood lacquered in color. 1924.
Ludwig Hirschfeld-Mack: colored peg top. Wood lacquered in color and colored cardboard disks. 1924.

c
Alma Buscher: toy ships. Wood lacquered in color. 1923.
Private collection, Frankfurt on Main.
Wooden blocks that can be put together at will. Educational aim: development of the imagination ("ship") and the feeling for form.

d
Josef Hartwig: Bauhaus chess set. Lacquered wood. Mass-produced. 1923.
Bauhaus-Archiv, Darmstadt.
The form of the chessmen is reduced to basic stereometric elements. "Pawn and castle move at right angles to the edge of the board: expressed by the cube. The knight moves at right angles, taking a corner, on four fields: four cubes combined at right angles. The bishop moves diagonally with reference to the edge of the board: the form of a diagonal cross has been cut out of the cube. The king moves at right angles as well as diagonally: a small cube set diagonally on top of a larger one. The queen, being the most mobile member, is made of a cube and a sphere. She contrasts strongly with the king, castle, and pawn whose cubed shapes represent heaviness and solidity." (From: "Neue Arbeiten der Bauhauswerkstätten"—"New Products of the Bauhaus workshops").

e
Heinz Nösselt: chess table. Red beech, partly stained black. 1924.
Private collection, Munich.

f
The same chess table with drawers pulled out (container for chessmen; ashtray) and with chessmen by Hartwig.

b

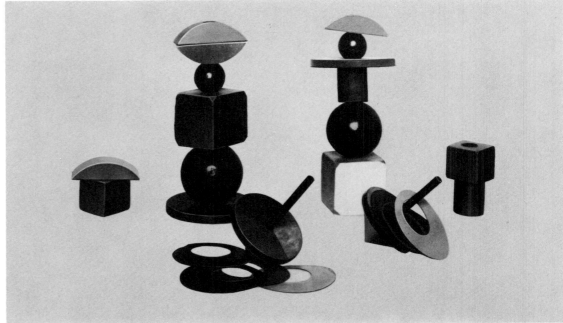

c

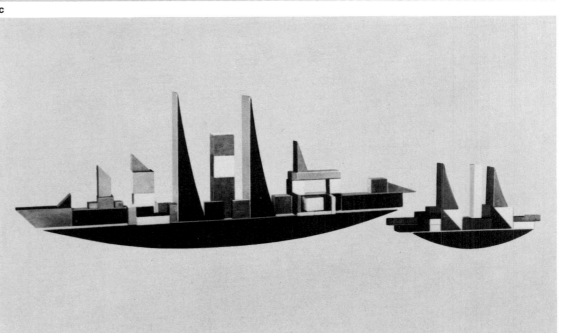

a

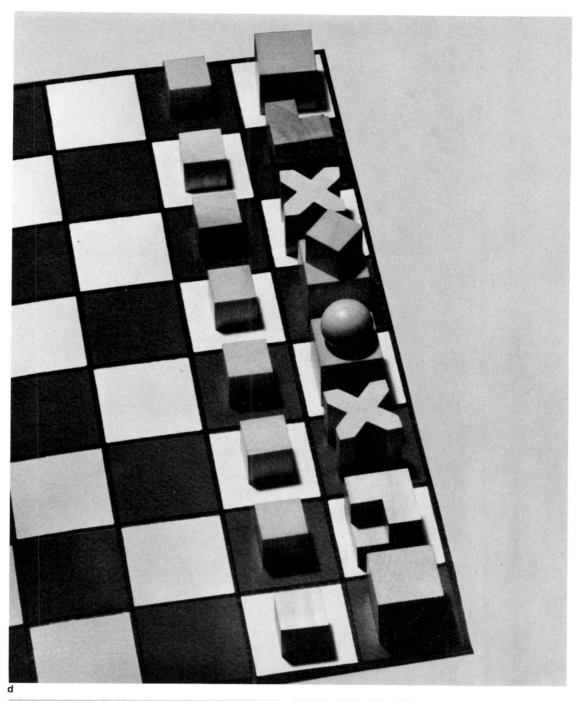

d

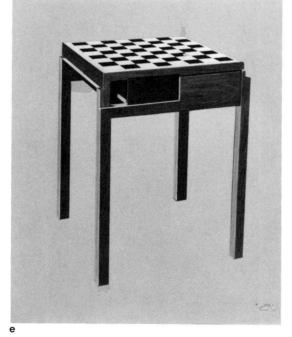

e

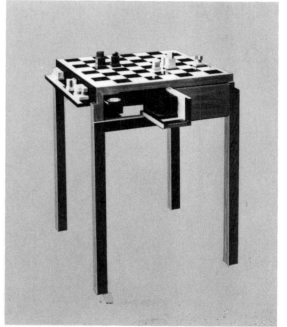

f

The Metal Workshop

When the Weimar Bauhaus was dissolved, Christian Dell, the technical supervisor (master craftsman) of the metal workshop, was officially acknowledged to have developed it since 1922 "from modest beginnings to full bloom." His predecessor, a master craftsman named Kopka, had not proven suitable. During the early years of the workshop the artistic leadership was unsteady at best. The domain of each artist was revised repeatedly, so that not even the master craftsmen always knew with which form master they were supposed to work. But it is certain that in general Johannes Itten was responsible for the metal workshop until 1923. From 1923 on Moholy-Nagy conducted its work and with his esthetic energy put his stamp on it. He directed this workshop in Weimar until 1925 and later in Dessau until 1928. Technically the workshop functioned exceptionally well. Its apprentices and journeymen—like Marianne Brandt, Wilhelm Wagenfeld, Otto Rittweger, K. J. Jucker, and Wolfgang Tümpel—did superior work. Freely associated with the metal workshop, which was oriented along practical lines—primarily toward development and manufacture of articles for everyday use—was a workshop for precious metals (jewelry) at the Weimar Bauhaus. It was operated as a private workshop by Naum Slutzky.

a
The metal workshop of the Bauhaus in Weimar. 1923.
b
Moholy-Nagy and Dell with apprentices and journeymen of the metal workshop. About 1924.
c
K. J. Jucker and Wilhelm Wagenfeld: table lamp. Glass base and stem, globe of frosted glass. Journeyman project. 1923–1924.
Bauhaus-Archiv, Darmstadt.
Attempt at creating a straightforward and functional form. In 1924 Wagenfeld designed a variation of this lamp which had a metal stand concealing the electrical cord.
d
K. J. Jucker: pull-out wall lamp. Iron and brass, nickel plated. Apprentice project. About 1923.
Attempt at developing a new mechanism and an appropriate form for practical requirements.
e
K. J. Jucker: piano lamp. Annealed iron and brass stand. Apprentice project. 1923.
The lamp—a first step along the road to functional form—was constructed in such a way that the stand could be turned and moved radially; in addition, the shade was adjustable.

a

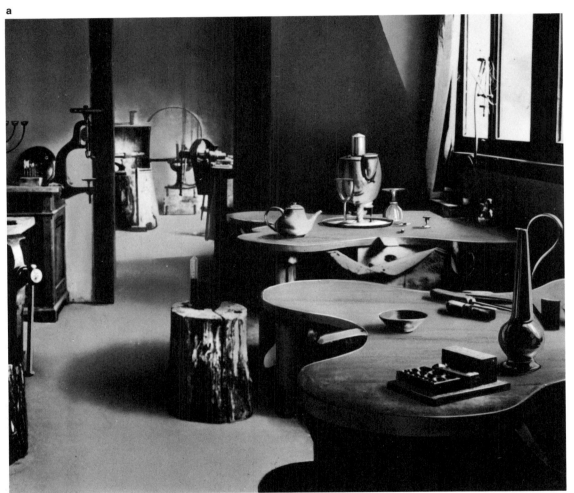

b

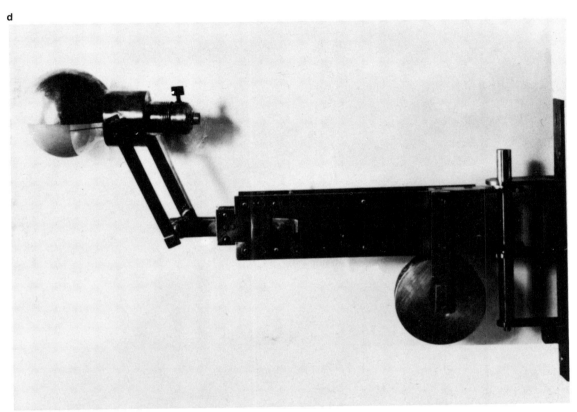

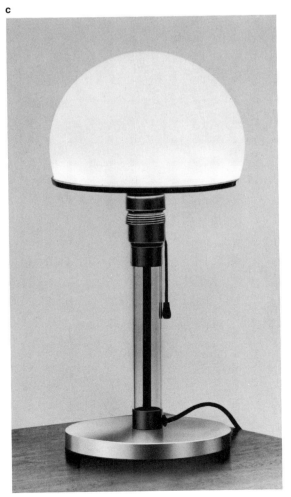

a

b

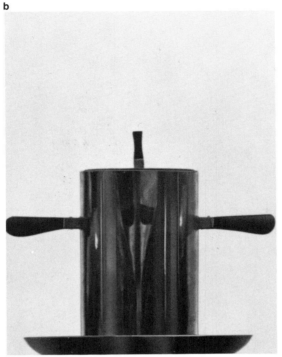

d

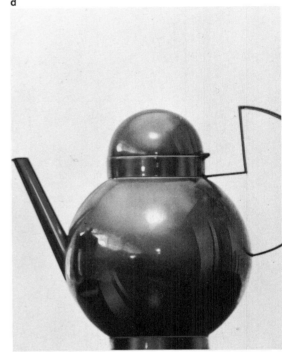

c

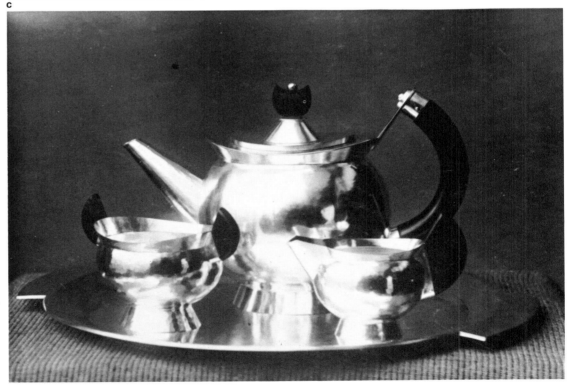

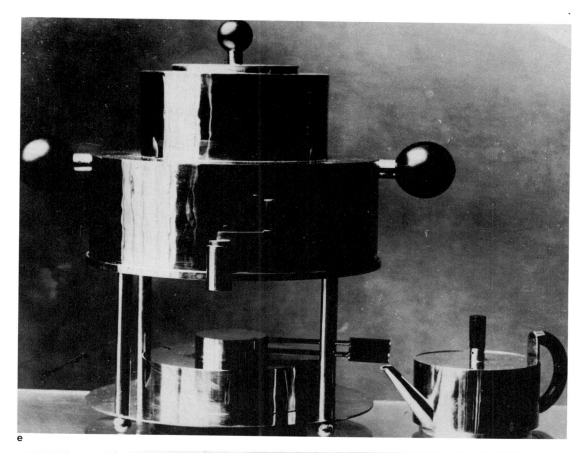

e

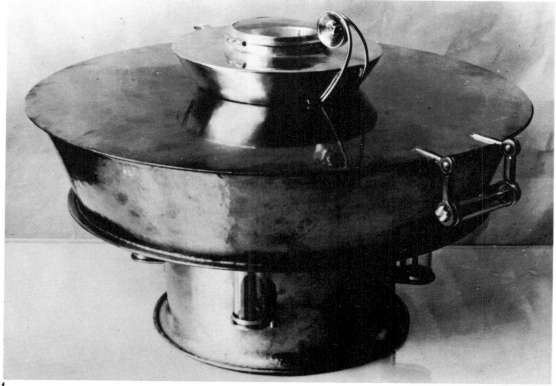

f

During the early years there predominated among the students a propensity for tackling designs with complicated forms, like a samovar. This showed how visual problems, too, were of prime concern. The object to be designed was viewed as a sculptural body, the parts of which were meant to be articulated and proportioned with esthetic clarity. But in Dell's pleasing and attractively shaped tea set one recognizes models such as became known, for instance, from the products of the Wiener Werkstätte. The efforts to arrive at uncompromisingly new forms emanated from the artists, teachers, and students; the master craftsmen, coming from a different background, adjusted to them.

In the products made around 1924 it becomes more and more evident that the consideration that things should be primarily functional and handy modified the desire for a strictly stereometric construction of the form. In this process, those involved—teachers and students—built on a free exchange of ideas. Not the least of the credit is due Moholy-Nagy for having helped the students to drop their partiality for the notions of cubism (as well as traditional ideas) and also their early formalistic play.

a
Christian Dell: decanter. German silver; silver-plated inside; ebony lid, knob, and handle. About 1924.
On loan to the Bauhaus-Archiv, Darmstadt.
b
Wilhelm Wagenfeld: gravy container and tray. German silver, ebony handles. 1924.
Bauhaus-Archiv, Darmstadt.
c
Christian Dell: tea set with teapot, cream pitcher, sugar bowl, and tray. German silver. About 1923–1924.
d
Wolfgang Rössger and F. Marby: pot. Tombac and German silver. 1924.
Bauhaus-Archiv, Darmstadt.
e
Josef Knau: tea urn with spirit burner and small pot for tea essence. Tombac, German silver; handles made of ebony. Inside silver-plated. 1924.
f
K. J. Jucker: electric samovar. Brass; silver-plated inside. 1924.

Products of the metal workshop, such as these, demonstrate the possible approaches to form that were explored during the Weimar period. However much industrial mass-production methods might have been considered by the designer, these goods are still characterized by the fact that they were made by hand. Yet the step toward what has come to be known as "industrial design" is no longer a big one.

a
Otto Rittweger: tea set, consisting of a pot for tea essence, cream pitcher, sugar bowl, candy box, and tray. German silver (?), ebony handles. About 1924.

b
Marianne Brandt: tea and coffee set, consisting of kettle with spirit burner, small pot for tea essence, coffee pot, cream pitcher, and sugar bowl. Silver, ebony knobs and handles. About 1924.

c
Josef Albers: tea glass. Glass, metal band (flexible), ebony handles; porcelain saucer. About 1924.
Bauhaus-Archiv, Darmstadt.

d
Josef Albers: fruit dish. Glass, German silver, wooden balls. 1924.
Bauhaus-Archiv, Darmstadt.

e
Otto Rittweger and Wolfgang Tümpel: spherical tea infusion spoons with stands. German silver. 1924.
One copy of the set without the semicircular handle is owned by the Staatliche Kunstsammlung in Weimar. Another version, made by Wagenfeld, is also in Weimar, and one copy is in the Bauhaus-Archiv in Darmstadt.
A well-thought-out solution to a limited design problem. This apparently very simple problem of designing a practicable spherical tea-infusion spoon utterly fascinated the students around 1924; one can assume that here the compulsion for reducing things to their most concise and mass-producible form found expression.

a

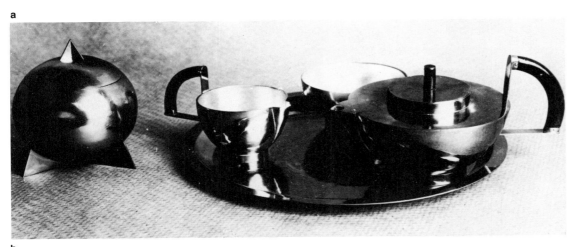

b

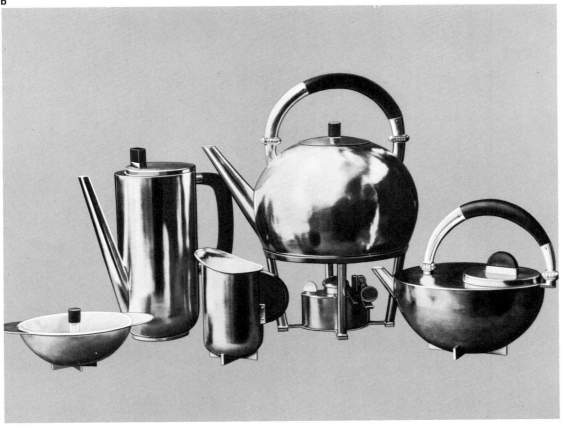

c

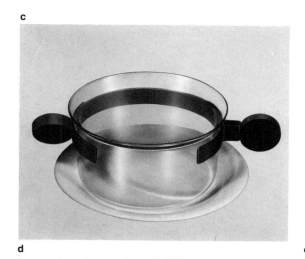

d

e

a
Marianne Brandt: small pot for tea essence with deep tea strainer. Brass container, silver-plated inside; ebony handle. Strainer (set in) made of silver. 1924. Bauhaus-Archiv, Darmstadt.
b
Marianne Brandt: ashtray with cutout, removable lid. German silver (lid) and bronze. 1924. Bauhaus-Archiv, Darmstadt.
c
Marianne Brandt: ashtray with tilt-up lid and attachment for depositing a cigarette. German silver. 1924. Private collection, Dessau.
d
Top view of the pot, fig. a.
This item is a "classic" example of the Weimar metal workshop, in its originality as well as in its conciseness of form and function.
e
The ashtray, fig. c (closed).

a

b

d

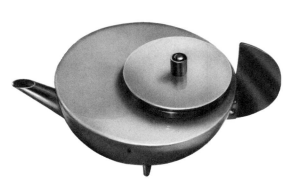

c

e

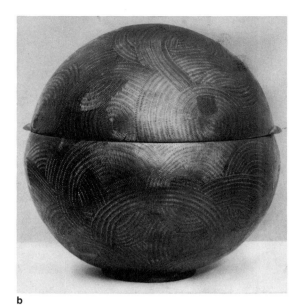

b

a

Metal Workshop:
Decorative Work

The task of designing ornamental metal work was assigned only in the early stage; after Moholy-Nagy had taken charge of the workshop this effort disappeared completely. This type of work was done as a specialty by Naum Slutzky in his private workshop, which was affiliated with the metal workshop.

a
Naum Slutzky: pendant. Silver, wood, quartz. About 1922.
A similar pendant is in the collection of the Bauhaus-Archiv, Darmstadt.

b
Naum Slutzky: container made of copper. About 1922.
In his designs, the results of which were original and entirely independently arrived at, Slutzky was in part inspired by primitive native folk art. Though he was an isolated phenomenon at the Bauhaus, he did have some influence on students like Karl Auböck and—outside the Bauhaus—a large sector of the public.

c
Apprentices of the metal workshop: door handle. Iron, nickel plated. About 1922.
Destroyed.
Attempt at applying compositional principles of constructivism to a functional detail.

a

c

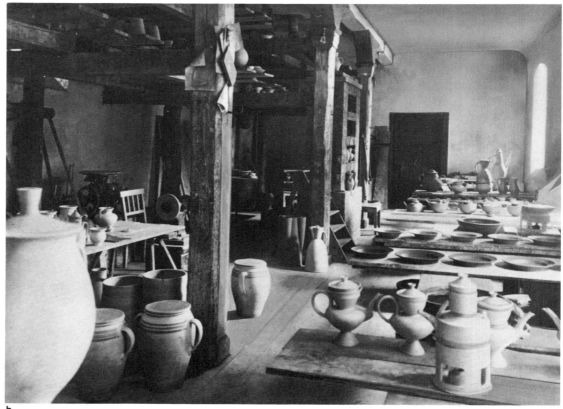

b

The Pottery Workshop of the Staatliche Bauhaus (Dornburg on the Saale)

The pottery workshop of the Weimar Bauhaus was housed in one of the wings of the castle in Dornburg on the Saale. Dornburg, though about 20 miles from Weimar, was chosen as the domicile because this was a place with an old pottery tradition, with workrooms, helpers, and appropriate technical facilities. In a period of want, like that after the war, such aid was highly valued. Nevertheless, the working conditions were unsatisfactory. Time and again, the reports from the workshop lamented the shortage of firewood, the little that was available being wet. The set-up was obsolete, and repairs and improvements had to be postponed until 1924. The workshop activity was inaugurated in 1921 under the competent technical supervision of Max Krehan. As master of form, Gerhard Marcks influenced the pottery workshop more indirectly by artistic inspiration and through his personality than by giving instruction. Most of all, he pointed out to the students the richness of folklore (which in part they used in a remarkably creative way). From among the students, the strongest supporters of the pottery workshop were Otto Lindig and Theodor Bogler. When in 1923 the workshop was divided into a workshop for instruction ("Bauhaus workshop") and one for production, spatially separated on two different floors, the supervision of one was given to the journeymen Lindig and Bogler, while the other remained under Krehan. Since about 1923, Lindig and Bogler stressed the importance of coping with the problems of mass production, which at that time, however, was to be implemented to a modest extent only. During the succeeding years Lindig, who directed the workshop during the Bartning era from 1925 to 1930, after that continued it privately and did significant work in this area.

a
The castle in Dornburg, seen from the river Saale. About 1923.
The extensive buildings consisted of several sections, having been built in the Middle Ages, the late Renaissance, and the Rococo periods. Goethe was often in the Dornburg castle.

b
A workroom in the pottery workshop of the Bauhaus. About 1923.

c
Wing of the castle in Dornburg on the Saale. About 1923.

d
Max Krehan (seated in the center) with apprentices and journeymen at work in the pottery workshop. 1924.

e
Gerhard Marcks in his studio in the castle at Dornburg, part of the facilities of the pottery workshop. About 1924.

d
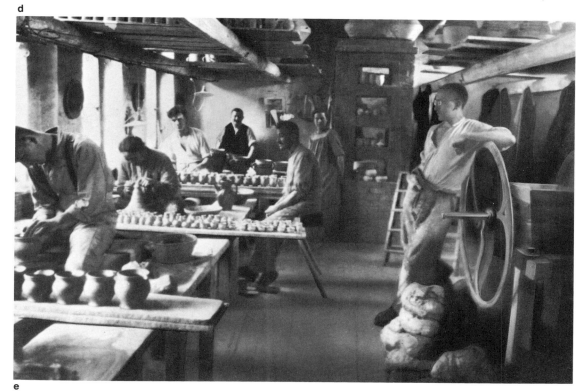

e

d

a

b

c

e

324

The statuary ideal, which was still in the mind of the Bauhaus potters during the early stage of development, is manifested in the choice of forms for these works—demonstrated especially by pronounced bulging and the doubling of spouts and handles, characteristic of the water jug. Often, as in the present examples, associations with faces and Janus-like heads are created. The suggestion of organic human forms is meant to represent metaphorically the elemental quality and earthiness of the ceramic product and the importance it has enjoyed in the everyday life of man since prehistoric times.

The Bauhaus pottery workshop never reached the stage of doing more extensive model work for ceramic production. Some of its members, notably Lindig, later worked independently in this area.

a
Johannes Driesch: *poròn*. Fired clay, partially glazed. About 1922.
Bauhaus-Archiv, Darmstadt.
The idea of producing a variation of the form of the old Spanish water and wine jug was instigated by Marcks.

b
Otto Lindig (?): pot with handles. Fired clay, partially glazed. About 1922.
Typical of the work of the early phase of development.

c
Gerhard Marcks (design) and Max Krehan (implementation): water jug. Fired clay. About 1922.
This form is a free interpretation of late medieval shapes of Central German pottery art.

d
Otto Lindig: water jug with a filling aperture on top. Fired clay, glazed. About 1923.
Staatliche Kunstsammlungen, Weimar.
It was due to Marck's initiative that, during the stage of development when handwork was practiced, the potters of the Bauhaus emphasized the sculptural aspect, in analogy to antique form principles. This explains why the handles of the pots and pitchers are not always functional in their number and arrangement; why their bases are relatively small (sometimes too small). In this case, it also accounts for the asymmetry of the design of the top (filling funnel). The container was primarily considered as a sculptural body.

e
Gerhard Marcks (design and ornament) and Max Krehan (implementation): vase-shaped milk jug with representation of a cow. Light-colored clay, glazed. About 1922.

f
Gerhard Marcks (design and ornament) and Max Krehan (implementation): bottle-shaped jug with handle and with the representation of a ploughing team. Light-colored clay, glazed. About 1922.
Bauhaus-Archiv, Darmstadt.
This kind of "woodcut" style, reminiscent of primitive paintings, was extremely well suited for the antique forms Marcks preferred.

f

a

a
Johannes Driesch: egg cup and breakfast plate. Clay,
glazed in honey-colored and brown tones. About 1922.
On loan to the Bauhaus-Archiv, Darmstadt.
b
Johannes Driesch: cup and saucer. Clay, dark-brown
glaze. About 1922.
On loan to the Bauhaus-Archiv, Darmstadt.
The relief figures on the cup are: a boy, a girl, a dog,
a stag, a rabbit, and between each of them a tree. This
is typical handwork, with a tendency toward folklore,
developed in the immediate joy of creating without
considering the possibilities of series manufacturing.
c
Otto Lindig: "Ceramic Temple of Light." (Small tower.)
Fired clay. 1921–1922.
One of the few attempts among students to freely
create something by means of ceramics. Lindig had
no intention of making a decorative object; instead,
he was guided by the wish to "build," using the
expressive medium available to him. In addition, this
probably reflects some politico-philosophical aspects
in the sense of the Bauhaus program and of the group
around Itten and Marcks.
d
Otto Lindig: milk pitcher. Fired clay, glazed. Journey-
man work. About 1922.
e
Otto Lindig: cup and saucer (part of the same set to
which the coffee pot, shown above, belongs). Fired
clay, glazed. Journeyman work. About 1922.
f
Otto Lindig: coffee pot. Fired clay, glazed. Journey-
man work. About 1922.
g
Otto Lindig: water jug. Fired clay, glazed. Journey-
man work. About 1922.

b

c

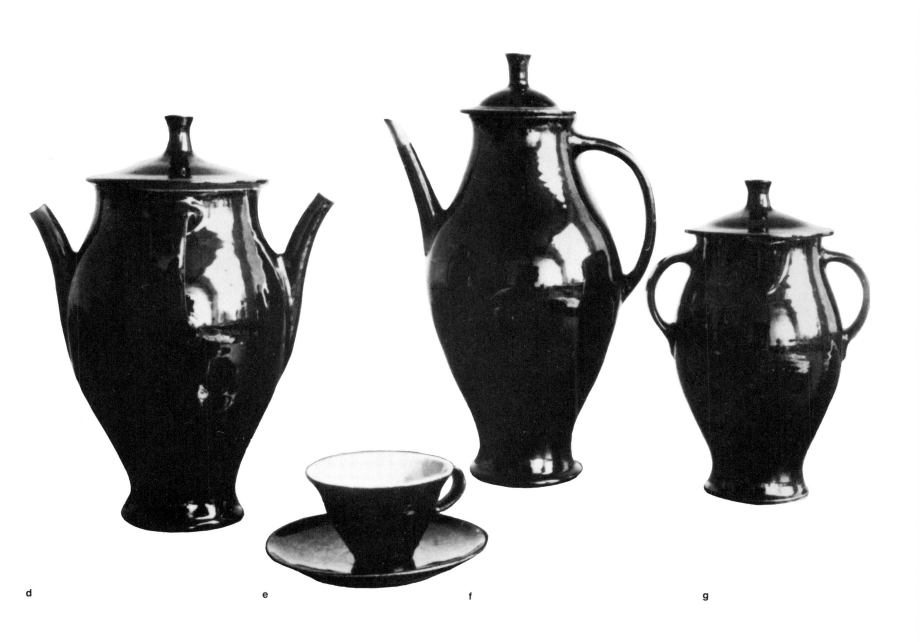

d e f g

a

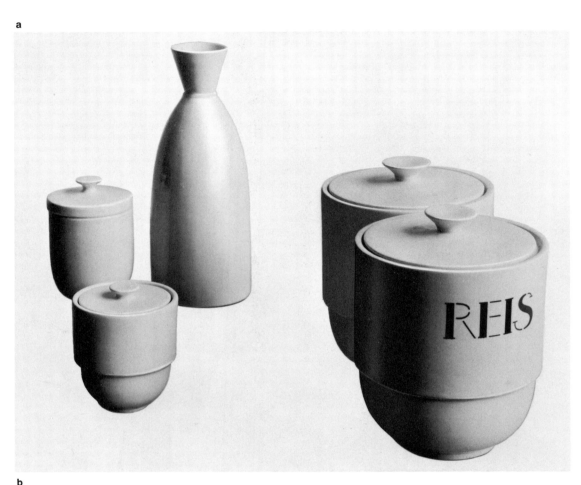

b

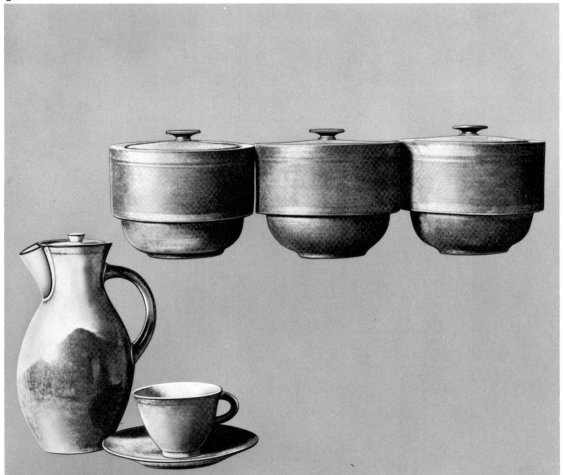

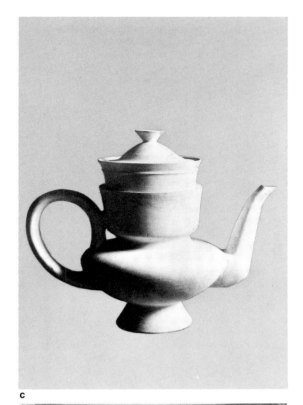

c

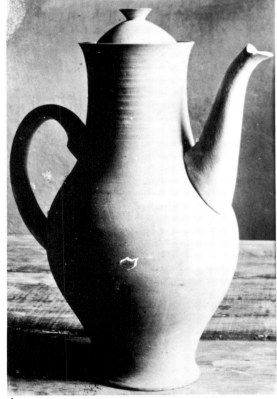

d

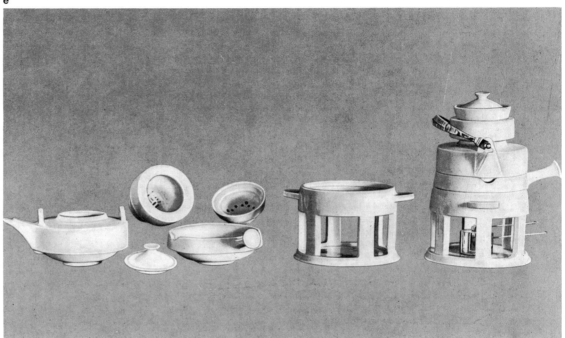

e

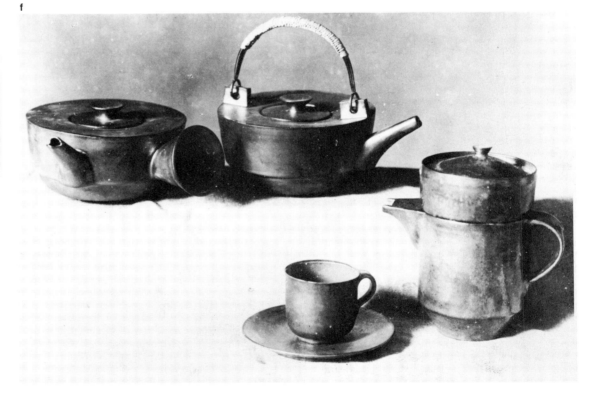

f

a

Stained-Glass Workshop

In the beginning Itten was responsible for this workshop; from 1922 on it was Paul Klee. Technically it was supervised by Albers, who had worked in it before, from 1923 on. Before he took charge, this workshop vividly demonstrated how difficult it can sometimes be to find master craftsmen with sufficient artistic sensitivity and penetration. A routine glazier and glass stainer by the name of Kraus, who ran his own workshop in Weimar, turned out to be totally unsuitable. Albers gave the stained-glass workshop meaning and substance. Aside from small pictures, comparatively little was produced. The sacred character of glass staining limited its application within the framework of architecture. Important commissions were a rare event. Hence, the Dessau Bauhaus abandoned this undertaking.

a
The stained-glass workshop in the Staatliche Bauhaus. Weimar. About 1923.

b
Josef Albers: stained-glass window in the staircase of Sommerfeld House, Berlin-Dahlem. 1922.
Next in importance to the wood carvings by Joost Schmidt is this window made by a member of the workshop for the Sommerfeld House, designed by Gropius and Meyer in 1921.

c
Josef Albers: stained-glass window in the hall of the house of Dr. Otte in Berlin-Zehlendorf. Journeyman work. About 1923.
In addition to the staircase window for Sommerfeld and the hall window for Dr. Otte, the third major commission for Albers was the design and execution of colored staircase windows for the Ullstein Publishing Company building in Berlin.

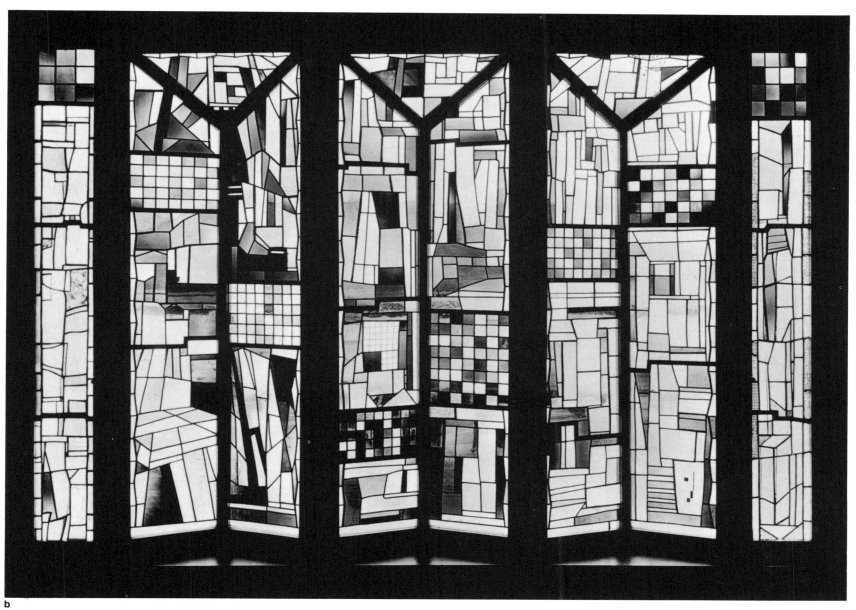

b

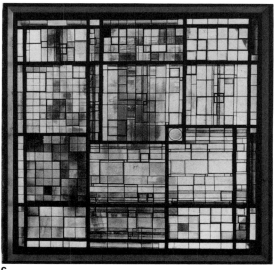

c

Wall-Painting Workshop

The wall-painting workshop received its artistic substance essentially from Kandinsky, who directed its work from 1922 until 1925. Before that time the artistic responsibility (here as well as in other workshops) had not always been clearly defined; Schlemmer and Itten were alternately in charge. The employment of a competent master craftsman caused great difficulties. A master from Weimar by the name of Mendel resigned in early 1921 after a short trial period. Carl Schlemmer (brother of Oskar Schlemmer) provided exceptional manual talent but did not adapt to the community of the Bauhaus masters. Involved in an intrigue which eventually climaxed in the "Yellow Brochure," he forced Gropius to file a suit against him. Carl Schlemmer contributed more than others to undermining the position of the Bauhaus within the politically minded public. In Heinrich Beberniss the workshop had an upright and competent master craftsman from 1923 on. Among the students, apprentices, and journeymen, Arndt, Bayer, Maltan, Mezel, Paris, and Scheper were remarkable talents. However, commissions which would have lent themselves to the implementation of great artistic possibilities were lacking. The production work consisted mainly of painting jobs in buildings and work for the cabinetmaking workshop. Strong colors were favored. Since an important creative impetus was lacking, exhibitions and celebrations offered the members of the wall-painting workshop a particularly welcome chance to give free rein to their imagination and manifest their artistic programs.

The sgraffito work on the wall on the left in Fig. b was done by Bayer, the painting with calcimine on the right by Paris. The determining idea underlying the training in the workshop was the integration of color as a factor into the architectural environment. With this point of view, the workshop participated in 1922 in the interior work (painting in color) of the theater in Jena, of the Sommerfeld House and the Dr. Otto House, both in Berlin. In 1922 the workshop did one of the rooms of the "Juryfreien" Exhibition, also in Berlin, after designs by Kandinsky, and in 1923 it furnished the painting of the Bauhaus experimental house. Private commissions were very modest, to the point that in February 1924, the master craftsman Beberniss made the suggestion of establishing a branch workshop in Berlin which he hoped would be more successful. But what the students needed most of all were opportunities for the artistic implementation of their ideas, not just more or less noncommittal student exercises. The really outstanding contribution to the subject of wall-painting did not come from a member of the workshop but from Oskar Schlemmer, who painted the murals in the stairwell of the Weimar workshop building.

a
The wall-painting workshop in Weimar. 1923.

b
Herbert Bayer and Rudolf Paris: wall painting in sgraffito and calcimine (in various techniques), done in the wall-painting workshop, Weimar. 1923.

c
Josef Maltan and Alfred Arndt: fresco in the workshop building, Weimar. Journeyman and apprentice work. 1923.

a

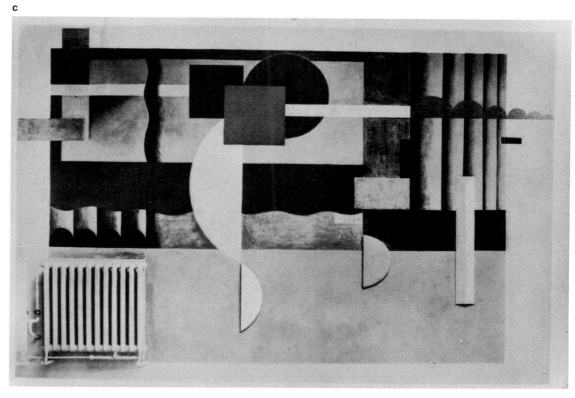

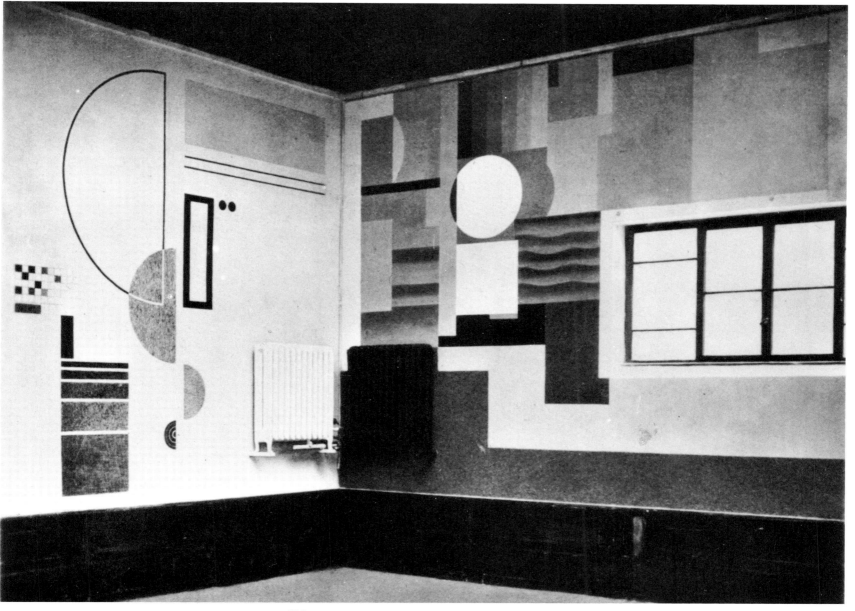

333

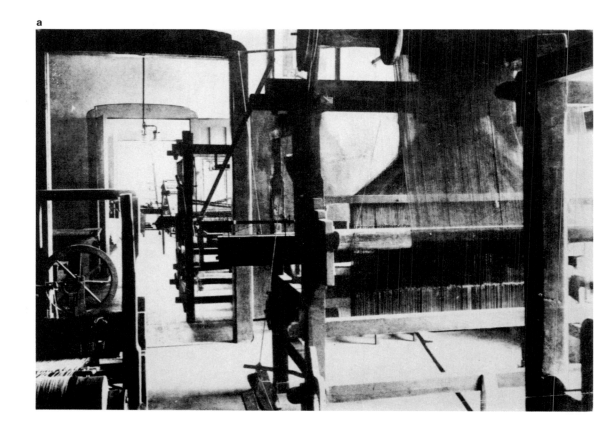

a

Weaving Workshop

The form master in the weaving workshop was Georg Muche. The master craftsman, Helene Börner, was an experienced teacher, having been on the staff of van de Velde's arts and crafts school. After the arts and crafts school was dissolved, she took over the weaving workshop under her own management. Since she provided the Bauhaus with the looms, it was possible to assume regular work in this workshop at a time when the other workshops were still lacking the most basic equipment. Nevertheless, there were difficulties. Some of them were caused by a shortage in materials, and others at times by the opposition of the students against contract work based on serial reproduction.

Designing and creating something new was preferred to repetition, despite the fact that the latter was financially more rewarding. In the design of commercial fabrics, rugs, and hangings, various suggestions by Muche and Klee and other contemporary painters, as well as motifs of folklore, were taken up and modified according to the techniques and materials of weaving. The products of that workshop were marked by unmistakable characteristics. The students in the weaving workshop were primarily women, among them such talented individuals as Lies Deinhardt, Martha Erps, Gertrud Hantschk, Ruth Hollós, Benita Otte, and Gunta Stölzl, who was subsequently given the directorship of the workshop in Dessau.

a
The weaving workshop in the Staatliche Bauhaus. 1923.
b
Max Peiffer-Watenphul: tapestry. Sheep's wool. Apprentice work. About 1920.
Bauhaus-Archiv, Darmstadt.
Strong colors are set against a light-gray background —yellow, orange, several variations of red, and blue-green. This tapestry was given to Itten as a farewell present when he left the Bauhaus, as an expression of the students' gratitude.

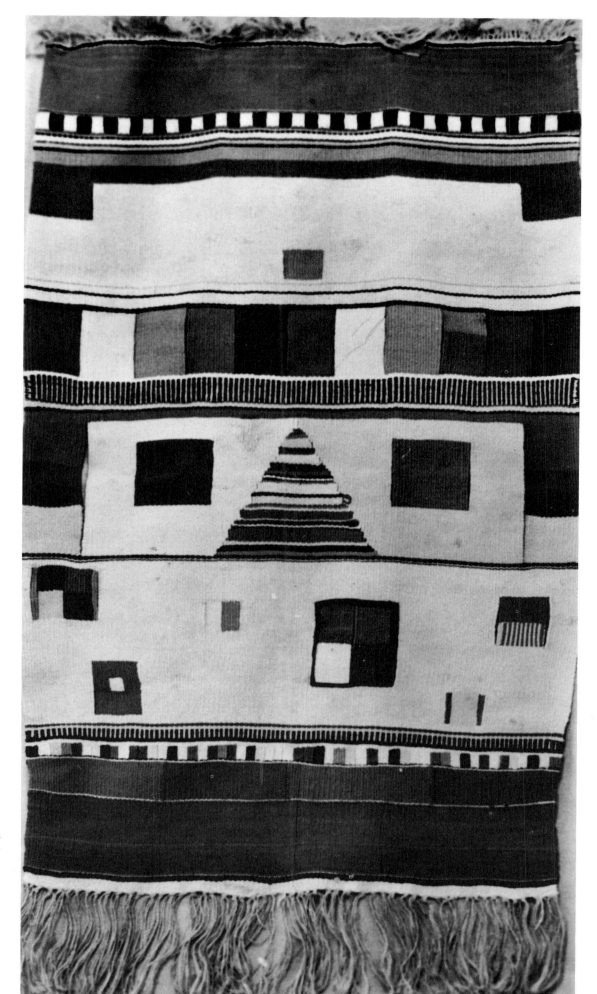

b

a
Students of the weaving workshop: two blankets with striped patterns. Wool and rayon; the lower one also contains cotton.
Upper blanket: unbleached background and narrow stripes in rainbow colors.
Lower blanket: black and white stripes.
About 1921–1923.
Staatliche Kunstsammlungen, Weimar.

b
Students of the weaving workshop: woven wall hanging. Sheep's wool and silk. About 1921–1923.
Staatliche Kunstsammlungen, Weimar.
The panels and the horizontal stripes are unbleached (sheep's wool), gray, and black. Some of the vertical stripes are black; the warp is white.

c
Margarete Köhler: wall hanging. Semi-Gobelin (dobby weaving). Wool, cotton, silk, and viscose.
Colors: gray-silver, black, and white. 1921.

d
Students of the weaving workshop: textile (blanket) with displaced rectangles. Cotton.
Colors: yellow, red, blue, black, and white.
About 1921–1924.
Staatliche Kunstsammlungen, Weimar.

e
Hedwig Jungnik: tapestry. Sheep's wool. Apprentice work. About 1921.
Staatliche Kunstsammlungen, Weimar.
Colors: various shades of green, beige, dark brown, and black. The warp-threads have been tied into fringes at both ends. The choice of forms seems to have been directed by suggestions from Muche.

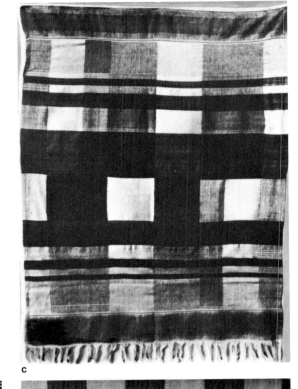

c

a

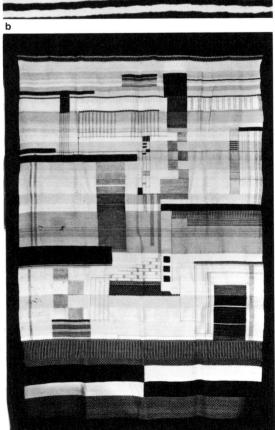

b

d

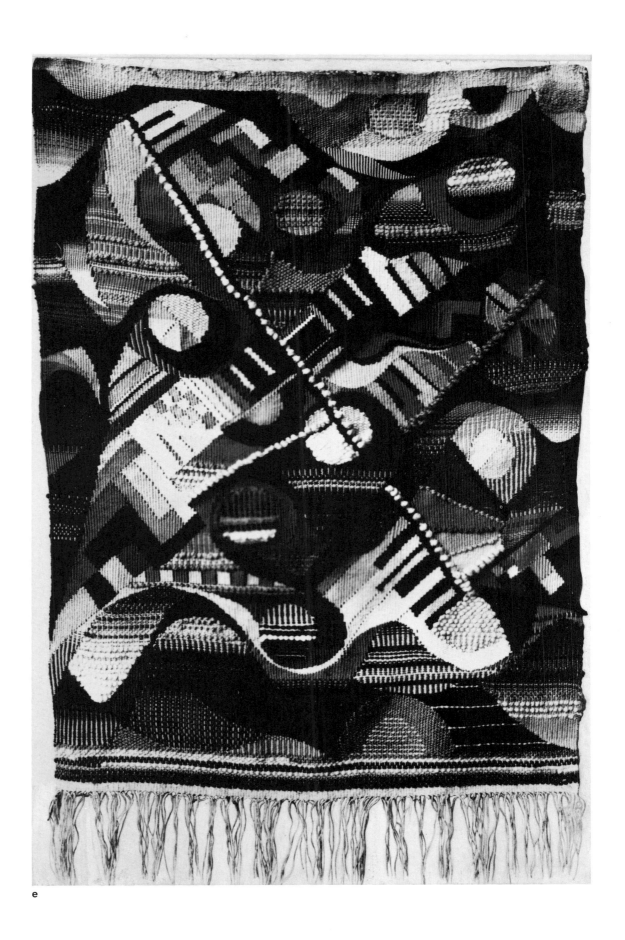

e

The painter Ida Kerkovius had studied with
Hölzl in Stuttgart and was already forty years
old when she came to Weimar to join the Bau-
haus about which she felt very enthusiastic.
She remained a member of the Bauhaus com-
munity until 1923.
a
Ida Kerkovius: rug made of textile remnants. Appren-
tice work. About 1920.
b
Benita Otte: tapestry. Smyrna wool.
Color scale: blue-yellow and various shades of
brown. 1924.

a

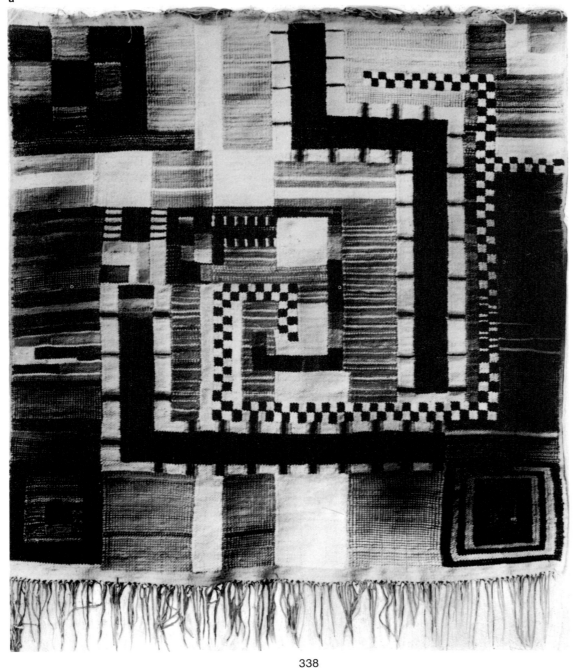

b

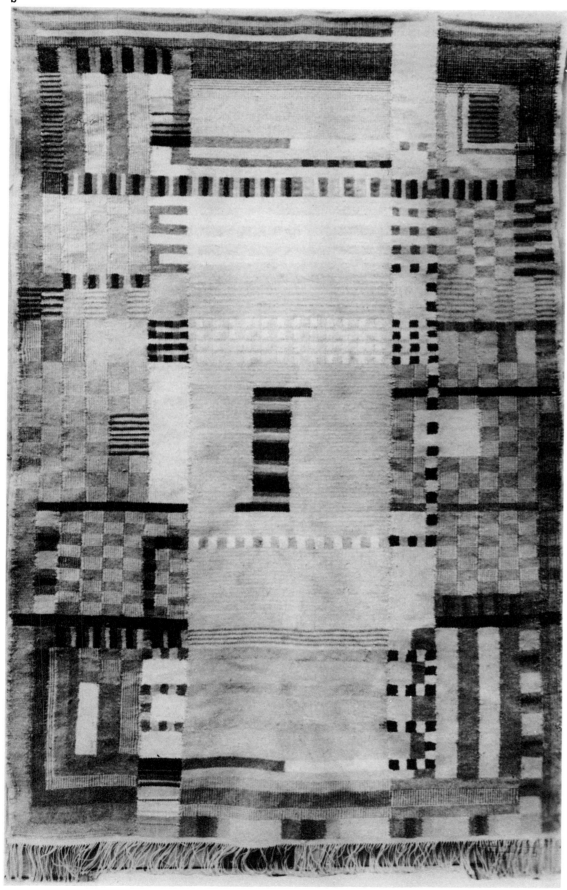

a

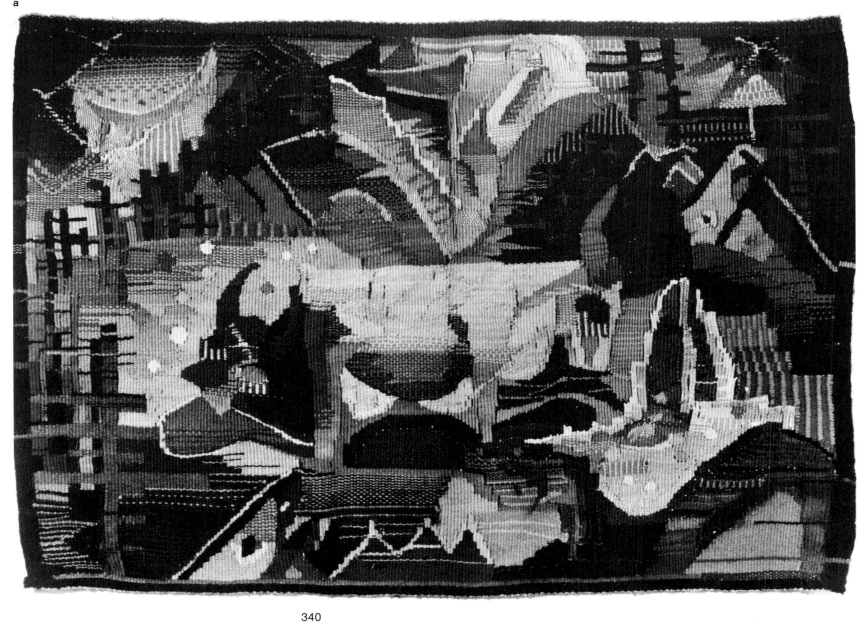

Gunta Stölzl was a member of the weaving
workshop from the fall of 1919. Even in the early
nineteen twenties she occupied something of a
special position in the workshop, a position
which was underlined even more by the fact
that she passed her journeyman's examination
already in 1922. Thus, in order to enable her to
supplement and relieve Helene Börner, the
Bauhaus sent her to attend special courses at
the technical schools for dye-work and textiles
in Krefeld. The weaving workshop in Weimar
was to a large extent sustained by her initiative.

a
Gunta Stölzl: tapestry. Wool. Apprentice work. 1920.
Collection Professor Peter Meyer, Zurich.
At a width of less than 20 inches this represents an
almost miniature format for a tapestry. The rendering
is characterized by a joyful telling of lyrical stories.
There is a landscape, in the center of which has been
placed a fairy-tale-like cow. The colors are intense;
in the landscape they range from deep, nonchromatic
values to green and blue. The cow is mainly ochre,
the horns are red.

b
Gunta Stölzl: Smyrna rug, hand-knotted. Smyrna
wool. Journeyman work. 1922–1923.
This rug was sold to someone in Holland during the
Bauhaus exhibition in the summer of 1923; where-
abouts unknown.
The rug is multicolored in strong tones. The designer
herself, aided by some of her fellow-students, did the
manual work.

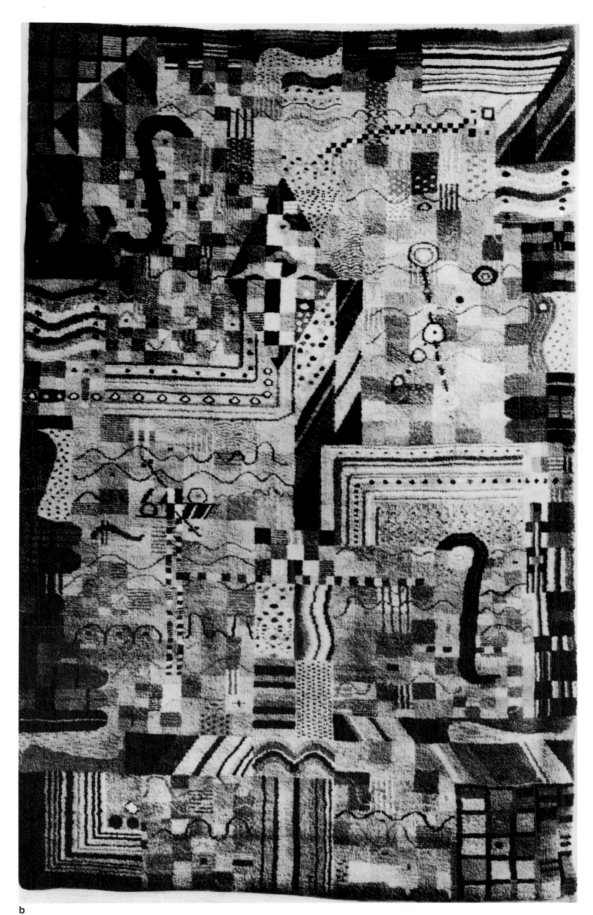

b

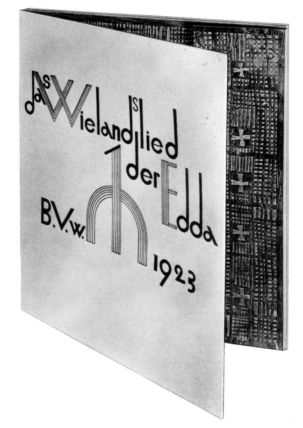

Bookbinding Workshop

The bookbinding workshop (like the weaving
workshop) was a privately operated workshop
that had originated in the Grand-Ducal Arts and
Crafts School. It was owned by the bookbinding
master Otto Dorfner, a technically extremely
competent man, and was affiliated with the
Bauhaus as an instruction workshop. The reali-
zation of artistic advice, which was to be pro-
vided by Paul Klee, met with quite insurmount-
able obstacles because Dorfner himself was a
designer, concerned with more than technical
manufacture, and as such had very definite
ideas of his own. His ideas concerning form
were shaped by the classicistic tradition. Thus,
the Bauhaus canceled the contract with him and
his workshop in 1922. But Dorfner continued to
accept work from the Bauhaus; for example, he
produced the covers for the Bauhaus portfolios.

a
Otto Dorfner: portfolio for the series of woodcuts
"Das Wielandslied der Edda" (The Song of Wieland in
the Edda) by Gerhard Marcks. Parchment. 1923.
Bauhaus-Archiv, Darmstadt.
Produced in 110 copies, each containing eleven wood-
cuts by Marcks. The woodcuts were printed in the
Bauhaus printing workshop. The portfolios were put
on the market by the Bauhaus Press (Munich and
Weimar) in 1923.
b
Otto Dorfner: book cover. Leather. About 1920.
c
Otto Dorfner: cover for Knut Hamsun's book "Pan."
Leather (with wood?) and cording. About 1920.
d
Anni Wotiz: bookcover for "Ekstatische Konfessionen"
(Ecstatic Confessions). Parchment (?). About 1920.
e
Student of the bookbinding workshop: cover for the
book "Die kleine Stadt" ("The Little Town") by
Charles Louis Philippe. Woven fabric. About 1920.

a

b

c

d

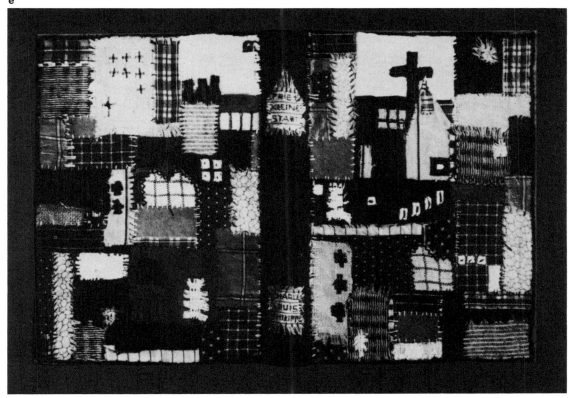

e

a

Printing Workshop

The workshop was set up for the printing of graphic art sheets (lithographs, etchings, etc.). Lyonel Feininger led its work as form master, and Carl Zaubitzer was responsible for the technical supervision. The latter was a reliable master craftsman of the older generation who stayed with the Weimar Bauhaus from 1919 until its dissolution in 1925. After that he continued working for a time under Bartning. Ludwig Hirschfeld-Mack moved up from apprentice to journeyman (the first one to do so at the Bauhaus) as early as 1922. Both he and Rudolf Baschant showed artistic talent. The students' desire to do creative work was a source of permanent problems to Zaubitzer, for at least from 1922 on the workshop had ample reproduction work to do. There was the graphic art for the portfolios of woodcuts by Feininger and Marcks, for the four Bauhaus portfolios "Neue europäische Graphik," ("New European Graphics"), (Müller & Co. Press), for the "Meistermappe" (Masters' Portfolio) edited in the Bauhaus' own press, for a Schlemmer portfolio (published by himself), and for Kandinsky's portfolio "Kleine Welten" ("Small Worlds") (Propyläen Press). In addition, there were numerous single graphics by masters and students to be printed by the workshop, as well as the contracts for outsiders, important because they represented income. But the finances did not suffice for setting up a book-printing or even an offset-printing workshop.

Among the highest-quality work carried out by the printing workshop of the Weimar Bauhaus was the printing of the eight sheets of graphic art reproduced on pages 346–353. They were produced in a small edition and put together into a "Meistermappe," published by the Bauhaus Press in 1923. Within a decade this portfolio had already become a collector's item.

a
The printing workshop of the Staatliche Bauhaus. 1923.
b
A selection of products of the graphic workshop of the Bauhaus, made prior to 1923 (letterpress, lithograph, and intaglio).
Reproduced from the copy owned by the Hessische Landesmuseum in Darmstadt.

b

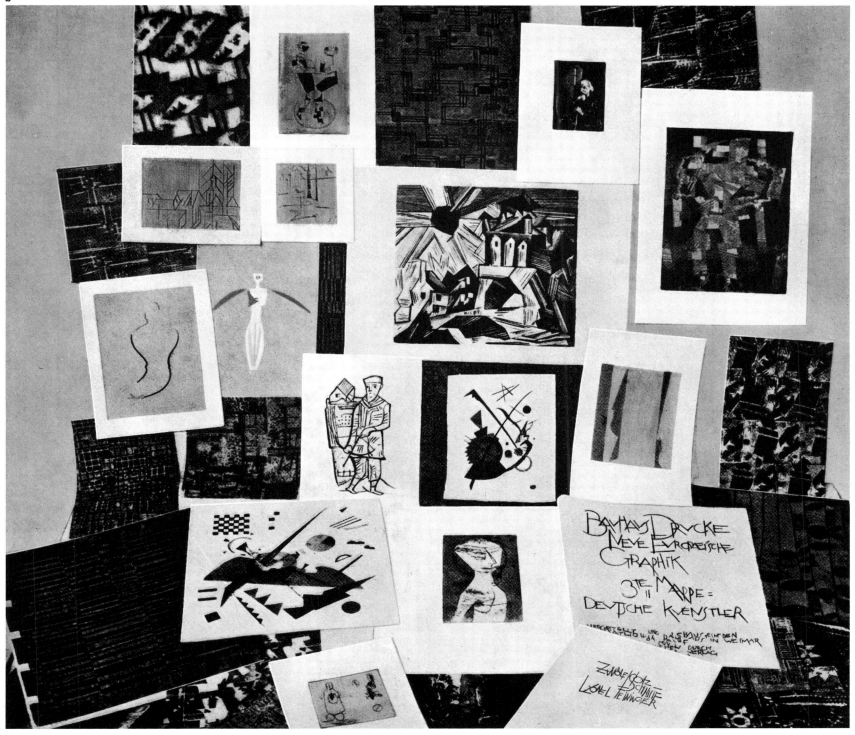

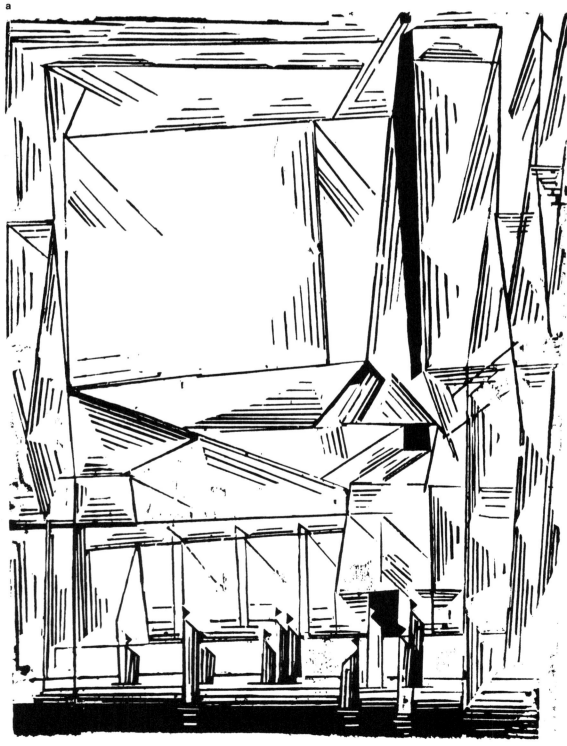

a

a
Lyonel Feininger: woodcut.
Print 1 of the "Meistermappe" 1923.
b
Wassily Kandinsky: color lithograph.
Print 2 of the "Meistermappe" 1923.

b

1923 91 Der Verliebte.

a
Paul Klee: color lithograph ("Der Verliebte,"
"The Lover").
Print 3 of the "Meistermappe" 1923.
b
Gerhard Marcks: woodcut.
Print 4 of the "Meistermappe" 1923.

349

a

a
Georg Muche: etching.
Print 5 of the ''Meistermappe'' 1923.
b
Laszlo Moholy-Nagy: color lithograph.
Print 6 of the ''Meistermappe'' 1923.

a

352

a
Oskar Schlemmer: etching.
Print 7 of the ''Meistermappe'' 1923.
b
Lothar Schreyer: woodcut.
Print 8 of the ''Meistermappe'' 1923.

The Bauhaus portfolios "Neue europäische Graphik" represented the largest assignment carried out by the printers at the Bauhaus. The edition was planned in late 1921 by the management of the Bauhaus in cooperation with the Müller & Co. Press in Potsdam, which took charge of the sales. Of the five portfolios announced in 1921, four had been published by 1923. The first was made up of fourteen graphics by Bauhaus masters. The third, entitled "German Artists," consisted of fourteen contributions by Baumeister, Campendonk, Hoetger, Macke (bequest), Marc (bequest), Schwitters, and others. The twelve prints of the fourth portfolio originated with Italian and Russian artists, among them Archipenko, Boccioni (lithograph from his bequest), Carra, Chirico, Javlensky, Kandinsky (who was not yet at the Bauhaus), Larionov, and Severini. The fifth one—containing 13 graphics—was again devoted to German artists, including Beckmann, Grosz, Heckel, Kirchner, Kokoschka, Kubin, Pechstein, and Schmidt-Rottluff. In portfolio number two, which did not materialize, first because of the political tensions during the postwar period, later because of economic difficulties and the dissolution of the Weimar Bauhaus, the editors had planned to present contributions by living French artists—like Braque, Delauney, Derain, Gleizes, Léger, Matisse, and Ozenfant. In the fall of 1924 editions were printed of the four plates that had been received at the Bauhaus by that time. The four were by Otokar Coubine, Fernand Léger, Louis Marcoussis, and Léopold Survage. Letters in which Gropius asked the other artists to send their plates were never sent out.

a
Léopold Survage: woodcut in red. Before 1924.
b
Louis Marcoussis: etching, dated 1912.
c
Fernand Léger: lithograph, dated 1921.

Contributions to the unpublished Bauhaus portfolio "French Artists."
Bauhaus-Archiv, Darmstadt, on permanent loan from the City of Darmstadt.

b

a

c

Typography, Commercial Art

The Weimar Bauhaus did not conduct classes in typography and commercial art. The printing workshop lacked technical facilities for such work. But on their own initiative students experimented a great deal in this area, with remarkable results.

The typography of the printed material published by the Bauhaus during its early years was hardly different from other typography of that time. It had to be produced in workshops outside the Bauhaus using the type faces available to them. Exceptions were such printed matter as required special cuts. In some cases, when line cuts were made, Itten's expressive calligraphy, felt to be very incisive, asserted itself. The development of a specific "Bauhaus" type style began around 1923. Into this typography some ideas of the Dadaist Kurt Schwitters, who was a friend of the Bauhaus, and of the "de Stijl" group around Theo van Doesburg were accepted and used, particularly by Moholy-Nagy and, at least partly because of his influence, by students like Bayer, Arndt, and Joost Schmidt. It was primarily from Schwitters and "de Stijl" that the very characteristic predilection for the use of typographical signs was derived; they were used as eye-catchers in the composition of the plane, but not always with motivation. Designs for the artistic arrangement of cultural and commercial exhibitions were part of the experiments in advertising art. Herbert Bayer and Joost Schmidt in particular did a great deal of work in the area of advertising and exhibition techniques. The collage technique of the Cubists and the Dadaists turned out to be assets for their own design work, especially for the "photoplastics" which Moholy-Nagy introduced to the Bauhaus, combining elements drawn by hand with those of photographs. On the whole, Moholy-Nagy was the decisive stimulus for everything done at the Bauhaus in the area of typography and advertising techniques from 1923 until the beginning of the Dessau period. His most important personal contribution, the designs of the "Bauhaus Books" (begun in Weimar), became effective only in Dessau.

a
Joost Schmidt:
title page of the November 1924 issue of the magazine "Junge Menschen," dedicated to the Bauhaus.
Copy in the Bauhaus-Archiv, Darmstadt.

b
Herbert Bayer:
large, turnable sphere for advertising purposes. Tempera, about 1924.
Private Collection, Aspen, Colorado.
Colored electric bulbs were to cover the entire sphere and make advertising in luminous letters possible.

a

Der Bezugspreis beträgt ganzjährlich für Amerika 2 Dollar, Frankreich und Belgien 30 Fres., England 10 Schilling, Finnland 65 Finnmark, Holland 5 Gulden, Schweden 5 Kronen, Norwegen und Dänemark 10 Kronen, Jugoslawien 160 Dinar, Polen und Österreich 130000 Kronen, Rumänien 200 Lei, Schweiz 10 Fres., Tschechoslowakei 50 Kronen, für das übrige Ausland den Wert von 10 Schweizerfranken. Für Deutschland gilt der aufgedruckte Heftpreis.

ORT DES ERSCHEINENS
MELLE IN HANNOVER

JUNGE MENSCHEN

MONATSHEFTE
FÜR POLITIK, KUNST, LITERATUR UND LEBEN
AUS DEM GEISTE DER JUNGEN GENERATION
HERAUSGEGEBEN VON WALTER HAMMER

SCHRIFTLEITUNG: WERTHER B. BIELEFELD ● VERLAG: HAMBURG 13, JOHNSALLEE 54.

POSTSCHECK HAMBURG 31941

HEFT **8**

SONDERHEFT

Bauhaus

WEIMAR

5. JAHRGANG

NOVEMBER 1924

HEFTPREIS 0.50 G.-M.

356

b

357

In some of the most interesting and stimulating typographical efforts, the element of playfulness is very important. An example is the invitation for the last party of the Weimar Bauhaus, designed by Herbert Bayer. Alluding in an ironic manner to the general mood of dejection and simultaneously overplaying it, he spread and gaily mixed a whole sample catalogue of all kinds of modern as well as old-fashioned rather dusty print. No matter if the typographers of "de Stijl" and "Dada" stood godfather for such examples as this; something original and characteristic evolved from these attempts and proved to be extraordinarily suited for further development later at Dessau.

a
Herbert Bayer: banknotes of the state government of Thuringia and the Thuringian "Staatsbankdirektoriums" (State Finance Board). 1923.
Specimen at the Busch-Reisinger Museum, Cambridge, Mass.
This emergency money became worthless a few days after its issuance, because of inflationary money devaluation. But it was noteworthy that a state bank had in fact printed money of such unconventional design.
b
Herbert Bayer: invitation to the farewell party of the Weimar Bauhaus on March 28 and 29, 1925.
Copy in the Bauhaus-Archiv, Darmstadt.

a

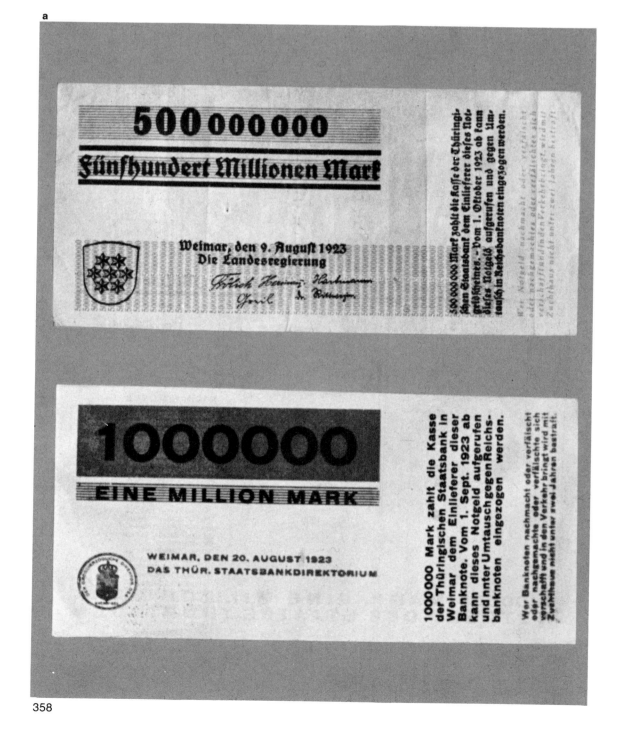

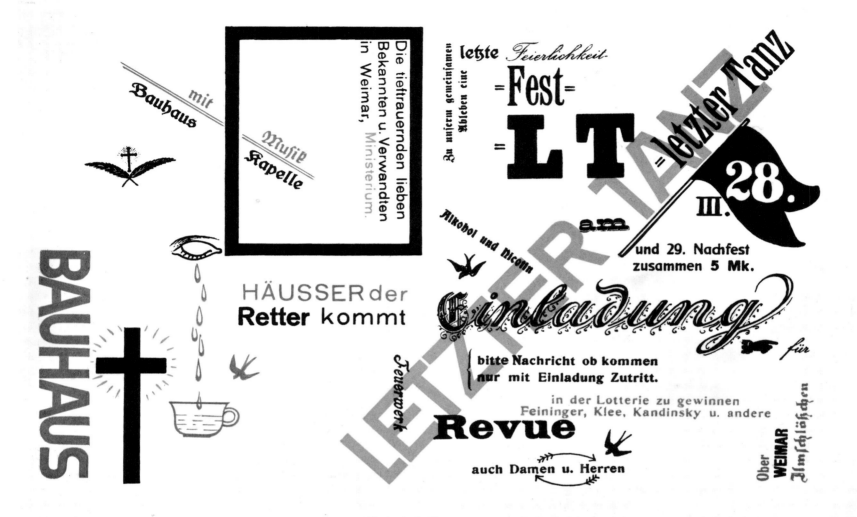

BAUHAUS

Bauhaus mit Musik Kapelle

Die tieftrauernden lieben Bekannten u. Verwandten in Weimar, Ministerium.

HÄUSSER der Retter kommt

letzte Feierlichkeit
=Fest=
LT
=letzter Tanz=
Zu unserm gemeinsamen Ableben eine

III. 28.
am und 29. Nachfest
zusammen 5 Mk.

Alkohol und Nicotin

Einladung für

bitte Nachricht ob kommen
nur mit Einladung Zutritt.

Feuerwerk

in der Lotterie zu gewinnen
Feininger, Klee, Kandinsky u. andere
Revue
auch Damen u. Herren

Ober WEIMAR Umschläßchen

LETZTER TANZ

b

The Stage Workshop (Bauhaus Stage)

Among the workshops of the Weimar Bauhaus the stage workshop was in a special position because it was able to interpret the Apprenticeship Board's regulations on professional training in free analogy. There was no regular craft apprenticeship for the stage workshop, and, instead of the journeyman's and the master's certificate of the Apprenticeship Board, the Bauhaus issued its own certificate of graduation. The workshop began in 1921 when Lothar Schreyer was appointed to direct it. He introduced the ideas of the literary Expressionism of the "Sturm" group. His dramaturgical ideal was a kind of religious play. The theater of the "Sturm" Expressionism largely dissolved the syntax and logic of the plot, language became stammerings pregnant with meaning and reinforced by pantomimic gesticulations, by movement and sound, color and light. The happenings on stage were reduced to melodramatic elements with symbolic content. Feelings were more important as well as more significant than the form of theatrical communication; content was not expressed but only hinted at in fragments, as for instance in an outcry or in hectic gesticulations. This manner of playing, practiced by Expressionism, did not get at the substance of performing, nor did it find any direct relationship to the theater and to things theatrical. This became evident in February 1923 at a rehearsal of some of Schreyer's sketchlike pieces for the stage which were being prepared for the Bauhaus Week in the summer of 1923. Since serious differences of opinion arose over this issue, Schreyer announced his resignation from the staff for the fall of the same year. The direction of the Bauhaus stage was immediately transferred to Oskar Schlemmer, making it possible for the workshop to introduce itself with programmatical performances during the "Bauhaus Week" in 1923.

a
Lothar Schreyer: sheet II of the score for the play "Crucifixion." Published in the form of a book of woodcuts; made by the workshop of the "Kampfbühne" ("Fighting Stage") in Hamburg in 1920. Reproduced in the book "Bauhaus 1919–1923" as a representative work by Schreyer. A complete copy of the score is in the possession of the Bauhaus-Archiv in Darmstadt.

a
The score contains:
word sequence = words and sounds, divided into measures
tone sequence = rhythm/pitch/volume, divided into measures
movement sequence = movement of colored forms, divided into measures
rhythm in common time = black zigzag line
Simultaneously played measures are written below each other/simultaneously played word sequences are bound together by vertical bars/the sign of the colored form marks the beginning of each time it is played/intonation sound speaking

word	word	crying	word	word	word
	half turn left		kneeling		from to

Meaning of the symbols

very high	high	middle	sound tone	low	very low
soft to	very soft	medium strong	strong	very strong	strong
very soft	quarter rest	broken rhythm	mother	half rest	beloved
whole rest	man movement	man movement	movement	whole rest	movement
		same as previous measure			

SCHEMA FÜR BÜHNE, KULT UND VOLKSFEST, UNTERSCHIEDEN NACH

ORTSFORM	MENSCH	GATTUNG			SPRACHE	MUSIK	TANZ
TEMPEL	PRIESTER	RELIGIÖSE KULTHANDLUNG			PREDIGT	ORATORIUM	DERWISCH-TANZ
WIRKLICHE ODER BÜHNEN-ARCHITEKTUR	VERKÜNDER	WEIHE-BÜHNE FESTSPIEL		ARENA	ANTIKE TRAGÖDIE	HÄNDEL-OPER	OLYMPISCHE SPIELE
STILBÜHNE	SPRECHER	GRENZGEBIET			SCHILLER BRAUT VON MESSINA	WAGNER	TANZCHÖRE
ILLUSIONS-BÜHNE	SCHAUSPIELER	THEATER		GUCKKASTEN	SHAKESPEARE	MOZART	PARISER BALLETT
PRIMITIVE KULISSEN	KOMÖDIANT	GRENZGEBIET			STEGREIF COMEDIA DEL ARTE	OPERA BUFFA OPERETTE	MUMMEN-SCHANZ
EINFACHSTE BÜHNE ODER APPARATE U. MASCHINEN	ARTIST	KABARETT VARIETÉ ZIRKUS			CONFERENCIER	COUPLET JAZZBAND	GROTESK-TANZ
PODIUM GERÜST	ARTIST			ARENA	CLOWNERIE	BLECHMUSIK	SEILTANZ
FESTWIESE BUDE	SPASSMACHER	VOLKSBELUSTIGUNG			KNITTELVERS MORITAT	VOLKSLIED SCHRAMMELN	VOLKSTANZ

(Vertical labels at center: BÜHNE · GUCKKASTEN)

Oskar Schlemmer's stage conceptions were in essence based on those of Expressionism. If one confines one's attention to the purely programmatical, the common characteristics are more apparent than the differentiating ones. Still, Schlemmer's horizon was broader than that of the Expressionists and even though for him too the stage was the place for a secularized cultic act, so to speak, there remained enough room on it for fun and jokes, for the basic comedy situation, and above all for artistic experiment. The mask Schlemmer used as a means for intensifying expression both for his serious characters and his clowns, was of cultic origin. The "religious play," nevertheless, is a borderline case for him which he put on stage only in a grotesquely comical modification. Schlemmer's small, sketchlike pieces belong roughly in this category, in which the satiric play re-emerges in a new form (like antique tragedy). Man is always at the center of Schlemmer's stage. With pantomimic and dancing movements he experiences both himself and the space he moves in. Schlemmer's choreography is visually conceived; it designs "space plans" (alluding to a word coined by his predecessor) and is thereby closer to being architectonic than any other of its kind. What is particularly original in Schlemmer's conception is the integration of the moving body, unfolding in dance, and architecture as a space phenomenon. By 1923 the Bauhaus stage was already molded according to his ideas. His brother Carl Schlemmer provided valuable help in producing the costumes and masks (even after he had left the Bauhaus); moreover, the various Bauhaus workshops were used for technical help when needed. At Dessau, Oskar Schlemmer continued the work he had started in Weimar.

b
Oskar Schlemmer: "Scheme for Stage, Cult, and Folk Festival." From the essay "Mensch und Kunstfigur" ("Man and Art-figure"), published in *Die Bühne im Bauhaus* ("The Theater of the Bauhaus")—volume 4 of the "Bauhaus Books."

Scheme for State, Cult, and Folk Festival, Differentiated According to

Kind of scene (place)	Person	Genre			Speech	Music	Dance
Temple	Priest	Religious cult act			Sermon	Oratorio	Dervish dance
Real or stage architecture	Proclaimer	Consecrated stage festival		Arena	Antique tragedy	Handel opera	Olympic games mass gymnastics)
Style stage	Narrator (speaker)	Border area			Schiller The Bride of Messina	Wagner	choric dance
Stage of illusions	Actor	Stage	Theater	Peep Show ("picture frame show")	Shakespeare	Mozart	Parisian ballet
Primitive stage sets	Comedian	Border area			Ex-tempore commedia dell'arte	Opera buffa Operetta	Mime and mummery
		Cabaret					
Simplest stage or devices and machinery	Artiste	Variety show			Conferencier (M.C.)	Couplet jazz	Grotesque dance (caricature and parody)
				Arena			
Podium Scaffold	Artiste	Circus (Vaudeville)			Buffoonery	Brass music	rope-dance (acrobatics)
Fair-grounds sideshow	Fool jester	Folk entertainment			Doggerel ballad	Folk song	Folk dance

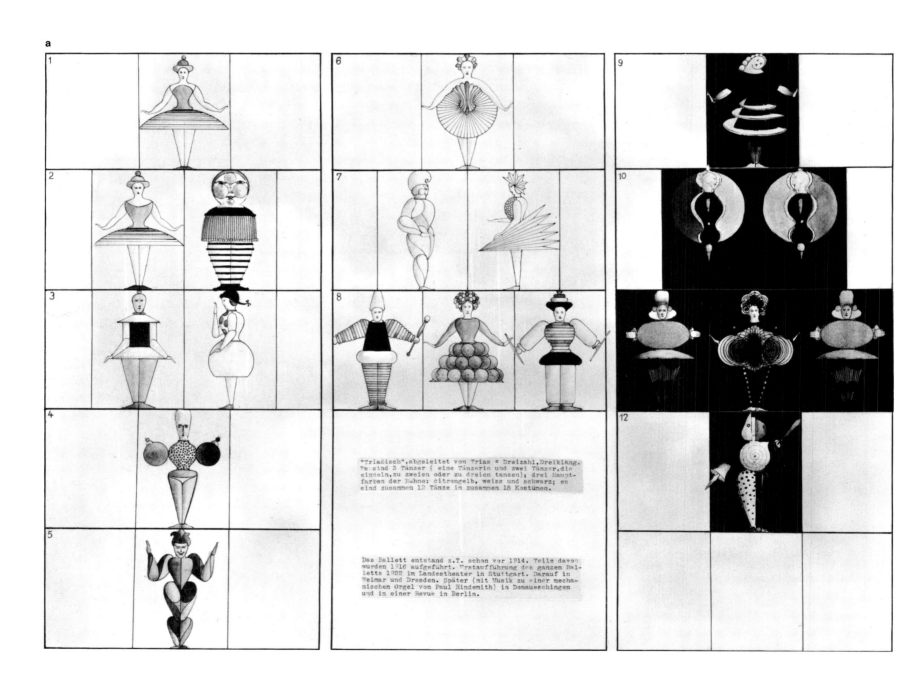

a

1

2

3

4

5

6

7

8

9

10

12

"Triadisch",abgeleitet von Trias = Dreizahl.Dreiklang.
Es sind 3 Tänzer (eine Tänzerin und zwei Tänzer,die
einzeln,zu zweien oder zu dreien tanzen); drei Haupt-
farben der Bühne: citrongelb, weiss und schwarz; es
sind zusammen 12 Tänze in zusammen 18 Kostümen.

Das Ballett entstand z.T. schon vor 1914. Teile davon
wurden 1916 aufgeführt. Erstaufführung des ganzen Bal-
letts 1922 im Landestheater in Stuttgart. Darauf in
Weimar und Dresden. Später (mit Musik zu einer mecha-
nischen Orgel von Paul Hindemith) in Donaueschingen
und in einer Revue in Berlin.

Schlemmer's major choreographic work, the "Triadic Ballet," had its beginnings in the years before the First World War. It was performed in the "Landestheater" (state theater) in Stuttgart in September 1922; in 1923, on the occasion of the Bauhaus Week there was a performance in the National Theater in Weimar. This ballet pointed the direction for the Bauhaus stage under Schlemmer. Schlemmer noted in his diary in September 1922: "The theatrical dance today can again become the starting point for a regeneration. Unencumbered by tradition—unlike opera and plays—and committed to word, sound, and gesture, the dance is independent and predestined to gently drive into the senses whatever is new. . . . The triadic ballet, dance of triplicity, change from the one, two, and three, in form, color, and movement, shall also establish the planimetry of the dance area and the stereometry of bodies in motion, that dimension of space which must necessarily evolve by tracing elementary forms such as the straight line, the diagonal, the circle, the ellipse, and their interconnections. Thus, the dance, according to its origin, becomes Dionysian and pure feeling, symbol for the balancing of polarities." (Quoted from "Briefe und Tagebücher"—Letters and Diaries)—edited by Tut Schlemmer, Munich, 1958.

In a letter of October 4, 1922, addressed to the art historian Hans Hildebrandt (published in "Letters and Diaries," Munich, 1958) Schlemmer writes about his Triadic Ballet: "In general and in particular, the symphonic character of the ballet is so essential to me that musical-symphonic names could be applied to the individual dances. For example, the Eroica character of the third part and the scherzo character of the first. The second one is hard to tell. Anyway, first, the burlesque, the picturesque; second, the serious and festive; third, the heroic and monumental. What is also important to me is the so-called 'floor geometry,' the figure forms that determine the path of the dancers and are identical with the figure forms. Both are fundamentally primary. By the way, I should like to develop this choreography further; I mean the graphic representation of the lines along which the dancer moves, a problem that has not yet been solved satisfactorily, because too much has to be represented in too small a space and then appears either confusing or incomplete. Thus, for instance, a dance moves only from downstage to the footlights along a straight line. Then the diagonal or the circle, the ellipse, and so on. There were no underlying definite 'intellectual' considerations. Rather, it was the inventive, esthetic joy of fusing contrasts into form, color, and movement and yet to put them together into something that had concept and meaning. . . . First came the costume, the figurine. Then the music was searched out which most closely corresponded to the former. The dance evolved from the music and the figurine. . . . I don't know what else to say than maybe this, that the Triadic Ballet in its present form is a beginning, a stage (for me), and that ideas for a purely comical ballet as well as for a transcendental one are ready." The considerable weight of the costumes became a problem during the performance of the ballet. Schlemmer overcame this creatively by including this factor, originally not planned for, into his choreographic-rhythmic conception. The costumes were made of padded fabrics and rigid plastic configurations treated with color or metallic luster. Twelve different dances were performed alternately by two male dancers and one female dancer in eighteen costumes.

a
Oskar Schlemmer: designs of the costumes for the "Triadic Ballet." Pen-and-ink drawing and watercolor, 1922.
b,c
Oskar Schlemmer: figurines for the "Triadic Ballet." Made by Carl Schlemmer. 1922–1923.

In the "Figural Cabinet" Schlemmer revealed his extraordinary talent for farce. It was performed for the first time at a Bauhaus party in Weimar in 1922 (hence even before Schlemmer joined the stage workshop as its Director). It was staged again during the 1923 "Bauhaus Week" (performance in the Jena Municipal Theater) and during a tour of the Bauhaus stage in Frankfurt on Main in 1926 and in Halle on the Saale in 1928. This play—for which Schlemmer also designed a variation—poked fun at the optimism embodied in the faith in progress and organization-directedness of his time, using cabaret effects that only an artist could devise. In this connection Schlemmer noted (in "The Theater of the Bauhaus," Bauhaus Books volume 4): "Slowly the figures march by in procession: the white, yellow, red, and blue sphere strolls, sphere becomes pendulum, pendulum swings, clock runs. The Violin Body, the Checkered One, the Elemental One, and the Better-Class Citizen, the Questionable One, Miss Rosy-Red, the Turk. The bodies are searching for heads; they file past diametrically. A jolt, a bang, a triumphal march when they have found each other: the Hydrocephalus, the body of Maria, and the body of the Turk, Diagonals and the body of the Better Citizen. The gigantic hand calls a halt. The lacquered angel rises and twitters tralala. . . . In the middle, spooking around, directing, gesticulating, and telephoning, the Master, E.T.A. Hoffmann's Spallanzani, dying a thousand deaths from self-inflicted gunshots and from worry over the function of the functional. Imperturbably the window shade unwinds, showing colored squares, arrow and signs, comma, parts of the body, numbers, advertisements . . . The barometers get out of hand, the screw screws, an eye glows electrically, deafening sounds, red. In the end, the Master shoots for the last time—the curtain drops—and successfully shoots himself."

"Meta" was first performed in Weimar in 1924 as an improvisation by the Bauhaus Players. The Bauhaus had rented a hall for this purpose. In "The Theater of the Bauhaus" Schlemmer explains his intentions: "The various stages of the course of a simple plot are freed from all accessories and are defined on stage by placards like 'entrance,' 'intermission,' 'suspense,' 'first, second, third increase,' 'passion,' 'conflict,' 'climax,' etc., or are announced on a movable frame as needed. The actors perform the designated action at the appropriate spot. The props are: couch, stairs, ladder, door, parallel bars, horizontal bar." Parody and persiflage—in this case of conventional drama—were Schlemmer's very own means of theatrical expression. In this play it becomes particularly evident how important the human being was to him as a supporting element of the action on stage. Despite the masquerade, this is true of the "Triadic Ballet" as well, which by no means should be taken as a manifestation of a desire to mechanize, to exchange the living, organic being for one functioning like a machine. In this respect, Schlemmer's ideas are decidedly different from those propounded at the same time by, for instance, the "de Stijl" group. Despite his revolutionary attitude and his in part completely new formal and dramaturgical ideas—which have been exploited by more efficient businessmen, especially in the film industry—as a stage author Schlemmer built on the fertile soil of a tradition leading him from romanticism via Grabbe and the early Kokoschka dramas ("Job").

a
Oskar Schlemmer: figurines for the "Figural Cabinet." Made by Carl Schlemmer. 1922–1923.
b
Oskar Schlemmer: "Figural Cabinet I." Technical production of the scenery by Carl Schlemmer. 1922–1923.
c
Oskar Schlemmer: scene from "Meta, or the Pantomime of Scenes." 1924.

a
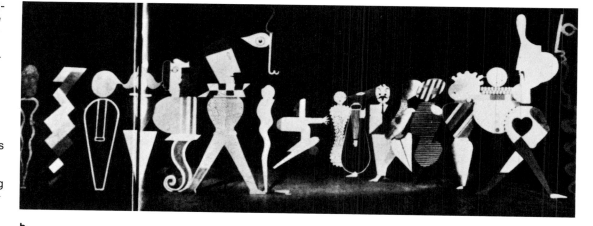

b

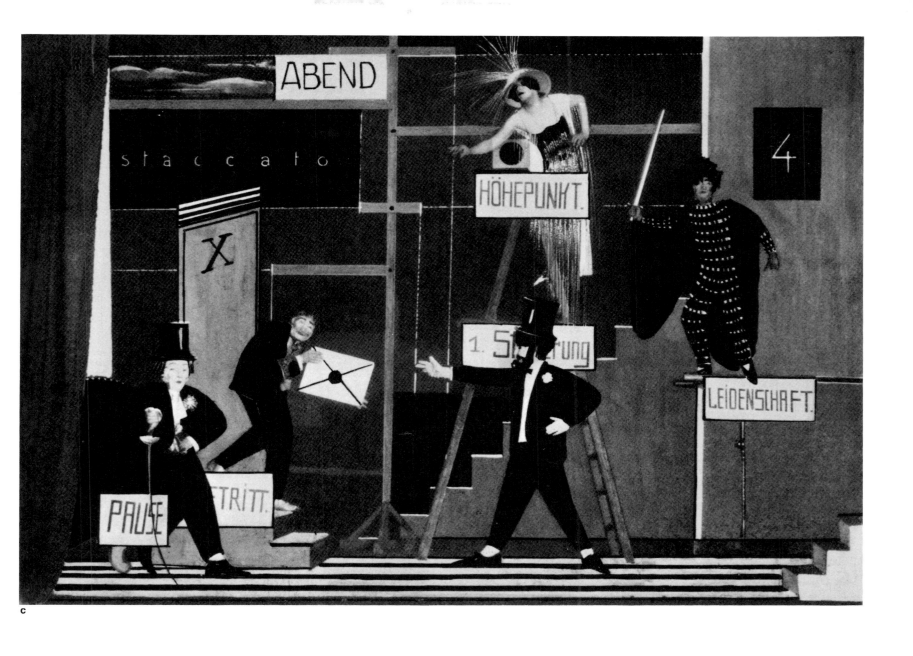

c

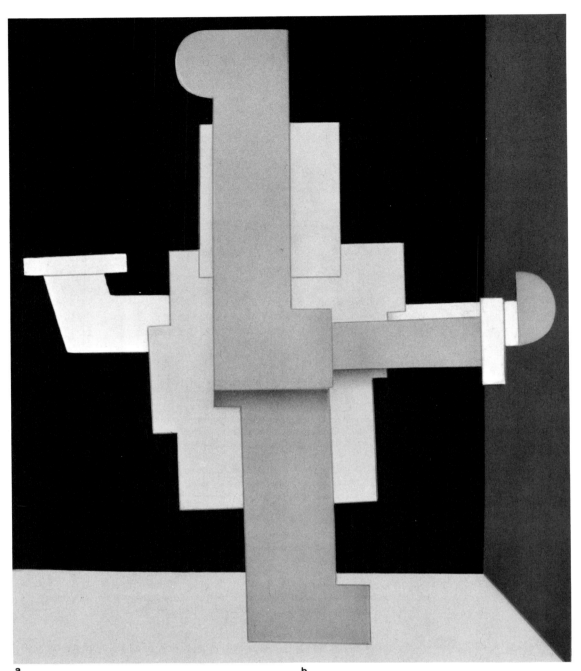

a
Kurt Schmidt, with F. W. Bogler and Georg Teltscher: figurine for the "Mechanical Ballet." 1923.
The "Mechanical Ballet" was first performed during the Bauhaus Week in the Jena Municipal Theater. It was an interesting student work in which was reflected the public's worship of progress and machines, so typical of the nineteen twenties. The abstract figures with movable joints—identified in an abstract way in the program by the letters A, B, C, D, E—were carried by invisible dancers; for the audience this created the illusion of watching dancing automatons. The name "Mechanical Ballet" was later changed to "Stage Organization with Simple Forms," because it was felt that the term was to define the visual appearance and not the method of production.

b
Kurt Schmidt: "Man + Machine." Design for a ballet. About 1924.
Like the "Mechanical Ballet," the ballet "Man + Machine" was the result of an attempt to reduce organic forms to simpler, geometric ones, or—as in this case—to confront them with one another. On stage and in the dance, abstract forms are granted rights of their own. Actually, the robot as dancer was not new—he had a predecessor on the puppet stage. The specific forms, as Kurt Schmidt used them, can be found similarly in the work of the constructivists and above all in the work of Léger who was not unknown at the Bauhaus.

c
Kurt Schmidt (design) and T. Hergt (execution): "doctor" and "servant," figurines from the marionette play "The Adventures of the Little Hunchback." About 1924.
For Schlemmer and his co-workers on the Bauhaus stage the marionette was the quintessence of dancing in the sense defined by Heinrich von Kleist. Kleist's essay was keenly debated. In addition to the marionette plays, another interesting experiment—undertaken by Ilse Fehling—of constructing a flexible marionette stage, originated in the Bauhaus.

d
Alexander Schawinsky: scene from "Circus." Schawinsky as "tamer" and von Fritsch as "lion." 1924.
The Circus was performed in Weimar in 1924 and 1925. Schawinsky, one of Schlemmer's most talented collaborators, designed his dance sketches out of a naive pleasure in inventing and in theatrical action. In 1926 he was engaged by the Zwickau Municipal Theater as set designer, straight from the Dessau Bauhaus stage. He returned once more to the Bauhaus to complete his studies of the stage (unitl 1929) and, in fact, to perform the duties of an assistant.

d
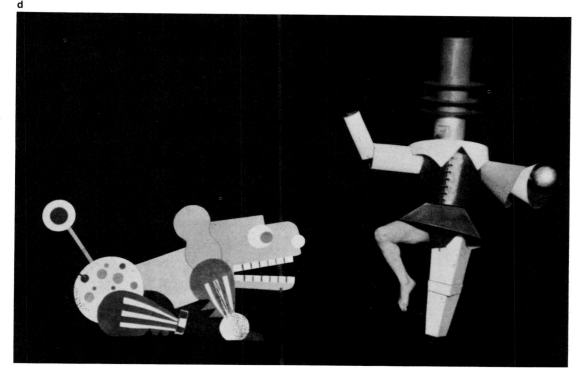

c
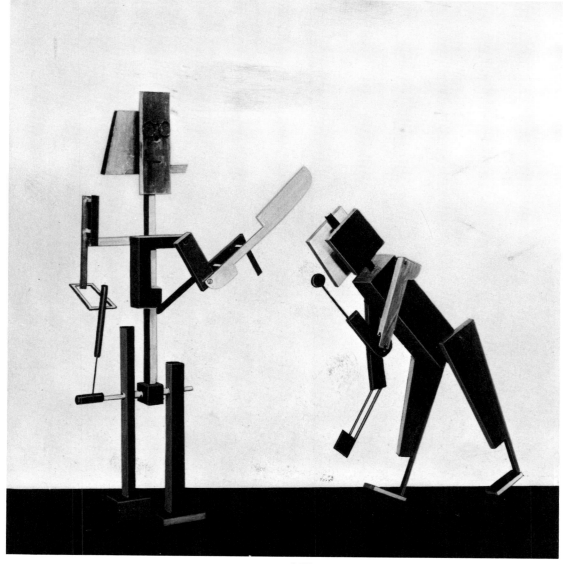

a

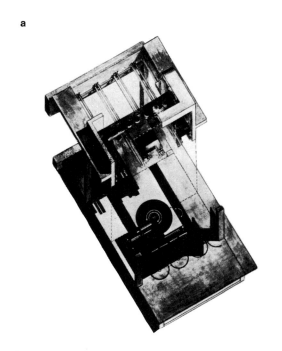

c

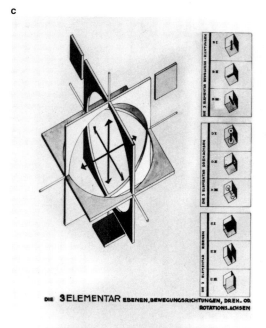

f

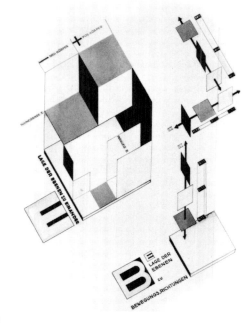

b

2. MECHANISCHE BÜHNE

d

3.ᵃ MECHANISCHE BÜHNE

BEWEGUNGSRICHTUNGEN

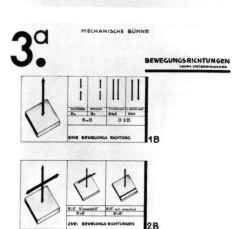

g

3.ᵇ MECHANISCHE BÜHNE

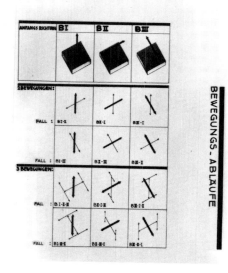

e

4. MECHANISCHE BÜHNE

DREH ACHSEN (ROTATIONS-ACHSEN) LAGEN UNTEREINANDER

D

h

DREH (ROTATIONS) ACHSEN UND EBENEN

D

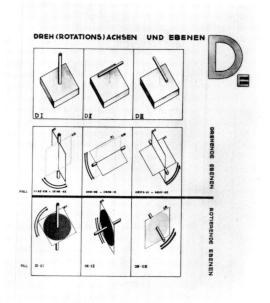

368

The dynamics of the nineteen twenties forced the demand for a stage that would meet a variety of technical and scenic requirements. Next to Joost Schmidt's project, not to speak of the "Total Theater" designed a short time later by Gropius, Andreas Weininger's "Spherical Theater" and Molnár's "U-Theater" distinguished themselves for their remarkable inventiveness. Molnár planned three stages, arranged one behind the other, 12 × 12, 6 × 12, and 12 × 8 meters in size. In addition, he provided a fourth one that was supposed to be hung above center stage. The first stage protruded into the audience like a proscenium, so that everything happening on stage (such as dancing or acrobatics) could be watched from three sides. The second stage, like the first, was designed to be variable in height, depth, and sides; it was intended for representations and constructions in relief (each of which could be prepared on the third stage, concealed behind a curtain). The third one corresponded roughly to the customary principle of the picture-frame stage. Molnár's technical perfectionism reached a climax in a number of complicated devices—a cylindrical hollow tube hovering above the front stages and the audience, designed to lower people and objects, drawn between the stages and the balconies, hanging floors and apparatus to produce special effects; in fact, even a "water machine" and a "perfume diffuser" were contemplated.

a–h
Joost Schmidt: "Mechanical Stage." Studies for the construction of a mechanical multipurpose stage. About 1925.
Schmidt's suggestions for the setting up of a flexible stage were intended for use by the Bauhaus itself. However, they were never put into practice. The drawings show the construction principle and some of the possibilities for variations.
i
Farkas Molnár: "U-Theater" (in action). Design. 1924.

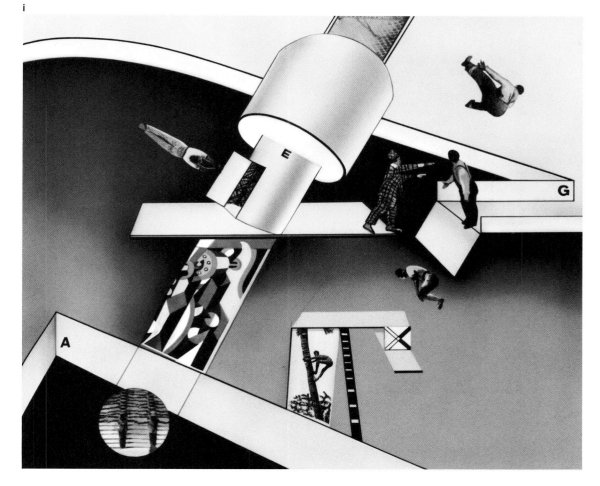

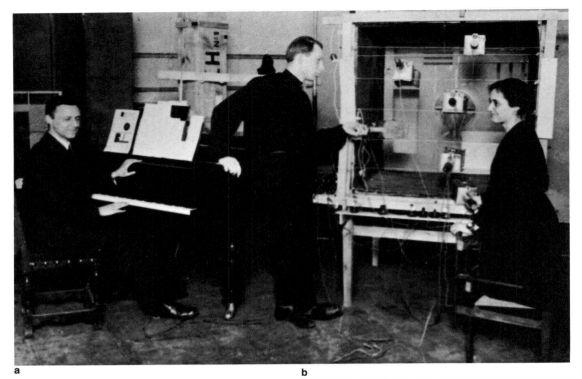

a

b

Reflected-Light Compositions

The "Reflected-Light Compositions" were an experiment undertaken by students of the Bauhaus on their own initiative, independently of the stage workshop. The idea evolved around 1922 from conversations between the master craftsman Josef Hartwig and the journeymen Kurt Schwerdtfeger and Ludwig Hirschfeld-Mack. They formed two distinct performing groups. During subsequent years they showed their experiments not just in Weimar, but on tour in numerous other cities, such as Berlin and Vienna for instance, where Hirschfeld-Mack's group performed. The principle as well as the procedure for producing Reflected-Light Compositions was quite simple. Templates in various colors were superimposed and moved back and forth in front of a spotlight, projected on the back of a transparent screen, thus producing a colored and kinetic abstraction on the front of the screen, which faced the audience. The sequence of projections was determined by a plan, but despite that there was room for improvisation. Hirschfeld-Mack also added music to his performances. The Reflected-Light Compositions expressed the age-old longing for making the immaterial visible, for the picture sublimed by dematerialization. Many others had dreamed of such pictures, not the least among them the circle of the symbolists. Nevertheless, the Reflected-Light Compositions resulted from concrete historical circumstances. The "Blaue Reiter" and constructivism, the artistic ideal of abstraction from the object, and the call for a kinetic work of art provided the necessary conditions.

a
The projection booth for the "Colored Reflected-Light Compositions," Hirschfeld-Mack (at the piano) and his group. About 1924.
b
Kurt Schwerdtfeger: reflected-light composition. Colored, cinematographic projection. About 1923.
c,d,e
Ludwig Hirschfeld-Mack: "Cross Composition." Different phases of one colored reflected light composition. About 1923. The alterations of the forms and the color mixtures were produced by shifting the templates used for the projection. The effect was that of an abstract color film. But the "Reflected Light Compositions" were different from the film in that they were not mechanically fixed, but rather were created anew during each performance.
In their later years, Schwerdtfeger and Hirschfeld-Mack have resumed their experiments. Some of their light compositions were perpetuated in documentary films after their deaths, in 1965 and 1967.

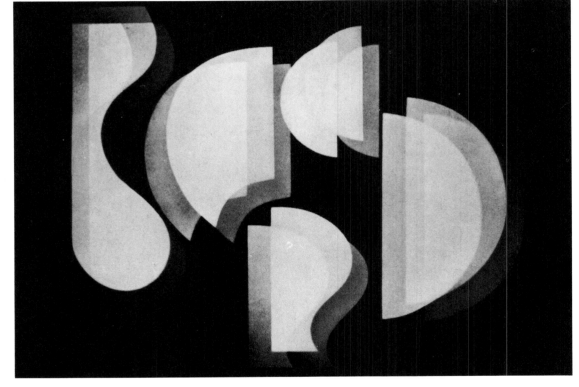

e

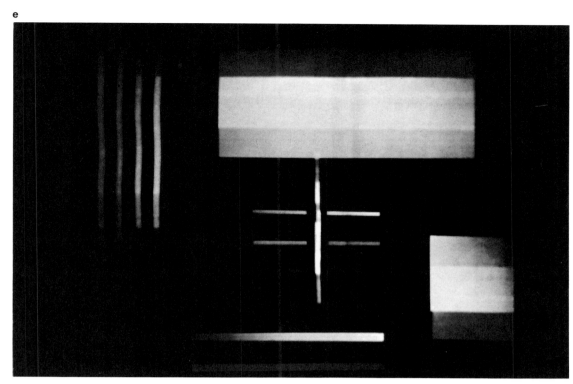

c

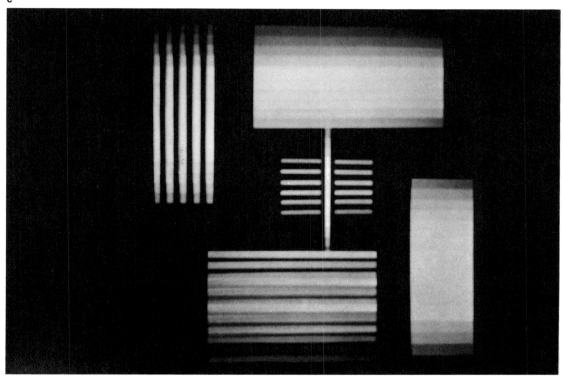

d

Life at the Bauhaus

The life of the Weimar "Bauhäusler" (Bauhaus member) bore in its outward appearance the imprint of the poverty of the postwar years and the inflation period. But in the Bohemian appearance of the bulk of the students there also was something of a protest against middle-class conventions and of the "Sturm und Drang" kind of challenge. The great moments of life at the Bauhaus were the festival parties, planned or improvised; there the visual imagination of the students materialized in a way that forced recognition even from the institution's most outspoken opponents.

a
Ludwig Hirschfeld-Mack: postal card (colored lithograph) for the "Kite Festival" of the Bauhaus in the fall of 1922.
On loan to the Bauhaus-Archiv, Darmstadt.
The spirit of the young peoples' movement of the prewar period lived on in these kite and lantern student festivals. Fanciful kites, put together by the "Bauhäusler" rose into the autumn skies, cheered by the children of a citizenry not at all friendly to the Bauhaus. The lantern festivals conciliated even Weimar citizens. Colored postal cards, designed by students and teachers, announced these parties.

b
"Prellerhaus" behind the main building of the Weimar Bauhaus (formerly the Art Academy). About 1920.
Twenty-three selected students had their quarters and studios in the "Prellerhaus." Among good middle-class circles, the kind of life led in this not particularly solid building was a preferred and regular cause for anger. The barracklike building in the front yard served as a canteen where the "Bauhäusler" could get an inexpensive meal. People considered themselves lucky to get a bowl of soup during those troubled years, even though it was made with a great deal more Mazdaznan diet philosophy and garlic than good nourishing ingredients.

c
"Bauhäusler" in front of the workshop building and the "Brütt statue." 1920.
One night in May 1920 students of the Bauhaus daubed the stone figure of a girl in front of the workshop building, done by the sculptor Adolf Brütt, with "futuristic designs," as the Weimar public discovered with indignation. The malefactors were disciplined, the offending colors removed, and some of the completely unrepentant lined up in front of the photographer's lens.

d
Alfred Arndt, apprentice at the Bauhaus. 1921.
Part academic artist with Bohemian tendencies, and still part "Wandervogel" with missionary zeal: he was typical of the "Bauhäusler" at a time when the Bauhaus was still in a state of coming to grips with itself.

e
Leonard Stark, a political apostle of the postwar years. 1921.
During the years after World War I numerous reformers, or "world improvers," talking politics and moralizing, wandered through a destitute land troubled by unrest. One of them, Louis Haeusser, appeared at the Bauhaus, among other places, preaching and rallying adepts around himself, who celebrated him as a savior. His power to exert influence on others (which he had in common with other desperadoes, ultimately including Hitler himself) introduced considerable unrest into the young and still insecure institute.

a

b

d

c

e

a

b

c

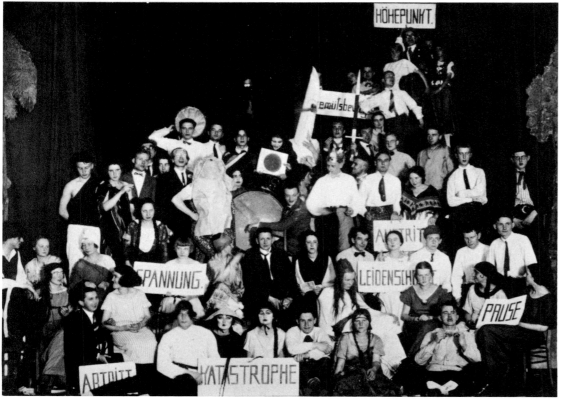

a
Theo van Doesburg and his circle of friends in Weimar. Summer 1922.
Spokesman of the constructivist group "de Stijl" and publisher of the programmatical journal by the same name, Theo van Doesburg, spent much of his time in Weimar during 1921–1922. Publicizing the ideas of Dutch constructivism and in rivalry with the Bauhaus, he berated the public in incisive lectures. He gathered his friends in his Weimar home, among them, in addition to the German members of "de Stijl" (like Max Burchartz, Werner Graeff, and Hans Richter), several students of the Bauhaus who constituted a countermovement within the Bauhaus itself. With its opposition and its overstated criticism of the Bauhaus, albeit with basically very similar objectives, "de Stijl" acted as regulative agent and catalyst. In Weimar in September of 1922 van Doesburg called for the establishment of a "constructivist, international, creative working community" in which Moholy-Nagy (last row on the right), at that time still living in Berlin, represented the Hungarian "Ma" group.

b
The Bauhaus band. Weimar, 1924.
The Bauhaus band was a product of Bauhaus life; it sprang up spontaneously, without planning. It resulted from the musical improvisations of students "who, on excursions into the surroundings of Weimar, with accordion music and chair pounding, with rhythmic smacking of a table and revolver shots in time with fragments of German, Slavic, Jewish, and Hungarian folksongs, would swing their audience into a dance." ("Bauhaus 1919–1928," published by Herbert Bayer, Walter and Ise Gropius.) At Dessau more instruments were added, so that eventually the band consisted of two pianos, two saxophones, clarinet, trombone, trumpet, banjos, and some others. Soon the Bauhaus band became so widely known that it was invited to play guest performances, for example in Berlin. Their improvised performances were never rehearsed.

c
Bauhaus celebration at the "Ilm Castle" near Weimar, June 1924.
Often the students met for gay dancing parties at which the dynamic force inherent in the Bauhaus and the "Bauhäusler" became rhythmic. Much less attention was here given to the accuracy of the dance step than to the originality of the experience and to self-expression. Next to improvised activities, parties planned around decorations and costumes were also arranged. For the party in June 1924, students borrowed the quasidramaturgical ideas from Schlemmer's "Meta" performance, which had been put on only a short time before. During the Dessau period the Bauhaus developed its own style of big costume parties which were always given a title.
(Translation of the words in the pictures)

Gemütsbewegung	= emotion
Höhepunkt	= climax
Auftritt	= entrance
Spannung	= suspense
Leidenschaft	= passion
Pause	= intermission
Austritt	= exit
Katastrophe	= catastrophe

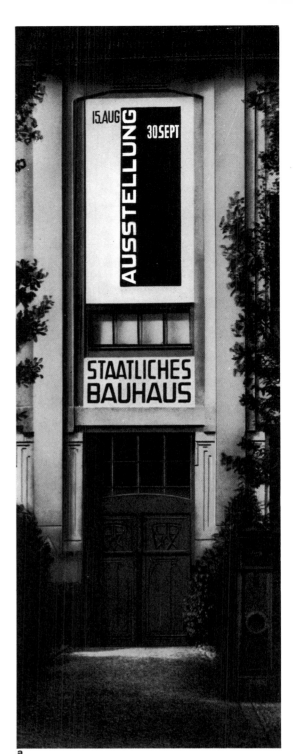

a

Bauhaus Exhibition Summer 1923

During the summer of 1923, little more than four years after it had been founded, the Bauhaus gave an account of its work publicly, in an exhibition embracing all the areas of its creative activities. Masters and students participated in it, and in addition prominent guests were invited to join actively in the "Bauhaus Week" (consisting of musical, theatrical, and programmatical presentations). The exhibition, lectures, and performances stirred up a lively echo, not with the visitors alone—who numbered in the thousands—but also with the qualified press all over Central Europe. The Bauhaus name became well known. Due to the strain of putting this large exhibition together, the Institute matured more during this one year than during all the preceding years. Hence, the exhibition of 1923 became the decisive turning point and indicator, decisive particularly for the inner development of the Institute.

a
Herbert Bayer and Josef Maltan: poster announcing the exhibition, put up over a side entrance to the main building of the Bauhaus. 1923.
Student work from the preliminary course as well as an exhibit of international architecture was shown in the main building. The products made in the workshops were displayed in the same building and also in the building of the former Arts and Crafts School.
b
Joost Schmidt: poster for the Bauhaus exhibition 1923.
Black and red, printed on yellow-toned paper. The wall reliefs in the vestibule of the main building and the festive entrance to the exhibition were also carried out by Schmidt.

b

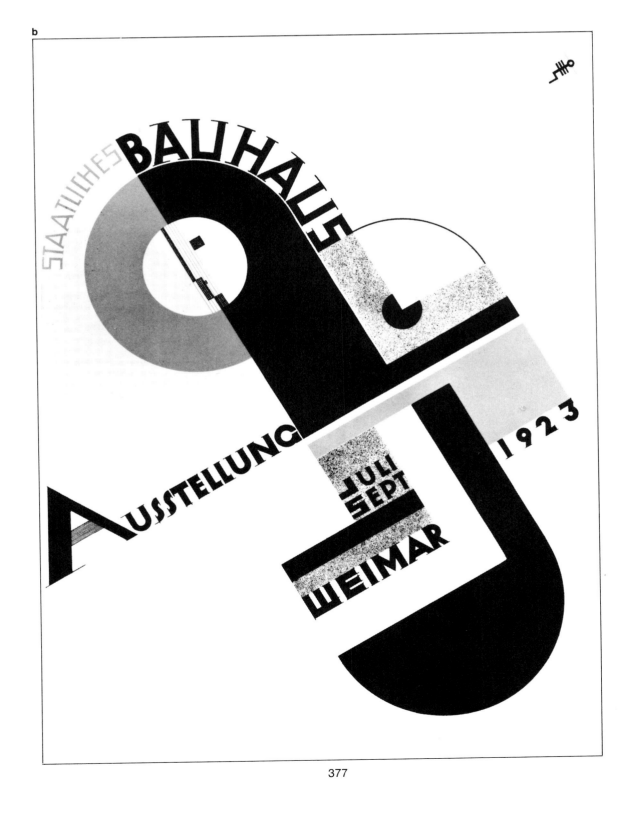

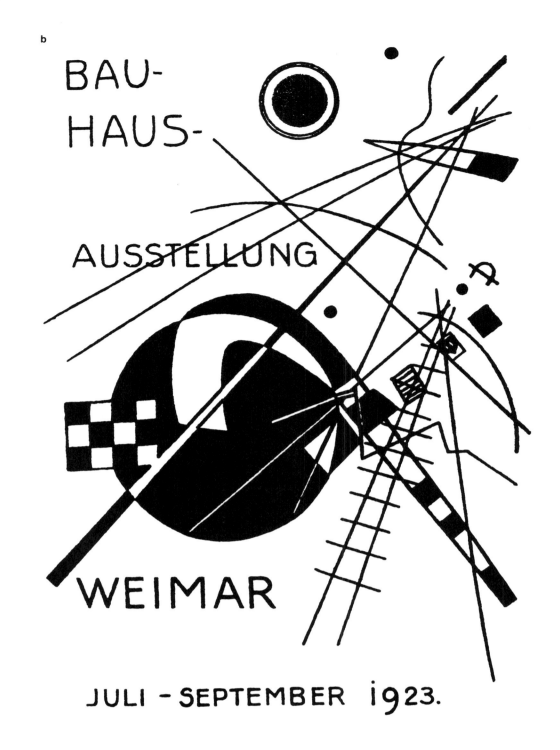

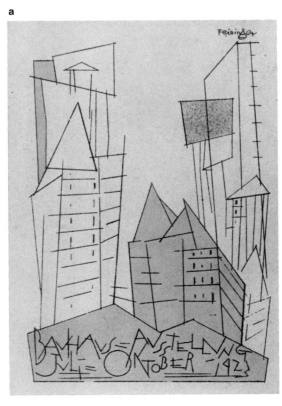

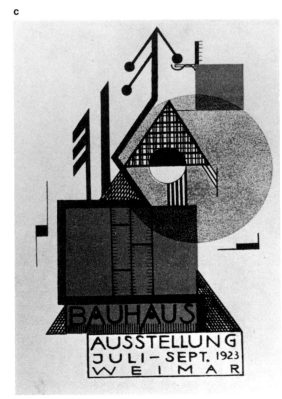

To publicize the Bauhaus exhibition of 1923, teachers and students alike designed postal cards, twenty of which were reproduced as lithographs—mostly in several colors.

a
Lyonel Feininger: exhibition card 1 (black, yellow, blue).

b
Wassily Kandinsky: exhibition card 3 (brown, black, blue, red).

c
Rudolf Baschant: exhibition card 9 (black, red, blue).

d
Kurt Schmidt: exhibition card 19 (black, red, green, blue).

e
Paul Klee: exhibition card 4 (blue, black, yellow, red).

f
Georg Teltscher: exhibition card 20 (blue, yellow, red)
The reproductions of the postcards on these pages were made from copies in the possession of the Darmstadt Bauhaus-Archiv.

f

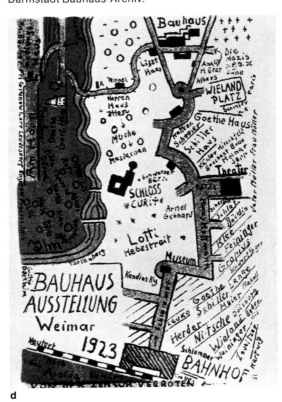

d

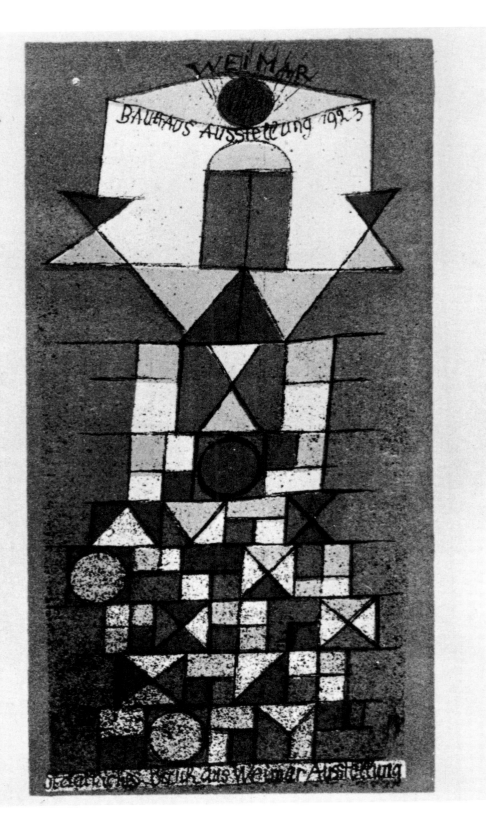

e

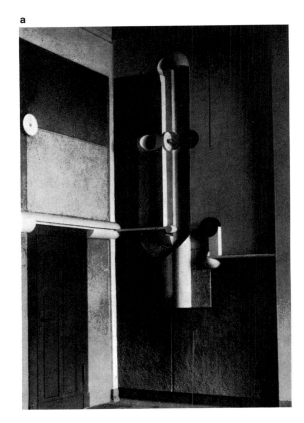

a

For the exhibition of 1923 the vestibule of the main building—the former Art Academy designed by Henry van de Velde—was remodeled. Using interior design as a guideline, the Bauhaus demonstrated its idea of the unity of all the arts in architecture. Joost Schmidt did four abstract reliefs, the conventional lighting fixtures were exchanged for constructivist ones, and the open banisters were put into a massive-looking casing. The space received an entirely new appearance, though the architecture of the vestibule remained basically unchanged. The remodeling of the vestibule was the cause for polemic discussions that lasted for years. The stand of the Bauhaus was made difficult because the space designed by van de Velde, and Rodin's "Eve" (which was removed to make way for the remodeling), had unquestionably formed a coherent whole. The original interior design was restored to a degree (according to a promise the Bauhaus had given the Ministry of Culture and van de Velde before the remodeling), shortly after the close of the exhibition. Eventually, in 1924, Joost Schmidt's reliefs were removed as well.

a,b
Joost Schmidt: reliefs in the vestibule of the main building of the Bauhaus in Weimar (former Art Academy building). Stucco. 1923.
Demolished.

c
Alfred Arndt: model of the vestibule and stairwell of the workshop building of the Bauhaus in Weimar (former Arts and Crafts School), designed by Henry van de Velde, decorated with murals and reliefs by Oskar Schlemmer. Wood, Plexiglas, etc. Reconstructed in 1955 after old plans.
Bauhaus-Archiv, Darmstadt.

b

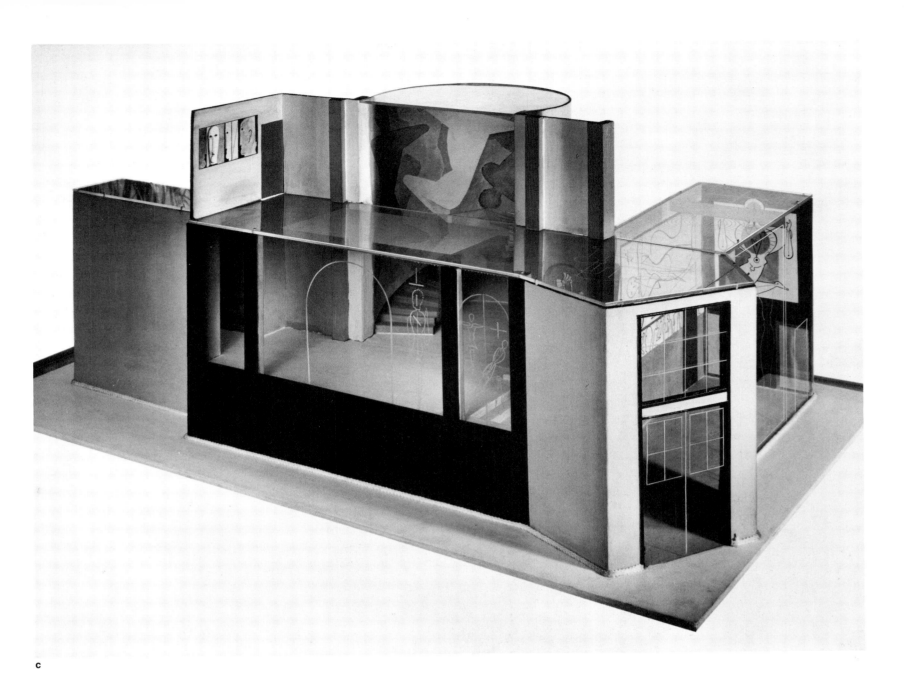

c

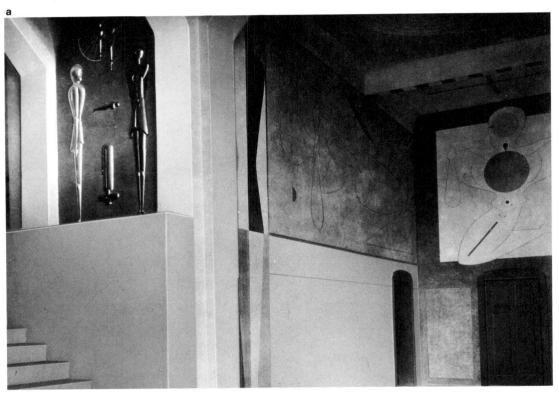

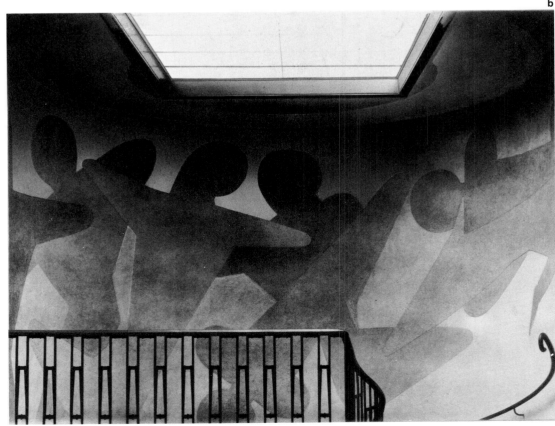

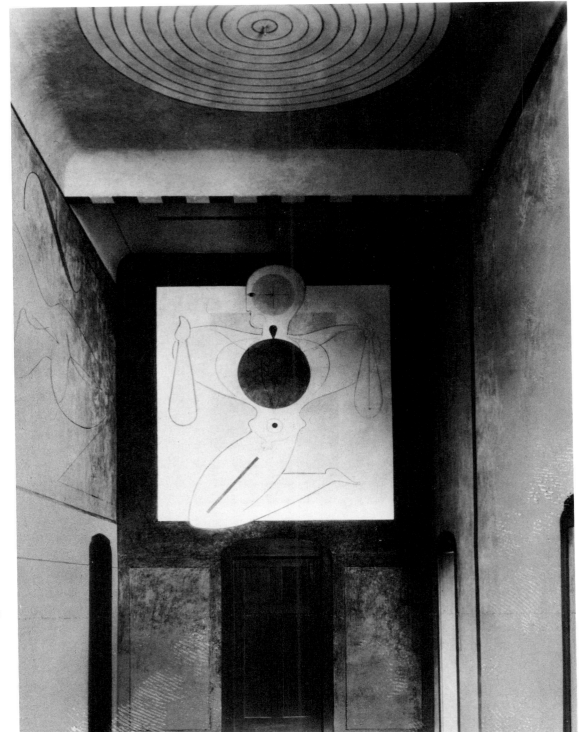

c

Schlemmer's murals and reliefs of 1923 were demolished in 1930, only seven years after their completion. The National Socialist art ideologist Schultze-Naumburg, who succeded Bartning as Director of the Weimar Art Academy, ordered them removed. In response to this news Schlemmer wrote in his diary ("Briefe und Tagebücher," edited by Tut Schlemmer, Munich 1958) on November 1930: "On the occasion of the first big exhibition of the Bauhaus in Weimar, I chose the workshop building, designed by Henry van de Velde, with its various opportunities of walls, niches, stairs, and hallways in order to make it the object of a coherent and comprehensive work of murals and reliefs. . . . Among the various innovations the Bauhaus showed in Weimar at that time, this work, together with my Triadic Ballet which was performed there at the same time, was appreciated and acknowledged as one of the few important efforts today at recovering the old and lost relations in architecture, painting, and sculpture which formerly had been very closely linked . . . Even conceding to Professor Schultze-Naumburg that this work is opposed to his mode of thinking, that he considered it to be 'exercises without artistic value' and that 'their present condition justified a removal,' in my opinion it is barbaric, in the artistic sense, to carry out their destruction without informing the originator."

"The mural," Oskar Schlemmer wrote in his diary in November 1922, "must have an ethical foundation or carry within itself the values for acquiring it. To work on the 'great theme' is the task of the mural. It still has its function today; it has it to an even greater degree today." The theme of the murals which Schlemmer carried out during the following months in the entrance halls and the stairwell of the Weimar workshop building was "man"—the grand figural composition. On the ceilings he added geometric abstractions, as expression of an order-giving principle. Included in the remodeling were the entrance hall, the hall by the stairwell, the walls of the stairs to the rear exit (opposite the entrance), the large, curved wall of the stairwell, and one hall and a niche on the upper floor. The murals and reliefs integrated perfectly with the architecture of van de Velde. Their demolition, which Schultze-Naumburg ordered in 1930, was effected by painting over the murals and removing the reliefs.

a
Oskar Schlemmer: murals in the right-hand section of the entrance hall and (left) reliefs above the steps leading to the vestibule of the stairwell in the workshop building. Earth and bronze colors, plaster, and stucco. 1923.
b
Oskar Schlemmer: murals in the upper section of the stairwell of the workshop building in Weimar. Earth and bronze colors. 1923.
c
Oskar Schlemmer: murals in the right-hand section of the entrance hall of the workshop building in Weimar. Earth and bronze colors. 1923.

a

Experiments in Architecture

There was no regular architecture department in the Weimar Bauhaus. Nevertheless, lectures were given on subjects of architectural history and statics, and Gropius's private architectural office offered an opportunity to get information. Gropius thought the time had not yet come for the establishment of an architecture department capable of functioning efficiently. Yet the students pressed for it. When—starting in the fall of 1922—the exhibition was being prepared for the summer of 1923, they demanded that the Bauhaus manifest its architectural intentions in an example. The result was the experimental house designed by Georg Muche. As a longer-range plan, a "Bauhaus housing settlement," which was to be developed on a site "am Horn" (along the edge of the park, not far from Goethe's summer house) had been designed under Gropius's guidance in 1922. Houses were considered for the faculty and for students. The financing for the project was to be done through a corporation, which had actually been founded but soon proved to be illusory. The only part of the housing settlement that was actually constructed was the "experimental house"; it was sold to a private owner as early as 1924 because of the financial straits of the Bauhaus. Quite apart from the unpromising housing-settlement project, architectural design work remained the desired goal of many students. With the approval of the Director and the Council of Masters an architectural study group was formed in 1924, which included, among others, form master Georg Muche, master craftsman Josef Hartwig, and Bauhaus journeyman Marcel Breuer. This group set itself the task of investigating problems of housing. It could have become the nucleus for an architecture department, if it and the Weimar Bauhaus had been allowed to continue its development.

The "experimental house" of the Bauhaus was built for the 1923 exhibition as the first and only contribution to the project of a Bauhaus housing settlement. The technical supervision was carried out by Adolf Meyer and the architectural studio of Gropius. The house was designed by Georg Muche. For the construction (which was made difficult by the inflation), industrially prefabricated products and new building materials were used wherever possible. This first building was an experiment in every respect. The workshops of the Bauhaus, particularly the cabinet-making workshop, participated in the interior work and the furnishing. Muche conceived this experimental house according to his ideal of a single-family residence. He clustered the various bedrooms and subsidiary rooms around a central living room that was almost 20 feet square, and which received its light from clerestory windows. The rooms on the outside, serving specific purposes and primarily the individual, were designed much more moderately in floor area and height than the central living room which was intended to bring the whole family together.

a
View of the entire "Bauhaus housing settlement" planned for the site "am Horn" in Weimar. The plan was developed by Gropius together with Fred Forbat and other collaborators and students. Drawing by Farkas Molnár: 1923.
b
Georg Muche: floor plan of the experimental house of the Bauhaus in Weimar, 1923.
c
Georg Muche (design) and Adolf Meyer together with Gropius's architectural studio (technical execution): the "experimental house" in Weimar, view from the street "am Horn." The walls were made of "Jurko" plates and were stuccoed. 1923.

b

c

a

Rooms in the "experimental house" constructed for the 1923 exhibition in Weimar; industrially manufactured products were used for appliances, equipment, and installations, and most of the furniture was custom-made for this house by the Bauhaus workshops.

a
Vestibule. Radiator with opaque glass shelf and mirror (prefabricated). Skylight with wrought-iron frame.

b
View of the living room as seen from the dining room. Furniture by Marcel Breuer (design) and the Bauhaus cabinetmaking workshop (execution). Rug designed and made by Martha Erps (Bauhaus weaving workshop).

c
Master bedroom. The furniture was made in the cabinetmaking workshop from designs by Erich Dieckmann (wood: paduc and oak). The bedspread was woven in the Bauhaus weaving workshop according to a design by Lies Deinhardt. The lighting fixtures, designed by Moholy-Nagy, were made in the metal workshop of the Bauhaus.

d
Children's room with view through the dining room into the kitchen. The cabinetmaking workshop built the furniture from designs by Alma Buscher and Erich Brendel. Wainscot made of colored wooden sheets (can be used as chalkboards). Multicolored boxes for the children to build with and to sit on. Cabinet for toys which can also be used for a Punch-and-Judy show. Lighting fixtures: frosted plate-glass disks.

e
Kitchen. Furniture (wood) manufactured in the cabinetmaking workshop from designs by Benita Otte and Ernst Gebhardt. Canisters mass-produced by the ceramic company Velten-Vordamm from models made by Theodor Bogler. Glass containers by Schott & Gen (Jena Glass).

f
Lady's bedroom. The furniture was built in the cabinetmaking workshop of the Bauhaus according to designs by Marcel Breuer (wood: walnut and lemon). The rug was designed and made by Agnes Roghé (Bauhaus weaving workshop).

b

c

d

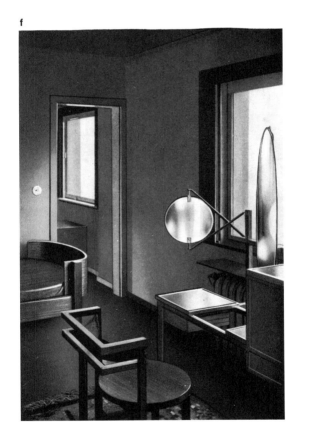

f

e

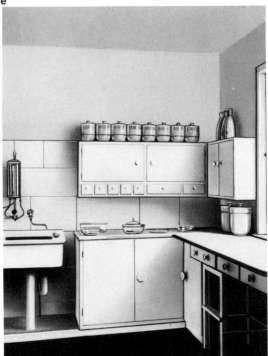

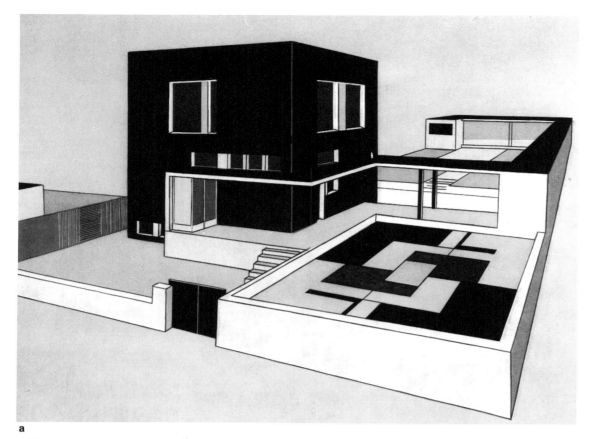
a

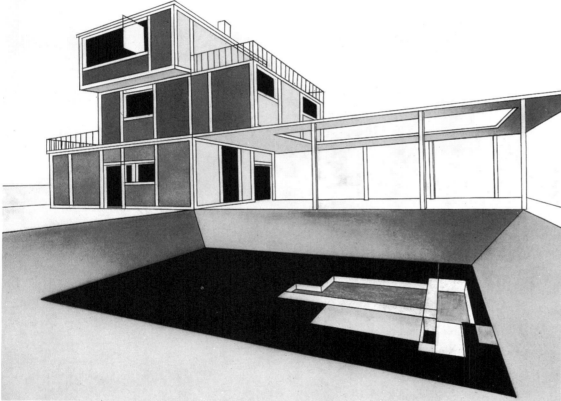
b

Despite the absence of a regular architecture department (and perhaps partly because of it) there was enthusiastic interest in architectural design problems at the Weimar Bauhaus around 1923–1924. Whoever desired help was of course able to get it from Gropius and his staff in his architectural studio. Among the members in his studio, Adolf Meyer and the assistant Ernst Neufert in particular were sought out by students for advice. The temporary opposition against Gropius, whose skeptical attitude toward the urging of students for the establishment of an architecture department and the introduction of regular architecture classes was not understood, presumably explained why those hoping to become architects reflected the unmistakable influence of "de Stijl." The way Molnár and Muche approached the subject, architectural design was by no means merely an amateurish game. The designs were esthetically sound and at least practicable and functionally ready for development. The strongest and most independent achievements of that group came from the then journeyman cabinetmaker Marcel Breuer.

Georg Muche and Marcel Breuer were the driving forces in the architectural study group, which was formed in the spring of 1924. Muche had gathered some practical experience from working on the experimental house (1923). Later in Dessau he was once more given the opportunity of carrying out an architectural idea. But on the whole his desire to build was not fulfilled. Marcel Breuer had to wait for a while longer before he was able to put into practice his extraordinary talent as an architect. With his slab-shaped, high-rise apartment building of 1924—the work of a beginner who had no practical experience whatsoever—he created an entirely new type of building which years later became commonly accepted and an integral component of modern apartment architecture.

a
Farkas Molnár: "The red cube." Design for a residence, view from the street. 1923.
Not carried out.
b
Farkas Molnár: design for a residence in half-timber framing technique. 1923.
Not carried out.
c
Georg Muche: design for a city apartment building in reinforced concrete. 1924.
Not carried out.
d
Marcel Breuer: model for an apartment building with small apartments (type of the slab-shaped, high-rise apartment building). 1924.
Entry for a magazine competition.
Not carried out.

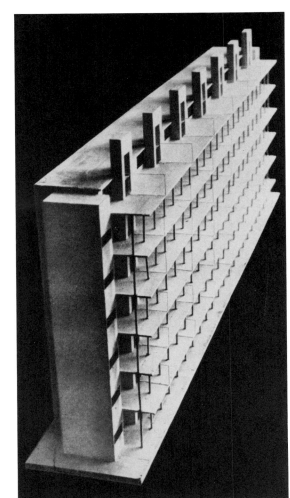

d

c

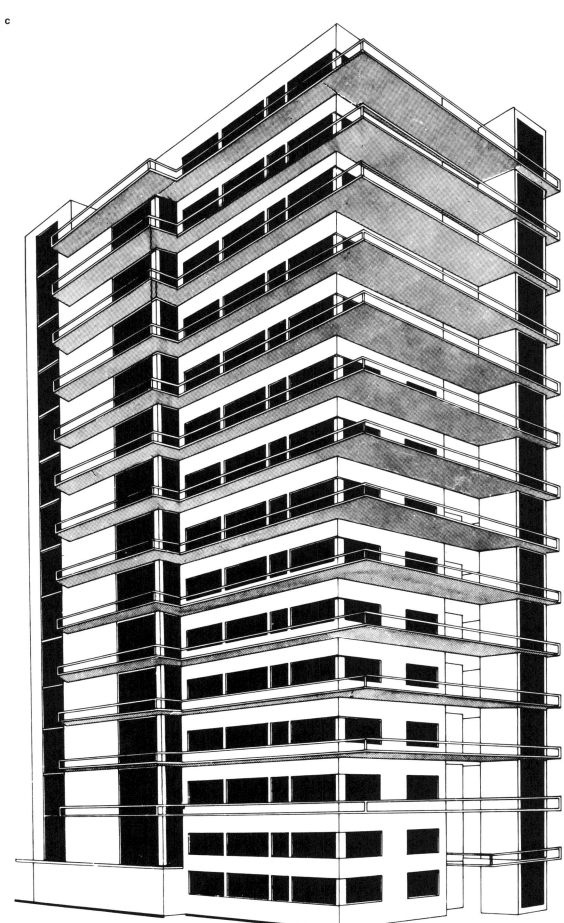

389

Bauhaus Dessau 1925–1932
School of Design

Dessau, the capital of the state of Anhalt, situated near the confluence of the rivers Mulde and Elbe, was a burgeoning industrial city with a population of 70,000. Still, it had kept a good deal of the character of the former princely residence in the old center of the city, which was rich with buildings of the Renaissance and Classicist period, and in the immediate surroundings, with their castles.

a
Dessau, map of the city, about 1930.
Drawn by Joost Schmidt.
From a prospectus issued by the Dessau tourist office.
(100 m = 328 feet 1 km = 0.62 miles)

Sights in Dessau and Surroundings
1 Big market
2 Castle
3 Pleasure garden
4 *Gestänge*
5 Friedrich-Theater
6 Marien-Church
7 Small market
8 Kalitsch house
9 Hilda palace
10 New market
11 Art gallery
12 Messel house
13 City gardens
14 Former court Theater
15 Memorial cemetery, Boelcke monument, crematorium
16 Cemetery I
17 Bauhaus
18 Masters' houses
19 Employment office
25 Housing development Törten
29 Mount Wallwitz
30 Zoological gardens
31 Kornhouse
32 Public beach
33 Georgium
34 Gr. Kühnau park
35 Luisium
36 Mosigkau
37 Oranienbaum
38 Wörlitz park
39 Mount Sieglitz

Libraries
27 State library
40 Municipal library and reading room

Museums
11 Art gallery
12 Messel house
28 Museum for natural science and prehistory Junker display

Public Buildings
41 State office building I
42 State office building II
43 State and district court
42 Chamber of Commerce
44 Post office
19 Labor department
7 City hall
45 City swimming pool
46 Youth hostel

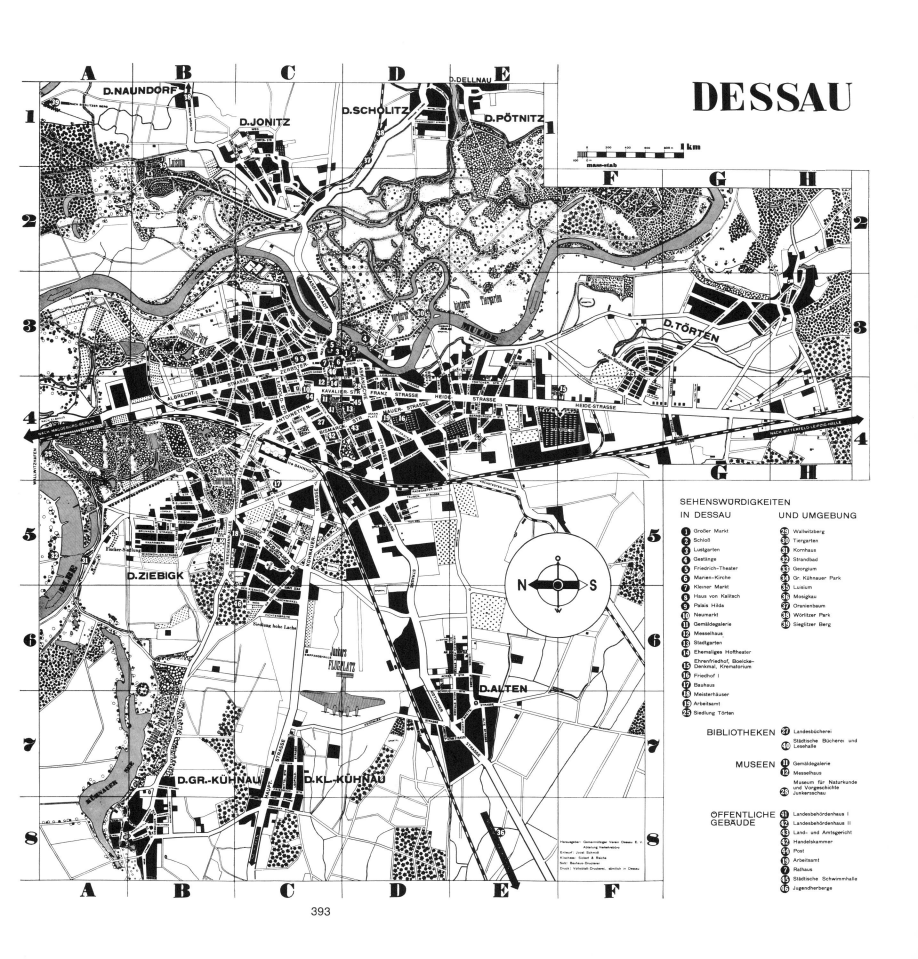

DESSAU

1 km
mass-stab

SEHENSWÜRDIGKEITEN
IN DESSAU

1 Großer Markt
2 Schloß
3 Lustgarten
4 Gestänge
5 Friedrich-Theater
6 Marien-Kirche
7 Kleiner Markt
8 Haus von Kalitsch
9 Palais Hilda
10 Neumarkt
11 Gemäldegalerie
12 Messelhaus
13 Stadtgarten
14 Ehemaliges Hoftheater
15 Ehrenfriedhof, Boelcke-Denkmal, Krematorium
16 Friedhof I
17 Bauhaus
18 Meisterhäuser
19 Arbeitsamt
25 Siedlung Törten

UND UMGEBUNG

29 Wallwitzberg
30 Tiergarten
31 Kornhaus
32 Strandbad
33 Georgium
34 Gr. Kühnauer Park
35 Luisium
36 Mosigkau
37 Oranienbaum
38 Wörlitzer Park
39 Sieglitzer Berg

BIBLIOTHEKEN
27 Landesbücherei
40 Städtische Bücherei und Lesehalle

MUSEEN
11 Gemäldegalerie
12 Messelhaus
28 Museum für Naturkunde und Vorgeschichte Junkersschau

ÖFFENTLICHE GEBÄUDE
41 Landesbehördenhaus I
42 Landesbehördenhaus II
43 Land- und Amtsgericht
42 Handelskammer
44 Post
19 Arbeitsamt
7 Rathaus
45 Städtische Schwimmhalle
46 Jugendherberge

Herausgeber: Gemeinnütziger Verein Dessau E. V.
Abteilung Verkehrsbüro
Entwurf: Josef Schmidt
Klisches: Sickert & Reiche
Satz: Bauhaus-Druckerei
Druck: Volksblatt-Druckerei, sämtlich in Dessau

c

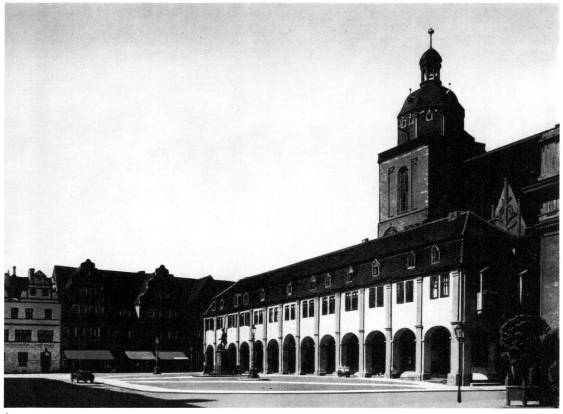

a

d

b

The Beginning in Dessau

The very existence of the Bauhaus Dessau depended on Fritz Hesse. Made aware of the significance of the Bauhaus in 1925 by the art historian Ludwig Grote, he succeeded in having the city of Dessau accept the Bauhaus into its care, and he guarded it until 1932—when the National Socialists came to power in the state of Anhalt—with diplomatic skill and with exemplary courage of his convictions. It was because of him that the city parliament voted the considerable funds for the construction of the Bauhaus building and the Masters' houses. When he was turned out of office by the National Socialists, his support of the Bauhaus was the prime accusation against him. After the Second World War, Hesse put his efforts into rebuilding Dessau. Forced to resign, he moved to West Berlin where he is now maintaining a law practice.

At the time Dessau took over the Bauhaus in 1925, it was originally planned to merge it with the city Arts and Crafts School. But this plan was carried out only with respect to the general administration which was put under the authority of the Director of the Bauhaus. Those concerned refrained from fusing or affiliating the classes of the two schools, since they feared a repetition of the difficulties that had developed with the old Art Academy professors in Weimar. For this reason the Arts and Crafts School in 1926 did not move into the (technical school) wing of the Gropius-designed Bauhaus building which had originally been intended for it. Up to the opening of its own building, the Bauhaus with its administrative offices and its classrooms was provisionally housed in the building of the Arts and Crafts School, completed in 1898, in the Mauerstrasse. During this time the workshops found accommodations in the storage rooms of a wholesale dealer, and master studios were set up in the Municipal Art Museum.

a
The "Big Market" in Dessau.
A square in the center of the old city enclosed by well-built Burgher houses of the Renaissance and the Baroque period.

b
The castle in Dessau as seen from the river Mulde. This was formerly the residence of the Dukes of Anhalt. A building of the sixteenth century with distinct elements of Italian influence. It was later partially altered by the Prussian court architect Knobelsdorff.

c
Fritz Hesse, mayor of Dessau. About 1928.

d
The "Kavalierstrasse" in Dessau, around 1930.
A generously planned main street which, despite its predominantly new buildings, manifests the spaciousness of classicistic city planning.

e
City Arts and Crafts School and Trade School in Dessau, Mauerstrasse 36.

f
"Gothic House" in the Wörlitz park near Dessau. Next to the magnificent classicistic architecture of Erdmannsdorf, "Gothic" buildings, harbingers of the arrival of historicism, rose in Wörlitz park around 1780, dreams of an intact medieval world.

f

e

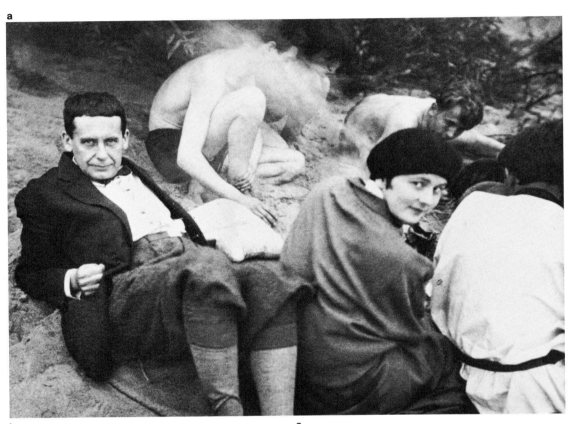

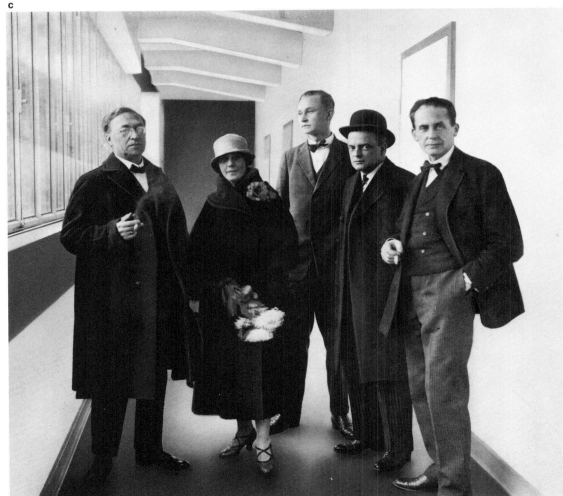

d

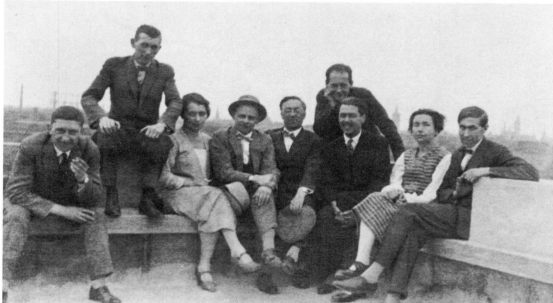

e

The beginnings in Dessau had been lent wings, it seemed, by well-justified optimism. It was beyond question that the temporary arrangements would soon come to an end and one would be able to work under nothing short of ideal conditions. The vivacity of this new beginning sustained the community life as well. Parties and excursions were improvised. Everyone went out into the parklike meadow landscape of the Elbe lowlands, engaged in sport, and enjoyed free and easy sociability. Wörlitz was enticing, having one of the oldest and most expansive formal parks and a castle, designed by the architect Erdmannsdorf, in which the treatment of the walls and ceilings with color seemed curiously modern. But an incomparable fascination emanated from the Junker airplanes which were manufactured in Dessau and which could be seen circling overhead on their daily test flights. On the whole, Dessau was drawn into the stream of modern life quite differently from Weimar. The cities of Magdeburg, Leipzig, and Halle were only one hour by express train away and Berlin was just a two-hour trip from Dessau. The day of the opening of the Dessau Bauhaus building was probably the brightest in the history of the Bauhaus. More than one thousand guests from at home and abroad participated in the celebration. Following the ceremony, the visitors were shown the Bauhaus accomplishments in an exhibition and in guided tours through the building, the Masters' houses, and the Dessau-Törten housing development. Of the latter, the first stage was already completed. That same evening the program provided a presentation by the Bauhaus theatre—again in the auditorium. The next day, films of the Bauhaus work were shown. The completion and opening of the Bauhaus building was praised by the big newspapers and by the international architectural and engineering journals as a cultural event of the highest order.

a
Picnic on the river Elbe near Dessau, July 1927. Walter and Ise Gropius (facing the camera) with students.

b
Werner Siedhoff dressed as cavalry officer "Gropius," at the birthday party for Walter Gropius on May 18, 1926. The "Bauhäusler" always celebrated Gropius's birthday with an inventive congratulatory reception. These events evidenced how much Gropius meant to his collaborators and students. For the occasion of May 18, 1926, Siedhoff put on Gropius's Hussar uniform of the First World War.

c
Bauhaus Masters in the passageway on the second floor between the workshop building and the wing of the technical school. December 1926.
From left to right: Wassily Kandinsky and his wife Nina, Georg Muche, Paul Klee, and Walter Gropius. The administration offices led off this corridor, the lowest one in the bridgelike connecting wing. The floor above this one housed the architecture department.

d
Opening ceremonies in the auditorium of the Dessau Bauhaus building on December 4, 1926.

e
Members of the Bauhaus on the roof of the studio building in Dessau. About 1927.
From left to right: Josef Albers, Marcel Breuer, Gunta Stölzl, Oskar Schlemmer, Wassily Kandinsky, Walter Gropius, Herbert Bayer, Lucia Moholy-Nagy, Hinnerk Scheper.

Gropius: Bauhaus Building

The construction of the Bauhaus buildings was approved by the Dessau city legislature the very month—March 1925—it decided to take the Bauhaus under its wings. Hence, it was possible to start the planning right away. At first, 680,000 reichsmarks were granted in a preliminary estimate for the classroom and workshop wing, but in reality the costs for the entire building (including the studio wing and the wing for the technical school), added up to approximately one million reichsmarks. Since the site was situated on Friedrichsallee, then at the edge of the city, in a region still free of buildings, there was no urban environment to have to take into account. Gropius was able to carry out his intentions without restraint. A usable basis to work on existed in the design for an International Academy of Philosophy of the previous year, which had not been carried out. The plaster model here shown of the Bauhaus building, which Gropius presented and explained to the finance committee of the Dessau city legislature on June 22, 1925, is still relatively close to the project of 1924. The drawing by Fieger, developed in Gropius's architectural studio, also does not yet differ significantly in its distribution of building masses. In this connection the drawing is interesting in that it reproduces, on the whole, ideas which Gropius had considered at this early stage in the development of his conception— except for the curves, which were Fieger's own paraphrasing additions.

The plans for the Dessau Bauhaus building took final shape in a remarkably short span of time, during July and August 1925. The definitive grouping of building masses was done during that phase of the planning. Crucial for the impact of the entire building was the compositional uniformity of the cantilevered glass wall of the workshop wing. Construction was started in September 1925, and the exterior was up by March 1926. The studio building (student dormitory) was occupied one year after construction had begun. The other wings of the building were in use from October 1926 on. The entire building covered about 28,500 square feet of floor area and enveloped 1,150,000 cubic feet of built-in space.

"The typical building of the Renaissance and the Baroque has a symmetrical façade, with access on the central axis. The view offered to the approaching spectator is flat and two-dimensional. A building emanating from the contemporary spirit rejects the representational appearance of the symmetrical façade. One must walk all around this structure in order to understand the three-dimensional character of its form and the function of its parts." (Gropius, "Bauhausbauten Dessau" volume 12 of the Bauhaus Books).

a
Gropius's architectural studio (drawing by Carl Fieger): preliminary design for the Bauhaus building in Dessau. Charcoal drawing. 1925.
Private collection, Dessau.

b
Walter Gropius (design) and collaborators: model of the Bauhaus building in Dessau. Plaster. June 1925. Presumed destroyed.

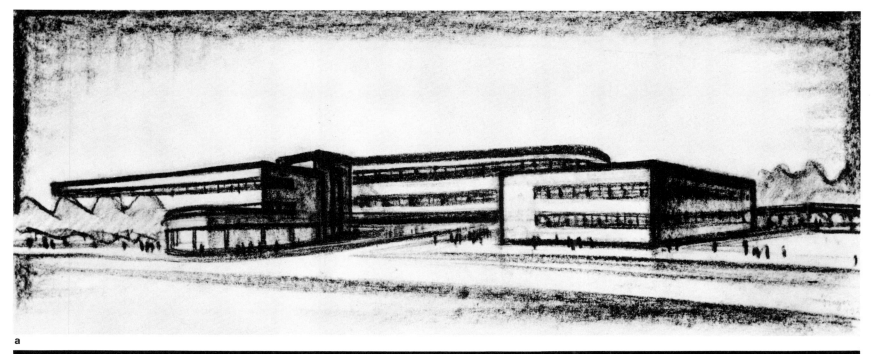

a

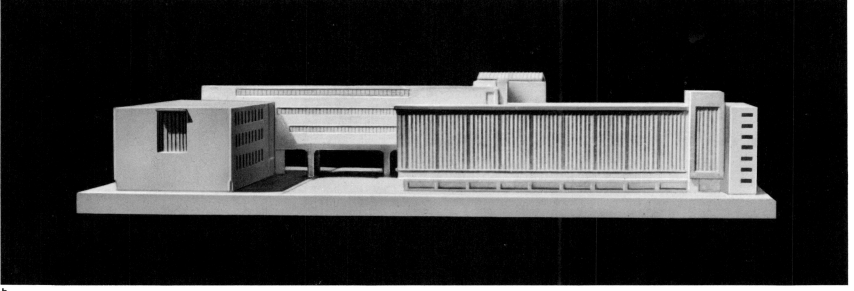

b

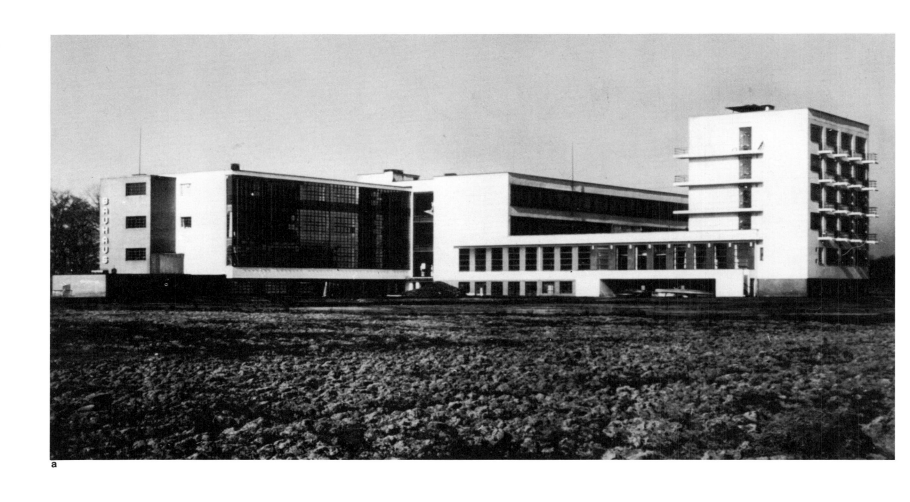

a

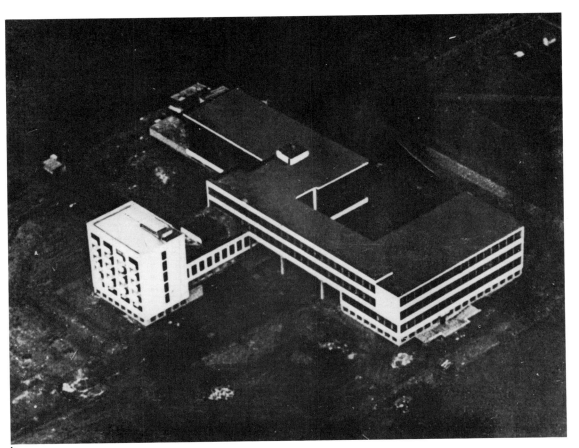

b

"Air traffic routes place a new demand on the builders of houses and cities: to deliberately shape the appearance of the building as seen from the air, which the people of former ages were unable to see" (Gropius, "Bauhausbauten Dessau"). In photograph a, the part in the left foreground is the studio building; in the background on the left is the workshop section and on the right-hand side in the foreground the wing of the technical school. The center of this photograph shows the bridge, on columns, with the offices of the architecture department and the administration. The single-story part between the bridge and the studio wing housed the auditorium, the stage, and the canteen. The trees in the background on the left are part of the Friedrichsallee. The workshop wing is on the left, and adjoining it is the bridge crossing over to the wing of the trade school (not shown). In front of the bridge is the single-story part connecting it to the studio rooms of the students. It houses the auditorium, the stage, and the canteen. With regard to the material and the method of construction employed, the Bauhaus building was partly an experiment. Structurally it was a reinforced concrete skeleton with brick masonry and reinforced hollow tile floors supported on beams. For the basement floor a structurally sturdier "mushroom ceiling" had been selected. The walls were given a coat of cement stucco and were protected with a mineral paint. The flat roofs were covered with a newly developed roofing material (whose defects became apparent too late and caused a great many difficulties). The roof of the studio building was flat and could be walked on. The steel window sash was made with double weathering contacts and plate glass. The Bauhaus workshops helped in doing the interior finish. The painting was done by the department for wall painting. The lighting fixtures were products of the metal workshop and the tubular steel furniture (for the auditorium, the dining room, and the studios) was manufactured according to designs by Marcel Breuer. Lettering was executed by the printing workshop of the Bauhaus.

Gropius: Bauhaus building.
a
View from the southeast. Photograph taken around 1928.
b
Bird's-eye view. 1926.
c
Site plan of the entire grounds. 1926.

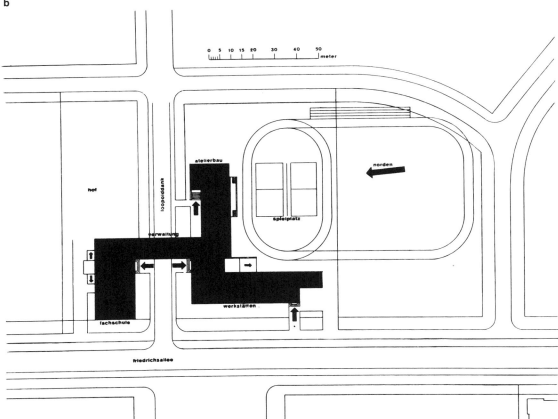

c

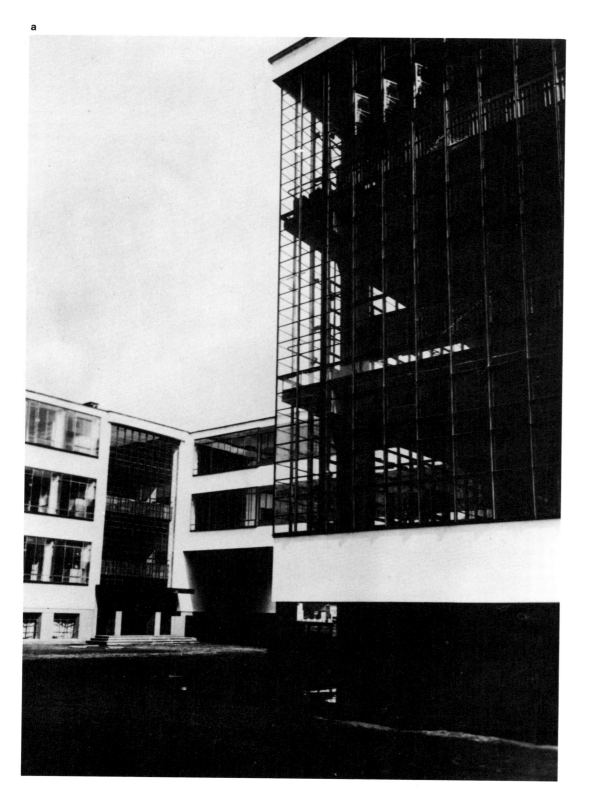

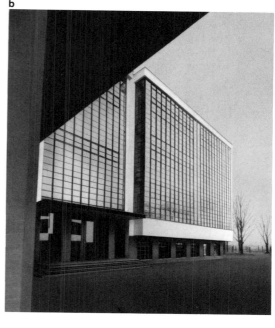

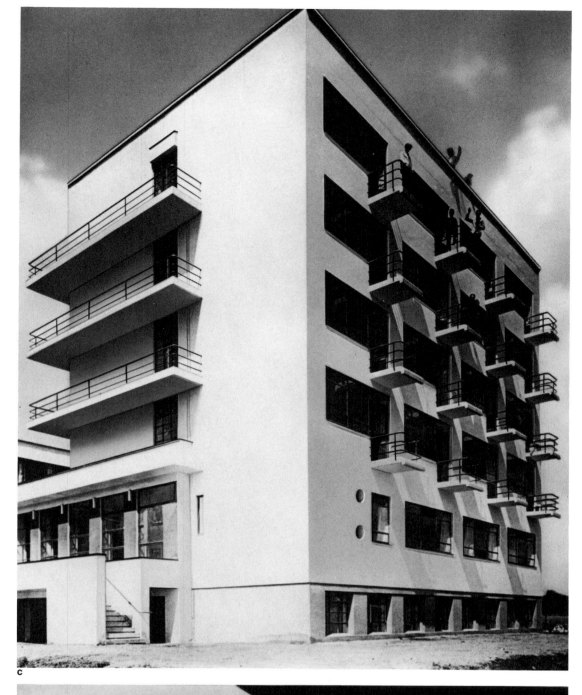

In its basement, half below and half above ground, the workshop wing housed the stage workshop, the printing workshop, the dyeing section, the sculpture workshop, packing and storage rooms, the apartment of the custodian, and the heating plant with fuel (coal) storage bunker extended out in front. On the first floor of the same wing were the cabinetmaking workshop, display rooms, a large vestibule and— merging into the connecting section with the studio wing—the auditorium with raised stage. The second floor housed the weaving workshop, the classrooms for the preliminary course, and a large lecture room; the administrative offices were on the lower floor of the bridge that led to the technical school wing. On its third floor were the workshops for wallpainting and for metalwork as well as two lecture rooms capable of serving as a single display room when combined. The adjoining upper floor of the bridge was given over to the architecture department and to Gropius's architectural studio. The technical school wing (which was originally planned for the arts and crafts school but later redesigned for technical schools) housed classrooms and administrative offices, staff rooms, a physics room, rooms for model building, and a library.

The stage, flanked by the auditorium and the canteen, was in the low section connecting the workshop and the studio wings. The partitions were capable of being opened on both sides, making both the auditorium and the canteen into spectator areas and integrating the sequence canteen—stage—auditorium—vestibule "into a large festival area" (Gropius). In the studio building, on the first floor bordering on the canteen, were the kitchen and its supporting rooms. Below, in the basement floor of the studio building, were baths, a room for gymnastics with a locker room, and a room with electric washing machines. On four floors above the first floor were 28 studio apartments for students, with a kitchenette on each floor. The balconies, belonging to the studio apartments, were favorite places for sunbathing as well as for cabaret improvisations by students.

Gropius: Bauhaus building.
a
Northwest corner of the workshop wing, bridge, and entrance to the technical school section.
b
Main entrance and side elevation of the workshop wing.
c
Studio and dormitory building for the students (in remembrance of the Weimar studio house also named "Prellerhaus").
d
Studio building and single-story connecting wing to the workshop building.

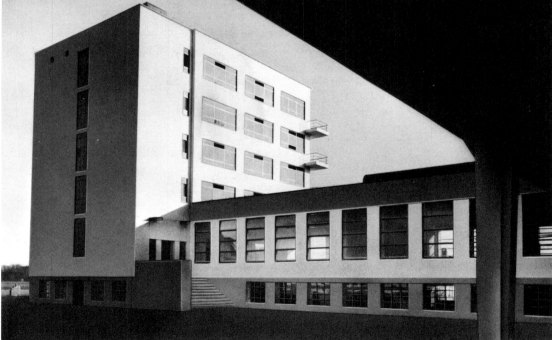

Gropius: Bauhaus building

a
Vestibule. The lighting fixtures are by Moholy-Nagy and the metal workshop. The painting in color was done by the department for wall painting.
The swinging doors on the left lead to the entrance at the main door. On either side is a flight of stairs constituting the main stairwell. The three doors on the right connect the auditorium with the vestibule.

b
Auditorium. Lighting fixtures by the metal workshop (Moholy-Nagy). Tubular steel furniture designed by Marcel Breuer. The room was painted in color by the department for wall painting (Hinnerk Scheper).
The auditorium, together with the adjoining stage, was used for assemblies, lectures, and performances. The small opening in the rear wall (on the right) was designed for film and slide projections.

c
Canteen (dining room). The furniture was built by the cabinetmaking workshop (Marcel Breuer), and the lighting fixtures were made in the metal workshop (Moholy-Nagy). The room was painted in color by the department for wall painting (Scheper). By opening the black and white folding "accordion" doors in the rear of the picture, the dining room could be combined with the adjoining stage.

d
Gropius and the Bauhaus workshops: studio apartment of a student in the studio building of the Bauhaus.
These studio apartments were furnished with a bed alcove, two wall cabinets, a wash basin with running hot and cold water, a desk, and chairs. The studios were meant to provide the students with a place to work without interference, at the same time giving them the opportunity to withdraw in order to be alone.

a

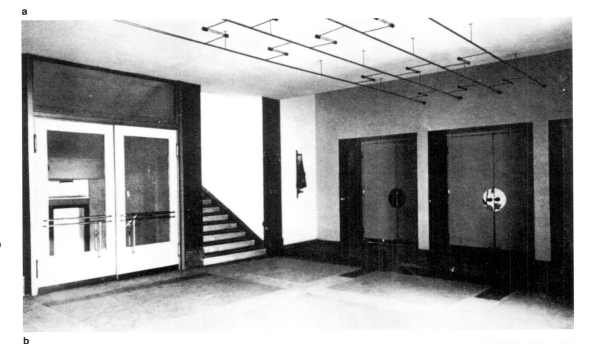

b

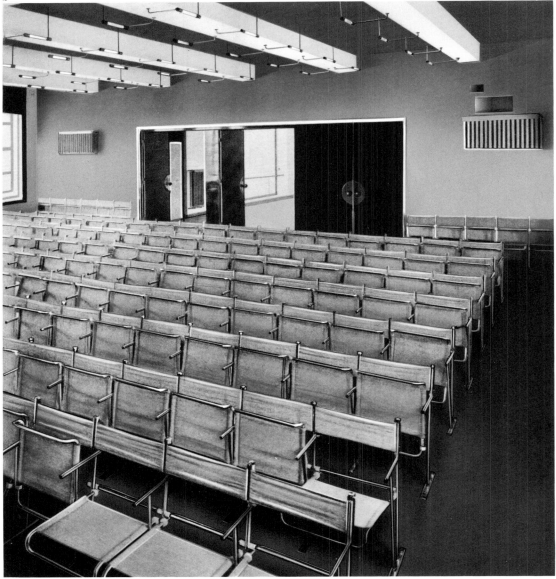

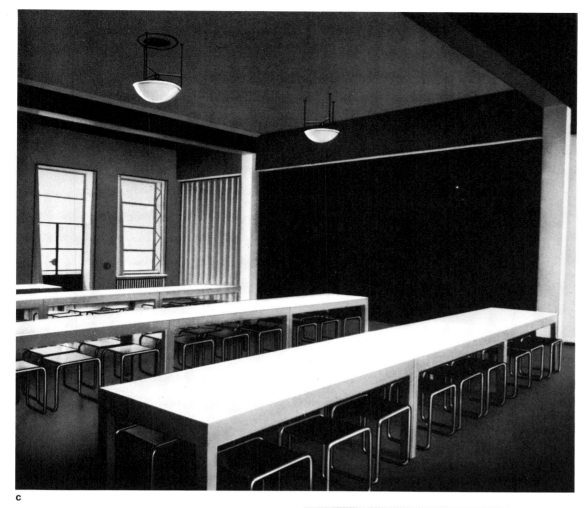

c

d

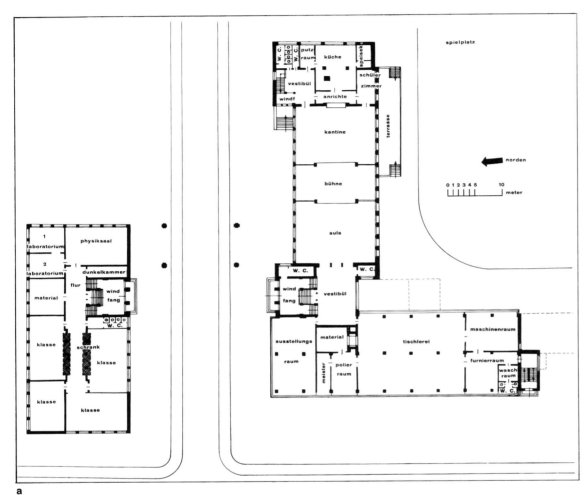

a

"Objective for the organization of a good floor plan: Proper utilization of the exposure to the sun; short time-saving communicating passages, clear separation of the individual departments of the organism, opportunity for altering the sequence of rooms for possibly needed organizational changes using a well-thought-out module . . . It is crucial in evaluating a building to find out whether the architect and engineer has, with the least expenditure of time and material, created an instrument that will function; that is to say, one that serves the required purpose for the life it harbors, in that this purpose may be based on psychological as well as material requirements" (Gropius, "Bauhausbauten Dessau," volume 12 of the Bauhaus books).

Gropius: Bauhaus building.

a
Ground-floor plan. On the lower edge of the plan is the "Friedrichsallee," running in a north-south direction. Facing it is the west elevation of the workshop wing and opposite, on the other side of the secondary road that cuts through the site and is bridged over, is the narrow side of the technical school wing. Adjoining the workshop building in the east (in the upper part of the plan) is the connecting section to the studio building, with the terrace taking advantage of the southern exposure. The area in the south-east corner of the site was reserved for sport activities and was leveled some time after the building had been completed.

(Explanations in the plan:) (10 meters = 32.8 feet)

Technical School Building

laboratorium	= laboratory
klasse	= classroom
physiksaal	= physics room
flur	= hall
windfang	= porch
schrank	= lockers
w.c.	= toilets
dunkelkammer	= darkroom
spielplatz	= playground
norden	= north

Workshop Building

ausstellungsraum	= display room
material	= materials
meister	= master
polierraum	= room for foreman
tischlerei	= cabinetmaking workshop
maschinenraum	= machine shop
furnierraum	= room for veneerwork
waschraum	= washroom

1-Story and Studio Wing

putzraum	= broom closet
küche	= kitchen
speisekammer	= pantry
vestibül	= vestibule
anrichte	= serving counter
Schüler zimmer	= student room
kantine	= canteen
terrasse	= terrace
bühne	= stage
aula	= auditorium

(Explanations in the plan:)
b
Second floor.

Bridge (Administration Building)
flur	= hall
atelier	= studio
bibliothek	= library
schreibm.	= typing
warter.fachsch.	= waiting room technical school
verwalt.	= administration
bespr raum	= conference room
direktion	= director
verwalt. bauhaus	= Bauhaus administration
buchhaltung	= bookkeeping (accounting)
kasse	= cashier
warter bauhaus	= bauhaus waiting room
telefon	= telephone
lehrraum	= lecture room
flur	= hall

Technical School
(studio building)
lehrer zimmer	= staff room
vestibül	= vestibule
klasse	= classroom
schrank	= lockers
material	= materials
grundlehrewerkstatt	= workshop for prelim. course
weberei	= weaving workshop
meister	= master
garderobe	= wardrobe
waschraum	= washroom

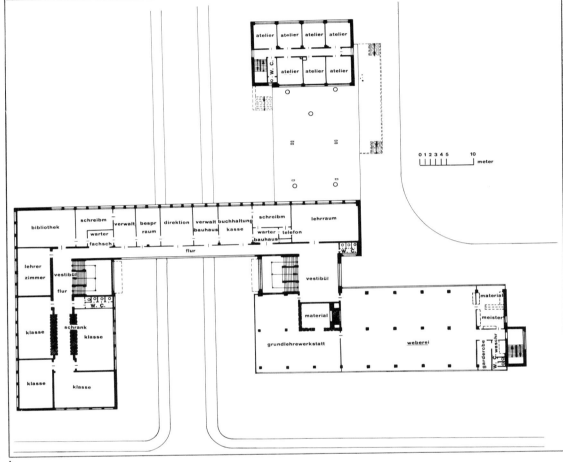

b

407

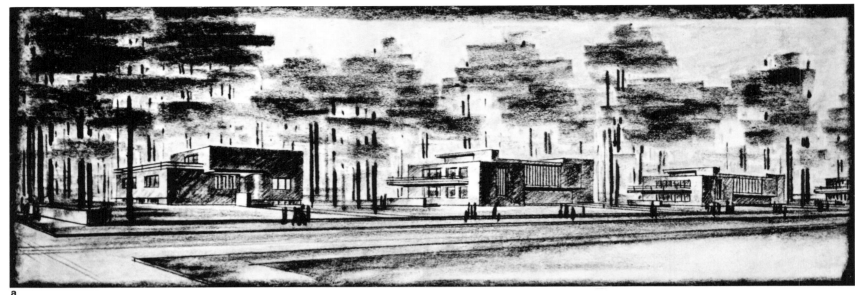

a

Gropius: "Masters' Houses"

The rendering records an early stage in the development; Fieger based it on Gropius's ideas, probably altering them but slightly. Like the Bauhaus building, the Masters' houses were financed by the city of Dessau. There were seven units: one single house for the Director and three duplexes, for Moholy-Nagy and Feininger, for Muche and Schlemmer, and for Kandinsky and Klee and their families. The volume of the single residence was 67,000 cubic feet and that of the duplexes was 88,300 cubic feet. Construction of these houses was started in the summer of 1925. They were completed one year later and their occupants moved in. The site was a thin pine forest not far from the Bauhaus. The houses were surrounded by level lawns with trees and were 65½ feet apart. Their fronts were parallel to the street, which ran in an east-west orientation. The lots were not fenced in, and only the Director's residence on the corner lot at the beginning of the street was protected on that side by a wall. In constructing these houses the most progressive building methods were used wherever possible. The foundations were made of a dry-mix concrete and the walls were erected with slabs of medium size (consisting of cinder, sand, and cement). Of course, the utilities and appliances met the latest technological standards. The workshops of the Bauhaus, particularly the department for wall painting, the metal workshop (lighting fixtures), and the cabinet-making workshop (furniture), aided in giving these buildings their interior character.

a
Gropius's architectural office (rendering by Carl Fieger): the "Masters' houses" of the Bauhaus in Dessau, seen from the Burgkühnauer Allee. Preliminary design. Charcoal drawing on yellow paper. 1925. Private collection, Dessau.

Gropius: "Masters' houses"—single residence, Gropius house. Designed in 1925 and completed in 1926. (Destroyed during the Second World War)
b
View from the garden (south).
c
Street elevation (north).
d
Plan of the ground floor.
e
Plan of the second floor.

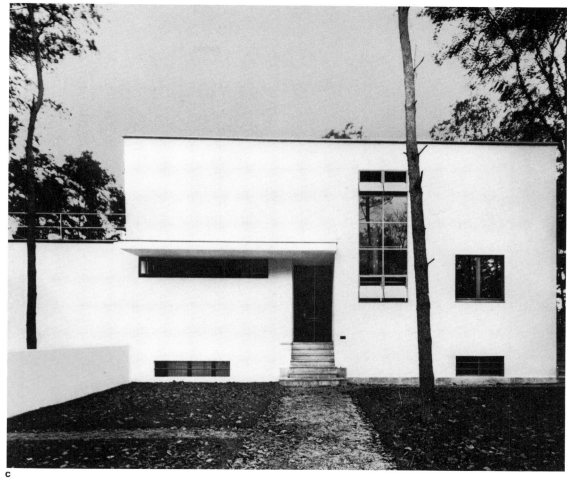

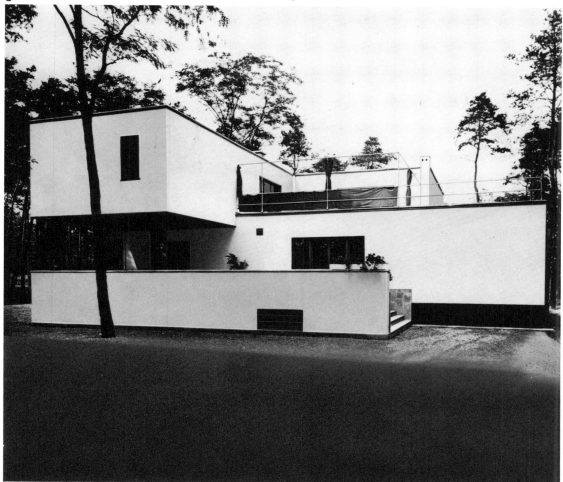

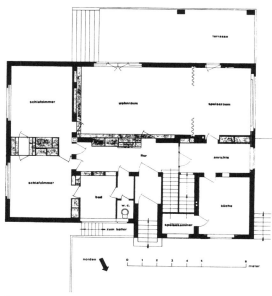

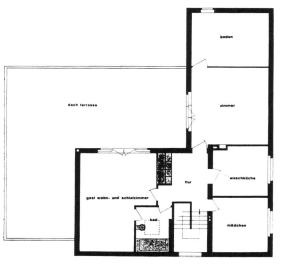

409

"Smooth and sensible functioning of daily life is not an end in itself, it merely constitutes the condition for achieving a maximum of personal freedom and independence. Hence, the standardization of the practical processes of life does not mean new enslavement and mechanization of the individual, but rather frees life from unnecessary ballast in order to let it develop all the more richly and unencumbered." (Gropius, "Bauhausbauten Dessau," volume 12 of the Bauhaus Books.)

Gropius: "Master's houses"—single residence, Gropius house. 1926.

a
Dining room with built-in cabinet for glassware and china and passage to the pantry and scullery. The painting of the walls was done by Marcel Breuer and the department for wall painting. The cabinet was designed by Gropius and Breuer and produced in the cabinetmaking workshop of the Bauhaus.

b
Bedroom with deep built-in cupboards in the wall between two rooms. The painting of the walls was done by Marcel Breuer and the department for wall painting. The wall cupboards were designed by Gropius and Breuer and produced in the cabinetmaking workshop.

c
Guest room, dressing alcove with mirrors. Tubular steel furniture designed by Breuer.

d
Pantry and scullery and view into the kitchen. The kitchen cabinet was produced in the cabinetmaking workshop after designs by Breuer.

e
Porch in front of the dining room, with view of the garden and the neighboring duplexes. The painting in color was done by Marcel Breuer and the department of wall painting. The lighting fixture was made in the metal workshop and the tubular steel furniture was designed by Breuer.

a

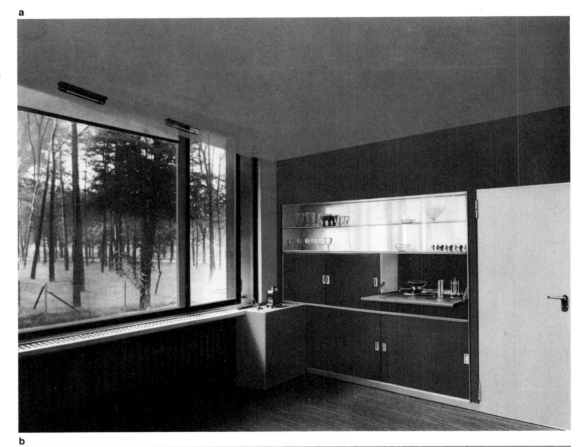

b

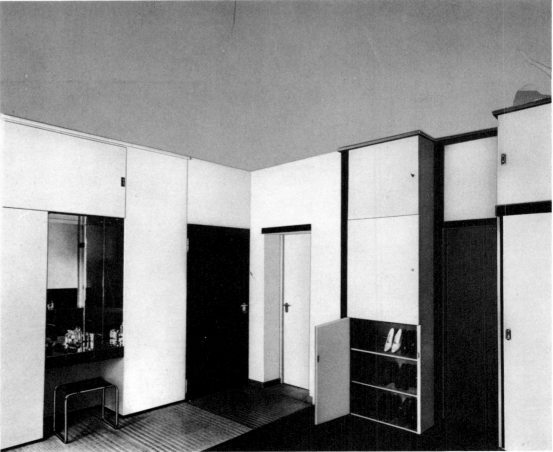

410

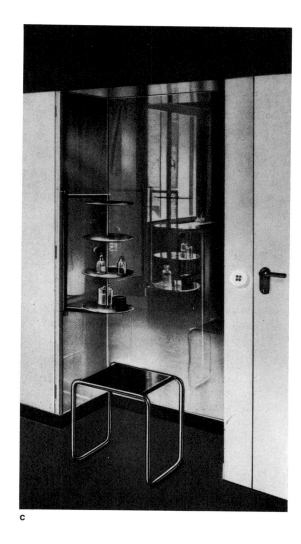

c

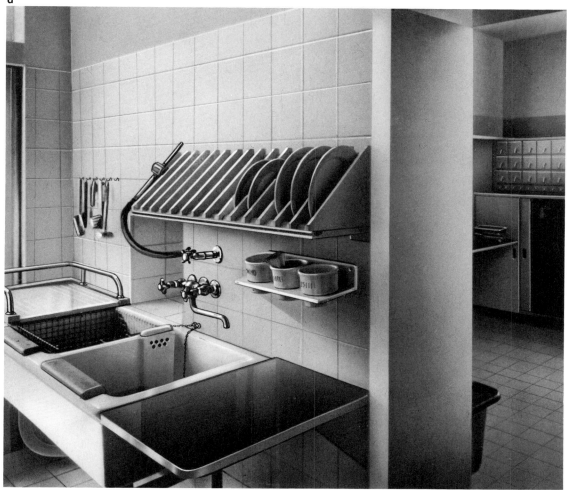

d

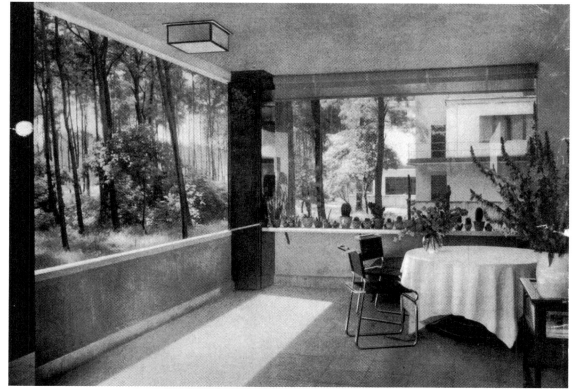

e

411

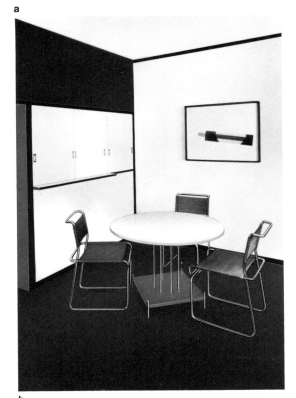

a

"All six homes in the three duplexes are alike right down to the last detail and yet different in their effect. Simplification through multiplication means a reduction in price. . . . The floor plan of one of the two homes is the mirror image of the floor plan of the other one, interlocked and turned by 90 degrees from east to south. Exactly the same construction units have been used, but the elevations of the two sections of the duplex are different because they are interlocked. The difference in height between the studio and the other rooms intensifies this impression. Studio, stairwell, kitchen, pantry, and bathroom face north, avoiding the direct rays of the sun; living, dining, bedrooms, and children's room with garden, terraces, balconies, and roof gardens face the sun. Kitchen and utility rooms, living and dining room are on the ground floor, the bedrooms and the studio are on the upper floor. The painting of the interior in color, done by the wall-painting department of the Bauhaus, emphasizes the spatial organization within the home but simultaneously effects strong variations in the appearance of identical rooms" (Gropius, "Bauhausbauten Dessau.")

The furniture for the duplexes was largely made according to Bauhaus designs, but the Masters were free to furnish their homes differently according to their individual tastes. Thus, Feininger preferred to put distinguished antique furniture into his rooms. One of the most important aspects of the duplexes and their grouping was the proximity of their studios; the masters stimulated each other productively, working, so to speak, "wall to wall" in their homes. The "Masters' houses" were centers of intellectual exchange. Their example demonstrated—in publications and numerous tours in which the interested public was permitted to participate—the functionality and above all the relatedness to life of modern residential building design, which was attacked by its opponents in a stereotyped manner as being a "machine for living." The buildings were partially altered after 1933. The duplexes, except for the first one in the row adjoining the Gropius house, sustained relatively little damage during the Second World War.

Gropius: "Masters' houses"—duplexes. Designed in 1925, completed in 1926.
a
Dining room in one of the duplexes (Moholy-Nagy). Painting of the walls and ceiling by Moholy-Nagy and the department for wall painting. Table and chairs made according to designs by Marcel Breuer. The built-in cabinet for glass and china (accessible also from the adjoining pantry and scullery) was made in the cabinetmaking workshop.
b
View of a duplex as seen from the garden (south). Terraces and balconies on all floors. The balconies were formed by cantilevering the ceiling slabs.
c
Duplexes, seen from the northwest (street elevation). 1926.
d
View of a duplex from the east.
The terraces and balconies were so designed as to permit direct access to the outdoors from nearly all rooms.

b

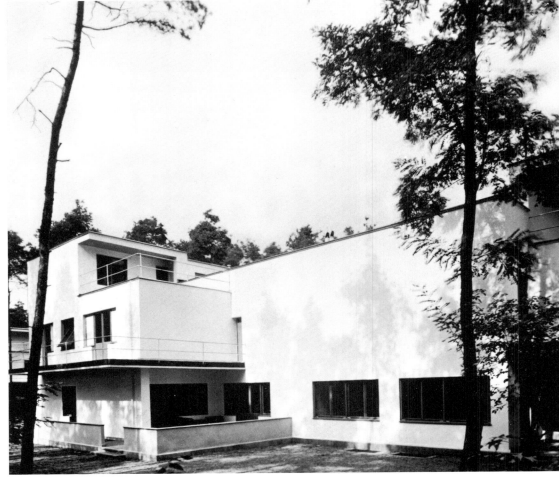

d

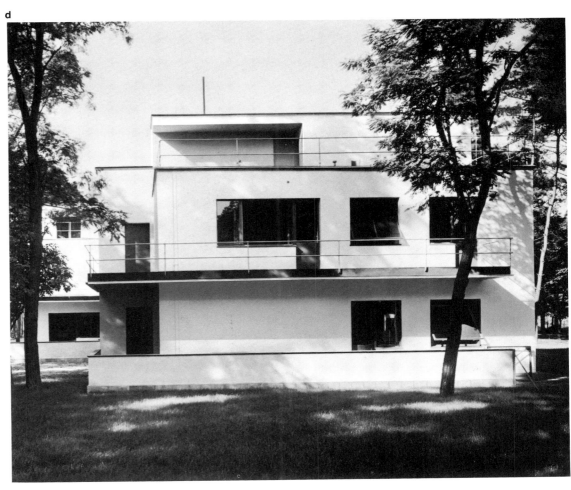

c

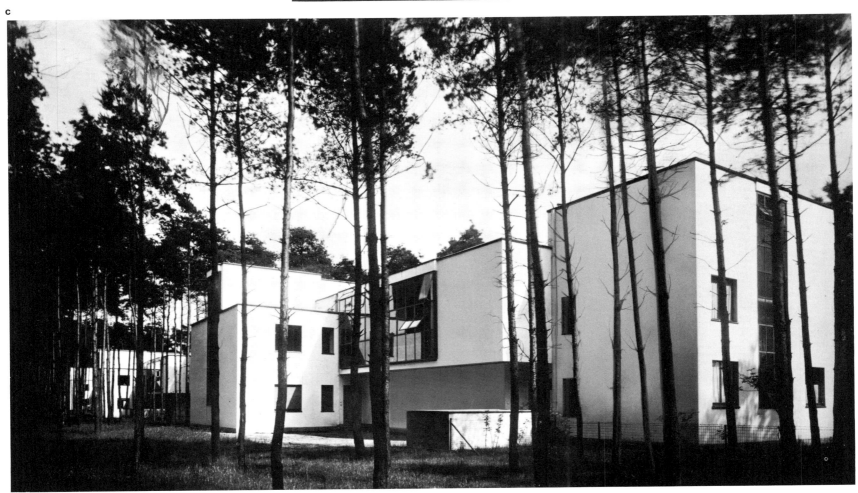

Gropius:
Dessau-Törten Housing Development

In three stages of construction—1926, 1927, and 1928—the "National Homesteads Housing Development" ("Reichsheimstattensiedlung") in Dessau-Törten was built according to plans and under the direction of Walter Gropius. The commission was given by the city of Dessau. Prior to the design, extensive research was done into the possibilities of rationalization. Since the site had soil composed of sand and gravel usable for a concrete mix, Gropius decided "to use a method of concrete construction according to my own system, keeping the amount of material to be moved to the construction site low, for the presence of sand and gravel requires no more than the transport of cement and cinder to the site for the manufacture of the cinder concrete wall units" (Gropius, "Bauhausbauten Dessau"). The units were produced right on the site. The production process was controlled by an "on-site work plan" which made possible the assembly-line manufacture of the wall slabs and the concrete ceiling beams. "The principle of work at the site was to reuse the same man for the same phase of the construction in each block of houses and thereby increase output. In order to insure the interlocking of the individual construction phases from the start of the rough construction and interior work, an accurate timetable was worked out, similar to the ones used by railroads...." In 1926 sixty houses were completed, in 1927 one hundred, and in 1928 one hundred and fifty-six. Based on the experiences of the first stage, the experiments were continued to a larger extent and utilized during the second and third construction stages with the aid of the National Society for Research into Economic Building and Housing. However instructive and revealing this operation was in principle, its concrete effectiveness was marginal. The project was too modest in size for industrialization of building methods to yield a reduction in construction costs. Disappointment over this—the people who moved into the development were of the lower income brackets—resulted in (partisan) political difficulties which became quite troublesome for the Bauhaus, since they devolved on Gropius.

In Gropius's architectural studio creative cooperation was always welcome, even if it did not distinguish itself by extraordinary quality. Like the Bauhaus, the principle of teamwork was practiced. Thus, for a long time it was in a position to function as a substitute for the missing architecture department for the Bauhaus and to prepare the conditions for its eventual establishment.

a
Gropius: Dessau-Törten housing development. General plan. Building lots 1926 (60 units), 1927 (100 units), and 1928 (156 units).

b
Gropius's architectural studio (rendering by Carl Fieger): preliminary design of the building for the cooperative store in the Dessau-Törten housing development. Charcoal drawing. About 1927.
Private collection, Dessau.
Fieger's design is noticeably conventional in comparison with the building that was eventually erected. Apparently Fieger wanted to make his own contribution in this case and departed from Gropius's intentions.

c
Gropius: Dessau-Törten housing development, building of the cooperative store (1928) and row-houses (type 1927).

a

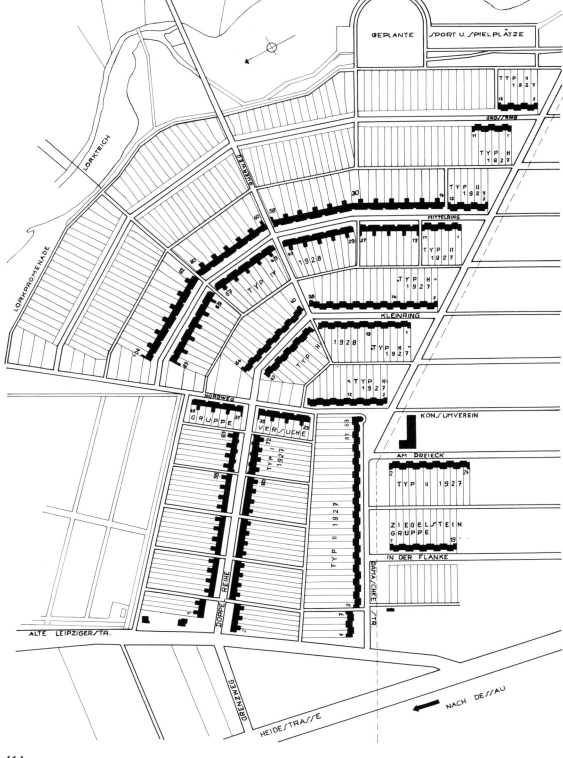

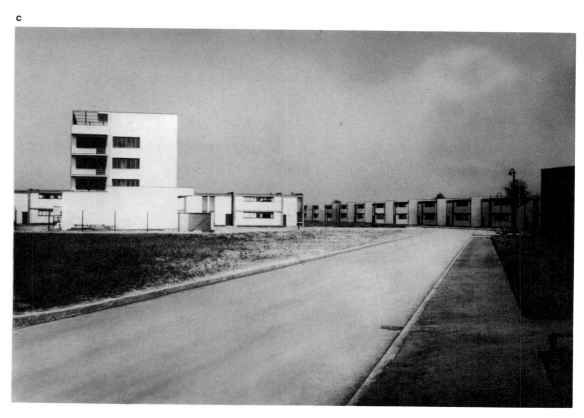

c

b

The Dessau-Törten housing development was generally looked on as a product of the Bauhaus, even though Gropius had personally received the commission for its design. It represented to a certain extent the Bauhaus ideas on the subject of housing developments for everyone. In that respect it was an important supplement to the architectural program which had been demonstrated with the Bauhaus building and the Masters' houses. The development was built for members of the working class, who relied on the extra income from the produce of their gardens and the keeping of small farm animals. The concept of Dessau-Törten was that of a "half-rural" development with small, two-story, single-family houses in a row, each with a narrow garden plot adjoining that of its neighbor. The lots were between 3750 and 4300 square feet each. The fact that the success anticipated in the Dessau-Törten experiment was lessened, was, aside from calculation problems, in large part due to technical shortcomings, caused by pilferage, unauthorized use of poor materials, and by acts of sabotage by contractors. Dessau-Törten became the cause for quarrels between different interest groups, carried out partially in the open and partially under cover, as is probably always the case when new construction methods are developed. The Bauhaus, the architect, and the work suffered from that struggle. Within a very few years the condition of the buildings was no longer perfect. After 1933 the windows, above all, were changed. During World War II the development was partially damaged. After 1945 the only authentic element remaining was the conception of a planned city.

Gropius: Dessau-Törten housing development.
a
Houses of the 1926 construction stage. Drawing in black, blue, and red. Published in the special edition on the Bauhaus of the journal "Offset, Buch- und Werbekunst," ("Offset, Book, and Commercial Art"), Leipzig 1926.
b
Houses of the 1927 construction stage.

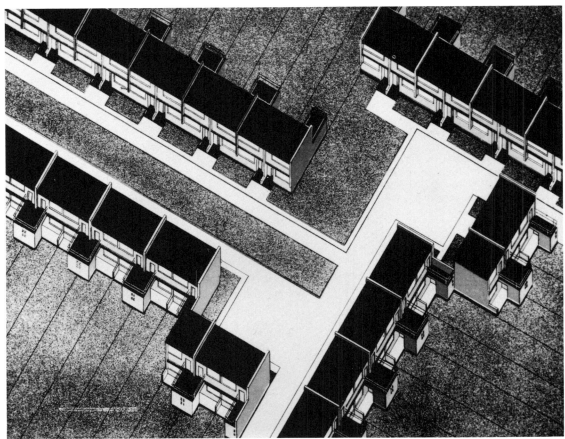

a

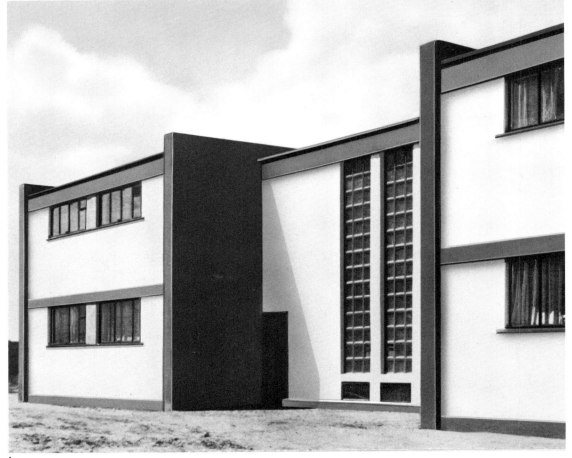

b

416

Törten—Other Buildings

Dessau-Törten was an experimental arena not only for Gropius but, during the Hannes Meyer era, for the whole architecture department of the Bauhaus. During the time the Gropius housing development was under construction, Törten was already Bauhaus domain, so to speak. Carl Fieger, who was employed as draftsman in Gropius's architectural studio, built his own house at the edge of the development, demonstrating the possibilities of attuning the avantgarde language of forms to the feelings of the middle-class citizen. Georg Muche and Richard Paulick contributed their "steel house," a noteworthy—at least as an object for discussion—variation of the problem of standardization and the application of new building materials. Muche writes about his intentions in the Bauhaus Journal (number 2, 1927): "My first design for a steel house dates back to 1924, being a further development of the experimental house which had been erected in Weimar in 1923. It was evolved in an effort to determine the requirements of modern living for a family from an exact definition of the terms . . . The customary house is built on a floor plan, fixed in the organization of its rooms. This would be correct if the number of family members always remained the same and if the space requirements remained unchanged. But the family is a flexible organism, and its numbers increase or decrease with time. Hence, the floor plan must be worked out in such a way that enlargement or diminution is possible as a natural arrangement, without having to demolish building units. . . . The residence which can be added on to and which has a flexible floor plan is a requisite of our era. . . . The possibility of improving the organism 'home' thoughtfully is the chief benefit which steel housing construction, and with it all types of light-weight assembly constructions, will provide." At that time, the technical prerequisites for building a really usable steel house were not yet available. "At present," Muche pointed out, "all types of steel constructions for houses are still primitive. The amount of material needed is still too large. Only specially developed constructions . . . will make the steel house into a modern industrial product with respect to purpose, form, and price."

c
Georg Muche and Richard Paulick: "steel house" in Dessau-Törten. 1926.
Assembly construction with prefabricated components (steel supports, metal sheets) on a concrete foundation.

d
Carl Fieger: design for his own residence. Drawing. 1927.
Built in 1927 on the periphery of the Dessau-Törten housing development. This house is symptomatic of the transformation of the new architectural ideas into general building practice.

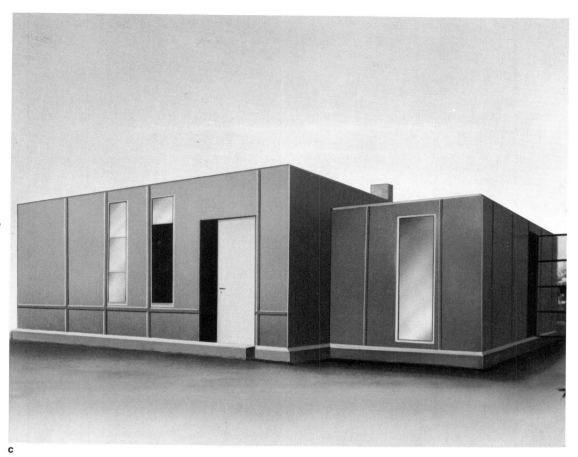

c

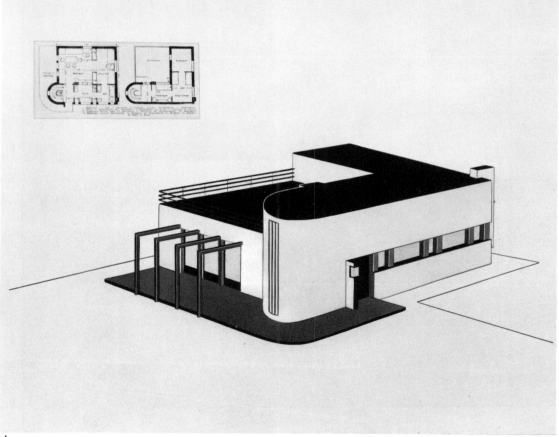

d

417

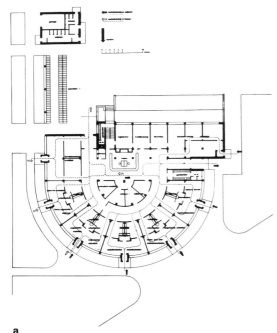

a

The building of the Dessau labor office was designed by Gropius in 1927 as his entry for a competition; it was constructed between 1928 and 1929. The structure was a steel skeleton filled in with leather-colored facing brick. The plan had to make it possible for a modest staff of officials to service a large number of persons seeking employment. "From that requirement results the semicircular form of the floor plan, enabling the deployment of the large waiting rooms—divided into segments according to vocational groups—at the periphery, and that of the individual counseling offices, on the other hand, behind them in the interior. This solution has the added advantage that the changing space requirements for male and female counseling offices can be accommodated by moving the partitions in the interior passage" (Gropius, "Bauhausbauten Dessau"). The offices in the inner part of the semicircle received daylight from skylights. Gropius added a two-story administration building to this single-story wing that housed the offices that served the public. Of all the buildings Gropius built in Dessau, the labor office is the only one that has remained completely intact.

Gropius: labor office in Dessau.
a
Plan of the ground floor. Designed in 1927 and built in 1928–1929.
b
View from northwest. The single-story building in the foreground is the placement section; the administration building is in the background.
c
Interior passage in the single-story building.

b

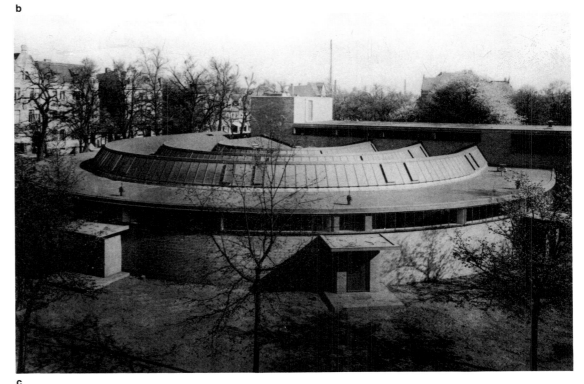

c

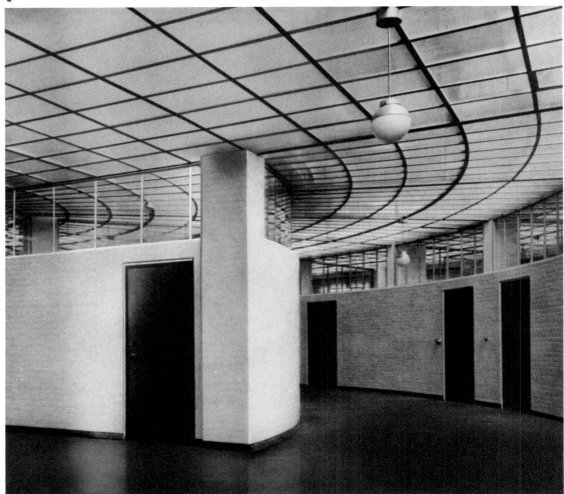

418

Gropius: Total Theater

One of the most interesting architectural experiments, and surely the boldest Gropius attempted in the Dessau Bauhaus period, was his conception of the "Total Theater." He designed this theater in 1927 for the Berlin stage director Erwin Piscator and thereby left far behind such projects as Molnár and others at the Weimar Bauhaus had worked on. The Total Theater was to be an instrument uniting the various possibilities of the deep stage, the proscenium, and the arena stages into the same building. The auditorium is formed by a shell-shaped oval supported on twelve columns. Adjoining it is the deep stage in three parts. From the wings of the deep stage a circular passage led around the auditorium, which could be used by stage carts, and which made it possible for a chorus to move around the auditorium. The proscenium stage was designed as a platform constituting a part of the orchestra seating which extended in front of the deep stage. The platform could be raised or lowered—even during performances—or could be turned by 180 degrees, together with the entire orchestra section, which was in the shape of a disk. This rotation moved the proscenium stage into the center of the auditorium, converting it into an arena stage surrounded on all sides by rising tiers of spectators. Since for the arena there was no backdrop scenery, great emphasis was placed on the possibility of projections. Screens were planned all around the auditorium, giving each spectator in the audience, no matter where seated, a part of the scenic background in his line of sight. With the design on the Total Theater, Gropius made an effort to achieve a "unity of the scene of action and the spectator," the "mobilization of all three-dimensional means to shake off the audience's intellectually directed apathy, to overwhelm them, stun them, and to force them to participate in experiencing the play" (quoted from *"Convegno di lettere,"* in *"Reale Accademia d'Italia,"* Rome 1935). Because of financial difficulties, Piscator was unable to have the "Total Theater" built.

Gropius: "Total Theater."
d
Design, showing the possibility of using the proscenium platform for orchestra seating or as a proscenium stage (left); or, by rotating the whole disk of orchestra seats and proscenium stage, creating an arena at the center of the audience (right). 1927.
e
Model. 1927.
The deep stage is at the left; on the right is the auditorium (walls removed to show the interior).

d

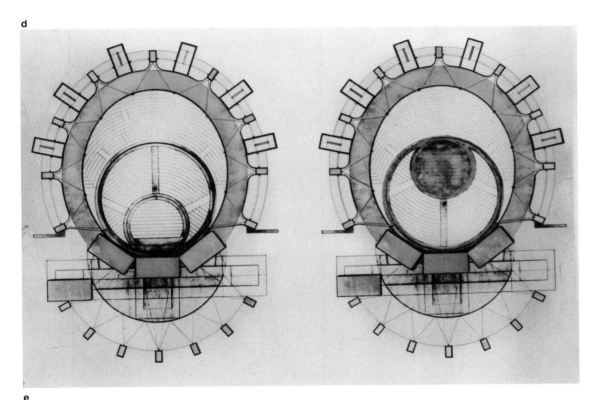

e

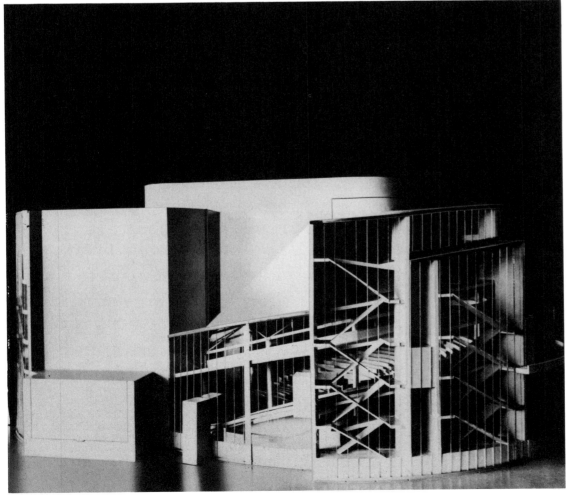

a

The Teaching Staff—
Professors and Junior Masters

At the Dessau Bauhaus, Gropius abandoned the distinction between "form master" and "master craftsman" which had been made in Weimar. At the Weimar Bauhaus young people had been trained who now, as workshop leaders in the Dessau Bauhaus, were capable of mastering the artistic and form-related problems as well as the technical tasks. Those "junior masters" (as they were unofficially called) appointed to the staff in 1925 were: Bayer, conducting the work of the printing workshop, Breuer, leading the cabinet-making workshop, Scheper, who supervised the wall painting, and Joost Schmidt who was responsible for the sculpture ("plastic") workshop. Albers, who in Weimar had in fact already led the preliminary course he had developed, was now officially confirmed as a member of the teaching staff. The responsibilities Gunta Stölzl was given were limited at first to the technical direction of the weaving workshop. After Muche resigned, she was given complete leadership of the workshop. Finally, in 1927, Hannes Meyer was appointed and joined the group of the younger teachers. His field was architecture, for which a department was now established.
The nucleus was formed by the former "form masters" who had joined Gropius in Dessau: Kandinsky and Klee, who worked primarily in general art education, Moholy-Nagy, who was responsible for the preliminary course and the metal workshop, Muche, who (until 1927) conducted the work of the weaving workshop, and Schlemmer, who developed the Bauhaus stage into a significant locale for theatrical experiments. Feininger had no teaching responsibilities. In line with the tendency of consolidating and institutionalizing, characteristic of this phase in the development of the Bauhaus, the "Master" title, an unusual title for a teacher in an academic institution, was no longer used in Dessau. When in the fall of 1926 the state of Anhalt granted the Bauhaus the status of an "Institute of Design," the right of carrying the title "Professor," to which they had already been entitled in Weimar, was formally conferred upon the "old" masters. The junior masters were to be granted the title of Professor at a later date, but that never took place.

a
The faculty of the Dessau Bauhaus. 1926.
In the photograph, taken on the roof of the studio building of the Bauhaus, are, from left to right: Josef Albers, Hinnerk Scheper, Georg Muche, Laszlo Moholy-Nagy, Herbert Bayer, Joost Schmidt, Walter Gropius, Marcel Breuer, Wassily Kandinsky, Paul Klee, Lyonel Feininger, Gunta Stölzl, and Oskar Schlemmer.

Works of the "Old" Masters

The "old" masters—those who had been Masters in Weimar—differed from the "junior masters," with the exception of Gropius, in that they were primarily painters. The "junior masters," too, did painting and drawing to some extent, but their development and importance in the domain of art was only partly reflected in free art works. Feininger, Kandinsky, Klee, Moholy-Nagy, Muche, and Schlemmer, on the other hand, articulated with autonomous artistic means what was essential to their development. But in spite of this, painting during those years was merely a phenomenon on the fringes of Bauhaus activity.

b
Oskar Schlemmer: "Something Roman." Oil on canvas. 1925.
Art Museum, Basel.

c
Wassily Kandinsky: "Three Sounds." Oil on canvas. 1926.
Solomon Guggenheim Museum, New York.

d
Georg Muche: "Strange Fish." Oil on canvas. 1928.
Private collection Lindau-Schachen (Lake Constance).

e
Paul Klee: "View of a Mountain Sanctuary." Pencil, pen and ink, and watercolor. 1926.
Bienert Collection, Munich.

f
Laszlo Moholy-Nagy: "A m 4." Oil on canvas. 1926.
Hessisches Landesmuseum (State Museum of Hesse), Darmstadt.

g
Lyonel Feininger: "Market Church in Halle on the Saale." Oil on canvas. 1929.
Städtische Kunsthalle (City Art Museum), Mannheim.

b

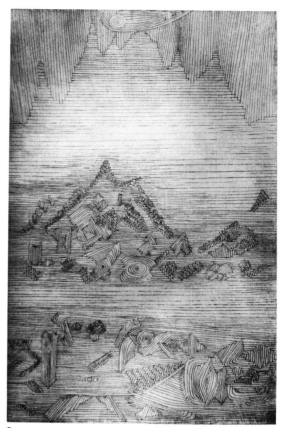

e

c

f

d

g

421

a

b

Josef Albers

Albers was born in Bottrop (Westphalia) on March 19, 1888. He studied at the Royal Art School in Berlin (1913–1915), at the Arts and Crafts School in Essen (1916–1919) and at the Art Academy in Munich (1919–1920). From 1920 to 1923 he continued his studies at the Weimar Bauhaus. Here, in 1923, he was given the technical direction of the glass workshop and a teaching position in the workshop class of the preliminary course. In 1925 the Dessau Bauhaus officially confirmed the "junior master's" position as full member of the teaching staff. In Dessau he continued teaching the preliminary course, and after Moholy-Nagy resigned (1928) he took charge of the entire preliminary course. He also took over Breuer's position as head of the furniture workshop in 1928. Albers remained a member of the Bauhaus until it was permanently closed in Berlin in 1933. His accomplishments are primarily in the area of education, in the methods for elementary instruction which he introduced. But at the Bauhaus he also distinguished himself as a glass painter and as a designer of furniture and lettering, having made distinct and essential contributions. In 1933 he was appointed to teach at Black Mountain College, North Carolina, where he remained until 1949. During that period he also taught summer courses at Harvard. In 1949 and 1950 he was a guest lecturer at the Cincinnati Art Academy, at Yale, at the Pratt Institute, and in the summer school at Harvard. In 1950 he was appointed professor at Yale University and made chairman of the department of design. He has given guest lectures in Mexico, Cuba, Chile, Peru, Hawaii, and Ulm (Institute of Design). Next to Gropius, Albers contributed most decisively to the dissemination of Bauhaus educational ideas. He lives in New Haven, and is primarily active with painting and systematic color investigations.

a
Josef Albers: "Wall-hung glass painting 28/8." Flashed glass. 1928.
Kunsthaus, Zurich.

b
Josef Albers, portrait photograph from the Dessau Bauhaus period.

c

d

Herbert Bayer

Bayer was born in Haag (Upper Austria) on April 5, 1900. He went to school in Linz and after serving in the Army in 1919 studied in an arts and crafts studio in Linz. In 1920 he went to work for the architect and designer Margold at the Darmstadt artists' colony. Beginning in 1921 he studied at the Weimar Bauhaus where he was trained chiefly in the wall-painting workshop, but he also worked on problems of typographical design at the same time. After traveling in Italy in 1923–1924 and painting in Berchtesgaden, he accepted an appointment to the staff of the Bauhaus in 1925, taking charge of the printing workshop. His field of responsibility was typography and advertising techniques. He has decisively influenced and developed both areas. From 1928 to 1938 Bayer worked in Berlin as commercial artist, typographer, painter, photographer, and display designer; he was director of the advertising agency "Dorland" during those years and art director of the journal "Vogue." In 1938 Bayer emigrated to America, where he lived in New York until 1946. He played a vital part in arranging the big Bauhaus exhibition at the Museum of Modern Art (1938) and in developing exhibition techniques and commercial art in America in general. One of the large department stores (Wanamaker's) and one of the most important advertising agencies (Thompson) employed him as art consultant. "Dorland International" appointed him director of art and design. He moved to Aspen, Colorado, in 1946, where he now resides. Here too, he was a consultant to leading firms on problems of form design, particularly to the Container Corporation of America. He contributed to the artistic decor of the Graduate Center at Harvard and other prominent buildings. In addition, he designed a world atlas (1948–1953) which is unique in its class, and through exhibitions in Europe and America has become known as a painter.

c
Herbert Bayer: "Flat Trees." Water-color. 1928. Kunst-Kabinett Klihm, Munich.

d
Herbert Bayer, photograph from the period around 1927.

423

a

Marcel Breuer

Marcel Breuer was born in Pécs in Hungary on
May 21, 1902. At first he had planned to become
a sculptor. Beginning in 1920 he studied at the
Bauhaus, training mainly in the cabinetmaking
workshop. As early as 1921 he attracted atten-
tion with his completely unconventional design
for chairs and tables (in part influenced by Riet-
veld). In 1923 he made important contributions
to the furniture of the "experimental house."
On the side he worked on graphic art and archi-
tectural projects (model of a high-rise apartment
building, 1924). The Bauhaus Dessau put him in
charge of the cabinetmaking workshop (furni-
ture workshop) in 1925. At that time he con-
structed the first tubular steel chair. He became
one of the most important furniture designers
and, being an autodidact, one of the leading
architects of his generation. In 1928–1931 he
was in Berlin, repeatedly working for Gropius.
After that he traveled most of the time. Breuer
moved to London in 1935 and to Cambridge,
Massachusetts, in 1937 to accept a professor-
ship at Harvard. From 1937 to 1941 he was a
partner in Gropius's firm. In 1946 he opened his
own architecture firm in New York. In North and
South America and in Europe Breuer has built
numerous residential, apartment, office, church,
and cultural buildings; among them, the central
office building for UNESCO in Paris (in collabo-
ration with Nervi and Zehrfuss). He now lives in
New York and New Canaan, Connecticut. In ad-
dition to his New York office, Breuer maintains
a second one in Paris, which deals specifically
with European commissions.

a
Breuer photograph from the Dessau Bauhaus period.
b
"Every day we are getting better and better." A series
of photographs published by the Bauhaus Journal in
1926 (number 1), showing Breuer's chairs of 1921
(first and second from the top), 1924 (third and fourth)
and 1925 (fifth). "In the end we will sit on resilient air
columns," reads the caption for the last illustration,
proclaiming the editor's prophecy with typical opti-
mism in progress.
c
Marcel Breuer: small home, type "Bambos 1." De-
signed in 1927. Steel skeleton structure filled in with
wall units assembled in a dry technique. There are two
main rooms (which can be subdivided) for living and
working.
d
Marcel Breuer: small home, type "Bambos 2." De-
signed 1927.
The second type was the same in size (756 square feet)
and technical execution as the first "Bambos 1." While
in the first type the living room is on the same level as
the garden, in the second it is the work room. Breuer
also planned "Bambos 3" with only one main room
and sleeping berths.

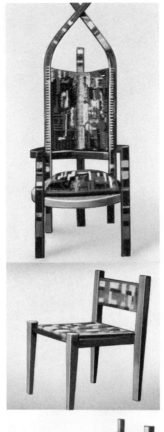

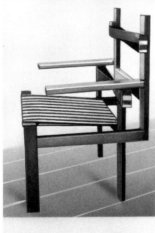

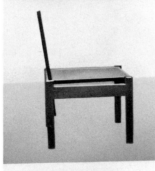

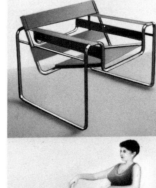

b

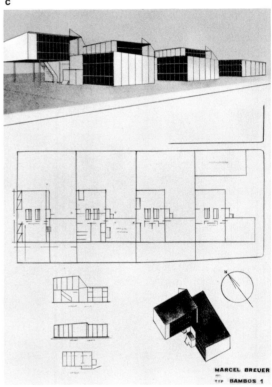

c

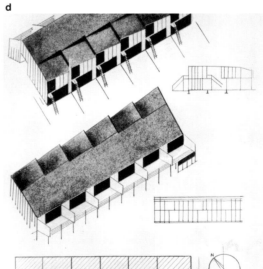

d

424

Hinnerk Scheper

Hinnerk Scheper was born in Badbergen near
Osnabrück on September 6, 1897. After com-
pleting his training as an apprentice in wall
painting and studying in Düsseldorf (Arts and
Crafts School and Academy) and Bremen (Arts
and Crafts School), he enrolled as a student at
the Bauhaus in 1919. Here, too, he chose the
field of wall painting. In 1922 he received his
master's certificate. Until 1925 he did free-lance
art work, being concerned primarily with the
function of color in architecture—the integra-
tion of planes of color with architecture and thus
its intensification. He was appointed head of the
department for wall painting in the Dessau Bau-
haus in 1925. He remained in this position until
1933, when the institute was dissolved in Berlin,
with the exception of a sabbatical leave from
1928 to 1931 during which time he was in Mos-
cow (as consulting specialist for the applica-
tion of color to architecture). The way in which
Scheper treated walls with color pointed to a
new direction. After returning from Moscow, he
exerted significant influence on the design of
the Bauhaus wallpaper. From 1933 to 1945 he
managed to live by means of free-lance work
(partly working on preserving historical monu-
ments). In 1945 he was entrusted with the re-
sponsibilities of conservator in Berlin and con-
sultant on color in architecture; he taught at the
Technical University. From 1953 until his death
there on February 5, 1957 he was state conserva-
tor for West Berlin.

e
Hinnerk Scheper, portrait photograph taken around
1928.

f, g
Hinnerk Scheper: two designs for the application of
color to walls. 1927.

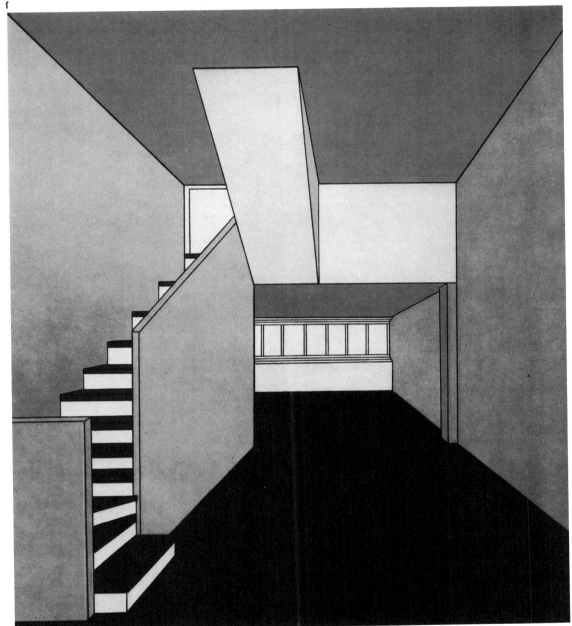

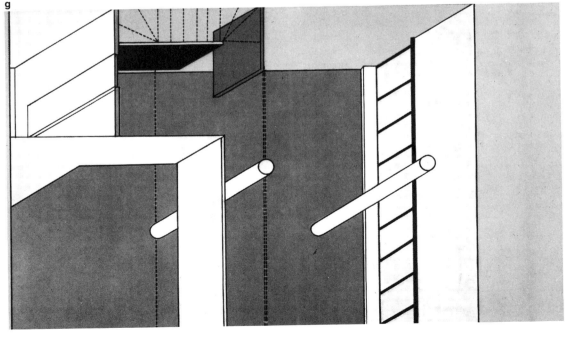

Joost Schmidt

Joost Schmidt was born in Wunstorf in Lower Saxony on January 5, 1893. He grew up in Hamlin. Beginning in 1910 he studied painting on a scholarship at the Weimar-Academy of Art. In 1914 he became a master student and received a diploma in painting. During the First World War he served in the infantry. Wounded toward the end of the war, he was captured and placed in an American prisoner-of-war camp, from which he returned to Weimar in 1919. At the Bauhaus he completed his apprenticeship in sculpture and received his journeyman's certificate. He also worked in the printing workshop. He distinguished himself with mature (typo-)graphical work. For the exhibition in 1923 he executed four wall reliefs for the vestibule of the main building. "Schmidtchen" was loved by everyone at the Bauhaus for his human qualities and was esteemed for his outstanding pedagogical talent. In the fall of 1925 he was appointed head of the sculpture ("plastic") workshop at the Dessau Bauhaus. After Bayer left in 1928, he also took charge of the printing shop (typography and commercial art). Previously he had held classes in lettering. With his brilliant exhibition technique he created one of the most characteristic achievements. After the Dessau Bauhaus had been closed, he worked for a time for the architect Hugo Häring and at the Reimann School in Berlin. When he had been prohibited from working by the National Socialist regime, he earned his livelihood by accepting odd jobs. Nevertheless he devoted himself to painstaking investigations of color and to writing (in 1938 to 1944) a "History of Perspective" (not completed). In 1944 he was called up to serve in the Army once more. From Thuringia he returned to Berlin in 1945, where the Academy of Art appointed him Professor. He led a preliminary course for architects and, at the same time, was the leading graphic artist at the American Exhibition Center. Joost Schmidt died in Nuremberg on December 2, 1948.

a
Joost Schmidt, photograph taken around 1930.
b, c
Joost Schmidt: "Paraboloid Sculpture." Wood, glass, and string. 1928.

d

e

Hannes Meyer

Hannes Meyer, unlike the "junior masters," was not trained at the Bauhaus. He first visited it in December 1926 (for the opening of the new building) and, beginning in April 1927, taught in the architecture department. Shortly thereafter he became the head of that department. From April 1928 until the summer of 1930 he was Director of the Bauhaus. He was born in Basel on November 18, 1889 and studied at the Basel Trade School (1905–1909) and at the Arts and Crafts School in Berlin (1909–1912). Following that, he spent one year studying in England. In 1916–1919 he collaborated in the design of housing developments in Munich, for Krupp in Essen, and in Lausanne. In 1919 he opened his own architectural firm in Basel. Wittwer joined him in 1926. Meyer's work was characterized by his receptivity for social problems and his propensity for cooperatives. Most of his building projects were carried out in connection with the cooperative organizations movement. His most important projects, however, were the entries for competitions to design the Peters School building in Basel and the general secretariat building for the League of Nations in Geneva (1926, together with Wittwer). Suspended from the Bauhaus in 1930, he accepted an appointment to teach at the School of Architecture in Moscow. He kept his professor's chair there until 1926, and was a consultant at the "National Institute for City Planning" as well as a member of several committees and institutes for architecture and city planning. From 1936 to 1939 he worked primarily on problems of city planning in Geneva. He accepted the post of director at the *Instituto del Urbanismo y Planificación* in Mexico. While in Mexico, particularly from 1942 until he returned to Switzerland in 1949, he served as a city planner in the Department of Labor and on government committees. In 1949 he moved to Crocifisso di Savosa-Lugano (Tessin) where he died on July 19, 1954.

d
Hannes Meyer, photograph taken about 1928.

Hans Wittwer

When Wittwer joined the Bauhaus together with Hannes Meyer in 1927, he was first of all an assistant in the architecture department. He was raised to full-time teacher and chief designer in 1928. He delivered architectural lectures on acoustics, problems of lighting and heating, and installation. He participated in all matters of building, largely in a leading role. Wittwer was born in Basel in 1894. He received his degree in architecture at the "Eidgenössische Technische Hochschule" (Swiss Institute of Technology) in Zurich in 1916. He was self-employed in 1925 and joined Meyer as partner in 1926. This partnership was ended in 1929 when Wittwer was appointed to the art school in Burg Giebichenstein. Among his original architectural accomplishments is the enlargement of the airport in Halle. In 1934 Wittwer returned to Basel where he died after a prolonged illness in 1952.

e
Hans Wittwer, photograph taken about 1928.

f
Hannes Meyer and Hans Wittwer: entry for the design competition for the general secretariat building of the League of Nations in Geneva. 1926.
Not carried out.

f

Gunta Stölzl

Gunta Stölzl was born in Munich on March 5, 1897. After matriculating she studied from 1914 to 1919 at the Munich Arts and Crafts School and served in the Red Cross. Beginning in the fall of 1919 she transferred her studies to the Bauhaus and took supplementary courses in Krefeld (Technical School for Dyeing and Textiles). She took her journeyman's examination in the weaving workshop and in 1924 set up a hand-loom weaving shop in Zurich-Herrliberg. After that she returned to the Bauhaus. In Dessau she was at first responsible for the technical supervision of the weaving workshop and then succeeded Muche in charge of the entire workshop from 1927 to 1931. Since 1931 she has had her own workshop in Zurich. Gunta Stölzl (married name from 1929 on Sharon, from 1942 on Stadler) exerted considerable influence on the development of both hand-loom and industrial weaving.

a
Gunta Stölzl, photograph taken about 1927.
b
Gunta Stölzl: tapestry. Jacquard fabric. 1928–1929. The whereabouts of the finished tapestry is unknown. Water-color sketch in the possession of the Bauhaus-Archiv, Darmstadt.

a

b

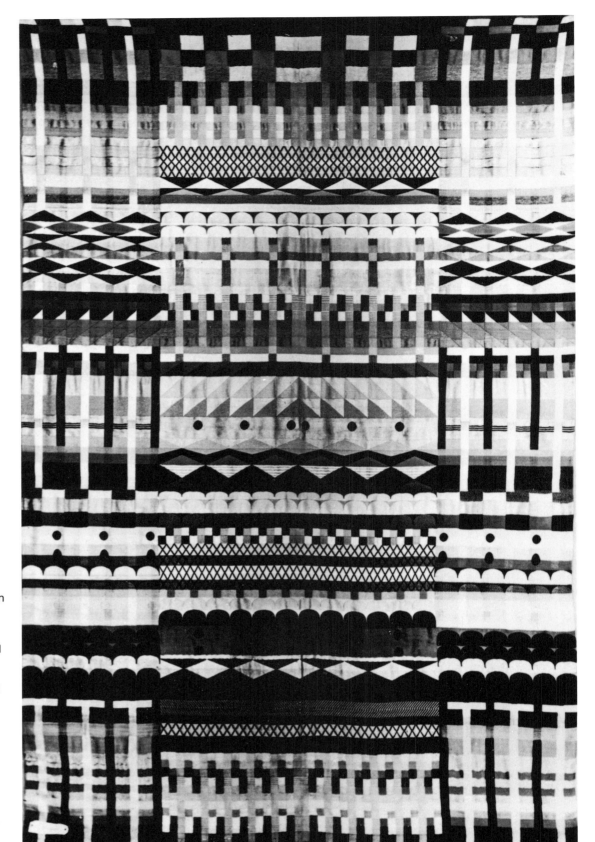

c

d

Engineer, Business Manager

c
Dr. Friedrich Köhn (photograph from around 1928) taught engineering at the Bauhaus from 1927 to 1928. The subjects taught by engineers (who were usually part-time teachers and were often changed) were mathematics, strength of materials, and science of building materials. In later years Dr. Köhn lived in Nienburg (Lower Saxony). He died in 1962.

d
Margarete Sachsenberg (photograph taken around 1930) was born in Dessau in 1898 and was the business manager of the Bauhaus from 1926 until 1932. She served at the same time as general secretary of the Bauhaus Corporation. In 1932 and 1933 she organized the transfer of the Bauhaus to Berlin and set up the administration. She now lives in Gottlieben on Lake Constance (Switzerland).

Preliminary Course

During the years between 1925 to 1928 the preliminary course for the first semester was headed by Josef Albers and for the second semester by Laszlo Moholy-Nagy. After the latter left in the spring of 1928, Albers was put in charge of the entire preliminary course. He kept that position until the Bauhaus was closed in Berlin. The courses which both teachers conducted in Dessau were a direct continuation of what had been developed in Weimar. Moholy-Nagy was primarily concerned with making students aware of three-dimensional, sculptural relationships and tensions. The ultimate aim was to educate the student to be capable of architectural and visual experience. In order to develop this capacity, construction exercises were done with wood, sheet metal, wire, string, and other materials, which demonstrated, for example, problems of balance, optical weight, and three-dimensional expansion. In "From Material to Architecture" ("Von Material zu Architektur," volume 14 of the Bauhaus Books) Moholy-Nagy states: "Today spatial design is an interweaving of spatial shapes, shapes that are ordered into certain well-defined, although invisible, space relationships and which represent the fluctuating play of tensions and forces. . . . Space arrangement is not a mere question of building materials. Hence, a modern space composition is not a mere combination of building stones, not the putting together of differently shaped blocks and specifically not the building of rows of blocks of the same size or of different sizes. Building materials are only a means, to be used as far as possible in expressing the artistic relations of created and divided space. The primary means for the arrangement of space is still space itself and the laws of space condition all esthetic creation in architecture."

Albers's course investigated the subject of the material itself, the experience and understanding of the characteristics of materials and their variability.

In Albers's preliminary course students worked chiefly with scissors and paper. By cutting and folding—whereby greatest possible economy in method of construction and use of material were indispensable prerequisites—unthought-of structural and visual possibilities were tested. The student learned that alterations of shape can, despite unvarying material composition, result in a changing of the qualities and the reaction of materials. Also, phenomena of optical illusion were studied and represented. The appearance of the surface, the epidermis, of materials was investigated, both as to its optical and tactile qualities, and was classified according to structure, facture and texture. In this way, experiencing with the senses supplemented systematic knowledge and training to use material economically.

In all of his material studies, it was Albers's concern to articulate the material employed for each task. Economy of means and work processes and limitation to a single material whenever possible serve to emphasize the specific qualities of the material. For better visualization examples of three-dimensional paper exercises are illustrated in the preceding pages. A group of studies with other materials is included in the section covering the years 1928–30 (era Hannes Meyer). The exact chronological sequence cannot be established with accuracy.

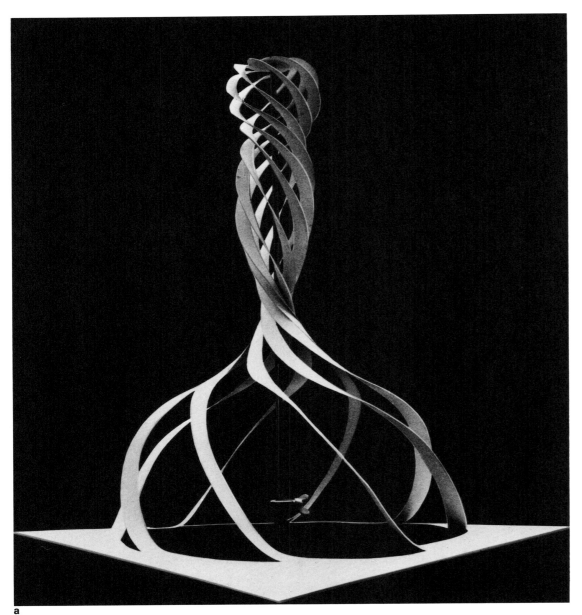

a
Student in Albers's preliminary course: study in the three-dimensional use of paper, cut without waste from one piece of paper. 1927.
The twisting effect results from stretching or compressing.
b
Student in Albers's preliminary course: studies in the three-dimensional use of paper. About 1927.
Different paper foldings. Multiplicity of possibilities for different designs with, and despite, economical utilization of the given material.

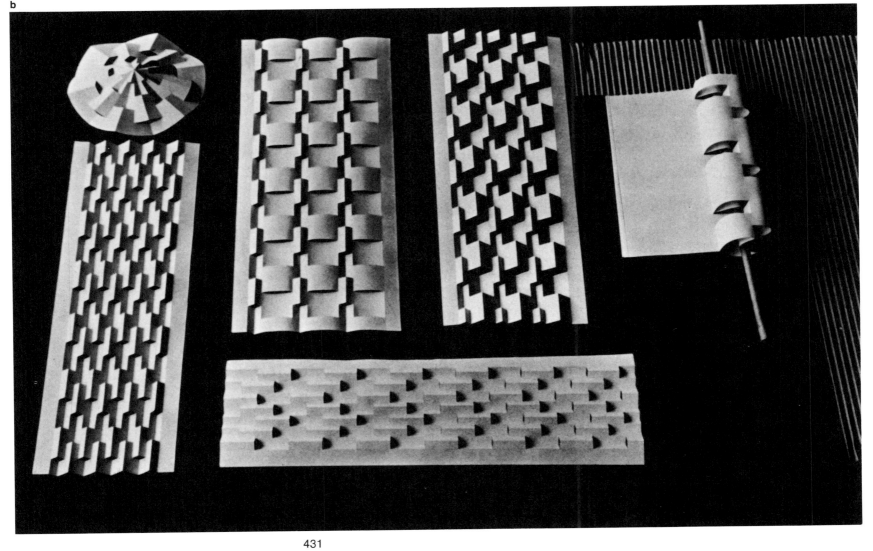

431

a
Students in Albers's preliminary course (Werner Zimmermann and others): material study of wall board. 1927–28. Folds. Rigidity and construction exercises.

b
Students in Albers's preliminary course: paper exercises. 1927–28. Construction of three-dimensional structures from single pieces of paper, resp. cardboard, by means of cuts without waste. Folding serves the purpose of achieving rigidity, so that the structures can stand by themselves. Left: folds in recurring right angles. Right: curved shapes, collar-like rings (which however have no structural function).

c
Student in Albers's preliminary course: paper exercises. 1927–28. Cuts and folds. Subdivision of the paper into triangles and circles. Because of the folds, the paper shrinks until, for example, the upper of the two round structures is changed from a circle into an ellipse.

d
Students in Albers's preliminary course: material exercises in paper. 1927.
Rigidity and construction studies without waste.
Walter Tralau: upright sheet of paper, three-dimensionally folded, protruding in both directions. (Left.)
Arieh Sharon: paper foldouts (standing semicircles at right angles to one another). Mutual support by means of alternating locking devices. (Center.)
Arieh Sharon: variations of the other foldouts. Paper semicircles in geometrically progressing ratios of magnitude, attached to one another by contacts in a 45° angle. Effect: "active negative form and active repose." (Right.)

e
Student in Albers's preliminary course: corrugated-paper exercise. 1927–28. Demonstration of the various light effects of the three-dimensional surface, which is generated through composition of corrugated-paper pieces. Light and shadow effects depending on the direction of the ribs.

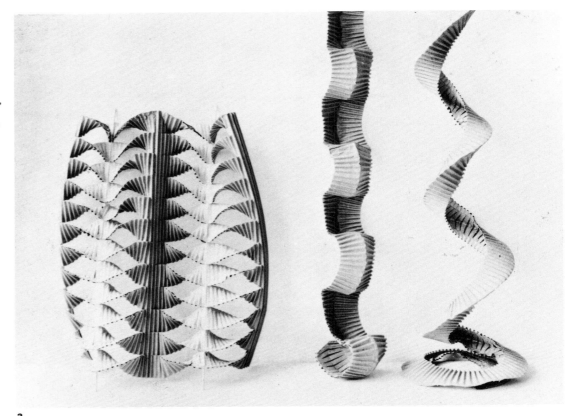

a

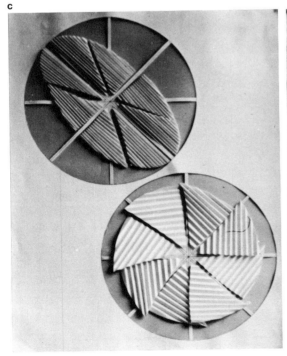

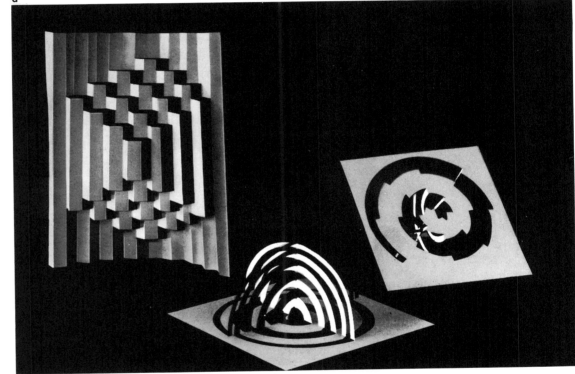

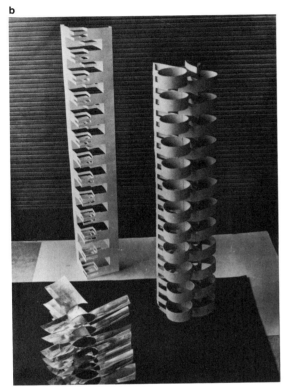

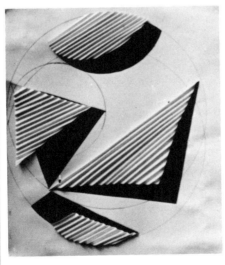

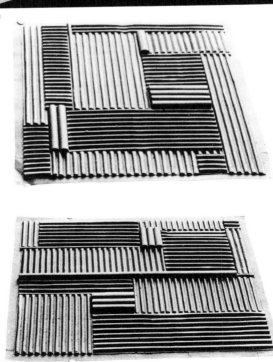

a

a
Student in Albers's preliminary course: paper study. 1927–28. The shape results automatically; it is the result of back-and-forth folds in concentric circles. One special feature of this form is its mobility. The development of the curve form is of special pedagogic value, because it provides the student with unexpected revelations concerning the material and the construction principles.

b
Students in Albers's preliminary course: paper study. 1927–28. Foliate construction: a circular piece of paper was folded like a fan, from two opposite points of departure. This resulted in a shrinkage which altered the periphery (form) of the sheet.—Square sheet: here too the paper was folded fanlike from two opposite sides. The folds cross each other and result in a "snake" effect—one edge curves up, the other down.
Wing form: automatic result of folding concentric squares.

c
Students in Albers's preliminary course: paper study. 1927–28. The dome-shaped structure evolves from a flat sheet of paper by means of cuts which make extension into a dome shape possible.

d
Students in Albers's preliminary course: paper studies. 1927–28. Both exercises took advantages of a given material quality: the paper was rolled and tended to remain rolled. The columnar form (left) resulted from cuts. The conic forms (right) derive automatically from cutting two concentric circles out of rolled paper.

e
Students in Albers's preliminary course: studies with paper and acetate. 1927–28. Various zigzag folds—fundamental exercises. Two-dimensional shrinkage is one result of such folds in the case of flat structures. Two of these structures are made of paper; the transparent one in center foreground is made of acetate. Iridescent colors in the corners of the acetate structure indicate areas of especially high tension. The camera bellows (upper right) is the result of zigzag folds in a single direction. The corners were so rounded off that only a single overlap resulted; bevels were not permitted because otherwise the specific qualities of a camera bellows, light and air impermeability, would not be achieved. The task of constructing a camera bellows was assigned by Albers to every student; the student had to solve it entirely independently. No technical explanations were given.

f
Student in Albers's course: investigation of optical illusions. About 1927.
Systematic arrangements of identical circles. The repetition and superposition of two-dimensional elements (circles) evokes the illusion of three-dimensional structures (such as of wire coils or tubing). Moments of direction and motion are suggested.

Analytical Drawing (Kandinsky)

Kandinsky taught classes in analytical drawing within the framework of the first-semester preliminary course. The still-life compositions were arranged by the students themselves. They favored subjects that could be easily reduced to geometrical forms, such as a table, a chair and a ladder, baskets, containers and similar objects. The first problems were to subordinate the entire composition to one simple, major form, to be drawn like an outline with greatest precision. The characteristic shapes were to be extracted and at the same time shown in context with the whole. The composition was to be represented in a minimum essential scheme. In the second phase of the analysis the tensions perceived in the composition of the still-life were to be expressed as linear forms. The principal tensions were accentuated by broader lines or (during later development stages) by color. The constructional net was indicated by dotted lines, and the starting or focal point was marked. The problem for the third phase of the analysis was to confine the rendering of the composition of the objects, now regarded solely as (energy) tension phenomena, to arrangements of lines. Different possibilities of the composition were shown: the evident and the hidden construction. The student had to try to capture the whole composition and the individual tensions as concisely, accurately, and reduced to essentials as possible. In part these exercises were differentiated further. For instance, the optical weight relationships, the positions of the centers of importance and the centers of the composition and the character of the shapes were investigated. The intellectual origins of analytical drawing are in the theoretical foundations of Kandinsky's own work.

a
Student of the course "Analytical Drawing": still-life composition with table, chair, ladder, tablecloth, wastepaper basket, and bread basket. Set up in a class in 1929 to serve as model. Still lifes such as this were put together every first semester of Kandinsky's course.

The four illustrations reproduced on the adjoining page show abstractions of the still-life composition. From Kandinsky's course in "Analytical Drawing." Hanns Beckmann: studies from the phases of analysis.
b
Hanns Beckmann: study from the first phase of the analysis—definition of the characteristic forms of the still life and their relation to the whole.
c
Hanns Beckmann: study from the second phase of the analysis—rendering of the tension components. Accentuation of the principal tensions by broader lines.
d
Hanns Beckmann: study from the second phase of the analysis—rendering of the construction by dotted lines and determination of the focus of the composition.
e
Hanns Beckmann: study from the third phase of the analysis—making evident the composition of the still life with regard to energy relationships. The objects in the composition are reduced to essential, linear forms.

a

b

c

d

e

437

a

Sculpture ('Plastic') Workshop

The "plastic workshop," as it was officially called, was established in the fall of 1925 and was headed by Joost Schmidt. The objective of this workshop was not—as it had been in Weimar—to foster the making of autonomous sculpture or sculpture in connection with architecture, but rather the elementary study of three-dimensional, sculptural relationships, of concave and convex shapes and the possibilities of their interpenetration. Also, the apparent change of shape of (static) configurations in motion and the evolution of imaginary forms created by motion were examined. By its nature and Schmidt's intention his course supplemented the preliminary course in a different area; he trained and refined visual thinking, emphasized extreme conscientiousness in the process and imparted to the young designers and architects fundamental conceptions of form, which they were also able to apply to the field of technology.

Although Joost Schmidt rejected autonomous "art work" as a task for the sculpture workshop (this was true as well for architectural sculpture, in which he no longer saw a genuine problem), his courses were capable of developing in the student a subtle sensitivity for the composition of sculptural elements and for sculptural qualities in general, from which the desire for creative conceptualization resulted quite naturally.

Most of the student exercises were already "art" even if this was not what they were after. Schmidt's extraordinary pedagogical talent rested in his impeccably systematic approach and in his ability to understand his students, never making them feel constricted but rather stimulating them and letting them develop their own powers. In his own sculptural work Schmidt acknowledged the significance of organic, figural subjects, the representation of the nude human body, in addition to abstraction.

a
Franz Ehrlich (sculpture workshop): study of interpenetration. Separate forms (hollow cylinder, sphere, and rod) and one possibility of combining them. Plaster. 1928.

b
Franz Ehrlich (sculpture workshop): interpenetration of forms, hollow cylinder, sphere, and rod. Plaster. 1928.

c
Student in the sculpture workshop: rendering of sculptural elements by rotating simple objects (wooden disk, iron rod, wire ring). 1928. Bottom row: a hyperboloid and a sphere are the result of rotating a straight line (rod) and a circle (ring).
Top row: a cylinder is transformed into a hyperboloid by rotating and slanting a straight line (rod).

d
Student of the sculpture workshop: hollow cylinder, double cone, cube, sphere, and plate, in a free compositional relationship. Plaster. 1928.

e
Student of the sculpture workshop.
Variation of the composition shown in Fig. d.

c

b

In 1928 Heinrich Neugeboren (who later in Paris called himself Henri Nouveau) designed on his own initiative the sculptural rendering of a fugue by Johann Sebastian Bach. He was evidently inspired by the synesthetic ideas, which had been discussed particularly in the group of the "Blaue Reiter" by Kandinsky and others. Such considerations played a part in the visual thinking of the Bauhaus, yet nowhere did they reveal themselves as strikingly as in Neugeboren. Neugeboren commented on his design (Bauhaus Journal 1929, number 1): "The . . . illustrations show parts of a graphically (two-dimensionally) represented fugue by Bach as well as the possibility of a three-dimensional representation (design for a Bach monument). Neither case is concerned with an emotionally personal reinterpretation, but rather with a scientifically exact transformation into another system. The representation in two dimensions came about from the desire not only to hear the progression of music in time and space, but also to see, and to see more clearly than ordinary written music allows. . . . The various clefs only obstruct the meaning for the unbiased eye, just as both empty and filled notes' heads merely signify the length of the notes, without showing them . . . Desiring to counter such deficiencies, the enumeration of which, incidentally, would open the difficult and rather unpromising question of an entirely new and better method of notation, there resulted the graphic representation of a fugue from the "Well-tempered Clavier," drawn on graph paper. . . . The principal purpose of the graphical presentation is instructional, demonstrating the construction of Bach's works independently of fictions. Without clef, without any ligature . . . the progression of each voice as a coherently ascending and descending color line is visible as a broad paper strip . . . To supplement the planimetric representation, a three-dimensional one was developed, whereby the apparent rise or fall of the voices was enlarged into an actual one." In three zones, one behind the other, there is three-dimensionally represented: (1) horizontally, the constructional progression, (2) vertically, the distance in pitch of each tone from the keynote, the tonic, and (3) from front to rear—rising along the base as well as along a 45-degree line—the distance of the voices from each other. "This kind of rendering," explains Neugeboren, "so far represents an experiment. It has a disadvantage as it stands: the high number of vibrations of the soprano tones are represented by an appropriate spatial altitude in the corresponding plane. This high range in its towering monumentality smothers the bass." The model embodies four stereometrically represented measures of Bach's e-flat minor fugue. "These measures show the climax of the fugue, which, particularly in the model, appears so architectonic and monumental that one may well ask whether such a representation would not be a worthier kind of Bach monument . . . Thus, a monument could be erected to the greatest German creator which, like a pyramid, would not only be monumental but have a deeper meaning as well. . . ."

a
Heinrich Neugeboren: graphic (planimetric) representation of a fugue from the "Well-tempered Clavier" by Johann Sebastian Bach. Contralto and bass are recorded in black lines, soprano and tenor in red. Drawn on graph paper. 1928.
Bauhaus-Archiv, Darmstadt.
b
Heinrich Neugeboren: stereometric representation of four measures (Nos. 52–55) of the E-flat minor fugue by Johann Sebastian Bach. Proposal for a Bach monument. 1928.
c
Replica made of wood and cardboard after the original produced by Gerda Marx.
Bauhaus-Archiv, Darmstadt.

c

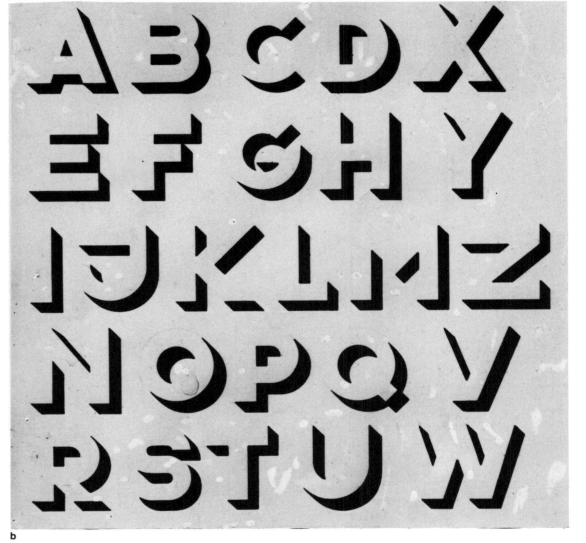

dem **bauhaus in dessau**
ist eine **bühnenabteilung** angegliedert
leitung **oskar schlemmer**
sie übernimmt das **bühnenbild** für moderne inscenierungen
die raumgestaltung für **feste und bälle**
die anfertigung von **kostümen**
masken
sowie **entwürfen**
anfragen erbeten an das sekretariat des bauhauses in dessau abteilung bühne

a

b

Printing Workshop
(Typography and Commercial Art)

In Herbert Bayer's terms, the printing workshop of the Dessau Bauhaus was set up for work in "typography and advertising art." Bayer was in charge of that workshop from the spring of 1925 until June 1928. Design development was the task in hand; printing was produced there in modest volume only, in such work such as letterheads and prospectuses. Printing of graphic art was not planned. Bayer had already examined problems of typographical design during his studies at the Weimar Bauhaus. He consolidated the ideas which at that time originated with the Dadaists, Theo von Doesburg, and Moholy-Nagy, with an unmistakable sense for the specific characteristics of printing techniques. Layout and type area relieved of the picturesque quality which the rather ample use of typographical symbols (in Moholy-Nagy's designs it was the emphasis placed by the use of bold lines) had put into them. The sans-serif type, preferred by Bayer, became a characteristic feature of the Bauhaus and its publications, in the sense of intellectual approach and program. Bayer was fond of accentuating his copy with a second color. For instance, in a letterhead he would underline the word to be emphasized with red. He developed his own type face in his "Universal Type" and his "contourless shadow script." Bayer was most influential in the design of book jackets and prospectuses, which lent themselves to combining picture and typographical elements. He transposed principles of surrealistic composition into (commercial) graphics with extraordinary impact. How much these experiments were recognized became evident when the "Association of German Advertising Specialists" decided to convene part of their "Instruction Weeks in Advertising Art" in Dessau, in October 1927, in association with the Bauhaus. Distinguished typography designers during those years, next to Bayer, were Moholy-Nagy, Albers, and Joost Schmidt. Moholy-Nagy presented to the public the "Bauhaus Books" which had been designed by him (all except two volumes); their layout had already been prepared in Weimar. Josef Albers developed a stencil script, conceived especially for advertising purposes. Joost Schmidt proved to be exceedingly imaginative in this field of design. He gave a course in lettering under Bayer, which became a compulsory part of the general education program until the dissolution of the Dessau Bauhaus. In 1928, Schmidt succeeded Bayer in the printing workshop and further developed its work in advertising and exhibition techniques. Among the characteristics of Bayer's layout during the Dessau period belong the slogan-like accentuations of parts of the text by printing type over a tinted base, the inclusion of photographic illustrations (sometimes reproduced in nonrealistic, hence "alienated," colors) and, above all a pointed effort at giving the text a telling arrangement which at the same time put order into the composition and "expression" into the content. The latter explains the occasional artistic use of the trick of turning parts of the text by 90 degrees. This extraordinarily new way of designing in the period around 1925 rapidly became a part of common practice.

a
Herbert Bayer: postal card advertising the Bauhaus stage. Produced in the Bauhaus printing workshop. About 1926. The bold lines at the top and the bottom of the card are printed in red.
the bauhaus in dessau/now includes a stage department/direction oskar schlemmer/it will design stage sets for modern productions/do the interior decoration for parties and balls/make costumes/masks/and designs/address inquiries to the secretary's office at the bauhaus in dessau, stage department.

b
Herbert Bayer: design of a "contourless shadow script." Bayer designed this type especially for use in commercial art, for posters and prospectuses.

c
Herbert Bayer: postal card advertising Bauhaus products. Produced in the Bauhaus printing workshop. About 1925. The disk in the center and the name in the lower line are printed in red.

d
Herbert Bayer: invitation to the opening ceremonies of the Dessau Bauhaus building on December 4 and 5, 1926. Produced in the Bauhaus printing workshop. Accentuation through bold lines in color.

d

c

STÄNDIGER VERKAUF
ALLER ERZEUGNISSE
DES BAUHAUSES IN DESSAU

The printed material designed by Bayer around 1927 shows a tendency toward a more elegant and to a certain extent lighter face of type and layout, and for simplification in general. Whenever Bayer now had a chance to select the type face from among different varieties, he chose the sans-serif, which, especially because of him, became inseparably linked to the Dessau Bauhaus. The dropping of capital letters, which the Bauhaus propagated, was a much debated issue and, in some respects, questionable indeed —despite its esthetic advantages and the opportunities it offered the typographer intent on achieving a pronounced coherence.

a
Herbert Bayer: letterhead of the Director's office of the Dessau Bauhaus. Produced in the Bauhaus printing workshop. 1927.
The name of the Institute is accentuated by printing over red. The letterhead was repeatedly changed by Bayer during the period between 1925 and 1928.

b
Herbert Bayer: advertising leaflet with invitation to subscribe to the Bauhaus Journal. Produced in the Bauhaus printing workshop. 1927–1928.
Printing in black on white over a strong yellow base. Typographically this leaflet represents a summary of the development that took place in the Bauhaus printing workshop under Bayer's direction until 1928.

c
Herbert Bayer: cover design for the Bauhaus Journal 1928, number 1.
The journal was published up to the date of this issue, which was typographically designed and edited by Bayer. This cover is a conspicuous example of the fruitful influence that can result from a typographer's or commercial artist's ties to avant-garde painting, or because he is such a painter himself—as was the case with Bayer.

a

b

444

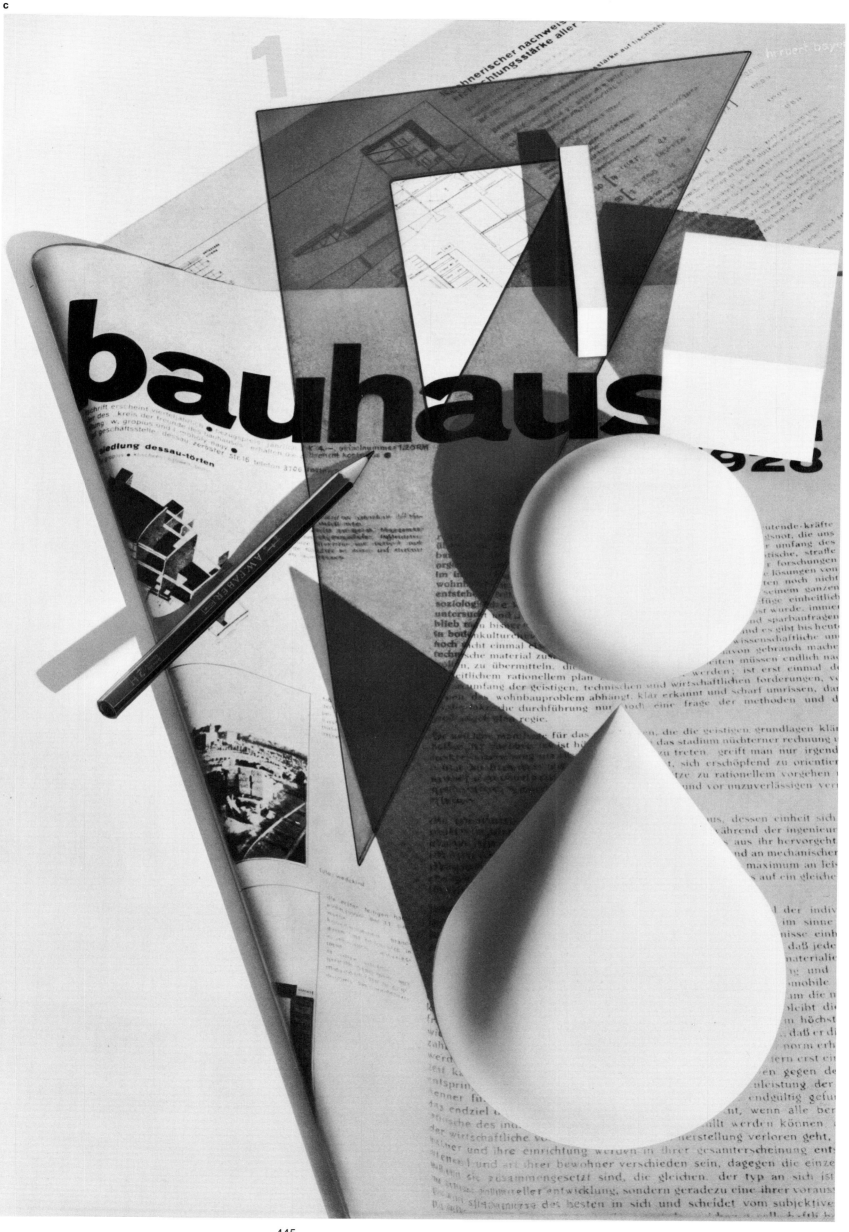

a

The 1925 edition of the first series of the "Bauhaus Books" (volumes 1–8) was followed by the appearance of additional volumes in 1926 (9 and 10), 1927 (11), 1928 (13), 1929 (14), and 1930 (12). The covers of the paperback editions and the identical jackets of the bound editions were designed by Moholy-Nagy, except for one design by Bayer. Color was used in most of the designs, including those of the first series. For instance, the numerals and the front side of the cube in volume 1 are red; in volume 3 the title of the book and in volume 5 the bold twin lines horizontally underlining the title are red. The panels of the dust jacket of volume 6 are red, grey, yellow, and blue. Also blue is the left edge of the cross on the cover of number 7 and the background of the text on volume 9. Red was also used as a design element for the covers of "Bauhaus Books" 8, 11, and 14; yellow was used in number 10 (with charcoal grey), 12, and 13. The clothbound covers were all made according to a uniform principle decided upon by Moholy-Nagy, differing just slightly in arrangement. On yellow cloth the title of the series, the number of the volume, and the horizontal or vertical lines subdividing the face were printed in red. Since 1965 a series of "New Bauhaus Books" is being published by Hans M. Wingler, to continue the old series along the same lines. Especially significant titles are being reissued. Dust jackets and covers are designed by Herbert Bayer.

a
Moholy-Nagy: "14 Bauhaus Books." Cover design for an eight-page prospectus of the Albert Langen Press. 1929.
The numeral in the upper left corner is printed in blue.
The "Bauhaus Books" by Gropius and Moholy-Nagy were published by the Albert Langen Press (Munich). During the years from 1925 to 1931, 14 volumes appeared, some of them in several editions. Originally, however, the series was planned on a much larger scale. The typographical layout for all but two of the books was designed by Moholy-Nagy. For the first eight volumes the designs were already prepared by 1924. The book jackets of the bound edition, identical to the covers of the paperback edition, were designed by different artists.

b–h
Cover designs of the paperback edition or the book jackets of the bound edition of volumes 1 through 7 of the "Bauhaus Books." Designed in 1924, first published by the Albert Langen Press in 1925. The designs of the covers are by:
volume 1 Farkas Molnár
volume 2 Laszlo Moholy-Nagy
volume 3 Adolf Meyer
volume 4 Oskar Schlemmer
volume 5 Laszlo Moholy-Nagy
volume 6 Theo van Doesburg
volume 7 Laszlo Moholy-Nagy

i–l; n–o
Book covers of the paperback edition or jackets of the bound edition of volumes 8 to 11 and 13 and 14 of the "Bauhaus Books." Published by the Albert Langen Press 1925–1930.
Designs by:
volume 8, 10, 11, 13, 14 Moholy-Nagy,
volume 9, Herbert Bayer

m
Cloth-bound cover of volume 12 of the "Bauhaus Books." Designed by Moholy-Nagy, published by Albert Langen Press 1930.
Yellow cloth and red imprint. The book jacket as well as the cover for the paperback edition of this book were also designed by Moholy-Nagy.

b

c

d
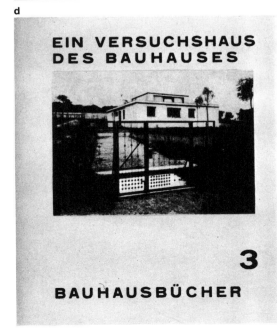

e

f

g

h

i

j

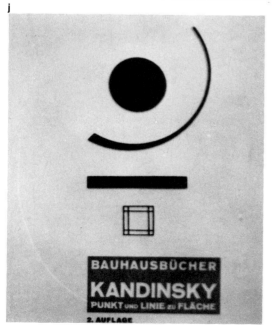

k

l

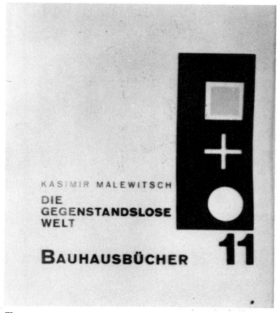

m

n

o

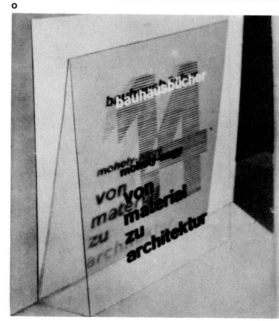

447

In connection with his stencil lettering Albers explained that he had also intended it to be used as large lettering for advertising billboards and posters, which would be legible at a distance. In comparison with most of the customary types of printing, he claimed, his actually improved in legibility at a certain distance. "Like the Egyptienne, in part, and the sans-serif type, it is constructed from basic geometric shapes exclusively, specifically from only three: the square, the triangle as half of the square, and the quarter section of a circle having the same radius as the side of the square. The elements of the letters, made up from these basic shapes, are placed alongside each other without connection; the serifs have been saved because of the proportions and the relationships of movement of the purely flat elements." The individual elements relate to each other in the proportion 1:3. The line is not extended to the width of the block. "The unequal sizes of the spaces between letters are no longer the exception but rather become distributed across the page with greater frequency. They will liven up its appearance as the capital letters in the middle of a word did in the Baroque period. Hence, the grouped style has been abandoned. Vertical alignment of the lines can be done to the left or right at will, or not at all. . . ." When needed, particularly large and rarely used letters can be put together from the individual elements to suit the case at hand. The advantage of standardization of the print, Albers thought, is the economy with respect to form and material, which will do justice to everyday requirements, "to the language of everyday life," better than conventional printing does with its comparatively complicated composition." (Quoted from "Offset, Buch- und Werbekunst," number 7, 1926.) Albers was not alone with his endeavors. To attain a new economy for the arrangement of type was also the guiding idea for Bayer when he designed the "universal type," which was based on calligraphy and had rather the character of handwriting, as well as for Joost Schmidt in his analogous experiments in construction.

a, b
Josef Albers: designs for stencil lettering.
Black and blue ink on graph paper. Published in "Offset, Buch- und Werbekunst," number 7, 1926.
c
Laszlo Moholy-Nagy: advertising poster for automobile tires. Design in tempera and photocollage ("photoplastic"). 1926.
Private collection, Munich.

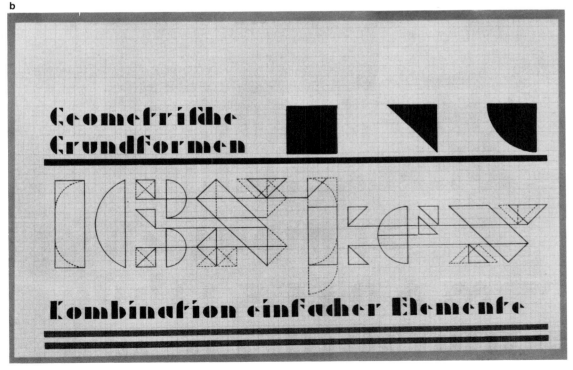

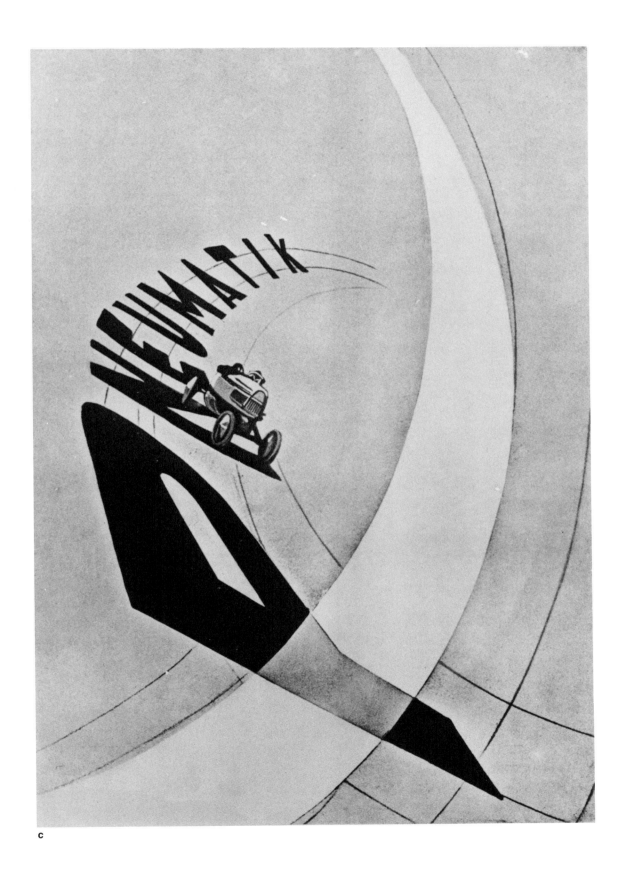

c

Cabinetmaking Workshop
(Furniture Workshop)

The cabinetmaking workshop was headed by
Marcel Breuer from the beginning of the Dessau
Bauhaus until the spring of 1928. After he left
the Institute, Albers took his place. Having done
pioneering work in the functional design of
chairs as a student in Weimar, Breuer con-
structed the first tubular steel chair in Dessau in
1925. This was a private project, which he car-
ried out aided by a locksmith, and consequently
not in the Bauhaus. Nevertheless, this tubular
steel chair was in its conception a true product
of the Bauhaus. It was of the greatest importance
for the further development of the cabinet-
making workshop, for all at once the workshop
was faced with the task of working with an un-
familiar material as well as with the conven-
tional wood, namely metal. Though metal work
within the program of the cabinetmaking work-
shop remained the exception, this new method
of construction called for a fundamental mod-
ification. Now it was more exact to speak of a
"furniture workshop" than of a "cabinetmaking
workshop." In an article published in the maga-
zine "Das neue Frankfurt" in 1927, Breuer wrote
that the furnishings, the interior design, should
be neither a "self-portrait of the architect" nor
a way of living, attempting to impose itself on
the occupant, forcing him, so to speak, into a
predetermined pattern. "And so we have fur-
nishings, rooms and buildings allowing as much
change and as many adaptations and different
combinations as possible. The pieces of furni-
ture and even the very wall of a room have
ceased to be massive and monumental, appar-
ently immovable, and built for eternity. Instead,
they are more opened out, or are placed freely
in space. They hinder neither the movement of
the body nor of the eye. The room is no longer a
closed composition, a narrowly defined box, for
its dimensions and different elements can be
varied in many ways. From that, one may con-
clude that any object properly and functionally
designed should 'fit' into any room as does a
living object, like a flower or a human being."
The projects for development of furniture were
concerned principally with problems of stan-
dardization, the design of unit furniture and
folding chairs and generally with functional and
constructional improvements. The most impor-
tant commissions were the furnishing of the
Bauhaus building, the Masters' houses in Des-
sau, and Piscator's home in Berlin.

a

a
The cabinetmaking workshop of the Dessau Bauhaus.
About 1927.
b
Marcel Breuer: tubular steel chair. Nickel-plated steel
tubing, seat, back and armrests made of fabric (iron
yarn). Designed in 1925.
Specimen in the Bauhaus-Archiv. Darmstadt.
This is the very first steel chair. Since 1926 it has been
manufactured and sold by a Berlin concern ("Stan-
dard-Möbel").
c
Marcel Breuer: standardized unit furniture. Design.
1925.
space divisions appr. 13 inches; vorderansicht = front
elevation

masseinheit 33 cm

c vorderansicht

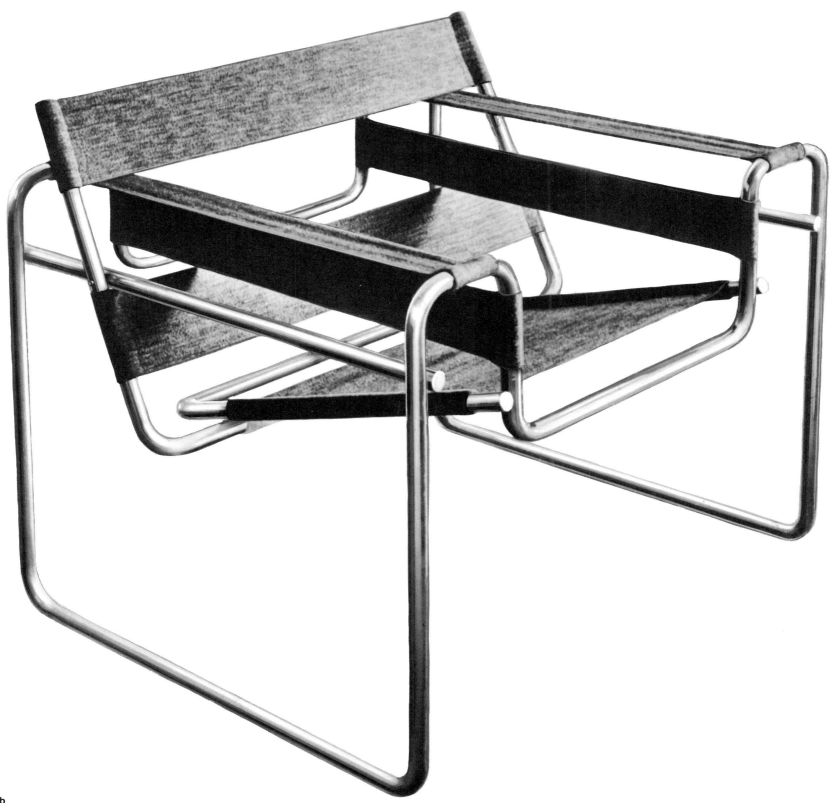

b

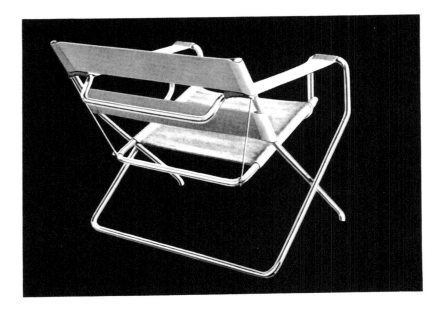

BREUER-METALLMÖBEL

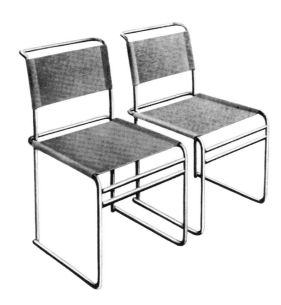

PRODUKTION UND VERTRIEB:

STANDARD-MÖBEL
LENGYEL & CO.
BERLIN W 62
Tel. Nollendorf 4009 BURGGRAFENSTRASSE 5

a

HOCKER, STUHLE, DREHSTUHLE, KLUBSESSEL
THEATERSESSEL, KLAPPSTUHLE, TISCHE USW

die stoffbespannten stahlrohrmöbel haben die **bequemlichkeit** von guten polstermöbeln, ohne deren gewicht preis, unhandlichkeit und unhygienische beschaffenheit. je ein **typ** wurde für die notwendigen anwendungsarten ausgearbeitet und soweit verbessert, bis eine variation nicht mehr möglich war. hier ist zum ersten mal präzisionsstahlrohr zur konstruktion von sitzmöbeln verwendet worden. das stahlrohr ist in geringen querschnittdimensionen widerstandsfähiger als irgend ein anderes material, welches bisher für sitzmöbel angewandt wurde. es ergibt besondere **leichtigkeit** und auch eine besonders leichte erscheinung. sämtliche typen sind zerlegbar. die teile sind auswechselbar. beim transport spielt die leichtigkeit eine große rolle ein stahlklubsessel z. b. wiegt ca. 6 kg (ein viertel bis ein sechstel eines gepolsterten klubsessels). in teile zerlegt lassen sich ca. 54 klubsessel oder ca. 100 ruckenlehnstuhle in 1 cbm verpacken. der **preis** eines klubsessels z. b. beträgt ca. 30 prozent von dem eines gepolsterten sessels, der eines theatersessels oder eines ruckenlehnstuhles, beide mit stoffbespannung, beträgt ca. 75 prozent vom preise ähnlich flachgepolsterter holzmöbel durch ihre haltbarkeit und hygienische beschaffenheit sind die **breuer-metallmöbel** im gebrauch ca 200 proz. wirtschaftlicher als die üblichen sitzmöbel.

Breuer Metal Furniture
Stools, chairs, swivel-chairs, easy chairs, theater chairs, folding chairs, tables, etc.

a

"Breuer metal furniture." Advertisement of the firm "Standard-Möbel" Berlin.
"tubular steel furniture with fabric seat, back, and armrests is as *comfortable* as well-upholstered furniture, without having its weight, price, unwieldiness, and unsanitary quality. one *type* has been worked out for each of the required kinds of uses and improved to the point where no other variation was possible. this is the first time that precision steel tubing has been used for the construction of chairs. steel tubing of small cross-section is stronger than any other material used so far in the production of chairs. the result is a particular lightness and a particularly light appearance. all types can be taken apart. the parts are interchangeable. the light weight plays an important role in transportation. for instance, an easy chair of tubular steel weighs about 13¼ lbs (one fourth to one sixth of an upholstered easy chair). taken apart, approximately 54 easy chairs or about 100 chairs with backrests can be packed into a space of 30 cubic feet. the *cost* of an easy chair, for example, is about 30 per cent of that of an upholstered armchair. the cost of a theater chair or a chair with backrest, both fabric covered, is roughly 75 per cent of similar thinly upholstered wooden furniture. due to its durability and sanitary quality breuer metal furniture is approximately 200 per cent more economical in use than ordinary chairs."
From: Bauhaus Journal 1928. No.1.
The furniture shown in the advertisement was designed by Breuer in 1926. The chair reproduced twice was one of the best selling models.

b

Marcel Breuer: stool, can also be used as small table. Nickel-plated precision steel tubing. The wood sections painted in flat black. 1927.
Manufactured in four different sizes (13.8" by 17.8"; 17.8" by 13.8" by 19.8"; 19.4" by 13.8" by 21.8"; and 22.2" by 13.8" by 23.8") by "Standard-Möbel" and sold for between 16 and 24 reichsmarks.

c

Marcel Breuer: folding chair, model b 8. Nickel-plated precision steel tubing. Seat and backrest of flat black painted wood. 1927.
This folding chair was manufactured by the "Standard-Möbel" concern and sold for the remarkably low price of 21.20 reichsmarks.

c

b

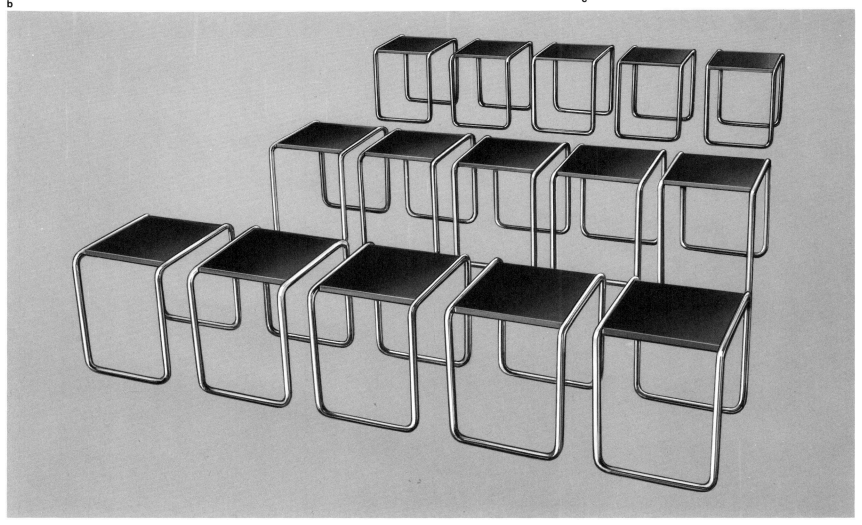

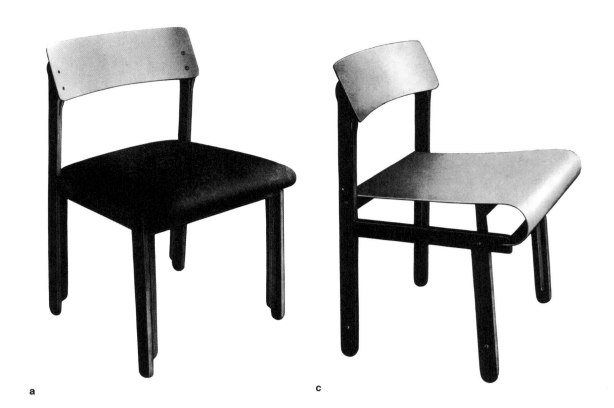

a

c

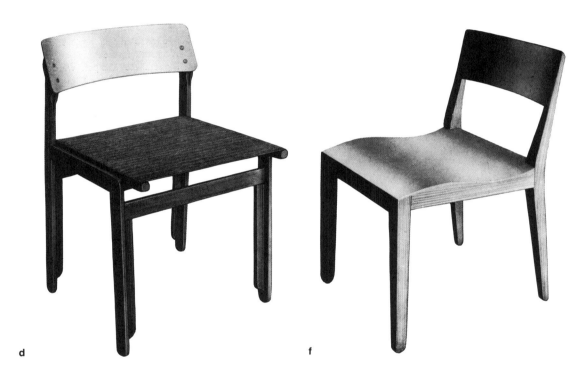

d

f

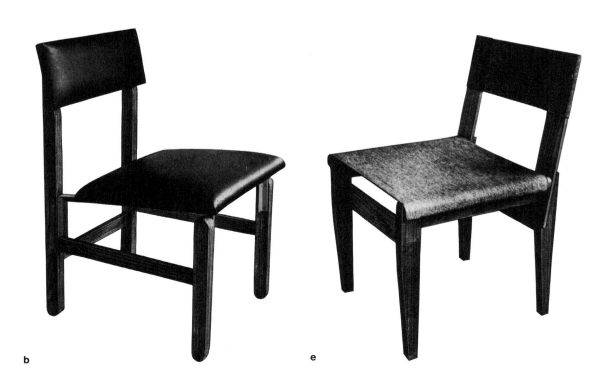

b

e

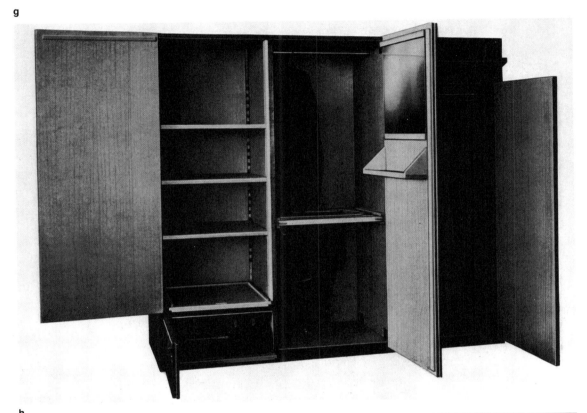

g

Breuer put the emphasis on tubular steel furniture in his own designs, but he continued to work with wood as well. When steel furniture first came out, industry was not very receptive; Breuer carried out his intentions without significant aid from that source. By 1928 the production of steel furniture had already become a noteworthy factor in the economy. Next to Breuer's, the most important designs at that time originated with two architects who only a short time later became also linked to the Bauhaus: Ludwig Mies van der Rohe and Mart Stam. Some younger members of the Bauhaus also attracted attention with carefully thought-out designs during the period Breuer was in charge of the cabinetmaking workshop. But the talent of students like Bücking, Decker, and Hassenpflug was only able to come to the fore after Breuer had resigned. Exceptional designs were produced independently by Josef Albers (especially in the development of a bent wood armchair).

a
Peer Bücking: upholstered chair (model ti 200 b). Wood, fabric upholstery. 1928.

b
Gustav Hassenpflug: upholstered chair (model ti 202). Wood, leather upholstered seat and backrest. 1928.

c
Peer Bücking: chair (model ti 200). Wood, plywood seat and backrest. 1928.

d
Peer Bücking: chair with resilient seat (model ti 200 a). Wood, fabric seat. 1928.

e
Martin Decker: chair (model ti 201). Wood, plywood seat and backrest. 1928.

f
Marcel Breuer: chair with resilient seat (model ti 2). Wood, fabric seat and backrest. 1927–1928.
The chairs reproduced on page 454 were made as prototypes in the Bauhaus cabinetmaking workshop. Additional copies were made as required.

g
Max Bayer: Wardrobe for a gentleman (model ti 114). Cherry and maple (interior), stained in two colors with a matte finish; fittings made of nickel. Produced in the cabinetmaking workshop of the Bauhaus. 1927.
In the left section of the wardrobe there are four shelves for shirts and underwear, and at the bottom a shelf for shoes, which can be pulled out. In the center, the upper part is for jackets, shirt, and other short hanging pieces, and below is a pull-out frame with metal rods for trousers. In the right section are a shelf for hats on the top and a compartment below for long hanging garments. The cabinet can be taken apart; it is 71″ high and wide and 23″ deep.

h
Marcel Breuer: children's room with playpen (model ti 136) and crib (model ti 11). Lacquered wood. Produced in the Bauhaus cabinetmaking workshop. 1927. The playpen is held together at the corners by springs. It has a linoleum floorboard consisting of two sections so that it can also be used outside. The sides of the crib can be folded down. All sides of the crib are perforated to permit air circulation.

h

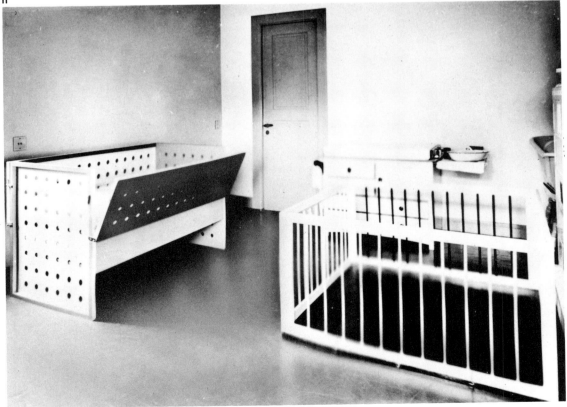

a

b

456

Metal Workshop

Laszlo Moholy-Nagy was in charge of the metal workshop of the Dessau Bauhaus until the spring of 1928. After his departure it was no longer run as an independent workshop. This decision corresponded to the development resulting principally from the invention of tubular steel furniture and the increasing use of synthetic materials, so that the coordination of design subject and material had become ambiguous. Metal had suddenly become one of the materials used by the "cabinetmaking workshop" too, and the making of lamps—the most characteristic object of the design work in the metal workshop—expanded from metal to include the new synthetic materials. Around 1928 the classification of the workshops for the most part no longer corresponded to the actual design projects being worked on. As a consequence the cabinetmaking workshop was eventually merged into a more comprehensive "workshop for interior design" under Mies van der Rohe in which the metal workshop also continued its work as an integral component. Functional lamps were now manufactured by industry everywhere. The best of them were probably those designed by Christian Dell, who, after the Weimar Bauhaus had been dissolved, was appointed head of the class for metal work at the art school in Frankfurt on Main. Nevertheless, the Bauhaus—particularly Marianne Brandt—deserves credit for having opened doors and for having produced designs which (like the "Kandem" lamp for instance) are absolutely perfect examples of their kind. The free play with forms and the tentative trials of the Weimar period had been left far behind. The shape of objects, lamps, and utensils was determined solely by their practical purpose and their technical modalities, without concessions to conventional esthetic concepts and without the visual ambitions of attempting to mold "bodies," as in sculpture.

a
The metal workshop of the Dessau Bauhaus. About 1927.

b
Marianne Brandt: egg-cooker with inset (model me 22). Aluminum with ebony handle. 1926.
Produced in the metal workshop. When desired, the cooker could also be made of nickel-plated German silver. It was to be industrially manufactured by deep-drawing and riveting the metal in order to avoid soldering. The pot could also be used without the egg inset.

c
Marianne Brandt and Hans Przyrembel: adjustable (reflector) ceiling fixture. Aluminum and electric cord. 1926.
The lamp was industrially produced by a Berlin firm. Models such as this one were soon in common use. At the Dessau Bauhaus the students in the metal workshop in particular were thinking in such practical and technically functional terms that with respect to form no difference could be detected between their designs and those developed by engineers. They were even in a position to give industry some technical advice. The Bauhaus products were of nearly revolutionary originality. What had been offered on the market up to that time had been, by and large, conventional arts and crafts products, notwithstanding the pioneering work that had been done by designers like Behrens and firms like A.E.G. (General Electric Company) and Carl Zeiss (Jena). The success of the Bauhaus lamps is explained by the congruity of form and function which was accomplished unostentatiously and hence was all the more convincing.
Copy in the Bauhaus-Archiv, Darmstadt.

c

The minute technical attention that guided the
design work in the metal workshop led to nu-
merous innovations which later became com-
mon property. Hence, the idea of constructing
lighting fixtures consisting of shallow glass
dishes attached directly to the ceiling probably
originated in the metal workshop of the Bau-
haus. Similarly, the ideas of combining opaque
and frosted glass, of making lighting fixtures of
aluminum and of designing ceiling fixtures with
concentric glass cylinders appear to have first
been thought of in the Bauhaus. Here, intuitive
visual and exact engineering thinking became
completely identical in the sense of modern in-
dustrial design.

a
Member of the metal workshop: glass globe lighting
fixture (models 94 a and 94 b). Opalescent and frosted
glass, aluminum. About 1927–1928.
Made with globes of 10″ and 16″ diameter, primar-
ily for indirect lighting. For reasons of proper lighting
the globe was made from two hemispheres, one of
flashed opalescent and one of frosted glass. Like 52
other models designed in the Bauhaus, this lamp was
industrially produced by a Berlin firm (Schwintzer &
Gräff).

b
Marianne Brandt: glass globe lighting fixture (ceiling
fixture). Glass and aluminum, 1926.
The diameter of the globe was 16″. The lamp was in-
dustrially manufactured by a firm in Berlin.

c
Member of the metal workshop: table lamp (model me
143 b). Aluminum (lacquered) and brass (nickel-
plated). 1928.
The reflector is adjustable. Total height, 16½″. Indus-
trially produced by a Leipzig firm.

d
Marianne Brandt: "Kandem" bedside-table lamp.
Metal, nickel-plated and lacquered. About 1927.
Specimen in the Bauhaus-Archiv, Darmstadt.
The reflector is adjustable. Produced in quantity by the
firm of Körting & Matthiesen in Leipzig. Beginning in
1928, this company regularly solicited advice from the
Bauhaus for its own designs of ceiling fixtures and
desk lamps. Contractual arrangements continued be-
tween the Bauhaus and the Körting and Matthiesen
firm until 1932. During these years, more than fifty
thousand lamps were sold that had been designed by
or had significantly involved the Bauhaus.
With the "Kandem" bedside-table lamp Marianne
Brandt and the Bauhaus presented a formal design
which remained exemplary for decades.

e
Marianne Brandt: wall fixture (model b s 7). Nickel-
plated metal mounted on a white-lacquered wooden
board. 1927.
The arm is jointed and movable and the reflector can
be adjusted. "By moving the arm sideways and turn-
ing the reflector correspondingly against the white
board, it is possible to get indirect light: the light is
reflected by the white surface. Beside the white sur-
face, a black surface can also be mounted (wooden
board or painted directly on the wall). This tones down
the light significantly (application primarily as bedside
lamp; also in hospital rooms). Push-button switch,
mounted on the wooden board, makes switching
easier even when one is half-awake." (Quote from the
Bauhaus Journal 1927, number 4.) The lamp was in-
dustrially manufactured by casting, pressing, and riv-
eting, with a minimum of soldering. It was marketed by
a Stuttgart metal firm.

a

b

c

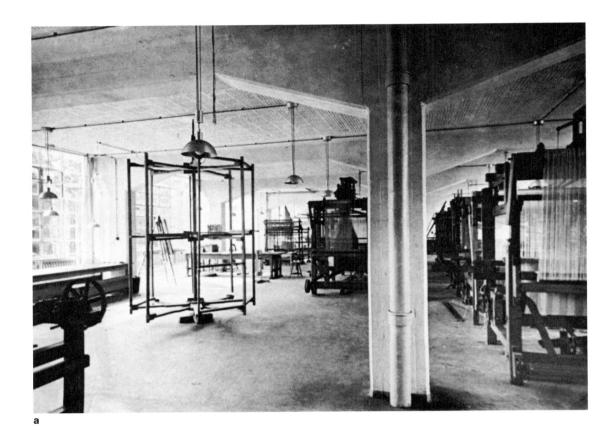

a

460

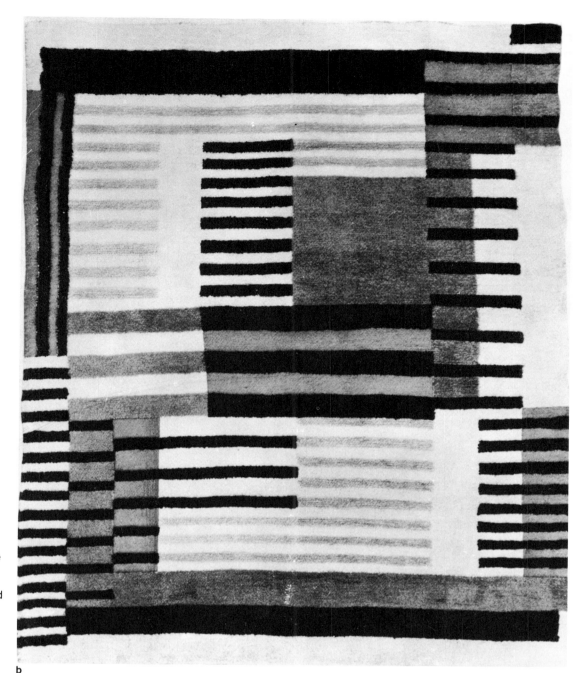

b

Weaving Workshop

At first, the technical and artistic directions of the weaving workshop were not united in one person at the Dessau Bauhaus. Georg Muche, who had the artistic responsibility, continued the work he had begun as form master in Weimar. Gunta Stölzl assisted him as technical supervisor. Differences of opinion between Muche and the students that developed in the spring of 1926 caused him to leave the weaving workshop and, after a temporary leave of absence, to resign from the Bauhaus as of March 31, 1927. Gunta Stölzl then took charge of the entire workshop as "junior master." She kept this position until the fall of 1931 (in 1932 she was succeeded by Lilly Reich). During that time the weaving workshop, a decisively important factor in the development of the Bauhaus, adapted itself to the problems of designing for industry. While earlier work was more or less determined by artistic improvisation, it was now systematized, both with respect to instruction and experiments with materials. Various materials, such as textiles with cellophane additives, were tested for their applicability in the textile industry and their specific physical properties (such as light reflection and sound absorption). New textures were tried out and textiles were designed with respect to machine manufacture. In slipcover fabrics and drapery material striking results were achieved, which were valued by industry and soon put to good use. The field of instruction comprised fundamental subjects, like mathematics and geometry, technical and organizational topics (technology, workshop instruction, binding techniques, organization of the working process, and calculation) and the "principles of artistic design." In the years following Muche's resignation Paul Klee delivered profound lectures on the latter topic. Despite the substantial ideas contributed by him, the development of the weaving workshop was primarily based on the work of Gunta Stölzl and her co-workers from among the students—Otti Berger, who did a great deal of experimenting, and Anni Albers, Lis Beyer, and Helene Nonné-Schmidt. That students learned from each other was more true of the weaving workshop than of any other workshop in the Bauhaus.

a
The weaving workshop in the Dessau Bauhaus. About 1927.
b
Anni Albers: knotted rug. Smyrna wool. 1925. Black, shades of gray, and red. Gascard-Diepold Collection, Berlin.

461

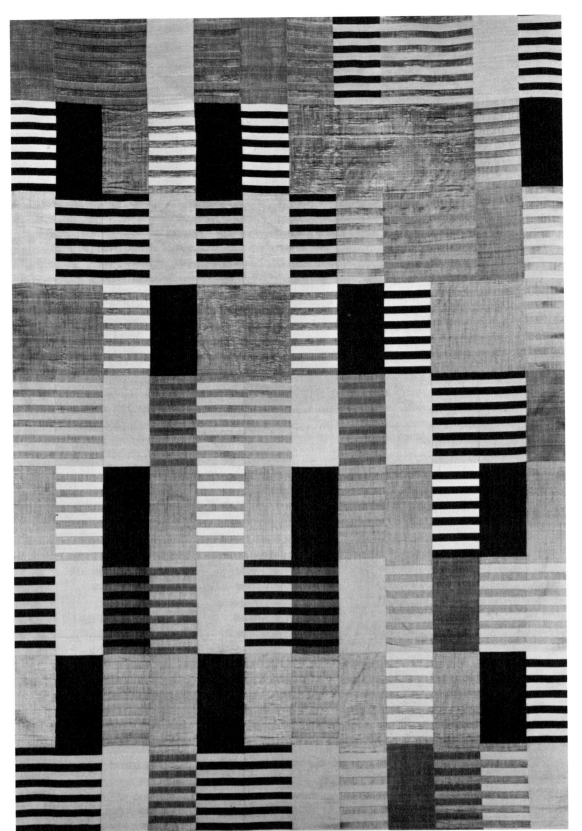

a

a
Anni Albers: tapestry. Woven silk. 1927. Black, different shades of gray and white.
Busch-Reisinger Museum, Cambridge, Mass.
The years of handweaving in Weimar were still evident in the large rugs and wall hangings of the weaving workshop of the Dessau Bauhaus. In regard to composition, tendencies toward greater regularity and stricter order appeared.

b
Otti Berger: knotted rug. Wool. Around 1928.
Black, gray, blue, and red.
Private collection, Chicago.
One of the early hand-woven works by Otti Berger. During the subsequent years she developed her specific qualities in designing textiles for industrial manufacture.

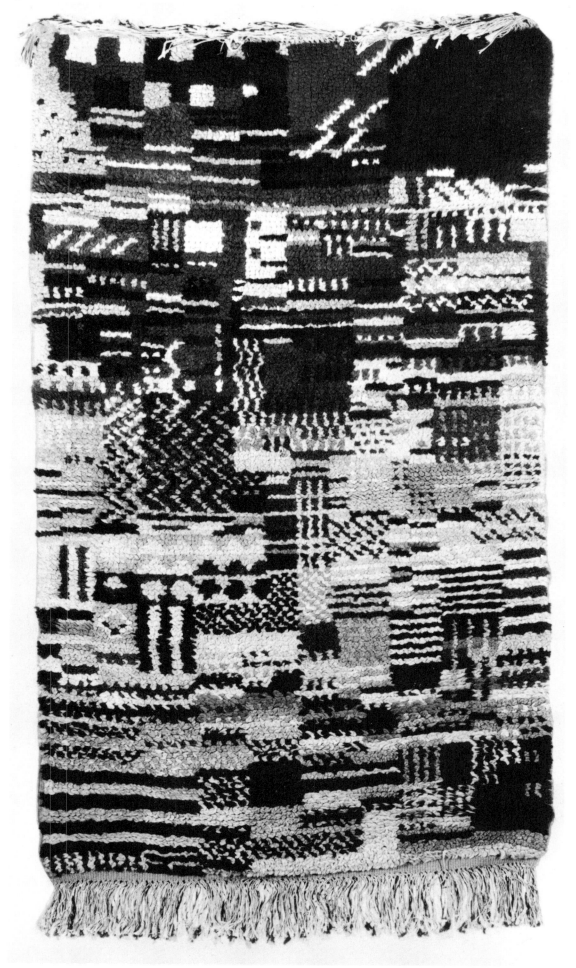

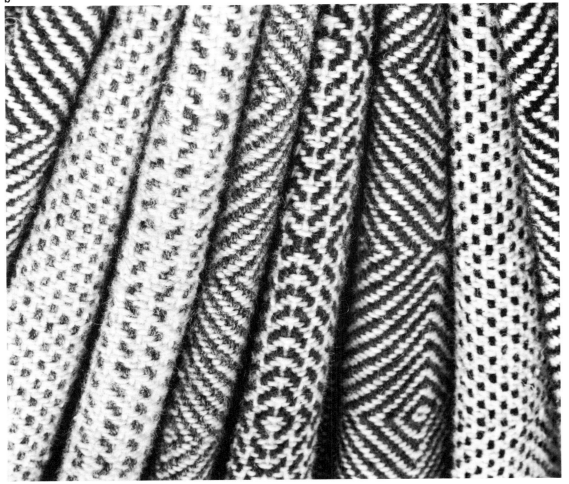

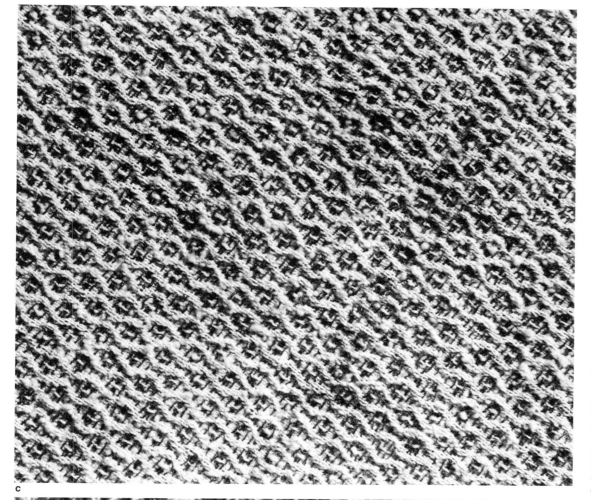

c

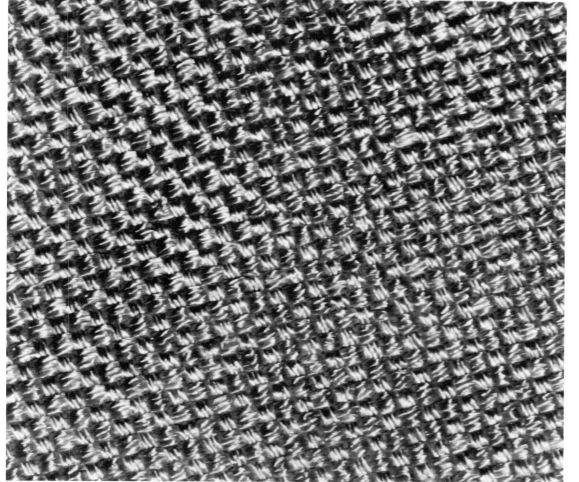

d

"Weaving is an old craft, which developed its own principles upon which present-day mechanical weaving must still build." This is what Gunta Stölzl wrote in a review of the history of the Bauhaus weaving workshop (Bauhaus Journal 1931, number 2). "Manual skills, ability, and knowledge must be thoroughly mastered and are not—as is the case with a tapestry—to be nourished on imagination and artistic perception. A very natural result of the work with the flat-loom was economy in the use of materials, moderation of color range, and relating the form to the process of weaving. On the other hand, the ultimate function of a fabric sets limits and determines the choice of elements. Inferences based on function are always dependent on the outlook on life and on the home. We had a very different idea about the home in 1922–1923 than we have today. Our textiles were still permitted then to be poems heavy with ideas, flowery embellishment, and individual experience! They quickly drew approval from a broad public even outside the Bauhaus walls—they were the most easily understandable and, by virtue of their subject matter, the most ingratiating articles of those wildly revolutionary Bauhaus products. Gradually there was a shift. We noticed how pretentious these independent, single pieces were: cloth, curtain, wallhanging. The richness of color and form began to look much too autocratic to us, it did not integrate, it did not subordinate itself to the home. We made an effort to become simpler, to discipline our means and to achieve a greater unity between material and function. This way we came to produce textiles sold by the yard, which were clearly capable of serving the needs of the room and the problems of the home. The slogan of this new area: prototypes for industry!"

Since the workshop was furnished with modern looms (among which the Jacquard loom was now especially important), the weaving workshop of the Dessau Bauhaus was able to satisfy to a greater degree the need for the manufacture of mass-produced textiles for everyday use. The entire attitude toward the problem in weaving changed and it seemed that, with increasing self-confidence, the weavers' readiness to assume responsibilities grew, as did their willingness to conduct experiments of lesser artistic challenge, such as designing prototype textiles for industry. A new stage of development began with great impetus, the most essential achievement of which was the production of simple textiles for practical use, deriving their effect solely from their textural properties and material quality. This development continued from the Gropius era until the 'thirties. The textile designs of the Bauhaus weaving workshop were extremely successful with industry. The "Deutschen Werkstätten" in Dresden and firms in Berlin (Polytextil-Gesellschaft) and Stuttgart (Pausa) regularly bought designs from the Bauhaus. Bauhaus textiles became widely accepted. Some designs, especially those by Otti Berger, were still being studied, analyzed, and evaluated by industry decades later.

Samples of textiles of the second half of the nineteen twenties:

a
Lis Beyer: rug. Heavy wool and fine hemp.
b
Lis Beyer: upholstery and cover fabrics. Heavy-duty wool.
Samples of textiles of the second half of the nineteen twenties.
c
Gunta Stölzl: coating material. Wool.
d
Otti Berger: textile. Cotton with white cellophane.

Wall-Painting Workshop

In Dessau and Berlin the wall-painting workshop was under the supervision of Hinnerk Scheper, except for a period during his leave of absence (1929–1931) when he spent a year and a half in Russia. During the interim Alfred Arndt was in charge and the workshop was a component of the "workshop for interior design," as were the cabinetmaking and the metal workshops. Before and after that it was an independent unit. The training in wall painting acquainted the student with the laws of color, form, and materials and with their esthetic interrelationships. Both the theoretical and practical instruction were extraordinarily thorough. The students learned how to prepare the painting ground (lime plaster, facing plaster, gypsum plaster; marble dust and alabaster plasters for tempera painting; spatula work on plaster, wood, and metal; preparation of the ground for panel pictures) and how to handle all known painting techniques of the past. New techniques, which emerged from experiments in wall painting, were tested in practice. Chemical properties and the material as well as visual characteristics of paints (lime, casein, and mineral paints: tempera, water-color; lacquer, oil paint, calcimine, wax, bronze, and metallic paints) were investigated. Part of the basic training was also instruction in the use of tools, the making of working drawings, stencils, cartoons, perspectives, and models, the erection of scaffolding, and preparation of estimates. Instruction in the fundamental principles of color harmony introduced the student to the essential esthetic foundation. The training culminated in design projects of color schemes for rooms, executed with plans, elevations, and architectural models. Another part of the curriculum in the wall-painting workshop was the painting of posters.

The guiding principle of wall painting, which was to use color as an architectural component in the design of a room, was carried out in practice during the first phase of development under Scheper (until 1929) with the means of painting —brush painting and spraying—and plaster techniques exclusively. In part the colors were revolutionary; for instance, the ceilings of some of the rooms in the Masters' houses were painted black. The members of the workshop were in favor of experiments and they learned from them. That wallpaper could be functional and an honest use of material, like paint or a plaster wall, was recognized only at a relatively late date. Bauhaus wallpaper was made from 1929 on, at first under Arndt's direction.

After work on the Bauhaus building and the Masters' houses, Scheper directed the color design of interiors for several public buildings in Dessau, for the Folkwang Museum in Essen, a hospital in Münster, the Institut für Schwingungsforschung in Berlin, and a number of other buildings. Scheper's principles of color design for walls has a wide following. Figurative and abstract ornamental wall painting, as conceived by Schlemmer in Weimar and carried out there in the workshop building in 1923, in short the whole domain of monumental painting, had no part in the wall-painting workshop of the Dessau Bauhaus.

a
Workshop for wall painting: experimental wall for plaster and painting techniques. About 1927.
Painting in fresco, with wax color, encaustic, with casein, tempera, calcimine, and wax emulsion. Plaster: lime sand, lime marble, fresco, sand, and marble plaster (colored), marble sand plaster (Pompeiian technique), stucco lustro, gypsum, cast gypsum, and gypsum sand.

b
Workshop for wall painting: experimental wall for various spray-gun techniques. About 1927.

c
The wall-painting workshop in the Dessau Bauhaus. About 1927.
On the wall at right are experimental panels in various techniques and materials on plaster.

a

b

c

Stage Workshop

Schlemmer began his work as Director of the Bauhaus stage in Dessau in October 1925. Ample opportunity for development was given after the later part of 1926, when a stage workshop and an experimental stage were included in the new Bauhaus building. The stage of the Bauhaus was Schlemmer's very personal accomplishment. It ceased to exist when Schlemmer moved to Breslau in the fall of 1929. Despite Schlemmer's commanding importance, it is beyound doubt that essential contributions were also made by those who worked with him— above all by Xanti Schawinsky, after whom Andor Weininger and Roman Clemens, for instance, should be mentioned. Even some of the primarily interpretative individuals, the dancers Werner Siedhoff and Manda von Kreibig, had an important function, taking part in the creative process. This is because improvisations were an ingredient of the stage work at the Bauhaus despite the most accurate preparations in rehearsals and despite demand for and implementation of scrupulous choreographic exactitude. The development within the Bauhaus stage took place mainly in 1926 and 1927. It was manifest in the design and realization of dances, pantomimes, and sketches. The Bauhaus stage achieved its greatest impact in public shortly before its dissolution during a tour in 1929. According to a prospectus of 1926–1927, the stage department trained "painters and technicians, actors, dancers, and stage directors in practical and theoretical collaboration for the common objective of the new stage form." Included in its work was the preparation of masks, costumes, and properties, the study of mechanical, visual, and acoustic conditions for stage work, the spatial design of the stage, studies of movement and interpretation (singly and in chorus), exercises in directing, and performances. The action on stage was experienced primarily visually, based on choreographic and spatial relationships and on color and form. As Schlemmer explained, using a quote from Delacroix, it was supposed to be a "feast for the eyes."

a
Oskar Schlemmer: pantomime "Treppenwitz." Bauhaus stage, 1925–1929. Photograph posed in the stage workshop in 1926 or 1927.

b
Oskar Schlemmer: pantomime "Treppenwitz." Bauhaus stage. 1925–1929.
Photograph posed in the stage workshop in 1926 or 1927. Performers were Hildebrandt, Siedhoff, Schlemmer and Weininger. This pantomime was probably rehearsed in the latter part of 1925 and was repeatedly performed until 1929.

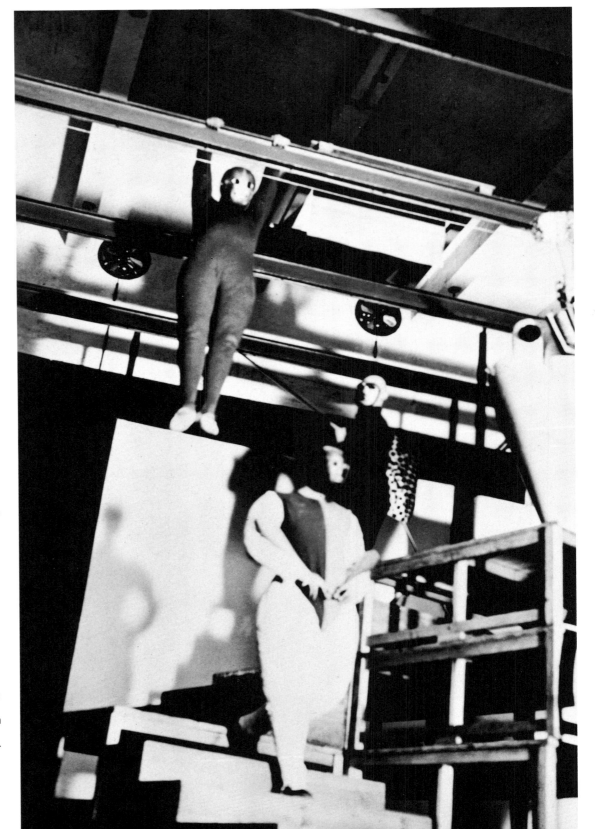

a

468

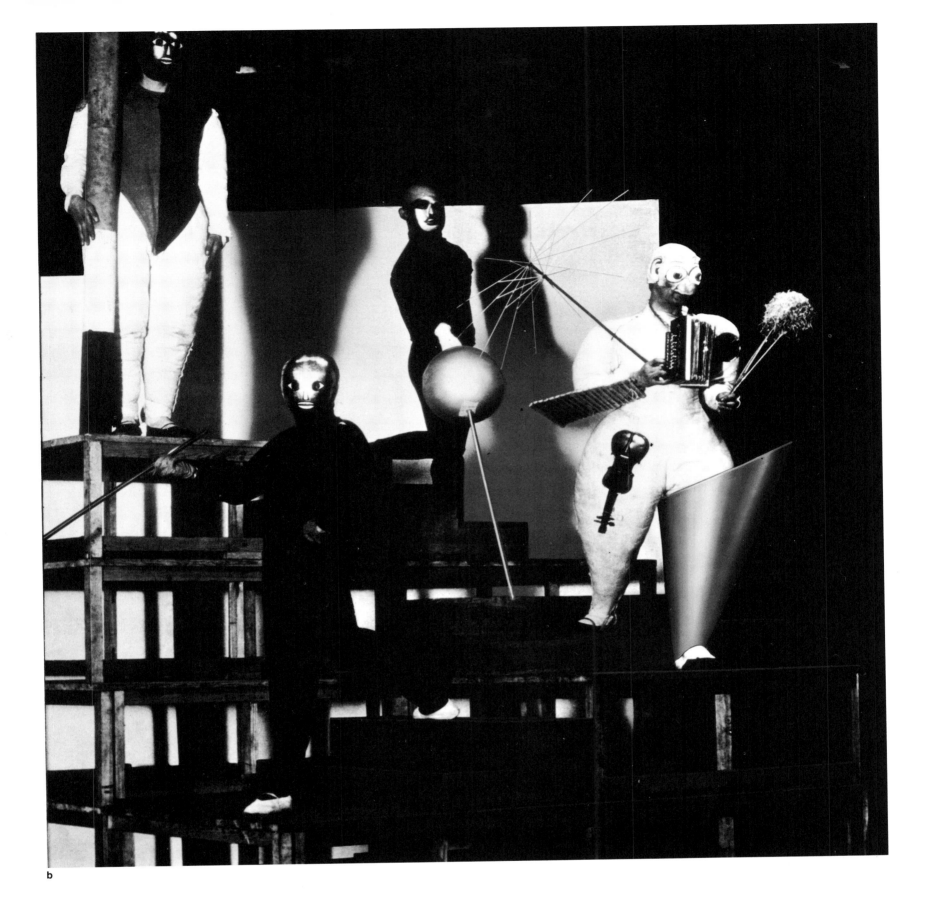

b

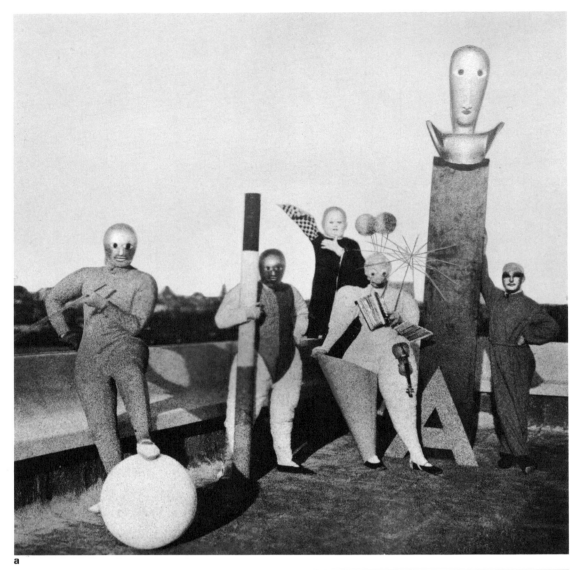

a

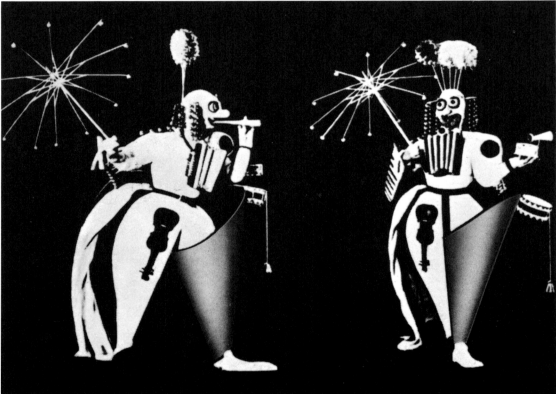

b

The architectonic element played a leading role in the plays of the Bauhaus stage. This is borne out with special clarity in Schlemmer's "Treppenwitz" pantomime in which the stairs directly contribute in causing and shaping the sequence of movements. A second, equally significant, characteristic is the propensity of Schlemmer and those who worked with him for stressing the grotesque and the comical, with clownery as one of the original elements of the theater. For its studies and publications during those years the Bauhaus stage benefited from the joy which the photographers at the Institute took in experimenting. The surprising perspectives of the workshop photographs of the "Treppenwitz" pantomime made by Lux Feininger are imaginative and amusing from the photographer's point of view and at the same time comment on the subject. The technique of double exposure also opened up striking possibilities.

An essential and not least of all, human, component of the stage department and its productions, was Oskar Schlemmer's scurrilous and placable humor. An excellent dancer and mimic himself, Schlemmer was also exemplary in the practical implementation of the pieces on stage.

a
Members of the stage workshop dressed in masks and costumes (belonging primarily to Schlemmer's "Treppenwitz" pantomime), on the roof of the Dessau studio building. 1926 or 1927.
This photo, like those on the two preceding pages, was taken by Lux Feininger.

b
Oskar Schlemmer: musical clown from the pantomime "Treppenwitz," performed by Andor Weininger. 1926 or 1927.
The same person twice (double exposure).

c
Oskar Schlemmer: "Musical Clown" (first version). Acted by Schlemmer himself. About 1926–1928.

d
Oskar Schlemmer: "Musical Clown" (second version). Acted by Schlemmer himself. About 1926–1929.

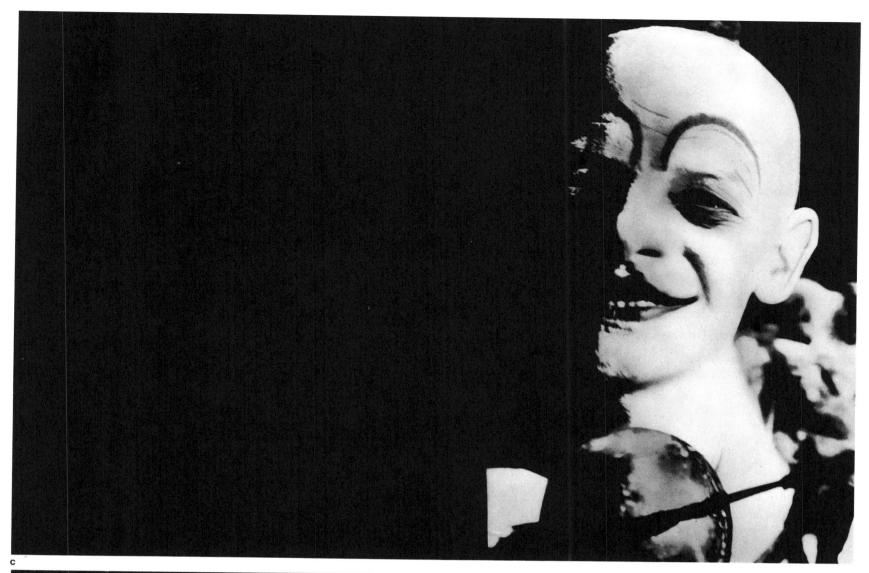

c

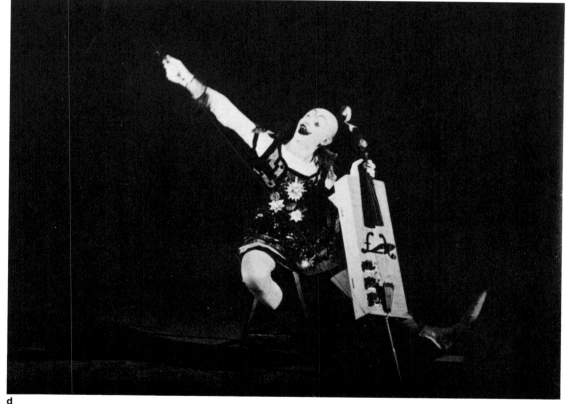

d

"The organism 'man' stands in cubical, abstract space." This is Schlemmer's view, as stated in 1928 in an essay on "Abstraction in Dance and Costume", quoted from the catalog for the exhibition "Oskar Schlemmer and the Abstract Stage", Zurich, 1961. "Man and space have their laws. Which law shall be valid and make itself felt? When we move in the open, in unlimited space, the dance becomes correspondingly untrammeled, exuberant, and Dionysiac—and rightly so. When we move in a room, we are necessarily under the 'spell of the room,' a part of the same, enveloped and held captive by it; from this, according to sensitivity and intensity of the will of the dancer, a 'space dance' results, integrating space and body into an indissoluble unity. In this dance space and body are the instruments of the dancer, which he will play better the more intensively he experiences, feels, and senses them. Like the music of Johann Sebastian Bach, which should be called abstract since, 'secluded' from all natural, illusionary elements, it is developed purely from the means of the specific instrument and put together contrapuntally and mathematically, but of course is also sustained by the nobleness of an idea; so, too, the abstract dance is to be a creation, born of itself, sufficient in itself. The music of the future approaches this austerity of law, and the abstract dance will do the same, following or leading it."

"The diagram, the linear representation of the lines of movement, the projection of the forward movement onto the area of the action is one of the devices for defining a sequence of movements graphically. The other device is to describe it. Both these means of representation supplement each other, without, however, exhausting the event totally—despite directions for tempo and sound. Still missing is a precise definition of the gestures (the movements of the body, the legs, the arms, and the hands), the mimetics (movements of the head and facial expressions), the pitch of voices, etc. . . ." (Bauhaus Journal 1927, number 3).

"What is 'abstract,' what does it signify, what does it mean? To put it in general and short terms: it means the simplification, the reduction to essentials, to fundamentals, to primary aspects, in order to contrast the multiplicity of things with a unity. Seen this way, it means the finding of the common denominator, the counterpoint (not only that of music), the law in art.

. . . Space and body mathematics, the planimetric and the stereometric relationships of space together with the metaphysics inherent in the human body shall unite into a numerical, mystical synthesis . . . space! Only to be comprehended by feeling; then by pacing and touching its boundaries: a help is the geometry of the floor: center mark, axes, diagonals, circle, etc. A help also perhaps the lines through space, which separate and divide the room in order to make it understandable and comprehensible in this way. May the delineation of space solidify into two-dimensional shapes and the shapes crystallize into bodies that will analyze the nature of space and will vary the space as a whole."
(From Schlemmer's essay "Abstraction in Dance and Costume," 1928.)

a
Oskar Schlemmer: diagram for the "Dance of Gestures." 1926–1927.

b
Oskar Schlemmer: "Disk Dancer" (left) and the "Spiral." Figurines from the "Triadic Ballet." The costumes were made by Carl Schlemmer for the performance of the ballet in Stuttgart in 1922. They were revised for the showing at the music festival in Donaueschingen in 1926 and displayed at the "German Theater Exhibition" in Magdeburg in 1927. According to a letter by Schlemmer of May 1927, the alcove which the Bauhaus stage provided at the Magdeburg theater exhibition was "the most modern." During the following year the Bauhaus players performed with distinction at a congress for dancers in Essen.

c
Oskar Schlemmer: "Space Dance," dance performed by Schlemmer, Siedhoff, Kaminsky. Bauhaus stage. 1925–1927.

d
Oskar Schlemmer: "Space Dance" ("Delineation of Space with Figure"). Performed by Werner Siedhoff. Multiple-exposure photograph taken by Lux Feininger. Bauhaus stage. 1927.

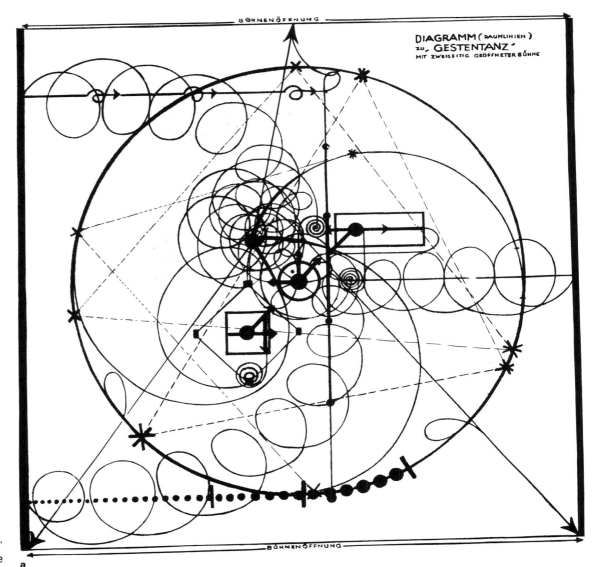

a

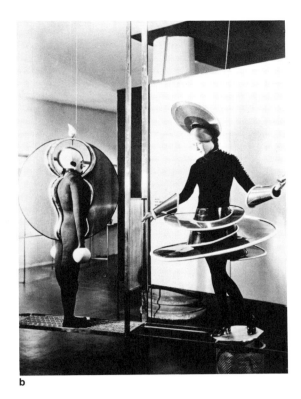

b

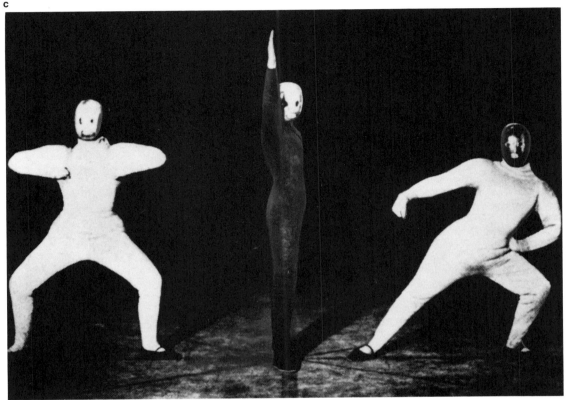

c

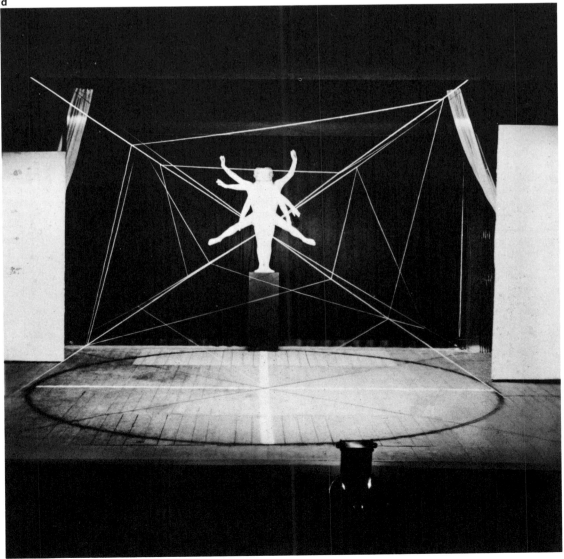

d

"We shall observe the appearance of the human figure as an event and recognize that at the very moment it has become a part of the stage, it is a 'space-bewitched' creature, so to speak. With a certainty that is automatic, each gesture and each movement is drawn into the sphere of significance. The human figure, then, the actor, naked or in white tights, stands in space. Before him, the receptive spectator, anxious for every action; behind him, the secure backing of a wall; at each side, the wings for his entrance and exit. This is the situation which any person instinctively creates for himself who, for example, steps out from among a group of curious spectators in order to 'do something' for them. This is the situation which produced the peep-show and, if you will, might be called the origin of all theatrical play.

"From this point on, two fundamentally different creative paths are possible: that of psychic expression, of emotional passion, of dramatic mimetics and gesture; or that of motion-mathematics, of the mechanics of joints and numerical rhythmics and gymnastics. Each of these paths, if pursued to its end, can result in the highest achievement, just as their fusion can lead to a unified art form. The actor is now so susceptible to being altered, transformed, or bewitched by each of the objects applied to him—mask, costume, prop—that his habitual behavior, his physical and psychic structure are thrown off or put into a different balance. . . .

". . . We shall standardize and make uniform the one, two, or three actors by dressing them in padded tights and papier-mâché masks that reduce the differentiated parts of the human body to simple, unifying forms. Furthermore, we shall clothe the three actors in the primary colors: red, yellow, blue. If we assign to each of these actors a different way of walking—slow, normal step, and tripping gait—and if we let them measure out the space, so to speak, in time to a kettledrum, a bass drum, and wooden blocks, then the result will be what we call a 'space dance.' If we put certain elementary forms, such as a ball, a club, a slat, and a pole into their hands and if we let them handle these forms accordingly and let them move about, the result will be what we call a 'dance of forms.' If we equip the masks with mustache and glasses, the hands with gloves, the torso with a stylized dress-coat, and if we add to their various ways of walking places to sit down, such as a swivel chair, an armchair, a bench, and also various kinds of sounds, like murmuring and hissing noises, jabbering, a racket, a phonograph, piano, and trumpet, the result of it will be what we call a "dance of gestures." The "Musical Clown," intentionally exalted to be grotesque, with his bare-ribbed umbrella, glass curls, colored pom-pom tuft, goggle eyes, balloon nose, toy saxophone, accordion chest, xylophone arm, miniature fiddle, funnel-shaped leg with military drum attached, gauze train [and] pointed shoes is the sensitively sound-producing companion to the other 'three' to make a serious quartet. We shall expand the group of four actors into a chorus of gray ghosts, of stereotype figures, and this chorus, either performing independently or accompanying others, will demonstrate both rhythmic and dramatic patterns of motion. We shall create for the players an environment of walls, stands, apparatus, and instruments that can be easily transported and put up anywhere. . . ." (From Schlemmer's lecture "Bühne" (Stage) delivered on March 16, 1927 in Dessau, published in the Bauhaus Journal 1927, No. 3.)

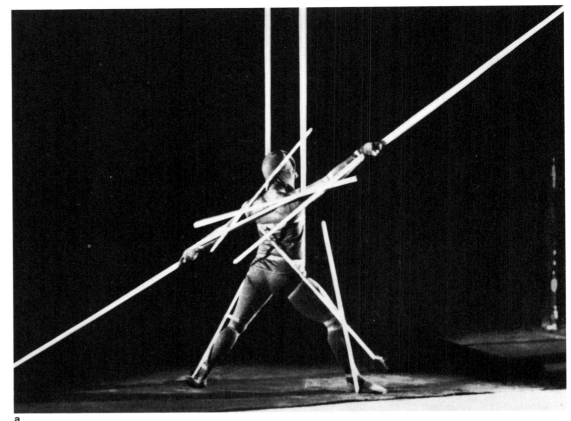

a

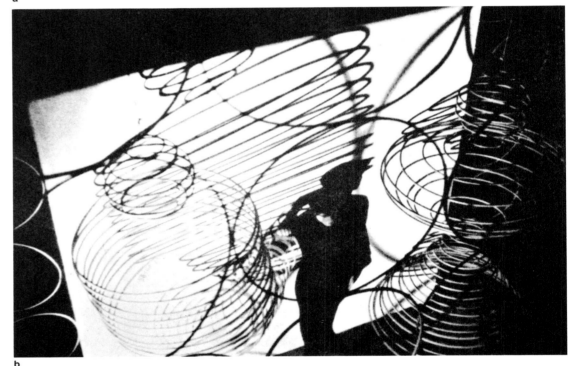

b

c

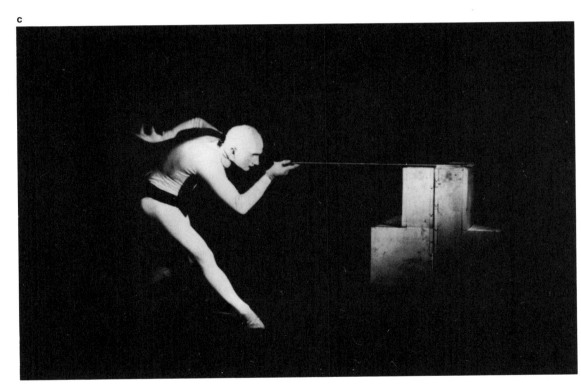

A demonstration of Schlemmer's manifesto-like pieces for the stage (as for instance the "Dance of Gestures" and the "Dance of Hoops"), presented at a lecture to the "Circle of Friends of the Bauhaus" on March 16, 1927, marked a significant point in the development of the Bauhaus stage.

a
Oskar Schlemmer: "Dance of Slats," performed by Manda von Kreibig. Bauhaus stage. 1927.

b
Oskar Schlemmer: "Dance of Hoops." The shadow effects were achieved by a multiple-exposure photograph taken by Albert Braun. Bauhaus stage. About 1927.

c
Oskar Schlemmer: "Baukastenspiel" (Play with building blocks). Performed by Werner Siedhoff. Bauhaus stage. 1927.

d
Oskar Schlemmer: "Equilibristics." The performers are Loew, Hildebrandt, Lou Scheper, Siedhoff, and Weininger. Bauhaus stage. 1927.

The short pieces, or studies, for the stage, of the period around 1926–1927 still occupied a prominent place in the program of the Bauhaus stage on its tour in 1929.

d

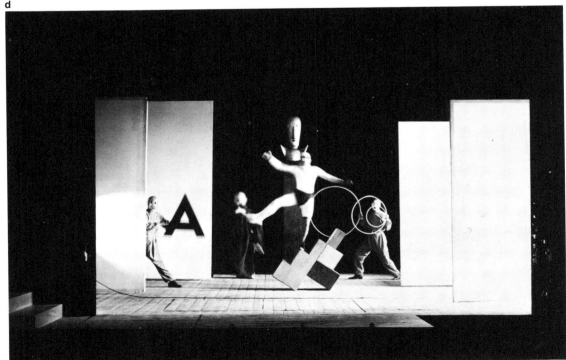

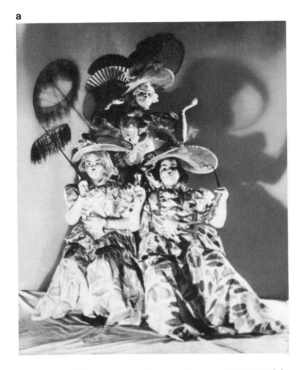

Despite all the abstraction and experiments with the dance, Schlemmer and those who worked with him by no means forgot the fundamental significance of masquerade and the element of parody (not least of which was the importance of psychological release). These were sketches in their own right and served to loosen up the program.

a
Oskar Schlemmer: "Wives' Dance" ("Three Baroque Ladies"). The performers are Siedhoff, Östreicher, and Schlemmer. Bauhaus stage. 1926–1928.

b
Members of the Bauhaus stage: parody "A visitor from the city at professor L.'s." Performed by Rubinstein ("professor"), Siedhoff ("socialite lady"), Rothschild ("hostess"). 1929.

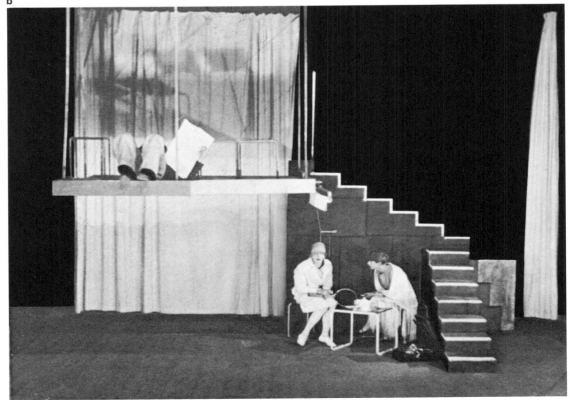

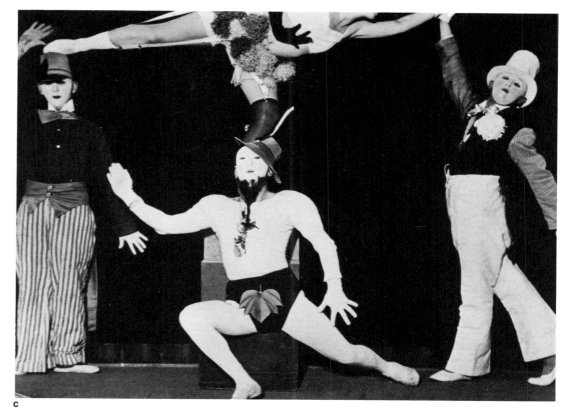

c

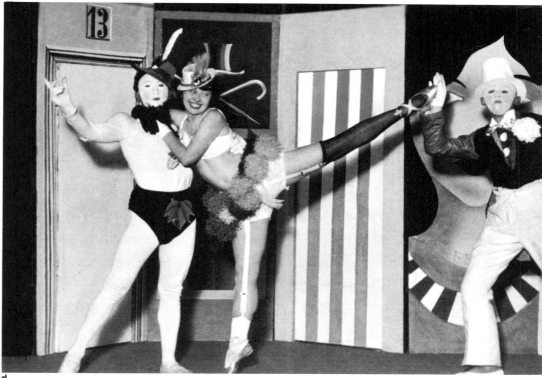

d

Xanti Schawinsky (born in Basel in 1904) was a
student at the Bauhaus from 1924 until 1926
and, after a short term as stage designer at the
city theater in Zwickau, again from 1927 to 1929.
He was one of the most active participants of the
Bauhaus stage. One of his specific accomplish-
ments was his "spectrodrama" in which, stimu-
lated by the Reflected Light Experiments of the
Weimar Bauhaus, he created abstract stage
compositions consisting of elementary forms.
This conception, dating from 1926, he then de-
veloped further at Black Mountain College,
North Carolina, in 1936. During the Bauhaus
period, Schawinsky produced mainly sketches,
in which his characteristic talent for comedy
was able to come fully to life.
c, d
Xanti Schawinsky: "Olga—Olga," sketch. Danced by
Röseler, Schawinsky, Schlemmer, and Kreibig. Per-
formed on the Bauhaus stage under the direction of
Schawinsky. 1927.

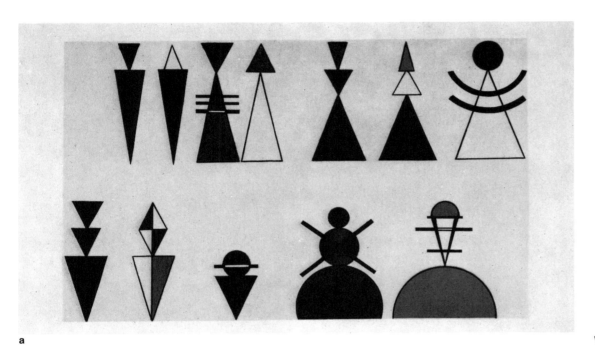

a

Wassily Kandinsky, like Schlemmer, also worked on personal commissions for the theatre quite apart from the Bauhaus stage. Moholy-Nagy, after he had left the Bauhaus, continued to design stage sets primarily in Berlin. In the beginning of April 1928 Kandinsky put on stage at the Friedrich-Theater the "Pictures at an Exhibition," a musical poem by his fellow-countryman Modest Mussorgsky (1839–1881). Kandinsky not only designed the sets, he also directed. Mussorgsky was inspired for this composition by sixteen (probably realistic) watercolors. He transformed the pictures into absolute music. Kandinsky on his part now designed "visual equivalents by following the movement of the musical phrases with movable colored forms and projections of light" (Grohmann). Dancers performed in only two of the scenes. In an essay (published in "Kunstblatt," August 1930) Kandinsky explained his artistic intentions and sketched out the action. For example, on the darkened stage in the fourth picture ("The Old Castle"), "during the first *espressivo* . . . only three long vertical stripes were to be seen. They disappear. With the next *espressivo* the large red backdrop moves in from the right (in two colors). Following from the left is the green backdrop. Out of the trap-door appears the center figure. Intense colored lights are focused on that figure. . . ."

a
Wassily Kandinsky: figurines (design) for Mussorgsky's "Pictures at an Exhibition." Water-color. 1928. Theater museum of the Institute for Theatrical Science, Cologne-Wahn.

b, c
Wassily Kandinsky: stage design for the performance of Mussorgsky's "Pictures at an Exhibition" in the Friedrich-Theater in Dessau. Water-color. 1928. Theater museum of the Institute for Theatrical Science, Cologne-Wahn.

b

Bühnenbild und Regie: Kandinsky　　　**Moussorgsky: Bilder einer Ausstellung**

c

Experiments in Photography

Though photography was not included in the Bauhaus curriculum until 1929 (with the appointment of Peterhans), in actual fact it already played an important part four or five years earlier. Laszlo Moholy-Nagy provided the stimulus for the interest in photography, being occupied with the "photogram" and similar artistic, photographic techniques at the time he was appointed to the Bauhaus in Weimar (1923). He was aided by his wife, Lucia Moholy-Nagy, who was an excellent photographer, both artistically and technically. The manifesto-like Bauhaus book "Malerei, Photographie, Film" ("Painting, Photography, Film") was prepared in 1924 and was published at the beginning of the Dessau period as the eighth volume in the Bauhaus series. The students were fascinated by the work of Laszlo and Lucia Moholy-Nagy, since it opened an entirely new point of view to them. From now on there was generally a great deal of photographic experimentation at the Bauhaus, the results of which were the necessary prerequisites and the foundation for the entire line of development which in the second postwar era came to be called "subjective photography." In the photographs made at the Bauhaus the environment was viewed and interpreted in new, surprising perspectives. Contrary to all existing rules, people and things were captured in the photographs in "accidental" or apparently arbitrary arrangements, either diagonally, from above, or from below. The photographers were not afraid of unclear object relationships produced by cast shadows or light effects in the picture. They became aware that photography meant composing with light and shade. This recognition made possible and justified the use of techniques with expressive or abstract effects—double exposure, double printing of different exposures, and enlargement of the negative. These photographic experiments were not merely an excellent visual teaching device; they also had a positive impact on applied design, especially on commercial art.

It is remarkable how few of the student photographs from this period, before the introduction of special instruction in photography, were "amateurish," either artistically or technically. Students like Lux Feininger, Erich Consemüller, and Albert Braun, as self-taught photographers, did pioneering work that can stand up to that of leading specialists in the field.

a
L. Moholy-Nagy: "Dolls." 1926
Published in volume 8 of the Bauhaus Books, second edition (1927).
Moholy-Nagy comments: "Because of the light-dark arrangement and the delineation resulting from the shadow, the toy is moved into the realm of the fantastic."

b
L. Moholy-Nagy: "photogram" (exposure without a camera). About 1924.
It is worth noting that the abstract painter Moholy-Nagy began his photographic experiments with exposures made without a camera. The "photogram" reproduced here was published in both editions of volume 8 of the Bauhaus Books. "The organized effects of light and shadow produce a new enrichment vision" (Moholy-Nagy).

c
L. Moholy-Nagy: negative-photo. About 1926.
Published in volume 8 of the Bauhaus Books, second edition (1927).
Concerning this photograph Moholy-Nagy explains: "The inversion of light-dark values also reverses the relationships. The small amount of white becomes extremely active and thereby determines the whole picture."

d
Lucia Moholy-Nagy: Oskar Schlemmer on vacation in Ascona. 1927.

e
Lux Feininger: improvisation by members of the Bauhaus stage standing on the balconies of the studio building. About 1927.
The accent here is on the improvisational and playful, accomplished by the use of selection, perspective, and overlapping elements. The "snapshot" character here—as in many of the more successful photographs done by students—is an intentional artistic device.

a

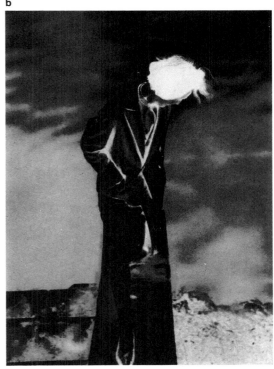

b

c

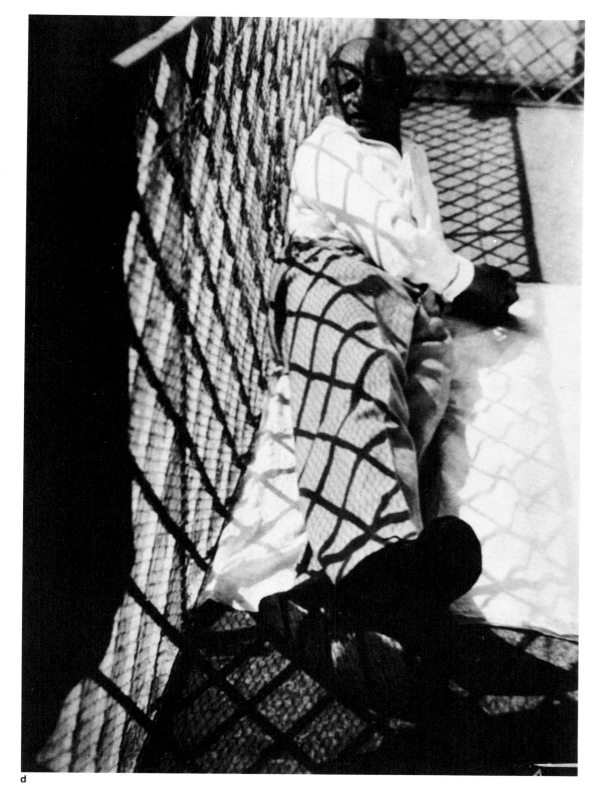

d

e

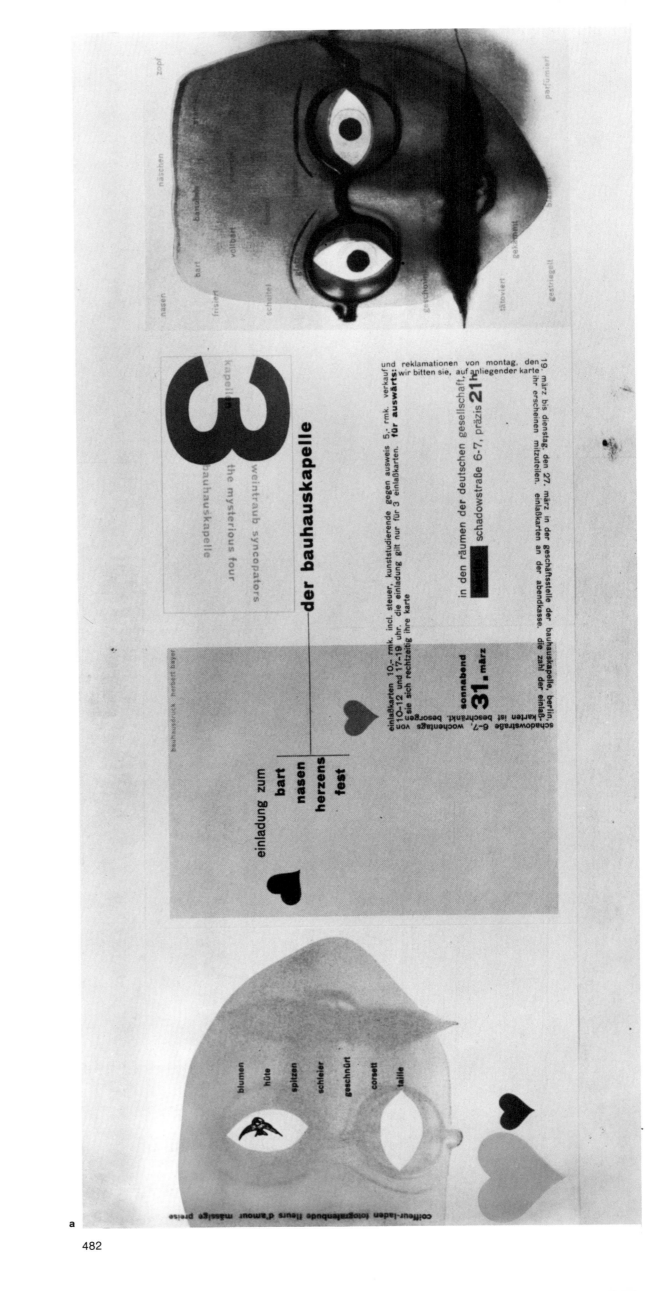

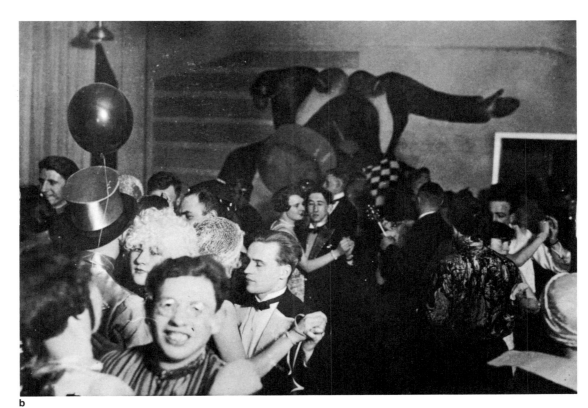

b

Parties and Festivals

Each of the festive celebrations of the Dessau
Bauhaus—the climaxes of these were the car-
nival ("Fasching") balls—was given a motto pro-
viding a cue for the design of the decorations
and the costumes. Preparations for these festi-
vals—this constituted their importance to the
Institute—inspired the students' creativity, free
from and unburdened by actual design prob-
lems. Unrestrained zest and carnival humor
combined with something of the splendor and
imaginativeness of the grand festivals of the
Renaissance and the Baroque. Oskar Schlem-
mer usually directed the evenings with a sure
hand, and hence unnoticeably, by thinking up a
motto and preparing the conditions for its im-
plementation. The most brilliant events up to
1928 were "The White Festival" and the "Beard,
Nose, and Heart Festival." For the first Schlem-
mer contrived that everyone was to appear in a
costume "dotted, checkered, and striped," two-
thirds in white and one-third in colored cos-
tumes. The second was arranged in Berlin by
the Bauhaus band and was tremendously suc-
cessful.

a
Herbert Bayer: invitation to the "Beard, Nose, and
Heart Festival," arranged by the Bauhaus band in Ber-
lin on March 31, 1928.
Leaflet, printed in black, blue, and red.
b
"The White Festival." Bauhaus "Fasching" party with
the motto "Dotted, checkered, and striped," on March
20, 1926.

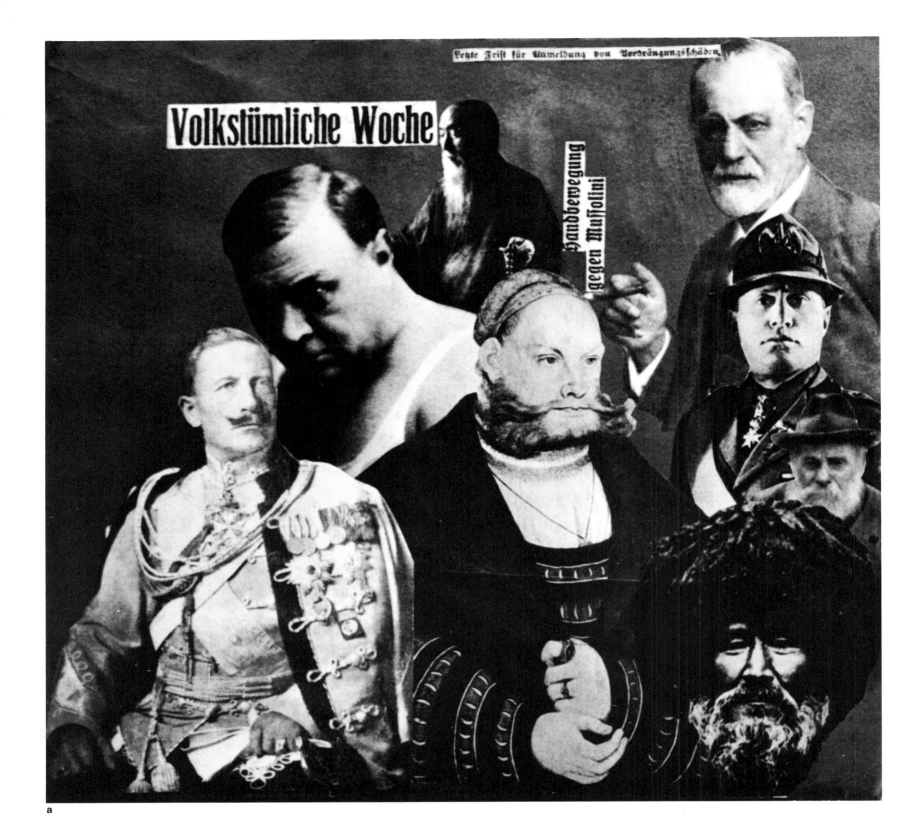

Ise Gropius in her (unpublished) diary of the Bauhaus years writes about the Fasching festival of 1926, "The White Festival": "Different altars were erected inside on the balcony, a Director's 'collection of oddities,' etc.; very witty ideas, everything put up with infinite care. . . . Because a definite catchword had been given for the festival, a very coherent appearance was achieved. I can't remember a festival with more beautiful masks." The stage department, which up to this time had usually detracted from its own merit by an overproduction of ideas, functioned well on this occasion, Ise Gropius observed. Above all, she noted, Schlemmer and Joost Schmidt were brilliant. Nothing attests more convincingly to the dynamic energy immanent in the Bauhaus than its abstention from commercially exploiting the wealth of ideas produced for the festivals and parties by the members of the Bauhaus stage, the teachers, and the students.

During the Dessau period the Bauhaus band was so well known everywhere that it was repeatedly invited to play in Berlin and other major cities. The vivacity of their improvisations turned this band into something unique in Germany at that time. The band consisted of students and, understandably, its composition was not constant. The four who had founded it in Weimar—Weininger, Hoffmann, Paris, and Koch—were replaced during the course of the years in Dessau by Lux Feininger, Schawinsky, Clemens, Egeler, Strenger, Adler, Collein, Tokayer, and others. The musical offerings of the Bauhaus band retained the same high quality as long as the band existed.

a
Helene Nonné-Schmidt: Humorous collage from a birthday album for Walter Gropius. 1926.
Gropius collection, South Lincoln, Mass.
b
Masks at a Bauhaus party, probably the "Beard, Nose, and Heart Festival" in March 1928.
c
The Bauhaus band. About 1928.
Double-exposure photograph, or rather two different exposures superimposed on the same print. The band consisted of five musicians at that time.
d
The Bauhaus band. About 1929.
Band with six players from among the students.

Hannes Meyer Era

Under Hannes Meyer, who succeeded Gropius as Director of the Bauhaus on April 1, 1928, a sweeping transformation in the structure and the mental attitude of the institute took place. Meyer was able to profit from what had been built up under Gropius. During no other stage in the development were the workshops of the Bauhaus as productive as now. Although workshop production now placed greater emphasis on a social rather than an artistic, esthetic point of view, it was, by and large, continued along established lines, utilizing the existing facilities. But a new element of the work program was the vigorous concentration on architecture. Here, too, the social aspect was the determining factor. Similar emphasis was given to the strengthening of secondary subjects (the science of industrial organization, psychology, among others) with the same purpose of preparing students for practical work in socially determined building programs. The faculty was enlarged by the appointment of several first-rate professionals, among them Hilberseimer and Peterhans, as well as numerous guest lecturers. It was certainly a positive development for the Bauhaus to finally offer lectures in city planning and a professional class in photography. The free artistic disciplines became more independent. This isolation of the artistic factor, which continued later under Mies van der Rohe, broke the former unity of the ideal program and initiated a development, the consequences of which would have turned the Bauhaus into a technical school for architects and industrial designers had it existed long enough to reach that point. This transformation was the most important and most influential one since the shift that occurred around 1923. The fact that Meyer tolerated radical political tendencies at the Bauhaus and even supported those on the extreme left had very serious effects. The disintegration of discipline, which hampered the conducting of orderly classes and provided the opponents of the Bauhaus with a dangerous point of attack, eventually forced the Dessau City Council and mayor Fritz Hesse to appoint a new man to the post of Bauhaus Director in the summer of 1930. Thus, the Hannes Meyer era covered little more than two years.

At the beginning of 1930 the Bauhaus had 190 students. Matters of the Institute were decided by the "staff council" wherever decision was not reserved by city and state authorities. The members of the staff council, in addition to the Director, were eleven full-time faculty members, the business manageress and two representatives of the student body. Productive activity (workshops) was divided into four main departments: the architecture department (architecture administration and architectural office), the commercial-art department (photography workshop, sculpture ("plastic") workshop, printing workshop), the department for interior design (wall painting, metal workshop, and cabinetmaking workshop) and the textile department (dye workshop, weaving workshop, and tapestry production). The organizational structure which Hannes Meyer developed was, by and large, very successful. The "Circle of Friends of the Bauhaus," as can be seen from the organization plan, had a membership of 503—a considerable number indeed.

a
Hannes Meyer, Director of the Bauhaus in Dessau. About 1928.
b
Scheme for the organization of the Bauhaus under the direction of Hannes Meyer. Drawing prepared by the architecture class of the Bauhaus. January 1930.

a

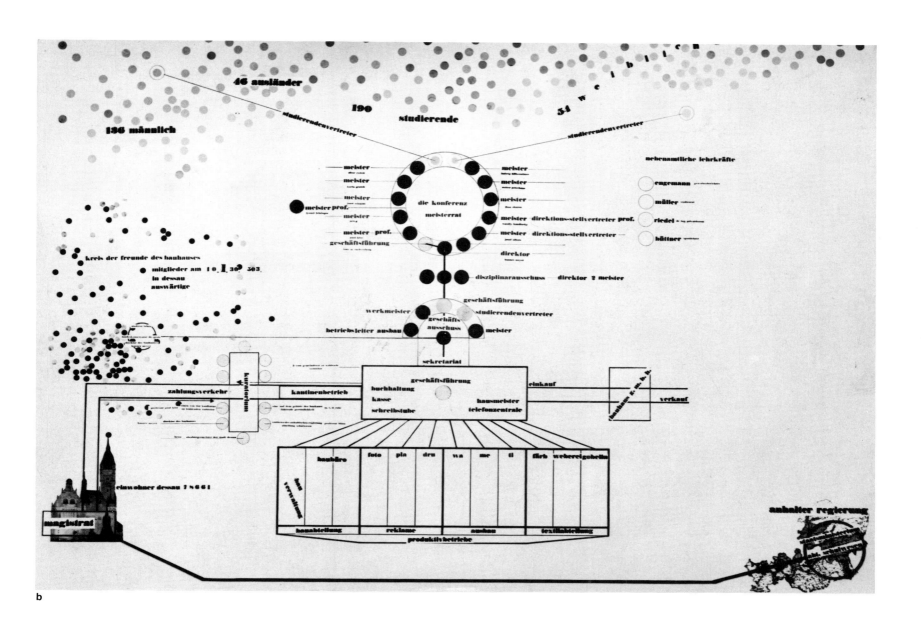

b

487

Architecture Department

One of Meyer's personal achievements was his success in giving a systematic foundation to architectural instruction and in providing a methodical expansion of the curriculum. Hence, the calculation of floor plans was based on an investigation of the practical and psychological functions which the rooms were intended to serve. Special emphasis was placed on the possibilities for ventilation and good lighting (angle of inclination of the sun). Possible disturbances (acoustical disturbances within and outside the house, disturbances through unpleasant odors, lack of privacy, or irritations caused by possible social frictions) were taken into account in the planning stage and were eliminated as far as possible. The implementation of Meyer's systematic studies was restricted, however, for the necessary exact scientific preconditions were still quite limited. Special studies were conducted centering on the small home and the house in a housing development. In addition to Meyer himself, who in his capacity as Director also supervised the architecture department, the faculty consisted of Hans Wittwer (until 1929), Ludwig Hilberseimer (head of instruction in architecture, and classes in constructional design), Anton Brenner (head of the architectural studio), Alcar Rudelt (structural engineer), Edvard Heiberg (housing developments), and—as part-time staff member—Carl Fieger (architectural draftsmanship). Mart Stam joined the faculty as guest lecturer (for elementary instruction in architecture and for city planning).

a
View of the drafting room in the architecture department of the Bauhaus (design of the building: Gropius). About 1928.

b
Instruction in architecture by Hannes Meyer: schematic diagram showing an investigation into neighborhood and external relationships in a housing development. About 1929.
(Explanations in the figure:)

I. Relationships to the neighbor
1. Acoustic relationships
a. from house to house, music, etc.
b. from garden to garden, playing area
c. from summerhouse to summerhouse
d. from the street, motorcycle, etc.
e. domestic animals, dog, chickens, cat, etc.
2. Olfactory relationships
a. smoke—chimney, garden fire
b. kitchen odors
c. dungpile, domestic animals
d. laundry, vapors
e. motorcycle, etc.
3. Optical relationships
a. from house to house (opposite)
b. from garden to garden
c. from house to street
d. from street to house
4. Social relationships
a. (different) social position
b. ″ political party
c. communal use of a laundry
d. friendly relationships

man⬒man
woman⬓woman

II. Relationships to the external world
Postman—gas—electricity—water—chimney-sweep—heating attendant—fuel supply access—repairs—laundress—manager
Relatives—friends—(house guest)—visitor—beggar—thief
Children—passer-by—car—etc.
Illness—vermin
Advertisement—radio—etc.

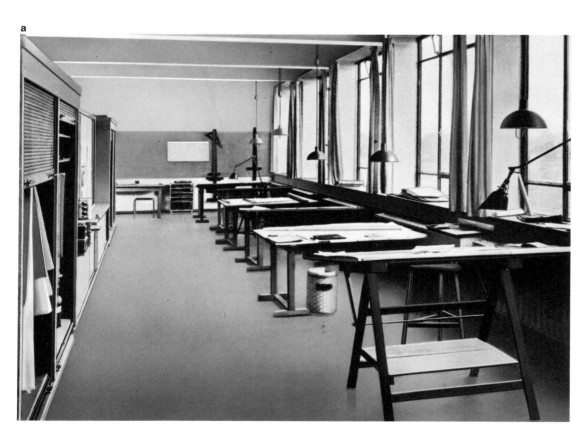

a

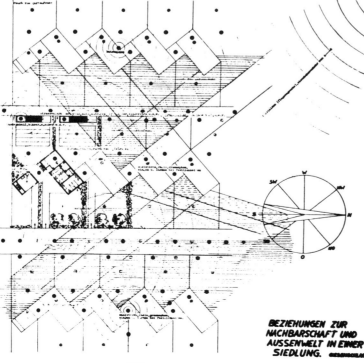

b

I. BEZIEHUNGEN ZUM NACHBAR

● 1 AKKUSTISCHE BEZIEHUNGEN
a. VON HAUS ZU HAUS, MUSIK u.a.
b. VON GARTEN ZU GARTEN, SPIELRASEN
c. VON GARTENLAUBE ZU GARTENLAUBE
d. VON DER STRASSE, MOTORRAD u.a.
e. HAUSTIERE, HUND, HÜHNER, KATZE u.a.m.

● 2. GERUCHSBEZIEHUNGEN
a. RAUCH – SCHORNSTEIN, GARTENFEUER
b. KÜCHENGERÜCHE
c. DUNGHAUFEN, HAUSTIERE, METROCLO.
d. WASCHKÜCHE, WRASEN
e. MOTORRAD u.a.m.

▬ 3. OPTISCHE BEZIEHUNGEN
a. VON HAUS ZU HAUS (GEGENÜBER)
b. VON GARTEN ZU GARTEN
c. VON HAUS ZUR STRASSE
d. VON DER STRASSE ZUM HAUS

4. SOZIALE BEZIEHUNGEN
a. (VERSCHIEDENE) GESELLSCHAFTL. STELLUNG
b. ″ PARTEI
c. GEMEINSAME BENUTZUNG EINER WASCHKÜCHE
d. FREUNDSCHAFTL. BEZIEHUNGEN

MANN⬒MANN
FRAU⬓FRAU

II. BEZIEHUNGEN ZUR AUSSENWELT

POSTBOTE - GAS - ELEKTRIZITÄT - WASSER -
SCHORNSTEINFEGER - HEIZER - KOHLENANFUHR -
REPARATUR - WASCHFRAU - VERWALTER
VERWANDTE - FREUNDE - (HAUSFREUND) - BESUCHER -
BETTLER - DIEB
KINDER - PASSANT - AUTO u.a.m.
KRANKHEIT - UNGEZIEFER
REKLAME - RUNDFUNK u.a.

BEZIEHUNGEN ZUR
NACHBARSCHAFT UND
AUSSENWELT IN EINER
SIEDLUNG.

Instruction in architecture by Hannes Meyer: synoptical table of the calculations for the floor plan for a community apartment house (project of Weiner and Tolziner). 1930.
(Explanations in the synoptical table:)
the floor plan is calculated from the following factors

1. factors of movement
the order of the functions is given from the workplan

↓ coming
↑ going
○ dressing ○ changing
sheltered living○ ○ bathing ○ sleeping
unsheltered living○

2. sun
in the morning sun is needed in the bedroom
in the evening sun is needed in the living room
thus

	living	sleeping

bedrooms facing east
living rooms facing west
since the living units have to be adjoining, they can be:
1. vertically accessible.
there are a maximum of two living units to one entrance.
2. horizontally, by way of an enclosed entrance hall, since the living unit is only part of the rooms in the house.
a. bedroom, dressing and bathroom separated from the living room by the entrance hall
does not meet the requirement for unity
b. enclosed entrance facing east
does not meet the requirements of direct sun and ventilation.
c. entrance above bedroom
too expensive
1 and 2 yields 4 2 and 3 yields 5

3. calculation of sun exposure
calculation for location: latitude: 47° 30′N
 longitude: 0° 00′

spring and fall
winter
summer

	living room	balcony
exposure to the sun during winter, until	4:15 PM	4:15 PM
exposure to the sun during spring and fall, until	4:20 PM	6:00 PM
exposure to the sun during summer, until	5:10 PM	4:30 PM

construction
assembly method (dry) steel skeleton paneling
amount of air required for bedroom
1. required air circulation
carbon dioxide production 0.015 m³/hr
carbon dioxide content in 1 m³ fresh air 0.0004 m³
Maximum allowable carbon dioxide content in 1 m³ air in room 0.001 m³

$$a = \frac{0.015}{0.01 - 0.0004} = 25 \text{ m}^3/\text{hr}$$

2. natural ventilation
the computation is based only on the natural equalization of differences in air densities caused by air leaks in closed windows.
window area 1.98 m² temperature difference 30°C
volume of bedroom and dressing room 22.0 m³
excessive pressure of air in room 0.54 kg/m²
air movement through window 8.65 m³/hr
3. window ventilation
required fresh air 16.35 m³/hr
air velocity at temperature difference of 30°C
v = 2.95 m/sec requires a ventilation average of 15.5 cm
efficiency of ventilators 72% requires a working size of 20.60 cm
range of vision when waking
last ray in living room
last ray on the balcony
ray, in spring 6:30 AM
ray, in summer 6:30 AM
south east
floor plan of the individual living unit

der grundriß errechnet sich aus folgenden faktoren

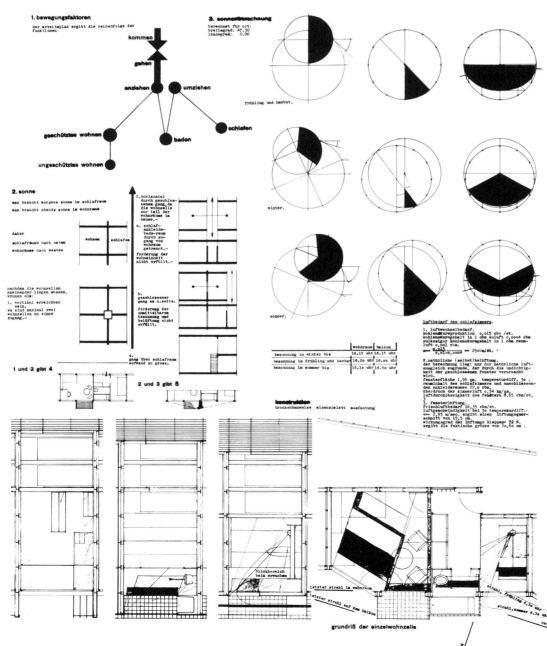

grundriß der einzelwohnzelle

a

der garten als erweiterung des wohnraums

räumliche erweiterung :

gartensitzplatz laube kinderspielplatz
gartenwege pflanzfläche

funktionelle erweiterung :

verbreiterung und verlegung des wohnvorgangs ins freie
gartenarbeit luft - sonnenbäder freiluftgymnastik
ozonisierung der luft

mensch
atmung

sauerstoff kohlendioxyd

pflanze
assimilation

erholungswert :

gegensatz zu berufsarbeit und -raum

der garten als nährbasis

pflanzliche nahrungsmittel :

gemüse obst küchenkräuter

tierische nahrungsmittel :

garten ermöglicht kleintierzucht :
fleisch eier

soziale stufen des gartens :

blumentopf bis herrschaftspark

der garten als erweiterung des erlebnisraums

sinneseindrücke :

gesicht :
 pflanzengrün blüten - früchtefarben
 blatt - blüten - früchteformen pflanzenformen allgemein
geruch :
 pflanzengerüche allgemein : koniferen minze geranium
 blütengerüche erdgeruch herbstgeruch
haut :
 kühle im baumschatten : stufen der schattendichte : rosskastanie bis birke
gehör :
 vogelgesang insektensummen baumrauschen herbstlaubraschlen

psychische wirkungen :

hauptsächlich durch farben :
 grün - blaureihe tonisch
 gelb - rotreihe erregend

assoziationen :

individuell verschieden
abhängig von mit den assoziationsstützen verknüpften erlebnissen
durchschnittsassoziationen :

schneeglöckchen nahender frühling
eiche kraft „deutsch"

alpinum hochgebirge

wasserbassin see meer

kakteen übersee

gartentypen :

der garten in berlin o :	mietskasernenhof
der improvisierte garten :	restaurationsgarten
der zimmergarten :	blumentopf bis wintergarten
der naive garten :	bauerngarten
der kultische garten :	japanischer garten
der modische garten :	staudengarten
der repräsentierende garten :	herrschaftgarten
der garten im grosstadtgeschäftsviertel :	dachgarten

der garten steigert das erleben der jahresperiodizität unserer lebenskurve

	frühjahr zentrifugal	sommer exzentrisch	herbst zentripetal	winter konzentrisch
mensch :	steigende erregung	äusseres leben	zunehmende ruhe	inneres leben
gartenarbeit :	säen	pflegen	ernten	ruhe
vegetation :	keimen	blühen	reifen	ruhe

a
the garden as extension of the living space

spatial extension:
garden seating arrangement arbor
children's play area garden walks planted area

functional extension:
broadening and transfer of home functions into the open
gardening air and sun baths open-air gymnastics
ozonizing the air

oxygen
man (breathing)
plant (assimilation)
carbon dioxide

relaxation value:
contrast to profession and work place
the garden as extension of the space for experiencing sensory perceptions:

eyes:
green of the plants colors of flowers and fruit
forms of leaves, flowers, and fruit
forms of plants in general

scent:
scent of plants in general: conifer mint geranium
scent of flowers scent of the earth scent of fall

skin:
coolness in the shade of a tree: different densities of shade: horse-chestnut to birch

hearing:
song of the birds humming of insects wind through the trees rustle of the fall foliage

psychological effects:
primarily through colors:
green—blue scale tonic
yellow—red scale exciting

associations:
individually different
dependent on experiences connected with associational reinforcements

average associations:

snow-drop	approaching spring
oak tree	strength "German"
alpine garden	high mountains
water pond	sea ocean
cacti	overseas

the garden as a basis for food supply
vegetable food: vegetables fruit kitchen-herbs

animal feed: the garden makes keeping of small animals possible: meat eggs

social levels of the garden: flower pot to manorial park

garden types:

the garden in Berlin east:	yard in a tenement block
the improvised garden:	restaurant garden
the garden inside the house:	flower pot to wintergarden
the naive garden:	farmer's garden
the cult garden:	Japanese garden
the fashionable garden:	shrub garden
the representational garden:	manorial garden
the garden in the downtown shopping area in a city:	roof garden

The garden intensifies the experience of the seasonal periodicity of our life cycle

	spring centrifugal	summer eccentric	fall centripetal	winter concentric
human being:	growing excitation	external life	increasing rest	inner life
garden work:	sowing	cultivating	harvesting	rest
vegetation:	budding	blooming	ripening	rest

Collective work occupied an important place in the activities of the architecture department of the Bauhaus under Hannes Meyer. In the curriculum one preliminary course semester was followed by two semesters in the workshops for interior design—very much along the lines of the ideal plan Gropius had once set up for himself. During this period the instruction was supplemented by courses in theory, art, and science. From the fourth to the sixth semester the "trained journeyman," who was not necessarily an aspiring architect, joined the instruction in architecture. Building was interpreted here as the "design for all the processes of life." With Meyer's view it was natural that the "architectural-scientific approach" which he imparted to the students of his course in architecture, was adjusted to the principles of materialism and was very definitely oriented toward social factors. The practical training in architecture was given during the last three semesters in the architectural office, bringing the student up to the ninth semester. After successful completion of a course of studies, a "Bauhaus Diploma" was awarded.

a
Instruction in architecture by Hannes Meyer: analysis of the garden as an extension of the space for living and experiencing. 1930.

b
Ernst Göhl: design for an eight-classroom grade school. Student work of the architecture department. 1928.
Single-story system of classrooms facing south, with gardens and playgrounds extending from them. Planned for a housing project in the vicinity of a large city and "based on new pedagogical knowledge."

c
Architecture department of the Bauhaus: residence of Dr. Karl Nolden in Mayen (Eifel). 1928.
The plans for this house were designed and worked out by the student Hans Volger under the guidance of Hans Wittwer. Local circumstances had to be taken into consideration. Economy was highly valued.

b
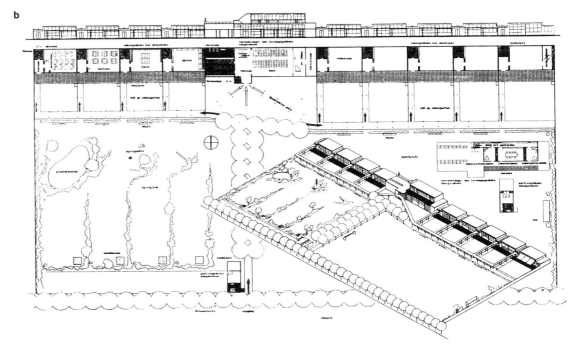

c
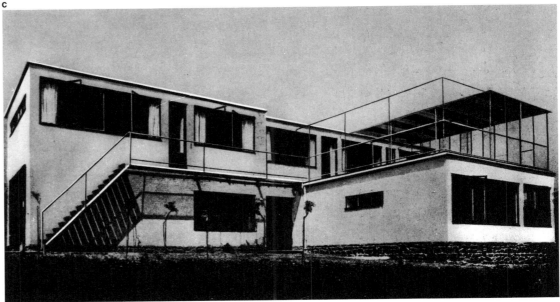

a

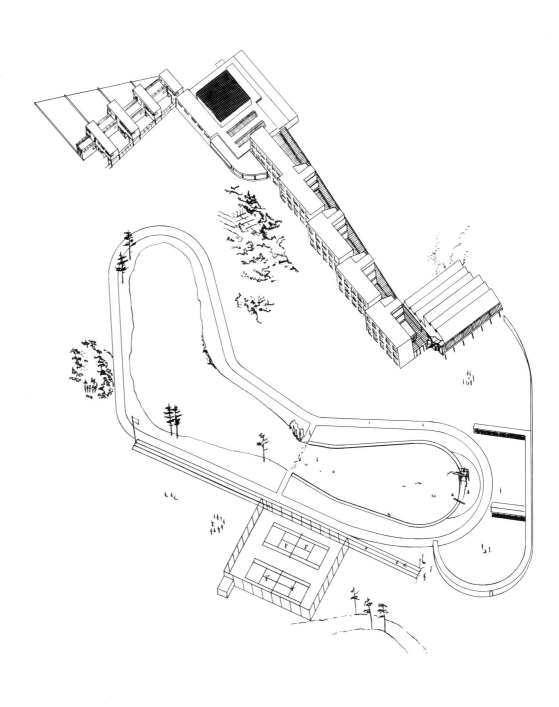

Under Hannes Meyer the architecture department carried out a number of commissions for new buildings and alterations. The most important were the designing and building of the Union School of the General Federation of German Trade Unions in Bernau near Berlin and four balcony-houses erected adjacent to the housing development in Dessau-Törten. The different workshops of the department for interior design aided in the work for the trade union school. The purpose of this union school was to train functionaries and to make them acquainted in particular with questions of social politics, labor laws, and hygienic working conditions and with the tasks of conducting meetings, of arbitration, of being a judge in a Labor Court, or a speaker reporting to labor meetings. The school had the character of a boarding school, conducting four-week courses for participants of all age groups. Hannes Meyer won the commissions for this school in a competition in which other prominent architects (Max Berg, Klement, Ludewig, Mendelsohn, and Max Taut) had also submitted entries. The plan included facilities for 120 students, two teachers, a guest teacher, and the personnel required for the operation of the school. In addition to classrooms and living quarters, there was a kitchen, dining and administrative facilities, and recreational and sports grounds. Meyer wrote in the Bauhaus Journal (1928, number 2–3): "This school may rightly appear loose in arrangement. The shortest ways of getting together are not created by shortening the hallways but rather by the opportunity for establishing friendly contact ... The result: not concentric accumulation of the building masses, but instead an eccentric, loose arrangement of the parts." A lake on the site and the surrounding Bernau forest provided a most favorable setting. "The position and arrangement of the dormitory wing was governed by the intention of obtaining maximum exposure to the sun for all 60 living rooms [designed for two persons each].... Placing the three classrooms into the "raised" story on top of the gymnasium was done with the thought that this process of learning constitutes an unusual event for the simple 'man of the working people' in the prime of his years.... The floor plan of the auditorium is intentionally designed as an exact square: second only to the circle, this square is architecturally the strongest expression of unity, of the social coherence of a community. The walls of the auditorium have intentionally been designed without windows: the impression of the room is 'inner directed,' while the dining room faces the lake ... offering brightness and plenty of light, with a view of the lake and the forest through the glass walls of the lounge."

Hannes Meyer: Union School of the General Federation of German Trade Unions (A.D.G.B.) in Bernau near Berlin.
a
Site plan. 1928.
b
Seen from the air. Built in 1928–1930.
c
Dormitory wing.

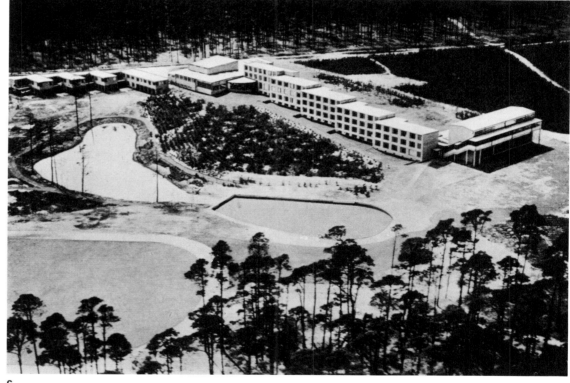

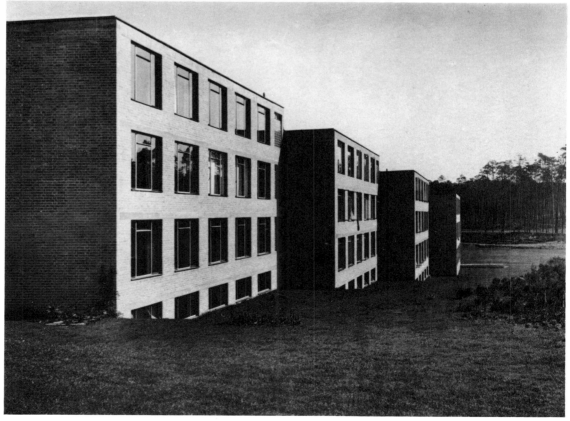

493

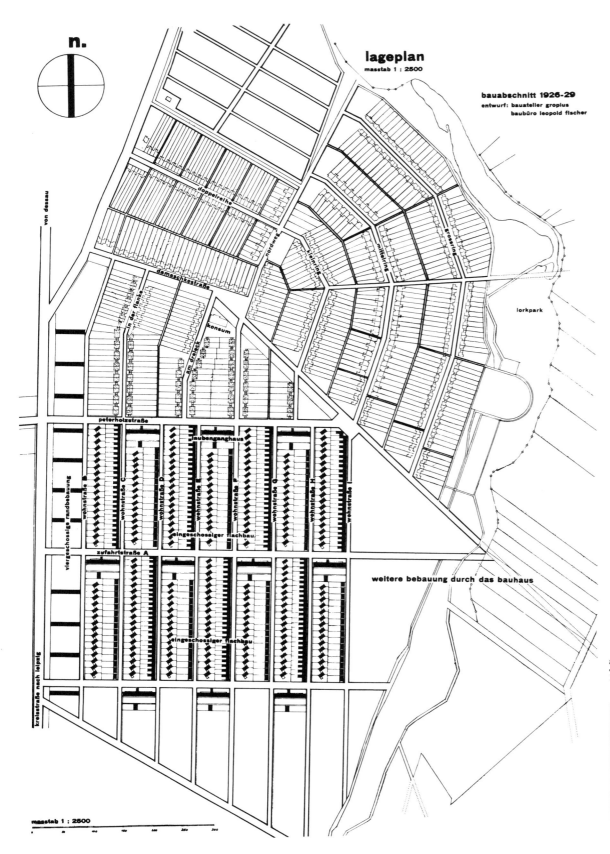

n.

lageplan
masstab 1 : 2500

bauabschnitt 1926-29
entwurf: bauatelier gropius
baubüro leopold fischer

lorkpark

doppelreihe

damaschkestraße

konsum

peterholzstraße

laubenganghaus

eingeschossiger flachbau

zufahrtstraße A

eingeschossiger flachbau

viergeschossige randbebauung

weitere bebauung durch das bauhaus

masstab 1 : 2500

a

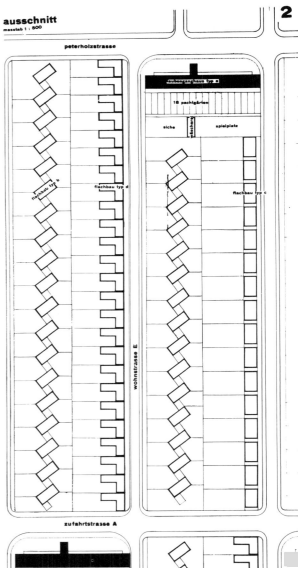

2

ausschnitt
masstab 1 : 500

peterholzstrasse

laubenganghaus typ a

18 pachtgärten

siche spielplatz

flachbau typ b flachbau typ d wohnstrasse E flachbau typ c

zufahrtstrasse A

b

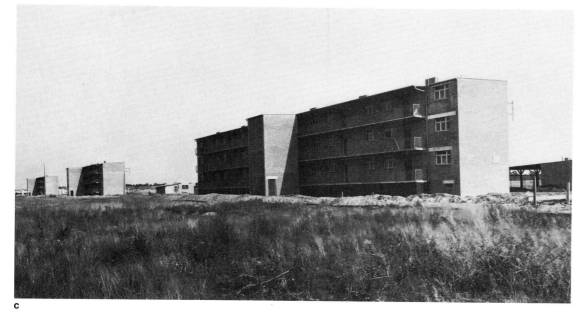

c

The Dessau-Törten housing development, the first three stages of which had been built by Walter Gropius in 1926–1928, was planned to be extended during the years following. The design was given to Hannes Meyer in 1928, who involved the architecture department of the Bauhaus in the planning. Adjoining the Gropius development in the south, there were to be rows of single-story houses, staggered at an angle (to take advantage of the sun) and long balconied houses, each of them standing at the head of a row of low buildings. In the west a number of four-story apartments were planned along the edge of the development. Plans for a further extension of this housing area to the east and the south were no longer considered. Firm contracts were actually given for only five of the balcony apartment houses; construction of these was completed in 1930, just as Hannes Meyer was dismissed from office. His departure and the deterioration of the world economic situation prevented continuing the construction of this exemplary project which was both technically and functionally well conceived. In place of the single-story homes a number of emergency shelters were later constructed.

The particular advantage of the balcony apartment house was its technical solidity and the economy of its floorplan arrangement. Each of the blocks had 18 apartments which consisted of three rooms plus secondary rooms, adding up to a total floor area of only 518 square feet per unit without seeming cramped. The rooms were faced south (garden area). The stairs were placed in one stair tower extending from the building on the north side, from which the apartments were accessible by way of exterior passages. Meyer decided on this arrangement—which was being tested at the same time in Frankfurt under Ernst May—for social, sanitary, and psychological considerations. He held that some of the otherwise inevitable frictions developing in densely populated lodgings could be reduced if the many neighbors did not have to meet and step out of each other's way in closed hallways (which, being closed, amplify the noise), but instead would be able to get from their own apartments directly into the "open." The Second World War spared these balcony apartments; the natural brick façade remained in excellent condition.

a
Hannes Meyer: site plan for the project of extending the Dessau-Törten housing development. Designed by the architecture department of the Bauhaus. 1928–1930.
The upper section of the plan shows the Gropius development.

b
Hannes Meyer: section of the site plan of the extension project for the Dessau-Törten housing development, worked out in cooperation with the architecture department. 1928–1930.

c
Hannes Meyer: balcony apartment houses (north elevation with stair towers and balconies) in Dessau-Törten. 1930.

d
Hannes Meyer: balcony apartment (north elevation) of 1930 in Dessau-Törten. Photograph dates from 1958.

e
Hannes Meyer: balcony (access to the apartments) facing north, in one of the balcony apartment houses in Dessau-Törten. 1930.

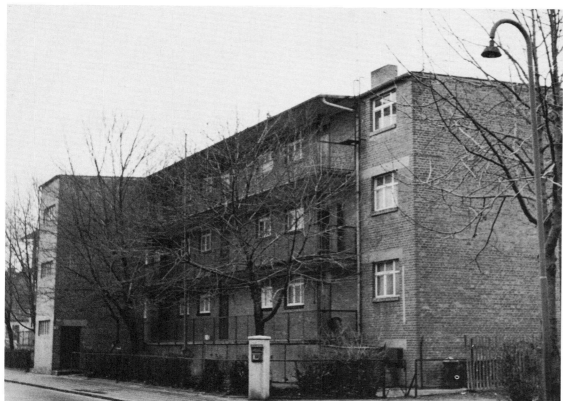

d

e

a

Ludwig Hilberseimer

The appointment of the architect, city planner, and theoretician Ludwig Hilberseimer was an extraordinary gain for the Bauhaus. He was put in charge of the architecture program in the spring of 1929, but his sphere of activity also extended to construction design and in part to work in the architectural studio. He was a member of the Bauhaus until it was closed in the summer of 1933. Hilberseimer was born in Karlsruhe on September 14, 1885. He studied at the Institute of Technology in his home town. Except for the period in Dessau, he lived mainly in Berlin until 1938, when he was forced to emigrate. Like his friend, Ludwig Mies van der Rohe, he went to the United States where he became professor of city planning in the architecture department of the Illinois Institute of Technology in Chicago. He remained in Chicago after being made professor emeritus and was busy chiefly with the continuation of his investigations and publications on the subject of "The City" with which he had made his name during the 'twenties as a bold theoretician of modern city planning. He died in Chicago on May 6, 1967. Hilberseimer's ideal plans for the future city to some extent conformed to the ideas of Le Corbusier and in part varied, corrected, and supplemented them in important points. For the future, Hilberseimer envisioned the possibility of a way out of the chaotic absence of order and the paralyzing effect on the individual of the vastness of the city, by proposing far-sighted planning of skyscraper cities. He wanted to reduce the area covered by a building radically in favor of green areas, hence the possibility of communicating with nature; in this he definitely went much further than Le Corbusier. Pedestrian and automobile traffic, living units and commercial activities in Hilberseimer's ideal project were strictly separated by a vertical arrangement of levels. The base of the enormous buildings was occupied by shops, surrounded by automobile traffic. The buildings on top, set back from the edge by the width of a pedestrian walk, housed the apartments. Industrial sections were carefully separated from living and shopping areas. Later Hilberseimer revised this project in some respects. His guiding principle was always the idea that the city would again have to become an organism able to function, not just technically but also with consideration for the people living in it. In addition, he thought that one of the main tasks of the planner was to take precautions against the danger of city areas deteriorating into slums. He provided a place for the housing development where he thought decentralization or a non-urban organization was required. The development was also dealt with in his classes at the Bauhaus.

a
Ludwig Hilberseimer. Portrait. Spring 1933.
b
Ludwig Hilberseimer: project of a skyscraper city. North-South street. 1927.
c
Ludwig Hilberseimer: proposal for the construction of high-rise city buildings. Drawing (bird's-eye view). About 1927.
(Insert in lower right-hand corner: variation, introducing three levels of traffic.)

b

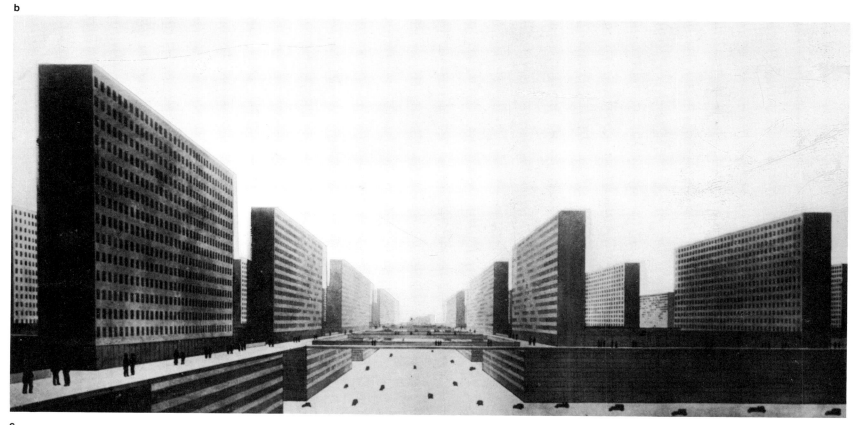

c

VORSCHLAG ZUR CITYBEBAUUNG

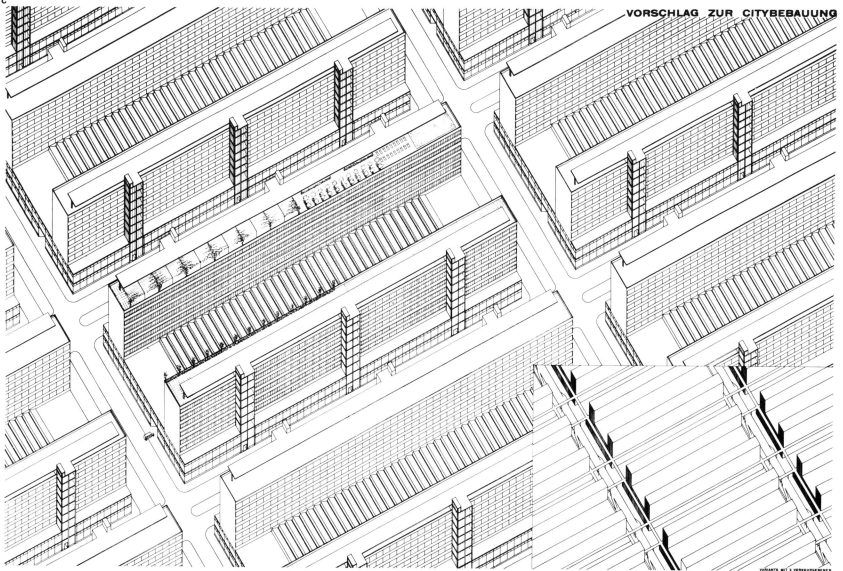

VARIANTE MIT 3 VERKEHRSEBENEN

497

a

Walter Peterhans

Peterhans was a member of the Dessau and the
Berlin Bauhaus, heading the photography de-
partment from the spring of 1929 until the clos-
ing of the Institute in the summer of 1933. He
was not only an outstanding photographer for
whom the photograph was a "painting with
light" and simultaneously a way for exact visual
reproduction; he enriched his classes with a
kind of speculative, philosophical thought pro-
cess which made purely technical problems the
component of a larger context challenging the
mind. Peterhans was born in Frankfurt on Main
on June 12, 1897. He grew up in Dresden, stud-
ied at the Institute of Technology in Munich, at
the University in Göttingen (mathematics, phi-
losophy, art history) and at the state Academy
for Graphic Arts and Book Production in Leip-
zig. After the Bauhaus era he remained in Berlin
until 1937, first working for the Reimann-Häring
School and later doing free-lance work. In 1938
he accepted an appointment to a professorship
at the Illinois Institute of Technology in Chicago
where he lectured in elementary art instruction
(Visual Training, Analysis) and art history. He
gave guest lectures at a number of American
and German universities and institutes of tech-
nology and at the "Institute of Design" in Ulm.
His publications dealt mainly with problems of
photography. Peterhans died on April 12, 1960
in Stetten near Stuttgart after he had just com-
pleted a series of guest lectures at the Hamburg
Academy.

a
Walter Peterhans. Portrait from the later years of his
life.
b
Walter Peterhans: photographic study (third variation
in a series). About 1930.
In conjunction with the composition, the (floral) sub-
ject of which is by and large alien to the materials used
(wood with worm holes, paper, textiles, gauze, and
asparagus leaf), it is the extreme sharpness of the ob-
ject more than anything else which fosters from it the
effect of an abstraction.
c
Walter Peterhans: photographic study. About 1930.
Composition with still-life qualities achieving a graphic
effect; as a part of the whole composition the objective
detail becomes secondary.
d
Walter Peterhans: photographic study, transparency
effect. About 1930.
The "floating" of the liqueur glass, the opalescent re-
flections and the graphic shadow evoke the effect of a
free artistic composition.

b

c

d

a

Alfred Arndt

Alfred Arndt, born in Elbing on November 26, 1898, studied at the Bauhaus (in the wall-painting workshop) from 1921 until 1926. Before that he had been a student at the Königsberg Academy for a short period. While studying at the Bauhaus he prepared himself for the architectural profession, to which he adhered from that time on. During the first years of private practice in Probstzella (Thuringia) he carried out prominent commissions ("Haus des Volkes"—"House of the People"—among others). He returned to the Bauhaus in 1929 as a full-time teacher and remained until the closing of the Institute in Dessau in 1932. Until 1931 Arndt was in charge of the department for interior design and in this capacity led the furniture workshop in particular. He also headed the wall-painting workshop during Scheper's leave of absence. During the last years he taught interior construction, design drawing, and perspective. From Dessau he was attracted back to Probstzella from where he moved in 1948 to Darmstadt via Coburg. There he works as painter and architect. Among his other achievements was the residence of the collector Karl Ströher.

a
Alfred Arndt in Dessau. 1929.
b
Alfred Arndt and the department for interior design of the Bauhaus: conference room (partial view) of the Municipal Savings Institution in Dessau.
Walnut furniture produced in the Bauhaus furniture workshop. 1930.
c
Alfred Arndt: Bauer House in Probstzella (Thuringia), south and east elevation. 1927–1928.

b

c

a

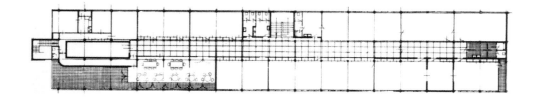

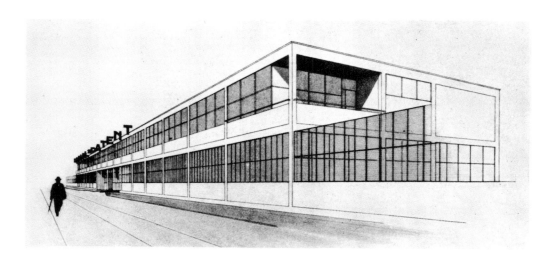

Mart Stam

Although Mart Stam taught at the Bauhaus for only a short period from 1928 to 1929 as part-time guest lecturer (one week per month, giving seminars on the elementary principles of architecture and on city planning), his significance by far exceeded that suggested by the bare facts. It was based on his clearly articulated architectural ideas and the superior quality of his own work with respect to form, which derived from Dutch functionalism ("de Stijl"). Gropius had tried to win Stam for the Bauhaus as early as 1926, but Stam preferred to stay in architectural practice. He was born in Purmerend (Holland) on August 5, 1899. He went to school in Amsterdam and then worked with architects in Rotterdam. In 1924 he was in Germany and Switzerland. Returning to Rotterdam, he worked for Brinkmann and van der Vlugt. In 1927 he attracted attention with his contribution to the Stuttgart "Weissenhof" housing development. During the following two years, which he spent in Frankfurt—this was the period during which he guest-lectured at the Bauhaus—Stam produced masterful achievements with his designs for the "Hellerhof" housing development and the "Budge-Stiftung." From 1929 to 1935 he worked in Russia and in other countries, from 1935 to 1948 in Amsterdam, where he was Director of the Institute for Art Industry beginning in 1939. The Academy of Art in Dresden appointed him Director in 1948, and in 1950 he became head of the Art Academy in Berlin-Weissensee. He returned to Amsterdam in 1953. He now spends most of his time on the Mediterranean.

a
Mart Stam. Portrait. About 1929.
b
Mart Stam: "Hellerhof" housing development (street front) in Frankfurt on Main. 1929.
c
Mart Stam: design for an office building in Amsterdam. 1928.
This design originated during the time Stam studied at the Bauhaus. The ground floor was intended primarily for offices, and the upper story for administrative quarters, laboratories, a drafting room, a cafeteria, and the custodian's apartment. According to a publication in the Bauhaus Journal of January 1929, "the fact was taken into consideration that as a rule every living and growing business concern must reorganize its structure from time to time." Construction: steel skeleton, with concrete facings.

Anton Brenner

Anton Brenner was born in Vienna on August 12, 1896, the son of a factory worker. Because of his background he became familiar at an early age with the problems of the housing conditions among the underprivileged classes. In 1914 he had to interrupt a just-begun visit to England, because of the war. He enlisted in 1915, and in 1916 was captured by the Russians. While a prisoner of war in Siberia he acquired a modicum of architectural knowledge. After the Russian capitulation he constructed a Presbyterian church and a school in Tsing-Tao. Upon his return home he took up the study of architecture at the Academy of Art in Vienna, under Behrens and Holzmeister. After conclusion of his studies he practiced architecture, with outstanding success, in Frankfurt on Main. In his capacity as Ernst May's co-worker at the municipal Department of Buildings and Structures it was his task to approve plans for housing developments in the process of construction or already in existence. His influence on the development of Frankfurt housing settlements was largely due to his conception of new plan types. One of his pet ideas was the pergola house. From spring of 1929 until summer of 1930 he headed the architecture studio at the Bauhaus in Dessau. During this period there arose, among other things, the youth home "Settlement" in Vienna. He remained active in Vienna, where he died in 1957. During the last decades of his life he distinguished himself above all as designer of housing settlements (in Vienna and Graz, inter alia) and as theoretician.

a
Anton Brenner. Studio portrait, around 1930.
b
Anton Brenner: youth home "Settlement," Vienna. View from the northeast. 1929–1930.
Shelter for homeless young people. Unified conception, including all details of interior furnishings.
c
Anton Brenner: youth home "Settlement," Vienna. Floor plans of ground floor (lower) and first floor (upper).

b

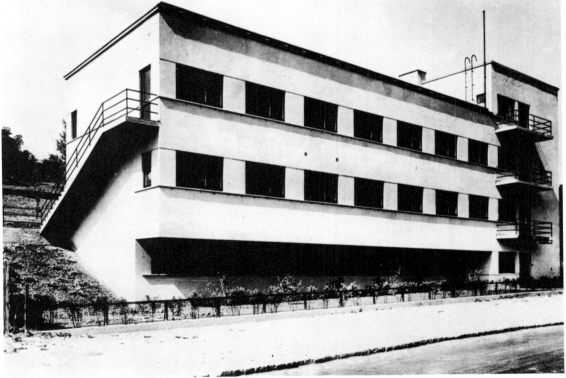

a

c

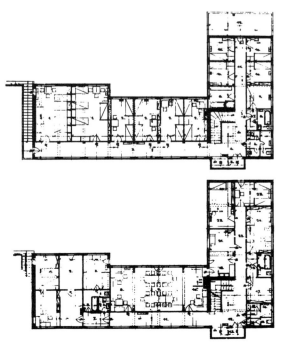

a

b

c

d

e

f

Teachers and Co-Workers

a

Karla Grosch (born in Weimar in 1904, drowned near Tel Aviv in 1933) taught physical education and was sports coach at the Bauhaus from 1928 to 1930. In addition, she danced for the Bauhaus stage.

b

Edvard Heiberg (born in Oslo in 1897, died in Copenhagen in 1958) taught at the Bauhaus from the beginning until the middle of 1930 as an architect. He designed row houses for the development in Dessau-Törten (which were not carried out). Heiberg followed Meyer to Moscow; he worked as housing-development architect and designer in Copenhagen from 1932. During the war he was imprisoned in a concentration camp. In his last years he worked on standardized plans for the Danish Building Research Institute.

c

Alcar Rudelt (born in Leipzig in 1900) had been trained as construction engineer in Dresden and in that capacity worked at the Bauhaus from the fall of 1928 until the spring of 1933. Fields of instruction: mathematics, statics, strength of materials, steel and reinforced concrete construction, engineering construction, heating and ventilation techniques. Rudelt later settled in Hannover.

d

Otti Berger (born in Vörösmart, Hungary in 1898, murdered in a concentration camp, circa 1942) entered the Bauhaus as a student in 1927. She was a weaver and played an important part in the development work that led to the designs of textiles for industrial production. During the absence of Anni Albers she was acting head of the weaving workshop for some months. Residing in Berlin, she worked with large textile firms in Germany, Holland, England, and last in Czechoslovakia.

e

Ernst Kállai (born in Szakalháza, Hungary, in 1890, died in Budapest in 1954) edited the Bauhaus Journal from 1928 to 1929. He was in America for a short time before 1914 and in Germany from 1920 on; he became known for his books, such as "Neue Malerei in Ungarn" ("New Painting in Hungary"—1925), lectures and essays (in the "Weltbühne"—"World Stage"—among others). Since 1935 in Budapest; in 1946 he was appointed professor at the Arts and Crafts Academy.

f

Anni Albers, née Fleischmann (born in Berlin in 1899) studied at the Bauhaus from 1922 to 1930. After February 1930 she held a part-time teaching post at the Bauhaus weaving workshop. In the fall of 1931, after Gunta Stölzl's resignation, she became temporary head of the workshop. Her special achievement lay in the systematic investigation of weaving materials. In 1933 she emigrated to the United States with her husband, Josef Albers, and until 1949 was assistant professor at Black Mountain College, N.C. She carried out large-scale commissions, published articles and books concerning weaving, and exhibited her work. Anni Albers at present lives in New Haven, Conn.

Preliminary Course

Josef Albers, who was head of the entire preliminary course following the resignation of Moholy-Nagy, readjusted his methods year by year according to newly gained experience. The workshop instruction conducted by Albers himself was supplemented by the introductory courses into the principles of artistic design given by Kandinsky and Klee, by practical exercises in objective free-hand drawing and figure drawing as well as in lettering, which was chiefly Joost Schmidt's responsibility, and by a series of introductory lectures in the natural sciences. The analogous elementary instruction in drawing was continued in 1928–1929 in Schlemmer's seminar on "Man" (life drawing and figure drawing).

a
Student in Albers's preliminary course: reorganization of a given structure. About 1928.
Out of a sheet having black and white stripes of equal width a circular field has been cut out. In this field a new organization is created by additional cutting and reassembling.

b
Student in Albers's preliminary course: construction with a typewriter. About 1928
One of the first exercises of this type. The viewer's attention is drawn to the positive volume (pyramid at left), which appears to be statically secure, rather than to the negative one. This gives him a more enjoyable sensation. The upside-down pyramid (right) appears negative (empty) and transparent.

c
Student in Albers's preliminary course: construction with a typewriter. About 1928.
The cubelike structures (above) have a three-dimensional effect on the observer. Their reduction to the purely two-dimensional form becomes possible after a while only; the illusion of three-dimensionality continues to assert itself. The lower image attempts to create the impression that the zigzag, ribbon-like structure penetrates the transverse one.

d
Student in Albers's preliminary course: typofacture study with materials on the phenomenon of optical illusion (apparent three-dimensionality). Printed paper (stock-market report), distorted. About 1928.
Here the distortion represents a means of expression: The stock exchange about which the clipping reports has begun, in a manner of speaking, to stagger; the originator of this work appears to doubt the stability of the exchange.

e
Student in Albers's preliminary course: series of a given image (banknote) by means of successive cutting and reassembling. About 1928.
At the bottom is the original banknote, a worthless bill Irom the inflation period. Above it there are illustrated several possibilities for modification: expansion toward the height (left panel), toward height and breadth (center panel), and maximum distortion approaching the limits of recognition (right panel).

b

c

a

d

e

a
Ursula Schneider (Albers's preliminary course): study with materials and center of gravity. Wire mesh, cellophane, rubber. About 1928.

b
Alphons Frieling (Albers's preliminary course): material study with aluminum plate. 1927–1928.
A flowerlike structure is produced out of a rectangular aluminum sheet by means of cutting. Emphasis on economy of material (cut from a rectangle without waste) and of labor (the only tool used was tin shears; outside of the mounting on a base there is only a single work process). At the same time determination of stability (finding the maximum height).

c
Student in Albers's preliminary course: material study with wire netting. About 1928.
The material used was wire netting cut on the bias. The possibilities of shrinkage were to be examined. By compressing the corners of the net, forms reminiscent of organic structures were created.

d
Student in Albers's preliminary course: material study with wire and glass. About 1928.
Wire constructions, stabilized and balanced by insertion of glass panels, enabling them to stand upright.

e
Student in Albers's preliminary course: material study with metal sheeting. 1927–1928.
The problem was to investigate the possibilities of point contacts in metal. The minimal connecting joints that result from cutting sheet metal into strips are sufficient to hold these together, despite the fact that the material is further stressed by the bending at the contacts.

f
Takehito Mizutani (Albers's preliminary course): plastic abstraction of copper sheeting. 1927–1928.
Three metal parts, so cut and formed (bent) and inserted into one another that balance is achieved. In this study, artistic and esthetic values are an essential consideration.

b

a

c

d

e

f

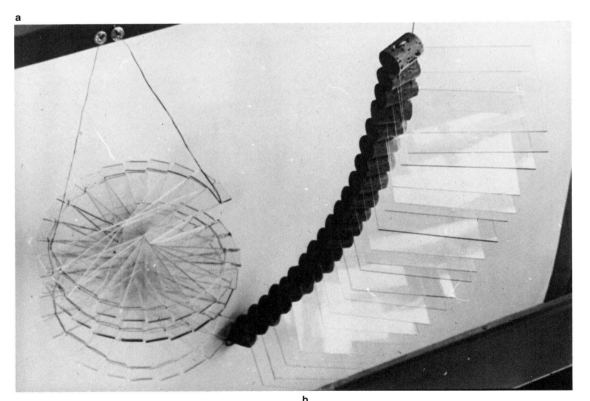

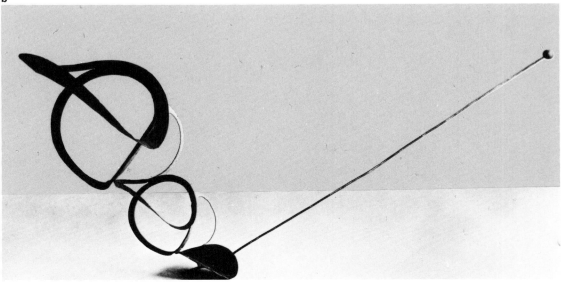

a
Student in Albers's preliminary course: material studies with glass and thread and with glass, corks, and wire. About 1928.
Investigation of possibilities for hanging. Left: a series of glass strips of equal dimensions, held together and suspended by a thread (seam), produces the effect of a circular staircase. Right: This structure also retains its form only when suspended. Glass panes (photographic plates) are forcibly inserted by one corner between bottle corks that are pierced by a wire. The weight results in bending the entire suspended structure.

b
Student in Albers's preliminary course: balance exercise in metal. 1927–1928.
Study of the question of perfect balance. Weight and leverage.

c
Student in Albers's preliminary course: studies concerning positive and negative forms. Hammered metal sheeting. About 1928.
Rectangular metal sheets are so modulated by hammering that they assume torso-like shapes. They combine negative and positive half-cylinders within themselves. Investigation of optical, three-dimensional possibilities and effects.

Commercial Art Department
(Printing Workshop, Exhibit Design)

Under Joost Schmidt—who also instructed the beginners in lettering and headed the sculpture workshop—the printing workshop was enlarged in the direction of commercial art and exhibit design. Advertising work came to the fore. The design problem arose from the task of informing and influencing the public through the use of printed matter, cultural and commercial displays, in writing, and through pictures. In this connection, exhibit design proved to be Schmidt's very own field. He developed principles of architectural and typographical arrangements which were suggestive and capable of variation and therefore have remained basic for several decades. Opportunities for practicing the new exhibition style were provided, above all, by some large commissions from firms. Thus, the Bauhaus commercial art department carried out, among others, the displays for the Junkers Works at the exhibitions "Gas and Water" in Berlin and "Home and Work Environment" in Breslau and the stands for the canned-goods industry at the Dresden "International Hygiene Exhibition." These were prominent events, fully covered by the entire German press. The commercial art department also had commissions to design posters (for example, for a large cigarette company and a chocolate factory). They designed printed advertising matter for firms in various categories.

In the typography of the period after 1928 one notices a considerable increase in the range of variation. During the first years at Dessau the problems of typographical design were dealt with in a comparatively dogmatic way: Bayer first had to eliminate the residues of a Dadaistic toying with forms and to bring out the elements appropriate for the Bauhaus. Thus, his successor, Joost Schmidt, found a secure base, able to assimilate enrichment and capable of sustaining it. He introduced, in his promotion matter in particular, new and sometimes alien elements, recognizable as such, so that they would function as tension factors. On occasion Schmidt even set some words or sentences in decorative letters or script. A number of firms took advantage of the striking—and psychologically shrewd—effect of Bauhaus designs for promotional printed matter. The advertising leaflets were compositionally coherent and yet differentiated in their individual elements, and thus were impressive. Larger commissions were carried out for textile and metal companies, for a firm in the wood industry, and for the manufacturer of the Bauhaus wallpaper. Good examples were the designs for two prospectuses for the Dessau travel agency. As early as the end of the 'twenties, Bauhaus advertising layout had a measure of influence on commercial art in Germany much greater than its dissemination would lead one to assume.

Commercial art department of the Bauhaus: posters from the years 1929 and 1930.
a
Examples of typographical designs, executed either as commissions or on the occasion of the Bauhaus traveling exhibition and the last tour of the Bauhaus stage.
b
Joost Schmidt: design for an advertisement for Bauhaus wallpaper. India ink. About 1930.
Bauhaus-Archiv, Darmstadt.
c
Joost Schmidt: the letters MOP in parallel perspective, in mirrored shadow construction. Water color and pen-and-ink. About 1930.
Germanisches Nationalmuseum, Nürnberg.

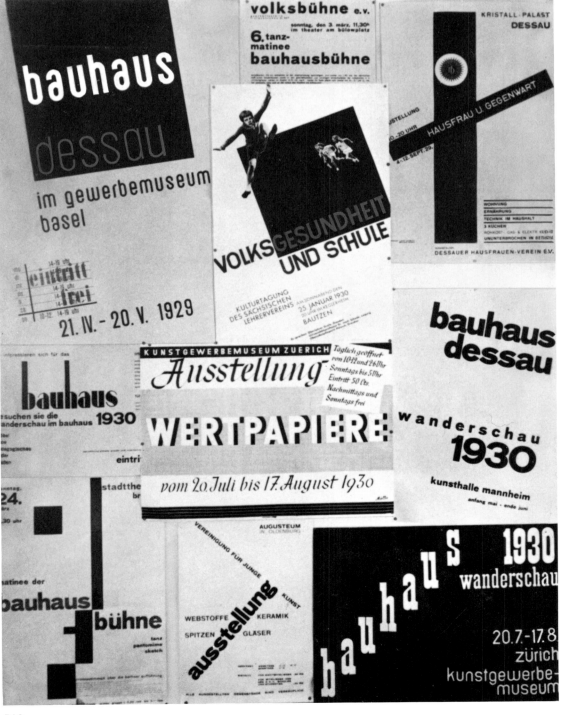

a

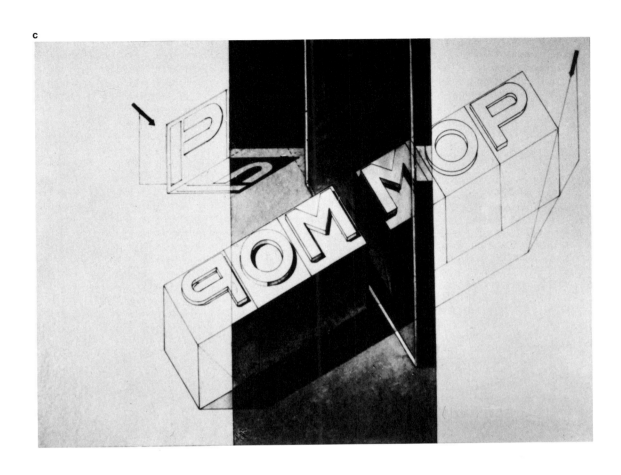

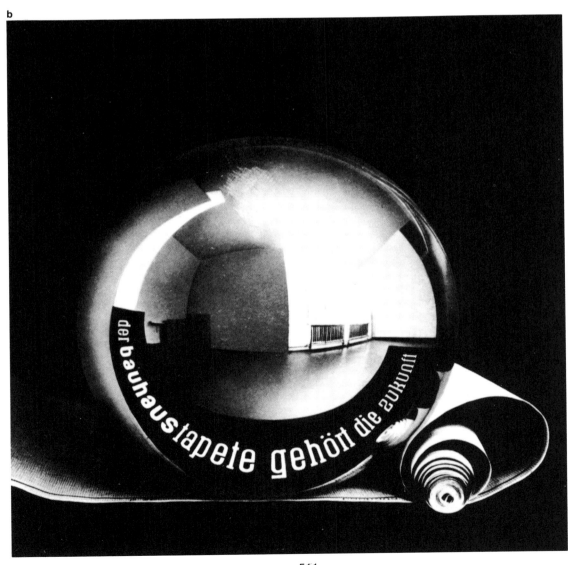

Joost Schmidt developed his technique of compiling different typographical and visual elements in the design of advertising pamphlets and exhibition stands to a high level of artistic and commercial psychological impressiveness. Of the pamphlets he designed, the one for the Dessau travel agency in 1930 was visually the richest and most complex. He carried out his most important commission in an exhibit design for the Junkers Works in 1929, together with the commercial art department and in conjunction with the cabinetmaking, metal, and sculpture workshops. The commission consisted of the design and construction of a stand 40 meters long and subdivided into a number of boxes, for a Berlin exhibition called "Gas and Water." Joost Schmidt apportioned the design work: Xanti Schawinsky was given the advertising painting job in the narrow sense of the term (especially at the entrance and on the outer wall of the stand); Schmidt himself did the design of the "scientific, technical propaganda" (put up in the boxes); Johan Niegeman was made responsible for the architectural design. The display stand was received as such a coherent and exemplary achievement that it was kept over "as a demonstration of the advertising design of the Bauhaus" for the International Advertising Exhibition" which was held on the same premises.

In 1930 the Bauhaus was commissioned by the "Industrial Association of Canned Goods Manufacturers" (Berlin) to design and build a display stand advertising the Association at the "International Hygiene Exhibition" in Dresden. Joost Schmidt's ideas were carried out by the commercial art department with the aid of the cabinetmaking, metal, and sculpture workshops, as had been done the previous year with the display stand for the Junkers Works.

Here, too, Schmidt's superior exhibition technique became evident. In every case, he approached the formal design of the display from the given data, the exhibitor's communication intentions. Garish advertising was avoided. Schmidt preferred "objective" advertising achieved by explaining facts—which at that time was quite unusual. Scientific, economic, and technical data were reproduced on synoptical tables and in part effectively illustrated. The size of the plates was based on a module enabling them—and all the demonstration material—to be incorporated into an (imaginary) grid system, integrating everything coherently and yet letting the particulars stand in their own right. The module was altered from one commission to another, always corresponding to the subject.

a
Joost Schmidt: cover page for an advertising pamphlet by the Dessau tourist office. 1930.
The typesetting was done in the printing workshop of the Bauhaus. The print was black and red.
Copy in the Bauhaus-Archiv. Darmstadt.
b
Xanti Schawinsky: painted posters at the entrance to the display of the firm Junkers & Co. (Dessau) at the "Gas and Water" exhibition in Berlin. 1929.
Implemented by the commercial art department (including the printing workshop) in conjunction with a number of other Bauhaus workshops.
c, d
Joost Schmidt: display stand of the Industrial Association of Canned Goods Manufacturers (Berlin) at the International Hygiene Exhibition in Dresden. 1930.
The work was carried out by the commercial art department (including the printing workshop) in conjunction with the cabinetmaking, metal, and sculpture workshops of the Bauhaus.

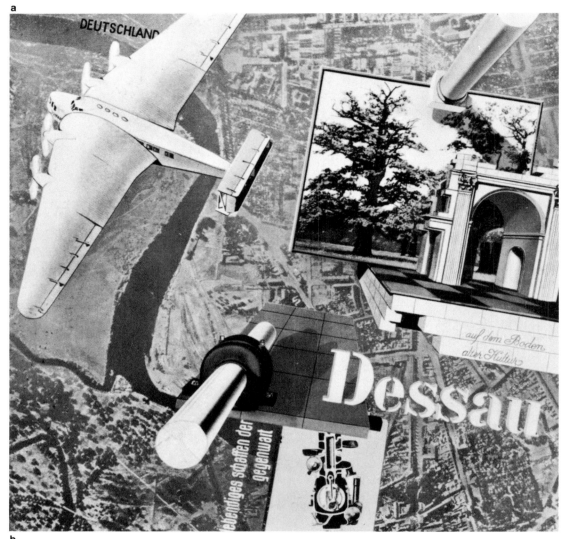

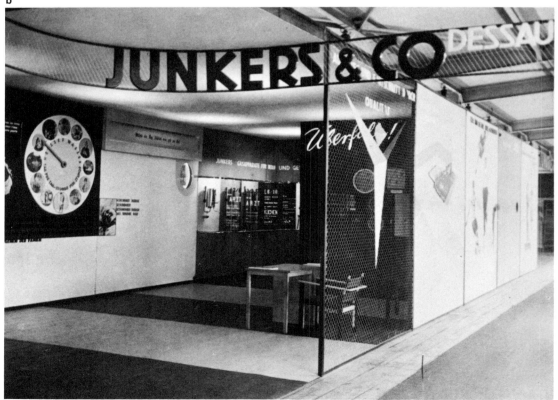

c

d

Cabinetmaking Workshop
(Furniture Workshop)

Under Josef Albers who was in charge of the
workshop in 1928 and 1929 and under Alfred
Arndt who headed it thereafter until 1931, the
cabinetmaking workshop was primarily con-
cerned with the development of low-cost and
practical furniture which would also fit into the
environment of a modest home. A Bauhaus
"Volkswohnung" (people's home) that an-
swered such requirements was shown in ex-
hibitions: furniture with clean lines and a rea-
sonable price for everyone. The originators of
the new models in general remained anony-
mous. Albers himself worked at perfecting his
bent-wood armchair in particular, which he had
already designed in its principal features. This
chair has become an oft-copied and varied pro-
totype for other furniture designers. Arndt
chiefly worked on problems of unit furniture and
standardization.

a
Bauhaus cabinetmaking workshop: desk (model ti
207/217). Wood. 1929.
This desk is composed of a table (ti 207) and a drawer
unit (ti 217).
b
Bauhaus cabinetmaking workshop: drawer unit
(model ti 217). Wood. About 1929.
The front section is pulled up and slides in above the
top drawer; drawer shelves and file rack can be pulled
out.
c
Bauhaus cabinetmaking workshop: folding deck chair
with transverse fabric (model ti 240). Wood, fabric.
1929.
Shown here set up and folded.
d
Josef Albers: armchair (model ti 244), disassembled.
Bent wood, spring upholstery, tubular steel. 1929.
e
Josef Albers: armchair (model ti 244) assembled.

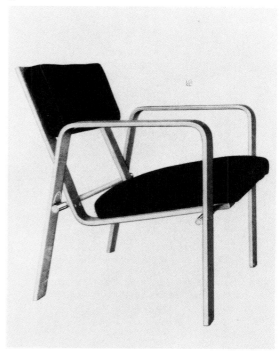

e

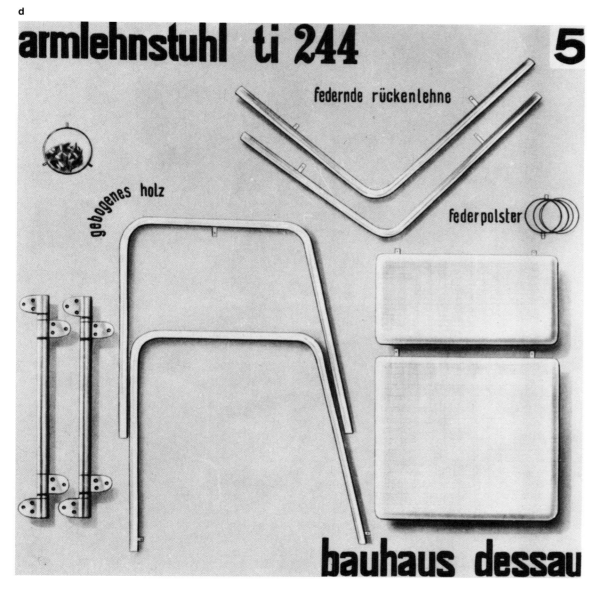

d

armlehnstuhl ti 244

5

federnde rückenlehne

gebogenes holz

federpolster

bauhaus dessau

a

a, b, c
Members of the cabinetmaking workshop (workshop for interior design): folding chair. Tubular steel and plywood. 1930.
The illustrations show the chair folded up (top), being unfolded (center), and set up ready for use (bottom).
d
Hinrich Bredendieck: chair. Tubular steel and plywood. Produced in the workshop for interior design. 1930.
e
Members of the cabinetmaking workshop (workshop for interior design): small writing and work desk. 1930.
The chair (in front of the desk) is made by the furniture company Thonet. The photo shows a corner of one of the dormitory rooms for the participants of courses at the union school of the A.D.G.B. (General Federation of German Trade Unions) in Bernau near Berlin.
f
Members of the cabinetmaking workshop (workshop for interior design): "Bauhaus bedroom" on display in the traveling exhibition of the Bauhaus in 1930.
This is an example of the "Everyman's furnishings" composed of Bauhaus models and standard commercial furniture (i.e., chairs by Thonet). On display, with others, at the Arts and Crafts Museum of the city of Zurich.
g
Members of the cabinetmaking workshop: "Bauhaus Volkswohnung" consisting of a living room, a bedroom (in the background), and kitchen. 1929.
The furnishings for a "Volkswohnung," composed of various Bauhaus furniture models, were shown in September 1929 in Leipzig for the opening of the Grassi Museum.

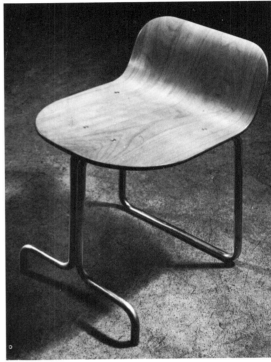

d

b

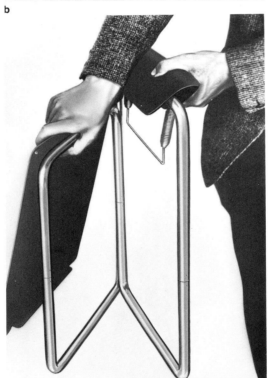

c

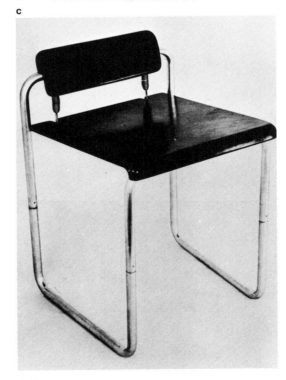

e

f

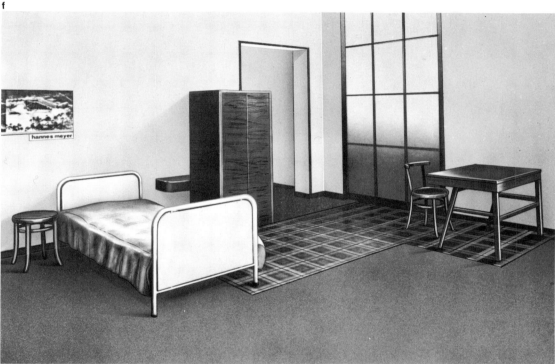

g

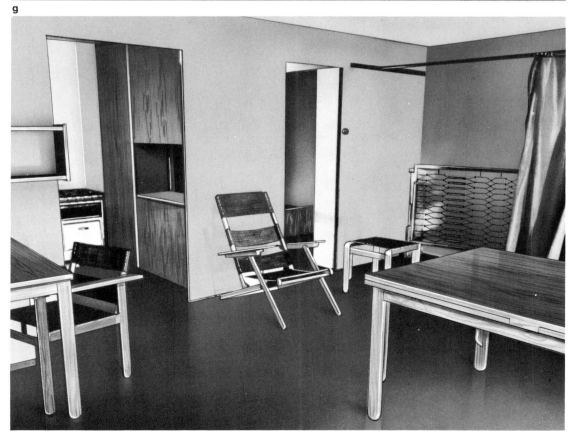

a

Department of Wall Painting: Bauhaus Wallpaper

Following a suggestion by and based on a commission given by the wallpaper manufacturer Rasch Brothers & Co. (Bramsche near Osnabrück), Bauhaus wallpaper was designed by the department for wall painting beginning in 1929. At first the development and design were supervised by Arndt, for Scheper, having established the principles, was on leave of absence from the Bauhaus during this period. Scheper was in charge beginning in 1931. The leading thought was to produce a wall-covering material that would be appropriate for modern home architecture, fair in price, and hence suitable especially for the more modest apartment and development house. Thus the designers were given the opportunity of transferring the specific color range of the painting work at the Bauhaus and the texture effects accomplished with plaster, to paper, and hence to a material which was inexpensive to produce and easy to use. "We were thus able to popularize and to generalize our way of treating walls and our principle of interior design by way of mechanical reproduction in an industrial product, available to everyone." (Bayer—Gropius, "Bauhaus 1919–1928.") Success justified the experiment. During the first year, Rasch produced four and one half million rolls of wallpaper. The royalties received from the sale of wallpaper, made from Bauhaus designs, became one of the most important and during the last years even vital factors in the budget of the Institute. The permanent commission to design wallpaper was supplemented by contracts for the design of advertisements by the commercial art department.

b

a
Bauhaus wallpaper. Design: department of wall painting. Manufacturer: Rasch Brothers & Co. From the selection 1930–1931.
"In accordance with the philosophy of the Bauhaus the pattern is quiet and reserved, the colors are exclusively light and are based on a common color scale. . . ." (From a prospectus by the manufacturer, 1930).

b
"Bauhaus—the modern card." Cover of a prospectus by the wallpaper company Rasch Brothers & Co. Design and setting by Joost Schmidt and the commercial art department (printing workshop) of the Bauhaus. 1930.

Weaving Workshop (Textile Department)

For the weaving workshop the late nineteen twenties meant an intensification of the effort of cooperating with industry. This workshop had probably been dominated more and longer than the other craft workshops by a desire for artistic-esthetic design. Now it too acquired the character of a "research laboratory" (to quote a term often used at the Bauhaus). Materials that had not previously been utilized for textiles were used experimentally. The experiments examined possibilities of technical improvements (for instance with respect to the wear and tear quality of the material) and development of fabrics for special purposes. Contact with scientific laboratories was established. The weaving workshop periodically issued textile samples for mass production by some of the larger firms in the textile industry. The designs of these fabrics were characteristic, typically Bauhaus, but despite the uniform basic attitude expressed by them, they were diversified. The workshop received independent and capable leadership from Gunta Stölzl. Those who were able to follow the differentiated theoretical lectures with which Paul Klee supplemented the instruction in the weaving workshop found essential enrichment in them. But the general tendency was decidedly in favor of the practical aspects.

a
Bauhaus weaving workshop (anonymous): five upholstery fabrics for furniture. About 1929.
The design was determined chiefly by the works of Gunta Stölzl. The material was usually about 1½ yards wide and cost between 13.80 and 23.00 RM per yard.

b
Anni Albers and the Bauhaus weaving workshop: ribbed, silvery drapery material for the union school of the labor union A.D.G.B. in Bernau near Berlin. Front with cellophane (increasing light reflection), back with chenille (sound absorption), cotton warp. 1929–1930. The level of daylight reflection was established experimentally in cooperation with the Zeiss-Ikon Goertz Works (Berlin).

a

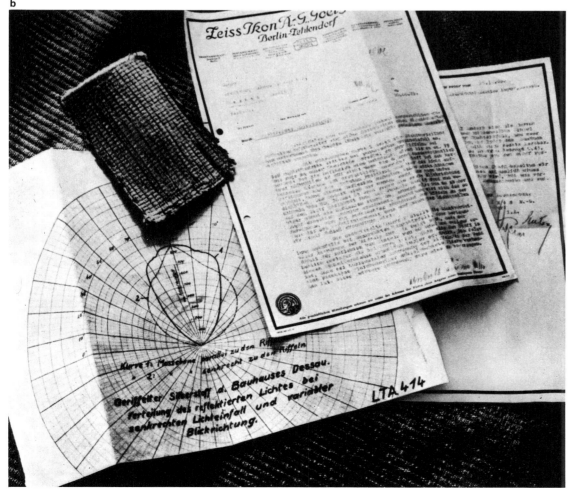

b

Bauhaus Stage

The extent to which the Bauhaus stage was the work of Oskar Schlemmer was demonstrated when he left the Bauhaus about the middle of the year 1929 to assume his professorship at the Breslau Academy. He had given the Bauhaus stage content and profile. After his departure, the position of the head of the workshop remained vacant and its activities were in fact discontinued, though some students tried to continue the work in their "Junge Bühne am Bauhaus" ("Young stage at the Bauhaus"). Schlemmer's own experiments and those of the students inspired by him were just one part of his contribution enriching the activities of the Bauhaus. For demonstrations of modern dance—and the dance constituted the substantial core in his concept of the stage—he brought to the Bauhaus prominent guests such as the dancer Palucca. Thus the Bauhaus became a center for the intellectual challenge of the problems of avant-gardistic dance creation. During the last years that he was a member of the Bauhaus and its stage workshop, Schlemmer brought the various productions to perfection—by and large they dated from before 1928—so that they became artistically and technically exemplary performances, ready to be shown to even the most sophisticated audiences. In June of 1928 the Bauhaus stage performed at the Second German Congress of the Dance in Essen. During a tour beginning in February 1929 and lasting several months, it exerted its strongest direct influence, felt by some to be a provocation. The stops on that tour were Berlin (Volksbühne), Breslau (Stadttheater), Frankfurt on Main (Schauspielhaus), Stuttgart (Landestheater), and Basel (Stadttheater). In Breslau Schlemmer continued his stage work. The effects of his conception of the stage, implemented by him at the Bauhaus and demonstrated on tours, were soon felt elsewhere.

The repertory shown on the 1929 tour was quite extensive. It consisted of short, individual pieces, being a particularly striking show of Schlemmer's intentions: the "Dance in Space," "Dance of Forms," "Dance of Gestures," "Dance of the Stage Wings," the "Box Play," the "Dance of Slats," the "Dance in Metal," "Dance with Glass," "Dance of Hoops," "The Wives' Dance," and the "Company of Masks" (which had received much attention at the Dancer's Congress in Essen the year before); all these were on the program. In a number of cities sketches like Schlemmer's "House Py" and the students' own burlesque stage piece "3 against 1" were performed in addition. Elements of the Bauhaus stage productions were occasionally taken over, accepted, and copied by other dance and acting groups and were even filmed. For instance, unmistakable variations on Schlemmer's masks reappeared in one of the Utopian films of the late nineteen twenties and the most successful dance pantomime of the years around 1930. "The Green Table" by Kurt Jooss, reminded one more than just superficially of the "Company of Masks." Nevertheless, Schlemmer's stage work was not developed further at that time along logical, intellectually founded lines. His achievements remained the subject of heated discussions. They were brought back to the stage in the nineteen fifties, as part of an attempt at an "absolute" design for the dance.

a
Oskar Schlemmer: "Dance in Metal," performed by Karla Grosch. 1928–1929.
Part of the repertory of the Bauhaus stage on its tour in 1929.
b
Oskar Schlemmer: dance pantomime "Company of Masks." Performed by members of the Bauhaus stage. 1928–1929.
The pantomime was shown in Essen in 1928 and on the tour of the Bauhaus stage in 1929. This piece was also entitled "Chorus of Masks" (the names for most of the pieces were occasionally altered slightly).
c
Bauhaus stage: "3 against 1." Cooperative project by the group "the Young Stage at the Bauhaus" with Karla Grosch ("girl"), Georg Hartmann ("policeman"), Werner Feist ("criminal"), and Albert Mentzel ("gent"). 1928–1929.
Performed in Dessau in 1928, and in Berlin, Breslau, Frankfurt on Main, and Stuttgart in 1929.

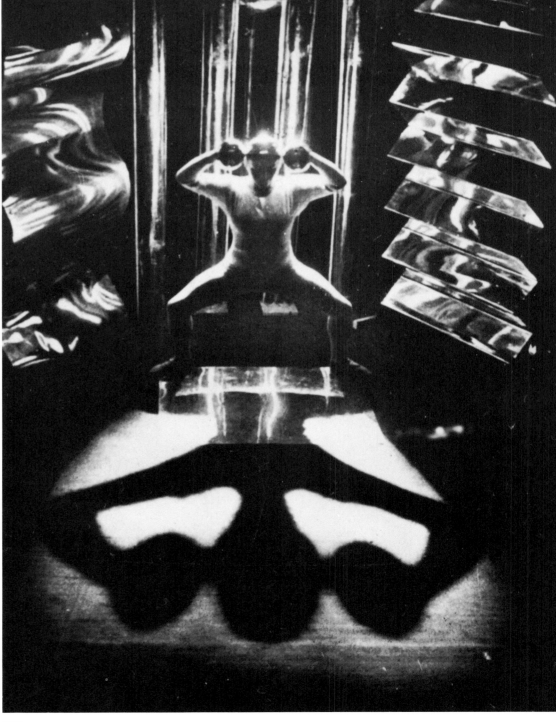
a

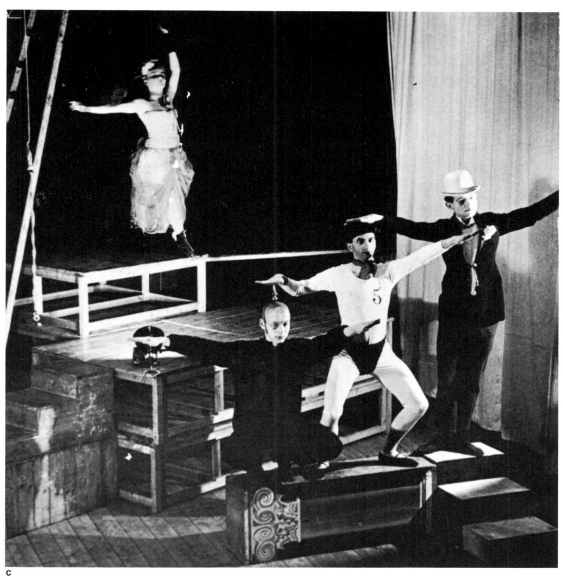

c

b

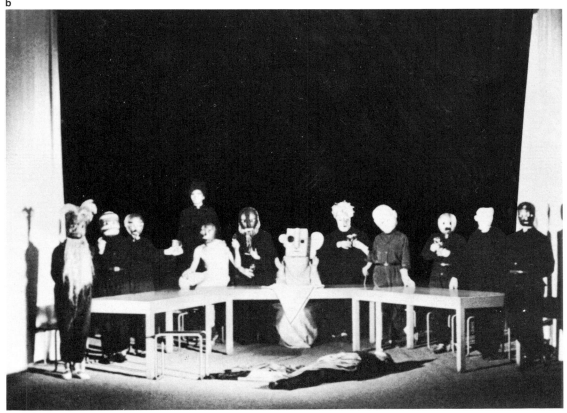

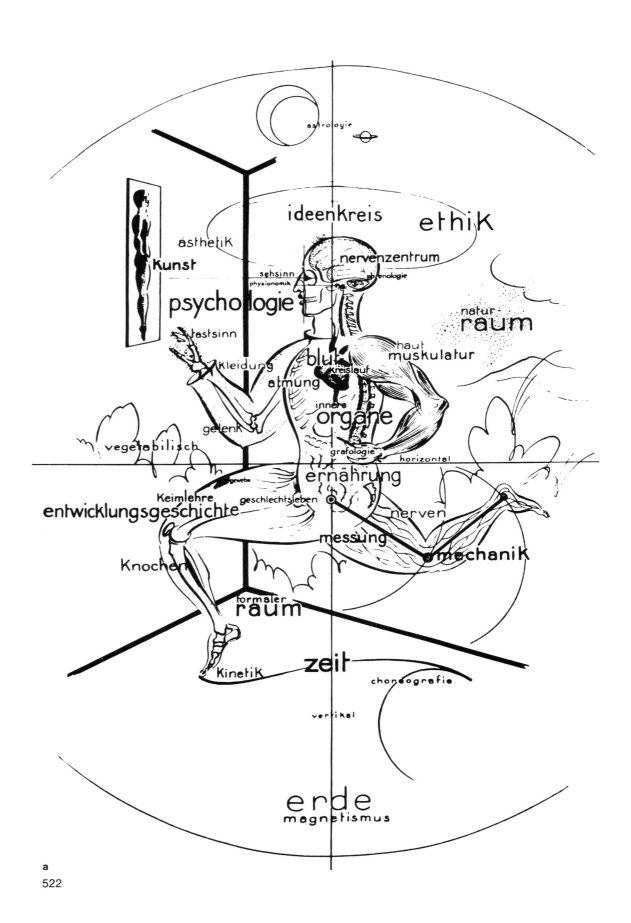

Schlemmer's Course: "Man"

In the summer of 1928 and the winter of 1928–1929 Schlemmer conducted a course, compulsory for students of the third semester, on "man." This class had been preceded since the winter of 1928–1929, by a course in figure drawing—the schematic rendering of the human body. Life-drawing in the narrower sense of the word was always practiced in the Bauhaus independently of this course. The broader view of 'man' conceived him as a totality, as the unity of body, soul, and spirit. Thus, the course on "Man" was divided into formal, biological, and philosophical parts. Schlemmer himself explained (Bauhaus Journal 1928, number 2–3): "Within the course these three parts run next to each other in turn, only to unite finally into the totality of the term 'man.' The part dealing with figural rendering, mainly one of drawing, deals with schemata and systems of lines, planes, and body sculpture: the standard measures, the theory of proportions, Dürer's measurements, and the golden section. From these develop the laws of movement, the mechanics and kinetics of the body, within itself as well as in space, in the natural as well as in the cultural sphere. . . . The paths of movement, the choreography of every day, form a transition to the conscious, shaped movement in gymnastics and the dance, and further to the art form of the stage. Analyses of figural renderings in old and new art conclude this section. The natural-science part begins with the mysteries of the world, ether and plasma, and deals with the theory of cells and seeds, birth and growth, life and death. The organization of the joints of the skeleton, the functions of the muscles, the internal organs (and their functions) are illustrated from a biomechanical and biochemical point of view . . ." The course made painstaking inquiries into sensory perception. The philosophical part considered man as a "thinking and feeling being" in his world of conceptions and ideas and in the struggle of politico-philosophical views. Drawings and diagrams added a visual element to the theoretical investigations. Life-drawing from a model (usually one of the students), was scheduled for the evening before each class on "man."

a
Oskar Schlemmer: schematic survey of the field of instruction "Man." 1928–1929.

(Explanations in the figure:)

astrologie	= astrology
ideenkreis	= sphere of ideas
kunst	= art
nervenzentrum	= nerve center
sehsinn	= sense of vision
physionomik	= physiognomy
phrenologie	= phrenology
psychologie	= psychology
naturraum	= sphere of nature
tastsinn	= sense of touch
kleidung	= clothing
blutkreislauf	= blood circulation
haut	= skin
muskulatur	= muscular system
atmung	= respiration
innere organe	= internal organs
gelenk	= joint
vegetabilisch	= vegetal
grafologie	= graphology
horizontal	= horizontal
gewebe	= tissue
ernährung	= nutrition
geschlechts-leben	= sex life
keimlehre	= embryology
entwicklungsge-schichte	= development
nerven	= nerves
messung	= measurement
knochen	= bones
mechanik	= mechanics
formaler raum	= formal space
kinetik	= kinetics
zeit	= time
choreografie	= choreography
vertikal	= vertical
erde	= earth
magnetismus	= magnetism

ästhetik	= esthetics
ethik	= ethics

b
Schlemmer's course: synoptical table on the biological part of the topic "Man". 1928–1929.

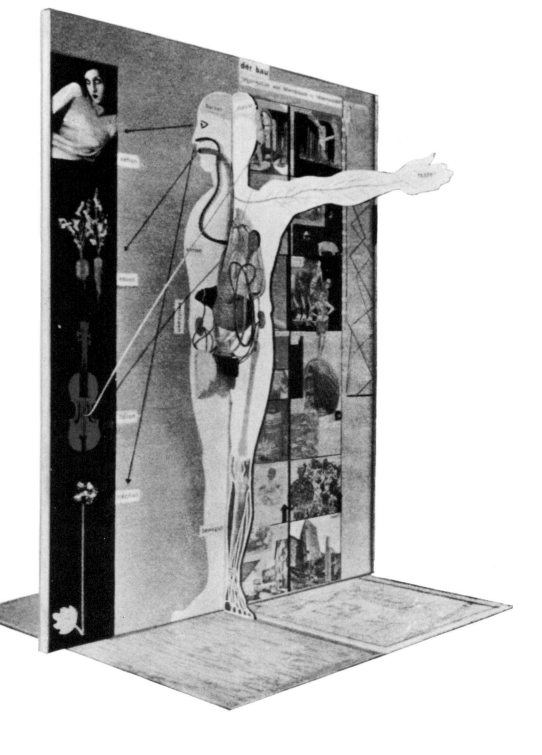

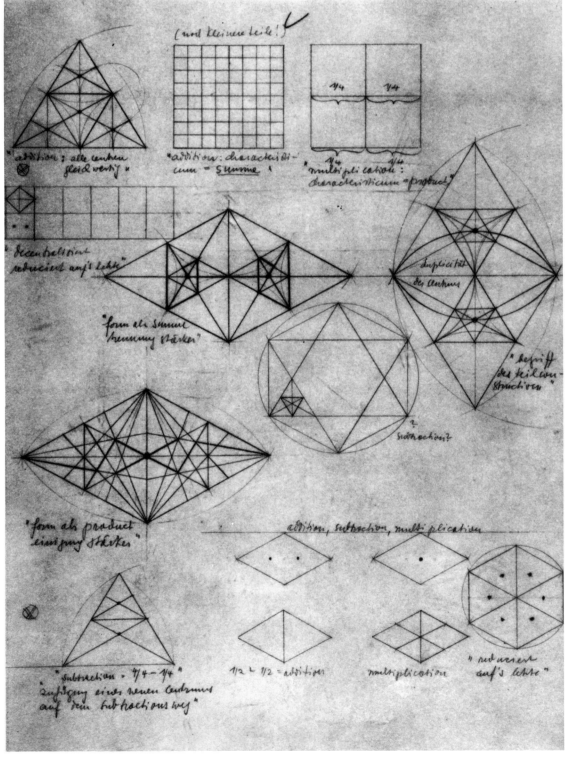

a

Paul Klee's Course

During the period in the development of the Dessau Bauhaus between 1928 and 1930 Paul Klee's pedagogical obligations were very extensive. In addition to an elementary course on problems of artistic design, already given during the Weimar period, he delivered lectures specifically for the weaving workshop (for all semesters simultaneously) and held a class for free painting. Thematically his teaching was generally divided into form theory, developed in his lectures, and analysis of paintings and drawings, which he carried out in the free painting class. The fundamental lectures on artistic design were conducted for students of the second and third semesters. Klee himself characterized his courses as being "familiarity with the means of form." He began with problems of geometry and stereometry to lead the students to visual phenomena. "The way the problem was posed often sounded like the formula of a mathematician or physicist, but, considered carefully, it was pure poetry," writes Helene Nonné-Schmidt. Klee was concerned with the origins of form, with the realization of the possibilities and laws of its transformation and development. "This teaching was more than a mere presentation of the means of form: it encompassed the whole human being, for it called upon him to take part, to share in the experience, to become clear in his mind about the elemental, the primeval phenomena ('Urphänomene'). The invisible became visible, roots [were] uncovered, and sources revealed. Fundamentals were imparted, orientation in the province of form. . . ." Klee made it clear that behind and above the rational factor on which he had to base his demonstrations there stood the element of intuition, and that that element is both the primary and the final criterion in all creative activity.

"There was," reports Helene Nonné-Schmidt further on the studies with Paul Klee, "a fortunate division of his courses into two sections . . . for the students who were working as free painters. One part consisted of theoretical instruction in the means of design, meaning form and color theory, and the other of criticism of work in the class for free painting. Here one had to explain the intentions behind one's work and with what means one thought these to have been implemented. Klee took a small slate and with a slate-pencil drew on it what should have happened to have accomplished the desired effect, debated this with his small audience, erased it again, and left the student to draw his own conclusions from it. . . . For two semesters, during the years 1928–1929, the theme for the theoretical courses in free artistic design was 'the three-dimensional' ('das Räumliche'). As the most obvious example, Klee chose the cube. He explained this phenomenon in such a way that it relinquished its 'thing-character' and turned into a partly active and partly passive personality. In minutely detailed operations every part was scrutinized and palpated, examined from the outside and the inside, the internal space explored, from the center of the axis, constructed in that space, outward to the exterior surfaces, and eventually the now familiar space configuration regarded from the outside; but what had happened in the meantime: subdivisions into the smallest cells, determination of their special character as seen from the inside and the outside, bracing of planes into points of junction in space, partitions drawn from all sides, diagonal stairs built and climbed, cubes of various different positions working together within the major cube—all that done with the tools of the painter, with point, line, and plane, with light and dark and color (dimension, weight, and quality peculiar to these means). The result corresponded to that arrived at by the computing scientist, but full of life, since it was won with the means of art . . ." (quoted from the exhibition catalogue "Die Maler am Bauhaus" ("The Painters at the Bauhaus"—Munich, 1950.)

c

Klee's course, lecture in the weaving workshop: "addition—subtraction—multiplication—sum." Demonstrations on the origin of form.
Entries in the notebook of Helene Nonné-Schmidt. 1928.

b

Klee's course, "Artistic design": "Change of position" —its importance for distance and height. Demonstration on the theme "the three-dimensional." From the lecture of June 22, 1929. Entries in a notebook of Helene Nonné-Schmidt.

c

Klee's course, "Artistic design": "Striving upward, growing upward . . ." Demonstration on the theme "the three-dimensional." From the lectures of June 22, 1929. Entry in a notebook of Helene Nonné-Schmidt.

c

Independent Work by the Students

"It is . . . not uninteresting to note that what is being done at the Bauhaus in Dessau is not just building and not just workshop production for the manufacture of practical commodities. People are painting as well. Shoulder to shoulder with the imposing reinforced concrete configurations and glass planes, in the shadow, so to speak, of these intellectually cool, function-devoted and industrially-esthetic strutting space structures. Were the legendary devil to look into the rooms and studios of the Bauhaus members at night, he would be surprised at the many painters standing in front of their easels dabbling at paintings, here and there and everywhere . . ." (Ernst Kállai in "Der Kunstnarr"—1929, number 1).

"During the early years of the Bauhaus in Dessau all energies were enlisted for the practical implementation of the theoretical knowledge developed in Weimar," observes Ludwig Grote in the Bauhaus Journal of 1928 (number 2–3, "Junge Bauhausmaler"). "First, the practical, the purely rational had to be completely to the fore in Dessau. . . . When the needs of the day receded and the important tasks were fulfilled, then the irrational, the artistic element which alone represents the driving force of vigorous development and forestalls lifelessness of structure and technique, was freed again. A large number of the masters and heads of workshops as well as of the older journeymen and students turned out not to have been dreaming of living for practical work entirely; in the meantime they had taken up their painting activities again." During the Meyer era, however, justification of free artistic production was still being questioned—now the chief argument was of a social nature—but at the same time painting classes under the direction of Kandinsky and Klee were put into effect and almost every month the Bauhaus conducted exhibitions of student art work. There were several talented students there, including Fritz Winter and Hermann Röseler. Exhibitions of the young painters at the Bauhaus in art galleries and art clubs, for instance in Dessau and Halle in 1928 and in Braunschweig in 1929, testified that the Bauhaus was more than just a "laboratory" for the development of standard products and rational building methods. They proved that it was an art institute, that it received its vigor not least of all from the Muses.

The paintings reproduced on these two pages were shown in 1928 at an exhibition of young Bauhaus painters at the Artists Club in Halle (Saale).
a
Fritz Winter: "Drover." Oil on Japanese paper. About 1928.
b
Fritz Winter: "Coal." Oil on Japanese paper. About 1928.
c
Fritz Kuhr: watercolor. About 1928.
d
Lou Scheper: "Port." Oil on canvas. About 1928.

Daily Life and Festivities

Life at the Bauhaus was never isolated from the reality of the everyday world. During the Meyer era more than at any time after its founding years, general political and economic history was reflected in it. The students were receptive to the problems of the day. Political groups of predominantly Socialist tendencies formed among the students. The debate on the various politico-philosophical attitudes was passionate and the beginning of the depression intensified the clash of opinions. Keeping domestic peace at the Institute became a problem. But despite some discordant notes, life at the Bauhaus was characterized by an enthusiastic youthful liveliness. It was captured with the new photographic insight with cheerful "subjectivity"; as students remarked with self-irony, a sort of "photographitis" had broken out at the Bauhaus.

"Bauhäusler" on the Bauhaus and about themselves:
Hubert Hoffmann:
"I went to the Bauhaus for its powerful idea—although I did not know what it was. I went with the intention of trying only the first semester, since I was afraid of experiencing the same disillusionment as at other art schools. . . . I see the value of the Bauhaus more in the will to go on accomplishing something than in what has actually been accomplished, and in the influence of that will on the world around us. Above all, too, in the atmosphere at the Bauhaus which enables one to work independently as no other place does."
Lotte Burckhardt:
". . . We cannot avoid politics at the Bauhaus. I even think it is important for everyone to face these problems and to be active politically. Of course, we cannot build houses for a situation that does not exist, but a reasonable social situation will not come of itself either. Work and the shaping of life must go hand in hand."
Wera Meyer-Waldeck:
"The most positive thing for me is the pedagogical work being done here, which of course cannot be written into a timetable but which represents one of the most essential factors of the Bauhaus idea."
Otti Berger:
"In order to become an artist one must be an artist, and in order to become one when one already is one, one comes to the Bauhaus; to make of that 'artist' a human being again is the task of the Bauhaus."
(From: "Interviews mit Bauhäuslern" Bauhaus Journal 1928, numbers 2–3 and 4).

a
Walter Funkat: the vestibule of the Bauhaus building with the decorations for the "Metallic Festival," mirror image in one of the metal globes suspended from the ceiling. Photograph. 1929.
b
Lux Feininger: "Bauhäusler." Photograph. About 1928.
c
Lux Feininger: "Bauhäusler" (Siedhoff, Mentzel, Rubinstein). Photograph. About 1928.
d
Ernst Kállai: caricatures of Bauhaus Masters. (Left) Hannes Meyer as blindfolded Justicia. (Right) Oskar Schlemmer as the jovial uncle. Drawings with mounted photographs. 1928–1929.
Kállai lampooned other faculty members, including himself, in a similarly pointed manner.

a

At solstice celebrations and during vacation trips the optimistic attitude of the youth movement came to be expressed, an attitude which had left its stamp on the Bauhaus during the early years in Weimar. This youthful and optimistic spirit with or without commitment to a politico-philosophical movement, characterized the bulk of the students during all phases of the development of the Bauhaus, right up to the last and dramatic phase in Berlin.

There was a strange discrepancy between the proletarian tendency of the average workday at the Bauhaus, which Hannes Meyer promoted, and the social radiance surrounding the "Metallic Festival" of February 1929. The party was lavishly staged, like a fancy revue. Decorations and costumes topped everything that had gone before. But the simple enjoyment of the festivities, always present during the earlier periods, did not quite come off. The reason was surely not just the changed psychological climate at the Bauhaus itself; in the world outside, in the whole social and political sphere, antagonisms and tensions had sharpened.

a
Setting out on a trip to Yugoslavia by a group of students during the semester vacation in the summer of 1931.
Photo by a student.

b
"Solstice celebration of Bauhäusler in Dessau-Kühnau." 1929.
Photo by a student.

c
"Metallic Festival": Carnival celebration in the main building of the Bauhaus. The entire Bauhaus was transformed. Three bands played and improvisations and cabaret performances added to the entertainment.

d
"Metallic Festival": chute in the connecting wing between the trade school building and the workshop wing of the Bauhaus.

e
Invitation to the "Metallic Festival" (Bauhaus carnival celebration) on February 9, 1929. Printed in blue and yellow. The cover was coated with metallic foil. Produced in the Bauhaus printing workshop.
Copy in the Bauhaus-Archiv, Darmstadt.

f
Xanti Schawinsky: poster for the "Metallic Festival" of the Bauhaus. 1929. Reproduced as an advertisement in the Bauhaus Journal 1929, number 1.

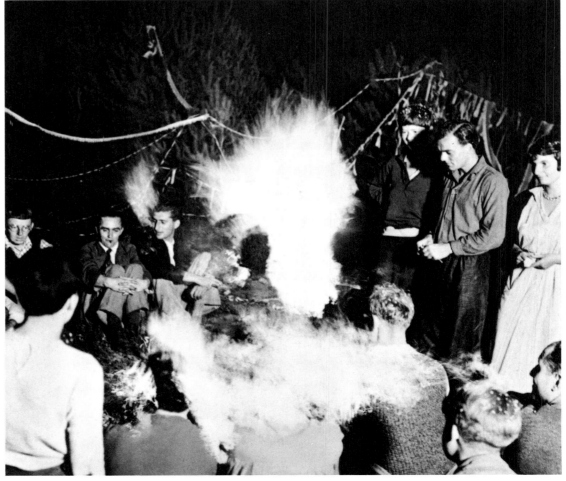

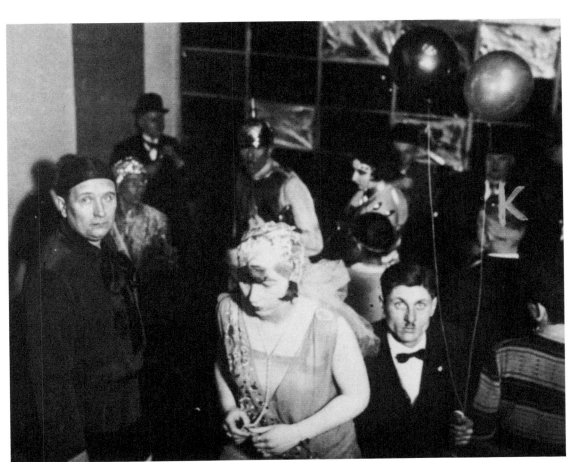

c

d

sind sie ein herr, kommen sie als ●

schellenhans (oder -as) - glöckner (aber bringen sie notre dame mit) - geheimer lagerungs-
rat - zinn- oder bleisoldat (besser noch: belätzinn-soldat) - grosse kanone - schaumschläger -
rauschgold (der podkneckt (der podkneckt (an der theke zu bekommen) - eiserner gustav - gehörnter sieg-
fried - quecksilber - klinkenputzer - blechrechen - haken (der sich bezeiten krimmen - armleuchter - metall-lurch - erzgauner - mag-
heisser - kettzange - schellenbaum - gasometer - schienenstrang (um darüber zu
schlagen) - glockenspiel - renswächte - stahl-
sichelt - blafoe - gustav negel - trinkbecher - glockenschwengel - kar-nickel - gelbiger gegenknopf - posaunen-
engel - nickburge stichler - tellerweibl - korrosionsrat - lärmram - wolfram
kobolt - alter freund und kupfernickel - laschischbier - lenkstange - eisenbahnverkehrsamt - gold-
magnet - anker - drani - bücheröffner - kurbelgetriebe - puffer - eiserner bestand - rocher de
bronce (für herren in höherer stellung) - schimmelpfennig - saxo-von der seite - rocher da
franz bier - schraubschloss - silberfuchs - goldfasan - gussform (russform) - glühfaden usw.

kommen sie nicht als ●

bronce-statue (bavaria, berolina, siegesallee) - bronze- und
steinzeitliches fossil - herzschlange - normalprofil - krat-
bürste - überdrehte schraube - plombierter zahn der zeit -
gold- und dämelsack - verzätzte niete - fünftes rad am wagen -
plätteisen - kanonenofen - schall und auch - schwer an meiner
hemmschuh - angeschliffener bolzen - schwert - jungfrau -
linker - kanegiesser - schwertlilie - prinz karneval - blech-
jungfrau von orleans - blindgänger - eisern jungfrau
quadratischem kopf - klingelbolle - weltflache - wellblechbaracke
zwischen hammer und amboss dra- - klingelbolle - käseglocke
badewanne - weit-fahne lautsprecher - ver-
nagelies, verbohrtes, vorguges, verrostetes, patiniertes, vor-
schrobenes, getauschtes, plombiertes, kon- und resoniertes,
subjekt - platoniker (soll heissen: platiniker) - eisernes kreuz -
wortkisui!

?

wir wiederholen die wichtigsten daten nochmals ●

tag ihrer glanzvollen erscheinung: **9. februar 1929,**
anfang der metallorgie **20 h,**
verhüttungsort: **dessau bauhaus,** friedrichsallee 12.
handlungen : improvisationen auf der bühne, tänze, vorträge.
attraktionen : verraten wir ihnen nicht.
tombola : nietliche erwerbung von kunst-u. bauhausprodukten.
ausstellung : bauhausarbeiten (letzte novitäten, derniers cris).
(auch am 10. februar ab 11 uhr noch geöffnet).
eintrittspreise siehe bestellkarte.
wir bitten, die beigelegte postkarte ausgefüllt bis spätestens
20. januar 1929 zurückzusenden.
bitte nageln sie auch darin ihre betten fest, sonst liegen sie nach-
her auf der strasse, wir übernehmen keine verantwortung, wenn
sie dort unter die räder geraten ●

e

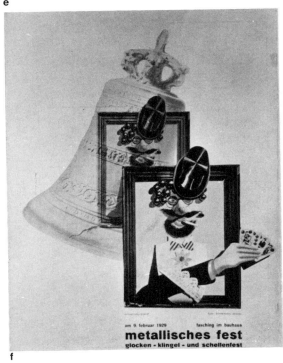

am 9. februar 1929 fasching im bauhaus

metallisches fest
glocken - klingel - und schellenfest

f

a

Mies van der Rohe Era

In August 1930 the architect Ludwig Mies van
der Rohe was appointed successor to Hannes
Meyer. At that time he already figured among
the exponents of the "new architecture." He was
Director of the Bauhaus and at the same time of
the architecture department until the Bauhaus
was closed in Dessau in late summer 1932. Dur-
ing the following months until its definite disso-
lution in the summer of 1933 he continued to
lead the Bauhaus in Berlin as a private institute.
One of the characteristic features of the Bau-
haus under Mies van der Rohe's direction was
the extraordinary discipline with which it ap-
proached its work and for which he himself
stood as an example. The development of the
educational method tended more toward a
school-like approach. Production by the work-
shops for industry was drastically reduced in
favor of the teaching program. The workshops
were integrated with architecture and interior
decoration even more than had been the case
under Meyer. Class instruction and practical
training were conducted along stricter lines.

Lilly Reich

Lilly Reich, interior architect, was born in Berlin
in 1885 and since 1927 was Mies van der Rohe's
closest associate. She was called to the Bau-
haus by him in early 1932 and until its final
dissolution headed the seminar for interior
design and the weaving workshop. At the out-
set of her professional career (1908) she was
connected with Josef Hoffmann and the
"Wiener Werkstätte," and at all times main-
tained contact with the German Werkbund. Her
association with Mies van der Rohe, ever since
her participation in the Stuttgart "Weissenhof"
housing settlement, has borne fruit time and
again. As an interior decorator she had out-
standing success at the Berlin architectural
exhibition of 1931 and at other exhibits ex-
pounding the "neue Wohnform" ("the modern
home"). She remained in Berlin after Mies van
der Rohe emigrated and died there, after a long
and severe illness, in December 1947.

b

Ludwig Mies van der Rohe

Biographical notes: Ludwig Mies van der Rohe was born in Aachen on March 27, 1889. After he finished school he moved to Berlin in 1905 and was an apprentice in the office of Bruno Paul until 1907. From 1908 until 1911 he worked as assistant to Peter Behrens. In 1912 he designed a house for the collector Mrs. Kröller in The Hague (not built). He opened his own architectural firm the same year in Berlin, and kept it until 1937. Initially his orientation followed the classicism of Schinkel. But immediately following the First World War (he served in the army from 1914 to 1918) he arrived at his own independent concept of refining engineering architecture artistically and esthetically, which had a revolutionizing influence on contemporary architecture. The boldest of the steel-and-glass building projects of the nineteen twenties were never carried out. In the avant-garde "Novembergruppe" he joined with painters and sculptors advocating a cultural regeneration. Characteristic of his mental attitude was his pronounced interest in all things related to art. He was co-founder in 1925 of the exclusive architectural association "The Ring" which was limited to ten members. In 1926 he was appointed vice chairman of the German Werkbund and charged with the over-all direction of the planning and construction of the Stuttgart "Weissenhof" housing development (1927). With the "Barcelona pavilion" in 1929 he succeeded in finding the absolutely classical statement on the architectural design topic "exhibition construction." The "Tugendhat House" (Brno, 1930) and the rooms at the Berlin Building Exhibition (1931) designed by him, coincide with his Bauhaus period. He went on his first trip to the United States in 1937 and in 1938 emigrated and settled down in Chicago to become head of the architecture department at the "Armour Institute" (since 1940 the Illinois Institute of Technology). After the Second World War in particular, Mies van der Rohe's building activity represented an extraordinary and exemplary achievement. His main achievements after 1945 were: buildings for the Illinois Institute of Technology and the tower apartments in Chicago, the Seagram Building (office skyscraper) in New York, and museum buildings in Houston, Texas, and in Berlin. The many honors he received are eloquent testimony to the world-wide recognition of his importance.

a
Ludwig Mies van der Rohe. Portrait. About 1931.
b
Lilly Reich. Portrait. Spring 1933.
c
Mies van der Rohe: model of a glass skyscraper (skeleton construction). 1920–1921.
Not carried out.

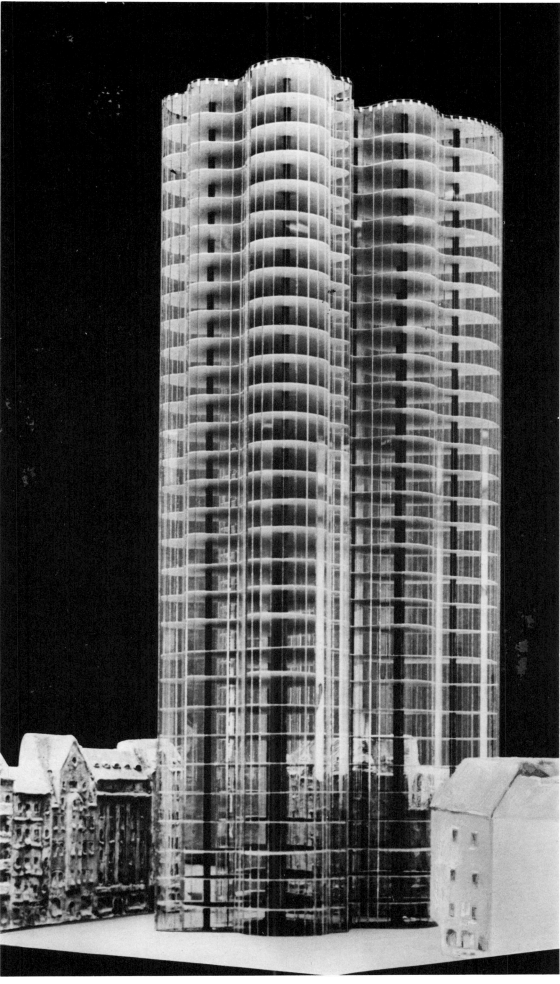

c

The "Weissenhof" housing development, built
in 1927 on a slope overlooking Stuttgart, was
meant to be a demonstration of the ideas on
housing design that had been developed by
leading European architects. It was constructed
under the direction of Mies van der Rohe as an
object for the second exhibition of the German
Werkbund. In addition to Mies van der Rohe
himself, Peter Behrens, Bourgeois, Döcker,
Frank, Gropius, Hilberseimer, Le Corbusier
(with Pierre Jeanneret), Oud, Poelzig, Rading,
Scharoun, Schneck, Stam, Bruno and Max Taut
designed individual buildings for the develop-
ment. The Weissenhof housing development, as
Philip Johnson has put it, proved to be "the most
important group of buildings in the history of
modern architecture."
For some of his buildings Mies van der Rohe
designed functional furniture that ranks tech-
nically and esthetically among the master-
pieces. The "Weissenhof" chair and armchair
of 1927 was followed in 1929 by the "Barce-
lona" chair, and in 1930 by the "Brünn" arm-
chair and the "Tugendhat" chair. Two of these
models were again or are still being produced
by one of the most prominent furniture manu-
facturers, more than thirty years after they had
been designed.

a
Bird's-eye view of the Stuttgart "Weissenhof" housing
development, built in 1927 under the direction of Mies
van der Rohe (photograph foreground).
b
Mies van der Rohe: apartment house (street elevation)
in the "Weissenhof" housing settlement in Stuttgart.
1927.
c
Mies van der Rohe: "Weissenhof" armchair. Nickel-
plated tubular steel with cane-work designed by Lilly
Reich. 1927.
Specimen at the Bauhaus-Archiv, Darmstadt.
d
Mies van der Rohe: "Barcelona" chair. Chromium-
plated tubular steel with cane-work. 1927.
Copies from the production of Knoll International.

a

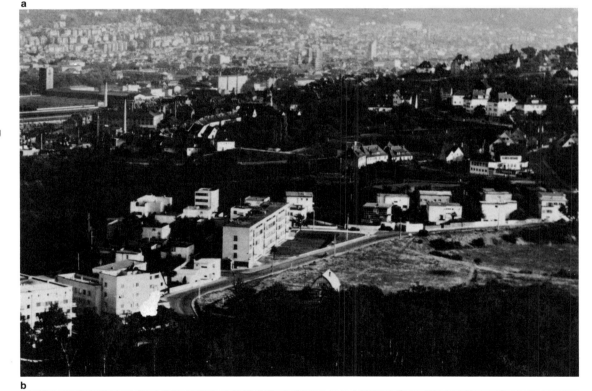

b

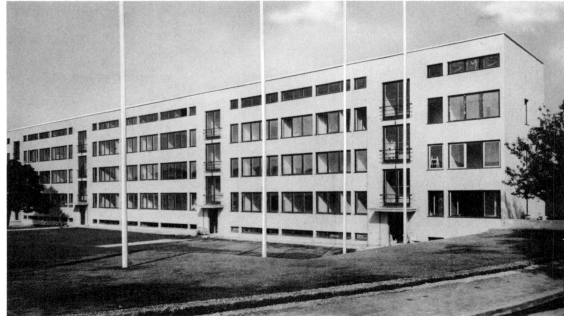

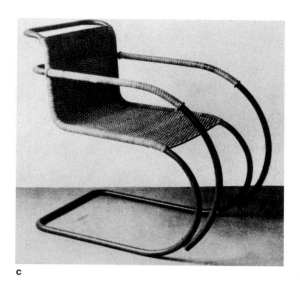

c

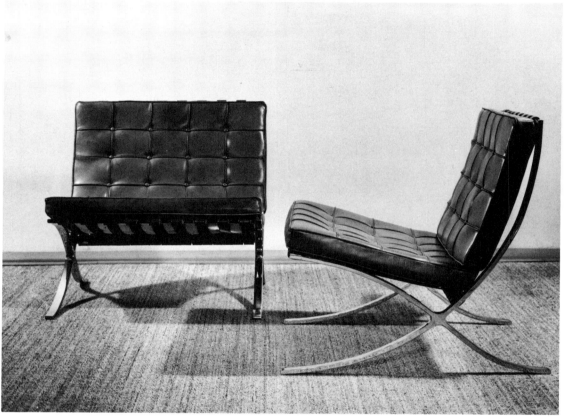

d

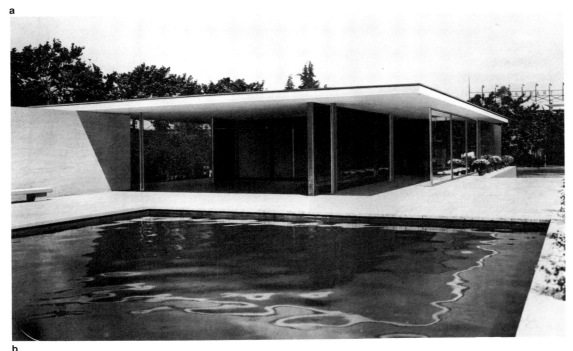

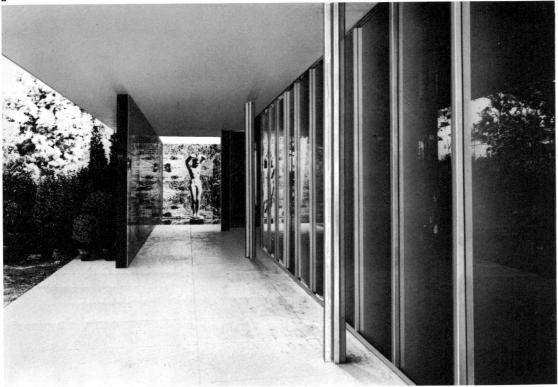

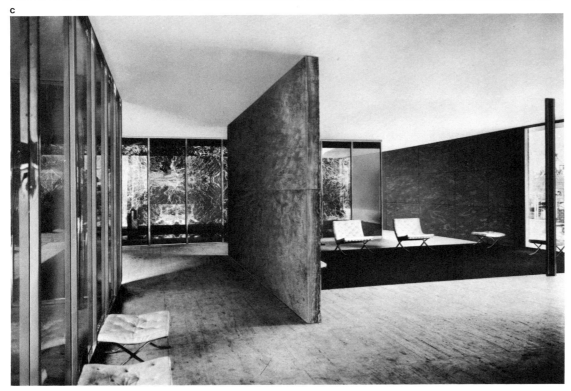

The German pavilion at the 1929 World's Fair in Barcelona, designed by Mies van der Rohe—generally called the "Barcelona pavilion" for short—became the prototype of the modern exhibition building. The effect of the architecture was based on the proportions of the spaces and the planes, on the material and its shades of color. Base and exterior walls were made from Roman travertine, the walls around the pool were green marble; the free-standing onyx partition in the hall was a treasure in itself. For the transparent partitions, Mies van der Rohe used gray glass in the rear section of the hall and bottle-green glass between the hall and the pool. For a double wall (the light source) he used etched glass and for the edge of the pool black glass. Mies van der Rohe recognized a very essential function inherent in building for an exhibition. In 1928 he wrote in the magazine "Die Form" (third year, number 4), "Exhibitions are instruments for economic and cultural activity. They must be manipulated with awareness. The nature as well as the effect of an exhibition is determined by the way its underlying problem is posed. . . . Decisive for our period is the productive accomplishment of an exhibition, and its value is manifest only in its cultural effects. Economic, technical, and cultural conditions have changed fundamentally. Technology and economy are facing entirely new problems . . . We are right in the middle of a transformation, a transformation which will change the world. To demonstrate and to promote this transformation will be the task of future exhibitions. They will have a productive effect only if we can succeed in casting a clear light on this transition. They will acquire meaning and justification only if the central problem of our time—the intensification of life—becomes the content of the exhibitions."

For the dwelling of the manufacturer Tugendhat in Brno (Brünn), Mies van der Rohe applied the design principles of the "Barcelona pavilion," finished the year before, in an analogous modification. The motif of the free-standing partition and the "flowing" space returns in the ground floor of this house, whose central room, measuring about 30 by 78 feet, was subdivided by an onyx partition and a semicircular wall of Macassar ebony into living and dining room, library, and vestibule. "The impression of an endless, flowing space is heightened by the two exterior walls which are dissolved completely in glass, opening up the view of the sloping garden and the city. Some of the glass panes can be lowered into the floor, thereby emphasizing the integration of indoors and outdoors. At night, unbleached silk curtains reaching from floor to ceiling are drawn in front of the glass walls. By their color and texture they underline the luxurious atmosphere of the interior. The elegance of this room rests not only in its size and the simple beauty of its design but also on the contrast of the precious materials and the perfection of the details. Mies van der Rohe personally designed every visible element, including the lighting fixtures, the curtain rods, and the heating pipes, with a conscientiousness hardly paralleled in our time. In addition, the art with which he integrated the arrangement of the furniture into the design as a whole is inimitable." (Philip C. Johnson, "Mies van der Rohe," Stuttgart, 1957.) The chairs, upholstered with white sheepskin, natural colored pigskin, and pale green cowhide, were set on white linoleum and rugs made of sheep's wool. Both the house and its furnishings were badly damaged in the war and in postwar events.

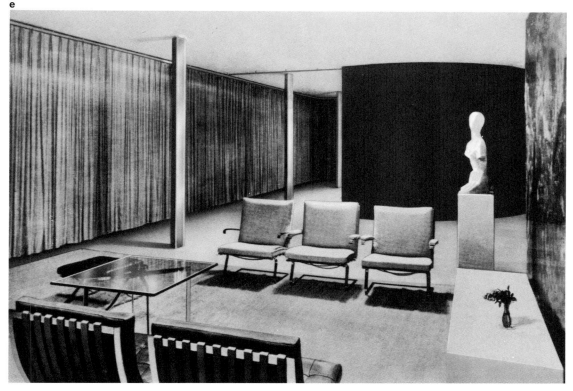

Mies van der Rohe: German pavilion at the World's Fair in Barcelona. 1929.
Removed at the close of the exhibition.
a
Inner view with pool.
b
Covered area in front of the pool.
c
Hall.
Mies van der Rohe: Tugendhat house in Brno, Czechoslovakia. 1930.
d
Living room and working room on the ground floor, partition of golden yellow and white onyx.
e
Living room with curtains drawn. The wall in the background is semicircular, made from brown-and-black striped Macassar ebony.

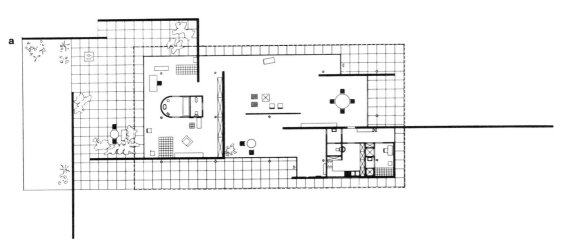

a

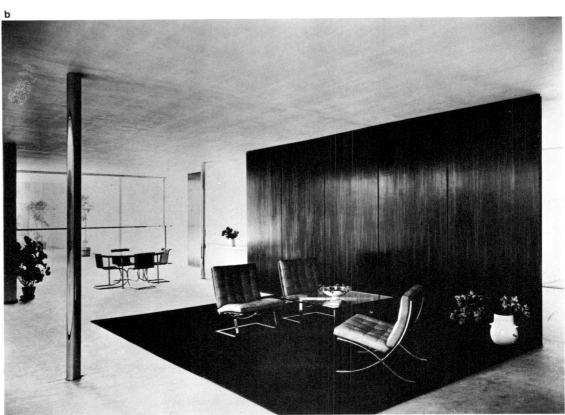

b

Bauhaus Masters: Architecture

During his Bauhaus period, Mies van der Rohe was preoccupied chiefly with the design of one-family residences—apart from dealing with problems resulting from giving classes and from directing the Institute. In these designs the outdoor garden patio was part of the "flowing" space of the house. The interior space merged with the outside space of the walled-in patio, separated only by a glass partition. Among the designs in this category which were carried out was a sample house constructed at the 1931 Berlin Building Exhibition. To this Mies van der Rohe, whom the German Werkbund had charged with the over-all direction for the arrangement of the department, "The Home," also contributed a model design for a bachelor apartment. Of the former Bauhaus members it was above all Gropius who was represented at the Building Exhibition with samples of his work. By and large, the exhibition made evident the timeliness and superior quality of Bauhaus architecture. In addition to residential and apartment buildings between 1930 and 1933, Mies van der Rohe designed a club house, an industrial building, and a power station for a firm in Krefeld and (as an entry in a competition) an administration building for the "Reichsbank" in Berlin. Due to the extremely trying economic situation of these years, few of the projects were actually built. But this problem was unimportant in its influence on the Bauhaus and the students, for it went without saying that the projects of the Director of the Institute were followed with great interest.

Ludwig Hilberseimer, the theorist of city planning, who, out of his deep critical insight, outlined in his books radical reform plans for the contemporary and gigantic visions for the future city, in his Bauhaus period dealt chiefly with the more modest but not less pressing problems of housing developments. His methodical approach was the right tool for such fundamental investigations, being all the more important in this field and at this time of depression because it could bear fruits in practice. The topics dominating his own work were the same he tackled with his students in class. They were primarily the problems of standardization and the integration of the residential settlement house into the general plan, as well as the search for possibilities of economical solutions for the arrangements of floor plans. In the latter investigation of the specific requirements for the house, different social conditions and the possible growth of the family had to be considered. The properties of the "minimum home in a house without stairs" were analyzed in detail. Though Hilberseimer in fact did little building and was always primarily concerned with principles, he was actually a practical man, very different in nature from Mies van der Rohe whom, in his way, he was able to supplement very successfully. Their association dated back to 1927 (when neither was yet at the Bauhaus) and was already promising then; in that year Hilberseimer contributed to the design of a house for the "Weissenhof" housing development.

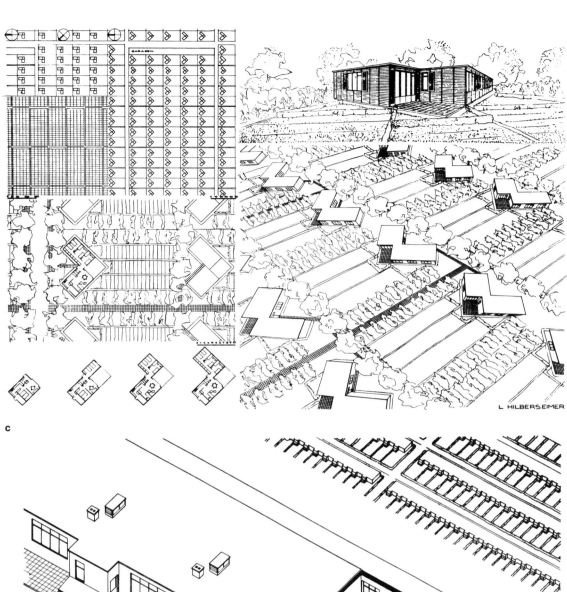

L HILBERSEIMER

c

d

Mies van der Rohe: house at the Building Exhibition in Berlin. 1931.
Removed at the close of the exhibition.

a
floor plan of the house showing the patio integrated in the design concept.

b
living room.

c
Ludwig Hilberseimer: "The growing house in the housing development." 1930–1931.
A model house, the result of fundamental considerations.

d
Ludwig Hilberseimer: design of row housing. 1930–1931.
Result of systematic investigations.

Architecture and Interior Design:
Architectural Instruction

When Mies van der Rohe took office he revised the curriculum. The version of September 1930 (in use until spring 1932) for the first time speaks of "architecture and interior design." This new combination of terms resulted from the joining of the workshop for interior design and the architecture department. The special fields of study enumerated in the curriculum (1930) were: structural work; finish work; construction design; heating and ventilating; installation; lighting technique; cost estimating; strength of materials; statics; steel and reinforced concrete structures; comparative types of buildings and design; city planning; seminar for interior design; practical training in the cabinetmaking, metal, and wall painting workshops.

The over-all direction rested with Mies van der Rohe. Within the architecture department he personally conducted those courses that tended to deal primarily with the artistic aspects of designing—the studio and the design classes. For this instruction the term "architecture seminar" was introduced (in 1932 at the latest). Hilberseimer at first conducted the "instruction in architecture" as he had under Hannes Meyer. Beginning in 1932 his course was called "seminar for housing and city planning." Experts for the technical instruction were the structural engineer Alcar Rudelt, and Friedrich Engemann. Rudelt lectured on statics, mechanics, strength of materials, building construction, steel and reinforced-concrete structures. Engemann (born in Meuselwitz near Görlitz in 1898, taught at the Bauhaus until 1933, professor at the Giebichenstein Art School since 1949) had been appointed by Meyer in 1929 to teach draftsmanship, mathematics, and geometry. His teaching responsibilities were now broadened to include construction design and architectural and interior construction.

As a creative individual Mies van der Rohe had a personality which must have fascinated everyone in his class. With the nobility and esthetic perfection of his own work he established a standard which put an obligation on the students, but at the same time was liable to become dangerous to them, for the temptation was great to imitate the forms of their prominent example—but for Mies van der Rohe himself these were never form alone but the inspired result of a thorough and intensive design process. Hence, some of the students tended to apply the formal language of their teacher schematically. Those possessing greater talent (like Wils Ebert, Herbert Hirche, Eduard Ludwig, Gerhard Weber) matured under his influence and in the dialogue with him. In the few years Mies van der Rohe taught at the Bauhaus he effectively shaped the school. Hilberseimer's rational and sober way of thinking constituted a very important counterfoil to the emphasis on art in architecture.

In the architectural seminar Mies van der Rohe gave his students concrete problems. Thus, for example, during the last months of the Dessau period and in Berlin (the seminar was continued without interruption) he had the students design residences that had to answer given purposes. Floor plans, elevations, and renderings, drawn to scale, had to be handed in. The principal theme to be worked out in variations was the "single-story residence with patio." A series of study projects resulted in suggestions for a "House A" (residence with studio), "House B" (a two-story single residence), and a "House C" (a single-story, single-family residence). In general the drawings were done with remarkable care.

a

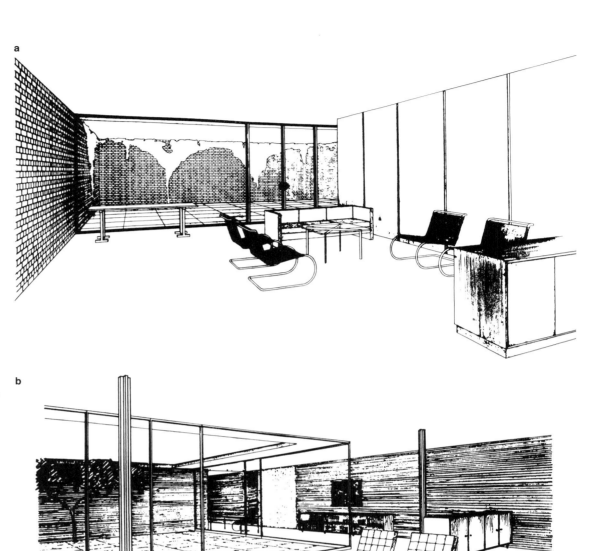

b

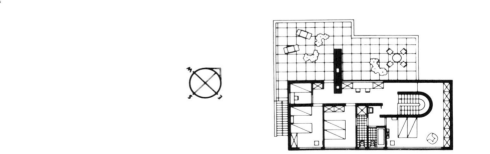

c

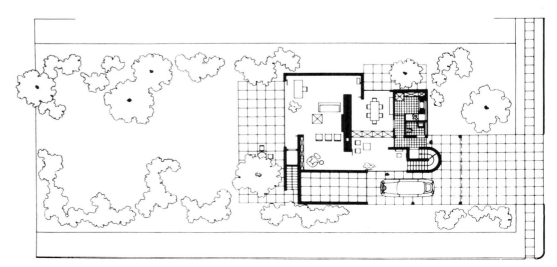

540

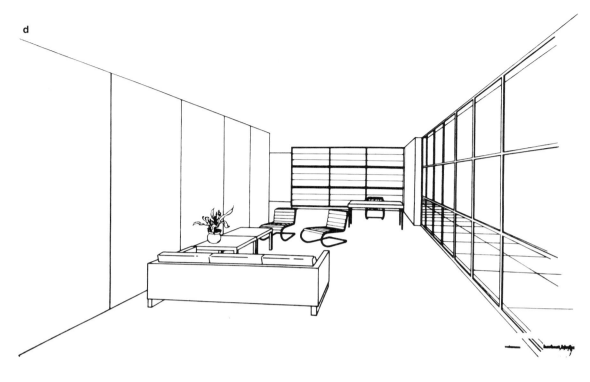

d

Projects done in Mies van der Rohe's class (architectural seminar). 1932–1933.

a
Günter Conrad: "House A" (studio house). View through the living room into the patio.

b
Günter Conrad: "House C." Living room and patio.

c
Howard Dearstyne: floor plan of free-standing residence.

d
Herbert Hirche: "House B" [?]. View into the living room.

e
Eduard Ludwig: single-story residence with patio (in series). Floor plan, elevation, and view from the street side. Area 734 sq. ft.

f
Eduard Ludwig: single-story residence with patio, view of the living room and patio.

e

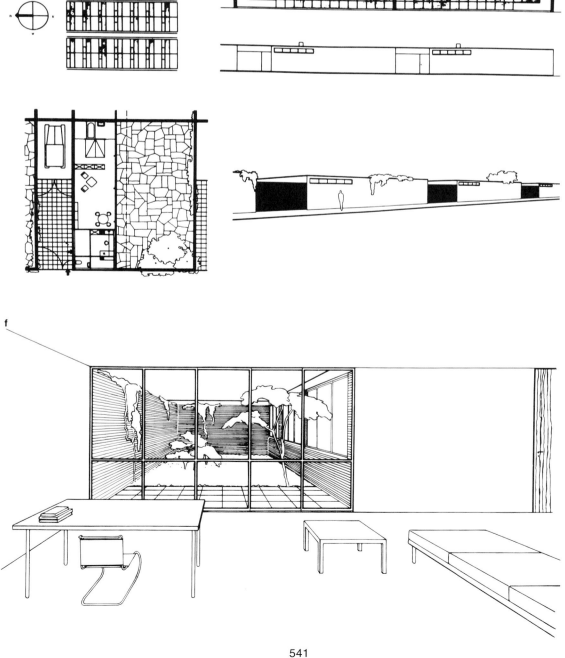

f

Architecture and Interior Design:
Interior Design Seminar

Until 1931 Alfred Arndt was in charge of the department of interior design. From 1930 on it was joined with the architecture department and carried the designation "architecture and interior design." It consisted of the three workshops—cabinetmaking, metal, and wall-painting. In January 1932 the supervision of the department of interior design and especially the interior design seminar was assigned to Lilly Reich, who also maintained these responsibilities after the Bauhaus moved to Berlin. Arndt held lectures in 1932 on interior design and also on perspective and on descriptive geometry. He remained until the end of the Dessau Bauhaus. The wall-painting workshop continued to be the specific domain of Hinnerk Scheper who returned to the Bauhaus in 1931 after a leave of absence of almost two years, and remained a member until it was permanently dissolved in 1933.

The design of reasonably priced, standardized and also disassembled furniture was an important part of the program of the interior design seminar as it was headed by Arndt and his successor, Lilly Reich. Precise construction drawings were made, and the possibilities of implementing such designs in the difficult economic situation were calculated in scrupulous detail. Under Arndt's supervision the work of developing designs for industrial goods was checked against the realities of life. Commissions from manufacturers declined, except in the wall-painting workshop where they still played an important part, with the further development of the Bauhaus wallpapers (first under Arndt's direction and then under Scheper's) assuming a prominent role.

Seminar for interior design under Arndt.
a
Design drawings for chairs (wood and cane) and for various wooden pieces of equal over-all size (chest with drawers, small wardrobe, shelves). 1931.
These designs were entered in the competition of the German Werkbund conducted to find standardized home furniture. Each of them was worked out by several students of the interior design seminar The designs received awards.
b
Design drawings for an armchair made with tubular steel (with chrome or celluloid coating) and canework, and sketch for the construction of a small occasional table. 1931.
Entries in the competition for standardized home furniture conducted by the German Werkbund. Each of the designs was worked out by several students and was awarded a prize, as were the other entries by the seminar for interior design.
c
Design drawings for desks or dressing tables and for small cabinets for a record player. 1931.
Award-winning entry for a German Werkbund competition on the standardization of home furniture. The designs of the individual objects were worked out by groups of students.

a

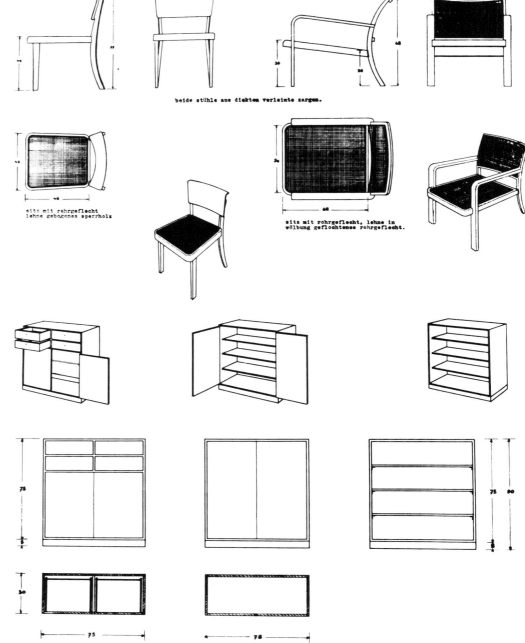

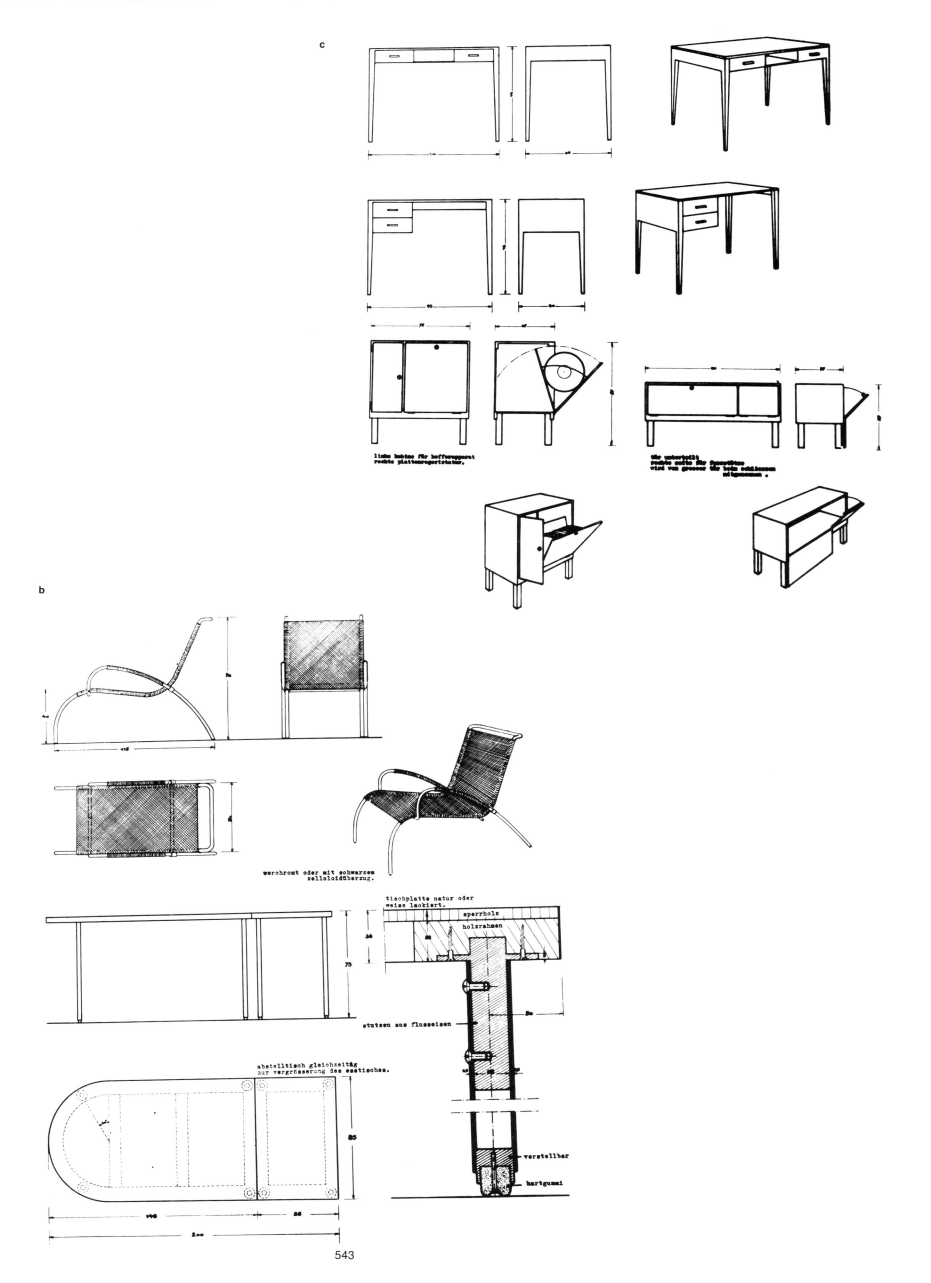

c

linke kabine für kofferapparat
rechte plattenregistratur.

tür unterteilt
rechte seite für apparaten
wird von grosser tür beim schliessen
aufgenommen .

b

verchromt oder mit schwarzem
zelluloidüberzug.

tischplatte natur oder
weiss lackiert.

sperrholz

holzrahmen

75

stutzen aus flusseisen

abstelltisch gleichzeitig
zur vergrösserung des esstisches.

85

verstellbar

hartgummi

Weaving Workshop

Until the fall of 1931 the weaving workshop was headed by Gunta Stölzl. During the months after her departure it was under the temporary leadership of Anni Albers, and at times also of Otti Berger as substitute. Lilly Reich took charge of the weaving workshop in January 1932. Later, when the Bauhaus moved to Berlin, she continued there in that capacity (with looms provided by the city of Dessau). The weaving workshop had talented workers, in addition to the women in charge of it, especially Margarete Leischner and Tonja Rapoport. As in the previous period, the work of developing designs for fabrics centered on the testing of new materials and techniques and the manufacture of prototype textiles for industrial production (drapery material for M. van Delden in Gronau, Westphalia, among others). But most of the designs completed for industry during the last years did not in fact reach the manufacturing stage. The fields of instruction as laid down in the curriculum (1930 edition) were study of the weave (the patterns or methods of interlacing the threads of woven fabric), analysis of materials and acquisition of weaving techniques on the leaf loom, leaf machine (Dobby), the Jacquard loom, the frame for knotting rugs, and the loom for making tapestries; also cost estimating, analysis of patterns, drawing patterns from stencils, improvement of materials, design drawing, analysis of commercial textiles, testing of materials, dye-work, and practical training in the workshop.

a
Gunta Stölzl: wall-covering fabric (with addition of cellophane). About 1931.
b
Margarete Leischner: "Drehergewebe." Napped material. About 1931.

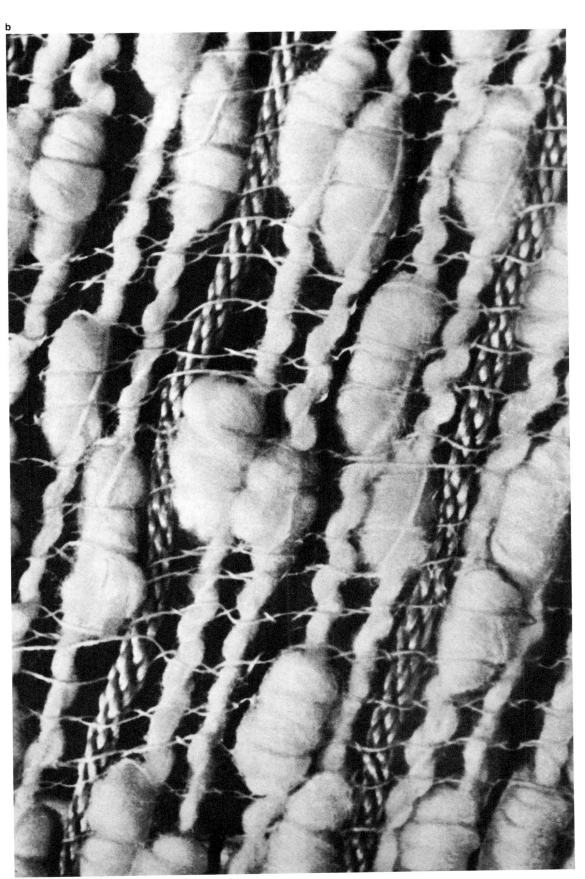

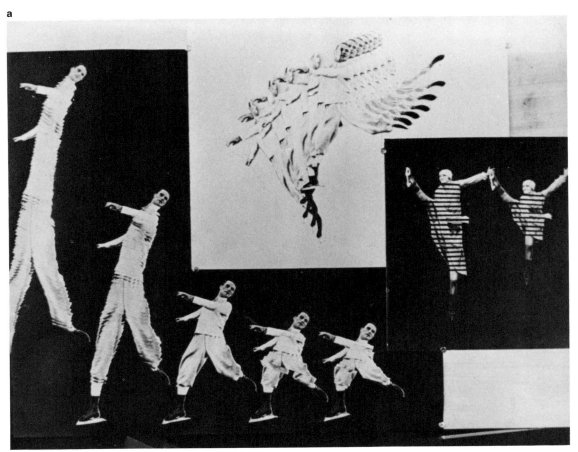

Elementary and General Instruction

Josef Albers's workshop course (preliminary course), which endeavored to serve the "development of the feeling for material and space" in the student, had been and continued to be the nucleus of the elementary instruction for the first semester. The curriculum for the beginners' course was moreover comprised of representational drawing (Albers), lettering (Joost Schmidt), descriptive geometry (Engelmann until 1931, Arndt until 1932), and introduction to artistic design (Kandinsky, also Klee until 1931); in addition mathematics, science of materials, psychology, principles of standardization, and workshop training in conjunction with instruction in construction.

The general courses for students in all other semesters (as a rule there was now a total of six) continued with primary artistic design, including color theory, classes in representational drawing, lettering, descriptive geometry, and lectures in psychology. In addition (beginning with the second semester) there were classes in life-drawing and figure drawing, which were conducted by Joost Schmidt during the later years of the Dessau Bauhaus. Practical training in the workshop was part of the general education. During the last phase of the development of the Dessau Bauhaus, Joost Schmidt emerged as a remarkably active and versatile individual, employing these qualities productively in teaching. His fields of instruction were closely interrelated, even though they were concerned with topics ranging from introductory and general considerations to specifics. Every student took lettering and life and figure drawing; but at the same time the drawing course was a very important component of the instruction in the advertising workshop which in turn had some points of contact with the sculpture workshop (for instance in exhibition design).

a
Student in Albers's preliminary course: Study about the possibilities of modifying given elements by means of serialization, foreshortening, and stretching. About 1930.
The figures, taken from illustrated magazines, were cut up and reassembled by the student. By close or loose reassembly the proportions can be compressed or stretched out. Serialization (repetition) of elements results in the illusion of movement.

Joost Schmidt's course.
b
Student work (collage) on a composition of "Direction-indicating figurative forms." 1931.
c
Exercise in parallel perspective. Student work (drawing). 1931.
d
Student work on "Contrasts to the letter P, drawn in linear outline." 1931.
e
Student work on "Three plane forms of equal size + eight points." 1930.
f
Course in life-drawing and figure drawing conducted by Joost Schmidt: study from the nude. Ink drawing. 1930–1931.

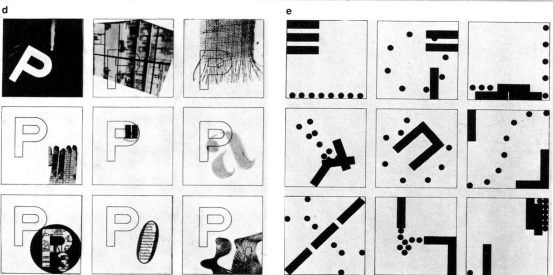

Commercial Art

The teaching program of the commercial art department headed by Joost Schmidt (now listed in the curriculum as "professional field of advertising"), provided, for the first stage of instruction, practical training in typography, printing and reproduction techniques in the printing workshop, cost estimating, photo techniques, and life and figure drawing. In the second stage of instruction, consisting of the fourth to sixth semesters, students took advertising theory, did independent and experimental work in the field of advertising, designed promotional printed matter and exhibition stands, and prepared statistical tables and schematic illustrations. Schmidt put the accent chiefly on exhibition design, and, during the final years, on the drawing of posters. At the Berlin Bauhaus, where the commercial art department combined with the photography workshop because Peterhans was made responsible for both of them, the opportunities for advertising using the means of photography and reporting were by their very nature stressed more than before.

a
Student in the commercial art department: design for a poster advertising matches. Spring 1932.
b
Student in the commercial art department: design of a poster for a music store. Spring 1932.

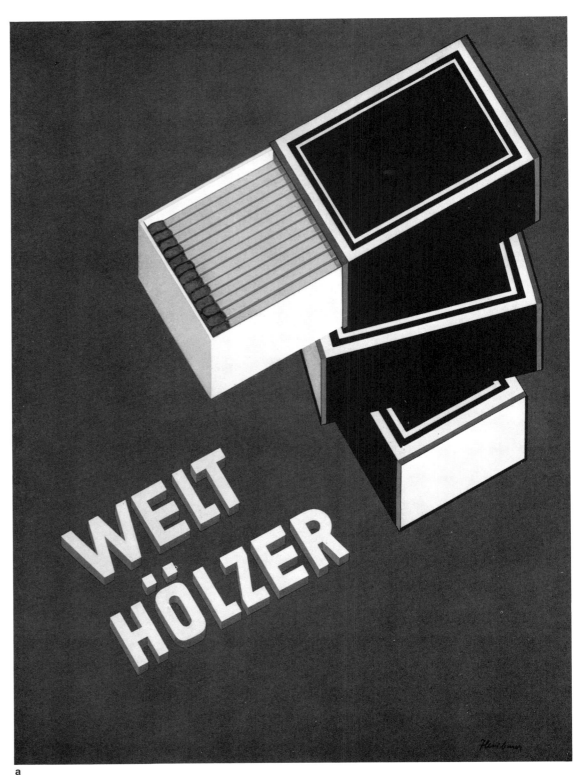
a

548

b

Creative Work of the Masters

Paul Klee left the Bauhaus in the spring of 1931 for the Düsseldorf Academy, where he was appointed professor. The lectures on artistic design which he had given regularly ever since the Weimar period were of inestimable value to the Bauhaus. The opportunities for teaching a class in free painting were richer in an art academy than in the Bauhaus—even though one had been provided for him in 1928. This may have been the reason prompting his decision for Düsseldorf. He kept his residence in one of the Dessau ''Masters' houses'' until 1933. As a personality he was sovereign, talented with an unerring faculty for judgment. ''Klee was a man of deep wisdom and remarkable knowledge,'' observed Feininger in retrospect. ''A man not bound to time and of indeterminate age, yet to whom—as to a keenly alert child—all the experiences of the senses, the eyes and ears, the senses of touch and of taste were eternally captivating and new. A mature human being who did not let his very acute mind lose control, Klee was very calm and collected in his movements; he never lost his repose—there was no need for outbursts. The onrush of all experience and feelings found its relief in forms of creative activity, in deep silence, and on the violin, an instrument he mastered with clear and pure interpretation. . . . In Klee's studio—with himself in the middle of the apparent, but in reality carefully ordered, 'disarray' (for Klee was meticulous in his habits)—there were always some of his paintings standing on easels, under observation so to speak, which slowly and gradually evolved to perfection. We remember what a close friend who was fortunate enough to study Klee's work in his studio told us: how Klee would often sit for hours in one corner, his pipe in his mouth, smoking, seemingly not occupied with anything—but alert inside—and then would get up and with never-erring certainty place a color into a painting here and draw a line there and thus slowly bring these magical creations closer to perfection. Born of the unconscious, comparable to the organic growing of a plant, with inner, unmistakable logic, the visions developed into reality, tranquil-serene, seemingly without effort.'' (Quoted from ''Erinnerungen an Paul Klee,''—''Reminiscences of Paul Klee,'' published by Ludwig Grote, Munich, 1959.)

Joost Schmidt, the Bauhäusler par excellence, withdrew from the Bauhaus—like Arndt—when it moved to Berlin. ''He was one of the most richly endowed in plans and ideas,'' his one-time fellow student Hirschfeld-Mack said of him; ''his knowledge was of philosophical depth and breadth.'' This made him a born teacher. ''Remembering the sad experiences at the Art Academy, I tried to bring life into teaching,'' he remarked about himself, for ''education should address the entire human being, achieve a harmonious relation between the sphere of thinking and feeling, awaken the creative imagination and develop it.'' His most significant achievements in the domain of the visual arts lay in the border area between free and applied art. Of the many facets of his talent in art, his sculptural capability was probably the most pronounced of all. Due to the events of the war, most of his works were demolished while he was still alive.

Lyonel Feininger, who was a member of the Bauhaus from its founding in 1919 but only taught actively at Weimar, decided to remain in Dessau when the Institute was transferred to Berlin. Here in Dessau, in his ''Master's house,'' his colleagues and some of his students often visited him to seek his advice. He was a thoughtful and conciliatory man of outstanding human qualities. He had great musical talent, working on compositions himself, and in his paintings he transposed architectonic and similarly structured motifs into visionary configurations which carried something of the ''organ sounds that make the heavens, too, vibrate'' (Grote). Though he did not teach in Dessau, some of the young Bauhaus painters received lasting stimulation from him.

a
Paul Klee: ''Suspended (before ascent).'' Oil on canvas. 1930.
Klee Foundation, Bern.
b
Joost Schmidt: ''Runner.'' Relief made of wood painted white. 1932.
This relief was burned during the Second World War.
c
Lyonel Feininger: ''Pyramid of sails.'' Oil on canvas. 1930.
Private collection, Stuttgart.

c

b

a

Josef Albers and Hinnerk Scheper were the only teachers trained at the Bauhaus itself who went to Berlin with the Bauhaus in 1932. Albers, whose teaching methods were among the most significant and historically productive accomplishments of the Bauhaus, was a practical man first. His workshop instruction was based on a knowledge of materials and how to deal with them, and from the concrete data of the material he moved to the visual conception, finding valid expression first in stained glass work. The first of these were still made according to traditional methods with lead fillets. At about the middle of the nineteen twenties, Albers began making geometric abstractions arranged in gradations, like steps, by treating flashed glass partially with a sand blaster or with a corrosive fluid. Similar to these in surface texture were his woodcuts in which he used "positive" and "negative" shapes. Later—in America—Albers did abstract colored paintings consisting of simple geometric elements, which he based on the knowledge of visual weight relationships and the interrelations of colors he had gained in extensive studies. His visual art work is an avowal to underlying and elementary laws; one comes closest to the nature of a painting or a piece of graphic art when looking at it as an object of meditation.

a
Josef Albers: "Surrounded." Woodcut. 1933. Copy in possession of the Bauhaus-Archiv, Darmstadt.

Wassily Kandinsky was the outstanding figure among the artists who followed the Bauhaus to Berlin, both because of his age and because of his importance in the history of art. During the latter Dessau period his dignity was often misunderstood by the younger members of the Institute. But in the painting class he had a devoted following. His most significant contribution to the Bauhaus was his general instruction on artistic design (like the one conducted by Klee) resulting for the most part from a preoccupation with the visual problems in his own work as a painter. He went through a transformation during his creative period at Dessau, preparing for the work of his later years. "At one point he is interested in discontinuity and in spreading the inventions over the painting disconnectedly and spasmodically," states Will Grohmann in his monograph on Kandinsky (Cologne, 1958), "then his efforts center on the problem of how a static situation can develop from retarded movement, and still a third time he approaches the question of how to capture movement. In some of his paintings one single color determines the character of the picture, while in other, more vaporous ones one would seek in vain to find a dominant color. The Dessau years are characterized by a unique multiplicity, though they do show consistency. . . ."

b
Wassily Kandinsky: "Between Light." Oil on canvas. 1931.
Marlborough Fine Art Ltd., London.

b

The End of the Dessau Bauhaus

The decision carried in the Dessau city legislature on August 22, 1932 by the votes of the majority National Socialist Party to dissolve the Dessau Bauhaus, effective October 1 of the same year, was deplored and regretted by those of a culturally progressive attitude everywhere in Germany and abroad. But protests were of no use. The decision to dissolve the Institute was all the more alarming since it was dictated by political hatred and was highly contestable on legal grounds. The fact that the National Socialist decree was legally questionable provided Mies van der Rohe with the opportunity for negotiating the continuation of salary payments up to the date when notice of termination of employment was first permitted by contract agreement, and for compensation in the form of materials and facilities needed for the courses. He was helped as much as possible in these negotiations by Mayor Hesse. The success of this effort enabled Mies van der Rohe to continue the Bauhaus as a private institute, which he moved to Berlin. The National Socialists' original intention of tearing down the Bauhaus building was not carried out. The flat roofs were covered in part by a ridged roof and even a National Socialist office was moved into the building. The part of the building damaged most during the Second World War was the workshop wing. Its glass curtain wall was not restored after the war, but bricked up instead. The interior was renovated so that schools could use the rooms. Some of the walls (above all in the vestibule and the stairwell) were decorated, thus revealing inability to recognize the functional architecture of the building. The genuine restoration of the building to its original state has been demanded repeatedly—but so far Dessau has not been able to make the decision.

a
The workshop wing of the Bauhaus building in 1926.
b
The workshop wing as seen from the same position in 1958.
c
"Obituary notice on the Dessau Bauhaus." Page from the newspaper "Neue Leipziger Zeitung," September 4, 1932.
(Translation:)
The architect Mies van der Rohe, the last director of the Dessau Bauhaus.
The architect Prof. Gropius, the founder of the Bauhaus and brilliant creator of new forms in architecture. The end of the Bauhaus? Would to God it were not so, for architecture needs our "Bauhaus" as man needs his daily bread. This was the place where students were able to find the way gropingly to good forms of art without having traditional dogma pounded into them.

b

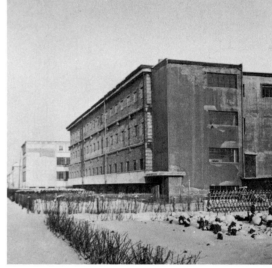

a

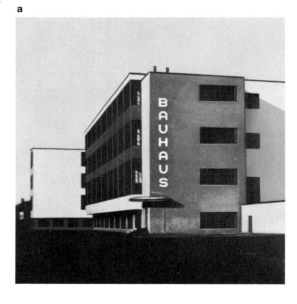

c

NACHRUF
AUF DAS DESSAUER
BAUHAUS

Nachruf auf das Dessauer Bauhaus
Architekt Prof. Gropius, der Gründer des Bauhauses und geistvolle Schöpfer neuer Bauformen

**Architekt Mies van der Rohe
der letzte Leiter des Dessauer Bauhauses**

Ende des Bauhauses? Gebe Gott, daß es nicht so ist, denn unser „Bauhaus" tut der Baukunst not, wie das liebe Brot dem Menschen. Hier war die Stätte, wo Schüler, ohne daß ihnen das Herkömmliche eingebleut wurde, tastend den Weg zu guten Formen der Kunst finden konnten.

Bauhaus Berlin 1932–1933

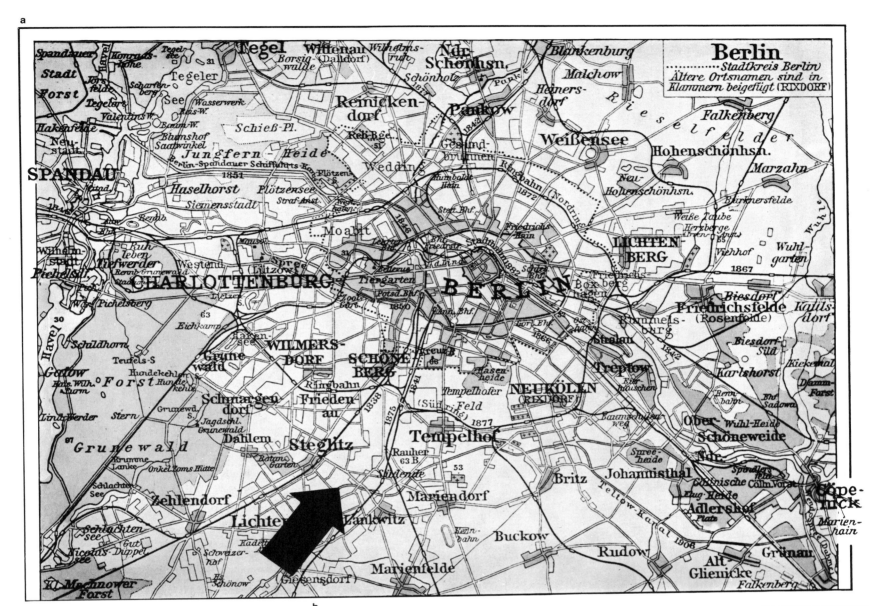

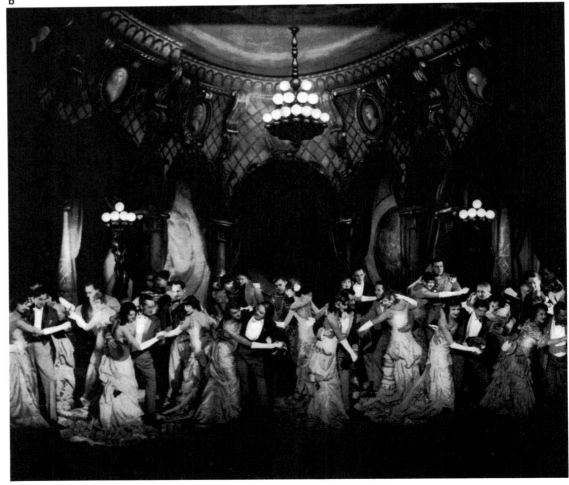

558

Berlin: Splendor and Misery

Berlin, metropolis and seat of the government of Prussia and the German Reich, was during the early nineteen thirties a city with a population of four million, a focus of political and economic life, and the most important industrial center on the European continent. Its intellectual life was extraordinarily active, receiving its impetus from leading artists and scholars. Berlin was the home of outstanding research institutes and libraries and some of the most valuable museum collections, among which were also those of modern art. For German-speaking areas, the city was also the leader in the world of the theater. But at the same time, Berlin was the center of many partisan struggles, from which Hitler emerged victor in 1933. The Republic, whose constitution had been established in Weimar in 1919, died in Berlin.

Berlin was a metropolis, sparkling in splendor, yet overshadowed by misery, vibrant with hectic life. Since the turn of the century it had exerted an irresistible fascination on artists. In Herwarth Walden's "Sturm" group and at other places in Berlin many of the men who were to become Bauhaus teachers had met long before the Staatliche Bauhaus existed in Weimar. Most of those who had left the Bauhaus returned to the city: Itten, Schreyer, Muche, Gropius (who was born in Berlin), Moholy-Nagy, Breuer, and Bayer. They all sought to further their careers in the capital of the nation. Schlemmer also came to Berlin (in 1932) by way of a detour via Breslau. Mies van der Rohe had his private architectural firm here, which he maintained during the years he spent in Dessau. The intellectual life was comparable to perhaps no other city at that time. Exhibitions spanned the entire scope of modern art. Significant experiments were done on the stage, where directors of the caliber of Max Reinhardt were working. Sophisticated Berlin indulged in glittering social events and whispered about its scandals; in life and on stage it was engaged in one big show. On the other hand, there was unprecedented unemployment. In all of Germany there were roughly six million people without work and income. The year 1932 was shaken by continuous governmental crises, to the extent that the authority of the state was dependent solely on emergency decrees which curtailed the constitution. Political extremism proliferated. From the summer of 1932 on, the NSDAP (National Socialist German Workers Party) represented by far the strongest faction in the German Reichstag, holding 230 of the 608 seats. The Communist Party, too, won a considerable number of seats, mainly at the expense of the Social-Democratic Party. Meanwhile, the middle-of-the-road parties, the so-called "democratic center," were hopelessly split. Street fights and strikes were the order of the day, and in this general chaos Joseph Goebbels, the unscrupulous National Socialist district leader of Berlin, managed to get the city, little by little, more firmly into his grip.

a
Berlin. Map of the city. Early nineteen thirties. The arrow marks the position of the building the Berlin Bauhaus rented in Berlin-Steglitz (Birkbuschstrasse). It was far removed from the center of the city. Berlin (including the suburbs incorporated into the city) had a diameter of approximately 28 miles.

b
Sophisticated Berlin: gala performance of Franz Lehár's operetta "The Merry Widow" (ball scene) at the Metropol Theater. About 1930.

c
Hungry Berlin: march by the "Iron Front" in the "Lustgarten." July 1932.

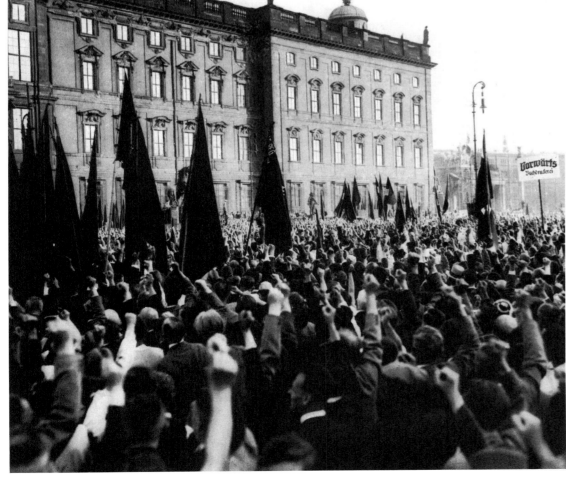

c

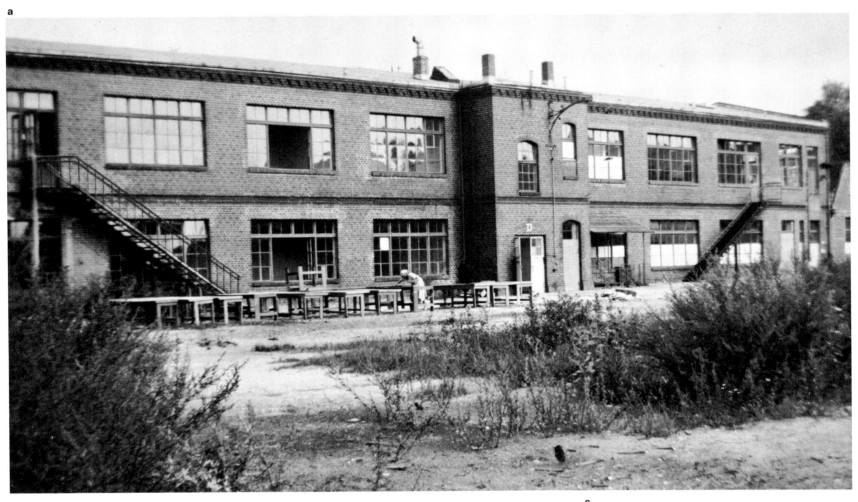

a

c

b

a
Bauhaus Berlin in the Birkbuschstrasse in Berlin-Steglitz. 1932–1933. Formerly building of a telephone company.

Teachers, associates, and students of the Berlin Bauhaus. March 1933.
b
From right to center: Hauswald (printing technician), Rudelt, Albers, and Beck (technician in the weaving workshop).
c
Josef Albers is at the far right (seen in profile).
d,e
Students moving into the Bauhaus in Berlin. October 1932.

Figures d and e, from the Keystone View Co., dated October 25, 1932, carried a caption announcing that the work "of the Institute, world-famous for the characteristics of its art . . . began today without any ceremonies."

d

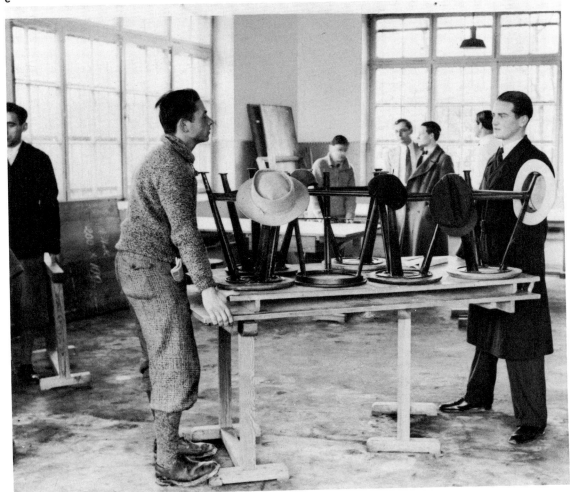

e

Independent Teaching and Research Institute

Immediately following the dissolution of the Dessau Bauhaus, the Berlin Bauhaus resumed its activities as an "independent teaching and research institute" in the fall of 1932. The Institute was housed in the empty building of a telephone company in Berlin-Steglitz, rented by Mies van der Rohe, far outside the city, at the southern periphery. Students and teachers worked side by side in setting up for classes to be held there. Some of the tools and machines needed for the work (especially the looms) had been provided by the city of Dessau. Thus it was possible to start school after a remarkably short interim. Classes connected up directly with those of the last semester at the Dessau Bauhaus. Continuity was disrupted only in those courses in which replacements were needed because of the resignation of Arndt and Schmidt. Mies van der Rohe and Hilberseimer conducted the architectural instruction—supplemented by Rudelt and Engemann with technical lectures that were a part of the general education. Lilly Reich conducted the work of the seminar for interior design and the weaving workshop, and Scheper was still in charge of the wall-painting workshop. Albers gave the elementary instruction and Kandinsky continued his lectures on artistic design and the work in his painting class. The artistic component of the curriculum was of course weakened now, since the sculpture workshop (Schmidt's domain in Dessau) had been abandoned. The commercial art department came under the auspices of Peterhans who, in addition, was in charge of the photography workshop, as before. Out of necessity Mies van der Rohe refrained from appointing new teachers except where absolutely vital. For the lettering course (to replace Schmidt) he employed the Berlin painter and graphic artist Hanns Thaddäus Hoyer, and after Alcar Rudelt's resignation from the Bauhaus in the spring of 1933, the engineer Ernst Walther filled his position. All told, the Bauhaus Berlin had no more than the period of one semester to do productive work. At first, life and work at the Bauhaus went on nearly undisturbed, though the attacks on the Institute from the outside became more virulent and political passion took hold of the students to a growing degree. Their partisan interest produced different groups and eventually caused a rift between them.

After Hitler's assumption of power, someone secretly hoisted the swastika in front of the Bauhaus; Mies van der Rohe ordered it removed. On carnival in 1933 the Bauhaus gave its last party.

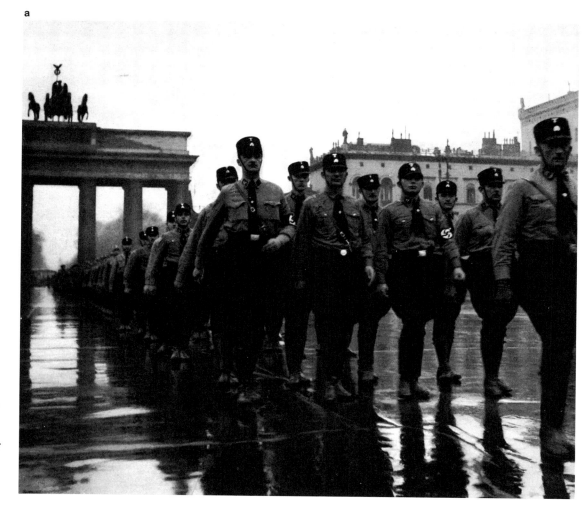

"Assumption of Power"

The extremists hated the Bauhaus for its liberal attitude which was consonant neither with their radical political opinions nor with their conservative views in cultural matters. Personal attacks were most vehement against Hilberseimer and Kandinsky. Many people believed Hitler's phrases would quickly wear out and more reasonable views would soon banish the "brown specter." But in reality the situation was hopeless after Hitler's appointment as Chancellor of the Reich and after his "taking of power" on January 30, 1933. Hitler's followers were consumed with joy, and during the subsequent months, one by one, the norms of a constitutional state were abolished. The conflagration in the Reichstag building on February 28, 1933 provided the pretext for eliminating opponents by means of force. The Communists were charged with having set the fire. Their party was banned on the basis of an "emergency decree." Whoever rebelled against the new power was put into concentration camps or terrorized by other means. A large segment of the people saw in Hitler the savior from a general collapse. In the last free election on March 5, 1933 the National Socialists received 43.8 percent of the votes and with their coalition partners held 51.9 percent, thus controlling a majority. Hitler's power was legalized. His "Enabling Act," passed with the help of the votes of the parties of the center on March 24, meant conferring absolute power on him and in effect annulling the constitution. After the Social Democratic Party had been dissolved and the center parties had been forced to dissolve themselves, there was no way left, parliamentary or practical, to intervene against the dictatorial measures. The Bauhaus Masters felt the effects of this when the city of Dessau abruptly stopped the salary payments that were due them by contract. In order to unearth incriminatory material against the deserving Mayor Hesse and to provide grounds for eliminating him, the Dessau public prosecutor's office ordered a search of the "Communist" Berlin Bauhaus. This arbitrary action represented a crushing blow.

a
Berlin in 1933: Storm troopers marching through the Brandenburg Gate on Hitler's birthday (April 20).
b
Berlin in 1933: the burning of the Reichstag building (February 28).

b

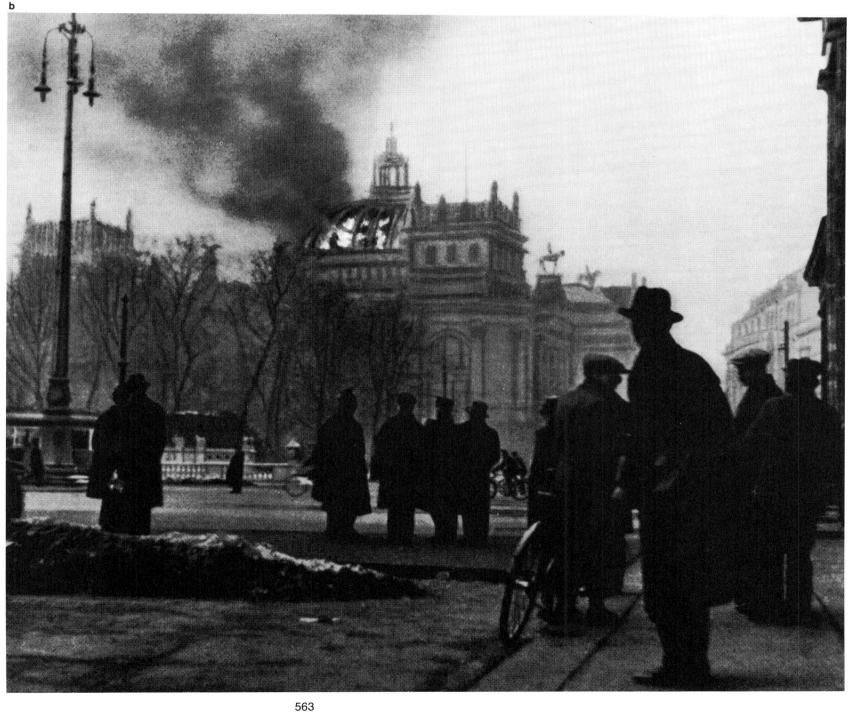

The Closing

On April 11, 1933, shortly after the opening of the summer semester, the Bauhaus in Berlin was searched, on behalf of the Dessau public prosecutor's office, by Berlin police and auxiliary police of the Storm Troopers, for Communist propaganda material allegedly hidden there. This action was directed primarily against Fritz Hesse, against whom an "investigating committee" had been appointed in Dessau, but of course it was also directed against the Bauhaus itself. Since there were no illegal pamphlets hidden at the Bauhaus and since therefore none could be found, the police, not wanting to leave empty-handed, arrested those students who had not been able to produce identity papers. The doors of the building were sealed to make it impossible for anyone to enter, at least officially. In public, it was claimed the police had confiscated a number of boxes containing illegal printed material. Another fabrication was the contention that the year previously the Bauhaus had done away with a number of boxes which had been sealed by the Dessau police. Nor was it true that Mies van der Rohe—as was proclaimed by the newspapers—had "preferred" to escape to Paris; nor that Gropius was staying in Russia. Both were in Berlin. In negotiations with Alfred Rosenberg, the then very influential cultural theorist in the National Socialist German Worker's Party, and with the Ministry of Culture and police officials, Mies van der Rohe tried to obtain permission for the resumption of teaching activities. This permission was granted by the Secret Police (Gestapo) on July 21 with some limiting clauses directed principally against the further employment of Hilberseimer and Kandinsky as teachers. Two days before this qualified permission was communicated, the faculty meeting on July 19 had decided to dissolve the Institute because of financial difficulties and the recognition that the Bauhaus could not be maintained in the "Third Reich." Like the first German Republic, the Bauhaus had existed for fourteen years; also like this Republic, it had been founded in Weimar and had met its ultimate fate in Berlin. But its ideas were impossible to obliterate.

a

Haussuchung im „Bauhaus Steglitz"
Kommunistisches Material gefunden.

Auf Veranlassung der Dessauer Staatsanwaltschaft wurde gestern nachmittag eine größere Aktion im „Bauhaus Steglitz", dem früheren Dessauer Bauhaus, in der Birkbuschstraße in Steglitz durchgeführt. Von einem Aufgebot Schutz-

war jedoch verschwunden, und man vermutete, daß sie von der Bauhausleitung mit nach Berlin genommen worden waren. Die Dessauer Staatsanwaltschaft setzte sich jetzt mit der Berliner Polizei in Verbindung und bat um Durch-

Alle Anwesenden, die sich nicht ausweisen konnten, wurden zur Feststellung ihrer Personalien ins Polizeipräsidium gebracht.

polizei und Hilfspolizisten wurde das Grundstück besetzt und systematisch durchsucht. Mehrere Kisten mit illegalen Druckschriften wurden beschlagnahmt. Die Aktion stand unter Leitung von Polizeimajor Schmahel.

Das „Bauhaus Dessau" war vor etwa Jahresfrist nach Berlin übergesiedelt. Damals waren bereits von der Dessauer Polizei zahlreiche verbotene Schriften beschlagnahmt worden. Ein Teil der von der Polizei versiegelten Kisten

suchung des Gebäudes. Das Bauhaus, das früher unter Leitung von Professor Gropius stand, der sich jetzt in Rußland aufhält, hat in einer leerstehenden Fabrikbaracke in der Birkbuschstraße in Steglitz Quartier genommen. Der augenblickliche Leiter hat es aber vor wenigen Tagen vorgezogen, nach Paris überzusiedeln. Bei der gestrigen Haussuchung wurde zahlreiches illegales Propagandamaterial der KPD. gefunden und beschlagnahmt.

b

a
Newspaper article concerning the search (and the
closing) of the Berlin Bauhaus on April 11, 1933.
Newspaper the "Lokal-Anzeiger" (Berlin) of April 12,
1933.
(Translation:)
Search of the "Bauhaus Steglitz"
Communist material found
On orders of the Dessau public prosecutor's office, an
extensive operation was carried out in the "Bauhaus
Steglitz," the former Dessau Bauhaus, in Birkbusch-
strasse in Steglitz. The grounds were occupied by a
strong force of security and auxiliary police, who
searched the site systematically. Several boxes con-
taining illegal pamphlets were confiscated. Police
Major Schmahel was in charge of this police action.
The "Bauhaus Dessau" moved to Berlin about a year
ago. At that time the Dessau police had already con-
fiscated numerous illegal publications. But some of
the boxes the police had sealed disappeared and it
was assumed that the Director's office of the Bauhaus
had taken them along to Berlin. The Dessau public
prosecutor's office now contacted the Berlin police
and asked for a search of the building. The Bauhaus,
which at one time had been under the Direction of
Professor Gropius who at present is in Russia, has
taken up quarters in the empty barracks of a firm in
Birkbuchstrasse in Steglitz. The present Director,
however, preferred to move to Paris a few days ago.
Yesterday's search of the building turned up a large
amount of illegal propaganda material of the KPD
(German Communist Party), which has been confis-
cated.

b
Iwao Yamawaki: the end of the Dessau Bauhaus.
Collage. 1932.
One of the few free artistic products brought out by
the student body during the period of gloom pervad-
ing the final last months of Bauhaus activity. Published
in a Japanese journal, December 1932.

The Influence of the Bauhaus

The world-wide influence of the Bauhaus in the fields of art education, architecture, industrial design, and free and applied art rests primarily on the fact that its former members continued their active participation in teaching and professional practice outside Germany. Also important for the dissemination of its ideas were the artistic-programmatical and art-scientific publications and exhibitions.

Two years after he had resigned from the Bauhaus, in 1930, Walter Gropius, commissioned by the German Werkbund, designed the German section at the international exhibition of applied art, organized by the "Société des artistes décorateurs" in Paris. Within the space of five rooms the entire German contribution to the development of modern furniture, commodities, and industrial design, in the broadest sense of the term, had to be represented. Gropius himself set up a lounge. He assigned to Moholy-Nagy and to Breuer the design of one room of displays each; Herbert Bayer was given two rooms to arrange. Though the items on display by no means consisted of Bauhaus products exclusively, the German section turned into an excellent manifestation of its program. The exhibition ran for two months. Its influence was of long duration and of far-reaching effect.

In New York, where the work of the Bauhaus had been publicized in a smaller exhibition as early as early as 1931, the Museum of Modern Art arranged a highly representative display of the history of Bauhaus exhibitions. It ran from December 1938 to January 1939. The exhibition carried the title "Bauhaus 1919–1928" and gave a comprehensive review of the development of the Institute under the direction of Gropius. Its organizers were forced to abstain from displaying material representing the later Bauhaus, "for reasons not within the power of anyone involved, to change." The preparations and the technical arrangements of the exhibition were entrusted to Herbert Bayer. Compiling the collection met with the difficulty of having to avoid endangering the artists who had remained in Germany—where at that time the operation "degenerate art" was being carried out. The work that went into the exhibition "Bauhaus 1919–1928" resulted in a book by the same name, edited by Herbert Bayer with Walter and Ise Gropius. The English language original has seen several editions and after the Second World War it was also published in German. In his preface to the first edition (1938) Alfred H. Barr, Director of the Museum of Modern Art, observed that the world began to accept the Bauhaus from about 1930 on. "In America, lighting fixtures and tubular steel chairs were imported or the designs pirated. American Bauhaus students began to return; and they were followed, after the revolution of 1933, by Bauhaus and ex-Bauhaus masters who suffered from the new government's illusion that modern furniture, flat-roofed architecture, and abstract painting were degenerate or bolshevistic. In this way, with the help of the fatherland, Bauhaus designs, Bauhaus men, Bauhaus ideas, which taken together form one of the chief cultural contributions of modern Germany, have been spread throughout the world." (Quoted from the English original, published by Charles T. Branford Company, Boston.)

a
Walter Gropius: lounge and coffee-bar at the German section of the "Exposition de la société des artistes décorateurs" in the Grand Palais in Paris. 1930.
b
New York, Museum of Modern Art: exhibition "Bauhaus 1919–1928."
Display of work from the preliminary course.
December 1938—January 1939.
Selection, arrangement, and display design by Herbert Bayer.

b

a

During the early nineteen sixties the ideas of the Bauhaus began reaching countries which previously had been little or not at all affected by them. Their dissemination was even promoted officially from Germany, where after the war the significant cultural contribution of the 'twenties had been rediscovered. Thus, on behalf of the government, a traveling exhibition was put together by Roman Clemens, who had studied in Dessau. It was shown in the larger Italian cities and then sent to the Far East. Australian museums showed a Gropius exhibition which had been arranged by the Bauhaus-Archiv in Darmstadt. Remarkable interest in the Bauhaus and its architecture developed in South Africa and above all in Latin America, where a display selected by Ludwig Grote provided an opportunity for getting acquainted with the Bauhaus painters. An exhibition of Bauhaus paintings found enthusiastic support in London in 1962. Although Klee and Kandinsky had long ago become part of the international artistic heritage, painters like Schlemmer, and the intellectual relationships of the artists at the Bauhaus and their stimulating power were not clearly understood. Slowly Schlemmer began to receive more favorable critical response—one of the manifestations being an extensive exhibit in Rome. The Bauhaus-Archiv in Darmstadt contributed appreciably to the constantly increasing exhibit activity. It directed its attention to such sectors of the Bauhaus endeavors—as for example the weaving workshop—that had hitherto been neglected by the critics and had been insufficiently appreciated by the public. Traveling exhibits were assembled and sent throughout Europe, to America, Africa, Australia, and Asia, where they were shown in museums, universities, and centers of information. The most extensive Bauhaus exhibit put together up to the present has been largely the result of the painstaking research and acquisition work done in Darmstadt. It was prepared, with the support of the West German federal government, by the Württemberg Art Association and has been sent, after an initial showing in Stuttgart, to a large number of cities in Europe and North America. A considerable portion of the approximately 2000 objects in this assemblage comes from the collections of the Bauhaus-Archiv.

a
Milan, Palazzo Reale: Bauhaus Exhibition.
October 1961.
Selected and designed by Roman Clemens.
In the foreground there is a reconstruction of a project from Albers' preliminary course ("Studies in construction and structural strength").
b
Rome, Galleria d'Arte Moderna: Bauhaus Exhibition.
November—December 1961.
Selected and designed by Roman Clemens.
Collection of photographic plates (photographs of people and of the most important achievements of the Bauhaus) and reconstructions of sculptural projects (from the preliminary course). The arrangement was carried out using exhibition techniques developed at the Bauhaus.

b

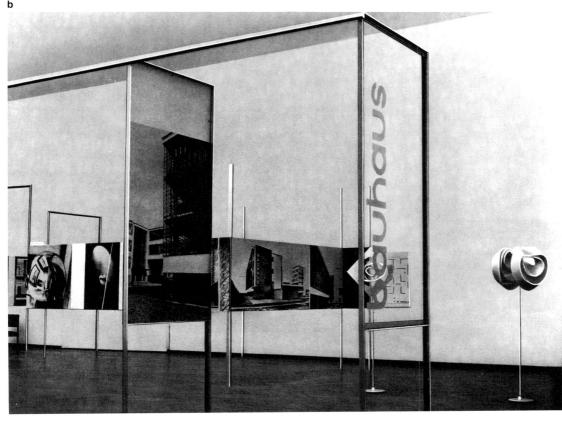

Apart from Germany, the ideas of the Bauhaus have produced a strong resonance in the United States and in Japan for many years. Japanese students of the Bauhaus have practiced Bauhaus teaching in their own country. What the Bauhaus strove for coincided to a large extent with their own tradition, both as to ideals and to forms. This tradition had, since the later part of the nineteenth century, been a source of inspiration for European art and handicrafts. Students at the Weimar Bauhaus studied the philosophy of the Far East and were interested—quite generally, it appears—in Chinese brush painting with which they were able to acquaint themselves from illustrations in the Institute library (which, incidentally, was not frequented particularly eagerly). Far Eastern influence is doubtlessly evident in the paintings of Klee and Kandinsky, though difficult to pinpoint concretely. But there was no organized study of Oriental art and product design at the Bauhaus. What may have made the Japanese feel at home at the Bauhaus was the experience of an inner harmony in relation to the problems of creativity. Bauhaus ideas were able to develop deeper roots in them. Works of the Bauhaus were publicized and exhibited in Japan as early as 1930. Publications in the form of books (among them one, on the Bauhaus in particular, and two on Gropius) had been available since the nineteen fifties. The influence of the Bauhaus on Japanese architecture and industrial design is immeasurable.

In the United States the Bauhaus has influenced not only design practice but most of all art education. That it has entered into the general education consciousness is to be attributed specifically to the activities of a number of museums. In addition to the Museum of Modern Art in New York, numerous smaller museal institutes have arranged exhibits concerning the Bauhaus or individual Masters. The leading architects and painters of the Bauhaus have—of course—long been given their honored place in the hierarchy of art history. As early as the nineteen twenties Feininger, Kandinsky, and Klee had their collectors and friends. To those interested they were known primarily through the exhibitions they put together with Jawlensky, calling themselves "Die blauen Vier" ("The blue four"). During a period of more than two decades, the Harvard-affiliated Busch-Reisinger Museum of Germanic Culture in Cambridge, Massachusetts, permanently championed the cause of the Bauhaus. Under its curator, Charles Kuhn, it organized instructive exhibitions and lecture series and added a comprehensive collection of documents and archival material to an excellent art collection. With Gropius, whom it had appointed professor in 1937, Harvard University (and, because of its proximity in Cambridge, the Massachusetts Institute of Technology) became one of the centers of the Bauhaus tradition in the United States. A remarkably broad influence became apparent after 1945 and was supported by publications. The fact that English editions of some of the volumes of the Bauhaus series could be published is further confirmation of the esteem which America expresses for the Bauhaus.

A hopeful development in Czechoslovakia since the middle of the nineteen twenties, instigated to a large degree by the Bauhaus, was discontinued by the political events of 1938 and the years following. The Bauhaus was attended by many students of Slavic origin. Very active connections with Prague existed above all during the Meyer era. In 1928 Albers lectured there on the preliminary course (education congress); in 1930 works of the Bauhaus were put on display, and the magazine "RED" published a special edition on the Bauhaus. The achievements of its architects and painters were known at least to professionals. Even in Moscow, thanks to Meyer's activity, people were able to acquire an impression of the Bauhaus.

In Germany before 1933 Bauhaus teaching had gained a foothold in a number of art academies and schools of arts and crafts. As early as 1923, the city art school (Städelschule and Kunstgewerbeschule) in Frankfurt on Main reorganized its curriculum according to the precepts of the Weimar Bauhaus. In part, principles of the Bauhaus curriculum have been adopted by the art academies in Berlin and Breslau and by the arts and crafts schools in Hamburg, Halle, and Stettin. After 1945 the methods of the preliminary course were incorporated into the programs of most of the art schools in the Federal Republic. The Art Academy in Berlin, the State Art School (Academy) in Hamburg, and the "Werkakademie" (arts and crafts school) in Kassel were the most lively schools in the sense of teaching in the Bauhaus manner. The Hochschule für Gestaltung ("Institute of Design") in Ulm derived from the Bauhaus but since then developed a profile of its own.

Beginning in the early nineteen twenties until the day when freedom of opinion was repressed by Hitler's dictatorship, and again after 1945, many leading newspapers vigorously promoted the Bauhaus with publicity and by providing information. The number of more or less detailed publications inquiring into the matter of the significance of the Bauhaus and its masters is legion. Museums and art clubs, large and small, have at all times contributed substantially to informing the public by developing their own collecting and exhibiting activities. Hence, before 1933, the museums in Halle, Erfurt, Zwickau, and Stettin, in particular, owned excellent collections of the works of the Bauhaus Masters. To be sure, these men were represented in distinguished collections, as in the Folkwang-Museum in Essen or the Berlin "Kronprinzenpalais," with valid examples of their attainment. In the years since 1945, every art museum able to afford them has bought works that originated in the Bauhaus. Three institutions are primarily concerned with the Bauhaus and its aftermath with regard to the promulgation of the well-designed industrial product; they are the "neue Sammlung" ("New Collection") in Munich, the "Villa Hügel" ("Hügel Villa") in Essen, and the "Institut für neue technische Form" ("Institute for New Technical Form") in Darmstadt. The "Rat für Formgebung" ("Council for Industrial Design"), also in Darmstadt, has been active in a consulting and informative capacity. As a man who knows the Bauhaus and who is a good friend of it, Ludwig Grote (Munich and Nuremberg) put together a private collection with due consideration of workshop products as well.

The Bauhaus-Archiv in Darmstadt serves as a center for documentation, for historically critical research, and for the dissemination of the ideas manifest in the Bauhaus. It was founded in 1960 and officially opened in 1961. A collection of archival material, a museal department, and a library were set up in the "Ernst-Ludwig-Haus" on the Mathildenhöhe, the original center of the "artists' colony." When the archive was founded, its nucleus was a comprehensive collection of Bauhaus documents donated by Walter Gropius. The scientific field of research includes all cultural phenomena related to the Bauhaus and goes back to Semper and Morris; the Bauhaus itself is seen as the culmination of a multifaceted and comprehensive development. The Bauhaus-Archiv plans exhibitions, editions, and lecture series (on its own as well as in conjunction with other German institutes and those in other countries). Staying in contact with the old and with new friends of the Bauhaus, it endeavors to keep alive the realization of its continuing influence.

a
Opening of the Bauhaus-Archiv in Darmstadt on April 8, 1961.
The opening ceremony received special significance through an address by Walter Gropius (at the lectern) and the opening lecture delivered by Georg Muche (fourth from the left). A large number of former members of the Bauhaus attended the ceremony which took place in the Hessian State Museum (Hessisches Landesmuseum). Among the guests of honor was Johannes Itten (third from the left).
b
Busch-Reisinger Museum, Harvard University, Cambridge, Massachusetts: information leaflet and cover of the catalog for the exhibition "Bauhaus in Germany and America." May—June 1956.
c
Cover of a Japanese publication on the Bauhaus. Edited by Iwao and Michiko Yamawaki. Tokyo 1953.

a

b

BAUHAUS

in germany
and america

MAY 14
JUNE 15

busch-reisinger museum
harvard university

a museum course exhibition

c

bauhaus

weimar—dessau—berlin

近代建築家

7

山脇 巌

Concerning the influences exerted by the preliminary-course methods of the Bauhaus on elementary art instruction in the United States, Charles L. Kuhn remarked that they were evident simply "everywhere." The fact that they have been so widely disseminated is especially due to the work of Josef Albers and Laszlo Moholy-Nagy. Albers created a powerful focal point for the educational philosophy of the Bauhaus at Black Mountain College in North Carolina, an experimental school derived out of an artistic-humanistic spirit and influenced by the theories of John Dewey. It became widely influential. Albers taught here from 1933 until 1949, and from 1950 until his retirement in 1959 he held a significant professorship at Yale University. Guest lectures at Harvard and elsewhere widened the horizon of his activities. To an increasing extent he now included color in his creative studies; its mutual relationships constituted an essential pedagogic subject. The impulses emanating from his work have exerted a decisive influence on the "Op" art of the nineteen sixties.

Even though the artistic activities at Black Mountain College were of an extremely lively and enthusiastic nature, and even though, in addition to Josef Albers, Anni Albers and for a brief period also Xanti Schawinsky worked there, the institution can be regarded as a true successor to the Bauhaus in a rather broad sense only. A truly legitimate continuity for the Bauhaus arose in a school of design to which Laszlo Moholy-Nagy contributed the elementary program and the artistic substance of his life work: the "New Bauhaus," founded in Chicago in 1937 and continuing its activities to the present day in the Institute of Design of the Illinois Institute of Technology.

The large number of specialized disciplines of the Illinois Institute of Technology in Chicago includes three that are direct descendants of the Bauhaus heritage. In addition to the "Institute of Design," originated by Moholy-Nagy, they are the department of architecture, under the leadership of Mies van der Rohe, and the department for city and regional planning under Hilberseimer. At the same time Hilberseimer taught in Mies van der Rohe's department as well as in both seminars. Peterhans conducted the elementary instruction—called "Visual Training,"—until his death in 1960. The Bauhaus-trained architect Howard Dearstyne taught along with the Bauhaus Masters. Hence, the departments of architecture and city and regional planning were the actual and legal continuation of the Bauhaus of the later phase in Dessau and the period in Berlin. In addition, the character of being the Bauhaus successor was significantly underlined by the fact that Mies van der Rohe's and Hilberseimer's departments and the "Institute of Design" together received an eminently representative building, designed by Mies van der Rohe (as were other buildings of the Illinois Institute of Technology). Several other American colleges, institutes, and universities also employ former members of the Bauhaus, in part in positions of influence.

a

Walter Gropius and Marcel Breuer: building complex for Black Mountain College in North Carolina. Model (not carried out). 1939.

b

Ludwig Mies van der Rohe: "Crown Hall," the building of the department of architecture, city planning, and industrial design at the Illinois Institute of Technology in Chicago. 1955–1956.

a
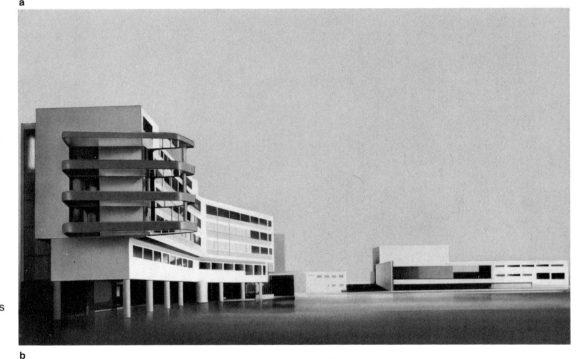

b
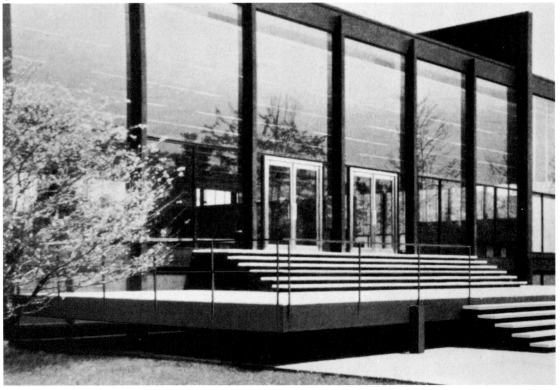

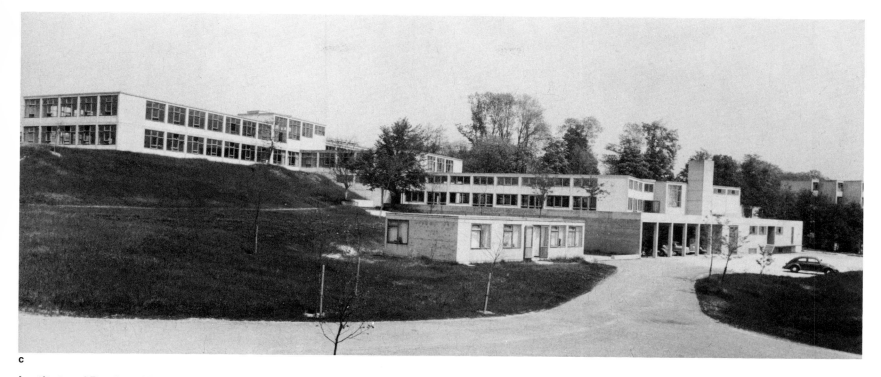

c

Institute of Design, Ulm

The "Institute of Design" was founded in 1950
in recognition of the fact that "a place for re-
search and training in the design problems of
our time is needed. Such an institution has been
lacking ever since the closing of the Bauhaus."
But the possibility for seeking new ways was left
open by avoiding the establishment of a mere
replica. Max Bill had an important part in the
planning of the school. He designed the com-
plex of buildings which were put into operation
in 1955, and was its Director from the time of the
provisional beginning of the classes until the
spring of 1956. While Bill attempted to orient
his approach along the lines laid down by the
Bauhaus and perhaps to an even greater ex-
tent by the curriculum of Chermayeff's Institute
of Design, and at the same time to retain his
own, creative independence, his immediate
successor, Tomás Maldonado, increasingly
adhered to Hannes Meyers' scientific-dogmatic
tendencies. "Design, as this school sees it,"
it says in an announcement (prospectus, 1956),
"has nothing to do with vagaries of fashion or
the unrelenting search for new effects. . . . The
development of an object requires intensive
research and methodical work, in order to do
justice to all the technical, functional, esthetic,
and also economical requirements. A good
design has to live up to reality. For that reason,
the work of the school must be done in con-
junction with sociology, contemporary history,
and other disciplines relating to our social
structure." The students work in groups and in
contact with their teachers "on the solution of
problems occurring in practice; theoretical
knowledge is imparted in direct relation with
the problems." In addition, the school offers
lectures in the arts and sciences and sociology.
The areas in which problems are being studied
are: "formal product design, architecture, city
planning, and visual communication and in-
formation. They are regarded as an entity. . . ."
In 1968 the Ulm Institute of Design experienced
critical difficulties, because the financial sup-
port from public funds was severely curtailed
and the authorities showed little understanding
for the specific tasks and for the needs of the
school. As soon as it became known that the
danger of dissolution was imminent, protests,
petitions, and declarations of solidarity arrived
from all over the world, proving that the work
done at the Ulm Institute was taken seriously
by the international community of scholars and
artists. The crisis came to a head at the end of
1968, at which time the Baden-Württemberg
authorities decided to close the Institute. The
faculty was dismissed, but the government let
it be known that it had the intention, in principle,
to continue the school on a more solid basis and
with a revised curriculum.

c
Max Bill: "Hochschule für Gestaltung" ("Institute of
Design") in Ulm (Germany). 1953–1955.

**The New Bauhaus
School of Design in Chicago
Institute of Design**

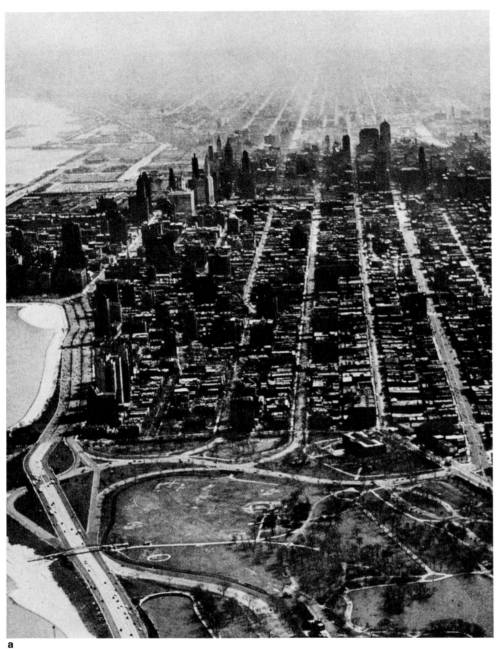

a

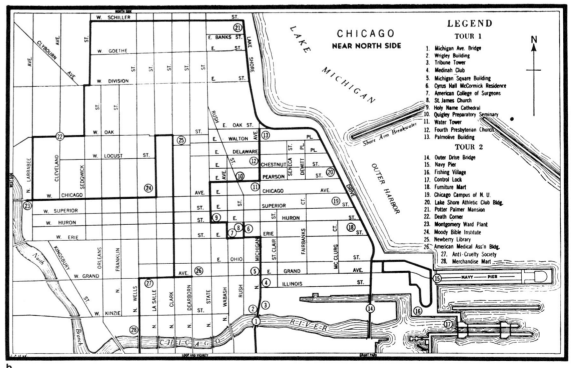

b

The New Bauhaus 1937–1938
School of Design in Chicago 1939–1944
Institute of Design since 1944

During the last quarter of the nineteenth century—after the great fire which had totally destroyed the city—Chicago became the greatest architectural experimental proving ground in America, if not in the whole world. It was here that the skeletal structures were developed and that the first skyscrapers arose. Architects such as Louis Sullivan and later his pupil Frank Lloyd Wright established a new criterion of quality. By the nineteen thirties the era of Chicago's great architectonic accomplishments had become a thing of the past. Still, certain individuals and small groups were keenly aware that this mighty commercial metropolis had definite cultural obligations and that one of these, aside from academic and scientific disciplines, was Design—the formation of the environment. This was the premise on which the New Bauhaus and its successor institutions, the School of Design and the Institute of Design, were founded.

a
Chicago. Aerial view, looking south across the Loop with Lake Michigan (left) and Lincoln Park (foreground). Before 1948.

b
Chicago. Near North Side.
The School of Design, resp. the Institute of Design, had three homes in this area: East Ontario Street, North State and Rush Streets, and North Dearborn Street.

c
Chicago. South Side.
The New Bauhaus was installed on Prairie Avenue. With its incorporation into the "Crown Hall" on the campus of the Illinois Institute of Technology in 1956, the Institute of Design returned to the neighborhood in which Moholy-Nagy had first established his New Bauhaus.

CHICAGO
SOUTH SIDE

LAKE MICHIGAN

LEGEND

1. Coliseum
2. John J. Glessner House
3. W. W. Kimball House
4. Marshall Field Mansion
5. Second Presbyterian Church
6. New Michigan Hotel
7. Lakeside Press
8. Burnham Park (extends southward)
9. Chinatown
10. Quinn Chapel A. M. E. Church
11. Illinois Institute of Technology
12. Comiskey Park
13. Union Stock Yards
14. University of Chicago Settlement
15. Victory Monument
16. Stephen A. Douglas Monument
17. Abraham Lincoln Centre
18. Poro College
19. Widow Clarke's House
20. Michigan Boulevard Garden Apartments
21. St. Xavier College
22. Washington Park
23. Temple Isaiah Israel
24. Oak Woods Cemetery
25. Marquette Park
26. Chicago Municipal Airport
27. Wentworth Farm House
28. Ryan Woods
29. John H. Vanderpoel Memorial Art Gallery
30. Morgan Park Military Academy
31. Town of Pullman
32. South Works of Carnegie-Illinois Steel Corp.

N

a
Chicago, 1905 Prairie Avenue
Home of the New Bauhaus, 1937–1938.

b
Chicago, 247 East Ontario Street
The second story served as domicile for the School of Design, resp. the Institute of Design, from 1939 until 1945.

c
Chicago, 1009 North State Street (corner Rush and Oak Streets)
The Institute of Design was housed in the upstairs floor in 1945–1946.

d
Chicago, 632 North Dearborn Street
Formerly home of the Historical Society; taken over by the Institute of Design in 1946 (shortly before Moholy-Nagy's death). Occupied by the Institute until 1955.

e
Chicago, "Crown Hall," 3360 South State Street, Model. 1955.
Since 1956 the Institute of Design has been housed in the basement of this building, designed by Ludwig Mies van der Rohe.

d

e

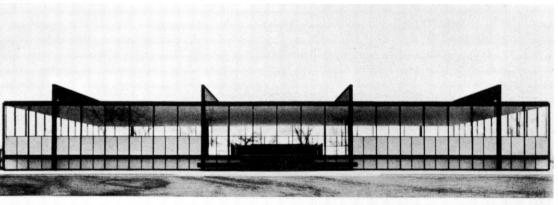

Chronology

1937

Establishment of the New Bauhaus in Chicago. Sponsor: The Association of Arts and Industries. Director: Laszlo Moholy-Nagy. Consultant: Walter Gropius.

The faculty includes Alexander Archipenko, Hin Bredendieck, George Fred Keck, Gyorgy Kepes, and others. Members of the University of Chicago serve as science guest lecturers.

1938

Lack of support on the part of the sponsors leads to the closing of the Institute.

1939

Moholy-Nagy founds the School of Design. Financial support furnished by Moholy-Nagy and his colleagues of the former New Bauhaus. Faculty gradually extended (Marli Ehrman, Nathan Lerner, Frank Levstik, Johannes Molzahn, and others). Animated by Moholy-Nagy's conception and determination, the industrialist Walter Paepcke contributes increasingly to the financial maintenance. This aid secures the Institute's viability for several years.

1944

Change of title to Institute of Design. It obtains college status. Tremendous increase in student enrollment.

1946

Moholy-Nagy's death. Successor: Serge Chermayeff. Extension of faculty, drawn largely from former students. Examples: Richard Koppe and (1950) Elmer Ray Pearson.

1949

Incorporation of the Institute of Design into the Illinois Institute of Technology. It obtains university status. Faculty joined by Konrad Wachsmann, a pupil of Poelzig, to head the department of Building Research.

1951

Chermayeff resigns. New acting Director: the architect Crombie Taylor.

1955

Jay Doblin appointed to head the Institute. Many faculty members resign. With the transfer of the Institute of Design into Crown Hall at the Illinois Institute of Technology the Building Research department is discontinued. Following the compulsory preliminary course, four departments are available to the student body: visual design, product design, photography, art education. The curriculum remains constant in the years following.

1964–1966

During Doblin's absence the Institute of Design is headed by Lute Wassman.

a

The Directors of the Institute

a
Laszlo Moholy-Nagy surrounded by his students at the School of Design in Chicago. About 1941.
Not only did Moholy-Nagy found and head the Institute until his death on November 24, 1946; it constituted intrinsically his own life's work. He had brought into it his artistic and pedagogic knowledge and influenced the work of the Institute for decades to come, even though his program was subsequently reduced in scope and modified in substance. A passionate teacher, entirely absorbed in his work, he was revered by his students. As has been shown time and again, many personalities ineradicably bore the stamp of his influence.

b
Serge Chermayeff as Director of the Institute of Design, 1946/47 to 1951. Born in southern Russia on October 8, 1900, Chermayeff was brought to England at the age of 10. He remained there until the second World War, at which time he emigrated to the United States. While in England, he worked partly on his own and partly (1933–1936) in collaboration with Erich Mendelsohn. From 1942 to 1946 he was Chairman of the Department of Design at Brooklyn College. The qualifications that especially recommended him to head the Institute of Design in Chicago were above all his intellectual capabilities and his worldly hability. Still, frequent difficulties arose in his contact with his co-workers. Chermayeff later taught architecture at the Massachusetts Institute of Technology (1951–1952), at Harvard University (1953–1962), and at Yale University (since 1962). His chief contribution to the Institute of Design lay in the fact that he extended the curriculum in Moholy-Nagy's tradition; he both differentiated and tightened the pedagogic program. In this form it became the prototype for other institutions, such as the Hochschule für Gestaltung (Institute of Design) in Ulm.

c
Jay Doblin, Director of the Institute of Design since 1955. Before accepting the call to head the Institute of Design, Doblin was active in practical design work. For eleven years he was collaborator of Raymond Loewy in New York. He received his education at the Pratt Institute in Brooklyn, where he subsequently conducted an evening class in industrial design for three years. Doblin, only thirty-five years old when called to Chicago, succeeded in consolidating the Institute, which had been badly shaken by the fact that the Director's position had been vacant during several years. He trained a large number of capable designers. The accomplishments of the Institute remained on an even high level.

d
Laszlo Moholy-Nagy: Space Modulator. 1940. Construction in Plexiglas on a mirroring plane.
Moholy's artistic intentions constituted an integral element of his conception and thus also of his pedagogic program. The free creative works of the last years of his life are particularly revealing with respect to the visual problems that constantly preoccupied him, in every phase of his activity. In those years these problems primarily concerned kinetics, light, and transparence.

b

c

d

583

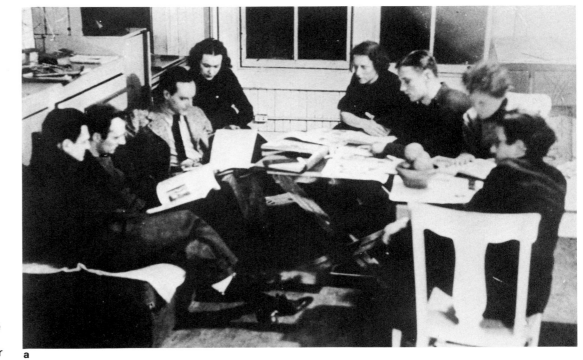

a

Life and Work

Herbert Read concerning Moholy-Nagy and the Institute of Design. From a letter to David H. Stevens of the Rockefeller Foundation, October 18, 1946:

"I was in Chicago for a week earlier this year (April 17–24): I gave two lectures at the Institute, visited it several times, and had full opportunity not only to see it at work, but to discuss its organization and methods of teaching. . . .
I had known Mr. Moholy-Nagy during the two or three years he was in [England], and I had had letters from him at rare intervals from Chicago. I was also familiar with the ideals and the history of the original Bauhaus established by Walter Gropius in Germany in 1919. I was therefore very interested to see how this institution had fared since its transplantation to the United States . . .
I was delighted to find a thriving and apparently well-established school. Moholy himself, in spite of recent illness, seemed to be overflowing with energy and initiative, and what particularly struck me was the enthusiasm and devotion which he seemed to have inspired in a very efficient staff of teachers. I was also struck by the general brightness and keenness of the students—the whole place had that sweet sound of a hive 'humming.'
I was not able, on such a short visit, to judge what degree of integration with industry had been achieved by the school, but I gathered that many of the Institute's designs had already been taken up by manufacturers, and that the Institute in its short history had already acquired considerable prestige. This impression was confirmed by competent observers with whom I discussed the Institute in other cities . . .
No doubt the Institute has its limitations, but my impression is that such as they are, they are due entirely to lack of space and equipment. Some people might question its underlying principles, its methods of teaching, but I think they would be flying in the face of all the evidence. These methods and principles have stood the test of more than twenty-five years experience. All that is most fruitful in modern design can be traced to this fountain-head. I would say that the Institute of Design is the best school of its kind that exists anywhere in the world today."

a
Faculty members and students of the New Bauhaus, 1937–1938. Left to right: Giampietro, Bredendieck, Kepes, Mrs. Kepes, Mrs. Bredendieck, Koppe, Mrs. Corazzo (?), Corazzo.
b
Modeling workshop of the School of Design at 247 East Ontario Street. 1939.
c
The sculpture class of the summer school in Somonauk, Ill. 1939 or 1941. The summer courses took place during 1939, 1941, 1942, and 1943 in a country home placed at the disposal of the School of Design by the industrialist Walter Paepcke and his wife Elizabeth. It was located in Somonauk, Ill., about two hours' drive from Chicago.
d
The annual auction of student and faculty work of the School of Design, for the benefit of the Moholy-Nagy fellowship fund. After 1946. The auctions took place each year, starting soon after Moholy-Nagy's death. In the center, standing in front of the auctioneer, Serge Chermayeff in profile.

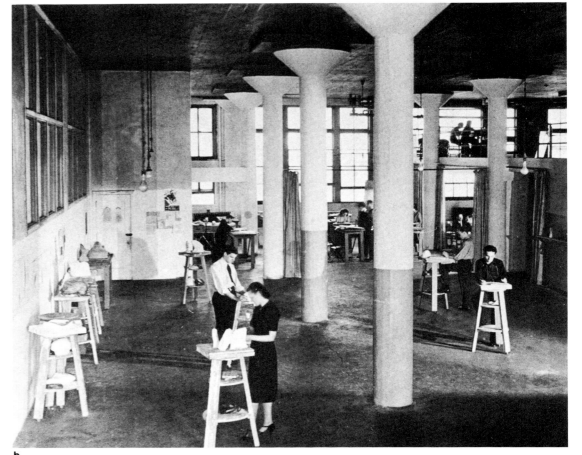

b

584

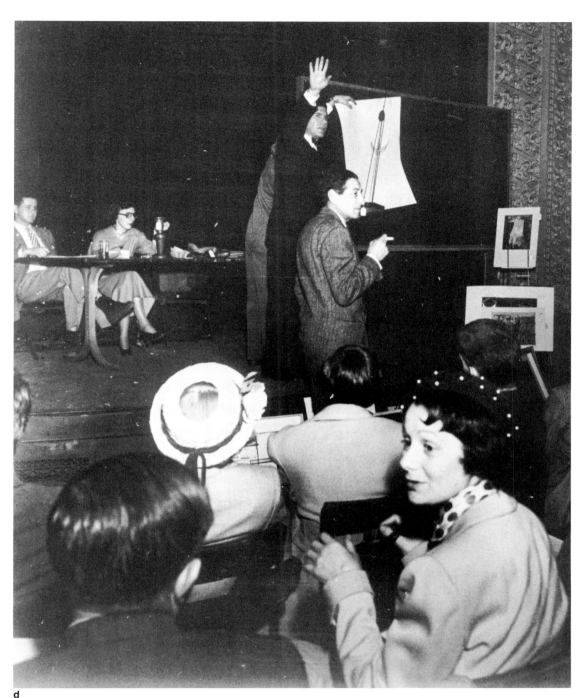

d

c

New Bauhaus—
Brochures, typography, layout

By the time the special edition of "More Business," containing significant articles and illustrations appeared, the New Bauhaus had ceased to exist. A few months later Moholy-Nagy established the "School of Design," founded on the same intellectual principles.

a
Reproductions of paper cuttings and wood cuttings from the preliminary course at the New Bauhaus. Page from the November 1938 edition of "More Business," typography designed by Moholy-Nagy.
b
Laszlo Moholy-Nagy: front page of prospectus "the new bauhaus." 1937.
c
Gyorgy Kepes:
Front page of the periodical "More Business," November 1938.
d
Page designed by Moholy-Nagy for the special Bauhaus edition of the periodical "More Business," November 1938, with reproductions of tactile exercises and hand sculptures. In the original the background is yellow.

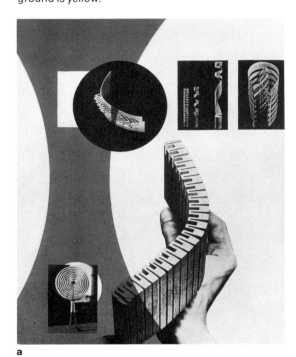

a

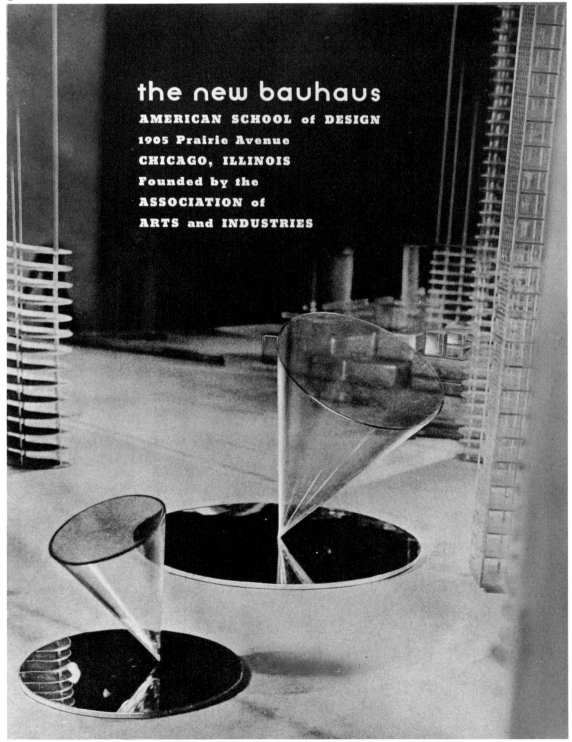

b

the new bauhaus
AMERICAN SCHOOL of DESIGN
1905 Prairie Avenue
CHICAGO, ILLINOIS
Founded by the
ASSOCIATION of
ARTS and INDUSTRIES

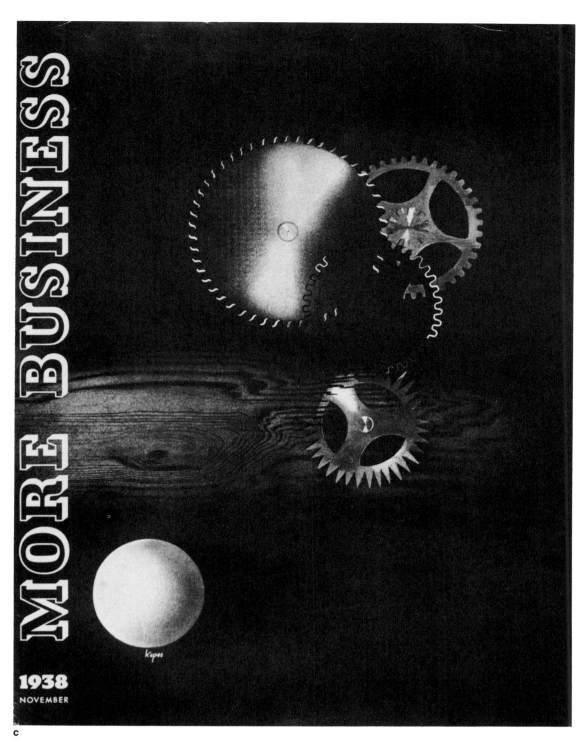

c

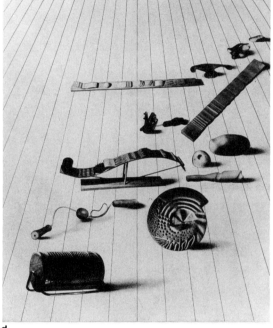

d

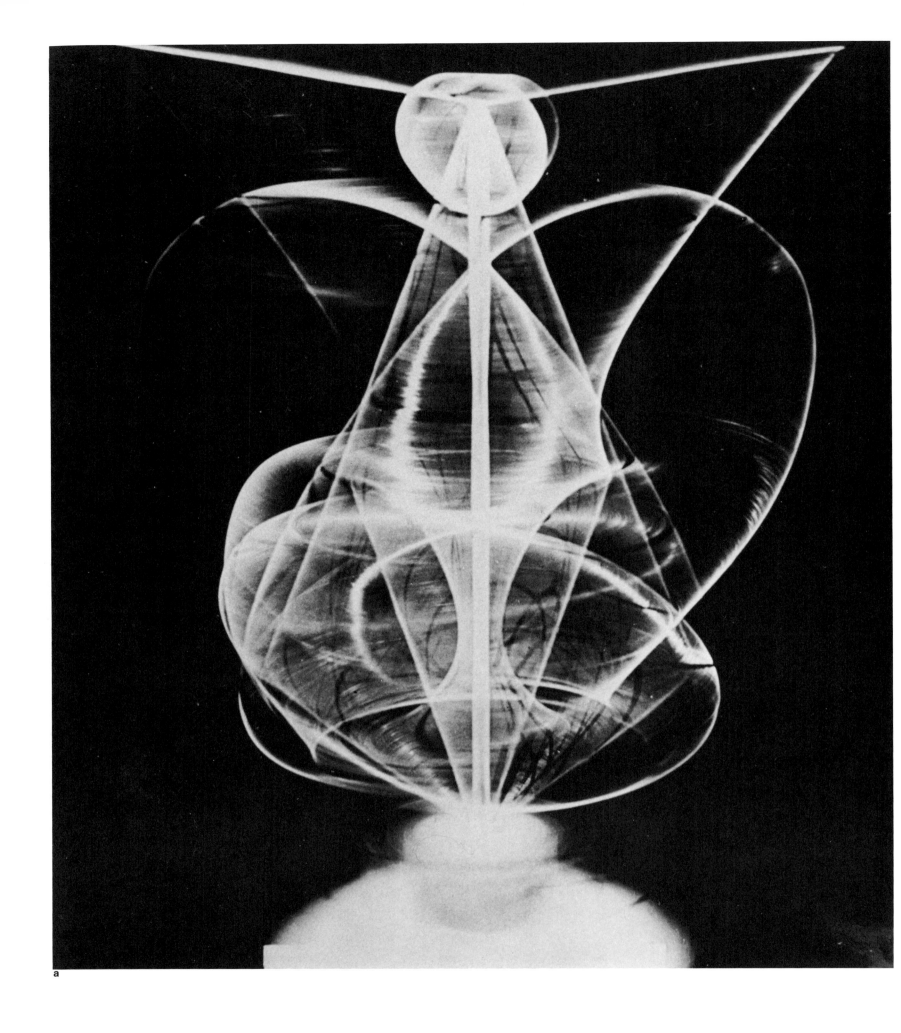

a

Preliminary course 1937–1946

a

Preliminary-course study from the first-semester class given at the New Bauhaus: Virtual volume, produced through the rotation of a wire construction. 1937. Originator of the study and of the photograph: Richard Koppe.

b

Students' work from Hin Bredendieck's preliminary course at the New Bauhaus. 1937–1938. Wood carvings, mechanically produced. Problem: To determine the specific possibilities of machine-working of wood.

c

Students' work from the preliminary course at the New Bauhaus, 1937–1938. Foreground: tactile chart and wood sculpture from Hin Bredendieck's course. Along the walls: two-dimensional studies, especially color problems.

d

Students' work from Hin Bredendieck's preliminary course at the New Bauhaus. 1937–1938.

c

d

b

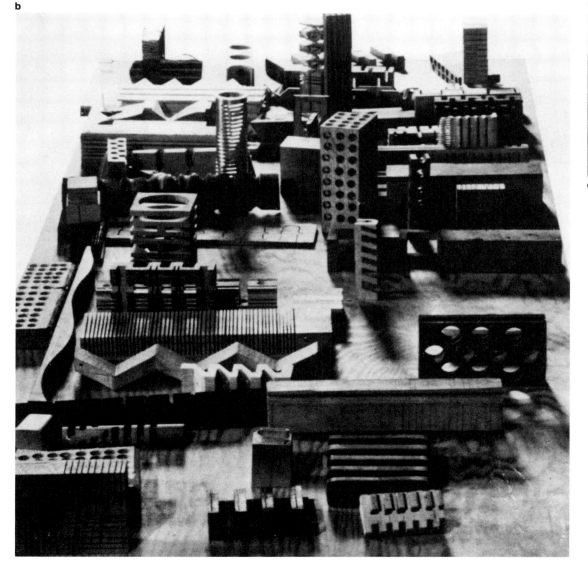

a
Students' work from the preliminary course at the
Institute of Design. 1944. Sheet metal, structurally
bent. Investigation of the specific possibilities of the
material, simultaneously tactile exercise.
b
Student work by Richard Koppe of Hin Bredendieck's
preliminary course at the New Bauhaus. 1937–1938.
(Replica of an original no longer existing.)
c
Paper cutting from Hin Bredendieck's preliminary
course at the New Bauhaus. 1937–1938.
''The paper cuttings show how the student has to
change a flat surface through cutting and folding,
without any loss of material, into a three-dimensional
structure. The wood cuttings show the potentialities
of the woodworking machines.'' (Quotation from the
November 1938 issue of the periodical ''More Busi-
ness.'')

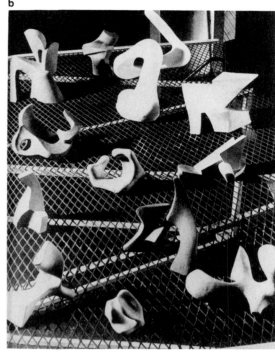

b

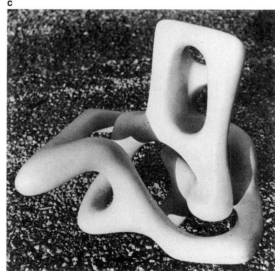

c

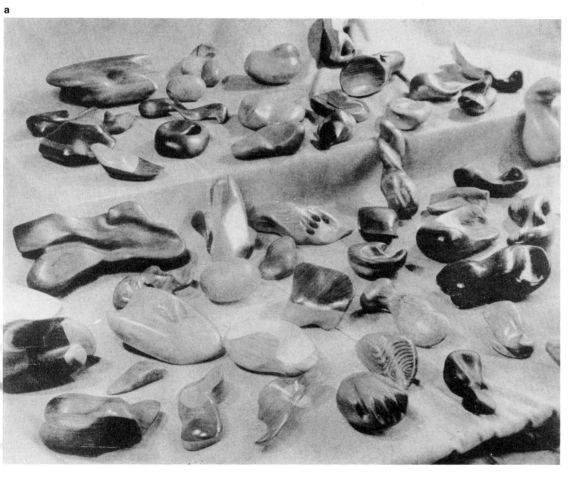

a

Sculpture 1937–1946

The sculpture class assumed a very significant
function, within the frame of elementary instruc-
tion, as a means of education and of the refine-
ment of tactile sensitivity, for every budding
designer and architect requires the ability to
imagine within the concepts of space and
dimension. The "hand sculpture," a form of
abstract miniature sculpture pleasant to the
touch, flattering the hand, as it were, appeared
particularly suitable in teaching refinement of
the tactile sensitivity. Thanks to Alexander
Archipenko, the sculpture class at the New
Bauhaus got off to a promising start. Later,
during the final years of the War, new substance
was instilled into it by Johannes Molzahn.
During the period after Moholy's death its signi-
ficance declined substantially.

a
Hand sculptures. Institute of Design. 1944–1946.
b
Exercises from the sculpture class of Johannes
Molzahn. Institute of Design. 1944.
c
Abstract sculpture in the round (direct work in plaster,
first year). Student: Catherine Hinkle. Institute of
Design. 1945–1946.

a

Foundation course,
after Moholy-Nagy's death

The accurate optical grasp and graphic repro-
duction of natural or man-made structures
remained an important factor of the elementary
education after Moholy-Nagy's death. The con-
struction of complicated abstract (geometrical)
structures was likewise recognized as a means
for training visual capabilities. Constructions
were especially valuable in familiarizing stu-
dents with the phenomenon of optical illusion
and the possibilities of exploiting it creatively.
Here the methods developed by Josef Albers at
the Bauhaus and later at Black Mountain Col-
lege were partly taken over. Free-hand drawing
was increasingly supplemented by the handling
of mechanical drawing implements. The training
from the very beginning was more and more
directed toward practical design, which was
what the students at the Institute of Design were
preparing for.

a
S-shaped construction of superimposed circles.
Graphic presentation emanating from two foci, result-
ing in a three-dimensional effect. From the course in
the foundation year at the Institute of Design. About
1960.

b
Superimposition of the two star-shaped structures.
Mechanical drawing from the course in the foundation
year at the Institute of Design. 1960. Teacher: Elmar
Ray Pearson.

c
Value study of a shape. Foundation course at the Insti-
tute of Design, second semester. Course in visual
fundamentals. 1948. Instructor: Richard Koppe;
student: P. Jones.

d
Undulated surface. Two-dimensional representation.
From the foundation course at the Institute of Design.
1951–1952.

b

c

d

a

b

Basic workshop—Recent works

The basic workshop serves for the investigation of materials and of three-dimensional experimentation within the framework of the elementary training at the Institute of Design. Elmar Ray Pearson, who received his own education under Moholy-Nagy, is committed to its principle of training not only the ability for visual imagination but also manual skills on as broad and comprehensive a basis as possible. The work with hand tools is supplemented with experiments with machinery and synthetic materials, so as to permit the student to become acquainted with the specific attributes and capabilities of highly developed mechanical tools while at the same time working with his hands. In addition to practical experience, the student also gains fundamental knowledge and insights.

a
Endless column. Vacuum-formed plastics.
From the basic workshop course at the Institute of Design. 1967.
Teacher: Elmar Ray Pearson.
b
Endless column. Vacuum-formed plastics.
From the basic workshop course at the Institute of Design. 1967.
Teacher: Elmar Ray Pearson.
c
Sculptural structure. Glue and paper.
From the basic workshop course at the Institute of Design. 1967.
Teacher: Elmar Ray Pearson.
d
Sculptural structure. Glue and paper.
From the basic workshop course at the Institute of Design. 1967.
Teacher: Elmar Ray Pearson.

c

d

a

Photography

Ever since the inception of the New Bauhaus, photography constituted one of the specialized disciplines of education in every phase of the new institution. Moholy-Nagy introduced the name "Light Workshop," thereby emphasizing the optical phenomenon, which was to be studied and used as a means of creative form. Later this department was named "Photography and Film" or just "Photography." Already during the foundation year, photography was and remained a significant aid to education. Its possibilities in illusionistic space and solid-body reproduction, for example, or in the reduction of the three-dimensional reality to two-dimensionality, opened basic insight into optical law and order. At the same time, essential elements for abstract artistic design could be gleaned from the study of the autonomous play of light, particularly within the framework of special instruction. Specialization in photography had as one of its professional goals, in addition to the actual photographic skills, design of commercial art (advertising). The extraordinarily high level of photography at the Chicago institution was primarily due to Moholy-Nagy, who revolutionized this field ever since his time at the Bauhaus. Based upon this intellectual background, Gyorgy Kepes continued his independent buildup as head of the photography class (light workshop). A group of strong talents ripened to superior craftsmanship under his guidance; some of them later benefited the Institute by becoming teachers themselves—among them Nathan Lerner, Arthur Siegel, Frank Levstik, and others. The accomplishments of the Institute of Design in the area of photography were documented time and again in exhibitions and in publications.

a
Gyorgy Kepes: Photogram. About 1940.
b
Gyorgy Kepes: Light Reflections. 1946
c
Gyorgy Kepes: Rhythmic Light Mural. 1940.
d
Gyorgy Kepes: Photodrawing 1940. Museum of Modern Art, New York.

b

c

d

a

b

c

d

Lerner was one of the first graduates of Moholy's Chicago Institute. Already as a student, and later as assistant to Kepes and instructor at the School of Design, he attracted attention by the universality of his talents and the wealth of his original ideas. For example, work with a primitive light box was one of his inspirations. Lerner subsequently excelled as a highly qualified product designer.

a
Nathan Lerner: ''Eye and Barbed Wire.'' Photographic study. School of Design. 1940.
b
Nathan Lerner: ''Eye on Window.'' Photographic study. School of Design. 1943.
c
Nathan Lerner: ''Cake in Window.'' Photographic study. New Bauhaus. 1937.
d
Nathan Lerner: ''Light Drawing 6.'' Photograph. New Bauhaus. 1938.
e
Nathan Lerner: Study of Light Volume. Light workshop at the School of Design. 1939.
f
Nathan Lerner: ''Light Drawing 5.'' Photograph. New Bauhaus. 1938.
g
Nathan Lerner: ''Lightbox Study 4.'' Photograph. New Bauhaus. 1938.
h
Nathan Lerner. ''Lightbox Study 6.'' Photograph. New Bauhaus. 1938.

e

f

g

h

a

d

e

b

c

Visual Design
(Visual Communication)
The primary objectives of the professional education in visual design were those intended to communicate a thought content that could be transposed into the visual. For a certain period of time, beginning in the late nineteen forties, the department was therefore called "Visual Communication." The most common practical goal of the students being trained here was commercial art (advertising), but the study also prepared for the professions of book illustrator and book designer. In a formal sense the Visual Design department continuously absorbed strong impulses from the equally avant-garde painting and graphic-arts departments. At the outset, it was above all Moholy-Nagy's influence that made itself felt.

a
Photomontage from the Visual Design course. Student: C. Hinkle. About 1945–1946.
b
Photo, color, and lines affected by three-dimensional forming. A study from Richard Koppe's course in Visual Design, Junior year. 1958. Student: Nancy Johnson.
c
Photomontage from the Visual Design course. Student: C. Hinkle. About 1945–1946.
d
One-word communication, as in a billboard. About 1954. Student: I. Chermayeff.
e
Angular composition of type and montage for implied message. Student work from the Visual Design course. About 1957–1958. Teacher: Richard Koppe, head of Visual Design.
f
A volumetric study and three-dimensional forming and the effect on color and pattern. (The round one contains alternating stripes of complimentary color; when rotated on a turn table, severe visual reactions occur.) A study from Richard Koppe's course in Visual Design, Junior year. 1958. Student: V. Jachna (Kemper).
g
Three-dimensional paper fold with type, color, and photomontage for message. A study from Richard Koppe's course in Visual Design, Junior year. 1958. Student: V. Jachna (Kemper).
h
Modification of the expressivity of a photograph by cutting and altered reassembly. A study from Richard Koppe's course in Visual Design, Junior year. 1958. Student: V. Jachna (Kemper).
i
Montage, type and lines affected by three-dimensional forming. From the Visual Design course. About 1950. Student: T. Shorer.

f

g

h

i

Product Design

The significance of the Product Design department for the entire Institute, for its self-evaluation and its reputation increased with the emphasis which it placed on practical work and its results. During the first years after the foundation by Moholy-Nagy, the design work was essentially tied to the legacy of the Bauhaus. Especially notable results were achieved in the area of woodworking. The plywood chairs originating around 1940 represented a formal and technical achievement that was fully equivalent to the achievements made in the furniture-design work of the Bauhaus. Moholy-Nagy and his collaborators explored entirely unconventional paths during the war, using substitute materials for the metals that were in short supply, in their experiments with industrial products. To arrive at the idea of constructing mattress springs out of bundles of wooden sticks and to realize this idea successfully presupposed a thorough knowledge of materials and a constructive imagination. The wooden springs were a temporary expedient born out of necessity, but they were a good one; industrially produced by a manufacturing concern, they fulfilled their purpose.

The formal orientation of the Product Design course toward the Bauhaus legacy was soon overshadowed by its development predicated on creative impulses; this already took place during the Moholy-Nagy period. Attempts in fields such as ceramics, which involved considerations of craft and therefore appeared sterile, were soon abandoned. Design work in urgent, even critical, and in part technically extremely complicated form problems became increasingly active, especially during the Chermayeff era. It was during his time that work with the design of building elements (for prefabricated building assemblies) was begun; basic studies looked into the most diversified aspects of fundamental problems (such as those of materials, optimal exploitation of space, etc.), which confront the designer, regardless of whether he sketches a building element, a tool, a household article, or a packing method. Doblin advanced this tendency even further. The goal of the designer's training was, and remained, to get him to acquire the ability "to think comprehensively and to act effectively in the complex, industrial world"—"to face all kinds of problems, not because he is a prodigy, but because he has built up to himself a correct approach." (Quotations from the undergraduate catalog, Institute of Design, 1957–1959.) Under Doblin's guidance a number of highly demanding design themes were tackled and worked out over a period of years; for example the development of an inexpensive, readily transportable house (paperboard house), a space-saving, easily maneuverable automobile for city traffic, and the socially critical problem of passenger transportation occupied the Product Design department particularly during the nineteen sixties. The accompanying figures illustrate but a few of the many characteristic attempts at solutions to design problems with which the Institute has come to grips during its existence. This small selection of pictures can of course convey no idea of the multiplicity and breadth of scope of the themes that presented themselves.

a
Armchair, laminated hardwood. School of Design. Design by Kenneth Evertsen. 1940.
b
Plywood chair, weighing four and a half pounds. School of Design. Design by Charles Niedringhaus. 1941.
c
Chair made from bent plywood. School of Design. Design by Nathan Lerner. 1940.
d
Chair made of light metal and impregnated paper board. Institute of Design. Product Design section. About 1951–1952.

a
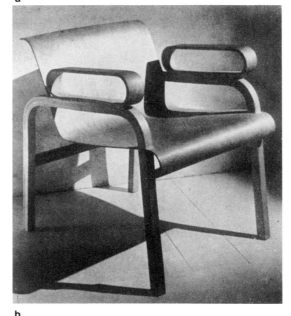

c
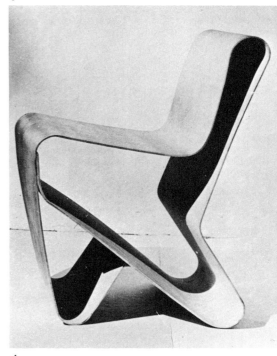

b
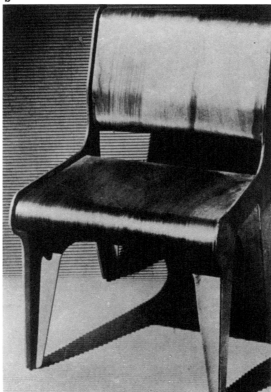

d
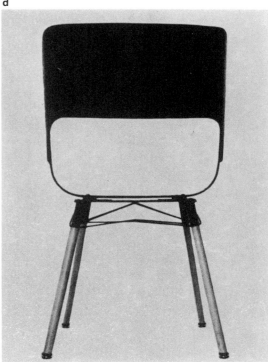

e

f

g

h

i

Some of the works of fundamental importance. The photographs of Figs. g and h were kindly furnished by C. B. Reynolds, those of Figs. e and f by R. K. Adams. Reproduction of all four figures with kind permission of Robert K. Adams.

e
Panel system. Product Design Section, sixth semester. 1954. Teacher: Robert Nickle.

f
Panel system. Product Design Section, sixth semester. 1954. Teacher: Robert Nickle.

g
Study of space-filling polyhedron. Product Design Section, fifth semester. 1953.

h
Study of the rhombic dodecahedron. Product Design Section, fifth semester. 1953.

i
''Paperboard houses designed to be used as a temporary shelter; folded from small modules. Below: Cocooning—used to build experimental structures to test their efficiency and durability.'' Product Design Section. About 1960.

c

a
Tools. "Left: The handles of this flexible-shaft sander are movable. Below: Assortment of hand tools. Right: Miniaturized powered chain saw. Below: A motorized file (motor of a saber saw, attached to a file)." Product Design Section. About 1960.

b
"A variety of approaches to structure and communication are evident in the solutions offered to this packaging problem." Product Design Section. About 1960.

c
Vehicles—Contributions to the solution of the transportation problems. Left above: The 'Unipack' uses a Corvair front and rear end. Right above: Designed to replace the police three-wheeler; uses a Fiat 600 chassis. Left below: The 'Skeeter,' a miniature vehicle. Right below: 'Sparky,' electric car, designed for urban use." Product Design Section. About 1960.
These figures were taken from a prospectus published by the Institute of Design of Illinois Institute of Technology in the early 1960's.

a

Architecture 1937–1955

(Shelter Design, Building Research)
From the very outset of the New Bauhaus, its
Architecture Department was an integral part
of the Institute; it remained part of the successor
institution until 1955, at which time the latter
was domiciled at Crown Hall, under the same
roof as the Architecture Department of the
Illinois Institute of Technology, headed by Mies
van der Rohe. The department, as envisaged by
Moholy-Nagy, signified the achievement of a
goal, same as it did in the conception of the old
Bauhaus: Architecture was considered the most
exalted and the most comprehensive field of
design activity. But already in Moholy-Nagy's
days its ties to reality were not neglected. Prac-
tical projects were undertaken, especially to
satisfy the demand for housing. Moholy was
able to obtain the services of an outstanding
architect, George Fred Keck, a native American,
to head the department. His talents included
pedagogical ones, and by the late nineteen
thirties he could definitely be considered part
of the avant-garde. Other faculty members,
such as Robert B. Tague, showed superior
qualities not only in their creative work but also
in their classroom instruction. After the director-
ship of the Institute of Design passed into the
hands of Chermayeff, who himself was an
architect, especially well known in England, the
department received a strong impetus to go
ahead. The curriculum was reorganized and
systematized. The traditional concept that archi-
tecture had to ''represent something'' was alien
to his philosophy, as it had already been to that
of Moholy and Keck. The concept of ''shelter
design,'' the practical and social function of
architecture, was emphasized throughout the
work program. The work was strongly directed
toward the design of industrially produceable
structures—in other words toward the problem
of prefabrication and the development of tech-
nically revolutionary constructions. Chermayeff
succeeded in securing the services of the prom-
inent architectonic designer Buckminster Fuller
(1948), who developed his ''Pentahexaedron'' at
the Institute of Design.

a
George Fred Keck and William Keck: Apartments.
Chicago. 1937. (Designated as an architectural land-
mark.)

b
School of Design: Study by Rosalind Wheeler: flexible
apartment for parents, children, and outdoor living.
Draft. 1942.

c
Institute of Design: Student project, advanced under-
graduate development; shelter utilizing panel-joint
system. About 1953.

d
Buckminster Fuller: ''Pentahexaedron'' (dome struc-
ture, diameter about 14 feet, weight about 24 lbs).
Constructed in cooperation with the Institute of
Design. 1948.

b

d

c

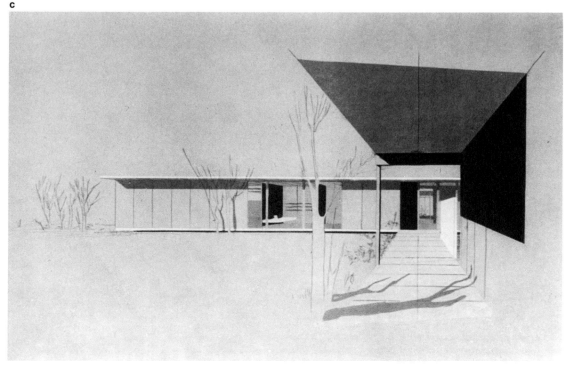

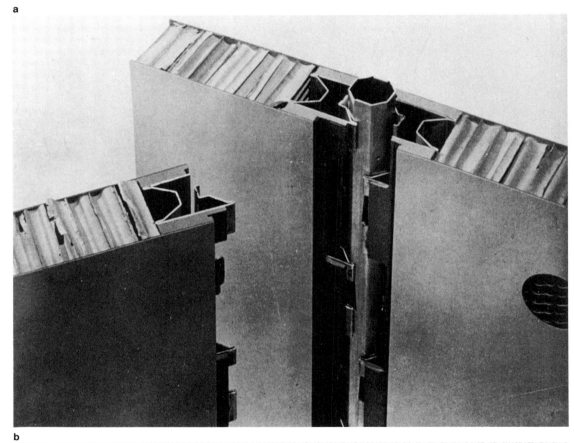

c

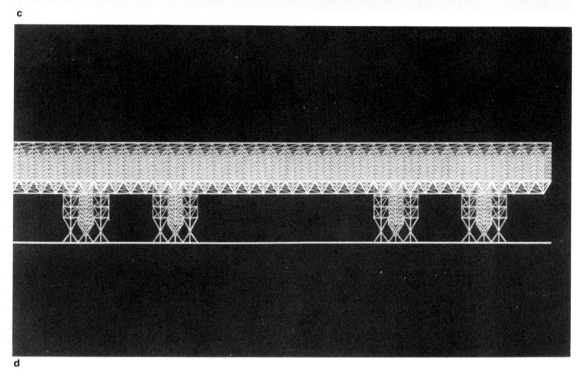

d

Perhaps the most significant appointment was that of Konrad Wachsmann in 1949. He was a German emigrant who, during the war, had worked in partnership with Gropius and together with him had established the "General Panel Corporation." Wachsmann contributed his wide experience to the Institute. Under his guidance construction and development projects were carried out that not only provided criteria for professional training but also exerted a broad practical influence. Among the exemplary solutions achieved under his supervision was an aircraft-hangar system (1951) commissioned by the United States Air Force. To accommodate development work of this and similar types, a Department of Building Research, resp. of Advanced Building Research, was established, in which all avenues toward scientific insight and cooperation were pursued. After his resignation from the Institute of Design and the dissolution of its Department of Architecture, Wachsmann continued his work as guest lecturer at the Hochschule für Gestaltung in Ulm and, more recently, as professor at the University of Southern California in Los Angeles.

a
Shelter Design Section: Joint for prefabricated panel system. 1952. Teacher: Konrad Wachsmann.
The units consist of plastic sheets reinforced at the edges with aluminum profiles. A corrugated-paper core serves as filler.
b
Advanced Building Research Section, under Konrad Wachsmann's supervision: Cantilevered airplane hangar, designed for industrial production. 1951. View from above; under the roof of the hangar, and through it, the outlines of several aircraft are visible.
c
Shelter Design Section, fourth year: industrialized building project. Construction scheme for a pavilion for TB patients. Teacher: Konrad Wachsmann.
d
Advanced Building Research Section, under Konrad Wachsmann's supervision: Cantilevered airplane hangar. Draft. Partial view. 1951.

"The United States Air Force in 1951 commissioned research and development of a large span airplane hangar. The extraordinary specifications included (1) the development of a minimum of two standard connecting devices, (2) the use of no more than two major structural members, (3) maximum overall dimension of all preassembled parts of 10′ × 30′ × 3′ for reason of shipping, (4) an assembly technique which would permit the use of unskilled labor, (5) unlimited flexibility in design of buildings to any form, shape and size, (6) the maximum span of 150′ cantilever, (7) unobstructed opening at all four sides of any given building, and (8) complete demountability of the whole structure without any loss permitting re-use of all standardized parts for entirely different purposes, designs and dimensions. An additional requirement was greatest possible lightness of the structure which finally resulted in an overall weight of 16.8 lbs/sq. ft. including roof structure and supports. To eliminate maintenance, all steel parts had to be covered with hard plastic coating." (From "arts & architecture," May 1967, p. 17.)

The accompanying figures show a pavilion for TB patients, constructed by the Architecture Department (Shelter Design) of the Institute of Design, under Konrad Wachsmann, during the winter semester 1954–1955. The structure was based on the panel system conceived in 1952 (edge-reinforced plastic sheeting with corrugated-paper core). The pavilion was to be constructed industrially. It was conceived to conform to a large extent to the requirements of fresh-air therapy. Air circulation was provided everywhere, even between ceiling and roof and under the flooring.

a
Side view of the pavilion model.
b
View of the supporting structure for the pavilion.
c
View of the underconstruction. Aluminum.
d
View of the pavilion model from below.
Reproduction of Figures a–d by permission of Robert K. Adams, architect.

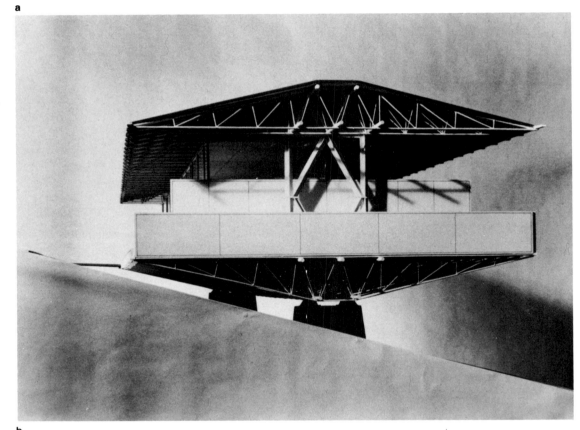
a

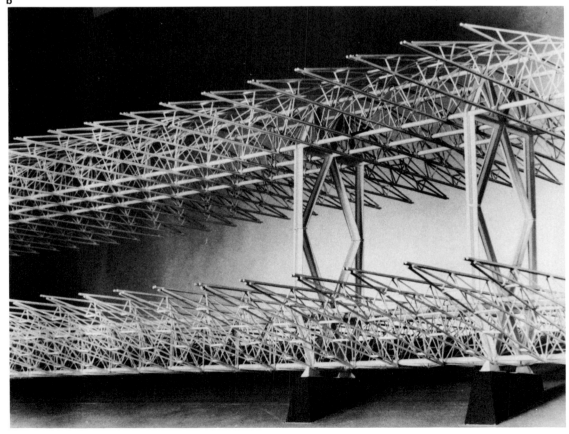
b

Konrad Wachsmann: The Means for Design: "We have to visualize that building is basically the creation of shelters. It is a struggle with materials—with forces. The architect is confronted with problems which are on the one hand in the field of chemistry and physics and, on the other hand, to deal with the client, with the person for whom he finally builds.
There is one thing that is basic and the starting point of every effort which he is making: that is energy. The force he controls to create things. In classical times, the people knew nothing but human force and human energy. Every tool they had was so designed that human energy could handle it. Today we have an entirely different picture: We know much greater energies than the human being could ever produce. . . .
This means that we now have, when we think of building, to think of machines which create the building. There is a certain contradiction in the fact that today a house is built by the same means, with the same tools, as it was built long ago. In our political life, in the whole economic structure of this country, the organization which is visible to us in the form of a community or a whole state is expressed in the use of mechanical forces in the form of machines . . . Everything that we have and what we own is made by machines. . . .
In comparison with a radio set, television set, refrigerator, airplane, automobile, the construction of the house looks rather silly. Even if such a house is modern in design.
'Modern' is not a problem of appeal, of sophisticated tastes. It goes much farther. An automobile is modern, of course. An airplane is modern. An airplane has an entirely new appearance. Construction and design of airplanes is based on scientific facts, on which the designer himself has very little influence. If a house is truly modern, it has to express in itself the fact which our life, our time, characterizes. And this is industrialization, mechanization. It is a machine-made product. . . .

Since we all have to live in houses, are born in houses, as were our grandmothers and grandfathers, the situation in regard to houses is especially bad. Everybody has, from childhood on, certain opinions about how a house should look. If a man remembers from childhood very happy days in the living room of his mother or grandmother, he certainly wants to reproduce the same room in which he had been so happy. . . .
I will try to explain briefly what we are trying to do . . . We say that everything which comes to building is the result of a conjunction of parts. The combination of parts and their relation to each other creates finally walls, rooves, partitions, buildings, communities, cities. By starting in the beginning, we can say that combinations of relationships to each other are expressed in a certain point, which is the *joint*. If you put two bricks together, then you have a joint between the two bricks. If you place two pieces of wood together and drive a nail, the nail joins the two pieces of lumber. It is always the joint which determines what the final shape and form of the product will be.
We have a situation in which we are just starting to create a certain universality in construction. We know that with machines we can work with the highest precision, and we can make today the most complicated joint with less money than it would take to have a carpenter take a handsaw and make a very simple saw cut. . . . We have reached the point where we can say that we have horizontally and vertically always the same jointing. We can concentrate on one single point . . . If we are able to solve this one joint, we would have something which is different from any other building and which does not depend on any tradition. . . .
It is a fact that in design of buildings today the designer has great difficulty expressing the kind of building he is thinking of . . . Today architects are involved in designing new structures. Today pure science builds our world. And since we have based our life on science, we have to understand that, even if sometimes we used to go to an architect and let him build our house, we will someday have to live in a world in which the architect no longer builds the house, but the scientist.
'The king is dead. Long live the king! L'architecture est morte. Vive l'architecture!' "
(From a seminar about "Society and Design," Institute of Design, April 8, 1948.)

c

d

University of Illinois at Chicago Circle

The ideas and method of the Institute of Design were adopted by numerous other educational institutions and underwent variations, to a more or less independent degree. One of these was the University of Illinois in its Departments of Architecture and Art, which are situated in Chicago. Both are remarkably productive. More than thirty faculty members, themselves trained at the Institute of Design (partly still under Moholy-Nagy), contributed to securing the position of the University of Illinois as a representative exponent of the Bauhaus succession. Especially since the middle fifties it profited from the exodus of teachers who had disagreed with the personnel policies of the Institute of Design. Walley, Dana, and Koppe—to name but a few of the more prominent ones—had earlier taught at the Institute. Especially the library of the University of Illinois in Chicago has made efforts to honor the accomplishments made by Moholy-Nagy's circle and by the institutions founded or influenced by him.

Figures a–d show a few characteristic products of the preliminary course. They represent no mere attachments to comparable work at the Institute of Design but rather parallel developments based on common ground, which were partly undertaken cooperatively with workers now active at the University of Illinois. Richard Koppe, as head of the Foundation Course, deserves special mention.

When, in 1937, Moholy-Nagy called the New Bauhaus into being in Chicago, it was a derivative of the European Bauhaus of long ago. It was primarily the thought and the creative forces of European emigrants from which the institution drew its substance. But in the course of a few years, in the School of Design and in the Institute of Design, specifically American thought processes were adapted. American pragmatism as formulated primarily in John Dewey's philosophy, and above all American every-day life with its stringent demands exerted their influence on the school, its concepts and their realizations. A new American generation of designers grew up and determined the image. That which had once been the New Bauhaus in Chicago changed into an unmistakably American institution, which in its influence and its work output became exemplary. It no longer confines itself to the immediate succession of the Bauhaus; it becomes a reality that is just as valid in the Art Department of the University of Illinois or in the seminar headed by Gyorgy Kepes at the Massachusetts Institute of Technology, to name but two examples, and it powerfully radiates back into the Old World, which increasingly strives to come to terms with this American development.

a

b

c

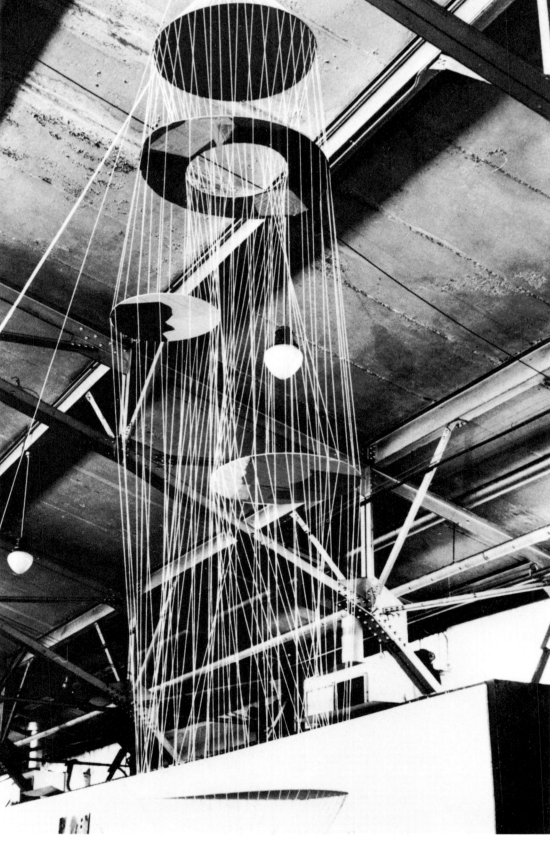

d

a
Three-dimensional work. Student projects from the
Foundation Course. 1966.
b
Moiré effect by a visual structure against a patterned
background. From the Basic Design course, first
semester. 1964–1965. Student: M. Topielec.
c
Repetitive structural unit, opened and closed refer-
ences. From the Basic Design course, first semester.
1965. Student: L. Jones.
d
Suspended string construction, twenty feet tall. From
the Basic Design course, second semester. 1964.
Student: M. Merchant.

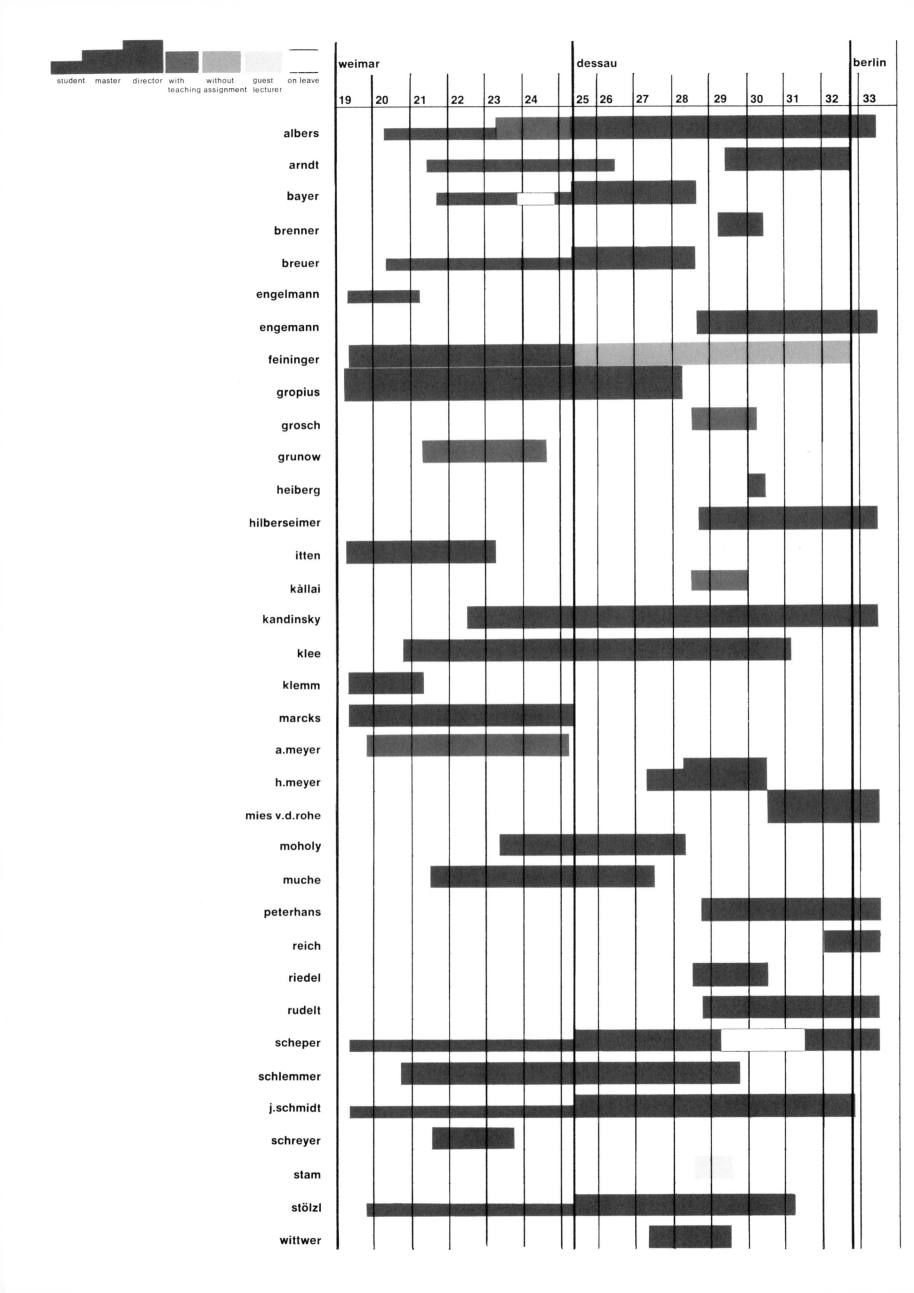

Roster of Bauhaus Students, 1919–1933
Compiled in collaboration with the Bauhaus-Archiv, Darmstadt

A complete, official list of all the students of the Weimar Bauhaus is evidently no longer in existence. The student rosters were compiled in alphabetical order and bound into folders, only part of which reached the Thuringian State Archive (Landeshauptarchiv). Thus, the following list of names is incomplete up to the closing of the Weimar Bauhaus. It was assembled from excerpts of the Weimar files and from a register of addresses that was started by Mrs. Tut Schlemmer after 1945 and methodically corrected and extended by the Bauhaus-Archiv in Darmstadt. The number of students at the Weimar Bauhaus, including those taken over from the former Grand-Ducal Institute and those who left after a brief trial period because of incompatibility, can be estimated to amount to about 600. An additional 650 joined in Dessau and Berlin. For these the names of all students as well as their dates of entry into the Bauhaus are known, thanks to the immatriculation rosters, which have been preserved in their entirety (see the second section). In a few exceptional cases certain young people have participated in the Dessau classes who—for whatever reason—have never been registered but who, beyond any doubt, formed part of the Bauhaus community. Their names, although absent in the immatriculation roster, are taken into consideration in the following listing. All in all, there can be only a very few students of the early Bauhaus period whose traces have been completely lost. It is established that the total number of Bauhaus alumni hardly exceeds 1250. The names listed are those under which the students were known at the Bauhaus. Later names are shown in square brackets.

Abbeg, Lies
Ackermann, Suse
Agatz, August
Agsten, Walter
Ahlfeld, Fritz
Ahmdelt, Kurt
Ahrens, Elisabeth
Aichinger, Franz J.
Albers, Josef
Alder, Waldemar
Allner, Heinz Walter
Allwart, Rudolf
Andrée, Werner
Arend, Herbert von
Arndt, Alfred
Arnold, Hans
Arp, Hans
Aschauer, Kurt
Auboeck [Auböck], Karl
Auerbach, Johannes
Bab, Lieselotte
Backjensen [?], Alfred
Bär, Hans
Bago, Max
Bahelfer, Moses
Ballmer, Theo
Balzer, Gert
Balzer, Melanie
Bampi, Richard
Banki, Susanna
Baranyai, Mas
Barthelmess, Claus Rudolf
Bartoluzzi, Alfreddo
Bartsch, Karl
Baschant, Rudolf
Basedow, Heinz
Basedow, Johann Bernhard
Batz, Eugen
Bauer, Karl [Carl]
Bauer, Marius
Baumann, Fritz
Baumann, Leo
Bayer, Herbert
Bayer, Irene
Bayer, Max
Bech, Johanna
Beck, Ernst
Becken, Suse
Becker, Egon
Becker, Else
Becker, Gerhard
Beckmann, Hannes
Beese [Stam], Lotte
Bellmann, Hans
Berenbrok, Otto
Berger, Otti
Berger, Rosa
Bergner [Meyer], Helene [Léna]
Berkenkamp [Scheper], Lou
Bernays, Gertrud
Berndt, Max
Berndt, Wolfgang
Bernestein, Solomon
Bernouilly, Amy
Bernstein, Hans Karl
Bernstein, Simon
Berthold, Johannes
Bertolf, Hans
Bethmann, Hans
Beunomeum, Josef
Beuren, Michael von
Beust, Hermann
Beyer [Volger], Lis
Bhilz, Irene
Biehl, Karl
Bienert, Ise
Bill, Max
Bischoff, Clara
Bittkow [Köhler], Margarete
Blaneke, Erna
Bleek, Hans Werner
Bloh, Willy
Blomeier, Hermann
Blüh, Irene
Blüthner
Blumenthal, Ernst
Bock, Alfred
Böhm, Alfred
Boerl, Else
Böning, Mila
Bönisch, Fritz
Bogler, Friedrich W.
Bogler, Theodor

Bohien [?], Elisabeth
Bohutinsky, Jaetav
Bolek, Else
Bondi, Johanna
Bonert, Arthur
Boosten, Louis
Borchers, Heinz
Borchert, Erich
Borkowsky [Stephan], Dolly
Bormann, Heinrich
Born, Walter
Borowsky, Natan
Bortnyik, Sandor
Bosshard, Margrit
Both, Katt
Brach, Bernhard
Brachmann, Käthe
Bracht, Ludwig
Brandt, Lotte
Brandt, Marianne
Brasch, Käthe
Brasche, Eva
Brauer, Anneliese
Braun, Albert
Braun, Eduard
Braun, Lotte
Braun, Rudolf
Braun, Samuel
Braune, Ursula
Brauneck
Bredendieck, Hinrich [Hin]
Breithaupt, Erika von
Bremer, Gertrud
Brendel, Erich
Breuer, Jupp
Breuer, Marcel
Breuer, Otto
Breusing, Ima
Breustedt, Hans-Joachim
Brinkmann, Walter
Brocksieper, Heinrich
Brodowsky, Theo
Brodtkorb, Hermann Espeler
Bronstein, Max [=Ardon, Mordekai]
Brückner, Heinrich
Bruhlmann, Otto
Bruynzeel, Regine
Buchbinder, Margarete
Buchmann, Julius
Budkow, Isaak
Bücking, Klaus
Bücking, Peter [Peer]
Bugya, Werner
Buntel, Eduard
Bunzel, Hermann
Burchard, Eveline
Burckhardt, Andreas
Burghardt
Burkhardt, Hermann
Burri, Werner
Burzi, Ettore
Burzi-Laurent, Henriette
Buscher [Siedhoff], Alma
Buske, Albert [Walter ?]
Busse, Eva
Busse, Heinrich
Cacinovic, Ludwig
Callmann, Georg
Capron, Léon
Carl, Alfred
Casparius, Robert
Cernigoj, Augusto
Chomton, Werner
Christen, Alessandro
Chrsine [?], Max
Cieluszek, Karl
Citroen, Paul
Clasing, Heinz
Clausing, Hugo
Clemens, Hermann Roman
Cöster, Otto
Cohn [Kaiser], Ruth
Cohrs, G.B. Adolf
Coja, Gertrud
Collein, Edmund
Collignon, Margarete
Comeriner, Erich
Conrad, Günter
Consemüller, Erich
Coppola, Horacio
Coste, Rudolf
Coster-Henri, Florence
Cramer, Ilse

Hardmeyer, Anna
Harklang, Walter
Harms, Milon
Harms, Paul
Hartmann, Georg
Hartmann, Rudolf
Hartogh, Rudolf F.
Hartwig, Emil Bert
Harwig, Arno
Hassenpflug, Gustav
Hauck [Winckelmayer], Lilli
Haumeyer, Margarethe
Haupt, Karl Hermann
Hausbrand, Franz
Hauschild [Cöster, Peterhans], Ellen
Hausenblas, Josef
Hausmann, Maria
Hausmann, Rudolf
Havemeyer, Martha
Hecht, Edgar
Heckendorff, Käthe
Heffels, Franz
Hegel, Ernst
Heide, Helmut
Heiman [Ehrman], Marie Helene [Marli]
Heinze, Fritz
Heitmeyer [Nebel], Hildegard
Heller, Walther Erich
Hellriegel, Heinz
Helm, Dörte
Hemberg, May
Hengstenberg, Lydia
Henneberger, Elisabeth
Hennig, Albert
Hennings [Schütt], Annemarie
Henri, Florence
Henschel, Erich
Herbst, Hans
Hergt, Toni
Herold, Gertrud
Herricht, Walter
Herrlich, Gertrud
Herrmann, Karl
Herrmann, W.
Herschenberg
Hertel, Christof
Hertig, Klaus
Herzfeld, Anni
Herzge, Herbert Gottfried
Herzger, Walter
Hess, Estella
Hess, Wilhelm Jacob
Heubner, Albrecht
Heye, Laurita
Heyerhoff, Wilhelm [Willy]
Heymann [Ahlfeld], Marianne
Heymann [Marks], Grete
Heyn, Helene
Hildebrandt, Wolfgang
Hilgers, Robert
Hilker, Reinhard
Hill, Elsa Hempel
Hill, Leila
Hill, Samuel Theodore
Hirche, Herbert
Hirsch, Betty
Hirsch, Hanna
Hirschel-Protsch, Günter
Hirschfeld-Mack, Ludwig
Hirz, Friedrich Wilhelm
Hoeschen
Hoffmann, Else
Hoffmann [Hoffmann-Lederer], Hanns
Hoffmann, Herbert
Hoffmann, Hubert
Hoffmann, Irene
Hoffmann, Käte
Hofmann, Otto
Hofmann, Walter
Hohn
Hollós [Consemüller], Ruth
Holthoff, Erich
Holzhausen, Walter
Hopf-Kleinwork, Else
Hoppe, Anna
Horn, Hilde
Horstmann, Edgar
Horwitz, Erik
Hotthoff, Erich
Hotzen, Otto
Hubbuck, Hilde
Huber [Keller], Marti
Hübner, Erich

Hübner, Herbert
Hübner, Werner
Hüffner, Fritz Christoph
Hürlimann
Hüsing, Waldemar
Hütig, Wolfgang
Hüttmann, Egon
Hummel, Walter
Imkamp, Wilhelm
Isaacsohn [Jackson], Werner
Itting, Gotthardt
Itting [Gaebler], Wera
Ivanovic, Gertrud
Jacobs, Ernst
Jäckel
Jäger [Kadow], Elisabeth
Jaensch, Wilhelm
Jahn, Martin
Jaspers [Schenk zu Schweinsberg], Martha
Jelimowskaja, Lola
Jelinek, Rudolf
Jörner, Herbert
Johann, Hugo
Josefek [Henschel], Ruth
Jucker, K. J.
Junge, Walter
Jungmittag, Willi
Jungnik [Dostert], Hedwig [Jadwiga]
Kadow, Gerhard
Kähler [Neter], Greten
Kahler, Otto
Kahmke, Albert
Kaiser, Richard
Kallin [Fischer], Margit
Kaminski, Walter
Kaminsky, Lothar (?)
Kannier, Walter
Kanow, Ernst
Kárász, Judit [Indrit]
Katz, Hilde
Kaufmann, Erich
Keil, Marianne
Keil, Martha
Keler, Peter
Keller, Fritz
Keller, Karl
Keller, Theo
Keller-Rueff, G.
Kempfer, Paul
Kempin, Wilhelm
Kerbe, Arthur
Kerbs, Liselotte
Kerkovius, Ida
Kessinger [Petitpierre], Friedly [Petra]
Kessler, Hans
Kirschenbaum [Kirszenbaum], Jesekiel
Klapper, Sophie
Klawun [?], Ulrich
Klee, Felix Paul
Klein, Paul
Kleinwart, Elsa
Klipphahn, Karl
Klode, Karl
Kloidt, Erich
Klumpp, Hermann
Knake, Arnold
Knapp [Strieff], Elfriede
Knau, Josef
Knaub, Heiner
Knittmann, Minna
Knoblauch, Elfriede
Knoblauch, Hans Georg
Knorr, Maria
Knott, Elfriede
Koch, Bruno
Koch, Fritz
Koch, Heinrich
Koch, Kurt
Köhler, Hans
Köhler, Otto [= Balden, Theo]
Kölling, Hein
Köppe, Walter
Körte, Hugo
Köster, Elsbeth
Kohler, Fredonic
Kohler, Reingard
Kohn, Heinrich
Konnerth, Hermann
Konnerth, Lotte
Konrad, Heinrich
Korner, Sophie
Korsen, Napoleon
Kosnick
Kostorz [?], Eva

Kowarski, Michael
Krämer
Krajewski, Max
Kramer, Ferdinand
Krantz, Erich
Kranz, Kurt
Krause, Corona
Krause, Erich
Krebs, Grete
Kroenberg, Ida
Kronberg [Engelien], Inka
Kroner, Curt
Krückeberg, Cäcilie
Krüger-Back, Lissy
Krum, Rudolf
Kube, Felix
Kubsch, Hermann Werner
Kühnert, Kurt
Kümmel, Willi
Kuhl, Ruth
Kuhn, Johannes
Kuhnke, Erika
Kuhr, Fritz
Kuhr [Heubner], Meta
Kujawa, Ursula von
Kukowka, Robert Eduard
Laermann, Josef
Lakeit
Lambau, Karl
Lambert, Margarethe
Landwehr, Hans
Lang, Lothar
Lange, Horst
Lange, Karl
Langenstrass, Magda
Langewiesche, Hanna
Lasnitzki, Toni
Latzko, August
Lederer [Hoffmann], Mila
Lehnen, Josef
Lehnert [Weintraud], Maria [May]
Leirer, Sepp
Leischner, Margarete
Leiteritz, Margaret
Le Juge, Eva von
Lenz, Robert
Leppien, Kurt [Jean]
Leudesdorff-Engstfeldt [Ribbentrop], Lore
Leuthold [Rüegg], Melanie
Levedag, Fritz
Lewin, Eva Lilly
Lichtenthal, Ernst
Liesche, Elisabeth
Lille, Ludwig
Lindemann, Otto
Lindemann, Paul
Linden, Cornelis van der
Linden, Johannes Jacobus van der
Linder, Paul
Lindig, Otto
Lindner, K. Emanuel
Lindstroem, Sune
Linzen, Heinrich
Linzen-Gebhardt, Hilde
Lion
Lipovec, Alfred
Lippmann
Loebell, Lilly
Loeben, Inge von
Löber, Wilhelm
Loew, Heinz
Loewe, Margot
Loewengard, Kurt
Loja, G.
Loviscach, Max
Lubbrich, Hilde
Lütkemeyer, Gustav
Ludwig, Eduard
Ludwig, Peter
Lutz, Rudolf
Maas, Lena
Maass, Luise
Machnow, Richard
Majowski, Wilhelm
Malhald [?], Susan
Mallö-Christensen, Hans
Maltan, Josef
Manuckiam, Myriam Marie-Luise
Marby, Friedrich
Marc, Maria
Marchand, Maria
Marck, Richard
Markiewitz
Markos-Ney [Leppien], Susanne
618

Martin
Martin, Jacques
Marwitz, Rudi
Marx, Erika
Marx [Bijhouwer], Gerda
Marx, Karl
Marx, Lippje
Mass, Arnold Fernand
Mass, Lena
Mathiessen, Walter
Matthiessen, Dora
Matzenstein, Ilse
Mayweg, Erna
Mecklenburg, Walter
Mehner, Marlene
Meier Kreuzberg
Meisel, Fritz
Meltzer, Riccarda
Melze
Mende, Erich
Mendel, Resi
Menge, Adolf
Mengel, Günter
Mensch, René [=Niemeyer, Erna], later
Soupault, Ré
Mensching, Herbert
Mentzel [Flocon], Albert
Menzel, Günter
Menzel, Walter
Meppke, Margarete
Mestetchkin [Miesteckin], Samuel
Meussling, Herbert
Meyer, Grete
Meyer, Kurt
Meyer, Otto
Meyerholz, Anna-Luise
Meyer-Thalhoff, Margarete
Meyer-Waldeck, Wera
Milch, Gertrud
Mill-Decker, Kitty van der
Minkwitz, Ida von
Minn, Burkhard
Mirkin, M.
Mitschke, Rudi
Mittag, Gerhard Ernst
Mizutani, Takehito
Mögelin, Else
Mörchen, Fritz
Möller, Rolf
Mohl, D. von
Mohn, Hedwig
Moholy-Nagy, Lucia
Moller, Hans
Moller, Julie
Molnár, Farkas [Wolfgang]
Monastirsky, Ljuba
Morgenstern, Milan
Moser, Gerhard
Mrozek, Erich
Mührer
Müllauer, Ingeborg
Müller, Elisabeth
Müller, Erich
Müller, Hermann
Müller, Marcella
Müller, Margarete
Müller, Maria
Müller, Nikolaus
Müller, Theo
Müller-Jena, Ilse
Münkwitz, Ida von
Münz, Rudolf
Münz, Walter
Münzberg, Albert
Muth, Ida
Naepf, Paul
Namer, Henry
Nantke, Kurt
Nauheim, Heinz
Naumann, Charlotte
Negenborn, Hildegard
Nehrling, Max
Neidenberger, Georg
Nemecek, Wladimir
Netzel, Bernhard
Netzel, Eugen
Neumann, Ellen
Neumann, Gertrud
Neumann, Klaus
Neumann, Wally
Neuner, Hannes
Neuner, Hein [Henny]
Neustadt [Greger], Else
Neuy, Heinrich

Schmidt [Burgk], Käte
Schmidt, Kurt
Schmidt, Otto
Schmidt, Wilhelm
Schmidt-Schaller, Erich
Schmitz, Elisabeth
Schmitt, Hans
Schneckenburger, Walter
Schneider, Bruno
Schneider, M.
Schneider [Weiss], Gertrud Ursula
Schneiders, Karl
Schnelitzky, Edith
Schniewind, Gerd
Schön [Viereck], Margarete
Schönfeld, Friedrich
Schönthaar, Johann Andreas
Scholz, Ernst
Schorpelt, Otto
Schrammen, Eberhard
Schreiber, Fritz
Schreiber, Lotte
Schröder, Christa
Schröder, Paul
Schröer, A.
Schröter, Alfred
Schröter, Herbert
Schubert, Werner
Schürmann, Herbert
Schultz, Erika
Schultz, Lilli
Schulz, Lotte
Schulz, Melanie
Schulz, Peter Walter
Schulze, Helmut
Schumann
Schumann, Ernst
Schunke, Gerhard
Schuster
Schwabacher [Rossman], Nelly
Schwarer, Tetrain
Schwarz, Bruno
Schwarz, Herbert
Schwerdtfeger, Kurt
Schweitzer, Elisabeth
Schwerin, Heinz
Schwollmann [Mitscherlich], Immeke
Schwoon, Karl
Schwormstädt, Konrad
Seinfeld, Margarete
Seitz, Fritz
Seligmann, Gertrud
Sell [Brendel], Gertrud
Selmanagić, Selman
Sendker, Hendirk
Sharon, Arieh
Sichel, Max
Siedhoff, Werner
Sigbert, Norman
Sigl
Simon-Wolfskehl, Toni [= Lasnitzki, Toni]
Singer, Franz
Sistig, Rudi
Sitte, Franz
Sklarek, Rolf
Slutzky, Naum
Sörensen [Popitz], Irmgard
Solyga, Hans Georg
Sonntag, Fritz
Spaemann, Heinrich
Spangenberg, Thea
Spiero [Gova], Sabine
Spindler, Luise-Margret
Spitzer, Gerhard
Städter, Flora
Stål, Ivan
Stammwitz, Artur
Stefan
Stegmann, Johann
Steiger, Liselotte
Steinert, Elfriede
Steinkühler, Theodor
Stephan, Heinrich
Stern, Grete
Steuwaels, Friedrich
Steyn, Stella
Stipanitz, Inge
Stock, Willi
Stölzl [Sharon, Stadler], Gunta
Stohmann, Enno-Friedrich
Stolp, Kurt
Stratenberg [Kloidt], Hilde
Straub, Karl
Streiff, Bruno
620

Strenger, Friedrichwilhelm [Friedhelm]
Stümpel, Heinrich [Heini]
Suchnitzky, Edith
Süvern, Liese
Suhrkamp, Teta
Svipas, Vladas
Taesler, Werner
Tafel, Maria
Tamae, Ohno
Tanzmann [?], Ilse
Taudte, Fritz
Teichgräber, Paul
Teichgräber, Walter
Teichmann
Teltscher [Adams], Georg
Téry [Adler, Buschmann], Margit
Tetzner, Hans
Thain, Joseph
Thal, Ida
Thalmann, Max
Thielmann, Hedwig
Thielsch, Lies
Thiemann, Hans
Thierfeldt, Marie
Thüring, Rolf [?]
Tinzmann [?]
Tokayer, Josef
Tolziner, Philipp
Tomljenović, Ivana
Tot, Americo
Träger [Steiner], Elisabeth
Tralau, Walter
Transfeld, Johanna
Treuer, Wolfgang
Trinkaus, Hermann
Troschel, Hans
Troschel, Hilde
Trudel, Frank
Tschaschnig, Fritz
Tümpel, Wolfgang
Ućkanova [Auboeck], Mara
Ullmann [Browner], Bella
Ulrich, Erwin
Ulrich [Koppelmann], Lila
Umbehr, Otto
Umlauf, Karl
Unger
Unruh
Urban, Antje
Urban, Paul
Urias, Annje [?]
Ursin, Max
Väch, Heinz
Valentin, Gerhard
Valentin [Cidor], Ruth
Valeur, Helga
Vallentin = Valentin [Cidor], Ruth
Varges, Heinrich
Vichauer, Heinz
Voepel [Neujahr], Charlotte
Vogel, Hans
Vogt, Karl
Voigt, Günther
Voigt [Schröter], Ilse
Voigt, Reingard
Voigt, Walter
Voigt, Werner
Volger, Hans
Volhard, Hans
Vollmer [Neufert, Spiess], Alice
Voltz, Josef
Wähner-Schmidt, Trude
Waga, Charlotte
Wagenfeld, Wilhelm
Wagner, Edeltraut [Traute]
Waldstein, Margarethe
Wallbrecht, Irene
Wallis, Margarete
Walter, Jupp
Walther, Ernst
Walther, Kurt
Wassermann, Leo
Wassilieff, Nicol
Watznauer, Rudolf Alois
Way, Josse
Weber, Gerhard
Weber, Helmuth
Weber, Vincent
Weber, Werner
Wedel, Marie-Luise
Wegehaupt, Herbert
Weidemann, Eva
Weil, Annie
Weiner, Tibor

Weinfeld, Isaak [= Jaschek]
Weinfeld, Wolf
Weininger, Andreas [Andi]
Weinraub, Munyo [Mumé]
Weisbecker, Johannes
Weise, Rudolf
Weisheit, Maria
Weiss, Ursula
Weisshaus, Virginia
Weitsch, Heinrich
Wendeborn, Carla
Werner, Karl
Werner, Otto
Wettengel, Anny
Wichmann
Widmer, Hans
Wieghardt, Paul
Wiener [Weiner], Matty
Wigand, Karl
Wigand, Sibylle
Wildberg, Anni
Wildenhain, Frans
Wildgrube, Selma
Wilenik, Heinrich
Wilke, Annemarie
Willers, Margarete
Willing, Heinrich
Wimmer [Lange], Anne-Marie
Winkel, Willum
Winkelmayer, Richard
Winter, Fritz
Wirsing, Elisabeth
Wirth, Lisa
Wisch, Roland
Wolff, Maria
Wolffenstein, Berthold
Wollny, Alfred
Wolpe
Woltze
Worobeitschik, Moses [= Raviv, Moshe]
Woti[t]z, Anni
Wulff, Lene
Yamawaki, Iwao
Yamawaki, Michiko
Zabel, Johannes
Ziegfeld, Arnold
Ziegfeld, Hillen
Ziegfeld, Ruth
Zierath, Willy
Zimmermann, Werner
Zistig, Rudi
Zitzewitz [Schlieffen], Jutta von
Zraly, Václav
Zschimmer, Erika
Zweig, Beatrice
Zwiauln, Ernst P.

Immatriculation List of Bauhaus
Students of the Dessau and Berlin Periods

PA Mies van der Rohe (First publication)
The roster, entered into a 200-page folio volume of which 68 pages have been used, contains the names of all students who have registered at the Bauhaus secretariat in Dessau and Berlin. The approximately 650 entries have been made by the students themselves; they range in time from the opening of the Dessau Bauhaus to the very day of the forcible closing of the Bauhaus in Berlin. They are headed by the names of those who came to Dessau from Weimar. Some of the names were crossed out immediately after having been inscribed; others appear twice (because the student had temporarily absented himself). Several are practically illegible. The serial numbers have in a few cases been inadvertently repeated or else skipped. The register shows how cosmopolitan and how variegated the composition of the student body was. It is worthy of note that in the later years names of Slavic and Jewish derivation become more frequent, but there are also some of English-American, Scandinavian, Italian, and even Japanese origin.

1 Schwollmann, Immecke
2 Wagner, Traute
3 Moser, Gerhard
4 Both, Katt
5 Zabel, Johannes
6 Nonné-Schmidt, Lene
7 Fricke, Hans
8 Langenstrass, Magda
9 Svipas, Vladas
10 Paris, Rudolph
11 Koch, Heinrich
12 Röseler, Hermann
13 Kohler, Fredonic
14 Arndt, Alfred
15 Becker, Else [deleted]
16 Schawinsky, Alexander
17 Müller, Nikolaus
18 Gottschalk, Ernst
19 Consemüller, Erich
20 Beyer, Lis
21 Hollós, Ruth
22 Heimann, Marli
23 Krajewski, Max
24 Rittweger, Otto
25 Valentin, Ruth
26 Voigt, Günther
27 Gräbner, Ludwig [deleted]
28 Knau, Josef
29 Brandt, Marianne
30 Rössger, Wolfgang
31 Mörchen [?], Fritz
32 Gürtler, Egon [deleted]
33 Albers, Anneliese
34 Bayer, Irene
35 Hantschk, Gertrud
36 Sell, Gertrud
37 Born, Walter [deleted]
38 Isaacsohn, Werner
39 Schmidt, Otto
40 Nösselt, Heinz
41 Bienert, Ise
42 Otte, Benita
43 Volger, Hans
44 Scheerbarth, Liselott
45 Lederer, Mila
46 Buscher, Alma
47 Rückert, Karin [deleted]
48 Herzge, Herbert Gottfried
49 Spitzer, Gerhard
50 Rittsche, Willi
51 Wolffenstein, Berthold
52 Bago, Max
53 Straub, Karl
54 Lenz, Robert
55 Harms, Paul
56 Lange, Karl
57 Schmetzer, V.
58 Loew, Heinz
59 Itting, Gotthardt
60 Günther, Herbert [deleted]
61 Kirschenbaum
62 Fiek, Walter
63 Göhl, Ernst
64 Rantzsch, Hilde
65 Gerngemann, Luise
66 Tanzmann [?], Ilse
67 Fissmer, Fritz
68 Berger, Rosa
69 Beust, Hermann
70 Spaemann, Heinrich
71 Front, Bernhard [?]
72 Przyrembel, Hans
73 Hüffner, Fritz
74 Kukowka, Eduard
75 Kuhr, Meta
76 Sklarek, Rolf
77 Grote, Thoma
78 Imkamp, Wilhelm
79 Sichel, Max
80 Tetzner, H.
81 Weininger, Andreas
82 Borchert, Erich
83 Reichardt, Grete
84 Hertig, Klaus
85 Scheffler, Abel
86 Berenbrok, Otto
87 Braun, Albert
88 Meyer, Kurt
89 Schulze, Helmut
90 Siedhoff, Werner
91 Muche, El
92 Piotrkowski, Ladek
93 Gebhardt, Ernst

94 Mensching, Herbert
95 Rehberg, Helmut
96 Döhler, Erich
97 Jörner, Herbert
98 Hoffmann, Hanns
99 Hauschild, Ellen
100 Klawun, Ulrich
101 Voltz, Josef
102 Hildebrandt, Wolfgang
103 Kaminski, Walter
104 Levedag, Fritz
105 Tralau, Walter
106 Östreicher, Lisbeth
107 Bergner, Helene
108 Wegehaupt, Herbert
109 Bücking, Peter
110 Sander, Rudolf
111 Volhard, Hans
112 Kempfer, Paul
113 Beese, Lotte
114 Püschel, Konrad
115 Feininger, Lukas
116 Monastirsky, Ljuba
117 Lang, Lothar
118 Rauch, Martin
119 Bab, Lieselotte
120 Fritze, Walter
121 Sitte, Franz
122 Peschel, Hugo
123 Frieling, Alphons
124 Hoffmann, Hubert
125 Halil Bey, Seif Naki
126 Brandt, Lotte
127 Ostermaier, Jobst
128 Preiswerk, Gertrud
129 Sharon, Arieh
130 Scheper-Berkenkamp, Lou
Summer term 1927
131 Berger, Otti
132 Tolziner, Philipp
133 Clausing, Hugo
134 Reichardt, Werner
135 Knake, Arnold
136 Rexhausen, Gerd
137 Hansen, Sven
138 Netzel, Eugen
138a Netzel, Bernhard
139 Comeriner, Erich
140 Eckel, Otto
141 Gross, Georg
142 Wallis, Margarete
143 Lenz, Robert
143a Plockross, Irmelin
144 Müller, Elisabeth
145 Müller-Jena, Ilse
146 Leuthold, Melanie
147 Hajek, Asta
148 Marx, Gerda
149 Mass, Arnold Fernand
150 Mizutani, Takehito
151 Bill, Max
152 Rumpe, Heinz
153 Neumann, Klaus
154 Zimmermann, Werner
155 Hassenpflug, Gustav
156 Köppe, Walter
157 Flake, Thomas
158 Giesenschlag, Siegfried
159 Bunzel, Hermann
160 Hummel, Walter
161 Decker, Martin
162 Marwitz, Rudi
163 Buske, Albert
164 Clemens, Hermann Roman
165 Ehrlich, Franz
166 Funkat, Walter
167 Meyer-Waldeck, Wera
168 Waldstein, Margarethe
169 Oertling, Robert
170 Henneberger, Elisabeth
171 Reindl, Paul
172 Ziegfeld, Ruth
173 Schneider, Ursula
174 Gebhardt, Max
175 Laermann, Josef
176 Stock, Willi
177 Agatz, August
178 Gerson, Lotte
179 Bücking, Klaus
180 Schmidt, Hans
181 Fernbach, Eva
182 Bredendieck, Hinrich
183 Way, Josse

184 Stegmann, Johann
185 Knapp, Elfriede
186 Streiff, Bruno
187 Schall, Margarete
188 Pfeffer, Schiel
189 Körte, Hugo
190 Kerbs, Liselotte
191 [no entry]
192 Zierath, Willy
193 v. Ernest, Wolfgang
194 Philipp, Willy
195 Rizzo, Maria Grazia
196 Thal, Ida
197 Drewes, Werner
198 Huber, Marti
199 Coster-Henri, Florence
200 Stephan, Heinrich
201 Pach, Lotte
202 Mengel, Günter
203 Heinze, Fritz
204 Brach, Bernhard
205 Dreesen, Walter Rudolf

Winter term 1927–1928
206 Feist, Werner
207 Panozzo, Giovanni
208 Kubsch, Hermann Werner
209 Gautel, Hermann
210 Schwoon, Karl
211 Träger, Elisabeth
212 Hamann, Willy
213 Winter, Fritz
214 Stolp, Kurt
215 Mensch, René
216 Thüring, Rolf [?]
217 Leischner, Margarete
218 Fritzsche, Einh.
219 Worobeitschik, Moses
220 Collein, Edmund
221 Rönsch, Wolfgang
222 Mentzel, Albert
223 Kallin, Margit
224 Hausenblas, Josef
225 Voigt, Ilse
226 Bartoluzzi, Alfreddo
227 Voepel, Charlotte
228 Maass, Luise
229 Trinkaus, Hermann
230 Leirer, Sepp
231 Mende, Erich
232 Hartwig, Emil
233 Grunicke, Walter
234 Rauh, August
235 Burckhardt, Andreas
236 Schaidt, Gustav
237 Menzel, Günter
238 Henneberger, Elisabeth
239 Gatermann, Karl
240 Zimmermann, Werner
241 Oertling, Robert
242 Landwehr, Hans
243 Bracht, Ludwig
244 Hartmann, Georg
245 Lambert, Margarethe
246 Funken, Max
247 Bischoff, Clara

Summer term 1928
245 Raichle, Karl
246 Enderlin, Max
247 Fischli, Hanns
248 von Arend, Herbert
249 Ruff, Else
250 Lehnen, Josef
251 Urias, Annje [?]
252 Harklang, Walter
253 Manuckiam, Myriam Marie-Luise
254 Leiteritz, Margaret
255 Jungmittag, Willi
256 Hütig, Wolfgang
257 Keller, Fritz
258 Schumann, Ernst
259 Ertl, Fritz
260 Scharoun, W.
261 Schröter, Herbert
262 Allner, Heinz
263 Bonert, Arthur
264 Willing, Heinrich
265 Hennings, Annemarie
266 Rogler, Elsa
267 Knaub, Heinz
268 Fohmann, Friedrich
269 Neumann, Lony
270 Rubinstein, Naftaly
271 Herold, Gertrud

272 Wallbrecht, Irene
273 Svipas, Vladas
274 Suhrkamp, Teta [deleted]

Winter term 1928–1929
275 Etuchen [?], Georg
276 Treuer, Wolfgang
277 Bloh, Willy
278 Hofmann, Walter
279 Cohn, Ruth
280 Fodor, Ethel
281 Wimmer, Anne-Marie
282 Lindstroem, Sune
283 Bertolf, Hans
284 Egeler, Ernst
285 Klipphahn, Karl
286 Harms, Milon
287 Schmidt, Herbert
288 Ludwig, Eduard
289 Haas, Willy
290 Müller, Maria
291 Krause, Erich
292 Jelimowskaja, Lola
293 Dearstyne, Howard B.
294 Sigbert, Norman
295 Hotthoff, Erich
296 Galandi, Emil
297 Fischer, Hermann
298 Balzer, Melanie
299 Gerber, Anton
300 Rauh, Georg
301 Hofmann, Otto
302 Genz, Kurt
303 Ehrhardt, Alfred
304 Budkow, Isaak
305 Bahelfer, Moses
306 Preiswerk, Gert
307 Sendker, Heinrich
308 Rawitzer, Else
309 Wassermann, Leo
310 Tokayer, Josef
311 Fröhlich, Paul
312 Fischer, Edward L.
313 Geroc-Tobler, Maria
314 Hahlo, Mlius Raiko
315 Engemann, Friedrich
316 Glaser, Alice
317 Rapoport, Tonja

Summer term 1929
318 Braun, Eduard
319 Schwarz, Herbert
320 Leppien, Kurt
321 Rettybander [?]
322 Hertel, Christof
323 Brückner, Heinrich
324 Roether, Reinhold
325 Kroner, Curt
326 Neuner, Hanns
327 Hellriegel, Heinz
328 Busse, Eva
329 Meppke, Margarete
330 Taessler, Werner
331 Enders, Lore
332 Matthiessen, Walter
333 Beckmann, Hanns
334 Loewe, Margot
335 Rothschild, Lotte
336 Haumeyer, Margarethe
337 Bohien [?], Elisabeth
338 Cieluszek, Karl
339 Dollner, Hugo
340 Kadow, Gerhard
341 Balzer, Gerd
342 Reindl, Hilde
343 Kähler, Greten
344 Minn, Burkhard
345 Engemann, Herbert
346 Bernstein, Hans Karl
347 Voigt, Reingard
348 Rossig, Reinhold
349 Hecht, Edgar
350 Franke, Else
351 Hoffmann, Irene
352 Thielsch, Lies

Winter term 1929–1930
353 Wedel, Marie-Luise
354 Ahrens, Elisabeth
355 Cohrs, G. B. Adolf
356 Wilke, Annemarie
357 Brodtkorb, Hermann Espeler
358 Fussmann, Ladislaus
359 Safran, Fritz
360 Lambau, Karl
361 Baranyai, Mas

362 Klumpp, Hermann
363 Neidenberger, Georg
364 Batz, Eugen
365 Schwarer, Tetrain
366 Jacobs, Ernst
367 Alder, Waldemar
368 Mittag, Gerhard Ernst
369 Wähner-Schmidt, Trude
370 Schulz, Lotte
371 Baumann, Leo
372 Reimer, Oskar
373 Orth, Walter
374 Meyerholz, Anna-Luise
375 Kessinger, Fried
376 Schmeil, Lotte
377 von Loeben, Inge
378 Nemecek, Wladimir
379 Zraly, Václav
380 Ebert, Willy [Wils]
381 Brodowsky, Theo
382 Schmidt, Arthur
383 Schmidt, Hans
384 Ahlfeld, Fritz
385 Schnelitzky, Edith
386 Köster, Elsbeth
387 Exsternbrick, Hellmut
388 Paulick, Rudolf [?]
389 Meier Kreuzberg
390 Ninnemann, William
391 Weiner, Tibor
392 Mrozek, Erich
393 Pohl, Josef
394 Ullmann, Bella
395 Zistig, Rudi
396 Lichtenthal, Ernst
397 Selmanagić, Selman
398 Schmitt, Hans
399 Burkhardt, Hermann
400 Schiess, Hans R.
401 Borowski, Natan
402 Tschaschnig, Fritz
403 Schanzer, Erwin
404 Tomljenović, Ivana
405 Graef, Hedwig
406 Martin, Jacques
407 Forster, Lucci
Winter term 1930
408 Agsten, Walter
409 Becker, Egon
410 Ballmer, Theo
411 Bartsch, Karl
412 Berndt, Wolfgang
413 Bolek, Else
414 Bormann, Heinrich
415 Bosshard, Margrit
416 Burchard, Eveline
417 Clasing, Heinz
418 Frentzel, Chanan
419 Dirks, F. W.
420 Hirche, Herbert
421 Hüsing, Waldemar
422 Hüttmann, Egon
423 Kranz, Kurt
424 Krebs, Grete
425 Krum, Rudolf
426 Knittmann, Minna
427 Loviscach, Max
428 Meltzer, Riccarda
429 Menge, Adolf
430 Namer, Henry
431 Neuy, Heinz
432 Rose, Hans-Joachim
433 Lindner, K. Emanuel
434 Schmidt, Kurt
435 Münz, Rudolf
436 Strenger, Friedrichwilhelm
437 Thain, Joseph
438 Thiemann, Hans
439 Städter, Flora
440 Dietrich, Else
441 Raemisch, Elli
442 Weinraub, Mumé
443 Bohutinsky, Jaetav
444 [no entry]
445 Buntel, Eduard
446 Golde, Gitel
447 Cramer, Ilse
448 Bruhlmann, Otto
449 Klode, Karl
Winter term 1930–1931
450 Kahmke, Albert
451 Nowag, Heinz
452 Dolecelowa, Marie

453 Josefek, Ruth
454 Plans, Ahave
455 Meyer, Grete
456 Hess, Wilhelm
457 Steuwaels, Friedrich
458 Reiss, Hilde
459 Banki, Susanna
460 Wiener, Mathy
461 Wettengel, Anny
462 Sauer, Hildegard
463 Itting, Wera
464 Beunomeum, Josef
465 Weber, Helmuth
466 Christen, Alessandro
467 Schorpelt, Otto
468 Pahl, Pius
469 Yamawaki, Iwao
470 Yamawaki, Michiko
471 van der Linden, Johannes Jacobus
472 [no entry]
473 Kárász, Indrit [deleted]
474 Fischer, Josef
475 Rückert, Willy [deleted]
476 Henschel, Erich
477 von Kujawa, Ursula [deleted]
478 Petersen, Wilhelm Bjerke
479 Vogt, Karl
480 Mohn, Frau Hedwig
481 Marx, Frau Lippje
482 Schenk, Frau Ursula
483 Stål, Ivan
484 Heubner, Albrecht
485 Weinfeld, Isaak
486 Heyerhoff, Willy
487 Braun, Samuel
488 Blomeier, Hermann
489 Breuer, Jupp
490 Pfeil, Fritz
491 Grau, Alice
492 Grunert, Charlotte
493 Solyga, Hans Georg
494 Machnow, Richard
495 Weise, Rudolf
496 Lubbrich, Hilde
497 Hotzen, Otto
498 Dieckmann, Willi
499 Walter, Jupp
500 Burzi, Ettore
Summer term 1931
501 Kümmel, Willi
502 Felgenträger, Lothar
503 Hägg, Gertrud
504 Schreiber, Fritz
505 Jaensch, Wilhelm
506 Gulzow, Ernst
507 Hegel, Ernst
508 Schubert, Werner
509 Heckendorff, Käthe
510 Möller, Rolf
511 Weisshaus, Virginia
512 Bethmann, Hans
513 Markos-Ney, Susanne
514 Kárász, Judit
515 Bugya, Werner
516 Kölling, Hein
517 Hartmann, Rudolf
518 Konnerth, Lotte
519 Feuss, Gert
520 Kuhn, Johannes
521 Robra, Kurt Karl
522 Reimann, Friedrich
523 Mitschke, Rudi
524 Schwerin, Heinz
525 Jelinek, Rudolf
526 Grote, Gertrud
527 Noll, Helmut
528 Schmidt, Käthe
529 Biehl, Karl
530 Hill, Samuel Theodore
531 Goldmann, Karel
532 Heide, Helmut
533 Rossmann, R. [deleted]
533 Engemann, Alma Else
534 Klumpp, Werner
Winter term 1931–1932
535 Zwiauln, Ernst P.
536 Bernd, Max
537 Korsen, Napoleon
538 Hilgers, Robert
539 Bernestein, Solomon
540 van Beuren, Michael
541 Beck, Ernst
542 Koch, Fritz

543 Conrad, Günter
544 Kessler, Hans
545 Görisch, Bruno
546 Kowarski, Michael
547 Weber, Gerhard
548 Bruynzeel, Regine
549 Bhilz, Irene
550 Burzi-Laurent, Henriette
551 Hill, Elsa Hempel
552 Ross, Charles W.
553 Stümpel, Heini
554 Watznauer, Rudolf Alois
555 Rust, Karl
556 Buchmann, Julius
557 Väch, Heinz
558 Germain, Jacques
559 Bauer, Karl
560 Feininger, Andreas
561 Ulrich, Lila
562 Haase, Lawrence
563 Steyn, Stella
564 Stipanitz, Inge
565 Mestetchkin, Samuel
566 Aichinger, Franz J.
567 v. Kujawa, Ursula
568 Diederich, Ursula
569 Rauh, Hermann
570 Goerke, Senta
571 Schürmann, Herbert
572 Blumenthal, Ernst
573 Ulrich, Erwin
574 Duguid, John Francis
575 Milch, Gertrud
576 Wollny, Alfred
577 Rindler, Edit
578 Hausbrand, Franz
579 Bondi, Johanna
580 Sandvik, Olav Mörk
581 Reichel, Herbert
582 Havemeyer, Martha
583 Weinfeld, Wolf
Summer term 1932
584 Hennig, Albert
585 Stern, Grete
586 Trudel, Frank
587 Rakette, Egon
588 Nauheim, Heinz
589 Schneckenburger, Walter
590 Stohmann, Enno-Friedrich
591 Frör, Josef
592 Hesse, Martin
593 Franke, Walter
594 Schröder, Christa
595 Widmer, Hans
596 Weitsch, Heinrich
597 Gunerick, Wolfram
598 Faust, Hans
599 Dinning, Kurt
600 Marx, Karl
601 Andrée, Werner
602 Müller, Erich
603 Chrsine [?], Max
604 Müllauer, Ingeborg
605 Rohwer, Franz-Detlef
606 Ross, Nancy Nelson
607 Oelschig, Werner
608 Günther, Albrecht
609 Kannier, Walter
Winter term 1932–1933
610 von Schlieffen, Jutta
611 Matzenstein, Ilse
612 Katz, Hilde
613 Coste, Rudolf
614 Quermonprez, Paul
615 Naepf, Paul
616 Knoblauch, Hans Georg
617 Mendel, Resi
618 Schlagerhaufer, Grete
619 von Ruppert, Walter
620 Press, Angela
621 Vichauer, Heinz
622 Weisheit, Maria
623 Lewin, Eva Lilly
624 Coppola, Horacio
625 Peissachowitz, Nelly
626 Malhald [?], Susan
627 Goldberg, Bertrand
628 Hausmann, Rudolf
629 Scholz, Ernst
630 Becker, Gerhard
631 Brauer, Anneliese
632 Knoblauch, Elfriede
633 Gehrke, Siegfried

634 Kanow, Ernst
635 Hoffmann, Herbert
636 Ortner, Rudi
637 Priestley, William T.
638 Frnka, Otokar
639 Latzko, August
640 Schönthaar, Johann Andreas
Presumably summer term 1933
... Tamae, Ohno
... Horwitz, Erik
... Rape, Albert-Friedrich
... Weber, Werner
... Hess, Estella
... Blaneke, Erna
... Schröer, A.
... Roeser von Aesch, Johanna
... Santar [?], Gert
... Mallö-Christensen, Hans
... Haase, Gerhard
... Rodgers, John B.
... Wolff, Maria

Bibliography

Compiled with the assistance of Ursula Call-
mann, librarian of the Bauhaus-Archiv, Darm-
stadt. Much information and particulars were
provided by Bernard Karpel, librarian of The
Museum of Modern Art, New York.
The listing contains programs, statutes, and art
publications by the Bauhaus; selected publica-
tions about the Bauhaus and its members;
selected publications by and about the Bauhaus
Masters and some of their students; and a selec-
tion of publications from the New Bauhaus/
School of Design/Institute of Design. A complete
bibliography, in so far as this is at all possible,
is being prepared by the Bauhaus-Archiv in
Darmstadt.
The standard works here listed provide the best
available information about the prehistory of
the Bauhaus and about the trends that led to
the Bauhaus, about the artistic environment into
which the Bauhaus had been growing, and
about related tendencies, especially in the fields
of architecture and arts and crafts.

Prehistory—general

Behrendt, Walter Curt. Der Kampf um den Stil im
Kunstgewerbe und in der Architektur. Deutsche Ver-
lags-Anstalt, Stuttgart, 1920.

Condit, Carl W. The Rise of the Skyscraper. The Uni-
versity of Chicago Press, Chicago, 1952.

Giedion, Siegfried. Mechanization Takes Command:
Contribution to Anonymous History. Oxford University
Press, New York, 1948.

_____. Space, Time and Architecture. Harvard Univer-
sity Press, Cambridge, Mass., 1941; 2nd ed., 1956.

Herrmann, W. Deutsche Baukunst des 19. und 20.
Jahrhunderts, Breslau, 1932.

Hitchcock, Henry-Russell. Architecture, Nineteenth &
Twentieth Centuries ("The Pelican History of Art").
Penguin Books Ltd. Harmondsworth, Middlesex, 1958
(with comprehensive bibliography).

Hüter, Karl-Heinz. Henry van de Velde. Akademie-
Verlag, Berlin, 1967.

Madsen, Stephan Tschudi. Sources of Art Nouveau.
Aschehoug & Co., Oslo, 1956.

Muthesius, Hermann. Der kunstgewerbliche Dilet-
tantismus in England. Architektonische Zeitbetrach-
tungen. Wilhelm Ernst & Sohn, Berlin, 1900.

_____. Das englische Haus. 3 vols. Wasmuth, Berlin.
Vol. I, 1904; Vol. II, 1905; Vol. III, 1908.

_____. Stilcharakter und Baukunst. Mühlheim-Ruhr,
1902.

_____. Kunstgewerbe und Architektur. Diederichs,
Jena, 1907.

_____. Die Werkbundarbeit der Zukunft und Aus-
sprache darüber. Diederichs, Jena, 1914.

Pevsner, Nikolaus. Pioneers of Modern Design. From
William Morris to Walter Gropius. Faber, London,
1936. Italian ed., Rosa e Ballo, Milan, 1945; American
ed., Museum of Modern Art, New York, 1949; German
ed. Rowohlt, Hamburg, 1957.

_____. Academies of Past and Present. Cambridge,
1940.

_____. "Fünfhundert Jahre Künstlerausbildung.
William Morris." Two lectures at the Bauhaus-Archiv,
Darmstadt, 1962.

Semper, Gottfried. Kleine Schriften. Ed. by Manfred
and Hans Semper. W. Spemann, Berlin and Stuttgart,
1884. (A selection of Semper's works on architecture
and art pedagogy was published in the series "Neue
Bauhausbücher," ed. by Hans M. Wingler, Verlag
Florian Kupferberg, Mainz and Berlin, 1966.)

Stelzer, Otto. Erziehung durch manuelles Tun. Lecture
at the Bauhaus-Archiv, Darmstadt, 1966.

_____. Vorgeschichte der abstrakten Malerei. Die
Piperdrucke, Munich, 1964.

Waentig, Heinrich. Wirtschaft und Kunst. Gustav
Fischer, Jena, 1909 (treatise on the history and theory
of the movement of modern arts and crafts).

Werkbund. Yearbooks of the Deutsche Werkbund.
Jena, 1914–1919.

Zevi, Bruno. Storia dell'architettura moderna. Guilio
Einaudi, Turin, 1950; 3rd ed., 1955 (with comprehen-
sive bibliography, 130 pages).

Publications by the Bauhaus

Program of the Staatliche Bauhaus in Weimar. Wood-
cut by Lyonel Feininger. Preface by Walter Gropius.
1919. 4 pages.

Program of the Staatliche Bauhaus in Weimar (terms
of admission for the applicants). 1 page.

Bauhaus Evenings. Invitation to lecture-evenings.
4-page folder.

Twelve woodcuts by Lyonel Feininger. Portfolio with
twelve woodcuts, printed and bound in the Staatliche
Bauhaus, Weimar, 1921.

Bauhaus prints.
"Neue europäische Graphik." Original works in five
portfolios. Ed. and prod. by the Staatliche Bauhaus in
Weimar. Verlag Müller, Potsdam, 1921–1923.
First portfolio:
Masters of the Staatliche Bauhaus in Weimar. 14
woodcuts, lithographs, and etchings by Feininger,
Itten, Klee, Marcks, Muche, Schlemmer, and Schreyer.
First and final numbered edition of 110 copies. Nos.
1–10 on India paper, wholly bound in parchment.
Second portfolio:
French artists. Unpublished. Publication was planned
for 1924. Four plates by Survage, Léger, Coubine, and
Marcoussis had already been printed.
Third portfolio:
German artists. 14 lithographs, woodcuts and lino-
cuts by Bauer, Baumeister, Campendonk, Dexel,
Fischer, Heemskerck, Hoetger, Macke, Marc, Molzahn,
Schwitters, Stuckenberg, Topp, and Wauer. First and
final numbered edition of 110 copies. Nos. 1–10 on
India paper, wholly bound in parchment. One an-
nounced leaf by Max Ernst replaced with a lithograph

by Hoetger.
Fourth portfolio:
Italian and Russian artists. 11 etchings and lithographs
by Archipenko, Boccioni, Carra, Chagall, Chirico,
Gontscharowa, Jawlensky, Kandinsky, Larionow,
Prampolini, and Severini. First and final numbered
edition of 110 copies. Nos. 1–10 on India paper, wholly
bound in parchment. A twelfth chart by Soffici was
announced but not published.
Fifth portfolio:
German artists. 13 etchings, lithographs, woodcuts,
and linocuts by Beckmann, Burchartz, Gleichmann,
Grosz, Heckel, Kirchner, Kokoschka, Kubin, Mense,
Pechstein, Rohlfs, Scharff, and Schmidt-Rottluff.
First and final numbered edition of 110 copies. Nos.
1–10 on India paper, wholly bound in parchment.
"Neue europäische Graphik."
Ed. and prod. by the Staatliche Bauhaus in Weimar.
Pamphlets describing the Bauhaus portfolios, with an
invitation to subscribe. 5 pages.

Statutes of the Staatliche Bauhaus in Weimar. 1921.

Statutes of the Staatliche Bauhaus in Weimar. 1922.
Folder with 6 small brochures.
A Curriculum. 8 pages. B. Rules of administration.
4 pages. C. Appendix 1: Teachers and plan of subjects.
4 pages. D. Appendix 2: Subjects of the training work-
shops; regulations for conducting the examination.
4 pages. E. Appendix 3: Publishing, stage. 2 pages.
F. Appendix 4: Kitchen, housing. 2 pages.

Wassily Kandinsky. Kleine Welten. Zwölf Blatt
Originalgraphik (twelve leaves of original graphics).
Propyläen-Verlag, Berlin, 1922. Printed at the Staat-
liche Bauhaus in Weimar.

Die Bauhausbühne (The Bauhaus Stage). Lothar
Schreyer, Director. First communique. December
1922. 4 pages.

Exhibition of works by the apprentices and journey-
men of the Staatliche Bauhaus in Weimar, April–May
1922. Information leaflet. 1 page.

Portfolio of the Masters of the Staatliche Bauhaus,
1923. 8 etchings, woodcuts and lithographs by
Feininger, Kandinsky, Klee, Marcks, Muche, Moholy-
Nagy, Schlemmer, and Schreyer. Bauhaus-Verlag
G.m.b.H., Munich and Weimar, 1923. First and final
numbered edition of 100 copies.

Das Wielandslied der Edda (The Wieland Saga of the
Edda) Trans. by K. Simrock. Woodcuts by Gerhard
Marcks. Bauhaus-Verlag, Munich and Weimar, 1923.
Portfolio with 10 woodcuts and 4 pages of text.

Staatliches Bauhaus Weimar 1919–1923. Bauhaus-
Verlag, Munich and Weimar 1923, 226 pages, 147 ills.,
20 color ills. Layout by L. Moholy-Nagy. Cover design
by Herbert Bayer.

The First Bauhaus Exhibition in Weimar. July–Septem-
ber 1923. Information leaflet. 1 page.

Bauhaus postcards.
20 postcard-lithographs, published on the occasion of
the Bauhaus exhibition, July–September 1923.
No. 1 Lyonel Feininger, No. 2 Lyonel Feininger, No. 3
Wassily Kandinsky, No. 4 Paul Klee, No. 5 Paul Klee,
No. 6 Gerhard Marcks, No. 7 L. Moholy-Nagy, No. 8
Oskar Schlemmer, No. 9 Rudolf Baschant, No. 10
Rudolf Baschant, No. 11 Herbert Bayer, No. 12 Herbert
Bayer, No. 13 Paul Häberer, No. 14 Dörte Helm, No. 15
Ludwig Hirschfeld-Mack, No. 16 Ludwig Hirschfeld-
Mack, No. 17 Farkás Molnar, No. 18 Kurt Schmidt,
No. 19 Kurt Schmidt, No. 20 Georg Teltscher.
Feininger, Klee, Hirschfeld-Mack, Molnar and Schreyer
also designed invitation postcards for the Kite and
Lantern Festivals held at the Bauhaus in Weimar,
1921–1922.

Oskar Schlemmer. Spiel mit Köpfen (Portfolio with 6
lithographs). 50 copies autographed. Printed at the
press of the Staatliche Bauhaus in Weimar. Utopia
Verlag, Weimar, November 1923.

Walter Gropius. Idee und Aufbau des Staatlichen
Bauhauses Weimar. Bauhaus-Verlag G.m.b.H.,
Munich and Weimar, 1923, 12 pages.

Kreis der Freunde des Bauhauses (Circle of the Friends
of the Bauhaus). Invitation to join. 4 pages.

Pressestimmen für das Staatliche Bauhaus Weimar
(newspaper commentaries in favor of the Bauhaus):
Weimar, 1924, pp. 1–72. Nachtrag (supplement)
March–April 1924, pp. 72–101. Kundgebungen (decla-
rations of solidarity) für das Staatliche Bauhaus
Weimar. October 1924, pp. 105–143.

Walter Gropius. "Die bisherige und zukünftige Arbeit
des Staatlichen Bauhauses Weimar." 1924. 7 pages.

L. Moholy-Nagy. "Die Arbeit des Staatlichen Bau-
hauses. Ziele und Bestrebungen." In: Thüringer
Allgemeine Zeitung, Vol. 75, No. 288, October 19,
1924 (special issue of the newspaper).

Bauhausbücher (Bauhaus books)

Edited by W. Gropius and L. Moholy-Nagy. Verlag
Albert Langen, Munich, 1925–1930.
1. Walter Gropius. Internationale Architektur. 1925.

111 pages, ill. Typography and cover by L. Moholy-Nagy. Jacket by Farkas Molnár. 2nd ed. 1927.
2. Paul Klee. Pädagogisches Skizzenbuch. 1925. 51 pages, 87 ills. Typography and jacket design by L. Moholy-Nagy. 2nd ed. 1928.
3. Adolph Meyer. Ein Versuchshaus des Bauhauses in Weimar, 1925. 78 pages, ill. Typography by Adolf Meyer.
4. Oskar Schlemmer (ed.). Die Bühne im Bauhaus. 1925. 87 pages, ill., 3 color plates. Title page by Oskar Schlemmer. Typography by L. Moholy-Nagy.
5. Piet Mondrian. Neue Gestaltung, Neoplastizismus, nieuw beelding. Trans. by Rudolf F. Hartogh and Max Burchartz. [1925.] 66 pages. Typography, binding, and jacket by L. Moholy-Nagy.
6. Theo van Doesburg. Grundbegriffe der neuen gestaltenden Kunst. Trans. by Max Burchartz. 1925. 40 pages, 32 ills., some colored. Typography and binding by L. Moholy-Nagy. Jacket by Theo van Doesburg.
7. Walter Gropius (ed.). Neue Arbeiten der Bauhauswerkstätten. 1925. 115 pages, ill. Typography, binding, and jacket by L. Moholy-Nagy.
8. L. Moholy-Nagy. Malerei, Photographie, Film. 1925. 133 pages, ill. Typography, binding, and jacket by L. Moholy-Nagy. 2nd ed., 1927.
9. Wassily Kandinsky. Punkt und Linie zu Fläche. Beitrag zur Analyse der malerischen Elemente. 1926. 198 pages, 102 text ills., 25 plates, 1 color plate. Typography by Herbert Bayer. 2nd ed., 1928.
10. J. J. P. Oud. Holländische Architektur. 1926. 107 pages, 55 ills. Typography, binding, and jacket by L. Moholy-Nagy. 2nd ed., 1929.
11. Kasimir Malewitsch. Die gegenstandslose Welt. Trans. by A. von Riesen. 1927. 104 pages, 92 ills. Typography, binding, and jacket by L. Moholy-Nagy. English ed. trans. by Howard Dearstyne. Theobald, Chicago, 1959.
12. Walter Gropius. bauhausbauten dessau. 1930. 221 pages, ill. Typography, binding, and jacket by L. Moholy-Nagy.
13. Albert Gleizes. Kubismus. 1928. 101 pages, 47 ills. Typography, binding, and jacket by L. Moholy-Nagy.
14. L. Moholy-Nagy. von material zu architektur. 1929. 241 pages, 209 ills. Typography, binding, and jacket by L. Moholy-Nagy.

Neue Bauhausbücher
see page 631
Hirschfeld-Mack, Ludwig. Farbenlichtspiele. Wesen—Ziele—Kritiken (meaning—aims—criticism.) Published by the author, Weimar, 1925.

Bauhaus. Zeitschrift für Gestaltung (quarterly).
Vol. 1, 1926–1927.
No. 1, 1926, ed. by W. Gropius and L. Moholy-Nagy.
Walter Gropius. "Statt einer Vorrede. Bauhaus-Chronik 1925/26.
W. Kandinsky. "Der Wert des theoretischen Unterrichts in der Malerei."
Moholy-Nagy. "Geradlinigkeit des Geistes—Umwege der Technik."
Georg Muche. "Bildende Kunst und Industrieform."
No. 2, 1927, ed. by W. Gropius and L. Moholy-Nagy.
Walter Gropius. "Systematische Vorabeit für rationellen Wohnungsbau."
Georg Muche. "Stahlhausbau."
No. 3, 1927, ed. by W. Gropius and L. Moholy-Nagy.
Oskar Schlemmer. "Bühne." From a lecture with demonstrations on the stage for the Circle of the Friends of the Bauhaus on March 16, 1927.
No. 4, 1927, ed. by W. Gropius and L. Moholy-Nagy.
K. von Meyenburg. "Kultur von Pflanzen, Tieren, Menschen."
Walter Gropius. "Versuchshauswohnung auf der Stuttgarter Wohnbauausstellung 1927."
Hannes Meyer and Hans Wittwer. "Ein Völkerbundgebäude für Genf," 1927.
Vol. 2, 1928
No. 1, 1928, ed. by W. Gropius and L. Moholy-Nagy.
Werbwart Weidenmüller. "Gestaltende Anbiet-Arbeit."
L. Moholy-Nagy. "Fotografie ist Lichtgestaltung."
Herbert Bayer. "Typografie und Werbsachengestaltung."
Marcel Breuer. "Kleinwohnungstyp 'bambos.'"
No. 2/3. 1928. ed. by Hannes Meyer and Ernst Kállai.
Ernst Kállai. "Das Bauhaus lebt!"
Josef Albers. "Werklicher Formunterricht."
W. Kandinsky. "Kunstpädagogik."
Adolf Behne. "Die Bundesschule des ADGB in Bernau bei Berlin."
Hannes Meyer. "Erläuterungen zum Schulprojekt."
Mart Stam. "M-Kunst."
Paul Klee. "Exakte Versuche im Bereich der Kunst."
Joost Schmidt. "Schrift?"
Joost Schmidt. "Plastik . . . und das am Bauhaus!?!?"
Oskar Schlemmer. "Unterrichtsgebiete."
Ernst Kállai. "Interview mit Bauhäuslern, ein Bild, ein Mensch."
Ludwig Grote. "Junge Bauhausmaler."
No. 4. 1928. ed. by Hannes Meyer and Ernst Kállai.
Ernst Kállai. "Bescheidene Malerei."
N. Gabo. "Gestaltung?"

Hugo Häring. "Probleme um die Lichtreklame."
"Internationaler Kongress für neues Bauen." Report.
Ph. Tolziner. "Reihenhausprojekt für Tel Aviv."
Ernst Göhl. "Entwurf zu einer Siedlungsschule."
Hannes Meyer. "Bauen."
Gustav Hassenpflug. "Möbel aus Holz oder Metall oder??"
Ernst Kállai. "Ein beliebter Vorwurf gegen das Bauhaus."
Interview with Members of the Bauhaus.
Vol. 3, 1929
No. 1. 1929, ed. by Hannes Meyer and Ernst Kállai.
Hannes Meyer. "Bauhaus und Gesellschaft."
Lu Märten. "Historischer Materialismus und neue Gestaltung."
Ernst Kállai. "Wir leben nicht, um zu wohnen."
Ernst Kállai "Bauen und Leben."
Ernst Kállai. "Goldene Ketten—eiserne Ketten."
H. Neugeboren. "Eine Bachfuge im Bild."
Mart Stam. "Entwurf zu einem Bürogebäude."
"Bauhausstil." Polemik zwischen M. Brandt und N. Gabo.
Arieh Sharon. "Entwurf zu einem Haus des Arbeiterrates in Jerusalem."
No. 2. 1929, ed. by Hannes Meyer and Ernst Kállai.
Ludwig Hilberseimer. "Kleinstwohnungen."
Filmrhythmus, Filmgestaltung.
Malerei und Film.
Augendemokratie und dergleichen.
Ludwig Hilberseimer. "Handwerk und Industrie."
Zwei Plakate (two posters) der HAPAG.
No. 3. 1929, ed. by Hannes Meyer and Ernst Kállai
Junkerskoje "gas und wasser."
Hans Riedel. "Verantwortung des Schaffenden."
E. Giménez Caballero. "Lob des Plakates."
Ein Laden für Suchard.
Lene Schmidt-Nonné. "Kinderzeichnungen."
H. F. Geist. "Schöpferische Erziehung."
Ernst Kállai. "Kindheit der Iris."
Fritz Kuhr. "Den Fragern."
No. 4. 1929, ed. by Hannes Meyer and Ernst Kállai.
Oskar Schlemmer. "Die Bühne."
Oskar Schlemmer. "Analyse eines Bildes."
Le Corbusier. "Die Geometrie."
Willi Baumeister. "Bildbau."
Albert Renger-Patzsch. "Hochkonjunktur."
Vordemberge-Gildewart. "Optik—die grosse Mode."
Bauhausvolkswohnung.
Hubert Hoffmann. "Mietshaus oder Siedlungshaus."
Hans Volger. "Wohnhaus für einen Arzt."
Vol. 5, 1931
No. 1. 1931, ed. by Ludwig Hilberseimer.
Ludwig Hi berseimer. "Die Kleinstwohnung im treppenlosen Hause."
Josef Albers. "Kombinationsschrift '3.'"
No. 2. 1931, ed. by Josef Albers.
Gunta Sharon-Stölzl. "Die Entwicklung der Bauhaus-Weberei."
Amédée Ozenfant. "Mein Besuch in der Textilwerkstatt des Bauhauses."
No. 3. 1931, ed. by W. Kandinsky.
Ludwig Grote. "An Paul Klee."
Will Grohmann. "Paul Klee und die Tradition."
Christof Hertel. "Genesis der Formen, oder über die Formentheorie von Klee."

Partial Index of the Periodical "bauhaus"
Albers, Josef. "Werklicher Formunterricht." No. 2/3, 1928, pp. 3–7; "Kombinationsschrift '3,'" No. 1, 1931, pp. 3–4, 4 ills. Illustrations: tea glass, No. 4, 1927, p. 1; ti 244, chair with armrests and single parts, No. 2, 1929, pp. 20–23.

Albers's preliminary course, works by Bredendieck, Frieling, Gerson, Hassenpflug, Henneberger, Kallin, Meumann, Mizutani, Schneider, A. Sharon, and Tralau. No. 2/3, 1928, pp. 3–7.

Architecture. Göhl, Gropius, Häring, Hilberseimer, Hoffmann, Kállai, Klee, Le Corbusier, H. Meyer, Mies van der Rohe, Muche, Rietveld, A. Sharon, Stam, Tolziner, and Volger.

Ausbauwerkstatt. 3 illustrations: Volkswohnung, Ausstellung Grassi-Museum Leipzig, No. 4, 1929, pp. 22–24.

Bard, Jean, and Hannes Meyer. "Das Propagandatheater co-op," 1 ill., and "Die Arbeit co-op," No. 3, 1927, p. 5.

Bauhausnachrichten. No. 2/3, 1928, pp. 32–33; No. 4, 1928, p. 24; No. 1, 1929, pp. 24–25; No. 2, 1929, pp. 26–27; No. 3, 1929, pp. 26–29; No. 4, 1929, pp. 28–29; No. 1, 1931, p. 4; No. 3, 1931, p. 8.

Baumeister, Willi. "Bildbau," No. 4, 1929, pp. 15–16; Tennisspiele Fassung B (with 3 analyses), No. 4, 1929, pp. 14–15.

Bayer, Herbert. "Typografie und Werbsachengestaltung," No. 1, 1928, p. 10. prospectus of the Bauhaus G.m.b.H., No. 1, 1926, p. 6. photomontage, No. 1, 1928, p. 1 (frontispiece).

Bayer, Max. Illustration: men's wardrobe, No. 4, 1927, p. 3.

629

and diagrams, interior and detailed views), No. 1, 1929, pp. 20–21.

Svipas, Vladas. Interview: No. 4, 1928, p. 20.

Tolziner, P. H. (of the architectural department), "Studienarbeit: Reihenhausprojekt für Tel Aviv" (Ill. with diagrams), No. 4, 1928, p. 10.

Tralau, Walter. Illustration: "Materialübung in Papier" (Albers's preliminary course), No. 2/3, 1928, p. 5.

Tümpel, Wolfgang, and Max Krajewsky. Illustration: tea set for one person (1923–1925), No. 2, 1927, p. 6.

Typography. Albers, No. 1, 1931, pp. 3–4; Herbert Bayer, No. 1, 1926, p. 6, No. 1, 1928, title page, pp. 1, 10; Joost Schmidt, No. 2/3, 1928, pp. 18–20.

Urzidil, Johannes. "Paul Klee und die Zöllner," No. 1, 1929, p. 12.

Vantongerloo, Georges. "Exakte Gestaltung," No. 4, 1929, pp. 16–17.

Volger, Hans. "Wohnhaus für einen Arzt, Haus Dr. Nolden in Mayen/Eifel" (views and diagrams), No. 4, 1929, pp. 26–27, 7 ills.

Vordemberge-Gildewart, Friedrich. "Optik—die grosse Mode," No. 4, 1929, p. 21. Illustration: composition No. 26, No. 4, 1929, p. 16.

Weaving Workshop (Weberei). See Beyer, Grohmann, Leischner, Ozenfant, Rapoport, Schenk zu Schweinsberg, Schütz-Wolff, Sharon-Stölzl.

Weidenmüller, Werbwart. "Gestaltende Anbiet-Arbeit," No. 1, 1928, p. 1.

Weininger, Andreas. "Kugeltheater," No. 3, 1927, p. 2, 1 ill.

Wittwer, Hans, and Hannes Meyer. Illustrations: 2, Petersschule Basel (diagram for the competition, 1926), No. 2, 1927, p. 5; building for the League of Nations (Ein Völkerbundsgebäude) in Geneva (diagram for the competition, 1927), No. 4, 1927, p. 6, 1 ill.

Winter, Fritz, Interview: No. 4, 1928, p. 21. Illustrations: "Die Kohle" (oil on India paper), No. 3, 1929, p. 23; oil on paper, No. 4, 1928, p. 21.

Zimmermann, W. See Brandt, Marianne (with W. Zimmermann).

"bauhaus dessau." Statute, curriculum (approx. 1925–1926).

"bauhaus dessau—hochschule für gestaltung." Prospectus published by Artur Bodenthal, 1927, 34 pages. (Containing curriculum, program of the different departments and two articles by Walter Gropius).

"bauhaus—siedlung dessau-törten." Planning and supervision by Walter Gropius. 6-page folder (approx. 1927–28).

"bauhaus." Prospectus. Printed by the Bauhaus, 1929.

"junge menschen kommt ans bauhaus!" Prospectus ed. by Bauhaus Dessau approx. at the end of 1929, 48 pages.
Partial contents: "paul klee spricht." "bauhaus organisation." "unterricht w. kandinsky." "josef albers, aus: werklicher formunterricht." "werklehre josef albers." "stundenplan der weberei." "unterrichtsprogramm des bauingenieurs alcar rudelt." "dr.ing. hanns riedel spricht." "w.peterhans über fotografie." "der mensch als einheit. geist/seele—leib/seele." "aus dem haushaltsplan der stadt dessau für das jahr 1929." "der lehrkörper."

"bauhaus dessau—hochschule für gestaltung." Supplement to the statute—rules for the students. October 15, 1930.

Tapeten (wallpaper). Sample catalogs of the Hannover wallpaper manufacturers Gebr. Rasch. Designs and color schemes by the wall-painting workshop of the Bauhaus. 1930, 1931, 1932, 1933. Since 1934 the "Bauhaus Tapeten" are designed by the studio of the company Rasch.
Advertising material of Rasch & Co. from 1930 to 1933 was designed with the assistance of the commercial art department of the Bauhaus (Joost Schmidt).

"Bauhaus Dessau." Brochure. Edited in July 1931 for the Circle of the Friends of the Bauhaus.

"bauhaus dessau." Curriculum, Spring 1932.

"bauhaus berlin." Prospectus. 1932. 6 pages.

Periodicals:
Junge Menschen. Vol. 5, No. 8, November 1924. Special number devoted to the Bauhaus in Weimar (layout by Joost Schmidt).

Vivos Voco. Zeitschrift für neues Deutschtum. Estab. by H. Hess and R. Woltereck. Verlag der Werkgemeinschaft, Leipzig. W. Gropius, "Bauhaus," Vol. IV, No. 1, 1924; contributions by W. Gropius, L. Moholy-Nagy, and O. Schlemmer, Vol. V, No. 8/9, 1926.

Offset. Buch und Werbekunst. No. 7, 1926, pp. 355–432. Special number produced by the Bauhaus. Jacket design by Joost Schmidt.

RED (Prague). Vol. 3, No. 5, 1930. Special number: "bauhaus—dessau". K. Teige, "K Sociologii Architetury," Vol. 3, No. 6/7, 1930.

Der Austausch. Publication of the students at the Staatliche Bauhaus in Weimar (reflections on art, thoughts about life at the Bauhaus, poems, book reviews, etc.). May 1919, "Erstes Flugblatt" (leaflet), 2 pages, woodcut on title page by E. Schrammen; May 1919, 4 pages, woodcut on title page by R. Riege; June 1919, 6 pages, woodcut on title page by Hans Gross; July 1919, 4 pages, woodcut on title page by R. Riege.

bauhaus. Sprachrohr der Studierenden. Responsible, Paul Kmiec, Dessau. Hectographed periodical averaging 10–15 pages; about 15 numbers, 1930–1932, and 1 special issue (not numbered). (Student organ of the radical left at the Bauhaus in Dessau.)

Neue Bauhausbücher
New series of the "Bauhausbücher." Edited by Hans M. Wingler.
Verlag Florian Kupferberg, Mainz and Berlin.
1. Walter Gropius. Die neue Architektur und das Bauhaus. 1965, 74 pages.
2. Paul Klee. "Pädagogisches Skizzenbuch. 1965, 55 pages. Helene Schmidt-Nonné, "Der Unterricht von Paul Klee in Weimar und Dessau," p. 53.)
3. Oskar Schlemmer, Laszlo Moholy-Nagy, Farkas Molnar. Die Bühne im Bauhaus. 1965, 91 pages. Epilogue by Walter Gropius.
4. Theo van Doesburg. Grundbegriffe der neuen gestaltenden Kunst. 1966, VIII, 73 pages. With a contribution by the editor and an epilogue by H. L. C. Jaffé.
5. Gottfried Semper. Wissenschaft, Industrie und Kunst. 1966, 128 pages and Appendix. Selected by Hans M. Wingler. With an essay by Wilhelm Mrazek.
6. Walter Gropius. Apollo in der Demokratie. 1967, 139 pages. Selected and edited by Ise Gropius.
7. Ludwig Hilberseimer. Berliner Architektur der 20er Jahre. 1967. 102 pages. With an epilogue by the editor.
8. Laszlo Moholy-Nagy. Malerei, Fotografie, Film. 1967, 147 pages. With a comment by the editor and an epilogue by Otto Stelzer.
9. Laszlo Moholy-Nagy. Von Material zu Architektur. 1968, 252 pages, 209 ill. With an essay by Otto Stelzer.
10. Oskar Schlemmer: Der Mensch. Compiled and commented by Heimo Kuchling. (in preparation)

Publications about the Bauhaus
Adler, Bruno. Das Weimarer Bauhaus. Bauhaus-Archiv, Darmstadt, 1963. Anhalt Legislature, minutes. Third election period, 1924–1928; 3 volumes, stenographic reports of the 1st–71st sessions; Fourth election period, 1929; 1 volume, stenographic reports of the 1st–20th sessions.

Argan, Giulio Carlo. Walter Gropius e la Bauhaus. Giulio Einaudi, Turin, 1951. German ed. S. Fischer, Frankfurt a.M., 1962. Review in: Architectural Review, Vol. 112, July 1952, pp. 3–4; and in: Journal of the Royal Institute of British Architects, Ser. 3, Vol. 59, May 1952, p. 249.

"Bauhaus." In: Art Digest, Vol. 5, January 15, 1931, pp. 27–28.

"Bauhaus" (2nd generation exhibition in Zurich). In: Werk, Vol. 48, September 1961, Sup. 205.

"Bauhaus Defended." In: Art Digest, Vol. 13, January 1939, p. 8.

"Bauhaus Exhibit, Becker Gallery." In: Art News, Vol. 29, January 1931, p. 12.

"Bauhaus Revisited." In: Industrial Design, Vol. 7, March 1960, pp. 43–44.

"Bauhaus—Wanderschau 1930" (traveling exhibition). Commentary by the Kunstgewerbemuseum, Zurich, July 20–August 17.

Bayer, Herbert, and Walter and Ise Gropius. Bauhaus 1919–1928. The Museum of Modern Art, New York, 1938; Allan Ltd., London, 1939; 2nd ed. Branford, Boston, 1952, Bailey Bros., London, 1952; 3rd ed. Hatje, Stuttgart, 1955; 3rd ptg., Branford, Boston, 1959. Review in: Werk, Vol. 39, September 1952, Sup. 130.

Bowman, Ned. A. "Bauhaus Influences on an Evolving Theatre Architecture. Some Developmental Stages." In: Theatre Survey, Vol. VI, No. 2, 1965.

Bredendieck, H. "Legacy of the Bauhaus." In: Art Journal, Vol. 22, No. 1, Fall 1962, pp. 15–21.

"Closing of the Bauhaus at Dessau." In: Studio, Vol. 104, November 1932, p. 295.

Dessau. Budgets of the City of Dessau for the Years 1926–1932.

———. Records of Proceedings of the Municipal Council of the City of Dessau. Vol. 1, 1923–25; Vol. 2, 1927, 1929–1933.

Eckardt, Wolf von. "The Bauhaus." In: Horizon, A Magazine of the Arts, Vol. IV, No. 2, November 1961, pp. 58–77.

Erffa, Helmut von. "The Bauhaus before 1922." In:

College Art Journal, Vol. 3, November 1943, pp. 14–20.

Erffa "Bauhaus: First Phase." In: Architectural Review, Vol. 132, August 1957, pp. 103–105.

Giedion, Siegfried. "Das Bauhaus und seine Zeit." In: Baukunst & Werkform, Vol. 15, No. 2, 1962, pp. 59–60.

Goldring, Maurice. "The Bauhaus—30 years after." In: Architectural Design, Vol. XXVIII, March 1958.

Grohmann, Will. "Art into Architecture: Painters of the Bauhaus at the Marlborough Gallery." In: Apollo, No. 76, March 1962, pp. 37–41.

———. "Bauhaus." In: L'Oeil (Paris), No. 28, April 1957.

Gropius, Walter. "Bauhaus: Crafts or Industry?" Reply to H. Dearstyne. In: American Institute for Architecture Journal, Vol. 40, September 1963, pp. 105–106.

———. "Das Bauhaus in Dessau." In: Heimatliches Jahrbuch für Anhalt. A calendar for the year 1925. Heimat-Verlag Karl Rauch, Dessau, pp. 15–22, 5 ills., 3 plates.

———. "Das Bauhaus in Weimar." In: Der Querschnitt durch 1921, marginal notes of the Galerie Flechtheim, 1922, pp. 134–136.

———. "Bauten." In collaboration with Adolf Meyer. Wasmuth, Berlin, 1924.

———. "The New Architecture and the Bauhaus." The Museum of Modern Art, New York, 1936; Faber & Faber Ltd., London, 1935.

"Gropius Symposium at the American Academy of Arts and Sciences, Boston." In: Arts & Architecture, Vol. 69, May 1952, pp. 27–31.

Grote, Ludwig. "Zum Gestaltwandel des Bauhauses." In: Die Kunst, 1961.

———. "Die Maler am Bauhaus" (Exhibition catalog). Munich, 1950.

Guaneri, Libero. "L'Evoluzione dell'Architettura moderna." Görlich, Milan, 1954.

Halle, Fannina, "Dessau: Burgkühnauer Allee 6–7 (Kandinsky and Klee)." In: Das Kunstblatt 13, 1929.

Herfurth, Emil (ed.), "Weimar und das Staatliche Bauhaus." Weimar, 1920 (hostile brochure).

Hesse, Fritz. Von der Residenz zur Bauhaus-Stadt. Published by the author, Bad Pyrmont, 1963.

Huszar, V. "Das Staatliche Bauhaus in Weimar." In: De Stijl, Vol. 5, No. 9, September 1922.

Itten, Johannes. "Pädagogische Fragmente einer Formlehre. Aus dem Unterricht der Itten-Schule." In: Die Form, Zeitschrift für gestaltende Arbeit, Vol. 5, No. 6, March 1930, pp. 141–161.

Kennedy, R. W. "Heritage of the Bauhaus." In: Progressive Architecture, Vol. 33, December 1952, pp. 132–133+.

Koffler, Annemarie (ed.), Karl Pietschmann. Mit Verstand und Herz. Notes of the painter Karl Pietschmann. Mänken-Verlag, Schwerin, 1954.

Kühnlenz, Fritz. "Ideen und Voraussetzungen zur Gründung der Weimarer Kunstschule im Jahre 1860." In: Wissenschaftliche Zeitschrift der Hochschule für Architektur und Bauwesen Weimar, Vol. VIII, 1961.

Lang, Lothar. Das Bauhaus 1919–1933. Idee und Wirklichkeit. Zentralinstitut für Formgestaltung, Berlin, 1965.

Levy, J. F. "Bauhaus and Design, 1919–1939." In: Architectural Record, Vol. 85, January 1939, pp. 71+.

Logan, F. M. "Kindergarten and Bauhaus." In: College Art Journal, Vol. 10, No. 1, 1950, pp. 36–42. Reply by S. Moholy-Nagy in: College Art Journal, Vol. 10, No. 3, 1951, pp. 270–272.

Lotz, Wilhelm. "Das Ende des Bauhauses in Dessau." In: Die Form, Vol. 7, No. 9, 1932.

Lowenstein, M. D. "Germany's Bauhaus Experiment." In: Architect (New York), Vol. 60, July 1929, pp. 1–6.

Lynton, Norbert. "The Bauhaus in Perspective." In: Impulse, No. 21, 1962.

Márta, Rados. A Bauhaus és Mühelyei Epités. Közlemenyek, 1962.

Matustik, Radislav. Bauhaus. Slovensky fond, vytvarných umeni, 1965.

Miller Lane, Barbara. Architecture and Politics in Germany 1918–1945. Harvard University Press, Cambridge, Mass., 1968.

Moholy-Nagy. L. "Das Bauhaus in Dessau." In Qualität, Vol. 4, No. 5/6, May/June 1925.

Moholy-Nagy, S. "Bauhaus and modern typography." In: Print, Vol. 14, January 1960, pp. 45–48.

Muche, Georg. Blickpunkt, Sturm, Dada, Bauhaus, Gegenwart. Langen-Müller, Munich, 1961.

———. "Das Einfamilienhaus des Staatlichen Bau-

hauses." Velhagen and Klasings Monatshefte, Vol. 38, No. 9, May 1924.

Müller, Arno (responsible for the contents). "Das Staatliche Bauhaus Weimar und sein Leiter." Weimar, April 1924. (So-called "Gelbe Broschüre" with attacks against the Bauhaus.)

Necker, W. F. "Bauhaus '23–'24." In: Architectural Review, Vol. 134, September 1963, pp. 157–159.

Peters, Heinz. Die Bauhaus-Mappen "Neue europäische Graphik" 1921–23. Czwiklitzer, Cologne, 1957.

Popp, Joseph. "Das Dessauer Bauhaus." In: Der Kunstwart. Hermann Rinn, Munich, Vol. 40, No. 4, 1926/27.

Roessger, Karl. "Das Bauhaus." In: Neue Bahnen (illustrated monthly magazine for education), Vol. 36, No. 2, February 1925.

Roters, Eberhard. Maler am Bauhaus. Rembrandt, Berlin, 1965.

Scheidig, Walther. Bauhaus Weimar 1919–1924. Werkstattarbeiten. Plates by Klaus G. Beyer. Edition Leipzig, Leipzig, and Süddeutscher Verlag, Munich, 1966. French ed. Leipzig, 1966; English ed. London, 1966.

Schlemmer, Oskar, Laszlo Moholy-Nagy, and Farkas Molnar. The Theater of the Bauhaus. Intro. by W. Gropius. Trans. by Arthur S. Wensinger from Die Bühne im Bauhaus ("Bauhausbuch," No. 4). Wesleyan University Press, Middletown, Conn., Hall, New York, and Burns & MacEachern, Toronto, 1961.

Schmidt, Diether. bauhaus weimar 1919–1925, dessau 1925–1932, berlin 1932–1933. VEB Verlag der Kunst, Dresden, 1966.

Schreyer, Lothar. Erinnerungen an Sturm und Bauhaus. Langen-Müller, Munich, 1956.

Strobl, J. W. "Une lettre à Zodiac: Le Bauhaus de demain." In: Zodiac, No. 5, 1960, pp. 12–17. English translation.

"Der Streit um das Staatliche Bauhaus" (The dispute about the Bauhaus). Typewritten, mimeographed, 1920 (not paged).

Suschitzky, E. "University of Commercial Art." In: Commercial Art, Vol. 10, March 1931, pp. 113–114.

Teige, Karel, Vymarsky Bauhaus a nemecka moderna (Weimar Bauhaus and German Moderns), in "Stavba," 2nd year. Prague 1923, pp. 200–202.

Teige, Karel, Deset let Bauhausu (Ten Years of Bauhaus), in "Stavba," 8th year. Prague 1929–1930, pp. 146–151.

Teige, Karel, Bauhaus, in "Panorama," 3rd year. Prague 1930, Nr. 5, pp. 94–96, continuation Nr. 6, pp. 130–134.

Thuringia. Stenographic reports of the sessions of the First Legislature of Thuringia. Böhlaus, Weimar, Vol. 1, 1st–47th sessions, 1920–1921; Vol. II, 48th–83rd sessions, 1921.
Publications of the Second Legislature of Thuringia, 1921–1923. Vol. I, pp. 1–936; Vol. II, pp. 937–1820. Stenographic reports of the Second Legislature of Thuringia. Vols. I–V, 1st–212th sessions, 1921–1923. Publications of the Third Legislature of Thuringia, 1924–1926. Vol. I, Nos. 1–380. Vol. II, Nos. 381–525. Negotiations between the legislature and the district representatives of Saxony, Weimar, and Eisenach, 1919–1921.
Verhandlungen (negotiations) of Volksrat of Thüringen 1919–1920. Hof-Buchdruckerei, Weimar.
Protocols for records of the negotiations of the legislatures of Saxony, Weimar and Eisenach, 1919–1921. Vol. I 1st–48th sessions, 1919; Vol. II, 49th–103rd sessions, 1919–1921.

Thwaites, J. A. "Bauhaus Painters and the New Style-Epoch." In: Art Quarterly, Vol. 14, No. 1, 1951, pp. 19–32.

Wingler, Hans M. Das Bauhaus, 1919–1933, Weimar, Dessau, Berlin. Rasch, and DuMont Schauberg, Bramsche and Cologne, 1962; enlarged 2nd ed. 1968.

———. Die künstlerische Graphik des Bauhauses, Vol. 1. Die Mappenwerke "Neue europäische Graphik." Kupferberg, Mainz—Berlin, 1965, 163 pages. English edition under the title "Graphic work from the Bauhaus" transl. by Gerald Onn. Lund Humphries, London, 1968, 168 pages.

———. "Origine et Histoire du Bauhaus." In: Cahiers Renaud Barrault, February 1966.

Yamawaki, Iwao and Michiko. bauhaus und bauhäusler. Shoko Kushra, Tokyo, n.d.

Exhibition catalogs:
Basel:
Kunsthalle, April 20–May 9, 1929. ("Das Bauhaus Dessau").
Basel:
Gewerbemuseum, April 21–May 20, 1929 ("Das Bauhaus Dessau").

Paris:
Grand Palais, May–June 1930 (exhibition of the Sociétée des Artistes décorateurs, arranged by the Deutsche Werkbund. Layout of the catalog by Herbert Bayer.
Berlin:
arranged by the Amt für Kunst of the City Council of Greater Berlin, 1950 ("22 berliner bauhäusler stellen aus").
Darmstadt:
Kunsthalle, June 24–August 6, 1961 ("bauhaus"; editing and layout by Roman Clemens, Zurich).
Melbourne:
Gallery A, 1961 ("The Bauhaus, Aspects and Influence").
London:
Marlborough Gallery, March–April 1962 ("Painters of the Bauhaus," 85 pages, with illustrations).
Stuttgart:
Württembergischer Kunstverein, May 5–July 28, 1968 ("50 Jahre Bauhaus," 367 pages, illustrated); and special catalog ("Bauhaus Grafik," 61 pages with illustrations.) English, Dutch, French and other editions for the traveling exhibition (England, Netherlands, U.S.A., and other countries 1968ff.).

Publications by and about the Masters of the Bauhaus and by some of the students

Albers, Josef
Publications by Albers:
"Historisch oder jetzig?" In: bauhaus no. 8, November 1924, p. 171.

"Gestaltungsunterricht." In: Böttcherstrasse, Vol. 1, 1925.

"Werkstattarbeiten des Staatlichen Bauhauses zu Weimar." In: Neue Frauenkleidung und Frauenkultur (supplement), January 1925.

"Zur Ökonomie der Schriftform." In: Offset, No. 7, 1926, pp. 395–397.

"Zur Schablonenschrift." In: Offset, No. 7, 1926, p. 397.

"Werklicher Formunterricht." In: bauhaus, No. 2/3, 1928, pp. 3–4.

"Schöpferische Erziehung." In: IV. Internationaler Kongress für Zeichnen, Kunstunterricht und angewandte Kunst in Prag, 1928. Prague, 1931.

"Kombinationsschrift 3." In: bauhaus I, 1931, pp. 3–4.

"Concerning art construction." In: Black Mountain College Bulletin, No. 2, June 1934, pp. 2–4.

"Art as experience." In: Progressive Education, October 1935.

"Abstract-Presentational." In: American Magazine of Art, April 1936.

The Educational Value of Manual Work and Handicraft in Relation to Architecture. In: Paul Zucker (ed.), New Architecture and City Planning. New York, 1944, pp. 688–694;

"Note on art in education." In: American Abstract Artists. New York, 1946, pp. 63–64.

"Present and/or Past." In: Design, Vol. 47, April 1946, pp. 16–17.

"On my brick mural." In: Eleanor Bitterman, Art in Modern Architecture. New York, 1952, pp. 148–149. German in: Spirale, No. 5, Fall 1955.

Zeichnungen (drawings). New York and Bern, 1956.

Poems and Drawings. New Haven, 1958 (German and English); 2nd enlarged ed. New York, 1961.

Despite Straight Lines. Captions by J. Albers. Analysis of Albers's graphic construction by Francois Bucher. New Haven, 1961. German ed. Bern, 1961.

"Homage to the Square." In: Art News, Vol. 60, October 1961, pp. 60–67.

"Homage to the Square," and "Color in my Paintings." Catalog Gimpel Fils, London, 1961.

Self report. In: Leonhard Reinisch (ed.), Die Zeit ohne Eigenschaften. Eine Bilanz der 20er Jahre. Stuttgart, 1961, pp. 146ff.

Interaction of Color. Yale University Press, New Haven and London, 1963. 1 Vol. Text 80 pages; 1 Vol. Commentary 48 pages and 80 color plates.

"Interaction of Color." In: Art News, Vol. 62, March 1963, pp. 33–35, 56–59.

"Wechselwirkung der Farbe" ("Interaction of Color"). In: Ulm, No. 8/9, 1963.

"Op-Art and/or Perceptual Effects." In: Yale Scientific, Vol. 15, No. 2, November 1965.

"Origin," third series, selection of poems, writings, etc., in honor of Josef Albers. No. 8, January 1968.

Publications about Josef Albers:

Ponce, Matilde. "Revolutión." In: Espacio, Vol. I, No. II, 1952.

Charlot, Jean. "Nature and the Art of Josef Albers." In: College Art Journal, Vol. XV, No. 3, Spring 1956.

"A Tribute to Josef Albers on his Seventieth Birthday." In: Yale University Art Gallery Bulletin, Vol. 24, No. 2, 1958.

Albers, Josef. "Homage to the Square: White Setting 1959, 36″ × 36″, Collection of the Artist." In: American Art in the American Embassy, Moscow, n.d.

Current Biography (entry in). Vol. 23, No. 6, 1962.

Secunda, Arthur. "Tamarind." In: Art Forum, Vol. 1, No. 3, 1962.

"Renée Sintenis and Josef Albers 75 years Old." In: Cultural News from Germany, May 1963.

"The World of Josef Albers." In: Graphic design (Tokyo), No. 11, 1963.

"Sekai" (Japanese magazine). No. 225, September 1964, frontispiece and pp. 224–227.

Barnitz, Jacqueline. "Taped Interview with Josef Albers. Famed Colorist Discusses Perceptual Art." In: Art Voices, Winter 1965.

Dienst, R. G. Die Oberflache. Agis-Verlag, Baden-Baden, 1965.

Reep, Edward. "Article about the Interaction of Color." In: Labyrinth (school newspaper, Los Angeles, Calif.), No. 1, June 1965.

Finkelstein, Irving. "The Hochschule at Ulm and Albers's 'Graphic Tectonics.'" In: Form, 4, 1967.

Gomringer, Eugen. Josef Albers. Das Werk des Malers und Bauhausmeisters als Beitrag zur visuellen Gestaltung im 20. Jahrhundert. Josef Keller, Starnberg, 1968. English ed. Wittenborn, New York, 1968.

Exhibition catalogs (one-man shows):

Hartford, Conn.: Wadsworth Atheneum, 1953 (Josef & Anni Albers).

Paris: Galerie Denise René, 1957.

Freiburg: Kunstverein, 1958 (70th Anniversary).

New York: Sidney Janis Gallery, 1958 (70th Anniversary).

Locarno: Galleria "la palma," after 1959.

New York: Sidney Janis Gallery, 1961.

Amsterdam: Stedelijk Museum, 1961 (containing texts by Albers).

London: Gimpel, 1961 (containing texts by Albers).

Raleigh: North Carolina Museum of Art, 1962.

New York: Sidney Janis Gallery, 1964 ("40 new paintings by Josef Albers").

New York: The Museum of Modern Art, 1964. ("Homage to the Square") (also in Spanish).

Hartford, Conn.: Trinity College. The Austin Arts Center, 1965.

New Haven, Conn.: The Center Gallery, 1965 ("Interaction of Color").

Milano: Toninelli Arte Moderna, 1965.

Washington: Washington Gallery of Modern Art, 1965–66 ("The American Years.")

Los Angeles County Museum of Art, 1966 ("White Line Squares") (with texts).

Arndt, Alfred
Publications about Arndt:
Wingler, Hans M. (ed.): Alfred Arndt, Maler und Architekt. Exhibition at the Bauhaus-Archiv, Darmstadt, Nov. 30–Dec. 22, 1968 (catalog).

Bayer, Herbert
Publications by Bayer:
"Versuch einer neuen Schrift und Struktur der Aussenwerbung." In: Offset, Buch und Werbekunst (Leipzig), No. 7, 1926.

"Typografia." In: Brezno, No. 3, 1927.

"Aus dem optischen Notizbuch." In: Das illustrierte Blatt (Berlin), No. 5, 1928. 2 pp.

"Die Schwebefähre von Marseille." In: Das Illustrierte Blatt (Berlin), No. 49, 1928. 3 pp.

"Typographie und Werbsachengestaltung." In: bauhaus, No. 1, 1928, p. 10.

"Werbephoto." In: Wirtschaftlichkeit (Leipzig), 1928. 4 pp.

"Towards a universal Type." In: Industrial Arts (London), Fall 1936, 7 pp.

"Per un carattere tipografico universale." In: Linea Grafica (Milan), No. 1/2, 1954.

"Contribution toward rules of advertising design. 'Fundamentals of exhibition design' and 'Towards a universal type.'" In: pm magazine (New York), 1939.

Bauhaus 1919–1928 (with Walter and Ise Gropius). The Museum of Modern Art, New York, 1938.

"Design Analysis." In: Advertising & Selling (New York), February 1940, 4 pages.

Books for our time. Ed. and designed by Marshall

Lee. Contributions by Herbert Bayer [and others]. Preface by George Nelson. Oxford University Press, New York, 1951.

"Goethe and the Contemporary Artist." In: College Art Journal, Vol. 11, No. 1, 1951, pp. 37–40.

"On Design." Lecture at the International Design Conference in Aspen, 1951. In: Magazine of Art, Washington, D.C., December 1951.

"design as an expression of industry." In: Gebrauchsgraphik, No. 9, 1952 (special number about Container Corporation of America).

"on trademarks." In: Egbert Jacobson (ed.), Seven designers look at trademark design. Theobald, Chicago, 1952.

World Geo-Graphic Atlas. Ed. and designed by Herbert Bayer. Privately printed for Container Corporation of America, Chicago, 1953.

Preface to Erberto Carboni, Esposizioni e mostre silvana editoriale d'arte. Milan, 1954.

Lecture on communication, International Design Conference in Aspen, 1955. In: one-quarter scale (Univ. of Cincinnati), Vol. 3, No. 2, 1955/56.

"a contribution to book typography." In: Print, March/April 1959.

"un contributo alla tipografia del libro." In: Linea Grafica (Milan), March/April 1960.

"design reviewed." Address at the World Design Conference, Tokyo, Japan, 1960. In: Form, No. 12, 1960, pp. 34–35.

"on typography." In: Print, January/February 1960, 3 pages.

Aspen Institute for Humanistic Studies, 1960–1961.

"Aspects of Design of Exhibitions and Museums." In: Curator (American Museum of National History, New York), No. 3, 1961.

Book of Drawings. 42 drawings, Foreword by Otto Karl Bach. Introduction by Herbert Bayer. Theobald, Chicago, 1961.

Introduction to the catalog "great ideas of Western man" (CCA1961). In: graphic design (Tokyo), October 1962.

"Paintings, architecture and graphics." Exhibition at the Roswell Museum and Art Center, Roswell, New Mexico, 1962.

"A Statement for an Individual Way of Life." In: Print, Vol. 16, May 1962, pp. 26–33.

"basic alphabet." In: Print, May/June 1964. 4 pages. ill.

"homage to gropius" (poem, 1961). In: Catalog of the Bauhaus exhibition, Frankfurt, 1964. 6 ills.

"typography." In: Print, January/February 1964. 1 page. ill.

Herbert Bayer: Painter, Designer, Architect. Reinhold, New York, 1967. German ed. Ravensburg, 1967.

Publications about Bayer:

Westheim, Paul. "Herbert Bayer, Photograph und Maler." In: Das Kunstblatt (Berlin), 1929.

Frenzel, H. K. "Herbert Bayer." In: Gebrauchsgraphik, No. 5, 1931, pp. 2–79.

Poli, Luigi. "Herbert Bayer, un maestro dell' arte grafica." In: Natura (Milan), No. 11/12, 1933.

Hölscher, Eberhard. "Herbert Bayer." In: Gebrauchsgraphik, April 1936, pp. 18–28.

Dorner, Alexander. "Herbert Bayer" (exhibition catalog of paintings). London Gallery Ltd., 1937.

Kraus, H. Felix. "Herbert Bayer—Architect and Artist." In: Art and Industry (London), July 1942, pp. 9–13.

Giedion, S. "Herbert Bayer und die Werbung in Amerika." In: Graphis (Zurich), October/November 1945.

Dorner Alexander. The Way Beyond Art—the Work of Herbert Bayer ("Problems of Contemporary Art," No. 3). Wittenborn & Schultz, New York, 1947.

"Eyrie on Red Mountain: Bayer's studio." In: Interiors, Vol. 110, June 1951, pp. 88–93.

"Across the Line. Portrait of Herbert Bayer." In: Time, Vol. 61, March 1953, p. 68.

Fortini, F. "Herbert Bayer." In: Linea Grafica (Milan), No. 3/4, 1954, pp. 67–76.

"Personality in Print." In: Print, Vol. 9, July 1955, pp. 33–43.

Bill, Max
Publications by Bill:
Quinze variations sur un même thème. Editions des Chroniques du Jour, Paris, 1932.

"Konkrete Kunst." In: Werk, No. 8, 1938.

"Paul Klee." In: Werk, No. 8, 1940.

x = x. Allianz-Verlag, Zurich, 1942.

Obituary for Oskar Schlemmer. In: Neue Zürcher Zeitung, May 4, 1944.

Obituary for Wassily Kandinsky. In: Neue Zürcher Zeitung, December 29, 1944.

"Zum 25. Gründungstag des Staatl. Bauhauses in Weimar." In: Werk, No. 4, 1944.

"Wassily Kandinsky." In: Weltwoche, March 23, 1945.

Wiederaufbau (reconstruction). Verlag für Architektur, Erlenbach-Zurich, 1945.

"Laszlo Moholy-Nagy." In: Domus, No. 216, July–October 1946.

Review of Ludwig Hilberseimer's The New City. In: Werk, No. 11, 1946. "Joost Schmidt." In: Werk, No. 2, 1949.

"Kandinsky." Holbein-Verlag, Basel, 1949.

Moderne Schweizer Architektur 1925–45. Karl Werner, Basel, 1949. (English & French & German).

Robert Maillart. Verlag für Architektur, Erlenbach-Zurich, 1950.

"Bauhaus-Chronik, Vom Bauhaus in Weimar zur Hochschule für Gestaltung in Ulm." In: Deutsche Universitätszeitung, Vol. 7, No. 23/24, December 22, 1952.

Form. Bilanz der Formentwicklung um die Mitte des 20. Jahrhunderts. Karl Werner, Basel, 1952. (A Balance Sheet of Mid-Twentieth-Century Trends in Design.)

"Walter Gropius siebzigjährig." In: Werk, No. 5, 1953.

"Josef Albers." In: Werk, No. 45, 1958.

Text and documentation "Vorfabriziertes bauen—freiheit oder bindung?" In: Form, No. 24, 1963.

Publications about Max Bill:
Tomàs Moldonado. Max Bill. Buenos Aires, 1955.

Gomringer, Eugen (ed.). Max Bill. Teufen, 1958.

Margit Staber. Max Bill. London, 1964.

Bredendieck, Hinrich (Hin)
Publications by Bredendieck:
"Design methodology." In: I.D.E.A., conference in Philadelphia, 1955.

"Legacy of the Bauhaus." In: Art Journal, Vol. 22, No. 1, Fall 1962, pp. 15–21.

"The Aspen International Design Conference." In: Aspen Times, 1964.

Objectology. A study of the man-made object. (In preparation.)

Brenner, Anton
Publications by Brenner:
"Mit Ach und Krach durchs Leben." Mimeographed paper, after 1931.

Der wirtschaftlich durchdachte Plan des Architekten ("Wirtschaftlich Planen—rationell Bauen," Vol. 1). Ertl-Verlag, Vienna, 1951.

Breuer, Marcel
Publications by Breuer:
"Die Möbelabteilung des Staatlichen Bauhauses zu Weimar." Fachblatt für Holzarbeiter, Vol. 20, February 1925.

Metallmöbel, Deutscher Werkbund, Innenräume (Interiors, furniture, furnishings of the Werkbund exhibition). Die Wohnung, Weissenhofsiedlung in Stuttgart. Wedekind, Stuttgart, 1928.

"Metallmöbel und moderne Räumlichkeit." In: Das Neue Frankfurt, January 1928.

"Beiträge zur Frage des Hochhauses." In: Die Form, No. 5, 1930.

"Eine kleine Berliner Mietwohnung." In: Moderne Bauform, No. 30, October 1931, pp. 515–519.

"Das Innere des Hauses." In: Bauwelt, Vol. 22, No. 19, 1931.

"Where do we stand?" In: Architectural Review, Vol. 77, 1935. Reprinted in: Casabella, No. 87, March 1935.

Architecture and Material in Circle (international survey of constructive art). Faber, London, 1937.

"New Kensington defence houses" (with W. Gropius). In: Architectural Forum, Vol. 75, October 1941, pp. 218–220.

"Wayland house. Views, plans and construction outline," (with W. Gropius). In: Architectural Forum, Vol. 77, November 1942, pp. 76–77.

"Project for a worker's house; designs and plans." In: California Arts & Architecture, Vol. 60. December 1943.

"Aluminum City Terrace housing, New Kensington, with tenants' opinions" (with W. Gropius). In: Architectural Forum, Vol. 81, July 1944.

"Stuyvesant Six: Redevelopment Study Based on Stuyvesant Town." In: Pencil Points, Vol. 25, June 1944.

Statement at Museum of Modern Art symposium:

"What is Modern Architecture?" In: Museum of Modern Art Bulletin, Vol. 15, 1948.

"Aspects of the art of Klee." In: Museum of Modern Art Bulletin, Vol. 17, No. 4, 1950, pp. 3–5.

"Building Paris Doesn't Want: Proposed Headquarters for UNESCO." In: Architectural Record, Vol. 112, December 1952, pp. 11–14.

"Cooperative dormitory, Vassar College." In: Architectural Record, Vol. 111, January 1952, pp. 127–134.

"Grosse Pointe, Mich., Public Library." In: Architectural Record, Vol. 112, December 1952, pp. 158–159.

"Internat des jeunes filles, Vassar College." In: Architecture d'Aujourd'hui, No. 23, November 1952, pp. 78–81.

"House in Ligonier, Pa." In: Architectural Review, Vol. 113, March 1953, pp. 152–155.

Sun and Shadow: The Philosophy of an Architect. Ed. and with notes by Peter Blake. Book design and cover by Alexey Brodovitch. Dodd, New York, 1955; Longmans Green & Co. Ltd., London, 1956.

Publications about Marcel Breuer:
"Portrait." In: Architectural Forum, Vol. 79, October 1943; Architectural Record, Vol. 94, October 1943. (Short biography.)

Blake, Peter. Marcel Breuer, Architect and Designer. The Museum of Modern Art, New York, 1949 (with bibliographical notes by Hannah B. Muller).

Argan, G. C. Marcel Breuer, Disegno industriale e architettura. G. G. Görlich, Milan, 1957.

Stoddard, Whitney Snow. Adventure in Architecture: Building the New St. John's. Pictures by the author. Plans by Marcel Breuer. Longmans Green & Co. Ltd., New York and Toronto, 1958.

"Recent Work of Marcel Breuer." In: Architectural Record, Vol. 127, January 1960, pp. 123–138.

Marcel Breuer: Buildings and Projects, 1921–1961. Captions and introduction by Cranston Jones. Thames, London and Hatje, Stuttgart, 1962; Praeger, New York, 1963.

Citroen, Paul
Publications by Citroen:
Material, Notizen eines Malers. Amsterdam, 1933.

Licht in de Groene Schaduw, Poezie en Proza Bij tekeningen van P.C. The Hague, 1941.

Kunsttestament. The Hague, 1952.

Introvertissimento. The Hague, 1956.

32 portraits, Gezien door Paul Citroen. The Hague, 1956.

Feininger, Lyonel Charles Adrian
Publications by Lyonel Feininger:
See also publications by the Bauhaus
Autobiographical essay. In: Les Tendances Nouvelles, No. 56, c. 1912, pp. 1338–1340. 6 ills.

"Zwiesprache Lyonel Feininger und Adolf Knoblauch." In: Der Sturm (Berlin), Vol. 8, No. 6, 1917–1918, pp. 82–86.

Letter to Paul Westheim, March 14, 1917. In: Das Kunstblatt, Potsdam and Berlin, Vol. 15, 1931, pp. 215–220.

"Briefe [letters] an Frau Julia Feininger, 1910–1929" (excerpts). In: Catalog for the Feininger exhibition, Amsterdam, 1954–1955.

Letters in excerpt, 1925–1932. Catalog for the Feininger exhibition, Bayerische Akademie der schönen Künste, Munich, and Kestner-Gesellschaft, Hannover, 1954–1955.

"Briefe an einen Kunstfreund." Henner Menz, Briefe und Zeichnungen von Lyonel Feininger, 1932–1937 (Festschrift Johannes Jahn). Seemann, Leipzig, 1957, pp. 331–336.

"Lyonel Feininger über Georg Muche." From a letter of November 25, 1950. In: Hans M. Wingler. Wie sie einander sahen. Moderne Maler im Urteil ihrer Gefährten. Langen-Müller, Munich, 1957, pp. 94–95.

Publications about Lyonel Feininger:
"Exhibition at the Buchholz and Willard Galleries." In: Art Digest, Vol. 17, February 1943, p. 14.

M. Riley. "Exhibition at the Nierendorf Galleries." In: Art Digest, Vol. 18, November 1943, p. 26.

"Exhibition at the Buchholz Gallery." In: Art News, Vol. 43, February 1944, p. 21.

Lyonel Feininger. The Museum of Modern Art, New York, 1944; reprinted 1966 (with Marsden Hartley).

"The Work of Lyonel Feininger." Exhibition at the Cleveland Museum of Art, 1951.

"Retrospective Show at the Metropolitan Museum." In: Art News, Vol. 55, April 1956, p. 79.

Memorial exhibition at the Willard Gallery and at the Metropolitan. In: Art in America, Vol. 44, 1956, pp. 56–57.

Werner, A. "Lyonel Feininger and German Romanticism." In: Art in America, Vol. 44, 1956, pp. 23–27.

Lieberman, A. "Feininger." In: Vogue, Vol. 127, April 15, 1956, pp. 90–93.

Muche, Georg. "Lyonel Feininger." (Obituary). In: Werk und Zeit. Vol. V, No. 2, 1956. Reprinted in: Hans M. Wingler, Wie sie einander sahen. 1957, p. 90.

Hess, Hans. Lyonel Feininger. Abrams, New York and Thames, London, 1961, 354 pages (monograph on the life and work of Lyonel Feininger with life-work catalog of 539 numbers, comprehensive bibliography by Annemarie Heynig, and list of exhibitions). German ed. Kohlhammer, Stuttgart, 1959.

Werner, A. "Lyonel Feininger 1871–1956." In: American Artist, Vol. 24, October 1960, pp. 26–31+.

Ruhmer, Eberhard. Lyonel Feininger, Zeichnungen, Aquarelle, Graphik. Bruckmann, Munich, 1961. 34 pp. 38 ills., some colored.

"The Intimate World of Lyonel Feininger." Exhibition at The Museum of Modern Art, New York, 1963.

Scheyer, Ernst. Lyonel Feininger, Caricature & Fantasy. Wayne State University Press, Detroit (Mich.) and Ambassador Books Ltd., Toronto, 1964. 196 pp.

Feininger, T. Lux. Lyonel Feininger, City at the Edge of the World. Photographs by Andreas Feininger. Praeger, New York and Burns & MacEachern, Toronto, 1965. 121 pp.

Flocon-Mentzel, Albert
Publications by Flocon-Mentzel:
"Vom Bauhäusler zum Studierenden." In: RED, (Prague), Vol. 3, 1930, pp. 158–160.

Perspectives. Galerie Maeght, Paris, 1949.

Traité du Burin. Librairie Auguste Blaizot, Paris, 1952. (23 engravings.)

"Une Expérience objective sur l'espace plastique: la perspective curvilique." In: Revue de synthèse, May/June 1962; with André Barre.

"Histoire succincte de la perspective." In: la revue en Europe, April 1963.

La perspective (with René Taton) Presses Universitaires de France, Paris, 1963.

La perspective en question. Public lecture by Albert Flocon held on November 16, 1964; preceded by an allocution by Roger Limouse, Ministère d'Etat des Affaires Culturelles, Ecole nationale supérieure des Beaux-Arts, Paris, 1965.

"Die Kurvenperspektive." Neue Bauhausbücher, Kupferberg, Mainz, (in preparation); with André Barre.

Publications about Flocon-Mentzel:
Wingler, Hans M. (ed.). "Perspektive und Klang." Exhibition at the Bauhaus-Archiv, Darmstadt, Nov. 5–Dec. 12 1966 (catalog).

Forbat, Fred
Publications about Forbat:
Fred Forbat, Architekt und Stadtplaner. Preface by Hans M. Wingler. Exhibition at the Bauhaus-Archiv, Darmstadt, Febr. 28–March 27, 1969 (catalog).

Goldberg, Bertrand
Publications by Goldberg:
"Unical Cellular Laminated Freight Car." In: Pressed Steel Car Company Booklet (Chicago), September 1950.

"City Within a City." In: International Design Conference. Colorado, 1962.

"Marina City Towers." In: Civil Engineering Magazine, December 1962.

Graeff, Werner
Publications by Graeff:
"Was wissen Sie vom Auto der Zukunft?" In: G, No. III, June 1924, pp. 18–20.

"Die Notwendigkeit der neuen Technik." In: G, No. III, June 1924, pp. 22–23.

"Die meisten deutschen Autos haben Spitzkühler. Sie sind mitschuldig." In: G, No. III, June 1924, pp. 56–57.

"Das Motorboot." In: Qualität, No. 4/5, May/June 1925.

Vergnüglicher Überfluss—durch neue Technik. In: G, No. IV, March 1926, pp. 8–9.

"Zur Form des Automobils." In: Die Form, Vol. 1, 1926, pp. 195–202; 252–265.

Willi Baumeister. Wedekind, Stuttgart, 1927.

Bau und Wohnung; Innenräume. Both edited on behalf of the Deutsche Werkbund, Stuttgart, 1927–1928.

Es kommt der neue Fotograf. Hermann Reckendorf, Berlin, 1929, 126 pp.

Jetzt wird Ihre Wohnung eingerichtet. Müller & Kiepenheuer, Potsdam, 1931.

Warenbuch für Wohnbedarf. Müller & Kiepenheuer, Potsdam, 1931.

Kamera und Auge. Urs Graf, Basel and Olten, 1942.

Vor und Schlussbericht des internationalen Kongresses für Formgebung, 1957. Rat für Formgebung, Darmstadt, 1957–1958.

"Bemerkungen eines Bauhäuslers." In Catalog W. Graeff, Kunsthalle Bochum, 1963.

Gropius, Walter
Publications by Gropius:
Programm zur Gründung einer Allgemeinen Hausbaugesellschaft auf künstlerisch einheitlicher Grundlage m.b.H. Manuscript, 1910.

"Sind beim Bau von Industriegebäuden künstlerische Gesichtspunkte mit praktischen und wirtschaftlichen vereinbar?" In: Der Industriebau, No. 1, 1912.

"Die Entwicklung moderner Industriebaukunst." In: Jahrbuch des Deutschen Werkbundes, 1913, pp. 17–22.

"Der stilbildende Wert industrieller Bauform." In: Jahrbuch des Deutschen Werkbundes, 1914, pp. 29, 32.

"Baugeist oder Krämertum." In: Schuhwelt, No. 37–39, 1919.

Entries by Gropius in: Ja—Stimmen des Arbeitsrats für Kunst. Photographische Gesellschaft, Charlottenburg, 1919, pp. 26–29.

"Was ist Baukunst?" In: Weimarer Blätter, ed. by Hans E. Mutzenbecher, Vol. 1, No. 9, May 1, 1919, pp. 220 ff. and in: folder of the Ausstellung für unbekannte Architekten. Im graphischen Kabinett J. B. Neumann, Berlin, 1919.

"Baugeist oder Krämertum." In: Der Qualitätsmarkt (Leipzig), Vol. 2, No. 1, 1920.

"Idee und Entwicklung des Staatlichen Bauhauses zu Weimar." In: Amtsblatt des thüringischen Ministeriums für Volksbildung, Vol. 2, No. 1, 1923.

"Baugeist der neuen Volksgemeinde." In: Glocke (Berlin), Vol. 10, 1924, p. 311.

"Bauhaus." In: Vivos Voco, Vol. IV, 1924, pp. 11–16.

"Grundziele des Staatlichen Bauhauses." In: Hilfe, 1924, pp. 1–3.

"Idee und Aufbau des Staatlichen Bauhauses." In: Wohnkultur, 1924.

Statement (lawsuit against Beyer). In: Weimarische Zeitung, July 12, 1924.

"Wie wollen wir in Zukunft bauen?" In: Wohnungsfürsorge (Vienna), Vol. 5, 1924, p. 152.

"Wohnhäuser." In: Berliner Tagblatt, September 1924.

"Neue Bau-Gesinnung." In: Innendekoration (Darmstadt), Vol. 36, 1925, p. 134.

"Der Bauplan für das neue Friedrich-Fröbel-Haus." In: Kindergarten, Vol. 66, No. 2, February 1925.

"Grundsätze der Bauhaus-Produktion." In: Gropius, Neue Arbeiten der Bauhauswerkstätten, Munich, 1925, pp. 5–8 (Bauhausbücher, Vol. 7), and in: Neue Erziehung, Vol. 6, 1925, p. 656, and in: Vivos Voco, Vol. V, 1926, pp. 265–267.

"Die Aufgabe des Bauhauses in Dessau." In: Velhagen & Klasings Monatshefte, Vol. 41, 1926, pp. 86–90.

"Bauhauschronik 1925/26." In: bauhaus, No. 1, 1926, pp. 1–3.

"Das flache Dach." In: Bauwelt, Vol. 17, 1926, pp. 162–168, 223–227, 361. (General inquiries by W. Gropius.)

"Glasbau." In: Die Bauzeitung, May 1926.

"Grundlinien für Neues Bauen." In: Bau- und Werkkunst (Vienna), 1926, pp. 13–47.

"Das Manifest der Neuen Architektur." In: Stein, Holz, Eisen (Frankfurt a. M.), 1926.

"Spitzes und flaches Dach. Reply to O. Trinte." In: Bauwelt, Vol. 17, 1926, p. 1038.

"Wie bauen wir billigere, bessere und schönere Wohnungen?" In: Werkland (Vivos Voco) (Leipzig), Vol. V, 1926, p. 268.

"Wo berühren sich die Schaffensgebiete des Technikers und Künstlers." In: Die Form, Vol. 1, 1926, p. 117.

"The Aim of the Bauhaus." In: Passing Through Germany, 1927, pp. 187–190.

"Entwurf für ein Arbeits-Nachweisamt in Dessau." In: bauhaus, No. 4, 1927, p. 4.

"Geistige und technische Grundlagen des Wohnhauses." In: Stein, Holz, Eisen (Frankfurt/Main), No. 14, April 1927.

"Geistige und technische Voraussetzung der neuen Baukunst." In: Umschau (Frankfurt/Main), Vol. 31, 1927, p. 909.

"Normung und Wohnungsnot." In: Technik und Wirtschaft, Vol. 20, 1927, p. 7.

Nove cesty vytvarne prace [New Paths to Forming Methods], in Almanach "Fronta," Brno 1927, S. 140–142.

"Systematische Vorarbeit für rationellen Wohnungsbau." In: bauhaus, No. 2, 1927, pp. 1–2.

"Trockenbauweise." In: Baugilde (Berlin), Vol. 2, 1927, p. 1362.

"Versuchswohnhaus auf der Stuttgarter Wohnbauausstellung." In: bauhaus, No. 4, 1927, p. 2.

"Vom modernen Theaterbau." In: Berliner Tagblatt, November 2, 1927.

"Wege zur fabrikatorischen Hausherstellung (units 16 and 17)." In: Bau und Wohnung, ed. by the Deutsche Werkbund. Wedekind, Stuttgart, 1927, pp. 59–67. (Buildings of the Weissenhofsiedlung housing project in Stuttgart, built in 1927 according to suggestions by the Deutsche Werkbund on behalf of the City of Stuttgart and as part of the Werkbund exhibition: "Die Wohnung.")

"Wirtschaftlichkeit neuer Baumethoden." In: Bauamt und Gemeindebau, 1927, p. 219.

"Zum Streit um das flache Dach." In: Stein, Holz, Eisen (Frankfurt/Main), Vol. 41, 1927, pp. 125, 129, 191.

"Der grosse Baukasten." In: Das neue Frankfurt, Vol. I/II, 1927/1928, pp. 25–30.

"Staffelung der Energien. Von der neuen Einstellung zur Arbeit." In: Innendekoration (Darmstadt), Vol. 39, 1928, p. 478.

"Bauen und Wohnen." In: Baugilde (Berlin), Vol. 10, 1928, p. 1313.

"Der Architekt als Organisator der modernen Bauwirtschaft und seine Forderungen an die Industrie." In: F. Block, Probleme des Bauens. Müller & Kiepenheuer, Potsdam, Vol. 1, 1928: Wohnbau, pp. 202–214; and in: Kreis (Hamburg), Vol. 4, 1928, pp. 119–122.

"Moderner Theaterbau unter Berücksichtigung des Piscator-Theaterneubaus in Berlin." In: Scene (Berlin), Vol. 18, 1928, p. 4.

"Der Gedanke der Rationalisierung in der Bauwirtschaft." In: publication of the Reichsforschungsgesellschaft für Wirtschaftlichkeit im Bau- und Wohnungswesen, technical convention in Berlin, April 15–17, 1929, pp. 14–26 and in: Deutsche Kunst und Dekoration, Vol. 33, 1929, p. 231.

"Nichteisenmetall, der Baustoff der Zukunft." In: Metallwirtschaft, Vol. 8, 1929, pp. 88–91.

"Siedlung in Stuttgart, Weissenhof." In: publication of the Reichsforschungsgesellschaft für Wirtschaftlichkeit im Wohnungsbau, No. 6, April 1929, pp. 104–106, 133, 136, 144, 147, 148 (special number).

"Stahlbau." In: Rundschau, Vienna, Vol. 21, 1929, p. 60.

"Systematische Vorarbeit für rationellen Wohnungsbau." In: Bauwelt, No. 9, 1929.

"Versuchssiedlung in Dessau." In: publication of the Reichsforschungsgesellschaft für Wirtschaftlichkeit im Wohnungsbau, No. 7, 1929, pp. 1–136 (special number).

"Grosssiedlungen." In: Zentralblatt der Bauverwaltung (Berlin), March 1930.

"Die Soziologischen Grundlagen der Minimalwohnung für die Städtische Industriebevölkerung." In: Die Justiz, Vol. V, No. 8, May 1930. Reprinted in: Die Wohnung für das Existenzminimum. Publication of the Internationale Kongresse für Neues Bauen (CIAM) und Städtisches Hochbauamt in Frankfurt a.M., 1930, pp. 17–27; 3rd ed. Julius Hoffmann, Stuttgart, 1933, pp. 113–123. (On the sociological bases for apartments with minimum space for the industrial population of cities.)

"Arquitectura Funcional." In: Arquitectura (Madrid), No. 2, 1931.

"Arquitectura Funcional." In: Sur (Buenos Aires), No. 3, 1931.

"Byggnadväsendets Rationalisiering." In: Stockholms Gyggnadsförening, 1931.

"Conferencia de Walter Gropius en la Residencia de Estudiantes de Madrid." In: Arquitectura (Madrid), Vol. 13, 1931, pp. 50–62.

"Flach-, Mittel- oder Hochbau?" Report of the 3rd International Congresses for New Building (CIAM) in Brussels, November 1930. Published in: Rationelle Bebauungsweisen—Ergebnisse des dritten Internationalen Kongresses für Neues Bauen, ed. by S. Giedion in collaboration with V. Bourgeois, C. van Esteren and R. Steiger. J. Hoffmann, Stuttgart, 1931, pp. 26–47.

"Flach-, Mittel- oder Hochbau." In: Das neue Frankfurt, No. 2, 1931, pp. 22–34.

"Flach-, Mittel- oder Hochbau?" In: Moderne Bauformen, Vol. 30, 1931, pp. 321–338.

"Flach-, Mittel- oder Hochbau?" In: Schweizer Bauzeitung, Vol. 98, 1931, pp. 95–101.

"Small House of Today." In: Architectural Forum, Vol. 54, 1931, pp. 266–278.

"Was erhoffen wir vom russischen Städtebau?" In: Neues Russland (Berlin), Vol. 8, No. 6/7, 1931, pp. 57–61.

"Was erwartet der moderne Architekt von der Baustoffchemie?" In: Zeitschrift für angewandte Chemie, Vol. 44, 1931, pp. 765–768; and in: Moderne Bauformen (supplement), Vol. 31, 1932, pp. 67–72.

"Wohnen im Hochhaus." In: Grundstücks-, Bau- und Hypothekenmarkt (weekly supplement to the "Hannoversche Anzeiger"), July 21, 1931.

"Die Wohnformen: Flach-, Mittel- oder Hochbau? In: Neues Berlin, 1931, pp. 74–80.

"Wohnhochhäuser." In: Stein, Holz, Eisen (Frankfurt, a.M.), Vol. 45, 1931, p. 142.

"Wohnhochhäuser im Grünen. Eine Grossstädtische Wohnform der Zukunft." In: Zentralblatt der Bauverwaltung, No. 49/50, 1931.

"Zukunftsforderung an unsere Wohnung." In: Haus, Hof, Garten (illustrated weekly of the "Berliner Tageblatt"), June 6, 1931.

"Kupferhaus, Bericht über das Kupferhaus der Hirsch Kupfer- und Messingwerke A.G., Finow." In: Martin Wagner, Das wachsende Haus. Bong, Berlin, 1932, pp. 65–68.

"Bilanz des neuen Bauens." In: Technische Rundschau (Bern), November 30, 1934, pp. 1–3, 26–28.

Formal and Technical Problems of Modern Architecture and Planning." In: Journal of the Royal Institute of British Architects, Ser 3, Vol. 41, 1934, p. 679.

"Minimum Dwellings and Tall Buildings." In: C. Aronovici, editor, America Can't Have Housing. Museum of Modern Art, New York, 1934, pp. 41–43.

"Rehousing in Big Cities—Outwards or Upwards?" In: The Listener (London), Vol. 11, 1934, pp. 814–816.

"The Role of Reinforced Concrete in the Development of Modern Construction." In: The Concrete Way, Vol. 7, No. 3, November/December 1934, pp. 119–133.

"Low, Medium or High Buildings?" Ed. by the Housing Study Guild. In: Abstract of Papers, Ser. 1, No. 1, 1935, pp. 3–7.

"The New Architecture and the Bauhaus." Trans. from the German by P. Morton Shand. Introd. by Frank Pick. Faber and Faber, London, 1935, 80 pages, ill. Reprinted by Faber and Faber, 1936, 1937, 1955, and 1965 (paperback); Museum of Modern Art, New York, 1936; M.I.T. Press, Cambridge, Mass., 1965 (paperback). German ed. Kupferberg, Mainz and Berlin, 1965 ("Neue Bauhausbücher" 1).

"Theaterbau." In publication of the Reale Accademia d'Italia, Fondazione Alessandro Volta, Convegno di Lettere, October 1934, Rome, 1935, pp. 154–177.

"Architects in the Making." An exhibition by the Liverpool School of Architecture at the Building Centre, London, 1936. Typewritten Manuscript of the Royal Institute of British Architects Library.

"Art Education and the State." In: Circle, pp. 238–242. From the Yearbook of Education, Faber, London, 1936.

"Background of the New Architecture." In: Civil Engineering, Vol. 7, 1937, pp. 839–843.

"Education Toward Creative Design." In: American Architect and Architecture, Vol. 150, 1937, pp. 26–30, and in: Industrial Education Magazine, Vol. 40, 1938, pp. 241–248.

"Essentials for Creative Design." In: Octagon, Vol. 9, 1937, pp. 43–47.

"Incontro con l'America." In: Casabella, No. 120, December 1937.

"Bauhaus 1919–1928." By Herbert Bayer, Walter and Ise Gropius (eds.), Museum of Modern Art, New York, 1938; 2nd ed. Branford, Boston, 1952; German ed. Hatje, Stuttgart, 1955.

"Essentials for Architectural Education." In: PM, An Intimate Journal for Production Managers, Vol. 4, No. 5, February/March 1938, pp. 3–16.

"Towards a Living Architecture." In: American Architect and Architecture, Vol. 152, January 1938, pp. 21–22, and February 1938, pp. 23–24.

"Towards a Living Architecture." In: Kokusai Kentiku, Vol. 14, 1938, pp. 105–107.

Reprinted under the title: "Verso una Architettura Vivente." In: Nuova Città, Vol. 1, No. 11/12, 1946.

"Training the Architect." In: Twice a Year, No. 2, 1939, pp. 142–151.

"How to bring forth an ideal solution of the Defense Housing Problem." In collaboration with M. Wagner. In: U.S., 77th Congress, 1st session, House, Select Committee Investigating National Defense Migration. National Defense Migration Hearings. Government Printing Office, Washington, Vol. XVII, 1941, pp. 6949–56.

"Training the Architect for Contemporary Architecture." In: National Education Association, Dept. of Art Education Bulletin, Vol. 7, 1941, pp. 137–146. (Record of the Convention at Atlantic City and Boston.)

"Cities Renaissance" (with M. Wagner). Cambridge, Mass., 1942, Mimeographed. 15 pages. Reprinted in: Kenyon Review, Vol. V, 1943, pp. 12–33.

"Housing as a Townbuilding Problem." A postwar housing problem for the students of the Graduate School of Design, Harvard University, Cambridge, Mass., February/March 1942. Mimeographed. 60 pages.

"New Boston Center." (with M. Wagner). Harvard University, Cambridge, Mass., September 1942. Mimeographed. 66 pages. (A planning problem for Harvard's School of Design.)

"The New City Pattern for the People and by the People" (with M. Wagner). In: Conference on Urbanism: The problem of the Cities and Towns. Harvard University, Cambridge, Mass., 1942, pp. 95–116.

"The Architect's Contribution to the Postwar Construction Program." In: Bay State Builder, Vol. 1, December 1943, pp. 27–30, 36–37.

"General Panel System" (with K. Wachsmann). Introduction by H. Herrey. In: Pencil Points, Vol. 24, April 1943, pp. 36–47.

"Program for City Reconstruction," (with M. Wagner). In: Architectural Forum, Vol. 79, July 1943, pp. 75–86.

Prefabricated, demountable, packaged building system (with K. Wachsmann) for the General Panel Corporation. New York, 1944. (3 Pamphlets).

"Practical Field Experience in Building to be an Integral Part of an Architect's Training." In: Bay State Builder, Vol. III, No. 7, July 1945, pp. 3–4, 18.

"Field Experience and the Making of an Architect" (excerpt). In: American Institute of Architects Journal, Vol. 4, November 1945, pp. 210–212.

"Rebuilding our Communities" (lecture held in Chicago). Theobald, Chicago, 1945. 61 p. [ID Books No. 1.]

"Living Architecture or International Style?" In: Design, Vol. 47, April 1946, pp. 10–11.

"Design Topics." In: Magazine of Art, Vol. 40, December 1947, pp. 298–304.

"Frank letter to J. D. Leland." In: American Institute of Architects Journal, Vol. 7, April 1947, pp. 198–203.

"UNO and the Architects" (comment by W. Gropius). In: Architect and Building News, Vol. 190, June 1947, pp. 232.

Editorial on CIAM, Report at Bridgewater, England. In: Architects Journal, Vol. 106, September 1947, pp. 246–248.

"House in industry; a system for the manufacture of industrialized building elements by K. Wachsmann and W. Gropius for the General Panel Corporation." In: Arts and Architecture, Vol. 64, November 1947, pp. 28–37.

"Progress in Housing" (prefabrication). In: The New York Times (letters to the editor), March 2, 1947.

"Urbanism" (A lecture given at Bridgewater, England, at the International Congress for Modern Architecture). In: Architects Journal, Vol. 106, September 1947, pp. 276–277.

"Reconstruction: Germany." In: Task No. 7/8, 1948, pp. 35–36.

"In Search of a New Monumentality: A Symposium." Gropius and others. In: Architectural Review, Vol. 104, 1948, pp. 117–122, 127.

"Teaching the Arts of Design." In: College Art Journal, Vol. 7, No. 3, 1948, pp. 160–164.

"In Search of a Common Denominator of Design Based on the Biology of the Human Being." In: Creighton, Th. (ed.), Building for Modern Man. Princeton University Press, 1949, pp. 169–174.

"Not Gothic but Modern for our Colleges." In: New York Times Magazine, October 23, 1949, pp. 16–18. Reprinted in many Papers and Journals.

"Organic Neighborhood Planning." In: Housing and Town and Country Planning Bulletin, No. 2, April 1949, pp. 2–5.

"Topics for the Discussion on Architectural Education." In: Metron, No. 33/34, 1949, pp. 65–66. A Message to the Congress (CIAM) by Walter Gropius.

Introduction to L. Moholy-Nagy, Experiment in Totality, By Sybil Moholy-Nagy. Harper & Brothers, New York, 1950.

"Design and Industry" (One of three addresses given at the Blackstone Hotel, Chicago, April 17, 1950, by Ludwig Mies van der Rohe, Serge Chermayeff, and Walter Gropius on the occasion of the celebration of the addition of the Institute of Design to Illinois Institute of Technology). 14 pages.

"Le Théatre total." In: L'Architecture d'Aujourd'hui, No. 28, 1950, pp. 12–13. (Special number: Walter Gropius et son école.)

"Tradition and the Center." In: Harvard Alumni Bulletin, Vol. 53, October 1950, pp. 65–71. Portrait on cover.

"Architectural Education." In: International Congress for Modern Architecture (CIAM 8), Hoddesdon, England, 1951. (Report of Hoddesdon conference, July 12, 1951).

"Architecture in a Scientific Age." In: The Listener (London). Vol. 46, August 1951, pp. 297–299. Reprinted many times.

"The Position of Architecture in the Century of Science." In: Architect and Building News, Vol. 200, July 1951, pp. 71–74.

"Speech at the 36th Annual Convention of the Association of Collegiate Schools of Architecture." In: Journal of Architectural Education, No. 6, 1951, pp. 78–87.

The Gropius Symposium held at the American Academy of Arts and Sciences, Boston. In: Arts and Architecture, Vol. 69, May 1952, pp. 27–31.

"Faith in Planning." In: Planning 1952, Proceedings of the Annual National Planning Conference Held in Boston, Mass., Oct. 5–9, 1952. American Society of Planning Officials, Chicago, 1952, pp. 4–15.

"Not Gothic but Modern for our Colleges" (Gropius awarded the Howard Myers Memorial Award for Architectural Writing, 1951). In: American Institute of Architects Journal, Vol. 17, April 1952, pp. 152–157.

"Wie sollen wir bauen (die Baukunst ist keine angewandte Archäologie)." In: Die neue Zeitung, May 16–17, 1953. (Transl. of "Not Gothic but Modern for our Colleges.")

"Speech on the occasion of his seventieth birthday, celebrated at the Illinois Institute of Technology." In: Arts and Architecture, Vol. 70, June 1953, pp. 18–19, 41–42.

"Mastery of Space and Techniques." In: Progressive Architecture, Vol. 36, March 1955, pp. 12, 15–16, ill. Reprinted many times, also in: Werk, Vol. 42, June 1955, pp. 186–188 under the title "Kompass für Architekten."

"Necessity of the Artist in a Democratic Society." In: Arts and Architecture, Vol. 72, December 1955, pp. 16–17 and also in: American Institute of Architects Journal, Vol. 26, August 1956, pp. 55–61. (Address given at the opening of the new Hochschule für Gestaltung in Ulm, Germany.)

Scope of Total Architecture. Harper & Brothers, New York, 1955. Reprinted many times under various titles. German ed. "Architektur, Wege zu einer optischen Kultur." Fischer-Bücherei, Frankfurt/Hamburg 1956.

"Apollo in the Democracy." In: Zodiac, No. 1, 1957, pp. 9–14.

"Democracy and Apollo." In: Architectural Forum, Vol. 108, May 1958, p. 88.

"Testimonianze dei protagonisti sul palazzo dell' UNESCO." In: Casabella, No. 226, April 1959, pp. 5–7.

"Testimonianze (Adolf Loos)" In: Casabella, No. 233, November 1959, p. 45.

"An die Freunde und ehemaligen Mitglieder des Bauhauses" (appeal to support the Bauhaus-Archiv in Darmstadt). Cambridge, Mass., June 1960. 6-page folder.

"Una testimonianza diretta." In: Casabella, No. 240, January 1960, p. 3. (For Peter Behrens.)

"Address upon Receiving the Honorary Degree of Doctor of Humane Letters from Columbia University, March, 1961." In: Arts and Architecture, Vol. 78, May 1961, pp. 14–15, 28–30. (The Goethe Prize Speech, delivered in Frankfurt the same year, was similar to the Address.) Reprints under various titles: "The Architect, Citizen and Professional." In: Zodiac, Vol. 8, 1961, pp. 48–53 (with Italian and French summaries). "Die Rolle des Architekten in der modernen Gesellschaft." In: Bauen und Wohnen, Sept. 1961.

"The Architect in Society: A Discussion with Dr. Walter Gropius." In: Architectural Association Journal, Vol. 135, January 1962, pp. 134–142.

"Bauhaus Contribution." In: American Institute of Architecture Journal, Vol. 39, June 1963, pp. 120–121. Reply by Howard Dearstyne, pp. 121–122.

"Bauhaus: Crafts or Industry?" In: American Institute of Architecture Journal, Vol. 40, September 1963, pp. 105–106. Reply by Howard Dearstyne, December 1963, pp. 104–106.

"L'architetto e la società." In: Casabella, No. 298, October 1965, pp. 18–21.

Architettura in Giappone. G. G. Görlich, Milan, 1965, 53 pages.

"Museum Lighting." In: Journal of the American Institute of Architecture, Vol. 43, April 1965, p. 58. Excerpted from the German "Gestaltung von Museumsgebäuden." In: Jahresring (Stuttgart), 1955/56.

The Architects Collaborative 1945–1965. Ed. by Walter Gropius and others. Niggli, Teufen (Switzerland), 1966. 300 pages.

Apollo in der Demokratie. Kupferberg, Mainz and Berlin, 1967. ("Neue Bauhausbücher." 6.)

Publications about Gropius:

Cook, Ruth V. A Bibliography: Walter Gropius 1919–1950. American Institute of Architects, Chicago, 1951. 26 pages.

Giedion, Siegfried: Walter Gropius; Work and Teamwork. Reinhold, New York, 1954. 249 pages. 317 ills. German ed. Gerd Hatje, Stuttgart, 1954 (with comprehensive bibliography by Walter and Ise Gropius).

Schadendorf, Wulf. "Das Fagus-Werk Karl Benscheidt, Ahlfeld/Leine." Kleine Kunstführer für Niedersachsen, No. 5, Göttingen, 1954.

Herbert, Gilbert. The Synthetic Vision of Walter Gropius. In: South African Architectural Record, December 1955. (Special issue.)

Fitch, James Marston. Walter Gropius. Braziller, New York, 1960. German ed. Verlay Otto Maier, Ravensburg, 1962.

Hoffa, Harlan. Walter Gropius—Innovator. In: Art Education, Vol. 14, No. 1, January 1961.

Weber, Helmut. Walter Gropius und das Faguswerk. Callwey, Munich, 1961.

Schmidt, Doris. Gropius baut für Rosenthal. Rosenthal-Porzellan A.G., Selb (Bavaria), 1965.

O'Neil, William B., Walter Gropius. The American Association of Architectural Bibliographers. Papers, Vol. III. The University Press of Virginia, Charlottesville, 1966, xi + 138 pages.

Hartwig, Josef
Publications by Hartwig:
Ein altes und vier neue Alphabete (One old and four new type faces). Mappenwerk I (portfolio) published by the author, n.d.

Leben und Meinungen des Bildhauers Josef Hartwig. Mitteldeutscher Kunstgewerbe-Verein, Frankfurt am Main, 1955.

Hassenpflug, Gustav
Publications by Hassenpflug:
"Möbel aus Holz oder Metall oder?" In: bauhaus, No. 4, 1928, p. 14.

"Ein Vorschlag zur Erweiterung des Kulturparks in Moskau." In: Die Neue Stadt (Frankfurt), No. 2, 1932.

"Ein neuer Wohnhaustyp in Russland." In: Baugilde, No. 2, 1933.

"Metallmöbel als Industrieerzeugnisse." In: Bauwelt (Berlin), No. 35, 1935 and also in: Monatshefte für Baukunst und Städtebau, No. 9, 1935.

"Raumverbundene Möbel im Mietswohnungsbau." In: Bauwelt, No. 48, 1941, p. 751.

"Auflockerung der alten Mietskasernenblöcke." In: Bauwelt, No. 21, 1946, pp. 10–12.

"Neue Erkenntnisse im Städtebau." In: Bauwelt, No. 3, 1946, pp. 9–10.

"Neuer Wohnungstyp durch Terrassenbau." In: Bauhelfer (Berlin), No. 3, 1946, pp. 10–12.

"Reihenhaus mit gewölbter Decke." In: Bauhelfer, No. 5, 1946, pp. 13–17.

"Seuchen- und Krankenbettenaktion Berlin, Winter 1945–46" (with Prof. Dr. Vogler). In: Das deutsche Gesundheitswesen (Berlin), March 31, 1946.

"Städtebaufibel Part I: Stadttypen." In: Telegraf (Berlin), June 6, 1946. "Part II: Wohnen und Arbeiten." In: Telegraf (Berlin), August 13, 1946.

"Was geschieht mit den Trümmern?" In: Berliner Zeitung, January 24, 1946.

"Wiederinstandsetzung der Charité." In: Das deutsche Gesundheitswesen, April 15, 1946.

"Die Karussell-Kreuzung." In: Bauwelt (Berlin), No. 7, 1947, p. 27.

"Kunst im Menschen verankert." In: Bildende Kunst (Berlin), No. 7, 1947, pp. 20–23. (spirit and history of the Bauhaus.)

"Möbel und Raum." In: Architektur und Wohnform (Stuttgart), No. 2/3, 1947, pp. 44–45 and also in: Athena (Berlin), No. 4, January 1947, pp. 77–80.

"Studenten planen den Wiederaufbau eines Stadtteils." In: Bauplanung und Bautechnik (Berlin), No. 6, 1947, pp. 167–174.

Baukastenmöbel. Rudolf A. Lang, Pössneck, 1948.

"Bauplanung und Baupraxis im Gesundheitswesen Berlins (with Prof. Dr. Vogler). In: Bauhelfer, No. 13, 1948, pp. 343–347.

Das Gesundheitswesen in der Bauplanung Berlins. Werner Saenger, Berlin, 1948.

"Auf der Suche nach neuen Wohn- und Siedlungs-

formen." In: Wohnen heute und morgen (Stuttgart), 1949, pp. 2–6.

"Die Ideale Stadtlandschaft." In: Architektur und Wohnform (Stuttgart), No. 3, 1950, p. 55.

"Strukturwandel und Wiederaufbau Berlins." In: Die neue Zeitung (Berlin), April 26, 1950.

"Neue Ziele der Kunstschulen." In: Bauhefte (Hamburg), No. 2, pp. 67–70.

Handbuch für den neuen Krankenhausbau (with Prof. Dr. Vogler). Urban & Schwarzenberg, Munich and Berlin, 1951 and 1962.

"Die Werkbundausstellung im Hamburger Museum für Kunst und Gewerbe." In: Bauwelt (Berlin) 1951, No. 51, pp. 201–202.

"Angewandte Kunst und industrielle Formgebung an Kunstschulen." In: Architektur und Wohnform (Stuttgart), 1952, No. 4, pp. 138–144.

"Bauen und Gesundheit—offene Fragen in der Zusammenarbeit von Architekt und Arzt" (with Prof. Dr. Vogler). In: Städtehygiene (Freiburg—Hamburg), No. 8, August 1952, pp. 203–205.

"Die Bedeutung der Werkarbeit in der Schule." In: Handbuch der Kunst- und Werkerziehung, 1953, pp. 286–288.

"Neue Wege im Mietshausbau." In: Bauen und Wohnen, No. 7, 1955, pp. 358–360.

Geschichte der Kunstschule Hamburg. Heinrich Ellermann, Munich and Hamburg, 1956.

Das Werkkunstschulbuch. Konradin-Verlag Robert Kohlhammer, Cologne and Stuttgart, 1956.

"Einbaumöbel—variabel." In: Die Bauzeitung, No. 5, 1957, pp. 202–204.

"Forderungen an die Wohnung unserer Zeit." In: Medizin und Städtebau, 1957, pp. 197–209.

"Krankenhausbau." In: Handbuch moderner Architektur, 1957, pp. 527–609.

"Neue Möbel in neuen Räumen." In: Tagesspiegel (Berlin), July 21, 1957.

"Die mobile Formgeberschule, Information EE." In: Report of the Internationaler Kongress für Formgebung, Darmstadt, August 1957.

"Sitzmöbel in Konstruktion und Form." In: Werk und Zeit, Monatszeitung des Deutschen Werkbundes, No. 9, 1957; and also in: Baukalender, 1957.

"Why teach handcrafts today?" In: School Arts, No. 9, May 1957, pp. 25–27.

"Heilen und Helfen, Weltausstellung Brüssel." In: Architekt, No. 8, 1958, pp. 213–216.

"Kleine Entwicklungsgeschichte des Stahlrohrstuhles." In: Form (Cologne), No. 8, 1958, pp. 8–15.

"Die raumverbundenen Möbel." In: Die Innenarchitektur, No. 8, 1958, pp. 509–512.

"Abstrakte Malerei in Lehre und Kunsterziehung." In: Kunst der Gegenwart (Brunswick), 1959, pp. 31–63.

Abstrakte Maler lehren. Heinrich Ellermann, Munich and Hamburg, 1959.

"Die neue Gestalt der Biologischen Anstalt" (dominating aspects in planning the new building). In: Helgoländer wissenschaftliche Meeresuntersuchungen, Vol. 7, No. 1, 1959, pp. 25–30.

"Krankenhäuser" (Hospitals). In: Planen und Bauen im neuen Deutschland, 1960, pp. 482–511.

"Der Mensch und die Technik im Krankenhaus." In: Der Architekt, No. 5, 1960, p. 129.

Stahlmöbel. Verlag Stahleisen, Düsseldorf, 1960.

"Der Stuhl als Symbol und Vorbote einer technischen und künstlerischen Entwicklung." In: Bauen und Wohnen, No. 11, 1960, pp. 13–14.

"Das Bauhaus in seiner Zeit." In: Die Zeit ohne Eigenschaft, eine Bilanz der Zwanziger Jahre (a review of the nineteen-twenties), 1961, pp. 148–159.

Stahlmöbel für Krankenhaus und ärztliche Praxis. Verlag Stahleisen, Düsseldorf, 1963.

Scheibe, Punkt und Hügel—Neue Wohnhochhäuser (with Dr. P. Peters). Callwey, Munich, 1966.

"Studie über die Sanitärzone der Krankenzimmer." In: Das Krankenhaus, 1966, pp. 245–250.

Heiberg, Edvard
Publications by Heiberg:
"2 Vaerelser straks" (2 rooms in one). 1932. (analysis of the housing conditions in Denmark)

Planlaeging af Kokkener (planning of kitchens). 1949.

Hilberseimer, Ludwig
Publications by Hilberseimer:
"Paul Scheerbart und die Architekten." In: Kunstblatt, III, 1919, pp. 271–274.

"Architektur." In: Kunstblatt, VI, 1922, p. 132.

Arthur Segal. Berlin, 1922.

"Das Hochhaus." In: Kunstblatt, VI, 1922, pp. 525–531.

"Mexikanische Baukunst." In: Kunstblatt, VI, 1922, p. 163.

"Bauhandwerk und Bauindustrie." In: G, No. II, September 1923, p. 2.

"Das Hochhaus." In: G, No. II, September 1923, p. 3.

"J. J. Ouds Wohnungsbauten." In: Kunstblatt, VII, 1923, p. 289.

"Der Wille zur Architektur." In: Kunstblatt, VII, 1923, p. 5.

"Konstruktion und Form." In: G, No. III, June 1924, pp. 14–16.

"Atrappenarchitektur." In: Qualität, No. 4/5, May/June 1925, pp. 102–103.

Grossstadtbauten. Hannover, 1925.

"Amerikanische Architektur." In: G, No. IV, March 1926, pp. 4–8.

"Architekturausstellung der Novembergruppe." In: Die Form, Vol. I, 1926, pp. 172–175.

"Grossstadtbauten." In: März, No. 18/19, January-April 1926.

"Über die Typisierung des Mietshauses." In: Die Form, Vol. I, 1926, pp. 338–340.

Grossstadtarchitektur. Hoffmann, Stuttgart, 1927.

Internationale neue Baukunst. Hoffmann, Stuttgart, 1927.

"Nicht lesen, verbotener Film." In: G, No. V/VI, about 1927.

Beton als Gestalter (with Julius Wischer). Hoffmann, Stuttgart, 1928.

"Entwicklungstendenzen des Städtebaus." In: Die Form, Vol. IV, 1929, pp. 209–211.

"Glasarchitektur." In: Die Form, Vol. IV, 1929, pp. 521–522.

"Handwerk und Industrie." In: bauhaus No. 2, 1929, pp. 21–24.

Review of "Wie Bauen" by H. and B. Rasch. In: Die Form, Vol. IV, 1929, pp. 399–400.

"Städtebau und Wohnungsbau." In: Die Form, Vol. IV, 1929, pp. 294–296.

"Über Stahlmöbel." In: Bauwelt, No. 34, 1929.

"Wohnung und Werkraum." In: Die Form, Vol. IV, 1929, pp. 451–452.

"Zur Neuvorlage des Städtebaugesetzes." In: Die Form, Vol. IV, 1929, pp. 236–237.

"Neue Literatur über den Städtebau." In: Die Form, Vol. V, 1930, pp. 518–521.

"Reichstagserweiterung und Platz der Republik." In: Die Form, Vol. V, 1930, pp. 337–341.

"Vorschlag zur Citybebauung." In: Die Form, Vol. V, 1930, pp. 608–611.

Hallenbauten. Leipzig, 1931.

"Die Kleinstwohnung im treppenlosen Haus." In: bauhaus, No. 2, 1931, pp. 1–2.

"Vorschlag zur Citybebauung." In: Moderne Bauform, Vol. 30, March 1931, pp. 55–59.

"Die Wohnung in unserer Zeit." In: Die Form, Vol. VI, 1931, p. 249.

"Raumdurchsonnung." In: Moderne Bauform, Vol. 34, January 1935, pp. 29–36.

"Raumdurchsonnung und Siedlungsdichtigkeit." In: Moderne Bauform, Vol. 35, February 1936, pp. 69–76.

The New City, Principles of Planning. Intro. by Mies van der Rohe. Theobald, Chicago, 1944.

New Regional Pattern; Industries and Gardens, Workshops and Farms. Theobald, Chicago, 1949. 197 pages.

The Nature of Cities; Origin, Growth and Decline, Pattern and Form, Planning Problems. Theobald, Chicago, 1955, 286 pages; Tiranti, London, 1956.

Ludwig Mies van der Rohe. Theobald, Chicago, 1956, 199 pages; Tiranti, London, 1956.

"Observations on the New Art." In: College Art Journal, Vol. 18, No. 4, 1959, pp. 349–351.

"Automobile and the City." In: Journal of the American Institute of Architecture, Vol. 34, December 1960, pp. 30–31.

"Kasimir Malevitch and the Non-objective World." In: Art Journal, Vol. 20, No. 2, 1960, pp. 60–61.

Entfaltung einer Planungsidee. Frankfurt and Berlin, 1963.

Contemporary Architecture; Its Roots and Trends. Theobald, Chicago, 1964. 221 pages.

Berliner Architektur der 20er Jahre. Florian Kupferberg, Mainz and Berlin, 1967. (Neue Bauhausbücher 7.)

639

Hoffmann, Hubert
Publications by Hoffmann:
Die gegliederte und aufgelockerte Stadt (with Goede-ritz and Rainer). Wasmuth, Tübingen, 1945.

"Eine Analyse: Der Raum Dessau." In: Der Bauhelfer, No. 20, 1949.

"Das Historische Bauhaus." In: Baukunst und Werk-form, 1953.

Neue Deutsche Architektur. Hatje, Stuttgart, 1956.

"Die Idee der Städteplanung." In: Medizin und Städtebau (Munich), Vol. 1, 1957.

"Das Unternehmen Interbau." In: Bauen und Wohnen, 1957.

"Hauptstadt Berlin." In: Bauen und Wohnen, 1959.

"Tagung der CIAM—Nachfolge in Otterlo." In: Zodiac, No. 6, 1960, pp. 190–191.

"Modern kann ich besonders gut." In: Baukunst und Werkform, Vol. 14, 1961, p. 348.

"Wandlungen im Städtebau." In: Baukunst und Werk-form, Vol. 15, 1962, pp. 38f.

"Ländliches Bauen und Planen." In: Handbuch des Bauwesens, Stuttgart, 1963.

Expert's report. " 'City und Nebencity' in Graz." Graz, 1964.

"Wohnen oder Hausen?" Forum Stadtpark Graz, Graz, 1964.

"Flächenbedarf des urbanen Flachbaues." In: Deutsche Bauzeitung, No. 3, March 1966, pp. 135–138.

Urbaner Flachbau. Hatje, Stuttgart, 1967, 175 pages.

Itten, Johannes
Publications by Itten:
"Analysen alter Meister." In: Bruno Adler (ed.), Utopia, Dokumente der Wirklichkeit. Utopia Verlag, Weimar, 1921.

"Wie lernt man Kunstwerke richtig sehen?" In: Uhu, 1927.

"Pädagogische Fragmente einer Formenlehre, aus dem Unterricht der Itten-Schule." In: Die Form, Vol. V. No. 6, 1930.

Tagebuch, Beiträge zu einem Kontrapunkt der bildenden Kunst. Verlag der Itten-Schule, Berlin, 1930.

"Studien zu alten Meistern." In: Das Kunstblatt, Vol. 15, No. 12, 1931.

"Aus meinem Unterricht." In: Catalog 143 of the Kunstgewerbemuseum, Zurich, 1939.

"Die Farbe." In: Catalog 159 of the Kunstgewerbe-museum, Zurich, 1944.

"Wassily Kandinsky—Kunst und Erziehung." Essay in: Debrunner, Hugo, Wir entdecken Kandinsky. Origo, Zurich, 1947, pp. 49f.

"Kunsterziehung." In: Der Pelikan (Hannover), No. 50, 1950.

"Even Trade: Lenin's $125 Tea Things for $50,000 Worth of Art." In: Life, Vol. 31, December 17, 1951, p. 37.

Introduction to "Wegleitung 200" (exhibition catalog). Kunstgewerbemuseum, Zurich, January-February 1954. Kunstgewerbeschule, Zurich.

"Aus meinem Unterricht." In: Catalog 169 of the Stedelijk Museum, Amsterdam. (Exhibition by Johannes Itten, April–May 6, 1957.)

Kunst der Farbe. Otto Maier, Ravensburg, 1961.

The Art of Color. Reinhold, New York, 1961; 3rd ed. 1965. Japanese ed. Tokyo, 1964. Italian ed. Milan, 1965.

Contribution to "Adolf Hölzel und sein Kreis." In: Der Pelikan (Hannover), No. 65, 1963.

Mein Vorkurs am Bauhaus. Otto Maier, Ravensburg, 1963.

Design and Form, the basic course at the Bauhaus. Trans. by John Maass. Reinhold, New York, Burns & MacEachern, Toronto, and Thames, London, 1964.

"Meine Bauhaus-Jahre." In: Werk, Vol. 51, January 1964, pp. 27–28.

Publications about Johannes Itten:
"Die Werkbund-Ausstellung im Kunstgewerbe-museum Zurich." In: Werk, Vol. 37, August 1950, pp. 226–229.

"Das Museum Rietberg der Stadt Zurich." In: Werk, Vol. 39, December 1952, pp. 407–415.

"Das Menschbild in unserer Zeit, Darmstädter Gespräch. P. Fehl." In: College Art Journal, Vol. 13, No. 2, 1954, pp. 145–147.

"Rücktritt." In: Werk, Vol. 41, June 1954, Sup. 117.

"Johannes Itten zum 75. Geburtstag." (75th birthday). In: Die Form, No. 24, 1963.

"Wie konnte die grosse Wirkung des Bauhauses

entstehen?" In: Bauhaus, Idee—Form—Zweck—Zeit (exhibition catalog), Göppingen Galerie, Frank-furt a.M., 1964.

"Aquarelle und Zeichnungen." Catalog Bauhaus-Archiv, Darmstadt, 1967.

Kállai, Ernst
Publications by Kállai:
"Der Kubismus und die Kunst der Zukunft." In: MA (Hungary), Vol. VII, No. 2, 1922.

"Technik und konstruktive Kunst." In: MA (Hungary), Vol. VII, No. 5/6, 1922.

"Neue Malerei in Ungarn." (Junge Kunst in Europa, II) (Leipzig) 1925. 124 pages, 80 plates. Hungarian ed. Budapest, 1925.

Ludwig Kozma. Leipzig, 1926.

"Malerei und Photographie." In: "i 10," 1927, pp. 148–157, and "Antwort auf Zuschriften." In: "i 10" (Amster-dam), 1927, pp. 237–240.

"Der Plastiker Gabo." In: "i 10," 1927, pp. 245–249.

"Bauhauspädagogik—Bauhausbaukunst." In: Tér és Forma, Vol. I, 1928, pp. 317–322.

"Grenzen der Technik." In: Weltbühne, January 21, 1930.

"Vision und Formgesetz." In: Blätter der Galerie Fer-dinand Möller, No. 8, September 1930.

"Kunst und Technik." In: Forum, Vol. II, 1932, pp. 186–187.

"Kunst und Wirklichkeit." In: Forum, Vol. III, 1933, pp. 8–11.

Béla Czóbel. Budapest, 1934.

"Das neue Helldunkel. Zu den Bildern von Julius Pap." In: Forum, Vol. IV, 1934, pp. 14–15.

"Idea a vyvoj Bauhausu" [The Bauhaus—its idea and development], in: "Vytvarna vychova," 1st year. Prague 1935, No. 3, pp. 10–14.

"Paul Klee als Zeichner." In: Forum, Vol. V, 1935, pp. 150–151.

"Zur Malerei in Ungarn." In: Forum, Vol. VI, 1936, pp. 35–37.

"Zum Wesen der ungarischen Kunst." In: Forum, Vol. VIII, 1938, pp. 215–218.

"Zu den Arbeiten von Max Bill." In: Plastique (Paris), No. 5, 1939.

Mednyánzky László. Budapest, 1943.

Cézanne és a XX. Század konstruktiv müvészete (Cézanne and the constructive art of the 20th cen-tury). Budapest, 1944.

A természet rejtett arca (the hidden face of nature). Budapest, 1947.

Picasso. Budapest, 1948.

See also Index of the Periodical "bauhaus," p. 629.

Kandinsky, Wassily
Publications by Kandinsky:
Principal works:
Schwarz und Weiss. Grüner Klang. 1909. (2 unpub-lished plays in Russian)

Violett. 1911 (unpublished play in German. Fragment printed in: bauhaus No. 3, 1927, p. 6)

Über das Geistige in der Kunst. Insbesondere in der Malerei. Piper, Munich, 1912. 104 pages, 8 plates, 10 original woodcuts; 2nd enlarged edition 1912; 3rd edition 1912; Excerpts In: Der Sturm No. 106 April 1912 and in: Blast No. 1, 1914, pp. 119–125. 4th edition with Intro. by Max Bill. Bern-Bümpliz, 1952, 144 pages; 5th edition 1956.

The Art of Spiritual Harmony. Trans. and Intro. by M.T.H. Sadler. Constable, London; and Houghton Mifflin, Boston, 1914, XXVII, 112 pages, 9 plates.

The Art of Spiritual Harmony (in Japanese). Trans. by Ohara Kuniyoshi. Idea Shoin, Tokyo, 1924.

Della Spiritualità nell'Arte. Trans. by Colonna di Cesaró. Edizione di Religio, Roma, 1940, 110 pages, 12 plates.

On the Spiritual in Art; first complete English transla-tion with four full-page color reproductions, woodcuts and half tones. Solomon R. Guggenheim Foundation, New York, 1946, 152 pages, Published for the Museum of Non-objective painting. With Supplements: "Short Survey of artistic Evolution . . . 1904–1944," p. 105, and "Public Comments," pp. 127–152.

Concerning the Spiritual in Art, and Painting in Par-ticular, 1912. [A version of the Michael Sadler transla-tion with considerable re-translation by Francis Golffing and others] ("Documents of Modern Art," No. 5.) Wittenborn, Schultz, New York, 1947, and May-flower, London, 1955, 95 pages, 10 plates; with notes by Motherwell, Nina Kandinsky, Julia and Lyonel Feininger and Stanley Hayter.

Du Spirituel dans l'Art, et dans la Peinture en Par-ticulier. Trans. by M. Deman. Drouin, Paris, 1949.

Du Spirituel dans l'Art. De Beaune, Paris, 1951.

De lo Espiritual en el Arte. Trans. from the French by Edgar Bayley. Galatea and Nueva Visión, Buenos Aires, 1956.

Der Blaue Reiter. Ed. by W. Kandinsky and Franz Marc. Piper, Munich, 1912, 131 pages, 141 ills. and 3 musical additions.

2nd ed. 1914. Therein by Kandinsky: Obituary for Eugen Kahler, pp. 53–55; "Über die Formfrage," pp. 74–100; "Über die Bühnenkomposition," pp. 103–133. "Der gelbe Klang" (a composition for the stage), pp. 115–131.

New documentary edition by Klaus Lankheit. Piper, Munich, 1965, 363 pages.

Klänge. Piper, Munich, 1913, 67 pages. (Poems in prose with black-and-white and colored woodcuts.)

Kandinsky, 1901–1913. —Rückblicke—. Der Sturm, Berlin, 1913, 67 pages ills. and XXXXI pages text.

V. V. Kandinskii. Tekst Khudozhnika. Izdanie Narodnago Kommissariata po Prozveshcheniiu, Moscow, 1918, 56 pages, 26 ills.

Kandinsky. Ed. by Hilla Rebay. Solomon R. Guggenheim Museum, New York, 1945, 46 pages with ills.

In Memory of Wassily Kandinsky. Solomon R. Guggenheim Museum, New York, 1945, 117 pages with ills. (English translation from the Russian original, Moscow, 1918.)

Regard sur le Passé (excerpt). In: Derrière le Miroir, Paris, No. 42, November-December 1951, pp. 2, 3, 5, 8.

Rückblicke. Intro. by Ludwig Grote. Klein, Baden-Baden, 1955, 48 pages, 8 col. plates.

Punkt und Linie zu Fläche: Beitrag zur Analyse der malerischen Elemente. ("Bauhausbuch" No. 9). Langen, Munich, 1926, 198 pages, 102 text ills., 25 plates, 1 color plate; 2nd ed. 1928; 3rd ed. Intro. by Max Bill. Bern-Bümplitz, 1955, 210 pages, ills.

Analyse des éléments premiers de la peinture. In: Cahiers de Belgique, No. 4, May 1928, pp. 126–132. Trans. by Hermann Closson.

Ekdhosi Pneumatikis Kalliergeis Kai Tekhins. Edition of Fine Arts and Crafts, Athens, 1937. An outline of "Punkt und Linie zu Fläche."

Point and Line to Plane; Contribution to the Analysis of the Pictorial Elements. Ed. and Preface by Hilla Rebay. Trans. by Howard Dearstyne and Hilla Rebay. Solomon R. Guggenheim Museum, New York, 1947, 196 pages, ill.

Essays über Kunst und Künstler. (Selected writings from 1912–1943). Ed. and comments by Max Bill. Hatje, Stuttgart, 1955, 247 pages, ill.

Kleine Welten. Intro. by Peter A. Riedl. Reclam, Stuttgart, 1962, 32 pages, ill. (See also Publications by the Bauhaus: Bauhaus-Prints, p. 627.)

Selected Letters, Articles, and catalogs:
Pismo iz München (letter from Munich). In: Apollon, St. Petersburg, II, pp. 17–20, IV, pp. 12–15, VIII, pp. 4–7, XI, pp. 13–17, 1909–1910. (5 letters from the years 1909–1910.) Newly ed. in: Zwiebelturm No. 5, 1950, pp. 24–44.

Essay in the bulletin of the All-Russian Congress of Artists. St. Petersburg, 1910.

Über Kunstverstehen. In: Der Sturm. Vol. 3, No. 129, October 1912, pp. 157–158.

Malerei als reine Kunst. In: Der Sturm, No. 178–179, 1913, pp. 98–99.

Wassily Kandinsky: Self-Characterization. In: Das Kunstblatt. Vol. 3, No. 6, 1919.

Ein neuer Naturalismus. In: Das Kunstblatt, Vol. 6, No. 9, 1922.

Abstrakte Kunst. In: Der Cicerone, Vol. 17, 1925, pp. 638–647.

Tanzkurven: To the dances of Palucca. In: Das Kunstblatt. Vol. 10, 1926, pp. 117–120.

Der Wert des theoretischen Unterrichts in der Malerei. In: bauhaus, No. 1, 1926 (compare Publications by the Bauhaus).

Über die abstrakte Bühnensynthese. In: bauhaus, No. 3, 1927 (compare Publications by the Bauhaus).

"Und" Einiges über synthetische Kunst. In: "i 10," Amsterdam, No. 1, 1927.

Kunstpädagogik. In: bauhaus 2/3, 1928.

Unterricht Kandinsky. In: bauhaus 2/3, 1928. English trans. In: "Bauhaus 1919–1928."

Die kahle Wand. In: Der Kunstnarr, Dessau, Vol. 1, 1929, pp. 20–22.

Der blaue Reiter, Rückblick (Retrospect). In: Das Kunstblatt, Vol. 14, 1930, pp. 57–60.

Pictures at an Exhibition (Modeste Mussorgsky). In: Das Kunstblatt, Vol. 14, No. 8, 1930.

Paul Klee. In: bauhaus, No. 3, 1931 (written on the occasion of the farewell of Paul Klee from the Bauhaus).

Réflexions sur l'Art Abstrait. In: Cahiers d'Art, Vol. 6, Nos. 7–8, 1931, pp. 350–353.

Line and Fish. In: Axis, London, No. 2, 1935.

Omaggio a Baumeister. In: Il Milione, Milano, No. 41, 1935.

To retninger (det abstrakte rene malerei skåber). In: Konkretion, Copenhagen, 1935.

Toile vide, etc. In: Cahiers d'Art, Vol. 10, No. 5/6, 1935.

Abstrakte Malerei. In: Kronick von Hedendaagsche Kunst en Kultuur, Amsterdam, No. 6, 1936.

Franz Marc. In: Cahiers d'Art, Vol. 11, No. 8–10, 1936.

Respuetas de Kandinsky (al cuestionario de Gaceta de Arte). In: Gaceta de Arte, Canarias, No. 38, 1936.

Tilegnelze af Kunst. In: Linien, Copenhagen, 1937.

Salongespräch (June 1937)—Testimonium Pauperatia (1937)—Weiss-Horn. In: Plastique, No. 4, Paris 1939.

Blick und Blitz (etc). In: Transition No. 27, 1938, poems and texts.

Mes gravures sur bois. In: XXe Siècle No. 3, 1938 and XXe Siècle No. 21, December 1959, pp. 11–12.

La valeur d'une œuvre concrète. In: XXe Siècle, Vol. 1, No. 1, 1938.

Konkrete Kunst. In: Abstrakt, Konkret (Zürich) No. 8, 1945.

Upon the occasion of the Kandinsky Memorial Exhibition. Solomon R. Guggenheim Foundation, New York, 1945. 43 pages, col. ill.

Valore di un opera concreta. In: Forma, Vol. 22, No. 1, 1950.

Un Poème Inédit de Kandinsky. In: XXe Siècle No. 3, 1952.

Drei Briefe von Kandinsky (letters to Hans Hildebrandt). In: Werk, Vol. 42, No. 10, 1955.

[letter to Hermann Rupf.] In: DU, Vol., 16, No. 3, Zürich, 1956

L'Art Concret. In: XXe Siècle, No. 21, December 1959. pp. 7–11. (With English translation.)

Watercolors, drawings, writings; with an essay by Jean Casson [tr. by Norbert Guterman]. Abrams, New York 1961, 51 pages, ill.; same, 25 pages, Thames, London 1961.

"Wassily Kandinsky 1866–1944." Solomon R. Guggenheim Museum, New York, 1962. (Catalog.)

Catalog of fifty paintings by Wassily Kandinsky (The property of the Solomon R. Guggenheim Foundation). Sotheby & Co., London, day of sale, January 30, 1964. 50 plates.

"The Bauhaus years." Marlborough-Gerson Gallery, New York, 1966. (Catalog.)

"Kandinsky and his Friends." Marlborough Gallery, London, 1966. (Catalog.)

Publications about Wassily Kandinsky:

Marc, Franz. "Kandinsky." In: Der Sturm. Vol. IV, 1913, p. 130.

Zehder, Hugo. Wassily Kandinsky, ("Künstler der Gegenwart" Vol. 1) Kaemmerer, Dresden, 1920. 53 pages, 13 ills.

Klee, Paul. "Kandinsky." In: Anniversary Exhibition on Kandinsky's 60th Birthday (Catalog), Galerie Arnold, Dresden, 1926.

Grohmann, Will. Kandinsky. Éditions Cahiers d'art, Paris, 1930. 30 pages, 75 ills.

Debrunner, Hugo. Wir entdecken Kandinsky. Origo, Zurich, 1947. 64 pages, ill.

Bill, Max, editor. Wassily Kandinsky. Maeght Éditeur, Paris, 1951. 178 pages, ill.

Lindsay, Kenneth C. An Examination of the Fundamental Theories of Wassily Kandinsky. University of Wisconsin, Madison, Wis., 1951. 244 pages, 57 ills.

Lieberman A. Kandinsky. In: Vogue, Vol. 126, November 1, 1955, pp. 134–137, ill.

"Kandinsky Murals at the Museum of Modern Art." In: Arts, Vol. 30, June 1956, p. 29.

Lindsay K. C. "Kandinsky in 1914 New York; Solving a Riddle" (panels commissioned by an American before World War I). In: Art News, Vol. 55, May 1956, pp. 32–33+.

Volboudt P. "Wassily Kandinsky." In: Cahiers d'Art, Vol. 31/32, 1956/1957, pp. 177–215, 52 ills.

Eichner, Johannes. Kandinsky und Gabriele Münter. Bruckmann, Munich, 1957. 221 pages, 89 ill.

Eitner L. "Kandinsky in Munich." In: Burlington Magazine for Connoisseurs, Vol. 99, June 1957, pp. 192–197.

Heron P. "London: The Riddle of Kandinsky's Influence as Propounded by the Tate's Display of a Guggenheim Selection." In: Arts, Vol. 31, September 1957, p. 12.

Selz P. "Aesthetic Theories of Wassily Kandinsky and their Relationships to the Origin of Non-Objective Painting." In: Art Bulletin, Vol. 39, June 1957, pp. 127–136 (with bibliographic footnotes).

Grohmann, Will. Kandinsky ("Modern Painters"). Abrams, New York, 1958, 444 pages, ill. German ed. DuMont Schauberg, Cologne, 1958, 425 pages, ill.; English ed. Thames, London, 1959 (with complete monograph of life and work of Kandinsky, oeuvre-catalog, list of exhibitions, and bibliography by Bernard Karpel, librarian of the Museum of Modern Art, New York).

Kandinsky (1866–1944). Introduction and notes by Herbert Read. George Wittenborn, New York, 1959, 24 pages, ill. Faber, London, 1959.

Lindsay K. C. "Will Russia unfreeze her first modern master?" In: Art News, Vol. 58, September 1959, pp. 28–31+.

Kimball, M. "Kandinsky and Rudolf Steiner." In: Arts, Vol. 34, March 1960, p. 7.

Melville, R. "Blaue Reiter Exhibition at the Tate." In: Architectural Review, Vol. 128, December 1960, p. 445.

Roditi, E. "Interview with Gabriele Münter." In: Arts, Vol. 34, January 1960, pp. 36–41.

Ettlinger, C. D. "Kandinsky's 'At rest'." Oxford University Press, New York and Toronto, 1961, 21 pages.

Fingesten, P. "Spirituality, mysticism and non-objective art." In: Art Journal, Vol. 21, No. 1, 1961, pp. 2–6 (with bibliographic footnotes).

Grohmann, Will. "Kandinsky et Klee retrouvent l'Orient." In: XXᵉ Siècle, No. 23, December 1961, pp. 49–56.

Brion, Marcel. Kandinsky. Trans. from the French by A. H. N. Molesworth. Daily Express Book Department (Oldbourne Press book), London, 1961, 94 pages, ill.; in the "Student's Series of Great Artists," Harry N. Abrams, New York, 1962, 94 pages, 35 color plates.

Lassaigne, Jacques. Kandinsky: Biographical and Critical Study ("The Taste of Our Time," Vol. 41) Trans. from the French by Mrs. H. S. B. Harrison. Skira, New York, 1964, 131 pages, 52 color plates.

"Wassily Kandinsky, 1866–1944" In: XXᵉ Siècle, No. 27, 1966, pp. 1–120, i–xi (special issue).

Klee, Paul
Publications by Klee:
"Die Ausstellung des Modernen Bundes im Kunsthaus Zürich." In: Die Alpen, Vol. 6, No. 12, 1912.

Robert DeLaunay. "Über das Licht." Trans. by Paul Klee. In: Der Sturm, Vol. 3, No. 144/145, 1913.

"Schöpferische Konfession." In: Tribüne der Kunst und Zeit, ed. by Kasimir Edschmid, Berlin, 1920.

"Antwort auf eine Rundfrage an die Künstler: Über den Wert der Kritik." In: Der Ararat, Munich No. 2, 1921.

"Wege des Naturstudiums." In: Staatliches Bauhaus in Weimar 1919–1923. See also publications by the Bauhaus.

Pädagogisches Skizzenbuch ("Bauhausbuch," No. 2). Munich, 1925, 51 pages, 87 ills. "Neue Bauhaus-bücher," No. 2, 1965. See also Publications by the Bauhaus. English eds.: Trans. by S. Moholy-Nagy, Nierendorf Gallery, 1944; Praeger, New York; Faber & Faber, London; and Smithers & Bonelli, Toronto, 1953. Trans. and Intro. by S. Moholy-Nagy, Praeger, New York and Burns & MacEachern, Toronto, 1960.

"Kandinsky." In: Anniversary Exhibition on Kandinsky's 60th Birthday, (exhibition catalog), Galerie Arnold, Dresden, 1926.

"Emil Nolde." In: Festschrift für Emil Nolde, on the occasion of his 60th birthday. Dresden, 1927.

"Exakter Versuch im Bereich der Kunst." In: bauhaus, No. 2/3, 1928. Über die moderne Kunst. Benteli, Bern-Bümpliz, 1945.

English eds.: On Modern Art. Trans. by Paul Findlay. Introd. by Herbert Read. Faber & Faber, London, 1948, 55 pages, 24 ills. Evron, New York, 1949.

"Gedichte" (Poems). In: Carola Giedion-Welcker (ed.), Poètes à l'écart. Benteli, Bern-Bümpliz, 1946.

"The Novices of Sais." Prose Poem by Novalis. Trans. by Ralph Manheim. Preface by Stephen Spender. Sixty drawings by Paul Klee. Valentin, New York, 1949.

Das bildnerische Denken. Schriften zur Form- und Gestaltungslehre. Ed. by Jürg Spiller. Benno Schwabe, Basel and Stuttgart, 1956. (Important authentic material from the pedagogical writings and lecture manuscripts; posthumous works.)

English translation: The Thinking Eye; note books. ("Documents of Modern Art," Vol. 15). Ed. by Jürg Spiller. Trans. by Ralph Manheim. Preface by C. G. Argan. Wittenborn, New York, with 574 pages, 1200 ills. and also with 541 pages, 1313 ills.; Lund Humphries, London; and Clarke Irwin, Toronto, 1961.

Tagebücher von Paul Klee 1898–1918. Ed. with an intro. by Felix Klee. DuMont Schauberg, Cologne,

1957, 423 pages, ill.; 2nd ed. ("DuMont Dokumente—Texte und Perspektiven"), 1957. English translation: The Diaries of Paul Klee 1898–1918. Ed. with an intro. by Felix Klee. University of California Press, Berkeley, 1964, xx + 424 pages, ill.; Peter Owen, London, 1965.

Inward Vision; Watercolors, Drawings, Writings. Trans. from the German by Norbert Guterman. Intro. by Werner Haftmann. Abrams, New York and Thames, London, 1958.

Some Poems. Trans. by Anselm Hollo. Scorpion Press, Lowestoft, Suffolk, England, 1963.

Publications about Paul Klee:
Paintings, Water Colors, 1913–1939. Ed. by Karl Nierendorf. Introd. by James Johnson Sweeney. Oxford University Press, New York, 1941.

Riley, M. "Exhibition, New Art Circle." In: Art Digest, Vol. 18, November 1943, p. 20.

Grohmann, Will (text). Drawings by Paul Klee. Trans. by Mimi Catlin and Margit von Ternes. Valentin, New York, 1944, xiv + 31 pages, 72 plates in portfolio.

New York Museum of Modern Art. Paul Klee. 2nd rev. & enlarged ed. Museum of Modern Art, New York and Musson, Toronto, 1945.

Ten reproductions in facsimile of paintings. Selected and with an introductory essay by Georg Schmidt. English version by Robert Allen and Douglas Cooper. Wittenborn, New York, 1946.

Klee 1879–1940 ("Faber Gallery"). Intro. and notes by Herbert Read. Faber & Faber, London, 1948, 24 pages, ill., color plates; ("Pitman Gallery"), Pitman, New York, 1949.

Paintings, Drawings and Prints; from the Klee foundation, Berne, Switzerland; with additions from American collections. Introductory note signed: James Thrall Soby. Museum of Modern Art, New York, 1949, 59 pages.

Armitage, Merle. Five Essays on Paul Klee. Duell, Sloan, and Pierce, New York and Collins Sons, Toronto, 1950, 121 pages, ill.

Giedion-Welcker, Carola. Paul Klee. English edition by Alexander Gode, Viking Press, New York, 1952, 156 pages, 128 ills., 13 color plates; Faber & Faber, London and Macmillan, Toronto, 1952. German edition Hatje, Stuttgart, 1954. Paperback edition Rowohlt, Hamburg, 1961.

Grohmann, Will. Paul Klee ("Library of Great Painters"). Abrams, New York, 448 pages, ill., Lund Humphries, London; and Clarke Irwin, Toronto, 1954. 2nd ed. Lund Humphries, London and Clarke Irwin, Toronto, 1958. 1st German ed. Kohlhammer, Stuttgart, 1954; 2nd ed. 1955; 3rd ed. 1959. French eds. Flinker, Paris and Édition des Trois Collines, Geneva. Italian ed. Sansoni, Florence. (Main work about Paul Klee with extensive catalog of works and bibliography by Hannah Muller-Applebaum, librarian at The Museum of Modern Art, New York.)

Haftmann, Werner. Mind and Work of Paul Klee. Praeger, New York, Burns & MacEachern, Toronto, Faber & Faber, London, and British Book Service, Toronto, 1954.

Klee ("Faber Gallery"). Intro. and a note on each plate by Andrew Forge. Faber & Faber, London, 1954, v 2–24 pages, 10 color plates.

Henninger, Gerd. Paul Klee. Theorie von der Malerei in ihrem Verhältnis zur Struktur des Gesamtwerkes. Dissertation, Berlin, 1955.

Heise, Carl George. Paul Klee. Revolution des Viadukts. In: Jahresring 1955/1956.

Hulton, Nika. Approach to Paul Klee. Pitman, New York, 1956, 68 pages 25 plates, 8 color plates; Dent, Toronto; and Phoenix House, London, 1956.

Paul Klee Foundation. Berner Kunstmuseum, August 11-November 4, 1956. (Catalog.)

Muche, Georg. "Der Fisch des Kolumbus. Erinnerungen an Paul Klee." In: Frankfurter Allgemeine Zeitung. No. 150, June 30, 1956. Reprinted in: Hans M. Wingler, Wie sie einander sahen. 1957, p. 87.

Grohmann, Will. Paul Klee und die Anfänge einer Harmonielehre in der Kunst. In: Neue deutsche Hefte, No. 39, 1957.

Hofmann, Werner: Klee und Kandinsky. In: Merkur 11, 1957.

Kessler, C. S. "Science and Mysticism in Paul Klee's 'Around the Fish'." In: Aesthetics, No. 16, 1957.

Petitpierre, Petra, Aus der Malklasse von Paul Klee. Benteli, Bern-Bümpliz, 1957.

San Lazzaro, Gualtieri di. Klee; A Study of his Life and Work. Trans. from the Italian by Stuart Hood. Praeger, New York, 304 pages, ills., color plates; Thames, London and Hazan, Paris, 1957. German ed. Droemersche Verlagsanstalt, Munich, 1958.

Grohmann, Will. Paul Klee, Handzeichnungen. DuMont Schauberg, Cologne, 1959.

Grote, Ludwig (ed.). Erinnerungen an Paul Klee. Prestel, Munich, 1959.

Paul Klee Drawings. Text by Will Grohmann. Trans. by Norbert Guterman. Abrams, New York 1960, 176 pages and Thames, London, 1960; Daily Express Book Department, London, 1963.

Ponente, Nello. Klee; Biographical and Critical Study ("The Taste of our Time," Vol. 31). Trans. from the Italian by James Emmons. Skira, New York, 140 pages, color plates and Zwemmer, London, 1960.

Klee, Felix. Paul Klee. Leben und Werk in Dokumenten, ausgewählt aus den nachgelassenen Aufzeichnungen und den unveröffentlichten Briefen. Diogenes-Verlag, Zurich, 1960.

Klee, Felix. Paul Klee, His Life and Work in Documents. Trans. from the German by Richard and Clare Winston. Braziller, New York, 1962, 212 pages. (Selections from posthumous writings and unpublished letters, with 121 reproductions of paintings, drawings, photographs, and other documents.)

Spiller, Jürg. Paul Klee (Barnes & Noble art series). Barnes & Noble, New York, 1962, 90 pages, ill.

Lynton, Norbert. Klee. Spring Books, Greenford, Middlesex, England, 1964, 44 pages, ill., 48 color plates.

Marcks, Gerhard
Publications by Marcks:
Tierplastik. Insel-Verlag, Wiesbaden, n.d.
Publications about Marcks:
Kállai, Ernst. "Der Bildhauer Gerhard Marcks." In: Die Form, Vol. 5, 1930, pp. 92 f.

Haftmann, Werner. "Gerhard Marcks und der griechische Traum." In: Konrad Tegtmeier, Kleine Beiträge zur Buchkunde, Kunstgeschichte und Literatur. 5th ptg. Hamburg, 1951.

Hans Vollmer. comprehensive bibliography in: Künstlerlexikon des 20. Jahrhunderts, Vol. 3. Seemann, Leipzig, 1956.

Rieth, Adolf. Gerhard Marcks. Aurel Bongers, Recklinghausen, 1959.

"Gerhard Marcks—Skulpturen und Zeichnungen" (exhibition catalog). Wallraf-Richartz-Museum, Cologne, 1964.

"Gerhard Marcks—Plastik, Handzeichnungen, Druckgraphik" (exhibition catalog). Kunsthalle, Bremen, 1964.

"Gerhard Marcks—Lübecker Figuren" (exhibition catalog). Galerie Rudolf Hoffmann, Hamburg, 1964.

"Gerhard Marcks—Zeichnungen und Graphik" (exhibition catalog). Karl and Faber, Munich, 1965/1966.

"Gerhard Marcks—Bronze Sculpture" (exhibition catalog). Leonard Hutton Galleries, New York, 1967.

Meyer, Adolf
Publications by Meyer:
Ein Versuchshaus des Bauhauses ("Bauhausbuch," No. 3). Munich, 1925, 78 pages, ill.

"Umbau der Frankfurter Gasgesellschaft; und Arbeiten aus der Hochbauklasse" (Director A. Meyer). In: Das Neue Frankfurt, Vol. II, May 1928.

"Neue Möglichkeiten im Stuckgewerbe" (lecture given in 1928 in Würzburg). Manuscript in the Bauhaus-Archiv, Darmstadt.

"Industriebau." In: Hundert Jahre Frankfurter Gas 1828–1928, anniversary publication of the Frankfurt Gas Company, Frankfurt 1928.

"Glas als Baustoff." In: Frankfurter Zeitung, July 31, 1929.

Adolf Meyer 1904–1929 (diary of Adolf Meyer). Original in the possession of Otto Meyer, Düsseldorf; a copy in the Bauhaus-Archiv, Darmstadt.

Meyer, Hannes
Publications by Meyer:
(See also publications by the Bauhaus).
Essay in: Die Siedlungsgenossenschaft Freidorf, Basel, 1921.

"Siedlungsgenossenschaft Freidorf." In the memoir of the Verband Schweizerischer Konsumvereine on the occasion of the Internationale Genossenschaftskongress in Basel, 1921.

"Das Theater CO-OP." In: Werk, December 1924.

"Foto-Construction CO-OP." In: Pasmo (Brno), 1925.

"Das junge Belgien." In: Werk, No. 9, 1925 (special number).

"Die Vitrine CO-OP." In: MA (Vienna), 1925.

"Abstrakte Kunst." In: ABC (Basel), No. 2, 1926 (special number, Hannes Meyer, ed.).

"Die neue Welt." In: Werk, No. 7, 1926 (special number).

"League of Nations Building in Geneva." In: Die Bauwelt (Berlin) 1927.

"Bauhaus und spolecnost." In: RED (Prague), Vol. 3, No. 5, pp. 130–133.

"Mein Hinauswurf aus dem Bauhaus." In: Das Tagebuch (Berlin), August 1930.

"From the Travel Diary of an Architect." In: Arkitektura CCCP (Moscow), No. 6, 1933. (Russian.)

"How I work." In: Architektura CCCP (Moscow), No. 6, 1933. (Russian.)

"Leap into life." Reflections on the subway in Moscow. In: Iskusstvo, No. 10, 1934. (Russian.)

"The Sculptor Karl Geiser." In: Architektura za Rubezhom, (Moscow), No. 1, 1934.

"Experiencias de Urbanismo" (experiences in urban planning). In: Arquitectura y Decoración (Mexico), No. 12, 1938 (special number dedicated to Hannes Meyer with a biography and bibliography).

"La Formación del Arquitecto" (training of an architect). In: Arquitectura y Decoración (Mexico), No. 12, 1938.

"Bauhaus Dessau 1927–30. Experience of a polytechnical education." In: Edificactión (Mexico), No. 34, 1940.

"Projects in City Planning from the U.S.S.R." In: Arquitectura y Decoración (Mexico), October 1940.

"La Realidad Soviética: Los Arquitectas." In: Arquitectura (Mexico), No. 9, 1942 and in: Task, No. 3, 1942.

"Mexico City. Fragments of an Urban Study." In: Arquitectura (Mexico), April 1943.

"Messico/Svizzera." In: Edilizia Moderna, Milan, No. 45, December 1950 (postwar architecture in Mexico and Switzerland).

"El Taller de Grafica Popular" (The Studio for Popular Graphic Arts in Mexico). In: Graphis (Zurich), No. 30, 1950.

"Schulbau (school architecture) in Mexico." In: Bauen und Wohnen, No. 1, 1951.

"Kinderheim (children's home) at Mümliswil." In: Werk, No. 7, July 1953.

Publications about Hannes Meyer:
Schnaidt, Claude. Hannes Meyer: Buildings, Projects and Writings. English version by D. Q. Stephenson (parallel English and German texts). Architectural Book, New York; 123 pages, ill.; Tiranti, London; and Niggli, Teufen, Switzerland, 1965.

Mies van der Rohe, Ludwig
Publications by Mies van der Rohe:
(See also Publications by the Bauhaus)
"Hochhausprojekt für Bahnhof Friedrichstrasse in Berlin." In: Frühlicht, No. 1, 1922.

"Bürohaus." In: Zeitschrift für elementare Gestaltung, Berlin, June 1923.

"bauen." In: G, No. II, September 1923, p 1.

"Baukunst und Zeitwille." In: Der Querschnitt, No. 4, 1924.

"Industrielles Bauen." In: G, No. III, 1924.

"Briefe an die Form." In: Die Form, Vol. 1, No. 1, 1926.

Preface. In: Deutscher Werkbund, Stuttgart. Bau und Wohnung: die Bauten der Weissenhofsiedlung in Stuttgart errichtet 1927. Wedekind, Stuttgart, 1927.

"Zu meinem Block." In: ibid.

"Werkbundausstellung: Die Wohnung, Stuttgart 1927." In: Die Form, Vol. 2, No. 1, 1927. Introduction to the special number.

"Zum neuen Jahrgang." In: Die Form, Vol. 2, No. 1, 1927.

"Rundschau: Zum Neuen Jahrgang." In: Die Form, Vol. 2, No. 2, 1927.

"Zum Thema: Ausstellungen." In: Die Form, Vol. 3, No. 4, 1928.

"Über Kunstkritik." In: Das Kunstblatt, No. 14, 1930.

"Die neue Zeit: Schlussworte des Referats Mies van der Rohe auf der Wiener Tagung des deutschen Werkbundes." In: Die Form, Vol. 5, No. 15, 1930.

Introduction to Ludwig Hilberseimer's "The New City." Theobald, Chicago, 1944.

"Metals and Minerals Research Building. Illinois Institute of Technology." In: Architectural Forum, Vol. 79, November 1943, pp. 88–90.

"Buildings of 194 X: Museum." In: Architectural Forum, Vol. 78, May 1944, pp. 84–85.

"Only the Patient Counts: Some Radical Ideas on Hospital Design . . . as told to Mildred Whitcomb." In: Modern Hospital, Vol. 64, No. 3, 1945.

"A Tribute to Frank Lloyd Wright." In: College Art Journal, Vol. 6, No. 1, 1946.

"Architecture and Technology." In: Arts & Architecture, Vol. 67, October 1950, p. 30.

"Chicago Style and Religion: Mies van der Rohe design for the Episcopal Chapel of St. Saviour for the Illinois Institute of Technology Chicago." In: Art News, Vol. 50, October 1951, p. 54, ill.

"Edith Farnsworth sues Mies." In: Architectural Forum, Vol. 95, November 1951, p. 67.

"Fox River, Farnsworth House." In: Architectural Forum, Vol. 95, October 1951, pp. 156–162. Discussion in: Architectural Forum, Vol. 95, December 1951, p. 70.

"Word on Design." In: Interiors, Vol. 112, December 1952, pp. 116+.

"Chapel, Illinois Institute of Technology." In: Arts & Architecture, Vol. 70, January 1953, pp. 18–19, ill.

"Glass House Stories: The Farnsworth House." In: Newsweek, Vol. 41, June 8, 1953, p. 90, ill.

"Ein Werk des Neuen Bauens unter Denkmalsschutz." In: Werk, Vol. 42, September 1955, sup. 177, ill.

"Eight Chicago apartment projects; Commonwealth promenade and 900 Esplanade; IIT housing." In: Architectural Forum, Vol. 103, November 1955, pp. 140–141, 144–145, ill.

"Detroit Redevelopment." In: Architectural Forum, Vol. 104, April 1956, pp. 122–123, ill.

"Mies van der Rohe. Latest IIT Building—the S. R. Crown Hall." In: Architectural Record, Vol. 120, August 1956, pp. 133–139, ill.

"Mies' Enormous Room: Crown Hall—IIT's Newest Building." In: Architectural Forum, Vol. 105, August 1956, pp. 104–111, ill.

"Four Great Makers of Modern Architecture: Gropius, Le Corbusier, Mies van der Rohe, Wright." Verbatim record of a symposium held at the School of Architecture, March–May 1961. Columbia University Press, New York, 1964, 296 pages, ill.

"Peterhans' Visual Training Course at the Architectural Department of IIT." In: Catalog W. Peterhans, Bauhaus-Archiv, Darmstadt, 1967.

Publications about Ludwig Mies van der Rohe:
Dearstyne, H. "Basic Teaching of Architecture." In: Liturgical Arts Vol. 12, May 1944, pp. 56–60.

Philip C. Mies van der Rohe: analysis and appreciation of his work, together with all of his own writings. Museum of Modern Art, New York and Musson, Toronto, 1947. Rev. 2d ed. Museum of Modern Art, New York, 1954, 215 pages, ill.

"Mies and Nature; Effect of Time on Architecture." In: Architectural Review, Vol. 109, March 1951, p. 185, ill.

Wachsmann, K. Presentation of honorary degree of doctor of engineering. In: Arts & Architecture, Vol. 68, June 1951, p. 29+.

Wachsmann K. "Mies van der Rohe: His Work" In: Arts & Architecture, Vol. 69, March 1952, pp. 16–31+, ill.

Hilberseimer, L. Mies van der Rohe. Theobald, Chicago, 1956.

Kennedy, W. "Famous Living Architects." In: Journal of the Royal Architectural Institute of Canada, Vol. 33, May 1956, pp. 187–191.

Blake, Peter. "Modern Architecture: The Difficult Art of Simplicity." In: Architectural Forum, May 1958.

Creighton, Thomas H. "Seagram House Re-assessed." In: Progressive Architecture, June 1959.

Blake, Peter. Master Builders [Le Corbusier, Mies van der Rohe, Frank Lloyd Wright]. Knopf, New York, 1960, 399 pages, ill.; McClelland & Stewart, Toronto; and Gollancz, London, 1960, 306 pages, ill.

Drexler, Arthur. Ludwig Mies van der Rohe. Reihe "Grosse Meister der Architektur," Otto Maier, Ravensburg, 1960.

Drexler, Arthur. Ludwig Mies van der Rohe ("Masters of World Architecture"). Braziller, New York, 127 pages, ill.; Mayflower, London; and Sanders, Toronto, 1960.

Blaser, Werner. Mies van der Rohe. The Art of Structure. Thames and Hudson, London, 1965, 226 pages. German and French eds. Zurich, 1965.

Moholy-Nagy, Laszlo
Publications by Moholy-Nagy:
Horizont. Vienna, 1921.

Buch neuer Künstler. Ed. with L. Kassák. Vienna, 1922. Hungarian ed. Budapest.

"Die neue Typographie." In: Staatliches Bauhaus in Weimar 1919–23, Munich, 1923, p. 141.

"Die Arbeit der Bauhaus-Werkstätten." In: "Thüringische Allgemeine Zeitung," No. 288, October 19, 1924 (supp. to the newspaper).

"Das Bauhaus in Dessau." In: Qualität, No. 4/5, May/June 1925.

Die Bühne im Bauhaus (with Oskar Schlemmer)

("Bauhausbuch," No. 4). Munich, 1925. Newly ed. by Hans M. Wingler in "Neue Bauhausbücher No. 3," 1965.

Malerei, Fotografie, Film ("Bauhausbuch," No. 8). Munich, 1925; 2nd ed. 1927. Newly ed. by Hans M. Wingler in "Neue Bauhausbücher," No. 8, Kupferberg, Mainz and Berlin, 1967.

"Zeitgemässe Typographie—Ziele, Praxis, Kritik." In: Gutenberg-Festschrift, Mainz, 1925.

"Zeitgemässe Typographie." In: Offset, No. 7, 1926, pp. 375–385.

"Fotoplastische Reklame" (the photogram and the photoplastic in advertising). In: Offset, No. 7, 1926, pp. 386–394.

"Ismus oder Kunst?" In: Vivos Voco (Leipzig), Vol. 5, 1926, pp. 272–277.

"Geradlinigkeit des Geistes—Umwege der Technik." In: bauhaus, No. 1, 1926, p. 5.

"Wie soll das Theater der Totalität verwirklicht werden? (1924)." In: bauhaus, No. 3, 1927, p. 6.

"Fotografie ist Lichtgestaltung." In: bauhaus, No. 1, 1928, pp. 2–9.

"Die Geradlinigkeit des Geistes." In: "i 10" (Amsterdam, 1927, p. 35.

"Die beispiellose Fotografie." In: "i 10," 1927, pp. 114–117.

Contribution to the discussion about Ernst Kállai's article "Malerei und Fotografie." In: "i 10," 1927, pp. 233–234.

"Zum sprechenden Film." In: "i 10," 1928, pp. 69–71.

"Sturm über Asien." In: "i 10," 1929, pp. 143–144.

"Scharf oder unscharf." In: "i 10," 1929, p. 163.

"Fotogramm und Grenzgebiete." In: "i 10," 1929, p. 190.

"Die Photographie in der Reklame." In: Photographische Korrespondenzen, Vol. 63, No. 9, September 1927 (No. 758 of the series).

"Fotogramme und Grenzgebiete." In: Die Form, Vol. 4, No. 10, 1929, pp. 256–259.

Von Material zu Architektur ("Bauhausbuch," No. 14). Munich, 1929, 241 pages, 209 ills. Newly ed. by Hans M. Wingler in "Neue Bauhausbücher," No. 9, 1968. English eds.: The New Vision. From Material to Architecture. Brewer, Warren and Putnam, New York, 1930. 2nd ed.: New Vision. Fundamentals of Design, Painting, Sculpture, Architecture ("New Bauhaus books," No. 1). Trans. by Daphne M. Hoffmann. Rev. and enlarged ed. Norton, New York, 1938. 3rd, completely revised ed., with "Abstract of an Artist." Wittenborn, New York, 1946. 4th rev. ed. Also containing "Abstract of an Artist." ("Documents of Modern Art," Vol. 3). Wittenborn, New York, 1947, 92 pages, ill.; Mayflower, London and Vision, London, 1955.

"60 Photos." In: Fototek (Berlin). Ed. by Franz Roh. Vol. 1, 1930.

"Lichtrequisit einer elektrischen Bühne (Lichtmodulator)." In: Die Form, Vol. 5, No. 11/12, 1930, pp. 297–299.

"Problème du Nouveau Film." In: Cahiers d'Art, Vol. 12, March 1933, pp. 277–280.

"From Pigment to Light—A New Instrument of Vision —Problems of the Modern Film." In: Telehor (Brno), No. 1/2, 1936.

"Subject without Art." In: Studio, Vol. 112, November 1936, p. 259.

"Modern Art and Architecture." In: Journal of the Royal Institute of British Architects, January 1937, pp. 210–213.

"New Bauhaus and Space Relationship." In: American Architect & Architecture, Vol. 151, December 1937, pp. 22–28.

Illustrations in line and half-tone by L. Moholy-Nagy and others. In: Betjeman, John, Oxford University Chest; comprising a description of the present state of the town and University of Oxford, with an itinerary arranged alphabetically. Miles, London, 1938.

"Light, a New Medium of Expression." In: Architectural Forum, Vol. 70, May, 1939, pp. 388–392.

"New Bauhaus, American School of Design, Chicago." In: Design, Vol. 40, March 1939, pp. 19–21.

"Better than Before." In: The Technology Review. Vol. XLVI, No. 1, Massachusetts Institute of Technology, Cambridge (Mass.), 1943.

"Space modulator, papmac." In: Art Digest, Vol. 17, July 1943, p. 17.

"New Education—Organic Approach." In: Art & Industry, Vol. 40, March 1946, p. 66–77, ill.

Vision in Motion (Chicago Institute of Design "ID

Book," No. 2). Theobald, Chicago, 1947, pp. 9–371, 450 ills.

Portrait of Eton, Photos. Intro. by Bernard Fergusson. Muller, London, 1949, 80 pages.

Publications about Laszlo Moholy-Nagy:
Moholy-Nagy, Dorothea Maria Pauline Alice Sibylle, *see* Moholy-Nagy, Sibyl.

Moholy-Nagy, Sibyl. Moholy-Nagy: experiment in totality. Intro. by Walter Gropius. Harper, New York, 1950, ix + 253 pages, ill. and Musson, Toronto, 1950. Revised edition, The M.I.T. Press, Cambridge, Mass., 1969 (biography; main work about Moholy-Nagy).
Reviews in: American Artist, Vol. 14, October 1950, p. 16; Architecture d'Aujourd'hui, No. 21, December 1950, p. XXI; Architectural Review, Vol. 109, March 1951, p. 192; Art Digest, Vol. 26, May 15, 1952, p. 21; College Art Journal, Vol. 10, No. 3, 1951, p. 300; Interiors, Vol. 110, December 1950, p. 20; Magazine of Art, Vol. 45, January 1952, p. 44; Progressive Architecture, Pencil Points, Vol. 32, April 1951, p. 125; Journal of the Royal Institute of British Architects, Ser. 3, Vol. 59, June 1952, p. 303.

Moholy-Nagy, Sibyl. "L. Moholy-Nagy." In: Art d'Aujourd'hui, 1951.

"24 pieces from the collection of Sibyl Moholy-Nagy at the Klemann Gallery." In: Art News, Vol. 56, October 1957, p. 16 (catalog).

Melville, R. "Paintings at the New London Gallery." In: Architectural Review, Vol. 130, August 1961, p. 129.

Rickey, G. "Kinetic international." In: Arts, Vol. 35, September 1961, p. 18.

Seuphor, H. "Art construit." In: XX^e Siècle, No. 24, June 1962, p. 23.

Soucek, Ludvik. "L. Moholy-Nagy." Bratislava (Czech), 1965.

"From the Bauhaus. L. Moholy-Nagy." In: Camera, Vol. 46, April 1967, pp. 24–35.

Georg Muche
Publications by Muche:
"Das Versuchshaus des Bauhauses." In: Adolf Meyer, ein Versuchshaus des Bauhauses in Weimar ("Bauhausbuch," No. 3). Munich, 1925, p. 15.

Contribution to the discussion about Ernst Kállai's "Malerei und Fotografie." In: "i 10" (Amsterdam), 1927, pp. 235–236. Reprinted in the new edition in Facsimile "de internationale avant-garde tussen de twee wereldoorlogen." The Hague, 1963.

"Buon Fresco—letters from Italy about the crafts and the style of the original painting in fresco." Berlin, 1938; Tübingen, 1950. Excerpts, "Letters from Florence," reprinted in: Blickpunkt, Munich, 1961, p. 91.

Bilder—Fresken—Zeichnungen. Tübingen, 1950. Excerpts reprinted in: Blickpunkt, Munich, 1961, pp. 27, 112.

"Warum bin ich gegenständlich geworden?" In: Das Kunstwerk, Vol. VII, No. 3/4, Baden-Baden, 1953, p. 10.

"Textilkunst." In: Hundert Jahre Textilingenieurschule Krefeld, 1955, p. 97.

"Textilentwerfer und Industrie." In: Die Textilindustrie, Darmstadt, 1957, p. 129.

"Poesie der heiteren Farben." In: Architektur und Wohnform, Vol. 68, Stuttgart, 1960, p. 145.

"Blickpunkt, Sturm—Dada—Bauhaus—Gegenwart." Munich, 1961; 2nd edition, Wasmuth, Tübingen, 1965. (Collection of essays and lectures.)

"Die Zeit ohne Eigenschaften—eine Bilanz der zwanziger Jahre" (contribution to the discussion of Giedion's paper at the 3rd Philosophical Congress in the City of Munich). Stuttgart, 1961.

"Address on the 75th birthday of Johannes Itten." In: Bauhaus, Idee—Form—Zweck—Zeit, Dokumente und Äusserungen. Catalog of the Göppinger Galerie, Frankfurt, 1964, p. 53.

"L'année 1913 à Munich." In: XX^e Siècle, Paris, 1966, p. 33.

"Parnassisches Spiel—elektronisch." In: Frankfurter Allgemeine Zeitung, No. 47, 1966. Reprinted in: Klischograph, Kiel, No. 1, 1967, p. 26 (also in English and French).

Publications about Georg Muche:
"Lyonel Feininger über Georg Muche." From a letter of November 25, 1950. In: Wingler, Hans M., Wie sie einander sahen. Moderne Maler im Urteil ihrer Gefährten. Langen-Müller, Munich, 1957, pp. 94–95.

Richter, Horst. Georg Muche, Monographien zur Rheinisch-westfälischen Kunst der Gegenwart, Vol. 18, Recklinghausen, 1960.

Catalog Städtische Galerie im Lenbachhaus, Munich, 1965.

Peterhans, Walter
Publications by Peterhans:

"Zum gegenwärtigen Stand der Fotografie." In: RED (Prague), No. 5, 1930.

Die Sammlung Ida Bienert (with Will Grohmann). Potsdam, 1933.

Das Entwickeln entscheidet. Halle/Saale 1937 f.; English eds. London and Boston, 1937 f.

Richtig kopieren. Halle/Saale 1937 f.; English eds. London and Boston, 1937 f.

Was, wann, wie vergrössern? Halle/Saale 1937 f.; English eds. London and Boston, 1937 f.

Herstellung gerasterter grossflächiger Negative mit kleinen Rastern. U.S. patents No. 2 282 337, 1942, and No. 2 532 585, 1950.

"Visual Training." In: Dimension, Ann Arbor (Mich.), 1955.

"Fragment über Ästhetik." In: Ratio (Frankfurt), No. 2, 1960; Oxford, 1961.

Publications about Walter Peterhans:
"Walter Peterhans—Elementarunterricht und photographische Arbeiten" (exhibition catalog). Bauhaus-Archiv, Darmstadt, 1967.

Schlemmer, Oskar
Publications by Schlemmer:
"Kritik als Kunst—der Lüge." Leaflet on behalf of Paul Klee against H. M., Stuttgart, 1919.

"Paul Klee und die Stuttgarter Akademie." In: Das Kunstblatt, Potsdam, 1919.

Program of the first performance of the Triadic Ballet on September 20, 1922, at the Staatstheater, Stuttgart.

"Gestaltungsprinzipien bei der malerisch-plastischen Ausgestaltung des Werkstattgebäudes des Staatlichen Bauhauses in Weimar." In: Das Kunstblatt, Vol. VII, No. 11/12, 1923.

Die Bühne im Bauhaus (with L. Moholy-Nagy) ("Bauhausbuch," No. 4). Munich, 1925. Newly edited by Hans M. Wingler in "Neue Bauhausbücher," No. 3, 1965.

"Der theatralische Kostümtanz." In: Europa-Almanach (Potsdam), 1925.

"Tänzerische Mathematik." In: Anbruch Vienna, 1926 (special number "Tanz in dieser Zeit").

"Bühne und Bauhaus." In: Offset, Buch- und Werbekunst (Leipzig), 1926 (special number "Bauhaus").

"Abstraktes Theater." In: Berliner Illustrierte Zeitung, January 1, 1927.

"Ausblicke auf Bühne und Tanz." In: Melos (Mainz), Vol. 6, No. 12, 1927.

"Der entfesselte Bühnenraum." In: Berliner Tageblatt, April 6, 1927.

"Mechanisches Ballett." In: "Tanz und Reigen," ed. by Bühnenvolksbund e.V., Bühnenvolksbundverlag, Berlin, 1927 (omnibus volume).

"Moderne Bühnenmittel." In: Magdeburgische Zeitung, May 15, 1927.

"Der neue Bühnenbau" and "Die Bühne am Bauhaus." Essays in: Almanach des Theaters der Stadt Münster i.W., Münster, 1927.

"Die Bauhausbühne." Part of a lecture in: Werk (Zurich), Vol. 15, No. 1, 1928.

"Piscator und das moderne Theater." In: Das Neue Frankfurt (Frankfurt), Vol. II, No. 2, 1928.

"Neue Formen der Bühne." In: Schünemanns Monatshefte, 1928, No. 10.

"Abstraktion in Tanz und Kostüm." Essay, 1928, publisher unknown.

"Alte und neue Oper." In: Die Oper, Blätter des Breslauer Stadttheaters, Breslau, 1929.

"Analyse eines Bildes und anderer Dinge." In: bauhaus, No. 4, 1929.

"Neue Bauhaustänze." In: Die Dame (Berlin), Vol. XIII, No. 17, 1929.

"Erster Entwurf der Folkwang-Bilder." In: Das Kunstblatt (Berlin), Vol. XIII, 1929.

"Über das kommende Theater." In: Leipziger Zeitung, January 3, 1929.

"Gestaltung aus dem Material." In: Das Neue Frankfurt (Frankfurt), Vol. IV, No. 10, 1930.

"Alte Oper—Neue Oper." In: Das Kunstblatt, Vol. XIV, No. 8, 1930.

"Akademie und Bühnenstudio." In: catalog, exhibition of students of the Staatliche Akademie für Kunst und Kunstgewerbe Breslau, Breslau, 1930.

"Missverständnisse." In: Schrifttanz (Vienna), Vol. 4, No. 2, 1931.

"Bühnenbild und Bühnenelemente." In: Wegleitungen des Kunstgewerbemuseums der Stadt Zürich zur Theaterkunst-Ausstellung, April-May 1931, Zurich, 1931.

"Zu meinen Wandbildern für das Folkwang-Museum in Essen." In: Museum der Gegenwart (Berlin), Vol. I, No. 4, 1931.

"D'après Oskar Schlemmer." In: Archives Internationales de la Danse, Paris, 1932.

"Notzeit." Preface to the catalog of the annual exhibition of the Künstlerbund Schlesien, Breslau, 1932.

"Die Wandbilder des Folkwang-Museums." In: Sperrholz (Berlin), Vol. 4, No. 2, 1932.

"Zur Lage der heutigen Kunst." In: Die schlesischen Monatshefe (Breslau), Vol. IX, No. 4, 1932.

"Otto Meyer." In: Werk, Vol. 20, No. 3, 1933.

"Zum Geleit." Preface to the catalog of the exhibition in memory of Otto Meyer-Amden in the Kunsthaus Zurich, December, 1933–January 1934. Zurich, 1933.

"Otto Meyer-Amden." In: Werk, Vol. 21, No. 2, 1934.

"Otto Meyer-Amden. Aus Leben, Werk und Briefen." In: Johannespresse, Zurich, 1934.

"Otto Meyer-Amden (1885–1933), Persönlichkeit." In: Werk, Vol. 21, No. 3, 1934.

"Otto Meyer-Amden." In: Werk, Vol. 40, May 1953, pp. 162–163.

"Study for The Triadic Ballet." In: Museum of Modern Art, New York, Vol. 24, No. 4, 1957, p. 16 (reproduction).

Briefe und Tagebücher. Ed. by Tut Schlemmer. Langen-Müller, Munich, 1958.

"From the diaries of Oskar Schlemmer, 1921." In: Industrial Design, Vol. 7, March 1960, p. 44.

"Der Mensch." (Lectures given at the Bauhaus.) "Neue Bauhausbücher, No. 10" Kupferberg, Mainz and Berlin 1969.

Publications about Oskar Schlemmer:
Baumeister, Willi. "Oskar Schlemmer." In: I Hear America Singing. (Program of the Kammerspiele of the Stuttgarter Neues Theater. 1946.)

Thwaites, J. A. "Bauhaus Painters and the New Style-Epoch." In: Art Quarterly, Vol. 14, No. 1, 1951, pp. 19–32.

Hildebrandt, Hans. Oskar Schlemmer. Prestel, Munich, 1952. (Main work about Schlemmer with œuvre-catalog and comprehensive bibliography by Mrs. Tut Schlemmer.)

Review in: Werk, Vol. 39, June 1952, Sup. 87.

"Oskar Schlemmer und die abstrakte Bühne" (exhibition catalog). Kunstgewerbemuseum Zurich June 13–August 27, 1961; Neue Sammlung, Munich November 20, 1961–January 8, 1962.

Grohmann, Will. Intro. to "Oskar Schlemmer, Zeichnungen und Graphik." Hatje, Stuttgart, 1965 (life-work catalog).

"Schlemmer." Exhibition catalog of the Staatsgalerie Stuttgart, 1968.

Schreyer, Lothar
Publications by Schreyer:
Die neue Kunst. Berlin, 1916. Reprinted in: A. Soergel, Dichtung und Dichter der Zeit (Neue Folge: "Im Banne des Expressionismus"). Leipzig, 1926, p. 594.

Jungfrau. Berlin, 1917 (play).

Meer sehnte Mann. Berlin, 1918 (play).

Nacht. Berlin, 1919 (play).

Kreuzigung. Berlin, 1920 (play, with 77 woodcuts).

Verantwortlich. Hamburg, 1922.

Psalm 121. Lithograph published by the author, 1926.

Die Bildende Kunst der Deutschen. Hamburg, Berlin, and Leipzig, 1931 and 1948.

Das expressionistische Theater. 1948, p. 207. (Retrospective thoughts.)

Der Schauende Mensch. 1951; 2nd ed., Herder, Freiburg, 1952.

Ein Jahrtausend deutscher Kunst. Wegner, Hamburg, 1954.

Der Sturm. Ein Erinnerungsbuch an Herwarth Walden und die Künstler des Sturmkreises (ed. with Nell Walden). Berlin, 1954.

Erinnerungen an Sturm und Bauhaus. Langen-Müller, Munich, 1956; abridged ed. Paul List, Munich, 1966.

Christliche Kunst des 20. Jahrhunderts in der katholischen und protestantischen Welt. Wegner, Hamburg, 1959.

Das Christusbild und die Kunst des Zwanzigsten Jahrhunderts. Otto Müller, Salzburg, 1960

Abstrakte christliche Kunst. Ars Lithurgica Buch- und Kunstverlag, Maria Laach, 1962.

Introduction to "Kurt Schwerdtfeger." Munich, n.d. [1962].

Der Engel und sein Bild. In: Lebendige Kirche (Freiburg), No. 4, 1964.

Wagenfeld, Wilhelm
Publications by Wagenfeld:
"Glas als Gebrauchsgerät." In: Glastechnische Berichte, Vol. 12, 1934.

"Betrachtungen zur Frage der Wertarbeit bei der Glasveredelung." In: Glastechnische Berichte, Vol. 15, 1937.

"Glassimpeleien eines Qualitätsnarren." In: Deutsche Glaserzeitschrift, No. 27/28, July 6, 1938.

"Drei Jahre Aufbau und Entwicklung einer Entwurfsarbeit in der Glasindustrie." In: Glastechnische Berichte, Vol. 17, No. 8, August 1939, pp. 247–250.

"An den Rand geschrieben." Künstler in der Industrie (exhibition catalog); Städtische Kunsthalle, Mannheim, December 1941—January 1942.

Formgebung der Industrieware. Metall. Glas. Porzellan. 2nd ed. Riemerschmidt, Berlin, 1942.

Wesen und Gestalt der Dinge um uns. Verlag Stichnote, Potsdam, 1948.

"Hausrat." In: Wie wohnen (Stuttgart), 1949/1950.

Deutsches Institut für Industrielle Standardform. Ein Vorschlag. 1950 zur Diskussion gestellt. Hatje, Stuttgart, 1950.

"Vorträge." In: Gestaltete Industrieform in Deutschland, ed. by Zentralstelle zur Förderung Deutscher Wertarbeit e.V. in connection with Arbeitskreis für industrielle Formgebung im Bundesverband der Deutschen Industrie, Econ, Düsseldorf, 1954; Droste Verlag, Düsseldorf.

"Was wir brauchen." In: Die Kultur, Vol. 3, No. 51, 1955, pp. 4–5.

"Es ist nur Werkzeug." In: Die Kultur, Vol. 4, No. 59, 1956, pp. 9–10.

"Zweck und Sinn der Künstlerischen Mitarbeit in Fabriken." In: Internationaler Kongress für Formgebung, Rat für Formgebung, Information BB, September 14–21, 1957.

"Eine Glühlampe, die anders geworden ist." In: Form, No. 9, 1960.

"Eine sachverständige Jury." In: Form, No. 11, 1960.

"Gläser für Blumen." In: Form No. 18, 1962.

"Gute Form—Gute Ware?" In: Form, No. 23, 1963, pp. 25–27.

"Das Staatliche Bauhaus—die Jahre in Weimar." In: Form, No. 37, 1967, pp. 17–26.

"Industriemesse contra Museum." In: Künstler in der Industrie (exhibition catalog), Städtische Kunsthalle, Mannheim, April 1967.

Preface to Zeitgemässe Form. Süddeutscher Verlag, Munich, 1967.

Preface to Spiel mit den bildnerischen Mitteln, Vol. 7: Werkstoff Metall. Otto Maier, Ravensburg, 1967.

Publications about Wilhelm Wagenfeld:
Exhibition catalog of the Akademie der Künste. Berlin, 1962.

"Wilhelm Wagenfeld vom Bauhaus in die Industrie" (exhibition catalog). Landesgewerbeamt Baden-Württemberg, Stuttgart, 1965.

The New Bauhaus / School of Design / Institute of Design.

Selected Publications by the Institute and some of its members:
the new bauhaus chicago; prospectus. Chicago [1937–1938].

More Business, Vol. 3, No. 11, November 1938. (Special issue of the periodical prepared, written and designed by the New Bauhaus.) Partial contents: L. Moholy-Nagy, "New Approach to Fundamentals of Design," p. 4. Kepes, George, "Education of the Eye," p. 9. Bredendieck, Hin, "Lettering," p. 17.

New Bauhaus Books. Ed. by Walter Gropius and L. Moholy-Nagy. Norton, New York.

No. 1. Laszlo Moholy-Nagy, New Vision. 1938. (= 2nd English ed. of "Von Material zu Architektur." See also publications by Moholy-Nagy.)

School of Design in Chicago: prospectus [1939–1940] and 1942–1943.

ID Books (Institute of Design, Chicago). Editor L. Moholy-Nagy. Theobald, Chicago.

[1] Gropius, Walter. Rebuilding our Communities. 1945.

[2] Moholy-Nagy, Laszlo. Vision in Motion. 1947. (See also Publications by Gropius and Moholy-Nagy.)

Institute of Design; prospectus 1946 and 1948.

Ludwig Mies van der Rohe, Serge Chermayeff and Walter Gropius. Three addresses at the Blackstone Hotel, Chicago, April 17, 1950 on the occasion of the

celebration of the addition of the Institute of Design to the Illinois Institute of Technology.

Catalogs of the Institute of Design of Illinois Institute of Technology, Chicago. 1953, 1957, 1960.

Members of the I.D. / I.I.T. Manifesto, 1955 (leaflet).

The Maremont Collection at the Institute of Design, Illinois Institute of Technology, Crown Hall, April 5 through April 30. Preface to the Exhibition catalog by Katherine Kuh. Institute of Design Press, Chicago, 1961, 40 pages, ill.

I.I.T. Institute of Design. Graduate Theses Completed 1957–1966 (hectographed list).

I.I.T. Bulletin. Regular information about the Institute of Design can be found in the Illinois Institute of Technology Bulletins since 1949, when the Institute was officially annexed by the Illinois Institute of Technology. First special issue about the Institute of Design appeared in Vol. X, No. 3, 1950.

Archipenko. Fifty Creative Years, 1908–1958. By Alexander Archipenko and 50 Art Historians. Preface by Erich Wiese. Published by the author, New York, 1960, 109 pages, 292 ills.

Callahan, Harry, The Multiple Image. Chicago, 1961 (Catalog published by the Press of the Institute of Design).

Chermayeff, Serge, Comments after judging 735 Entries to the Annual Exhibition of Design in Chicago Printing. The Society of Typographic Arts, Chicago, 1948.

Chermayeff, Serge, "L'Architecture au Bauhaus de Chicago." In: L'Architecture d'Aujourd'hui, No. 28, February 1950, pp. 50–68 (French and English texts).

Chermayeff, Serge, and Christopher Alexander, Community and Privacy. Toward a New Architecture of Humanism. Doubleday, New York, 1963, 236 pages, ill.; Anchor Books Edition 1965.

Doblin, Jay, "Graduate Study at IIT's Institute of Design." In: Industrial Design, Vol. 10, March 1963, pp. 64–73, ill.

Fuller, Buckminster, Ideas and Integrities. Ed. by Robert W. Marks. Prentice-Hall, Englewood Cliffs (N.J.), 1963, 318 pages, ill.

Keck, George Fred, "The Problem of Architecture." In: Shelter, March 1938. Reprinted in: 'School of Design in Chicago' Prospectus [1939–1940].

Kepes, Gyorgy, Language of Vision. Theobald, Chicago, 1944.

_____. The New Landscape in Art and Science. Theobald, Chicago, 1956.

_____. Education of Vision ("Vision and Value"). Braziller, New York, 1965; German Ed. 1967.

The Nature and Art of Motion ("Vision and Value"). Braziller, New York, 1965.

_____. Structure in Art and in Science. ("Vision and Value"). Braziller, New York, 1965. German Ed. 1967.

_____. Module, Proportion, Symmetry, Rhythm ("Vision and Value"). Braziller, New York, 1966.

_____. Sign, Image, Symbol ("Vision and Value"). Braziller, New York, 1966.

Koppe, Richard, "The Sources of Contemporary Painting." In: Arts & Architecture (Los Angeles), October 1962, p. 14+, ill.

Koppe, Richard, "The Work of Richard Koppe." In: Arts & Architecture (Los Angeles), November 1965, p. 28+, ill.

Martin, Gordon, The Playbill. The development of its typographic style. The Institute of Design Press, Chicago, 1963, 56 pages, ill.

Moholy-Nagy, Laszlo. See Publications by and about the Masters of the Bauhaus.

Selz, Peter and Richard Koppe. "The Education of the Art Teacher." In: School Arts, April 1955.

Wachsmann, Konrad. Wendepunkt im Bauen. Krausskopf, Wiesbaden, 1959. English ed.: The Turning Point of Building, Structure and Design (tr. by Thomas E. Burton). Reinhold, New York, and Burns & McEachern, Toronto, 1961.

Publications about the New Bauhaus/School of Design/Institute of Design and some of its members:

"Chicago's Bauhaus." In: Art Digest, Vol. 11, September 1937, p. 20.

"Moholy-Nagy, Gropius, in New Chicago School." In: Architectural Record, Vol. 82, October 1937, p. 41.

"New Bauhaus." In: Architectural Forum, Vol. 67, October 1937, Sup. 22+.

"New Bauhaus." In: Art News, Vol. 36, October 1937, p. 18.

Moholy-Nagy, L. "New Bauhaus and Space Relationship." In: American Architect & Architecture, Vol. 151, December 1937, pp. 22–28.

"Bauhaus Touch: Student Exhibition." In: Art Digest, Vol. 12, August 1938, p. 27.

Benson, E. M. "Chicago Bauhaus." In: Magazine of Art, Vol. 31, February 1938, pp. 82–83.

"New Bauhaus." In: American Architecture, Vol. 152, January 1938, p. 100.

"Bauhaus Announces Faculty Appointments." In: Pencil Points, Vol. 19, September 1938, Sup. 40.

"Bauhaus Re-opens." In: Art Digest, Vol. 13, February 1939, p. 10.

"Chicago Bauhaus Reborn." In: Architectural Forum, Vol. 70, June 1939, Sup. 72.

Gaunt, W. "Great Design Experiment." In: Art and Industry, Vol. 27, August 1939, pp. 37–39.

"Moholy Explains Closing." In: Art Digest Vol. 13, January 1939, p. 27.

Moholy-Nagy, L. "New Bauhaus, American School of Design." In: Design, Vol. 40, March 1939, pp. 19–21.

"School of Design." In: Art Digest Vol. 14, January 1940, p. 27.

"Unique School of Design." In: Architect and Engineer, Vol. 140, January 1940, p. 70.

"Chicago's Bauhaus." In: Art Digest, Vol. 18, December 1943, p. 26.

Moholy-Nagy, Laszlo. "Better than Before." In: The Technology Review. Vol. XLVI, No. 1. Massachusetts Institute of Technology, Cambridge (Mass.), November 1943.

Yoder, R. M. "Are You Contemporary? Work of Moholy-Nagy." In: Saturday Evening Post, Vol. 216, July 3, 1943, pp. 16–17+.

"Form and Function: A U.S. Bauhaus." In: Art News, Vol. 44, August 1945, p. 23, ill.

"L. Moholy-Nagy Announces the Organization of a Separate Photographic School." In: Design, Vol. 48, October 1946, p. 23.

Moholy-Nagy, L. "New Education—Organic Approach." In: Art & Industry, Vol. 40, March 1946, pp. 66–77, ill.

"Chermayeff appointed Director to succeed Moholy-Nagy." In: Progressive Architecture, Vol. 28, January 1947, p. 136.

"Serge Chermayeff named acting director." In: Architectural Forum, Vol. 86, February 1947, p. 68.

Martin, J. L. "Laszlo Moholy-Nagy and the Chicago Institute of Design." In: Architectural Review, Vol. 101, June 1947, pp. 224–226.

"Institute of Design integrates Art, Technology and Science." In: Interiors (New York), Vol. 108, No. 2, Sept. 1948, pp. 142–151, ill.; Vol. 108, No. 3, Oct. 1948, pp. 134–140, ill.; Vol. 108, No. 4, Nov. 1948, pp. 118–125, ill.

"Chicago Institute of Design." In: Art & Industry, Vol. 46, June 1949, p. 234.

"Exhibition of the work of the Institute held in London by the Council of Industrial Design." In: Architectural Review, Vol. 106, September 1949, p. 198, ill.

Chermayeff, S. "L'Architecture au Bauhaus de Chicago." In: Architecture d'Aujourd'hui, No. 28, February 1950, pp. 50–68 (French and English texts).

"Institute of Design joins Illinois Tech." In: Art Digest, Vol. 24, January 1950, p. 31.

"Open House: Institute of Design in 1952." In: Arts & Architecture, Vol. 69, July 1952, pp. 16–33, ill. (special issue).

"Building for the College of Architecture, Planning and Design; L. Mies van der Rohe, Arch." In: Arts & Architecture, Vol. 71, August 1954, pp. 16–19, ill.

"IIT dedicates Crown Hall, New Design Building by Mies." In: Architectural Forum, Vol. 104, June 1956, pp. 17+, ill.

Kula, E. "Institute of Design." In: Print, Vol. 14, January 1960, pp. 49–51, ill.

McHale, John. R. Buckminster Fuller. Braziller, New York, 1962. German ed. Otto Maier Verlag, Ravensburg, 1964.

"Sculpture by Richard Koppe." In: Arts & Architecture (Los Angeles), September 1963, p. 22+, ill.

"George Fred Keck and William Keck, Architects." In: Inland Architect (Chicago), July 1965, 16 pages, ill.

"Konrad Wachsmann." With a preface by John D. Entenza, an introd. by David Travers, and an article by Wachsmann himself "Research: The Mother of Invention." In: Arts & Architecture (Los Angeles), May 1967, 28 pages, ill. Special issue.

Picture Credits

The reproduction of Bauhaus products was done with authorization of the last Director of the Institute, who according to his contract holds the rights ever since the dissolution of the Dessau Bauhaus. Permission was granted by Professor Ludwig Mies van der Rohe with the consent of Professor Walter Gropius. All work produced by the teachers and the students within the framework of the artistic, craft, pedagogic, and administrative activity are considered "products of the Bauhaus."

For permission to reproduce free artistic works that originated outside of the Institute and independent of projects devised by the Bauhaus, special thanks are due to the Bauhaus Masters and their families: Professor Josef Albers, Alfred Arndt, Herbert Bayer, Marcel Breuer, Julia Feininger, Professor Walter Gropius, Professor Ludwig Hilberseimer, Professor Johannes Itten, Nina Kandinsky, Felix Klee, Professor Gerhard Marcks, Lena Meyer-Bergner, Professor Ludwig Mies van der Rohe, Sibyl Moholy-Nagy, Professor Georg Muche, Helene Nonné-Schmidt, Brigitte Peterhans, Lou Scheper, Tut Schlemmer, Dr. Lothar Schreyer, Gunta Stadler-Stölzl.

Photographic and other materials for reproduction were generously put at the disposal of the publishers by the aforementioned Bauhaus Masters and their families and furthermore in particular by Messrs. Bogler, Hauswald, Hirschfeld-Mack, Schawinsky, Siedhoff, and Skrebba.

Valuable aid was accorded by the Bauhaus-Archiv in Darmstadt, the Busch-Reisinger Museum of Harvard University in Cambridge, Mass., the Museum of Modern Art in New York City, and also the State Art Museum (Staatliche Kunstsammlung) and the Thuringian Main Archive (Thüringisches Landeshauptarchiv), both in Weimar. Both the editor and the publishers express their deep appreciation to those named and to many who must remain unnamed.

Color plate 13 was furnished by the Museum Boymans-van Beuningen in Rotterdam, plate 14 by Colorphoto Hans Hinz in Basel, and plate 16 by the Museum of Modern Art in New York.

Plates 1-8 and 17-24 were supplied by the Württemberg Art Association (Württembergischer Kunstverein) in Stuttgart and are reproduced with their permission.

Additional illustrations were produced from old photographic prints whose origins could no longer be traced, or else directly from originals and from Bauhaus publications.

In the listing that follows, simple numbers refer to figure numbers in the documentary part (pp. 1-217); numbers followed by letters refer to page numbers and figure codes in the pictorial part (pp. 223-613).

Adams, Robert K. 603e-k, 609c, 610a-b, 611c-d.
Albers, Josef (New Haven) 244a, 532a
Bauhaus Dessau 450a, 466a-b
Baum, Klaus (Dieburg) 335b, 440a, 446b-g, 447h-m, 552a
Bayer, Irene 423d, 424a, 476a
Beckmann, Hannes (New York) 436a, 437b-e
Berliner Bild-Bericht (Berlin) 536a-c, 538b, 568a
Binnemann, R. (Dessau) 483b, 531c-d
Braun, Albert 474a
Brandt, Marianne (Berlin) 456a
Bredendieck, Hin 589b-d, 590c
Bruck & Sohn (Meissen) 322a
Busch-Reisinger Museum of Germanic Culture (Cambridge, Mass.) 250c, 277c-d, 362a, 462a, 539d, 540a-c, 541d-f
Clasen 456
Clemens, Roman (Zurich) 570a, 571b
Consemüller, Erich 403c, 404a-b, 405c, 431b, 433d, 435f, 453b, 455g-h, 458c, 460a, 470b, 473c, 475d, 504a, 506a-b
Davis Studio, George H. (Boston) 574a
Dearstyne, Howard (Chicago) 560a
Desandalo, Atelier (Brünn) 536c, 537e
Eckner, Hermann (Weimar) 241c, 242a, 279b
Engdahl, Bill, Hedrich-Blessing Studio 574b
Entzeroth, Hans (Zurich) 340a
Fayer (Vienna) 502a
Feininger, Lux (Cambridge, Mass.) 468a, 469b, 470a, 471c-d, 473d, 481e, 520a, 529b-c
Frankl (Berlin) 370a, 371c-e
Funkat, Walter (Halle-Giebichenstein) 528a
Gropius, Walter 419d-e, 420a
Haug, Arthur 578a
Hedrich-Blessing 606a
Held, Louis (Weimar) 231b-d, 232a-c, 233d-f, 234a-c, 236a, 287b
Hertig, Klaus 556a
Hollos, Ruth 475c
Homer, Henry 578b, 579c
Institute of Design in Ulm (Photograph by Ernst Scheidegger) 575c
Janda, Annagret (Berlin) 324a, 336a-b, 336d
Jonals Co. (Copenhagen) 503b
Keystone View Co. 561d-e
Koppe, Richard 580c, 581d, 584a, 588a, 590b, 591d, 593c, 600a-i, 612a-b, 613c-d
Kunsthalle Mannheim 421g
Kunst-Kabinett Klihm (Munich) 421e
Kunstmuseum Bern 266a
Lederbogen, R. (Chemnitz) 395f
Lerner, Nathan 599g-h
Lossen & Co. (Stuttgart) 534b
Ludwig, Pit (Darmstadt) 573a
Luftverkehr Stähle (Schorndorf) 534a
Meier-Ude, Klaus (Frankfurt am Main) 240b, 246b, 250a-b, 251e, 280b, 281d, 282a, 282c, 307e, 310d, 312a, 313d, 315c, 316a-b, 316d, 319c-d, 320a-b, 320d, 342a, 354a-b, 355c, 381c, 399a, 408a, 415c, 417d, 457c, 535d
Meyer-Bergner, Léna (Basel) 148, 149
Moholy-Nagy, Laszlo, 480a-c
Moholy-Nagy, Lucia (Zurich) 274a, 402a, 403d, 409c, 410a-b, 411c-e, 412a-b, 413c-d, 458a, 450e, 481d
Musche (Dessau) 416b
Museum of Modern Art (New York) 569b (photograph by Soichi Sunami)
Neumann, Eckhard 495c, 557c
NYFA 498a
Pearson, E. R. 592b, 594a-b, 595c
Peterhans, Walter 267b, 400a, 415d, 421e, 498a-c, 499d, 517g, 545a-b
Petschow, R. (Berlin) 401b
Phototek (Berlin) 396c, 397d
Rheinisches Bildarchiv (Cologne) 273b
Saurin Sorami, Kurt (Wuppertal) 246a
Schmitt, Lorenz (Darmstadt) 394c
Schmölz, H., D. W. B. (Cologne) 227a, 228b-c
Staatliche Bildstelle (Berlin) 329c
Stockmar, Paula (Weimar) 252a, 253b, 260a, 264a, 281e, 282b, 285c-e, 287d, 342b, 343c-e
Stoedtner, Franz (Düsseldorf) 224b-c, 225d-h, 228a, 241d, 243c, 318a-b
Stone, Cami (Berlin) 512b
Strauch (Halle) 364a-b
Theis (Dessau) 415c, 418b-c

Theobald, Paul, and Co. (Chicago) 583d, 590a, 591a-b, 596a, 597b-d, 598a-b, 599e, 602a-c, 606b
Thür. Landeshauptarchiv Weimar 2, 4, 5, 6, 7, 9, 10, 11, 12, 13, 15, 18, 19, 22, 23, 24, 26, 27, 36, 41, 230a, 444b
Ullstein-Bilderdienst (Berlin) 558b, 559c, 562a, 563b
Wingler, H. M. (Darmstadt) 3, 16, 21, 53, 58, 60, 66, 67, 69, 72, 227d, 243c, 251d, 290b-d, 296c, 378a-c, 379d-f, 484a, 501b, 524a, 525b-c

Index